W9-BCF-308

Women in Artists America

18th Century To The Present
(1790 - 1980)

Edited by Jim Collins & Glenn B. Opitz

Published By
APOLLO

391 South Road
Poughkeepsie, N.Y. 12601

Thanks to
Resse & Steve Greenwald
Martha Opitz
Ellen Koloski
Linda Beatty
Anne Scharfenstein

DEDICATED TO—
THE GREATEST KIDS,
ADAM AND NANCY

Published in 1973 and 1975, Revised and Enlarged in 1980.
Copyright 1980
ISBN 0-938290-00-2

Printed In Canada

Introduction

WOMEN ARTISTS IN AMERICA brings together and updates the
biographical data that J.L. Collins compiled in two earlier volumes.
His intention was to list all American artists, both men and women,
but his research revealed an alarming lack of commonplace
information about this country's women artists. The result of his new
awareness was WOMEN ARTISTS IN AMERICA: 18th CENTURY
TO THE PRESENT, a collection of biographical information on 170
years of its subject, published in 1973.

Painters, sculptors, printmakers, graphic artists and other women
working in the arts were included in Collins' book; it appears as Part
I of the present volume. In 1975 he updated the listing, concentrating
primarily on American women working at that time; this second
book appears here as Part II. Part III constitutes a recent updating.

There is, of course, more to WOMEN ARTISTS IN AMERICA than
the convenience of a biographical listing. While such a work has
value merely as a resource, the information supplied here also serves
to improve awareness. Women in the arts represent the fact of their
existence while also sometimes expressing feminist issues in a creative
context. Contemporary women artists demand a certain amount of
attention simply by their existence but also by their work.

Collins did not intend to make a political statement with his books
but, rather, to provide a source material for researchers in the arts in
general as well as in women's studies. Even the most respected classic
reference books about artists (Pliny, Vasari, etc.) neglect women's
work. While many professional women artists have risen above the
difficulties of ignorance and prejudice, it takes much time for
recognition to improve. In his 1975 introduction, Collins observed
that there has been an improvement in the image of women artists
because "there are more women who are artists [and] because these
women are more in evidence in today's American society."
Nonetheless, many barriers remain.

For centuries, women's contributions to the arts were generally
ignored. Some women artists were directly repressed while others
were simply trivialized. The net effect, however, was to minimize all
their contributions and keep them in the shadows of men's work.
Over time, some things changed, some awareness was made keener,

some artists earned attention. Mary Cassatt achieved an outstanding reputation among the 19th century Impressionists but was almost the only recognized woman artist of her time. A national exhibition in the 1970's, called "Woman Artists: 1750-1950," demonstrated to a huge general public across the United States the enormous accomplishments of women painters. In 1979, Germaine Greer published *The Obstacle Race* and made similar points in print. It is worth commenting on the odd fact that the history of art tends to be told in terms of specific and extraordinary male accomplishments yet art is usually represented, allegorically, in female terms. Perhaps eventually artists will be considered without note of their gender but simply because of their work.

In the introduction to his 1975 book, Collins paid tribute to several groups who encourage awareness of women's participation in the arts based on their work rather than their sex. Organizations such as Women's Interart Center, Inc., Ad Hoc Women Artists, AIA Task Force on Women, Women's International Network, Women's Art Center, and publications such as "Feminist Art Journal of Liberation," "Women Artists' Newsletter," and "Art Workers News," all work steadily and tirelessly.

The women artists included in this volume were the main sources of information on themselves. They also provided illustrations, some of which are included. The work shown reveals clearly the variety of individual styles and skills of women artists. Some work represents what art critic Barbara Rose calls "Vaginal Iconology," a deliberate attempt to outrage and bring attention to what its practitioners believe to be the plight of women. Other work, however, represents essentially genderless art, work produced by artists who simply happen to be women and which treats subjects of no particular sexual import. All the work deserves attention just because it is being produced and therefore exists within the framework of American Art.

And that, after all, is the point. Women artists can create works of aesthetic value and integrity. They are part of the history of art and should be recognized as such. WOMEN ARTISTS IN AMERICA heightens awareness of women's participation while also being a welcome and useful reference tool.

Anne Bel Geddes
Poughkeepsie, New York

While researching art and antiques for business purposes, I discovered that volumes I and II were an incomplete index of woman artists. I realized the need to expand this invaluable source of reference. In doing so, I have sought to incorporate all women artists who were neglected in the preceeding volumes. Volume III is dedicated solely to women of the Twentieth Century, primarily contemporary artists, whose art has finally become accepted and appreciated.

As each new artist gains recognition in the art world, our index becomes larger and more detailed. I sincerely hope that this newly found well of information and awareness continues to grow, creating the need for a fourth volume of *Women Artists In America*.

Glenn B. Opitz

SECTION
I

INTRODUCTION

Jim Collins set himself a staggering and long overdue task in the compilation of WOMEN ARTISTS IN AMERICA. He did not set out to present the material here enclosed. His original intention was to do a comprehensive book on American Artists, their sex being of no special moment. The work took its present form after a lengthy period of research which brought to his attention a vast body of creative people who had, therefore, never been assembled. He became convicted that an index of American women artists (dating from 1790 to today) would be of inestimable value to professionals in the field and to the lay public. Mr. Collins' insatiable curiosity and interest in women artists of America motivated him to publish this accounting.

The artists listed are either American by birth or best known by work done in this country. The roll includes painters, sculptresses, printmakers and, occasionally, a designer of ceramics. They number four thousand, a sizable portion of all who have contributed to our national artistic heritage. It is irrefutable that much excellence has been passed over by lack of interest and historical research on the group.

Surely, this book is a tribute to a group and a convincing answer to those uninformed interrogators who keep asking: "Why are there so few 'good' women artists?"

Mr. Collins offers the information he has gleaned, succinctly and tersely, that American women artists have been around for a long time, creating works of integrity and aesthetic value. He does not ask for your agreement or disagreement that these people have functioned as artists.

I am convinced the author's main interest does not lie in championing a cause, but rather in introducing or reintroducing to the world, an arresting assemblage of artists. While doing the extensive research vital to his kind of inquiry, Mr. Collins was too often frustrated by lack of definitive information. It is hoped that with WOMEN ARTISTS IN AMERICA as a reference book, other historians will become sufficiently aroused and will delve deeper into the rich reserve of art produced by American women artists.

WOMEN ARTISTS IN AMERICA is the only book of its kind. And it is timely now as it would have been 50 years ago. However, the need for such a source book is greater today than ever before, because the doors are opening wider and wider for the talents of women, and soon those portals will be ajar.

Ida Kohlmeyer

New Orleans
February, 1973

THIS SYMBOL BY AN ARTIST'S NAME INDICATES HER WORK IS ILLUSTRATED.

AARON, May Todd. Painter. Born: LaCelle, Iowa. Studied: Art
Institute of Chicago and in Paris, France with Andre L'Hote.
Collections: Pennsylvania Academy of Fine Arts; Hugo Gallery,
New York; Art Club of Chicago; National Association of Women
Artists in Paris; Philbrook Art Center; University of
Oklahoma.

ABADI, Fritzie. Painter. Born: Allepo, Syria in 1915. Studied:
Art Students League of New York and with Nabum Tschucbasov.
Awards: National Association of Women Artists, 1949, 1950.
Collections: Butler Institute of American Art

ABBATT, Agnes Dean. Painter. Born 1847 and died 1917.
Studied: Cooper Union and the National Academy of Design.
Awards: Cooper Union, and first prize at San Antonio, Texas.
Noted for paintings of Landscapes and flowers in oil and
watercolor. Elected member of National Academy in 1902.

ABBE, Elfriede Martha. Sculptor and Illustrator. Born:
Washington, D. C. in 1919. Studied: Cornell University
and Syracuse University. Awards: Cornell University, 1938,
1940; Tiffany Foundation Fellowship, 1948. Collections:
World's Fair, New York, 1939; Memorial panels, Ellis Room,
Wiegand Herbarium, 1953 and Mann Library, 1955, Cornell
University and Boston Museum of Fine Arts.

ABBEY, Iva L. Painter. Born: Chester, Conn. in 1882.
Studied: With Hale, Benson, and C. J. Martin.

ABBEY, Rita Deanin. Painter. Born: Passaic, New Jersey in
1930. Studied: Goddard College; Art Students League
(Woodstock, New York); University of New Mexico, New York
University; Hans Hofmann School of Art.

ABBOTT, Agnes Anne. Painter. Born: Potsdam, Germany, 1897.
Studied: School of Fine Arts and Crafts, Boston, with C.
Howard Walker and Katherine B. Child. Collections: Boston
Museum of Fine Arts and Fogg Museum of Art. Exhibited:
Mainly in Northeastern United States.

ABBOTT, Anne Fuller. Painter. Born: Brandon, Vermont.
Studied: with William M. Chase and the National Academy
of Design; Art Students League and Corcoran School of Art.
Collection: Navy Department, Washington, D. C.

ABBOTT, Edith Abigail. Painter. Born: Randolph, Vermont.
Studied: University of Vermont; Mt. Holyoke College and
Columbia University. Awards: Clearwater, Florida 1941;
Rockport, 1942; Daytona Beach Art Association, 1944.

ABBOTT, Eleanore P. Painter. Born: Lincoln, Maine in 1875.
Studied: Pennsylvania Academy of Fine Arts and Simon and
Cottet in Paris.

ABBOTT, Emily. Painter. Born: Minneapolis, Minnesota in 1900. Studied: University of Minnesota; Minneapolis School of Art. Awards: Minnesota State Fair, 1937; Minneapolis Institute of Art, 1938, 1944. Collections: Walker Art Center. Exhibited mostly in the Minneapolis area.

ABDY, Rowena Meeks. Painter. Born: Austria in 1887 of American parents. Came to San Francisco. Studied: with Arthur F. Mathews. Awards: California Museum of Art, 1920. Exhibited: Pennsylvania Academy of Fine Arts.

A'BECKET, Maria J. C. Painter. Born: Portland, Maine and died in 1904. Studied: White Mountains with Homer Martin in 1865 and with William Hunt in Boston 1875-1878. She exhibited in Boston, Baltimore, Philadelphia and Washington and has traveled in France.

ABEL, Louise. Sculptor. Born: Widdern, Wurttemberg, Germany in 1894. Studied: Cincinnati Art Academy; Art Students League; Kunstgewerbe Schule, Stuttgart. Awards: fellowship, Tiffany Foundation; Julian Bechtold award, 1955. Collections: Cincinnati Museum Association: Employees Country Club, Endicott, New York; Trail Side Museum, Cincinnati. Exhibited: widely in Ohio.

ABELL, Margaret Noel. Sculptor. Born: New York City in 1908. Studied: Art Students League; Breckenridge School, Gloucester, Massachusetts and with Alexander Archipenko. Exhibited in Eastern United States.

ABLE, Louise. Sculptor in pottery. Born: Mt. Healthy, Ohio in 1894. Studied: Cincinnati Art Academy.

ABRAMOVITZ, Carrie. Sculptor. Born: New York City in 1913. Studied: Brooklyn College and Columbia University. Lived in Paris 1962-63. Awards: Morrison medal, Oakland Museum in 1960. Exhibited: Mostly in San Francisco area.

ABRAMS, Ruth. Painter. Born: New York City in 1912. Studied: Columbia University; Art Students League; New York School for Social Research; and with Wallace Harrison. Collections: Carnegie Institute, Pittsburgh; George Walter Vincent Smith Art Museum, Springfield, Massachusetts. Exhibited: Extensively in the United States.

ABRAMSON, Rosalind. Painter. Born: Norfolk, Virginia in 1901. Studied: Art Students League of New York, with Henri and Bellows.

ACHESON, Alice. Painter and illustrator. Born: Charlevoix, Michigan in 1895. Studied: Wellesley College; Boston Museum of Fine Arts School. Collection: Watkins Gallery, Washington, D.C. Exhibited extensively in the Washington, D. C. area.

ACHESON, Georgina Elliott. Noted for her miniature and watercolors. She was exhibiting in 1924.

ACHNING, Estellyn Allday. Painter. Born: Atlanta, Texas in 1909. Studied: Colorado Springs Fine Arts Center; University of New Mexico and with Andrew Dasburg, Charles Rosen and Henry McFee. Exhibited in Texas.

ADAMS, Alma C. Painter. Born: Custer City, Oklahoma in 1907.

ADAMS, Mrs. J. G. Painter. Worked as a portrait painter during the years 1856, 1859 and 1860.

ADAMS, Jean Crawford. Painter. Born: Chicago, Illinois. Studied: Art Institute of Chicago with George Bellows and John Vanderpoel. She has exhibited in many major museums in the United States.

ADAMS, Katharine Langhorne. Painter. Born: Plainfield, New Jersey. Studied: Art Students League. Awards: National Association of Women Artists, 1936; Junior League, Alexandria, Virginia, 1957. Collections: Art Institute of Chicago; Pennsylvania Academy of Fine Arts.

ADAMS, Margaret Boroughs. Painter. Born: Austin, Texas. Studied: University of Texas; Newcomb College, Tulane University; Columbia University; New York School of Fine and Applied Arts. She has been actively exhibiting since 1936.

ADAMS, Marjorie Nickles. Painter. Born: Shippensburg, Pennsylvania. Studied: Shippensburg Teachers College; Philadelphia Museum School of Industrial Art; Pennsylvania Academy of Fine Arts; Chester Springs Academy of Fine Arts. Awards: fellowship, Pennsylvania Academy of Fine Arts, 1922, 1923. Cresson traveling scholarship for study in Europe, 1924; Philadelphia Plastic Club, 1929. Collections: In the United States and abroad.

ADAMS, Marjory. Studied: with John J. Baumgartner in San Francisco; University of Kansas; and with Eliot O'Hara and Frederic Taubes, New York City. Her husband was head of the 20th Century Fox Art Department until his death. Award: Annual Allied California Exhibition.

ADAMS, Velma. Lithographer. Born: Fruita, Colorado in 1902.
Studied: Los Angeles County Art Institute; Art Students
League; Grand Central School of Art; and with George Biddle,
F. Tolles Chamberlin and Leo Katz. Awards: Ebell Annual,
1939, 1948; California Art Club, 1940, 1947; Los Angeles
County Art Institute, 1941, 1942, 1943, 1945; Southern
Printmakers, 1941; Women Painters of the West, 1944;
National League of Pen Women, 1949. Collections: Southwest
Museum, Los Angeles; Appalachian Museum of Art, Mt. Airy,
Georgia; Los Angeles Museum of Art; Triptych, United States
Navy.

ADAMS, Winifred Brady. Painter. Born: Muncie, Indiana in
1871. Studied: Drexel Institute, Philadelphia. Noted for
her still-life paintings.

ADDELSTERREN, Mrs. L. E. Painter. Working around 1830.

AGATE, Miss H. Painter. A landscape painter working in 1833.

AHRENS, Ellen Wetherald. Painter. Born: Baltimore, Maryland
in 1859. Awards: Pennsylvania Academy of Fine Arts;
Carnegie Institute, Pittsburgh. She was noted for portraits
and miniatures.

AIMAN, Pearl. Painter. She was exhibiting her work in
1920 at the Pennsylvania Academy of Fine Arts.

AKED, Aleen. Painter. Born: in England. Studied: Ontario
College of Art; Ringling School of Art; and with Sydney
March, Abbott Graves and Robert Brackman. Awards: Ontario
College of Art; Ringling Museum of Art, 1938. Exhibited
widely in Canada and New York.

AKIN, Mrs. The alleged wife of James Akin. She worked
in Newburyport, Massachusetts in 1806-1808.

ALBEE, Grace. Engraver. Born: Scituate, Rhode Island in
1890. Studied: Rhode Island School of Design and with
Paul Bornet in Paris. Awards: National Academy of Design;
Providence Art Club; Society of American Graphic Artists,
1951; Connecticut Academy, 1955, 1958; Hunterdon County
Art Center, 1958; Boston Printmakers; Audubon Art; Artists
fellowship. Collections: Metropolitan Museum of Art;
Carnegie Institute; Cleveland Museum of Art; Oklahoma
Agricultural and Mechanical College; John Herron Art
Institute; Rhode Island School of Design; Library of Congress;
National Museum, Stockholm; National Academy of Design;
Philadelphia Museum of Art; Cleveland Printmakers Club;
Marblehead Art Association; New York Public Library;
Newark Public Library; Boston Public Library; Culver
Military Academy; National Museum, Israel; Collection of
King Victor Emmanuel, Italy.

ALBRIGHT, Gertrude P. Painter. Born: England. She is in the collection of the City of San Francisco.

ALCOT, May. Painter. Born: Concord, Massachusetts in 1840 and died in 1879. Studied: Boston School of Design and studied abroad. Worked in Boston, London and Paris. Noted for her still-life painting.

ALEXANDER, Francesca or Esther Frances. Painter. Born: in 1837 and died in 1917.

ALEXANDER, (Sara) Dora Block. Painter. Born: Suwalki, Poland in 1888. Studied: with Charles Reiffel and Ruby Usher. Awards: Women Painters of the West, 1949; California Art Club, 1955. Collection: Federated Womens Club collection.

ALEXANDER, Frances B. Painter. Born: Moreland, Georgia in 1911. Studied: University of Georgia; High Museum of Art School. Awards: High Museum of Art, 1944. Collection: mural,Grady Hospital, Atlanta, Georgia.

ALEXANDER, Mary Louise. Studied: with Duveneck and Meakin. Active in the Cincinnati area.

ALEXANDER, Nina. Painter. Born: Auburn, Kansas. Studied: Pennsylvania Academy of Fine Arts; and with Chase and Henri.

ALLAIRE, Louise. Painter.

ALLAN, Mrs. Charles. Painter. Born: Detroit, Michigan in 1874.

ALLEN, Agnes. Painter. Born: in Philadelphia in 1897. Studied: Pennsylvania Academy of Fine Arts; University of Pennsylvania; Barnes Foundation and with Clinton Peters, Frank Linton and Hobson Pittman. Awards: Pennsylvania Academy of Fine Arts, 1947; National League of American Pen Women, 1948, 1953, 1955. Collections: State portraits in Schuylkill, Pennsylvania; American Oncologic Hospital and University of Pennsylvania.

ALLEN, Anna Elizabeth. Painter. Born: Worcester, Massachusetts in 1881. Studied: Massachusetts School of Art; Ogunquit, Maine with Charles Woodbury; Gloucester, Massachusetts with Hugh Breckenridge. Awards: Boothbay Harbour, Maine; Daytona Beach, Florida, 1945. Collections: Carnegie Library; Turner Falls, Massachusetts; Methodist Church, Titusville, Florida.

ALLEN, Anne Huntington. Painter. Born: in New York in 1858. Studied: Cooper Institute with Eaton and Carolus Duran.

ALLEN, Greta. Painter. Born: Boston, Massachusetts.
Studied: with DeCamp Benson. Known as a portrait painter.

ALLEN, Hazel Leigh. Sculptor. Born: Morrilton, Arkansas
in 1892. Studied: Art Institute of Chicago; and with
Ferdinand Koenig. Exhibited in Milwaukee as early as
1923.

ALLEN, Louise. Sculptor. Born: Lowell, Massachusetts.
Studied: Rhode Island School of Design; Boston Museum of
Fine Arts. Collections: Cleveland Museum: World War
Memorial, East Greenwich, Rhode Island; World War tablet,
Gloucester, Massachusetts; Memorial tablet, Brancroft Hall,
Annapolis, Maryland.

ALLEN, Maria W. Noted for crayon drawings and monochromatic
printing. Worked around 1855.

ALLEN, Marion B. Painter. Born: Boston, Massachusetts in
1862. Studied: School of Boston Museum of Fine Arts.
Noted for her portraits.

ALLEN, Margo. Sculptor. Born: Lincoln, Massachusetts in
1895. Studied: Boston Museum of Fine Arts; British
Academy, Rome. Award: Delgado Museum of Art. Collections:
Busts, bas-reliefs, U.S. Frigate "Constitution"; HMS
"Pragon"; Cohasset War Memorial; Church, Winchester,
Massachusetts; Clearwater Art Museum; Butler Art Institute;
Cincinnati Museum Association; Von Pagenhardt Collection;
Museum of New Mexico, Santa Fe; National Museum, Mexico
and Dallas Museum of Fine Arts.

ALLEN, Mary Coleman. Painter. Born: Troy, Ohio in 1888.
Studied: Cincinnati Art Academy; American Society of
Miniature Painters; Art Students League. Collections:
Brooklyn Museum; Dayton Art Institute.

ALLEN, Miss. Crayon Portraitist working in Philadelphia
in the mid 19th Century. Noted for her portraits in
crayons.

ALLEN, Patricia. Painter. Born: Old Lyme, Connecticut
in 1911. Studied: Rollins College; Art Students League;
and with George B. Burr and Malcolm Fraser. Exhibited
extensively in the United States.

ALLEN, Sara Lockhart. Painter. Born: Salem, Massachusetts
in 1793 and died in 1877. Known for her miniatures and
portraits in crayons.

ALLER, Gladys. Painter. Born: Springfield, Massachusetts in 1915. Studied: Otis Art Institute; Choninard Art Institute; Art Students League and with George Grosz. Awards: California Watercolor Society, 1936; Los Angeles Museum of Art, 1942. Collection: Metropolitan Museum of Art.

ALLIS, Genevieve. Painter. Born: in 1864 and died in 1914.

ALTSCHULE, Hilda. Painter. Born: Russia. Studied: Hunter College; Cornell University. Awards: Rochester Memorial Art Gallery, 1935, 1940, 1942, 1944; Albright Art Gallery, 1939; Lillian Fairchild Award, Rochester, 1945; Finger Lakes Exhibition, 1950; New York State Exhibition, Syracuse, 1950; Cortland Fair, 1953. Collection: Rochester Memorial Art Gallery and in private collections in United States and Canada.

ALTORFER, Gloria F. Born: Peoria, Illinois in 1931. Has collections in seven states and exhibited in many shows.

ALTVATER, Cathy. Painter. Born: Little Rock, Arkansas in 1907. Studied: Art League of Long Island. Awards: Over 60 awards including 20 first prizes. Collections: in museums in United States, Europe, Japan, Canada and South America.

ALVAREZ, Mabel. Painter. Born: in Hawaii. Studied: with Cahill and McBurney. Awards: California Exposition, San Diego, 1916; California Art Club, 1918, 1919, 1933. Federation of Women's Club, 1923; Laguna Beach Art Association, 1928; Ebell Club, 1933-1935; Honolulu Print-makers, 1939; Oakland Art Gallery, 1838; Madonna Festival, Los Angeles, 1954. Palos Verdes Annual, 1957. Collections: Honolulu Art Academy; San Joaquin Museum; University of Southern California.

ALVORD, Muriel. Painter. Born: Goshen, Connecticut. Studied: Yale University and with Wayman Adams and Arthur J. E. Powell. Awards: Beaux-Arts Institute of Design; Meriden Art and Crafts Exhibition, 1944; Salisbury popular prize, 1945. Exhibited widely throughout New England.

AMES, Frances. Painter. Born: Massina, New York in 1868. Studied: with Chase and in Paris. Known as a portraitist.

AMES, Maria. Artist. Born: about 1836.

AMES, Sarah Fisher. Sculptor. Born: Lewis, Delaware in 1817 and died in 1901. Studied: in Boston and Rome. Noted for her presidental portrait busts. In particular the one of President Lincoln with whom she was personally acquainted.

ANDERSON, Alma. Painter. She has exhibited in the Northwest Annual Exhibition, Seattle Art Museum.

ANDERSON, Dorothy V. Painter. Born: Oslo, Norway.
Studied: Art Institute of Chicago; and with Chase. Awards:
Springfield, Illinois; Los Angeles Museum of Art, 1937.
Collections: Vanderpoel College. Exhibited widely in the
United States and Europe.

ANDERSON, Ellen G. Painter. Born: Lexington, Virginia.
Studied: with Charles Guerin; and in Paris.

ANDERSON, Emily Delia. Painter. Born: Gloucester,
Massachusetts in 1899. Studied: Massachusetts School of
Art; School of Practical Art, Boston. Exhibited in the
Boston area.

ANDERSON, Genevieve Dillaye. Painter. Born: Avon, New
York in 1900. Studied: Skidmore College; Columbia University
Hillyer College; University of Guadalajara, Mexico;
University of Hawaii; Alfred University, New York. Award:
Connecticut Watercolor Society, 1944.

ANDERSON, Martha Fort. Painter. Born: Macon, Georgia.
Studied: Piedmont College; Boston Museum of Fine Arts
School; Art Students League. Collections: University
of Alabama; University of Pennsylvania; St. Paul's
Church, Richmond, Virginia; Lakeview Library, Birmingham,
Alabama; Federal Building, Fairfield, Alabama; Fulton
County Court House; New York Public Library and University
of Georgia.

ANDERSON, Ruth A. Painter. Born: Carlisle, Pennsylvania.
Studied: Pennsylvania Academy of Fine Arts.

ANDERSON, Ruth Bernice. Painter. Born: Indianapolis,
Indiana in 1914. Studied: John Herron Art Institute;
Awards: Allied State Exhibition, Tucson, Arizona, 1937;
L. S. Ayers and Company award, 1954; Edward Gallahue prize,
1955. Collections: Daily Memorial Collection, Indiana
University; DePauw University.

ANDERSON, Sophie. Painter. Born: in France and came to
the United States in 1849. Noted for portraits and landscapes.

ANDREWS, Helen F. Painter. Born: Farmington, Connecticut in
1872. Studied: Art Students League; and in Paris.

ANDREWS, M. Minnigerode. Painter. Born: Richmond, Virginia
in 1869. Studied: with Andrews and Chase. Collection:
University of Virginia.

ANDREWS, Mariette. Painter. Born: in 1869. Noted for her
watercolor paintings.

ANDRUS, Vera. Painter. Born: Plymouth, Wisconsin. Studied:
University of Minnesota; Art Students League; and with
Boardman Robinson and George Grosz. Awards: Minneapolis
Institute of Art, 1928; Westchester Federation of Women's
Club, 1954; Albert H. Wiggins Memorial prize, National
Association of Women Artists, 1941. Collections: Library
of Congress; Minneapolis Institute of Art; Boston Museum
of Fine Arts; Smithsonian Institute.

ANNAN, Alice H. Painter. Born: New York. Studied: Art
Students League and with Snell and Ben Foster.

ANSHUTZ, Elsa Martin. Painter. Born: Pittsburgh,
Pennsylvania. Studied: Cleveland School of Art; Boston
Museum of Fine Arts. Had several one-man shows in the
Northeast.

ANTHONY, Elizabeth Mary. Painter. Born: New York City.
Studied: National Academy of Design; with Charles
Hawthorne; New York University. Collections: Bergen County
Historical Museum; mural, Pollack Hospital Chapel, Medical
Center, Jersey City, New Jersey, 1955.

APEL, Marie. Sculptor. Born: England in 1888. Collections:
Langdon Memorial, Augusta, Georgia; Hodges Memorial,
St. Paul's, Baltimore, Maryland.

APPEL, Marinne. Painter. Born: New York in 1913. Studied:
Woodstock School of Painting. Awards: Keith Memorial,
Woodstock Art Association, 1938; Carville, Louisiana, 1940;
Dutchess County Fair, 1935. Collections: Metropolitan
Museum of Art; Marine Hospital, Carville, Louisiana;
United States Post Offices, Middleporte, New York and
Wrangell, Alaska.

APPLETON, Eliza B. Sculptor. Born: in 1882. Studied: in
Rome with M. Ezekiel.

ARCHAMBAULT, A. Margaretta. Painter. Born: Philadelphia,
Pennsylvania. Studied: Pennsylvania Academy of Fine Arts;
Julian Academy. Noted for miniature paintings and portraits.
Collection: of the White House, Washington, D.C.

ARCHER, Dorothy G. Painter. Born: in Virginia in 1919.
Has exhibited in Hawaii and Texas.

ARMS, Winifred Lefferts. Painter. Born: Newtonville,
Massachusetts in 1903. Studied: Pratt Institute Art School;
National Academy of Design; Tiffany Foundation. Awards:
Tiffany Foundation fellowship, 1925; National Art Club, 1931,
1933, 1936.

ARMSTRONG, Barbara. Painter. Born: Bellaire, Ohio in 1896. Studied: with Hamilton E. Field.

ARMSTRONG, Carolyn Faught. Painter. Born: Asbury Park, New Jersey in 1910. Studied: Philadelphia School of Art and Pennsylvania Academy of Fine Arts. Collections: Springhouse School; Pennsylvania Academy of Fine Arts. Exhibited extensively in 1940 and 1950.

ARMSTRONG, Estelle M. Painter. Exhibiting her work in 1924.

ARMSTRONG, Helen Maitland. Painter. Born: Florence, Italy in 1869. Studied: Art Students League. Known as a mural painter.

ARNETT, Eleanor. Painter. Born: Philadelphia, Pennsylvania in 1895. Studied: Hans Hofman School of Art, Munich, Germany; Pennsylvania Academy of Fine Arts; Awards: Society of Four Arts, Palm Beach, Florida.

ARNOLD, Clara M. Painter. Born: East Providence, Rhode Island. Noted for her flower and fruit paintings.

ARP, Hilda. Collections: Norfolk Museum, Norfolk, Virginia; Wagner College, New York. Also in many collections in Europe.

ASAWA, Ruth (Lanier). Sculptor. Born: Norwalk, California in 1926. Studied: Milwaukee State Teachers College; Black Mountain College with Josef Albers. Exhibited since 1952.

ASCHER, Mary G. Painter. Born: Leeds, England. Studied: College City of New York; New York University; Grand Central School of Art; Art Students League. Awards: gold medal of honor, Painting and Sculpturing Society of New Jersey, 1958. Collections: Ein Harod Museum, Israel; National Collection of Fine Arts; Smithsonian Institute; Norfolk Museum of Fine Arts and U. S. National Museum of Sports, New York City.

ASHER, Lila Oliver. Painter. Born: Philadelphia, Pennsylvania in 1921. Studied: Philadelphia Museum School of Art. Collection: Howard University and Barnett Aden Gallery; Corcoran Gallery of Art. Executed 3600 portraits of Servicemen in Army and Navy Hospitals for USO. Exhibited in Philadelphia and Washington, D. C. area.

ASHTON, Ethel V. Painter. Born: Philadelphia, Pennsylvania. Studied: Moore Institute Art Science and Industry; Pennsylvania Academy of Fine Arts. Awards: Philadelphia Sketch Club, 1937, 1945; DaVinci Alliance, 1943; fellowship, Pennsylvania Academy of Fine ARts, 1943, 1945; gold medal, DaVinci Society, 1955; Charles K. Smith prize, Woodmere Art Gallery, 1956. Collection: mural, United States Post Office, Tunkhannock, Pennsylvania.

ASKENAZY, Mischa. Painter. Born: Odessa, Russia in 1888.
Studied: National Academy of Design; France and Italy.
Awards: Oakland Art Museum, 1952; M. H. deYoung Museum
of Art, 1950, 1952, 1955; Laguna Beach Art Association,
1951-1953. California Art Club 1951-1955;

ASMAR, Alice. Awards: Ancona, Italy-Biennale Della Regioni
International Platform Association, Washington, D. C.
Huntington Hartford Foundation. Collections: Huntington
Hartford Museum, New York. Many public and private collections
throughout Europe and the United States.

ATKIN, Mildred Tommy. Painter. Born: New York, City.
Studied: Metropolitan Art School and with Winold Reiss
and Arthur Schweider. Collections: Washington County
Museum of Fine Arts, Hagerstown, Maryland; Robert Hull
Fleming Museum, Burlington, Vermont; Georgia Museum of
Art, Athens, Georgia.

ATKINS, Florence Elizabeth. Sculptor. Noted for exhibiting
animal sculpture in 1921.

ATKINSON, Alica. Painter. Born: Brookline, Massachusetts
in 1905. Studied: Boston Museum of Fine Art School; Art
Students League of New York; Fontainebleau School of Art.
Awards: Junior League Exhibition, Boston, 1931; Fitchburg
Art Association, 1947; South County Art Association, 1954
1958; Merrimac Valley Exhibition, 1953. Exhibited widely
in the United States and Paris.

ATKINSON, Mary B., Artist. Born: 1830.

ATKINSON, Ruth M. Painter. Born: Hazelhurst, Mississippi
in 1914. Studied: Mississippi State College for Women;
Southwest Junior College. Awards: Allison A. Colony,
1953-1955; Mississippi Art Association, 1956. Collections:
murals, Church of God, McComb, Miss; Progressive Bank,
Summit, Mississippi. Exhibited predominately in South.

ATTRIDGE, Irma Gertrude. Painter. Born: Chicago, Illinois
in 1894. Studied: Chouinard Art Institute. Awards: Los
Angeles Museum of Art, 1944; Los Angeles Public Library,
1943, 1946; Whittier Art Association, 1954; City Hall,
Los Angeles, 1953, 1954; Los Angeles Greek Theatre, 1951;
Bowers Memorial Museum, 1952; Frye Museum, Seattle,
Washington, 1957. Collection: USO portraits, Army Hospitals,
Italy.

ATTWOOD, Miss. E. H. Painter. Active in New York City in
1845. Noted for her watercolors.

AUBERT, Mrs. Paul. Painter. Active in San Francisco in the
mid 19th Century. Noted for portraits and watercolor paintings.

AUBERY, Jean. Painter. Born: in 1810 and died in 1893.
Noted for her religious paintings and portraits.

AUCHMOODY, Elaine Plishker. Painter. Born: New York City
in 1910. Studied: Traphagen School of Design; Grand
Central School of Art; Art Students League. Awards:
Parkersburg Fine Arts Center; Painters and Sculptors
Society, New Jersey; Douglaston Art League; Great Neck Art
Association. Collection: Dayton Art Institute.

AUD, Roxie Hunt. Painter. Studied: Morehead University,
Morehead, Kentucky; George Peabody College, Nashville,
Tennessee. Awards: Annual Jury Show, Rockford, Illinois.

AUNIO, Irene. Painter. Born: Finland in 1919. Studied:
Art Students League. Awards: National Association of Women
Artists, 1952, 1958; Pen and Brush Club, 1953; Ranger purchase
prize, National Academy of Design, 1953; Catherine L. Wolfe
Art Club, 1955, 1957; Art Students League, Johnson Merit
scholarship, 1954-55; Michael Engel award,1958. Collections:
Art Students League; National Academy of Design; Seton Hall
University.

AURNER, Kathryn Dayton. Painter. Born: Iowa City, Iowa.
Studied: State University of Iowa; Carnegie Institute;
University of Wisconsin. Exhibited widely throughout the
United States. Frequent contributor to art magazines and
newspapers during 1950.

AUSTRIAN, Florence H. Painter. Born: Baltimore, Maryland
in 1889. Studied: Goucher College with Charles Hawthorne.
Awards: Medal, Maryland Institute, 1931; Municipal Museum,
Baltimore, 1945; News-Post-Century Theatre prize.
Collection: Municipal Museum, Baltimore.

AVERY, Frances. Painter. Born: Kitchner, Ontario, Canada.
Studied: Wicker's School Fine Arts, Detroit, Michigan; Art
Students League. Awards: Yolens Interiors award for
Contemporary Oil, Silvermine Guild, 1956. Collection:
Georgia Museum of Art, Athens.

AVERY, Hope. Painter. Portraitist active in 1924.

AVLON-DAPHNIS, Helen. Painter. Born: New York City in 1932.
Studied: Hunter College. Awards: Scholarship, Brooklyn
Museum School; Colorado Springs Fine Arts Center. Exhibited
in various museums and galleries in the United States.

AYRES, Martha Oathout. Sculptor. Born: Elkader, Iowa in
1890. Studied: Carleton College. Awards: Art Institute of
Chicago, 1914; Los Angeles County Fair, 1915. Collection:
Forest Lawn Cemetery, Glendale, California. Statues and
bas-relief in many high schools and colleges in the United
States.

BAAR, Marion. Painter. Born: New York City in 1899.
Studied: Art Students League with Frank Dumond, Johansen
and Henri; in France with Charreton; College of Mount St.
Vincent. Awards: John W. Alexander prize for portraiture;
the Johansen and Henri scholarships.

BABCOCK, Elizabeth (Jones). Painter. Born: Keokuk, Iowa
in 1887. Studied: with Duveneck and Chase; Cincinnati
Academy of Art; Art Students League; Fontainebleau, France.
Collections: murals, Marine Hospital, New York; Triptychs,
Army and Navy Hospitals.

BABOT, Amy W. Painter. She was exhibiting in 1924.

BACA, Catherine Eaton. Painter. Born: Oakland, California
in 1907. Studied: California College of Arts and Crafts.
Awards: Santa Cruz, California, 1948; Oakland Art Gallery,
1952. Noted specifically for her water colors.

BACH, Florence J. Painter. Born: Buffalo, New York in 1887.
Studied: with William M. Chase and DuMond.

BACHE, Martha Moffett. Painter. Born: Flint, Michigan in
1893. Studied: Pratt Institute Art School; Art Institute of
Chicago; Chicago Academy of Fine Arts; University of Michigan.
Awards: Garfinckels, Washington, D. C. 1936; Georgetown
Gallery, 1939; American Artists Professional League, 1950,
1957; Miniature Painters Sculptors and Gravers, 1956;
Washington D. C. 1956, 1958; Art and Music Center, Bethesda,
Maryland.

BACHMURA, Barbara Lee. Painter. Born: Detroit, Michigan in
1925. Studied: Wayne University; University of Mexico;
Mexican Art Workshop; University of Oslo. Award: Fulbright
Award, 1952. Collections: Wayne University; Denison
University; Motive Magazine; Vanderbilt Hospital; Nashville
Art Guild, Nashville, Tennessee; Crandall Art Gallery,
Alliance, Ohio.

BACHRACH, Gladys Wertheim. Painter. Born: New York City in
1909. Studied: Columbia University. Award: Florida Southern
College, 1952. Collection: Florida Southern College.

BACIGALUPA, Andrea. Painter. Born: Baltimore, Maryland
in 1923. Studied: Maryland Institute of Fine Arts with Jacques
Maroger; Art Students League; Academia di Belli Arti,
Florence, Italy with Ottone Rosai; American University,
Biarritz, France, 1945; Alfred University. Awards: Maryland
Institute of Fine Arts, 1950. Collections: Murals, St. Stanley
Catholic Church, Coatesville, Pennsylvania, 1950; Santa Fe,
1955.

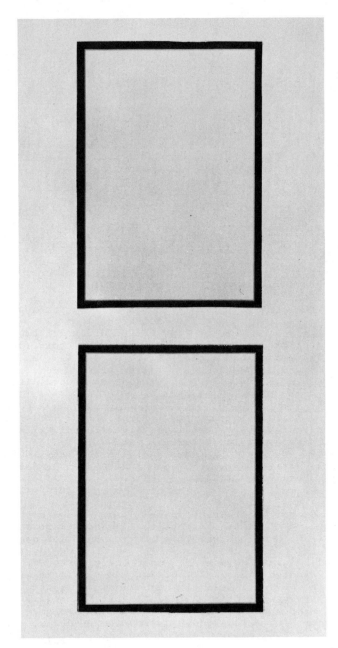

Jo Baer, HORIZONTAL FLANKING, 1966. The Solomon R. Guggenheim
Museum.

BACKSTROM, Florence J. Painter. Born: New York City.
Studied: Pennsylvania Academy of Fine Arts; Art Students
League. Award: Garden State Plaza, gold cup.

BACON, Mary Ann. Painter. Born: in 1787. Noted for her
watercolor paintings.

BACON, Peggy (Brook). Painter. Born: Ridgefield,
Connecticut in 1895. Studied: New York School of Fine and
Applied Arts; Art Students League. Awards: Guggenheim
fellowship, 1934; National Academy of Arts and Letters, 1944.
Collections: Metropolitan Museum of Art; Whitney Museum of
American Art; Brooklyn Museum; Museum of Modern Art. Also
as an illustrator of 45 books she was author of 14.

BAEHR, Francine. Painter. Born: Chicago, Illinois in 1897.
Studied: University of Chicago; Julian Academy; Grande
Chaumiere, Paris. Collections: World's Fair, New York,
1939; United States Public Health Service, Washington, D.C.

BAHR, Florence Riefle. Painter. Born: Baltimore, Maryland
in 1909. Studied: Dickinson College and Maryland Institute.
Awards: Boston Museum of Fine Arts, 1953. Collections:
Baltimore Museum of Art; John Hopkins Hospital.

BAER, Jo. Painter. She is known for her minimalist paintings.
First major showings of her minimal paintings in the 1960's in
New York City.

BAER, Lillian. Sculptor. Born: New York City in 1887.
Studied: Art Students League.

BAILEY, Minnie M. Painter and Illustrator. Born: Oberlin,
Kansas in 1890.

BAIN, Joan. Painter. Born: Manila, Philippine Islands in
1910. Studied: Newcomb College; Tulane University; Corcoran
School of Art.

BAINS, Ethel F. Betts. Painter. Was exhibiting in 1922.

BAKER, Anna P. Painter. Born: London, Ontario, Canada in
1928. Studied: University of Western Ontario; Art Institute
of Chicago. Awards: Art Institute of Chicago, 1956;
Cleveland Institute of Art, 1956, 1958. Collections:
Library of Congress; London Public Library; Art Museum,
London; Cleveland Museum of Art.

BAKER, Doris Winchell. Painter. Born: Washington, D.C. in
1905. Studied: Chouinard Institute of Art; Otis Art
Institute. Awards: Art in National Defense, 1943; Palos
Verdes, California, 1955; Women Painters of the West, 1941,
1946, 1949.

BAKER, Elizabeth Gowdy. Painter. Born: Xenia, Ohio in 1860
and died in 1927. Studied: Art Students League; Cooper Union
School of Art; Cowles Art School, Boston. Collections: Xenia
Theological Seminary, St. Louis; State Capitol, Des Moines.

BAKER, Maria M. Painter. Born: Norfolk, Virginia in 1890. Studied: Pennsylvania Academy of Fine Arts; Corcoran Art Gallery.

BAKER, Martha S. Painter. Born: in 1871. Studied: Chicago Art Institute. Noted for her miniature paintings in oils and watercolors. Has also done some mural work.

BAKER, Mary F. Painter. Born: New Orleans, Louisiana in 1879. Studied: Pennsylvania Academy of Fine Arts.

BAKER, Mary Hofstetter. Painter. Born: Philadelphia, Pennsylvania in 1913. Studied: Pennsylvania Academy of Fine Arts; Philadelphia Museum School of Industrial Art; Barnes Foundation. Collection: Pennsylvania Academy of Fine Arts, Philadelphia.

BAKER, Miss M. K. Painter. Born: New Bedford, Massachusetts. Noted for her figure painting and portraits.

BAKOS, Teresa. Painter. Born: Nervi, Italy. Collections: in many private collections in the United States and abroad.

BALANO, Paula H. Painter. Born: Germany in 1878. Studied: Pennsylvania Academy of Fine Arts; with Chase and Mucha in Paris. Awards: gold medal for water colors.

BALCH, Georgia W. Painter. Born: Toronto, Canada in 1888. Studied: Kansas City Art Institute. Award: Federation of Women's Club, 1954. Collection: Vermont Society of Arts and Crafts.

BALCH, Gertrude Howland. Painter. Born: Flushing, New York in 1909. Studied: Wilmington Academy of Art. Collection: Delaware Art Center.

BALDWIN, Barbara. Sculptor. Born: Portland, Maine in 1914. Studied: Portland School of Fine Arts; Pennsylvania Academy of Fine Arts; National Academy of Design; Art Students League. Collections: Deering High School, Portland, Maine; Worlds Fair, New York, 1939; Pathe News.

BALDWIN, Frances. Painter. Born: San Francisco, California in 1907. Studied: California School of Fine Arts; Art Students League. Collection: San Francisco Museum of Art.

BALFOUR, Helen. Painter. Born: in England. Also an illustrator.

BALL, Alice Worthington. Painter. Known for her landscape paintings in 1921.

BALL, Caroline Peddle. Sculptor. Born: Terre Haute,
Indiana in 1869. Studied: with St. Gaudens and Kenyon
Cox in New York. Known for her memorial corbels, Grace
Church in Brooklyn; memorial fountain in Auburn, New York

BALL, Kate Kraus. Painter. Born: El Paso, Texas.
Studied: University of California; also with Eugen Neuhaus,
Perham H. Nahl and Henry Balink. Awards: Collection of
parchment scrolls, engrossed and illuminated in the
Library of Congress in 1952 and on tour of galleries
throughout the United States.

BALL, Margaret. Painter. A watercolorist working in New
York in the mid 1800s.

BALL, Ruth N. Sculptor. Born: Madison, Wisconsin. Studied:
with Liberty Tadd in Philadelphia. Collection: City Art
Museum, S. Louis, Missouri.

BALL, Sophia. Painter. An amateur working in New York
in 1842.

BALLOU, Bertha. Painter. Born: Hornby, New York in 1891.
Studied: Randolph-Macon Woman's College; Art Students
League; Corcoran Gallery of Art; Boston Museum of Fine Arts
School. Collections: Eastern Washington Historical Museum;
Spokane Public Library; Spokane County Courthouse;
Washington State College; First Federal Savings Loan Bank,
Spokane.

BALMANNO, Mrs. Robert. Painter. Noted for her still-life
paintings in Brooklyn in the mid 1800s.

BANKS, Virginia. Painter. Born: Norwood, Massachusetts in
1920. Studied: Smith College; Butera School of Fine Arts;
State University of Iowa; Colorado Springs Fine Arts
Center. Awards: San Francisco Museum of Art, 1947;
Washington State Fair, 1949; Audubon Art, 1951; Hallmark,
1949. Collections: Seattle Art Museum; International
Business Machines; Davenport Municipal Gallery; Plattsburg
State College.

BANNING, Beatrice Harper. Etcher. Born: Staten Island,
New York in 1885. Studied: Cooper Union Art School; Art
Students League; National Academy of Design. Awards:
Connecticut Academy of Fine Arts, 1944; Bridgeport Art
League, 1945. Collections: Metropolitan Museum of Art;
New York Public Library; Library of Congress.

BANNISTER, Eleanor C. Painter. Born: New York City.
Studied: with Whittaker in Brooklyn; Constant and
Lefebvre in Paris. Collection: Brooklyn Museum.

BANTA, Ethel Zabriskie. Painter. Born: Philadelphia, Pennsylvania. Studied: Cornell University; Art Students League. Awards: Mineola, New York, 1942; Florida Federation of Art, 1954; Mineola, New York, 1942, 1943; Pinellas, Florida, 1955, 1956, 1957. Collections: First National Bank, Tarpon Springs; Public Library and Woman's Club, Tarpon Springs, Florida; Federal Savings and Loan, Tarpon Springs.

BARANCEANU, Belle. Painter. Born: Chicago, Illinois in 1905. Studied: Minneapolis School of Art. Award: Art Institute of Chicago, 1931. Collections: San Diego Fine Arts Society; Library of Congress; La Jolla Art Center; murals, United States Post Office, La Jolla, California; La Jolla Jr. High School, La Jolla, California; Roosevelt Junior High School, San Diego, California.

BARBER, Judy. Painter. Born: Roanoke, Virginia in 1943. Studied: Georgia State University. Collections: Georgia State University; Hunter Gallery, Chattanooga, Tennessee and Dekalb Junior College, Georgia.

BARBER, Muriel V. Painter. Born: West Orange, New Jersey. Studied: Fawcett Art School, Newark; Wayman Adams School of Art; and with Hubert DeGroat Main. Awards: American Artists Professional League; New Jersey Federation of Women's Club, 1957; Warren Hotel, Spring Lake, New Jersey, 1957; Maplewood Watercolor Club, 1958. Collection: Davis and Elkins College, West Virginia.

BARCLAY, Edith Lord. Painter. Has exhibited in the National Association of Women Painters and Sculptors.

BARD, Sara Foresman. Painter. Born: Slippery Rock, Pennsylvania. Studied: Pratt Institute Art School; Grand Central School of Art; Art Institute of Chicago. Awards: Baltimore Watercolor Club, 1928; New York Watercolor Club, 1928, 1929; National Association of Women Artists, 1931; Springfield Art League, 1939; Hoosier Salon, 1929, 1931, 1934, 1936 and Studio Guild, 1941.

BARHYDT, Jean K. Painter. Born: Brooklyn, New York in 1868. Studied with G. A. Thompson.

BARKER, Miss E. J. Watercolorist working in Brooklyn in the mid 1800s.

BARKER, Katherine. Painter. Born: Pittsburgh, Pennsylvania in 1891. Studied: with Breckenridge, Anshutz, Carlson, Hale, Beaux and Vonnoh.

BARKER, Olive (Ruth). Painter. Born: Chicago, Illinois. Studied: New York School of Fine and Applied Arts, Paris Branch; Oberlin Conservatory; and with F. Tolles Chamberlin, Willard Sheets and Paul Sample. Collections: Children's altar-piece, St. Matthew's Church School, Pacific Palisades; Bishop Clarkson Memorial Hospital, Omaha, Nevada.

BARLOGA, Viola H. Painter. Born: Camden, New Jersey in 1890. Studied: Art Institute of Chicago; Chicago Academy of Fine Arts; Art Students League; Rockford College with Sidney Laufman. Awards: Rockford Art Association, 1941, 1946, 1949; Montclair Art Association. Collection: Burpee Art Gallery, Rockford, Illinois.

BARNARD, Elinor M. Painter. Born: Kensington, London, England in 1872. Known for her portraits in watercolor.

BARNARD, Josephine W. Painter. Born: Buffalo, New York in 1869. Studied: with Dow, Snell and Carlson.

BARNES, Gertrude J. Painter. Born: Tyngsboro, Massachusetts, in 1865. Noted for her landscape paintings.

BARNES, Penelope Birch. Painter. Noted for still-life paintings in the early to mid 1800s.

BARNEY, Alice Pike. Painter. Born: Cincinnati, Ohio in 1860. Studied: with Duran, Whistler and Henner. Known for her portrait paintings.

BARNHARDT, Jane Sargent. Painter. Born: Rochester, New York. Studied: Boston School of Design; Cleveland School of Art; Art Students League.

BARNUM, Emily K. Painter. Born: New York in 1874. Studied: with Vibet in Paris; with Irving Wiles in New York. Worked chiefly with watercolors.

BARRER, Gertrude (Russell). Painter. Born: New York City in 1921. Studied: Art Students League; Iowa State University. Collections: University of Maine; Riverside Museum, New York.

BARRET, Laura A. Painter.

BARRETT, Elizabeth Hunt. Painter. Born: New York City in 1863. Studied: National Academy of Design.

BARRETT, Lisbeth S. Painter. Born: Seattle, Washington in 1904. Studied: Newcomb College; Tulane University; Art Students League; Grand Central School of Art; Julian Academy, Paris; Pennsylvania Academy of Fine Arts. Award: Pennsylvania Society of Miniature Painters, 1949. Collection: Philadelphia Museum of Art.

BARRINGTON, Amy L. Painter.

BARRON, Grace. Painter. Born: Buffalo, New York in 1903.
Studied: Boston School of Fine Arts and Crafts;
Fontainebleau, France. Awards: Albright Art Gallery, 1935,
1941. Collection: Albright Art Gallery.

BARRY, Edith C. Painter. Born: Boston, Massachusetts.
Studied: Art Students League; Paris, France; Rome, Italy.
Collections: Portraits in public buildings in New Jersey,
Massachusetts and Maine. Murals in New York and Maine.

BARSTOW, S. M. (Miss). Painter. She did landscape
paintings while working in New York in the mid to late 1800s.

BARTLE, Sara N. Painter. Born: Washington, D.C. Studied:
Art Students League; and with Carroll Beckwith.

BARTELL, Sarah. Watercolor portraitist working in 1790.

BARTLETT, Madeleine A. Painter. Born: in Woburn. Studied:
Cowles Art School. Noted for her small bas-reliefs. She
exhibited in 1924.

BARTO, Emily. Painter. Born: Greenport, Long Island,
New York in 1886. Studied: Cooper Union Art School;
National Academy of Design and with Bridgman and Hawthorne.

BARTOL, Miss E. H. Painter. She was a follower of William
M. Hunt and worked in the Boston area.

BARTON, Catherine G. Sculptor. Born: Englewood, New Jersey
in 1904. Studied: Cooper Union Art School; Art Students
League and with Archipenko and in Paris. Awards: Fine Arts
Commission, Washington, D. C. 1930; National Association
of Women Artists, 1931. Collection: Dwight School for
Girls, Englewood, New Jersey.

BARTON, Loren. Painter. Born: Oxford, Massachusetts in
1893. Studied: University of Southern California. Awards:
National Association of Women Artists, 1928; Arcadia
California, 1924; Pacific Southwest Exhibition, 1928;
Los Angeles Museum of Art, 1937; American Watercolor
Society, 1941; Santa Paula, California 1941, 1947; California
Watercolor Society, 1945; Santa Cruz Art League, 1946;
Clearwater Art Museum, 1946; Gardena, California, 1947, 1950;
San Fernando, California, 1947. Collections: Art Institute
of Chicago; California State Library; Los Angeles Public
Library; New York Public Library; Brooklyn Museum; San
Diego Fine Arts Society; Los Angeles Museum of Art; National
Library, France; Metropolitan Museum of Art; Wesleyan
College; Phoenix Municipal College; Virginia Museum of Fine
Arts, Richmond, Virginia; National Gallery of Fine Arts.

BARTON, Macena Alberta. Painter. Born: Union City, Michigan in 1901. Studied: Art Institute of Chicago. Awards: Augustus Peabody prize, Art Institute of Chicago, 1927; Chicago Woman's Aid, 1931, 1932; Chicago Galleries, 1945, 1956. Collections: City of Chicago College; Chicago Public Schools; Vanderpool Art Gallery, Chicago.

BARTOO, Catherine R. Born: Williamsport, Pennsylvania. Studied: with Henri and Mora.

BARUCH, Anne Barbara. Painter. Born: Boston, Massachusetts in 1903. Studied: Rhode Island College; and with Bessie Kaufman and Francine Utrecht. Collection: Norton Gallery of Art.

BASCOM, Ruth Henshaw. "Aunt Ruth" as she was known. Born: in 1772 and died in 1848. Known as a primitive crayon artist.

BASSETT, Margaret G. Painter. Born: Pittsburgh, Pennsylvania in 1904. Studied: Carnegie Institute; and with Joseph B. Ellis. Exhibited in the Pittsburgh area in 1940s and 1950s.

BASSIE, Adele. Painter. Working in portraits in New York City about 1850.

BATES, Bertha Day. Painter. Born: Philadelphia, Pennsylvania in 1875. Studied with Howard Pyle.

BATES, Gladys Edgerly. Sculptor. Born: Hopewell, New Jersey in 1896. Studied: Corcoran Gallery of Art; Pennsylvania Academy of Fine Arts and with Grafly. Awards: Pennsylvania Academy of Fine Arts, 1931; National Association of Women Artists, 1934; Pennsylvania Academy of Fine Arts, 1920; Connecticut Academy of Fine Arts, 1933; Art Institute of Chicago, 1935; Pen and Brush Club, 1944; National Association of Women Artists, 1948. Collections: Metropolitan Museum of Art; Pennsylvania Academy of Fine Arts.

BATHIER, Mme. Painter. Miniature painter working in New Orleans from 1851 to 1855.

BATSON, Melvina Hobson. Painter. Born: 1826 and died in 1853. She was known for her portrait paintings.

BAUGH, Dorothy Geraldine. Painter. Born: Bath, England in 1891. Studied: Pomona College. Awards: Los Angeles Museum of Art, 1942, 1944; Pasadena Art Institute, 1950; Ebell Club, Los Angeles; Glendale Library and Women's Club; Pomona College, 1953; Julia Ford prize, 1943. Collection: Hamilton College, Clinton, New York.

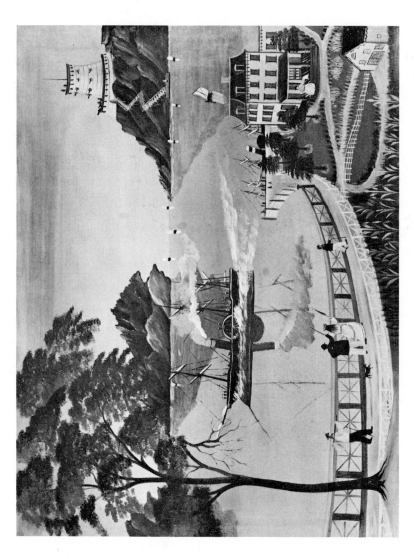

Leila T. Bauman, U. S. MAIL BOAT, c. 1870. Canvas, 20 1/4" X 26 1/4". The National Gallery of Art, Washington, D. C.

BAUGHMAN, Mary. Sculptor. Born: Richmond, Virginia.
Studied: Colarossi Academy.

BAUMAN, Leila T. American primitive painter active around 1870.

BAXTER, Bertha E. Painter. Her oil paintings were
exhibited in the early 1920s in Pennsylvania and
New York.

BAXTER, Martha W. Painter. Born: Castleton, Vermont in
1869. Studied: Pennsylvania Academy of Fine Arts; Art
Students League; also studied in Paris and Venice.

BAYLISS, Lillian. Known for her work in miniature
paintings.

BAYLOS, Zelma. Painter and sculptor. Born: in Hungary.
Studied: with Will Low.

BAYNE, Eliza. Painter. A miniaturist working around 1841.

BEACH, Beata. Painter. Born: Rome, Italy in 1911.
Studied: Julian Academy, Paris; Art Students League.
Collection: United States Post Office, Monticello, Georgia.

BEACH, Sara Berman. Painter. Born: Lodz, Poland in 1897.
Studied: Cooper Union Art School; DaVinci Art School;
Polish Art Academy. Awards: DaVinci Art School, 1927.
Collection: New-Age Gallery; Aviation Club, New York.

BEACHEY, Margaret. Painter. Born: Lebanon, Ohio.
Studied: Cincinnati Art Association; Art Students League.

BEADENKOPF, Anne. Painter. Born: Baltimore, Maryland in
1875. Studied: Art Students League and with Henry Roben
and Ivan Olinsky. Collections: City Hall, Peale Museum,
School Administration Building, Provident Hospital,
American Cancer Society, Happy Hills Convalescent Home
for Children, Urban League, Young Mens Christian Association,
Maryland University Hospital, all in Baltimore, Maryland.

BEAN, Caroline Van Hook. Painter. Born: Washington, D.C.
Studied: Smith College; and with Chase and Sargent.
Collection: Dayton Art Institute.

BEARD, Adelia Belle. Painter. Born: Painesville, Ohio.
Studied: Cooper Union; Art Students League and with Eaton
and Chase. Has illustrated in many books and magazines.

BEAUMONT, Lillian A. Painter. Born: Jamaica Plain,
Massachusetts. Studied: School of Boston Museum of Fine
Arts and with Benson, Tarbell and Hale. She died in 1922.

Cecilia Beaux, *A GIRL IN WHITE: ERNESTA*. *Oil on canvas,
71 3/4" X 43 1/4"*. *The Metropolitan Museum of Art (Arthur
H. Hearn Fund, 1915)*.

BEAUX, Cecilia. Painter. Born: Philadelphia, Pennsylvania.
Studied: Julien School; Lazar School in Paris. Awards:
Pennsylvania Academy of Fine Arts; gold medal, Philadelphia
Art Club; National Academy of Design. Collections:
Pennsylvania Academy of Fine Arts; Toledo Art Museum,
Metropolitan Museum, New York; Brooks Memorial Gallery,
Memphis; John Herron Art Institute, Indianapolis.

BECK, Carol H. Painter. Born: Philadelphia, Pennsylvania
in 1859 and died in 1908. Studied: Pennsylvania Academy
of Fine Arts; Dresden and Paris. Known for her portrait
paintings.

BECK, Minna McLeod. Painter. Born: in Atlanta, Georgia in
1878. Studied: with Arthur Dow in New York.

BECK, Rosemarie. Painter. Born: New York City in 1923.
Studied: Oberlin College, Ohio; Columbia University; New
York University. Collections: Whitney Museum of American
Art; University of Nebraska; State University of New York.

BECKINGTON, Alice. Painter. Born: St. Louis in 1868.
Studied: Art Students League; Academie Julien, Paris; and
with Charles Lazar in Paris. She was the founder of the
American Society of Miniature Painters.

BEECHER, Hilda. Painter. Was exhibiting in 1924.

BEEK, Alice D. Painter. Born: Providence, Rhode Island
in 1876. Studied: with Puvis de Chavennes.

BEGIEN, Jeanne. Painter. Born: Cincinnati, Ohio in 1913.
Studied: Richmond Professional Institute; Colorado Springs
Fine Arts Center. Awards: Academy of Science and Fine Arts,
Richmond, Virginia, 1939; Virginia Museum of Fine Arts;
Hollins College; murals, Church of the Good Shepherd,
St. Luke's Episcopal Church, Southern States Cooperative,
all in Richmond Virginia.

BEILER, Ida Zoe. Painter. Born: Lima, Ohio. Studied:
Lima College; Michigan State Teachers College; Art
Institute of Chicago; University of Chicago. Awards:
Fargo, North Dakota, 1938; Golden Gate Exposition, 1939;
American Artists Professional League, 1950. Collections:
International Business Machines; Fine Arts College, Fargo,
North Dakota; Mayville State College; Fargo Agricultural
College; Dickinson Public Library; Capitol Building,
Bismarck; State College, Dickinson, North Dakota.

BELCHER, Hilda. Painter. Born: Pittsford, Vermont in 1881.
Studied: New York School of Art; and with Chase, Henri,
Bellows and Luks. Awards: Strathmore Competition, 1908;
New York Watercolor Club, 1909, 1915; American Watercolor
Society, 1918; National Academy of Design, 1926, 1931;
Pennsylvania Academy of Fine Arts, 1932; Brown-Bieglow
Company, 1925; Philadelphia Watercolor Club, 1935;
Middlebury College, 1941. Collections: Montclair Museum
of Art; Museum of Fine Arts of Houston; Wood Museum of Art;
High Museum of Art; Dumbarton House, Washington, D. C.;
Vassar College; Laurence Museum, Williamstown, Massachusetts;
American Unitarian Association Headquarters, Boston,
Massachusetts; Pennsylvania Academy of Fine Arts;
Newark, New Jersey Museum of Art; Maryland Institute.

BELCHER, Martha Wood. Painter. Born: England in 1844.
Studied: Cooper Institute, New York; and in Munich.

BELING, Helen. Sculptor. Born: New York City in 1914.
Studied: College City of New York; National Academy of
Design; Art Students League. Awards: Audubon Art, 1952;
National Association of Women Artists, 1951; Silvermine
Guild Art, 1957; Sabena Company (International), 1953.
Collections: Butler Institute of American Artists,
Youngstown, Ohio; Jewish Community Center, White Plains,
New York.

BELL, Clara Louise. Painter. Born: Newton Falls, Ohio.
Studied: Cleveland School of Art; Art Students League.
Awards: Cleveland Museum of Art, 1919, 1923, 1925, 1956.
Studio Club, 1926, 1928; National Association of Women
Artists, 1949, 1930, 1952. Collections: Metropolitan
Museum of Art; Brooklyn Museum; Masonic Temple, Youngstown,
Ohio; Butler Institute of American Artists; Coast Guard
Academy, Hamilton Hall, New London, Connecticut.

BELL, Enid. Sculptor. Born: London, England in 1904.
Studied: in England and Scotland; Art Students League.
Awards: Paris International Exhibition, 1937; American
Artists Professional League, 1934; New Mexico State
Fair, 1940, 1941; Newark Art Club, 1933; New Jersey
Exhibition, 1949, 1951. Collections: Congressional medal
for Lincoln Ellsworth; Carved wood murals, Robert Treat
School, Newark, New Jersey; United States Post Office,
Mt. Holly, Boonton, New Jersey; Beth Israel Hospital,
Newark, New Jersey; Armenian Cultural Foundation, Boston,
Massachusetts.

BELLE, Cecile. Painter. Born: Verdun, France in 1900.
Studied: Oxford University; France; School of Fine Arts,
Antwerp, Belgium. Collections: International Business
Machines; Coca Cola Company. Has exhibited widely
throughout the United States.

BELLIS, Daisy Maude. Painter. Born: Waltham, Massachusetts.
Studied: Massachusetts School of Art; University of Vermont;
Montreal Art Gallery; Breckenridge School of Painting,
Gloucester, Massachussets and in Paris, France. Has exhibited
widely throughout the United States and abroad.

BELMONT, Ira Jean. Painter. Born: Kaunas Lithunia in
1885. Studied: Konigsberg, Paris; New York. Collections:
Brooklyn Museum; University of Georgia; Tel-Aviv Museum,
Israel; Crocker Collection, San Francisco; Musee du Jeu
de Plume, Paris; Denver Museum of Art; Heckscher
Foundation. Exhibited widely nationally and internationally.

BELMONT, Lu. Painter. Born: New York City in 1907.
Studied: Art Students League. Has exhibited extensively
through the New England states.

BEMUS, Mary B. Painter. Born: Leicester, New York in
1849. Studied: with L. M. Wiles.

BENDELL, Marilyn. Awards: Elected member Royal Society of
Arts, London, England. Collections: Hadley School for the
Blind, Winnetka, Illinois; Huntington Gallery, Huntington,
West Virginia. Has exhibited in Chicago, Florida and
California.

BENJAMIN, Lucile J. Painter. Born: Genesco, Illinois
in 1876 and died in 1924. Studied: Art Institute of
Chicago and with John Vanderpoel. She painted under the
name of Lucile Joullin. Collection: Bohemian Club, San
Francisco, California.

BENNETT, Belle. Sculptor. Born: New York City in 1900.
Studied: with Solon Borglum; School of American Sculpture.

BENNETT, Bertha. Painter. Born: Eastland, Texas in 1883.
Studied: San Antonio School of Art with Henry F. McFee;
San Antonio Art Institute. Exhibited predominately in the
Southwest.

BENNETT, Emma D. Sculptor. Born: New Bedford, Massachusetts.
Studied: in Rome.

BENNETT, Mary Elizabeth. Painter. Born: Coventry,
Connecticut in 1877. Studied: Pratt Institute Art School.
Has exhibited in Connecticut.

BENSON, Hannah Nicholson. Painter. Born: Pawtucket, Rhode Island. Studied: Brown University; and with Henry Davenport. Has exhibited in the New Haven, Connecticut area.

BENSON, Tressa E. Painter. Born: Bucksport, Maine in 1896. Studied: Syracuse University; and with Charles Hawthorne; also studied in Europe. Awards: Syracuse University, 1923; Kansas City Art Institute, 1929; Art Institute of Chicago, 1937. Exhibited extensively in the Chicago area.

BERDICK, Veronica (Vera). Painter. Born: Chicago,Illinois in 1915. Studied: Art Institute of Chicago. Awards: Renaissance Society; Art Institute of Chicago; Northwest Printmakers; Pennsylvania Library of Congress (2 purchase awards); Huntington Hartford Study grant, 1955. Collections: Art Institute of Chicago; Library of Congress; New York public Library; Museum of Lyon, France; Bibliotheque Nationale, Paris, France; Victoria and Albert Museum, London.

BERGAMO, Dorothy Johnson. Painter. Born: Chicago, Illinois in 1912. Studied: University of Chicago; Art Institute of Chicago; Northwestern University; Arizona State College; University of Colorado. Awards: fellowship, Art Institute of Chicago, 1937; Arizona State Fair, 1950, 1952; Texas Watercolor Society, 1952; Tucson Fine Arts Association, 1955. Collections: Public Health Service Hospital, Lexington, Kentucky; Witte Museum of Art; Marion Koogler McNay Art Institute; Agricultural and Technical High School, San Antonio, Texas; Municipal collection, Phoenix, Arizona; Grand Canyon College, Phoenix; Olsen Foundation, Cheshire, Connecticut.

BERGLUND, Amanda. Painter. Born: Stockholm, Sweden in 1879. Studied: Art Institute of Chicago. Exhibited in the Chicago area.

BERK, Henrietta. Studied: California College of Arts and Crafts. Awards: Annual Pageant of Arts, Walnut Creek, California.

BERKMAN-HUNTER, Bernece. Painter. Born: Chicago, Illinois. Studied: Art Institute of Chicago; New School for Social Research; Hunter College; Columbia University. Award: Seattle Art Museum, 1946. Collections: Evansville State Hospital; Kelly High School, Chicago; Art Institute of Chicago; Carnegie Institute; Seattle Art Museum; University of Iowa; University of Michigan. Exhibited extensively throughout the United States.

BERMAN, Anni Radin. Painter. Born: New York City in 1914.
Studied: American School of Design; Traphagen School of
Fashion; American Art School. Has exhibited in New York
State.

BERNAT, Martha, Miligan. Sculptor. Born: Toledo, Ohio in
1912. Studied: Cleveland School of Art; Syracuse University;
Budapest School Industrial Art, Hungary. Awards: Cleveland
Museum of Art, 1935; Toledo Museum of Art, 1936, 1947;
Mansfield Fine Arts Guild, 1947, 1948; Rochester Memorial
Art Gallery, 1948. Collections: St. Peter's Church,
Mansfield, Ohio; Churches in Hollywood, Pacific Palisades
and Norwalk, California.

BERNHARDT, Barbara. Painter. Born: Richmond, Indiana in
1913. Studied: Earlham College; Art Students League with
John Sloan. Awards: Richmond Art Association, 1922, 1925,
1942, 1952. Exhibited in Illinois.

BERNSTEIN, Sylvia. Painter. Born: Brooklyn, New York in
1918. Studied: National Academy of Design. Awards:
Jane C. Stanley Memorial Award; National Association of
Womem Artists, 1954, 1957. New Haven R. R. Painting, 1956;
Silvermine Guild, 1957; gold medal, National Arts Club.
Collection: New York University.

BERNSTEIN, Theresa F. Painter. Born: Philadelphia,
Pennsylvania. Studied: Philadelphia School of Design;
Pennsylvania Academy of Fine Arts; Art Students League.
Awards: Philadelphia Plastic Club; French Institute of
Art and Science; National Association of Women Artists,
1949, 1951, 1955; Society of American Graphic Artists,
1953; Library of Congress (purchase prize), 1953; North
Shore Art Association; American Color Printmakers
Society. Collections: Art Institute of Chicago; Library
of Congress; Boston Museum; Princeton University; Harvard
University; Dayton Art Institute; Whitney Museum of American
Art; Bezalel Museum, Jerusalem; Tel-Aviv and Ain Harod
Museum, Israel; Metropolitan Museum of Art.

BERRESFORD, Virginia. Painter. Born: New York City in
1904. Studied: Wellesley College; Columbia University;
Ozenfant School of Art, Paris and New York. Collection:
Whitney Museum of American Art.

BERRY, Camelia. Painter. Born: Washington, D. C. in 1918.
Studied: Art Students League; Barnard College. Collections:
Stillwater Oklahoma Library; public buildings and churches
Stillwater, Oklahoma.

BERRY, Helen Murrin. Painter. Born: Philadelphia,
Pennsylvania in 1900. Studied: Pennsylvania Academy of
Fine Arts. Collection: Pennsylvania Academy of Fine Arts.

BERRY, Ruth Linnell. Painter. Born: Watertown, Massachusetts in 1909. Studied: Boston University; Radcliffe College. Collection: State House, Concord, New Hampshire.

BETSBERG, Ernestine. Painter. Born: Bloomington, Illinois in 1909. Studied: Art Institute of Chicago. Awards: Raymond Traveling fellowship; Art Institute of Chicago. Exhibited extensively in the United States, Japan, France and Italy.

BETTS, Anna Whelan. Painter. Born: Philadelphia, Pennsylvania. Studied: with Howard Pyle and Vonnoh. Award: Pan-Pacific Exposition. Collection: Illustrations in color for Harper's, Century and other magazines.

BEVERLY-HAYNES, Dorothy Frances. Painter. Born: Hartford, Connecticut. Studied: Hartford School of Art; and with Joseph C. Chase. Awards: Travelers Insurance Company of New York; Connecticut General Life Insurance Company; gold award, Ogunquit National Exhibition, 1953, 1954; Hartford Society of Women Painters, 1953. Collections: United States Coast Guard; State Capitol, Connecticut; Rochester Museum of Art.

BIAFORD, Enea. Sculptor. Born: in Italy in 1892. Came to the United States in 1914 and has exhibited in the National Academy.

BICKNELL, Evelyn M. Painter. Born: New York. Her specialty is watercolors.

BIGELOW, Constance. Painter. Exhibited watercolors in Philadelphia in 1925.

BIGELOW, Olive. Painter. Born: Mountain Station, New Jersey in 1886. Studied: Art Students League and in Paris, France. Awards: Royal Drawing Society, London, 1902, 1904; Newport Art Association, 1901. Collections: Providence Museum; Vienna Military Museum; Norwich Museum of Art, England; Naval Museum, Annapolis; New York Historical Society; St. John's Hospital, London; St. Elizabeth's Hospital, London; Palmella Palace, Portugal; Portuguese Embassy, London; Vassar College, New York; Oakwood School, Poughkeepsie, New York; Chinese Embassy, Washington, D.C. She has designed covers for Vogue, Harper's Weekly and other magazines. Also known for her condensed version of King James, Old and New Testaments "Olive Pell Bible" 1952-55, now in 6th edition.

BIGLER, Mary Jane White. Painter. Born: Columbia City,
Indiana. Studied: Indiana University; Wayne University;
Taylor School of Art; Art Institute of Chicago; Detroit
Society of Arts and Crafts. Awards: Michigan Watercolor
Society, 1946-1958; Michigan Artists, 1952-1958; Butler
Institute American Artists, 1952-1958; Detroit Society of
Women Painters and Sculptors, 1946-1958; Palette and
Brush, 1951; Scarab Club, 1951, 1953; Newberry prize, 1951;
Michigan Watercolor Society, 1952-1956.

BILLINGS, Mary H. Painter. Born: Brooklyn, New York.

BINNS, Elsie. Sculptor. Exhibiting in Philadelphia in 1924.

BIRCH, Geraldine. Painter. Born: Sussex, England in 1883.
Studied: Slade School of Art, London; London University;
and with Georges Desvallieres in Paris. Collections: State
Library, Sacramento; Episcopal Church, Sierra Madre,
California; Oakland Art Gallery; United States Airforce
Academy, Colorado Springs, Colorado; Fletcher Aircraft
Company, Rosemead, California.

BIRGE, Laura C. Painter. Died in 1928. Studied: New York,
Munich and Paris. Collection: State House, Columbus, Ohio.

BIRGE, Mary Thompson. Painter. Born: New York in 1872.
Studied: Yale School of Fine Arts.

BIRRELL, Verla Leone. Painter. Born: Tacoma, Washington
in 1903. Studied: University of Utah; Claremont College.
Awards: Utah Art Institute; Utah State Fair. Collections:
Ephraim Art Gallery; Utah State Capitol; Cache Valley High
School; Pleasant Grove High School; University of Utah;
Brigham Young University.

BISHOP, Annette. Genre painter in the New York area in
1859 to 1867.

BISHOP, Isabel. Painter. Born: Cincinnati, Ohio in 1902.
Studied: Art Students League; New York School of Applied
Design. Awards: National Academy of Design, 1936, 1943,
1945, 1955; Society of American Graphic Artists, 1939;
Butler Art Institute, 1941; Pennsylvania Academy of Fine
Arts, 1953; Corcoran Gallery of Art, 1945; Library of
Congress, 1946. Collections: Whitney Museum of American
Art; Metropolitan Museum of Art; Pennsylvania Academy of
Fine Arts; Addison Gallery of American Art; Springfield
Museum of Art; Butler Art Institute; Baltimore Museum of
Art; City Art Museum of St. Louis; New York Public Library;
Library of Congress; New Britain Art Museum; Tel-Aviv
Museum, Israel; Des Moines Art Center; John Herron Art
Institute; Cranbrook Academy of Art; United States Post
Office, New Lexington, Ohio.

BISHOP, Marjorie. Painter. Born: Melrose, Massachusetts, in 1904. Studied: Art Students League; New School of Social Research; and in Paris, France. Award: Walker Art Center, Minneapolis, Minnesota, 1946. Collection: Walker Art Center.

BISSELL, Dorothy P. Sculptor. Born: Buffalo, New York in 1894. Studied: with Arthur Lee. She specializes in heads of children and animals.

BISTLINE, Edna. Painter. Born: Elliottsburg, Pennsylvania in 1914. Studied: Pennsylvania Academy of Fine Arts. Award: prize, DaVinci, 1944. Collection: Pennsylvania Academy of Fine Arts.

BLACK, Eleanor Simms. Painter. Born: Washington, D. C. in 1872. Was exhibiting in Pennsylvania in 1924.

BLACK, Kate Eleanor. Painter. Born: London in 1855. Came to Cincinnati in 1899 and died in 1924. Award: Provincial Exhibition, New Westminster, British Columbia, Canada.

BLACK, Mary C. W. Painter. Born: Poughkeepsie, New York. Studied: Art Students League.

BLACK, Mrs. Norman I. Painter. Born: Providence, Rhode Island in 1884. Studied: Eric Pape School, Boston; Julien Academy in Paris; also studied in Munich.

BLACK, Olive Parker. Painter. Born: Cambridge, Massachusetts in 1868. Studied: with H. Bolton Jones and with Chase; Art Students League.

BLACKMAN, Carrie Horton. Painter. Born: Cincinnati, Ohio. Studied: St. Louis School of Fine Arts; Chaplin in Paris. Her specialty, children's portraits.

BLACKSHEAR, Anne. Painter. Born: Augusta, Georgia in 1875. Studied: Cooper Union Art School; Chase School of Art; Art Students League; Pennsylvania Academy of Fine Arts. Collections: Georgia Agriculatural Extension Building; University of Georgia, Law School, Academic Building; Georgia Museum of Art; Piedmont College.

BLACKSHEAR, Kathleen. Painter. Born: Navasota, Texas in 1897. Studied: Baylor University; Art Institute of Chicago; Art Students League. Collection: Museum of Fine Arts of Houston.

BLACKSTONE, Harriet. Painter. Born: New Hartford, New York. Studied: Julien Academy in Paris; Chase Summer Schools; Pratt Institute, Brooklyn. Collections: Vincennes Art Association; San Francisco Museum; National Gallery of Art, Washington.

BLADES, Mary. Water-colorist working before 1840.

BLAINE, Nell. Painter. Born: Richmond, Virginia in 1922.
Studied: Richmond Professional Institute; Richmond School
of Art; and with Hans Hofmann. Awards: Virginia Museum
of Fine Arts, 1943, 1946; Norfolk Museum of Art, 1946.
Collections: Whitney Museum of Art; Virginia Museum of
Fine Arts; Museum of Modern Art, New York; murals in
Tishman Building, New York City.

BLAIR, Camille. Painter. Born: Sabetha, Kansas in 1894.
Has exhibited in California, Kansas, Illinois and Ohio.

BLAIR, Marion. Born in 1824 and died in 1901. She was a
portrait painter.

BLAKELY, Joyce C. Born: New Orleans, Louisiana in 1929.
Has exhibited mainly in the South.

BLAUMEUSER, Sister M. Fleurette. Exhibitions in Wichita
Art Museum and Layton Art Gallery.

BLANCHARD, Eliza H. Painter. Known for her miniature
portraits. She was active between 1843-1846.

BLANKE, Esther. Painter. Born: Chicago, Illinois in 1882.
Studied: City Art Institute and in London and Munich.

BLANKE, Marie Elsa. Painter. Born: Chicago, Illinois.
Studied: Art Institute of Chicago; Munich and London.
Collection: State Museum, Springfield, Illinois.

BLASINGHAM, Katherine Groh. Painter. Born: Logansport,
Indiana in 1893. Studied: Indiana State Teachers College;
John Herron Art Institute. Awards: Canton Art Institute,
1936, 1938; Indiana Art Club, 1941, 1945; Swope Gallery
of Art, 1950, 1954; Hoosier Salon, 1950. Collection:
Canton Art Institute.

BLASS, Charlotte L. Painter. Born: Orange, New Jersey in
1908. Studied: National Academy of Design; Art Students
League. Collections: Brooklyn Museum; United States
Military Academy, West Point, New York; Columbia University,
New York.

BLATTNER, Rose. Painter. Born: Pittsburgh, Pennsylvania
in 1900. Studied: Art Students League with Hans Hofman,
Benton and Robinson. Very active exhibiting in the early
1940s.

BLESCH, Clara. Painter. Born: Columbus, Ohio. Noted for her watercolor landscapes. She has exhibited in Buffalo, Cincinnati and Washington, D.C.

BLEY, Elsa W. Painter. Born: New York City in 1903. Studied: Art Students League; Grand Central School of Art; and with George Luks, Wayman Adams and Snell. Awards: School Art League, 1919; Scarsdale Art Association, 1936, 1938, 1944, 1945.

BLISS, Alma Hirsig. Painter. Born: Berne, Switzerland. Studied: with Willard Metcalf; New York University; Harvard University. Awards: Pennsylvania Society of Miniature Painters, 1931; American Society of Miniature Painters, 1932; National Association of Women Artists, 1932, 1937, 1941; California Society of Miniature Painters, 1938. Collections: Corcoran Gallery of Art; Philadelphia Museum of Art; Brooklyn Museum; Norfolk Museum of Art; murals, Wilbraham Academy, Massachusetts.

BLOCK, Julia. Printmaker. Born: Philadelphia, Pennsylvania in 1903. Studied: Philadelphia School of Design for Women; Pennsylvania Academy of Fine Arts; Philadelphia Museum School of Industrial Arts. Collection: Carnegie Institute. Exhibited widely in Pennsylvania.

BLOCK, Dorothy. Painter. Born: Brooklyn, New York. Studied: Art Students League. Collection: Several private. She has exhibited in the United States and Italy.

BLOCK, Lou. Painter. Born: New York City in 1895. Studied: National Academy of Design; Art Students League; and in Europe. Awards: Kentucky and Southern Indiana Annual, 1952; Evansville Regional Exhibition, 1947. Collections: University of Louisville; Rikers Island, New York; murals in homes, hotels and steamships.

BLUME, Melita. Painter. Born: in Germany. Studied: Art Students League of New York. Known for her landscape paintings.

BLUMBERG, Yuli. Painter. Born: Kaunas, Lithuania in 1894. Studied: in Europe. Collections: J. B. Neumann Gallery; Tel-Aviv Museum, Israel; Phillips Collection, Washington, D.C.; Butler Institute of American Art.

BLUMENSCHEIN, Helen Greene. Painter. Born: New York City in 1909. Awards: New Mexico and Arizona State Fairs. Collections: New York Public Library; Library of Congress; Newark Public Library; Carnegie Institute; Cincinnati Museum Association.

BLUMENSCHEIN, Mary S. G. Painter. Born: New York in 1869. Studied: with Herbert Adams in New York and Collin in Paris.

BOAL, Sara M. Painter. Born: Wheeling, West Virginia in 1896. Studied: Wellesley College; Cornell University; Teachers College, Columbia University. Awards: Hudson Valley Art Association, 1950; American Artists Professional League, 1951; Catherine L. Wolfe Art Club, 1953; Manor Club, Pelham, New York, 1955. Collections: Starr Museum, Albion, Michigan; Wheeling West Virginia Public Library; Barnesville, Ohio Public Library; Barbizon Plaza Hotel, New York.

BOARDMAN, Nell. Painter. Born: Calendar, Iowa in 1894. Studied: Iowa State Teachers College; Traphagen School of Design; National Academy of Design. Awards: Industrial Institute, 1947; Wolfe Art Club, 1948; American Artists Professional League, 1955. Collection: Florida Southern College.

BOARDMAN, Rosina Cox. Painter. Born: New York City. Studied: Art Students League; Chase School of Art with William Chase, DuMond and Mora. Awards: Boardman prize, New York; Pennsylvania Society of Miniature Painters, 1949; American Society of Miniature Painters, 1952; National Association of Women Artists, 1932, 1958; Los Angeles Society of Miniature Painters; Boston Museum of Fine Arts. Collections: Metropolitan Museum of Art; Brooklyn Museum; City Art Museum of St. Louis; Corcoran Gallery of Art; Fairmont Museum of Art, Philadelphia.

BOBBS, Ruth Pratt. Painter. Born: Indianapolis, Indiana in 1884. Studied: Julien Academy, Paris; Chase School of Art; Art Students League; Boston Museum of Fine Arts School. Awards: John Herron Art Institute; Hoosier Salon; Indiana Art Club. Collection. Indianapolis Art Institute. Known for her portrait paintings.

BODKIN, Sally Grosz. Sculptor. Born: Budapest, Hungary. Studied: Art Students League; Science Center, New York. Awards: National Association of Women Artists, 1949. Collections: private collections.

BOERICKE, Johanna M. Painter and sculptor. Born: in Philadelphia in 1868. Studied: Pennsylvania Academy of Fine Arts; Rome; and in Paris.

BOGARDUS, Margaret Maclay. Painter. Born: in 1804 and died in 1879. Noted for her miniature portraits.

BOGART, Stella Marshall. Painter. Born: Terra Haute, Indiana. Studied: in Paris, France. Collections: Thomasboro, Illinois; Atlanta University, Atlanta, Georgia.

BOHAN, Ruth H. Painter. Awards: Mid-western Exhibition, Kansas City; Terry Art Institute, 1952. Collections: University of Kansas Hospital; St. Luke's Hospital, Kansas City. Has exhibited extensively through museums in the East.

BOHNERT, Rosetta. Painter. Born: Brockton, Massachusetts. Studied: University of Rhode Island; and with Maud Mason and Walter Farndon. Awards: Hudson Valley Art Association; National Art Club, New York; Wolfe Art Club. Collection: Bruckner Museum.

BOLMAN, Miss. An amateur painter. She exhibited her miniature paintings widely around 1827.

BOLTON, Mimi Dubois. Painter. Born: Gravlotte, France in 1902. Studied: Marquette University; Corcoran School of Art; Phillips Memorial School. Awards: Washington Society of Art, 1952. Collection: Corcoran Gallery of Art.

BONAPARTE, Charlotte Julie. Born: in 1802 and died in 1839. Known for her portraits, landscape and flower paintings.

BOND, Gwendoline M. Etcher. Born: India in 1890. Studied: Columbia University; New York University; Pennsylvania Academy of Fine Arts; Art Students League. She exhibited mainly in New York.

BONN, Marion. Sculptor. Born: Barbados, British West Indies in 1890. Studied: Alfred University. Awards: Mt. Vernon Art Association, 1952, 1953, 1955; New Rochelle Art Association, 1952, 1953, 1954; Westchester Arts and Crafts Guild, 1952-1955; Rye Federation of Women's Club, 1954; Mamoroneck Federation of Women's Club, 1954. Junior League, Mt. Kisco, 1957; Pleasantville Women's Club, 1956; American Artists Professional League, 1956; New Jersey Painters and Sculptors, 1954. Bedford Hills Community House, 1955. Collections: in private collections.

BONSALL, Elizabeth F. Painter. Born: Philadelphia in 1861. Studied: Pennsylvania Academy of Fine Arts; also in Paris with Collin and Courtois. Collection: Pennsylvania Academy of Fine Arts.

BONSALL, Mary W. Painter. Born: Fernwood, Pennsylvania. Studied: Cecilia Beaux, Chase and Vonroh. A miniaturist.

BONTA, Elizabeth B. Painter. Born: Syracuse, New York. Award: St. Paul Institute, 1916.

BONTECOU, Lee. Born: Providence, Rhode Island in 1931. Studied: Bradford Junior College; Art Students League; Fulbright to Rome 1957-58. Tiffany Grant, 1959. Collections: Whitney Museum of American Art; Museum of Modern Art; Stedelijk Museum, Amsterdam.

BOORAEM, Elizabeth V. Painter. Born: Minneapolis, Minnesota in 1919. Awards: Authoress of "Drawing, Printing, Painting Philadelphia Landmarks by the Hundreds." Collections: Bellevue Stratford Hotel; Barclay Hotel.

BOOTH, Zadie Cory. Sculptor. Born: Crete, Nebraska in 1905. Studied: Doane College; University of Nebraska; University of Colorado. Award: University of Nebraska, 1951.

BOOTT, Elizabeth. Painter. Born: Cambridge, Massachusetts. Studied: in Europe. Some of her paintings were exhibited in Boston in 1877 and 1878. She was also exhibiting as late as 1886.

BORGATTA, Isabel Chase. Sculptor. Born: Madison, Wisconsin in 1921. Studied: Smith College; Yale University School of Fine Arts; Art Students League. Awards: Village Art Center, 1946; National Association of Women Artists, 1952; Village Art Center, 1951. Collection: Wadsworth Atheneum, Hartford, Connecticut.

BORNSTEIN, Yetta. Painter. Studied: with private instructors in Richmond Virginia; William and Mary College. Award: Museum Annual Tidewater Artists.

BORONDA, Beonne. Sculptor. Born: Monterey, California in 1911. Studied: Art Students League. Awards: National Association of Women Artists, 1938; New Jersey Society of Painters and Sculptors, 1945, 1946; Pen and Brush Club, 1945; Norwich Art Association, 1953; Silvermine Guild Association, 1955. She is noted for her animal sculpture.

BORTIN, Dora. Painter. Born: Ukraine in 1888. Studied: Pennsylvania Academy of Fine Arts. Awards: Pennsylvania Academy of Fine Arts, 1954. Collection: private collections.

BOSE, Norma. Painter. Born: San Francisco, California. Studied: George Washington University; Columbia University. Has exhibited extensively throughout the Washington, D.C. area.

BOSSERT, Edythe Hoy. Painter. Born: Pennsylvania in 1908.
Studied: Carnegie Institute; Lock Haven State Teachers
College. Has exhibited throughout the Eastern United States.

BOSTELMAN, Else W. Painter: Born: Leipzig, Germany.
Studied: University of Leipsig; Academy of Fine Arts,
Germany. Awards: Pen and Brush Club, 1953, 1954.
Collections: executed over 300 plates of deep-sea and
shore fish and series of floral watercolors for National
Geographic Magazine.

BOSWORTH, Sala. Painter. Born: in 1805 and died in 1890.
She was noted for her portraits and landscapes.

BOSWORTH, Winifred. Painter. Born: Elgin, Illinois in
1885. Studied: Boston Museum of Fine Arts; Art Students
League; Laurens in Paris; Eisengruber in Munich. She is
also an etcher.

BOTKE, Jessie A. Painter. Born: Chicago, Illinois in 1883.
Studied: with Johansen, Woodbury and Herter. Awards:
Englewood Woman's Club, 1917; Peoria Society of Allied
Arts, 1918; Chicago Society of Artists, 1919. Collections:
Municipal Gallery, Chicago; University of Chicago; Chicago
Art Institute.

BOUGUEREAU, Elizabeth Gardinier. Born: Exeter, New
Hampshire in 1851 and died in 1922. Studied: In Paris.
Award: Philadelphia Centennial, 1876. Her specialty was
ideal figure-pieces.

BOURGEOIS, Louise. Sculptor. Born: Paris, France in 1911.
Studied: Ecole des Beaux-Arts, Paris; Art Students League;
and with Fernand Leger. Awards: Museum of Modern Art,
1943. Collections: Albright Art Gallery; Museum of Modern
Art; Whitney Museum of American Art.

BOURNE, Gertrude B. Painter. Born: Boston, Massachusetts.
Studied: with Snell and Henry W. Rice. She is noted for
her watercolors.

BOWDITCH, Mary O. Sculptor. She was exhibited in 1920
in Pennsylvania.

BOWDOIN, Hariette. Painter. Born: in Massachusetts.
Studied: with Eliot Daingerfield.

BOWER, Helen Lane. Painter. Born: Lanesville, New York
in 1898. Studied: Pratt Institute Art School; and with
Ennis. Awards: Wolfe Art Club, 1939, 1944.

BOWERS, Beulah Sprague. Painter. Born: Everett, Massachusetts in 1892. Studied: Massachusetts Institute of Technology; South Boston Art School; Massachusetts School of Art; University of New Hampshire; Cooper Union Art School. Awards: Arts and Crafts Association, Meriden, Connecticut.

BOWMAN, Dorothy. Serigrapher. Born: Hollywood, California in 1927. Studied: Chouinard Art Institute; Jepson Art Institute. Awards: Los Angeles County Fair, 1952, 1953; National Serigraph Society, 1952; Brooklyn Museum, 1954; Library of Congress, 1954; University of Illinois, 1956; Boston Printmakers, 1956, 1958; California Artists, 1957; Wichita, Kansas, 1957. Collections: New York Public Library; Immaculate Heart College, Los Angeles; Brooklyn Museum; Crocker Art Gallery, Sacramento, California; Metropolitan Museum of Art; Library of Congress; San Jose State College; Boston Museum of Fine Arts; Rochester Memorial Art Gallery; University of Wisconsin.

BOWMAN, Jean. Painter. Born: Mt. Vernon, New York in 1917. Studied: Grand Central Art School; National Academy of Design; Scott Carbee School of Art. Award: Grand Central Art School, 1936. Collection: National Museum of Racing.

BOYER, Helen King. Engraver. Born: Pittsburgh, Pennsylvania in 1919. Studied: with Boyd Hanna, Wilfred Readio and Samuel Rosenberg. Awards: Society of American Graphic Artists, 1943; Library of Congress, 1943; Tiffany Foundation grant, 1949; New Jersey Federation of Women's Club, 1952, 1953, 1954. Collections: Library of Congress; Carnegie Institute; Metropolitan Museum of Art; Henning Company, 1955.

BOYER, Louise (Rive-King) Miller. Engraver. Born: Pittsburgh, Pennsylvania in 1890. Studied: Carnegie Institute. Awards: Association of Artists of Pittsburgh; John Herron Art Institute, 1946. Collections: Library of Congress; Metropolitan Museum of Art; Carnegie Institute; Richard C. du Pont Memorial; Aluminum Company of America.

BOYLE, Sarah Y. Painter. Born: Germantown, Pennsylvania. Studied: Drexel Institute; and with Howard Pyle. Was exhibiting in Pennsylvania in 1924-1925.

BRACKEN, Clio Huntion. Sculptor. Born: in 1870 and died in 1925. Studied: Art Students League; and with Rodin. Among her work is a statue of General Fremont in California and a bust of General Pershing.

BRACKEN, Julia M. Sculptor. A leader of the women sculptors of the West. Her best known work is in bronze in the capitol at Springfield, Illinois.

BRACKET, Miss H. V. Engraver. Possibly the earliest woman engraver in the United States, evidenced by a large bible plate of "Ruth and Boaz," published in 1816 which bears her name.

BRADFIELD, Elizabeth P. Sculptor. She was exhibiting in 1925.

BRADFIELD, Margaret. Painter. Born: Danville, Illinois in 1898. Studied: Northwestern University; Art Institute of Chicago; Columbia University; Detroit Society of Arts and Crafts. Awards: Detroit Society of Women Painters; Ann Arbor Art Exhibition. Best known for her production of over 100 full color film-strips for schools.

BRADFORD, Myrtle Taylor. Painter. Born: Indianapolis, Indiana in 1886. Studied: Harvard University; in Germany; and in Italy. Awards: Miami Woman's Club; American Artists Professional League, 1951; Florida Southern College, 1950; Citation "Woman of Achievement," 1958, Florida Federation of Business and Professional Women's Club; Citation, Miami-Dade County Chamber of Commerce, 1958. Contributor to many folklore stories.

BRADISH, Ethelwyn. Painter. Born: Springfield, Illinois in 1882. Studied: Columbia University; and in Paris. Has exhibited in many one-man shows.

BRADLEY, Anne Cary. Painter. Born: Fryeburg, Maine in 1884. Studied: Portland, Maine; and with Browne, Jacobs and Poore. Awards: County Fair, Rochester, New Hampshire; County Fair, Fryeburg, Maine.

BRADLEY, Susan H. Painter. Born: Boston in 1851. Studied: School of Boston Museum; and with Chase and Thayer. Known as a landscape painter. Her work is in the Herron Art Institute, Indianapolis, Indiana.

BRADSHAW, Alexandra Christine. Painter. Born: in Nova Scotia, Canada. Studied: Stanford University; University of California; Columbia University; and with Hans Hofmann. Awards: San Francisco Society of Women Artists, 1932; Laguna Beach Art Association, 1941, 1942, 1948. Collections: Fresno State College; East Bakersfield High School.

BRADT, Delphine. Painter. Noted for her flower paintings which she exhibited at the Pennsylvania Academy of Fine Arts in 1924.

BRADWAY, Florence Dell. Painter. Born: Philadelphia, Pennsylvania in 1897. Studied: Philadelphia School of Design; also with Snell. Awards: Moore Institute, 1934, 1955.

BRAINARD, Elizabeth H. Painter. Born: Middleboro and died in Boston in 1905. Collection: Boston College. She was best known as a portrait painter.

BRALL, Ruth. Sculptor. Born: New York City in 1906. Studied: Columbia University. Awards: New Jersey Painters and Sculptors Society; Hudson Valley Art Association; Pen and Brush Club. Collections: Columbia University; New York School of Social Work; Paine College, Atlanta, Georgia.

BRANNAN, Sophie Marston. Painter. Born: Mountain View, California. Studied: Mark Hopkins Institute of Art; and in Paris. Awards: National Association of Women Artists; Connecticut Academy of Fine Arts; McMillan prize, New York Society of Women Painters. Collections: National Academy of Design; Corcoran Gallery of Art; Art Institute of Chicago; Syracuse Museum of Fine Art; Pennsylvania Academy of Fine Arts; Museum of Fine Arts, Toronto, Canada; Brooklyn Museum; Vanderpoel College; American Watercolor Society of New York.

BRANNIGAN, Gladys. Painter. Born: Hingham, Massachusetts. Studied: Corcoran Art School. Exhibited at the Pennsylvania Academy of Fine Arts in 1924.

BRAUM, Cora Fischer. Painter. Born: Jordon, Minnesota in 1885. Studied: with Graber, Breckenridge, Chase, Beaux and Joseph Pearson.

BREGY, Edith. Painter. Born: Philadelphia. Studied: Pennsylvania Academy of Fine Arts; and with Beaux and Carlsen. Collection: Herron Art Institute, Indianapolis. Exhibited at Pennsylvania Academy of Fine Arts in 1924.

BREHME, Claire. Painter. Born: Berlin, Germany in 1886. Studied: with Franz von Skarbina. Author of many articles on art.

BREMER, Anne. Painter. Born: San Francisco and died in 1923. Studied: Art Students League. Collections: her mural panels are in many cities in California. She was known as a mural decorator.

BRENDEL, Bettina. Born: Luneburg, Germany. Awards: Long
Beach Museum of Art; San Francisco Museum of Art; La Jolla
Art Center. Collections: International Center, Turin,
Italy; Pasadena Art Museum; San Francisco Museum of Art;
Santa Barbara Museum of Art; and in private collections in
New York and France.

BRETT, Dorothy Eugenie. Painter. Born: London, England in
1883. Studied: Slade School of Art, London. Exhibited in
Texas, Illinois and she also contributed to the New Yorker
magazine.

BREWER, Alice Ham. Born: Chicago, Illinois in 1872.
Studied: Art Students League; Art Institute of Chicago.
She was best noted for her miniatures.

BREWER, Laurana Richards. Painter. Born: in 1808 and died
in 1843.

BREWER, Mary Locke. Painter. Studied: in Rome in 1911 with
Signor Tanni; in Paris with Henri and Ernest Laurent. Noted
for such paintings as "The Sun Dial," and "High and Dry."

BREWSTER, Anna Richards. Painter. Born: Germantown,
Pennsylvania in 1870. Studied: with Dennis Bunker and
Mowbray; and in Paris with Laurens. Award: Dodge prize,
National Academy of Design, 1889. She was also an
accomplished illustrator and sculptor.

BREZEE, Evelyn. Painter. Born: Seattle, Washington in 1912.
Studied: University of California. Has exhibited
extensively in the state of California in the 1940s and 1950s.

BRIDGE, Evelyn. Etcher. Born: Chicago, Illinois in 1872.
Studied: Art Institute of Chicago; College de France,
Sorbonne. Collections: Metropolitan Museum of Art;
Carnegie National Gallery of Art, Washington, D.C.

BRIGANDI, Beverly M. Painter. Born: Brooklyn, New York
in 1943. Recent exhibitions in Galleries in New York City.

BRIGGS, Berta N. Painter. Born: St. Paul, Minnesota in
1884. Studied: Art Students League; Pratt Institute of
Art School; Columbia University; Minneapolis Craft School.
Awards: National Association of Women Artists, 1954.
Collection: Wesleyan College, Macon, Georgia.

BRINTON, Caroline P. Born: Pennsylvania. Studied:
Pennsylvania Academy of Fine Arts.

BRODEAU, Anna Maria. Painter. Born: in 1775 and died in
1865. She was known for her miniatures.

BRODHEAD, Quita. Painter. Born: Wilmington, Delaware.
Studied: Pennsylvania Academy of Fine Arts; Grande
Chaumiere, Paris. Awards: Pennsylvania Academy of Fine
Arts; Wilmington Art Association, 1941, 1942; Ohio
University College of Fine Arts, 1947. Collection: Creuze
Gallery, Paris.

BROH, Minerva M. L. Painter. Born: High Spire,
Pennsylvania. Has exhibited in New York and Pennsylvania.

BROMWELL, Elizabeth H. Painter. Born: Charleston, Illinois.
Studied: in Denver, Colorado and in Europe.

BROOKS, Amy. Painter. Born: Boston, Massachusetts.
Studied: Boston Museum School. She also illustrated her
own books.

BROOKS, Caroline Shawk. Sculptor. Born: Cincinnati, Ohio
in 1840. Best Known for her marble portraits of Garfield,
George Eliot and Thomas Carlyle.

BROOKS, Cora S. Painter. Studied: Philadelphia School of
Design.

BROOKS, Isabel. Painter. Known for her exhibition at the
Academy of Fine Arts, Philadelphia in 1925.

BROUDY, Miriam L. Painter. Born: Altoona, Pennsylvania in
1905. Studied: Pratt Institute Art School; Art Students
League; and in Paris. Awards: Connecticut Academy of Fine
Arts, 1956. New England Exhibition, 1957; Silvermine Guild
Association, 1950-1958.

BROWN, Abby M. Painter. She was a miniature painter whose
work flourished between 1800-1822. She also did portraits.

BROWN, Agnes. Born: Newburyport, Massachusetts. She was
best known for her paintings of landscapes, flowers and cats.

BROWN, Alice V. Painter. Born: Hanover, New Hampshire in
1862. Studied: Art Students League. Co-author on a book
entitled "Short History of Italian Painting."

BROWN, Anne R. Painter. Born: Des Moines, Iowa in 1891.
Studied: Drake University; State Teachers College, Albany,
New York. Has exhibited in New York and Florida.

BROWN, Charlotte H. Illustrator. Born: Newark, New Jersey
in 1873. Studied: Philadelphia School of Design for Women.

BROWN, Dorothy H. Painter. Known in the Providence, Rhode
Island area for her art.

BROWN, Dorothy. Painter. Born: Houston, Texas in 1899.
Studied: Stanford University Art Association; University
of California. Awards: San Diego Fine Art Society, 1955;
California Watercolor Society, 1953; Los Angeles Museum
of Art, 1958; La Jolla Art Center. Collections: University
of California, Los Angeles Collection; La Jolla Art Center;
Stanford Research Institute; Long Beach Museum of Art.

BROWN, Ethel P. Painter. Born: Wilmington, Delaware.
Studied: with Howard Pyle; Pennsylvania Academy of Fine
Arts.

BROWN, Gertrude G. Painter. Born: Malden, West Virginia in
1880. Studied: Maryland Art Institute; Columbia University;
and in Europe; and with Snell.

BROWN, Grace E. Painter. Born: Beverly, Massachusetts
in 1873. Studied: with Joseph De Camp, and Armand Clements.

BROWN, Irene. Painter. Born: Hastings, Michigan. Studied:
with William M. Chase. She is also a sculptor.

BROWN, Joan. Painter. Born: San Francisco in 1938. Studied:
California School of Fine Arts. Is married to painter
Manuel Neri. She has exhibited at the Pennsylvania Academy
of Fine Arts and Whitney Museum of American Art.

BROWN, Lillian C. Painter. Member of Art Students League
of New York.

BROWN, Mary Ann. Painter. Known as a still-life artist;
genre and landscape painter. Worked in the mid 1800s.

BROWN, May Morgan. Painter. Born: Hartwell, Ohio. Studied:
University of Michigan. Awards: Detroit Institute of Art,
1938; Detroit Society of Women Painters, 1943. In many
exhibits in the Detroit area.

BROWN, Pamela V. Painter. Exhibited her portraits and
miniatures around 1922.

BROWNE, Frances E. Painter. Active in the Cincinnati area.

BROWNE, Margaret F. Painter. Born: Boston, Massachusetts
in 1884. Studied: Massachusetts Normal Art School; Boston
Museum of Fine Arts School; also with Frank Benson and
Joseph De Camp. Awards: North Shore Art Association, 1925;
Brooklyn Museum, 1928; Ogunquit Art Center, 1941; Rockport
Art Association, 1955; Connecticut Academy of Fine Arts.
Collections: Massachusetts Institute of Technology; Boston
University; Harvard University; Bureau of Standards,
Washington, D.C. Buckley School, New York; Powers School
Boston; Driscoll School, Brookline, Massachusetts.

BROWNE, Matilda. Painter. Born: Newark, New Jersey in 1869. Studied: with Julien Dupre, Dewey and Bisbing. Awards: Columbian Exposition, Chicago.

BROWNELL, Matilda A. Painter. Born: in New York. Studied: with Chase.

BROWNWELL, Rowena P. Painter. Well known in the Providence Rhode Island area for her art.

BROWNING, Colleen. Painter. Born: Fermoy County Cork, Eire in 1925. Studied: Slade School of Art, London, England. Awards: Anna Lee Stacey Scholarship; Slade School of Art; Carnegie Institute, 1952; Butler Art Institute 1954; National Academy of Design; Los Angeles County Fair; Stanford University; American Watercolor Society. Collections: Butler Art Institute; Williams College; Detroit Institute of Art; Rochester Memorial Art Gallery; Spaeth Foundation; Columbia South Carolina Museum of Art; Grinkle Hall, Yorkshire, England; Sibley, Lindsay and Curr, Rochester, New York.

BROWNING, Mrs. Miniature painter whose work flourished around 1839 in New York.

BROWNSCOMBE, Jennie (Augusta). Painter. Born: Honesdale, Pennsylvania in 1850. Studied: with Wilmarth; National Academy of Design; with Mosier in Paris. She specialized in historical figure-subjects.

BRUMBACK, Louise Upton. Painter. Born: Rochester, New York. Studied: with William Chase.

BRUNET, Adele L. Painter. Born: Austin, Texas. Studied: University of Texas; Art Students League; Art Institute of Chicago. Awards: Federation of Dallas Artists, 1848-1951, 1953-1955. Collections: Newman Club Hall, Austin, Texas; Parkland Hospital, Dallas, Texas.

BRUSKIN, Kathleen Spencer. Painter. Born: Omaha, Nebraska in 1911. Studied: Pennsylvania Academy of Fine Arts. Collection: mural, Unitarian Church, Arlington, Virginia.

BRY, Edith. Painter. Born: St. Louis, Missouri in 1898. Studied: in Europe; Art Students League; and with Archipenko and Locke. Collections: Metropolitan Museum of Art; Library of Congress; New York Public Library.

BRYAN, Mary (TAYLOR LEWIS). Painter. Born: Carlsbad,
New Mexico in 1907. Studied: Eliot O'Hara School Watercolor,
and with Emil Gruppe. Awards: American Watercolor Society,
1953, 1955; Women's National, 1954; North Shore Art
Association, 1949, 1951, 1954; Rockport Art Association,
1956; Silvermine Guild Art., 1954, 1955; Fleming Museum of
Art, 1958.

BRYANT, Maud D. Painter. Born: Wilmington, Delaware in
1880. Studied: Pennsylvania Academy of Fine Arts with Chase;
Colarossi Academy in Paris.

BRYANT, Nanna Mathews. Sculptor. Was exhibiting in 1924.

BUCHANAN, Ella. Sculptor. Born: Canada. Collection: Martha
Baker Memorial, Chicago.

BUCHANAN, Laura. Painter. Born: Waxahachie, Texas. Studied:
with Reaugh and John Knott. Award: Federation Dallas Artists,
1954, 1955. Collections: Waxahachie High School; Elizabet
Ney Museum of Art; Parkland Hospital, Dallas.

BUCHHOLZ, Emmaline (Hardy). Painter. Born: Ormondsville,
North Carolina. Studied: Randolph-Macon College; Art
Institute of Chicago; Pennsylvania Academy of Fine Arts.
Collections: Florida State College for Women; University of
Florida; State Library, Tallahassee.

BUCK, Emma G. Painter and Sculptor. Born: Chicago, Illinois
in 1888. Collection: Wisconsin, Perry's Centennial Medal.

BUCK, Leslie (Binner). Painter. Born: Chicago, Illinois.
Studied: Art Institute of Chicago; Studio School of Art,
Chicago. Awards: Sanity in Art, Chicago, 1938; Santa Cruz
Art League, 1944; Santa Cruz County Fair, 1947, 1950;
Chicago Galleries Association, 1941, 1944; Oakland Art
Gallery, 1947, 1948. Collections: Vanderpoel College; Public
School, La Grange, Illinois.

BUCKLEY, Jean. Sculptor. Born: Sacramento, California in
1925. Studied: Sacramento College; Chouinard Art Institute;
Art Students League; California College of Arts & Crafts;
University of Southern California. Awards: California
Watercolor Society, 1952; Unitarian Exhibition, Los Angeles,
1954; California State Fair, 1955; Orange County National
Exhibition 1957; Los Angeles Art Festival, 1957.
Collections: California State College, Sacramento; Immaculate
Heart College; Grant Beach School of Arts & Crafts, Oakland,
California.

BUDD, Katherine C. Painter and Illustrator. Studied: with
William M. Chase.

BUDELL, Ada. Painter. Born: Westfield, New Jersey in 1873. Studied: Art Students League. Awards: Art Center of the Oranges, 1927, 1931; Westfield Art Association, 1932, 1933, 1935, 1936, 1940, 1952; Plainfield Art Association, 1941, 1950, 195; National Association of Women Artists, 1952. Collections: Asbury Park Museum; State House, Trenton, New Jersey; Beckley Company, Garwood, New Jersey.

BUDELL, Emily Hortense. Born: Lyons, France in 1884. Studied: with Carlson, Snell and Browne. Awards: Art Center of the Oranges, 1926, 1931, 1953; National Association of Women Artists, 1931; Plainfield Art Association, 1931, 1938; Contemporary Gallery, New Jersey, 1933, 1935, 1936, 1938, 1941; Montclair Art Museum, 1936; Irving Art and Museum Association, 1944, 1949; Rahway Art Center, 1953; Westfield Art Center, 1940, 1950, 1952, 1953, 1955 and 1957. Collection: Asbury Park Museum.

BUEHR, Mary G. (Hess). Painter. Born: Chicago, Illinois. Studied: Holland and France. Known for her miniatures.

BUELL, Alice S. Etcher. Born: Oak Park, Illinois. Studied: Oberlin College; Art Students League. Awards: Southern States Art League; Southern Printmakers, 1938; Philadelphia Printmakers Club, 1939; Pen and Brush Club, 1953. Collections: Library of Congress; Dartmouth College; University of Wisconsin; Montclair Art Museum; Art Students League.

BUGBIRD, Mary Bayne. Painter. Born: Richmond Virginia in 1889. Studied: Art Students League. Awards: Whitney Studio Club; Newark Art Club, 1940; National Association of Women Artists, 1955; Verona-West Essex Art Association, 1957.

BUHOLZ, Frances. Painter. Born: Red Wing, Minnesota in 1896. Studied: Minneapolis School of Art. Awards: Minneapolis Institute of Art, 1935.

BULLER, Audrey. Painter. Born: Montreal, Canada. Studied: Art Students League. Awards: National Academy of Design, 1937; Pepsi-Cola; National Association of Women Artists, 1953. Collections: Metropolitan Museum of Art; Whitney Museum of American Art.

BULLOCK, Mary Jane (McLean). Painter. Born: Fort Worth, Texas in 1898. Studied: Texas Christian University; Art Institute of Chicago. Awards: Southern States Art League, 1936, 1938, 1946. Collections: Women's Club, Tyler, Texas.

BULL-TEILMAN, GUNVOR (Mrs). Painter. Born: Bodoe, Norway in 1900. Studied: Grande Chaumiere, Julian Academy, Paris; Academy of Fine Arts, Leipzig. Awards: Albany Institute of History and Art, 1935; Salon d'Automne, Paris, 1926; Germanic Museum, Harvard University, 1933; Am-Scandinavian Art Group, 1936. Collections: murals, Waldorf-Astoria Hotel, New York City; United States Time Corporation, Waterbury, Connecticut.

BUMSTEAD, Ethel Quincy. Painter. Born: London, England in 1873. Studied: Boston Museum School.

BURD, Clara Miller. Painter and illustrator. Born: New York. Studied: in New York; and in Paris.

BURD, Eliza Howard. Watercolorist working in 1840.

BURDETTE, Dorothy May. Painter. Born: Arkansas City, Kansas in 1893. Studied: State College, Pittsburg, Kansas; Scranton, Pennsylvania.

BURDOIN, Juliet (Howson). Painter. Born: Toronto, Canada in 1873. Studied: Ontario Art School; also studied in Paris and Holland. Collections: private in the United States and Canada.

BURGESS, Alice L. Painter. Born: St. Louis, Missouri in 1880. Studied: with William M. Chase.

BURGESS, Ruth P. Painter. Born: Montpelier, Vermont. Studied: Art Students League; also in Germany and Italy. Has painted portraits of many outstanding men.

BURKE, Ainslie. Painter. Born: Omaha, Nebraska in 1922. Studied: Maryland Institute of Art; John Hopkins University; McCoy College; Art Students League; San Miguel Allende, Mexico. Collections: Columbia University, Students Center: Springfield Museum of Art.

BURKE, Frances. Painter. Known principally for her copy of Washington's portrait (the original painted by William Joseph Williams in 1792) which is in the Philadelphia Masonic Hall.

BURKENROAD, Flora S. Painter. Born: Lafayette, Indiana in 1873. Studied: National Academy of Design; and in Paris.

BURLINGAME, Shelia E. Sculptor. Born: Lyons, Kansas in 1905. Studied: Art Institute of Chicago; Grande Chaumiere, Paris. Awards: St. Louis Art Guild; Pen and Brush Club; National Association of Women Artists; American Artists Professional League. Collections: Vanderpoel College; Leonberger Davis College; Kroeger Memorial, St. Louis; many figures and reliefs in churches in Missouri, Colorado, Arkansas and Montana.

BURNETT, Mrs. Walter O. Pastel portraitist working in 1856.

BURNHAM, Anita W. Painter and etcher. Born: Brooklyn, New York in 1880. Studied: with William M. Chase; Ralph Pearson for etching; Art Students League; Pennsylvania Academy of Fine Arts. Awards; Art Institute of Chicago, 1903, 1905, 1916; North Shore Art Association, 1936. Collection: Children's Hospital, Chicago; Beloit College.

BURNHAM, Carol-Lou. Painter. Born: Chicago, Illinois in 1908. Studied: Fontainebleau School of Fine Arts; Art Institute of Chicago. Collection: Decatur Art Center.

BUROS, Luella. Painter. Born: Canby, Minnesota. Studied: Rutgers University; Columbia University; Ohio State University. Awards: Columbus Art League, 1935; Asbury Park Society of Fine Arts, 1938; New Jersey Gallery, 1938, 1940; Montclair Art Museum, 1938-40-41; Springfield Art League, 1941; Norfolk Museum of Art and Science, 1944, 1945; Washington Watercolor Club, 1945; Art Council of New Jersey 1949, 1952; Plainfield Art Association, 1950-1951; Rahway Art Center, 1951-1952; Newark Art Club, 1940, 1953; National Association of Women Artists, 1953; Old Mill Gallery, 1954; Hunterdon County Art Center, 1955. Collections: Montclair Art Museum; Newark Museum of Art; City of Cape May.

BURR, Frances. Painter. Born: Boston, Massachusetts in 1890. Studied: Art Students League; Provincetown School of Art. She was the originator of a new method for emphasizing mountains on aeronautical charts known as the Burr Three-Dimensional Charts, used by the United States Government.

BURRAGE, Mildred Giddings. Painter. Born: Portland, Maine in 1890. Studied: Academie Colorossi, Grande Chaumiere in Paris. Awards: International Art Union, Paris, 1912. Collection: Bryn Mawr Science Library.

BURRELL, Louise. Painter. Born: London, England. Studied: with Herkomer.

Edith Woodman Burroughs, ON THE THRESHOLD. Stone. The Metropolitan Museum of Art, Purchase (Amelia B. Lazarus Fund, 1919).

BURROUGHS, Edith W. Sculptor. Born: in 1871 and died in 1916. Studied: Art Students League; and in Paris. Collection: Metropolitan Museum of Art.

BURROUGHS, Sara A. Painter. Noted for he landscape paintings around 1830.

BURROWS, Pearl. Painter. Born: Shoals, Indiana in 1916. Studied: Boston Museum of Fine Arts; Harvard University. Collections: Court House, Dalhart, Texas; Public Library, La Junta, Colorado.

BURT, Beatrice M. Painter. Born: New Bedford, Massachusetts in 1893. Studied: New York; and in Paris. She was known for her miniature paintings.

BURT, Marie Haines. Painter. Born: Cincinnati, Ohio. Studied: Cincinnati Art Academy; Art Institute of Chicago; National Academy of Design. Awards: Southern States Art League, 1930, 1937. Collections: Museum of New Mexico, Santa Fe; Texas Agricultural and Mechanical College; Austin High School, Bryan, Texas; Ehlinger-Grant Clinic, Bryan, Texas.

BURT, Mary T. Painter. Born: Philadelphia. Studied: Pennsylvania Academy of Fine Arts; Julien Academy, Paris.

BURTIS, Mary E. Painter. Born: Orange, New Jersey in 1878. Studied: with Mme Christine Lumsden.

BURTON, Netta M. Painter. Born: Scott, Pennsylvania. Studied: Columbia University. Awards: National Association of Somen Artists; Ossining Art Association; Westchester Art Guild, 1940-1951, 1953; Pleasantsville Art Club, 1954.

BUSCH, Elizabeth W. Painter. Born: Dayton, Ohio in 1897. Studied: Stout Institute, Menomonie, Wisconsin; Dayton Art Institute. Awards: Springfield Art Association, 1955; Dayton, Ohio, 1954; Little Jury Award, 1957; Ohio Valley, 1957. Has exhibited mainly throughout the Dayton and Springfield area.

BUSH, Agnes S. Painter. Born: Seattle, Washington. Studied: with Ella S. Bush and Paul Morgan Gustin.

BUSH-BROWN, Margaret L. Painter. Born: Philadelphia, Pennsylvania, 1857. Studied: Pennsylvania Academy of Fine Arts; Julien Academy in Paris. She is known by her portraits of Lincoln and Lee. She is also a miniature painter.

BUTLER, Esteria. Painter. A miniature and landscape painter working before 1850.

BUTLER, Helen S. Painter. Born: West Chester, Pennsylvania.
Studied: with Chase.

BUTLER, Mary. Painter. Born: Philadelphia, Pennsylvania.
Studied: with Chase and Henri. Collections: Pennsylvania
Academy of Fine Arts; West Chester State Normal School;
Williamsport High School.

BUZBY, Rosella T. Painter. Born: Philadelphia in 1867.
Studied: Pennsylvania Academy of Fine Arts. She was also
an illustrator.

BUZEK, Irene M. Painter. Born: Camden, New Jersey in
1891. Studied: Pennsylvania Academy of Fine Arts; Tyler
School of Fine Arts. Awards: Pennsylvania Academy of
Fine Arts; Montclair Art Association, 1943; Woodmere Art
Association, 1944.

BYERS, Evelyn. Painter. Known for her watercolors. She
has exhibited at the Pennsylvania Academy of Fine Arts.

BYRNE, Ellen A. Painter. Born: Fort Moultrie, South
Carolina in 1858. Studied: Corcoran School of Art,
Washington, D. C.; with William M. Chase; and in Paris.

CADY, Emma. Painter. Still-life water colorist working about 1820.

CAESAR, Doris. Sculptor. Born: New York City in 1893. Studied: Art Students League; Archipenko School of Art. Collections: Utica Public Library; Addison Gallery of American Art; Newark Museum of Art; Whitney Museum of American Art; Connecticut College; Fort Worth Art Association; University of Iowa, University of Minnesota; University of Delaware; Wadsworth Atheneum; Dayton Art Institute; Minneapolis Institute of Art; Chapin School; Chapel of Our Redeemer, Chappaqua, New York; Philadelphia Museum of Art; Pennsylvania Academy of Fine ARts; Albion College; Farnsworth Museum of Art; Wellesley College; Atlanta Art Center.

CAFARELLI, Michele A. Painter. Born: Laurenzana, Italy in 1889. Studied: Art Students League. Collection: Paterson, New Jersey, Court House; Jersey City Public Library; Borough of Lodi, New Jersey; City of Newark; Bayonne, New Jersey.

CALAMAR, Gloria. Painter. Born: New York City in 1921. Collection: Santa Barbara Museum, California. She has exhibited in California, New Orleans and Paris.

CALDER, May. Painter. Painting landscapes around 1858.

CALIFF, Marilyn I. Painter. Awards: Mid-South Annual Exhibition; National B'nai B'rith Women's Art Exhibition, Washington, D.C. Collection: Brooks Memorial Art Gallery.

CALLERY, Mary. Sculptor. Born: New York City in 1903. Studied: Art Students League. Collections: Toledo Museum of Art; San Francisco Museum of Art; Addison Gallery of American Art; Detroit Institute of Art; Aluminum Company of America.

CALVERT, Bertha W. Painter. Born: Nashville, Tennessee in 1885. She specialized in ivory miniatures.

CALVERT, Melvina. Painter. Born: Carterville, Missouri in 1908. Studied: Washington University; St. Louis School of Fine Arts. Awards: St. Louis Art Guild, 1954; City Art Museum of St. Louis, 1951, 1952, 1954, 1955.

CALVIN, Katharine. Painter. Studied: in Europe. Painted portraits and landscapes.

CAMERO, Blanche Gonzalez. Painter. Born: New York City in 1894. Studied: Philadelphia Museum School of Industrial Arts; Pennsylvania Academy of Fine Arts. Awards: Pennsylvania Academy of Fine Arts; Philadelphia Museum School of Industrial Arts, 1916, 1918. Collections: Shoemaker Junior High School, Philadelphia, Pennsylvania; Overbrook High School, Philadelphia.

CAMERON, Emma. Painter. Working about 1850.

CAMERON, Josephine E. Painter. Born: Portland, Oregon in 1925. Studied: Portland Museum Art School; Maryhurst College, Oregon; Seattle College. Award: Alaskan Exhibition, 1957, Anchorage, Alaska. Collections: Airport Heights Elementary School, Anchorage, Alaska; Henry Gallery, University of Washington; Sandy Union High School, Sandy, Oregon.

CAMERON, Marie G. Painter. Born: France. Studied with Laurens and Constant; Art Institute of Chicago.

CAMERON-MENK, Hazel. Painter. Born: St. Paul, Minnesota in 1888. Studied: Ringling School of Art; George Washington University; Corcoran School of Art. Awards: League of American Pen Women, 1933, 1935, 1937; Society of Independent Artists, 1933; Arlington Women's Club, 1934; Collections: Clarendon Library, Arlington, Virginia.

CAMFFERMAN, Margaret G. Painter. Born: Rochester, Minnesota. Studied: Minneapolis School of Fine Arts; New York School of Design. Awards: Women Painters of Washington, 1942, 1944, 1945, 1951; National League of American Pen Women, 1947, 1952, 1954, 1955. Collection: Seattle Art Museum.

CAMPBELL, Anna B. Painter. Born: St. Louis, Missouri in 1879. Studied: Art Students League; Corcoran Art Gallery, Washington, D.C.

CAMPBELL, Annie. Painter. Studied: with Otto Dow and Ralph Beck. Known for her landscapes.

CAMPBELL C. Isabel. Painter. Born: Brooklyn, New York. Studied: Philadelphia School of Design for Women; also studied with Snell, Garber and Daingerfield. Awards: Sesquicentennial Exposition, Philadelphia, 1926; Moore Institute, 1948; Philadelphia School of Design for Women. Collection: Philadelphia Commercial Museum, Philadelphia.

CAMPBELL, Cora A. Painter. Studied: Pennsylvania State College; Cornell University. Award: Philadelphia Plastic Club.

CAMPBELL, Harriet Dunn. Painter. Born: Columbus, Ohio
in 1873. Studied: Columbus Art School; Ohio State
University; Art Students League; and with Bridgman, Dow,
Henri and Chase; Thurn School of Art; and with McNulty.
Awards: Columbus Art League, 1920, 1921, 1923, 1927, 1933,
1935; Ohio Watercolor Society, 1950, 1952. Collection:
University of Ohio, Athens, Ohio.

CAMPBELL, Helena E. Painter. Born: Eastman, Goergia.
Studied: with William M. Chase and Henri. Awards:
Wesleyan College, Macon, Georgia; Crestwood Woman's Club,
1954; New Rochelle Woman's Club, 1955; American Artists
Professional League, 1957. Collections: Columbia
University; State Teachers College, Upper Montclair,
New Jersey; Mid Valley Hospital, Pennsylvania; Museum of
City of New York; Historical Department, United States
Navy; Public Library, Boonville, New York; American
Mathematical Society, Columbia University.

CAMPBELL, Isabella F. Painter. Born: Rockford, Illinois
in 1874. Studied: Art Institute of Chicago; Art Students
League; and with William M. Chase. Awards: Women
Painters of the West, 1940; American Artists Professional
League, 1949; League of American Pen Women, 1949.
Collection: Hollywood Congregational Church.

CAMPBELL, Sara W. Painter. Born: St. John, New Brunswick,
Canada. Studied: Eric Pape School of Art, Boston; Chase
School of Art. Collections: Art work in many magazines
such as McCalls, Scribner and cover designs for leading
advertising companies.

CAMPBELL, Shirley A. Painter. Born: Cleveland, Ohio in
1925. Studied: Cleveland Institute of Art; Art Students
League; Pratt Institute of Art School. Awards: Cleveland
Institute of Art, 1947; Cleveland Museum of Art, 1956, 1957,
1958; Ohio State Fair; Jay Show Awards, Cleveland, 1957,
1958; Fashion Group award, Cleveland, Ohio. Collection:
Cleveland Museum of Art.

CAMPRUBI, Leontine. Painter. Born: Caldwell, New Jersey
in 1916. Studied: Art Students League; Colorado Springs
Fine Arts Center; Switzerland. Has exhibited extensively
throughout the United States, especially the South; and
in Brazil.

CANNON, Beatrice. Painter. Born: Louisville, Kentucky in
1875. Studied: Art Institute of Chicago.

CANNON, Florence V. Painter. Born: Camden, New Jersey. Studied: Philadelphia Museum School of Industrial Art; Pennsylvania Academy of Fine Arts; Grande Chaumiere, Paris. Awards: Cresson traveling scholarships, Pennsylvania Academy of Fine Arts, 1928, 1929; Toppan Award, 1930; Northwest Printmakers, 1933; National Association of Women Artists, 1936; Southern Printmakers, 1937; Plastic Club, 1943; fellowship, Pennsylvania Academy of Fine Arts; Camden High School, Camden, New Jersey. Collections: Pennsylvania Academy of Fine Arts; Philadelphia Art Alliance; Harcum Junior College, Bryn Mawr, Pennsylvania; Philadelphia Museum of Art; Woodmere Art Gallery; Northwest Printmakers; Southern Printmakers.

CANTARELLA, Maria Boveri. Painter. Born: New York City. Studied: New York University; National Academy of Design; Cooper Union Art School. Awards: American Women's Club; National Association of Women Artists; American Artists Professional League.

CANTIENI, Margaret B. Painter. Born: Newton, Kansas in 1914. Studied: Carleton College; Art Institute of Chicago. Awards: Art Institute of Chicago, 1946; Intermont College, Bristol, Virginia, 1945.

CANTRALL, Harriet M. Painter. Born: Springfield, Illinois. Studied: Pratt Institute.

CAPARN, Rhys. Sculptor. Born: Onteora Park, New York in 1909. Studied: Bryn Mawr College; Archipenko School of Fine Arts; and in Paris with Navellier. Awards: National Association of Women Artists, 1944, 1945; Metropolitan Museum of Art, 1951. Collections: Brooklyn Botanical Gardens; Whitney Museum of American Art; Fogg Museum of Art; Corcoran Gallery of Art; Colorado Springs Fine Art Center; City Art Museum of St. Louis; Barnard College.

CAPLANE, Felice. Painter. Born: Hamburg, Germany in 1912. Studied: Academy of Art, Hamburg, Germany. Collection: Florida Southern College.

CARAVIA, Thalia F. Painter. Was exhibiting in 1925.

CAREW, Bertha. Painter. Born: Springfield, Massachusetts in 1878. Studied: in New York with Blashfield, Mowbray and Chase; in Rome with Carlandi; and in Paris with Mme. Richarde.

CAREWE, Sylvia. Painter. Born: New York City in 1914.
Studied: Columbia University. Awards: Art Gallery
Competition, 1947. Collections: Brandeis University;
Butler Art Institute; Howard University; Musee de l'Arte
Moderne, Paris; Richmond Indiana Art Association; Tel-Aviv
Museum; Museum of Modern Art Rental Library.

CARISS, Marguerite. Painter. Born: Green Tree,
Pennsylvania in 1883. Studied: Philadelphia Museum School
of Industrial Art; with Ludwig Faber. Collections:
Pennsylvania Academy of Fine Arts; Philadelphia Museum of
Art; National Collection of Fine Art, Washington, D. C.

CARL, Katherine A. Painter. Born: New Orleans, Louisiana.
Studied: in Paris with Bouguereau and Gustave Courtois.
Painted portrait of Empress Dowager of China.

CARLES, Sarah. Painter. Was exhibiting in 1924.

CARLISLE, Mary Helen. Painter. Award: McMillin prize,
National Academy of Women Painters and Sculptors, 1914.

CARLSEN, Flora Belle. Painter. Born: Cleveland, Ohio
in 1878. Studied: with Du Bois, Matzen and F. C. Jones.
Member of the National Academy of Women Painters and
Sculptors.

CARLSON, Margaret G. Painter. Born: Plainsfield, New
Jersey in 1882. Member National Academy of Women Painters
and Sculptors.

CARLSON, Margaret M. Illustrator. Born: Deming,
Washington in 1892.

CARLSON, Valerie Klee. Painter. Born: Cincinnati, Ohio
in 1907. Studied: Cincinnati Art Academy; Frankfort,
Germany; Westminister School of Art, London; Academy of
Fine Arts, Munich, Germany. Awards: Cincinnati Museum
Association, 1945; Cincinnati Woman's Club, 1949, 1950.

CARMICHAEL, Jae. Painter. Born: Hollywood, California
in 1925. Studied: University of Southern California
with Francis deErdely; Claremont College with Millard
Sheets, Phil Dike; Mills College with Roi Partridge, Raymond
Puccinelli, Dong Kingman and William Gaw. Awards: Orange
County Fair, 1953; Pasadena Society of Art, 1955; Pasadena
Art Museum, 1954; Julia Ellsworth Ford Award, 1956; Laguna
Beach Art Festival, 1957. Collections: Mills College;
Scripps College; mural, Crippled Children's Society,
Conoga Park, California, 1955.

CAROTHERS, Sarah Pace. Etcher. Born: Baltimore, Maryland in 1910. Studied: Maryland Art Institute; Art Students League. Awards: Art Foundation, Maryland, 1945; State Exhibition, Annapolis, 1954, 1956; Baltimore Museum of Art, 1946.

CARPENTER, Ellen M. Born: Killingly, Connecticut in 1830. Studied: in Paris with Lefebvre and Fleury. She has done numerous portraits and landscapes.

CARPENTER, Helen K. Illustrator. Born: Philadelphia in 1881. Studied: Pennsylvania Academy of Fine Arts; and with Chase, Breckenridge and Anshutz.

CARPENTER, Mildred Bailey. Painter. Born: St. Louis, Missouri. Studied: St. Louis School of Fine Arts; University of Madrid; Provincetown, Massachusetts; Puerto Rico. Awards: St. Louis Art Guild, 1919-1946, 1954, 1957; Kansas City Art Institute; Art Institute of Chicago; St. Louis Woman of Achievement, 1947. Collections: Christian Orphans Home, St. Louis; murals, St. Louis public schools and hotels.

CARR, Alice R. Sculptor. Born: Roanoke, Virginia in 1899. Studied: with C. Stirling Calder.

CARROTHERS, Grace Neville. Painter. Born: Abington, Indiana. Studied: with John Carlson, Anthony Thieme. Awards: Oklahoma State Exhibition, 1938. Collections: New York Public Library; Gibbes Art Gallery, Charleston, South Carolina; National Gallery of Art; British Museum; Library of Congress; Royal Ontario Museum, Toronto; Bibliotheque Nationale, Paris, France; Philbrook Art Center.

CARRY, Marion K. Painter. Born: Newport, Rhode Island in 1905. Studied: Rhode Island School of Design, Art Students League. Awards: Traveling scholarship, Newport Art Association, 1939; Newport Art Association, peoples prize, 1950, 1955. Collection: Rhode Island School of Design.

CARTER, Betty M. Painter. Born: New York City. Studied: Parsons School of Design; and with George Ennis and Howard Giles.

CARTER, Esther F. Painter. Born: Winchester, New Hampshire in 1895. Studied: Radcliffe College; University of Minnesota; New School of Design, Boston. Collection: easel paintings and portraits in United States and Japan.

Mary Cassatt, *GIRL ARRANGING HER HAIR*. Canvas, 29" x 24 1/2".
The National Gallery of Art (Chester Dale Collection 1962).

CARTER, Mary M. Painter. Born: Philadelphia in 1864.
Studied: with Carl Weber. Is known chiefly as a miniature
painter.

CARTWRIGHT, Isabel B. Painter. Born: Coatesville,
Pennsylvania in 1885.

CARVALLA, Suzanne. Painter. Born: Paris, France in
1883. She has exhibited in Paris and New York.

CARVER, Mabel M. Painter. Born: Forest, Illinois in 1891.
Studied: Wicker School of Fine ARts, Detroit, Michigan;
Grande Chaumiere, Paris, France. Awards: Pen and Brush
Club, 1951; Village Art Center, 1949. Collection: St.
Basil's Cathedral.

CASEY, Mrs. L. W. Painter. Member of Socity of Washington
Artists.

CASSADY, Edithe Jane. Painter. Born: Chicago, Illinois
in 1906. Studied: Chicago Academy of Fine Arts; Art
Institute of Chicago. Awards: Union Club, Chicago;
Connecticut Academy of Fine Arts, 1947; South Side Art
Association, 1944, 1946, 1947; Association of Chicago
Painters and Sculptors; Magnificent Mile Exhibition,
Chicago, 1952; Allied Illinois Society of Fine Arts,
1933; gold medal, Association of Chicago Painters and
Sculptors, 1948. Collection: Board of Education, Chicago;
City of Chicago Collection.

CASSATT, Mary. Painter. Born: in Pennsylvania in 1855.
Studied: Pennsylvania Academy of Fine Arts. Elected
Associate of the National Academy of Design in 1910. She
has exhibited in Paris since 1872. She is also represented
in principal American Museums.

CASSIDY, Laura E. Painter. Member of the Cincinnati
Women's Art Club and the California Watercolor Society.

CASTALDO, Amaylia. Painter. Born: New York City in
1906. Studied: Art Students League with Kroll and Boardman
Robinson. She is noted for her portrait paintings.

CASTERTON, Eda N. Painter. Born: Brillion, Wisconsin
in 1877. Studied: Minneapolis School of Art; Art Institute
of Chicago; Chicago Academy of Fine Arts; and in Paris.
Awards: Pan-Pacific Exposition, 1915; Sesquicentennial
Exposition, Philadelphia, 1926; Evanston Woman's Club,
1942, 1944, 1946; League of American Pen Women, 1949-1951.
Collections: Smithsonian Institute; Brooklyn Museum; Illinois
State Museum.

CATLETT, Alice E. Sculptor. Studied: Howard University;
University of Iowa. Award: 1st prize for sculpture at the
Negro Exposition in Chicago, 1940.

CATOK, Lottie M. Painter. Born: Hoboken, New Jersey.
Studied: New York School of Fine and Applied Arts. Awards:
Springfield Art Guild, 1932; Springfield Art League, 1942.
Collections: Florida Southern College; portraits of
prominent Springfield persons in public buildings and
schools in Springfield.

CAVANARO, Mildred S. Painter. Decorative and modernistic
figures.

CAVANNA, Elise. Painter. Born: Philadelphia, Pennsylvania.
Studied: Pennsylvania Academy of Fine Arts. Awards: Ebell
Club, Los Angeles. Collections: Los Angeles Museum of Art;
United States Post Office, Oceanside, California.

CAWEIN, Kathrin. Etcher. Born: New London, Connecticut
in 1895. Studied: Art Students League. Awards: Society of
American Graphic Artists, 1936; Village Art Center, 1944;
National Association of Women Artists, 1947; Pleasantville
Woman's Club, 1949, 1953; Westchester Federation of Women's
Club, 1950. Collection: Metropolitan Museum of Art;
St. Mark's Church, Van Nuys, California.

CECERE, Ada R. Painter. Born: New York City. Studied:
Art Students League; National Academy of Design; Beaux-
Arts Institute of Design. Awards: Treasury Department,
1941; National Academy of Women Artists, 1943-1958;
Pen and Brush Club, 1950-1955. Collections: murals, Hyde
Park Restaurant; Broadway Central Hotel; Hotel Newton.

CHASE, Dorothea. Painter. Born: Buffalo, New York in
1894. Studied: Albright Art Gallery School; Art Students
League. Awards: Wichita Art Museum, 1937; National
Association of Women Artists, 1935. Collections: in
private collections.

CHAMBERLAIN, Emily H. Illustrator. Born: Shelby, Ohio and
died in 1916. Studied: in Paris; in London; and Pratt
Institute. Drawing children, her specialty.

CHAMBERLAIN, Judith. Painter. Born: San Francisco,
California in 1893. Studied: with Max Weber.

CHAMBERLIN, Edna W. Sculptor. Exhibited at the
Pennsylvania Academy of Fine Arts.

CHAMBERS, Christine F. Painter. Was exhibiting in 1924
at the Pennsylvania Academy of Fine Arts.

CHAMBERS, Hallie W. Painter. Born: Louisville, Kentucky
in 1881. Studied: with Hugh Breckenridge. Her specialty
is still-life paintings.

CHAMPLIN, Ada B. Painter. Born: St. Louis, Missouri.
Studied: Art Institute of Chicago; Art Students League.

CHANDLER, Helen C. Painter. Born: Wellington, Kansas
in 1881. Studied: with MacMonnies and Birge Harrison.
She is also an illustrator and etcher.

CHAPIN, Cornelia Van Auken. Sculptor. Born: Waterford,
Connecticut in 1893. Studied: in Paris with Hernandez.
Awards: National Association of Women Artists, 1936;
Paris International, 1937; American Artists Professional
League, 1939; Pen and Brush Club, 1942-1945; Meriden,
Connecticut, 1951. Collections: Cathedral St. John the
Divine, New York; Rittenhouse Square, Philadelphia;
International Business Machines; Dumbarton Oaks,
Washington, D. C.; Brookgreen Gardens, South Carolina;
Corcoran Gallery of Art; Brooklyn Museum; Springfield
Art Museum; Pennsylvania Academy of Fine Arts; National
Zoological Gardens, Washington, D. C.

CHAPIN, Jane Catherine. Born: in 1814 and died in 1891.
She was a miniaturist and portraitist.

CHAPIN, Lucy C. Painter. Born: Syracuse, New York in 1873.
Studied: in Paris with Prinet, Merson and Collin.
Collection: State Gallery, Capitol, Augusta, Maine;
Dickinson Seminary, Williamsport, Pennsylvania.

CHAPLIN, Christine. Painter. Born: Bangor, Maine in 1842.
Studied: in London and Paris. Her specialty painting wild
flowers in water color.

CHAPLIN, Margaret. Painter. Member of National Academy
of Painters and Sculptors.

CHAPMAN, Esther McCord. Painter. Member of the Washington
Watercolor Club.

CHAPMAN, Minerva J. Painter. Born: Altmar, New York in
1858. Studied: Art Institute of Chicago; in Paris with
Lazar

CHARD, Louise Cable. Painter. She was a member of the
Society of Independent Artists.

CHARLOT, Jean. Painter. Born: Paris, France in 1898.
Studied: Lycee Condorcet, Paris. Awards: Guggenheim
fellowship, 1945-1947; Grinnell College, 1946; St.
Mary's College, 1956; Ryerson L. Yale University, 1948;
Los Angeles County Fair, 1949, Honolulu Academy of Art.
Collections: Museum of Modern Art; Rochester Memorial
Art Gallery; Dallas Museum of Fine Arts; San Francisco
Museum of Art; Metropolitan Museum of Art; Art Institute
of Chicago; San Diego Fine Arts Society; University of
Georgia Fine Arts Building; Arizona State College;
University of Hawaii; churches in Hawaii, Notre Dame
Indiana, and Lincoln Park, Michigan; murals, Des Moines
Fine Arts Center; St. Catherine's Church, Kauai;
Hawaiian Village Hotel, Waikki; St. Leonard Friary,
Centerville, Ohio.

CHARMAN, Laura B. Sculptor. Fellowship, Pennsylvania
Academy of Fine Arts.

CHASE, Adelaide Cole. Painter. Born: Boston in 1868.
Studied: with Tarbell in Boston; and Duran in Paris.

CHASE, Ellen W. Painter. Born: Faribault, Minnesota.
Studied: Buffalo, Boston, New York City and in Paris.

CHASE, Elsie R. Painter. Born: Saratoga Springs, New
York in 1863. Studied: Yale School of Fine Arts.

CHASE, Jessie K. Painter. Born: Baileys Harbour,
Wisconsin. Studied: Art Institute of Chicago. Awards:
Milwaukee Art Institute, 1925; Madison Art Guild, 1928.
Collections: High School and Bank of Sturgeon Bay,
Wisconsin; High School, Madison, Wisconsin.

CHASE, Marion C. Painter. Born: New York City in 1926.
Studied: Skidmore College; University of Colorado.
Awards: Canyon City Art Festival, 1955. Collection:
Canyon City Art Museum.

CHASE, Susan B. Painter. Born: St. Louis, Missouri.
Studied: with Snell and R. E. James.

CHEESEBOROUGH, Mary Hugger. Born: in 1824 and died in
1902. Known for her miniature paintings.

CHENEY, Harriet Elizabeth. Painter. Born: in 1838 and
died in 1913. She was a portrait painter.

CHERRY, Emma R. Painter. Born: Aurora, Illinois in
1859. Studied: Art Students League; Julien Academy, Paris.

Chryssa, NEWSPAPER NO. 3, 1961. Oil on canvas, 80 1/4" X 103 3/4".
The Solomon R. Guggenheim Museum.

CHERRY, Kathryn. Painter. Born: Quincy, Illinois in 1880. Studied: St. Louis Art School; and with Hugh Breckenridge. Her specialty was landscapes. She exhibited in 1924 at the Pennsylvania Academy of Fine Arts.

CHESTER, Charlotte W. Painter. Born: Columbus, Ohio in 1921. Awards: Frankfurt, Germany; Ocean City, New Jersey.

CHILD, Mrs. Willard. Portrait painter. Was working with crayon portraits in Vermont around 1858.

CHILDS, Lillian E. Painter. Born: Little Silver, New Jersey. Studied: Art Institute of Chicago; and with William M. Chase in New York. She was known for her miniature paintings.

CHISOHN, Mary B. Painter. Was exhibiting in 1924 at the National Association of Women Painters and Sculptors.

CHITTENDEN, Alice B. Painter. Born: Brockport, Maine in 1860. Studied: California School of Design. Collection: California Society of Pioneers. She specialized in portraits.

CHRISSINGER, Mary H. Painter. Born: Hagerstown, Maryland in 1877. Studied: Kee Mar College; Maryland Institute of Art; Rinehart School of Sculpture; Columbia University. Awards: Rinehart School of Sculpture; Washington County Museum of Fine Arts. Collection: Washington County Museum of Fine Arts.

CHRISTALDI, Angeline A. Painter. Born: Philadelphia Pennsylvania. Studied: University of Pennsylvania; Tyler School of Fine Arts, Temple University; Pennsylvania Academy of Fine Arts. Awards: Cape May, New Jersey, Plastic Club.

CHRISTENSEN, Ethel M. Painter. Born: Glendive, Montana in 1926. Studied: University of Minnesota. Awards: Mulvane Art Center, Topeka, 1956; Berkshire Museum, Pittsfield, Massachusetts, 1958. Collection: Mulvane Art Center.

CHRYSSA, V. Sculptor and Painter. Born: Athens, Greece in 1933. Studied: Grande Chaumiere, Paris and in California. Collections: Museum of Modern Art; Whitney Museum of American Art; Albright-Knox Art Gallery and The Solomon R. Guggenheim Museum. Actively exhibiting in major galleries during the 1960's.

CHRYSTIE, Margaret H. Painter. Born: Bryn Mawr, Pennsylvania in 1895. Studied: Pennsylvania Academy of Fine Arts; Philadelphia School of Occupational Therapy. Awards: fellowship, Pennsylvania Academy of Fine Arts; Chester County Art Association, 1953. Collections: Pennsylvania Academy of Fine Arts; Woodmere Art Gallery; Allentown Museum.

CHURCH, Angelica S. Sculptor. Born: Scarborough-on-Hudson, New York in 1878. Studied: New York School of Design. Collections: Calvary Church, New York; New York City Police Department.

CHURCHILL, Rose. Painter. Born: New Britain, Connecticut in 1878. Studied: with Gonzalez, Martin, O'Hara. Awards: National Association of Women Artists, 1946; Hartford Society of Women Painters, 1944, 1946. Collection: New Britain Art Museum.

CIKOVSKY, Nicola. Painter. Born: Russia in 1894. Studied: Vilna, Penza, Moscow. Awards: Art Institute of Chicago, 1931, 1932; Worcester Museum of Art, 1933, 1937; Society of Washington Artists, 1941. Collections: Museum of Modern Art; Brooklyn Museum; Art Institute of Chicago; Pennsylvania Academy of Fine Arts; City Art Museum of St. Louis; Worcester Museum of Art; Los Angeles Museum of Art; Nelson Gallery of Art; Whitney Museum of American Art; Department of the Interior, Washington, D. C.; United States Post Office, Towson, Silver Springs, Maryland.

CITRON, Minna W. Painter. Born: Newark, New Jersey in 1896. Studied: Brooklyn Institute of Arts and Science; Art Students League; College City of New York. Awards: New York School of Applied Design, 1926; Society of American Graphic Artists, 1942, 1943; Norton Gallery of Art, 1948; Boston Society of Independent Artists, 1949; Brooklyn Society of Artists, 1950; Society of Four Arts, 1951; Dallas Museum of Fine Arts, 1953; California Society of Printmakers, 1956. Collections: Metropolitan Museum of Art; Whitney Museum of American Art; Norfolk Museum of Art and Science; Newark Museum of Art; Corcoran Gallery of Art; Art Institute of Chicago; Library of Congress; New York Public Library; New Jersey Public Library; Detroit Institute of Art; Museum of Modern Art; Worcester Art Museum; Rhode Island School of Design; Howard University; Fogg Museum of Art; Baltimore Museum of Art; Rosenwald College; National Gallery of Art; murals in United States Post Offices, Manchester and Newport, Tennessee.

CLAD, Jean Davies. Painter. Born: Alexandria, Minnesota in 1925. Studied: University of California; with Andre L'Hote in Paris. Has exhibited widely in United States and in Italy. She is the widow of novelist, Noel Clad.

CLAPP, Marcia. Sculptor. Born: Hartsville, Indiana in 1907. Studied: John Herron Art School; Butler University; Art Students League. Awards: John Herron Art Institute, 1931; fellowship, Tiffany Foundation, 1932, Griffith fellowship, for study abroad. She is a portrait sculptor.

CLARK, Mabel B. Painter. Born: San Rafael, California. Studied: privately. Awards: Los Angeles Museum of Art, 1943-1945; Friday Morning Club, 1943, 1945, 1953; California Art Club, 1955; American Artists Professional League. Has exhibited mainly in California.

CLARK, Virginia K. Painter. Born: New Orleans, Louisiana. Studied: Indiana School of Art; Art Students League; in Spain. Awards: Art Institute of Chicago, 1923; St. Paul, Minnesota, 1924. Collections: John Herron Art Institute.

CLARKE, Rene. Painter. Born: Eustis, Florida in 1886. Award: gold medal, Harvard.

CLARKE, Sara Ann. Painter. Born: in 1808. Known for her landscape paintings.

CLAUS, May A. Painter. Born: Berlin, New York in 1882. Studied: Boston Museum School. She specialized in miniatures which she exhibited in 1922 at the Pennsylvania Academy of Fine Arts.

CLAY, Mary F. R. Painter. She was exhibiting her work in 1924.

CLEMENT, Shirley. Painter. Born: New York City in 1922. Studied: Ringling School of Art; Amagansett Art School. Awards: Florida Federation of Art, 1948, 1949; special jurors award, Florida Federation of Art, St. Petersburg, 1950. Pinellas Lumber, Tampa, 1952; Grumbacher award, 1952; Ringling award, 1954; Lykes purchase award, Tampa, 1956; Clearwater, Florida, 1952; Sarasota, 1953. Collection: University of Florida.

CLENDENIN, Eve. Painter. Born: Baltimore, Maryland. Studied: Banff School of Fine Arts; and with Eliot O'Hara and Hans Hofmann. Awards: National Association of Women Artists, 1957; Baltimore Museum of Art. Has exhibited in the United States and Abroad.

CLEPHANE, Rosebud. Painter. Born: Atlanta, Georgia. Studied: George Washington University; Corcoran School of Art. Awards: Florida, 1936; League of American Pen Women, 1939; Palm Beach Art Association, 1940. Collection: Children's Home, Miami, Florida.

CLINEDINST, May S. Painter. Born: Brooklyn, New York in 1887. Studied: Cornell University; Brooklyn Institute of Art and Science. Awards: National Art Club, 1951; St. Petersburg Art Club; Tampa, Florida, 1953; Largo, Florida, 1954.

CLOPATH, Henriette. Painter. Born: in Switzerland. Award: gold medal, University of Oklahoma, 1916. Writer and lecturer on modern painting.

CLUTE, Beulah M. Painter. Born: Rushville, Illinois. Studied: Art Students League; Art Institute of Chicago. Her specialty, bookplates.

COAN, Helen E. Painter. Born: Byron, New York. Studied: Art Students League; and with William E. Chase. Awards: Alaska-Yukon-Pacific Exposition, Seattle, 1905; San Diego Exposition, 1915.

COBB, Mrs. C. S. Landscape painter. She was exhibiting her work in 1855.

COCHRAN, Dewees. Painter. Born: Dallas, Texas in 1902. Studied: Philadelphia Museum School of Industrial Art; University of Pennsylvania; Pennsylvania Academy of Fine Arts. Awards: Bowers Memorial Museum, Santa Ana, California, 1954; Goodwill Industries, San Diego, California, 1955. She was also a craftsman and executed 6 full-color historical maps of Dartmouth College for building promotion program. She also contributed to craft magazines.

COCHRAN, Eliza T. Painter. Her specialty was landscapes. She was working during 1800-1810.

COCHRANE, Constance. Painter. She was exhibiting in 1924.

COCKCROFT, Edith V. Painter. Born: Brooklyn, New York in 1881. Member of National Association of Women Painters and Sculptors.

COCKING, Gretta. Painter. Born: Mineral Point, Wisconsin in 1894. Studied: University Nebraska; University of Oregon; State College of Education, Greeley, Colorado; Montana State College. Awards: Black Hills Regional Exhibition, 1935. Collection: murals, University of Oregon.

COCKRELL, Dura. Painter. Born: Liscomb, Iowa in 1877. Studied: with William M. Chase.

CODMAN, Ruth. Painter. Born: New York City in 1920. Studied: Pasadena School of Fine Arts; Pasadena City College. Awards: Los Angeles All-City Exhibition, 1953; Santa Paula Chamber of Commerce, 1955; Pasadena Art Museum; San Gabriel Valley Exhibition, 1955; National Printmakers Exhibition, Pasadena, 1958; Los Angeles City Hall, 1956-58. Collections: Pasadena Art Museum; Santa Paula Chamber of Commerce; Long Beach Museum of Art; Home Savings and Loan Association.

COE, Ethel L. Painter. Born: Chicago, Illinois. Studied: Art Institute of Chicago. She was also an illustrator.

COE, Helen Stotesbury. Painter. Born: New York City; Studied: Grand Central Art School; Art Students League; and with O'Hara and Wayman Adams. Has had many exhibits and one-man shows.

COFFIN, Sarah T. Painter. Born: Vassalboro, Maine in 1844. Studied: with Swain and Duveneck.

COHEE, Marion M. Painter. Born: Baltimore, Maryland in 1896. Studied: University of Pennsylvania; Temple University. Awards: Philadelphia Art Teachers Association; gold and silver medals, Plastic Club, 1945, 1951, 1957. Collection: Tyler School of Fine Art, Temple University.

COHEN, Isabel. Painter. Was exhibiting in 1924.

COHEN, Katherine M. Sculptor and painter. Born: Philadelphia in 1859 and died in 1924. Studied: Pennsylvania Academy of Fine Arts; Art Students League; and with Augustus Saint Gaudens, and in Paris with Mercie.

COHEN, Nessa. Sculptor. Born: New York City. Studied: with James Fraser in New York; with Despiau, Charles Malfrey in Paris. Awards: 9th Olympiad, Amsterdam, Holland, 1928. Collection: American Museum of Natural History; School of Architect and Allied Art, Portland, Oregon; Stanford University.

COLBURN, Eleanor R. Painter. Born: Dayton, Ohio in 1866. Studied: Art Institute of Chicago. Collection: Chicago Art Institute.

COLBY, Josephine W. Painter. Born: New York City in 1862. Studied: with Will Low and John W. Alexander. Collections: Gallery of the Pennsylvania Academy of Fine Arts; Manchester Art Gallery, England.

COLE, Ann. Painter. Born: Brooklyn, New York in 1903.
Studied: Pratt Institute Art School; Art Students League;
Montclair Museum Art School. Awards: Audubon Arts, 1957;
National Association Women Artists, 1955; Montclair Art
Museum; Essex Watercolor Club; American Artists Professional
League; New Jersey Watercolor Society. Collection: private
collections; mosaic column and fountain, 1957; textile
mural, 1958; tile interiors.

COLE, Annie E. Painter. Born: Providence, Rhode Island
in 1880. Studied: with Henry W. Moser, Edgar Nye and
Bertha E. Perrie.

COLE, Gail (SHEPARDSON). Painter. Born: San Diego,
California in 1914. Studied: Stanford University with
George Post, Victor Arnautoff; California School of Fine
Arts with Maurice Sterne, Otis Oldfield, Spencer Macky
and William Gaw. Awards: San Francisco Art Festival, 1951;
San Francisco Women Artists, 1952; California State Fair,
1952; Hallmark award, 1953; 10th and 12th Annual San
Francisco Art Festival, 1956, 1958.

COLE, Jessie (DUNCAN).Painter. Born: Pass Christian,
Mississippi in 1858. Studied: with Wyatt Eaton and John
La Farge.

COLE, Sarah. Painter. Landscape artist active from 1848
to 1852.

COLER, Stella C. Painter. Born: Grand Rapids, Michigan.
Studied: University of Michigan; John Herron Art Institute;
and with Farnsworth, Aaron Bohrod, Hilton Leech and Will
Barnet. Awards: John Herron Art Institute, 1942; Hoosier
Salon, 1946, 1953, 1955, 1956; Indiana Art Club, 1946,
1950, 1951, 1953, 1954, 1957; Sarasota Art Club, 1951;
Florida Southern College, 1952; Manatee Art Center, 1958;
Hoosier Salon Gallery, 1947, 1952, 1956; Goddard Gallery,
Sarasota, 1953; Manatee Art Center, 1957.

COLES, Ann Cadwallader. Painter. Born: Columbia, South
Carolina in 1882. Studied: Converse College; Art Students
League; and with F. Luis Mora, Vincent Tack and Harry
Sternberg. Collections: University of North Carolina;
Yale University Library; Parish House, Charlotte, North
Carolina; Columbia Museum of Art; South Carolina Supreme
Court, State Capitol; Winthrop College, Rock Hill, South
Carolina; Columbia, South Carolina.

COLLES, Gertrude. Painter. Born: Morristown, New Jersey in
1869. Studied: Laurens in Paris; with George de Forest
Brush and B. R. Fitz in New York. Collection: State House,
Trenton, New Jersey.

COLLIDGE, Bertha. Painter. Born: Lynn, Massachusetts in
1880. Studied: School of Boston Museum of Fine Arts with
Tarbell and Benson. Best known for her miniatures.

COLLINS, Marjorie S. Painter. A miniature painter who
exhibited her miniature portraits at the Pennsylvania
Academy of Fine Arts in 1922.

COLLINS, Mary Susan. Painter. Born: Bay City, Michigan.
Studied: Art Students League; Museum of Fine Arts, Boston;
Columbia University. Award: Cleveland, Ohio, 1924.
Collection: Cleveland Museum of Art.

COLLIVER, Ethel Blanchard. Painter. Born: Boston,
Massachusetts. Studied: Academie, Colarossi, Naudin,
Guerin in Paris; in Boston with Benson, Tarbell and Hale.

COLMAN, Blanche E. Painter. Born: Somerville, Massachusetts.
Studied: Boston Museum of Fine Arts School; American
Academy in Rome; Boston University; and with Charles
Woodbury and Harry Leith Ross. Collection: Boston Museum of
Fine Arts.

COLOSI, Eleanor Fortuna. Painter. Born: Philadelphia in
1919. Awards: Moore College of Art; The Pennsylvania
Physicians Art Association.

COLT, Martha Cox. Painter. Born: Harrisburg, Pennsylvania
in 1877. Studied: Moore Institute; Pennsylvania Academy
of Fine Arts; University of Pennsylvania; with Kenneth Hayes
Miller; Henry B. Snell and Calder Penfield. Collections:
Philadelphia Museum of Art; University of Pennsylvania;
Pennsylvania State Museum.

COLTMAN, Ora. Painter and sculptor. Born: Shelby, Ohio
in 1860. Member of Art Students League and Julien Academy
of Paris.

COLTON, Mary R. Painter. Born: Louisville, Kentucky in
1889. Studied: Moore Institute; Philadelphia School of
Design for Women; and with Eliot Dangierfield. Was
exhibiting in 1922.

COLWELL, Elizabeth. Illustrator and etcher. Born: Michigan in 1881. Studied: Olson-Nordfeldt in Chicago. Collection: Art Institute of Chicago.

COMAN, Charlotte Buell. Painter. Born: Waterville, New York in 1833 and died in 1924. Studied: with James Brevoort, in New York; with Vernier in Paris. Collections: Metropolitan Museum, New York; National Gallery, Washington, D.C.

COMES, Marcella. Painter. Born: Pittsburgh, Pennsylvania. Studied: Carnegie Institute with Alexander Kostellow, Kark Knath; and studied in Europe. Awards: Pittsburgh Art Association, 1929; Carnegie Institute, 1936, 1941; Society of Washington Artists, 1946; Gerogetown Artists, 1955. Collections: murals, Pittsburgh Public Library; United States Military Academy, West Point, New York; Pittsburgh Public School; Pittsburgh Parochial School; mural, Stone Ridge Convent of the Sacred Heart.

COMFORT, Barbara. Painter. Born: Nyack, New York in 1916. Studied: National Academy of Design; Art Students League; Ecole des Beaux-Arts. Awards: American Artists Professional League, 1942; Audubon Art, 1954.

COMINS, Alice R. Painter. Was exhibiting in 1924.

COMPTON, Caroline Russell. Painter. Born: Vicksburg, Mississippi in 1907. Studied: Sweet Briar College; Grand Central Art School; and with Grant Reynard, Wayman Adams, George Ennis and George Luks. Awards: Mississippi Art Association, 1933, 1934, 1954. Collections: 19 portraits for "River Hall of Fame" Museum on "The Sprague." steamboat at Vicksburg, Mississippi; Mississippi Art Association; Mississippi State College for Women.

COMSTOCK, Frances B. Painter, sculptor and illustrator. Born: Elyria, Ohio in 1881. Studied: with Gari Melchers and John Vanderpoel.

CONANT, Marjorie. Painter. Born: Boston in 1885. Studied: with Hale Benson and Tarbell. Was exhibiting in 1924.

CONARD, Grace D. Painter. Born: Dixon, Illinois in 1885. Studied: Art Institute of Chicago.

CONGDON, Adairene Vose. Painter. Born: New York City. Studied: Art Students League of New York. Collection: Petit Palace, Paris; Library of Congress; New York Public Library.

CONKLING, Mabel. Sculptor. Born: Boothbay, Maine in 1871. Studied: Paris with Bouguereau and Collin in 1899; with MacMonnies in 1900 she studied sculpture. She executed portrait reliefs during that period.

CONLEY, Sarah W. Painter. Born: Nashville, Tennessee in 1861. She was also a sculptor and illustrator. Studied: with Bouguereau, Julien and Bridgman in Paris; with Ferrari in Rome.

CONNERY, Ruth (McGRATH). Painter. Born: New York City in 1916. Studied: Mills College; Art Students League with Frank DuMond and William von Schlegell. Awards: New Rochelle Art Association, 1954, 1955; Larchmont Art Association, 1954; Mamaroneck Art Association, 1955. Collections: in private collections.

CONSTANT, Marjorie. Painter. She was exhibiting in 1924.

CONVERSE, Lilly S. Lithographer. Born: St. Petersburg, Russia in 1892. Studied: Pennsylvania Academy of Fine Arts; Art Students League; and with Kenneth Hayes Miller, and Andre L'Hote in Paris. Awards: Wilmington Society of Fine Arts, 1940; Chester County Pennsylvania Art Association, 1941; Springfield Art Association; Painters and Sculptors Society, New Jersey; Clearwater Museum of Art; Virginia Museum of Fine Arts. Collections: Metropolitan Museum of Art; Philadelphia Museum of Art; Boston Museum of Fine Arts; Detroit Institute of Art; Philadelphia Printmakers Club; North Carolina State Museum; New York Public Library; National Museum, Washington, D. C.; Berkshire Museum of Art; Brooklyn Museum; British Museum, Victoria and Albert Museum, London; Bibliotheque Nationale, Paris.

CONNELL, Averil C. Painter. Born: Belvidere, Illinois. Studied: Art Institute of Chicago; Chicago Academy of Fine Arts; and with Edmund Giesbert, Jon Corbino, John Vanderpoel and John Norton. Awards: Chicago Gallery Association, 1941; Austin Oak Park and River Forest Art League, 1943-1945; Cincinnati Museum Association, 1945; Albany Institute of History and Art, 1958. Collections: Mirror Lake Inn, Lakeside Inn, Lake Placid, New York; Whiteface Inn, Whiteface, New York.

COOK, Blanche M. Painter. Born: Moulton, Iowa in 1901.
Studied: Philadelphia School of Design; Central Washington
College of Education. Awards: Washington State Fair, 1930,
1931; Fellowship Philadelphia School of Design; Spokane
5 State Competition, 1954.

COOK, I. Vernon. Painter. Born: Brooklyn, New York,
Studied: Art Students League and with Chase.

COOK, May Elizabeth. Sculptor. Born: Chillicothe, Ohio
in 1881. Studied: Ecole des Beaux Arts: Colarossi Academy
in Paris. Collections: Ohio State University; National
Museum, Washington, D. C.

COOKE, Abigail W. Painter. Studied: Rhode Island School
of Design.

COOKE, Edna. Illustrator. Born: Philadelphia in 1891.
Studied: Breckenridge and McCarter at the Pennsylvania
Academy of Fine Arts.

COOLEY, Ruth Patton. Painter. Born: Philadelphia,
Pennsylvania in 1901. Studied: Pennsylvania Academy of
Fine Arts, with Daniel Garber; Art Students League; and
with Nicolaides. Collection: Murals, Babcock School,
Cambridge, Massachusetts.

COOLIDGE, Rosamond. Painter. Born: Watertown, Massachusetts
in 1884. Studied: Massachusetts School of Art with Anson
K. Cross and Wilbur Dean Hamilton; Boston Museum of Fine
Arts School, with Edmund C. Tarbell. She was noted for her
portraits. Awards: gold medal, Jordan-Marsh Company, 1947;
National League of American Pen Women. Collections:
Framingham Normal School; Harvard University; Masonic
Temple and Channing House, Boston; First Parish and
Phillips School, Watertown; Jackson College, Tufts University.

COONSMAN, Nancy. Sculptor. Born: St. Louis, Missouri in
1888. Studied: with Zolnay and Grafly.

COOPER, Alice. Sculptor. Born: Denver, Colorado. Some of
best works are "Summer Breeze," and "Dancing Fawn."

COOPER, Elizabeth. Sculptor. Born: Dayton, Ohio in 1901.
Her specialty was animals.

COOPER, Emma Lampert. Painter. Born: Nunda, New York and
died in 1920. Studied: Cooper Union Art School; Art
Students League. She studied with Agnes D. Abbatt in water
colors; also studied in Paris.

COOPER, Florence A. Etcher. Born: Galion, Ohio in 1882.
Studied: Columbia University.

COOPER, Leone. Painter. Born: St. Louis, Missouri in 1902. Studied: Harris Teachers College. Collections: Bristol School, Edgar Road School, Douglass School, Sigma Nu House Washington University, St. Louis; Webster Groves High School.

COOPER, Margaret M. Painter. Born: Terryville, Connecticut in 1874. Was exhibiting at the National Academy of Design in 1925.

COPELAND, Lila. Painter. Born: Rochester, New York. Studied: Art Students League. Awards: Art Institute of Chicago.

COPELIN, Jeannette Knowles. Painter. Born: New York City in 1902. Studied: Parsons School of Design; Art Students League; National Academy of Design; and with Robert Brackman, Harry Sternberg. Awards: National Academy of Design, 1950. Collections: portraits in private collections.

COPPEDGE, Fern. Painter. Born: Decatur, Illinois in 1888. Studied: Art Students League; Art Institute of Chicago; Pennsylvania Academy of Fine Arts; and with Chase and Carlsen. Collection: Detroit Institute of Art; Pennsylvania State Capitol.

CORBETT, Gail Sherman. Sculptor. Born: Syracuse, New York. Studied: with Augustus Saint Gaudens. Awards: Panama Pacific Exhibition. Collections: Syracuse, New York; Auditorium and Municipal Building, Springfield, Massachusetts; Boston Museum.

CORCOS, Lucille. Painter. Born: New York City in 1908. Studied: Art Students League. Awards: Pepsi-Cola, 1944; Grumbacher award, 1956. Collections: Whitney Museum of American Art, U. S. Gypsum Company; Upjohn Pharmaceutical Company; Columbia Broadcasting System; Museum of Art, Tel-Aviv; mural, North Shore Hospital, Manhasset, New York; Life Magazine; mural, Waldorf-Astoria, New York.

CORNELIUS, Marty. Painter. Born: Pittsburgh, Pennsylvania in 1913. Studied: Carnegie Institute; and with Reginald Marsh, Alexander Kostellow. Awards: Association Art Pittsburgh, 1939, 1945, 1953. Martin Leisser School of Design, 1946-1949; Allegheny County, 1947, 1948, 1955; Butler Institute of American Art, 1948; Corcoran Gallery of Art, 1941, 1947; Kappa Kappa Gamma, 1952. Collections: Mercy Hospital, Pittsburgh; Latrobe Pennsylvania High School; Pittsburgh Public Schools.

CORNWELL, Martha J. Sculptor and painter. Born: West Chester, 1869. Studied: Philadelphia School of Design; Art Students League, and with Saint Gaudens, H. Siddons Mowbray and George deForest Brush. Her specialty was portraits in bronze.

CORRINGTON, Veronica E. Painter. Born: Chicago, Illinois
in 1891. Studied: Pratt Institute Art School, and with
O'Hara. Awards: Miami Art League, 1947, 1949, 1950;
Poinciana Festival, Miami, 1948; Coral Gables Jubilee,
1949; Miami Womens Club, 1949, 1952; Blue Dome Fellowship,
1950; Lowe Gallery of Art, 1953.

CORSON, Katherine Langdon. Painter and Illustrator. Born:
Rochdale, England. Studied: with Carlsen, H. Bolton Jones
and F. C. Jones in New York. Award: Atlanta Exposition,
1895. Collection: Hamilton Club. She was best known as
a landscape painter.

CORTLAND, Lyn. Painter. Born: New York, New York in 1926.
Studied: Chouinard Art Institute; Jepson Art Institute;
Art Students League; Pratt Institute Art School; Columbia
University School Painting & Sculpture; Hans Hofman
School of Art; China Institute in America. Awards:
Metropolitan Museum of Art; Boston Museum of Fine Arts;
Fogg Museum of Art; Art Institute of Chicago; Brooklyn
Museum; Boston Public Library; Baltimore Museum of Art;
City Art Museum of St. Louis; Springfield Museum of Art;
Stedelijk Museum, Amsterdam, Holland.

CORTRIGHT, Hazel Packer. Painter.

CORWIN, Sophie M. Born: New York. Awards: Phillips Gallery
of Art, Washington, D. C.; Creative Art Gallery. Collection:
New York University.

CORY, Kate T. Painter. Born: in Illinois. Studied: Cooper
Union Art School; Art Students League. Collection:
Smithsonian Institute, Washington, D. C.

COSTIGAN, Ida. Sculptor. Born: in Germany in 1894.
Was exhibiting in Pennsylvania in 1924.

COTHARIN, Kate Leah. Painter. Born: Detroit, Michigan in
1866. Studied: with J. M. Dennis in Detroit. Her specialty
pastel landscapes in miniature.

COTTON, Lillian. Painter. Born: Boston, Massachusetts,
Studied: Andre L'Hote Academy, Paris; Art Students League
with Robert Henri, George Bellows. Awards: National
Association of Women Artists, 1946, 1953; New England
Exhibition, 1954; Pen & Brush Club, 1955. Collections:
Florida Southern College; Seton Hall University, Jersey City
New Jersey; Staten Island Museum Art & Science.

COUDERT, Amalia K. Painter. Born: in 1876. Known for
her miniatures. Noted for her painting of King Edward
and many other English aristocracy.

COULTER, Mary J. Etcher. Born: Newport, Kentucky.
Studied: Cincinnati Art Academy; Art Institute of Chicago;
University of Chicago; and studied abroad. Awards:
Lewis & Clark Exposition, 1905; Pan-Pacific Exposition,
1915; Art Institute of Chicago, 1909; Los Angeles Museum
of Art; Huntington Library and Art Gallery, San Marino,
California. Collections: Chalcographie du Louvre, Paris;
British Museum; London; Huntington Library & Art Gallery;
John Herron Art Institute; California State Library,
Sacramento; University Club, San Diego; California Society
of Pioneers, San Francisco; National Gallery of Art;
Library of Congress Art Institute of Chicago; Boston
Museum of Fine Art; Metropolitan Museum of Art; Cooke
Gallery, Honolulu, Hawaii; 168 etchings for Matson
Navigation Company.

COUPER, B. King. Painter and Sculptor. Born: Augusta,
Georgia in 1867. Studied: with Chase and Dangerfield.

COUROUX, Alice Muth. Painter. Born: in Cincinnati, Ohio.
Studied: with Zuloaga. Worked with painting and batiks.

COUSINS, Clara Lea. Sculptor. Born: Halifax County,
Virginia in 1894. Studied: Cincinnati Art Academy;
Corcoran Art School; Grand Central Art School with Ennis,
Snell and with Cecilia Beaux. Collection: Stratford
College, Danville, Virginia.

COVELL, Margaret. Now deceased portrait and genre painter.

COVINGTON, Annette. Painter. Studied: with Twachtman,
Chase and Henry Mosler. Collections: Miami University,
Oxford, Ohio; Ohio State University.

COWAN, Sarah E. Miniature painter, whose work was
exhibited in 1922 at the Pennsylvania Academy of Fine Arts.

COWLES, Edith V. Painter and Illustrator. Born:
Farmington, Connecticut in 1874. Studied: with John T.
Niemeyer; Bruneau and Mme. Laforge in Paris. Collection:
Five stained glass windows in St. Michael's Church,
Brooklyn.

COWLES, Genevieve A. Painter. Born: Farmington, Connecticut
in 1871. Studied: Yale Art School with Niemeyer; Robert
B. Brandegee at Farmington. Her specialty, mural decorations
and stained glass windows. Collection: Chapel of
Connecticut State Prison (wax mural)

COWLES, Mildred. Painter. Born: Farmington, Connecticut
in 1876. Studied: Yale Art School.

COX, C. Lynn. Sculptor. Born: Chicago, Illinois in 1889. Studied: Art Institute of Chicago; with Albin Polasek, and Lorado Taft. Collections: Vanderpoel College; Munroe Memorial, Joliet, Illinois.

COX, Dorothy E. Painter. Exhibited in 1924 at the Pennsylvania Academy of Fine Arts.

COX, Louise. Painter. Born: San Francisco, California in 1865. Studied: Academy of Design ; Art Students League. Award: National Academy of Design, 1896.

COX-McCORMACK, Nancy. Sculptor. Born: Nashville, Tennessee in 1885. Collections: Original "Harmony," in collection of C. S. Scotten, Chicago; copy in Nashville Art Museum; Carmack Memorial, Capitol grounds, Nashville, Tennessee; bust of William H. Mitchell, Banker, Chicago.

COY, Anna. Painter. Born: Rockford, Illinois. Studied: with Chase, F. V. DuMond, and Henri.

COZZENS, Evangeline Chapman. Painter. Born: New York City in 1895. Studied: Halsted School, Yonkers, New York; Capen School, Northampton, Massachusetts. Collection: Metropolitan Museum of Art.

CRAIG, Anna Belle. Painter. Born: Pittsburgh, Pennsylvania in 1878. Studied: Art Students League with Chase, Shirlaw, Henry G. Keller and Howard Pyle. Illustrations of books for children.

CRAIG, Nancy Ellen. Painter. Born: Bronxville, New York in 1927. Studied: Sweet Briar College; Bennington College; Art Students League; Farnsworth School of Art; Academie Julien, Paris; Taubes-Pierce School of Art; Hans Hofmann. Awards: Hudson Valley Art Association 1951; National Association of Women Artists, 1953, 1954, 1956; National Academy of Design, 1954, 1957; Audubon Arts 1955; gold medal, All.Art of America, 1956. Collections: Metropolitan Museum of Art; New Britian, Connecticut Museum of Art.

CRAMER, Florence Ballin. Painter. Born: Brooklyn, New York in 1884. Studied: Art Students League with DuMond, Brush and Harrison.

CRAMER, Miriam E. Sculptor and Painter. Born: Hamburg, Germany in 1885. Studied: Cleveland, Ohio. Collection: Lima, Ohio Public Library.

CRANCH, Caroline A. Painter. Studied: Cooper Institute with William Hunt; and with her father Christoper P. Cranch. Her specialty, figurepieces.

CRANE, Ann. Painter. Born: New York City. Studied: with Twachtman in New York; with Merson in Paris.

CRAVATH, Ruth. Sculptor. Born: Chicago, Illinois in 1902. Studied: Art Institute of Chicago; Grinnell College; California School of Fine Art. Awards: San Francisco Art Association, 1924, 1927; San Francisco Society Women Artists, 1934, 1940. Collections: San Francisco Museum of Art: Stock Exchange, San Francisco; Vallejo, California; Chapel at the Archbishop Hanna Center for Boys, Sonoma, California; marble group, Starr King School, San Francisco, California.

CRAWFORD, Brenetta Hermann. Painter. Born: Toledo, Ohio in 1875. Studied Art Students League; Colarossi and Carman Academies in Paris.

CRAWFORD, Esther M. Painter. Born: Atlanta, Georgia in 1872. Studied: Whistler, Dow and Beck.

CRAWLEY, Ida J. Painter. Born: London County, Tennessee in 1867. Studied: Corcoran Art School, Washington, D.C.; and in Paris.

CREIGHTON, Bessy. Painter. Born: Lynn, Massachusetts in 1884. Studied: Boston Museum Fine Arts School. Has exhibited widely in the Southeastern United States.

CRESSON, Cornelia. Sculptor. Born: New York City in 1915. Studied: with Genevieve Karr Hamlin and Mateo Hermandez. Exhibited in New York and Pennsylvania.

CRESSON, Margaret French. Sculptor. Born: Concord, Massachusetts. Awards: National Academy of Design, 1927; Stockbridge Art Exhibition, 1929; Society of Washington Artists, 1937; Dublin Hill Art Exhibit, 1939, 1944. Collections: Berkshire Museum, Pittsfield, Massachusetts; Corcoran Gallery of Art; New York University; Monroe Shrine, Fredericksburg, Virginia; Rockefeller Institute; Massachusetts State Normal School; Prince Memorial, Harvard Medical Library.

CRITCHER, Catherine Carter. Painter. Born: Westmoreland County, Virginia. Studied: with Richard Miller and Charles Hoffbauer in Paris.

CRITTENDEN, Elizabeth C. Painter. Was exhibiting in 1924.

CROCKER, Martha E. Painter. Exhibited at the Pennsylvania Academy of Fine Arts in 1924.

CROMWELL, Joane. Painter. Born: Lewistown, Illinois. Studied: Art Institute of Chicago; Otis Art Institute; Collections: murals, Hollywood Park, California, 1941 Santa Anita Race Course, Los Angeles, California, 1939; St. George High School, Utah; Millersburgh Military Institute, Kentucky.

CRON, Nina. Painter. Known chiefly for her miniature paintings which she exhibited at the Pennsylvania Academy of Fine Arts in 1925.

CROSBY, Katharine V. R. Sculptor. Born: Colorado Springs, Colorado in 1897. Studied: with Jess M. Lawson. A member of the National Academy of Women Painters and Sculptors.

CROSMAN, Rose. Engraver. Born: Chicago, Illinois. Studied: Pennsylvania Academy of Fine Arts; Art Institute of Chicago.

CROSS, Amy. Painter. Born: Milwaukee, Wisconsin in 1856. Studied: Cooper Institute; Art Students League; Hague Academy, Holland with Jacob Maris and Albert Neuhuys; Julian Academy, Paris.

CROSS, Louise. Sculptor. Born: Rochester, Minnesota in 1896. Studied: Wellesley College; Minneapolis School of Art; Art Institute of Chicago; University of Chicago; and with Harriet Hanley. Award: Minneapolis Institute of Art. Collections: Memorial reliefs, Minnesota State Capitol; Todd Memorial Hospital, University of Minnesota.

CROSS, Maria C. Painter. Born: Fort Worth, Texas in 1911. Awards: Knickerbocker Annual; Texas Fine Arts. Collections: Texas Wesleyan College; Central Museum of Art, Utrecht, Netherlands.

CROSS, Sally. Painter. Born: Lawrence, Massachusetts. Studied: with De Camp and Ross Turner in Boston.

CROUCH, Emily H. Painter. Working with watercolors.

CROWE, Mrs. Phil. Painter. Born: in Ohio. Specialized in oil still-life paintings.

CROWE, Amanda Maria. Sculptor. Born: Cherokee, North Carolina in 1928. Studied: Art Institute of Chicago; Instituto Allende San Miguel, Mexico; De Paul University, Chicago. Awards: John Quincy Adams traveling scholarship, Art Institute of Chicago, 1952; Art Institute of Chicago, scholarship, 1946. Collections: Container Corporation of America; Cherokee Indian School in North Carolina; Museum of the Cerokee Indian, North Carolina.

Jennie Cullum, POPIES AND TULIP, YELLOW, c. 1870. Watercolor,
10 3/4" X 8 3/4". Private Collection.

CROWELL, Margaret. Illustrator, painter and sculptor. Born: Philadelphia, Pennsylvania. Studied: Pennsylvania Academy of Fine Arts.

CROWNINSHIELD, Hannah. Born in 1789 and died in 1834. She was known for her portraiture.

CRUMMER, Mary Worghington. Painter. Born: Baltimore, Maryland. Studied: Maryland Institute; Rinehart School with Denman W. Ross; Harvard University. Awards: Peabody Institute, 1923; Maryland State Fair, 1928; Baltimore Museum of Art, 1939.

CULIN, Alice Mumford. Painter. Born: Philadelphia in 1875. Studied: in Paris and France 1897-1900; and in Spain 1901-1902. She has exhibited in Paris and London.

CULLUM, Jennie. Watercolorist. Painted between 1840-1883. Resided in Beverly, Ohio where her husband was pastor of the Presbyterian Church. Made several trips to Florida to study the flora and fauna. She did commissions for the New York Gift Card Company. Made sketches of the rare VICTOR REGIA (Water lily plant) New York Botanical Gardens, 1864.

CUMING, Beatrice. Painter. Born: Brooklyn, New York in 1903. Studied: Pratt Institute Art School; and in France. Awards: Hartford, Connecticut, 1939, 1941; Springfield, Massachusetts, 1936; Bok Foundation Fellowship, 1939, 1940; Fellowship MacDowell Colony, New Hampshire, 1934, 1938, 1943, 1944, 1946, 1952; Fellowship Yaddo Foundation, 1950, 1951, 1953, 1955; Huntington Hartford Foundation, 1953,1956. Collections: Lyman Allyn Museum; Syracuse Museum of Fine Art.

CUMMING, Alice McKee. Painter. Born: Stuart, Iowa in 1890. Studied: State University of Iowa; Cumming School of Art. Awards: Iowa State Fair; Des Moines Women's Club, 1925; Art Institute of Chicago, 1942. Collections: Des Moines Women's Club; State Historical Gallery, Des Moines.

CUNLIFFE, Mitzi. Sculptor. Born: New York City in 1918. Studied: Columbia University; Art Students League. Awards: Smith Art Gallery, Springfield, Massachusetts, 1940, 1943, 1945; Widener gold medal, Pennsylvania Academy of Fine Arts, 1949; Irvington New Jersey Public Library, 1944.

CUNNINGHAM, Patricia. Painter. Born: California. Studied: University of California and with Hans Hofmann, Andre L'Hote. Award: Fellowship, University California.

CURTIS, Constance. Portrait painter. Born: Washington, D.C.
Studied: Art Students League, with William Chase. Awards:
National Art Club, 1922; National Association of Women
Artists, 1935; American Artists Professional League, 1944.

CURTIS, Elizabeth. Painter. Born: New York City. Studied:
with Twachtman and Chase.

CURTIS, Ida Maynard. Painter. Born: Lewisburg, Pennsylvania
in 1860. Studied: with Hawthorne, Ross, Maynard, Simon and
Jolley.

CUSHMAN, Alice. Landscape painter. Born: Philadelphia in
1854. Studied: National Academy of Design; Ross Turner in
Boston. Her specialty, water colors.

CUSTER, Bernadine. Painter. Born: Bloomington, Illinois.
Studied: Art Institute of Chicago. Collections:Metropolitan
Museum of Art; Detroit Institute of Art; Brooklyn Museum;
Addison Gallery of American Art; murals, Treasury Department,
Washington, D. C.; Whitney Museum of American Art; Williams
College.

CUSTIS, Eleanor Parke. Painter. Born: Washington, D. C. in
1779 and died in 1852. Studied: Corcoran Art School and
with Henry B. Snell. Collections: Public Library, New Haven,
Connecticut; Adams School, Washington, D. C. She was noted
for her landscapes and silhouettes.

CUTHBERT, Virginia. Painter. Born: West Newton, Pennsylvania
in 1908. Studied: Syracuse University; Carnegie Institute;
Chelsea Polytechnical Institute; University London and with
George Luks. Awards: Fellowship, Syracuse University for
European study; Carnegie Institute, 1934-35-37; Butler Art
Institute, 1940; Association of Artists of Pittsburgh,
1938, 1939. Pepsi-Cola 1946; Cortland State Fair, 1949-51-53;
Albright Art Gallery, 1944-46-50-52-55-58; National
Institute Arts & Letters grant, 1954; Chautauqua, New York,
1955; Buffalo, New York, 1956-57. Collections: Albright
Art Gallery; Syracuse University; One Hundred Friends of
Pittsburgh Art.

DAGGETT, Maud. Sculptor. Born: Kansas City, Missouri.
Studied: with Lorado Taft. Known for her design and
execution of fountains. One of which is at the Hotel
Raymond, Pasadena.

DAINGERFIELD, Marjorie. Sculptor. Born: New York City.
Studied: School of American Sculpture; Grand Central School
of Art; and with James Fraser, Edmond Amateis, and Solon
Borglum. Award: Pen & Brush Club, 1956. Collections:
School of Tropical Medicine, San Juan, Puerto Rico;
Hobart College, Geneva, New York; Queens College, Charlotte,
North Carolina; Georgetown University. She is perhaps
best known for her statuette-emblem for Girl Scouts of
America.

DALAND, Katharine M. Illustrator. Born: Boston,
Massachusetts in 1883. Has illustrated many books.

DALLAM, Elizabeth F. Painter. Born: Philadelphia in 1879.
Studied: Pennsylvania Academy of Fine Arts with Breckenridge.

DALRYMPLE, Lucile Stevenson. Painter. Born: Sandusky,
Ohio in 1882. Studied: Art Institute of Chicago; J. Francis
Smith Academy, Chicago. Awards: Illinois Academy of Fine
Arts, 1930, 1940. Collections: Wabash University; Marietta
University; University of Illinois; Illinois Academy of
Fine Arts; Vanderpoel College.

DALTON, Frances L. Painter. Born: Amesbury, Massachusetts
in 1906. Studied: Boston Museum of Fine Arts School, with
Philip Hale. Awards: Jordan Marsh Company, 1944; traveling
scholarship Boston Museum of Fine Arts School; Lawrence,
Massachusetts Centennial Exhibition, 1943.

DALY, Mrs. Matt. Painter for Rookwood pottery.

DAMROSCH, Helen T. Painter. Born: New York City in 1893.
Studied: with George De Forrest Brush. She was also an
illustrator.

DANNER, Sara Kolb. Painter. Born: New York City. Studied:
Philadelphia School of Design for Women; University of
California at Santa Barbara; California College of arts and
Crafts; Pennsylvania Academy of Fine Arts, Summer School.
Awards: Hoosier Salon, 1928, 1951; Women Painters of the
West, 1942, 1943; California Art Club.

DARLEY, Jane Cooper. Born: in 1807 and died in 1877. She
was the daughter of Thomas Sully, and before her marriage
to Darley painted under that name.

DARNAULT, Florence Malcolm. Sculptor. Born: New York City in 1905. Studied: Radcliffe College; National Academy of Design; Art Students League; and in Europe. Awards: Pen & Brush Club; National Art Club. Collections: College City of New York; U. S. Naval Academy; American Institute of Engineers; Whitehead Metals Company; New York University Medical School; American Telephone & Telegraph Company; Harvard University; Army Officers Club, Governor's Island, New York; Statue, Mexico City; Colombian Government, Cartagena, Colombía.

DARRAH, Ann Sophie Towne. Painter. She was born in 1819 and died in 1881. She was a painter of landscapes and marines. Also known as a pastel portraitist.

DAVENPORT, Jane. Painter. Born: Cambridge, Massachusetts in 1897. Studied: University of Chicago; Art Students League; Grande Chaumiere, Paris.

DAVID, Lorene. Painter. Born: Independence, Missouri in 1897. Studied: Teachers College, Columbia University with Charles Martin and Arthur Young; Art Students League with O'Hara; Kansas City Art Institute; International School of Art with George Ennis. Awards: National Association of Women Artists, 1936; New Orleans Art Association, 1939, 1943; Southern Printmakers, 1940; Texas Printmakers Exhibition, 1941, 1942. Collections: Southern Louisiana Institute; Pennsylvania Elementary School, Beaumont, Texas; Dallas Museum of Fine Arts; Texas Technical Institute; Southern Methodist University; Museum of New Mexico; State Teachers College, Huntsville, Texas.

DAVIDSON, Clara D. Painter. Exhibited in 1924.

DAVIDSON, Lillian Margaret. Painter. Born: Canton, Ohio in 1896. Studied: John Herron Art Institute; Art Students League; and with Bohrod, Burchfield, Chidlaw and Brucker. Awards: Whitney McGuire purchase prize, Richmond; Lucretia Carr prize, Richmond; Indianapolis, Indiana; National Association of Women Artists; Tri Kappa prize, Richmond; Ft. Wayne, Indiana.

DAVIESS, Maria T. Painter. Born: Harrodsburg, Kentucky in 1872 and died in 1924. Studied: with Blanche, Mucha, and Delecluse.

DAVIS, Cornelia Cassady. Painter. Born: Cleves, Ohio in 1870 and died in 1920. Studied: with Lutz and Duveneck. Awards: in 1905 and 1912. Collections: Westminster Central Hall, London; Eli Tovar Gallery, Grand Canyon, Arizona.

DAVIS, Elizabeth Logan. Painter. Born: Shelbyville,
Kentucky in 1886. Studied: Art Institute of Chicago;
with Ivanowski and Margery Ryerson. Awards: New Jersey
Woman's Club, 1945, 1955; Rahway Woman's Club, 1945;
American Artists Professional League, 1951. Collection:
portraits of Mothers of the Year at the Waldorf-Astoria
Hotel, New York City.

DAVIS, Elizabeth Upham. Painter. Born: Milwaukee, Wisconsin
in 1890. Studied: Milwaukee-Downer College; with Edward
Thatcher, Jerry Farnsworth and Robert Brackman. Awards:
Miami Art League, 1952, 1954; Blue Dome, 1955; Miami Beach
Art Center, 1957. Collection: portrait commissions.

DAVIS, Emma Earlenbaugh. Painter. Born: Altoona,
Pennsylvania in 1891. Studied: Philadelphia Museum School
of Industrial Art; Pennsylvania Academy of Fine Arts;
with Wayman Adams. Exhibited widely in Pennsylvania.

DAVIS, Emma Lu. Painter. Born: Indianapolis, Indiana in
1905. Studied: Vassar College; Pennsylvania Academy of
Fine Arts. Awards: traveling scholarship, Pennsylvania
Academy of Fine Arts, 1930; International Folk Art
Museum, Santa Fe, New Mexico, 1958. Collections: Whitney
Museum of American Art, Museum Modern Art; International
Business Machines; Beloit College; Social Security Building,
Washington, D.C.

DAVIS, Faith Howard. Painter. Born: Chicago, Illinois in
1915. Studied: Sarah Lawrence College; with Peppino
Mangravite, Bradley Tomlin and Kurt Roesch. Awards:
Buffalo, New York, 1946; James Carey Evans prize, Western,
New York Exhibition, 1955.

DAVIS, Gladys Rockmore. Painter. Born: New York City in
1901. Studied: Art Institute of Chicago with John Norton.
Awards: Corcoran Gallery of Art, 1939; Art Institute of
Chicago, 1937; Virginia Museum of Fine Arts, 1938;
Pennsylvania Academy of Fine Arts, 1938, gold medal, 1952;
National Academy of Design, 1944; gold medal, 1955;
Pepsi-Cola, 1946. Collections: Metropolitan Museum of Art;
Pennsylvania Academy of Fine Arts; Nebraska Art Association;
Toledo Museum of Art; Butler Art Institute; Swope Art
Gallery; Cranbrook Academy of Art; Dayton Art Institute;
Nelson Gallery of Art; University of Arizona; University of
Nebraska; Baltimore Museum of Art; Kent State University;
Miami University; Atlanta Museum of Art; Davenport Municipal
Museum; Birmingham Museum of Art; Encyclopaedia Britannica
Collection.

DAVIS, Hallie. Painter. Was exhibiting in 1924.

DAVIS, Helen S. Sculptor. Born: Philadelphia, Pennsylvania
Studied: Pennsylvania Academy of Fine Arts; Art Students
League; Cooper Union Art School. Award: Cooper Union Art
School. Collections: Community House, Coral Gables,
Florida; San Francisco California; Daytona Beach, Florida;
St. Petersburg Art Club; Florida Federation of Art.

DAWSON, Bess Phipps. Painter. Born: Tchula, Mississippi
in 1916. Studied: Belhaven College, Jackson, Mississippi;
with Zerbe, Fred Conway, Lamar Dodd. Awards: Allison's
Art Colony, 1953-1958; Mississippi Art Association, 1957.
Collections: murals, Church of God, McComb, Mississippi;
Progressive Bank Building, Summit, Mississippi.

DAY, Emily. Painter. Born: New York City in 1839. She
was known principally as a portrait painter.

DAY, Marion M. She was known for her crayon painting which
she exhibited in 1849.

DAY, Martha B. Willson. Painter. Born: Providence, Rhode
Island in 1885. Studied: Rhode Island School of Design;
Julian Academy, Paris. Award: Pennsylvania Academy of
Fine Arts, 1932. Collection: Pennsylvania Museum of Art.
She was a painter in miniatures for which she gave many
lectures.

DAY, Worden. Painter. Born: Columbus, Ohio in 1916.
Studied: Randolph-Macon College; Art Students League;
and with Maurice Sterne and Stanley William Hayter.
Awards: Traveling Fellowship, Virginia Museum of Fine Arts,
1940-1942; Guggenheim Fellowship, 1952-1953; Rosenwald
Fellowship, 1942-1944; Norfolk Museum of Art, 1944;
Corcoran Art Museum, 1948; Brooklyn Museum, 1949, 1950.
Collections: Virginia Museum Fine Arts; National Gallery
of Art; Museum of Modern Art; University of Minnesota;
Bradley University; Brooks Memorial Gallery; Library of
Congress; Corcoran Art Museum; Yale University; Brooklyn
Museum; University of Louisville, Metropolitan Museum of
Art; Brooklyn Museum of Art; Mills College.

DEACHMAN, Nelly. Painter. Born: Prescott, Arkansas in
1895. Studied: Arkansas State Teachers College; University
of Chicago; Art Institute of Chicago. Awards: National
League of American Pen Women, 1950, 1951, 1954, 1955,1956
1958; Illinois Federation Music Club, 1955. Collections:
Capitol Building, Little Rock, Arkansas; State Teachers
College, Conway, Arkansas; Hendrix College.

DEAN, Elizabeth M. Painter. Born: Cambridge, Massachusetts.
Studied: in London and Paris; and with Duveneck and Murphy
in Boston.

DEAN, Grace R. Painter. Was exhibiting in 1922 at the
Academy of Fine Arts.

DEANE, Lillian Reubena. Painter. Born: Chicago in 1881. Studied: Art Institute of Chicago. She was known as a miniature painter.

DE BAUN, Etta V. Painter. Born: Kripplebush, New York in 1902. Studied: with George Elmer Browne. Awards: Ridgewood Art Association, 1945, 1949.

DE BEUKELAER, Laura Halliday. Sculptor. Born: Cincinnati, Ohio in 1885. Studied: Cincinnati Art Academy; St. Louis School of Fine Arts. Collections: State Normal School, Geneseo, New York; Washburn College, Topeka, Kansas.

DECKER, Mrs. E. Bennett. Painter. Born: Washington, D.C. in 1869. Studied: with William H. Whittemore. She was known for her miniature paintings. She also did miscroscopic drawings for Smithsonian Institute.

DE COUX, Janet. Sculptor. Born: Niles, Michigan. Studied: Carnegie Institute; New York School of Industrial Design; Rhode Island School of Design; Art Institute of Chicago. Awards: Guggenheim Fellowship, 1938-39, 1939-40; Widener medal, 1942; Carnegie award, Pittsburg; National Sculpture Society; American Academy Arts and Letter, grant. Collections: College of New Rochelle; United States Post Office, Girard, Pennsylvania; St. Mary's Church, Manhasset, New York; Society of Medalists; Sacred Heart School, Pittsburgh; St. Vincent's, Latrobe, Pennsylvania; St. Scholastica, Aspinwall, Pennsylvania; Crucifixion Group, Lafayette, New Jersey; altar, St. Margaret's Hospital Chapel, Pittsburgh; Christ King Church of Advent, Pittsburgh; doors, St. Ann, Palo Alto, California; Charles Martin Hall Memorial, Thompson, Ohio; Brookgreen Gardens, South Carolina.

DEDEAUX, Helen. Painter. Born: Niles, California in 1915. Studied: University of Southern California; and with Paul Sample, Dan Lutz, Jean Ames and Glen Lukens. Award: Pomona Fair, 1942.

DE FOE, Ethellyn B. Painter. Born: New York; Studied: with Whittemore and Mowbray in New York. She was best known as a miniature painter.

DE FOREST, Julie Morrow. Painter. Born: New York City. Studied: Wellesley College; Columbia University; with Jonas Lie, Charles Hawthorne, and John Carlson. Awards: Women's Theodore Roosevelt Memorial Association; College Club, Cincinnati; Cincinnati Museum Association, 1958. Collections: Farnsworth Museum, Wellesley College; American Federation Women's Club.

Adelaide Milton de Groot, HARBOR AT TANGIER, 1928. Oil on canvas, 18 1/2" X 24". The Metropolitan Museum of Art (Arthur H. Hearn Fund, 1936).

DEGEN, Ida Day. Sculptor. Born: San Francisco, California
in 1888. Studied: California School of Fine Art; Art
Students League; with Ralph Stackpole, William Zorach.
Awards: Marin County Garden Center, 1948, 1950, 1952;
Frances Young Gallery, 1949, 1950, 1951; San Rafael,
California, 1941; Oakland Art Gallery, 1942, 1946, 1955;
San Francisco Museum of Art, 1942, 1943, 1950, 1951, 1955;
National League American Pen Women, 1957, 1958; Santa Rosa,
California, 1958. Collections: South Grace Cathedral;
deYoung Memorial Museum; Palace Legion Honor, Bohemian
Club, all in San Francisco, California.

DEGENHART, Pearl C. Painter. Born: Philipsburg, Montana.
Studied: University of Montana; Columbia University;
University of California; University of Oregon; University
of New Mexico. Award: University of Montana, 1919.

DE Ghize, Eleanor. Painter. Born: New York City in 1896.
Studied: Maryland Institute; and with Maurice Denis in
Paris; Kroll and Sloan in New York. Awards: Wilson Smith
prize, 1931; Baltimore Museum of Art, 1939. Collection:
Baltimore Museum of Art.

DE GROOT, Adelaide Milton. Painter. Born: New York City
in 1876. Studied: Art Students League; in France; and
with Frederic Taubes. Collections: Metropolitan Museum of
Art; Boston Museum of Fine Arts; Philadelphia Museum of
Art; Zanesville Ohio Museum of Art; Columbus Gallery of
Fine Arts; Springfield, Massachusetts Museum of Fine Arts;
New York Historical Society; Musee de Nice, France.

DE HELLEBRANTH, Bertha. Sculptor. Born: Budapest, Hungary.
Studied: Budapest Academy of Fine Arts; Julian Academy,
Grande Chaumiere, Paris. Awards: Budapest, 1938; American
Artists Professional League, 1938; Montclair Art Museum,
1941, 1956; Florida Southern College, 1951; gold medal,
Audubon Art, 1946. Collections: Brooklyn Museum; Fordham
University; Scranton University; Florida Southern College;
Cistercian Abbey, Trappist, Kentucky.

DE HELLEBRANTH, Elena Maria. Painter. Born: Budapest,
Hungary. Studied: Academy Fine Arts, Budapest; Julian
Academy, Grande Chaumiere, Paris. Awards: Budapest
Hungary; Ogunquit Art Center; Florida Southern College;
Jersey City Museum of Art; Montclair Art Museum, 1956.
Collections: International Business Machines; Brooklyn
Museum; Florida Southern College; Scranton Museum of Art;
Ventnor New Jersey Hospital; Scranton University;
Hungarian Legation, Washington, D. C.

DEHNER, Dorothy. Painter. Born: Cleveland, Ohio in 1908.
Studied: University of California at Los Angeles; Art
Students League; Skidmore College; with Kenneth Hayes
Miller and Boardman Robinson. Awards: Audubon Art, 1947.
Collections: Museum of Modern Art; Metropolitan Museum of
Art; Munson-Williams-Proctor Institute; United States
Embassies.

DEIKE, Clara L. Painter. Born: Detroit, Michigan in 1881.
Studied: Cleveland School of Art; in Munich; in Italy;
in Germany; and with Henry G. Keller, Hugh Breckenridge
and Hans Hofman. Awards: Cleveland Museum of Art, 1922,
1923, 1925-1928, 1940, 1957; Halle Brothers, Cleveland,
1928. Collections: Cleveland Museum of Art; Public schools,
Cleveland, Ohio.

DE KAY, Helena. Painter of flower-pieces and figure-pieces.
She was exhibiting in 1874-1878.

DE KOONING, Elaine Marie Catherine. Painter. Born: New
York City in 1920. Studied: American Art School; Leonardo
Da Vinci Art School; and with William de Kooning. She is
also the author of "Painting, Sculpture and Architecture
A Study in Integration," in 1952.

DE LAITTRE, Eleanor. Sculptor. Born: Minneapolis,
Minnesota in 1911. Studied: Boston Museum of Fine Arts
School; and with George Luks and John Sloan. Collections:
Walker Art Center; University of Minnesota.

DE LAMOTTE, Caroline J. Painter. Born: Pikesville,
Maryland in 1889. Studied: with Turner, Keyser and Webb.
Collection: M. E. Church, Le Compte, Louisiana.

DE LEON, Amanda. Painter. Born: Madrid, Spain in 1908.
Studied: San Jose de Tarbes Convent, Caracas, Venzuela.
Collections: Musee d'Art Moderne, Paris; National Gallery
Modern Art, Rome; Glasgow Art Gallery, Scotland; Museum
Modern Art, Barcelona; Musee de Beaux Arts, Lausanne;
Municipal Gallery Modern Art, Dublin; Municipal Gallery
Modern Art, Genoa; Art Gallery of Toronto, Canada; Denver
Museum of Art; Butler Art Institute; University of California;
Museum of Modern Art, Sao Paulo, Brazil; National Gallery
of Modern Art, New Delhi, India; National Museum of Modern
Art, Tokyo; Municipal Art Museum, Dusseldorf, Germany;
Neue Galerie der Stadt Linz, Austria; Hamburger Kunsthalle,
Germany.

D'ELIA, Teresa Ilda. Painter. Born: Greenwich, Connecticut
in 1918. Studied: Art Students League; New York School for
Social Research; with Charlot and Picken. Awards:
San Francisco Art Association, 1943; Douglas Aircraft
Exhibition, 1943; Springfield Art League, 1945, 1946.

DELLARIPA, Filomena Joan. Painter. Born: Philadelphia in
1922. Studied: Moore Institute of Art, Science and Industry;
Pennsylvania Academy of Fine Arts; Barnes Foundation; and
abroad. Awards: Fellowship, Pennsylvania Academy of Fine
Arts; Cresson scholarship, 1944, 1945; scholarship, Barnes
Foundation, 1944, 1945; Graphic Sketch Club, 1940;
Philadelphia Plastic Club. Ramborger prize, 1943.
Collection: Fleisher Art Memorial, Philadelphia, Pennsylvania.

DEL MAR, Frances. Painter. Born: Washington, D. C.
Studied: University College, London; Sorbonne, Julian
Academy, Paris; with Raphael Colin, and Julius Rolshoven.
Collections: murals, Caroline Rest Hospital; Hecksher
Foundation; Musee de la Guerre a Vincennes, France.

DE MARCO, Jean. Sculptor. Born: Paris, France in 1898.
Studied: Ecole Nationale des Arts Decoratifs, Paris.
Awards: New Rochelle Art Association, 1940; American
Academy of Arts & Letters, 1958; National Academy of Design,
1946; Architect League, 1958; National Sculpture Society,
1945, 1948, 1954. Collections: Whitemarsh Park Memorial,
Prospectiville, Pennsylvania; War Department Building,
Washington, D. C. United States Post Office, Weldon, North
Carolina; Danville, Pennsylvania; United States Capitol,
Washington, D. C. Joslyn Memorial Museum; Memorial Notre
Dame University; Metropolitan Museum of Art; reliefs,
Cathedral of the Assumption, Baltimore, Maryland.

DEMING, Adelaide. Painter. Born: Litchfield, Connecticut
in 1864. Studied: Pratt Institute Art School; Art Students
League; and with Chase, Lathrop and Snell. Collection:
Litchfield Public Library. She was a landscape painter.

DEMONET, Inez. Painter. Born: Washington, D. C. in 1897.
Studied: Corcoran School of Art; Philadelphia Museum School
of Art; with Benson Moore and Charles Hawthorne. Awards:
Corcoran School of Art, 1915; Society of Washington Print-
makers, 1935; Washington Watercolor Club, 1946; National
Museum, Washington, D. C. 1935. Her specialty is Medical
exhibits.

DENGROVE, Ida. Painter. Born: Philadelphia, Pennsylvania
in 1918. Studied: Philadelphia Graphic Sketch Club; Moore
Institute; Barnes Foundation. Award: Traveling fellowship
Moore Institute Art, Science and Industry. Collection:
United States Government.

DENNEY, Gladys A. Painter. Born: Portland, Indiana in
1898. Studied: Cooper Union Art School; Philadelphia
Museum School of Art; John Herron Art Institute; University
of Colorado. Awards: Cooper Union Art School, 1925;
Indiana State Fair, 1937-1940, 1946-1949; Hoosier Salon,
1946, 1948.

DENNEY, Irene. Painter. Born: Philadelphia, Pennsylvania.
Studied: Pennsylvania Academy of Fine Arts. Awards: Cresson
award, Pennsylvania Academy of Fine Arts; Smith award,
Pennsylvania Academy of Fine Arts, 1938. Collection:
Pennsylvania Academy of Fine Arts.

DENNING, Charlotte. Miniature painter whose work flourished
about 1834.

DENNISON, Dorothy. Painter. Born: Beaver, Pennsylvania in
1908. Awards: Cresson European Traveling Scholarship;
Butler Institute of American Art; Ohio State Fair.
Collections: Pennsylvania Academy of Fine Arts; Columbus
Art Gallery; Canton Art Institute; Marine Midland Bank;
Lawrence Fleishman; Olsen Foundation.

DENSLOW, Dorothea Henrietta. Sculptor. Born: New York City
in 1900. Studied: Art Students League. Collections:
Memorial plaque, Beth Moses Hospital, Brooklyn, New York;
Brookgreen Gardens, South Carolina.

DERCUM, Elizabeth. Painter. Was exhibiting in 1924.

DER HAROOTIAN, Koren. Sculptor. Born: Ashodavan, Armenia
in 1909. Studied: Worcester Museum of Art School.
Awards: Springfield Art League, 1945; Audubon Art, 1950,
gold medal, Pennsylvania Academy of Fine Arts, 1954;
American Academy of Art Letters, 1954. Collections:
Metropolitan Museum of Art; Worcester Museum of Art;
Pennsylvania Academy of Fine Arts; Arizona State College
Museum, Tempe; marble eagle, U.S. Pavillion, Brussels
World Fair, 1958. Fairmount Park Association, Philadelphia,
Pennsylvania.

DERBY, Mary. Born: in 1814 and died in 1900. She was a
portrait painter.

DESPRES, Joanna. Painter. Born: in 1912. Studied:
Connecticut College; Stanford University. She worked in
the San Francisco area.

DEWEY, Julia H. Painter and illustrator. Born: Batavia,
New York.

DEWING, Maria Oakey. Painter. Born: New York City in 1845. Studied: National Academy, New York; with John LaFarge and Thomas Couture. She specialized in flowers and portraits.

DEXTER, Mary L. Painter. Member of the Society of Independent Artists.

DEWITT, Jessie R. Painter. Born: De Queen, Arkansas. Awards: Los Angeles Museum of Art; Laguna Beach Art Association; San Diego County exhibition, Vista, California; Carlsbad-Oceanside Annual.

DICKERSON, Grace Leslie. Painter. Born: Fort Wayne, Indiana. Studied: Fort Wayne Art School; Instituto Allende, Mexico; Art Institute of Chicago; St. Francis College, Fort Wayne. Awards: Indiana State Fair, 1940, 1946, 1953, 1954, 1957; Fort Wayne Woman's Club, 1953, 1957; Hoosier Salon, 1954; South Bend Ceramic Exhibition, 1953; Northern Indiana Art Salon, Hammond, Indiana, 1955, 1956; Fort Wayne University, 1950. Collections: Cathedrals, in Fort Wayne, South Bend, Evansville and Indianapolis; Fort Wayne Schools; Keenan Hotel.

DICKEY, Helen P. Painter. Born: Cleveland, Ohio in 1915. Collections: Florida Presbyterian College; Loew's Theatre.

DICKINSON, Daisy Olivia. Sculptor. Born: Bellingham, Washington. Studied: Chouinard Art Institute; Santa Barbara School of Fine Arts; and with Chamberlin, and Fletcher. Award: Los Angeles County Fair, 1941.

DI CRISPINO, Mary Reina. Painter. Born: Catania, Italy in 1900. Studied: Maryland Institute; and with Herman Maril. Awards: Baltimore Municipal Art Society, 1941; Peale Museum of Art, 1943, 1945; National League American Pen Women. Collections: Peale Museum; Baltimore Friends of Art.

DIENES, Sari. Painter. Born: in Hungary in 1899. Studied: Ozenfant School of Fine Arts; and with Henry Moore in London and Andre L'Hote in Paris. Awards: Fellowship, MacDowell Colony, 1952-1954; Yaddo Foundation, 1953. Collection: Brooklyn Museum.

DILLAYE, Blanche. Painter. Born: Syracuse, New York. Studied: Pennsylvania Academy of Fine Arts; also in Paris. Award: gold medal, water color, National Conservation Exposition, Knoxville, Tennessee. Collections: Syracuse Museum of Fine Arts; University of Syracuse.

DILLER, Mary Black. Painter. Born: Lancaster, Pennsylvania. Studied: Carnegie Institute; Pennsylvania Academy of Fine Arts; Art Students League; Metropolitan Art School. Awards: Studio Club, 1923; Lancaster, Pennsylvania, 1925; Ogunquit Art Center, 1940. Collections: Albany Institute of History and Art; Tiffany Foundation; Florida Southern College. Special contributor to childrens magazines.

DILLON, Mildred Murphy. Printmaker. Born: Philadelphia, Pennsylvania in 1907. Studied: Philadelphia Museum School of Art; Pennsylvania Academy of Fine Arts; Barnes Foundation; and in Europe. Awards: Pennsylvania Academy of Fine Arts, 1953; American Color Printmaker Society, 1955. Collections: Philadelphia Museum of Art; Barnes Foundation; Philadelphia Printmaker Club; Canadian Painter & Etcher; Atwater Kent Museum; Philadelphia Free Library.

DINNEEN, Alice. Painter. Born: New York City in 1908. Studied: New York School Applied Design for Women; Art Students League; with Furlong. Collections: Carville, Louisiana; La Fortaleza, San Juan, Puerto Rico; New York Hospital; mural, United States Post Office, Warrenton, North Carolina; Corbin, Kentucky; Department of Labor, Washington, D. C.

DIUGUID, Mary Sampson. Painter. Born: Lynchburg, Virginia in 1885. Studied: Pennsylvania Academy of Fine Arts; Philadelphia Museum School of Art; with Henry B. Snell and George Ennis.

DIXON, Madeline. Painter. Born: Cullman, Alabama. Collections: Gadsden Museum of Art; Gadsden, Alabama; Blait Corporation, Birmingham, Alabama.

DODDS, Peggy. Painter. Born: Paterson, New Jersey in 1900. Studied: Collegiate Institute, Paterson, New Jersey; Art Students League. Awards: National Association of Women Artists; Montclair Art Museum; National League American Pen Women, 1950, 1952.

DODGE, Frances. Painter. Born: Lansing, Michigan in 1878. Studied: Michigan State University; Syracuse University; Cincinnati Art School; Art Students League. Award: Minnesota State Fair. Collections: Cincinnati Public School; Chicago Public School; Nebraska State University.

DODSON, Sarah Paxton Ball. Painter. Born: Philadelphia, Pennsylvania in 1847 and died in 1906. Studied: with M. Schussele in Philadelphia; and with Jules Lefebve in Paris. She was a landscapist and figure painter.

DOGGETT, Jean. Painter. Born: New York City in 1902.
Studied: Columbia University: Art Students League. Awards:
San Fernando Art Association, 1949, 1950, 1951, 1954;
Sherman Oaks Business and Professional Women's Club, 1950;
Women Painters of the West, 1951.

DOHERTY, Lillian C. Painter. Studied: Corcoran School of
Art; with Rhoda Nicholis and C. W. Hawthorne; in Europe.

DOKE, Sallie George. Painter. Born: Keachie Louisiana.
Studied: Cincinnati Academy; Chicago Academy of Fine Arts.
Award: gold medal, Dallas, 1916.

DOLE, Margaret Fernald. Painter. Born: Melrose,
Massachusetts in 1896. Studied: Radcliffe College; Boston
Museum of Fine Arts School; with Philip Hale and Charles
Woodbury. Awards: Hudson River Museum, 1957; American
Artists Professional League, 1957; National League of
American Pen Women, 1957, 1958; Greenwich Society of Art,
1957. Collections: Riverdale School for Girls; Riverdale
School for Boys.

DOMBECK, Blanche. Sculptor. Born: New York City in 1914.
Studied: Graduate Training School for Teachers; with Zeitlin
and Amino. Awards: Fellowship, MacDowell Colony, 1957;
Huntington Hartford Foundation, 1958. Collections:
Brooklyn Museum; Randolph-Macon Woman's College.

DONALDSON, Alice W. Painter and Illustrator. Born: in
Illinois in 1885. Studied: Cincinnati Academy. Collections:
Colored frontispieces and covers for "Touring Great Britian,"
and "The Book of New York," by Robert Shackleton.

DONALDSON, Elise. Painter. Born: Elkridge, Maryland.
Studied: Bryn Mawr College; Art Institute of Chicago;
and abroad with Andre L'Hote. Awards: Art Institute of
Chicago, 1934; San Diego Art Guild, 1954; San Diego Fine
Arts Society, 1956. Collections: San Diego Fine Arts
Society; Davenport Municipal Art Gallery.

DONELSON, Mary H. Sculptor. Born: Hermitage, Tennessee in
1906. Studied: Vanderbilt University; Art Institute of
Chicago. Awards: Art Institute of Chicago, 1928; Proctor
& Gamble Company, 1928; Public Health Association, 1929.
Collections: Tennessee State Capitol; University of
Tennessee; Davidson County Court House.

DONLEVY, Alice H. Painter and Illustrator. Born: Manchester,
England in 1846. Studied: Women's Art School of Cooper Union
in New York.

DONLY, Eva Brook. Painter. Born: Simcoe, Ontario, Canada, in 1867. Studied: with F. M. Bellsmith and John Ward Stimson. Collection: United States Government; National Gallery, Washington, D. C.

DONNELLY, Mary E. Painter. Born: New York City in 1898. Studied: Hunter College; Columbia University. Awards: New Jersey Gallery, 1939; Bell System Exhibition, 1946.

DONOVAN, Ellen. Painter. Born: Philadelphia, Pennsylvania. Studied: Philadelphia Museum School of Industrial Art; Barnes Foundation; and with Morris Davidson. Award: Plastic Club, 1930. Collection: Pennsylvania Academy of Fine Arts.

DOONER, Emilie L. Painter. Born: Philadelphia in 1877. Studied: Pennsylvania Academy of Fine Arts; also abroad.

DOREY, Elsie. Painter. Born: Newark, Ohio in 1907. Studied: Denison University; Columbus School of Art; Dayton Art Institute; Ohio State University. Awards: Naples, Florida, Art Assocation, 1956-1958; Florida Federation Women's Club, 1957.

DOUGHERTY, Bertha Hurlbut. Printmaker. Born: Plainfield, New Jersey in 1883. Studied: Vassar College; Fawcett Art School; New York School of Design for Women. Awards: Smithsonian Institute, 1952; Fairfax,Virginia; Montclair Art Museum; National League American Pen Women, 1956, 1957.

DOUGLAS, Laura Glenn. Painter. Born: Winnsboro, South Carolina. Studied: College for Women, Columbia, South Carolina; Corcoran School of Art; Art Students League; National Academy of Design with Hawthorne; and abroad. Awards: Metropolitan Museum of Art, 1926; Art Institute of Chicago, 1942. Collections: Rochester Memorial Art Gallery; Gibbes Art Gallery; United States Treasury Department, Washington, D. C. United States Post Office, Camilla, Georgia.

DOULL, Mary Allison. Painter. Born: in Canada. Studied: National Academy of Design, New York; Julien Academy, Paris. She was known as a miniature painter.

DOWLING, Colista. Painter. Born: Waverly, Kansas. Studied: Oregon State College; Art Students League. Collections: has many portraits in public buildings and murals in churches.

DOWNING, Martha J. Painter. Born: Lima, Ohio in 1917. Collections: Hospital and Court House in Lee County, Florida.

DOYLE, Margaret B. Painter. A portrait painter whose specialty was miniature portraits. She was very active between 1820 and 1830 in the Boston area.

DRABKIN, Stella. Painter. Born: New York City in 1906. Studied: National Academy of Design; Philadelphia Graphic Sketch Club, with Earl Horter. Awards: American Color Printmaker Society, 1944; Philadelphia Printmaker Club, 1955. Collections: Pennsylvania Academy of Fine Arts; Philadelphia Museum of Art; National Gallery of Art; Metropolitan Museum of Art; Pennsylvania State College; Library of Congress; Atwater Kent Museum; Tel-Aviv Museum, Israel, Bezalel Museum, Jerusalem.

DRAYTON, Grace G. Illustrator. Born: Philadelphia in 1877. Her specialty, illustrations and posters of children.

DREYFOUS, Florence. Painter. Born: New York City. Studied: with Henri.

DREYFUS, Isidora C. Painter. She was noted for her miniature paintings which she exhibited in 1925.

DRESSEL, Frannie. Printmaker. Born: Edwardsville, Illinois in 1921. Studied: Art Institute of Chicago. Awards: City Art Museum of St. Louis, 1947; American Institute of Decorators. Collections: Springfield Museum of Art; private chapel of Archbishop Ritter, St. Louis, Missouri.

DREW, Dorothy Hart. Painter. Born: Macon County, Missouri. Studied: with Bridgman, Alexander Abels, Ivan Olinsky and Sidney Dickinson. Collection: portraits in public buildings and private collections.

DREWELOWE, Eva. Painter. Born: New Hampton, Iowa. Studied: University of Iowa; University of Colorado. Awards: Colorado State Fair, 1931, 1932, 1950; Springfield Museum of Art; Denver Art Museum, 1932; Tri-State Exhibition, Cheyenne, Wyoming, 1958. Collections: University of Iowa; University of Colorado; Harkness House, London, England; Crippled Chidren's School, Jamestown, North Dakota; Agricultural College, Cedar City, Utah.

DREYER, Margaret Webb. Painter. Born: East St. Louis, Illinois, in 1917. Awards: Houston Artists Annual; Texas Watercolor Society. Collections: Institute of International Education; Witte Museum; Thomas P. Creaven.

DRIER, Katharine S. Painter. Born: Brooklyn, New York in 1877. Studied: with Walter Shirlaw.

DRIPPS, Clara Reinicke. Painter. Born: Amelia, Ohio in
1885. Studied: Otis Art School, Los Angeles; Corcoran
School of Art. Awards: Women Painters of the West; Las
Artistas, 1944, 1946; American Artist Magazine, 1952;
Odessa, Texas, 1954.

DRURY, Hope C. Painter. Born: Pawtucket, Rhode Island
in 1889. Studied: Rhode Island School of Design.

DRYDEN, Helen. Illustrator. Born: Baltimore, Maryland
in 1887. Studied: Pennsylvania Academy of Fine Arts. Was
a well-known designer for magazine covers, posters and stage
scenery.

DRYFOOS, Nancy P. Sculptor. Born: New Rochelle, New York.
Studied: Sarah Lawrence College; Columbia University; Art
Students League. Awards: National Art Club, 1947; New
Jersey Painters and Sculptors Society, 1950, 1957; Village
Art Center, 1950; Westchester Arts & Crafts Guild, 1950,
1951; Knickerbocker Artists, 1953, 1958; National
Association of Women Artists, 1953; Hudson Valley Art
Association, 1953; Silvermine Guild, 1954; Brooklyn Society
of Art, 1955.

DUBLE, Lu. Sculptor. Born: Oxford, England in 1896.
Studied: Art Students League; National Academy of Design;
Cooper Union Art School; with Archipenko and Hofmann.
Awards: Guggenheim Fellowship, 1937, 1938; Fellowship
Institute International Education; National Association
Women Artists, 1937; Audubon Art, 1950, gold medal, 1958;
National Academy of Arts & Letters, 1952; Audubon Art, 1947.
Collections: Newark Museum of Art; Whitney Museum of
American Art.

DUBOIS, Mary Ann Delafield. Sculptor. Born: 1813 and
died in 1888.

DU BRAU, Gertrude M. Painter. Born: in Germany in 1889.
Studied: Maryland Institute, Baltimore. Collections:
murals, Masonic Temple and City Hall, Cumberland, Maryland.

DUCASSE, Mabel Lisle. Painter. Born: La Porte, Colorado
in 1895. Studied: Art Students League; Pratt Institute of
Art School; University of Washington. Awards: Seattle Fine
Arts Society, 1918, 1923, 1925.

DUGGAR, Marie R. Sculptor. Died in 1922. Her specialty
was bas relief portraits of children.

Du JARDIN, Gussie. Painter. Born: San Francisco in 1918.
Studied: Unviersity of Colorado, State University of Iowa.
Awards: Roswell Museum of Art, New Mexico. Collections:
New Mexico Highlands University; Las Vegas, New Mexico
Hospital.

DULAC, Margarita W. Painter. Born: Asheville, North Carolina in 1922. Studied: Northwestern University; University of Chicago; Art Institute of Chicago; Academie Andre L'Hote, Paris. Awards: University of Chicago, 1942; Evanston Artists, 1942; Wooley Fellowship in painting, to Paris, 1938-1939; Fellowship, Northwestern University; University of Chicago, University of Iowa; New York University. Collections: Northwestern University; Stevens Store, Chicago; and in Italy.

DUMMETT, Laura D. Painter. Born: Allegheny, Pennsylvania in 1856. Studied: Pittsburgh School of Design for Women; Julien Academy, Paris.

DU MOND, Helen S. Painter. Born: Portland, Oregon in 1872. Known as a miniature painter.

DUNBAR, Daphne F. Lithographer. Born: Port Colban, Canada in 1883. Studied: Boston Museum of Fine Art School; with Ross, Zerbe, and Kenneth H. Miller. Awards: San Diego, California, 1941; Institute of Modern Art, Boston, 1945. Collections: Colorado Springs Fine Art Center; Boston Museum of Fine Art; Addison Gallery of American Art; Los Angeles Museum of Art; Detroit Institute of Art; Library of Congress.

DUNBAR, Miss. F. J. Painter. Working as a portrait painter in 1860.

DUNCAN, Jean. Painter. Born: St. Paul, Minnesota. Studied: Vassar College; University of Minnesota; Art Students League and with Hans Hofmann, and Eliot O'Hara. Awards: Minneapolis Institute of Art, 1925; Club Montparnasse in St. Paul 1934; Minneapolis Women's Club, 1944, 1949; National League American Pen Women, 1942. Collections: Minneapolis Institute of Art; St. Paul Gallery & School of Art.

DUNLAP, Helena. Painter. Born: Los Angeles, California. Studied: Academy of Fine Arts, Philadelphia; in Paris with Simon.

DUNLAP, Zoe F. Painter. Born: Cincinnati, Ohio in 1872. Studied: Cincinnati Academy; and in Paris. She was a miniature painter.

DUNN, Louise M. Painter. Born: East Liverpool, Ohio in 1875. Studied: with H. G. Keller. Award: Cleveland Museum, 1923.

DUNN, Marjorie Cline. Painter. Born: El Dorado, Kansas in 1894. Studied: Los Angeles School of Art & Design; and with Ella Shephard Bush and MacDonald-Wright. She specialized in miniatures.

DUNWIDDIE, Charlotte. Sculptor. Born: Strasbourg, France in 1907. Studied: Wilhelm Otto Academy of Art, Berlin; Mariano Benlluire y Gil, Spain and in Buenos Aires. Award: Pen & Brush Club, 1958. Collections: Marine Corp Museum, Washington, D. C.; Church of the Good Shepherd, Lima, Peru; Throne room of the Cardinal's Palace, Buenos Aires; Bank of Poland, Buenos Aires; Church of Santa Maria, Cochabamba, Bolivia.

DUPRE, Julia Clarkson. Painter. Portrait and landscape pastels; worked in South Carolina from 1841 until after 1865.

DURIEUX, Caroline. Lithographer. Born: New Orleans, Louisiana in 1896. Studied: Newcomb College, Tulane University; Louisiana State University; Pennslyvania Academy of Fine Arts. Awards: Delgado Museum of Art, 1944; Library of Congress, 1944, 1946, 1952; 50 Prints of the Year, 1944; 50 Books of the Year, 1949. Collections: Museum of Modern Art; Delgado Museum of Art; New York Public Library; Virginia Museum of Fine Arts; Gibbes Art Gallery; Brooks Memorial Gallery; Atomic Museum, Oak Ridge, Tennessee; Philadelphia Museum of Art; Addison Gallery of American Art.

DURKEE, Helen Winslow. Painter. Born: New York City. Studied: Art Students League; with Chase DuMond and Mora. Award: Baltimore Water Color Club. Best known as a miniaturist.

DURLACHER, Ruth. Painter. Born: Springfield, Massachusetts in 1912. Studied: Ecole des Beaux-Arts, Fontainebleau; Yale School of Fine Arts with Rathbone, York and Keller. Awards: Brush & Palette Club, Meriden, Connecticut; Scarsdale Art Association. Collections: School for the Deaf, New York; Springfield Hospital; Government House, Nassau, British, West Indies (Portrait of Princess Margaret)

DURY, Loraine Lucille. Painter. Born: Green Bay, Wisconsin. Studied: Milwaukee Teachers College; University of Minnesota; Columbia University. Awards: Green Bay Art Colony, 1935; Northwestern Wisconsin Exhibition; Green Bay Camera Club, 1958. Collections: Roi-Porlier-Tank Cottage Museum, Green Bay, Wisconsin; Green Bay Board of Education.

DU VAL, Flora. Painter. Born: Haskell, Oklahoma in 1906. Studied: Art Students League. Awards: Shreveport Art Club, Louisiana State Museum, 1956; Louisiana Art Guild, 1956.

DWIGHT, Julia S. Painter. Born: Hadley, Massachusetts in 1870. Studied: in Boston with Tryon and Tarbell; in New York with Brush.

DWIGHT, Mabel. Printmaker. Born: Cincinnati, Ohio in
1876. Studied: with Arthur Mathews. Collections:
Metropolitan Museum of Art; Museum of Fine Arts, Boston;
Art Institute of Chicago.

DYER, Agnes S. Painter. Born: San Antonio, Texas in 1887.
Studied: Art Students League; and with Carlson, Dow and
Onderdonk.

EARLE, Elinor. Painter. Born: Philadelphia, Pennsylvania. Studied: Pennsylvania Academy of Fine Arts. Awards: Smith prize, 1902; St. Louis Exposition, 1904.

EARLEY, Mary. Painter. Born: St. Louis, Missouri in 1900. Studied: Art Students League, with Nicolaides and Palmer. Award: 48 States Competition, 1939. Collections: Murals, United States Post Office, Delhi, New York; Middleburg, New York.

EAST, Pattie R. Painter. Born: Hardesty, Oklahoma in 1894. Studied: Art Institute of Chicgo; Broadmoor Art Academy. Collection: mural, Shady Oaks Country Club, Fort Worth, Texas.

EASTMAN, Charlotte Fuller. Painter. Born: Norwich Connecticut. Studied: Pennsylvania Academy of Fine Arts; Art Students League; Art Institute of Chicago; Boston Museum of Fine Arts School; and with Wayman Adams.

EATON, Dorothy. Painter. Born: East Orange, New Jersey. Studied: Smith College; Columbia University; Art Students League; and with Kenneth Hayes Miller. Award: National Association of Women Artists, 1944. Collection: Smith College.

EATON, Margaret F. Painter. Born: in England in 1871. Studied: Art Students League, New York; with Cox and Mowbray.

EBBELS, Victoria. Painter. Born: Hasbrouch Heights, New Jersey in 1900. Studied: with George Luks and Robert Henri.

EBERLE, Abastenia St. Leger. Sculptor. Born: in 1878 and died in 1942.

EBERSOLE, Mabel H. Painter. Born: Keokuk, Iowa. Studied: Art Institute of Chicago. Awards: Southern States Art League. Collection: Museum of Fine Arts, Little Rock, Arkansas.

EBERT, Mary R. Painter. Born: Titusville, Pennsylvania in 1873. Studied: Art Students League; and with Hunt and Twachtman.

ECHERT, Florence. Painter. Born: Cincinnati, Ohio. Studied: with William Chase.

EDDY, Sarah J. Sculptor. Exhibited at the Pennsylvania Academy of Fine Arts in 1914.

EDE-ELSE. Painter. Born: East Orange, New Jersey. Studied: Art Students League.

EDGERLY, Beatrice. Painter. Born: Washington, D. C.
Studied: Corcoran School of Art; Pennsylvania Academy of
Fine Arts; and studied abroad. Awards: Fellowship,
Pennsylvania Academy of Fine Arts; Pennsylvania Academy
of Fine Arts, 1921; National Association of Women Artists,
1937; Tuscon Fine Arts Association, 1938, 1939. Collection:
Pennsylvania Academy of Fine Arts.

EDMONDS, Esther. Painter. Born: New York City in 1888.
Studied: Coopers Union; Art Students League, and with
her father, A. Edmonds a painter of rare ability. In 1910
she worked with her father in his studio in Columbia,
South Carolina and upon his death she continued her
profession as a portrait painter.

EDMUNDSON, Carolyn. Painter. Born: Pittsburgh,
Pennsylvania in 1906. Studied: Carnegie Institute, College
of Fine Arts; Columbia University. Awards: Nevada Art
Association, 1952; Society Western Art, 1954. Collections:
Nevada State Museum, Carson City; still life paintings,
advertising illustrations for Cannon Mills, Forstmann
Woolens, Yardleys of London and many others.

EDSALL, Mabel Meeker. Painter. Born: Bay City, Michigan.
Studied: Art Students League; and with DuMond, Chase and
Hawthorne. Awards: St. Louis Art Guild, 1946; St. Louis
Art League, 1927; prize for painting for church chapel
giben by Eden Publishing House and Concordia Publishing
House, 1957. Collections: Young Womens Christian
Association, St. Louis; mural, Dr. Albert Schweitzer Organ
Studio, Green Lake, Wisconsin.

EDWARDS, Eleanor. Painter. Born: St. Louis, Missouri in
1906. Studied: Iowa Wesleyan College; Stephens College.

EDWARDS, Kate Flournoy. Painter. Born: Marshallville,
Georgia in 1877. Studied: Art Institute of Chicago;
Grande Chaumiere, Paris and with Charles Hawthorne. Awards:
Southeastern Fair Exhibition. 1916; Atlanta Art Association.
Collections: The Capitol, Washington, D. C.; Georgia School
of Technology; Mercer University; Wesleyan College, Macon,
Georgia; University of Georgia; Wake Forest College, North
Carolina; Governor's Palace, Puerto Rico; Court House,
Atlanta, Georgia; High Museum of Art; City Library, Dayton,
Washington; Westminster School, Atlanta, Georgia; Court
House, New Bern, North Carolina; University of Illinois;
Federal Reserve Bank, Atlanta; Calhoun Memorial Library,
Atlanta; Georgia Federated Mutual Insurance Building,
Atlanta and in many other hospitals, banks and universities
in Georgia.

EGAN, Eloise. Painter. Born: Ithaca, New York. Has exhibited widely in New York.

EHRENREICH, Emma. Painter. Born: New York City in 1906. Studied: National Academy of Design; Brooklyn Museum School; New School for Social Research; City College, New York; Long Island University; Hunter College; and with Àbraham Rattner and Morris Davidson. Awards: National Association of Women Artists, 1950, 1955; Brooklyn Society of Art, 1951, 1952, 1954, 1957. Collections: Denver Art Museum; Dayton Institute of Art; Brandeis University; Governours Hospital.

EILERS, Emma. Painter. Born: New York. Studied: Art Students League and with Cox.

EISNER, Anne. Painter. Born: Newark, New Jersey in 1911. Studied: New York School of Fine & Applied Arts; Art Students League. Awards: National Association of Women Artists, 1940, 1944.

EISNER, Dorothy. Painter. Born: New York City in 1906. Studied: Art Students League. Awards: Dance International, 1936; National Association of Women Artist.

EKDAHL, Anne Anderson. Etcher. Born: Elgin, Illinois. Studied: Chicago Academy of Fine Arts; Art Institute of Chicago; and with Hawthorne, Breckenridge and Richard Miller. Collections: National Gallery of Art; Vexsjo, Sweden.

ELDER, Inez Staub. Painter. Born: Kosuth, Ohio in 1894. Studied: Art Academy of Cincinnati; New School of Design, Boston; Art Students League; Otterbein College. Awards: Dallas, Texas, 1931, 1933, 1948; Southern States Art League, 1936; Dallas Museum of Fine Arts, 1942.

ELIASOPH, Paula. Painter. Born: New York City in 1895. Studied: Pratt Institute Art School; Art Students League; Columbia University. Awards: Queensboro Young Womens Christian Association, 1943; Long Island Art League, 1950. Collections: Metropolitan Museum of Art; Franklin D. Roosevelt Library; New York Public Library; Library of Congress; Brooklyn Museum; Washington, D. C. Public Library; Hillside Hollis Center, Jamaica, Long Island.

ELIOT, Lucy. Painter. Born: New York City in 1913. Studied: Vassar College; Art Students League; with George Bridgman, Morris Kantor and William von Schlegell. Awards: Rochester Memorial Art Gallery, 1946; Silvermine Guild Art, 1957. Collections: Rochester Memorial Art Gallery; Munson-Williams-Proctor Institute.

ELISE (Elise Rosen) Painter. Born: Vienna, Austria.
Studied: School Graphic Art., Vienna; City College, New York.
Award: Diplome de Medaille d'Argent, Paris.

ELLIOTT, Elizabeth Shippen Green. Illustrator and Painter.
Born: Philadelphia, Pennsylvania. Studied: Pennsylvania
Academy of Fine Arts; and with Howard Pyle. She specialized
in illustrations and paintings of children.

ELLIOTT, Ethel M. Painter. Born: Iowa City, Iowa in 1908.
Studied: with Leon Franks, Will Foster, E. Withers, Christian
Von Schneidau and Arla Franklin. Awards: Los Angeles City
Hall, 1951; Community Art League, 1952, 1955; Southeast Los
Angeles Community Fair; Los Angeles Exposition Park, 1951;
Southland Art Association, 1958; Downey Museum of Art, 1958;
California Federation Women's Club, 1950, 1952. Collections:
West Branch Iowa Public Library; Southgate, California, San
Diego California, Santa Cruz, California and San Fernando
High School.

ELLIOTT, Frances G. Painter. Pron: East Liverpool, Ohio in
1900. Studied: Ohio University. Awards: Huntington Gallery,
Huntington, West Virginia, 1954, 1955; Ohio University, 1954,
1955. Collections: Ohio University. Designer and Creator of
Elliott Dolls.

ELLIOTT, Ruth Cass. Painter. Born: Los Angeles, California
in 1891. Studied: University of California, Los Angeles;
Los Angeles Art Center; Otis Art Institute; with Millard
Sheets. Has exhibited widely throughout California.

ELLIS, Harriet. Painter. Born: Springfield, Massachusetts
in 1886. Studied: Pratt Institute Art School; also with
Hawthorne, Robert Brackman, Mabel Welch, Cecelia Beaux and
Ralph Johonnot. Collection: National Historical Museum,
Springfield; Arthur B. Talmadge School; Springfield Art
League.

ELLSWORTH, Cheryl (Lawther) Sculptor. Born: Dubuque, Iowa
in 1911. Studied: University of Wisconsin. Has exhibited
in New York and Pennsylvania.

ELMORE, Elizabeth Tinker. Painter. Was exhibiting her work
in 1924.

ELY, Lydia. Painter. Died in 1914. She was best known as
a watercolorist and was active between 1870 and 1890.

EMERSON, Edith. Painter. Born: Oxford in 1888. Studied:
Art Institute of Chicago; Pennsylvania Academy of Fine Arts;
and with Violet Oakley. Collection: mural in the Little
Theatre, Philadelphia, Pennsylvania.

EMERSON, Sybil (Davis). Painter. Born: Worcester, Massachusetts. Studied: Ohio State University; Art Students League; and in Paris.

EMEREE, Berla Ione. Painter. Born: Wichita, Kansas in 1899. Studied: San Antonio Art School; with Frank Linton, Jose Arpa, and Xavier Gonzales. Award: Boerne, Texas; Collections: Bowie High School, El Paso, Texas; Officer's Club, Biggs Field, Ft. Bliss, Texas.

EMMERICH, Irene H. Painter. Born: New York City in 1906. Studied: Cooper Union Art School; Traphagen School of Fashion; Art Students League. Award: Crestwood Women's Club, 1949, 1950, 1952; Hudson Valley Art Association, 1950; Bronxville Women's Club, 1953, 1954, 1956; Westchester Women's Club, 1955, 1956; Federation of Women's Clubs, 1956.

EMMET, Leslie. Painter. Exhibited in 1924 at the National Association of Women Painters and Sculptors.

EMMET, Lydia Field. Painter and illustrator. Born: New Rochelle, New York in 1866 and died in 1952. Studied: with Bouguereau and Fleury in Paris; Chase, MacMonnies, Mowbray, Cox and Reid in New York. She was known for her miniatures. Awards: Chicago Exposition, 1893; Pennsylvania Academy of Fine Arts, 1915; Corcoran Popular prize, 1917; Maynard prize, National Academy of Design, 1918.

EMMONS, Mrs. C. S. Painter. Born: Kingfield, Maine in 1858. Studied: with Enneking and Alice Beckington.

EMMONS, Dorothy Stanley. Painter. Born: Roxbury, Massachusetts in 1891. Studied: with Woodbury, Browne, Noyes and Thompson.

ENGEL, Wilhelmina. Painter. Born: Middleton, Wisconsin in 1871. Studied: Art Institute of Chicago; Colt School of Art; and in Europe.

ENGLISH, Mabel B. P. Painter. Born: Hartford, Connecticut in 1861. Studied: with Chase and Tryon.

ENTE, Lily. Sculptor. Born: Ukraine in 1905. Studied: in Europe. Awards: Brooklyn Museum, 1954; National Association of Women Artists, 1953; Painters and Sculptors Society of New Jersey.

EPPING, Franc. Sculptor. Born: Providence, Rhode Island in 1910. Studied: Otis Art Institute, Los Angeles; Corcoran Gallery of Art, Washington, D. C.; Academy of Fine Arts, Munich, Germany; also with Joseph Wackerle and Bernhard Bleeker. Awards: Academy of Fine Arts, Munich Germany, 1933; Connecticut Academy of Fine Arts, 1954; Silvermine Guild, 1955. Collections: Washington College; Nebraska Art Association; Berea College; High Museum of Art, Atlanta, Georgia; Public Buildings Administration, Washington, D. C.; United States Post Office, Alabama City, Alabama; Oakmont, Pennsylvania.

EPPINK, Helen B. Painter. Born: Springfield, Ohio in 1910. Studied: Cleveland School of Art; John Huntington Polytechnic Institute. Awards: Cleveland Museum of Art, 1933, 1935; Kansas City Art Institute, 1939; Prairie Watercolor Painters, 1954; Wichita, 1956. Collections: Kansas Federation of Women's Clubs; Wichita Art Museum.

ERES, Eugenia. Painter. Born: Ukraine in 1928. Awards: Sao Paulo, Brazil; The American Artists Professional League; Nell Boardman Memorial Award.

ERESCH, Josie. Lithographer. Born: Beloit, Kansas in 1894. Studied: New York School of Fine and Applied Arts; Federation School of Art; St. Mary-of-the-Woods College; in Japan and China. Awards: League of American Pen Women, 1937, 1938.

ERICKSON, Helen Mitchell. Painter. Studied: University of Minnesota; Indiana University. Award: Annual Area Show, Rochester, Minnesota.

ERICSON, Beatrice. Painter. Born: Paris, France in 1909. Studied: with Morris Davidson. Has exhibited extensively in New York State.

ERIK-ALT, Lenore. Painter. Born: Cadillac, Michigan in 1910. Studied: Art Institute of Chicago with Boris Anisfield. Collections: Veterans Hospital, Carville, Louisiana; St. Charles School for Boys, Maywood, Illinois.

ERLANGER, Elizabeth N. Painter. Born: Baltimore, Maryland in 1901. Studied: with Ralph M. Pearson, Umberto Romano, Liberte and Hans Hofmann. Awards: National Association of Women Artists, 1952, 1953, 1956; Brooklyn Society of Art, 1953, 1955, 1958; Village Art Center, 1953, 1955, 1956. Collections: Florida Southern College; University of Maine; Colby College; New York Public Library; Evansville, Indiana Museum of Art.

ESMAN, Betty. Painter. Born: New York City. Studied:
Syracuse University College of Fine Arts; National Academy
of Design; Ecole des Beaux-Arts, Paris; Also in South
America. Awards: National Association of Women Artists,
1955; Brooklyn Society of Art, 1955. Collections: Florida
Southern College; Brandeis University.

ESTE, Florence. Painter. Award: Pennsylvania Academy of
Fine Arts, 1925.

ETTING, Emlen. Painter. Born: Philadelphia, Pennsylvania
in 1905. Studied: Harvard University; Academy de la Grande
Chaumiere, Paris; and with Andre L'Hote, Paris. Award:
Italian Star of Solidarity. Collections: Whitney Museum
of American Art; Pennsylvania Academy of Fine Arts; Atwater
Kent Museum; Addison Gallery of American Art; Italian
Consulate, Philadelphia.

EVANS, Barbara. Painter. Studied: University of California,
Berkeley; Instituto de San Miguel d'Allende; San Francisco
Art Institute. Award: Marin Society of Artists Exhibition,
Ross, California.

EVANS, Elizabeth H. Painter. Has exhibited at National
Association of Women Painters and Sculptors.

EVANS, Grace. Painter and illustrator. Born: Pittston,
Pennsylvania in 1877. Studied: Pennsylvania Academy of
Fine Arts, with Chase and Breckenridge; Drexel Institute.
Collection: March High School, Easton, Pennsylvania.

EVANS, Hannah. Painter. Born: in 1801 and died in 1860.
She specialized in portraits and miniatures.

EVANS, Naomi T. Painter. Born: Santa Ana, California in
1902. Studied: Otis Art Institute; also with Sam Harris
and Ralph Holmes. Awards: California Art Club, 1950, 1953;
Glendale Art Association, 1951, 1954, 1958; Placer College,
1953; Placer Union High School; Auburn Art Festival, 1953,
1954; Mother Lode Art Association, Sonora, California,
1953; Greek Theatre, Los Angeles, 1957, 1958; Duncan-Vail
Gallery, 1954.

EVATT, Harriet. Painter. Born: Knoxville, Tennessee in
1896. Studied: Columbus School of Fine Arts. Specialized
in portraits and landscapes.

EVERETT, Elizabeth Rinehard. Painter. Born: Toledo, Ohio.
Studied: with Walter Isaacs. Awards: Western Washington
Fair, 1926, 1927, 1928.

EYRE, Louisa. Sculptor. Born: Newport, Rhode Island in 1872. Studied: with Augustus Saint Gaudens. Collection: West Point, New York (tablet to General George Sykes for Memorial Hall).

FABIAN, Lydia D. Painter. Born: Charlotte, Michigan in 1867. Studied: Art Students League; Art Institute of Chicago.

FAIG, Frances Wiley. Painter. Studied: with Hawthorne, Grover and Duveneck. Collection: University of Cincinnati (mural decorations in Engineering Library)

FAIRBANKS, Francis J. Painter. Born: in 1835 and died in 1913.

FAIRCHILD, May. Painter. Born: Boston Massachusetts. Specialty--miniature painting.

FAIRFIELD, Hannah T. Painter. Specialized in portraits. Active from 1836 to 1839.

FARNHAM, Sally J. Sculptor. Was exhibiting in 1925.

FARNUNG, Helen M. Painter. Born: Jersey City, New Jersey in 1896. Studied: Art Students League. She was also known for her etchings.

FARR, Dorothy. Painter. Born: St. Louis, Missouri in 1910. Studied: Portland Oregon Art Museum School; New School for Social Research; also with Wallace Harrison. Collection: murals, Social Security Building, Washington, D.C.

FARRELL, Katherine L. Painter. Born: Philadelphia. Studied: Pennsylvania Academy of Fine Arts. She was also an etcher.

FARRINGTON, Katherine. Painter. Born: St. Paul, Minnesota in 1877. Studied: Art Students League; and with De Camp.

FASANO, Clara. Sculptor. Born: Castellaneta, Italy in 1900. Studied: Cooper Union Art School; Art Students League; Adelphi College, Brooklyn, New York. Awards: National Association of Women Artists, 1945, 1950; Audubon Art, 1952; National Institute of Arts & Letters, 1952; Medal of Honor, 1956; Scholarship abroad, 1922-1923. Collections: United States Post Office, Middleport, Ohio; Technical High School, Brooklyn, New York; Port Richmond, Staten Island, New York, High School.

FASSETT, Cornelia A. Painter. Born: in 1831 and died in 1898. Studied: Abroad under Meisonier. She worked in the Washington, D.C. area around 1876. Collection: Capitol Building, Washington, D.C. She painted many portraits of men and women in public life of Washington.

FAULEY, Lucy S. Painter. Born: Fultonham, Ohio and died in 1926. She was noted for her landscapes and portraits.

FAULKNER, Kady. Painter. Born: Syracuse, New York in 1901. Studied: Syracuse University; Art Students League;and with Hans Hofmann, Boardman Robinson and Henry Poor. Awards: Joslyn Memorial, 1945; Springfield, Missouri, 1946; Madison, Wisconsin, 1953. Collections: International Business Machines; United States Post Office, Valentine, Nebraska; altar piece, St. Mary's Episcopalian Church, Mitchel, Nebraska; chapel Union College, Lincoln, Nebraska.

FAUNTLEROY, Martha L. Painter. Born: Yakima, Washington. Studied: Art Students League with Nicolaides, Miller and Sternberg; William & Mary College; Alfred University.

FAUSETT, Lynn. Painter. Born: Price, Utah in 1894. Studied: University of Utah; Art Students League; Brigham Young University; also studied in France. Collections: City Hall, Price Utah; University of Wyoming; White Pine High School, Ely, Nevada; Ward chapel, Farmington, Utah and Salt Lake City; Kennecott Copper Corporation, New York; Harmon Cafe, Salt Lake City, Utah; Utah State Pioneer Park, Salt Lake.

FAY, Nellie. Painter. Born: Eureka, California in 1870. Studied: with Arthur F. Mathews and Emil Carlsen.

FEARING, Kelly. Painter. Born: Fordyce, Arkansas in 1918. Studied: Louisiana Polytechnic Institute; Columbia University. Awards: Texas Annual, 1953, 1955; Texas Fine Arts Association, 1953, 1955; Texas State Fair, 1956. Collections: Fort Worth Art Museum; Louisiana Polytechnic Institute; Vancouver British Columbia Art Museum; Texas Fine Arts Association; Dallas Museum of Fine Arts.

Fe BLAND, Harriet. Painter. Awards: Hudson River Museum. Collections: Cincinnati Art Museum; Tweed Gallery, University of Minnesota; Horace Mann School; Hempstead Bank of Long Island; Hubert Wilkins Museum; Emile Lowe Gallery.

FEIGHNER, Marilyn Osborn. Painter. Studied: De Pauw University; Herron Art Institute, Indianapolis, Indiana. Award: Hoosier Salon, Indianapolis, Indiana.

FEIGIN, Dorothy Lubell. Painter. Born: New York City in 1904. Studied: Art Students League with Sloan and Luks. Awards: National Association of Women Artists, 1947, 1951. Collections: Library of Congress; Metropolitan Museum of Art.

FELDMAN, Hilda. Painter. Born: Newark, New Jersey in 1899. Studied: Fawcett School, Newark, New Jersey; Pratt Institute Art School. Awards: National Association of Women Artists, 1955, 1958.

FELKER, Ruth Kate. Painter and Illustrator. Born: St. Louis, Missouri in 1889. Studied: St. Louis School of Fine Arts; Art Students League; also in Europe. Collections: St. Louis Art Gallery; St. John's Hospital, St. Louis.

FELL, Amy Watson Wells. Painter. Born: Lynchburg, Virginia in 1898. Studied: School Industrial Arts, Trenton, New Jersey; Pennsylvania Academy of Fine Arts; Columbia University; Chicago School of Design; Also with Hans Hofmann and Charles Hawthorne. Award: Fellowship, Barnes Foundation. Collections: International Business Machines Collection; State Capitol, Trenton, New Jersey; Longfellow School, Philadelphia.

FELLOWS, Cornelia F. Painter. Born: Philadelphia. Studied: Pennsylvania Academy of Fine Arts; Drexel Institute. She was noted for her portraits. She was born in 1857.

FELS, Catherine P. Painter. Born: Kirksville, Missouri in 1912. Studied: Ball State College, Muncie, Indiana; Mayville State Teachers College, North Dakota; University of California. Collections: San Francisco Museum of Art; San Francisco Russian Relief Headquarters; Civic Center, San Francisco; University of Washington.

FENDERSON, Annie M. Painter. Born: Spartansburg, Pennsylvania. She was known as a miniature painter.

FENERTY, Agnes L. Painter. Born: Louisville, Kentucky in 1885. Studied: Art Institute of Chicago; University of Chicago; Chicago Academy of Fine Arts; Columbia University. Awards: Davenport Municipal Art Gallery; South Side Art; Gary Art League, 1954. Collection: Englewood High School, Chicago.

FENTON, Beatrice. Sculptor. Born: Philadelphia, Pennsylvania in 1887. Studied: Pennsylvania Academy of Fine Arts; Philadelphia Museum School of Industrial Art. Awards: Fellowship, Pennsylvania Academy of Fine Arts; Cresson traveling scholarship, 1909, 1910; Pennsylvania Academy of Fine Arts, 1922; Plastic Club, 1922; Sesquicentennial Exposition, Philadelphia, 1926; Moore Institute Art School and Industry. Collections: Fairmount and Wister Parks, Philadelphia; Danbury Park, Wilmington, Delaware; Brookgreen Gardens, South Carolina, Academy of Music, Philadelphia; John Hopkins University, Baltimore; University of Pennsylvania; Pratt Free Library, Baltimore; Rittenhouse Square, Philadelphia.

FENTON, Hallie C. Painter. Born: St. Louis, Missouri in 1880. Studied: Art Institute of Chicago; Blanche in Paris; National Academy of Design.

FERGUSON, Agnes Howell. Painter. Born: Dixon, Illinois in 1895. Studied: Chicago Academy of Fine Arts; Boston Museum of Fine Arts School. Award: Rockford Art Association. Collections: Lee County Circuit Court, Dixon, Illinois; Dixon Public Hospital; Community Art Gallery, Dixon, Illinois; Girls Club, Boston.

FERGUSON, Alice L. Painter. Born: Washington, D. C. Studied: Corcoran School; also with Hawthorne.

FERGUSON, Eleanor M. Sculptor. Born: Hartford, Connecticut in 1876. Studied: with C. N. Flagg; Art Students League.

FERGUSON, Elizabeth F. Illustrator. Born: Omaha, Nebraska in 1884. Studied: Pennsylvania Academy of Fine Arts.

FERGUSON, Lillian P. Painter.Born: Windsor, Ontario, Canada in 1871. Studied: Julien Academy, Paris.

FERGUSON, Nancy M. Painter. Born: Philadelphia, Pennsylvania. Studied: Philadelphia School of Design; Pennsylvania Academy of Fine Arts; and with Daingerfield, Breckenridge and Hawthorne. Awards: Fellowship, Pennsylvania Academy of Fine Arts; traveling scholarships, Pennsylvania Academy of Fine Arts and the Philadelphia School of Design; Philadelphia Sketch Club; National Association of Women Artists; Gimbel Brothers Exhibition; Reading Museum of Art; Woodmere Art Gallery; Germantown Art Exhibit; Moore Institute Art School and Industry. Collections: Friends Central School, Overbrook, Pennsylvania; Reading Museum of Art; Barnes Foundation; Woodmere Art Gallery; Pennsylvania Academy of Fine Arts; Moore Institute of Art & Science; Sellersville, Pennsylvania Art Museum.

FERNBACH, Agnes B. Etcher. Born: New York City in 1879. Studied: Art Students League.

FERNOW, Bernice P. Painter. Born: Jersey City, New Jersey in 1881. Studied: Olaf Brunner. Noted for her miniature paintings. Collection: Metropolitan Museum of Art.

FERRIS, Bernice B. Painter. Born: Astoria, Illinois in 1882. Studied: Chicago Art Institute.

FERRIS, Dorothy. Painter. Born: New York City. Studied: Art Institute of Chicago; Cranbrook Academy of Art; also with Henri. Awards: National Association of Women Artists, 1952, 1957; Pen & Brush Club, 1948.

FERRIS, Edythe. Painter. Born: Riverton, New Jersey in 1897. Studied: Philadelphia School of Design for Women; also with Henry B. Snell. Awards: Morris fellowship, 1919, 1920; Gimbels, 1932; J. Lessing Rosenwald prize, 1955. Collections: Philadelphia School of Design for Women Alumnae collection; St. Luke's Church, Kensington, Philadelphia; Philadelphia Museum of Art; Free Library of Philadelphia; Society of Canadian Painters and Etchers.

FERRY, Frances. Painter. Born: Salt Lake City, Utah. Studied: University of Washington, with John Butler, Walter Isaacs, Ambrose Patterson, Paul Guston; in Europe with Andre L'Hote; and Alfred University, New York.

FERRY, Isabella H. Painter. Born: Williamsburgh, Massachusetts. Studied: with Tryon, Henri and Bouguereau.

FIELD, Beatrice. Painter. Born: Jacksonville, Illinois in 1888. Studied: Smith College Graduate School of Architecture and Landscape; The Cambridge School; Vassar College. Known for her lectures on Landscape Designs and Civic Planning.

FIELD, Charlotte E. Miniature painter. Born: in 1838 and died in 1920.

FIELD, Louise B. Painter. Born: Boston, Massachusetts. Studied: with William Morris Hunt.

FIELD, M. Painter. Born: Stoughton, Massachusetts in 1864. Studied: Art Institute of Chicago.

FIELDS, Fredrica H. Painter. Born: Philadelphia in 1912. Awards: Corcoran Gallery of Art; National Collection of Fine Arts, Washington, D. C. Collections: Washington National Cathedral; Greenwich Connecticut Library Auditorium.

FIENE, Alica. Painter. Born: Chicopee, Massachusetts in 1918. Studied: Art Students League; Colorado Springs Fine Art Center; Warsaw Art Academy, Poland. Awards: Tiffany Foundation grant, 1948, 1949; Kosciuszko Foundation, fellowship, 1937. Collection: United States Post Office, Mooresville, North Carolina.

FIERO, Emilie. Sculptor. Born: Joliet, Illinois. Studied: Art Institute of Chicago; in Italy and France. Collections: Calvary Episcopal Church, Gramercy Park, New York City; Eccleston, Maryland; fountains, Cleveland Museum of Art.

FIFE, Mary E. Painter. Born: Canton, Ohio. Studied: Cooper Union Art School; Art Students League; Carnegie Institute; National Academy of Design; and in Paris. Award: Butler Art Institute, Youngstown, Ohio.

Perle Fine, MYSTERY OF BROWN. Watercolor and oil on paper,
19" X 19". The Solomon R. Guggenheim Museum.

FINCH, Elinor G. Painter. Knwn as a miniature painter. She was exhibiting portraits and miniatures at the Pennsylvania Academy of Fine Arts in 1922.

FINCK, Hazel. Painter. Born: New Haven, Connecticut in 1894. Studied: with Guy Wiggins, Sigismund Ivanowski. Awards: Newark Art Club, 1939; Irvington Art & Museum Association, 1940, 1943; Plainfield, New Jersey Art Association, 1941, 1942, 1950; New Jersey Gallery of Art, 1937, 1938, 1939, 1941; Westfield Art Association, 1949, 1950; American Artists Professional League, 1948. Collection: State Teachers College, De Kalb, Illinois.

FINDLEY, Ila B. Painter. Born: Birmingham, Alabama in 1900. Award: Birmingham Art Club, 1943. Exhibited predominately in the south.

FINE, Lois. Painter. Studied: Boston Museum of Fine Arts School; Newcomb College of Tulane University. She is also a printmaker. Award: Louisiana Annual Art Exhibition, Baton Rouge, Louisiana.

FINE, Perle. Painter. Born: Boston, Massachusetts in 1908. Collections: Whitney Museum of American Art; Smith College Museum; Rutgers University; Munson-Williams-Proctor Institute; Los Angeles Museum of Art; Guggenheim Museum of Art; The Miller Company Collection; Brandeis University; Brooklyn Museum.

FINLEY, Mary L. Painter. Born: San Francisco, California in 1908. Studied: University of California; also with Hans Hofmann. Awards: California State Fair, 1947, 1950; New Mexico State Fair, 1944; Art Fair, Washington, D. C. 1947; California Watercolor Society, 1946; Hermosa California Art Fair, 1950; Wilmington, California, 1952.

FINN, Kathleen Macy. Etcher. Born: in 1896. Studied: Art Students League, also with George Bridgmann, Joseph Pennell and others. Collections: Smithsonian Institute; Irvington, New York Public Library; Lenox, Massachusetts Public Library; Pennsylvania State University; Metropolitan Museum of Art.

FINNEY, Betty. Painter. Born: Sydney, Australia in 1920. Studied: Royal Art Society, Sydney; Academie des Beaux-Arts, Brussels; Otis Art Institute; also with Paul Clemens, Ejnar Hansen and Normal Rockwell. Awards: Scholarship, Royal Art Society, Sydney; Los Angeles, Stacy award, 1952; Traditional Art Show, Hollywood, 1955; Friday Morning Club.

FISCHER, Hulda Rotier. Painter. Born: Milwaukee, Wisconsin in 1893. Studied: Milwaukee, Wisconsin; Chicago, Illinois; New York City; Provincetown, Massachusetts. Awards: Milwaukee Painters & Sculptors, 1936, 1946; Women Painters of America, 1938; Madison Wisconsin Art Association, 1938; Wisconsin State Fair, 1938,1946,1947; Milwaukee Art Institute, 1946. Collections: Library of Congress; Milwaukee Art Institute; John Herron Art Institute; Winneconni School, Wisconsin; Merrill Wisconsin High School; Boys Therapeutic School, Iron Mountain, Michigan; Wood Wisconsin Veterans Hospital.

FISCHER, Mary E. Illustrator. Born: New Orleans in 1876.

FISHER, Alice R. Painter. Born: Owosso, Michigan in 1882. Studied: Cleveland School of Fine Arts; and in Paris, Italy and Germany. She specialized in still life and landscapes which she exhibited widely throughout the West.

FISHER, Anna S. Painter. Died in 1942. Award: National Academy of Women Painters and Sculptors. Collection: National Academy of Design.

FISHER, Anya. Painter. Born: Odessa, Russia in 1905. Studied: Jepson Art Institute; Academie Grande Chaumiere, Paris. Collections: Pasadena Art Museum; Long Beach Art Center.

FISHER, Ethel: Painter. Born: Galveston, Texas in 1923. Studied: University of Texas with Howard Cook and Everett Spruce; Washington University, with Fred Conway; Art Students League, with Morris Kantor. Awards: Lowe Gallery of Art, Coral Gables, Florida, 1953; Florida Art Group, 1956, 1957; Harry Rich Exhibition, 1957. Collections: Norton Gallery of Art, West Palm Beach; Lowe Gallery of Art.

FISHER, Irma. Was exhibiting her water colors in 1925 in Philadelphia.

FISHER, Stowell Le Cain. Painter. Born: Wellsville, New York in 1906. Studied: Art Students League; and in Paris. Exhibited widely in the Eastern United States.

FISKE, Gertrude. Painter Born:Boston, Massachusetts in 1879. Studied: with Tarbell, Benson, Hale and Woodbury. Awards: Pan-Pacific Exposition, 1915; Connecticut Academy of Fine Arts, 1918, 1926; Wilmington Society of Fine Arts, 1921; National Academy of Design, 1922, 1925, 1929, 1931, 1935; National Association of Women Artists, 1925; New Haven Paint & Clay Club, 1925, 1929; Springfield Art League, 1925, 1931; Ogunquit Art Center, 1932. Collections: Pennsylvania Academy of Fine Arts; John Herron Art Institute; Detroit Institute of Art.

FITTS, Clara Atwood. Illustrator. Born: Worcester, Massachusetts in 1874. Studied: School of the Boston Museum of Fine Arts. Collections: St. John's Church, Roxbury, Massachusetts.

FITZGERALD, Harriet. Painter. Born: Danville, Virginia in 1904. Awards: Randolph-Macon Womens College. Collections: Staten Island Museum, New York; Swope Gallery, Indiana.

FLECKENSTEIN, Opal. Painter. Born: Macksville, Kansas in 1912. Studied: University of Washington; Washington State College; Eastern Washington College of Education. Awards: Seattle Art Museum, 1943.

FLEISHER, Lillian B. Painter. Was exhibiting in 1924.

FLEMMING, Jean R. Painter. Born: Charleston, South Carolina in 1874.

FLISHER, Edith M. Painter. Born: Nashville, Tennessee. Studied: Pennsylvania Academy of Fine Arts. Collection: State Capitol of Tennessee.

FLOET, Lydia. Painter. Exhibited in New York in 1925.

FLORENTINO-Valle, Maude Richmond. Painter and Illustrator. Studied: Art Students League, with Chase, Brush and Beckwith; Academie Julien in Paris with Lefebvre and Constant.

FOLEY, Margaret. Sculptor. Born: Either in Vermont or in New Hampshire. Alleged to be largely self-instructed. She died in 1877. Collection: New York Historical Society (a cameo portrait of William Cullen Bryant).

FOLLETT, Jean Frances. Painter. Born: St. Paul, Minnesota in 1917. Studied: St. Paul School of Art; University of Minnesota Art Association; Hans Hofmann School of Fine Arts; Grande Chaumiere, Paris. Award: Scholarship, St. Paul School of Art.

FOLSOM, Mrs. C. A. Painter. Known predominately for her miniature paintings which flourished in New York during the period 1837-1838.

FOOTE, Mary. Painter. She was also an illustrator. Collection: Art Institute of Chicago.

FOOTE, Mary Hallock. Painter and engraver. Born: Milton, New York in 1847. Studied: at the Cooper Institute; with William J. Linton, the wood engraver. Collection: The Worcester Art Museum.

FORBES, Helen K. Painter and Etcher. Born: San Francisco, California in 1891. Studied: San Francisco Artists Association; and with A. Hansen.

FORBES-OLIVER, Harriette. Painter. Born: Atlanta, Georgia
in 1908. Studied: Lucy Cobb Institute; Newcomb College,
Tulane University. Exhibited throughout the United States,
Canada and widely abroad.

FORD, Ruth Van Sickle. Painter. Born: Aurora, Illinois in
1897. Studied: Chicago Academy of Fine Arts; Art Students
League; with George Bellows, Guy Wiggins and John Carlson.
Awards: Art Institute of Chicago, 1931; Chicago Woman's Aid,
1932; Connecticut Academy of Fine Arts, 1932; Professional
Art Show, Springfield, Illinois, 1958. Collections: Aurora
College; Valparaiso Indiana University.

FORESMAN, Alice C. Miniature Painter.

FORSYTH, Constance. Etcher. Born: Indianapolis, Indiana
in 1903. Studied: Butler University; John Herron Art School
Pennsylvania Academy of Fine Arts; Broadmoor Art Academy.
Awards: Dallas Printmaker Society, 1945; Indiana Society of
Printmakers, 1953; Texas Fine Arts Society, 1954; National
Association of Women Artists, 1955. Collections: John
Herron Art Institute; Ball State Teachers College; Manual
Training High School, Indianapolis; Texas Fine Arts
Association; State of Indiana Collection; Scottish Rite
Cathedral, Indianapolis; Witte Memorial Museum; Joslyn Art
Museum; Dallas Museum of Fine Arts.

FORTUNE, E. C. Painter. Born: in California in 1885.
Studied: In London.

FOSDICK, Gertrude C. Painter. Born: in Virginia in 1862.
Studied: Julien Academy, Paris.

FOSS, Florence W. Sculptor. Born: Dover, New Hampshire in
1882. Studied: Mt. Holyoke College; Wellesley College;
University of Chicago; Radcliffe College. Awards: Springfield
Art Association, 1941, 1943; Society of Washington Artists,
1936.

FOSS, Harriet Campbell. Painter. Born: in 1860.

FOSTER, Ethel Elizabeth. Painter. Born: Washington, D. C.
Studied: Art Institute of Chicago; Columbia University; also
with Ross, Snell and Ennis.

FOSTER, Judith. Painter. Born: Three Rivers, Michigan in
1930. Studied: Pratt Institute Art School. Award:
Philadelphia Museum of Art, 1958. Collection: Philadelphia
Museum of Art.

FOULKE, Viola. Painter. Born: Quakertown, Pennsylvania.
Studied: Philadelphia Museum School of Industrial Art;
University of Pennsylvania; Alfred University; also with
George Walter Dawson, and Earl Horter.

FOURCARD, Inez G. Painter. Born: Brooklyn, New York in 1926. Award: Louisiana State Art Competition.

FOURNIER, Alexia Jean. Painter. Born: St. Paul, Minnesota in 1865. Studied: with Douglas Volk; Julien Academy, Paris; with Laurens, Benjamin Constant, and Henri Harpignies. Collections: Pennsylvania Historical Building; Minnesota State Historical Society, St. Paul; Vanderbilt University; Congressional Library Print Department; Minneapolis Publishing Gallery; Detroit Art Museum.

FOX, Margaret M. T. Painter. Born: in 1857. Studied: with Peter Moran and Anshutz. She was also an illustrator and etcher and illustrated many books.

FOX, Edith C. Painter. Born: Cincinnati, Ohio in 1893. Studied: Cincinnati Art Academy; Pennsylvania Academy of Fine Arts with Garber and Pierson; Farnsworth School of Art. Collections: Deer Park High School, Cincinnati; Sacred Heart Academy, Cincinnati.

FRANCES, Gene. Painter. Born: San Francisco, California. Studied: Berkeley School of Arts and Crafts; also with Xavier Martinez and Francis McComas. Collections: Bender Collection; Del Monte Lodge, California; Spreckels Sugar Company, San Francisco; Monterey Peninsula Herald Building.

FRANCKSEN, Jean Eda. Painter. Born: Philadelphia, Pennsylvania in 1914. Studied: University of Pennsylvania; Philadelphia Museum School of Industrial Art; Barnes Foundation; with Arthur B. Carles and Stanley William Hayter. Collections: Library of Congress; Philadelphia Museum of Art; St. Joseph's Hospital, Carbondale, Pennsylvania; Jewish Community Center, Scranton, Pennsylvania; Community Building Philadelphia Printmakers.

FRANK, Bena Virginia. Painter. Born: Norfolk, Virginia. Studied: Art Students League; Cooper Union Art School; and studied abroad. Awards: Cooper Union Art School, 1916, 1917; National Association of Women Artists, 1951. Collections: Hunter College; Nassau County Hospitals, New York; Roosevelet High School, New York; Brooklyn Public Library; New York Public Library.

FRANK, Emily. Painter. Born: New York City in 1906. Studied: New York University; Art Students League; and with Kuniyoshi and Sternberg.

FRANK, Helen. Painter. Born: Berkeley, California. Studied: California College of Arts and Crafts; Art Students League; with Glenn Wessels, Hamilton Wolfe, Sheldon Cheny and Joseph Paget-Fredericks. Awards: California College of Arts and Crafts; Art Students League. Collections: Crocker Art Gallery, Sacramento, California; Templeton Crocker collection.

FRANKENTHALER, Helen. Painter. Born: New York City in 1928. Studied: Bennington College; with Hans Hofmann. Collections: Museum of Modern Art; Whitney Museum of American Art; Brooklyn Museum; Albright Art Gallery; Carnegie Institute; Temple of Aaron, St. Paul, Minnesota.

FRANKLIN, Arla. Painter. Born: Florence, Wisconsin in 1897. Studied: Chicago Academy of Fine Arts; Ecole des Beaux-Arts, Paris; University of Southern California; LaFayette College, Easton, Pennsylvania. Awards: Greek Theatre, Los Angeles, 1948, 1949. Collections: in many private collections.

FRANKLIN, Charlotte White. Painter. Born: Philadelphia, Pennsylvania in 1923. Awards: Fulbright Fellowship; Philadelphia Board of Education fellowship to University of Madrid and Rome; Les Beaux Arts Exhibition, Philadelphia.

FRANKLIN, Ione. Sculptor. Born: Texas. Studied: Texas State College for Women; Columbia University; Art Students League, with William Zorach, and William Palmer. Awards: Southern States Art League, 1936, 1946; Texas General Exhibition, 1941, 1945. Collection: Dallas Museum of Fine Arts.

FRASCH, Miriam R. Painter. Studied: St. Lawrence University; Columbus Art School; Ohio State University.

FRASER, Laura Gardin. Sculptor. Born: Chicago, Illinois in 1889. Studied: Art Students League. Awards: National Academy of Design, 1916, 1919, 1924, 1927, 1931; American Numismatic Society, 1926; National Association of Women Artists, 1929. Collections: Equestrian statue, Baltimore Maryland; Brookgreen Gardens, South Carolina.

FRASER, Mary A. Sculptor. Born: New York City in 1884. Studied: with William Ordway Partridge and Georg Lober. Award: Central Florida Exposition, Orlando Florida. Collections: National Cathedral, Washington, D. C.; St. John's Cathedral, New York City; Garden City Cathedral, Long Island, New York; St. Luke's Cathedral, Orlando, Florida.

FREEDLEY, Elizabeth C. Painter. Was exhibiting in 1924.

FREEDMAN, Ruth. Painter. Born: Chicago, Illinois in 1899. Studied: Chicago Academy of Fine Arts.

FREELAND, Anna C. Painter. Born: in 1837 and died in 1911. She was a painter of historical scenes and figures. Collection: Worcester Art Museum.

FREEMAN, Florence. Sculptor. Born: Boston, Massachusetts
in 1836. Studied: with Richard Greenough; and studied abroad
with Hiram Powers. She has produced several bas-reliefs
and portrait busts.

FREEMAN, Mrs. H.A.L. Sculptor. Born: in 1826. She was the
wife of the artist James E. Freeman. Had her studio in
Rome.

FREEMAN, Jane. Painter. Born: Newton, Derbyshire, England
in 1885. Studied: Art Students League, with DuMond, Chase
and Henri; Grande Chaumiere, Paris. Awards: Springville,
Utah Art Center; 1944; National Association of Women
Artists; Hudson Valley Art Association, 1953-1958; Rockport
Art Association, 1958. Collection: Springville Art
Association.

FRENKEL, Nora. Painter. Born: Shanghai, China in 1931.
Studied: Cooper Union Art School; Cranbrook Academy of Art;
Smith College. Award: Springfield Massachusetts Museum of
Art, 1951. Collection: Smith College Museum.

FREY, Grace Eggers. Sculptor. Was exhibiting in Cincinnati
in 1925.

FRIEDENBERG, Elizabeth Z. Painter. Born: New York City in
1908. Studied: Centenary College; Art Students League;
Cornell University; Tschacbasov School of Art, Woodstock,
New York. Awards: Louisiana State Museum, 1949, 1957;
Louisiana Art Commission, 1948; Baton Rouge, Louisiana, 1951;
Donaldsonville, Louisiana, 1955; Jackson, Mississippi, 1957.

FRISHMUTH, Harriet W. Sculptor. Born: Philadelphia in 1880.
Studied: with Rodin and Injalbert ir Paris; in New York with
Borglum; National Sculpture Society; Academician of
National Academy of Design; Awards: National Academy of
Design, 1922. Collections: Metropolitan Museum of Art;
Los Angeles Museum of Art; Museums in Ohio, New Hampshire,
Georgia, New Jersey; John Herron Art Institute.

FROMEN, Agnes Valborg. Sculptor. Born: Waldermasvik,
Sweden in 1868. Studied: Art Institute of Chicago, with
Lorado Taft. Award: Municipal Art Leage of Chicago, 1912.
Collections: Art Institute of Chicago; Washington Irving
School, Bloomington, Illinois; Englewood High School; Hyde
Park Church of Christ, Chicago.

FROST, Anna. Painter. Born: Brooklyn, New York. Studied:
with Hawthorne and Breckenridge. She was also a lithographer.

FROTHINGHAM, Sarah C. Painter. Born: in 1821 and died in
1861. She was a miniature painter and exhibited between 1838
and 1842.

FRY, Georgia Timken. Painter. Born: St. Louis, Missouri
in 1864 and died in 1921. Studied: with Harry Thompson,
Aime Morot, and in Paris with Cazin. Collection: Boston
Art Club has her painting "Return of the Flock." She
specialized in landscapes with sheep.

FRY, Laura A. Painter. Born: Cincinnati, Ohio. Studied:
with Noble and Rebisso; also studied in England and France.
Award: Columbian Exposition, 1893.

FRY, Rowena. Painter. Born: Athens, Alabama. Studied:
Watkins Institute, Nashville, Tennessee; Art Institute of
Chicago; Ropp School of Art. Award: Chicago Society of
Art, 1959. Collection: Abbott Laboratories Collection.

FRY, Sherry E. Sculptor. Born: Creston, Iowa in 1879.
Studied: Art Institute of Chicago; Julian Academy, Paris;
Ecole des Beaux Arts, Paris; Florence, Italy; with
Frederick MacMonnies, Verlet and Lorado Taft. Awards:
Salon Paris, 1906, gold medal, 1907. Collection: Worcester,
Massachusetts.

FUERST, Shirley. Studied: Brooklyn Museum Art School.
Award: Annual Oil Competitition, New York City.

FULLER, Lucia Fairchild. Painter. Born: Boston,
Massachusetts in 1872 and died in 1924. Studied: Art
Students League, with Chase and Siddons Mowbray. Her
specialty was miniatures. Awards: Paris Exposition, 1900;
Buffalo Exposition, 1901.

FULLER, Meta Vaux Warrick. Sculptor. Born: Philadelphia,
Pennsylvania in 1877. Studied: Philadelphia Museum School
of Industrial Art; Pennsylvania Academy of Fine Arts; in
Paris; and with Rodin. Collections: New York Public
Library; Garfield School, Detroit, Michigan; Cleveland
Museum of Art.

FULLER, Sue. Born: Pittsburgh, Pennsylvania in 1914.
Studied: Carnegie Institute; Columbia University. Awards:
Association of Artists Pittsburgh, 1941, 1942; Northwest
Printmakers, 1946; Philadelphia Printmakers Club, 1944, 1946,
1946, 1949; Fiffany Foundation Fellowship, 1947; National
Institute of Arts and Letters, 1950; New York State Fair,
1950; Guggenheim Fellowship, 1948. Collections: New York
Public Library; Library of Congress; Harvard University
Library; Carnegie Institute; Whitney Museum of American
Art; Ford Foundation; Art Institute of Chicago; Museum of
Modern Art; Brooklyn Museum; Metropolitan Museum of Art;
National Academy of Design; Baltimore Museum of Art;
Philadelphia Museum of Art; Seattle Art Museum.

FULTON, Agnes. *Painter and Sculptor. Born: Yonkers, New York in 1898. Studied: with Dow and Martin.*

FULTON, Dorothy. *Painter. Born: Uniontown, Pennsylvania in 1896. Studied: Pennsylvania Academy of Fine Arts; Columbia University; Philadelphia Museum School of Industrial Art; University of Southern California; University of Kansas; University of Pennsylvania. Award: Fellowship, Pennsylvania Academy of Fine Arts. Collections: Mulvane Art Museum, Topeka, Kansas; Washburn College; Linden Hall, Lititz, Pennsylvania.*

FULTON, Ruth M. *Painter. Born: Rome, Georgia in 1905. Collections: Crossroads Gallery; Scheidt Collection, Chicago; Stevens collection, London; Hays House, Gatlinburg.*

GABRIEL, Ada V. Painter. Born: Larchmont, New York in 1898. Studied: Barnard College; New York School of Design, with Erich Gletter in Munich; Emil Ganso, New York. Awards: Albany Institute of History and Art, 1949; National Association of Women Artists, 1950; National Academy of Arts & Letters, 1950, 1954. Collections: National Association of Women Artists; New York Public Library; Library of Congress; Toledo Museum of Art.

GABRIELE, Gabrielle. Painter. Born: Philadelphia, Pennsylvania in 1906. Studied: Pennsylvania Academy of Fine Arts; Philadelphia Museum School of Industrial Art. Award: Fellowship, Pennsylvania Academy of Fine Arts.

GAG, Wanda H. Illustrator. Born: New Ulm, Minnesota in 1893. Studied: Art Students League. Award: Minnesota State Art Society.

GAGE, Jane. Painter. Born: La Grange, Illinois in 1914. Studied: Rockford Illinois College; American Academy, Chicago; with Sterba, Gunther, George Elmer Browne. Award: Rockford Art Association, 1946.

GAGE, Nancy. Born: in 1787 and died in 1845. Her specialty was still life, landscapes and genre water colors.

GAINES, Natalie Evelyn. Sculptor. Born: Detroit, Michigan. Studied: Detroit Society for Arts and Crafts; Greason School, Detroit. Awards: Crespi Gallery, 1958; Temple Emanu-El, New York, 1959.

GALE, Jane Greene. Painter. Born: Leipzig, Germany in 1898. Studied: Minneapolis School of Art; Art Students League; Duluth State Teachers College; Columbia University; with Jean Charlot, Hans Hofmann and others. Awards: California State Fair, 1949; Newport, California, 1951; San Diego Art Guild, 1947, 1951, 1953; Art League of Fresno, 1948, 1950, 1954, 1955. Collections: San Diego Fine Arts Gallery; Newport Harbor High School.

GAMBERLING, Grace Thorp. Painter. Was exhibiting in 1924.

GAMMON, Estella. Painter. Born: Pasadena, California in 1895. Studied: Pomona College; Columbia University; with Anna Hills, Charles Reifle, Orin White.

GANNON, Clell Goebel. Painter. Born: Wisner, Nebraska in 1900. Studied: Art Institute of Chicago with Vanderpoel, Lorado Taft, George Bellows and others. Awards: "Artist of the Year," North Dakota, 1948; National League of American Pen Women. Collections: Bismarck Public Library; Burleigh County Court House; Bismarck High School Library; North Dakota Historical Society.

GANO, Katharine V. Painter. Born: Cincinnati, Ohio in 1884. Studied: with Duveneck.

GARA, Calista Ingersoll. Painter. Actively engaged in painting portraits around 1853-1898.

GARDIN, Laura. Sculptor. Born: Chicago, Illinois in 1889. Studied: with James E. Fraser. Awards: Helen Foster Barnett prize, National Academy of Design, 1916; Shaw Memorial prize, National Academy of Design, 1919.

GARDINER, Eliza D. Painter. Born: Providence, Rhode Island in 1871. Studied: Rhode Island School of Design. Collections: Detroit Institute; Springfield Public Library; Philadelphia Print Club. She was also an engraver.

GARDNER, Beatrice. S. Painter. Born: Westtown, New York in 1893. Studied: Columbia University; Ecole des Beaux-Arts, Paris. Awards: American Art Week, Balboa, Canal Zone, 1941, 1955; Florida International Exhibition, 1952. Collections: St. Luke's Cathedral, Canal Zone; Hotel Bout de L'ile, Canada.

GARDNER, Gertrude G. Painter. Born: Palo Alto County, Iowa, in 1878. Studied: Ecole des Beaux-Arts, Fontainebleau, France; Pratt Institute Art School; with Henry B. Snell and Eliot O'Hara. Awards: Pen & Brush Club, 1941; Laguna Art Festival, 1957; National League of American Pen Women, 1954, 1958.

GARFIELD, Marjorie S. Painter. Born: Boston, Massachusetts in 1903. Studied: Syracuse University; with Henry B. Snell George Pearse Ennis, Albert R. Thayer and Henry W. Rice. Awards: Catherine Lorillard Wolfe Art Club, 1930; League of American Pen Women, 1936, 1946; Association of Artists Syracuse, 1936, 1937. Collections: Syracuse Museum of Fine Arts; Dwight Art Gallery, Mt. Holyoke; University of Manitoba, Canada.

GARRETT, Anne Shapleigh. Painter. Was exhibiting in 1924.

GARRETT, Clara P. Sculptor. Born: Pittsburgh, Pennsylvania. Studied: St. Louis School of Fine Arts; Ecole des Beaux-Arts, Paris. Collections: Metropolitan Museum of Art; City of St. Louis; Eugene Field School, St. Louis.

GARRETT, Priscilla L. Painter. Born: Chatham, New Jersey in 1907. Studied: Philadelphia School of Design for Women; Drexel Institute; Pennyslvania Academy of Fine Arts; and with George Harding. Awards: Pennsylvania Academy of Fine Arts; Chester County Art Association, 1939; Plastic Club, 1940. Collection: Pennsylvania Academy of Fine Arts.

GARRETT, Theresa A. Etcher. Born: 1884. Member of Chicago Society of Etchers.

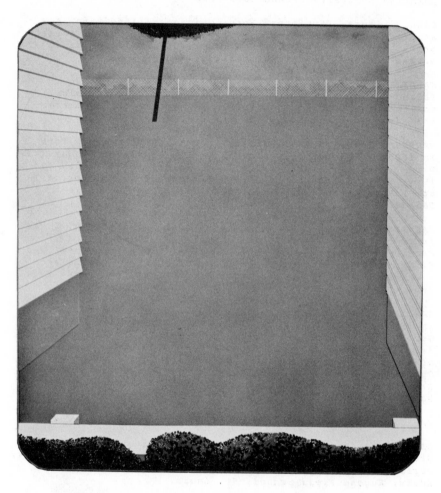

Maud Gatewood, BACKYARDS, 1971. Oil on board, 72" X 66".

GARRISON, Eve. Painter. Born: Boston, Massachusetts. Studied: Art Institute of Chicago. Award: gold medal, Corcoran Gallery of Art, 1933. Collections: University of Illinois; United States Treasury Department, Washington, D.C.

GARY, Louisa M. Painter. Noted for her miniatures which she was exhibiting in 1922.

GASKINS, Letha (Heckman). Painter. Born: Indianapolis, Indiana in 1900. Studied: John Herron Art Institute; DePauw University; Butler University; Ohio University with Leach and Burchfield. Awards: Indiana Art Club, 1956; Michiana Regional, South Bend, 1957. Collection: Butler University.

GATES, Margaret. Painter. Born: Washington, D. C. Studied: Corcoran Art School; Phillips Memorial Gallery Art School; Colorado Springs Fine Arts Center; with C. Law Watkins, and Henry Varnum Poor. Awards: Society of Washington Artists, 1945; Corcoran Gallery of Art, 1953. Collections: Phillips Collection, Washington, D.C. United States Post Office, Mebane, North Carolina.

GATEWOOD, Maud. Painter. Born: 1934. Studied: Womens College, University of North Carolina; Ohio State University. Awards: National Academy of Arts and Letters, 1972. Collections: Mint Museum, Charlotte, North Carolina; Coca Cola Company, Atlanta, Georgia.

GATH, Ethel Robertson. Painter. Studied: Flint Instructor Art School; with Richard Lahey, Heinz Warneke and Peggy Bacon. Awards: Flint Instructor of Art, 1937, 1939; Art Fair, Washington, D. C. 1944, 1947; Southern States Art League, 1947; Society of Washington Artists, 1943, 1944. Collections: Virginia Museum of Fine Arts; Corcoran Gallery of Art.

GAUG, Margaret Ann. Etcher. Awards: Chicago Society of Etchers, 1950, 1955. Collections: National Gallery of Art; Illinois State Library; Smithsonian Institute; Brussels Museum of Fine Arts, Belgium; Metropolitan Museum of Art. She designs greeting cards.

GAUL, Arrah L. (Mrs) Painter. A member of the American Water Color Society.

GAY, Ruth A. Sculptor. Born: Ontario Canada in 1911. Studied: Syracuse University; Art Students League; with Alexander Brook, Henry Varnum Poor and Charles Cutler. Awards: Albright Art Gallery; Western New York Exhibition, 1948, 1949.

GAZZETTA, Mary A. Painter. Born: Newark, New Jersey in 1911. Studied: Pratt Institute Art School; Leonardo de Vinci Art School; Art Students League with McNulty, DuMond, Brackman and Cusumano. Collections: Soldiers and Sailors Memorial Hospital, Penn Yan, New York; Public Library, Penn Yan, New York; Penn College, Pen Yan, New York; American Export Lines.

GEBHARDT, Ann Stellhorn. Painter. Born: Leavenworth, Kansas in 1916. Studied: Lake Erie College for Women; Ohio State University, with Carolyn G. Bradley, James R. Hopkins and Alice Schille.

GEER, Grace Woodbridge. Painter. Born: Boston, Massachusetts in 1854. Studied: Massachusetts Normal Art School; Lowell Institute; with Tarvell, Vonnoh and others. A portrait painter. Collections: International Institute for Girls, Madrid, Spain; Girls High School, Boston, Massachusetts.

GELB, Jan. Painter. Born: New York City in 1906. Studied: Yale School of Fine Arts; Art Students League with Sigurd Skou. Award: Boston Art Festival, 1953. Collection: Metropolitan Museum of Art.

GELLMAN, Beatrice (McNulty). Painter. Born: Philadelphia, Pennsylvania in 1904. Studied: University of Pennsylvania; Art Students League, with McNulty, Kantor, Hale and Miller. A lecturer and advisor in painting.

GELTMAN, Lily. Painter. Born: New York City in 1903. Studied: Hunter College; with Davidson, Camilo Egas and Moses Soyer. Awards: National Association of Women Artists, 1949, 1954; Brooklyn Society, 1955.

GENIUS, Jeannette M. Painter. Born: Chicago, Illinois. Awards: Florida Federation of Art, 1948; Society of Four Arts, 1949, 1950, 1954; Pen and Brush Club, 1953; Hispanic Institute in Florida, 1952; Rollins College, 1943. Collections: Georgia Museum of Art, University of Georgia; Columbus Museum of Arts and Crafts.

GENTH, Lillian. Painter. Born: Philadelphia, Pennsylvania in 1876 and died in 1953. Studied: School of Design for Women, with Daingerfield; with Whistler in Paris. Collections: National Gallery, Washington, D. C.; Metropolitan Museum of Art; Engineers Club, New York; Carnegie Institute, Pittsburgh; Brooklyn Institute of Arts and Sciences; Philadelphia Art Club.

GEORGE, Dorothy. Painter. Born: Manchester, New Hampshire in 1898. Studied: State Teachers College, Framingham, Massachusetts; Simmons College, Boston, Massachusetts; University of California. Award: St. Croix, Virgin Islands.

GERARD, Allee Whittenberger. Painter. Born: Rochester, Indiana in 1895. Studied: Ft. Wayne Art School; Miami Art School; and with Homer Davisson, Clinton Sheperd, Curry Bohm and Robert Connavale. Awards: Hoosier Salon, 1944; International Exhibition, Miami, 1948, 1951; Walter's award, 1950; Northern Indiana Salon, 1944; Ft. Wayne, 1954; League of American Pen Women, 1956. Collections: Indiana University; Hoosier Salon; Warsaw Indiana High School; Young Womens Christian Association, Loganport, Indiana.

GERARD, Paula. Painter. Studied: Art Institute of Chicago; also abroad. Collection: Library of Congress. Exhibited in recent years throughout the midwest.

GERARDIA, Helen. Painter. Born: Ekaterinislav, Russia in 1903. Studied: Brooklyn Museum; Art Students League; and with Hans Hofmann, Charles Seide, Adam Garret and Nahum Tschacbasov. Awards: Boston Society of Independent Artists, 1952, 1956, 1957; Village Art Center, 1952, 1954, 1955; Fellowship Research Studios, Maitland, Florida, 1952-1953; Fellowship, Yaddo Foundation, 1955; Woodstock Art Association 1956; Abraham Lincoln High School; National Association of Women Artists, 1958. Collections: University of Illinois; Smith College; University of Maine; Dartmouth College; Colby College; Lincoln High School; Yeshiva College; Butler Art Institute; Research Studios Art Center; Cincinnati Museum Association; Fogg Museum of Art.

GERE, Nellie H. Painter. Born: Norwich, Connecticut in 1859. She was known chiefly as a landscape painter.

GERSHOY, Eugenie. Sculptor. Studied: Art Students League; California School of Fine Arts; and in Europe with Sloan, Miller and Robinson. Awards: St. Gaudens medal; Red Cross National Competition, 1941; Metropolitan Museum of Art, 1943; Rotunda Gallery, San Francisco, 1950; Fellowship, Yaddo Foundation, 1951. Collections: Art Institute of Chicago; Metropolitan Museum of Art; Whitney Museum of American Art; Biggs Memorial Hospital; Astoria Public Library, New York.

GERSTLE, Miriam A. Painter. Born: San Francisco, California in 1868. She was also an illustrator.

GEST, Margaret. Painter. Born: Philadelphia, Pennsylvania in 1900. Studied: Philadelphia Museum School of Industrial Art; Pennsylvania Academy of Fine Arts; also with Hugh H. Breckenridge. Awards: Fellowship, Pennsylvania Academy of Fine Arts; Cresson Traveling scholarship, Pennsylvania Academy of Fine Arts, 1927, 1928. Collections: Philadelphia Water Color Club; Pennsylvania Academy of Fine Arts; Friends Central School; Penn Charter School.

GETCHELL, Edith L. Etcher. Born: Bristol, Pennsylvania.
Studied: Pennsylvania Academy of Fine Arts. Collections:
Library of Congress; Boston Museum of Fine Arts; Worcester
Art Museum; Walters Collection, Baltimore, Maryland.

GETZ, Ilse. Painter. Born: Nurnberg, Germany in 1917.
Studied: Art Students League, with George Grosz and Morris
Kantor. Collection: Carnegie Institute, Pittsburgh,
Pennsylvania. Has exhibited widely here and abroad.

GIBALA, Louise. Painter. Born: Allegheny, Pennsylvania.
Awards: American Artists Professional League; National
Art League; Low Ruins Gallery, Tubac, Arizona. Collections:
Christ Lutheran Church, Little Neck, New York; Dutch
Reformed Church, Flushing, New York.

GIBBONS, Margarita. Painter. Born: New York City in 1906.
Studied: Art Students League; Pratt Institute Art School;
and abroad.

GICHNER, Joanna E. Sculptor. Born: Baltimore, Maryland
in 1899. Studied: with Grafly.

GIFFEN, Lillian. Painter. Born: New Orleans, Louisiana.

GIFFORD, Frances Eliot. Painter. Born: New Bedford,
Massachusetts in 1844. Studied: Coopers Institute, New
York; and with S. L. Gerry in Boston, Massachusetts. Her
specialty was birds and landscapes. She was also a
magazine illustrator.

GIFFUNI, Flora B. Painter. Born: Naples, Italy in 1919.
Awards: Pietantonio Gallery; American Artists Professional
League. Exhibited predominately in New York.

GIKOW, Ruth. Painter. Born: in Russia. Studied: Cooper
Union Art School. Awards: fellowship, Yaddo Foundation,
1943; National Institute of Arts and Letters, grant, 1959.
Collections: Brandeis University; Springfield Museum of
Art; American Academy of Arts and Letters; Whitney Museum
of American Art; Metropolitan Museum of Art; Museum of
Modern Art; Philadelphia Museum of Art; murals, Bronx
Hospital, Rockefeller Center, New York.

GILBERT, Caroline. Designer and etcher. Born: Pardeeville,
Wisconsin in 1864. Studied: Art Students League.

GILBERT, Charlotte. Painter. Known as a portrait painter
working around 1830.

GILBERT, Louise L. Painter. Born: Detroit, Michigan in 1900. Studied: University of Washington. Award: Women Painters of Washington, 1941, 1942, 1944. Collection: Seattle Art Museum.

GILBERT, Sarah. Painter. Studied: Cooper Institute. She was chiefly known as a painter of flowers and did several figure pieces which she exhibited in New Haven, Connecticut where her studio was located.

GILKISON, Mrs. A. H. Painter. Member of the Pittsburgh Artists Association.

GILL, Rosalie L. Painter. Born: New York City and died in Paris. She was known principally as a portraitist and landscapist.

GILL, Sue May. Painter. Born: Sabinal, Texas. Studied: Pennsylvania Academy of Fine Arts. Awards: Fellowship, Pennsylvania Academy of Fine Arts, Cresson traveling scholarship, Pennsylvania Academy of Fine Arts, 1922, 1923, 1933. National Association of Women Artists, 1932; Women's Achievement Exhibition, Philadelphia, 1933; Philadelphia Sketch Club, 1942, 1943; Philadelphia Plastic Club, 1943, 1944; National Association of Women Painters and Sculptors, 1933. Collection: West Point Military Academy.

GILLIAM, Marguerite Hubbard. Painter. Born: Boulder, Colorado in 1894. Studied: with Breckenridge, Carlsen, Sloan and Blashfield.

GILMAN, Esther M. Painter and Lithographer. Born: Cleveland, Ohio in 1922. Studied: Cleveland School of Art; University of Wisconsin; University of Michigan; Art Students League. Awards: Painters and Sculptors Society of New Jersey, 1956, 1958. Collections: Museum of Modern Art; National Academy of Design; Riverside Museum.

GILMORE, Ada. Painter and wood engraver. Born: Kalamazoo, Michigan in 1882. Studied: Art Institute of Chicago; in Paris; and in New York with Henri. Collection: Municipal Art Commission, Chicago, Illinois.

GILMORE, Ethel. Painter. Born: New York City. Studied: Hunter College; Columbia University; with Dasburg, Martin, Chaffee and others. Awards: Kearney Museum, 1947; Painters and Sculptors Society of New Jersey, 1947; Art Council of New Jersey, 1948, 1950; Gotham Painters, 1948; Jersey City Museum Association, 1949, 1951, 1953; Hudson Art, 1953.

Mina K. Goddard, BIRD DRAWING, 1888. Pencil on paper, shown here actual size. Private Collection.

GINNO, Elizabeth. Etcher. Born: London, England in 1911.
Studied: Mills College; California College of Arts and Crafts;
San Francisco School of Fine Arts; and with John Winkler.
Collections: Mills College; deYoung Memorial Museum;
California State Library; Achenback collection.

GIORDANO, Joan M. Painter. Born: Staten Island, New York
in 1939. Awards: Museum of Modern Art.

GLAMAN, Mrs. F. F. Painter. Born: St. Louis, Missouri in
1873. Studied: Art Institute of Chicago. Her specialty
was animal subjects.

GLASELL, Criss. Painter. Born: Vienna, Austria in 1898.
Studied: Art Institute of Chicago; with Grant Wood, Francis
Chapin, Adrian Dornbush. Awards: Iowa Art Salon, 1931, 1934,
1938, 1939, 1941. Collections: Dubuque Art Association;
United States Post Office, Leon, Iowa.

GLASS, Sarah Kramer. Painter. Born: Troy, Ohio in 1885.
Studied: Art Students League; Grand Central Art School and
with Bertha Peyton.

GLEESON, Adele S. Sculptor. Born: St. Louis, Missouri in
1883. Studied: St. Louis School of Fine Arts.

GLENN, Sally. Painter. Born: Los Angeles, California in
1917. Studied: University of California at Los Angeles.
Awards: Santa Paula, California, 1954; Pasadena Society of
Art; San Gabriel Playhouse Exhibition. Collection: Santa
Paula, California.

GLENNY, Alice R. Painter and sculptor. Born: Detroit,
Michigan in 1858. Studied: in New York with Chase; in
Paris with Boulanger.

GODDARD, Mina K. Painter. Born: New England. Worked late
in 19th Century and early 20th Century. Noted for drawings
of Vermont scenes, children, flowers and birds. Few were in
color.

GOETZ, Esther B. Painter. Born: Buffalo, New York in 1907.
Studied: Art Students League. Collection: Albright Art
Gallery.

GOLDSMITH, Deborah. Born: in 1808 and died in 1836. She was
a portrait and miniature painter.

GOITEIN, Olga. Sculptor. Born: Vienna, Austria. Studied:
Boston Museum of Fine Arts School; Brooklyn Museum School
of Art; Scuola Rossi, Paris. Awards: Brooklyn Society of
Art, 1949, 1951; New Haven Paint and Clay Club, 1949, 1951,
1952. Collection: Bezalel Museum, Jerusalem.

Anne Goldthwaite, *THE GREEN SOFA*. Oil on canvas, 30" X 36". The

GOLBIN, Andree. Painter. Born: Leipzig, Germany in 1923. Studied: in Switzerland with Henri Bercher; New York School of Fine and Applied Arts; Art Students League; Hans Hofmann School of Art. Awards: National Association of Women Artists, 1950; Grumbacher prize, Laurel Gallery, 1950.

GOLDMAN, Julia. Painter. Born: Boston, Massachusetts. Studied: Massachusetts Teachers Training College; New York School of Fine and Applied Arts; Columbia University; Harvard University; Courtauld Institute of Art, University of London; and with Charles Hawthorne and Denman Ross. Award: traveling scholarship, New York School of Fine and Applied Arts.

GOLDSBOROUGH, Mrs. N. Cox. Painter. She painted a number of portraits and exhibited them in Paris Salons before her death in 1923.

GOLDSTEIN, Gladys. Painter. Born: Newark, Ohio in 1918. Studied: Maryland Institute; Pennsylvania State University; Columbia University. Awards: Pennsylvania State University, 1954; Berney Memorial award, Maryland, 1956; National League of American Pen Women, 1956; Rulon-Miller award, Baltimore, 1957. Collections: Pennsylvania State University; University of Arizona; University of Pennsylvania; Baltimore Museum of Art.

GOLDSWORTHY, Emelia M. Painter. Born: Platteville, Wisconsin in 1869. Studied: Art Institute of Chicago; Otis Art Institute, Los Angeles, California.

GOLDTHWAITE, Anne. Painter and etcher. Born: Montgomery, Alabama. Studied: National Academy of Design; Academie Moderne, Paris. Award: National Academy of Women Painters and Sculptors. Collection: Library of Congress, Washington, D.C.

GONZALES, Carlotta. Painter. Born: Wilmington, North Carolina in 1910. Studied: Pennsylvania Academy of Fine Arts; National Academy of Design; Art Students League.

GOODMAN, Ann Taube. Painter. Born: Newark, New Jersey in 1905. Studied: with Philip Evergood and Walter Emerson Baum. Award: Pennsylvania Academy of Fine Arts, 1944. Collection: Lehigh University.

GOODNOW, Catherine Spencer. Painter. Born: Passaic, New Jersey in 1904. Studied: Art Students League; Bradford Massachusetts Academy; Smith College; Boston Museum of Fine Arts School. Best known as a portrait painter. Collections: Scituate High School; many portrait commissions.

GOODRIDGE, Elinor. Painter. Born: Cambridge, Massachusetts in 1886. Studied: Boston Museum of Fine Arts School with Umberto Romano and Prescott Jones; Smith College; and with Philip Hicken. Was exhibiting extensively in the Boston area.

GOODRIDGE, Sarah. Painter. Born: Massachusetts in 1788 and died in 1853. Studied: She was largely self-taught. In 1812 she studied with Gilbert Stuart in Boston. Best known as a miniature painter. Collections: Metropolitan Museum; Boston Museum; Herbert Pratt, New York.

GOODWIN, Alice H. Painter. Born: Hartford, Connecticut in 1893. Studied: with Emil Carlsen.

GOODWIN, Frances M. Sculptor. Born: Newcastle, Indiana. Studied: Chicago Art Institute; Art Students League. Collections: Columbian Exposition; Riverhead Cemetery, New York; Senate Gallery; Statehouse, Indianapolis, Indiana.

GOODWIN, Helen M. Painter. Born: Newcastle, Indiana. Studied: in Paris with Collin and Courtois. Known chiefly as a miniaturist.

GORDON, Alice Reis. Painter. Born: Germany in 1921. She has exhibited extensively in New York City.

GORDON, Elizabeth. Sculptor. Born: St. Louis, Missouri in 1913. Studied: The Lenox School; sculpture with Walter Russell, Edmondo Quattrocchi. Awards: Brooklyn War Memorial Competition, 1945; Catherine L. Wolfe Artist Club, 1951, 1958; Pen and Brush Club, 1954; National Academy of Design, 1956; gold medal, Hudson Valley Art Association, 1956; Pen and Brush Club, 1957. Collections: The Lenox School, New York; Aircraft Carrier "U.S.S. Forrestal"; James L. Collins Parochial School, Texas; Woodstock Cemetery; Kensico Cemetery, New York; James Forrestal Research Center, Princeton University.

GOTH, Marie. Painter. Born: Indianapolis, Indiana. Studied: Art Students League, with DuMond, Chase and Mora. Known chiefly as a portrait painter. Awards: Evansville, Indiana Museum of Art and History, 1939; Indiana Art Club, 1935, 1939, 1944, 1945, 1956; Brown County Art Gallery, 1933; Hoosier Salon, 1926, 1929, 1932, 1934, 1942, 1945, 1946, 1948, 1949, 1951, 1952, 1957, 1958; National Academy of Design, 1931. Collections: Hanover College; Franklin College; Purdue University; Indiana University; Butler College; John Herron Art Institute; Florida State University. Honeywell Memorial Community Center, Wabash, Indiana; John Howard Mitchell House, Kent, England.

GOTTHOLD, Florence W. Painter. Born: Uhrichsville, Ohio in 1858. Studied: with H. Siddons Mowbray.

GOULET, Lorrie. Sculptor. Born: Riverdale, New York in 1925. Studied: Inwood Studios; Black Mountain College, with Josef Albers and Jose deCreeft. Awards: Norton Gallery of Art, 1950, 1951; Society of Four Arts, 1950. Collections: New York Public Library (ceramic relief for Grand concourse); Sarah Roby collection; Joseph Hishhorn collection.

GOVE, Elma Mary. Crayon portraitist. She was active in New York between 1851 and 1855.

GRAHAM, Elizabeth. Painter. A miniature painter exhibiting her work in 1925.

GRAHAM, Josephine. Awards: Arkansas Art Festival; Arkansas Regional. Collection: Governor and Mrs. Winthrop Rockefeller.

GRAHAM, Laura M. Painter. Born: Washington, Indiana in 1912. Studied: Art Students League; Traphagen School of Design; with DuMond, Rittenberg and Bridgman. Awards: Studio Club, 1932, 1935, 1937, 1938; National Art Club, 1939, 1940, 1942; Terry Art Institute, 1952.

GRAHAM, Payson. Sculptor and illustrator. Member of the Art Students League.

GRANBERY, Virginia. Painter. Born: 1831 and died in 1921. She was a still life painter.

GRANDIN, Elizabeth. Painter. Born: Hamden, New Jersey. Studied: with Henri and Dow; and in Paris with Guerin.

GRANDY, Julia S. Painter. Born: Norfolk, Virginia in 1903. Studied: Grand Central Art School, with Edmund Greacen, and Leonard Bahr. Award: Baltimore Museum of Art, 1942.

GRANGER, Caroline G. Painter. Was exhibiting in 1924.

GRANT, Catherine. Painter. Exhibited at the Pennsylvania Academy of Fine Arts in 1924.

GRASSO, Doris Elsie. Painter. Born: Sullivan County, New York in 1914. Studied: with Moses Soyer, Alexander Dobkin; Newark Art Center; North Bergen Art School with Fabian Zaccone. Awards: Knickerbocker Art, 1958; Jersey City Museum, 1957; Talens and Son award, 1956; Hudson Valley Art Association, 1956; State Federation Women's Club, 1957.

GRAVES, Elizabeth E. Painter. Exhibited in 1924 at the National Association of Women Painters and Sculptors, New York.

GRAY, Kathryn. Painter. Born: Jefferson County, Kansas in
1881. Studied: Art Students League; with Weber; and in
Paris with La Forge.

GRAY, Mary. Painter. Born: in 1891. Was exhibiting in
the 1920's.

GRAY, Mary Chilton. Painter. Born: Philadelphia. Studied:
John Herron Art Institute. Collection: Denver Art Museum.

GREACEN, Nan. Painter. Born: Giverny, France in 1908.
Studied: Grand Central School of Art. Awards: National
Academy of Design; National Association of Women Artists;
National Art Club; Montclair Art Museum; Hudson Valley
Art Association; Albers Memorial, 1954.

GREATOREX, Eleanor. Painter. Born: New York City in 1854.
She was noted for her illustrations also. Many of her
flower painting have been exhibited.

GREATOREX, Eliza. Painter. Born: Ireland in 1820 and died
in 1897. Studied: with James and William Hart in New York.
She had the honor of being the first woman elected as an
Associate of the National Academy. She worked chiefly in
oils.

GREATOREX, Kathleen Honora. Painter. Born: Hoboken, New
Jersey in 1851. Studied: Rome, New York and Munich.
Awards: Paris Salon; gold medal, Philadelphia; gold medal,
Chicago; gold medal, Atlanta Exposition. Most of her
work was paintings of flower pieces in addition to her
illustrations.

GREELEY, Mary Elizabeth. Painter. Born: in 1836 and died
in 1924.

GREEN, Mrs. Erik H. Painter. Member of the Providence Art
Club.

GREEN, Mildred C. Painter and Illustrator. Born: Paris in
1874. Studied: with Bridgman, Hitchcock and Dufner.

GREEN, Myra. Painter. Born: Fayetteville, Tennessee in 1924.
Studied: Virginia Intermont College; also studied with Karl
Wolfe, Mildred Nungester and Marie Hull.

GREEN, Rena. Painter. Born: Sedalia, Missouri in 1874.
Studied: with Maurice Sterne, and Charles Martin. Awards:
Southern States Art League, 1940; San Antonio, Texas.
Collection: Witte Memorial Museum, San Antonio, Texas.

GREENAMYER, Leah J. Painter. Born: Ashtabula, Ohio. Studied: Pennsylvania Academy of Fine Arts; Youngstown College. Awards: Butler Art Institute, 1939, 1946; Ohioana Library Association, 1956. Collection: Mahoning County Court House.

GREENBAUM, Dorothea S. Sculptor. Born: New York City in 1893. Awards: Pennsylvania Academy of Fine Arts, 1941; Society of Washington Artists, 1941; International Business Machines, 1941; Audubon Art, 1954; Grant, American Academy of Arts and Letters, 1947; National Association of Women Artists, 1952, 1954. Collections: Whitney Museum of American Art; Lawrence Museum, Williamstown, Massachusetts; Oberlin College; Fitchburg Massachusetts Art Center; Huntington Museum; Brookgreen Gardens, South Carolina; Newark Museum of Art; Baltimore Museum of Art; Museum of Moscow, Russia; Puerto Rico; Ogunquit Museum of Art.

GREENE, Lucille B. Painter. Born: Los Angeles, California. Studied: University of California, Los Angeles; with Millard Sheets, Richard Haines and S. MacDonald Wright. Awards: California Art Club, 1951, 1953; Westwood Art Association, 1954; Women Painters of the West; Long Beach Art Association, 1957. Collections: Santa Monica High School; Utah State Agriculture College, Logan; Dixie College, St. George, Utah; Long Beach Art Center.

GREENE, Marie Zoe. Sculptor. Born: in 1911. Studied: Radcliffe College; New Bauhaus, Chicago; in France; in Italy. Award: gold medal, Cannes, France, 1969. Collections: Roosevelt University, Chicago; Southwest Missouri State College; Radcliffe College; Roosevelt University, Chicago.

GREENLEAF, Esther. Painter. Born: Ripon, Wisconsin in 1904. Studied: University of Minnesota; in Paris with Andre L'Hote. Awards: Minneapolis, Minnesota, 1944; Millburn-Short Hills Art Center, 1947, 1955, 1958; Summit Art Association, 1958; National Association of Women Artists, 1956; Pen and Brush Club, 1955.

GREENMAN, Frances C. Painter. Born: Aberdeen, South Dakota in 1890. Studied: Corcoran School of Art; Art Students League; Boston Museum Fine Arts School; Grande Chaumiere, Paris; with Chase, DuMond, and Henri. Awards: Corcoran School of Art; Minneapolis Institute of Art; Minnesota State Fair. Collections: New York University; Ohio State University; University of Minnesota; Hamline University; Cornell College; National Academy of Design; Minneapolis Public Library; Lawrence College; Aberdeen, South Dakota Public Library; Neville Museum; Minneapolis Institute of Art.

GREER, Blanche. Painter and Illustrator. Born: Eldora, Iowa in 1884. Studied: with chase and Collin; Pennsylvania Academy of Fine Arts.

GREGORY, Angela. Sculptor. Born: New Orleans, Louisiana in 1903. Studied: New York State College of Ceramics, Alfred, New York; Newcomb College of Tulane University; Parsons School in Paris and Italy; Grande Chaumiere, Paris; with Antoine Bourdelle. Awards: scholarship, Newcomb College; Southern States Art League, 1930, 1931; Louisiana Painters and Sculptors, 1929. Collections: International Business Machines; Delgado Museum of Art; Louisiana State Museum; Criminal Courthouse, New Orleans; Courthouse, Opelousas, Louisiana; Louisiana State University; Louisiar⁻ State Capitol; Tulane University; Howard-Tilton Memorial Library; La Tour Caree, Septmonts, France; Louisiana National Bank, Baton Rouge; Charity Hospital, New Orleans; Silver-Burdette Publishing Company, New York; Louisiana State University, Baton Rouge; St. Gabriel Church, St. Gabriel, Louisiana; McDonogh monument, Civic Center, 1938; Bienville monument, 1955, New Orleans, Louisiana.

GREGORY, Barbara Delle Simmons. Painter. Born: Fordyce, Arkansas, 1914. Studied: Hollins College; Allison's Wells Art Colony; with Louis Freund, Fred Conway, Karl Wolfe and Peter Baruzzi. Awards: All-Arkansas Competition, 1954, 1957; Allison's Wells, 1953, 1954.

GREGORY, Dorothy Lake. Painter. Born: Brooklyn, New York. Studied: Packer Institute; Pratt Institute Art School; Art Students League, with Henri and Bellows. Awards: Terry Art Institute, 1952, Hallmark award, 1953; Cape Cod Art Association, 1954. Collections: Library of Congress; Boston Museum of Fine Arts.

GREGSON, Marie E. Painter. Born: New York City in 1886. Studied: with Twachtman and Cox.

GREIMS, Mary H. Painter. Born: New York. Studied: Cooper Union; Philadelphia School of Design for Women; Pennsylvania Academy of Fine Arts.

GREY, Patricia. Painter. Born: New York City in 1939. Has exhibited in the New York City area.

GRIFFITH, C. Beatrice. Sculptor. Born: Hoylake, Cheshire, England in 1890. Studied: with Giuseppe Donato. Collections: Bennett School, Millbrook, Connecticut; Lahore Union College, Lahore, India; College of Pharmacy, Philadelphia.

GRIFFITHS, Elsa. A Miniature painter.

GRIFFIN, Nina K. Painter. Born: Wausau, Wisconsin in 1894. Studied: Art Institute of Chicago; with Charles Rosen, Wayman Adams and Victor Higgins. Awards: Art Institute of Chicago; Chicago Galleries Association. Collections: Wausau High School; Milwaukee-Downer College; Wellesley College; Illinois Veterans Orphanage.

GRIMES, Frances. Culptor. Born: Braceville, Ohio in
1869. Studied: Pratt Institute Art School; with Herbert
Adams and Augustus St. Gaudens. Awards: National
Association of Women Artists, 1916; Pan-Pacific Exposition,
1915. Collections: Toledo Museum of Art; Metropolitan
Musem of Art; Hall of Fame, New York University; Grace
Church, New York; Town Hall, New York; Washington Irving
High School, New York.

GRISWOLD, Carrie. Painter. Born: Hartfort, Connecticut.
Studied: with Leutze in New York. She was a skilful
copyist.

GRISWOLD, Virginia. Painter. Studied: Art Students League;
University of Geneva; Academy Colorossi, Paris; and with
George Elmer Browne, Arthur Guptill and Eliot O'Hara.

GROOM, Emily. Painter. Born: Wayland, Massachusetts in
1876. Studied: Art Institute of Chicago; Boston Museum
of Fine Arts School; in London; with John Vanderpoel,
Frank Benson and Birge Harrison. Awards: St. Paul Institute
of Art, 1917; Milwaukee Art Institute, 1920, 1925, 1926,
1931, 1946. Collections: Milwaukee Art Institute; St. Paul
Institute of Art; Gimbel Brothers Collection, Wisconsin.

GROOMBRIDGE, Catherine. Born: in 1760 and died in 1837.
She was a landscape artist.

GROOME, Esther M. Painter and etcher. Born: York County,
Pennsylvania. Studied: with Chase, Henri and others.

GROSS, Alice. Painter. Born: New York City in 1913.
Awards: Allied Artists of America; Westchester Art League;
New Rochelle Art Association. Collection: Berkshire
Museum.

GROSS, Irene. Painter. Born: Germany. Awards: National
Association of Women Artists, Bocour Artists colors prize
and Goldie Paley prize. Collections: Springfield Museum of
Fine Arts, Massachussets; St. Vincent's College, Latrobe,
Pennsylvania.

GROSS, Juliet W. Painter. Born: Philadelphia, Pennsylvania
in 1882. Studied: Philadelphia School of Design;
Pennsylvania Academy of Fine Arts.

GROSVENOR, Thelma C. Illustrator. Born: Richmond Virginia
in 1891. Studied: New York Artist Students League; St.
John's Wood School, London, England. Illustrated for
Harper's, McClure's and Saturday Evening Post.

GROTENRATH, Ruth. Painter. Born: Milwaukee, Wisconsin
in 1912. Studied: State Teachers College, Milwaukee,
Wisconsin. Awards: Milwaukee Art Institute, 1934, 1940,
1944; Madison Art Association, 1935; Art Institute of
Chicago, 1936, 1944; Grand Rapids Art Gallery; Dayton
Company, Minneapolis. Collections: Madison University;
Milwaukee Art Institute; International Business Machines
collection; Wisconsin State Teachers College; United
States Post Office, Hart, Michigan; Hudson, Wisconsin;
Wisconsin State Teachers College.

GROVER, Laurine V. Painter. Born: Durham, Maine in 1920.
Award: T.V. Art Exhibit. Collections: St. Joseph's College.

GROVES, Hannah C. Painter. Born: Camden, New Jersey in
1868. Studied: School of Design, Philadelphia; with
William M. Chase.

GROW, Lottie Lyons. Painter. Born: Hymera, Indiana in
1884. Studied: St. Louis Art Institute; John Herron
Institute of Art; Marian College; with Harold West and
Edward K. Sitzman. Collection: Riley Hospital for
Crippled Children.

GROZELIER, Sara Peters. Born: 1821 and died in 1907.
She was a miniature painter.

GRUEN, Shirley S. Painter. Born: Port Washington, Wisconsin
in 1923. Awards: Wisconsin Painters and Sculptors; Slidell,
Louisiana Art League. Collections: Port Publications,
Wisconsin; Leffingwells, Whitewater, Wisconsin.

GRUENBERG, Ruth. Painter. A watercolorist who exhibited
at the Pennsylvania Academy of Fine Arts in 1922.

GUCK, Edna. Painter. Born: New York City in 1904.
Studied: Art Students League; in Paris. Award: Essex
Art Association, 1951. Collections: Seattle Art Museum;
Brooklyn Museum; Queens College; National Hospital for
Speech Disorders; Halloran Hospital; New York Public
School; New York Housing Projects.

GUELPA, Jean B. Painter. Worked predominately on portraits.

GUENTHER, Pearl Harder. Painter. Born: Winnipeg, Manitoba,
Canada in 1882. Studied: with M. DeNeale Morgan and Evylena
Nunn Miller. Awards: Los Angeles Musuem of Art, 1943; Greek
Theatre, Los Angeles, 1952.

GUERNSEY, Eleanor Louise. Sculptor. Born: Terre Haute,
Indiana in 1878. Studied: Art Institute of Chicago.

GUILLETT, Madame J. Painter. A French miniature painter who was active in New York between 1839 and 1842. She also painted in Virginia.

GUIMARD, Adeline. Painter. Born: New York City. Studied: Art Students League; and abroad with Joseph Bail, Henri Levy and Albert Maignan. Awards: Florida Southern College; Medaille de la Reconnaissance Francaise. Collections: Library of Congress; Florida Southern College; Musee St. Pierre, Lyons France.

GUINNESS. Mrs. Benjamin. Painter. A member of the National Academy of Women Painters and Sculptors.

GUION, Molly. Painter. Known predominately as a portrait painter.

GUION, Susan. Painter. A landscape painter working in the mid 1800's.

GULLEDGE, Josephine. Painter. A member of the Washington, D. C. Water Color Club.

GULLIVER, Mary. Painter. Born: Norwich, Connecticut in 1860. Studied: Boston Museum of Fine Arts School, with Vonnoh and Grundmann; in Paris with Whistler, Collin, Callot, Lazar.

GUNDLACH, Helen Fuchs. Painter. Born: Buffalo, New York in 1892. Studied: Syracuse University; Philadelphia Museum School of Industrial Art; Albright Art School. Awards: League of American Pen Women, 1950; Buffalo Society of Art, 1946. Collection: designed Zonta Club insignia.

GUNKEL, Virginia P. Painter. Born: Chicago, Illinois in 1916. Studied: University of Illinois School of Architecture; Northwestern University; Art Institute of Chicago; Art Students League. Awards: New Jersey Painters and Sculptors Society, 1948; Manhasset Art Association, 1953; Long Island Art Society, 1952, 1953; National Association of Women Artists, 1956. Collection: in the United States and abroad.

GUNTRUM, Emilie Ida. Painter. Born: Brooklyn, New York. Studied: New York School of Applied Design for Women; Art Students League; National Academy of Design; with Charles Hawthorne, George Luks, George Bridgman, and Hans Hofmann.

GURDUS, Luba. Painter. Born: Bialystok, Poland in 1914.
Studied: Art School, Lausanne, Switzerland; Academy of
Art, Warsaw, Poland; Institute of Fine Arts, New York
University; in Germany. Award: Warsaw Academy of Art,
1938. Collections: Tel-Aviv, Israel, Municipal College;
Howard University; Jewish Museum of New York; Israeli
Consulate; Stephen Wise House, New York.

GURR, Lena. Painter. Born: Brooklyn, New York in 1897.
Studied: Brooklyn Training School for Teachers; Art
Students League, with Sloan and Sterne. Awards: National
Association of Women Artists, 1937, 1947, 1950, 1952;
Brooklyn Society of Art, 1943, 1951, 1954, 1955; Albany
Printmakers Club, 1955; Painters and Sculptors of New
Jersey, 1956; Silvermine Guild, 1957; Audubon Art, 1958
Collections: Tel-Aviv Museum; Ain-Harod Museum, Israel;
New York Public Library; California State Library; Kansas
State College; Brandeis University; Virginia Museum of
Fine Arts; Howard University; Butler Institute of American
Art; Staten Island Museum of Art and Science.

GURREY, Hartley F. Lithographer. Born: Bloomington,
Illinois. Studied: Washington State College; University
of Oregon; Art Students League; with Wayman Adams and
Jean Charlot. Collections: Honolulu Academy of Art;
murals, Service Women's Center; Hawaiian Island Flower
Building; textile designer for Hawaiian Garment
Manufacturers.

GUYSI, Alice V. Painter. Born: Cincinnati, Ohio. Studied:
Colarossi Academy; with Harry Thompson in Paris.

GUYSI, Jeannette. Painter. Born: Cincinnati, Ohio.
Studied: with Harry Thompson in Paris; Colarossi Academy.

GUZEVICH, Cynthia. Awards: Black Range Exhibit; Albuquerque
Art League. Collections: Braniff Airline Collection; First
National Bank, Las Cruces, New Mexico.

HAACK, Cynthia R. Painter. Awards: Thalhimer's Salon Des
Refuses; Virginia State Fair Art Show; Petersburg Virginia
Annual Art Show.

HAAS, Clara. Painter. Born: New York City in 1895.
Studied: Art Students League; with Jonas Lie; Jerry
Farnsworth and Xavier Gonzalez. Awards: Village Art Center,
1954, 1955; American Artists Professional League, 1956;
Westchester Arts and Crafts, 1956; Silvermine Guild, 1956;
Pen and Brush Club, 1957.

HAAS, Helen. Sculptor. Born: Brooklyn, New York in 1904.
Studied: with Antoine Bourdelle, France. Collections:
Luxembourg Museum, Paris; Port Sunlight Museum, London;
New York Museum of Natural History.

HAASE, Madeline F. Painter. Born: Los Angeles, California
in 1931. Studied: Mount St. Mary's College, Los Angeles;
Immaculate Heart College, Los Angeles; in Europe. Award:
National Orange Show, San Bernardino, 1953. Collections:
Virginia Museum of Fine Arts; Oregon State College;
Achenbach Foundation, California.

HACK, Gwendolyn Dunlevy Kelley. Painter. Born: Columbus,
Ohio in 1877. Studied: Art Students League; with Mesdames
Debillement and Gallet in Paris. Her specialities were
miniatures on ivory, pastels, bas-reliefs. Has exhibited
paintings in United States and Paris. Received a decoration
in 1895 for a portrait on ivory of the Queen of Italy.

HACKETT, Grace E. Painter and illustrator. Born: Boston in
1874. Studied: Massachusetts Normal Art School; in Europe
with H. B. Snell.

HADEN, Eunice. Painter. Born: Washington, D.C. in 1901.
Studied: Oberlin College; Abbott School of Art; with Eliot
O'Hara. Award: Art Club of Washington, 1956. Collections:
in private collections.

HADLEY, Sara. Painter. Primitive landscape painter working
early in 1850.

HAGAN, Ethel H. Painter. Born: Cleveland, Ohio in 1898.
Studied: National Academy of Design; Pratt Institute Art
School; Corcoran Gallery of Art; with Eliot O'Hara, Richard
Lahey and Weiss. Awards: Federation of Womens Club, 1950,
1952; San Diego Men's Art Institute, 1955; Carlsbad-Oceanside
Art League, 1956, 1958. Collection: portrait of General
Merritt Edson, U. S. Destroyer "Edson," 1958.

HAGEN, Louise. Painter. Born: Chicago, Illinois in 1888.
Studied: with Henri and Jonas Lie.

HAHN, Nancy C. Sculptor. Born: St. Louis, Missouri in 1892.
Studied: Washington University; St. Louis School of Fine
Arts; with George Zolnay and Charles Grafly. Awards: St.
Louis School of Fine Arts; St. Louis Art Guild; Kansas City
Art Institute. Collections: City Art Museum of St. Louis;
Cleveland Museum of Art; Missouri State Memorial, in France;
Sears School, Kenilworth, Illinois; Rosehill Cemetery,
Chicago; Culver, Indiana; Memphis, Tennessee; Frederick,
Maryland; New London, Missouri; Chicago, Illinois; Clayton,
Missouri.

HAIGHT, Mary Trivett. Painter. Born: Cincinnati, Ohio.
Noted for her murals in the Woman's Building, World's Fair,
Chicago, 1893.

HAILMAN, Johanna K. Painter. Born: Pittsburgh, Pennsylvania
in 1871. Member of National Association of Women Painters
and Sculptors.

HAINES. Marie B. Painter and illustrator. Born: Cincinnati,
Ohio in 1885. Collections: State College, Texas.

HALE, Ellen Day. Painter. Born: Worcester, Massachusetts
in 1855. Studied: Academie Julien, Paris; with William
Morris Hunt and Dr. Rimmer. In 1904 she moved from Boston
to Washington. Collection: Capitol Building, Washington,
D.C.

HALE, Lilian W. Painter. Born: Hartford, Connecticut in
1881. Studied: Boston Museum of Fine Arts School; Hartford
Art School; with Tarbell, Hale and Chase. Awards: Pan-
Pacific Exposition, 1915; Philadelphia Art Club, 1919;
Art Institute of Chicago, 1920; Pennsylvania Academy of Fine
Arts, 1923; National Academy of Design, 1924, 1927; Concord
Art Association, 1925; North Shore Art Association, 1941;
Contemporary Art of New England, 1945. Collections:
Pennsylvania Academy of Fine Arts; Corcoran Gallery of Art;
Philadelphia Art Club; Metropolitan Museum of Art; Concord
Art Association; Boston Museum of Fine Arts.

HALE, Mary P. Painter and sculptor. Born: Kingston, Rhode
Island in 1862. Studied: Rhode Island School of Design;
and with Chase and Saint Gaudens.

HALE, Susan. Painter. Born: Boston, Massachusetts in 1834
and died in 1910. She executed landscape paintings in water
colors.

HALEY, Sally. Painter. Born: Bridgeport, Connecticut in 1908. Studied: Columbia University; Yale School of Fine Arts; in Munich, Germany. Awards: Mattatuck Historical Society, Waterbury, Connecticut, 1945, 1946; San Francisco, Pacific Art Festival. Collection: mural United States Post Office, McConnellsville, Ohio.

HALL, Anne. Painter. Born: Pomfret, Connecticut in 1792 and died in 1863. Studied: with S. King of Newport; Alexander Robertson, New York. She devoted herself to miniature painting which she exhibited at the National Academy of Design, New York City.

HALL, Alice. Engraver. Born: Halloway, London, England in 1847. While living in New York in 1900 she etched portraits of Washington.

HALL, Edith E. Painter. Born: Seymour, Wisconsin in 1883. Studied: with George Elmer Browne, John Carlson and Ivanowski. Awards: Raritan Valley Art Association, 1942; Plainfield Art Association, 1943, 1945, 1951, 1952; Newark, New Jersey, 1938; Millburn-Short Hills Art Center, 1946; Papermill Playhouse, 1956.

HALL, Frances D. Painter and Sculptor. Born: New Orleans, Louisiana. Studied: Sophie Newcomb College, New Orleans; with Howard Pyle, Charles Grafly and John Twachtmann.

HALL, Florence S. Painter. Born: Grand Rapids, Michigan. Studied: Art Institute of Chicago; with Johansen.

HALL, Norma B. Painter. Born: Halsey, Oregon in 1890. Studied: Portland Oregon Art Association School; Art Institute of Chicago; and in London. Awards: Southern Printmaker, 1938; Kansas State Federation of Art, 1937. Collections: Brooklyn Public Library; Doctors Hospital, Washington, D.C. Smithsonian Institute; Honolulu Academy of Art; California State Library; University of Tulsa; Wichita Art Association; University of Wichita; Currier Gallery of Art.

HALLIDAY, Mary H. Painter. Studied: with Chase; and abroad.

HAMAR, Irene. Painter. Born: Sao Paulo, Brazil in 1915. Studied: in France and Brazil. Awards: gold medal, Rio de Janeiro; Sao Paulo, Brazil. Collections: Metropolitan Museum of Art; William Rockhill Nelson Gallery of Art; The Hague, Holland, Paris, France. University of Rio de Janeiro, Brazil.

HAMBLETT, Theora. Painter. Born: Paris, Mississippi in 1895. Studied: University of Mississippi with Charles Mussett; Famous Artists Course. Collection: Museum of Modern Art.

HAMILL, Mildred. Painter. Studied: Art Institute of
Chicago; and with Mark Tobey. She specializes in
Alaskan scenes.

HAMILTON, Hildegard. Painter. Born: Syracuse, New York
in 1908. Studied: Art Students League; John Herron Art
Institute; Cincinnati Art Academy; Syracuse University;
Julian Academy, Ecole des Beaux-Arts, Paris. Collections:
Wesleyan College, Georgia; Hall of Art, New York; Evergreen
School, Plainfield, New Jersey; Eaton Gallery, New York;
Nassau, Bahamas.

HAMILTON, Norah. Etcher. Born: Fort Wayne, Indiana in
1873. Studied: with Cox in New York; with Whistler in Paris.

HAMLIN, Edith. Painter. Born: Oakland, California in
1902. Studied: California School of Fine Arts; and with
Maynard Dixon. Collections: San Francisco Museum of Art;
San Diego Fine Arts Gallery; Mission High School, San
Francisco, California; United States Post Office, Tracy,
California; Coit Memorial Tower, San Francisco; Santa Fe
Railroad Ticket Office, Chicago and Los Angeles; Arizona
Biltmore Hotel, Phoenix; Plains Hotel, Cheyenne, Wyoming;
Jacome's Department Store, Tucson, Arizona; St. Ambrose
Church, Tucson, Arizona; Old Pueblo Club, Tucson, Arizona.

HAMLIN, Genevieve K. Sculptor. Born: New York City in 1896.
Studied: Vassar College; also with Eberle, Henry Dropsy,
and Andre L'Hote, in Paris. Awards: fellowship, Cranbrook
Academy of Art. Collections: Joslyn Memorial, Omaha,
Nebraska; Antique and Decorative Art League. She specializes
in animals in low relief.

HAMMOND, Mildred W. Painter. Born: Red Oak, Missouri in
1900. Awards: Kansas City Art Institute, 1950; gold medal,
Midwest Exhibition, 1932, 1935. Collections: Kansas City
Southern Railroad; Kansas City Public Service.

HAMMOND, Natalie. Painter. Born: Lakewood, New Jersey in
1905. Collections: French Government; Pittsfield Museum of
Art. Has exhibited widely in United States, France and
England.

HAMMOND, Ruth E. Painter. Born: West Haven, Connecticut
in 1894. Studied: Mt. Holyoke College; Yale Graduate
School; with Dante Ricci in Rome. Awards: St. Petersburg
Art Club; Society of Four Arts; St. Augustine Art Club;
Brick Store Museum, Kennebunk, Maine. Collections: Bowdoin
College; Walker Art Gallery, Brunswick, Maine; William
Farnsworth Museum, Rockland, Maine; Ford Motor Collection.

HANNAFORD, Alice Ide. Sculptor. Born: Baltimore, Maryland in 1888. Studied: Art Students League; with Fraser. Collection: Brooklyn Institute Museum.

HANNAH, Muriel. Painter. Born: England. Studied: Boston Museum of Fine Arts School; Art Students League; also with Hale, Henri and James. Has exhibited in New York, Chicago, Hawaii and Alaska, California and Washington, D.C.

HANSCOM, Trude. Painter. Born: Oil City, Pennsylvania in 1898. Studied: Syracuse University; University of California; Scripps College; Otis Art Institute; University of Southern California. Awards: Art Festival, Arcadia, 1951; Art Festival, San Gabriel, 1951-1955; Printmakers of California, 1952; Pasadena Museum of Art, 1953. Collections: Library of Congress; National Academy of Design; Metropolitan Museum of Art; Pennsylvania State University; California State Library.

HANSEL, Miss. H. M. Still Life painter and teacher of drawing.

HANSEN, Florence F. Painter. Born: Sheboygan, Wisconsin in 1892. Studied: Art Institute of Chicago; Chicago Academy of Fine Arts; Acedemie Julien, Paris. Awards: gold medal, Miniature Society, London, 1925; gold medal, Academy of Fine Arts, Paris, 1927; Academy of Fine Arts, London, 1928. Collections: Stendahl Art Gallery, Los Angeles; Ebell Art Salon; Art Institute of Chicago; American Academy in Rome; Academy of Fine Arts, London.

HAPGOOD, Alice Hathaway. Painter and Illustrator. Born: Hartford, Connecticut in 1893. Studied: with Breckenridge; and with Emil Carlsen.

HARARI, Hananiah. Painter. Born: Rochester, New York in 1912. Studied: Syracuse University; Fontainebleau, Paris; with Leger, L'Hote and Gromaire, Paris. Awards: National Academy of Design, 1941; Audubon Art, 1945; Art Directors Club, Chicago; Ossining, New York, 1953, 1955, 1957; Mt. Kisco, New York, 1955. Collections: Whitney Museum of American Art; University of Arizona; Philadelphia Museum of Art; Museum of Modern Art; Albright Art Gallery; San Francisco Museum of Art; Rochester Memorial Art Gallery; Iowa State University.

HARBART, Gertrude F. Painter. Born: Michigan City, Indiana. Studied: University of Illinois; University of California; Art Institute of Chicago; Ohio University; also Charles Burchfield, Hans Hofmann, Paul Sample. Awards: John Herron Art Institute, 1958; South Bend Art Association, 1954,1956, 1957; Old Northwest Territory Exhibition,Springfield, Illinois, 1954, 1956; Ohio Valley, 1955; Hoosier Salon, 1958. Collections: South Bend Art Association; St. Mary's of Notre Dame, South Bend; Michigan City High School.

HARBESON, Georgiana. Painter. Born: New Haven, Connecticut in 1894. Studied: Pennsylvania Academy of Fine Arts; Moore Institute of Art, Science and Industry; New York School of Design; New York University; Philadelphia Museum School of Industrial Art. Awards: Pennsylvania Academy of Fine Arts; New York Women's Exposition of Art and Industry. Collections: Honolulu Academy of Art; St. Joseph's Chapel, Washington, D.C.; St. Paul's Chapel, Cincinnati, Ohio, 1958. Also known as a designer she has contributed to many stencilling and needlework magazines.

HARBAUER, Hazel Jacoby. Painter. Born: Toledo, Ohio in 1908. Studied: Toledo University; Cleveland School of Art; Art Institute of Chicago. Exhibited extensively.

HARDENBERGH, H. Elizabeth. Painter. Born: New Brunswick, New Jersey. Studied: with H. B. Snell and Mrs. E. M. Scott.

HARDING, G Powell (Mrs). Painter. Born: San Leandro, California in 1892. Studied: University of California; California School of Fine Arts; Columbia University. Award: California Watercolor Society.

HARDWICK, Alice R. Painter. Born: Chicago, Illinois in 1876. Studied: Art Students League; with DuMond, Birge Harrison and Melbourne H. Hardwick; also studied in Holland and Belgium.

HARDY, Anna E. Painter. Born: Bangor, Maine in 1839. Studied: in Paris with George Jeanin; and in Dublin, New Hampshire with Abbott H. Thayer. Her specialty was portraits and flower paintings.

HARDY, Beulah G. Painter. Born: Providence, Rhode Island. Studied: in Paris with Collin, Merson, Courtois and Virginia Reynolds; also studied in Boston and London.

HARDY, Mary Ann. Born: 1809 and died in 1887. She was a landscape and miniature painter.

HARGOFF, Lyla M. Painter. Born: Lafayette, Indiana. Studied: Purdue University; Art Institute of Chicago; and in Paris. Awards: Santa Barbara Museum of Art, 1944. Collections: Lafayette Indiana Art Museum; Santa Barbara Museum of Art; Santa Fe Railroad; United States Government.

HARHBERGER, Florence E. Painter and illustrator. Born: Freetown, Courtland County, New York in 1863. Studied: Art Students League; Cooper Union Art School.

HARKAVY, Minna. *Sculptor. Studied: Art Students League; Hunter College; in Paris with Antoine Bourdelle. Awards: National Association of Women Artists, 1940, 1941; National Exhibition of American Science, Metropolitan Museum of Art, 1951; Project award, United States Treasury. Collections: Whitney Museum of American Art; Museum of Modern Art; Musee Municipal, St. Denis, France; Museum of Western Art, Russia; Tel-Aviv, Ain Harod Museum, Israel; United States Post Office, Winchendon, Massachusetts.*

HARLAN, Roma C. *Painter. Born: Warsaw Indiana in 1912. Studied: Purdue University; Art Institute of Chicago with Constantine Pougialis and Francis Chapin. Collections: St. Joseph's College, Rensselaer, Indiana; Purdue University; Lake Shore Club, Chicago; Francis Hammond High School, Alexandria, Virginia; National Guard Building, Washington, D. C. Known as a portrait painter she has executed many portraits of prominent persons.*

HARLAND, Mary. *Painter. Born: England in 1863. Studied: in London and Paris.*

HARMON, Evelyn S. *Miniature painter. She was exhibiting her work in 1925.*

HARMON, Lily. *Painter and lithographer. Born: New Haven, Connecticut in 1913. Studied: Yale University School of Fine Art; Art Students League; also in Paris. Collections: Encyclopaedia Britannica; Butler Art Institute; Tel-Aviv, Ain Harod Museum, Israel; Newark Museum of Art; New York Jewish Community Center, Port Chester.*

HARPER, Edith W. *Painter. Exhibited at the Cincinnati Museum in 1925.*

HARPER, Marian D. *Miniature painter. Studied: Art Institute of Chicago; and in Paris.*

HARRIS, Alexandrina R. *Miniature Painter. Born: Aberdeen, Scotland in 1886. Studied: Adelphi College, Brooklyn, New York; Art Students League; American School of Miniature Painters; Fontainebleau, France, with Despujols. Awards: Baltimore Watercolor Club; National Association of Women Artists, 1935, 1944, 1951, 1958; California Society of Miniature Painters, 1941, 1947; Pennsylvania Society of Miniature Painters, 1950. Collections: Philadelphia Museum of Art; Corcoran Gallery of Art; Butler Art Institute; The Hermitage Museum, Norfolk, Virginia; Department of Archives, State Capitol, Alabama; Baltimore Museum of Art.*

HARRIS, Margie Coleman. Painter. Born: Washington, D.C. in 1891. Studied: Carnegie Institute; University of Pittsburgh; University of Chicago; Pennsylvania State College. Awards: Ebensburg Fair, 1935; Johnstown, 1933, 1937, 1951, 1952; Garden Club, 1938, 1945. Collections: Cambria Library; Veterans Hospital, Aspinwall, Bethlehem, Pennsylvania; State Teachers College, Indiana, Pennsylvania; Daughters of the American Revolution, Johnstown; Chamber of Commerce, Johnstown; State Museum, Harrisburg; Bethlehem Steel Company; Memorial Hospital, Johnstown.

HARRIS, Margo Liebes. Sculptor. Born: Frankfurt, Germany in 1925. Studied: In Germany and Italy; Art Students League, with William Zorach. Collections: in private collections.

HARRISON, Dorothy. Painter. Born: New York City. Studied: Columbia University.

HART, Agnes. Painter. Born: Connecticut in 1912. Studied: Ringling School of Art; also with Josef Presser, Lucile Blanch and Paul Burlin. Awards: Scholarship, Yaddo Foundation, 1947, 1948.

HART, Letitia Bennett. Painter. Born: New York in 1867. Studied: National Academy of Design; also with James M. Hart and Edgar M. Ward. She specialized in figure pictures and portraits. Awards: National Academy of Design, 1898

HARTIGAN, Grace. Painter. Born: Newark, New Jersey in 1922. Studied: Newark College of Engineering; and with Isaac Lane. Her subject matter usually abstract. Collections: Museum of Modern Art; Metropolitan Museum of Art.

HARTMETZ, Herrica H. Painter. Born: Oakland, California in 1925. Studied: University of Southern California; Chouinard Art Institute; Pasadena Art Institute. Awards: Women Painters of the West, 1955; Tri-State Exhibition, Evansville, Indiana, 1949. Collection: Evansville Museum.

HARTWIG, Cleo. Sculptor. Born: Webberville, Michigan in 1911. Studied: Western Michigan University. Awards: Detroit Institute of Art, 1943; National Association of Women Artists, 1945, 1951; New York Society Ceramic Association, 1945; Audubon Art, 1952. Collections: Newark Museum; Detroit Institute of Art; Pennsylvania Academy of Fine Arts; Montclair Art Museum; Mt. Holyoke College; Western Michigan University.

HARVEY, Jacqueline. Painter. Born: Lille, France in 1927. Studied: with Morris Davidson; Fernand Leger and Leopold Survage, Paris. Collection: in private collections.

HARVEY, Laura Cornell. Painter. Born: New York City. Studied: Hunter College; National Academy of Design; Art Students League. Awards: Museum of New Mexico, Santa Fe, 1958. Has exhibited extensively.

HASELTINE, Margaret W. Painter. Born: Portland, Oregon in 1925. Studied: Reed College; Eastern New Mexico University; Portland Museum of Art School; and with Frederick Littman.

HASTINGS, Alix Lee. Painter. Born: New York City. Studied: National Academy of Design; Loos School of Painting; Academie Julien, Paris. Her specialty--pastel portraits of children.

HATCH, Elisha. Painter. Known for her watercolor portraits. Active from 1835 to 1840.

HATCH, Emily N. Painter. Born: Newport, Rhode Island. Studied: with Charles Hawthorne, William Chase, Walter Shirlaw and George Wharton Edwards; in Paris with Eugene Paul Ullman. Awards: National Association of Women Artists, 1942; Pen and Brush Club, 1930, 1934; Hudson Valley Art Association, 1941, 1946; Westchester Arts and Crafts Guild, 1950. Collections: Richmond Indiana Art Museum; National Museum, Washington, D.C.

HAVLENA, Jari. Painter. Born: Grand Forks, North Dakota in 1923. Studied: Abbott School of Fine Arts, Washington, D. C. De Paul University, Chicago; Art Institute of Chicago; University of Kansas City; and with Robert von Neumann, Max Kahn and Paul Wiegert. Awards: Vandergritt scholarship, Art Institute of Chicago; Kansas des-Craftsmen, 1954. Collection: Quigley Music Studio, Kansas City.

HAWKINS, Vina S. Painter. Born: Chicago, Illinois. Studied: Art Institute of Chicago. Awards: Poland award, 1944; Palm Springs, 1949; La Jolla Art Association, 1955; Carlsbad-Oceanside Art League, 1955.

HAWKS, Rachel M. Sculptor. Born: Port Deposit, Maryland in 1879. Studied: Maryland Institute; Rinehart School of Sculpture. Collections: Maryland Casualty Company; Memorial Hospital, Baltimore, Maryland: City Hall, Baltimore,Maryland; Hockiday School, Dallas, Texas; United States Naval Academy.

HAWLEY, Margaret Foote. Painter. Born: Guilford, Connecticut in 1880. Studied: Corcoran Art School; with Howard Helmick; Academie Colorossi, Paris. Awards: Baltimore Watercolor Club, 1926; Sesqui-centennial Exposition, Philadelphia, 1926; Brooklyn Society of Miniature painters, 1931; National Association of Women Artists, 1931. Collections: Corcoran Gallery of Art; Concord Art Association; Metropolitan Museum of Art.

HAWTHORNE, Marion G. Painter. Born: Joliet, Illinois.
Studied: Chicago Art Institute.

HAY, Genevieve Lee. Sculptor. Born: Cleveland, Ohio
in 1881 and died in 1918. Studied: with Henri.

HAY, Velma. Painter. Born: Bloomington, Illinois in 1912.
Studied: Otis Art Institute, Los Angeles; Chouinard Art
Institute, Los Angeles; and with Messick, Bisttram and
Kingman. Award: Seton Hall University, 1958. Collection:
Seton Hall University.

HAYDEN, Bits. Painter. Studied: Atlanta Art Institute;
San Francisco Art Institute. Award: annual West Coast
Oil Painting Exhibition, Seattle, Washington.

HAYDEN, Ella Frances. Painter. Born: Boston,
Massachusetts in 1860. Studied: National Academy of
Design; also in Paris. She was noted for her landscape
paintings.

HAYDEN, Harriet C. Painter. Born: in 1840 and died in
1906. Best known for her flower paintings in oils and
water colors.

HAYES, Tua. Painter. Awards: Delaware Art Center;
Chester County Art Center; Collections: Delaware Art
Center; University of Delaware.

HAYSE, Martha S. Painter. Working on water color
landscapes around 1810.

HAYWARD, Mildred. Painter. Born: Chicago, Illinois in
1889. Award: Norton Gallery of Art, West Palm Beach,
Florida. Collection: Metropolitan Museum of Art.

HAYWOOD, Mary C. Painter. Born: Philadelphia in 1898.
Studied: with Breckenridge. Collection: Pennsylvania
Academy of Fine Arts.

HAZELETT, Sally Potter. Painter. Born: Evanston, Illinois
in 1924. Studied: Rollins College; Columbia University;
University of Louisville; Institute of Design, Chicago;
Illinois Institute of Technology. Awards: Fulbright
award, 1952. Collection: University of Louisville.

HAZELTON, Mary B. Painter. Born: Milton, Massachusetts.
Studied: with Edmund C. Tarbell.

HAZEN, Bessie E. Painter. Studied: Columbia University.
Known best by her etchings and works in water color.

HAZZARD, Sara. Painter. A member of the National Academy of Women Painters and Sculptors.

HEALY, Marion M. Painter. Born: Mobile County, Alabama. Studied: Cincinnati Art Academy; Art Students League; Pennsylvania Academy of Fine Arts. She is also an etcher and lithographer.

HEATH, Eugenia A. Painter. Born: Florence, Ohio. Studied: Art School of New York. Noted for portraits and landscapes.

HEBB, Mathilde M. Sculptor. Born: Baltimore, Maryland in 1911. Studied: Maryland Institute; Rinehart School of Sculpture; Goucher College. Awards: Maryland Institute, 1934; Rinehart School of Sculpture, 1935; traveling scholarship, Rinehart School of Fine Arts, 1936; Baltimore Museum of Art, 1936. Collection: sculpture figures and fountains, Baltimore, Maryland parks.

HERBERT, Marian. Painter, etcher, designer. Born: Spencer, Iowa in 1899. Studied: University of Montana; University of California; University Boston; Santa Barbara School of Art; also with Belmore Brown, Eliot O'Hara, Frank Fletcher and Maurice Lasansky. Awards: Library of Congress, 1948; Society of American Graphic Artists, 1938. Collections: Library of Congress; Santa Barbara City School; Chicago Society of Etchers; University of Nebraska; Society of American Graphic Artists; University of Boston; Santa Barbara Public Library; Boston Museum of Fine Arts; Veterans Memorial Building, Carpinteria, California; Mary Hardin-Baylor College; Beaux-Arts Club, Clarendon, Texas.

HEDDEN SELLMAN, Zelda. Awards: Central Illinois Artists; Northwest Territory Invitational; Ohio Valley Watercolor Show.

HEDDINS, Tincie H. Painter. Born: San Angelo, Texas in 1909. Studied: University of Texas, New Mexico Highlands University; with Xavier Gonzales. Awards: Texas General, San Angelo, 1952, 1953; West Texas Art Association, 1956. Collection: mural, Church of Christ, San Angelo.

HEELY, Emma A. Painter. She was a watercolorist who painted flowers and was exhibiting in 1847.

HEILOMS, May. Painter. Born: Russia. Studied: Art Students League. Awards: New Jersey Painters and Sculptors, 1952, 1955, 1956; Artists Equity Association, 1952; Jersey City Museum Association, 1950, 1951, 1958; Brooklyn Society of Art, 1958; National Association of Women Artists, 1954, 1958. Collections: Philadelphia Museum of Art; Samuel S. Fleisher Memorial Art Foundation; Collectors of American Art Association.

HEIM, Nara. Painter. Born: Caracas, Venezuela in 1921.
Studied: National Academy of Design; Art Students League;
Sculpture Center, New York. Awards: New Rochelle Art
Association, 1952; Manor Club, 1952; Westchester Arts
and Crafts Guild, 1955; Mount Vernon Art Association,
1955. Collections: Everhart Museum of Art, Scranton,
Pennsylvania; Lyman Allyn Museum; Howard University;
Farnsworth Museum of Art, Wellesley, Massachusetts;
Georgia Museum of Art, Athens; Hickory Museum of Art,
North Carolina; Mills College, Oakland, California.

HELD, Alma M. Painter. Born: Le Mars, Iowa. Studied:
State University, Iowa; National Academy of Design; with
Hawthorne, Cumming, and Dickinson. Awards: Iowa State
Fair, 1925, 1926, 1928, 1929; Cedar Falls, Iowa, 1943,
1945, 1948, 1951. Collection: Ft. Dodge Public School.

HELDER, Z. Vanessa. Painter. Born: Lynden, Washington
in 1904. Studied: University of Washington; Art Students
League, with Robert Brackman, George Picken and Frank
DuMond. Awards: Pacific Coast Painters and Sculptors,
1936, 1939; Women Painters of Washington, 1937; Seattle
Art Museum, 1936, 1939; National Association of Women
Artists, 1942; Women Painters of the West, 1946; Pen and
Brush Club, 1947; Greek Theatre, Los Angeles, 1948;
National Orange Show, 1949; Ramona High School, 1953;
Glendale Art Association, 1955; California State Fair, 1949.
Collections: Seattle Art Museum; Newark Museum; High Museum
of Art; International Business Machines; American Academy
of Arts and Letters; Eastern Washington State College;
Lynden Washington Public Library; Spokane Art and History
Museum; Coulee Dam Building; Glendale Art Association.

HELFOND, Riva. Lithographer. Born: New York City in 1910.
Studied: Art Students League. Awards: Museum of Modern Art,
1942; Montclair Art Museum, 1944, 1955; Library of Congress,
1950, 1954, 1955; Brooklyn Museum, 1948; Cincinnati Museum
Association, 1950, 1952; Society of American Graphic Artists,
1954. Collections: Metropolitan Museum of Art; Museum of
Modern Art; Los Angeles Museum of Art; Cornell University;
Princeton University.

HELLER, Eugenie M. Painter and sculptor. Studied: with
Alden Weir in New York; with Whistler in Paris.

HELLER, Mrs. T. Painter. Known as a portrait and figure
painter who was exhibiting in 1854.

HENDERSON, A. Elizabeth. Painter. Born: Ashland, Kentucky
in 1873. Studied: Art Students League of New York. She
was known principally as a miniature painter.

HENDERSON, Dorcas. Painter. Born: Kenton, Ohio. Studied: Cleveland Art School; and with George Elmer Browne. Noted for her landscapes.

HENDERSON, Helen Weston. Painter. Born: Philadelphia in 1874. Studied: Pennsylvania Academy of Fine Arts; Academie Colarossi, Paris.

HENRICH, Jean MacKay. Sculptor. Born: Halifax, Nova Scotia, Canada in 1909. Studied: Antioch College; Art Institute of Chicago; Art Institute of Buffalo; University of Buffalo; and studied abroad. Collections: Library of Congress; Veterans Memorial, Geneva, New York; Chautauqua County Jail, Mayville, New York.

HENRY, Anne Kolb. Studied: Chicago Academy of Fine Arts; Rhode Island School of Design. Awards: Exhibition of Art Association of Newport, Newport, Rhode Island.

HENRY, Natalie S. Painter. Born: Malvern, Arkansas in 1907. Studied: Art Institute of Chicago; Ropp School of Art, Chicago. Collection: mural, United States Post Office, Springdale, Arkansas.

HENWOOD, Mary R. Miniature painter. Was exhibiting at the Pennsylvania Academy of Fine Arts, Philadelphia in 1925.

HEPBURN, Nina Maria. Painter. Noted for her water colors which she was exhibiting in 1925.

HERBERT, Virginia. Painter. Born: Cairo, Illinois in 1912. Studied: Art Institute of Chicago, with Boris Anisfeld; University of Colorado, with James Ernst. Award: National Watercolor exhibition, Jackson, Mississippi, 1946. Collection: Marine Hospital, Lexington, Kentucky.

HERGESHEIMER, Ella S. Painter. Born: Allentown, Pennsylvania. Studied: Pennsylvania Academy of Fine Arts, with Cecilia Beaux and Chase; in Paris with Prinet and Mucha; also studied in Spain and Italy. Award: traveling scholarship, Pennsylvania Academy of Fine Arts.

HERING, Elsie Ward. Sculptor. Born: Howard County, Missouri and died in 1923. Studied: in Denver, Colorado with Augustus Saint Gaudens. Collection: Chapel of Our Savior, Denver, Colorado; St. Louis Museum.

HERMAN, Leonora Owsley. Painter and etcher. Born: Chicago, Illinois in 1893. Studied: with Simon, Menard, Hellen, and Leon in Paris.

HERPST, Martha. Painter. Born: Titusville, Pennsylvania. Studied: Pennsylvania Academy of Fine Arts, with Wayman Adams, Edmund Greacen, Harvey Dunn and Guy Pene du Bois. Collections: Titusville Recreation Center; Masonic Lodge, Womans Club, United States Marine Corp Lodge, Young Womens Christian Association, Titusville, Pennsylvania; National Arts Club.

HERRICK, Margaret C. Painter. Born: San Francisco, California in 1865. Studied: with Carlsen, Yates and Mary C. Richardson. Collection: Young Womens Christian Association, Oakland, California.

HERRMANN, E. Adele. Painter. Born: North Plainfield, New Jersey. Studied: Columbia University; Art Students League. Awards: Huckleberry Mountain exhibition, 1949; gold medal, Philadelphia Plastic Club, 1952; New Jersey Art Council, 1952; Warren prize, Middlesex County, 1957; American Artists Professional League, 1958

HERRON, Jason (Miss). Sculptor. Born: Denver, Colorado in 1900. Studied: Stanford University; Los Angeles County Art Institute; also with Merrell Gage, F. Tolles Chamberlin. Awards: Los Angeles County Fair, 1934; Los Angeles Art Association; Society for Sanity in Art, 1945; California Art Club, 1946. Collections: Los Angeles Museum of Art; Browning Museum, London, England; South Pasadena High School; Belmont School, Los Angeles; Santa Monica, California High School.

HERTER, Adele. Painter. Born: in New York in 1869. Studied:with Courtois, Bouguereau and Robert-Fleury in Paris. Awards: Pan-American Exposition, Buffalo, 1901; St. Louis Exposition, 1904.

HERTER, Christine. Painter. Born: Irvington-on-Hudson, New York in 1890. Studied: with Sergeant Kendall. Award: National Academy of Design, 1916.

HERTHEL, Alice. Painter. Born: St. Louis, Missouri. Studied: St. Louis School of Fine Arts; and with Simon and Anglada-Camarasa in Paris.

HERZ, Nora. Sculptor. Born: Hipperholme, England in 1910. Studied: Pratt Institute Art School; sculpture Center; and in Germany. Awards: Village Art Center, 1949, 1951; Montclair Art Museum, 1956; Pen and Brush Club, 1956; Hunterdon County Art Center, 1957; Bamberger Company, 1957, 1958. Collections: Bavarian National Museum, Munich, Germany; Athens, Georgia.

HESS, Sara. Painter. Born: Troy Grove, Illinois in 1880. Studied: Art Institute of Chicago; Julian Academy; and in Paris, with Richard Miller and Henry Hubbel. Awards: American Women Artists, Paris, France; Ridgewood Art Association. Collections: Oshkosh Museum of Art; Vanderpoel Collection; Gary Memorial Gallery, Gary, Indiana; Ridgewood New Jersey Women's Club.

HETFIELD, Mrs. E. H. Painter. Her specialty, portraits. Working in Ohio around 1857.

HEUERMANN, Magda. Painter. Born: Galesburg, Illinois in 1868. Studied: Art Institute of Chicago; and with Sammons, Roth and Max Doerner. Awards: Philadelphia, Pennsylvania, 1935; New Orleans, Louisiana; Atlanta, Georgia. Collections: Carnegie Library, Joliet, Illinois; University of Iowa; Beloit College; Vanderpoel Collection; Winfield, Scott Schley School, Chicago; Carnegie Library, Nashville, Tennessee; Springfield Illinois Academy of Fine Arts; Victoria and Albert Museum, London.

HEUSSER, Eleanore E. Painter. Born: North Haledon, New Jersey. Studied: Cooper Union Art School; Columbia University. Award: Fulbright fellowship, 1952-54. Collection: Newark Museum.

HEUSTIS, Louise L. Painter. Born: Mobile Alabama.Studied: Art Students League, with Chase; Julien Academy in Paris. Best known as a portrait painter.

HEYLER, Mary P. Painter. Born: Philadelphia, Pennsylvania. Studied: School of Design, Philadelphia; Pennsylvania Academy of Fine Arts. Her specialty--landscapes and figures. Designed stained glass windows: St. Johns P.E. Church, Suffolk, Virginia; Church of the Restoration, Philadelphia.

HIBBARD, Elisabeth H. Sculptor. Born: Portland, Oregon in 1894. Studied: Portland, Oregon Art School; University of Chicago; Art Institute of Chicago; Grande Chaumiere, Paris; also with Polasek, Bourdelle, Navellier and deCreeft. Awards: Art Institute of Chicago, 1925; Chicago Gallery Association, 1929, 1930, 1932; National Association of Women Artists, 1937. Collections: Illinois State Museum, Springfield; Vanderpoel Collection; University of Chicago; Norton Memorial Hall, Chautauqua, New York; Jackson Park, Chicago.

HIBEL, Edna. Painter. Born: Boston, Massachusetts in 1917. Studied: Boston Museum of Fine Arts School; and with Carl Zerbe and Jacovleff. Award: Boston Art Festival, 1956. Collections: Boston Museum of Fine Arts; Harvard University; Norton Gallery of Art.

HICKEY, Rose. Sculptor. Born: Passaic, New Jersey in 1917.
Studied: Pomona College; Art Students League; University of
Iowa; and with Bridgman, Zorach and Laurent. Awards:
Los Angeles Museum of Art, 1944; Oakland Art Gallery, 1945,
1946; Pasadena Art Institute, 1945, 1951; Joslyn Museum of
Art, 1950; Walter Art Center, 1951; Des Moines Art Center,
1953; National Association of Women Artists, 1952.

HICKOX, Anna L. Painter. As a water colorist she was
exhibiting her work at the Pennsylvania Academy of Fine Arts
in 1925.

HICKS, Elizabeth. Painter. Born: New York City in 1886.
Studied: New York University; also with Henri, Chase, Cox
and LaFarge. Collection: University of Connecticut.

HICKS, Fannie. Noted for her drawings in the Louisville,
Kentucky area.

HIGGINS, Mollie. Painter. Born: Bar Harbor, Maine in
1881. Studied: Art Students League, with Young Boardman
Robinson and John Sloan; Academie Julien, Paris; Academie
Ranson, and with Fernand Leger, Paris; in Woodstock with
Henry Mattson. Exhibited predominately in Woodstock.

HILDEBRANDT, Cornelia. Painter. Born: Eau Claire, Wisconsin.
Studied: Art Institute of Chicato; with Augustus Koopman,
and Virginia Reynolds; also studied in Paris. Awards:
National Association of Women Artists, 1946; Pennsylvania
Society of Miniature Painters, 1947, 1948; American Society
of Miniature Painters, 1941. Collections: Corcoran Art
Gallery; Metropolitan Museum of Art; Philadelphia Museum of
Art.

HILDRETH, Susan W. Painter. Born: Cambridge, Massachusetts.
Studied: Art Students League; and with Ross Turner.

HILER, Hilaire. Painter. Born: St. Paul, Minnesota in 1898.
Studied: University of Pennsylvania; University of Denver;
University of Paris, France; Golden State University, Los
Angeles; National College, Ontario, Canada. Awards:
Academie Latine; Society Academy d'Historical Internationale,
France. Collections: Musee du Luxembourg; California Play-
house; Santa Barbara Museum of Art; Museum of New Mexico;
Museum of Modern Art; Veterans Memorial Museum, San Francisco;
Los Angeles Museum of Art; Museum of Living Art, New York;
Harvard University; Aquatic Park Casino, San Francisco;
Grand Duc, Le Jockey, College Inn, Plantations restaurants
in Paris, France; Maryland Club Gardens, Benning, Maryland;
Hotel Lafayette Game Room, New York.

HILL, Miss C. Painter. Noted for her flower paintings.
She worked and exhibited in 1829.

HILL, Clara. Sculptor. Born: in Massachusetts. Studied:
with Augustus Saint Gaudens; and with Puech at the Julien
Academy and Injalbert at the Colarossi Academy in Paris.

HILL, Pamela E. Painter. Born: in 1803 and died in 1860.
As a miniature painter in Boston she exhibited at a number
of the Boston Athenaeum Exhibitions.

HILL, Pearl L. Painter. Born: Lock Haven, Pennsylvania in
1884. Studied: Pennsylvania Museum and School of Industrial
Art.

HILL, Polly K. Etcher. Born: Ithaca, New York in 1900.
Studied: University of Illinois; Syracuse University; and
with Hawley, George Hess and Jeannette Scott. Awards:
Society of American Graphis Artists, 1929, 1948; Brooklyn
Society of Etchers, 1930-1933; Florida Federation of Art,
1933, 1944, 1950; Southern States Art League, 1943; Gulf
Coast Group, 1946; Philadelphia Printmakers Club, 1941;
Philadelphia Sketch Club, 1957; Florida Art Group, 1951;
Library of Congress, 1950. Collections: Library of Congress;
Tel-Aviv Museum, Israel; Syracuse Museum of Fine Arts;
Metropolitan Museum of Art; J. B. Speed Memorial Museum.

HILL, Sara B. Etcher. Born: Danbury, Connecticut.
Studied: with Alphaeus Cole.

HILLES, Carrie P. Painter. Known as a miniature painter
she exhibited her paintings at the Pennsylvania Academy
of Fine Arts in 1925.

HILLS, Anna Althea. Painter. Born: Ravenna, Ohio.
Studied: Art Institute of Chicago; Cooper Union School;
Julien Academy, Paris. Awards: Pan-California Exposition,
1915; California State Fair, 1919.

HILLS, Laura Coombs. Painter. Born: Newburyport,
Massachusetts in 1859. Studied: Art Students League;Cowles
Art School with Helen M. Knowlton. Awards: Art Interchange,
1895; Paris Exposition, 1900; Panama Exposition, 1915;
Pennsylvania Society of Miniature Painters, 1916. Chiefly
painted miniatures.

HILLSMITH, Fannie. Painter. Born: Boston, Massachusetts
in 1911. Studied: Boston Museum of Fine Arts School; Art
Students League, with Alexander Brook, Sloan and Hayter.
Awards: Currier Gallery of Art, 1952; Berkshire Museum, 1956,
1957; Boston Art Festival, 1957; Portland Museum of Art,
1958; Boston Museum of Fine Arts School, Alumni Traveling
Scholarship, 1958. Collections: Museum of Modern Art; New
York Public Library; Currier Gallery of Art; Fogg Museum of
Art; Addison Gallery of American Art; Gallatin Collection.

HIMLER, Mary Martha. Painter. Born: Greensburg,
Pennsylvania in 1890. Studied: Pennsylvania State
University; Teachers College, Indiana, Pennsylvania;
University of Pittsburgh; Carnegie Institute; Columbia
University, also with Winslow, Edmund Ashe, Frank Bicknell.
Awards: Associated Artists of Pittsburgh, 1934; Greensburg
Art Club, 1935, 1939, 1953, 1946. Ebensburg Fair, 1939.
Collections: Public Library, Latrobe, Pennsylvania;
Associated Artists of Pittsburgh; Pennsylvania State
University.

HINCHMAN, Margaret S. Painter. A watercolorist she was
exhibiting her work at the Pennsylvania Academy of Fine
Arts in 1925.

HINKLE, Catherine. Painter. Born: St. Joseph, Michigan
in 1926. Studied: Kalamazoo College; Institute of Design,
Chicago; and with Alexander Archipenko, Richard Koppe and
Emerson Woelffer. Exhibited in the 1950 in the Chicago
area predominately.

HINTON, Mrs. Howard. Sculptor. Born: in 1834 and died in
New York City. Studied: with Lant Thompson.

HIRSH, Alice Y. Painter. Exhibited at the National
Association of Women Painters and Sculptors.

HIRST, Claude R. (Mrs.). Painter. Born: Cincinnati, Ohio.

HITCHCOCK, Orra W. Painter. Born: in 1796 and believed to
have died in 1851. She was chiefly a landscapist and
illustrator.

HITTLE, Margaret A. Painter. Born: in 1886. Studied:
Art Institute of Chicago. She was also an illustrator
and etcher and has executed several of her works in schools
in Chicago.

HOARD, Margaret. Sculptor. Born: in Iowa. Studied: Art
Students League; Collection: Metropolitan Musem of Art.

HOBBIE, Lucille. Painter. Born: Boonton, New Jersey in
1915. Awards: Montclair Art Museum, 1951, 1952, 1953;
Seton Hall University, 1954; National Arts Club, 1958;
Newark Art Club, 1954; Irvington Museum, 1951, 1952;
New Jersey Watercolor Society, 1956; Collections: Montclair
Art Museum; Williamsburg Foundation, Virginia.

HOBSON, Katherine T. Sculptor. Born: Denver, Colorado in
1889. Studied: Art Students League; also in Europe;
sculpture with Walter Sintenis and Dresden. Collections:
University of Konigsberg and Gottingen; University Library,
Gottingen; St. James Church, New York City; Bahnhofsplatz,
Gottingen; School of Technology, Dresden.

Malvina Hoffman, BACCHANALE RUSSE. Bronze with green patina, 14 1/2" high X 7 1/2". The Metropolitan Museum of Art (Bequest of Mary Stillman Harkness, 1950).

HODGE, Helen F. Painter. Born: Topeka, Kansas. Studied: Corcoran School of Art. Award: Kansas State Fair.

HOE, Mabel Kent. Painter. Born: Cranford, New Jersey in 1880. Studied: Art Students League; and with Archipenko, Bridgman, Miller, Nicolaides and Arthur Lee. Award: National Association of Women Artists, 1936.

HOENING, Margaret. Painter. Born: Hoboken, New Jersey. Studied: Smith College; Art Students League; with Allen Lewis, Harry Wickey, Charles Locke and William von Schlegell. Collection: Library of Congress.

HOFF, Charlotte M. Painter. Studied: Cleveland School of Art; New York School of Art; with Chase, Henri and Parsons. She was founder of Ohio-Born Women Artists Exhibit.

HOFF, Margo. Painter. Born: Tulsa, Oklahoma. Active in many areas of Art; Printmaking, stage and costume designing, and mosaics. She has received many prizes and awards. Since 1944 her work has been in well over a hundred exhibitions in the United States and abroad. She was visiting artist at the American University, Beirut, Lebanon in 1955.

HOFFMAN, Belle. Painter. Born: Garrettsville, Ohio in 1889. Studied: Cleveland School of Art; Art Students League; and with Henry Snell. Noted for her landscapes. Award: Cleveland Museum, 1923.

HOFFMAN, Florice W. Painter. Born: Scranton, Pennsylvania in 1893. Studied: California School of Fine Arts; Art Students League; Parsons School of Design, in Paris.

HOFFMAN, Malvina. Sculptor. Born: New York City in 1887. Studied: painting with John Alexander; sculpture with Gutzon Borglum, and Herbert Adams in New York; with Auguste Rodin, in Paris. Awards: Paris Salon, 1911; National Academy of Design, 1917, 1921; gold medal, Pennsylvania Academy of Fine Arts, 1920; gold medal, National Academy of Design, 1924; gold medal, National Association of Women Painters and Sculptors; New York League of Business and Professional Women, 1935; Career Tours Commission, 1939; Palmes Academiques, France, 1920; Royal Order of St. Sava III, Yugoslavia, 1921; Legion of Honor, France, 1951; Mount Holyoke College, 1937; University of Rochester, 1937; Northwestern University, 1945; Bates College, 1955. Collections: National Academy of Design; Brooklyn Institute of Arts and Science; Academy in Rome; Harvard War Memorial Chapel; Stockholm Art Museum; Chicago Museum of Natural History; Bush House, London; League of Red Cross Societies, Paris; Queen's Hall, London; Corcoran Gallery of Art;

Metropolitan Opera House, New York; Library, Medical Center, New York; Norton Gallery of Art; Frick Library, New York; Hobart College; Springfield Art Museum; American Academy of Arts and Letters; Hackley Art Gallery; Hall of Fame; New York Historical Society; Maryhill Washington Museum; Smith College; International Business Machines; Chapel of the American Military Cemetery, Epinal, France. Joslin Clinic, Boston, Massachussets; St. Andrews-by-the-Sea Church, Rye Beach, New Hampshire.

HOFFMAN, Ruth E. Painter. Born: Buffalo, New York in 1902. Studied: Wellesley College; Child-Walker School of Fine Arts and Crafts; and with Arthur Lee, Agnes Abbott, Edwin Dickinson and Charles Burchfield. Awards: Carnegie Institute, 1941, Terry Art Institute, 1952; Albright Art Gallery, 1939, 1940, 1946; Sisti Gallery, 1955. Collection: Northwestern University, Hall of Fame.

HOFFMASTER, Maud Miller. Painter and printmaker. Born: Manistee, Michigan. Studied: with John Carlson, Edward Timmins; Georges Bal, in Paris. Awards: Mark Twain Society; Beta Sigma Phi. Collections: State Hospital, Ypsilanti, Michigan; Olivet College; Olivet and Ryerson Library, Grand Rapids, Michigan; Highland Park Society of Art, Dallas, Texas; Traverse City State Bank; Munson Hospital, Traverse City; Masonic Temple, Traverse City; Designed the Fine Arts Building, National Music Camp, Interlochen, Michigan.

HOGAN, Jean. Painter. Born: Hartford, Connecticut. Studied: Pembroke College; Brown University. Awards: Springfield Art League, 1938, 1942; Connecticut Academy of Fine Arts, 1943.

HOHENBERG, Marguerite. Painter. Born: Vienna, Austria in 1883. Studied: University of Chicago; Chicago Academy of Fine Arts. Awards: Mississippi Valley Art, 1955; Guggenheim scholarship, 1943. Collections: Museum of Non-Objective Painting, New York; Illinois State Museum; Panelit Corporation, Skokie, Illinois.

HOLBROOK, Vivian N. Painter. Born: Mt. Vernon, New York in 1913. Studied: Yale School of Fine Arts. Awards: Florida Federated Art, 1942, 1943, 1951; Florida State Fair, 1947; Harry Rich Competition, Miami, 1957.

HOLCOMB, Alice. Studied: Smith College; Art Students League; National Academy, School of Fine Arts. Award: Annual Exhibition of Catherine Lorillard Wolfe Art Club, Inc, National Arts Club, New York. Mrs. Newcomb is listed in Who's Who of American Women.

HOLDEN, Cora. Painter. Born: In New England. Studied:
Massachusetts Normal Art School; Cleveland School of Art;
also studied in Europe. Collections: Federal Reserve Bank,
Cleveland; Goodyear Hall, Akron, Ohio.

HOLLERITH, Lucia Beverly. Painter. Born: Washington, D.C.
in 1891. Studied: Corcoran School of Art; and with Cameron
Burnside, Henry Snell and Karl Knaths.

HOLSMAN, Elizabeth T. Painter and sculptor. Born:
Brownville, Nebraska in 1873. Studied: Art Institute of
Chicago. She executed bas-reliefs as well as portrait
paintings.

HOLT, Dorothy M. Painter. Born: Providence, Rhode Island
in 1909. Studied: Rhode Island School of Design. Award:
Hallmark, 1952. Collections: Rhode Island School of
Design Museum; Bristol Yacht Club; Bristol Manufacturing
Company, Rhode Island; Ida Lewis Yacht Club, Newport; New
York Hospital; Ford Times, 1957, 1958; Preservation Society,
Newport.

HOLT, Julia Samuel Travis. Painter. Born: Hampton, Virginia
in 1897. Studied: State Teachers College, Farmville,
Virginia; William and Mary College; and with Jerry Farnsworth.
Award: Mariner's Museum, Newport News, Virginia, 1945.

HOLT, Naomi. Portrait painter. Born: Washington, D.C. in
1911. Studied: San Diego Academy of Fine Arts; Corcoran
School of Art; Pennsylvania Academy of Fine Arts. Awards:
St. Gaudens and Alexander medals 1930; Corcoran School of
Art, 1934.

HOMER, Henrietta Maria Benson. Born: in 1809 and died in
1884. She was known as a watercolorist of flowers.

HOOD, Ethel P. Sculptor. Born: Baltimore, Maryland in
1908. Studied: Art Students League; Julian Academy, Paris.
Awards: gold medal, Catherine L. Wolfe Art Club, 1954;
Society of Washington Artists, 1939. Collections: Radio
City and French Building, Rockefeller Center, New York City;
Brookgreen Gardens, South Carolina.

HOOK, Leah Verity. Painter. Studied: with Jane Freeman
and Alpheus Cole. A painter of portraits and still life.

HOOKER, Margaret Huntington. Painter. Born: Rochester,
New York in 1869. Studied: Art Students League;
Metropolitan School of New York; also in Paris and London.
She was illustrating for the New York Tribune in 1897.

HOOPER, Annie Blakeslee. *Painter and illustrator.* Born: in California. Studied: San Francisco Art School; Art Students League; and with Charles Melville Dewey.

HOOPER, Rosa. *Painter.* Born: in 1876. She was a genre painter.

HOOWIJ, Jan. *Painter.* Born: Hengelo, Netherlands in 1907. Studied: Academy of Fine Arts, The Hague; Grande Chaumiere, Paris. Awards: Royal subsidy for Artists, Holland, 1931-34; Van Duyl prize, 1935; Ebell Salon, Los Angeles, California, 1952, gold medal, Los Angeles City Art Festival, 1951. Collections: Brooklyn Museum; Joslyn Art Museum; Philbrook Art Center; Honolulu Academy of Art.

HOPKINS, Edna Boles. *Engraver.* Born: in Michigan. Collections: Library of Congress, Washington, D. C.; Walker Art Gallery, Liverpool; National Museum, Stockholm; Bibliotheque d'Art et Archaeologie, Paris; Cincinnati Art Museum; Detroit Institute of Arts.

HOPKINS, Ruth Joy. *Portrait Painter.* Born: Fremont, Nebraska in 1891. Studied: Colorado Springs Fine Arts Center; College of Fine Arts, Morelia, Mexico. Awards: Natrona County Fair, 1953; Wyoming State Fair, 1955. Collections: Wyoming State Capitol, Cheyenne; Wyoming National Bank, Casper; Fort Casper Museum; St. Francis Boys' Home, Salina, Kansas; Kansas State College; Swedish Crucible Steel Company, Detroit.

HOPPER, Jo N. *Painter.* Born: New York City. Studied: with Robert Henri, Kenneth Hayes Miller. Award: Huntington Hartford Foundation fellowship, 1957. Has exhibited extensively.

HORDER, Nellie P. *Painter.* Born: Mount Hope, Kansas in 1885. Awards: Western Washington Fair, 1951, 1952. Exhibited predominately throughout the Northwest.

HORDER, Jocelyn Clise. *Engraver.* Born: Seattle, Washington in 1923. Studied: University of Washington; Cornish School with Amelio Amero.

HORLE, Edith L. *Etcher.* Born: Syracuse, New York; Studied: Philadelphia Museum School of Industrial Art; and with Breckenridge. Awards: Rochester Memorial Art Gallery, 1945; Syracuse Printmakers, 1946, 1957, 1958; Finger Lakes Exhibition, 1945; Onondaga County Historical Society, 1947, 1951, 1952, 1958; Syracuse Museum of Fine Arts, 1946, 1955, 1957, 1958; Cayuga Museum of Art, 1946. Collections: Rochester Memorial Art Gallery; Woodcut Society, Kansas City, Missouri; Syracuse University; Onondaga Valley Academy; Syracuse Museum of Fine Arts.

HORNE, Laura T. Painter. Born: Dalton, Georgia in 1891.
Studied: National Academy of Design; and with George
Maynard, Francis Jones, George Bridgman and Leon Kroll.
Collections: Chinese Embassy, Washington, D. C.; Trinity
Church, Mt. Vernon, New York.

HORNE, Nellie M. Painter. Born: Eliot, Maine in 1870.
Studied: with N. D. Tenney. She was known as a portrait
painter.

HORTON, Harriet H. Painter. Principally a painter of
miniatures and portraits. She died in 1922. Collection:
Minnesota Historical Society.

HORWITZ, Louise McMahan. Painter. Born: Pauls Valley,
Oklahoma in 1903. Studied: Kidd Key College, Sherman,
Texas; Washington University; Skowhegan School of Art;
also with Arnold Blanch and Rollin Crampton. Awards:
St. Louis Art Guild, 1949-1951; National Association of
Women Artists, 1951; Hallmark award, 1952; City Art
Museum of St. Louis, 1955.

HOSKINS, Gayle Porter. Painter. Born: Brazil, Indiana in
1887. Studied: Art Institute of Chicago; also with Howard
Pyle. Award: Wilmington Society of Fine Arts.
Collections: Eleutherian-Hagley Mills Foundation Museum,
Wilmington; Delaware Chamber of Commerce; E. I. DuPont de
Nemours and Company, Wilmington; Wilmington Savings Fund
Society; Wilmington Artisans' Bank.

HOSMER, Florence A. Painter. Born: Woodstock, Connecticut.
Studied: Massachusetts School of Art; Boston Museum of
Fine Arts School; and with Joseph DeCamp, Anson Kent Cross,
Charles Woodbury. Collections: International Institute of
Boston; Essex Institute, Salem, Massachusetts; Park Street
Church, Boston.

HOSMER, Harriet. Sculptor. Born: Watertown, Massachusetts
in 1831. Studied: in Lenox, Boston; and in Rome.
Collection: Lafayette Park, St. Louis.

HOSTERMAN, Naomi S. Painter. Born: Elkhart, Indiana in
1903. Studied: Herron Art Institute; Scott Carbee School,
Boston; Indiana University; Cincinnati Museum Association
School. Awards: Allied Artists of West Virginia, 1938,
1942, 1946. Collection: First Presbyterian Church,
Charleston, West Virginia; Baptist Temple, Charleston,
West Virginia; Daywood Art Gallery, Lewisburg, West Virginia;
Laird Memorial Hospital, Montgomery, West Virginia;
Charleston Airport; Charleston General Hospital; Kanawha
Valley Hospital; Morris Harvey College.

HOUSTON, Caroline A. Painter. Born: 1871. She was a miniature painter.

HOUSTON, Frances C. Lyons. Painter. Born: 1867; died 1906.

HOVENDEN, Martha M. Painter. Was exhibiting in 1924 at the Pennyslvania Academy of Fine Arts.

HOWARD, Clara F. Painter. Born: Poughkeepsie, New York in 1866. Studied: National Academy of Design; Art Students League. She was a miniature painter.

HOWARD, Edith L. Painter. Born: Bellows Falls, Vermont. Studied: with Daingerfield and Snell.

HOWARD, Eloise. Painter. Exhibited at the 33d Annual Exhibition of the National Association of Women Painters and Sculptors.

HOWARD, Loretta. Painter. Born: Chicago, Illinois in 1904. Studied: Bennett School, Millbrook, New York; also with Robert Henri. Collection: Art Institute of Chicago.

HOWARD, Lucile. Painter. Born: Bellows Falls, Vermont in 1885. Studied: Philadelphia School of Design for Women; and with Elliott Daingerfield and Henry Snell. Award: Shillard medal, Philadelphia, Pennsylvania. Collections: Wilmington Society of Fine Arts; Swarthmore College; Alumni Association Philadelphia School of Design for Women; Thomas Jefferson High School, Brooklyn, New York.

HOWELL, Felice. Painter. Born: Honolulu, Hawaii in 1897. Studied: Corcoran School of Art; Philadelphia School of Design for Women. Awards: National Association of Women Artists, 1916; National Academy of Design, 1921; Art Institute of Chicago, 1921, 1927; Society of Washington Artists, 1921, 1922; Washington Watercolor Club, 1921. Collections: Corcoran Gallery of Art; Metropolitan Museum of Art; John Herron Art Institute; Art Institute of Chicago; Museum of City of New York; University of Pennsylvania.

HOWEN, Lillian H. Painter. Born: Pine Bluff, Arkansas in 1907. Studied: University of California; University of Alberta, Canada; and with A. Y. Jackson, J. W. G. MacDonald and James Dichmont. Awards: Kern County Fair, 1945-1957; American Association of University Women, 1958.

HOWLAND, Anna Goodhart. Painter. Born: Atchison, Kansas in 1871. Studied: with J. H. Moser.

HOWLAND, Charity. Primitive watercolor landscapist working around 1825.

HOWLAND, Edith. Sculptor. Born: Auburn, New York. Studied:
in Paris with Gustave Michel and Augustus Saint Gaudens.
Award: Paris Salon, 1913. Collection: Metropolitan Museum
of Art.

HOYT, Dorothy. Painter. Born: East Orange, New Jersey in
1909. Studied: Cornell University; Art Students League;
New School of Social Research. Awards: National Association
of Women Artists, 1955, 1958; New Jersey Society of Painters
and Sculptors, 1957.

HOYT, Mrs. E. C. Painter. She was exhibiting her landscapes
from 1859 to 1968.

HOYT, Edith. Painter. Born: West Point, New York in 1894.
Studied: Corcoran School of Art; with Henry B. Snell and
Charles Woodbury; and in France. Collections: Quebec
Provincial Museum; Quebec Historical Museum; Chateau
Frontenac; Canadian National Railways; Canada Steamships;
Clarke Steamship Lines, Guatemala; Tadoussac Hotel, Canada;
Little Rock Art Association; Robert Woods Bliss Collection,
Washington, D. C.

HUBBARD, Bess Bigham. Sculptor. Born: Fort Worth, Texas
in 1896. Studied: Chicago Academy of Fine Arts; and with
Boardman Robinson, Xavier Gonzalez, Alexandre Hogue, Octavio
Medellin, Ernest Freed, and William Zorach. Awards: Dallas,
Texas, 1944; Museum of Fine Arts, Abiline, Texas, 1949-1951;
Fort Worth Art Association, 1950. Collections: Colorado
Springs Fine Arts Center; Dallas Museum Fine Arts; Texas
Fine Arts Association; Elizabet Ney Museum.

HUBBARD, Mary W. Painter. Born: Springfield, Massachusetts
in 1871. Studied: Art Students League; Constant in Paris.

HUDSON, Grace Carpenter. Painter. Born: 1865. She was a
genre painter.

HUDSON, Jacqueline. Lithographer. Born: Boston,
Massachusetts. Studied: National Academy of Design;
Art Students League. Awards: Library of Congress, 1951;
Rockport Art Association, 1953, 1956, 1957.

HUEY, Florence Greene. Painter. Born: Philadelphia,
Pennsylvania in 1872. Studied: Pennsylvania Academy of
Fine Arts; also with DeCamp, Beaux, Clements, and Thouron.
Award: Baltimore Watercolor Club, 1927.

HUFFER, Cornelia C. Painter. Born: Savannah, Georgia in
1903. Studied: Cooper Union Art School; Grand Central
School of Art; National Academy of Design; also with Ernest
Roth. Awards: National League of American Pen Women, 1932.
Currier Gallery of Art, 1947; Ogunquit Art Center, 1947.
Collections: University of New Hampshire; Union College.

HUGHES, Daisy M. Painter. Born: Los Angeles, California in 1883. Studied: University of California; Art Students League; and with George Elmer Browne and George Bridgman.

HULBERT, K. A. Painter. Exhibited at the 33d Annual Exhibition of National Association of Women Painters and Sculptors.

HULL, Marie A. Painter. Born: Summit, Mississippi in 1890. Studied: Pennsylvania Academy of Fine Arts; Art Students League; Broadmoor Art Academy; also in France and Spain. Awards: Mississippi Art Association, 1951; Southern States Art League, 1926; New Orleans Art Association; San Antonio, Texas, 1929; Springville, Utah. Collections: Witte Memorial Museum; Springville Utah Museum; Mississippi Art Association; Municipal Art Gallery, Jackson, Mississippi; Mississippi State Capitol; Governor's Mansion, Jackson, Mississippi; Hinds County Court House; Memphis Court House; Delta State Teachers College; Mississippi State Office Building; Mississippi Hall of Fame; Tulane University, New Orleans; Mississippi Southern College; Port Gibson Mississippi Public Library; Mississippi State College, University, Mississippi; Texas State Teachers College; Meredith College, North Carolina; Blue Mountain College; Belhaven College, Mississippi; Brigham Young University; Abilene, Texas; Mississippi State College for Women; Laurel Mississippi Museum of Art.

HUMBER, Yvonne T. Painter. Born: New York City in 1907. Studied: National Academy of Design; Tiffany Foundation; and with Charles Hawthorne. Awards: Seattle Art Museum, 1945; Women Painters of Washington, 1945; League of American Pen Women, 1946; Stockbridge, Massachusetts, 1935. Collection: Seattle Art Museum.

HUMPHREY, Elizabeth B. Painter. Born: Hopedale, Massachusetts about 1850. Studied: Cooper School of Design; and with Worthington Whittredge. She was chiefly an illustrator which included landscapes, still life and figures.

HUMPHREYS, Marie C. Painter. Born: Deerfield, Massachusetts in 1867. She died in 1906. Known as a miniature painter she exhibited in Europe and America. She was the daughter of J. Wells Champney, who was well known for his works of art.

HUNT, Kari. Sculptor. Born: Orange, New Jersey in 1920. Studied: Cornell University; University of Buffalo; and with Doane Powell. Collections: Doane Powell Collection of portrait masks.

HUNT, Una C. Painter and illustrator. Born: Cincinnati, Ohio in 1876. Studied: Boston Museum of Fine Arts School.

*Anna Vaughn Hyatt Huntington, REACHING PANTHER. Bronze,
45 inches high. The Metropolitan Museum of Art (Gift of
Archer M. Huntington, 1925).*

HUNTER, Evangeline D. Painter. She painted miniatures
which she exhibited at the Pennsylvania Academy of Fine
Arts in Philadelphia in 1925.

HUNTER, Lizbeth C. Painter. Born: in California in 1868.
Studied: with Henry B. Snell.

HUNTINGTON, Anna H. Sculptor. Born: Cambridge,
Massachusetts in 1876. Studied: Art Students League;
also with Hermon MacNeil and Gutzon Borglum. Awards:
Academia Cultural Adriaica; Internationalia Studia
Scientiarum Litterarumque; Accademia di Belle Artes di
Santa Isabel de Hungaria di Seville; Accademia di Belles
Arti, Perugia; Officer, Legion of Honor, France; Grand
Cross Alfonso XII; Syracuse University; Brookgreen Gardens,
1956; fellowship, International Institute of Arts and
Letters, 1957; Citizen of Cuba, 1958; Woman of the Americas,
1958; fellowship, Pierpont Morgan Library, 1958; gold medal,
National Academy of Design, 1958. Collections: in over 200
museums and galleries in the United States. Statues in
New York City; San Francisco; San Diego; Gloucester,
Massachusetts; Newport News, Virginia; Brookgreen Gardens,
South Carolina; San Marcos, Texas; Blois, France; Seville,
Spain; Buenos Aires, Argentina.

HUNTINGTON, Elizabeth H. Painter. Born: South Braintree,
Massachusetts in 1878. Studied: Massachusetts School of
Art; Thayer Academy; and with Ernest Lee Major, and Vesper
George. Exhibited in the New England States.

HUNTLEY, Samantha L. Painter. Studied: Ecole des Beaux
Arts, in Paris; Academie Julien, in Paris. Known as a
portrait painter she has painted many prominent people.

HUNTLEY, Victoria H. Lithographer. Born: Hasbrouck
Heights, New Jersey in 1900. Studied: Art Students League;
also with John Sloan, Max Weber, William C. Palmer and
Kenneth Hayes Miller. Awards: Art Institute of Chicago,
1930; Philadelphia Printmaker Club, 1933; Library of
Congress, 1945, 1949; Association American Artists, 1946;
grant, American Academy of Arts and Letters, 1947
Guggenheim fellowship, 1948; Society of American Graphic
Artists, 1950, 1951; Art Students League, 1950, 1951.
Collections: Metropolitan Museum of Art; Art Institute of
Chicago; Boston Museum of Fine Arts; Philadelphia Museum
of Art; Cleveland Museum of Art; Whitney Museum of American
Art; International Business Machines; Library of Congress;
Brooklyn Museum; University of Florida; University of
Michigan; Albany Printmakers Club; Rochester Memorial Museum;
Art Students League; Cincinnati Museum Association; Paris,
France, 1954; also touring Italy, 1955-56, 1956-57; Museum
of Fine Arts of Houston; Pennsylvania Academy of Fine Arts;

New York Public Library; Newark Public Library; Philadelphia Printmaker Club; University of Glasgow; Italian Government; United States Post Office, Springville, New York; Greenwich, Connecticut.

HUNTOON, Mary. Painter. Born: Topeka, Kansas in 1896. Studied: Washburn University; Art Students League, with Henri and Pennell; and in Paris. Awards: Women Painters, Wichita, Kansas, 1936; "Woman of the Year" in Art and Science, Topeka, Kansas, 1954. Collections: Salina Art Association; Federation of Women's Club, Kansas; Topeka Public Library; Topeka State House.

HURD, Angela M. Painter. Born: Stafford, England in 1898. Studied: College of Notre Dame, Liverpool; in Italy; and with C. Law Watkins, Karl Knaths. Awards: Southern California Exhibition, Del Mar, 1956; Showcase of the Arts, 1957.

HURFORD, Miriam Story. Painter. Born: Rome, New York in 1894. Studied: Syracuse University; Albright Art School; Art Institute of Chicago. Collections: Illustrations of many school textbooks.

HURLBURT, Elizabeth. Painter. Born: in 1838. Known principally as a landscape painter.

HURLEY, Irene Bishop. Painter. Born: Colorado Springs, Colorado in 1881 and died in 1905. Studied: Art Students League. She was known as a miniature painter.

HURRY, Lucy Washington. Painter. Born: Hagerstown, Maryland in 1884. Studied: Art Students League; with Kenyon Cox, Marshall Fry and Fayette Barnum.

HUSE, Marion. Painter. Born: Lynn, Massachusetts. Studied: New School of Design, Boston; Carnegie Institute of Technology; also with Charles Hawthorne. Awards: Springfield Art League, 1925, 1936, 1941; Connecticut Academy of Fine Arts, 1933; Albany Institute of History and Art, 1938, 1944. Collections: Lawrence Museum of Art, Williamstown, Massachusetts; Wood Gallery of Art, Montpelier, Vermont; Bennington Vermont Museum of History and Art; Boston Museum of Fine Arts; Alabama Polytechnic Institute; American Association of University Women; University of Wisconsin; Library of Congress; United States State Department; Howard University; Virginia Museum of Fine Arts; Victoria and Albert Museum, London, England; Nelson Gallery of Art; Tel-Aviv Museum; State Teachers College, Albany, New York; Munson-Williams-Proctor Institute.

HUSEBY, Arleen M. Painter. Born: Park Ridge, Illinois.
Studied: Art Institute of Chicago; Chicago Academy of
Fine Arts. Awards: Dallas County Exhibition, 1955;
Federation of Dallas Artists, 1955; Texas State Fair,
Texas Fine Arts Society.

HUTCHINSON, Mary E. Painter. Born: Melrose, Massachusetts
in 1906. Studied: Agnes Scott College; National Academy of
Design; also studied in Europe. Awards: National Association
of Women Artists, 1935, 1938. Collections: High Museum of
Art; Saratoga California Museum; Syracuse University;
Georgia Museum of Art.

HUTCHISON, Ellen W. Painter. Born: East Hartford,
Connecticut in 1868. Studied: with C. E. Porter and
George Thomson.

HUTH, Marta. Painter. Born: Munich, Germany in 1898.
Studied: State School of Photography, Academy of Munich.
Has exhibited in California, Chicago and New York State.

HUTSON, Ethel. Painter. Born: in 1872. Studied: Pratt
Institute; National Academy of Design; Newcomb Art School,
New Orleans, Louisiana; Cooper Institute; Art Students
League. She was noted for her landscapes.

HUTTON, Dorothy W. Etcher. Born: Cleveland, Ohio in 1898.
Studied: Minneapolis School of Art; University of Minnesota;
Also studied in Paris. Awards: Philadelphia Plastic Club,
1943-1945; National Competition for needlepoint design,
National Cathedral, Washington, D. C. Collections: Mint
Museum of Art; Smithsonian Institute; Atwater Kent Museum,
Philadelphia.

HYDE, Helen. Painter and etcher. Born: Lima, New York
in 1863, and died in 1919. Collections: Library of Congress;
New York Public Library; Boston Museum.

HYDE, Josephine E. Painter. Born: Columbus, Ohio in 1885.
Studied: Stanford University; and with Will Foster, Nell
Walker Warner and Edward Withers. Award: Pacific Southwest
Exhibition.

INGERSOLL, Anna. Painter. Was exhibiting in 1924 at the Pennsylvania Academy of Fine Arts.

INGERSOLL, Emma K. Painter. Born: in Chicago in 1878. Award: bronze medal for her miniatures, 1904.

INGHAM, Elizabeth H. Painter and illustrator. Born: Easton, Pennsylvania. Studied: Pennsylvania Academy of Fine Arts; also with Whistler in Paris.

INGLIS, Antoinette. Painter. Born: Cortland, New York in 1880. Studied: Art Students League. Award: North Shore Art Association, 1944. Collection: Sheldon Swope Art Gallery, Terre Haute, Indiana.

INGRAHAM, Ellen M. Painter. Born: in 1832 and died in 1917. She painted portraits and miniatures.

INGRAHAM, Katherine Ely. Etcher. Born: Minneapolis, Minnesota in 1900. Studied: University of Wisconsin; Art Students League; and with Joseph Pennell. Awards: Madison Art Association, 1944, 1946. Collection: Library of Congress.

INMAN, Pauline W. Engraver. Born: Chicago, Illinois in 1904. Studied: Smith College; and with Allen Lewis. Collections: Carnegie Institute; Library of Congress; Metropolitan Museum of Art; Pennsylvania State; Montclair Art Museum.

IPCAR, Dahlov. Painter. Born: Windsor, Vermont in 1917. Studied: Oberlin College. Collections: murals, United States Post Office, La Follette, Tennessee; Yukon, Oklahoma; Whitney Museum of American Art; Newark Art Museum; Fairleigh Dickinson College; Metropolitan Museum of Art.

IPPOLITO, Angelo. Painter. Born: Arsenio, Italy in 1922. Studied: Ozenfant School of Fine Arts; Brooklyn Museum School of Art; Instituto Meschini, Rome, Italy. Collections: Whitney Museum of American Art; Phillips Collection, Washington, D. C.; Munson-Williams-Proctor Institute; Sarah Lawrence College.

IRELAND, Lucille R. Awards: The Barnes Foundation 1951-53; The European Travel Study, 1958. Collection: Henry P. Dubin, Manuel Cabral.

IRISH, Margaret H. Painter. Born: in 1878. Studied: St. Louis School of Fine Arts.

IRVIN, Sister Mary Francis. Painter. Born: Canton, Ohio in 1914. Studied: Seton Hall College; Carnegie Institute; Art Institute of Chicago; Cranbrook Academy of Art. Awards: Associated Artists of Pittsburgh; Greensburg Art Association, 1944, 1945, 1955, 1957. Collections: Carnegie Institute; St. Charles Boromeo Church, Twin Rocks, Pennsylvania; Peabody, Central Catholic and Elizabeth Seton High School, Pittsburgh.

IRVIN, Melita. Sculptor. Born: Port Hope, Ontario, Canada. Exhibited predominately in the Chicago area.

IRVIN, Rea. Painter. Born: San Francisco, California in 1881. Studied: Mark Hopkins Art Institute.

IRVIN, Virginia H. Painter. Born: Chicago, Illinois in 1904. Studied: Art Institute of Chicago; and with Elsie Dodge Pattee. She is a miniature painter. Awards: American Society of Miniature Painters, 1944; California Society of Miniature Painters, 1947, 1949; Pennsylvania Society of Miniature Painters, 1950, National Association of Women Artists, 1954, 1958. Collection: Philadelphia Museum of Art.

IRVING, Joan. Painter. Born: Riverside California in 1916. Studied: Riverside California College; Art Center School, Los Angeles, California; and with Barse Miller. Awards: Festival of Art, Laguna Beach, 1951; California Watercolor Society, 1951; National Orange Show, 1951. Collections: Metropolitan Museum of Art; Newport High School Collection.

ISAACS, Betty L. Sculptor. Born: Hobart, Tasmania in 1894. Studied: Cooper Union Art School; Art Students League; Alfred University; and in Vienna. Awards: National Association of Women Artists, 1955, 1957. Collections: Cooper Union Museum; Church of St. Anselm, Tokyo, Japan.

IZOR, Estelle P. Painter. Studied: with Forsyth and Steel in Indianapolis; in Chicago with Freer and Vanderpoel; in Boston with H. D. Murphy; and in New York with Chase and Herter.

JACKSON, Annie H. Miniature painter. Born: Minneapolis,
Minnesota in 1877. Studied: with Eric Pape, Murphy, O'Hara,
and Woodbury. Awards: Pennsylvania Society of Miniature
Painters, 1925; Sesqui-Centennial Exposition, Philadelphia,
1926; Boston Tercentenary, 1935; Collections: Brooklyn
Museum; Philadelphia Museum of Art.

JACKSON, Beatrice. Painter. Born: London, England, 1905 of
American parents. Studied: Grand Central Art School; Smith
College; Art Students League; Colorossi Academy, Paris; and
with Wayman Adams, George Elmer Browne, and Andre L'Hote,
Paris. Awards: Morristown Art Association, 1941, 1943;
National Association of Women Artists, 1953; National
League of American Pen Women, 1955, 1957; Connecticut
Academy of Fine Arts, 1955; Allied Artists of America, 1955,
1958; Academic Art Association, 1956; Wolfe Art Club, 1956;
Bronxville Public Library, 1956.

JACKSON, Ella F. Painter. Born: New York, New York in
1894. Studied: Cooper Union Art School; Columbia University;
and with Hans Hofmann, Gabor Peterdi. Awards: Brooklyn
Society of Art, 1950; Brooklyn Museum School, Alumni, 1958.

JACKSON, Hazel Brill. Sculptor. Born: Philadelphia,
Pennsylvania. Studied: Boston Museum of Fine Arts School;
in Italy; and with Bela Pratt, Charles Grafly. Awards:
National Academy, Rome, 1930; National Academy of Design,
1945, 1948. Collections: Concord Art Museum; Montpelier
Vermont Art Museum; Hotchkiss School, Lakeville, Connecticut.
Specializes in animal sculpture, especially horses and dogs.

JACKSON, Lesley (Miss) Painter. Born: Rochester, Minnesota.
Award: Washington Water Color Club, 1905.

JACKSON, May H. Sculptor. Born: Philadelphia, Pennsylvania
in 1877. Studied: Pennsylvania Academy of Fine Arts.
Collections: St. Thomas Church, Philadelphia; Dunbar High
School, Washington, D. C.; Howard University, Washington,
D. C.

JACOBY, Helen E. Painter and Illustrator. Born:
Indianapolis, Indiana. Studied: Pratt Institute; and with
Otto Stark in Indianapolis.

JACOBY, Ruth. Painter. Born: Pittsburgh, Pennsylvania in
1903. Studied: New York University; National Academy of
Design; Art Students League. Collections: Evansville
Indiana Museum; Museum of Modern Art.

JAMES, Alice. Painter and illustrator. Born: in Ohio in
1870. Has exhibited in Philadelphia, Chicago, Washington
and abroad. Illustrator for Harper's and Century
Magazines.

JAMES, Bess B. Painter. Born: Big Springs, Texas in 1897.
Studied: Las Vegas University; Southwest Texas College;
also with Marie Hull and Roy Henderson. Awards:
Louisiana Federation of Women's Clubs, 1936; Mississippi
Art Association, 1942; Lubbock, Texas, 1938.

JAMES, Esther M. Miniature painter. Born: Brookline,
Massachusetts in 1885. Studied: with Hale and Benson.

JAMES, Evalyn G. Painter. Born: Chicago, Illinois in
1898. Studied: Herron Art Institute; Earlham College;
Indiana University; and with William Forsythe. Award:
Indiana State Fair. Collections: Brazil Indiana Court
House; St. Paul's Lutheran Church, Brazil, Indiana; Bee
Ridge Christian Church, Brazil, Indiana.

JAMES, Frances K. Painter. Born: Los Angeles, California
in 1916. Studied: Los Angeles Art Institute; and with
Christian von Schneidau and Nicholi Fechin. Awards:
Grenshaw Fair, 1948; Madonna Art Festival, Los Angeles,
1955. Collection: murals, Rands, Hollywood, California.

JAMES, Sandra. Painter. Awards: Irvington Museum
Association; Sweat Memorial Museum, 1957. Collection:
Florida Gulf Coast Art Center.

JAMISON, Celia. Painter. Born: Prosper, Texas in 1920.
Studied: Texas State College for Women; University of Iowa;
and with Philip Guston. Award: Dallas Museum of Fine Arts,
1957. Collections: University of Iowa; Ft. Worth Art
Association.

JANOWSKY, Bela. Sculptor. Born: Budapest, Hungary in 1900.
Studied: Ontario College of Art; Pennsylvania Academy of
Fine Arts; Cleveland School of Art; Beaux-Arts Institute of
Design; and with Alexander Blazys and Charles Grafly. Award:
Allied Artists of America, 1951. Collections: Queens
University, Kingston, Ontario; Royal Society of Canada;
United States Department of Commerce Building, Washington,
D.C.; United States Post Office, Cooperstown, New York;
Naval Shipyard, Brooklyn, New York.

JANVIER, Catharine Ann. Painter. Born: in Philadelphia
and died in 1923. Studied: Pennsylvania Academy of Fine Arts;
Art Students League.

JAQUES, Bertha E. Etcher. Born: Covington, Ohio. Studied:
Chicago Art Institute. Collections: New York Public Library;
Congressional Library, Washington, D. C.

JAUSS, Anne Marie. Painter. Born: Munich, Germany in 1907. Studied: School of Art, Munich. Collection: New York Public Library.

JAY, Cecil. Painter. Known as a miniature painter and portrait painter in oil.

JECT-KEY, Elsie. Painter. Born: Koege, Denmark. Studied: Art Students League, with Frank DuMond, George Bridgman and Homer Boss; National Academy of Design, with Murphy, Olinsky and Neilson; Beaux-Arts Institute of Design. Exhibited widely in the United States and abroad.

JEMNE, Elsa L. Painter. Born: St. Paul, Minnesota in 1888. Studied: St. Paul Art School; Pennsylvania Academy of Fine Arts, and with Olle Nordmark. Awards: Cresson Traveling Scholarship, Pennsylvania Academy of Fine Arts; St. Paul Art School; St. Paul Institute; Minnesota State Fair; Minneapolis Institute of Art. Collections: Armory, Minneapolis; International Institute, St. Paul; St. Cloud, Minnesota; Ely, Minnesota; Hutchinson, Minnesota; Ladysmith, Wisconsin; City Club, St. Paul.

JENKINS, Hannah T. Painter. Born: Philadelphia. Studied: Pennsylvania Academy of Fine Arts.

JENKINS, Mattle M. Painter. Born: Whitman, Massachusetts in 1867. A painter of miniatures and illustrator.

JENKS, Phoebe P. Portrait painter. Born: Portsmouth, New Hampshire in 1847, and died in 1907. As a portraitist she painted many portraits of important women which was her specialty.

JENNEY, Priscilla B. Painter. Born: Sutton, Nebraska in 1916. Studied: Syracuse University; State University of Iowa; and with Emil Ganso and Fletcher Martin. Awards: Syracuse Association of Art, 1943; Cayuga Museum of History and Art, 1944, 1945. Collections: Syracuse Museum of Fine Arts; Rochester Memorial Art Gallery; Cazenovia Junior College; Radio Station WSYR, Syracuse; Children's Hospital, Iowa City, Iowa.

JENNINGS, Louise. Painter. Born: in 1870.

JENSEN, Margaret. Painter. Born: Buffalo, New York. Studied: Carnegie Institute; University of Pittsburgh; and with Hans Hofmann. Awards: Carnegie Institute Group, 1945; Virginia Museum of Fine Arts, 1947. Collections: Virginia Museum of Fine Arts; Pittsburgh Public Schools; Unity Center of Pittsburgh.

JEROME, Elizabeth. Painter. Born: New Haven, Connecticut in 1824 and died in 1910. Studied: National Academy, with E. Leutze. She was a painter of portraits and miniatures. She exhibited her figure paintings at the National Academy in 1866.

JEROME, Irene. Painter and illustrator. Born: New York in 1858. She had very little art instructions and was mostly self-taught. She illustrated for many books and publications. Noted especially for eighteen sketches of Colorado which she exhibited in 1882.

JERRY, Cherry Barr. Painter. Born: Denver, Colorado in 1909. Studied: National School of Fine and Applied Arts, Washington, D. C.

JESSE, Mira J. Painter. Born: Poznam, Poland in 1947. Has had exhibitions in New York City and Washington chiefly.

JEWETT, Maude S. Sculptor. Born: Englewood, New Jersey in 1873. Studied: Art Students League. Collections: Cleveland Museum.

JOCHIMSEN, Marion. Painter. Born: Juneau, Alaska. Studied: California School of Design; with Frank Van Sloan.

JOHANN, Helen L. Printmaker. Born: West Depere, Wisconsin in 1901. Studied: Milwaukee State Teachers College; Columbia University. Awards: Milwaukee Art Institute, 1936, 1940, 1945, 1951, 1952, 1954; Wisconsin State Fair, 1947. Collection: Library of Congress.

JOHN, Grace S. Painter. Born: Battle Creek, Michigan. Studied: St. Louis School of Fine Arts; Art Institute of Chicago; National Academy of Design; with Charles Hawthorne, Emil Bisttram. Collections: Houston Public Library; History Building, Austin, Texas; Museum of Fine Arts of Houston; Huntsville Texas Library; Princeton University; City Hall, Houston, Texas; Sidney Lanier School, Houston, Texas; Jack Tar Hotel, Galveston, Texas; Balinese Club, Galveston, Texas; Lakewood Yacht Club, Galveston, Texas; Roanoke Steel Corporation, Roanoke, Virginia; Public Library, Roanoke, Virginia; National Bank of Commerce, San Antonio; National Bank of Lufkin, Texas.

JOHNSEN, May A. Painter. Born: Port Chester, New York in 1921. Awards: Silvermine Art Guild; Columbia Fair; Hamilton, Ohio Miniature Painters.

JOHNSON, Adelaide. Sculptor. Born: Plymouth, Illinois. Studied: with Monteverde and Fabi Altini in Rome. Collection: Metropolitan Museum of Art.

JOHNSON, Belle. Sculptor. Exhibited her work in 1925 at the Pennsylvania Academy of Fine Arts.

JOHNSON, Buffie. Painter. Born: New York City in 1912. Studied: University of California at Los Angeles; Art Students League. Collections: Boston Museum of Fine Arts; Baltimore Museum of Art; Newark Museum of Art; Walker Art Center, Minneapolis, Minnesota; Metropolitan Museum of Art; Cincinnati Museum Association.

JOHNSON, Content. Painter. Born: Bloomington, Illinois. Studied: Julien Academy, with Constant and Laurens in Paris; with Chase at the New York School of Art.

JOHNSON, Cordelia. Painter. Born: Omaha, Nebraska in 1871. Studied: with J. Laurie Wallace.

JOHNSON, Doris M. Painter. Born: Oakland, California in 1909. Studied: University of California; California College of Arts and Crafts. Awards: Colorado Springs Fine Arts Center; San Francisco Women Artists, 1938; San Francisco Art Association, 1940.

JOHNSON, Edyth. Miniature painter. Was exhibiting in 1925.

JOHNSON, Grace M. Sculptor. Born: New York City in 1882. Studied: Art Students League; also with Gutzon Borglum. Awards: National Association of Women Artists, 1927, 1917, 1935, 1936. Collections: Whitney Museum of American Art; Brookgreen Gardens, South Carolina; Enclycopaedia Britannica; Public Library, Pleasantville, New York.

JOHNSON, Henrietta. Portrait draughtsman in pastels. She died in 1728. Her portraits are of men and women, famous in the early history of South Carolina.

JOHNSON, Jeanne P. Painter. Born: Danville, Ohio in 1887. Studied: Art Students League; and in Paris with Mme. La Farge, Richard Miller and Lucien Simon.

JOHNSON, Marie R. Painter. Born: Flemington, New Jersey in 1861. Studied: in New York with Chase; and in Paris with Girardot and Courtois.

JOHNSON, Mary Ann. Painter. She died in Connecticut where much of her still life paintings was done.

JOHNSON, Nellie B. Painter. Born: in Louisiana in 1920. She has exhibited in Baton Rouge, Louisiana.

JOHNSTON, Henrietta. Painter. A portraitist in pastels who died in 1729.

JOHNSTON, Marjorie D. Painter. Studied: Ontario College of Art, Toronto; St. Ives, Cornwall, England. Award: Annual Exhibition for Essex County Artists, Windsor, Ontario, Canada.

JOHNSTON, Mary V. Painter. Born: in Cuba in 1865. Studied: with Robert Henri.

JOHNSTON, Ynez. Painter. Born: Berkeley, California in 1920; Studied: University of California at Berkeley. Awards: Guggenheim fellowship, 1952-53; Tiffany Foundation grant, 1955; Metropolitan Museum of Art, 1952. Collections: Santa Barbara Museum of Art; Museum of Modern Art; Whitney Museum of American Art; Metropolitan Museum of Art; City Art Museum of St. Louis; Los Angeles Museum of Art; Philbrook Art Center; University of Michigan; University of Illinois; Wadsworth Atheneum; Philadelphia Museum of Art.

JOHNT, Ethel. Painter. Born: Hamburg, New York in 1904. Studied: Buffalo School of Fine Art; National Academy of Design. Award: Albright Art Gallery.

JOLLEY, Geraldine H. painter. Awards: Oakland Art Museum; Rochester Memorial Art Museum. Collections: Marcus Glaser Collection, Louisiana; Rochester Institute of Technology.

JONES, Amy. Painter. Born: Buffalo, New York in 1899. Studied: Pratt Institute Art School; and with Peppino Mangravite, Anthony di Bona, Xavier Gonzalez. Awards: fellowship, Buffalo, 1931; Baltimore Watercolor Club, 1941, 1954, 1958; Village Art Center, 1951, 1954, 1957; Women's Club, Ossining, New York; Junior League of Westchester, 1955; Saranac Art League, 1939-1942; National Academy of Design, 1956; Pleasantville, New York, 1957. Collections: Wharton School of Finance, University of Pennsylvania, Philadelphia, Pennsylvania; New York Hospital; Marine Hospital, Carville, Louisiana; murals, United States Post Office, Winsted, Connecticut; Painted Post, New York; Schenectady, New York.

JONES, Doris J. Painter. Born: Jersey City, New Jersey in 1911. Studied: National Academy of Design; Dwight School, Englewood; Parsons School of Design; Monmouth College; Rutgers University; Art Students League. Awards: American Artists Professional League, 1955, 1956, 1957; Bloomfield Art League, 1953. Collections: Bloomfield Civic Center; Daughters of the American Revolution, Tamassee, South Carolina Collection.

JONES, Elberta M. Painter. Born: Kansas City, Missouri in 1896. Studied: Art Institute of Chicago; Otis Art Institute; Chouinard Art Institute. Collections: Los Angeles Conservatory of Music; Birmingham Hospital; Los Angeles Athletic Club; Bethlehem Pacific Coast Company.

JONES, Elsie B. Painter. Born: Evanston, Illinois in 1903. Studied: Northwestern University; Art Institute of Chicago; and with Francis Chapin. Exhibited in Illinois chiefly.

JONES, Genevieve E. Painter. Born: Cleveland, Ohio in 1846 and died in 1879. A self-taught artist. She collaborated with Virginia Jones in illustrating the book, "Nests and Eggs of the Birds of Ohio."

JONES, Grace C. Painter. Born: West Falls, New York. Studied: Colarossi Academy in Paris; and with Gaspard and Calot.

JONES, Lois M. Painter. Born: Boston, Massachusetts in 1906. Studied: Boston Normal Art School; Boston Museum of Fine Arts School; Columbia University; Howard University; and in Paris and Rome. Awards: fellowship, General Education Board, 1937, 1938; Boston Museum of Fine Arts School, 1926; National Museum, Washington, D. C. 1940, 1947, 1954; Corcoran Gallery of Art, 1941, 1949; Atlanta University, 1942, 1949, 1952, 1955; Haitian Government, 1954; Lubin award, 1958. Collections: Brooklyn Museum; International Business Machines; Palais National, Haiti; Atlanta University; Howard University; West Virginia State College; Rosenwald Foundation; Retreat for Foreign Missionaries, Washington, D.C.; Barnett Aden Gallery; Cook Hall, Howard University.

JONES, Mildred C. Painter. Born: Scranton, Pennsylvania in 1899. Studied: Philadelphia Museum School of Industrial Art; Academies Julian, Colorossi, Grande Chaumiere, Paris. Awards: Rockport Art Association, 1949, 1953; North Shore Art Association, 1948.

JONES, Nancy. Painter. Born: Providence, Rhode Island in 1887. Studied: Rhode Island School of Design; Fontainebleau School of Fine Arts; and with Charles Hawthorne, Harry Leith-Ross. Collections: Rhode Island School of Design; Hebrew Synagogue, Washington, D. C.; Mt. Pleasant High School; Providence Art Club; Rhode Island School of Design Museum.

JONES, Nell C. Painter. Born: Hawkinsville, Georgia. Studied: Adelphi Academy. Awards: Pen and Brush Club, 1951, 1953; Lorillard Wolfe Art Club, 1950, 1954; National Association of Women Artists, 1955, 1958; Milledgeville Georgia State College for Women, 1951. Collections: High Museum of Art; Ft. Worth Museum of Art.

JONES, Susan A. Painter. Born: Philadelphia, Pennsylvania. Studied: Moore Institute; Pennsylvania Academy of Fine Arts. Award: fellowship, Cresson traveling scholarship, Pennsylvania Academy of Fine Arts.

JONES, Virginia. Painter. Born: New London, Connecticut in 1826 and died in 1906. She was self-taught. With Genevieve E. Jones she assisted in illustrating the book, "Nests and eggs of the Birds of Ohio."

JORDAN, Dorothy. Painter. Born: London, Ontario, Canada in 1912. Studied: San Diego State College; Art Students League. Awards: Pasadena Art Museum, 1952, 1955; Los Angeles Museum of Art, 1953; Laguna Beach, 1955; California Watercolor Society, 1954; Palos Verdes Community Art Association, 1950; Pasadena Society of Art, 1942, 1946, 1951. Collections: Pasadena Art Museum; Long Beach Municipal Art Center; Palos Verdes Community Art Association; Laguna Beach, California.

JORDAN, Mildred C. Miniature painter. Born: Portland, Maine. Studied: Yale School of Fine Arts.

JOSEPH, Adelyn L. Sculptor and illustrator. Born: Chicago in 1895. Studied: with Mulligan and Polasek.

JOSEPH, Joan A. Sculptor. Exhibited at the Academy of Fine Arts in 1924.

JOSLYN, Florence B. Painter. Born: Michigan. Studied: Art Students League; Art Institute of Chicago; Chicago Academy of Fine Arts. Exhibited predominately in the West and midwest.

JOULLIN, Amedee. Painter. Born: In San Francisco in 1862 and died in 1917. Studied: in San Francisco; and in France. She was a painter of Indian subjects. Collections: in many art galleries in California.

JUDKINS, E. M. (Miss). Portraitist. Born: in 1809 and died in 1887. She was known as a portrait artist who worked in crayons in New England around 1847.

JUDSON, Alice. Painter. Born: Beacon, New York. Studied: Art Students League; also with J. H. Twachtman. Collection: Administration Building, Matteawan State Hospital, Beacon, New York.

JUDSON, Almira. Painter. Born: Milwaukee, Wisconsin. Studied: Colarossi in Paris; with Henri in New York; Woman's Academy, Munich.

JUDSON, Minnie L. Painter. Born: Milford Connecticut in
1866. Studied: Yale School of Fine Arts.

JUDSON, Sylvia S. Sculptor. Born: Chicago, Illinois in
1897. Studied: Art Institute of Chicago; Grande Chaumiere,
Paris, France; and with Bourdella. Awards: Art Institute
of Chicago, 1929; Carr prize, 1947; International Sculpture
Show, Philadelphia, 1949; Municipal Art League, 1947;
Lake Forest College, 1952; Chicago Chapter of American
Institute of Architects, 1956, Garden Clubs of America,
1956. Collections: Philadelphia Museum of Art; Springfield
Museum of Art; Davenport, Iowa; Dayton Art Institute.

JUNGWIRTH, Irene G. Painter. Born: Pennsylvania in 1913.
Studied: Marygrove College, Detroit; Wayne University.
Collection: Detroit Institute or Art.

JUNOD, Ila M. Painter. Studied: University of Kansas.
Awards: George Innes scholarship, Luella Stewart scholarship;
United States Marine Corps, 1953. Collections: Philadelphia
Naval Base; Navy Building, Washington, D. C.; Naval War
College, Newport, Rhode Island; Unisted States Marine Corp,
Russell Hall, Quantico, Virginia; War Memorial Building,
Camp Lejeune, North Carolina; Commandant's House, Washington,
D.C.; Marine Corps Birthday poster, 1953; Marine Corps A
Bomb poster, 1952; First Methodist Church, Chanute, Kansas.

KAHN, Olivia. Painter. Born: New York City in 1920.
Studied: Fontainebleau, France; Art Students League;
Bryn Mawr College. Awards: National Association of Women
Artists, 1947, 1957.

KAINZ, Luise. Etcher. Born: New York City in 1902.
Studied: Columbia University; Munich Academy of Fine and
Applied Arts.

KAISH, Luise. Sculptor. Born: Atlanta, Georgia in 1925.
Studied: Syracuse University College of Fine Arts; Italy
and Mexico; also with ivan Mestrovic. Awards: Syracuse
Museum of Art, 1947; Rochester Memorial Art Gallery, 1951;
National Association of Women Artists, 1954; Emily Lowe
award, 1956; grant, Louis Comfort Tiffany Foundation,
1951; Guggenheim fellowship, 1959. Collections: Rochester
Memorial Art Gallery; Syracuse University Campus; American
Oil Company offices, New York City.

KAMINSKY, Dora. Serigrapher. Born: New York City in 1909.
Studied: Art Students League; in Paris; Stuttgart; Munich;
and in Vienna. Awards: Museum of New Mexico, Santa Fe, 1955.
Collections: Metropolitan Museum of Art; Albany Institute
of History and Art; Carville Marine Hospital; Moore
McCormick Lines; United States Lines.

KAMPF, Malissa Q. Painter. Born: Philadelphia, Pennsylvania
in 1867. Studied: with Chase and Carolus Duran.

KANE, Margaret B. Sculptor. Born: East Orange, New Jersey
in 1909. Studied: Syracuse University; Art Students League;
and with John Hovannes. Awards: National Association of
Women Artists, 1942, 1951; New Jersey State Exhibition,
1943; New York Architectural League, 1944; Brooklyn Museum,
1946, 1951; Greenwich Society of Art, 1952, 1954, 1958;
Silvermine Guild Art, 1954-1956. Collections: United States
Maritime Commission, Fairplay, Colorado; Limited Editions
Lamp Company.

KANE, Theodora. Painter. Born: Boston, Massachusetts in
1906. Studied: New York School of Fine and Applied Arts;
Corcoran School of Art; with Richard Lahey; also studied
abroad. Awards: National League of American Pen Women,
1950-1952; Washington Art Club, 1955; Georgetown Art Group,
1955; Harpers Ferry, West Virginia, 1955. Collection:
Claridge Hotel, Washington, D.C.

KAPPEL, R. Rose. Painter. Born: Hartford, Connecticut in
1910. Studied: Pratt Institute Art School, New York
University; Harvard University; Fordham University;
Washington University. Award: National Academy of Design,
1956. Collections: Library of Congress; Gloucester Art
Association; Boston Museum of Fine Arts; Cleveland Museum
of Art; Fogg Museum of Art; Culture & Health School, Brooklyn.

KARABERI, Marianthe. Sculptor. Born: Boston, Massachusetts. Studied: Pennsylvania Academy of Fine Arts; University of Pennsylvania; Barnes Foundation; Art Students League; and with John Hovannes, Antonio Salemme and Heinz Warnecke. Award: Corcoran Gallery of Art, 1957.

KATHE, Betty. Painter. Born: London, England in 1896. Studied: Brooklyn College; and with Yasuo Kuniyoshi. Awards: Brooklyn Society of Art, 1950, 1953. Collections: Florida Southern College; American Art Group.

KATZ, Ethel. Painter. Born: Boston, Massachusetts in 1900. Studied: Boston Museum of Fine Arts School; Massachusetts Normal Art School; Art Students League; and with Randall Davey, Howard Giles and Samuel Halpert. Awards: National Association of Women Artists, 1939, 1947, 1950, 1954; Booklyn Society of Art. Collection: Riversile Museum.

KATZ, Hilda. Painter. Studied: National Academy of Design; New School for Social Research. She is also a graphic artist. Awards: National Association of Women Artists, 1945, 1947; Mississippi Art Association, 1947; Society of American Graphic Artists, 1950. Collections: Library of Congress; Baltimore Museum of Art; Fogg Museum of Art; Santa Barbara Museum of Art; Colorado Springs Fine Arts Center; Society of American Graphic Artists; Pennell Collection; Syracuse University; California State Library; New York Public Library; Addison Gallery of American Art; Newark Public Library; Pennsylvania State Teachers College; Springfield Missouri Art Museum; Pennsylvania State University; Metropolitan Museum of Art; Bezalel Museum, Israel.

KAUFMAN, Enit. Painter. Born: Rossitz, Czechoslovakia in 1899. Studied: Teachers College; Columbia University; Kunstgewerbe Schule and Academy of Fine Arts, Vienna. Collections: New York Historical Society; University of Tennessee; Manchester Vermont Art Center.

KAUFFMAN, Camille Andrene. Painter. Born: Chicago, Illinois in 1905. Studied: Art Institute of Chicago; University of Chicago; and with Andre L'Hote. Awards: European Scholarship, Art Institute of Chicago, 1926. Collections: United States Post Office, Ida Grove, Iowa; Rockford Illinois College; Science Building, Rockford College; Third Unitarian Church of Chicago.

KAULA, Lee L. (Mrs). Painter. Born: Erie, Pennsylvania. Studied: with Dewey in New York and with Aman Jean in Paris.

KAVANAUGH, Katharine. Painter. Born: Falmouth, Kentucky in 1890. Studied: with William V. Cahill.

Lila Moore Keen, MAGNOLIAS, c. 1950. Watercolor, 26" X 20".
Private Collection.

KAWA, Florence K. Painter. Born: Weyerhauser, Wisconsin
in 1912. Studied: Wisconsin State Teachers College;
Louisiana State University; Columbia University; Cranbrook
Academy of Art; Minneapolis School of Art. Awards:
Milwaukee Art Institute, 1938; Wisconsin Salon, 1939, 1947;
Wisconsin State Fair, 1939; National Polish-American
Exhibition, 1940; Jackson Mississippi, 1943; Louisiana
Art Commission, 1949; Florida Federation of Art, 1950, 1951;
Florida Art Group, 1951; Florida Southern College, 1942.
Exhibited widely in the United States and abroad.

KAY, Gertrude A. Illustrator. Born: in 1884. Studied:
with Howard Pyle. She began her illustrating work in
1903 in Philadelphia.

KAY, Helena De. Painter. Born: in 1846 and died in 1916.

KAYE, Elizabeth G. Painter. Born: Baltimore Maryland
in 1887. Studied: with Hugh Breckenridge, H. B. Snell
and Edwin Whiteman.

KAYN, Hilde B. Painter. Born:in 1906 and died in 1950.

KEAST, Susette S. Painter. Born: Philadelphia, Pennsylvania
in 1892. Studied: with Breckenridge, Chase and Anshutz.

KEE, Esther. Painter. Born: Chestnut Hill, Pennsylvania
in 1913. Awards: Henry R. Poore award; Cresson European
scholarship, Pennsylvania Academy of Fine Arts; Toppan
award. Collection: Pennsylvania Academy of Fine Arts.

KEEN, Helen B. Painter. Born: Tacoma, Washington in 1899.
Studied: California School of Fine Arts; Art Students
League; and with Mark Tobey, Robert Beverly Hale, Jon
Corbino and Vaclav Vytlacil. Award: Tower Gallery, Tacoma,
Washington, 1945. Collection: Seattle Art Museum.

KEEN, Lila Moore. Painter. Born: Cleveland, Georgia in
1903 and died in 1963. Studied: Agnes Scott College; and
with Wayman Adams. Noted for her portraits, and flowers
in water color, especially camellias and magnolias.
Awards: National Gallery, 1945, 1946, 1947. She exhibited
widely in the Southeastern United States.

KEENER, Anna E. Painter. Born: Flaglor, Colorado in 1895.
Studied: Bethany College; Art Institute of Chicago; Kansas
City Art Institute; Colorado State Teachers College;
University of New Mexico. Awards: Kansas City Art Institute;
Museum of New Mexico, Santa Fe, 1953; Roswell Museum of Art,
1956. Collections: San Francisco Public Library; Vanderpoel
collection; Sul Ross State Teachers College; Museum of New
Mexico; Oklahoma University; Court House, Gallup, New Mexico.

KEFFER, Frances. Painter. Born: Des Moines, Iowa in 1881. Studied: Pratt Institute; also with Alex Robinson; Frank Brangwyn; Ossip Linde.

KEITH, Dora W. Painter. Born: Jamaica, Long Island in 1857 and died in 1940. Studied: with William Chase; and in Paris. She was a portrait painter and also an illustrator.

KELLNER, Mary. Sculptor. Born: New York City in 1900. Studied: Ogunquit School of Art; Clay Club, and with Robert Laurent; and with Chaim Gross. Awards: Brooklyn Society of Art, 1949, 1951, 1955; Silvermine Guild Artists, 1952. Collection: Bezalel Museum, Israel.

KELLOGG, Janet R. Painter. Born: Merrill, Wisconsin in 1894. Studied: Art Institute of Chicago; Milwaukee-Downer College; Grande Chaumiere, Paris and with George Pearse Ennis and George Elmer Browne. Awards: National Academy of Design, 1930, Milwaukee Art Institute.

KELLOGG, Mary K. Painter. Born: 1814 and died in 1889. She was a portrait painter.

KELLY, Grace Veronica. Painter. Born: Cleveland, Ohio in 1884. Studied: with H. G. Keller. Awards: Numerous awards for landscape painting.

KELSEY, Dorothy S. Painter. Born: Kingston, New York in 1893. Studied: Albany School of Fine Arts; Pennsylvania Academy of Fine Arts; Pratt Institute Art School. Awards: Albany Professional Women's Exhibition; Hartford Women Painters, 1954, 1955.

KELSEY, Muriel C. Sculptor. Born: Milford, New Hampshire. Studied: University of New Hampshire; Columbia University; New School for Social Research; also with Dorothea Denslow. Award: Sarasota Festival of Arts, 1953. Collection: Brookgreen Gardens, South Carolina.

KEMPER, Ruby W. Painter. Born: Cincinnati, Ohio in 1883. Studied: with Frank Duveneck and W. H. Fry.

KEMPSON, Julia Hart. Painter. Born: in 1835 and died in 1913. Known as a landscape painter.

KEMPSTER, Ruth. Painter. Born: Chicago, Illinois in 1904. Studied: Los Angeles County Art Institute; Art Students League; Academie des Beaux-Arts; National Academy, Florence, Italy. Awards: California State Fair, 1931, 1932, 1936; Pasadena Society of Art, 1936, 1940, 1944, 1951; Women Painters of the West, 1951; International Olympic Games, Exhibition, 1932. Collections: Pasadena Art Institute; Huntington Memorial Hospital, Pasadena. Toured Korea as portrait artist for Armed Forces, Far East Command, 1953.

KEMPTON, Elmira. Painter. Born: Richmond, Indiana in
1892. Studied: Cincinnati Art Academy; Cincinnati
University; Earlham College; and with Wayman Adams and
Eliot O'Hara, and Albert Krehbiel. Exhibited Nationally
and in Europe.

KENDALL, Beatrice. Painter. Born: New York City in
1902. Studied: Yale School of Fine Arts; University of
London. Awards: Winchester fellowship, Yale University,
1922; New Haven Paint and Clay Club. Collections: Lyman
Allyn Museum; Southern New England Telephone Company,
Building, New Haven, Connecticut.

KENDALL, Elizabeth. Painter, sculptor and illustrator.
Born in 1896. Studied: Yale School of Fine Arts.

KENDALL, Kate. Painter. Died in 1915. Has exhibited at the
Pennsylvania Academy of Fine Arts.

KENDALL, Margaret. Painter. Born: Staten Island, New
York in 1871. Studied: with J. Alden, Weir, Julius
Rolshoven and Sergeant Kendall. Exhibited extensively
from 1898 through 1904.

KENDALL, Marie B. Painter. Born: in 1885. Studied: with
Chase.

KENDALL, Viona A. Painter. Born: Berkeley, California
in 1925. Studied: Occidental College; Lukits Academy of
Fine Arts, with T. N. Lukits, Samuel Hyde Harris and
Leon Franks. Awards: Burbank Art Association, 1952-1954;
California Art Club, 1954, 1955; Valley Art Guild, 1956-1958;
Friday Morning Club, 1958; California State Fair, 1958.
Collection: in many private collections.

KENNEDY, Janet R. Painter. Born: Bridgeport, Connecticut
in 1902. Studied: Art Institute of Chicago, with Albin
Polasek and John Norton; Art Students League, with William
Zorach; also studied with Lauren Ford and Syd Solomon.
Awards: Sarasota Art Association, 1955; National Sacred
Heart Competition, 1946; Society of Four Arts, Palm Beach
1957; Boca Raton, 1958.

KENNEDY, Sybil. Sculptor. Born: Quebec, Canada in 1899.
Studied: Montreal Art School and with Alexander Archipenko.
Awards: Huntington prize, National Association of Women
Artists, 1941; Amelia Peabody prize, 1948. Collections:
National Gallery, Canada; Montreal Museum of Fine Arts.

KENNICOTT, Marie F. Painter. A portraitist who worked
in watercolors, pastels, oils and crayons was active in
the period 1851-1885.

KENT, Ada H. Painter. Born: Rochester, New York. Studied: with Abbott Thayer, Brush and Whistler.

KENT, Adaline. Sculptor. Born: Kentfield, California in 1900. Studied: Vassar College; California School of Fine Arts; Grande Chaumiere, Paris; also with Ralph Stackpole. Awards: San Francisco Museum of Art, 1937; West Coast Ceramics, 1945, 1958; San Francisco Art Council, 1952; Lafayette sculpture prize, 1955; Collections: Stanford University; Mills College; San Francisco Museum of Art.

KEPLINGER, Lorna M. Painter. As a miniature painter she exhibited her painting in 1925 at the Pennsylvania Academy of Fine Arts.

KERCHEVILLE, Christina. Painter. Born: Altus, Arkansas in 1906. Studied: University of South Dakota; University of Wisconsin; University of New Mexico; and with Kenneth Adams, Lloyd Goff, Lynn Mitchell and Randall Davey, and others. Exhibited for the most part in New Mexico.

KERNS, Fannie M. Painter and illustrator. Born: Los Angeles California; Studied: with Arthur Dow, Frank Ingerson and Ralph Johnnot.

KERNS, Maude Irvine. Painter. Born: Portland, Oregon in 1876. Studied: University of Oregon; Columbia University; Art Institute of Chicago; California School of Fine Arts; Academie Moderne, Paris and with Arthur Dow. Awards: Alaska-Yukon Exposition, Seattle, Washington; Pen and Brush Club, 1954. Collections: Murray Oriental Museum, Eugene, Oregon; Seattle Art Museum; Portland Art Museum; Solomon Guggenheim Museum.

KERR, Irene W. Painter. Born: Pauls Valley, Oklahoma in 1873. Studied: with William M. Chase, James Fraser, DuMond, Clarkson, Walcott and F. L. Mora.

KESKULLA, Carolyn W. Lithographer. Born: Farmingdale, New Jersey in 1912. Studied: Art Students League: Pratt Institute of Art School; New York University. Has her work in private collections and has exhibited extensively in the Eastern United States.

KETCHAM, Susan M. Painter. Born: Indianapolis, Indiana. Studied: Art Students League with Chase and Bell. Collection: Ogunquit, Maine; Herron Art Institute, Indianapolis.

KEY, Mabel. Painter. Born: Paris, France in 1874 of American parents. Awards: St. Paul Institute, 1915, 1916; Wisconsin Painters and Sculptors.

KEYES, Bessie P. Sculptor. Born: in 1872. Elected to the National Academy in 1921.

KEY-OBERG, Ellen B. Sculptor. Born: Marion, Alabama in 1905. Studied: Cooper Union Art School. Awards: Audubon Art, 1944; National Association of Women Artists, 1949. Collection: University of Wisconsin.

KILPATRICK, Mary. Painter. Born: Baltimore, Maryland in 1879. Studied: Bryan Mawr College; Maryland Institute, and with Charles Woodbury and Bernard Karfiol.

KIMBALL, Isabel M. Sculptor. Studied: with Herbert Adams. Collection: Winona, Minnesota (Winona Fountain in Central Park); Vassar College; the War Memorial Tablet for Essex Company.

KIMBALL, Katharine. Etcher and illustrator. Born: in New Hampshire. Studied: Art Students League. Collections: Victoria and Albert Museum, London; New York Public Library; Library of Congress; Boston Museum of Fine Arts.

KIMBERLY, Cora Draper. Painter. Born: St. Louis, Missouri in 1876. Studied: Washington University; Boston Museum of Fine Arts; Art Institute of Chicago; Chicago Academy of Art, and with Farnsworth, Vanderpoel, Messer and Hawthorne. Award: Society of Washington Artists. Collections: interiors of White House, Arlington House, Dumbarton House and Mt. Vernon.

KIMURA, Sueko M. Painter. Born: Hawaii in 1912. Studied: University of Hawaii; Chouinard Art Institute, Los Angeles, with Rico Lebrun; Columbia University with Dong Kingman. Awards: Honolulu Academy of Art, 1955-1957. Collections: Honolulu Academy of Art; Fresco mural, University of Hawaii Chemistry Building.

KINDLER, Alice R. Painter. Born: Germantown, Philadelphia in 1892. Studied: Pennsylvania Academy of Fine Arts.

KINDLUND, Anna Belle Wing. Painter. Born: 1876 and died in 1922. She was a miniature painter.

KING, Eleanor. Painter. Born: Marlow, Oklahoma in 1909. Studied: Oklahoma City College. Awards: Elmhurst Art Guild, 1952-1954; Gulf Coast Art Association, 1929; Pensacola Art Club, 1928. Collections: Tallahassee Woman's Club; Pensacola Art Club; Capitol City Bank, Tallahassee, Florida; Elmhurst College; Florida Capitol Building; Senate Chamber, Supreme Court of Florida; Pensacola Beach Corporation; Naval Air Station, Pensacola, Florida.

KING, Emma B. Painter. Born: Indianapolis. Studied: with Cox; Beckwith and Chase; Art Students League.

KING, Gertrude. Painter. Was exhibiting her water colors at the Pennsylvania Academy of Fine Arts in 1925.

KING, Helen A. Painter. Born: Huntington, Indiana in 1900. Studied DePauw University; Northwestern University; Art Institute of Chicago; Art Students League; Columbia University. Awards: Hoosier Salon, 1930, 1932. Work: Huntington Indiana Public Library.

KING, Jane S. Painter. Born: La Grange, Illinois in 1906. Studied: Art Institute of Chicago. Collections: Ryerson College, Chicago; Chicago Historical Society.

KING, Virginia M. Sculptor. Born: Norfolk, Virginia in 1879. Studied: with Salon Borglum and Harriet Frishmuth.

KINNEY, Margaret W. Illustrator. Born: Peoria, Illinois in 1872. Studied: Art Students League; Julien Academy in Paris with Robert-Fleury, Collin, Merson and Lefebvre.

KINSEY, Alberta. Painter. Studied: Cincinnati Art Academy; Chicago Art School. Collection: Cincinnati Art Museum; Delgado Museum.

KINSEY, Helen F. Painter and illustrator. Studied: with Breckenridge, Grafly, Chase and Anshutz.

KIRALFY, Verona A. Portrait painter. Born: New York City in 1893. Studied: Art Students League; with Chase.

KIRK, Marie L. Painter and illustrator. Born: in Philadelphia. Studied: Philadelphia School of Design; Pennsylvania Academy of Fine Arts. Award: Pennsylvania Academy of Fine Arts, 1894.

KIRKHAM, Charlotte B. Painter. Her specialty--miniatures which she was exhibiting in 1925.

KIRKPATRICK, Harriet. Painter. Studied: Columbus Ohio Art School; and with Hawthorne, Carlson, Thurn, Hofmann and Rattner. Awards: Columbus Art League, 1922, 1931, 1936, 1947, 1953; Ohio State Fair, 1954, 1955. Collection: Columbus Gallery of Fine Arts.

KITSON, Theo. Alice R. Sculptor. Born: Brookline, Massachusetts in 1871. Studied: with H. H. Kitson and Dagnan-Bouveret, Paris. Award: St. Louis Exposition, 1904.

Anna Elizabeth Klumpke, ROSA BONHEUR, 1898. Oil on canvas,
46" X 38 1/2". The Metropolitan Museum of Art (Gift of the
artist in memory of Rosa Bonheur, 1922).

KLAUDER, Alice. Painter. Born: San Diego, California in 1871. Studied: with Chase and Henri. She was chiefly a portraitist.

KLAUDER, Mary. Sculptor. Was exhibiting at the Pennsylvania Academy of Fine Arts in 1914.

KLEIDMAN, Rose. Painter. Born: New York City in 1910. Studied: with Moses Soyer. Award: Glendale Art Association, 1949.

KLINE, Edith L. Painter. Born: Philadelphia, Pennsylvania in 1903. Studied: Philadelphia Museum School of Industrial Art; Moore Institute; University of Pennsylvania; Ecole des Beaux-Arts, Fontainebleau, France; also with Earl Horter and John Lear. Awards: fellowship, Pennsylvania Academy of Fine Arts; National Arts Club, 1941; Philadelphia Art Teachers Association, 1944, 1954.

KLINKER, Orpha. Etcher. Born: Fairfield, Iowa. Studied: University of California, Los Angeles; Julian Academy, Paris, France; and with Will Foster, Mildred Brooks and Edgar Payne. Awards: fellowship, Andhra Research University, India; University of Panama; Academician American International Academy, Washington, D. C.; Croix de Commandeur, Belgium. Collections: Los Angeles City Hall; Los Angeles Polytechnic High School; Los Angeles Art Association; Metropolitan Museum of Art; City Hall, Los Angeles; Campo de Cuhuenga, Los Angeles.

KLITGAARD, Georgina. Painter. Born: New York City in 1893. Studied: Barnard College. Awards: Pennsylvania Academy of Fine Arts, 1930; Pan-American Exposition, 1931; Guggenheim fellowship, 1933; Carnegie Institute; Art Institute of Chicago. Collections: Metropolitan Museum of Art; Whitney Museum of American Art; Newark Museum; Dayton Art Institute; New Britian Art Institute; Brooklyn Museum; Wood Gallery of Art, Montpelier, Vermont; United States Post Office, Poughkeepsie, New York; Goshen, New York; Pelham, Georgia.

KLOUS, Rose. Painter. Born: St. Petersburg, Russia. Studied: Columbia University; Academie Julian, Paris. Collection: Kiev Museum, Russia.

KLUMPKE, Anna E. Painter. Born: San Francisco, California in 1856. Studied: with Fleury and Bouguereau. Collection: Paris Salon, 1888.

KNAUBER, Alma H. Painter. Born: Cincinnati, Ohio in 1893.
Studied: with Duveneck.

KNEE, Gina. Painter. Born: Marietta, Ohio in 1898.
Awards: California Watercolor Society, 1938; New Mexico
State Fair, 1939; New Orleans, Louisiana, 1947. Collections:
Denver Art Museum; Santa Barbara Museum of Art; Buffalo
Fine Arts Academy.

KNIGHT, Julia M. Painter. Born: Frankfort, Kentucky in
1889. Studied: Columbia University.

KNIGHT, Normah. Painter. Born: Dallas, Texas in 1910.
Studied: Dallas Art Institute; Southern Methodist
University; Art Instruction, Incorporated; Julian Academy,
Paris, and with Harry deYoung and Peter Hondstedt. Award:
Texas Federation of Women's Club. Collections: Allen
Gallery, Houston; Public Library, Harlingen, Texas;
Chamber of Commerce, Harlingen, Texas; National Bank,
Harlingen, Texas; Flamingo Hotel, Harlingen, Texas;
Reese-Wil-Mond Hotel, Harlingen, Texas; Holsum Baking
Company, Harlingen, Texas; Nehi Bottling Company, Harlingen,
Texas.

KNOBLER, Lois J. Painter. Born: New York City in 1929.
Studied: Syracuse University; Florida State University.
Awards: Berkshire Museum of Art, 1954; Springfield,
Massachusetts, 1956, 1957; Chambers-Storck Company,
Norwich, Connecticut, 1955; Mystic Art Association, 1957.
Collection: Florida State University.

KNOLLENBERG, Mary T. Sculptor. Born: Great Neck, New York
in 1904. Studied: School of American Sculpture, with
Mahonri Young; Grande Chaumiere, with Bourdelle, Paris,
France; Corcoran School of Art with Warneke. Award:
Guggenheim fellowship, 1933.

KNOPF, Nellie A. Painter. Born: Chicago, Illinois in 1875.
Studied: Art Institute of Chicago; and with Charles Woodbury.
Awards: Broadmoor Art Academy, Colorado Springs, Colorado;
MacMurray College. Collections: Lafayette, Indiana Art
Association; MacMurray College, Jacksonville, Illinois.

KNOWLES, Elizabeth. Painter. Exhibited at the 33d Annual
Exhibition of National Association of Women Painters and
Sculptors.

KNOWLTON, Helen M. Born: Littleton, Massachusetts in 1832
and died in 1918. Studied: with William M. Hunt. In 1867
she opened her studio in Boston. She exhibited many
charcoal sketches and many landscapes and portraits in oil.

KNOX, Helen E. Painter. Born: Suffield, Connecticut.
Studied: Smith College; Hartford Art School; and with
W. Lester Stevens, Harve Stein and E. F. Marsden. Award:
Stockbridge Massachusetts Art Association, 1931.
Exhibited predominately in New England.

KNOX, Susan R. Painter. Born: Portsmouth, New Hampshire.
Studied: Drexel Institute, Philadelphia; Cooper Union Art
School; and with Howard Pyle, Douglas Volk and Clifford
Grayson; also studied in Europe. Awards: St. Louis,
Missouri, 1929; Museum of Northern Arizona, 1932, 1935;
Ogunquit Art Association, 1946; North Shore Art Association,
1935. Collections: Cornell Collection, Mt. Vernon, Iowa;
Wesleyan College, Macon, Georgia; Brooks Memorial Art
Gallery; Kansas City Board of Trade; University of the South;
Home for Children, Cedar Rapids, Iowa; Morris High School,
New York; England and Mexico.

KOCH, Berthe C. Painter. Born: Columbus, Ohio in 1899.
Studied: Columbia University; Ohio State University; and
with Gifford Beal, Leon Kroll, Alexander Archipenko, and
James Hopkins. Awards: Fellowship, Ohio State University,
1928, 1929. Collections: International Business Machines
Collection; Passedoit Gallery; Ohio State University;
Syracuse Museum of Fine Arts.

KOCH, Helen C. Painter. Born: Cincinnati, Ohio in 1895.
Studied: University of Cincinnati; Cincinnati Art Academy;
and with Henry Snell. Awards: Cincinnati Museum Association,
1945; Woman's Art Club, 1951, 1955. Collections: East
Vocational High School, Cincinnati, Ohio; Central High School,
Cincinnati, Ohio and Bond Hill High School, Cincinnati, Ohio.

KOCH, Irene Skiffington. Painter. Born: Detroit, Michigan
in 1929. Studied: Wayne University. Award: California
Watercolor Society, 1957. Collections: Long Beach Museum of
Art; Pasadena Art Museum.

KOCHERTHALER, Mina. Painter. Born: Munich Germany.
Studied: City College of New York with Ralph Fabri. Award:
National Society of Painters in Casein, 1958.

KOCSIS, Ann. Painter. Born: New York City. Studied: Art
Institute, Pittsburgh, Pennsylvania. National Academy of
Design. Awards: scholarship, Art Institute of Pittsburgh;
Florida Southern College, 1952; Gold Key and Grumbacher
award, Seton Hall University, 1958. Collections: San Manuel
Library, Arizona; Arizona-Sonova Desert Museum, Tucson;
Florida Southern College; Square and Compass Crippled
Children's Clinic, Tucson; American-Hungarian Museum,
Elmhurst, Illinois.

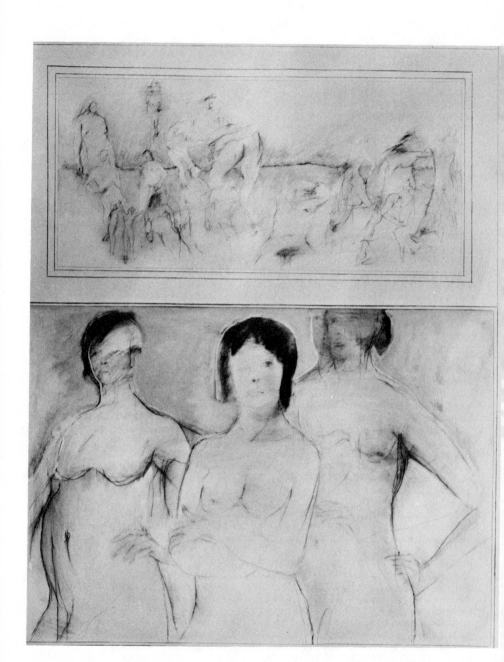

*Ida Kohlmeyer, COUNTERPOINT NO. 1, 1971. Mixed media,
61 1/2" X 51". Collection of Mr. and Mrs. Frank Moran.*

KOELKEBECK, Kathe. Painter. Awards: Trumbull Art Guild, Warren, Ohio; Lido Estense Ferrari, Italy. Exhibited in Ohio.

KOFFLER, Mary M. Painter. Born: Morristown, New Jersey in 1906. Studied: Art Students League. Awards: Hunterdon Art Center, 1955-1957; Morristown Art Association; Pennsylvania Academy of Fine Arts. Collection: Pennsylvania Academy of Fine Arts.

KOHLHEPP, Dorothy Irene. Painter. Born: Boston, Massachusetts. Studied: Massachusetts School of Art; New Orleans Art and Crafts; Grande Chaumiere, Julian Academy; and with Andre L'Hote in Paris. Awards: Louisville, Art, 1944, 1945; Jeffersontown Kentucky Fair, 1954; Kentucky and Southern Indiana Art, 1945, 1946, 1949; Louisville Art Club, 1946. Collections: Seagram Collection; University of Louisville; J. B. Speed Art Museum; Devoe and Raynolds Collection.

KOHLMEYER, Ida. Painter. Studied: Newcomb College; Newcomb Art Department, Tulane University. Awards: Southeastern Annual Exhibition, Atlanta, Georgia; Biennial Exhibition of Contemporary American Painting, Washington, D.C.

KOHN, Irma. Painter. Born: Rock Island, Illinois. Known as a landscape painter. Collection: Toledo Museum; Pennsylvania Academy of Fine Arts.

KOLLOCK, Mary. Painter. Born: Norfolk, Virginia in 1840 and died in 1911. Studied: Academy of Fine Arts; Julien School, Paris. She was not only a landscape painter, but a portrait and still life painter as well. Exhibited at the National Academy of Design and the Centennial, Philadelphia in 1876.

KOMINIK, Gerda. Painter. Born: Vienna, Austria. Awards: Riverdale Outdoor Show; Reilly's School of Fine Arts; Romanofsky's gold medal; San Miguel de Allende, Mexico. Collections: in Canada, Austria, England, Mexico and the United States.

KOPENHAVER, Josephine Y. Painter. Born: Seattle, Washington in 1908. Studied: University of California; University of Southern California; Chouinard Art Institute; and with Millard Sheets. Awards: Women Painters of the West, 1940; California Watercolor Society, 1944. Collection: Los Angeles City College.

KOPMAN, Katharine. Painter. Born: New Orleans. Studied: Newcomb School of Art; and with Molinary and Dodge MacKnight. Landscapes--her specialty.

KORMENDI, Elizabeth. Painter and sculptor. Born: Budapest,
Hungary. Studied: in Europe. Collection: Museum of the
City of Budapest; Nurnberg Museum; Immaculate Conception
Church, East Chicago, Illinois; Boy's Town; Our Lady of
the Lake Church, Wawasee, Indiana; St. Catherine's Church,
St. Louis, Missouri; Mt. Carmel, St. Louis, Missouri;
St. Peter's Church, Oshkosh, Wisconsin.

KORN, Elizabeth P. Painter. Born: Germany. Studied:
Breslau University; Academy of Fine and Applied Arts,
Berlin; Art Students League; Rome, Italy; Columbia
University; and with Emil Orlik, Berlin. Awards: Posnan
Museum, Poland; Newark Museum; New Jersey State Museum,
1949; Orange, New Jersey State Exhibition, 1952;
Grumbacher prize, Rahway, New Jersey, 1951. Collections:
Columbia University; Newark Museum of Art.

KRASNER, Lee. Painter. Born: Brooklyn, New York in 1911.
Studied: Cooper Union Art School; National Academy of
Design; Hans Hofmann School of Art. Collections: Whitney
Museum of American Art; Philadelphia Museum of Art.

KRATZ, Mildred S. Awards: National Arts Club, New York.
Collections: Reading Art Museum, Pennsylvania; Fine
American Art Collection, Cleveland, Ohio.

KRAUSE, La Verne. Painter and graphic artist. Born:
Portland, Oregon in 1924. Studied: University of Oregon;
Portland Art Museum School. Award: Northwest Printmaker,
1954. Collections: Henry Gallery, University of Washington;
Selling Building, Portland, Oregon.

KREBS, Columba. Painter. Born: Greensburg, Pennsylvania
in 1902. Studied: Hood College; Art Students League;
New York School of Fine and Applied Arts; National Academy
of Design. Collection: Textile High School, New York.

KREBS, Rose K. Ceramic sculptor. Born: Germany. Studied:
Bauhaus, Germany; Ceramic Workshop; Art Students League;
and with William Zorach. Award: Pen and Brush Club, 1958.
Collection: ceramic vases for Mercedes-Benz showrooms,
New York; Cooper Union Museum.

KREINDLER, Doris B. Painter and etcher. Born: Passaic,
New Jersey in 1901. Studied: Contemporaries Graphic Art
Center; New York School of Applied Designs for Women;
National Academy of Design; Art Students League, and
with Ethel Katz, Hans Hofmann, Ivan Olinsky and Charles
Hinton. Awards: fellowship, Research Studios, Maitland,
Florida; Brooklyn Society of Art, 1955; Contemporaries
Gallery, 1958; Artists Equity Association, 1953.

KREMP, Marie Ada. Painter and Etcher. Born: Reading
Pennsylvania. Studied: Pennsylvania Academy of Fine
Arts; Cleveland Museum of Art School; and with
Breckenridge, Garber and McCarter. Awards: fellowship,
Pennsylvania Academy of Fine Arts; H. C. J. Academy,
Sharon Hills, Pennsylvania. Collections: Pennsylvania
Academy of Fine Arts; West Philadelphia High School.

KRETZINGER, Clara J. Painter. Born: Chicago, Illinois.
Studied: Art Institute of Chicago; Chicago Academy of
Fine Arts; and with Lefebvre, Robert-Fleury, Laurens,
Congdon and Richard Miller in Paris. Award: Paris Salon.
Collection: Beloit Art Museum.

KRIZE, Emilie M. Painter. Born: Luzerne, Pennsylvania
in 1918. Studied: Maryland Institute; Pennsylvania
Academy of Fine Arts; John Hopkins University; Norfolk
Division of William and Mary College; and with Maroger.
Award: traveling scholarship, Maryland Institute.
Collections: Planters Nut and Chocolate Company Club;
Norfolk Naval Shipyard Library; State House, Annapolis,
Maryland.

KRONENGOLD, Naomi. Studied: Pratt Institute of Art
School; New York University. Award: Louisiana Art
Commission's Annual Louisiana State Art Exhibition,
Baton Rouge, Louisiana. She is listed in Who's Who
in American Art.

KRUGER, Louise. Sculptor and designer. Born: Los Angeles,
California in 1924. Studied: Scripps College. Collections:
Museum of Modern Art; New York Public Library; Museum of
Modern Art, Sao Paulo, Brazil.

KUMM, Marguerite E. Painter, Engraver and etcher. Born:
Redwood Falls, Minnesota. Studied: Minneapolis School
of Art; Corcoran Art School; and with Cameron Booth,
Richard Lahey, Anthony Angarola. Awards: Society of
American Graphic Artists, 1943; Library of Congress, 1951;
International award in Decorator Designer, New York, 1926.
Collections: Library of Congress; Boston Museum of Fine
Arts; Valentine Museum; Virginia Museum of Fine Arts;
Oregon State College; Society of American Graphic Artists;
Washington County Museum of Fine Arts, Hagerstown, Maryland;
College State Library; Witte Memorial Museum; Pennsylvania
State University; Metropolitan Museum of Art; Smithsonian
Institute; Mint Museum of Art; Butler Art Institute; Lowry
Hill Children's Clinic, Minneapolis, Minnesota.

KUPER, Rose. Painter. Studied: Hunter College; in France; and with Hans Hofmann, Abraham Rattner. Awards: National Association of Women Artists, 1952; Brooklyn Society of Art, 1954; Village Art Center. Collections: San Diego Fine Arts Society; Philbrook Art Center; Dallas Museum of Fine Arts; Santa Barbara Museum of Art; Jewish Museum, New York; Hunter College; Long Island University; Fashion Institute of Technology: Light House for the Blind, Israel; Ashlawn, Virginia (home of James Monroe); Riverside Museum; Design Center, New York.

KUSHNER, Dorothy B. Painter. Born: Kansas City, Missouri in 1909. Studied: Kansas City Teachers College; Art Institute of Chicago; Columbia University; Kansas City Art Institute, with Thomas Hart Benton; Art Students League, with Reginald Marsh. Awards: University of Missouri, 1926; Highland Park, California, 1951; Santa Paula, California, 1952, 1955; San Gabriel Mission, 1954, 1955; Pasadena Art Museum, 1955. Collections: Pasadena Art Museum; Camino Grove School, Arcadia, California; University of Illinois; Los Angeles Unitarian Church.

KUTKA, Anna. Painter. Born: Danbury, Connecticut. Studied: Art Students League, with Kimon Nicolaides, Kenneth Hayes Miller and Eugene Fitsch. Awards: Tiffany fellowship, 1928, 1930; Gladys Roosevelt Dick traveling scholarship, 1933. Collection: Portland Art Museum.

LABRIE, Rose. Painter. Award: Memorial painting of U.S.S.
Thresher. Collections: University of New Hampshire Film
Series; Strawberry Banke Colonial Preservation.

LADD, Anna C. Sculptor. Born: Philadelphia in 1878.
Studied: in Paris and Rome, with Ferrari and Gallori; and
with Charles Grafly in America. Exhibited in New York,
Washington, Philadelphia, Chicago, Boston and Paris.
Award: Panama Exposition.

LADD, Laura D. S. Painter. Exhibited at the 33d Annual
Exhibition of National Association of Women Painters and
Sculptors.

LAFON, Gertrude Van Allen. Painter. Born: Brooklyn, New
York in 1897. Studied: Cooper Union Art School; Pratt
Institute Art School; New York University, and with Ralph
Pearson, and Louis Wolchonok.

LA FONTAINE, Rachel A. Painter. Born: Zonnemaine, Holland
in 1845. Studied: Art Students League; and with Charles
Melville Dewey, J. H. Beard, Sr. and with Harry Chase.
Her specialty, sundowns and marines. Exhibited in National
Academy of Design in 1885.

LAGORIO, Irene R. Painter. Born: Oakland, California in
1921. Studied: University of California; Columbia University
Awards: San Francisco Women Artist, 1955; San Francisco
Museum of Art, 1953; California Watercolor Society, 1953.
Collections: San Francisco Museum of Art; San Francisco
Women Artists collection.

LAINE, Lenore. Painter. Born: Philadelphia, Pennsylvania.
Collections: Forth Worth Art Center Museum; Phoenix Art
Museum; Riverside Museum, New York City; National Museum of
Modern Art, Tokyo. Has exhibited in the United States, Paris,
Puerto Rico.

LAKEY, Emily Jane. Painter. Born: Quincy, New Jersey in
1837 and died in 1896. Studied: in Ohio and Tennessee; and
with Emile Van Marcke in Paris. She has exhibited at the
National Academy and in Chicago.

LALANNE, Mary E. Painter. Her miniature paintings were
exhibited at the Boston Athenaeum in 1833.

LAMB, Ella C. Painter. Born: In New York. Studied:
with William M. Chase, C. Y. Turner and Walter Shirlaw in
New York; in Paris with R. Collin; and in England with
Hubert Herkomar. Her specialty, miniatures, portraits and
decorative painting. Collections: St. John's Church,
Detroit; Cornell University; Wellesley College; Briarly
School, New York.

LAMBERT, Gertrude A. Painter. Born: South Bethlehem, Pennsylvania in 1885. Studied: Philadelphia School of Design for Women; Pennsylvania Academy of Fine Arts. Collection: Pennsylvania Academy of the Fine Arts.

LAMONT, Frances. Sculptor. Studied: with Solon Broqlum and Mahonri Young. Award: Allied Artists of America, 1958. Collections: Cleveland Museum of Art; New Canaan, Connecticut; New Rochelle, New York; Metropolitan Museum of Art; Cranbrook Museum of Art; Denver Art Museum; Colorado Springs Fine Arts Center; Ogunquit Art Museum; Albright Art Gallery.

LANDER, Louisa. Sculptor. Born: Salem, Massachusetts in 1826. Studied: in Rome with Thomas Crawford. She executed many busts and figures in marble of prominent people.

LANDERS, Bertha. Painter. Born: Winnsboro, Texas. Studied: Art Students League with Reginald Marsh; Colorado Springs Fine Arts Center; also with Boardman Robinson, Henry Varnun Poor and Arnold Blanch. Collections: Dallas Museum of Fine Arts; University of Texas; Corpus Christi Museum of Art; Witte Memorial Museum.

LANDERS, Della A. Painter. Born: Lawn, Texas. Studied: Hardin-Simmons University; University of Colorado; Peabody College; Colorado Springs Fine Arts Center; University of Texas; San Angelo School of Painting; East Hampton, Long Island School of Fine Arts. Awards: Abilene Museum of Fine Arts, 1948, 1950, 1952, 1953; Southern Sun Carnival El Paso, 1951, 1952; San Angelo Texas General, 1952; West Texas Art Association, 1957, 1958; West Texas Fair, 1956, 1958; Creative Art Club, Abilene, 1954, 1956, 1958. Collections: Abilene Museum of Fine Arts; Ovalo Baptist Church, in Texas.

LANDIS, Lily. Sculptor. Born: New York City. Studied: Art Students League; Also with Jose de Creeft, and abroad. Collections: Noma Electric Company; David Doniger Company.

LANE, Susan M. Painter. Born: Cambridge, Massachusetts in 1832 and died in 1893. Studied: with William Morris Hunt. She was a known landscape painter. Collection: Boston Museum of Fine Arts.

LANGE, Erna. Painter. Born: Elizabeth, New Jersey in 1905. Studied: Art Students League; National Academy of Design; Cooper Union Art School; Julian Academy, Grande Chaumiere, Paris; and with Cecilia Beaux and Ferninand Oliver.

LANGE, Katharine G. Sculptor. Born: Cleveland, Ohio in
1903. Studied: Cleveland School of Art; Smith College.
Awards: Cleveland Museum of Art, 1936, 1939, 1940, 1942,
1945, 1946, 1948-1950, 1952, 1953-1955, 1957. Collections:
Cleveland Museum of Art; Republic Steel Corporation,
Cleveland.

LANGENBACH, Clara E. Painter. Born: Ontario, Canada.
Studied: Albright Art School; Pratt Institute of Art
School; Art Students League, Woodstock, New York; and
with Carlson, and Walter Goltz and others. Awards:
National League of American Pen Women, 1936, 1942.

LANGFORD, Ruth Betty. Painter. Born: Sherman, Texas.
Studied: Harding College; Colorado Fine Arts Center;
University of Iowa; and with Fletcher Martin, Emil Ganso
and Philip Guston. Award: Arkansas State Exhibition,
1946. Collection: Hendrix College, Arkansas.

LANGLEY, Sarah. Painter. Was exhibiting her paintings
at the Pennsylvania Academy of Fine Arts in 1921.

LANGS, Mary M. Sculptor. Born: Burford, Ontario, Canada
in 1887. Studied: with Bourdelle, Despiau, Gimond in Paris.
Awards: Albright Art Gallery, 1938, 1941, 1945, 1950.

LANGTON, Berenice F. Sculptor. Born: Erie County,
Pennsylvania in 1878. Studied: with Augustus Saint-Gaudens,
and Augustus Rodin. Awards: Barnett prize, New York, 1915;
Crowninshield prize, Stockbridge, Massachusetts, 1939; Pen
and Brush Club, 1948. Collections: Booth Memorial, New
York; Haas Memorial, Paterson, New Jersey; Miller Memorial,
Vevey, Switzerland; Lawrence Hospital, New London,
Connecticut.

LANSING, Winifred J. Sculptor. Born: Rochester, New York
in 1911. Studied: Brooklyn Museum of Art Center; Art
Students League. Collections: Rochester Memorial Art
Gallery; Rochester Public Library.

LANSNER, Fay G. Painter. Born: Philadelphia, Pennsylvania
in 1921. Studied: Wanamaker Institute; Tyler School of
Fine Arts, Temple University; Art Students League; and with
Hans Hofmann, and in Paris with Leger and L'Hote; also
Holland and England.

LARNED, Marguerite Y. Painter. Exhibited at 33d Annual
Exhibition of National Association of Women Painters and
Sculptors.

LARSH, Theodora. Painter. Born: Crawfordville, Indiana.
Studied: Art Students League. Her specialty, Miniatures.

LASCARI, Hilda K. Sculptor. Born: in 1885 and died in
1937.

LASKOSKI, Pearl. Painter. Born: Steamboat Rock, Iowa.
Awards: Iowa Art Salon, 1947, 1949, 1951; Iowa Art
Competitition Exhibition, 1951. Collections: Des Moines
Art Museum; Iowa State Federation of Women's Clubs.

LATHAM, Barbara. Painter. Born: Walpole, Massachusetts
in 1896. Studied: Norwich Connecticut Art School; Art
Students League. Collections: Metropolitan Museum of Art;
Museum of New Mexico; Dallas Museum of Fine Arts.

LATHROP, Dorothy P. Graphic Artist. Born: in 1891.

LATHROP, Elinor L. Painter and sculptor. Born: Hartford,
Connecticut in 1899. Studied: with Hale, Logan and Jones.

LATHROP, Gertrude K. Sculptor. Born: Albany, New York
in 1896. Studied: Art Students League; School of American
Sculpture, New York, and with Charles Grafly and Solon
Borglum. Awards: National Academy of Design, 1928, 1931,
1936; Stockbridge Art Association, 1937; National
Association of Women Artists, 1933, 1943; American Academy
of Arts and Letters, 1943; National Sculpture Society, 1944;
Allied Artists of America, 1950; Hispanic Society of
America, 1950; American Numismatic Society, 1950.
Collections: Houston Texas Public Library; Albany Public
Library; New York State Teachers College; Smithsonian
Institute; Memorial Grove, Albany, New York; New Rochelle,
New York; Garden Club of America, 1942, 1950; Brookgreen
Garden, South Carolina, 1946; Hispanic Society of America,
1950; Mariners' Museum, Newport News, Virginia.

LATHROP, Ida P. Painter. Born: Troy, New York in 1859.
Painter of portraits, landscapes and still-life.

LATROBE, Mary. Painter. Specialty, water colorist of
landscapes and nature studies. Exhibited in 1812.

LAUTER, Flora. Painter. Born: New York in 1874. Studied:
with Chase and Mora in New York.

LAVENDER, Eugenie. Painter. Born: in 1817 and died in
1898. She was a religious painter.

LAW, Margaret Moffet. Painter. Born: Spartanburg, South
Carolina. Studied: with Chase, Henri, Mora and Hawthorne.
Collections: Kennedy Library, Spartanburg, South Carolina;
Converse College, South Carolina.

LAW, Pauline. Painter. Born: Wilmington, Delaware in 1908.
Studied: Art Students League; Grand Central Art School;
and with Carlson, Hibbard and Snell. Awards: Hudson Valley
Art Association 1955, 1957; Pen and Brush Club; Catherine
L. Wolfe Art Club. Collection: Athens Greece Museum of Art.

LAWSON, Adelaide J. Painter. Born: New York City in 1890.
Studied: with Kenneth Hayes Miller.

LAWSON, Helen E. Engraver. Was active between 1830 and 1842.

LAWSON, Katharine S. Sculptor. Born: Indianapolis,
Indiana in 1885. Studied: with Lorado Taft and Herman A.
MacNeil. Award: National Academy of Design, 1921.

LAYTON, Gloria. Painter. Born: New York City in 1914.
Award: Connecticut Academy of Fine Arts, 1956. Was
exhibiting widely in the 1950s.

LAZARD, Alice A. Painter. Born: New Orleans, Louisiana
in 1893. Studied: Newcomb College, Tulane University;
Art Institute of Chicago. Awards: North Shore Art League,
1948-1952; Mile of Art Exhibition, Highland Park, 1954.
Collections: Vanderpoel Collection; Sinai Temple, Chicago;
Vance Publishing Company, Chicago.

LAZZELL, Blanche. Painter and etcher. Born: Maidsville,
Monongalia County, West Virginia. Studied: with Guerin;
and William Schumacher. Collection: Detroit Art Institute;
West Virginia University Library.

LEACH, Ethel P. Painter. Born: Wilmington, Delaware.
Studied: Art Students League; Pennsylvania Academy of Fine
Arts; and with Howard Pyle. Awards: Wilmington Society of
Fine Arts; Rehoboth Beach Art League; Philadelphia Plastic
Club, 1944. Collections: Mississippi Art Association;
Wilmington Society of Fine Arts; State House, Dover,
Delaware; Dickinson College; Washington College, Chestertown,
Maryland; Court House, Bellefonte, Pennsylvania.

LEAKE, Mrs. S. C. Portrait painter. She was exhibiting in
1849.

LEAYCRAFT, Julia. Painter. Born: Saugerties, New York in
1885. Studied: Vassar College; Art Students League;
Woodstock School of Landscape Painting; and with Birge
Harrison.

LE BRON, Warree Carmichael (Mrs). Painter. Born: Elba,
Alabama in 1910. Studied: Huntington College; Sullins
College; Art Students League; Ecole des Beaux-Arts,
Paris. Award: Kelly Fitzpatrick award, 1954.
Collections: Montgomery Museum of Fine Arts; Alabama
College; Alabama War Memorial Museum; Sycamore, Alabama.

LEDERER, Edna T. Painter. Born: Cleveland, Ohio in
1909. Studied: Art Students League; Cleveland School
of Art; and with Sandor, Vago and Robert Brackman.
Awards: Cleveland Museum of Art, 1932, 1936.

LEDERER, Lucy C. Painter. Born: Milton, Pennsylvania.
Studied: Pratt Institute of Art School; Pennsylvania
State University; and with Pittman, Miller and Marsh;
Art Students League. Collections: Pennsylvania State
University; Presbyterian Church, State College,
Pennsylvania; American Legion Headquarters, Illinois.

LEDOUX, Eva M. B. Painter. Born: Manchester, New
Hampshire in 1899. Studied: University of New Hampshire;
School of Practical Art, Boston; Beaux-Arts, Montreal,
Canada; Manchester Institute of Art and Science; and
with Philip Hicken, R. Coleman and Charles Maillard and
others. Awards: Currier Gallery of Art, 1955; Manchester
Institute of Arts and Science, 1942, 1945; American
Society for Control of Cancer, 1942; Manchester Art
festival, 1958.

LEE, Amy Freeman. Painter. Born: San Antonio, Texas
in 1914. Studied: University of Texas; Incarnate Word
College. Awards: San Antonio Artists, 1949, 1956; Smith
College, 1950; Boston Society of Independent Artists;
Charles Rosen award, 1950; Texas Fine Arts Association,
1950, 1958; Texas Watercolor Society, 1955; Neiman-Marcus
award, 1953; Grumbacher award, 1953; Hall Memorial, 1954;
Rosengren award, 1953; Silvermine Guild, 1957; Beaumont
Museum, 1957; "Artist of the Year." San Antonio, 1958;
Theta Sigma Phi Headliner award, 1958. Collections:
Witte Memorial Museum; Smith College; Baylor University;
Baltimore Museum of Art; Dallas Republic National Bank.

LEE, Bertha S. Painter. Born: San Francisco, California
in 1873. Studied: in New York and abroad. Collections:
Del Monte Art Gallery; Golden Gate Park Museum, San
Francisco.

LEE, Doris. Painter. Born: Aledo, Illinois in 1905.
Studied: Rockford College; Kansas City Art Institute,
and with Ernest Lawson; California School of Fine Arts,
with Arnold Blanch; and with Andre L'Hote in Paris.
Awards: Art Institute of Chicago, 1935, 1936; Pennsylvania
Academy of Fine Arts, 1944; Rockford College; Russell Sage
College; Carnegie Institute, 1943; Library of Congress, 1947;
Art Directors Club, New York, 1946, 1950, gold medal, 1957;
Worcester Museum of Art, 1938. Collections: United States
Post Office, Washington, D. C.; Art Institute of Chicago;
Metropolitan Museum of Art; Library of Congress; Albright
Art Gallery; University of Nebraska; Cranbrook Museum;
Encyclopaedia Britannica Collection; Pennsylvania Academy
of Fine Arts; Lowe Gallery, Miami; Honolulu Academy of Fine
Arts; Rhode Island School of Design; University of Arizona;
Rockford College; Mt. Holyoke Museum; Florida Gulf Coast
Art Center.

LEE, Elmina Bennett. Painter. Born: in 1821 and died in
1908. Known as a landscape painter.

LEE, Laura. Painter. Born: in 1867.

LEE, Musier T. Painter. Born: New York City in 1909. Studied:
in France and italy. Art Students League. Exhibited mainly
in New York and Pittsburgh.

LEE, Ruth H. Painter. Born: Ellisburg, New York in 1885.
Studied: Syracuse University; and with Hawthorne, Adams,
Ennis and O'Hara. Awards: Syracuse Museum of Fine Arts,
1948; National League of American Pen Women, 1950; Rochester
Memorial Art Gallery, 1948; Munson-Williams-Proctor
Institute. Collection: Syracuse Museum of Fine Arts.

LEECH, Dorothy Sherman. Painter. Born: Pittsburgh,
Pennsylvania in 1913. Studied: Carnegie Institute;
Ringling Art School. Collections: Congregational Church,
Riga, New York; Wauchula Florida High School; Methodist
Church, Winter Park, Florida; Hamilton Art Gallery, Ontario,
Canada; Hickory Museum of Art, North Carolina; Montclair Art
Museum, New Jersey.

LEEPER, Vera. Painter. Born: Denver Colorado in 1899.
Studied: Denver University; Boston Museum of Fine Arts
School; New York University; and in Paris. Awards: Wolfe
Art Club, 1920; New York Watercolor Club, 1926; Kansas
City Art Institute, 1934; Brown Robertson competition,
New York, 1928; National Academy of Design, 1929.
Collections: Denver Art Museum; Public Schools in New York
and New Jersey.

LEFF, Rita. Painter, Printmaker. Born: New York City in 1907. Studied: Art Students League; Brooklyn Museum School of Art, and with George Picken, Louis Schanker, Abraham Rattner and Adja Yunkers. Awards: Audubon Art, 1955-58; National Academy of Women Artists, 1951, 1954, 1955, 1958; Brooklyn Society of Art, 1950, 1953, 1957; Brooklyn Museum Alumni Association, 1955-57; Boston Printmakers, 1954; Society of American Graphic Artists, 1954; Village Art Center, 1953-1955; Creative Graphic Exhibition, 1958. Collections: Metropolitan Museum of Art; Library of Congress; University of Maine; Pennsylvania State University; Dallas Museum of Fine Arts; Abraham Lincoln High School; Contemporary Gallery, 1956.

LEFRANC, Margaret. Painter. Born: New York City in 1907. Studied: New York University; also in Paris with Schoukaieff, Bourdelle and L'Hote. Exhibited extensively in the Southwest and in Paris.

LEGARE, Mary S. Painter. Born: in 1792. A landscape painter.

LEHMAN, Louise B. Painter. Born: Orwood, Mississippi in 1901. Studied: Mississippi State College for Women; George Washington University; Corcoran School of Art; Columbia University. Awards: Brooks Memorial Art Gallery, 1954; Tennessee All-State Art Exhibition, Nashville, 1955; Memphis Academy of Art. Collections: Montgomery Museum of Fine Arts; Mississippi State College for Women.

LEIF, Florence. Painter. Born: New York City in 1913. Studied: Rhode Island School of Design; also studied with John R. Frazier. Collections: Providence Art Club; International Business Machines Collection.

LEIGHTON, Clare Veronica. Graphic Artist. Born: in 1901

LEISENRING, Mathilde M. Painter. Born: Washington, D.C. Studied: Art Students League, in New York and Washington; also with Laurens, Constant and Henner in Paris.

LEKBERG, Barbara H. Sculptor. Born: Portland, Oregon in 1925. Studied: University of Iowa; and with Humbert Albrizio. Awards: National Institute of Arts and Letters 1956; Guggenheim fellowship, 1957, 1959. Collections: Knoxville Tennessee Art Center; Socony Building, New York; Des Moines Art Center; Beldon-Stratford Hotel, Chicago.

Le MERCIER, Rose J. Lithographer. Born: in 1803 and died in 1887.

LEMERE, Alexis. Painter. A landscape painter who worked
1844-1846.

L'ENGLE, Lucy. Painter. Born: New York in 1899. Studied:
Art Students League; and in Paris. She exhibited in the
1950s in Massachusetts, New York and Florida.

LENNEY, Annie. Painter. Born: Potsdam, New York. Studied:
College of St. Elizabeth, New Jersey; Grand Central Art
School: Art Students League; New York University; Syracuse
University; St. Lawrence University; also with Hayley Lever.
Awards: Newark Art Club, 1940, 1949, 1951; Irvington Art
and Museum Association, 1940, 1948; Kresge Exhibition,
1940; Spring Lake, 1946, 1948, 1950; National Association
of Women Artists, 1948, 1954; Art Club of the Oranges, 1952;
Montclair Art Museum, 1952, 1953; Seton Hall University;
College of St. Elizabeth Convent, New Jersey; Kappa Pi;
Public School, Newark.

LENSSEN, Heidi. Painter. Born: Frankfurt, Germany in
1909. Studied: in Europe. Awards: Baden, Germany, 1929,
1931. Collection: European museums and galleries.

LE ROY, Anita. Painter. Born: Philadelphia, Pennsylvania.
Studied: Pennsylvania Academy of Fine Arts. Her specialty,
Dutch scenes.

LEROY, Elizabeth E. Painter. Born: in 1794 and died in
1878. She painted portraits in pastels and oils.

LESLIE, Anne. Painter. She was a portrait painter and
sister of Charles Robert Leslie. In 1822 she was copying
portraits, some of which were her brothers paintings.
One such painting beautifully executed was exhibited in
1847 at the Pennsylvania Academy of Fine Arts.

LESLIE, Eliza. Painter. Born: Philadelphia in 1787 and
died in 1858. A portrait and figure painter she made a
few crayon portraits.

LEVENTHAL, Ethel S. Painter. Born: Brooklyn, New York
in 1911. Studied: Art Students League; New York University;
Brooklyn Museum School of Art; New School for Social
Research. She exhibited her work for the most part in the
New York area.

LEVY, Beatrice S. Painter. Born: Chicago, Illinois in
1892. Studied: Art Institute of Chicago; and with Charles
Hawthorne and Vojtech Preissig. Awards: Art Institute of
Chicago, 1923, 1930; Springfield Illinois Academy, 1928;
Coronado Art Association, 1952, 1956, 1957; Del Mar,
California, 1953; San Diego Fine Arts Guild, 1955, 1957.
Collections: Chicago Municipal collection; Bibliotheque
Nationale, Paris; Art Institute of Chicago; Library of
Congress; La Jolla Art Center; Davenport Municipal Art
Gallery; Smithsonian Institute; Vanderpoel Collection.

LEVY, Hilda. Painter. Born: Pinsk, Russia. Studied:
University of California, Berkeley; Jepson Art Institute;
and with Joseph Krause, Kenneth Nack and Leonard Edmondson.
Awards: California Watercolor Society, 1954-1957;
National Orange Show, 1955; New Orleans Art Association,
1955, 1956; Portland Art Festival, 1958. Has exhibited
widely in the United States.

LEWIS, Edmonia. Sculptor. Born: Albany, New York in 1845.
By birth she was part Indian and her work showed ideality
and talent. She executed portrait busts of Henry W.
Longfellow, John Brown and Abraham Lincoln.

LEWIS, Jeannette M. Etcher. Born: Oakland, California in
1896. Studied: California School of Fine Arts with Armin
Hansen; also studied with Winold Reiss, Hans Hofmann.
Awards: Boston Printmakers, 1954; California State Fair,
1954; Society of American Graphic Artists, 1954;
Society of Western Art, 1955.

LEWIS, Josephine M. Painter. Born: New Haven, Connecticut
in 1865. Studied: with Frederick MacMonnies and John F. Weir.

LEWIS, Lalla W. Painter. Born: Greenwood, Mississippi in
1912. Studied: Mississippi State College for Women. Awards:
Southern States Art League, 1935; Minneapolis Institute of
Art, 1936. Collections: Mississippi State College for
Women; Delgado Museum; Belhaven College and Municipal Art
Gallery, Jackson, Mississippi; Newcomb College, Tulane
University; Greenwood Mississippi Public Library.

LEWIS, Ruth. Painter. Born: New York City in 1905.
Studied: Art Students League; also with Raphael Soyer,
Moses Soyer, Francis Criss and Sidney Laufman. Awards:
National Association of Women Artists, 1947, 1956, 1957.
Collection: Everhart Museum of Art, Scranton, Pennsylvania.

LEYDEN, Louise H. Painter. Born: Fresno, California.
Studied: with William Griffith, Thomas Hunt and Eleanor
Colburn. Awards: Laguna Beach Festival of Art, 1939,
1958; Women Painters of the West; Las Vegas Art League
1957; National League of American Pen Women, 1958.

LIBOLT, Mrs. S. H. Painter. She was executing her
miniatures from 1838 to 1841.

LIDOW, Leza. Painter. Born: Kansas City, Missouri in
1924. Studied: in Europe. Awards: Denver Art Museum,
1952; Los Angeles Museum of Art, 1952; Art in
Electronics Exhibition, San Francisco, 1957.

LIEBMAN, Aline Meyer. Painter. Born: Los Angeles,
California. Studied: Barnard College; Columbia College;
also with Henry Mosler, Stephan Hirsch.

LIGGET, Jane Stewart. Sculptor. Born: Atlantic City,
New Jersey in 1893. Studied: Pennsylvania Academy of
Fine Arts with Beatrice Fenton; and in Paris. Awards:
fellowship, Pennsylvania Academy of Fine Arts; Cresson
traveling scholarship, Pennsylvania Academy of Fine
Arts.

LILLIE, Ella Fillmore. Lithographer. Born: Minneapolis,
Minnesota. Studied: Minneapolis School of Fine Arts;
Art Institute of Chicago; New York School of Fine Arts;
Cincinnati Art School. Awards: Southern Printmakers,
1938; Hoosier Salon, 1945, 1956, 1950, 1958; John
Herron Art Institute, 1956; Northwest Printmakers, 1940;
Springfield, Missouri, 1941, 1942; Library of Congress,
1945; Indiana Printmakers, 1947; Boston Printmakers,
1948; Society of American Graphic Artists, 1951.
Collections: Seattle Art Museum; Library of Congress;
Dayton Art Institute; California State Library; Fleming
Museum; Boston Museum of Fine Arts; Wesleyan College,
Macon, Georgia; Metropolitan Museum of Art; Pennsylvania
State University; Colt, Avery, Morgan Memorial; Carnegie
Institute; Art Institute of Chicago; Toledo Museum of
Art; Telfair Academy; High Museum of Art; Brooks
Memorial Art Gallery; Honolulu Institute of Art;
Minneapolis Art Institute.

LINDBORG, Alice W. Painter. Born: Wilmington, Delaware
in 1912. Studied: Smith College; Pennsylvania Academy of
Art; also with Arthur Carles. Awards: fellowship,
Pennsylvania Academy of Fine Arts; Wilmington Art Club,
1936, 1937; New Haven Paint and Clay Club, 1948.
Collection: Pennsylvania Academy of Fine Arts.

LINDSAY, Ruth A. Painter. Born: Ada, Ohio in 1888. Studied: Pennsylvania Academy of Fine Arts; Art Students League; also studied abroad. Awards: Pasadena Museum of Art, 1955; Friday Morning Club, 1957. Exhibited in California.

LINK, B. Lillian. Sculptor. Born: New York. Studied: with Herbert Adams, George Grey Barnard and Mrs. Charles Sprague-Smith.

LINTON, Mrs. Sculptor. Born: New York City. Studied: Brooklyn Academy; also with Robert Laurent, and Jose de Creeft. Awards: International Business Machines, 1947; National Association of Women Artists, 1947; Long Island Art Festival; Audubon Art. Collection: International Business Machines.

LIPPINCOTT, Janet. Painter. Born: New York in 1918. Studied: Art Students League; Bisttram School of Art, Taos, New Mexico; San Francisco Art League; and with Alfred Morang, and John Skolle. Exhibited chiefly in New Mexico.

LIPPINCOTT, Margarette. Painter. Born: Philadelphia in 1862. Studied: Pennsylvania Academy of Fine Arts. She was a noted flower painter.

LISZT, Maria. Painter. Born: Boston, Massachusetts. Studied: Scott Carbee School of Art; Boston Museum of Fine Arts School; Art Students League; Cincinnati Art Academy. Collections: Her work is in hotels and restaurants, in New York, Boston and Florida. She specializes in landscapes.

LITTLE, Ann. Painter. She was a primitive landscapist born in 1820.

LITTLE, Gertrude L. Painter. Born: Minneapolis, Minnesota. Studied: Art Students League; and with S. MacDonald-Wright and Ella Shepard Bush. Awards: Seattle Fine Arts Society, 1921; California Society of Miniature Painters, 1923, 1925, 1928; San Diego Fine Arts Society, 1926; Pacific Southwest Exposition, 1926; Los Angeles County Fair, 1928. Collection: Philadelphia Museum of Art. She was a noted miniature painter.

LITZINGER, Dorothea M. Painter. Born: Cambria County, Pennsylvania in 1889 and died in 1925. Studied: National Academy of Design. Well known for her flower paintings.

LIVERMORE, Mrs. Painter. Known as a miniature painter her work flourished in Boston 1847 to 1848.

LIVERMORE, Mary S. Painter. Born: in 1806. Known as a
miniaturist.

LIVINGSTON, Biganess. Painter. Collections: Cranwell
School, Lenox, Massachusetts; Radcliff College,
Cambridge, Massachusetts; Chase Manhattan Bank, New York.

LIVINGSTON, Harriet. Painter. An amateur miniaturist
who became the wife of Robert Fulton, 1808 and painted
a miniature of her father, Walter Livingston, which was
reproduced by C. W. Bowen.

LLOYD, Sara A. Painter. Studied: with Volk and Chase;
also with Swain Gifford. She also painted portraits.

LOBINGIER, Elizabeth M. Painter. Born: Washington, D.C.
in 1889. Studied: University of Chicago; Chicago Academy
of Fine Arts; Art Institute of Chicago. Awards:
Association of Georgia Art; High Museum of Art; Mint
Museum of Art, 1945; Boston Open exhibition, 1955;
Rockport Art Association, 1947, 1948, 1951, 1953; gold
medal, Jordan Marsh exhibition, 1957; Ogunquit Art
Center, 1951. Collection: Mint Museum of Art; Winchester
Massachusetts Public Library.

LOCHRIE, Elizabeth. Painter. Born: Deer Lodge, Montana
in 1890. Studied: Pratt Institute of Art School; Stanford
University; and with Winold Reiss, Nicholas Brewer, Victor
Arnautoff and Dorothy Puccinelli. Awards: National Pencil
Company, 1937; National Watercolor Competition, 1939.
Collections: United States Post Office, Burley, Idaho;
St. Anthony, Idaho; Dillon, Montana; Montana State
Tuberculosis Hospital, Galen, Montana; Finlen Hotel, Butte.

LOCK, Alice G. Painter. Exhibited at the 33d Annual
Exhibition of National Association of Women Painters and
Sculptors.

LOCKE, Lucie H. Painter. Born: Valdosta, Georgia in 1904.
Studied: Newcomb College, Tulane University; San Antonio
School of Art; and with Charles Rosen, Xavier Gonzales,
Increase Robinson, Frederic Taubes and others. Awards:
Corpus Christi Art Foundation, 1946, 1949, 1954, 1955.
Collections: Montgomery Museum of Fine Arts; Del Mar
College; Corpus Christi Art Foundation; Corpus Christi
Civic Center.

LOEB, Dorothy. Painter and etcher. Born: in Bavaria in
1887 of American parents. Studied: Art Institute of
Chicago; T. W. Stevens; Hawthorne; Also studied in Paris
and Munich.

LOEBL, Florence Weinberg. Painter. Born: New York in 1894. Studied: with Kenneth Hayes Miller.

LOGGIE, Helen A. Etcher. Born: Bellingham, Washington. Studied: Smith College; Art Students League; and with John Taylor Arms, Mahonri Young. Awards: Albany Printmakers Club, 1953; Florida Southern College, 1952; National Academy of Design, 1955; Northwest Printmakers, 1939; Library of Congress, 1943; Pacific Northwest Arts and Crafts Association, 1950. Collections: University of Nebraska; Library of Congress; Museum of Fine Arts of Houston; Seattle Art Museum; Western Washington College of Education; Springfield Museum of Art; Library of Congress; Metropolitan Museum of Art; Pennsylvania State University; National Museum, Stockholm; Glasgow University, Scotland; British Museum, England; Lyman Allyn Museum; International Business Machines; Albany Institute of History and Art; Philadelphia Museum of Art.

LOGUE, Kate. Painter. Born: 1825. A still life and water colorist.

LOHR, Kathryn L. Painter. Born: Johnstown, Pennsylvania in 1912. Studied: Johnstown Art Institute; University of Pittsburgh; Indiana State Teachers College; St. Francis College; Pennsylvania State College; and with Orval Kipp and Ralph Pearson. Awards: Allied Artists of Johnstown, 1940, 1942-1945; Cambria County Fair, 1937; Fine Arts Club, Johnstown, 1938; American Artists Professional League, 1949, 1950; Golden Triangle Art, 1948; gold pin, American Artists Professional League, 1949; Pennsylvania State University, 1952. Collections: State Teachers College, Indiana, Pennsylvania; United States Veterans Hospital, Aspinwall, Reading, Pennsylvania; University of Pittsburgh; Lebanon Valley Veterans Hospital.

LOMBARD, Catherine B. Born: in 1810. A noted portrait painter.

LONEY, Doris H. Painter. Born: Everett, Washington in 1902. Studied: University of Washington; Art Students League, with Robert Brackman, Yasuo Kuniyoshi; Farnsworth School of Art; Scripps College Graduate Art Department; and with Millard Sheets, Fletcher Martin and Dong Kingman. Awards: Seattle Art Museum, 1950; Arrow Head Show, Duluth, Minnesota, 1948-1950, 1958; Tri-State Fair, Superior Wisconsin, 1948-1950. Collections: Wisconsin State College, Superior, Wisconsin; First National Bank, Superior Wisconsin.

LONG, Adelaide H. Painter. Born: In New York. Studied: Art Students League; with Twachtman, Collins, and Knaufft; Also with Anglade in Paris.

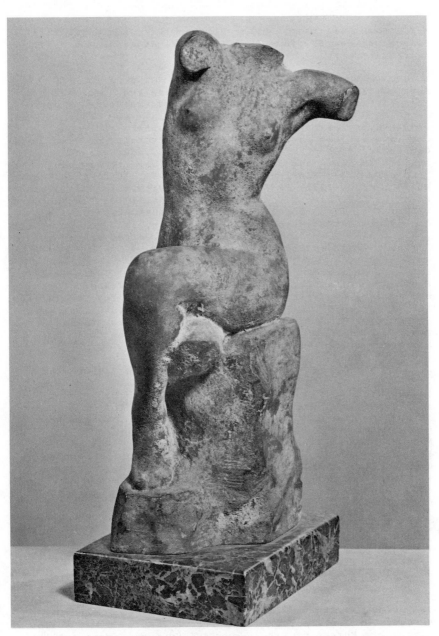

Evelyn Beatrice Longman, SEATED FEMALE FIGURE. Bronze, on green
marble base. The Metropolitan Museum of Art (Gift of E. D.
Edarns, 1927).

LONG, Gwen. Painter. Born: Oklahoma City, Oklahoma in 1926.
Awards: 63 awards since 1967 in State, Regional and National
Exhibitions.

LONGACRE, Lydia E. Painter. Born: In New York in 1870.
Studied: Art Students League, with Chase and Mowbray;
in Paris with Whistler. She was a noted miniature painter.

LONGACRE, Margaret G. Etcher, Lithographer. Born:
Cincinnati, Ohio in 1910. Studied: University of Cincinnati;
Cincinnati Academy of Art; and with E. T. Hurley; also
studied in Paris and Switzerland. Awards: Library of
Congress, 1943; Cincinnati Crafters, 1950, 1952; Cincinnati
Woman's Club, 1951, 1953, 1955, 1956; Washington Miniature
Painters and Graphic Society, 1952, 1954, 1958; Pan-American
Exhibition, 1949; Print of the Year, Massachusetts, 1943;
Cincinnati Museum Association, 1944; Cleveland Museum of Art,
1941. Exhibited very extensively in the United States and
Europe as well as South America.

LONGLEY, Bernique. Painter. Born: Moline, Illinois in 1923.
Studied: Art Institute of Chicago; and with Francis Chapin
and Edouard Chassaing. Award: Lathrop traveling scholarship,
Art Institute of Chicago, 1945; Museum of New Mexico; Mexico
State Fair. Collections: Museum of New Mexico; Dallas Art
Museum; mural, LaFonda Del Sol Restaurant, New York; mural,
Alexander Girard Home, Santa Fe.

LONGLEY, Evelyn. Painter. Born: Somerville Massachusetts
in 1920. Studied: Child-Walker School of Design, Boston,
Massachusetts; P. G. Stuart School of Design Department;
also with Albert F. Jacobson, Lawrence Beal Smith; Arthur
T. Lougee, Theodore Carl Muller and others. Awards: Royall
House, Medford, Massachusetts, 1947, 1948, 1950, 1951;
National League of American Pen Women, 1954, 1956; Florida
Federation of Art, 1956, 1957. Collections; The James
Wallace Longley Memorial, Christ Methodist Church, St.
Petersburg; World War II Memorial, Edward Peterson Post
#98, American Legion, Rockport, Massachusetts.Exhibited
extensively.

LONGMAN, Evelyn B. Sculptor. Born: Winchester, Ohio in
1874. Studied: Art Institute of Chicago; with Taft; in
New York with French. Awards: French gold medal, Art
Institute of Chicago, 1920; Widener gold medal,
Pennsylvania Academy of Fine Arts, 1921. Collections:
Bronze doors of Chapel, United States Naval Academy,
Annapolis; bronze doors of Library, Wellesley College,
Wellesley, Massachusetts; Metropolitan Museum; Toledo
Museum; Chicago Art Institute; City Art Museum, St. Louis;
Cincinnati Museum of Art; Cleveland Museum; Herron Art
Institute, Indianapolis.

LOOP, Jennette Shepherd. Painter. Born: New Haven, Connecticut in 1840 and died in 1909. Studied: with Henry A. Loop whom she married in 1865. She was noted for her figure and portrait paintings. Her specialty was portraits of children.

LORD, Caroline. Painter. Born: Cincinnati, Ohio in 1860. Studied: Cincinnati Art School; Julien Academy, Paris. Collection: Cincinnati Museum

LORD, Harriet. Painter and etcher. Born: Orange, New Jersey in 1879. Studied: with Tarbell, Benson and De Camp.

LORD, Phoebe G. Painter. Born: in 1797 and died in 1875. She was a miniature painter in water colors.

LORNE, Naomi. Painter. Born: New York City. Studied: City College of New York; Hunter College and with A. T. Hibbard, George Bridgmann and Frederick J. Waugh. Awards: Audubon Art, 1944,1947; Silvermine Guild Artist, 1956; National Association of Women Artists, 1956. Collection: Staten Island Hospital; General Steel Corporation; American Cyanamid Company; Ain-Harod Museum, Israel; Maryknoll Teacher College.

LOTTERHOS, Helen Jay. Painter. Born: McComb, Mississippi. Studied: Millsaps College; and with Marie A. Hull. Awards: gold medal, 1940, Mississippi Art Association; Mississippi Art Association, 1936, 1949-51, 1953, 1956; Southern States Art League, 1944; Mississippi College Watercolor Exhibition, 1955. Collections: Jackson Municipal Art Gallery; Mississippi State College for Women; Mississippi College.

LOUD, Mrs. H. C. Crayon portrait draughtsman. She was working about 1850 in Philadelphia.

LOUD, May Hallowell. Painter. Born: in 1860 and died in 1916.

LOVELL, Katherine A. Painter. Was exhibiting her work at the 33d Annual Exhibition of the National Association of Women Painters and Sculptors.

LOVICK, Annie Pescud. Painter. Born: Raleigh, North Carolina in 1882. Studied: with Greacen, Hilderbrandt, Mora, Brackman and Cole. Collections: portraits, National Museum; Guilford North Carolina Court House; altarpiece, children's room, Christ Church, New Bern, North Carolina.

LOW, Mary Fairchild. Painter. Born: New Haven, Connecticut in 1858. Studied: School of Fine Arts, St. Louis; Academie Julien, Paris and with Carolus-Duran. Awards: Chicago Exposition, 1893; Paris Exposition, 1900.

LOWE, Emily. Painter. Born: New York City in 1902. Studied: Columbia College; New York University; Academie Julian, Paris; Art Students League; Hofstra College; Miami University; also with George Picken, Frank J. Reilly, and Frank DuMond. Collections: in private collections in France, Canada and the United States. Founder and sponsor of the Emily Lowe Foundation.

LUCAS, Blanche Wingert. Painter. Born: Alburtis, Pennsylvania in 1888. Studied: Bloomsburg State Teachers College; Kutztown State Teachers College; New York University; Lehigh University; also with Walter Baum and Franz Cizek in Vienna; and with Augustus John in England. Collections: Everhart Museum of Art; Allentown Public Library and Hospitals, New Milford, Connecticut, and Galax Virginia.

LUCE, Laura H. Painter. Born: Salem, New York in 1845. Studied: with A. H. Wyant, C. B. Coman; and H. B. Snell in New York. She was a landscape painter.

LUCE, Marie Huxford. Painter. Born: Skaneateles, New York. Studied: with J. S. H. Keever in Holland; Mr and Mrs. Charles H. Woodbury in Boston.

LUCE, Molly. Painter. Born: Pittsburgh, Pennsylvania in 1896. Studied: Wheaton College; Art Students League with Kenneth Hayes Miller. Collections: Metropolitan Museum of Art; Whitney Museum of American Art.

LUDINS, Ryah. Painter. Studied: Columbia University; Art Students League; and with William S. Hayter; in Paris with Andre L'Hote. Collections: Cleveland Museum of Art; Toledo Museum of Art; Museum of Modern Art; American Institute of Graphic Arts; New York Public Library; Newark Public Library; J. B. Kendall Company, Washington, D.C. Bellevue Hospital, New York; United States Post Office, Nazareth, Pennsylvania; Courtland, New York; State Museum Michoacan, Mexico.

LUDOVICI, Alice E. Painter. Born: Dresden, Germany in 1872. Studied: with Julius Ludovici in New York. She was of Italian and English descent.

LUELOFF, Marjorie K. Painter. Born: Kenosha, Wisconsin in 1906. Studied: Art Institute of Chicago; University of Wisconsin; and with Hubert Ropp and John Carroll. Award: Milwaukee Art Institute, 1940.

*Jennie Lusk, PROVINCE ROSE, c. 1880. Watercolor, 9 3/4" X 8 1/4".
Private Collection.*

LUGANO, Ines Somenzini. Painter. Born: Verretto, Pavia, Italy. Studied: Academy of Fine Arts, Pavia, Italy; and with Romeo Borgognoni. Known as a miniature and portrait painter. Awards: National Exhibition, Milano, Italy; California Society of Miniature Painters, 1935; New Orleans Art Association, 1939. Collections: Tulane University; Delgado Museum of Art.

LUM, Bertha. Painter. Born: in Iowa. Studied: Art Institute of Chicago; also with Frank Holme and Anna Weston. Awards: Panama-Pacific Exposition, San Francisco, 1915. Specialty, wood block prints.

LUMSDON, E. Christine. Painter. Born: Brooklyn, New York. Studied: with Carolus-Duran, Henry Mosier, Childe Hassam and George de Forest Brush.

LUMIS, Harriet R. Painter. Born: Salem, Connecticut in 1870. Studied: with Willis S. Adams; New York Summer School of Art; also with Leonard Ochtman and Hugh Breckenridge.

LUNDBORG, Florence. Painter. Born: San Francisco, California. Studied: Mark Hopkins Institute of Art; also studied in Paris and Italy. Also a noted illustrator. Was represented at the Panama-Pacific Exposition by her mural panels in the California Building.

LUPTON, Frances P. Painter. Known as a landscape, miniature artist and sculptor who was exhibiting 1828-1831.

LUSH, Vivian. Sculptor. Born: New York City in 1911. Studied: Leonardo da Vinci Art School; National Academy of Design; Art Students League; also with Attilio Piccirilli, Charles Keck and Robert Aitken. Award: National Association of Women Artists. Collections: Riverside Church, New York; Rockefeller Center, New York; Port Richmond High School; Unity Hospital, Brooklyn, New York; Roosevelt High School, Bronx, New York; Children's Wing, Public Library, Trinidad, British West Indies.

LUSK, Jennie. Watercolorist. Was working between 1840-1883 in Marietta, Ohio and Boston, Massachusetts. Painted from nature, mostly flowers. Made several trips to Florida and the South to study the flora and fauna. She did commissions for the New York Gift Card Company.

LUX, Gladys Marie. Painter. Born: Chapman, Nebraska. Studied: University of Nebraska; Art Students League. Collections: Doane College; Peru State College; Nebraska Wesleyan; Lincoln Art Guild; Public School, Kearney, Nebraska.

LUX, Gwen. Sculptor. Born: Chicago, Illinois. Studied: Maryland Institute of Art; Boston Museum of Fine Arts School; in Paris; and with Ivan Mestrovic. Awards: Guggenheim fellowship, 1933; Detroit Institute of Art, 1945, 1956; National Lithograph prize, 1947; National Association of Women Artists, 1947; Audubon Art, 1954. Collections: Association of American Artists; Radio City, New York; Mc-Graw-Hill Building, Chicago; Trustees System Service, Chicago; University of Arkansas; Victoria Theatre, New York; Bristol Tennessee Hospital; Steamship "United States." Texas Petroleum Club, Dallas; Northland Shopping Center, Detroit; General Wingate School, Brooklyn; General Motors Research Center, Detroit; Socony Building, New York City; R. H. Macy-Roosevelt Field, New York; Public School 19, New York City; Aviation Trades High School, Long Island, New York; Country Day School, Lake Placid, New York.

LYNCH, Anna. Painter. Born: Elgin, Illinois. Known as a miniaturist.

LYNCH, Anna. Crayon artist working around 1853.

LYNCH, Irene Deroche. Painter. Born: Mattawa, Ontario, Canada in 1908. ·Studied: in Canada. Exhibited in Canada.

LYNN, Katherine N. Painter. Was exhibiting at the National Association of Women Painters and Sculptors, at their 33d Annual Exhibition.

MAC CORD, Mary. Painter. Exhibited in 1925 at the
Pennsylvania Academy of Fine Arts.

MAC CHESNEY, Clara Taggart. Painter. Born: Brownsville,
California. Studied: with Virgil Williams in San Francisco;
H. S. Mowbray and J. C. Beckwith in New York; and Courtois
and Girardot at Colarossi School, Paris. Awards: Buffalo
Exposition, 1901; St. Louis Exposition, 1904.

MAC DOWELL, Susan Hannah. Painter. Born: Philadelphia,
Pennsylvania in 1851. Studied: Pennsylvania Academy of
Fine Arts; and with Professor C. Schussele and Thomas
Eakins. As a portraitist chiefly, her paintings are in
private collections in Philadelphia.

MACFARLAN, Christina. Painter. Born: Philadelphia.
Studied: with Chase and Breckenridge at the Pennsylvania
Academy of Fine Arts.

MACHETANZ, Sara. Printmaker

MacKENDRICK, Lilian. Painter. Born: Brooklyn, New York.
Studied: New York University; College of City of New York;
Art Students League. Award: gold medal, Bordighera, Italy.
Collections: Walker Art Center; Georgia Museum of Art;
Wadsworth Atheneum; Musuem of Fine Arts of Houston;
Metropolitan Museum of Art; Brandeis University; Bezalel
Museum, Jerusalem; Galeria di Arti Contemporanea, Bordighera,
Italy.

MACKINTOSH, Miss. S. B. Painter. Miniaturist whose work
flourished in Philadelphia in 1850.

MACKUBIN, Florence. Painter. Born: in 1866 and died in
1918. Studied: in France and Italy. She was a portrait
and miniature painter. Collections: Walters Art Gallery,
Baltimore, Maryland.

MacLANE, Jean. Painter.

MacLEARY, Bonnie. Sculptor. Born: San Antonio, Texas in
1892. Studied: New York School of Art; Julian Academy,
Paris; Art Students League; with Frank DuMond, James Earle
Fraser. Awards: Women's Art and Industrial Exhibition,
1928, 1929. Collections: Metropolitan Museum of Art;
Brooklyn Children's Museum; Wesleyan College, Macon,
Georgia; Baylor University; Witte Memorial Museum; Corcoran
Gallery of Art; University of Puerto Rico; San Juan,
Puerto Rico; San Antonio, Texas.

MacLENNAN, Eunice Cashion. Painter. Born: St. Louis, Missouri in 1890. Studied: St. Louis Museum of Fine Arts; Washington University; Pratt Institute Art School; Art Institute of Chicago; Julian Academy, Grande Chaumiere, Paris. Awards: National Association of Women Artists, 1935; California State Fair, 1930, 1931; Santa Cruz, 1936; San Diego Fine Arts Gallery; Washington University. Collections: University of California, Santa Barbara branch; Santa Barbara Public Library; California State Library; Monterey Public Library; Santa Barbara Museum of Art.

MACNEIL, Carol Brooks. Sculptor. Born: Chicago, Illinois in 1871. Studied: Art Institute of Chicago with Lorado Taft; and in Paris with MacMonnies and Injalbert. Awards: Paris Exposition, 1900; St. Louis Exposition, 1900; St. Louis Exposition, 1904.

MACOMBER, Allison R. Sculptor. Born: Taunton, Massachusetts in 1916. Studied: Massachusetts School of Art; and with Cyrus E. Dallin and Raymond Porter. Award: Utopian Club, 1957. Collections: Edith C. Baker School, Brookline, Massachusetts; Reany Memorial Library, St. Johnsville, New York; State Teachers College, Lowell, Massachusetts; University of Mississippi; Notre Dame University; United States Marine Corps; Anaconda Copper Mines; St. Mary's Cathedral, Trenton, New Jersey; Buffalo Medical Society; Boston Gridiron Club; Dartmouth College; Moline Illinois Historical Society; Providence Water Commission; Jordan Hospital, Plymouth, Massachusetts; Boston University; Memorial Stadium, University of Rhode Island; rotunda, Howard State Hospital, Providence, Rhode Island; Masonic Lodge, Rhode Island; Masonic Lodge, Taunton, England; New Church of The Sacred Heart, Taftville, Connecticut; Chenery Library, Boston University.

MACOMBER, Mary L. Painter. Born: Fall River, Massachusetts in 1861. Studied: Boston Museum Art School; and with Duveneck. She died in 1916.

MacRAE, Emma Fordyce. Painter. Born: Vienna, Austria in 1887. Studied: Art Students League; New York School of Art, with Kenneth Hayes Miller. Awards: Pen and Brush Club, 1946, 1950, 1955; National Association of Women Artists, 1941, 1945; Allied Arts of American, 1942; National Art Club, 1930. Collections: Wesleyan College; Cosmopolitan Club; National Academy of Design.

MACY, Harriet. Painter. Born: Des Moines, Iowa. Studied: Art Students League.

MAGAFAN, Ethel. Painter. Born: Chicago, Illinois in 1916. Studied: Colorado Springs Fine Arts Center; and with Frank Mechau, Boardman Robinson and Peppino Mangravite. Awards: Fulbright fellowship, 1951; Tiffany scholarship, 1949; Stacey scholarship, 1947; National Academy of Design, 1951, 1956; Hallmark award, 1952; American Watercolor Society, 1955; San Francisco Museum of Art, 1950; National Exhibition, Pomona, California, 1956; Norfolk Museum of Art, 1957; Ball State Teachers College, 1958. Collections: Metropolitan Museum of Art; Denver Art Museum; World's Fair, New York, 1939; Wilmington Society of Fine Arts; Norfolk Museum of Art; Des Moines Art Center; Senate Chamber, Recorder of Deeds Building, Social Security Building, Washington, D.C. United States Post Office, Auburn, Nebraska; Wynne Arkansas; Madill, Oklahoma; South Denver Branch, Colorado.

MAGIE, Gertrude. Painter. Born: in 1862. Studied: with Chase; Colarossi's Studio in Paris. Her specialty--portraits. She exhibited at the National Academy.

MAGONIGLE, Edith. Painter. Born: Brooklyn, New York in 1877. Collection: frieze, Administration Building, Essex County, Newark, New Jersey.

MAHIER, Edith. Painter. Born: Baton Rouge, Louisiana. Studied: New York School of Fine Arts.

MAIRS, Clara Gardner. Painter. Born: Hastings, Minnesota in 1879. Studied: Pennsylvania Academy of Fine Arts; Grade Chaumiere, Julian Academy, Paris, France; and with Daniel Garber. Collections: Philadelphia Museum of Art; La Jolla Art Center; San Diego Fine Arts Society; Walker Art Center; Minneapolis Institute of Art; Library of Congress San Antonio Museum of Art; Atlanta, Georgia; Norton Gallery of Art, West Palm Beach, Florida.

MALCOM, Thalia W. Painter. Born: New York City in 1883. Studied: with Randall Davey and Albert Andre.

MALLONEE, Miss Jo. Painter. Born: Stockton, New York in 1892. Studied: with G. Bridgman.

MALLOY, Susan Rabinowitz. Painter. Born: New York City in 1924. Studied: Skidmore College; Art Students League; and with Morris Davidson. Awards: Allied Arts of America, 1957; Village Art Center, 1957. Collection: Birndy Library, Norwalk, Connecticut.

MALONE, Laetitia Herr. Painter. Born: Lancaster, Pennsylvania in 1881. Studied: with Chase, Mora, Beaux, Anshutz and McCarter at Pennsylvania Academy of Fine Arts. She was also a noted illustrator.

MANDELMAN, Beatrice. Painter. Born: Newark, New Jersey in
1912. Studied: Art Students League; Newark School of Fine
and Industrial Arts. Collections: Metropolitan Museum of
Art; Museum of Modern Art; Brooklyn Public Library; Museum
of New Mexico; University of Omaha.

MANLEY, Jane Helena. Amateur crayon artist working in the
mid 1800s.

MANOGUE, Esther S. Painter. Born: Boulder, Colorado in 1923.
Collection: New Mexico State University.

MANON, Estelle Ream. Painter. Born: Lincoln, Illinois in
1884. Studied: with Chase and Hawthorne.

MANSFIELD, Blance McManus. Painter. Born: East Feliciana,
Louisiana, 1870. Studied: in Paris. She was also an
illustrator. Her specialty, books and periodical
illustrations.

MANSFIELD, Louise B. Painter. Born: Le Roy, New York in
1876. Studied: Art Students League. She was also an
illustrator.

MANVILLE, Elsie. Painter. Born: Philadelphia, Pennsylvania
in 1922. Studied: Stella Elkins Tyler School of Fine Arts,
Temple University. Awards: Carol Beck medal and Mary Smith
prize, Pennsylvania Academy of Fine Arts, 1953; Tyler School
of Fine Arts, 1948, 1950, 1956. Collections: Lehigh
University; Temple University.

MANY, Alexis B. Painter. Born: Indianapolis, Indiana in
1879.

MAPES, Doris W. Awards: Arkansas State Penwoman; Arkansas
State Festival of Arts. Collections: College Museum;
Worthen Bank, Little Rock; First National Bank, Little Rock.

MARCUS, Marcia. Painter. Born: New York in 1928. Studied:
New York University; Cooper Union Art School; Art Students
League; and with Edwin Dickinson. Collections: Whitney Museum
of American Art; Newark Museum.

MARDER, Dorie. Painter. Born: Poland in 1916. Studied:
Sorbonne, Paris, France; Art Students League; and with
Louis Schanker, Abraham Rattner, Morris Kantor. She has
exhibited extensively in the United States.

MARGOLIES, Ethel Polacheck. Painter. Born: Milwaukee, Wisconsin in 1907. Studied: Smith College; Silvermine Guild School of Art; and with Revington Arthur, Gail Symon, Umberto Romano and Robert Roche. Awards: Burndy Engineering award, Silvermine Guild, 1957; Electric Regulator Corporation, 1954; New Haven Paint and Clay Club, 1955; Springfield Art League, 1957; Chautauqua Art Association, 1958. Collections: Burndy Library, Norwalk, Connecticut; Springfield Museum of Art; New Haven Paint and Clay Club.

MARGOULIES, Berta. Sculptor. Born: Lowitz, Poland in 1907. Studied: Hunter College; Art Students League; Julian Academy, Ecole des Beaux-Arts, Paris, France. Awards: fellowship, Gardner Foundation, 1929; Guggenheim fellowship, 1946; Architectural League, 1936; American Academy of Arts and Letters, 1944; Society of Four Arts, 1947; Pennsylvania Academy of Fine Arts, 1951; Montclair Art Museum, 1952, 1953. Collections: Willamette University, Salem, Oregon; Des Moines Public Schools; Whitney Museum of American Art; College, City of New York; Washington, D. C.; Monticello, Arkansas; United States Post Office, Canton, New York.

MARGULIES, Pauline. Sculptor. Born: New York in 1895. Studied: with Fraser, Brewster and Eberle.

MARIE-Teresa, Sister. Painter. Born: Stillwater, Minnesota in 1877. Studied: New York School of Art; with Robert Henri; and in Florence, Italy.

MARISOL. Sculptor. Born: Paris, France in 1930 of Venezuelan parents. Studied: Ecole des Beaux-Arts, Paris; Art Students League; and with Yasuo Kuniyoshi; Hans Hofmann; The New School for Social Research. Collections: Rose Art Museum; Brandeis University; Albright-Knox Art Gallery.

MARKELL, Isabella Banks. Graphic Artist. Born: Superior, Wisconsin. Studied: Maryland Institute; Pennsylvania Academy of Fine Arts; Ecole des Beaux-Arts, Paris and with O'Hara, Brackman and Farnsworth. Awards: Boston Printmakers; Pen and Brush Club, 1953; Providence, Rhode Island, 1953, 1955; National Association of Women Artists, 1958; Wilmington Society of Fine Arts, 1958. Collections: New York Public Library; New York Historical Society; Museum, City of New York; Northwest Printmakers; Metropolitan Museum of Art; State College; Philadelphia Free Library; Philadelphia Print-makers Club; New York Hospital; Providence Museum of Art; Grinnell Public Library; Wilmington Society of Fine Arts.

MARKHAM, Charlotte H. Painter. Born: in Wisconsin in 1892. Studied: Art Institute of Chicago.

MARKHAM, Kyra. Painter. Born: Chicago, Illinois in 1891.
Studied: Art Institute of Chicago; Art Students League with
Alexander Abels. Collections: Smithsonian Institute;
Library of Congress; New York Public Library; Metropolitan
Museum of Art; Whitney Museum of American Art.

MARQUIS, Gulielma D. Painter. Born: Fairfield, Iowa in
1900. Studied: Cummings School of Art; Parsons College,
Fairfield, Iowa. Awards: Iowa Art Club, 1933. Collections:
Iowa State College; Fairfield Iowa Public Library;
Congressional Building, Washington, D. C.; Charles City,
Iowa, Womens Club; Ames Woman's Club; Hoisington, Kansas;
Mt. Pleasant, Iowa.

MARREN, Janet. Painter. Born: New York City in 1913.
Studied: Metropolitan Art School; Master Instructor,
Roerich Museum; Art Students League; Fordham University;
and with A. S. Baylinson. Exhibited in the United States
and abroad.

MARRON, Eugenie Marie. Painter. Born: Jersey City, New
Jersey in 1901. Studied: Columbia University; and with
Alexander Archipenko, Rudolph Beling and Fernand Leger.
Awards: Montclair Art Association, 1944; American Artists
Professional League, 1944; Montclair Art Museum, 1944.

MARS, Ethel. Painter. Born: Springfield, Illinois. Also
an engraver. Her specialty, colored woodblock prints.

MARSCHALL, Nicola. Painter. Born: in 1829 and died in
1917. She was known as a portrait painter.

MARSH, Alice R. Painter. Born: Coldwater, Michigan.
Studied: Art Institute of Chicago; with Merson, Collin,
Whistler and MacMonnies in Paris. A miniature painter.

MARSH, Anne S. Painter. Born: Nutley, New Jersey in 1901.
Studied: Cooper Union Art School. Award: Philadelphia
Printmakers Club, 1952. Collections: Museum of Modern Art;
Library of Congress; Montclair Art Museum; Newark Public
Library; Metropolitan Museum of Art; Collectors of American
Art; Philadelphia Museum of Art.

MARSH, Mary E. Painter. Born: Cincinnati, Ohio. Studied:
Chicago Academy of Fine Arts; Cincinnati Academy of Art;
and with Birger and Sandzen.

MARSHALL, Margaret Jane. Painter. Born: Philadelphia,
Pennsylvania in 1895. Studied: Pennsylvania Academy of
Fine Arts. Awards: fellowship, Pennsylvania Academy of Fine
Arts; Cresson traveling scholarship, Pennsylvania Academy of
Fine Arts, 1918.

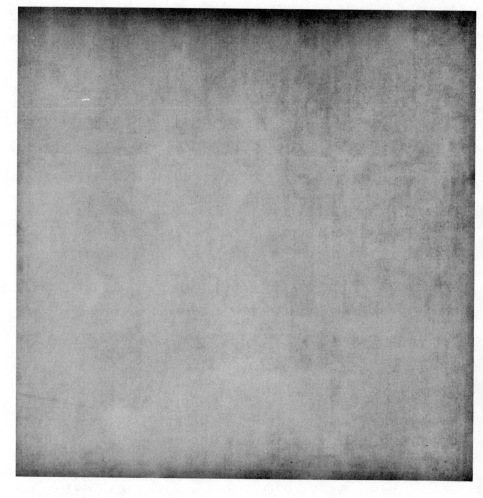

Agnes Martin, WHITE STONE, 1965. Oil and graphite on canvas,
71 7/8" X 71 7/8". The Solomon R. Guggenheim Museum (Gift of
Robert Elkon, New York).

MARTELL, Barbara B. Painter. Born: Trenton, New Jersey.

MARTIN, Agnes. Painter. Born: Macklin, Canada in 1911.
Studied: Columbia University. Collections: Union Carbide Co.,
Wadsworth Atheneum; Whitney Museum of American Art and The
Solomon R. Guggenheim Museum. She has exhibited widely
throughout the United States.

MARTIN, Christine. Painter. Born: New York City in 1895.
Studied: Teachers College, Columbia University; Art Students
League; and with Henry McFee, John Sloan and Judson Smith.

MARTIN, Edna M. Painter. Born: Seekonk, Massachusetts in
1896. Studied: Rhode Island School of Design.

MARTIN, Gail W. Painter. Born: Tacoma, Washington in 1913.
Studied: John Herron Art School; State University, Iowa;
and with Philip Guston, Fletcher Martin and Emil Ganso;
Boston Museum Art School with Karl Zerbe. Awards: Art Guild
of St. Louis, 1943; Norwich Connecticut, 1955; New England
Drawing Exhibition, 1958; Mary Millikan European traveling
scholarship, John Herron Art School, 1937. Collections:
Library of Congress; Wadsworth Atheneum, Hartford,
Connecticut; United States Post Office, Danville, Indiana.

MARTIN, Juliet. Painter. A watercolor artist working
in 1797.

MARTIN, Maria. Died in 1863. She was a painter of wild life.

MARTINET, Marjorie D. Painter. Born: Baltimore, Maryland
in 1886. Studied: Maryland Institute; Rhinehart School;
Pennsylvania Academy of Fine Arts; and with Cecelia Beaux,
and William Chase. Awards: fellowship, Pennsylvania Academy
of Fine Arts; Cresson traveling scholarship, Pennsylvania
Academy of Fine Arts, 1909.

MARYAN, Hazel Sinaiko. Painter. Born: Madison, Wisconsin
in 1905. Studied: Art Institute of Chicago; University of
Wisconsin; and with E. Chassaing, A. Polasek and E. Simone.
Collections: in private collections.

MASON, Alice F. Painter. Born: Chicago, Illinois in 1895.
Studied: Northwestern University. Awards: New Britian
Museum, 1953; Philadelphia Printmaker Club, 1957;
Pennsylvania Academy of Fine Arts, 1956; Illinois State
Museum, 1956; Illinois State Fair, 1957; Municipal Art
League, 1957. Collections: Metropolitan Museum of Art;
Library of Congress; Cincinnati Museum Association; New
Britian Museum.

MASON, Alice Trumbull. Painter. Born: Litchfield,
Connecticut in 1904. Awards: Philadelphia Printmakers Club,
1946; Society of American Graphic Artists, 1947; Silvermine
Guild, 1952. Collections: Museum of Modern Art; New York
Public Library; Berkshire Museum of Art; Library of Congress;
Brooklyn Museum; Solomon Guggenheim Museum of Art;
Philadelphia Museum of Art.

MASON, Alva. Engraver. The firm of W. & A. Mason operated an establishment about 1819 which embossed plates and did brass engraving.

MASON, Belle. Painter. Born: in Texas in 1927. Awards: Scarsdale Art Association; West Federated Womens Club; Chautauqua Art Association.

MASON, Doris Belle. Sculptor. Born: Green River, Wyoming in 1896. Studied: University of Idaho; University of Iowa; University of Southern California. Awards: Iowa State Fair, 1937, 1938. Collections: Spokane Art Association; Mt. Home Idaho Congregational Church.

MASON, Eleanor. Painter. A miniature painter who was exhibiting her work at the Pennsylvania Academy of Fine Arts in 1925.

MASON, Ella May. Painter. Born: Brookhaven, Mississippi in 1912. Studied: Art Institute of Chicago; and with Louis Ritman, Edmund Giesbert, and Elmer Forsberg. Awards: Mississippi Art Association, 1943, 1945. Collection: Mississippi Art Association.

MASON, Mary Stoddert. Sculptor. Born: Jackson, Tennessee. Her best works are: "Pilgrim Mother," "The Spirit of the New Era," and "Woman Triumphant."

MASON, Mary Townsend. Painter. Born: Zanesville, Ohio in 1886. Studied: with Chase and Breckenridge at the Pennsylvania Academy of Fine Arts. She was winner of many awards at the Pennsylvania Academy of Fine Arts.

MASON, Maud M. Painter. Born: Russellville, Kentucky in 1867. Studied: with Chase, Down and Snell; and with Brangwyn in London.

MASSEY (MASSY) Marie L. Painter. Noted for her portraits which she painted in the period 1857 to 1865.

MASSON, Emile. Crayon portraitist who was working around 1854-1856.

MAST, Josephine. Painter. A watercolorist who was exhibiting her work in 1925 at the Pennsylvania Academy of Fine Arts.

MATHEWS, Mrs. L. K. Painter. Born: San Francisco, California in 1872. Studied: with Whistler. She was also an illustrator.

MATSON, Greta. Painter. Born: Claremont, Virginia in 1915.
Studied: Grand Central School of Art; and with Jerry
Farnsworth. Awards: National Academy of Design, 1943,
1945; Southern States Art League, 1945, 1946; Virginia
Art, 1943, 1945, 1955; National Association of Women Artists,
1943, 1952, 1953, 1955-1958; State Teachers College,
Indiana, Pennsylvania, 1945, 1949, 1950; Norfolk Museum
of Art, 1943, 1948, 1954; Alabama Watercolor Society, 1950,
1951; Mississippi Art Association, 1951; Pen and Brush Club,
1948, 1951, 1952, 1954, 1956, 1958; Connecticut Academy
of Fine Arts, 1952, 1953; New Orleans Art Association,
1949, 1952; Butler Art Institute, 1948; New Jersey Artists,
1948, 1951; Virginia Museum of Fine Arts, 1957; New Jersey
Society of Painters and Sculptors, 1957. Collections:
Virginia Museum of Fine Arts; Norfolk Museum of Art; State
Teachers College, Indiana, Pennsylvania; New Britian Art
Institute; Texas Technical College; William and Mary
College; Texas College of Art and Industry; Mary Calcott
School, Norfolk, Virginia; Florida Southern College;
Longwood College, Farmville, Virginia; Little Rock Museum
of Fine Arts; Seton Hall University.

MATTHEWS, Anna L. Sculptor. Born: Chicago, Illinois.
Studied: Chicago Art Institute; and with Simon and Garrido
in Paris. She was also a noted painter.

MATHEWS, Lou. Painter. Born: Chicago, Illinois in 1882.
Studied: Art Institute of Chicago; Grande Chaumiere, Paris;
London School of Art; and with Lorado Taft, Lucien Simon
and Frank Brangwyn. Awards: Art Institute of Chicago,
1926, 1930, 1933; South Side Community Art Center, 1925.
Collections: Rosenwald Collection; Municipal Art League
of Chicago; Green Bay Art Museum; Neville Public Museum,
West High Library, Green Bay, Wisconsin; Chicago Municipal
Collection; Walter Scott Public School, Chicago.

MATTOCKS, Muriel. Painter. Born: Hastings,Nebraska. Studied:
with M. C. Carr, John S. Ankeney, Birger Sandzen; Art
Institute of Chicago. She was also an illustrator as well as
a painter.

MATULKA, Jan. Painter. Born: Czechoslovakia in 1890.
Studied: National Academy of Design; also in Paris.
Collections: Whitney Museum of American Art; New York
Public Library; Pennsylvania Academy of Fine Arts; San
Francisco Museum of Art; Detroit Institute of Art; Yale
University Art Gallery.

MAURICE, Eleanore. I. Painter. Born: East Orange, New
Jersey in 1901. Studied: Beards School, East Orange, New
Jersey; Art Students League, with DuMond and Tucker;
Montclair Art Museum School, with Avery Johnson and Estelle
Armstrong. Awards: American Artists Professional League,
1950, 1955, 1956 (gold medal); National Arts Club, 1947;
Knickerbocker Art, 1958; Seton Hall University, 1956;
Parrish Museum, Southampton, Long Island, 1951; Guild Hall,
Easthampton, Long Island, 1951-1953, 1955; Newark Art
Club, 1951; Hudson Valley Art Association, 1952, 1953,
1957, 1958; Art Center of the Oranges, 1952-1954, 1958;
West Essex and Verona Art Assocition, 1953; Montclair Art
Museum; Essex Watercolor Exhibition, 1955; New Jersey
Watercolor Society, 1955; Audubon Art, 1957; Pen and Brush
Club, 1958; Allied Artists of America, 1950, 1958; Butler
Art Institute, 1955; American Artists Professional League,
gold medal. Collections: Montclair Art Museum; Bloomfield
Public Library; Mt. Hebron School, Montclair; West Essex-
Verona Grammer School.

MAURY, Cornella Field. Painter. Born: New Orleans, Louisiana
in 1866. Studied: St. Louis School of Fine Arts; Julien
Academy, Paris. Collections: City Art Museum, St. Louis,
Missouri; Public Library, St. Louis, Missouri.

MAVERICK, Emily. Engraver. Born: in 1803 and died in 1850.

MAVERICK, Maria. Engraver. Born: in 1805 and died in 1832.
She was a sister of Emily. Both were working on stipple
illustrations for an edition of Shakespere, published about
1830. They were members of the Maverick family of New York
also engaged in the arts.

MAXWELL, Guida B. Painter. Born: Philadelphia, Pennsylvania
in 1896. Studied: with Fred Wagner.

MAY, Beulah. Sculptor. Born: Hiawatha, Kansas in 1883.
Studied: Lorado Taft; William Chase and Charles Grafly.

MAY, Caroline. Painter. A landscape painter who was
exhibiting in 1859.

MAY, Elizabeth M. Painter. Born: Chicago, Illinois in 1913.
Studied: University of Illinois; American Academy of Art,
Chicago. Awards: Miami Boat Show, 1949; Poinciana Exhibition,
1948-1956; Blue Dome, 1950, 1955; Miami Art League, 1952;
Wilfred Beattie awards, 1952-1954.

MAY, Maria B. Painter. She was a portrait and miniature
painter who was working around 1847-57.

MAYER, Bela. Painter. Exhibited at the National Academy of Design in 1925.

MAYER, Constant. Painter. Born: 1829 and died in 1911. She was a portrait and genre painter.

MAYHEW, Nell B. Painter. Born: Astoria, Illinois in 1875. Studied: University of Illinois; Chicago Art Institute. She was also an etcher.

MAYOR, Harriet H. Sculptor. Born: Salem, Massachusetts in 1868. Studied: in Boston with Henry H. Kitson and Dennis Bunker. Specialty, portraits. Collection: Princeton University Museum.

McAFEE, Ila. Painter. Born: Gunnison, Colorado in 1900. Studied: Western State College, Gunnison, Colorado; Art Students League; National Academy of Design. Awards: New Mexico State Fair, 1943, 1950. Collections: United States Post Office, Cordel and Edmond, Oklahoma; Gunnison, Colorado, Clifton, Texas; Greeley Colorado Public Library; Thomas Gilcrease Foundation, Tulsa; State Agricultural College, Logan, Utah; Public School, Cedar City, Utah; Amarillo Texas High School; Koshare Museum, La Junta, Colorado; Cedar City Public Library; Baylor University.

McALLISTER, Rosana. Painter. Awards: Pan American Art Exhibit, Miami; Society of the Four Arts, Palm Beach, Florida; Beaux Aɔt-Ft. Lauderdale Museum. Collections: Florida State Superior Court, Tallahassee, Florida; Miami Museum of Modern Art; Lowe Art Museum, Miami Florida.

MC CAIG, Flora T. Painter. Born: Royalton, New York in 1856. Studied: Pennsylvania Academy of Fine Arts; with Carroll Beckwith. Collections: Women's Union, Buffalo, New York; Genesee Hotel, Buffalo, New York.

McCALL, Virginia A. Painter. Born: Philadelphia, Pennsylvania. Studied: Pennsylvania Academy of Fine Arts. Awards: Cresson traveling scholarship, Pennsylvania Academy of Fine Arts, 1931, prize, 1932; Philadelphia Art Club, 1940; Philadelphia Gimbel award, 1946; Distinguished Daughter of Pennsylvania award, 1954; Collections: Pennsylvania Academy of Fine Arts; Philadelphia Museum of Art; Whitney Museum of American Art; University of Pennsylvania; Armed Forces Medical Museum, Washington, D.C.

McCALLUM, Corrie. Painter. Born: Sumter, South Carolina in 1914. Studied: University of South Carolina; Boston Museum of Fine Arts School, with Karl Zerbe. Awards: Carolina Art Association, 1945; South Carolina Annual, 1955; Guild South Carolina Artists, 1953, 1954. Collection: Gibbes Art Gallery.

McCANN, Mary A. Painter. A portrait and genre painter active 1850-1856.

MC CARTHY, Helen K. Painter. Born: Poland, Ohio in 1884. Studied: Philadelphia School of Design.

McCLELLAND, Jeanne C. Painter. Born: New York State in 1918. Collections: St. John Fisher College, Rochester, New York; Holyoke Museum, Massachusetts.

McCLOSKEY, Eunice. Painter. Born: Ridgway, Pennsylvania in 1906. Studied: Columbia University. Awards: Carnegie Institute (Association of Artists), 1950, Posner award, 1953; National League of American Pen Women, Kansas City, 1947; National League of American Pen Women, Washington, D.C., 1954; Aimee Jackson Short prize, Edwin Forrest Gallery, Philadelphia, 1953; "Woman of the Year" award, 1958. Collection: in private collections.

McCLOSKEY, Martha L. Painter. Born: Rogers, Ohio in 1899. Studied: Wooster College; Cambridge University, England. Awards: Butler Art Institute, 1943, 1946; Parkersburg, West Virginia, 1945; Collection: Butler Art Institute.

McCLUNG, Florence. Painter. Born: St. Louis, Missouri in 1896. Studied: Southern Methodist University; Texas State College for Women; Colorado College; Taos, New Mexico; and with Adolph Dehn, Alexandre Hogue, Frank Reaugh, Richard Howard and Frank Klepper. Awards: Dallas Allied Artists, 1942, 1943, 1944, 1946; National Association of Women Artists, 1945; Pepsi-Cola, 1942. Collections: Metropolitan Museum of Art; Dallas Museum of Fine Arts; Library of Congress; Mint Museum of Art; High Museum of Art; Delgado Museum; Birmingham Alabama Library; University of Kansas; University of Texas.

McCLUSKEY, Grace Dickover. Painter. Born: Long Beach, California in 1891. Studied: Stanford University; Santa Barbara State College; Donaldson School of Design; in Japan; and with Conrad Buff and Orrin White. Award: Hollywood, California, 1950. Exhibited extensively in California.

MC COMB, Marie L. Painter. Born: Louisville, Kentucky. Studied: Pennsylvania Academy of Fine Arts; and with Daniel Garber and Henry McCarter. Award: Cresson traveling scholarship, Pennsylvania Academy of Fine Arts, 1912.

McCOON, Betty. Studied: Fresno Art Center; Diablo Design Center, Danville. Award: Fresno District Fair Art Exhibit, Fresno, California.

MCCORMICK, Katharine H. Painter. Born: Philadelphia, Pennsylvania. Studied: Pennsylvania Academy of Fine Arts, with Henry McCarter, Fred Wagner, and Ralph Pearson. Awards: Philadelphia Plastic Club; Woodmere Art Gallery. Collections: Philadelphia Museum of Art; Atwater Kent Museum, Philadelphia; Woodmere Art Gallery.

MCCORMICK, M. Evelyn. Painter. Born: in 1869. A landscape painter.

MCCOY, Dorothy H. Painter. Born: Worcester, Massachusetts in 1890. Studied: Bradford Academy, Haverhill, Massachusetts, and with Jerry Farnsworth. Awards: Berkshire Art Museum, 1952; Worcester Museum of Art, 1952; Clearwater, Florida, 1949. Collection: Bennington Museum of History and Art.

MCCREADY, Carolin. Painter. Born: Oil City, Pennsylvania in 1907. Studied: Carnegie Institute, with Alexander Kostellow, Lazlo Gabor and Hans Hofmann. Awards: Pittsburgh Exhibition at Carnegie Institute, 1935, 1937, 1952, 1943, 1949, Pittsburgh Playhouse, 1955.

MCCREERY, Franc Root. Painter. Born: Dodge City, Kansas. Studied: Art Institute of Chicago; Students' School of Art, Denver, Colorado; Buffalo Society of Artists.

MCCULLOUGH, Lucerne. Painter. Born: Abilene, Texas in 1916. Studied: Tulane University; Art Students League. Awards: Art Students League; Art Directors Club, 1944; Direct Mail Advertising Association, 1944, 1945; Silvermine Guild of Artists, 1954, 1956. Collections: Museum of Modern Art; San Angelo Museum of Art; National Academy of Design; United States Post Office, Booneville, New York; United States Post Office, Thomaston, Connecticut.

MCDONALD, Ann H. Painter. Exhibited in 1924 at the Pennsylvania Academy of Fine Arts.

MCDOWELL, Helen. Painter. Born: Cleveland, Ohio in 1909. Studied: Collins Art School, Tampa, Florida; Tampa University; New York School of Interior Design; and with Asa Cassidy, James Lorne Eno. Award: Tampa Art Institute, 1951.

MCEWEN, Katherine. Painter. Born: England. Lived the most part of her life in Detroit. Painted landscapes of Arizona and Alaska.

MCFADDEN, Sybill M. Painter. Born: Pittsburgh, Pennsylvania. Awards: Chautauqua Bestor Plaza, Chautauqua County; Steuben County.

MCGEE, Julia. Painter. She was painting around 1853
with oils and watercolors.

MCINTIRE, Katherine Angela. Painter and Etcher. Born:
Richmond, Virginia in 1880. Studied: with George Bridgman,
Alice Beckington and Chase in New York; and with Mme
La Forge in Paris.

MCKEE, Katherine L. Painter. Studied: Columbia University;
Cleveland School of Art; Escuela de Pintura y Escultura,
Mexico City. Awards: Cleveland Museum of Art, 1934, 1937,
1938-1941, 1946-1948; American Fine Arts Gallery, New York,
1931; Butler Art Institute, 1943. Collections: Cleveland
Museum of Art; Cleveland Municipal collection.

MCKENNEY, Henrietta Foxhall. Born: in 1825 and died in
1887. She was a landscape painter.

MCKINSTRY, Grace E. Painter and Sculptor. Born: Fredonia,
New York. Studied: Art Students League; Julien Academy,
Paris. A painter of portraits.

MCLANE, M. Jean. Painter. Born: Chicago, Illinois in 1878.
Studied: Art Institute of Chicago. Awards: Hallgarten prize,
National Academy of Design, 1913; Walter Lippincott prize,
Pennsylvania Academy of Fine Arts, 1913; Panama Exposition,
1915. A painter of portraits. Collections: Museum of Art,
Syracuse, New York; Art Institute, Chicago; San Antonio Art
Museum; Toledo Museum of Art.

MCLAUGHLIN, Mary Louise. Painter. Born: Cincinnati, Ohio.
In 1898 she began making porcelain called Losanti ware.
Awards: Paris Exposition, 1889, 1900; Chicago Exposition.

MCLAWS, Virginia Randall. Painter. Born: in 1872.

MCMEIN, Miss N. M. Painter and Illustrator. Born: Quincy,
Illinois in 1889. Studied: Chicago Art Institute.

MCMILLAN, Mary. Painter. She was exhibiting her miniature
paintings in 1925 at the Pennsylvania Academy of Fine Arts.

MCMILLEN, Mildred. Wood-Engraver. Born: Chicago, Illinois
in 1884. Studied: New York, Chicago and Paris. Collections:
National Museum of Canada; Ottawa Public Library; New York
Public Library.

MCNETT, Elizabeth Vardell. Painter. Born: Newbern, North
Carolina in 1896. Studied: Flora MacDonald College; Art
Students League; National Academy of Design; Pennsylvania
Academy of Fine Arts; University of Pennsylvania; Johns
Hopkins University Medical School, Department of Medical
Art. She was a medical illustrator. Awards: Scholarship
to Pennsylvania Academy of Fine Arts. Collections:
College of Pharmacy, Philadelphia, Pennsylvania; Lankenau
Hospital, Philadelphia, Pennsylvania; Institute of Cancer
Research, Philadelphia, Pennsylvania.

MCVEIGH, Blanche. Etcher. Born: St. Charles, Missouri.
Studied: St. Louis School of Fine Arts; Art Institute of
Chicago; Pennsylvania Academy of Fine Arts; Art Students
League; with Daniel Garber, Doel Reed. Awards: Dallas
Printmakers Club, 1942, 1944, 1947, 1948, 1950; Connecticut
Academy of Fine Arts, 1941; Southern States Art League,
1945; Texas General Exhibition, 1944, 1945; Texas Fine
Arts Association, 1946; 100 Prints, Chicago, 1936, 1938;
Ft. Worth Art Association, 1948, 1950, 1952; Library of
Congress, 1947. Collections: Museum of Fine Arts of
Houston; Ft. Worth Art Association; Oklahoma Agricultural
and Mechanical College; Dallas Museum of Fine Arts;
Cincinnati Museum Association; Carnegie Institute; Library
of Congress; University of Texas.

MCVEY, Leza S. Ceramic Sculptor. Born: Cleveland, Ohio
in 1907. Studied: Cleveland School of Art; Colorado Fine
Art Center; Cranbrook Academy of Art. Awards: Syracuse
Museum of Fine Arts, 1950, 1951; Michigan Arts and Crafts,
1951; Cleveland Museum of Art, 1953-1958; Butler Institute
of American Art, 1958. Collections: Syracuse Museum of
Fine Arts; Cleveland Museum of Art; General Motors,
Detroit, Michigan; Butler Institute of American Art.

MEARS, Helen Farnsworth. Sculptor. Born: Oshkosh,
Wisconsin in 1878 and died in 1916. Studied: in New York;
and in Paris. Collections: Capitol, Washington;
Smithsonian Institute.

MEARS, Henrietta D. Painter and etcher. Born: Milwaukee,
Wisconsin in 1877. Studied: Art Students League; and
with Hawthorne and Pape.

MEDARY, Amie Hampton. Painter. Born: Groton, Connecticut
in 1903. Studied: Pennsylvania Academy of Fine Arts;
Boston Museum of Fine Arts School; and with A. Margaretta
Archambault. She was known as a miniature painter.

MEDRICH, Libby E. Painter. Born: Hartford Connecticut. Awards: National Arts Club; Westchester. She has exhibited predominately in the New England States and in Paris.

MEEKER, Barbara Miller. Painter. Born: Peru, Indiana in 1930. Awards: Indiana Artists Club. Collections: DePauw University Art Center; Indianapolis Public Schools; Purdue University, Calumet Campus.

MEESER, Lillian B. Painter. Born: Ridley Park, Pennsylvania in 1864. Studied: Pennsylvania Academy of Fine Arts; Art Students League; Worcester Art Museum.

MEGE, Violette. Painter and Sculptor. Born: Alger, French Algiers in 1889. Studied: Ecole Nationale des Beaux Arts; Academie Julien, with J. P. Laurens and Humbert, in Paris.

MEIERE, Hildreth. Painter. Born: New York City. Studied: Art Students League; California School of Fine Arts; Beaux-Arts Institute of Design; and with Miller,DuMond and Peixotto. Award: Architectural League, 1928. Collections: Nebraska State Capitol; National Academy, Washington, D.C.; St. Bartholomew Church, New York; Temple Emanu-El, Catholic Cathedral, St. Louis, Missouri; Irving Trust Company; cabin lounge decoration, Steamship "United States."

MELCHER, Bertha C. Painter and illustrator. Born: Denver, Colorado in 1872. Studied: with Volk in Minneapolis; Pyle at Drexel Institute, Philadelphia. Illustrations for children's books and miniatures were her specialty.

MELCHER, Betsy F. Painter. Born: New York City in 1900. Studied: with Mabel R. Welch, Cecilia Beaux and Alfred Hoen. Awards: Pennsylvania Academy of Fine Arts, 1933, 1937, 1944, 1945; Boardman Memorial prize, 1942; Howell Tracey Fisher prize, 1942, 1943; Cooperstown, 1954; National Academy of Women Artists, 1951, 1957. Collection: Pennsylvania Academy of Fine Arts.

MELICOV, Dina. Sculptor. Born: in Russia in 1905. Studied: Iranian Institute; Columbia University. Award: National Association of Women Artists. Collection: United States Post Office, Northumberland, Pennsylvania.

MELLEN, Margaret. Painter. Born: Cleveland Heights, Ohio in 1927. Studied: Cleveland Institute of Art; Western Reserve Graduate School; and with Louis Bosa, Carl Gaertner and Jack Levine. Awards: Cleveland Museum of Art, 1951; Cleveland Junior Chamber of Commerce, 1949, 1951; Ohio Watercolor Society, 1950; Mary A. Burnham award, 1945.

MELLON, Eleanor M. Sculptor. Born: Philadelphia in 1894.
Studied: Art Students League, with Robert Aiken; and with
A. A. Weinmann, Charles Grafly, Harriet Frishmuth and
Victor Salvatore. Awards: National Academy of Design,
1927; New York Junior League, 1942; Society of Washington
Artists, 1931; American Artists Professional League, 1945.

MELLOR, Margaret W. Painter. Was exhibiting in 1925 at
the Pennsylvania Academy of Fine Arts. Work predominately
in watercolors.

MELTZER, Anna E. Painter. Born: New York City in 1896.
Studied: Art Students League; Cooper Union Art School;
also with Alexander Brook. Awards: Audubon Art, 1942;
Florida Southern College. Collections: Brooklyn Museum;
Pittsfield Massachusetts Museum of Art; Joslyn Memorial
Museum; Florida Southern College; California Playhouse.

MELTZER, Doris. Printmaker. Born: Ellenville, New York
in 1908. Studied: Art Students League; New York
University; also in Europe. Founder of the Meltzer Gallery
in 1954. Arranged exhibitions of prints and paintings for
travel abroad.

MELVILL, Antonia. Painter. Born: Berlin, Germany in 1875.
Studied: Heatherley School of Art, London, England with
W. P. Frith. Came to America in 1894. She painted
portraits. Collections: Good Samaritan Hospital, Los
Angeles; Capitol of South Dakota at Pierre.

MELVILLE, Marguerite L. Painter. Born: Upper Montclair,
New Jersey in 1912. Studied: Brown University; Pembroke
College; Rhode Island School of Design; Art Students
League; and with Frederick Sisson, Victor Candell, Kimon
Nicolaides and Jose deCreeft.

MENDENHALL, Emma. Painter. Born: Cincinnati, Ohio.
Studied: Cincinnati Art Academy; Julian Academy, Paris.
Awards: National Arts Club; Washington Watercolor Club;
Cincinnati Museum Association; Ohio Watercolor Society;
Woman's Club, Cincinnati. Collections: Kirby High School,
Bond Hill High School and Hughes High School, Cincinnati.

MENKEN, Marie. Painter. Born: Brooklyn, New York in 1917.
Studied: New York School of Fine and Industrial Arts;
Art Students League; also with Hafner, Miller, Link and
Ballantyne. Awards: Yaddo Foundation, scholarship, 1949,
1950. Made many films for Brussels World's Fair, 1958
and created many film sets.

MENTEL, Lillian. Painter. Born: Cincinnati, Ohio in
1882. Studied: Cincinnati Art Academy; Pratt Institute.
An illustrator as well as a painter.

MENZLER-PEYTON, Bertha. Painter. Born: Chicago, Illinois. Studied: Art Institute of Chicago; with Merson, Collin and Aman-Jean in Paris. Known as a landscape (predominately western scenery) painter. Collections: Union League Club, Chicago, Illinois; West End Woman's Club, Chicago, Illinois; Evanston Illinois Woman's Club; Fine Arts Building, Chicago.

MERCER, Geneva. Sculptor. Born: Jefferson, Alabama in 1889. Studied: with G. Moretti. Collection: "Soldiers Memorial" Bronxville, New York.

MEREDITH, Dorothy L. Painter. Born: Milwaukee, Wisconsin in 1906. Studied: Layton School of Art; Milwaukee State Teachers College; Cranbrook Academy of Art; also with Zoltan Sepeshy, Robert von Neumann and Myron Nutting. Awards: Milwaukee Art Institute; Wisconsin State Fair; Milwaukee Art Institute, 1948; Wisconsin Designer-Craftsmen: Crafts State Fair. Collections: Cranbrook Academy of Art; Milwaukee Art Institute; National Soldiers Home, Wood, Wisconsin; Bay View High School, Milwaukee, Wisconsin; South Division High School, Milwaukee, Wisconsin.

MERINGTON, Ruth. Painter. Born: London, England. Studied: National Academy of Design; Art Students League with Edgar M. Ward, Bruce Crane and Birge Harrison; with Constant at Julien Academy in Paris.

MERMIN, Mildred S. Painter. Born: New York City in 1907. Studied: Art Students League; National Academy of Design. Award: National Association of Women Artists, 1957.

MERRELS, Mrs. Gray P. Painter. Born: Topeka, Kansas in 1884. Studied: Art Students League. A miniature painter.

MERRETT, Susan. Painter. A genre watercolorist working in the mid 1800s.

MERRIAM, Ann Page. Painter. Watercolor artist working around 1820.

MERRILL, Katherine. Etcher. Born: Milwaukee, Wisconsin in 1876. Studied: Chicago Art Institute; and in London with Brangwyn. Collection: Library of Congress.

MERRIMAN, Helen B. Painter. Born: Boston, Massachusetts in 1844. Studied: with William Hunt. A water color artist.

MERRITT, Anna L. Painter. Born: Philadelphia, Pennsylvania in 1844. Studied: painting privately. Collections: National Gallery of British Art; Pennsylvania Academy of Fine Arts; Memorial Hall, Harvard University. She was also a well known etcher.

*Jeanne Miles, NO. 13, 1960. Oil and gold leaf on canvas,
72" X 35 1/4". The Solomon R. Guggenheim Museum.*

MERWIN, Antoinette. Painter. Born: 1861. A landscapist.

MESS, Evelynne B. Etcher. Born: Indianapolis, Indiana
in 1903. Studied: John Herron Art Institute; Butler
University; Art Institute of Chicago; Ecole des Beaux-Arts,
Fontainebleau, France; and with Andre Strauss and Despujols.
Awards: Indiana State Fair, 1930, 1950, 1951; Indiana Art
Club, 1949, 1951, 1955, 1957; Indiana Federation of Art
Clubs, 1942; Hoosier Salon, 1947, 1948, 1950, 1953, 1958;
National Society of Arts and Letters, 1948; Indiana Art,
1949, 1955; California Society of Etchers; Holcomb prize,
John Herron Art Institute, 1958. Collections: John Herron
Art Institute; Library of Congress.

MEWHINNEY, Ella K. Painter. Born: Nelsonville, Texas in
1891. Studied: Texas Presbyterian College; Art Students
League; Broadmoor Art Academy; and with Bridgman, Davey and
Reid. Awards: Southern States Art League, 1928, 1931;
Davis competition, San Antonio, Texas, 1929. Collection:
Witte Memorial Museum.

MEYER, Elizabeth. Painter. Primitive water colorist working
around 1830.

MEYERCORD, Grace E. Painter. Exhibited her miniatures at
the Pennsylvania Academy of Fine Arts in 1925.

MEYROWITZ, Jenny D. Painter. Born: Washington, Hempstead
County, Arkansas in 1866. Studied: Cincinnati Art Academy;
St. Louis School of Fine Arts; and with Julien, Delaunee
and Delecluse studios, in Paris. Has painted portraits of
many important people one of which was Jefferson Davis.

MIKELL, Minnie. Painter. Born: Charleston, South Carolina.
Studied: witth Ambrose Webster, Edmund Kinzinger, Frank S.
Herring, Alfred Hutty and Edward Shorter. Has exhibited
in South Carolina.

MILAM, Annie Nelson. Painter. Born: in 1870.

MILES, Jeanne P. Painter. Born: Baltimore, Maryland.
Studied: George Washington University; Phillips Memorial
Gallery, Washington, D. C.; Grande Chaumiere, Paris;
Atelier Marcel Gromaire, Paris; New York University.
Awards: traveling scholarship, 1937-1939. Collections:
mural (100 portraits) Ramon's, Washington, D. C. Kentile
Company, New York and Philadelphia, Pennsylvania; Santa
Barbara Museum of Art.

MILLER, Barbara. Painter. Has exhibited extensively in
Hawaii and the far Western states.

MILLER, Donna. Lithographer. Born: Macon, Michigan in 1885. Studied: with Robert von Neumann, Gerrit Sinclair, and Emily Groom. Awards: Milwaukee Art Institute, 1937, 1940, 1943, 1946, 1955; Wisconsin State Fair, 1941-1944.

MILLER, Dorothy E. Painter. Born: Ambridge, Pennsylvania in 1927. Studied: Finch Warshaw School of Art; Santa Monica City College, Art Association; University of California at Los Angeles. Awards: San Francisco Museum of Art, 1958; Monterey County, 1958.

MILLER, Elizabeth S. Painter. Born: Lincoln, Nebraska in 1929. Studied: University of Nebraska, with Rudy Pozzatti, Walter Meigs, Kady Faulkner; Des Moines Art Center, with Louis Bouche; University of Colorado, with Carl Morris. Awards: Lincoln Art Guild, 1951; Iowa State Fair, 1956; Des Moines Art Center, 1956, 1958; Des Moines Womens Club, 1958; Sioux City Art Center, 1958; Mulvane Art Museum, Topeka, 1958. Collections: Lincoln Art Guild; Lutheran Life of Christ collection, Des Moines Art Center; Mulvane Art Museum.

MILLER, Eva H. Painter. Born: Brooklyn, New York. Collection: North Carolina University.

MILLER, Evylena N. Painter. Born: Mayfield, Kansas in 1888. Studied: Pomona College; University of California; Art Students League; also studied abroad. Awards: Woman's Club, Hollywood, California, 1930; California State Fair, 1925; Festival Allied Artists, 1934; Los Angeles Art Museum, 1937; Laguna Beach Art Association, 1953; Death Valley Exhibition, 1954. Collections: Smithsonian Institute; Pomona College; Women's Christian College, Tokyo and Kobe, Japan; Chinese Young Mens Christian Association, San Francisco, California; First Presbyterian Church, Santa Ana, California; Bowers Memorial Museum, Santa Ana, California.

MILLER, Iris A. Painter. Born: Ada, Ohio in 1881. Studied: with Chase, Henri and Breckenridge. Awards: Detroit Institute of Art, 1923, Scarab Club, 1929. Collections: Detroit Institute of Art; San Diego Fine Arts Society; University of Michigan; Wayne County Court Building, Detroit, Michigan; Law Club, Ann Arbor; Kenton Ohio Public Library; Topeka Church House; Ann Arbor Hospital; Detroit City Building; Kenton Hospital; Michigan Mutual Insurance Building, Detroit. She specialized in portraits.

MILLER, Isabelle L. Painter. Born: Philadelphia, in 1907. Studied: Philadelphia Museum School of Industrial Art; Graphic Sketch Club; and with Earl Horter. Collection: Atwater Kent Museum.

MILLER,Kate Reno. Painter. Studied: Cincinnati Art Academy.

MILLER, Marie Clark. Painter. Born: Springville, Utah in
1894. Studied: Brigham Young University; University of Utah;
University of Chicago; Columbia University; Art Institute of
Chicago; University of California at Los Angeles. Awards:
Utah State Fair; Midland Empire State Fair, Boseman, Montana;
Iowa State Fair; Glendale Art Association, 1945-52; Greek
Theatre, Los Angeles, 1952-1954; California Art Club, 1954,
1955; Dixie College, 1949, 1955; National Lecture award,
Washington, D. C. 1956; National League of American Pen Women,
1958; Springville, Utah, 1956. Collections: Brigham Young
University; Dixie College, St. George, Utah.

MILLER, Martha W. Painter. Born: New York City in 1924.
Studied: Tyler School of Fine Arts, Temple University;
Hans Hofmann School of Fine Arts; Universal School of
Handcrafts; Blumenaw Weaving Workshop. Collection: Staten
Island Museum of Arts and Sciences.

MILLER, Mildred B. Painter. Born: Philadelphia,
Pennsylvania, in 1892. Studied: Pennsylvania Academy of
Fine Arts; Art Students League. Awards: fellowship,
Pennsylvania Academy of Fine Arts; Cresson traveling
scholarship, Pennsylvania Academy of Fine Arts, 1914, 1915,
Mary Smith prize, 1920, 1931; Sand Diego Art Guild, 1947,
1949; Chester County Art Association, 1935; Vista, California
1952; San Diego Art Guild, 1952, 1955; Carlsbad-Oceanside Art
League, 1954, 1955, 1956, 1953; Philadelphia Plastic Club
1937; San Diego County Fair; San Diego Art Institute, 1958.
Collections: Pennsylvania Academy of Fine Arts; Mississippi
Art Association; Chester County Historical Society; Heyburn
Idaho High School; Kemper Military School, Booneville,
Missouri.

MILLER, Minnie M. Painter. Was exhibiting her flower
paintings at the Academy of Fine Arts in 1921.

MILLER, Reeva A. Painter. Born: Hollywood, California
in 1912. Studied: Santa Monica City College; University
of California at Los Angeles. Awards: Santa Monica Art
Association, 1945, 1956. Collections: Beth Sholom Temple,
Santa Monica; dome, Al Jolson Memorial, Los Angeles;
Beth Sholom Temple, Santa Monica (stained glass windows);
Maarev Temple, Encino, California; Temple Sinai, Oakland,
California; Temples in Santa Monica, Inglewood, Long Beach
and Burbank, California; Camp Shrader, Colorado.

MILLER, Geraldine B. Painter. Born: in America. Studied:
with Wyatt Eaton in New York; Carolus-Duran, Kerson, and
Alfred Stevens in Paris.

MILLIGAN, Gladys. Painter. Studied: Western College for
Women, Oxford, Ohio; Westminster College, New Wilmington,
Pennsylvania; Pratt Institute of Art School; Fontainbleau,
France; and with George Luks, and Andre L'Hote, in Paris.
Collection: Phillips collection, Washington, D. C.

MILLIS, Charlotte. Sculptor. Born: Palo Alto, California
in 1906. Studied: University of Chicago; Art Institute of
Chicago; Carnegie Art Center; University of Oregon.
Awards: Minneapolis Institute of Art, 1935, 1936, 1941,
1944; Minnesota State Fair, 1942; Walker Art Center, 1944.
Collections: International Business Machines collection;
Church of the Redeemer, Chicago, Illinois.

MILNE, May Frances. Painter. Born: Brooklyn, New York
in 1894.

MILSK, Mark. Etcher. Born: St. Paul, Minnesota in
1899. Awards: Syracuse, Indiana, 1944; California
Society of Etchers, 1942, 1943, 1945. Collections: San
Francisco Museum of Art; State Library Sacramento,
California; Achenback Foundation, California Playhouse;
and in Jerusalem.

MILSOM, E. Grace. Painter. Born: Buffalo, New York
in 1868. Studied: in Europe; and with Bischoff.
Collection: Albright Art Gallery, Buffalo.

MINER, Georgia W. Painter. Born: Springfield, Illinois
in 1876. Studied: with C. A. Herbert and Dawson-Watson.
Award: Illinois State Centennial, 1918.

MINGLE, Elizabeth. Painter. Born: in 1835.

MINOR, Anne B. Painter. Born: East Lyme, Connecticut
in 1865. Studied: with Robert C. Minor.

MITCHELL, Agnes. Painter. A landscapist working
1845 - 1847.

MITCHELL, Laura M. Painter. Born: Halifax, Nova Scotia,
Canada in 1883. Studied: Art Students League; and with
Lucia Fairchild Fuller, Kenyon Cox and George Bridgman.
Awards: Pan-Pacific Exposition, 1915, 1916; California
Society of Miniature Painters, 1923, 1929; Pacific
Southwest Exposition, 1928. Collections: California
State Library; Los Angeles Public Library.

MITCHELL, Marian. Painter. Born: in 1840 and died in 1885.

MITCHELL, Phoebe. Painter. A primitive watercolor landscape artist working early in the 1800s.

MITCHELL, Sue. Painter. Born: Copperhill, Tennessee in 1923. Studied: Agnes Scott College; Hans Hofmann School of Fine Arts. Awards: Louisville Public Library, 1955.

MITTLEMAN, Ann. Painter. Born: New York City. Studied: New York University; and with Philip Evergood, Robert Laurent and Tschacbasov. Collections: Everhart Museum of Art; Seattle Art Museum; Zanesville, Ohio; Smith College; Jewish Museum; Hickory,North Carolina; New York University Museum; Richmond Indiana Art Association; Evansville Indiana; Florence South Carolina Museum of Art; Delgado Museum of Art; Lowe Gallery of Art, Coral Gables; Birmingham Museum of Art.

MIX, Florence. Painter. Born: Hartford, Connecticut in 1881 and died in 1922. She was a portrait and landscape artist.

MIX, Jo Anne. Painter. Born: Long Beach, California. Awards: Various state regional awards. Collections: Western Association of Art, Museum Tour; International Orphans, Incorporated.

MOCK, Gladys. Painter. Born: New York City. Studied: Art Students League, and with Kenneth Hayes Miller. Awards: National Association of Women Artists, 1946, 1954; Pen and Brush Club, 1946, 1955; Champlain Valley Exhibition, 1951. Collections: Pennsylvania Academy of Fine Arts; Todd Museum, Kalamazoo, Michigan; Library of Congress; Kansas State College; Hays, Kansas; Metropolitan Museum of Art; Smithsonian Institute.

MODEL, Elisabeth. Sculptor. Born: Bayreuth, Bavaria in 1903. Studied: Munich, Germany; Academy of Amsterdam, Holland; and in Paris with Kogan. Awards:National Association of Women Artists, 1950, 1951, 1952; Brooklyn Society of Art, 1953, 1954. Collections: Corcoran Gallery of Art; Hartford Atheneum; Jewish Museum, New York; Rijksprenten Kabinet, Amsterdam, Holland.

MODJESKA, Marylka H. Etcher. Born: Chicago, Illinois in 1893. Studied: Art Institute of Chicago; Art Students League; with Eliot O'Hara, George Bridgman; Julien Academy, Paris; also with Jerry Farnsworth, George Senseney and George Degorce. Collection: Art Institute of Chicago.

MOELLER, Selma. Painter. Born: In New York in 1880. Studied: Art Students League, with Cox and Chase; also with Lucia Fairchild Fuller and Alice Beckington. She specialized in miniatures.

MOERSCHEL, Chiara. Painter. Born: Trieste, Italy in 1926. Awards: Gustave Goetsch Memorial prize; Vasen award.

MOHN, Cheri. Painter. Awards: Mademoiselle's one of Ten Top Women Artists in the United States.

MOLINARY, Marie S. Painter. Born: New Orleans, Louisiana in 1876. Studied: with William Chase and A. Molinary. Collection: Delgado Museum, New Orleans.

MOLLISON, Kay. Painter. Born: Ottumwa, Iowa in 1896. Studied: Smith College; Corcoran School of Art and with Wayman Adams. Awards: Hartford Women Painters, 1952, 1954, 1955; North Shore Art Association, 1952; Meriden Arts and Crafts, 1954, 1957; Springfield Academic Arts, 1956; Connecticut Academy of Fine Arts, 1957; Rockport Art Association, 1953, 1958; New Haven Paint and Clay Club, 1958.

MOLZAHN, Johannes. Painter. Born: Duisburg, Germany in 1892. Collection: Yale University; in museums in Weimar, Essen, Breslau, Darmstadt and Duisburg, Germany.

MONACHESI, Nicola. Painter. Born: in 1795 and died in 1851. Known as a portrait, historical and decorative painter.

MONAGHAN, Eileen. Painter. Born: Holyoke, Massachusetts. Studied: Massachusetts School of Art. Awards: National Academy of Design, 1958; New Haven Paint and Clay Club, 1958; Allied Artists of America, 1947, 1949, 1955; American Watercolor Society, 1958; Providence Watercolor Club, 1955; Silvermine Guild Art, 1955; Hudson Valley Art Association, 1954; Wolfe Art Club, 1954; Bridgeport Art League; Westchester Federation of Womens Club. Collection: Hispanic Society Museum; Atlanta Art Museum.

MONAGHAN, Gertrude. Painter. Born: West Chester, Pennsylvania. Studied: School of Design for Women; Pennsylvania Academy of Fine Arts. Noted Mural painter.

MOORE, Ellen M. Painter. Born: Kensington, Connecticut. Studied: Art Students League; also with Mary Elmer and I. A. Josephi. She specialized in miniatures.

MOORE, Emily S. Landscape artist working in charcoal
around 1855.

MOORE, Loraine. Etcher. Born: Oklahoma City, Oklahoma.
Studied: Oklahoma City University; Oklahoma Agricultural
and Mechanical College; and with Doel Reed, Marion
Hartwell, Xavier Gonzalez. Awards: Tulsa, Oklahoma,
(100 Best Prints of the year) 1941; Oklahoma Art
Association, 1941, 1942, 1950, 1952, 1953-55; South-
western Print Exhibition, 1948, 1951, 1953; Association
Oklahoma Artists, 1941, 1942, 1948, 1954, 1955;
California Society of Etchers, 1947; Northwest Printmakers,
1944.

MOORE, Lou Wall. Sculptor. Award: St. Louis Exposition,
1904.

MOORE, Martha E. Born: Bayonne, New Jersey. Studied:
Art Students League. Awards: Art Students League, 1943;
Art League of Long Island, 1950; Wolfe Art Club, 1951;
Barbizon Plaza Gallery, 1951, 1952; 8th Street Gallery,
1951; American Artists Professional League, 1948; Allied
Artists of America, 1951; Knickerbocker Arts, 1955.
Collections: St. Vincent's Hospital, New York; Merchant
Marine Military Academy, King's Point, New York;
Passionist Monastery, West Springfield, Massachusetts.

MORAN, Mary Nimmo. Etcher. A very distinguished woman
etchers in this country. Her work is very outstanding.

MORANG, Dorothy. Painter. Born: Bridgton, Maine in 1906.
Studied: with Raymond Jonson, Emil Bisttram and Alfred
Morang. Awards: New Mexico State Fair, 1949; Museum of
New Mexico, 1953, 1956; National League of American Pen
Women, 1953. Collections: Museum, New Mexico; Canyon
Texas Museum.

MORGAN, GLADYS B. Painter. Born: Houma, Louisiana in 1899.
Studied: Randolph-Macon College for Women; Columbia
University; also studied with Arthur C. Morgan and Will H.
Stevens. Collection: Excelsior Hotel, Jefferson, Texas;
Gilmer Hospital, Shreveport, Louisiana.

MORGAN, Helen B. Sculptor. Born: Springfield, Ohio in
1902. Studied: Art Institute of Chicago; Wittenberg College;
Dayton Art Institute. Awards: Springfield County Fair, 1951;
Dayton Art Institute, 1945, 1946, 1948; Springfield Art
Exhibition, 1946-1948, 1952, 1954; Clark County Fair, 1951.
Ohio State Fair, 1952.

MORLEY, Mary C. Painter. Born: Watertown, New York in 1900. Studied: St. Lawrence University, Canton, New York; Maryland Institute; Syracuse University; New York University. Has exhibited extensively.

MORPURGO, Vilna Jorgen. Painter. Born: Oslo, Norway in 1900. Studied: Maison Wateau, Paris; sculpture with Karl Eldh in Sweden. Collections: Gallery of Modern Art, Stockholm; in Royal collections in Sweden, Belgium and Italy.

MORRELL, Imogene Robinson. Painter. Born: Attleboro, Massachusetts and died in 1908. Studied: with Gamphausen; and in Paris with Couture. Awards: Mechanics Institute, Boston; Centennial Exposition, Philadelphia. Some of her best work is "First Battle between the Puritans and the Indians," "Washington and His Staff Welcoming a Provision Train," and "David before Saul."

MORRIS, Alice. Painter. Born: Lowell, Massachusetts. Studied: Emory University; Chicago University; University of Denver; New York University; Ecole du Louvre, Paris; University of Southern California; California School of Fine Arts; University of California; California College of Arts and Crafts; also studied with Maurice Sterne. Founder of the Outdoor Junior Art Exhibition held annually.

MORRIS, Hilda. Sculptor. Born: New York City in 1911. Studied: Art Students League; Cooper Union Art School. Collections: Munson-Williams-Proctor Institute; Seattle Art Museum; Portland Oregon Art Museum; San Francisco Museum of Art; Walter Chrysler collection.

MORRIS, Patricia M. Painter. Born: Ashtabula Harbor, Ohio in 1927. Studied: Scripps College with Millard Sheets; Los Angeles County Art Institute. Awards: Denver Art Museum, 1954; Los Angeles Museum of Art, 1952, 1955; Motion Picture Art Director award, 1952, 1955; Cole of California award, 1953.

MORROW, Julie. Painter. Born: New York City. Studied: with Jonas Lie and C. W. Hawthorne.

MORSE, Anne Goddard. Painter. Born: Providence, Rhode Island in 1854. Studied: Massachusetts Normal Art School; Art Students League; and with Wyatt Eaton; also with John La Farge for stained glass. She was also an illustrator.

MORSE, Mary Minns. Painter. Born: Dorchester, Massachusetts in 1859. Studied: with Ross Turner and Louis Ritter in Boston; and with George Hitchcock in Holland. Her specialty was landscapes and marines in water colors.

MORSE, Sadie May. Painter. Born: Lexington, Massachusetts
in 1873. Studied: Massachusetts Normal Art School, Boston;
and in Italy.

MORSON, Lidia. Painter. Born: Ekaterinoslav, Russia in
1909. Studied: Emerson College; and with Nicolai Abracheff.
Was exhibiting at the Contemporary Art Gallery in 1949,
1952.

MORTON, Christina. Painter. Born: Dardanelle, Arkansas.

MORTON, Josephine. Painter. Born: Boston, Massachusetts
in 1854. Studied: with Eakins; also studied in Paris
with Laurens and Constant.

MOSCON, Hannah. Painter. Born: New York, New York.
Studied: Art Students League; Brooklyn Museum School of
Art. Awards: Brooklyn Museum, 1947; National Association
of Women Artists, 1947, 1949, 1950, 1951.

MOSELEY, Helen E. Painter. Exhibited at the 33d Annual
Exhibition of National Association of Women Painters and
Sculptors.

MOSER, Julon. Painter. Born: Schenectady, New York in 1900.
Studied: Chouinard Art Institute; University of California;
Scripps College; and with Millard Sheets, Glen Wessels,
Frank Taylor Bowers. Awards: Greek Theatre, Los Angeles,
1951, 1955; Pasadena Art Institute, 1951; Women Painters
of the West, 1938, 1940, 1942, 1944; Laguna Beach, 1953;
Wilshire Ebell Club. Collection: Clearwater Museum of Art.

MOSES, Anna Mary (Grandma Moses) Painter. Born: Greenwich,
New York in 1860. Awards: Syracuse Museum of Fine Arts,
1941; Art Directors Club, 1947; Women's National Press Club,
award presented by President Harry S. Truman, 1949;
Russell Sage College, 1949; Moore Institute of Art,
Philadelphia, Pennsylvania, 1951; Society of Illustrators,
1955. Collections: Metropolitan Museum of Art; The White
House, Washington, D. C. Russell Sage College, Troy, New
York; Rochester Memorial Art Gallery; Austrian State Gallery;
Museum of Art, Providence, Rhode Island; Syracuse Museum of
Fine Arts; Pasadena Art Institute; William Rockhill
Nelson Gallery of Art; National Art Gallery, Sydney,
Australia; Musee Nationale d'Art Moderne, Paris, France.
She exhibited throughout the United States and in Europe.

MOSIER, Martha H. Painter. Born: Martinsville, Indiana
in 1915. Studied: Indiana University; Art Institute of
Chicago; and with Adolph R. Schulz. Awards: Indiana State
Fair, 1945-1950; Hoosier Salon, 1952; Swope Gallery of Art,
Terre Haute, 1957; Martinsville, Indiana, 1958.
Collections: Indiana University; Brown County Art Gallery;
DePauw University.

MOSKOWITZ, Shirley. Painter. Born: Houston, Texas in
1920. Studied: Museum School of Art, Houston; Rice
Institute; Oberlin College; Morris Davidson School of
Art. Awards: Museum of Fine Arts of Houston, 1945;
Norristown Art League, 1958. Collection: Allen Memorial
Museum, Oberlin College.

MOSS, Ella A. Painter. Born: New Orleans, Louisiana
in 1844. Studied: In Europe. Her studio was in New York
where she painted many portraits of prominent people.
She exhibited at the National Academy in 1878.

MOTLEY, Eleanor W. Painter. She was exhibiting her
watercolors at the Pennsylvania Academy of Fine Arts
in 1925.

MOTTS, Alicia Sundt. Painter. Born: Oslo, Norway.
Studied: Mayville College; Art Institute of Chicago;
and with Gerald Brockhurst, and Henry Keller. Awards:
Butler Art Institute, 1940; National Academy of Design,
1945. Collections: School of Nursing, Easton, Pennsylvania;
Franklin Square Medical Library, Baltimore; School of
Nursing, Frederick, Maryland; Youth Room, Brooklyn Young
Mens Christian Association.

MOTT-SMITH, Mae. Painter. Born: in 1879. Studied: in
Paris at Colarossi Academy. She was not only a miniature
painter but a sculptor as well. Her sculpture entitled
"A Berber Woman" was exhibited at the National Academy of
Design in 1925.

MOTTET, Jeanie Gallup. Painter. Born: Providence, Rhode
Island in 1864. Studied: with Chase, Richard E. Miller
and E. Ambrose Webster.

MOTZ-LOWDON, Elsie. Painter. Born: Waco, Texas.
Studied: Art Students League; American School of
Miniature Painters.

MOULD, Ruth Greene. Painter. Born: Morrisville, Vermont
in 1894. Studied: St. Paul Art Institute; Art Students
League and with DuMond, Bishop and Soyer. Award: St. Paul
Art Institute. Collections: Bennington Vermont Museum;
Fleming Museum of Art, Burlington, Vermont.

MOULTON, Sue Buckingham. Painter. Born: in 1873. She
was a miniature painter.

MOUNT, Pauline W. Painter. Born: Batavia, New York. Studied: Art Students League; New York University; also with Kenneth Hayes Miller, Albert P. Lucas, Fiske Kimball and Joseph P. Pollia. Awards: fellowship, Royal Society of Art, London; Jersey City Museum, 1941; Painters and Sculptors Society, New Jersey, 1943, 1951; Montclair Art Museum, 1945; New Jersey Art, 1945; Asbury Park Society of Fine Arts, 1946; Kearney Museum, 1947; Art Fair, New York, 1950. Collections: Library of Congress; The White House, Washington, D. C. ; Jersey City Museum; Carlebach Gallery; designed silver bell of America for American Bell Association, 1950; Painters and Sculptors Society, New Jersey. Has work also in Italy, Ireland, Holland, Germany, France Sweden and Switzerland.

MOUNTFORT, Julia Ann. Painter. Born: Barford, Province of Quebec, Canada in 1888. Studied: Fox Art School; Art Institute of Chicago; Chicago Academy of Fine Arts; and with Sargent and Townsley.

MOYNIHAN, Helen S. Painter. Born: Marcus, Iowa in 1902. Studied: Chicago Academy of Fine Arts; and with H. R. Fischer and Robert Von Neumann. Awards: Milwaukee Art Institute, 1944; Wisconsin State Fair, 1943, 1944, 1947; Minnesota Centennial, 1949. Collection: Minnesota Centennial collection; Jesuit Seminary, Florissant, Missouri.

MUELHAUSER, Eugenie V. Awards: American Artists Professional League; National Art League; Washington Square Art Show.

MUELLER, Henriette W. Painter. Born: Pittsburgh, Pennsylvania in 1915. Studied: Northwestern University; Art Institute of Chicago; Art Students League; University of Wyoming; and with Will Barnet, Ilya Bolotowsky, John Opper and George McNeal. Awards: Mary Griffiths Marshall Memorial fellowship, Alpha Chi Omega, 1952; Tri-State Exhibition, 1958; Cummington fellowship, 1954. Collections: New York Public Library; Joslyn Art Museum; Henry Gallery, University of Washington; Nelson Gallery of Art; Woman's College, University of North Carolina.

MUHLHOFER, Elizabeth. Painter. Exhibited her water colors at the Pennsylvania Academy of Fine Arts, 1925.

MUIR, Emily. Painter. Born: Chicago, Illinois in 1904. Studied: Vassar College; Art Students League with Richard Lahey, John Carroll, George Bridgman and Leo Lentelli. Collections: Brooklyn Museum; University of Maine; United States Government; Moore-McCormack Lines; American Caribbean Lines; American Scantic Lines; French Line; Pan-American Airways; Finnish Travel Bureau; Swedish Travel Bureau; Aluminum Corporation of America.

MULFORD, Laura L. Painter. Born: Stuart, Nebraska in
1894. Studied: Park College, Parkville, Missouri;
University of Nebraska; University of Chicago; Columbia
University; Colorado Springs Fine Arts Center.
Exhibited predominately in North Dakota.

MULLEN, Buell. Painter. Born: Chicago, Illinois in
1901. Studied: Tyler School of Art; British Academy
of Art, London; Rome, Italy with Petrucci, and
Lipinsky; and in Belgium with Cicquier. Collections:
Library of Congress (first mural to be made of stainless
steel); United States Naval Research Laboratory, Ministry
of Public Works, Rio de Janeiro; Ministry of War, Buenos
Aires; Great Lakes Naval Station; Dun & Bradstreet; Metals
Research Laboratory, Niagara; Electronic Tower,
International Telephone and Telegraph Company; General
Motors Styling Administration, Detroit; United States
Steel panels for private car; National Carbon Laboratory;
Searle Laboratory; Inland Steel, Indiana Harbor; Stainless
steel mural, ceiling North Adams Massachusetts Hospital;
Sorg Paper Middletown, Ohio; Gardner Board and Carton
Company, Middletown; Allegheny Ludlum Steel Laboratory;
John Woodman Higgins Armory, Worcester, Massachusetts;
Republic Steel Company; Physics Auditorium, Case Institute
of Technology; American Society of Chemists, Washington,
D.C.

MULLER, Helen Chance. Painter. Born: Philadelphia,
Pennsylvania in 1891. Studied: with Florence Cannon,
Eleanor Copeland and Earl Horter.

MULLER, Olga Popoff. Sculptor. Was exhibiting in 1924
at the National Association of Women Painters and
Sculptors.

MULLER, Yvonne C. Painter. Born: Ann Arbor, Michigan in
1943. Collections: Maguerite Hammond Collection.

MULLER-URI, Hildegarde. Painter. Born: New York City in
1894. Studied: Breckenridge Art School; Art Students
League and with Dumond, Olinsky, Adams and Lewis.
Collection: Bowery Savings Bank, New York; Ghent, Belgium.

MULLINEUX, Mary. Printmaker. Born: Philadelphia,
Pennsylvania. Studied: Pennsylvania Academy of Fine Arts;
with Chase, Pearson and Breckenridge. Awards: fellowship,
Pennsylvania Academy of Fine Arts.

Ethel F. Mundy, *LETTERHEAD USED BY THE ARTIST*. Printed, 2 3/4".
Private Collection.

MUNDAY, Rosemary. Painter. Exhibited in 1914 at the Pennsylvania Academy of Fine Arts.

MUNDY, Ethel F. Sculptor. Born: Syracuse, New York. Studied: Art Students League; Fontainebleau School of Art, France; also with Rochester Mechanics Institute; and Amy M. Sacker, Boston. Work: Syracuse Museum of Fine Arts; Frick Gallery, New York; J. B. Speed Memorial Museum; Louisville Kentucky Museum of Art. She discovered a new composition for use in wax portraiture and revived the art of wax portraiture which was known in Europe for 500 years before being lost in the 18th century.

MUNGER, Anne W. Painter. Born: Springfield, Massachusetts in 1862. Studied: with Brush in New York; with Philip Hale, Woodbury and De Camp in Boston. Her specialty was landscape Painting.

MUNGER, Caroline. Painter. Born: in 1808 and died in 1892. She was a miniature painter who exhibited her work at the National Academy of New York in 1841.

MUNGER, Clarissa. Painter. Born: in 1806 and died in 1889. She was a flower painter.

MUNIAK, Helen. Painter. Born: in Poland in 1910. Studied: with Simon Lissim. Awards: Florida Southern College, 1952.

MUNN, Marguerite C. Painter. She exhibited at the Pennsylvania Academy of Fine Arts and National Association of Women Painters and Sculptors.

MUNROE, Marjory. Painter. Born: New York City in 1891. Studied: with DuMond, Percy Moran and George E. Browne.

MUNROE, Sally C. Painter. Born: in 1881. Her specialty-- landscapes with figures.

MUNROE, Sarah Sewell. Painter. Born: Brooklyn, New York. Awards: Corcoran prize, Washington Water Color Club; Society of Washington Artists, 1921.

MURDOCH, Dora L. Painter. Born: New Haven, Connecticut in 1857. Studied with Courtois, Rixen and Boutet de Monvel in Paris. Award: Purnell prize, Baltimore Water Color Club, 1903.

MURDOCH, Florence. Graphic Artist. Born: Lakewood, New York in 1887. Studied: Cincinnati Art Academy; Art Students League; Ohio Wesleyan University; University of Cincinnati, with Novotny, Carlson and Sallie Humphreys. Awards: Ohioana Library Competition for drawings for historical calendar, 1957. Contributor to American Magazine of Art, with article and illustration, 1932; Sunday Pictorial Enquirer, Cincinnati.

MURPHEY, Mimi. Sculptor. Born: Dallas Texas in 1912. Studied: Southern Methodist University; Dallas Art Institute; Art Students League. Awards: Texas State Fair, 1933, 1947; American Artists Professional League, 1937; New Mexico State Fair, 1944, 1948, 1949; Southern States Art League, 1944-1946; Fiesta Exhibition, Santa Fe, 1957; Allied Albuquerque Artists, 1951. Collection: Museum of New Mexico, Santa Fe.

MURPHY, Ada C. Painter. Studied: Cooper Union Art School; and with Douglas Volk. Award: Hallgarten prize, National Academy of Design, 1894.

MURPHY, Alice H. Painter. Born: Springfield, Massachusetts in 1896. Studied: Parsons School of Design; Art Students League; National Academy of Design; Grande Chaumiere, Paris; and with Charles Hawthorne, Vaclav Vytlacil. Awards: National Association of Women Artists, 1946; Springfield Museum of Art, 1943; Wichita Art Association, 1939; Best Prints of the Year, 1936, 1942, 1947; National Academy of Design, 1951. Collections: Library of Congress; Williams College; New York Public Library; Philadelphia Artist Alliance; Metropolitan Museum of Art; Springfield Museum of Art; Art Students League; University of Maine.

MURPHY, Gladys W. Painter. Born: Providence, Rhode Island in 1907. Studied: Rhode Island School of Design. Exhibited extensively.

MURPHY, Minnie B. Hall. Painter. Born: Denver, Colorado in 1863. Studied: Art Students League; Art Institute of Chicago; and with Henry Read in Denver.

MURPHY, Nelly L. Painter. Born: Stockton, California in 1867. Studied: Museum of Fine Arts, Boston. She was also an illustrator.

MURRAY, Elenor. Painter. Water color artist working around 1820.

MURRAY, Elizabeth H. Painter. Born: in 1815 and died in 1882. She was a known landscape painter.

MURRAY, Floretta. Painter. Born: In Minnesota. Studied:
Winona State College; University of Minnesota; Minneapolis
School of Art; University of Chicago; also in France, Italy
and Belgium. Awards: Minnesota State Fair, 1938; Women's
Week Exposition, 1942; Independent Artists of New York,
1947; Walker Art Center, 1941, 1945; St. Paul Art Gallery,
1956. Collection: Winona County Historical Society.

MURRAY, Grace H. Painter. Born: in New York in 1872.
Studied: with Bouguereau and Gabriel Ferrier. Painter
of portraits and miniatures.

MURRAY, Mary. Painter. She was working in New York City
in 1834 painting portraits in oils, water color and crayons.

MUSGRAVE, Shirley D. Painter. Born: Lexington, Kentucky
in 1935. Studied: Mississippi State College for Women;
Colorado Springs Fine Arts Center School; Allison Art
Colony, Way, Mississippi; University of Kansas. Awards:
Scholarships, Mississippi Art Association, 1956, 1957;
Colorado Springs Fine Arts Center School, 1956; Graduate
scholarship in Fine Arts, University of Kansas, 1957, 1958;
Arkansas Artists, 1956; Allison Art Colony, 1957; Delta
Phi Delta, University of Kansas, 1958.

MYERS, Ethel. Sculptor. Born: Brooklyn, New York in 1881.
Studied: Hunter College; Columbia University; and with
William Chase, Robert Henri and Kenneth Hayes Miller.

MYRHL, Sarah. Painter. Born: New York City in 1912.
Studied: Hunter College; New School for Social Research;
Columbia University; Art Students League; and with Brook,
Zorach and Kuniyoshi. Award: Metropolitan scholarship
from Art Students League. Collections: Mural, La Guardia
Sea Plane Base, New York; also in private collections in
United States and Japan.

MYRICK, Katherine S. Painter. Known best for her miniature
paintings.

NAGEL, Elizabeth. Painter. Was exhibiting in 1921 at the
Pennsylvania Academy of Fine Arts.

NAGEL, Stina. Painter. Born: Ann Arbor, Michigan in 1918.
Studied: University of Michigan School of Design; Art
Students League; also with Jose de Creeft, Victor Candell
and Charles Seide. Award: Jan Highbee award, University
of Michigan, 1939.

NAGLER, Edith. Painter. Born: New York City in 1890.
Studied: National Academy of Design; Art Students League;
and with Douglas Volk, Robert Henri and Frank DuMond.
Awards: Springfield, Massachusetts, 1934; Stockbridge,
Massachusetts, 1932; Bronx Art Guild. Collections:
Wadsworth Atheneum, Hartford, Connecticut; Springfield
Museum of Art; Highland Park Museum, Dallas Texas;
Federal Court House, Boston, Massachusetts.

NASH, Anne Taylor. Painter. Born: Pittsboro, North
Carolina in 1884. Studied: School of Fine Arts,
Fontainebleau, France; Pennsylvania Academy of Fine Arts;
Institute San Miguel, Mexico; Winthrop College, Rock Hill,
South Carolina; and with Robert Brackman and Wayman Adams.
Award: Telfair Academy, 1951. Collections: Roper Hospital,
Charleston, South Carolina; Hibernian Society, Charleston,
South Carolina; St. Andrews Society, Charleston, South
Carolina; Colonial Dames House, Health Center, Savannah,
Georgia; New York Infirmary.

NASH, Katherine. Sculptor. Born: Minneapolis, Minnesota
in 1910. Studied: University of Minnesota; Minneapolis
School of Art; Walker Art Center. Awards: National Delta
Phi Delta Competition, 1932; Minnesota State Fair, 1941,
1942, 1944; Minneapolis Institute of Art, 1944; Swedish-
American Exhibition, 1948; Lincoln Art Guild, 1950;
Nebraska State Fair, 1951, 1952; Joslyn Art Museum, 1954;
Nebraska Art Association, 1955; Walker Art Center, 1951;
Sioux City, 1952. Collections: University Medical Building,
Omaha; Buffalo Minnesota Court House; Walker Art Center;
Lincoln Art Guild; Nebraska Art Association; Kansas State
College; Concordia College; Minneapolis Public Library;
Joslyn Art Museum; Omaha Association of Art.

NASON, Gertrude. Painter. Born: Everett, Massachusetts.
Studied: Massachusetts School of Art, with Joseph De Camp;
Boston Museum of Fine Arts School, with Edmund Tarbell.
Awards: National Association of Women Artists, 1939, 1945.
Collection: Boston Museum of Fine Arts.

NAY, Mary Spencer. Painter. Born: Crestwood, Kentucky
in 1913. Studied: Louisville Art Center Association
School; University of Louisville; Cincinnati Art Academy;
and with Maebelle Stamper; Art Students League with
Kuniyoshi, Barnet and Grosz; International School of Art,
Mexico and with Merida Zalce. Awards: Aetna Oil purchase
award, 1945, 1950; Evansville Tri-State Exhibition; Ohio
Valley Exhibition, Athens, 1954, 1955; Kentucky State
Fair, 1945; Woman's Club, 1955; International Business
Machines, 1940. Collections: International Business
Machines, 1940. Collections: University of Louisville,
Evansville Public Museum; J. B. Speed Art Museum; Ohio
University, Athens.

NAYLOR, Alice. Painter. Born: Columbus, Texas. Studied:
Witte Memorial Museum School of Art; San Antonio Art
Institute, and with Charles Rosen, Etienne Ret, Andrew
Dasburg, Xavier Gonzalez and Dan Lutz. Awards: River
Art Group, 1953-1956; Texas Watercolor Society, 1953,
1958; Texas Art Mart, Austin, 1955; "Woman of the Year,"
1953, San Antonio; Texas Fine Arts Association, 1957;
Columbus Tex-s Art Fair, 1957-1958; Beaumont Art Museum,
1958.

NEAFIE, Edith S. Painter. Born: Brooklyn, New York in
1884. Studied: Pratt Institute Art School; Grand Central
School of Art; New York State Normal; and with Anna
Fisher, and Lester Stevens. Award: Wolfe Art Club, 1932.

NEAGLE, Miss E. Painter. Was exhibiting her flower and
landscape paintings in 1819-1822.

NEAL, Grace Pruden. Sculptor. Born: St. Paul, Minnesota
in 1876. Studied: St. Paul Art School; Art Institute of
Chicago; Art Students League; Grand Chaumiere, Paris;
and with Knute Akerberg, and Injalbert. Awards: Minnesota
State Art Society, 1903-1905. Collections: Corcoran
Memorial Park, St. Paul, Minnesota; Thirty Club, London,
England.

NEAL, Lucinda. Painter. An amateur artist working in 1848.

NEDWILL, Rose. Painter. Born: New York City. Studied:
Art Students League, and with Harvey Dun, Ennis and Bridgman.
Exhibited chiefly in New Mexico.

NEEBE, Minnie Harms. Painter. Born: Chicago, Illinois in
1873. Studied: with Hawthorne, Browne, Webster and Reynolds.

NEGUS, Caroline. Painter. Born: in 1814 and died in 1867.
A portraitist working with crayons and miniatures, in
Boston, Massachusetts during the period 1844-1856.

NEWCOMB, Marie Guise. Painter. Born: in 1865. She was
a painter of landscapes and animals.

NEWER, Tresis. Painter. Born: New York in 1918.
Awards: National Art League, gold medal; American Artists
Professional League.

NEWHALL, Adelaide. Painter. Born: Worcester, Massachusetts
in 1884. Studied: Smith College; Syracuse University;
Montclair Art Museum with Estelle Armstrong; Douglas
Prizer, and Avery Johnson; also with Hawthorne, Farnsworth
and Dwight Tryon. Awards: Kresge Exhibition, Montclair,
1939; Art Center of the Oranges, 1953; Bloomfield New
Jersey Art League. Collections: in private collections.

NEWMAN, Anna M. Painter and Illustrator. Born: Richmond,
Indiana. Studied: Art Institute of Chicago. Noted for
her portraits of prominent persons.

NEWMAN, Irene H. Painter. Born: Cameron, Missouri. Has
exhibited widely throughout the United States.

NEWMAN, Willie Betty. Painter. Born: Murfreesboro,
Tennessee in 1864. Studied: Cincinnati Art School with
T. S. Noble; in Paris with Benjamin Constant, Laurens and
Bouguereau. Awards: Paris Salon, 1891, 1893-1900; Paris
Exposition, 1900.

NEWTON, Edith. Lithographer. Born: Saginaw, Michigan in
1878. Awards: Northwest Printmakers; Library of Congress,
1946. Collections: Whitney Museum of American Art;
Metropolitan Museum of Art; Newark Library; Seattle Art
Museum; Library of Congress; Boston Public Library;
Philadelphia Museum of Art.

NEWTON, Edith W. Painter. Has exhibited at the 33d Annual
Exhibition of the National Association of Women Painters
and Sculptors.

NEY, Elizabeth. Sculptor. Born: Westphalia. Soon after
the Civil War she moved to Texas. Collection: Memorial
to General Albert Sidney Johnson, in cemetery, Austin,
Texas.

NEWTON, Helen F. Painter. Born: Woodbridge, Connecticut
in 1878. Studied: Santa Barbara State College; Mount
Holyoke College; and with Harry L. Ross and Charles
Hawthorne. Awards: Bridgeport Art League, 1941, 1944;
State Federation of Women's Club, 1942. Collections:
New Haven Paint and Clay Club; City Hall, Norwich
Connecticut.

NEIDIGH, Pansy Mills. Painter. Born: New Ross, Indiana in 1907. Studied: Central Normal College; John Herron Art School; Columbia University. Awards: Indiana State Exhibition; Butler Art Institute.

NEILL, Frances Isabel. Painter and etcher. Born: Warren, Pennsylvania. Studied: Boston, New York and Paris.

NELKE, Dora K. Painter. Born: New York City in 1889. Award: Philadelphia Plastic Club, 1946.

NELL, Miss Tony. Painter and illustrator. Born: Washington, D. C. Studied: with Chase and DuMond; Students School of Art, Denver. Awards: Beal prize, New York Watercolor Club, 1910; Harriet Brooks Jones prize, Baltimore Watercolor Club, 1921.

NEUFELD, Paula. Painter. Born: Berlin, Germany. Studied: Art Institute, Berlin; Berlin Academy of Art; and with von Koenig, Eugene Spiro, and Willy Jaekel; Colorado Springs Fine Arts Center. Award: fellowship, Huntington Hartford Foundation, 1957. Collections: Bernheimer Memorial, Kansas City, Missouri; Temple B'nai Jehudah, Kansas City; Mannheim Museum, Germany; Jewish Museum, Berlin; Jackson County Circuit Court.

NEUHAUSER, Marguerite. Painter. Born: North Arlington, Virginia in 1888. Studied: Corcoran School of Art; and with George Noyes and Bertha Perrie.

NEUMARK, Anne. Painter. Born: Boston, Massachusetts in 1906. Studied: Massachusetts School of Art; Designer's Art School, Boston, Massachusetts. Collection: Edgar Allen Poe Shrine, Richmond, Virginia.

NEVELSON, Louise. Sculptor. Born: Kiev, Russia in 1900. Studied: in United States, Europe and Central America. Collections: Museum of Fine Arts, Houston; Farnsworth Museum, Rockland, Maine; Brandeis University; Birmingham Museum of Art; Whitney Museum of American Art; Museum of Modern Art; New York University; Queens College; Carnegie Institute; Riverside Museum; University of Nebraska; Brooklyn Museum. She has been called "the most distinguished woman sculptor in America and one of the great sculptors of the world." Her wooden assemblage sculpture is usually painted black.

NEVIN, Blanch. Sculptor. Born: Mercersburg, Pennsylvania in 1841 and died in 1925. Studied: in Philadelphia and Italy. Collection: statue of Peter Muhlenberg in the Capitol, Washington, D.C.

NEWTON, Marion C. Painter. Born: Boston, Massachusetts
in 1902. Studied: Radcliffe College; Parsons School of
Design; and with Ivan Olinsky, Lydia Field Emmet, and
George Bridgman; also studied in Paris. Collections:
Metropolitan Museum of Art; Museum of City of New York;
Detroit Institute of Art; United States Lines; Baseball
Hall of Fame, Cooperstown, New York; Ladies Home Journal,
Good Housekeeping and McCalls.

NEWTON, Mrs. Painter. A watercolor artist specializing
in flowers. Exhibiting in the period 1841-43.

NIBLOCK, Margery. Painter. Born: New York City in 1937.

NICHOLLS, Josephine L. Painter. Born: Ontario in 1865.
Studied: with Mowbray and Bridgman.

NICHOLLS, Rhoda H. Painter. Born: Coventry, England.
Studied: Bloomsbury School of Art, London. Awards:
Queen's scholarship; Interstate Expositions in Chicago,
Buffalo and St. Louis.

NICHOLS, Edith L. Painter. Born: Brooklyn, New York.
Studied: Pratt Institute Art School; Columbia University;
and with Henry B. Snell, Charles Martin and Anna Fisher.

NICHOLS, Jeannettie D. Painter. Born: Holland, Michigan
in 1906. Studied: Art Institute of Chicago; University
of Chicago; Institute of Design, Illinois Institute of
Technology; and with Frances Chapin and Peppino
Mangravite. Awards: Chesterton, Indiana, 1954, 1955; Gary
Art League, 1955; Gary Ceramic Exhibition, 1955; South
Bend Art Center, 1956.

NICHOLS, Peggy M. Painter and sculptor. Born: Atchison,
Kansas in 1884. Studied: with Cecilia Beaux and Chase.

NICHOLSON, Edith R. Illustrator. Born: Mount Vernon, New
York in 1896. Studied: New York School of Applied Design
for Women.

NICHOLSON, Elizabeth. Painter. Born: in 1833 and died
in 1926. Known as a landscape, portrait and china painter.

NICHOLSON, Susan F. Painter. A portraitist working around 1820.

NICKERSON, Jennie R. Sculptor. Born: Appleton, Wisconsin in 1905. Studied: National Academy of Design; Beaux-Arts Institute of Design. Awards: National Academy of Design, 1933; National Arts Club, 1933; Hudson Valley Art Academy, 1953; Westchester Arts and Crafts Guild, 1955; Montclair Art Museum, 1939; National Association of Women Artists, 1946; Guggenheim fellowship, 1946; American Artists Professional League, 1937. Collections: Newark Museum; Cedar Rapids Art Association; United States Post Office, New Brunswick, New Jersey; United States Post Office, Leaksville, North Carolina; Children's Library, Brooklyn, New York.

NICKSON, Lia. Painter. Born: Durham, North Carolina in 1924. Studied: Albion College; University of North Carolina; Art Students League; and with Louis Bouche; Jepson Art Institute, Los Angeles with Rico LeBrun; Grande Chaumiere, Paris. Award: Museum of New Mexico, 1958. Collections: Roswell Museum, New Mexico; Museum of New Mexico, Santa Fe.

NIETO, Grace A. Painter. Born: Los Angeles, California in 1899. Studied: Otis Art Institute with Lukits; and with Vysekel, Will Foster, Ralph Holmes and Sam Harris.

NILES, Rosamond. Painter and etcher. Born: Portsmouth, New Hampshire in 1881. Studied: Art Students League; and with DuMond, Bridgman and Pennell; in Paris with Andre L'Hote. Collections: Witte Memorial Museum; Randolph Aviation Field; Woodberry Forest School, Chatham School in Virginia; Radcliffe Hicks Memorial School, Tolland, Connecticut.

NIMBS, Areuna B. Painter. A portrait painter and photographer working in 1856-60.

NIMMO, Louise E. Painter. Born: Des Moines, Iowa in 1899. Studied: Grinnell College; Otis Art Institute; Chouinard Art Institute; Immaculate Heart College, mosaic workshop; Fontainebleau School of Art, Julian Academy, Paris, France. Award: Pacific-Southwest Exposition, 1928; Laguna Beach Art Association, 1923; California State Fair, 1936; California Art Club, 1951; Pasadena Art Institute, 1950. Collections: Opportunity School, Des Moines, Iowa; Beverly Hills Women's Club; St. Andrews Episcopal Church, Ojai, California.

NIMS, Mary Altha. Painter. Water color artist working around 1840.

NISWONGER, Ilse. Sculptor. Born: Metz, France in 1900.
Studied: Art Students League with Archipenko, Hofmann
and Belling. Collections: Sculpture in churches in the
following:Westport, Fairfield, New Haven, New Canaan, West
Hartford, Norwalk and Bolton, Connecticut; Harrisburg and
Pittsburgh, Pennsylvania; Brooklyn, New York; Glendora,
California; Moncton, Canada; Baraboo, Wisconsin; Don Bosco
School, Paterson, New Jersey.

NITZSCHE, Elsa K. Painter. Born: Philadelphia, Pennsylvania
in 1880. Studied: Pennsylvania Academy of Fine Arts;
Woman's School of Design; in France; in Germany; in Italy;
in Switzerland; and 8 years with Bougeret. Award: Paris
Salon. She was principally a portrait painter.

NOBLE, Mamie Jones. Painter. Born: Ellis County, Texas.
Studied: Art Institute of Chicago; and with Rose Crosman,
George Oberteuffer, Cyril Kay-Scott. Awards: Mississippi
State Fair, 1929, 1931; Federation of Women's Club,
Corsicana, Texas, 1937. Collections: Public Schools,
Corsicana, Texas; First Baptist Church, Itasca, Texas;
Memorial church and Emmanuel Church, Corsicana, Texas.

NORCROSS, Eleanor. Painter. Born: In Massachusetts and
died in 1923. Studied: with William M. Chase in New York;
with Alfred Stevens in Paris. A memorial exhibition of
her painting was held in the Louvre by the French
Government.

NORMAN, Mrs. Da Loria. Painter. Born: in Leavenworth,
Kansas in 1872. Studied: Abroad. Collection: New York
Public Library.

NORMAN, Emile. Painter. Born: in California in 1918.
Collections: Oakland Art Museum; San Francisco Museum of
Art.

NORRIS, Vera. Painter. Born: Nevada, Iowa in 1905.
Studied: with Trudy Hanscomb and Jennie Crawford. Award:
Friday Morning Club, Los Angeles, 1951.

NORTH, Mary. Painter. A painter of still life was
exhibiting 1828-1840.

NORTON, Ann. Sculptor. Studied: National Academy of
Design; Art Students League; Cooper Union Art School;
and with Leon Kroll, John Hovannes, Charles Rudy and
Charles Keck. Awards: Carnegie fellowship for European
study, 1932, 1935; Society of Four Arts, Palm Beach,
Florida, 1944, 1945; Lowe Gallery, 1952; Norton Gallery,
1943-1945.

NORTON, Clara M. Painter. Exhibited her water colors
at the Pennsylvania Academy of Fine Arts in 1925.

NORTON, Elizabeth. Painter and sculptor. Born: Chicago,
Illinois in 1887. Studied: Art Institute of Chicago;
Art Students League; National Academy of Design.
Collections: Detroit Athletic Club; Stanford University;
California State Library; All Saints Church, Palo Alto;
Metropolitan Museum of Art; Art Institute of Chicago;
Library of Congress; Smithsonian Institute; Hackley Art
Gallery; American Museum of Natural History; Menlo
School Teachers College, Menlo Park, California; Fogg
Museum of Art; San Mateo County Library, Redwood City,
California.

NORTON, Helen G. Painter. Born: Portsmouth, Ohio in
1882. Studied: Mills College; and with Jean Manheim.

NOURSE, Elizabeth. Painter. Born: Cincinnati, Ohio in
1860. Studied: Art Academy of Cincinnati; with Boulanger,
Henner, Lefebvre, Carolus-Duran in Paris. Awards:
Columbian Exposition, Chicago, 1893; gold medal, Panama-
Pacific International Exposition, San Francisco, 1915.

NOYES, Bertha. Painter. Born: Washington, D. C.
Studied: Corcoran School of Art; also with Charles
Hawthorne, and Jerry Farnsworth. Many exhibitions in
the Eastern United States.

NUHFER, Olive Harriett. Painter. Born: Pittsburgh,
Pennsylvania in 1911. Studied: University of Oklahoma;
Carnegie Institute. Collections: United States Post
Office, Westerville, Ohio; St. John's Church, Norman,
Oklahoma; Mellon Junior High School, Pittsburgh,
Pennsylvania; Penn Junior High School, Pittsburgh.

NUHN, Marjorie A. Painter. Born: Cedar Falls, Iowa
in 1898. Studied: Chicago Academy of Art; Art Institute
of Chicago; and with Grant Wood and Adrian Dornbush.
Awards: Sioux City Art Center, 1945; Cedar Falls Art
Gallery, 1944, 1945. Collection: Purdue College.

NUNN, Evylena. Painter. Born: Mayfield, Kansas in 1888.
Studied: Art Students League; Berkshire Summer School of
Art; School of Art and Design of Pomona College; with
A. A. Hills; also studied in Japan.

NUSBAUM, Esther C. Painter. Born: Richmond, Indiana
in 1907. Studied: University of Wisconsin. Awards:
Hoosier Salon, 1934; Indiana State Fair, 1947, 1948, 1952,
1957, 1958; Richmond Art Association, 1947, 1949, 1953,
1957; L. S. Ayers Award, Indianapolis, 1956, 1958; Virginia
Highlands Festival, 1958; American Association of University
Women, 1956. Collections: Richmond Art Association;
Richmond Young Womens Christian Association.

NUTTING, Emily. Painter. Known as a miniature painter
who was exhibiting in 1835.

OAKES, Mrs. A. T. Painter. Specializing in landscapes
and active in the period 1852-54.

OAKLEY, Georgina. Painter. Still life painter active
around 1859.

OAKLEY, Juliana. Painter. Died after 1912. Known as a
genre, still life and portrait artist.

OAKLEY, Violet. Painter. Born: Jersey City, New Jersey
in 1874. Studied: Art Students League; Pennsylvania
Academy of Fine Arts; Drexel Institute and in Paris;
also with Howard Pyle. Awards: Drexel Institute, 1948;
Delaware College, Newark, Delaware; gold medal, St. Louis
Exposition, 1904; gold medal, Pennsylvania Academy of
Fine Arts, 1905; gold medal, San Francisco Exposition,
1915; gold medal, Architectural League, 1916; Pennsylvania
Academy of Art, 1932; gold medal, Springside School,
Philadelphia, 1932; Pennsylvania Society of Miniature
Painters, 1941; Woodmere Art Gallery, 1947. Collections:
State Capitol, Harrisburg, Pennsylvania; All Angels
Church, New York; Chestnut Hill Academy Library; House of
Apostolic Delegate, Washington, D. C.; Cuyahoga County
Court House, Cleveland, Ohio; Vassar College; United
National Library, Geneva, Switzerland, Samuel Fleisher
Memorial, Philadelphia; First Presbyterian Church,
Germantown, Pennsylvania; Moral Re-Armament Headquarters,
London, England; Sarah Lawrence College; Bryn Mawr
College.

OBERTEUFFER, Henriette A. Painter. Born: in France in
1878. Her still life paintings are owned by the French
Government.

O'BRIEN, Nell P. Painter. Born: New Orleans, Louisiana.
Studied: Tulane University; Art Students League; New
Orleans Arts and Crafts School; Fontainebleau School of
Fine Arts; and with Wayman Adams. Awards: Delgado Museum
of Art, 1934, 1936, 1940, 1944-1946. Collections:
Browning Library, Waco, Texas, Louisiana State Museum;
New Orleans Association of Commerce, Court House and
Library; Loyola University; Beaumont Texas Art Club;
Woman's Club, Beaumont.

OCHTMAN, Dorothy. Painter. Born: Riverside, Connecticut
in 1892. Studied: Smith College; Bryn Mawr College;
National Academy of Design; also studied abroad. Awards:
National Academy of Design, 1921, 1924; Greenwich Society
of Art, 1930, 1945, 1947, 1951, 1953-1957; Fontainebleau
Alumni Association, 1937; National Association of Women
Artists, 1941, 1952; Guggenheim fellowship, 1927.

OCHTMAN, Mina Funda. Painter. Born: Laconia, New
Hampshire in 1862 and died in 1924. Her work has been
shown in exhibits throughout the country.

OEHLER, Helen G. Painter. Born: Ottawa, Illinois in 1893.
Studied: Art Institute of Chicago; and with George Elmer
Browne. Has exhibited widely in the United States.

OESINGER, Mrs. S. Painter. A miniature artist working in
1856.

O'GORMAN, Jacqui. Painter. Born: St. Louis, Missouri in
1930. Studied: Immaculate Heart College, Los Angeles.

O'HARA, Susan. Painter. A miniature artist who flourished
in New York in 1834-35.

O'KEEFFE, Georgia. Painter. Born: Sun Prairie, Wisconsin
in 1887. Studied: Art Institute of Chicago; Art Students
League; University of Virginia; Columbia University.
Awards: University of Wisconsin; William and Mary College.
Collections: Metropolitan Museum of Art; Museum of Modern
Art; Whitney Museum of American Art; Brooklyn Museum;
Springfield Museum of Art; Art Institute of Chicago;
Detroit Institute of Art; Newark Museum; John Herron Art
Insitute; Boston Museum of Fine Arts; Cleveland Museum of
Art; Philadelphia Museum of Art.

O'KEEFEE, Mary Catherine. Painter. A painter of flowers
and fruit whose work flourished around 1840.

OLCOTT, Lillia M. Painter. Born: Syracuse, New York in
1879. Studied: Syracuse University; New York University.

OLDS, Elizabeth. Painter. Born: Minneapolis, Minnesota
in 1897. Studied: University of Minnestoa; Minneapolis
School of Art; Art Students League; also with George Luks.
Awards: fellowship, Guggenhiem Foundation, 1926-27;
Philadelphia Printmakers, 1937; Philadelphia Museum
Competition, 1940; Museum of Modern Art, 1941; Baltimore
Museum of Art, 1953; Kansas City Art Institute, 1934.
Collections: Metropolitan Museum of Art; Museum of Modern
Art; Brooklyn Museum; Philadelphia Museum of Art; New
York Public Library; Library of Congress; Baltimore Museum
of Art; Seattle Museum of Art; San Francisco Museum of
Art; Glasgow University.

OLDS, Marion. Painter. Studied: University of Southern
California; Otis Art Institute. Award: Denver Art Museum,
1941. Collection: Chaffey College, Ontario, California.

OLDS, Sara Whitney. Painter. Born: Springfield, Ohio
in 1899. Studied: Carnegie Institute; Art Institute,
Pittsburgh; and with Guiseppi Trotta. Awards: Mineola
Fair, 1944, 1945; Springfield Art Association, 1952-1954;
Art League, Long Island, 1945, 1946, 1949, 1950; Stony
Brook Museum of Art, 1950; Springfield, Ohio, 1951;
St. James, Long Island, 1951. Collections: Medical
Library, United States Army, Washington, D. C.; Warder
Public Library, Springfield, Ohio; Station Hospital,
Mitchell Field, Long Island; Parrish Museum.

O'LEARY, Angela. Painter. Born: in 1876 and died in
1921. She was a genre and landscape artist.

OLIVER, Elizabeth P. Painter. Born: Rockridge County,
Virginia in 1894. Studied: Maryland Institute; with
George Elmer Browne; and in Europe. Awards: Lowenstein
prize; Atlanta Newspaper Association Award; Atlanta Art
Association. Collections: High Museum of Art; Corpus
Christi Texas Museum.

OLIVER, Jane. Painter. Born: West Haven, Connecticut
in 1921. Studied: Franklyn School of Professional Art.
Awards: Audubon Art, 1945, 1953; American Watercolor
Society, 1950; National Association of Women Artists,
1951, 1952; New Jersey Watercolor Society, 1954.
Collections: Newark Museum; Abilene Texas Museum of Art.
Upsala College Museum, East Orange, New Jersey.

OLMES, Mildred Y. Painter. Born: Oil City, Pennsylvania
in 1906. Studied: Carnegie Institute; Tyler School of
Fine Arts, Philadelphia, Pennsylvania; Royal University
for Foreigners, Perugia Italy; also studied in Paris.
Awards: Canton Art Institute, 1944, 1948, 1953; Chester
County Art Association, 1951; Ohio Drawing Exhibition,
1951; Ohio Valley Exhibition, 1951; Massilon Museum of
Art, 1949. Collections: Massilon Museum of Art; Canton
Art Institute; Canton Chamber of Commerce Building;
Aultman Hospital, Canton; Toledo Airport; Young Mens
Christian Association, West Chester, Pennsylvania.

OLSHANSKA, Stephanie. Painter. Born: Galicia in 1900.
Studied: Vienna, Austria; Art Students League; Columbia
University; Washington University; Cranbrook Academy of
Art; and with George Elmer Browne. Award: New Jersey
Gallery, Newark, 1936. Collection: Cliffside Park
Woman's Club.

O'MEALLIE, Kitty. Painter. Born: Bennettsville, South
Carolina in 1916. Studied: Newcomb Art School with
Xavier Gonzales and Will Stevens. Primarily a nature
painter but also executed group paintings of human face
and figure, semi-abstract compositions in oil, acrylic,
charcoal and mixed media. Awards: Gulf Coast Annual
Exhibition, Pass Christian, Mississippi; Masur Museum
of Art's 5th Monroe Annual, Monroe, Louisiana; Edgewater
Plaza 5th Art Exhibit, Gulfport-Biloxi, Mississippi;
Biloxi Art Associations Annual Tri-State Show; 2nd Greater
New Orleans National Exhibition. Collections: Wake
Forest University; Winston-Salem, North Carolina;
St. Martin's Protestant Episcopal School, Metairie,
Louisiana; Madewood Plantation, Assumption Parish,
Louisiana; Downtown Gallery, New Orleans; Sellers and
Sanders Clinic, New Orleans.

O'MEARA, Mae. Painter. Born: Weehawken, New Jersey.
Studied: Brooklyn Museum School of Art, with Konzal;
also with Guiseppi Trotta, and Ben Wilson. Awards:
Smithsonian Institute, 1950, 1951; Douglaston Art League,
1947, 1948. Collections: portraits in private collections.

ONTON, Sophie W. Painter. Born: New York City in 1907.
Studied: Parsons School of Design; Traphagen School of
Fashion; Industrial School of Art; and with Howard Giles.
Award: Traphagen School of Fashion. Collections:
American Appliance Corporation, Miami, Florida; Insular,
San Juan, Puerto Rico; Hall of Art, Miami, Florida.

OPPENHEIMER, Selma. Painter. Born: Baltimore, Maryland
in 1898. Studied: Goucher College; Maryland Institute.
Awards: Maryland Institute, 1933; Baltimore Museum of Art,
1935, 1938; National Association of Women Artists, 1952;
Maryland Federation of Women's Club, 1952. Collection:
Public Schools, Baltimore, Maryland.

OPPER, Laura. Painter. Studied: National Academy of Design
with Chase and Beckwith; also studied abroad. Known as
a portrait painter she died in 1924.

ORAM, Elizabeth. Painter. Active during the period 1815-1847

ORFUSS, Elsie. Painter. Born: Harrisburg, Pennsylvania
in 1913. Studied: Grand Central School of Art; Hans Hofmann
School of Fine Arts; Art Students League; also in Europe.
Award: National Association of Women Artists, 1956.
Collection: Chrysler collection.

ORGAN, Marjorie. Caricaturist. Born: New York in 1886.
Studied: with Daniel McCarthy and Robert Henri. An
illustrator for many New York papers.

ORLING, Anne. Painter. Born: New York City. Studied: with Paul Wood, Morris Davidson and Larry Rivers.

ORR, Eleanor Mason. Painter. Born: Newton Centre, Massachusetts in 1902. Studied: Boston Museum of Fine Arts School; also studied with Annie Hurlburt Jackson. Collections: Union Service Club, Boston; Cushing General Hospital, Framingham, Massachusetts. She painted many portraits of servicemen at Marine Hospital, Brighton, Massachusetts.

ORR, Frances Morris. Painter. Born: Springfield, Missouri in 1880. Studied:with G. A. Thompson.

ORTLIP, Aimee E. Painter. Born: Philadelphia, Pennsylvania in 1888. Studied: Pennsylvania Academy of Fine Arts. Award: Cresson traveling scholarship, Pennsylvania Academy of Fine Arts, 1909.

ORTMAYER, Constance. Sculptor. Born: New York City in 1902. Studied: Royal Academy of Fine Arts, Vienna, Austria. Awards: National Academy of Design, 1935; Whitney Museum of American Art, 1940; Florida Federation of Art, 1948; Rollins College, 1947. Collections: Brookgreen Gardens, South Carolina; American Numismatic Society, New York; United States Post Office, Arcadia, Florida; United States Post Office, Scottsboro, Alabama.

ORWIG, Louise. Painter and illustrator. Born: Mifflinburg, Pennsylvania. Studied: Pennsylvania Academy of Fine Arts; also studied with William Chase.

OSBORNE, Lue. Painter. Born: Belleville, Illinois. Studied: Art Institute of Chicago; also with Robert Henri.

OTIS, Amy. Painter. Born: Sherwood, New York. Studied: Pennsylvania Academy of Fine Arts; Colarossi Academy, Paris. Noted as a portrait and miniature painter as well as landscapes.

OUDIN, Dorothy S. Painter. Born: Baltimore, Maryland in 1898. Studied: Pennsylvania Academy of Fine Arts; also studied with Garber, Hawthorne, Adams and Carles. Awards: Pennsylvania Academy of Fine Arts fellowship, 1932; Baltimore, Maryland, 1924.

OVERBECK, Mary F. Painter. Born: Cambridge City, Indiana in 1878. Studied: Columbia University with Arthur Dow.

OWEN, Esther S. D. Painter. Born: Boston, Massachusetts in 1843. Studied: with Votin, Geary and Tuckerman. Collection: Worcester Art Museum.

OWEN, Eva Vatter. Painter. Born: Shreveport, Louisiana
in 1917. Awards: Le Petit Art Guild Show. Collections:
St. Vincent's Convent, Shreveport, Louisiana;
Haughton United Pentacostal Church.

OZMUN, Pauline Graff. Painter. Born: Evanston, Illinois
in 1902. Studied: Northwestern University; Art Institute
of Chicago; also with Andre L'Hote and Hans Hofmann.

PACE, Margaret. Painter. Born: San Antonio, Texas in
1919. Studied: Newcomb College; also with Will Stevens,
Etienne Ret, Xavier Gonzalez. Awards: Charles Rosen
award, 1947; Henry Steinbomer award, Texas Watercolor
Society, 1949; Emma Freeman award, 1951; Texas Craft
Exhibition, 1957; Texas Fine Arts, 1958.

PACKARD, Emmy Lou. Painter. Born: Imperial Valley,
California in 1914. Studied: University of California
at Berkeley; California School of Fine Arts; also studied
in Europe. Awards: San Francisco Women Artists, 1942,
1955, 1956; Gump award, 1947; California State Fair,
1948; San Fancisco Art Commission, 1951, 1953, 1954;
Oakland Art Festival, 1958. Collections: Princess
Kaiulani Hotel, Honolulu; Hillcrest Elementary School,
San Francisco; Rotunda Gallery, San Francisco; Addison
Gallery of American Art; Achenbach Foundation, San
Francisco.

PACKARD, Mabel. Miniature Painter. Born: in Iowa.
Studied: Art Institute of Chicago; Colarossi Academy,
in Paris. Award: St. Louis Exposition, 1904.

PADDOCK, Ethel L. Painter. Born: New York City in 1887.
Studied: New York School of Art; also with Henri.

PADDOCK, Jo (Josephine). Painter. Born: New York City
in 1885. Studied: Art Students League; also with William
M. Chase, John Alexander, Robert Henri and Kenyon Cox;
Barnard College. Awards: Brooklyn Museum, 1935; New
Haven Paint and Clay Club, 1935; Connecticut Academy of
Fine Arts, 1937; American Watercolor Society; Kappa Kappa
Gamma. Collections: Barnard College Club, New York;
Wesleyan College; Colgate University; Dayton Art Institute;
Berkshire Museum of Art; Newport Art Museum; Shelton
College, New Jersey.

PAEFF, Bashka. Sculptor. Born: Minsk, Russia in 1893.
Studied: Massachusetts Normal Art School; Boston Museum
of Fine Arts School; in Paris with Bela Pratt. Award:
Tercentenary Exposition, Boston, 1933. Collections:
State House, Boston, Kittery, Maine and Westbrook, Maine;
Waverly, Massachusetts, and Birmingham, Alabama; Harvard
University; Rockfeller Institute, New York; Boston Museum
of Fine Arts; Massachusetts Institute of Technology;
University of Buenos Aires.

PAGE, Elizabeth Amie. Painter. Born: Brookline,
Massachussets in 1908. Studied: Art Students League;
Boston Museum of Fine Arts School; also studied with
Alexander Brook. Awards: Philadelphia Printmakers Club,
1943.

PAGE, Marie D. Painter. Born: in Boston in 1869 and died
in 1940. Studied: Boston Museum of Fine Arts School.
Awards: Panama-Pacific Exposition, San Francisco, 1915;
Bok prize, Pennsylvania Academy of Fine Arts, 1916; Shaw
Memorial prize, National Academy of Design, 1916; Duxbury
Artists Association, 1920.

PAGON, Katharine D. Painter. Born: Philadelphia,
Pennsylvania in 1892. Studied: Pennsylvania Academy of
Fine Arts; Barnes Foundation; Columbia University; John
Hopkins University; Maryland Institute; also with Hugh
Breckenridge. Awards: Cresson Traveling scholarships,
Pennsylvania Academy of Fine Arts.

PAINE, Susannah (Susan). Painter. Born: in 1792 and
died in 1862. A painter of portraits and landscapes.

PALMER, Adelaide. Painter. Born: Oxford, New Hampshire.
Studied: in Boston with John J. Enneking and G. H. Bartlett.

PALMER, Adaline Osburn. Painter. Born: in 1817 and died in
1906. A portrait and miniature painter.

PALMER, Fanny (Frances Flora) Painter. Born: in 1812 and
died in 1876. She was a painter of landscapes and townscapes.

PALMER, Frances F. Painter. Painter and lithographers.
She worked for Currier and Ives. Her specialty was sporting
scenes.

PALMER, Mrs. Fredrikke S. Painter. Born: in Norway. She
worked for Woman's Journal as staff artist.

PALMER, Jane. Painter. A genre watercolorist working around
1780.

PALMER, Jessie. Painter. Born: Lawrence, Texas in 1882.
Studied: Dallas Technical College; Broadmoor Art Academy;
also with John Carlson. Awards: Dallas Woman's Forum, 1924;
Texas-Oklahoma Fair, 1926, 1927. Collections: Travis
School, Dallas, Texas; Dallas Woman's Forum.

PALMER, Julia Ann. Painter. A genre watercolorist working
around 1820.

PALMER, Lucia A. Painter. Born: Dryden, New York. Award:
Paris Exposition, 1900.

PALMER, Lucie Mackay. Painter. Born: St. Louis, Missouri in 1913. Studied: Boston Museum of Fine Arts School; St. Louis School of Fine Arts; Washington University; Art Students League; and with Raphael Soyer, J. N. Newell and Robert Brackman. Award: National Association of Women Artists, 1944.

PALMER, Pauline. Painter. Born: in McHenry, Illinois. Studied: Institute of Chicago; and with Collin, Prinet, Courtois and Simon in Paris. Collection: Art Institute of Chicago; Muncie Indiana Art Association.

PALMER, Theresa. Painter. A portrait artist working around 1846.

PARAVICINI, Lizette. Painter. Born: Philadelphia, Pennsylvania in 1889. Studied: University of Pennsylvania; Pennsylvania Academy of Fine Arts; also with Frank Linton, Earl Horter and Arthur Carles.

PARIS, Dorothy. Painter. Born: Boston, Massachusetts. Studied: University of Hawaii; Honolulu Academy of Art; Art Students League; Grande Chaumiere, Paris. Awards: Honolulu Academy of Art, 1946; National Association of Women Artists, 1953; Florida International Exhibition, 1952; Jersey City Museum of Art, 1956. Collections: University of Miami; Evansville Museum of Art; Richmond Indiana Museum of Art; Birmingham Museum of Art.

PARISH, Betty Waldo. Painter. Born: Cologne, Germany in 1910. Studied: Chicago Academy of Fine Arts; Art Students League; Julian Academy, Paris; New School for Social Research. Awards: National Association of Women Artists, 1939, 1946, 1957; United States Treasury Department; Washington Square Art Show, 1949; Library of Congress, 1949, 1952; Pen and Brush Club, 1954, 1956, 1957. Collections: Metropolitan Museum of Art; Library of Congress; Seattle Art Museum; Art Institute of Chicago; Treasury Department, Washington, D. C. Collectors of American Art; New York Public Library; Montgomery Museum of Art; Birmingham Public Library; College of Fine Arts, Syracuse University; Pennsylvania State University; New York Historical Society; Museum of the City of New York; British Museum, London; Royal Museum, Brussels.

PARK, A. E. (Betty) Painter. Has exhibited at the Seattle Art Museum.

PARK, Asa. Painter. Died in 1827. Known as a still life and portrait painter.

PARK, Hazel A. Painter. Born: Waukee, Iowa in 1887.
Studied: Otis Art Institute; Cummings Art School, Des
Moines; also with Lauritz, Ralph Holmes, Chamberlin,
Shrader and others. Awards: Whittier Art Association,
1942, 1943; San Fernando Valley Art Guild, 1948; California
Art Club, 1952; Ebell Club, 1955; Greek Theatre, Los
Angeles, 1953.

PARK, Madeline F. Sculptor. Born: Mt. Kisco, New York
in 1891. Studied: Art Students League; also with Proctor,
Naum Los, and Lawrence T. Stevens. Awards: American
Women's Association, 1933, 1940; Hudson Valley Art
Association, 1944. Specializes in wild and domestic
animal sculpture.

PARKE, Jessie Burns. Painter. Born: Paterson, New Jersey
in 1889. Studied: New York School of Applied Design for
Women; Boston Museum of Fine Arts School; and with Philip
Hale, William James, Frederick L. Bosley. Awards: Paige
traveling scholarship, Boston Museum of Fine Arts School,
1921; Pennsylvania Society of Miniature Painters, 1945;
Elizabeth Muhlhofer award, 1953. Collections: Northwestern
University; South Boston High School; Boston College High
School; Philadelphia Museum of Art.

PARKE, Mary. Painter. Primitive watercolorist of genre
subjects worked around 1825.

PARKER, Mrs. A. B. Painter.

PARKER, Dixie. Painter. Born: Cedar Rapids, Iowa in 1936.
Studied: Drake University.

PARKER, Cora. Painter and illustrator. Born: in Kentucky.
Studied: Cincinnati Art School; Julien Academy in Paris.
Collections: Kansas City, Missouri Art Club; Nebraska Art
Association, Lincoln.

PARKER, Emma Alice. Painter and illustrator. Born: Gardner,
Massachussets in 1876. Studied: with DuMond, Poore, Henri
and Sydney R. Burleigh.

PARKER, Margery. Painter. Born: Sauk County, Wisconsin in
1921. Studied: University of Wisconsin; Brooklyn Museum
School of Art; also with Reuben Tam, Yonia Fain, Louis
Grebenak and Irving Marantz.

PARKHURST, Anita. Painter and illustrator. Born: Chicago,
Illinois in 1892 Studied: Art Institute of Chicago.
Made illustrations for Saturday Evening Post.

PARKS, Asa. Painter. A portraitist working during 1858-59.

PARRISH, Clara W. Painter and etcher. Born: Selma Alabama and died in 1925. Studied: Art Students League, with Chase, Cox, Mowbray and J. Alden Weir; and in Paris with Collin. Awards: Watrous prize, New York Women's Art Club, 1902, 1913; Appalachian Exposition, Knoxville, 1910; Panama-Pacific Exposition, San Francisco, 1915.

PARSONS, Edith B. Sculptor. Born: Houston, Virginia in 1878. Studied: Art Students League, with French and Barnard. Her specialty--fountains.

PARSONS, Ernestine. Painter. Born: Booneville, Missouri in 1884. Studied: Colorado College; Columbia University; Broadmoor Art Academy; Art Students League; Colorado Springs Fine Arts Center, also with Randall Davey and Paul Burlin. Awards: Broadmoor Art Academy, 1927; Colorado State Fair, 1945. Collection: Colorado Springs High School.

PARSONS, Kitty. Painter. Born: Stratford, Connecticut. Studied: Pratt Institute Art School; Columbia University; Boston University; University of Chicago; and with Richard H. Recchia. Award: National League of American Pen Women, 1955, 1956. Collection: Rockport High School.

PASSAILAIGUE, Mary F. Awards: Eufaula Show, Alabama; La Grange Sidewalk Show. Collections: Columbus Museum of Arts and Crafts; Montgomery Museum, Alabama.

PATTEE, Elsie D. Painter. Born: Chelsea, Massachusetts in 1876. Studied: Julian Academy, Paris. Awards: Panama Pacific Exposition, 1915; Brooklyn Society of Miniature Painters, 1935, 1939; California Society of Miniature Painters, 1927; American Society of Miniature Painters, 1930, 1936. Collection: Metropolitan Museum of Art; Brooklyn Museum; Philadelphia Museum of Art; Pennsylvania Academy of Fine Arts.

PATTERSON, Catherine Norris. Painter. Born: Philadelphia. Studied: Pennsylvania Academy of Fine Arts. Known chiefly as a miniature painter.

PATTERSON, Margaret. Painter and illustrator. Born: Soerabaija, Java. Studied: Pratt Institute Art School, with Arthur Dow; in Boston with Charles H. Woodbury; and in Paris with Castellucho. Award: Panama-Pacific Exposition, San Francisco, 1915. Collection: Museum of Fine Arts, Boston; Oakland, California Art Museum.

PATTERSON, Patty. Painter. Born: Oklahoma City,
Oklahoma in 1909. Studied: University of Oklahoma;
Ecole des Beaux-Arts, Fontainebleau, France; Taos School
of Art; Art Students League; Oklahoma State University;
also with Emil Bisttram. Awards: McDowell Club, 1940,
1944; Oklahoma Art League, 1942.

PATTERSON, Rebecca. Painter. Born: Philadelphia,
Pennsylvania. Studied: Pennsylvania Museum; School of
Industrial Art, Philadelphia. Also studied with
Rebecca Van Trump and W. J. Whittemore in New York.

PATTERSON, Viola. Painter. Born: Seattle, Washington
in 1898. Studied; University of Washington; in Paris
with Andre L'Hote, Amedee Ozenfant and Alexander Archipenko.
Awards: Seattle Art Museum, 1932, 1946; Northwest Water-
color Exhibition, 1952, 1954; Artists of the Seattle
Region, 1955. Collection: Seattle Art Museum.

PATTON, Elizabeth. Painter. Exhibited in 1926 at the
Pennsylvania Academy of Fine Arts.

PATTON, Katharine. Painter. Born: Philadelphia,
Pennsylvania. Studied: with Cox, Hawthorne and Snell in
New York; with Frank Brangwyn in London. Awards: Knoxville
Tennessee Exposition, 1913; National Association of Women
Painters and Sculptors, 1918. Collections: Pennsylvania
Academy of Fine Arts; Southern High School, Philadelphia.

PATTON, Katherine Maxey. Painter. Award: Mary Smith prize,
Pennsylvania Academy of Fine Arts, 1921.

PAULLIN, Ethel Parsons. Painter. Born: Chardon, Ohio.
Studied: Boston Museum of Fine Arts School. Collections:
St. Barthalomew Church, Church of St. Vincent Ferrer,
New York; St. Stephen's Church, Stevens Point, Wisconsin;
Federal Building, Albany, New York; Mutual Casualty
Insurance Building, Stevens Point, Wisconsin; Christ Church,
West Haven, Connecticut; Trinity Church, Ft. Wayne, Indiana;
St. Paul's Episcopal Church, Brooklyn, New York; Church of
the Epiphany, Roslyn, Long Island, New York; Brooke General
Hospital Chapel, United States Army, San Antonio, Texas;
Dana Chapel, Madison Avenue Presbyterian Church, New York.

PAXSON, Ethel. Painter. Born: Meriden, Connecticut in
1885. Studied: Corcoran School of Art; Pennsylvania
Academy of Fine Arts; and with Cecilia Beaux, Hugh
Breckenridge, and William Chase. Award: Meriden Arts and
Crafts Association. Collection: American Embassy,
Rio de Janerio, Brazil.

PAXTON, Eliza. Painter. A water colorist of still-life working during the period 1814-16.

PAXTON, Elizabeth O. Painter. Born: Providence, Rhode Island. Studied: with W. M. Paxton. Award: Panama-Pacific Exposition, San Francisco, 1915.

PAYNE, Elsie P. Painter. Born: San Antonio, Texas in 1884. Studied: Best Art School, San Francisco, California; Chicago Academy of Fine Arts. Awards: Los Angeles Museum, 1942, 1944; California Art Club, 1943; Ebell Club, 1943; Greek Theatre, Los Angeles, 1948, 1949; Pasadena Art Institute, 1950; Laguna Beach Art Association, 1951; Laguna Beach Art Festival, 1952. Collections: Public School, Laguna Beach, Los Angeles, California; Laguna Beach ARt Gallery.

PEABODY, Amelia. Sculptor. Born: Marblehead Neck, Massachusetts in 1890. Studied: Boston Museum of Fine Arts School; also studied with Charles Grafly; Archipenko School of Art. Award: Arts and Crafts Society, Boston, 1950. Collection: Boston Museum of Fine Arts.

PEABODY, Evelyn. Sculptor. Exhibited at the Pennsylvania Academy of Fine Arts in 1924.

PEABODY, Evelyn. Sculptor. Exhibited at the Pennsylvania Academy of Fine Arts in 1924.

PEABODY, Sophia A. Painter. Born: in 1811 and died in 1871.

PEACOCK, Jean E. Painter. Born: Norfolk, Virginia. Studied: Longwood College, Virginia; Columbia University; Art Students League; also studied with Arthur Young, Harry Wickey and Edwin Ziegfeld. Exhibited extensively in the Alexandria, Virginia area.

PEALE, Anna C. Painter. Born: in 1791 and died in 1878. She was a still-life painter and miniaturist.

PEALE, Emma C. Painter. Born: in 1814.

PEALE, Harriet C. Painter. Born: in 1800 and died in 1869.

PEALE, Margaretta A. Painter. Born: in 1795 and died in 1882. A still-life and portrait painter.

PEALE, Maria. Painter. Born: in 1787 and died in 1866. She painted still-life subjects beginning around 1810.

PEALE, Mary Jean. Painter. Born: in 1826 and died in 1902. She was a still-life and portrait painter.

PEALE, Rosalba C. Painter. Born: in 1799 and died in 1874. She was a copyist.

PEALE, Sarah M. Painter. Born: in 1800 and died in 1855. At first she painted fruit and still life subjects about 1816. Later she became a portrait painter and worked in Philadelphia, Baltimore and Washington during the period 1820-1825.

PEARCE, Helen S. Painter. Born: Reading Pennsylvania in 1895. Studied: Philadelphia School of Design for Women; University of New Mexico with Raymond Jonson, Kenneth Adams and Randall Davey; Pasadena City College with Kenneth Nack; also studied with Snell and Bridgman. Awards: New Mexico State Fair, 1942-1945, 1957; National Museum, Washington, D.C. 1950, 1952; Albuquerque Art, 1953-1955.

PEARLE, Sarah W. Painter. A watercolor portraitist working around 1819.

PEARMAN, Katharine K. Painter. Born: Beloit, Wisconsin in 1893. Studied: with Hugh Breckenridge, Grant Wood and Francis Chapin. Awards: Rockford Art Association, 1927, 1930, 1931, 1934, 1935, 1937, 1939, 1942, 1943; Art Institute of Chicago, 1951; Wisconsin Salon, 1942, 1943. Collections: Burpee Art Gallery, Rockford, Illinois; Wisconsin University; Abbott Laboratories Collection; St. Pauls' Chapel, Camp Grant, Illinois.

PEARSON, Marguerite S. Painter. Born: Philadelphia, Pennsylvania. Studied: Boston Museum of Fine Arts School with William James and F. A. Bosley; also studied with A. T. Hibbard, and Harry Leith-Ross. Awards: North Shore Art Association; Springville Utah Art Association; New Haven Paint and Clay Club; Allied Artists of America; Ogunquit Art Center; Academic Art, Springfield, Massachusetts Art Museum; Rockport Art Association. Collections: Springville Art Gallery; New Haven Pulic Library; Beach Memorial Art Gallery, Storrs, Connecticut; Monson, Massachusetts State Hospital; Gardiner Massachusetts High School; Boston Music School; Brigham Young University; Mechanics Building, Boston; Episcopal Diocesan House, Boston; Trade School for Girls, and Wilson, Brooks and Burke Schools, Boston; Grimmins and Chandler School, Somerville, Massachusetts; Somerville, Medford and Gloucester City Halls; Case Institute of Technology, Cleveland, Ohio; Brooks School, Andover, Massachusetts; Draper School, Draper, Utah; Salem Massachusetts Court House; Bruckner Museum, Albion, Michigan.

PECK, Anna M. Painter and illustrator. Born: Piermont, New York in 1884. Studied: with Robert Henri and Irving R. Wiles. Her specialty, illustrating children's books.

PECK, Glenna. Painter. Born: Huntsburg, Ohio. Studied: New York School of Fine and Applied Arts; Syracuse University. Awards: Allied Artists of New York, 1931; Thibaut prize, 1932; United Piece Dyeworks prize, 1932; Associated Arts of Syracuse, 1940.

PECK, Natalie. Painter. Born: Jersey City, New Jersey in 1886. Collection: Pennsylvania Academy of Fine Arts.

PECK, Verna J. Painter. Born: Hutchinson, Kansas in 1889. Studied: Southwestern College; Wichita University; Kansas City Art Institute; Independence, Missouri; and with Grace Raymond, Clayton Henri Staples and Thomas Hart Benton. Awards: Kansas State Fair 1940, 1942; Kansas artists, 1942; State Fair, Sedalia, Missouri, 1955. Collection: Mid-American Art Gallery.

PECKHAM, Rosa F. Very little is known of this artist other than there is a portrait of Reverend August Woodbury which is signed by a Rosa F. Peckham, in the Phillips Academy at Exeter, New Hampshire.

PECORINI, Margaret R. Painter. Born: in 1879. She was a portrait painter of children.

PEET, Margot. Painter. Born: Kansas City, Missouri in 1903. Studied: Kansas City Art Institute; Colorado Art Academy; also with Randall Davey and Thomas Hart Benton.

PEIRCE, Miss. H. T. Painter. Was exhibiting in 1859.

PEIXOTTO, Mrs. Ernest. Painter. Born: San Francisco, California. Studied: San Francisco Artists Association; and with Delecluse.

PELTON, Agnes. Painter. Born: Stuttgart, Germany in 1881. Her parents were Americans. Studied: Pratt Institute Art School with Dow; also studied with W. L. Lathrop and Hamilton E. Field; studied in Rome also. Collections: San Diego Fine Arts Society; Santa Barbara Museum of Art.

PELL, Ella Ferris. Painter, sculptor and illustrator. Born: St. Louis, Missouri in 1846. Studied: Cooper Union Art School with Rimmer; and in Paris with Laurens, Ferinand Humbert and Gaston St. Pierre. Collection: Boston Art Club.

I. Rice Pereira, BLACK AND WHITE, 1940. Ink on scratchboard, 18 7/8" X 12 5/8". The Solomon R. Guggenheim Museum.

PEMBER, Ada H. Painter. Born: Shopiere, Wisconsin in 1859. Studied: with W. M. Clute and F. Fursman.

PENDLETON, Constance. Painter. Born: Philadelphia, Pennsylvania. Studied: Columbia University; with Arthur Carles, Hugh Breckenridge and Arthur Dow; also studied in Europe.

PENFIELD, Florence Bentz. Painter. Born: Buffalo, New York in 1895. Studied: University of Buffalo; Buffalo School of Fine Arts; Pennsylvania Academy of Fine Arts; and with Florence Bach, Roy Nuse, and Daniel Garber. Awards: Albright Art Gallery, 1941; Fellowship, Pennsylvania Academy of Fine Arts. Collection: Reading Pennsylvania Public Museum.

PENMAN, Edith. Painter. Was exhibiting during the period 1923-24.

PEOPLES, Augusta H. Painter. Born: Philadelphia, Pennsylvania in 1896. Studied: Philadelphia School of Design for Women; Spring Garden Institute; Pennsylvania Academy of Fine Arts. Collection: Moore Institute, Philadelphia.

PERCY, Isabelle. Illustrator and etcher. Born: in California in 1882. Studied: in New York with Dow and Snell; in London with Brangwyn.

PEREIRA, I. Rice. Painter. Born: Boston, Massachusetts. Studied: Art Students League of New York. Collections: Modern Museum of Art; Brooklyn Museum; The Solomon R. Guggenheim Museum, plus over forty other major public collections in the United States. She has exhitited extensively in the United State and Rome, Italy since 1933.

PERINI, Maxine W. Painter. Born: Houston, Texas in 1911. Studied: Wellesley College; Art Institute of Chicago; and with Boris Anisfeld. Has exhibited extensively in Texas.

PERKINS, Edna. Painter. Born: Jersey City, New Jersey in 1907. Studied: Art Students League with Kenneth Hayes Miller. Award: Montclair Art Museum, 1944.

PERKINS, Miss. Draughtsman. Known as a portrait draughtsman in pastels working in Connecticut around 1790. Collection: Connecticut Historical Society.

PERKINS, Mary. Painter. Born: Philadelphia, Pennsylvania. Studied: Pennsylvania Academy of Fine Arts. Collection: City Hall, Philadelphia, Pennsylvania.

PERKINS, Stella M. Painter. Born: Winslow, Illinois in
1896. Studied: University of Wisconsin; Rockford College;
and with Marques Reitzel, Frederic Taubes and Briggs
Dyer. Awards: Burpee Art Gallery, Rockford, Illinois,
1935, 1940, 1941, 1953, 1954, 1957. Collections: Freeport
Public Library; Freeport Historical Museum.

PEROT, Anna L. Painter. Born: in 1854. She was a
watercolorist who exhibited at the Pennsylvania Academy
of Fine Arts as late as 1924.

PERRY, Clara F. Painter. Exhibited at the 33d Annual
Exhibition in New York.

PERRY, Clara G. Sculptor. In 1915 she exhibited a
portrait bust at the Pennsylvania Academy of Fine Arts.

PERRY, Edith W. Painter. Born: New Haven, Connecticut
in 1875. Known for her miniature paintings.

PERRY, Emilie S. Painter. Born: in 1873 and died in
1929. She was a genre painter.

PERRY, Ione. Painter. Born: New York City in 1839.
Studied: Cooper Institute Art School and with Henry Loop.
Best known for her paintings such as "Hypatia,""Romola,"
and "Elsa, at the Coming of Lohengrin."

PERRY, Lilla Cabot. Painter. Born: Boston, Massachusetts.
Studied: in Boston; also studied in Paris at Julien's
and Colarossi studios in 1887. Awards: Massachusetts
Mechanics' Association, 1893; St. Louis Exposition, 1904;
Panama-Pacific Exposition, 1915.

PERSHING, Louise. Painter. Born: Pittsburgh, Pennsylvania.
Studied: Pennsylvania Academy of Fine Arts; Carnegie
Institute; University of Pittsburgh; and with Hans Hofman.
Awards: Association of Artists, Pittsburgh, 1931, 1932,
1940, 1941, 1943, 1946, 1947, 1949, 1950; Pennsylvania
Academy of Fine Arts, 1950; National Association of
Women Artists, 1936; Wichita Museum, 1936; Indiana State
Teachers College, 1944. Collections: Pittsburgh Public
Schools; Pennsylvania State College; Indiana State
Teachers College; Dormont Pennsylvania Public School;
Shadyside Hospital, Pittsburgh.

PETERSON, Miss C. Painter. A landscapsit working around
1859-60.

PETERSON, Elsa K. Sculptor. Born: New York City in 1891.
Studied: with Edith Woodman Burroughs and J. E. Fraser.

PETERSON, Jane. Painter. Born: Elgin, Illinois. Studied: Pratt Institute Art School; also with Sorolla, Brangwyn and L'Hote. Awards: Girls Art Club, Paris, France, 1915; Connecticut Academy of Fine Arts, 1916; National Association of Women Artists, 1919, 1927; Florida Society of Artists, 1938; Washington Watercolor Club, 1940; Gloucester Society of Art, 1955; American Artists Professional League, 1955. Collections: Brooklyn Museum; Grand Rapids Art Association; Boise City Iowa Art Collection; Sears Art Gallery, Elgin, Illinois; Syracuse Museum of Fine Arts; Richmond Indiana Art Museum; Frances Shimer College; Society of Four Arts, Palm Beach, Florida; Wesleyan College, Macon, Georgia; Wichita Art Museum.

PETICOLAS, Jane. Painter. Born: in 1791 and died in 1852. She was a portrait copyist.

PETIGRU, Caroline. Painter. Born: in 1819. Noted for her portraits and miniatures.

PETREMONT, Clarice M. Painter and illustrator. Born: Brooklyn, New York. Studied: with Marshall Fry and Paul Cornoyer.

PETRINA, Charlotte K. Painter. Born: Kingston, New York in 1901. Studied: Art Students League; Cooper Union Art School. Awards: Guggenheim fellowship, 1933, 1934. Collection: New York Public Library.

PEW, Gertrude L. Painter. She was exhibiting her miniature paintings at the Pennsylvania Academy of Fine Arts in 1925.

PEYTON, Ann M. Painter and illustrator. Born: Charlottesville, Virginia in 1891. Studied: with George Bellows.

PEYTON, Bertha M. Painter. She was exhibiting her landscape paintings at the National Academy of Design in 1924.

PFEIFFER, Hope V. Painter. Born: Coldwater Michigan in 1891. Studied: Adrian College; Detroit School of Design; and with Fritz Pfeiffer, and Blanche Lazell. Exhibited in the 1930s, 1940s and 1950s throughout the United States.

PFLAGER, Dorothy H. Painter. Born: Los Angeles, California in 1900. Studied: Wellesley College, Washington University; Award: Baltimore Museum of Art, 1942.

PHELPS, Edith C. Painter. Born: New York City in 1875. Studied: Julian Academy in Paris; and with Charles Hawthorne. Awards: San Diego Fine Arts Society, 1938; Sacramento State Fair, 1938, 1941; Connecticut Academy of Fine Arts; Madonna Festival, Los Angeles, 1951, 1956. Collections: New York City Court House; Wilshire Presbyterian Church.

PHELPS, Helen W. Painter. Born: Attleboro, Massachusetts
in 1859. Studied: Academie Julien, Paris; and with Collin.
Awards: Buffalo Exposition, 1901; Woman's Art Club, 1909;
Association of Women Painters and Sculptors, 1914.

PHELPS, Nan D. Painter. Collections: murals in churches
and private homes in the United States, Peru and West Indies.

PHILBRICK, Margaret. Etcher. Born: Northampton,
Massachusetts in 1914. Studied: Massachusetts School of Art.
Awards: Southern Printmakers award, 1939; Library of Congress,
1948; Society of American Graphic Artists, 1953; New Britain
Art Museum, 1953; Boston Printmakers, 1954; Springfield
Museum of Art. Collections: Library of Congress; Bezalel
Museum, Jerusalem; Metropolitan Museum of Art; New Britain
Art Museum; University of Maine; Fogg Museum of Art;
Addison Gallery of American Art.

PHILLIPS, Ammi. Painter. Born: in 1787 and died in 1865.
A portrait painter.

PHILLIPS, Ann C. Painter. Born: New York City in 1911.
Studied: National Academy of Design; Art Students League;
with Jose Clemente Orozco; also studied in France, Italy
and Spain. Awards: Karasink award, 1947; National Academy
of Design, 1955; Lehman award, 1956. Collections: Union
College, Schenectady, New York; New York University; Georgia
Museum of Art, Athens; Columbia South Carolina Museum of Art;
Washington County Museum, Hagerstown, Maryland; High Museum
of Art, Atlanta.

PHILLIPS, Blanche. Sculptor. Born: Mt. Union, Pennsylvania
in 1908. Studied: Cooper Union Art School; Art Students
League; Stienhofs Institute of Design; California School of
Fine Arts; also with Zadkine, and Hofmann. Collection:
Whitney Museum of American Art.

PHILLIPS, Claire. Painter. Born: Los Angeles, California
in 1887. Studied: Stanford University; Columbia University;
and with Arthur Dow. Awards: Yavapai County Fair; Arizona
State Fair. Collections: Prescott Arizona Public School;
Arizona Federation of Women's Clubs.

PHILLIPS, Margaret. Painter. Born: New York City. Studied:
Hunter College; Grand Central School of Art; and with Wayman
Adams School of Portraiture; with Eric Pape, Frank Schwartz
and Edmund Graecen. Awards: Florida Southern College; Grand
Central School of Art, scholarship; Nancy Ashton award,
Hunter College; Pennsylvania Academy of Fine Arts, scholar-
ship. Collections: Florida Southern College; Muskingum
College, New Concord, Ohio; Fifth Avenue Presbyterian Church,
New York; Eastern Star of New York State; Home for the Aged
and Infirm, New York.

PIERCE, Anna H. Painter and illustrator. Born: South Britain, Connecticut in 1880. Studied: with F. C. Jones, George Maynard, K. H. Miller, John F. Weir, E. C. Taylor, Mora, and Niemeyer.

PIERSON, Sarah. Painter. Genre painter working around 1821.

PINE, Geri. Painter. Born: New York City in 1914. Studied: Art Students League with John Sloan. Collection: Queens Public Library, New York.

PINEDA, Marianna. Sculptor. Born: Evanston, Illinois in 1925. Studied: Cranbrook Academy of Art; Bennington College; University of California at Berkeley; Columbia University; Zadkine School of Sculpture, Paris, France. Awards: Albright Art Gallery, 1948; San Francisco Art Association, 1955; Art Institute of Chicago, 1957; Portland, Maine, 1957; Providence Art Club, 1958; Boston Art Festival, 1957; Walker Art Center, 1951. Collections: Walker Art Center; Boston Museum of Fine Arts; Williams College; Dartmouth College; Wadsworth Atheneum; Munson-Williams-Proctor Institute; Addison Gallery of American Art.

PINNEY, Eunice G. Painter. Born: 1770 and died in 1849. A primitive genre watercolorist.

PINTNER, Dora. Painter. Born: Great Britain. Studied: Glasgow College of Art. Scotland; Radcliffe College; Boston University. Collections: stained glass windows, Angell Memorial Hospital, Boston; National Museum.

PITKIN, Caroline W. Painter, engraver and sculptor. Born: in 1858.

PITMAN, Sophia L. Painter. Born: Providence, Rhode Island.

PITT (Peat) Miss. Painter. A portraitist and copyist working during period 1811-1813.

PITTMAN, Kitty B. Painter. Born: Philadelphia, Pennsylvania in 1914. Studied: Oglethorpe University; also with Fritz Zimmer, Robert Dean and Maurice Seiglar. Collection: The Memminger Memorial Study, All Saints Church, Atlanta, Georgia.

PITZ, Molly W. Painter. Born: Ambler, Pennsylvania in 1913. Studied: Philadelphia Museum School of Industrial Art. Collection: Pennsylvania State University.

PLACE, Vera C. Painter. Born: Minneapolis, Minnesota in 1890. Studied: with Chase, Dufner, Richard Miller and Antonio de la Gandere. Award: Minnesota State Art Exhibit.

PLANTOU, Mrs. Anthony. Painter. Noted for her landscape, portrait, religious and historical paintings. She was working during the period 1818-1825.

PLATT, Alethea H. Painter. Born: Scarsdale, New York late in the 19th Century. Studied: Art Students League; Delecluse Academy, Paris. Awards: New York Woman's Art Club, 1903; Minnesota Art Association, Faribault, 1909. Collections: Public Library, Faribault, Minnesota; Anderson Indiana Art Gallery; Court House, White Plains, New York.

PLATT, Eleanor Portrait Sculptor. Born: Woodbridge, New Jersey in 1910. Studied: Art Students League. Awards: Chaloner scholarship, 1939-41; American Academy of Arts and Letters, 1944; Guggenheim fellowship, 1945. Collections: Boston Museum of Fine Arts; Metropolitan Museum of Art; New York Bar Association; Hebrew University, Jerusalem; Carnegie Corporation; Harvard University Law School Library; Museum of the City of New York; Supreme Court Building.

PLATT, Mary C. Painter. Born: New York City in 1893. Studied: Parsons School of Design; Art Students League; National Academy of Design; also with Bridgman, Crisp and Hawthorne. Collections: Russell Sage Foundation; Spanish House, Columbia University.

PLEADWELL, Amy M. Painter. Born: Taunton, Massachusetts in 1875. Studied: Massachussets Normal Art School, Boston; Colarossi Academy, Paris

PLEIMLING, Winnifred. Painter. Born: Jackson, Michigan. Studied: Art Institute of Chicago. Award: Chicago Art Club.

PLOCHMANN, Carolyn G. Painter. Born: Toledo, Ohio in 1926. Awards: Emily Lowe Award, New York; New York Graphics Society. Collections: Fleishmann Collection; Butler Institute of American Art; Toledo Federation of Art Societies; Toledo Museum of Art.

PLUMMER, Ethel. Painter. Born: Brooklyn, New York. Studied: with Henri and Mora. Has illustrated for Vanity Fair and Life Magazines.

PLUNGUIAN, Gina. Painter. Studied: Ecole Des Beaux-Arts, Montreal, Canada; Dayton Art Institute. Awards: Hunter Gallery, 1954, 1955; Delaware Art Center, 1958. Collections: Kirkman Vocational High School, Chattanooga; Tel-Aviv Museum, Israel; Southern Missionary College, Tennessee.

PNEUMAN, Mildred Y. Painter. Born: Oskaloosa, Iowa in 1899. Studied: University of Colorado. Collection: Memorial Library, Mt. Pleasant, Iowa.

POHL, Lavera Ann. Painter. Born: Port Washington, Wisconsin in 1901. Studied: University of Bonn; University of Cologne, Germany; Wisconsin School of Fine Arts; Milwaukee State Teachers College; Milwaukee Art Institute. Awards: Wisconsin Painters and Sculptors, 1942; Marquette University, Matrix award, 1953; Senior League Service Club of America award, 1954. Collections: Women's Army Corps; Milwaukee University.

POMEROY, Elsie L. Painter. Born: New Castle, Pennsylvania. Studied: Corcoran School of Art; and with Paul Dike, Millars Sheets and Eliot O'Hara. Awards: Art League of Washington, D.C., 1935; Marin Society of Art, 1948; Butler Art Institute, 1942; Riverside California Fine Arts Guild, 1946; Mill Valley, California, 1957. Collections: Los Angeles Art Association; Butler Art Institute; San Francisco Municipal Collection; Carville, Louisiana; Riverside, California High School.

POMMER, Mildred N. Painter. Born: Sibley, Iowa in 1893. Studied: Otis Art Institute; Chouinard Art Institute; California School of Fine Arts; and with Beniamino Bufano. Awards: San Francisco Art Association, 1939; San Francisco Museum of Art, 1943. Collections: San Francisco Museum of Art; California Historical Society; California Playhouse.

POOKE, Marion L. Painter and illustrator. Born: Natie, Massachusetts.

POPE, Marion H. Painter and etcher. Born: San Francisco, California. Studied: with A. Mathews and Whistler. Collection: Carnegie Library, Oakland, California.

POPE, Sarah. Painter. Born: in 1820.

PORCHER, Miss. Painter. Working around 1850.

PORTER, Doris. Painter. Born: Portsmouth, Virginia. Studied: Pennsylvania Academy of Fine Arts; Wayne University; University of Michigan. Awards: Grosse Pointe Artists, 1950; Detroit Society of Women Painters, 1947, 1949. Collections: Toledo Museum of Art; Pennsylvania Academy of Fine Arts; University of Michigan; Cranbrook Academy of Art; St. Mary's Hall, Burlington, New Jersey; Ford School, Highland Park, Michigan; Michigan State Normal College, Ypsilanti; Dearborn Historical Society.

PORTER, Laura S. Painter. Born: Fort Edward, New York in 1891. Studied: New York School of Art; Art Students League; Skidmore College; and with Henri, Chase, Miller, and Adams. Collections: Pittsburgh Library; Brenau College, Gainesville, Georgia; Simmons College Chapel; Walter Reed Hospital, Washington, D. C. Fort Edward Art Center; Labor Union Offices, Fort Edward; Kappa Pi Collection.

PORTER, Mary King. Painter. Born: in 1865. Known as a miniaturist.

PORTER, Mrs. S. C. Painter. Born: Hartford, Connecticut. Studied: in New York and Paris. She exhibited her work in Philadelphia and Paris around 1875.

PORTMANN, Frieda. Painter. Born: Tacoma, Washington. Studied: University of Washington; Oregon State College; Art Institute of Chicago; University of Chicago; University of Southern California; California School of Fine Arts. Awards: Women Painters of Washington, 1940, 1943, 1946; Puyallup Washington Fair, 1946, 1952. Collections: California College of Arts and Crafts; St. Joseph's School, Seattle.

POST, May Audubon. Painter and illustrator. Born: in New York City. Studied: Pennsylvania Academy of Fine Arts with Chase, Beaux, Grafly and Breckenridge; Drexel Institute with Howard Pyle; and with Lucien Simon in Paris. Awards: Traveling scholarship, Pennsylvania Academy of Fine Arts; gold medal, Art Club of Philadelphia, 1903.

POTTER, Martha J. Painter. Born: in 1864.

POTTER, Mary K. Painter. Studied: Metropolitan Museum of Art; Art Students League; Julien Academy in Paris.

POUCHER, Elizabeth M. Sculptor. Born: Yonkers, New York. Studied: Vassar College; New York University; Columbia University; Art Students League; and with Alexander Archipenko; La Grande Chaumiere, Ecole Animalier; and with Andre L'Hote. Awards: Gold medal, Hudson Valley Art Association, 1958; Pen & Brush Club, 1954; Bronxville Art Project, 1953, 1957; Westchester Federation of Women's Clubs, 1955, 1956; Hudson Valley Art Association, 1954.

POWELL, Caroline A. Wood engraver. Born: in Ireland. Studied: with W. J. Linton and with Timothy Cole. Collections: Boston Museum of Fine Arts; New York Public Library; Carnegie Institute, Pittsburgh.

POWELL, Pauline. Painter. Born: Oakland, California in 1876. Exhibited her paintings in Oakland, California in 1890. These were the first works ever shown by a black artist in California.

POWELL, Violet. Painter. Born: Philadelphia, Pennsylvania in 1902. Studied: Pratt Institute of Art School; Art Students League; and with James Lunnon. Awards: Art and Writers, Miami, 1948, 1951, 1952; Poinciana Festival, Miami, 1948; Miami Art League, 1949; American Artists Professional League, 1950.

POWERS, Marion. Painter. Born: London, England of American Parents. Studied: with Garrido in Paris. Awards: Pennsylvania Academy of Fine Arts, 1907; Buneos Aires Exposition, 1910; gold medal, Panama-Pacific Exposition, San Francisco, 1915. Collections: Luxembourg, Paris; Canadian Pacific Railway, Vancouver, British Columbia, Canada.

POWERS, Mary. Painter. Born: Leeds, Massachusetts in 1885. Studied: Framingham, Massachusetts Normal School. Collections: Williams College; Whitney Museum of American Art; Addison Gallery of Art; Wood Gallery of Art, Montpelier, Vermont.

PRADOS, Madame. Painter. A miniature portrait painter working in New Orleans around 1800.

PRAHAR, Renee. Sculptor. Born: New York City in 1880. Studied: with Bourdelle in Paris. Collection: Metropolitan Museum of Art.

PRATT, Elizabeth. Painter. Born: New York City. Studied: Massachussets School of Art; Cleveland School of Design; and in Paris, London, Florence and Rome. Award: National Association of Women Artists, 1957.

PRATT, Frances. Painter. Born: Glen Ridge, New Jersey in 1913. Studied: New York School of Applied Design for Women; Art Students League with Richard Lahey and Hans Hofmann. Awards: National Association of Women Artists, 1946, 1950, 1955; Audubon Artists, 1952. Collections: Virginia Museum of Fine Arts; Brooklyn Museum.

PRATT, Inga. Painter. Born: Brookings, South Dakota in 1906. Studied: Academy Colorossi in Paris. Art Students League. Award: Direct Mail Advertising Association, 1946.

PRECOUR, Mrs. Peter. Painter. Fan painter and drawing mistress working in 1732.

PRELLWITZ, Edith M. Painter. Born: South Orange, New
Jersey in 1865 and died in 1944. Studied: Art Students
League with Brush and Cox; Julien Academy in Paris with
Bourguereau, Robert-Fleury and Courtois. Awards:
National Academy of Design, 1894; Dodge prize, National
Academy of Design, 1895; Atlanta Exposition, 1895; Pan-
American Exposition, Buffalo, 1901.

PRENTISS, Sarah J. Born: in 1823 and died in 1877. She
was a still-life, figure and flower painter.

PRESCOTT, Katharine T. Sculptor. Born: Biddeford, Maine.
Studied: with E.Boyd in Boston, and F. E. Elwell in New
York. Has exhibited extensively in the New England states.

PRESSOIR, Esther. Painter. Born: Philadelphia
Pennsylvania. Studied: Rhode Island School of Design;
Art Students League. Collections: Pennsylvania Academy
of Fine Arts; Los Angeles Museum of Art.

PRESTON, Harriet. Painter. Born: Hackensack, New Jersey
in 1892. Studied: Trenton Normal College, New York
University; Columbia College; Parsons School of Design;
and with Harvey Dunn. Awards: New Jersey Woman's Club,
1950, 1951; Art Council of New Jersey, 1951; Bergen County
Art Guild, 1953, 1954; Pascack Valley Regional, 1955;
gold certificate, New Jersey Society of Painters and
Sculptors, 1955. Collections: Tenafly New Jersey High
School; Rockport Massachusetts High School.

PRESTON, Mary W. Illustrator. Born: New York in 1873.
Studied: Art Students League; National Academy of Design;
also with Whistler School in Paris. Award: Panama-Pacific
Exposition, San Francisco, 1915.

PREZZI, Wilma M. Painter. Born: Long Island City, New
York in 1915. Studied: New York State Education Department;
Metropolitan Art School; Art Students League. Awards:
International Fine Arts Council, 1949, 1954; Luxembourg,
and Paris, 1955; Paris, France, 1957; London, England,
1957; Naples, Italy, 1956; Tunis, North Africa, 1957;
Buenos Aires; Switzerland. Collections: Rickshaw
Restaurant, Boston; Museum Religious Art, Utrecht,
Netherlands; St. Gregory's Seminary, Cincinnati; Florida
State University, Olin Downs Music Library; Xavier
University, Albers Hall; Hermitage Foundation, Norfolk,
Virginia; Wisconsin Hall of Fame, Milwaukee; Baseball Hall
of Fame, Cooperstown, New York.

PRICE, Alice H. Painter. Born: Arcadia, Iowa in 1889.
Studied: Kansas City Art Institute; National Academy of
Design; New York School of Fine and Applied Arts; also
with Adams and Farnsworth. Awards: scholarship, New
York School of Fine and Applied Arts; Hudson Valley Art
Association, 1946; Westchester County Art Project, 1949,
1954, 1955; Crestwood, 1952; Pen and Brush Club, 1955.
Collections: National Academy of Design; Chapel, Christ
Church, Bronxville.

PRICE, Edith B. Painter and illustrator. Born: New
Brunswick, New York in 1897. Studied: with P. L. Hale,
A. R. James, Helena Sturtevant, George Maynard and
Thomas Fogarty. Collections: Author and illustrator
of "The Happy Venture", "Us and the Bottleman", "Blue
Magic" and others.

PRICE, Eugenia. Painter. Born: Beaumont, Texas in 1865
and died in 1923. Studied: St. Louis School of Fine Arts;
Art Institute of Chicago; Julien Academy in Paris.

PRICE, Helen F. Painter. Born: Johnstown, Pennsylvania
in 1893. Awards: Allied Artists of Johnstown, 1940, 1942,
1944, 1948, 1950. Collections: Public School, Somerset,
Pennsylvania; Lutheran College, Gettysburg, Pennsylvania;
Bethlehem Steel General Offices; Somerset Bank; University
of Pittsburgh; Johnstown Bank.

PRICE, Irene. Painter. Born: Savannah, Georgia in 1900.
Studied: Duke University; Corcoran School of Art; also with
Hawthorne and Brackman. She specialized in portraits.
Collections: Duke University; Virginia Military Institute.

PRICE, Llewellyn. Painter. Exhibited her water colors at
the Pennsylvania Academy of Fine Arts in 1925.

PRICE, M. Elizabeth. Painter. Born: Martinsburg, West
Virginia. Studied: Pennsylvania Museum School of Industrial
Art; Pennsylvania Academy of Fine Arts; and with William
L. Lathrop. Her work is in many private collections.

PRICE, Margaret E. Painter and illustrator. Born: Chicago,
Illinois in 1888. Studied: Massachusetts Normal Art School
and with Decamp and Major. She has illustrated many children's
books.

PRICE, Rosalie P. Painter. Born: Birmingham, Alabama.
Studied: Birmingham-Southern College; and with Hannah
Elliott, A. L. Bairnsfather, and Wayman Adams. Awards:
Birmingham Art Association, 1944, 1945, 1950; Alabama
Watercolor Society, 1948; New Orleans Art Association,
1948; Pen and Brush Club, 1950.

PRIDE, Joy. Painter. Born: Lexington, Kentucky. Studied: University of Kentucky; Julian Academy, Paris; Art Students League; Barnes Foundation; New York University; also with Stuart Davis. Collection: Senate Office Building, Washington, D.C.

PROPHET, Elizabeth. Sculptor. Studied: Rhode Island School of Design. A sculptor in wood.

PURCELL, Rosanna. Painter. A landscape and Genre painter working around 1836.

PURDIE, Evelyn. Painter. Born: in Smyrna, Asia Minor. Studied: with Carolus-Duran and Henner in Paris. Known as a miniature painter.

PURRIER, Erna G. Painter. Born: Brown County, Minnesota. Has exhibited in numerous group shows.

PURSER, Mary M. Painter. Born: Chicago, Illinois in 1913. Studied: Art Institute of Chicago; Louisiana College; University of Mississippi; University of Florida; also studied abroad. Awards: Florida Federation of Art, 1952, 1955; Florida State Fair, 1958. Collection: United States Post Office, Clarksville, Arkansas.

PUTNAM, Brenda. Sculptor. Born: Minneapolis, Minnesota in 1890. Studied: Boston Museum of Fine Arts; Corcoran School of Art; Art Students League; and with James Earle Fraser; with Charles Grafly and Archipenko; in Italy with Libero Andreotti. Awards: Barnett prize, National Academy of Design, 1922; gold medal, Pennsylvania Academy of Fine Arts, 1923; National Association of Women Artists, 1923; Architect-ural League, 1924; gold medal, National Academy of Design, 1935. Collections: Folger Shakespeare Library, Washington, D. C.; Academy of Arts and Letters; Hall of Fame, New York University; Detroit Institute of Art; Brookgreen Garden, South Carolina; Lynchburg, Virginia; South Orange, New Jersey; United States Post Office, Caldwell, New Jersey; St. Cloud, Minnesota; Norton Gallery of Art; House of Representatives, Washington, D. C.;Dallas Museum of Fine Arts.

PYLE, Margery Kathleen. Painter. Born: Wilmington, Delaware in 1903. Studied: Pennsylvania Academy of Fine Arts; University of Delaware. Awards: Wilmington Art Club, 1934.

QUASTLER, Gertrude. *Printmaker.* *Born: Vienna, Austria in 1909.* *Studied: Columbia University; University of Illinois; Chicago Institute of Design.* *Collections: Museum of Modern Art; Farnsworth Museum of Art; Art Institute of Chicago; Boston Museum of Fine Arts; Fogg Museum of Art; Boston Public Library; Philadelphia Free Library; Rhode Island School of Design; University of Delaware; University of Nebraska; University of Maryland.*

QUEST, Dorothy. *Painter.* *Born: St. Louis, Missouri in 1909.* *Studied: Washington University School of Fine Arts; Columbia University; and in Europe.* *Her specialty-- portrait painting.* *Collections: with Charles F. Quest (her husband) she painted murals in St. Louis, Missouri in the following: Carpenter Library, St. Michael Church, St. George Episcopal Church, Trinity Church, Herzog School; St. Mary's Church, Helena, Arkansas.*

RACHOTES, Matene. Painter. Born: Boston, Massachusetts
in 1905. Studied: Massachusetts Normal Art School;
Boston Museum of Fine Arts School; Child Walker School
of Fine Arts; Harvard University. Awards: Harvard
University, fellowship; Tiffany Foundation, fellowship.

RACKLEY, Mildred. Serigrapher. Born: Carlsbad, New
Mexico in 1906. Studied: University of Texas; New Mexico
Normal University; Kunstgewerbe Schule, Hamburg, Germany;
and with Walter Ufer and George Grosz. Awards: Diablo
Art Festival, 1958; Concord, California, 1958.
Collections: Metropolitan Museum of Art; Philadelphia
Museum of Art; Springfield Art Museum; Princeton Printmakers
Club.

RADITZ, Violetta C. Painter. Exhibited her water colors
in 1925 at the Pennsylvania Academy of Fine Arts.

RAINSFORD, Miss. Painter. A landscape artist exhibiting
during the period 1843-44.

RAMSDELL M. Louise. Painter. Born: Housatonic, Massachusetts.
Studied: University of California; Smith College; Art
Students League; Grand Central School of Art; in Vienna;
also with Wayman Adams, George Luks and Jerry Fransworth.
Awards: St. Petersburg Art Club, 1936, 1937; Pen and Brush
Club, 1951, 1954; Albany Institute of History and Art.
1955; Academic Art, Springfield, 1954.

RAMSEY, Rachel. Painter. An amateur who was exhibiting her
work in 1849.

RAND, Ellen G. Painter. Born: San Francisco, California
in 1876 and died in 1941. Studied: in New York and Paris.
Awards: St. Louis Exposition, 1904; gold medal, Panama-
Pacific Exposition, San Francisco, 1915. Collection:
Metropolitan Museum of Art.

RAND, Margaret A. Painter. Born: Dedham, Massachusetts in
1868. Collection: Boston Art Club.

RANDALL, Eleanor E. Painter. Born: Holyoke, Massachusetts
Studied: Wheaton College; Boston Museum Of Fine Arts School;
Boston University.

RANDOLPH, Gladys C. Painter. Born: Whitestone, Long Island,
New York. Studied: New York School of Fine and Applied
Arts; Terry Art Institute; Portland Oregon Art Museum;
University of Pennsylvania; New York University; also
studied with Hobson Pittman and Revington Arthur. Awards:
Miami Art League; Blue Dome; Florida Federation of Art;
Terry Art Institute; National League of American Pen Women;
American Artists Professional League.

RANKIN, Mary K. Painter. Born: El Paso, Texas in 1897.
Studied: Chouinard Art Institute; also studied with
Loren Barton and James Couper Wright. Awards: Hollywood
Library; Women Painters of the West, 1952.

RANSOM, Caroline L. Painter. Born: Newark, Ohio in 1838
and died in 1910. For the most part she was self taught.
Studied: landscape painting with A. B. Durand; portrait
painting with Thomas Hicks and Daniel Huntington; Munich,
with Kaulbach. She had her studio in Cleveland, Ohio for
some time then moved to New York prior to coming to
Washington, D. C. She painted many portraits of famous
persons such as Alexander Hamilton, James A. Garfield
and Thomas Jefferson.

RANSON, Nancy S. Painter. Born: New York City in 1905.
Studied: Pratt Institute Art School; Art Students League;
and with Laurent, Charlot and Brackman. Awards: Critic's
Choice Exhibition, 1947; National Association of Women
Artists, 1952, 1953, 1958, 1956; National Serigraphic
Society, 1953; Grumbacher award in Casein, 1954; American
Color Printmakers Society, 1955; Brooklyn Society of Art,
1955; Audubon Art, 1958. Collections: Brandeis University;
Mexican Government Tourist Commission; Key West Art and
Historical Society; Reading Public Musuem; Free Library,
Philadelphia; Museum of the City of New York; National
Art Gallery, Sydney, Australia.

RATH, Hildegard. Painter. Born: Freudenstadt, Germany in
1909. Awards: Stuttgart, Germany; Salon of the 50 States,
New York; Prix de Pair, Paris, France. Collections: Library
of Congress, Washington, D.C. Metropolitan Museum of Art;
New York Public Library.

RATHBONE, Augusta P. Painter. Born: Berkeley, California
in 1897. Studied: University of California; Grande
Chaumiere, Paris, France; and with Claudio Castelucho and
Lucien Simon. Awards: California Society of Etchers,
1947; San Francisco Art Festival, 1951. Collections:
de Young Memorial Museum; California State Library; Brooklyn
Museum of Art.

RATKAI, Helen. Painter. Born: New York City in 1914.
Studied: Art Students League; with Yasuo Kuniyoshi.
Collection: Abbott Laboratories.

RATLIFF, Blanche C. Painter. Born: in Texas in 1896.
Studied: with O. B. Jacobson. Collection: University of
Oklahoma.

RAVENSCROFT, Ellen. Painter. Born: in 1876. She exhibited at the 33d Annual Exhibition of Women Painters and Sculptors.

RAVLIN, Grace. Painter. Born: Kaneville, Kane County, Illinois. Studied: Art Institute of Chicago; Pennsylvania Academy of Fine Arts; and with Simon-Menard Cour, in Paris. Collections: Luxembourg Museum, Paris; French Government Collection.

RAWSON, Eleanor. Painter. A water colorist who did genre scenes around 1820.

RAY, Ruth. Painter. Born: New York City in 1919. Studied: Art Students League; and with Jon Corbino, Morris Kantor and George Bridgmann. Awards: National Association of Women Artists, 1945, 1952, 1953; La Tausca Competition, 1946; National Academy of Design, 1948; Springfield Museum of Art, 1946; Connecticut Contemporary Exhibition, 1951; Silvermine Guild Artists, 1953; Connecticut Academy of Fine Arts, 1953; Alice Collins Durham award, 1954, 1955. Collection: Springfield Museum of Art.

RAYMOND, Flora A. Painter. Born: Pewaukee Lake, Wisconsin. Studied: Art Institute of Chicago; Hyde Park Peoples College; and with Edmond Giesbert, Frederick Grant and others. Awards: Parent-Teacher Association, Springfield, Illinois, 1933; Federation of Women's Club, 1938; Highland Park, Illinois, 1938; League of American Pen Women, 1948-1950, 1953. Collection: University of California at Los Angeles.

RAYMOND, Grace R. Painter. Born: Mt. Vernon, Ohio in 1876. Studied: Chicago Art Institute; Corcoran School of Art; Pennsylvania Academy of Fine Arts; Southwestern College; Heatherleys School of Fine Arts, London, England; also studied with Henry Snell, George Elmer Browne, Guy Wiggins and Gertrude Massey. Collections: Winfield Kansas High School Art Gallery; Newton Memorial Hospital; Douglass Kansas Public Library.

RAYMOND, Leone E. Sculptor. Born: Duluth, Minnesota in 1908. Studied: Minneapolis School of Art; also studied with Charles S. Wells. Awards: Minnesota State Fair, 1941, 1943, 1944; Minneapolis Institute of Art, 1944; Walker Art Center, 1944, 1945. Collections: bas-relief, International Falls, Minnesota Stadium; Sebeka, Minnesota High School; Farmer's Exchange Building, St. Paul; Hall of Statuary, Washington, D. C. Lutheran Church of the Good Shepherd, Minneapolis; Church of St. Joseph, Hopkins, Minnesota; interior of St. George's Episcopal Church, St. Louis Park, Minnesota.

Hilla Von Rebay, HANS RICHTER, 1915. Pencil on paper,
10 1/2" X 8 1/4". The Solomon R. Guggenheim Museum.

RAYNER, Ada. Painter. Born: London, England in 1901.
Studied: Art Students League; Cape School of Art; and
with Henry Hensche.

RAYNESS, Velma W. Painter. Born: Davenport, Iowa in
1896. Studied: Cumming School of Art. Awards: Des Moines
Women's Club, 1919; Iowa State Fair, 1935. Collections:
Collegiate Presbyterian Church, Ames, Iowa; St. John's
Methodist Church, Van Buren, Arkansas; United States
Government; Botany Hall, Iowa State College, Ames, Iowa.

RAYNOR, Grace H. Sculptor. Born: New York in 1884. Her
specialty, portraits, statuettes and heads.

REA, Pauline De Vol. Painter. Born: Chicago, Illinois in
1893. Studied: Chicago Academy of Fine Arts; and with
Rudolph Schaeffer, Cyril Kay-Scott. Award: San Diego Fine
Arts Society, 1941. Collection: San Diego Fine Arts Society.

REAM, Vinnie. Sculptor. Born: Madison, Wisconsin in 1847.
Studied: abroad. She modelled a statue of "Lincoln" at the
Capitol as ordered by a vote of Congress.

REARDON, Mary A. Painter and etcher. Born: Quincy,
Massachusetts in 1912. Studied: Radcliffe College; Yale
University School of Fine Arts; and in Mexico. Collections:
St. Theresa's, Watertown, Massachusetts; Good Shepherd
Convent, New York; Radcliffe College; Cardinal Spellman
High School, Brockton, Massachusetts; Boston College;
St. Francis Xavier Chapel, Boston; St. Peter and St. Paul
Church, Boston, Massachusetts; St. John's Seminary, Boston;
Maryknoll and Brookline Chapel, Boston; Children's Medical
Center, Boston; Boston State Teachers College; triptych,
United States Ship Wasp.

REBAY, Hilla. Painter. Born: Strasbourg, Alsace in 1890.
Studied: Academies in Dusseldorf, Paris and Munich.
Collections: in Museums in New York, France, Italy, Germay
and Switzerland.

REDFIELD, Heloise G. Painter. Born: Philadelphia,
Pennsylvania in 1883. Studied: Pennsylvania Academy of
Fine Arts with Chase and Cecilia Beaux; also studied in
Paris with Mme. La Farge.

REDKA, Eugenia. Painter. Born: New York City. Studied:
Hunter College; Columbia University. Awards: Hunter
College; Popular Photography; World Telegram and Sun;
Travel and Flower Growers magazines. Collections:
Popular Photography Las Americas; Travel; The Priest.

REECE, Dora. Painter. Born: Philipsburg, Pennsylvania.
Studied: Philadelphia School of Design; Pennsylvania
Academy of Fine Arts; also studied in Europe. Awards:
Philadelphia School of Design; Rittenhouse Flower
Market, Philadelphia. Collections: Philadelphia Museum
of Art; Memorial Library, Philipsburg, Pennsylvania.

REED, Florence. Painter. Born: Belmont, Massachusetts in
1915. Studied: Massachusetts School of Art; Art Students
League; Massachusetts General Hospital Medical Arts Course.
Collection: Acton Massachusetts Public Library;
Massachusetts General Hospital.

REED, Helen. Painter and Sculptor. In Boston she drew
portraits in crayons. Later studied Sculpture in Florence,
Italy with Preston Powers. Her bas-reliefs in marble
have been exhibited in Boston and New York.

REEDER, Flora. Painter. Born: Saginaw, Michigan.
Studied: Ohio State University; University of Kansas;
Columbus Art School; San Francisco School of Art; also
studied with Hawthorne, Maurice Sterne, John Carroll and
William Thon. Awards: Ohio State Fair; Columbus Art
League, 1956; Ohio State Journal; Columbus Gallery of
Fine Arts, 1954, 1955; Ohio Watercolor Society; Ohio
Valley Exhibition, 1955; Collection: Columbus Gallery of
Fine Arts.

REGESTER, Charlotte. Painter. Born: Baltimore, Maryland
in 1883. Studied: Albright Art School; Art Students League;
Columbia University; Greenwich House. Award: Pen and Brush
Club, 1939.

REIBER, Cora S. Painter. Born: New York, New York. Studied:
New York School of Applied Design for Women; Art Students
League; and with Charles Jeltrup and Alphonse Mucha.
Collection: Wadsworth Avenue Baptist Church, New York City.

REICHMANN, Josephine. Painter. Born: Louisville, Kentucky
in 1864. Studied: Art Institute of Chicago; Art Students
League; and with Hawthorne.

REID, Aurelia W. Painter. Born: Beeckman, Dutchess County,
New York. Studied: Cooper Union Art School; Columbia
University; Winthrop College, South Carolina; University of
California at Los Angeles; Los Angeles County Art Institute.
Awards: San Pedro Fair; San Pedro Art Association.
Collections: Los Angeles State Building; miniature,
Philadelphia Museum of Art.

REID, Jean A. Painter. Born: Brooklyn, New York in 1882.
Studied: American School of Miniature Painting; Art Students
League; and with Brandegee. Known principally as a miniature
painter.

REILLY, Mildred A. Painter. Born: Milwaukee, Wisconsin in
1902. Studied: Milwaukee Art School; Layton School of Art;
Art Students League; and with Robert Brackman, Robert
Philipp, and Howard Trafton. Award: North Shore Hospital
Benefit, Levittown, New York, 1951.

REIMER, Cornelia. Painter. Born: San Jacinto, California
in 1894. Studied: Pomona College; University of California;
University of Panama, with Cedeno; Pasadena School of Fine
Arts, with Ejnar Hansen, Frode Dann and Orrin White.
Awards: National League of American Pen Women, (Canal Zone)
1949; National League of American Pen Women (Pasadena),1957.

REINDEL, Edna. Sculptor. Born: Detroit, Michigan in 1900.
Studied: Pratt Institute Art School. Awards: Art Directors
Club, 1935; fellowship, Tiffany Foundation, 1926, 1932;
Beverly Hills Art Festival, 1939. Collections: Metropolitan
Museum of Art, Dallas Museum of Fine Arts; Whitney Museum
of American Arts Ball;State Teachers College; Canajoharie
Art Gallery; Life Magazine Collection; New Britain Art
Institute; Labor Building, Washington, D. C. Fairfield Court,
Stamford, Connecticut; Governor's House, St. Croix, Virgin
Islands; United States Post Office, Swainsboro, Georgia.

REISS, Henriette. Painter. Born: Liverpool, England in 1890.
Studied: In Germany, England and Switzerland. Has exhibited
widely throughout museums in the United States.

REITER, Freda L. Painter. Born: Philadelphia, Pennsylvania
in 1919. Studied: Moore Institute of Design; Pennsylvania
Academy of Fine Arts; Barnes Foundation; San Carlos
Academy, Mexico. Award: Graphic Sketch Club, 1938, 1940.
Collections: Library of Congress; Carnegie Institute;
Philadelphia Inquirer. She was also a graphic artist.

RELIS, Rochelle. Painter. Born: Poland in 1918.
Award: Jewish Press award. Collection: Synagogue Museum,
Graz, Austria.

REMINGTON, Elizabeth. Painter. Born: in 1825 and died in
1917.

REMSEN, Helen Q. Sculptor. Born: Algona, Iowa in 1897.
Studied: University of Iowa; Northwestern University;
Grand Central School of Art; also studied with Georg
Lober and John Hovannes. Awards: Society of Four Arts,
Palm Beach, Florida, 1942; Norton Gallery of Art, 1944;
Dallas Museum of Fine Arts, 1944; Florida Federation
of Art, 1941, 1942, 1944; National Sculpture Exhibition,
Sarasota, 1953; Smithsonian Institute, 1954; New Orleans
Art Association, 1955, 1957. Collections: Jungle Gardens,
Sarasota; St. Boniface Church, Sarasota.

RENCH, Polly. Painter. She was painting miniatures in
Philadelphia around 1812.

RENNIE, Helen S. Painter. Born: Cambridge, Maryland.
Studied: Corcoran School of Art; National Academy of
Design. Awards: Society of Washington Artists, 1948;
Baltimore Museum of Art, 1958. Collections: Roosevelt
High School, Washington, D. C.; Phillips Collections,
Washington, D.C.

RENSIE, Florine. Painter. Born: Philadelphia, Pennsylvania
in 1883. Studied: Art Students League; with Alexander
Brook and Sidney Laufmann. Award: Terry Art Institute,
1952.

REYNARD, Carolyn C. Painter. Born: Wichita, Kansas in
1934. Award: Nine awards in State, Local and Regional
Exhibitions. Collections: Wichita State University Gallery.

REYNES, Mrs. Joseph. Painter. Born: in 1805. She was
a miniature painter.

REYNOLDS, Catherine. Painter. Born: in 1782 and died in
1864. She was known as an amateur landscape painter.

REYNOLDS, Nancy DuPont. Painter. Born: in Delaware in
1919. Collections: Science Library, Vanderbilt University,
Tennessee; Goldsbrough Building, Wilmington, Delaware;
Wilmington Trust Company; E. I. DuPont Company.

REYNOLDS, Virginia. Painter. Born: in 1866 and died in
1903. Known as a portrait and miniature painter.

RHETT, Hannah. Painter. Born: Columbia, South Carolina
in 1871. Studied: Art Students League; and in Paris with
Laurens.

RICE-MEYROWITZ, Jenney D. Painter. Born: in Arkansas.
Studied: St. Louis School of Fine Arts.

RICH, Frances. Sculptor. Born: Spokane, Washington in
1910. Studied: Smith College; Cranbrook Academy of Art;
Claremont College; Columbia University; with Malvina Hoffman,
Carl Miles and Alexander Jacovleff. Collections: Army and
Navy Nurse Memorial, Arlington National Cemetery; Purdue
University; Wayside Chapel of St. Francis, Grace Cathedral,
San Francisco; Mt. Angel Abbey, St. Benedict, Oregon;
Hall of Fame, Ponca City, Oklahoma; Smith College;
St. Peters Church, Redwood City, California; University of
California, Berkeley; Madonna House, Combermere, Ontario,
Canada; Carl Milles Museum Garden, Stockholm; University
of Oklahoma; science medal, Dr. Jonas Salk.

RICHARD, Betti. Sculptor. Born: New York City in 1916.
Studied: Art Students League with Mahonri Young, Paul
Manship. Awards: National Academy of Design, 1947; Pen
and Brush Club, 1951; gold medal, Allied Artists of America,
1956. Collections: doors, Oscar Smith Mausoleum; Church
of the Immaculate Conception, New York; Pieta Skouras
Memorial, New York; Bellingrath Gardens, Mobile, Alabama;
monument to race horse "Omaha" at Ak-Sar-Ben Track, Omaha;
figure, Austrian Legation, Tokyo; figure, Sacred Heart
Rectory, Roslindale, Massachusetts; House of Theology,
Centerville, Ohio; statue, St. Francis of Assisi Church,
New York.

RICHARDS: Christine L. Painter. Born: Radnor, Pennsylvania
in 1910. Collections: private commissions and collections.

RICHARDS, Ella E. Painter. Born: in Virginia. Studied:
in New York and Baltimore; also studied in Paris with Collin,
Lefebvre, and Robert-Fleury. Awards: Omaha Exposition, 1899;
Charleston Exposition, 1902. Collections: The American
Society of Civil Engineers, New York; Bank of Montclair,
New Jersey; Norfolk National Bank, Norfolk, Virginia;
Citizens Bank, Norfolk, Virginia.

RICHARDS, Glenora. Painter. Born: New London, Ohio in
1909. Studied: Cleveland School of Art. Awards: American
Society of Miniature Painters, 1947; Pennsylvania Society
of Miniature Painters, 1947; National Association of Women
Artists, 1953; Washington Miniature Painters and Sculptors
Society, 1956, 1957. She is a miniaturist. Collection:
Philadelphia Museum of Art.

RICHARDS, Harriet R. Painter and illustrator. Born: Hartford,
Connecticut. Studied: Yale School of Fine Arts; with
Frank Benson in Boston; Howard Pyle in Wilmington, Delaware.
Illustrated books by Louisa Alcott.

RICHARDS, Jeanne H. Etcher. Born: Aurora, Illinois in 1923.
Studied: University of Illinois; Colorado Springs Fine Arts
Center; Iowa State University; also studied with William S.
Hayter, Mauricio Lasansky. Awards: Fulbright fellowship,
1954-55; Des Moines Art Center, 1953; University of Southern
California; 1954; Bradley University, 1954; Nelson Gallery
of Art, 1954. Collections: Society of American Graphic
Artists; Des Moines Art Center.

RICHARDS, Lucy Currier. Sculptor. Born: Lawrence,
Massachusetts. Studied: Boston Museum School; Kops in
Dresden; Eustritz in Berlin; Julien Academy in Paris.

RICHARDS, Myra R. Sculptor and painter. Born: Indianapolis,
Indiana in 1882. Studied: Herron Art Institute with Otis
Adams, George Julian Zolnay and Rudolph Schwartz.

RICHARDSON, Catharine P. Painter. Known chiefly as a
portrait painter she was exhibiting at the National Academy
of Design in 1924.

RICHARDSON, Clara V. Painter and etcher. Born: Philadelphia,
Pennsylvania in 1855. Studied: with Ferris, Moran and Snell.

RICHARDSON, Constance. Painter. Born: Indianapolis,
Indiana in 1905. Studied: Vassar College; Pennsylvania
Academy of Fine Arts. Collections: John Herron Art
Institute; Detroit Institute of Art; Pennsylvania Academy
of Fine Arts; Saginaw Museum of Art; Grand Rapids Art
Museum; New Britain Institute.

RICHARDSON, Gretchen. Sculptor. Born: Detroit, Michigan
in 1910. Studied: Wellesley College; Art Students League
with William Zorach; Academy Julian, Paris. Awards:
National Association of Women Artists, 1952, 1955.

RICHARDSON, Helen E. Sculptor. She exhibited at the
Pennsylvania Academy of Fine Arts in 1924.

RICHARDSON, Margaret F. Painter. Born: Winnetka, Illinois.
Studied: with De Camp, Tarbell and Major. Awards: Art
Institute of Chicago, 1911; National Academy of Design, 1913.
Collection: Pennsylvania Academy of Fine Arts.

RICHARDSON, Marion. Painter and etcher. Born: Brooklyn,
New York in 1877. Studied: with Chase, Du Mond and Senseney.

RICHARDSON, Mary. Painter. Born: in 1848 and died in 1931.
She was a portrait painter.

RICHARDSON, Mary N. Painter. Born: Mt. Vernon, Maine in
1859. Studied: Boston Museum School; Colarossi Academy,
Paris. Collection: Walker Art Gallery, Bowdoin College,
Brunswick, Maine.

RICHMOND, Agnes M. Painter. Born: Alton, Illinois.
Studied: St. Louis School of Fine Arts; Art Students
League. Awards: National Association of Women Artists,
1911, 1922, 1933; New Rochelle, New York, 1932; Allied
Artists of America, 1947, 1952, 1953. Collections:
San Diego Fine Arts Society; Hickory North Carolina
Museum of Art.

RICHMOND, Evelyn K. Painter. Born: Boston, Massachusetts
in 1872. Studied: with Henry B. Snell.

RIES, Gerta. Sculptor. She was exhibiting her portraits
at the National Academy of Design in 1925.

RIGSBY, Mrs. F. G. Painter. A portrait painter who is now
deceased.

RILEY, Mary G. Painter. Was exhibiting at the Pennsylvania
Academy of Fine Arts in 1924.

RIPLEY, Lucy P. Sculptor. Born: in Minnesota. Studied:
with Saint Gaudens, French and Rodin. "The Inner Voice,"
a bronze statue is an example of her work.

RISING, Dorothy M. Painter. Born: Tacoma, Washington in
1895. Studied: Pratt Institute Art School; Cleveland
School of Art; University of Washington. Awards: National
League of American Pen Women, 1946, 1948, 1950, 1951, 1955,
1956, 1957; Women Painters of Washington, 1948, 1954, 1956,
1957; Woessner Gallery, Seattle, 1955; Spokane, Washington
1948; Henry Gallery, 1951; Northwest Watercolor Society,
1957. Collection: City of Spokane Collection.

RISQUE, Caroline E. Sculptor. Born: St. Louis, Missouri
in 1886. Studied: St. Louis School of Fine Arts; and in
Paris. Her specialty, small bronzes.

RIVERS, Cornelia M. Painter. Born: Savannah, Georgia in
1912. Studied: Vassar College; University of Georgia;
Art Students League; American Art School; and with Robert
Brackman. Awards: University of Georgia, 1935; Savannah
Art Club, 1942; Art Students League, 1946; Manchester,
Vermont, 1947. Collections: Woodville High School,
Savannah; Ericson Memorial Hall, Savannah.

ROBB, Elizabeth B. Painter. Awards: Artists Association
of Pittsburgh, 1914, 1915.

ROBBINS, Ellen. Painter. Born: in 1828 and died in 1905.
Studied: New England School of Design. Known as a water
colorist she is noted for her exquisite water color
paintings of flowers and autumn leaves.

ROBBINS, Hulda D. Serigrapher. Born: Atlanta, Georgia in
1910. Studied: Philadelphia Museum School of Industrial
Art; Barnes Foundation; Prussian Academy, Berlin. Awards:
scholarship, Barnes Foundation, 1939; Museum of Modern Art,
1941; Pepsi-Cola, 1945; National Serigraphers Society,
1947-1949, 1954. Collections: Lehigh University; American
Association of University Women; Smithsonian Institute;
Art Museum of Ontario, Canada; Princeton Printmakers Club;
New York School of Interior Decorators; Purchase School,
New York; Highview School, Oakville, Tennessee; United
States Army; Metropolitan Museum of Art.

ROBERTS, Alice M. Painter. Born: Philadelphia,
Pennsylvania in 1875. Studied: with Robert Henri, Carl
Newman and Joseph De Camp. Award: Pennsylvania Academy
of Fine arts, 1906.

ROBERTS, Blanche G. Sculptor. Was exhibiting at the
Pennsylvania Academy of Fine Arts in 1915.

ROBERTS, Elizabeth W. Painter. Born: Philadelphia,
Pennsylvania in 1871. Studied: in Philadelphia with
H. R. Poore and Elizabeth Bonsall; in Paris with
Bouguereau, Robert-Fleury, Lefebvre and Merson. Awards:
Pennsylvania Academy of Fine Arts, 1889; Paris Salon,
1892. Collections: Pennsylvania Academy; Asilo Giovanni,
Bragora, Venice, Italy; Public Library, Concord,
Massachusetts; Fenway Court, Boston.

ROBERTS, Priscilla. Painter. Born: in 1916.

ROBERTS, Violet K. Painter and illustrator. Born: "The
Dalles," Oregon in 1880. Studied: with Beck, Benson,
Moschcowitz and Prellwitz.

ROBERTSON, Mary A. Painter. A self-taught artist who
shares her studio with her husband, William A. Robertson,
a metal sculptor.

ROBERTSON, Persis W. Lithographer. Born: Des Moines,
Iowa in 1896. Studied: Wells College; Columbia University.
Award: Kansas City Art Institute, 1940.

ROBESON, Edna A. Painter. Born: Davenport, Iowa in 1887.
Studied: with Frank Phoenix; Art Students League.
She is noted for her miniature paintings.

ROBIN, Fanny. Painter. Born: Philadelphia, Pennsylvania
in 1888. Studied: Moore Institute of Design; Pennsylvania
Academy of Fine Arts; and with Breckenridge, Snell and
Horter. Awards: DaVinci Alliance, 1942; Philadelphia
Plastic Club, 1943, gold medal, 1955.

ROBINS, Susan P. B. Painter. Born: Boston, Massachusetts
in 1849. Studied: Boston Museum School with Philip Hale;
also studied with John Johnston, Ross Turner and F.
Crowninshield.

ROBINSON, Adah M. Painter. Born: Richmond, Indiana in
1882. Studied: Earlham College; Art Institute of Chicago;
and with John Carlson, Charles Hawthorne, and George Elmer
Browne. Award: University of Tulsa, 1936. Collections:
Oklahoma City Art League; Philbrook Art Center; First
Church of Christ Scientist, Tulsa, Oklahoma; Second Church
of Christ Scientist, Tulsa; Boston Avenue Methodist Church,
Tulsa.

ROBINSON, Florence V. Painter. Born: Taunton, Massachusetts
in 1874. Studied: in Paris with Bouveret, Vignal and
Harpignes. Noted as a water colorist and illustrator.
Collections: State, in France; Museum of Fine Arts; Harvard
University; Cleveland Art School.

ROBINSON, Mary T. Painter. Born: Massachusetts in 1888.
Studied: Vassar College; Art Students League; American
School of Fine Arts, Fontainebleau, France; and with
DuMond, Luks, Beaudoin and Despujols. Awards: Officer of
French Academy, France, 1933; American Woman's Association,
1937. Has exhibited widely in the United States and Europe.

ROBINSON, Nora B. Painter. She was exhibiting her miniatures
at the Pennsylvania Academy of Fine Arts in 1925.

ROBINSON, Pauline. Painter. She was working around 1846.

ROBINSON, Ruth M. Painter. Born: Philadelphia, Pennsylvania
in 1910. Studied: Moore Institute Art School and Industry;
Pennsylvania Academy of Fine Arts; also studied with Earl
Horter and Umberto Romano. Awards: Fellowship, Pennsylvania
Academy of Fine Arts; Moore Institute of Design, 1930;
Philadelphia Plastic Club, 1941. Collections: Marine
Hospital, Carville, Louisiana; Ft. Knox, Kentucky; Carnegie
Corporation.

ROBINSON, Virginia C. Painter. Born: Maryville, Missouri.
Studied: William Woods College; Northwest Missouri State
College; Columbia University. Awards: Kappa Pi, 1955;
Collections: Mississippi Department of Archives and History,
Jackson, Mississippi; Mississippi State College for Women;
Blue Ridge Assembly, Black Mountain, North Carolina.

ROBISON, Ann D. Painter. Born: Palmyra, Illinois. Studied:
University of California at Los Angeles; Otis Art Institute;
also with John Hubbard Rich, and Paul Clemens.

RODDY, Edith J. Painter. Born: Meadville, Pennsylvania.
Studied: Boston Museum of Fine Arts School; with Charles
Hawthorne, George Pearse Ennis; and in Europe. Awards:
Florida Federation of Art, 1938; Clearwater Art Association,
1946; Sarasota Federation of Art. Collection: Syracuse
Museum of Fine Arts.

ROGERS, Gertrude. Painter. Born: Ionia County, Michigan
in 1896. Awards: Grand Rapids Art Gallery, 1950, 1955;
Erie Pennsylvania Art Gallery, 1952; Huntington Gallery,
West Virginia, 1953.

ROGERS, Gretchen W. Painter. She exhibited her portrait
of a "Young Girl" at the Pennsylvania Academy of Fine Arts
in 1914.

ROGERS, Margaret E. Painter. Born: Birmingham, England in
1872. Studied: with F. L. Heath and L. P. Latimer; also
with Alexander Bower. Awards: California State Fair, 1938,
1939, 1941; Santa Cruz County Exhibition; Watsonville,
California annual.

ROGERS, Mary. Painter. Born: in 1882 and died in 1920.
She was a landscape, marine and figure painter.

ROGERS, Phyllis J. Painter. Born: Rochester, New York in
1925. Her work is well-known in the Akron Ohio area where
she has exhibited extensively.

ROLFE, Emma. Painter. She was working and exhibiting
around 1839.

ROLLINS, Helen J. Painter. Born: Hayward, California in 1893.
Studied: Los Angeles School of Art and Design; also studied
with J. E. McBurney, J. Francis Smith and Theodore Lukits.
Collections: Southwest Museum, Los Angeles, California;
Public Schools, Los Angeles; Education Building, San Diego,
California.

ROLLINS, Josephine L. Painter. Born: Sherburne, Minnesota in 1896. Studied: Cornell College; University of Minnesota; Corcoran School of Art; Minneapolis School of Art; also with Hans Hofmann, Cameron Booth and Edmund Kinsinger. Award: Walker Art Center. Collections: University of Minnesota; Virginia Minnesota Library; Owatonna Minnesota Library; Crosby-Tronton High School, Minnesota; University High School, Minneapolis, Minnesota.

ROMANO, Clare. Lithographer. Born: Palisade, New Jersey in 1922. Studied: Cooper Union Art School; Ecole des Beaux-Arts, Fontainebleau, France; Instituto Statale d'Arte, Florence Italy. Awards: Fulbright fellowship, 1958-59; Tiffany Foundation, 1952; Brooklyn Museum, 1951; Library of Congress, 1951; Society of American Graphic Artists, 1952. Collections: Brooklyn Museum; Metropolitan Museum of Art; New York Public Library; Library of Congress; Rochester Memorial Art Gallery; Pennsylvania State University.

RONNEBECK, Louise E. Painter. Born: Philadelphia Pennsylvania in 1901. Studied: Barnard College; Art Students League; American School, Fontainebleau, France; also studied with George Bridgman and Kenneth Hayes Miller. Collections: County Hospital, Greeley, Colorado; Morrey Junion High School, Denver, Colorado; Denver Art Museum; Albany Hotel, Denver, Colorado; Children's Hospital, Denver, Colorado; Sloanes Lake Club House, Denver, Colorado; Bermuda High School for girls; Bermuda Department of Agriculture; United States Post Office, Worland, Wyoming; Grand Junction Colorado.

ROOT, Elmira. Painter. Pin-prick and watercolor artist and portraitist active around 1840.

ROSE, Dorothy. Painter. Born: Brooklyn, New York. Studied: Beaux-Arts Institute of Design; New School for Social Research; Art Students League. Collection: Staten Island Museum of History and Art.

ROSE, Ruth S. Painter and sculptor. Born: Eau Claire, Wisconsin in 1887. Studied: Vassar College. Awards: National Association of Women Artists, 1937, 1944; State of New Jersey, 1944; Washington Printmakers, 1951; Norfolk Museum of Art and Science, 1950; Corcoran Gallery of Art, 1951; Virginia Printmakers, 1957; Washington Area Print-makers, 1957; Art Fair, Alexandria and Washington, 1957; Religious Art Fair, 1958. Collections: Library of Congress; Metropolitan Museum of Art; Vassar College; Philadelphia Museum of Art; Wells College; Williams College; Milliken College; Norfolk Museum of Arts and Science.

ROSEN, Esther Y. Painter. Born: Schenectady, New York in 1916. Studied: with Samuel Brecher. Award: Bergen County Art Guild, 1956. Collection: Collectors of American Art.

ROSENDALE, Harriet. Painter. Born: Buffalo, New York. Studied: New York School of Fine and Applied Arts; Art Students League with Frank DuMond and Jon Corbino. Awards: National Association of Women Artists, 1953; New England Regional, 1957.

ROSENSON, Olga. Painter. Born: Brooklyn, New York. Studied: Packer Collegiate Institute; Art Students League, with George Luks, Vincent DuMond and Joseph Penell; Brooklyn Museum School.

ROSENTHAL, Doris. Painter. Born: Riverside, California. Studied: Teachers College, Los Angeles, California; Columbia University; Art Students League with George Bellows and John Sloan. Awards: Guggenheim fellowship, 1932, 1936; Northwest Printmakers; National Academy of Design, 1952; American Academy of Arts and Letters grant, 1952. Collections: Metropolitan Museum of Art; Addison Gallery of American Art; Museum of Modern Art; Colorado Springs Fine Arts Center; Rochester Memorial Art Gallery; Toledo Museum of Art; University of Arizona; Library of Congress; San Diego Fine Arts Gallery; Davenport Municipal Art Gallery; Cranbrook Academy of Art. As a lithographer also she was a compiler on the Encyclopaedia Britannica.

ROSS, Barbara E. Painter. Born: Deadwood, South Dakota in 1909. Studied: University of Nebraska. Award: International Business Machines.

ROSSI, Jean. Painter. An artist who was active during the period 1859-1865.

ROTHSTEIN, Elizabeth L. Painter. Born: New York City in 1907. Studied: Pennsylvania Academy of Fine Arts; Arts Students League; Parsons School of Design; New York University; New School for Social Research; Brooklyn Museum School of Art. Award: First Civil Service Art Exhibition. Collections: Public Buildings: Public Service Commission, Albany.

ROTHSTEIN, Irma. Sculptor. Born: Rostov, Russia. Studied: Vienna, Austria and with Anton Hanak. Awards: Mint Museum of Art, 1946; American Artists Professional League, 1946; New Jersey Painters and Sculptors Society, 1948; Springfield Art League, 1951, 1958; National Association of Women Artists, 1954. Collections: Newark Museum of Art; Syracuse Museum of Fine Arts; G.W.V. Smith Museum, Springfield, Massachusetts.

ROUSSEAU, Angeline M. Painter. Born: Detroit, Michigan in 1912. Studied: Marygrove College, Detroit. Collection: American Library, color slides.

ROWAN, Frances. Painter. Born: Ossining, New York 1908. Studied: Randolph-Macon Woman's College; Cooper Union Art School. Awards: Nassau Art League, 1951, 1952, 1958; Malverne Art, 1954; gold medal, Hofstra College, 1957; gold medal, Malverne Art, 1952.

ROWE, Corinne. Painter. Born: Marion, Wisconsin in 1894. Studied: Detroit School of Fine Arts. Collection: Library of Congress.

ROWELL, Fanny. Painter. Born: Princeton, New Jersey in 1865. Studied: Colarossi Academy in Paris; and with J. B. Whittaker in Brooklyn; with Trager at Sevres.

ROWLETT, Margaret. Painter. She is also a fabric designer and has published several children's books.

ROYCE, Elizabeth R. Sculptor.

RUDD, Emma R. Painter. She exhibited at the 33d Annual Exhibition of the National Association of Women Painters and Sculptors.

RUDERSDORF, Lillian. Painter. Born: Clarkson, Nebraska in 1882. Studied: Art Institute of Chicago; University of Nebraska.

RUDOLPH, Pauline D. Painter. Born: in Chicago. Studied: Pennsylvania Academy of Fine Arts; and in Paris with Boulanger and Lefebvre.

RUDY, Mary E. Painter. Born: Burlington, Iowa in 1861. Studied: Art Institute of Chicago.

RUGGLES, Mary. Painter. A landscapist who was exhibiting during the period 1859-60.

RUSH, Olive. Painter. Born: Fairmount, Indiana in 1873. Studied: Corcoran School of Art; Art Students League. Awards: John Herron Art Institute; Hoosier Salon; Denver Art Museum; Nebraska Art Association; Wilmington Society of Fine Arts. Collections: Worcester Museum of Art; Brooklyn Museum of Art; John Herron Art Institute; Museum of New Mexico; Fine Art Center of Houston; Wilmington Society of Fine Arts; Witte Memorial Museum; Nebraska Art Association; La Fonda Hotel, Santa Fe, New Mexico; Public Library, Santa Fe, New Mexico; United States Post Office, Florence, Colorado; Pawhuska Oklahoma Post Office.

RUSSELL, Clarissa. Painter. Born: in 1810. She painted miniatures.

RUSSELL, Frances. Painter. Born: in 1856. Known as a genre painter.

RUSSELL, Lydia Smith. Painter. A portrait painter who worked around 1804.

RUTLAND, Emily. Painter. Born: Travis County, Texas in 1894. Studied: with Xavier Gonzales, Frederick Taubes and Jacob Getlar Smith. Awards: South Texas Art League, 1953-1958; Texas Watercolor Society, 1953, 1955; Art Foundation, 1953, 1954, 1956, 1958; Kingsville Texas, 1955. Collections: Witte Memorial Museum, San Antonio; Dallas Museum of Fine Arts; Texas Technical College, Lubbock; Delmar College, Corpus Christi; Corpus Christi Museum of Art.

RYAN, Sally. Sculptor. Born: New York City in 1916. Has exhibited extensively abroad and in the United States.

RYDER, Marilla. Painter. She was exhibiting in 1924 at the Pennsylvania Academy of Fine Arts.

RYERSON, Margery. Painter and etcher. Born: Morristown, New Jersey in 1886. Studied: Vassar College; Columbia University; Art Students League, with Bridgman, Henri and Hawthorne. Awards: Montclair Art Museum; Hudson Valley Art Association, 1952, 1956, 1957, 1958; National Arts Club, 1957; Society of Amerigan Graphic Artists. Collections: Brooklyn Museum; Bibliotheque Nationale, Paris; Cleveland Museum of Art; William Rockhill Nelson Gallery; International Business Machines; Smithsonian Institute; Library of Congress; Honolulu Academy of Art; New York Public Library; Montclair Art Museum; Metropolitan Museum of Art; Uffzi Gallery, Florence, Italy.

RYERSON, Mary. Sculptor. Born: Philadelphia, Pennsylvania. Studied: with Saint Gaudens and Fraser.

SAARINEN, Lily. Sculptor. Studied: with Heniz Warneke, Albert Stewart, Brenda Putnam and Maija Grotell. Awards: National Association of Women Artists, 1937, 1947; Washington, D. C. Art Fair, 1943; Detroit Institute of Art, 1954. Collections: bas-reliefs, foundations, United States Post Office, Carlisle, Kentucky and Bloomfield, Indiana; Crow Island School, Winnetka, Illinois; Tofanetti Restaurant, Chicago; Jefferson National Expansion Memorial, St. Louis, Missouri; Detroit Federal Reserve Bank; J. L. Hudson's Northland Shopping Center; International Business Machines collection.

SACKER, Amy M. Illustrator. Born: Boston, Massachusetts in 1876. Studied: with C. Howard Walker and DeCamp. Award: Pan-American Exposition, Buffalo, 1901.

SACKETT, Clara E. Painter. Born: Westfield, New York. Studied: Art Students League; and with Aman-Jean and Delecluse in Paris. Award: Buffalo Society of Artists.

SACKETT, Esther. Painter. A still-life Watercolorist active around 1840.

SAFFORD, Ruth P. Painter. Born: Boston, Massachusetts. Studied: Massachusetts School of Art; and with Henry B. Snell. Collections: Lee Mansion, Marblehead, Massachusetts; Arlington, Virginia; United States Naval Academy, Annapolis, Maryland; Roosevelt home, Hyde Park; National Gallery of Art, Washington, D. C.;National Headquarters, American Institute of Architects, Octagon House.

SAGE, Cornelia B. Painter. Born: Buffalo, New York. Studied: Art Students League; and with James Carroll Beckwith, John H. Twachtman, Robert Reid, Irving R. Wiles and Charles Curran; Ecole du Louvre, Paris, 1914. Awards: National Institute Social Sciences, 1914; Societe des Beaux Arts, Paris, 1916.

SAGE, Kay. Painter. Born: Albany, New York in 1898. Awards: Art Institute of Chicago, 1945; Corcoran Gallery of Art, 1951; Connecticut Development Commission, 1951. Collections: Art Institute of Chicago; California Playhouse: Whitney Museum of American Art; Wesleyan University, Connecticut; Metropolitan Museum of Art; Museum of Modern Art; Walker Art Center.

SAHLER, Helen G. Sculptor. Born: Carmel, New York. Studied: Art Students League, with Hermon MacNeil and Enid Yandell.

SAINT GAUDENS, Annetta J. Sculptor. Born: Flint, Ohio in 1869. Award: National Association of Women Painters and Sculptors, 1913. Collection: Boston Museum of Art.

SAINT GAUDENS, Carlotta. Painter. Born: Rochester, New York in 1884. Studied: Pennsylvania Academy of Fine Arts; Art Students League. She was a miniature painter and watercolorist.

SAINT REMY, Mme De. Painter. A portrait painter active in 1844.

SALA, Jeanne. Painter. Born: Milan, Italy in 1899. Studied: Wilmington Art Center; Barnes Foundation; Pennsylvania Academy of Fine Arts; also studied in Europe.

SALEMME, Martha. Painter. Born: Geneva, Illinois in 1912. Studied: with Antonio Salemme. Collection: New York Hospital.

SALISBURY, Alta W. Painter. Exhibited in the 33d Annual Exhibition of the National Association of Women Painters and Sculptors.

SALTONSTALL, Elizabeth. Lithographer. Born: Chestnut Hill, Massachusetts in 1900. Studied: Boston Museum of Fine Arts School; and with Andre L'Hote in Paris; also with Stow Wengenroth and Frank Swift Chase. Collections: Boston Museum of Fine Arts; Boston Public Library; Library of Congress; Yale University.

SALVIGNAC, Jean. Painter. Was painting and exhibiting her portraits in 1830.

SANDZEN, Margaret. Painter. Born: Lindsborg, Kansas in 1909. Studied: Bethany College; Columbia University; Art Students League; and in Paris with Edouard Leon; also studied with Bridgman and DuMond. Awards: Kansas State Fair, 1940; Rockefeller fellowship, 1939-1940, 1940-1941.

SANFORD, Isobel B. Painter. Born: Edmonton, Alberta, Canada in 1911. Studied: California School of Fine Arts; Art Students League; with Morris Kantor; Parsons School of Design.

SANFORD, Marion. Sculptor. Born: Guelph, Ontario, Canada
in 1904. Studied: Pratt Institute Art School; Art Students
League; and with Brenda Putnam. Awards: Guggenheim
fellowship, 1941-1943; National Academy of Design, 1943;
Allied Artists of America, 1945; National Academy of Design,
1947; Meriden, Connecticut, 1949; American Artists
Professional League, 1945; Springfield Massachusetts Museum
of Art, 1957. Collections: Pennsylvania Academy of Fine Arts;
Corcoran Gallery of Art; Brookgreen Gardens, South Carolina;
Warren Pennsylvania Public Library; Haynes Collection,
Boston; Norton Hall, Chautauqua, New York; Warren General
Hospital, Pennsylvania; Cosmopolitan Club, New York;
Trinity Memorial Church, Warren, Pennsylvania; St. Marys
Chapel, Faribault, Minnesota; United States Post Office,
Winder, Georgia.

SANGERNEBO, Emma. Painter. Born: Pittsburgh, Pennsylvania
in 1877. Studied: with William Forsyth. Collection: Loew's
Theater, Indianapolis, Indiana.

SANSAM, Edith. Painter. Born: Evanston, Illinois. Studied:
School of New Orleans Artists Association. Award: Pinckney
Smith award for sketches; Artists Association award for
landscape in oil.

SANTO, Pasquale (Patsy). Painter. Born: Corsano, Italy in
1893. Awards: Berkshire Museum, 1954; Portsmouth Art
Association, 1954. Collections: Museum of Moderan Art;
Canajoharie Museum; Whitney Museum of American Art; University
of Arizona; Carnegie Institute.

SARDEAU, Helene. Sculptor. Born: Antwerp, Belgium in 1899.
Studied: Art Students League; New York School of American
Sculpture. Award: Architectural League, 1934. Collections;
Croton-on-Hudson High School; United States Post Office,
Greenfield, Massachusetts; Fairmount Park, Philadelphia,
Pennsylvania; National Library; Rio de Janeiro; Supreme
Court, Mexico City; Whitney Museum of American Art; Philadelphia
Museum of Art; Pennsylvania Academy of Fine Arts; Tel-Aviv
Museum, Israel.

SARGEANT, Geneve R. Painter. Born: San Francisco, California
in 1868. Studied: with Carlsen and Chase. Collection:
Palace of Fine Arts, San Francisco, California.

SARGENT, Christiana K. Painter. Born: 1777 and died in 1867.
A painter of landscapes.

SARGENT, Margaret W. Sculptor. Born: Wellesley, Massachusetts in 1892. Studied: with Woodbury and Borglum.

SARGENT, Mary F. Etcher. Born: Somerset, Pennsylvania in 1875. Studied: Pennsylvania College for Women; Art Students League; Columbia University; and in Paris and London; also studied with William P. Robbins, Paul Bornet and St. Gaudens. Award: Pennsylvania College for Women. Collections: Metropolitan Museum of Art; Library of Congress; Brooklyn Museum; Brooks Memorial Art Gallery; G. W. V. Smith Art Museum.

SARRE, Carmen G. Painter. Born: Antwerp, Ohio. Studied: Agnes Scott College; University of Michigan; New York School of Design for Women: Philadelphia Museum School of Art.

SARTAIN, Emily. Engraver. Born: Philadelphia, Pennsylvania in 1841. Studied: with her father John Sartain; and with Scheussele in Philadelphia; and in Paris in 1871-75 with Luminais. She is a painter of portraits and genre subjects. In 1886 she was the principal of the Philadelphia School of Design for Women.

SARTAIN, Harriet. Painter. Born: in Philadelphia. Studied: Philadelphia School of Design for Women; Teachers College, New York.

SARTELLE, Mildred E. Sculptor. She exhibited at the Pennsylvania Academy of Fine Arts in 1924.

SAUER, Margarita. Painter. Born: New York City in 1925. Studied: Corcoran School of Art; and with Eliot O'Hara, Andrea Zerega, Peggy Bacon and Richard Lahey. Awards: Zerega Group, 1948; Florida Southern College, 1952.

SAUNDERS, Sophia. Painter. A painter of miniatures whose work flourished in 1851-52 in New York.

SAVAGE, Dorothy L. Painter. Exhibited her water colors at the Pennsylvania Academy of Fine Arts in 1925.

SAVAGE, Marguerite D. Painter and illustrator. Born: Bay Ridge, Long Island in 1879. Studied: with Messer, Morse and Miller.

SAVAGE-JONES, Trudi. Sculptor. Born: Roselle Park, New Jersey in 1908. Studied: Grand Central School of Art; Pennsylvania Academy of Fine Arts; Clay Club, New York. She is a sculptor of portraits. Award: Pennsylvania Academy of Fine Arts, 1930.

SAVELLI, Elena G. Painter. She exhibited in 1924 at the
Pennsylvania Academy of Fine Arts.

SAVITZ, Frieda. Painter. Born: New York City in 1932.
Studied: University of Wisconsin; Columbia University; New
York University; Cooper Union Art School; and with Hans
Hofmann; also studied abroad. Exhibited widely.

SAWRIE, Mary B. Painter. Born: Nashville, Tennessee in
1879. She was a miniature painter. Studied: with Chase,
Dow and Vanderpoel; Julien in Paris.

SAWTELLE, A. Elizabeth. Painter. Studied: Drexel Institute;
Corcoran Art School, Washington.

SAWTELLE, Mary. Painter. Born: Washington, D.C. in 1872.
Studied: Corcoran School of Art; Delecluse Academy in Paris.
and with Irving Wiles of New York.

SAWYER, Edith. Painter. A miniaturist who was exhibiting
her paintings at the Pennsylvania Academy of Fine Arts
in 1925.

SAWYER, Esther. Painter. Born: Buffalo, New York. Studied:
Albright Art School; Art Students League; and with Charles
Hawthorne, Edwin Dickinson and Nicholas Vasilieff.

SAWYER, Helen. Painter. Born: Washington, D.C. in 1900.
Studied: National Academy of Design; and with Charles
Hawthorne. Awards: Hudson Valley Art Institute, 1935, 1936;
Fine Prints of the Year, 1937; Ringling Museum of Art
Circus Exhibition, 1950, 1951; Florida Federation of Art,
1956, 1957. Collections: Library of Congress; Toledo Museum
of Art; Whitney Museum of American Art; John Herron Art
Institute; Pennsylvania Academy of Fine Arts; Vanderpoel
Collection; Miami University, Oxford, Ohio; International
Business Machines; Chesapeake and Ohio Collection; National
City Bank, New York; High Museum of Art, Atlanta.

SAXE, Carolyn N. Painter. Born: West Hurley, New York
in 1904. Studied: University of Buffalo; Parsons School
of Design; Columbia University; also studied with Charles
J. Martin.

SCARAVAGLIONE, Concetta. Sculptor. Born: New York City in
1900. Studied: National Academy of Design; Art Students
League. Awards: Prix de Rome, 1947-50; Pennsylvania
Academy of Fine Arts; American Academy of Arts and Letters,
grant. Collection: Whitney Museum of American Art; Roerich
Museum; Pennsylvania Academy of Fine Arts; Arizona State
College; United States Federal Trade Commerce Building,
Washington, D. C.; World's Fair, New York City, 1939.

SCHABACKER, Betty B. Painter. Collections: Western
Union, New York City; Erie Art Center.

SCHAEFER, Henri-Bella (Mrs). Painter. Born: New York
City. Studied: Columbia University Extension; Grande
Chaumiere; and with William A. McKay and Andre L'Hote,
Paris. Collection: Florida Southern College.

SCHAEFER, Josephine M. Painter. Born: Milwaukee,
Wisconsin in 1910. Studied: Layton School of Art;
Art Institute of Chicago; also studied in Europe, South
America and with Louis Ritman. Award: Wisconsin Painters
and Sculptors, 1945.

SCHAEFER, Mathilde. Sculptor. Born: New York City in
1909. Studied: with Raoul Josset, Walter Lemcke.
Collections: International Business Machines; Museum
of Northern Arizona; Katherine Legge Memorial, Hinsdale,
Illinois.

SCHAEFFLER, Lizbeth. Sculptor. Born: Sommerville,
Massachusetts in 1907. Studied: Pratt Institute Art
School; National Academy of Design; Art Students League;
Clay Club, New York; also with Mahonri Young. Award:
New Rochelle Art Association. Collection: Church of the
Highlands, White Plains, New York.

SCHAFER, Alice P. Etcher. Born: Albany, New York in
1899. Studied: Albany School of Fine Arts. Collections:
Metropolitan Museum of Art; Albany Printmakers Club;
National Commercial Bank and Trust Company, Albany
Society of American Graphic Artists.

SCHARFF, Constance. Painter. Born: New York City.
Studied: with George Pickens, Louis Schanker, Adja
Yunkers. She is also a printmaker. Awards: National
Association of Women Artists, 1951, 1958; Brooklyn Society
of Art, 1954; Village Art Center, 1954, 1955; gold medal,
Audubon Art, 1955. Collections: Collectors of American
Art (full edition of 100 prints purchased, 1956)

SCHARY, Susan. Painter. Born: Philadelphia, Pennsylvania
in 1936. Awards: Gimbel award (2 times). Collections:
City Hall, Philadelphia, Pennsylvania; Villanova University;
Temple University.

SCHAUFFLER, Margaret R. Painter. Born: Cleveland, Ohio
in 1896. Studied: Oberlin College; Cleveland School of
Art; Western Reserve University; also studied with
Forrest, Breckenridge and Warshawsky.

SCHELL, Dorothy. Painter.

SCHELL, Susan Gertrude. Painter. Studied: State Teachers
College, West Chester, Pennsylvania; Pennsylvania
Academy of Fine Arts. Awards: National Association of Women
Artists, 1936, 1940. Collections: New Britain Museum;
State Teachers College of Pennsylvania.

SCHESCH, Elizabeth Y. Painter. Born: Malden, Massachusetts
in 1913. Awards: Howland Memorial Library; American Artists
Professional League, fellowship.

SCHELE, Linda. Painter. Born: Nashville, Tennessee in 1942.
Collection: University of Cincinnati.

SCHETKY, Caroline. Painter. Born: in 1790 and died in 1852.
She was a landscape and flower watercolorist, a miniature
portrait painter and still-life painter. Her work was
flourishing in Philadelphia and Boston. She married T. M.
Richardson and exhibited at the Boston Athenaeum under that
name.

SCHIFFER, Ethel B. Illustrator, etcher and engraver. Born:
Brooklyn, New York in 1879. Studied: Art Students League;
Yale School of Fine Arts.

SCHILLE, Alice. Painter. Born: Columbus, Ohio. Studied:
Columbus Art School; Art Students League; New York School
of Art with Chase and Cox; at the Colarossi Academy in
Paris with Prinet, Collin and Courtois. Awards: Corcoran
prize, Washington Water Color Club, 1908; New York Woman's
Art Club; gold medal, Panama-Pacific Exposition, San
Francisco, 1915; Pennsylvania Academy of Fine Arts, 1915.

SCHLATER, Katharine. Painter. Studied: Philadelphia Museum
School of Industrial Art; and with Hugh Breckenridge and
Ralph M. Pearson. Collection: Fabric design for Celanese
Corporation.

SCHLEY, Mathilde G. Painter. Born: in Wisconsin in 1874.
Studied: with Lorenz.

SCHMEIDLER, Blanche J. Painter. Born: New York City in
1915. Studied: Hunter College; Columbia University;
Samuel Brecher Art School; Art Students League with
Sternberg and Vytlacil. Awards: National Association of
Women Artists; Jersey City Museum of Art, 1958.

SCHMID, Elsa. Painter. Born: Stuttgart, Germany in 1897.
Studied: Art Students League. Collections: Baltimore Museum
of Art; Newark Museum of Art; Fogg Museum of Art; Museum of
Modern Art; Yale University Chapel; Church of St. Brigid,
Peapack, New Jersey; United States Cemetery, Carthage,
Africa.

SCHMIDT, Katherine. Painter. Born: Xenia, Ohio in 1898. Studied: with Kenneth Hayes Miller.

SCHMITZ, Elizabeth T. Painter. Born: Philadelphia. Studied: Pennsylvania Academy of Fine Arts.

SCHNEIDER, Elsbeth. Painter. Born: Chicago, Illinois in 1904. Studied: University of California. Award: League of American Pen Women, 1937.

SCHNITTMAN, Sacha S. Sculptor. Born: New York City in 1913. Studied: Cooper Union Art School; National Academy of Design; Beaux-Arts Institute of Design; Columbia University; and with Attilio Piccirilli, Robert Aitken and Olympio Brindesi. Awards: Society of Independent Artists, 1942; City Art Museum of St. Louis, 1942; Junior League Missouri Exhibition, 1942; Kansas City Art Institute, 1942; Pan-American Architect Society, 1933; Fraser medal, 1937. Collections: Pan-American Society; American Museum of Natural History; Dayton Art Institute; Moscow State University, Russia; Memorial Plaza, St. Louis, Missouri; Dorsa Building, St. Louis, Missouri.

SCHOCH, Pearl. Painter. Born: New York City in 1894. Studied: Pratt Institute of Art School; New York University; Columbia University; and with Anna Fischer and Charles J. Martin and Morris Davidson. Award: Pen and Brush Club, 1952.

SCHOENFELD, Flora. Painter. She was exhibiting in 1921 in Philadelphia.

SCHOOLFIELD, Garcie M. Painter. Born: Knox, Indiana in 1915. Studied: Ringling School of Art; Art Institute of Chicago; University of Chicago; Texas State College for Women. Has had many exhibitions in Texas.

SCHOR, Rhea Iress. Painter. Born: New York City in 1906. Studied: Samuel Brecher School of Art; Lonzar School of Sculpture; Sculpture Center. Awards: Queens Fine Arts Society, 1950, 1952; Huntington Hartford fellowship, 1958. Collections: Columbia University; Barnard College; Dayton Art Institute.

SCHREIBER, Isabel. Painter. Born: Atchison, Kansas in 1902. Studied: Kansas University. Collections: Kansas State College; Dyche Museum, Lawrence, Kansas; Atchison Public School.

SCHUENEMANN, Mary B. Painter. Born: Philadelphia, Pennsylvania in 1898. Studied: University of Pennsylvania; Philadelphia Museum School of Industrial Art; Tyler School of Art; with John Lear, Ernest Thurn and Earl Horter. Awards: Plastic Club, 1945, 1946, 1952, 1953, 1954, 1955; Art Teachers Association, 1950. Collection: Philadelphia Public Schools.

SCHULTE, Antoinette. Painter. Born: New York City. Studied: Art Students League with George Bridgman, Homer Boss; Fontainebleau School of Fine Arts, Paris; and with Lopez Mezquita. Awards: Salons of America, 1931. Collections: Benjamin West Museum; Brooklyn Museum; Corcoran Gallery of Art; Newark Museum; Montclair Art Museum; Cincinnati Museum of Art; Metropolitan Museum of Art; French Government Collection: Aix-en-Provence, France.

SCHULZ, Ada W. Painter. Born: in 1870. She specialized in paintings of children.

SCHUSTER, Donna N. Painter. Studied: Art Institute of Chicago; and with Tarbell and Chase. Awards: gold medal, Minnesota State Art Exhibition, 1913; Minnesota State Art Exhibition, 1914; Northwestern Exhibition, St. Paul Institute, 1915; Panama-Pacific Exposition, San Francisco, 1915; Panama-California Exposition, San Diego, 1915;

SCHWAB, Edith Fisher. Painter. Born: Cincinnati, Ohio in 1862.

SCHWAB, Eloise M. Painter and etcher. Born: Havana, Cuba in 1894. Studied: in Paris; also studied with Kenneth Hayes Miller.

SCHWABACHER, Ethel K. Painter. Born: New York City in 1903. Studied: In Europe and with Max Weber, and Arshile Gorky. Collections: Whitney Museum of American Art; Rockefeller Institute.

SCHWARTZ, Elizabeth. Painter.

SCHWARTZ, Marjorie W. Painter. Born: Trenton, Tennessee in 1905. Studied: State Teachers College, Memphis, Tennessee; Newcomb College, Tulane University.

SCHWEBEL, Celia. Painter. Born: New York City in 1903. Studied: Art Students League with Kenneth Hayes Miller. Has exhibited in United States and Europe.

SCHWEIG, Aimee. Painter. Born: St. Louis, Missouri. Studied: St. Louis School of Fine Arts; Washington University; and with Charles Hawthorne and Henry Hensche. Collection: City Art Museum of St. Louis.

SCHWEITZER, Gertrude. Painter. Born: New York City
in 1911. Studied: Pratt Institute Art School; National
Academy of Design; Julian Academy, Paris. Awards:
Philadelphia Watercolor Club, 1936; Norton Art Gallery,
1946, 1947; Montclair Art Museum, 1947, 1952; Society of
Four Arts, 1947, 1948, 1950, 1951; Miami, Florida, 1951;
American Artists Professional League, 1953, 1956, 1957,
1934; American Watercolor Society, 1933. Collections:
Brooklyn Museum; Canajoharie Gallery of Art; Toledo
Museum of Art; Atlanta Art Association; Norton Gallery
of Art; Hackley Art Gallery; Davenport Municipal Art
Museum; High Museum of Art; Witte Memorial Museum;
Museum of Modern Art, Paris; Museum of Albi, France;
Montclair Art Museum.

SCHWINN, Barbara E. Painter. Born: Jersey City, New
Jersey in 1907. Studied: Parsons School of Design;
Grand Central Art School; Art Students League, with
Frank DuMond, Luigi Lucioni. Awards: Guild Hall, East
Hampton, New York; Art Directors Club. Contributed to
Ladies Home Journal; Good Housekeeping; Cosmopolitan;
McCalls and other magazines.

SCOLLAY, Catherine. Painter. Died in 1863. She was a
landscape and figure painter.

SCOTT, Anna Page. Painter. Studied: with Anshutz, Arthur
Dow; Colarossi Academy in Paris. Collection: Carnegie
Library, Dubuque.

SCOTT, Bertha. Painter. Born: Frankfort, Kentucky in
1884. Studied: Wellesley College; and with Anson Kent
Cross, Andrene Kauffman and Gerrit A. Beneker. She was
a portrait painter. Collection: Kentucky State Capitol.

SCOTT, Catherine. Painter. Born: Ottawa, Kansas in 1900.
Studied: Art Institute of Chicago.

SCOTT, Charlotte T. Painter. Born: East Liverpool, Ohio
in 1891. Studied: with Virginia B. Evans. Award:
Oglebay Mansion Museum of Art Festival, 1950. Collection:
Oglebay Mansion Museum.

SCOTT, Dorothy Carnine. Painter. Born: Hannaford, North
Dakota in 1903. Studied: Colorado College; University of
Chicago; Colorado Springs Fine Arts Center; Syracuse
University; and with Robinson, Snell, Lockwood and
Charman. Awards: Virginia Art Exhibition, 1939;
Lynchburg Civic Art League, 1937; Print of the Year,
Syracuse Printmakers, 1958. Collections: Sweet Briar
College; Bethel Hospital, Colorado Springs, Colorado;
Virginia Museum of Fine Arts; John Wyatt Junior School,
Lynchburg, Virginia.

SCOTT, Emily S. Painter. Born: Springwater, New York in 1832 and died in 1915. Studied: Art Students League; and in Paris. She was a painter of flowers. Collections: Metropolitan Museum of Art; Brooklyn Institute Museum.

SCOTT, Geraldine A. Painter. Born: Elkhart, Indiana in 1900. Studied: Northwestern University; New York School of Fine and Applied Arts; Parsons School of Design; and in Paris; Indiana University Center, Kokomo. Collections: Butler University; Carnegie Library, Kokomo; Carnegie Library, Tipton, Indiana; Indiana Federation Club; Northwestern University.

SCOTT, Jeannette. Painter. Born: Kincardine, Ontario in 1864. Studied: School of Design for Women; Pennsylvania Academy of Fine Arts; also studied in Paris; and at the Salon de Camps de Mars.

SCOTT, Katharine H. Painter. Born: Burlington, Iowa in 1871. Studied: with Vanderpoel and Chase. She was a portrait and miniature painter.

SCOTT, Stella Bradford. Painter and Lithographer. Born: Providence, Rhode Island in 1920. Studied: Rhode Island School of Design; Colorado Spring Fine Arts Center. Award: Rhode Island School of Design, 1941.

SCRUGGS-CARRUTH, Margaret Ann. Etcher. Born: Dallas, Texas. Studied: Bryn Mawr College; Southern Methodist University; and with Frank Reaugh and Ralph Person. Awards: Garden Center Flower exhibitions, Dallas, 1951-1955, 1958. Dallas Allied Artists, 1932. Collections: Elisabet Ney Museum; Corcoran Gallery of Art; American Embassy, Bucharest, Roumania; National Society of the Daughters of the American Revolution; Texas Federation of Garden Clubs Illustrations.

SCRUGGS-SPENCER, Mary. Painter. Born: Ancon, Panama in 1909. Awards: Beaumont Museum of Fine Arts; Texas Fine Arts Association; Junior Service League, Longview, Texas.

SCRYMSER, Christabel. Painter. She was exhibiting her miniatures at the Pennsylvania Academy of Fine Arts in 1925.

SCUDDER, Janet. Sculptor. Born: Terre Haute, Indiana in 1873 and died in 1940. Studied: Cincinnati Art Academy; Art Institute of Chicago; Vittis Academy; Colarossi Academy; and MacMonnies Studio in Paris. Awards: Chicago Exposition, 1893; St. Louis Exposition, 1904; Salon, Paris, 1911. Collections: Metropolitan Museum of Art; Paris Salon; Art Institute of Chicago; John Herron Institute, Indianapolis; Congressional Library, Washington; Peabody Institute; Baltimore.

Helen R. Searle, CHESTNUTS, 1848. Oil on paper, shown here actual size. Collection of S. L. Probasco, Jr.

SCULL, Nina W. Painter. Born: St. Petersburg, Russia, in 1902. Studied: Art Students League; Corcoran School of Art; Columbia University; and with Wayman Adams and George Elmer Browne. Collections: 100 Friends of Art, Pittsburgh; Imperial Gallery, Philadelphia; Pittsburgh Public Schools.

SEABURY, Roxoli. Painter. Born: in 1874. Studied with D. W. Ross, Robert Reid and Knirr in Munich; School of Boston Museum of Fine Arts.

SEAGER, Mrs. and Miss. Painters. Miniaturists who flourished in New York around 1834.

SEAGER, Sarah. Painter. A miniature and portrait painter who was active during the period 1833-1840.

SEARCY, Elisabeth. Painter. Born: Memphis, Tennessee. Collections: Library of Congress; Metropolitan Museum of Art; Museum of the City of New York; Museum of Art, Helena, Arkansas; Brooklyn Memorial Art Gallery; Phillips Collection, Washington, D. C.

SEARLE, Alice T. Painter. Born: Troy, New York in 1869. Studied: Art Students League; Colarossi Academy in Paris. She was a miniature painter.

SEARLE, Helen R. Painter. Born: Rochester, New York around 1827 and died in 1886. Studied: In Paris and Dusseldorf, Germany in 1849. She is noted for her still-life painting. She was the second wife of James William Pattison a noted American Artist.

SEARS, Sarah C. Painter. Born: Cambridge, Massachusetts in 1858. Studied: Cowles Art School; Boston Museum of Fine Arts. Awards: William T. Evans prize, 1892; Chicago Exposition, 1893; Paris Exposition, 1900; Buffalo Exposition, 1901.

SECKAR, Alvena V. Painter. Born: McMechen, West Virginia in 1916. Studied: Philadelphia Museum School of Industrial Art; New York University; and with Walter Emerson Baum, Sol Wilson and Phil Reisman. Awards: Herald Tribune Book Festival; Montclair Art Museum, 1957.

SEIDLER, Doris. Painter. Born: London, England in 1912. Studied: with Stanley W. Hayter. Awards: National Association of Women Artists; Washington Watercolor Club; Chicago Society of Etchers. She was also an etcher and engraver. Collections: Seattle Art Museum; Library of Congress; Hofstra College, New York; Philadelphia Museum of Art.

SEIPP, Alice. Painter and illustrator. Born: New York City in 1889. Studied: With Douglas Volk, B. W. Clinedinst and Jane Peterson.

SEKULA, Sonia. Painter. Born: Lucerne, Switzerland in 1918. Studied: Art Students League; and with Morris Kantor and Kurt Roesch; also in Italy. Collections: San Francisco Museum of Art; Brooklyn Museum.

SELDEN, Dixie. Painter and illustrator. Born: Cincinnati, Ohio. Studied: Cincinnati Art Academy with Duveneck; also studied with Snell and Chase.

SELLECK, Margaret. Painter. Born: Salt Lake City, Utah in 1892. Studied: Art Institute of Chicago; University of Wisconsin; Western University; and with Dudley Crafts Watson, Rudolph Weisenborn and Oskar Gross. Award: Allied Illinois Society of Fine Arts, 1934.

SELLERS, Mary. Painter. Born: Pittsburgh, Pennsylvania in 1869. Studied: with Alexander Robinson and August Hennicott in Holland.

SENIOR, Dorothy E. Painter. Awards: Contemporary Art Association, Providence, Rhode Island; Garden City, Rhode Island; Cranston, Rhode Island, Slater Mill Museum, Pawtucket, Rhode Island; National Arts Club, New York; South County Arts Association, Rhode Island. Collection: Admiral Inn, Cumberland, Rhode Island.

SERPELL, Susan W. Painter. Born: Born in California in 1875 and died in 1913. In 1912 she received many awards for her work.

SERRAO, Luella V. Sculptor. Born: Angola, New York in 1865. Collections: Roman Catholic Cathedral, Odessa, Russia; State Capitol of Minnesota; Seaton Hall, Newark, New Jersey; Cleveland Public Library; Catholic Cathedral, Cleveland, Ohio.

SEVERANCE, Julia G. Sculptor and etcher. Born: Oberlin, Ohio in 1877. Studied: Art Institute of Chicago; Art Students League; Oberlin College; Cleveland School of Art. Collections: Oberlin Conservatory of Music, Oberlin College, Ohio; Library of Congress, Washington, D. C.; Warner Hall Oberlin, Ohio; St. Mary's School, Knoxville, Illinois.

SEWALL, Blanche H. Painter. Born: Fort Worth Texas in 1889. Studied: with Fred Wagner.

SEWELL, Amanda B. Painter. Born: Essex County, New York.
Studied: Art Students League; and with Julien and Carolus-
Duran in Paris. Awards: National Academy of Design, 1888,
1903; Chicago Exposition. She was a 19th Century portrait
painter.

SEWELL, Harriet. Painter. A genre watercolorist working
around 1810.

SEWELL, Helen M. Painter. She was exhibiting in 1921 at
the Pennsylvania Academy of Fine Arts.

SEWELL, Lydia A. Painter. Born: in 1859 and died in 1926.

SEYFFERT, Helen F. Painter.

SHACKELFORD, Katharine B. Painter. Born: Fort Benton,
Montana. Studied: Montana State College; University of
California; and with Nicolai Fechin. Awards: Glendale Art
Association, 1953-1955; Women Painters of the West, 1954.

SHAFER, Elizabeth Dodds. Painter. Born: Cairo, Illinois
in 1913. Studied: Butler University; and with Wayman Adams
and Jerry Farnsworth. Awards: Indiana State Fair, 1949,
1952, 1954, 1957; Hoosier Salon, 1951, 1955, 1956;
Indiana Art Club, 1953, 1954, 1955, 1957; Michiana Regional,
1956.

SHANNON, Ailleen P. Painter. Born: Gillsburg, Mississippi
in 1888. Studied: Pennsylvania Academy of Fine Arts;
Chicago Academy of Fine Arts; and with Chase, Adams and
Ginther; Julian Academy, in Paris; Art Instruction,
Incorporated, Minneapolis. Collections: Mississippi Art
Association; Rock Springs Wyoming Art Association; New
Mexico State College; Brannigan Memorial Library, Las
Cruces, New Mexico.

SHARP, Marion L. Painter. Born: New York City. Studied:
Art Students League; and with Lucia Fairchild Fuller.
Awards: National League of American Pen Women, 1938;
National Collections of Fine Arts, Washington, D. C., 1946,
1952.

SHARPE, Julia G. Painter and designer. Born: Indianapolis,
Indiana. Studied: Art Students League; Indiana School of
Art; also studied with William M. Chase, J. Otis Adams,
William Forsyth, H. Siddons Mowbray and Saint Gaudens.

SHARPLES, (Ellen) Mrs. James. Painter. Born: Birmingham,
England in 1769 and died in 1849. She was a noted portrait
painter and draughtsman in pastels. She copied her husbands
portraits faithfully in the exact size. She founded the
Bristol Fine Arts Academy and the Sharples Collection of
ninety-seven pictures of her husband, herself and children
which are there today.

SHAW, Alice H. Painter and etcher. Born: Portland, Maine
in 1913. Studied: School of Fine and Applied Art,
Portland, Maine; and with Alexander Bower. Collection:
Farnsworth Museum, Rockland, Maine.

SHAW, Annie Cornelia. Painter. Born: West Troy, New York
in 1852 and died in 1887. Studied: in Chicago. She was
a landscape artist.

SHAW, Elsa V. Painter. Born: Cleveland, Ohio in 1891.
Studied: Cleveland School of Art; and with Henry Keller
and Charles Hawthorne. Awards: Cleveland Museum of Art,
1923, 1927, 1929, 1932, 1934, 1937, 1944, 1945, 1955;
Dayton Art Institute, 1934; Collection: Severance Hall,
Cleveland, Ohio; Steamship President Polk.

SHAW, Harriet McCreary. Painter. Born: in 1865. Known as
a portrait and miniature painter.

SHAW, Lois Hogue. Painter. Born: Merkel, Texas in 1897.
Studied. Art Institute of Chicago; Baylor College; Art
Students League; and with John Sloan. Awards: Texas Fine
Arts Association; West Texas Art Association; Fort Worth.
Collection: Sweetwater High School.

SHEA, Aileen O. Painter. Born: Philadelphia, Pennsylvania
in 1911. Studied: National Academy of Design; Sorbonne,
Paris, France. Award: Pulitzer Traveling scholarship,
1935.

SHEAFER, Frances B. Painter. Born: in Pennsylvania.
Studied: Pennsylvania Academy of Fine Arts; Philadelphia
School of Design for Women. Award: St. Louis Exposition,
1904.

SHEERER, Mary G. Painter. Born: Covington, Kentucky in
1867. Studied: Cincinnati Art Academy; Pennsylvania Academy
of Fine Arts.

SHEETS, Mrs. F. C. Painter. Born: Albany, Illinois in 1885.
Studied: with John Carlsen and Robert Reid.

SHELDON, Lucy. Painter. Born: in 1788 and died in 1889.
She was an amateur genre painter.

SHERINYAN, Elizabeth. Painter. Born: in Armenia. Studied:
with Hale, Murphy, Major and Greenwood; also studied at
Worcester Museum School; Massachusetts Normal Art School.

SHERMAN, Ella B. Painter. Born: New York City. Studied:
with Douglas Volk, William M. Chase and Robert Henri.

SHERMAN, Florence Taylor. Painter. Born: Boston,
Massachusetts in 1911. Studied: Boston Museum of Fine
Arts School; with Philip Hale, Florence Spaulding, and
Bernard Keyes. Awards: Florida Federation of Art, 1937;
Miami Art League, 1941, 1942, 1944; American Artists
Professional League, 1941, 1943, 1944.

SHERMAN, Lucy McFarland. Painter. Born: in 1838 and
died in 1878. She was an amateur water color artist.

SHERMAN, Mrs. P. A. Painter. She was a still-life
(fruit and flowers) artist who was exhibiting in 1860.

SHERMAN, Winnie B. Painter. Born: New York City in 1902.
Studied: Columbia University; Cooper Union Art School;
National Academy of Design; Art Students League. Awards:
American Artist magazine, 1953; New Rochelle Art
Association; Westchester County Federation of Women's
Clubs, 1954; Westchester Arts and Crafts, 1954; Florida
Southern College, 1952; New Rochelle Women's Club, 1954,
1957. Collections: Seton Hall University Library; Grand
Central Art Gallery; Grumbacher Collection; International
Business Machines.

SHERWOOD, Bette W. Painter. Born: Sheffield, Alabama in
1921. Collections: Acquisition for soon to be built
Museum at birth site of Helen Keller, Alabama.

SHERWOOD, Mary C. Painter and illustrator. Born: in France
in 1868. Studied: Art Students League with Weir and Chase.

SHERWOOD, Rosina E. Painter and illustrator. Born: New York
in 1854. Studied: with William Chase in New York; Julien
Academy, Paris. Awards: Paris Exposition, 1889; Chicago
Exposition, 1893, Buffalo Exposition, 1901; St. Louis
Exposition, 1904.

SHERWOOD, Ruth. Sculptor. Born: in Chicago in 1889.
Studied: Art Institute of Chicago.

SHIBLEY, Gertrude. Painter. Born: New York City in 1916.
Studied: Brooklyn College with Francis Criss; Hans Hofmann
School of Fine Art. Award: Village Art Center, 1949.

SHIFF, E. Madeline. Painter. Born: Denver, Colorado.
Studied: Adelphi College; Art Students League. Award:
Charlotte R. Smith memorial award, Baltimore, Maryland,
1923. Collection: Whitney Museum of American Art.

SHIRK, Jeannette C. Painter. She exhibited water colors
at the Pennsylvania Academy of Fine Arts in 1925.

SHONNARD, Eugenie F. Sculptor. Born: Yonkers, New York
in 1886. Studied: Art Students League; and with Rodin and
Bourdelle in Paris. Award: New Mexico State Fair, 1940,
1941. Collections: Tingley Hospital for Crippled Children,
Hot Springs, New Mexico; Luxembourg Museum, Paris;
Metropolitan Museum of Art; Cleveland Museum of Art;
Colorado Springs Fine Arts Center; Brookgreen Gardens,
South Carolina; Catholic Seminary, Santa, Fe; Supreme
Court, Santa Fe; Presbyterian Hospital, Albuquerque,
New Mexico; Statue, St. Francis, Denver, Colorado;
St. Andrews Episcopal Church, Las Cruces, New Mexico;
International Business Machines collection.

SHOOK, Janet. Painter. Born: Austin, Texas in 1912.
Studied: Incarnate Word College; and with Hugo Pohl,
Dan Lutz and Alice Naylor. Awards: Texas Fine Arts
Festival, Austin, 1953; Texas Watercolor Society, 1954;
San Angelo Museum of Art, 1954.

SHORE, Clover V. Painter. Born: Durango, Texas in 1906.
Awards: Texas Fine Arts Association; Fort Worth Art
Center Show; West Texas Annual Show, Abilene. Collection:
Central Museum, Utrecht, Netherlands.

SHORE, Henrietta M. Painter. Born: in Canada. Studied:
with Henri and Chase; also studied in London. Collection:
National Gallery of Canada.

SHOTWELL, Helen H. Painter and photographer. Born: New
York City in 1908. Studied: painting with Henry Lee McFee;
photography with Flora Pitt Conrey. Collections: Albert
Schweitzer Foundation; Fitchburg Art Museum; International
Business Machines Collection; China Institute, New York.

SHOVER, Edna M. Painter. Born: Indianapolis, Indiana.
Studied: Philadelphia Museum School of Industrial Art.
Award: Philadelphia Museum School of Industiral Art. Also
a well-known designer she was the author of "Art in Costume
Design."

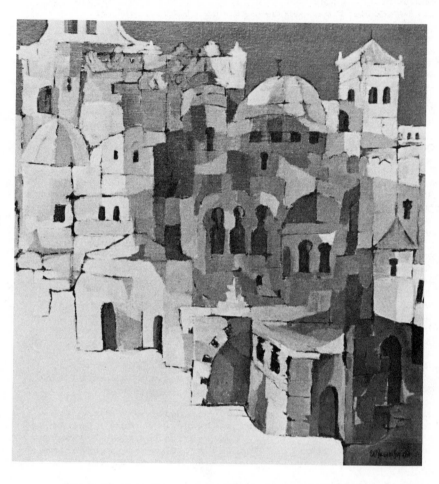

Elizabeth Shumacker, CADIZ, 1971. Polymer on canvas, 30" X 34". Collection of Harold and Myra Shapiro.

SHUFF, Lily. Painter and engraver. Born: New York City. Studied: Hunter College; Art Students League; Brooklyn Academy of Fine Arts; Farnsworth School of Art; and with Jon Corbino. Awards: Brooklyn Society of Art, 1953, 1957; New Jersey Society of Painters and Sculptors, 1956; Caravan Gallery, 1958; National Association of Women Artists, 1958; Connecticut Academy of Fine Arts, 1956. Collections: Pakistan Consulate, New York; Lane College, New York; James Fennimore Cooper High School; Georgia Museum of Fine Arts; Yale University; Mueller Collection, Paris, France.

SHULZ, Ada Walter. Painter. Born: Terre Haute, Indiana in 1870. Studied: Art Institute of Chicago; Vitti Academy in Paris. Collections: Milwaukee Art Institute; Art Institute of Chicago.

SHULZ, Alberta Rehm. Painter. Born: Indianapolis, Indiana in 1892. Studied: Butler University; University of Texas; Indiana University; Herron Art Institute; Ringling School of Art; and with Adolph Shulz and C. Curry Bohm. Has exhibited in Indiana and Florida.

SHUMACKER, Elizabeth Wight. Painter. Born: Chattanooga, Tennessee in 1912. Studied: University of Chattanooga with Frank Baisden; also with Stuart Purser, Weimer Purcell, George Cress and Joe Robertson; studied graphics with Carolyn Hilton; also studied at the Hunter Gallery of Art with Gray Phillips, James Watson and Alan Kuzmickie. Collections: High Museum, Atlanta; Brooks Memorial Gallery, Memphis; First National Bank of Little Rock; New York Times; South Central Bell, Birmingham.

SHUMATE, Jessamine W. Painter and serigrapher. Born: Martinsville, Virginia. Studied: University of North Carolina Woman's College; University of Virginia; Art Students League. Awards: Virginia Museum of Fine Arts; Association of University Women, Roanoke, Virginia, 1956; Virginia Highlands Festival, 1956. Collections: Virginia Museum of Fine Arts; University of North Carolina Woman's College.

SHURTLEFF, Elizabeth. Painter. Born: Concord, New Hampshire in 1890. Studied: Boston Museum School of Fine Arts.

SHUTE, Nell C. Painter. Born: Athens, Georgia in 1900. Studied: Hollins College; Atlanta Art Institute; Parsons School of Fine and Applied Arts; and in Paris at Fontainebleau. Award: High Museum of Art.

SHUTTLEWORTH, Claire. Painter. Born: In Buffalo. Studied:
Art Students League, Buffalo; also studied with DuMond and
Bridgman; and with Merson, Collin and Leroy in Paris.
Award: fellowship prize, Buffalo Society of Artists, 1910.
Collection: Arnot Art Gallery, Elmira, New York.

SIBLEY, Marguerite. Sculptor. Born: Butler, Indiana.
Studied: Minneapolis School of Art; Grande Chaumiere, Paris;
Rockford College; also studied with Marques Reitzel,
Stephen Beams and others. Collections: Burpee Art Gallery,
Rockford, Illinois; Chicago Temple, Chicago, Illinois;
Emanuel Episcopal Church, Rockford, Illinois.

SIBONI, Emma. Painter. A miniaturist who exhibited at the
Pennsylvania Academy of Fine Arts in 1925.

SICKMAN, Jessalee B. Painter. Born: Denver, Colorado in
1905. Studied: University of Colorado; Goucher College;
Corcoran School of Art. Awards: Corcoran School of Art, 1941;
Barney prize, Washington, D. C. 1945. Collection: Corcoran
Gallery of Art.

SIEBERNS, Caroline Lenore. Painter. Born: Spring Valley,
Wisconsin in 1911. Studied: Minneapolis School of Art;
Columbia University; and with B. J. O. Nordfeldt, Dong
Kingman and others. Awards: San Diego Fine Arts Society,
1940, 1941; Spanish Village Art Center, 1958. Collections:
Academy of the Holy Angels, Minneapolis, Minnesota; Hotel
Bella Vista, Cuernavaca, Mexico; President Aleman's Rancho
Florido.

SIGISMUND, Violet. Painter and lithographer. Born: New
York City. Studied: Art Students League. Awards: Village
Art Center; Knickerbocker Art, 1952.

SILKOTCH, Mary Ellen. Painter. Born: New York City in 1911.
Studied: Van Emburgh School of Art, Plainfield, New Jersey;
and with Jonas Lie, Sigismund Ivanowski. Awards: Plainfield
Art Association, 1950, 1952, 1955-1958; American Artists
Professional League, 1951; East Orange, New Jersey, 1952.

SILSBEE, Martha. Painter. Born: Salem, Massachusetts in
1858. She was a watercolorist.

SILVAN, Rita. Painter. Born: Minneapolis, Minnesota in
1928. Studied: University of Minnesota; University of
New York Graduate School; and with Paul Burlin, Ralston
Crawford and Cameron Booth. Awards: Minnesota State Fair,
1948, 1949.

SILVERCRUYS, Suzanne. Sculptor. Born: Maeseyck, Belgium.
Studied: Yale School of Fine Arts; and in Belgium, and
England. Awards: Temple University, 1942; Rome Aluminum
prize, 1928; Beaux-Arts Institute of Design, 1927.
Collections: Louvain Library; McGill University, Canada;
Yale School of Medicine; Reconstruction Hospital, New
York; First Lutheran Church, New Haven, Connecticut;
Duell award for New York Press Photographers Association;
Rumford Rhode Island Memorial; Government House, Ottawa,
Canada; Metropolitan Museum of Art; Amelia Earhart Trophy
for Zonta Club; Queen Astrid Memorial, Brussels; war
memorial, Shawinigan Falls, Canada; gold medal, presented
by Young Democrats to James Farley.

SIMES, Mary Jane. Painter. Born: in 1807 and died in
1872. She was a miniature painter whose work flourished in
Baltimore, Maryland during the period 1826-31. She was
the grand-daughter of James Peale.

SIMKHOVITCH, Helena. Sculptor. Born: New York City.
Studied: in Paris. Awards: Palmes Academiques; Officier
de l'Instruction Publique, Paris, 1955. Collections:
Whitney Museum of American Art; Wadsworth Atheneum.

SIMONSON, Marion. Painter. Born: New York City in 1913.
Studied: Phoenix Art Institute; Art Students League;
Grand Central Art School; Farnsworth School of Art; Also
studied with Jay Connaway. Awards: National Academy of
Design, 1941, 1942; Hudson Valley Art Association, 1954.
Collections: American University, Cairo, Egypt; Domestic
Relations Court, Birmingham, Alabama; Hunter College High
School; Denville Memorial Library, Denville, New Jersey;
Baptist Foreign Mission Board, Richmond, Virginia.

SIMPSON, Edna. Painter. A miniature painter who exhibited
her work at the Pennsylvania Academy of Fine Arts in 1925.

SIMPSON, Marilyn J. Painter. Award: Guild of Northwest
Florida.

SIMPSON-MIDDLEMAN, Roslynn. Painter. Born: Philadelphia,
Pennsylvania in 1929. Studied: New Jersey College for
Women; Newark School of Fine and Industrial Art; and
with W. Benda; also studied with R. Nakian and B. Gussow.
Collections: Metropolitan Museum of Art; Whitney Museum
of American Art; Newark Museum of Art.

SIMS, Agnes. Painter. Born: Rosemont, Pennsylvania in
1910. Studied: Philadelphia School of Design for Women;
Pennsylvania Academy of Fine Arts. Awards: American
Philosophical Society grant, 1949; Neosho grant, 1952.
Collections: Museum of New Mexico; Colorado Springs Fine
Arts Center; Denver Art Museum; Brooklyn Museum; Musee de
L'Homme, Paris.

SIMS, Florence. Painter. Born: Birmingham, Alabama in 1891.
Studied: Yale University. She was a miniature painter.
Awards: Pennsylvania Society of Miniature Painters, 1951.

SINCLAIR, Ellen C. Painter and Graphic artist. Born:
Philadelphia, Pennsylvania in 1907. Studied: Pennsylvania
Academy of Fine Arts; Colorassi Academy, Paris, France;
Barnes Foundation. Awards: Cresson traveling scholarship,
1930, 1931; Pennsylvania Academy of Fine Arts, 1932;
Indianapolis Art Association, 1938; Toledo Museum of Art,
1953; Downtown Exhibition, Toledo, 1955. Collections:
Pennsylvania Academy of Fine Arts; Toledo Federation of Art
collection.

SINGER, Burr. Painter and Lithographer. Born: St. Louis,
Missouri. Studied: St. Louis School of Fine Arts; Art
Institute of Chicago; Art Students League and Waltar Ufer.
Awards: Marineland Exhibition, 1955; Los Angeles County
Fair, 1951, 1953. Collection: Warren Flynn School,
Clayton, Missouri; Library of Congress; Beverly-Fairfax
Jewish Community Center, Los Angeles; Child Guidance Clinic,
Los Angeles.

SIRENA-CONTESSA ANTONIA MASTROCISTINO FANARA. Born: White
Plains, New York. Awards: Appolo II Award, Rome; Amita
Award, United States of America; Metal of Vatican.
Collections: Museum of Modern Art, Castello Storzesco,
Milan.

SKEELE, Anna K. Painter. Born: Wellington, Ohio. Studied:
Art Students League; Academy of Fine Arts, Florence, Italy;
also studied with Andre L'Hote in Paris. Awards: Madonna
Festival, Los Angeles, 1952; San Diego Fine Arts Society,
1930, 1933; Sacremento State Fair, 1930; Pomona County
Fair, 1930; Los Angeles Museum of Art. Collections: San
Diego Fine Arts Society; Los Angeles Museum of Art; Torrance
California High School.

SKELTON, Phillis H. Painter. Born: Pittsburgh, Pennsylvania
in 1898. Studied: University of Southern California; Scripps
Graduate College; also with Eliot O'Hara, Phil Dike, Millard
Sheets and Dong Kingman. Awards: California Watercolor
Society; American Watercolor Society. Collection: Pasadena
Art Museum.

SKINNER, Frances J. Painter. Born: Dallas, Texas. Studied:
Boston Museum of Fine Arts School; Chouinard Art Institute;
and with Everett Spruce. Awards: Dallas Museum of Fine Arts,
1940, 1941; Museum of Fine Arts of Houston, 1943; Texas Fine
Arts Association, 1943, 1948; Texas General, 1947; National
Association of Women Artists, 1945, 1949. Collections:
Dallas Museum of Fine Arts; Dallas Public School Collection;
Museum of Fine Arts of Houston; Texas Fine Arts Association.

SKLAR, Dorothy. Painter. Born: New York City. Studied:
University of California at Los Angeles. Awards: Alabama
Watercolor Society, 1944-1946; New Orleans Art Association,
1946, 1950, 1951; Laguna Beach Art Association, 1945-1947,
1952, 1954, 1957; California Art Club, 1949, 1951, 1953,
1954; Madonna Festival, 1955; Westwood Art Association,
1953, 1957; Santa Monica, 1946; National Association of
Women Artists, 1957; Women Painters of the West, 1958.

SLADE, Cora L. Painter. Studied: with Robert S. Dunning.

SLEETH, L. Mac D. (Mrs. Francis V.) Painter and sculptor.
Born: Croton, Iowa in 1864. Studied: with Whistler,
Mac Monies and Emil Carlsen. Collections: Corcoran Gallery
of Art; Memorial Continental Hall, Washington, D. C.;
Cathedral Foundation, Washington, D.C.

SLOAN, Marianna. Painter. Born: Lock Haven, Pennsylvania.
Studied: with Robert Henri and Elliott Daingerfield.
Awards: St. Louis Exposition, 1904. Collections: St. Louis
Club; Pennsylvania Academy of Fine Arts; Church of the
Annunciation, Philadelphia; St. Thomas Church, Whitemarsh,
Pennsylvania.

SLOCUM, Annette M. Sculptor. Born: Cleveland, Ohio.
Studied: Pennsylvania Academy of Fine Arts. Her specialty
is portraiture.

SLOPER, Norma. Painter. Born: New Haven, Connecticut in
1892. Studied: with A. E. Jones; and with Lucien Simon
and Rene Menard in Paris.

SLUTZ, Helen B. Painter. Born: Cleveland, Ohio in 1886.
Studied: Cleveland School of Art.

SMALL, Amy G. Sculptor. Born: New York City in 1915.
Studied: Hartford Art School; Art Students League;
National Park College; and with Seymour Lipton.

SMALL, Hannah L. Sculptor. Born: New York City in 1908.
Studied: Art Students League. Award: Art Institute of
Chicago, 1940. Collection: University of Nebraska.

SMALLEY, Janet. Illustrator.

SMART, Anna M. Painter. Born: in 1847 and died in 1914. Her specialty was water colors.

SMILLIE, Helen S. Painter. Born: New York in 1854. Studied: with Joseph O. Eaton and James D. Smillie. She was a painter of genre pictures in oil and water colors.

SMITH, Alice R. Painter and Illustrator. Born: Charleston, South Carolina in 1876. Her specialty was water colors and wood block prints.

SMITH, Anita M. Painter. Was exhibiting in New York and Pennsylvania in 1923.

SMITH, Anne Fry. Painter. Born: Philadelphia, Pennsylvania in 1890. Studied: with Fred Wagner.

SMITH, Mrs. Creagh. Painter. A religious and portrait painter who was exhibiting during the period 1860 and 1962.

SMITH, Ella B. Painter. She exhibited "The Long Wharf" at the Pennsylvania Academy of Fine Arts, Philadelphia in 1915.

SMITH, Emily G. Painter. Born: Ft. Worth, Texas in 1909. Studied: Texas State College for Women; Oklahoma University; Art Students League with Robert Brackman. Awards: West Texas annual, 1953; Ft. Work Art Association, 1955, 1957. Collections: Dallas Museum of Fine Arts; Ft. Worth Museum of Art; Lubbock Museum of Art; Lone State Gas Company; Eagle Mountain Marine Base; Ridgelea Country Club; Radio Station KFJZ; Western Hills Hotel; Kent Motor Company; Panther Oil Company; All Saints Hospital, Ft. Worth.

SMITH, Esther. Painter. Born: in Connecticut. Studied: with Edwin White in New York. As a portrait painter her specialty was children.

SMITH, Eunice H. Painter. Born: Mamaroneck, New York in 1911. Studied: Syracuse University; Art Students League. She as a portrait painter has worked here in the United States and abroad.

SMITH, Gertrude R. Painter. Born: Cambridge, Massachusetts. Studied: Massachusetts Normal Art School; Chase School, New York; also in Paris. Collections: Delgado Museum of Art; Louisiana State Museum, New Orleans. Her specialty, Landscapes and designs.

SMITH, Harriet F. Painter. Born: Worcester, Massachusetts in 1873. Studied: Massachusetts Normal Art School; and with Snell, Ross, Hamilton, Hale and Woodbury.

SMITH, Helen L. Painter. Born: Frederick, Maryland in 1894.
Studied: Maryland Institute of Art and Design. Collections:
Masonic Temple, Frederick, Maryland; Unionville Church,
Burkettsville, Maryland; Methodist Church, Livertytown,
Maryland; University of Virginia Masonic Temple, Frederick
and Baltimore, Maryland; Hood College; Maryland State School
for the Deaf; Frederick Memorial Hospital; University of
Maryland; First Baptist Church, Frederick, Maryland.

SMITH, Isabel E. Painter. Born: Smith's Landing, near
Cincinnati, Ohio. Studied: in Paris with L'hermitte,
Deliance and Callot.

SMITH, Jessie Willcox. Painter and illustrator. Born:
Philadelphia, Pennsylvania. Studied: Pennsylvania Academy
of Fine Arts; Drexel Institute with Howard Pyle. Awards:
Charleston Exposition, 1902; Pennsylvania Academy of Fine
Arts, 1903; St. Louis Exposition, 1904; Panama-Pacific
Exposition, San Francisco, 1915. Her specialty, paintings
and illustrations of children.

SMITH, Mary. Painter. Born: in 1842 and died in 1878.
She was a flower, animal and landscape painter.

SMITH, Minna W. Painter. Born: New Haven, Connecticut in
1883. Studied: Yale School of Fine Arts. Awards: Ogunquit
Art Center, 1932; New Haven Paint and Clay Club. Collection:
Wesleyan College Art Museum, Macon, Georgia.

SMITH, Miriam T. Painter. Born: Norwood, Pennsylvania.
Studied: Philadelphia Museum School of Industrial Art,
Philadelphia; and with Arthur Carles. Awards: Philadelphia
Sketch Club, 1940; Philadelphia Museum School of Industrial
Art, 1933. Collections: Lutheran Church, Norwood,
Pennsylvania; New York Central and Santa Fe railways;
Children's Ward, University of Pennsylvania Hospital.

SMITH, Mrs. Tryphena G. Painter. Born: in 1801 and died
in 1836. She was an amateur watercolorist and muralist.

SMITH, Violet Thompson. Painter. She was a miniature painter
who exhibited her work at the Pennsylvania Academy of Fine
Arts in 1925.

SMITH, Wuanita. Painter and illustrator. Born: Philadelphia,
Pennsylvania in 1866. Studied: Philadelphia School of
Design for Women; Pennsylvania Academy of Fine Arts; Art
Students League; and in Paris. Awards: fellowship,
Pennsylvania Academy of Fine Arts; Philadelphia Printmakers
Club; New Haven Paint and Clay Club; Irvington, New Jersey
Art Association. Collections: Library of Congress; Oklahoma
Art Center; Scranton Museum of Art and Science; Philadelphia
School of Design for Women; Philadelphia Museum of Art.

SMUL, Ethel L. Painter. Born: New York City in 1897.
Studied: Hunter College; Art Students League; and with
Brackman, Olinsky and Robinson.

SMYTH, Margarita P. Painter. Born: Newburgh, New York
in 1873. Studied: with Abbott H. Thayer.

SNEAD, Louise W. Painter. Born: Charleston, South
Carolina. Studied: Art Students League; and with Chase.
She was also an illustrator and a miniaturist.

SNELL, Florence B. Painter. She exhibited in 1915 at the
Pennsylvania Academy of Fine Arts.

SNOW, Jenny Emily. Painter. She was a painter of religious
subjects and landscapes working around 1845.

SNOW, Mary R. Painter. Born: Logan, Utah in 1908. Studied:
University of Utah; Corcoran School of Art; Art Students
League; Otis Art Institute; and in Paris. Awards: Society
of Washington Artists, 1952; Washington Art Club, 1952.

SOCHOR, Bozena. Painter. Born: Sonov, Czechoslovakia in
1901. Studied: Pennsylvania State College; Carnegie
Institute.

SOHIER, Alice Ruggies. Painter. Born: Quincy, Massachusetts
in 1880. Studied: School of Boston Museum of Fine Arts
with Tarbell; in Buffalo; and in Europe. Award: Panama-
Pacific Exposition, San Francisco, 1915.

SOMMER, A. Evelyn. Painter. Born: Jersey City, New Jersey.
Studied: Maryland Institute; John Hopkins University;
Columbia University; Woodstock, New York; Provincetown,
Massachusetts; also studied with Albert Heckman, Emil Ganso.

SOMMERBURG, Miriam. Sculptor. Born: Hamburg, Germany in
1910. Studied: with Friedrich Adler, Richard Luksch in
Germany. Awards: Florida Southern College, 1952; Village
Art Center, 1948, 1949, 1950, 1951, 1957; Creative Art
Gallery, 1950; New Jersey Painters and Sculptors, 1955;
Knickerbocker Art, 1954. Collections: Florida Southern
College; Springfield Missouri Art Museum; Metropolitan
Museum of Art.

SORENSON-DIEMAN, Clara. Sculptor. Born: Indianapolis,
Indiana in 1877. Studied: with Lorado Taft and Victor
Brenner. Collections:Shortridge High School, Indianapolis.
Art Association, Ceuar Rapids, Iowa; Young Mens Christian
Association, Cedar Rapids, Iowa.

SOUDER, Bertha. Painter. Born: La Crosse, Wisconsin in
1914. Studied: with Frank LaVanco, Gerald Foster, Joachim
Loeber and Maxwell Simpson. Awards: Rahway Art Center, 1954;
Westfield Art Association, 1955; American Veterans Society
of Art, 1957; St. John's Exhibition, Elizabeth, New Jersey,
1958;American Artists Professional League, 1958; Patrons
award, South Orange Art Gallery, 1958.

SOULE, Clara. Painter. She was executing her portrait
paintings in 1859.

SOULE, Octavia. Painter. Watercolorist and porcelain
painter working around the mid 1800s.

SOUTHWICK, Jeanie Lea. Painter. Born: Worcester,
Massachusetts. Studied: with Shurtleff, Ross Turner,
Woodbury and Chase; also studied in Paris with Carmine.
Her specialty, water colors.

SOUTHWICK, Katherine. Painter and illustrator. Born:
Buxton, Maine in 1887. Studied: Chicago Academy of Fine
Arts; Art Institute of Chicago. Award: Cresson traveling
scholarship, Pennsylvania Academy of Fine Arts, 1911-13.

SOUTHWORTH, Helen M. Painter. Born: Detroit, Michigan.
Studied: with Justin Pardi, Guy Wiggins. Awards:
Philadelphia Plastic Club, 1949, 1951, 1955, 1957; Florida
Southern College, 1952. Collections: Allentown Pennsylvania
Museum of Art; Woodmere Art Gallery.

SOWERS, Miriam. Painter. Born: Bluffton, Ohio in 1922.
Studied: University of Miami; Art Institute of Chicago.
Awards: Toledo Museum of Art, 1952; New mexico Art League,
1954. Collections: National Museum, Israel; Findlay Ohio
College; Lovelace Clinic, Albuquerque.

SOWINSKI, Jan. Sculptor. Born: Opatow, Poland in 1885.
Studied: Beaux-Arts Institute of Design; and in Poland.
Award: Beaux-Arts Institute of Design. Collection:
St. Stephen's Church, Paterson, New Jersey; Trinity Church,
Utica, New York.

SPAETH, Marie Houghton. Painter. Born: Hanover, New Hampshire. Her specialty, portraits of children. Collection: Pennsylvania Academy of Fine Arts.

SPALDING, Elisabeth. Painter. Born: Erie, Pennsylvania. Studied: Pennsylvania Academy of Fine Arts; Art Students League. A landscape painter chiefly. Collection: Denver Art Association; Erie Art Club.

SPALDING, Grace. Painter. She exhibited at the Pennsylvania Academy of Fine Arts in 1924.

SPARHAWK-JONES, Elizabeth. Painter. Born: Baltimore, Maryland in 1885. Awards: Cresson scholarship, Pennsylvania Academy of Fine Arts School; Charles Toppen prize, Pennsylvania Academy of Fine Arts; Mary Smith prize, 1908, 1912, Pennsylvania Academy of Fine Arts; Carnegie Institute, Pittsburgh, 1909. Collection: Art Institute of Chicago.

SPEAKMAN, Esther. Painter. A portrait painter and daughter of John Speakman, Treasurer of the Academy of Natural Sciences, in Philadelphia--she was exhibiting about 1843-61.

SPEARS, Ethel. Painter, lithographer, serigrapher. Born: Chicago, Illinois in 1903. Studied: Art Institute of Chicago; also with Alexander Archipenko. Awards: Art Institute of Chicago; Rogers Park Woman's Club, Chicago.

SPEED, Rosalie. Painter. Born: Dallas, Texas in 1908. Studied: Aunspaugh Art School, Dallas, Texas; Southern Methodist University; Texas State College for Women, Denton, Texas. Awards: Dallas Museum of Fine Arts, 1935, 1940, 1943. Collection: Dallas Museum of Fine Arts.

SPELLMAN, Coreen Mary. Lithographer. Born: Forney, Texas in 1909. Studied: Texas State College for Women; Columbia University; Art Students League; University for Women; Columbia University; Art Students League; University of Iowa; and with Charles Martin. Awards: West Texas Art Exhibition, 1940, 1942, 1945, 1946; University of Iowa, 1942; Texas Printmakers Exhibition, 1942, 1943, 1945; Texas Fine Arts Association, 1943, 1945; Texas General Exhibition, 1943; Dallas Museum of Fine Arts, 1951; Southern States Art League, 1944.

SPENCER, Ann Hunt. Painter. Studied: National Academy of Design; Sarah Lawrence College; and with Jerry Farnsworth. Awards: National Arts Club, 1937; traveling scholarship, Kosciuszki foundation, 1937; United States Government, mural, Southington, Connecticut. Collection: No. 2 Fifth Avenue, New York.

Mary Spencer (Ohio), PORTRAIT OF A LADY. Oil on canvas, 20" X 16". Collection of Pedro Campa.

SPENCER, Edna Isbester. Painter, sculptor. Born: St. John, New Brunswick, Canada in 1883. Studied: Boston Museum of Fine Arts School; Art Students League; and with Bela Pratt, and Robert Aitken. Awards: Concord Art Association; Miami Art League, 1940.

SPENCER, Jean. Painter. Born: Oak Park, Illinois. Studied: Wellesley College; Art Institute of Chicago; Grand Central School of Art; and with Wayman Adams. Awards: Grand Central Art School; Pen and Brush Club; National Association of Women Artists. Collections: Charlottesville, Virginia; Sioux Falls, South Dakota; Trenton, New Jersey; Court House, High Point, North Carolina; New York Public Library; Osteopathic Clinic, New York; House Office Building, Washington, D.C.; Florida Southern College.

SPENCER, Leontine G. Painter. Born: New York City. Studied: Hunter College; Art Students League; Columbia University; Grand Central School of Art; and with Frank DuMond, George Pearse Ennis and Arthur Woelfle. Exhibited extensively in New York State.

SPENCER, Lillie Martin. Painter. Born: in 1811 and died in 1902. Known for her portrait and genre paintings.

SPENCER, Margaret Fulton. Painter. Born: Philadelphia, Pennsylvania in 1882. Studied: Bryn Mawr College; Massachusetts Institute of Technology; New York School of Design; and in Paris; also with Birge Harrison. Has exhibited in the United States and abroad.

SPENCER, Marion D. Painter. Born: Grand Rapids, Michigan in 1909. Studied: Western Michigan University; Colorado State College. Awards: Kalamazoo Institute of Art, 1937; Grand Rapids Art Gallery, 1942.

SPENCER, Mary. Painter. Born: in Fitchburg, Massachusetts and died in 1923. Studied: with Henry B. Snell, Arthur Dow and Richard Miller; also Pratt Institute. Her specialty was water color painting.

SPENCER, Mary. Painter. Born: Springfield, Ohio in 1835. Studied: with C. T. Webber in Cincinnati. Collection: Cincinnati Museum.

SPENCER, Mary Jones. Painter. Born: Terre Haute, Indiana in 1900. Studied: Indiana State Teachers College; Art Institute of Chicago; Chicago Academy of Fine Arts. Award: Hoosier Salon, 1940. Collection: Mason City Iowa Public Library; Public Schools, Chicago, Illinois.

SPENCER, Mrs. Painter. An American painter of genre subjects.

SPENCER, Selina. Painter. A painter of portraits working
during the period 1847-60.

SPIDELL, Enid Jean. Painter. Born: Hampton, New Brunswick,
Canada in 1905. Studied: Parsons School of Design; New
York University; Columbia University; also with George
Pearse Ennis. Awards: American Art Group design competition,
1943.

SPIEGEL, Doris. Etcher. Born: New York City in 1907.
Studied: with Clinton Balmer; also in Paris. Award:
Guggenhiem fellowship, 1930. Contributor to New Yorker
magazine.

SPIEGEL, Dorothy A. Painter. Born: Shelbyville, Indiana
in 1904. Studied: Indiana University; John Herron Art
Institute; Butler University; and with O'Hara, Bisttram
and others. Awards: Hoosier Salon, 1936; Indiana State
Fair, 1941; Goose Rocks Beach, Maine.

SPINGARN, Amy. Painter. Born: New York in 1883.
Studied: with K. H. Miller.

SPONGERG, Grace. Painter. Born: Chicago, Illinois in
1906. Studied: Art Institute of Chicago. Collections:
Bennett School, Chicago; Byford School, Chicago; Horace
Mann School, Chicago; Museum Vaxco, Sweden.

SPOONER, Jane E. Painter. She exhibited her work in oils
in 1845.

SPRAGUE-SMITH, Isabelle. Painter. Born: Clinton, New York
in 1861. Studied: Art Students League; also in Paris.

SPRINGER, Eva. Painter. Born: Cimarron, New Mexico. Studied:
Highlands University, Las Vegas, New Mexico; Columbia
University; Julian Academy, Grande Chaumiere, Paris; Art
Students League. Award: Julian Academy, Paris. Collections:
Museum of New Mexico, Santa, Fe; Pennsylvania Society of
Miniature Painters; Philadelphia Museum of Art.

SQUIRE, Maud H. Illustrator, Painter. Born: Cincinnati,
Ohio.

ST. JOHN, Lois Alberta. Painter. Born: Albany, Indiana in
1879. Studied: Cincinnati Art Academy with Nowottny and
Meakin; with H. R. McGinnis; and with J. O. Adams and Brandt
Steele, Indianapolis. Award: Muncie Artists Association.
Collection: Montpelier, Indiana Library.

STACEY, Anna Lee. Painter. Born: Glasgow, Missouri.
Studied: Pritchett Institute; Art Institute of Chicago.
Awards: Young Fortnightly prize, Chicago Artists
Exhibition, 1902; Martin B. Cahn prize, Exhibition by
American Artists, 1902; Marshall Field prize, 1907;
Clyde M. Carr prize, Chicago Artists Exhibition, 1912.
Collection: City of Chicago.

STACEY, Dorothy H. Painter. Born: Des Moines, Iowa in
1904. Studied: Des Moines University; Cumming School of
Art. Awards: Des Moines Library, scholarship, 1925;
Iowa Art Salon, 1929, 1933, 1935. Des Moines Women's
Club, 1930.

STACEY, Lynn. Painter. Born: Washington, D. C. in 1903.
Studied: University of Iowa; Cumming School of Art;
National Academy of Design with Frances Jones, and
Raymond Neilson. Awards: Des Moines Women's Club, 1928,
1955, 1956; Iowa Art Salon, 1927-1928, 1930, 1931;
Cleveland Museum of Art, 1957. Collections: University
of Iowa; Corcoran Gallery of Art; National Bank, Dallas,
Texas; Iowa State College; Des Moines Women's Club;
Public buildings, Washington, D. C.

STACKEL, Alie. Sculptor. Born: New York City in 1909.
Award: Sculpture House. Collection: Educational Art
School, Port Hope, Ontario, Canada.

STADELMAN, Henryette L. Painter. She exhibited in 1924
at the Pennsylvania Academy of Fine Arts, Philadelphia.

STAFFORD, Mary Painter. She exhibited at the National
Academy of Design in 1925.

STAHL, Louise Zimmerman. Painter. Born: Philadelphia,
Pennsylvania in 1920. Studied: Moore Institute of Art;
Philadelphia Museum School of Industrial Art; Pennsylvania
Academy of Fine Arts with Millard Sheets, Henry Pitz
and Daniel Graber.

STANLEY, Jane C. Painter. Born: in 1863. A water-colorist
who exhibited her work at the Pennsylvania Academy of Fine
Arts in 1925.

STANTON, Elizabeth C. Painter. Born: New York City in
1894. Studied: Art Students League; Tiffany Foundation;
and with Cecilia Beaux, F. Luis Mora and George Bridgman.
Awards: Columbia University, 1954; National Association
of Women Artists, 1957.

STANTON, Lucy M. Born: Atlanta, Georgia in 1875. Studied: in New Orleans, Louisiana; Colarossi School in Paris with M. Koopman; also with Lucien Simon and Blanche in Paris. She has exhibited in the United States and Abroad.

STANWOOD, Gertrude. Painter. Born: West Newbury, Massachusetts in 1874. Studied: with De Camp, Major and Lasar.

STARBIRD, Many Ann. Painter. Born: in 1830.

STARKEY, Jo-Anita. Painter. Born: Gresham, Nebraska in 1895. Studied: with Loren Barton, Orris White and Marion K. Wachtel. Awards: Hollywood, California, 1948; Ebell Club, Los Angeles, 1949, 1950; Pasadena Art Institute, 1950; Greek Theatre, Los Angeles, 1950.

STARKWEATHER, Miss. J. M. Painter. A landscape artist who was exhibiting in 1855.

STARR, Eliza. Painter. Born: in 1824 and died in 1901.

STARR, Lorraine Webster. Painter. Born: Old Holderness, New Hampshire in 1887. Studied: Vassar College; Boston Museum of Fine Arts School; Art Students League; American School of Miniature Painters; and with Mabel Welch, Elsie Dodge Patee, William Paxton, Philip Hale and Lewis Pilcher. Collection: Philadelphia Museum of Art.

STAUFFER, Edna. Painter. Born: Phoenixville, Pennsylvania in 1887. Studied: with Chase, Beaux, Anshutz and Dow. She is also an illustrator and etcher.

STEADMAN, L. Alice. Sculptor. Born: Stokes County, North Carolina in 1907. Studied: Meredith College, Raleigh; Pennsylvania Academy of Fine Arts; and with Breckenridge, O'Hara and others. Awards: Margaret Graham silver cup, 1935; Raleigh Studio Club, gold medal, 1936; Ethel Parker silver cup, 1937; Blowing Rock, North Carolina, 1957, 1958; Mint Museum of Art, 1958.

STEARNS, Mary Ann. Painter. A still-life water colorist working around 1827.

STEBBINS, Emma. Painter and sculptor. Born: New York City in 1815 and died in 1882. Studied: in Italy with Paul Akers. She was a portrait artist in oils, water colors and pastels and a monumental sculptor. Collections: Central Park fountain, the figure "Angel of the Waters"; Statue of Horace Mann in Boston.

STEDMAN, Jeanette. Painter. Born: in 1881 and died in 1925. Studied: in Paris.

STEELE, Marian Williams. Painter. Born: Trenton, New Jersey in 1916. Studied: Pennsylvania Academy of Fine Arts; Trenton School of Industrial Arts; Barnes Foundation. Awards: Cresson traveling scholarship, Pennsylvania Academy of Fine Arts, 1936; Pennsylvania Academy of Fine Arts, 1933-37; Americal Artists Professional League, 1938, 1939; Laguna Beach Art Association, 1933, 1934; Santa Paula, California, 1944; North Shore Art Association; Long Beach Art Association, 1944; Busch-Reisinger Museum, Harvard University, 1958. Collections: New Jersey State Hospital; Leahy Clinic, Boston; Boston Skating Club.

STEELE, Zulma. Painter. Born: Appleton, Wisconsin in 1881. Studied: Pratt Institute of Brooklyn; Art Students League.

STEERE, Lora Woodhead. Sculptor. Born: Los Angeles, California in 1888. Studied: University of Southern California; Boston Museum of Fine Arts School with Bela Pratt; Stanford University; George Washington University; California School of Fine Arts; and in Berlin with Herr Torff; also with Ralph Stackpole. Collections: Los Angeles Museum of Art; University of Southern California; Lincoln Memorial University, Cumberland Gap, Tennessee; Jordan High School, Los Angeles, California; Forest Lawn, Los Angeles; Albert Wilson Hall, Los Angeles; Stanford University, Scientific drawings for Smithsonian Institute; Idyllwild School of Music and Art.

STEES, Sevilla L. Painter. She exhibited her water colors at the Pennsylvania Academy of Fine Arts, in 1925.

STEGALL, Irma Matthews. Painter. Born: Llano, Texas in 1888. Studied: North Texas State Teachers College; Dallas Art Institute; and with Martha Elliott, Olin Travis and others. Awards: Alabama Art League, 1932,1947.

STEIN, Evaleen. Painter. Born: Lafayette, Indiana. Studied: Art Institute of Chicago. As a decorative designer and illuminator she exhibited illuminated manuscripts at the Art and Crafts Society in Chicago and Indianapolis.

STEINKE, Bettina. Painter. Born: Biddeford, Maine in 1913. Studied: Cooper Union Art School with Alpheaus Cole; Phoenix Art Institute with Gordon Stevenson, Thomas Fogarty. Awards: New Rochelle Art Association; Cooper Union Art School. Collections: Baldwin Piano Company; Circus Saints and Sinners Collection; The Press Box, New York; Pratt and Whitney Company; United Fruit Company; Standard Oil Company of New Jersey; Philbrook Art Center; National Broadcasting Company.

STELSON, Sylvia. Painter. Born: in 1828 and died in 1872. She was a nature painter.

STEPHENS, Alice B. Illustrator and wood engraver. Born: Salem, New Jersey in 1858. Studied: Pennsylvania Academy of Fine Arts.

STERCHI, Eda. Painter. Born: Olney, Illinois. Studied: Art Institute of Chicago; Grande Chaumiere, Paris, France. Awards: French decoration, "Palmes Academique"; Tunisian decoration, "Nichan Iftikhar."

STERINBACH, Natalie. Painter. Born: New York City in 1910. Studied: Art Students League with Morris Kantor, Sam Adler and Camilo Egas. Award: Village Art Center.

STERLING, Lindsey Morris. Sculptor. Born: Mauch Chunk, Pennsylvania in 1876. Studied: Cooper Union Art School; also studied in Paris.

STERN, Caroline. Painter. Born: in Germany in 1894. Studied: Julian Academy in Paris.

STERN, Lucia. Painter. Born: Milwaukee, Wisconsin in 1900. Awards: Milwaukee Art Institute, 1945, 1946. Collections: Smith College Museum; Milwaukee Art Institute; Museum of Non-Objective Painting, New York.

STERN, Mildred B. Painter. She exhibited her portraits at the Pennsylvania Academy of Fine Arts in 1915.

STERNFELD, Edith A. Studied: Northwestern University; University of Iowa; Cranbrook Academy; and with Eliot O'Hara and Grant Wood. Awards: Iowa Exhibition, 1937; Joslyn Memorial, 1937, 1940; Iowa Watercolor Exhibition, 1945, 1953; Chicago Tribune Competition, 1953.

STERNE, Hedda. Painter. Born: Bucharest, Roumania in 1916. Studied: in Paris, Bucharest and Vienna. Award: Art Institute of Chicago Annual in 1957. Collections: University of Illinois; Metropolitan Museum of Art; University of Nebraska; Whitney Museum of American Art; Carnegie Institute; Rockefeller Institute; Detroit Institute of Art; Toledo Museum of Art.

STETSON, Katharine Beecher. Sculptor. Born: Providence, Rhode Island in 1885. Studied: Pennsylvania Academy of Fine Arts with Kendall, Anshutz and Poore; also studied in Europe. Awards: Los Angeles Museum of Art, 1925; Los Angeles County Fair, 1927; Pasadena Society of Art, 1940.

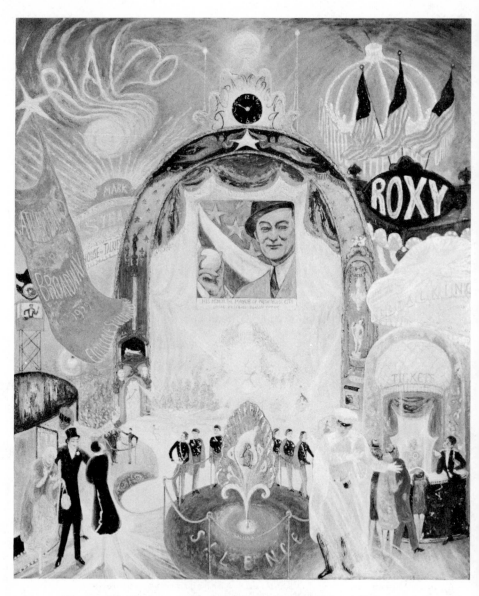

Florine Stettheimer, THE CATHEDRALS OF BROADWAY. Oil on canvas, 60 1/8" X 50 1/8". The Metropolitan Museum of Art (Gift of Ettie Stettheimer, 1953).

STETTHEIMER, Florine. Painter. Exhibited in 1921 at the
Pennsylvania Academy of Fine Arts.

STEVENS, Dorothy. Etcher and painter. Born: in Toronto
in 1888. Studied: Slade School in London. Award:
Panama-Pacific Exposition, San Francisco, 1915.

STEVENS, Esther. Painter. Born: Indianapolis, Indiana in
1885. Studied: with Robert Henri; Art Students League.

STEVENS, Helen B. Etcher. Born: Chicago, Illinois in 1878.
Studied: Art Institute of Chicago; also in England with
Frank Brangwyn. Award: Panama-Pacific Exposition, San
Francisco, 1915.

STEVENS, May. Painter. Born: Boston, Massachusetts in 1924.
Studied: Massachusetts School of Art; Art Students League;
Julian Academy, Paris; Queens College; City College of New
York; Hunter College. Award: Silvermine Guild of Art, 1958.

STEVENS, Mildred Lapson. Painter. Born: New York City in
1923. Studied: Boston Museum School of Art; Art Students
League; American School of Design, New York; Jepson Art
Institute, Los Angeles. Awards: City-wide Exhibition,
Rockefeller Center, 1935; scholarships, Art Students League,
Boston Museum School of Art, American School of Design;
Gregor Beaux-Arts, Hartford; Wadsworth Atheneum;
Los Angeles County Fair, 1951.

STEVENS, Vera. Painter. Born: Hustontown, Pennsylvania
in 1895. Studied: Philadelphia Museum School of Industrial
Art; and with George Elmer Browne. Has exhibited in the
United States and abroad.

STEVENSON, A. May. Painter. Exhibiting her landscape
paintings during the period 1853-61.

STEVENSON, Amy Leanor. Painter. Born: St. Sylvestre, Quebec,
Canada. Studied: Cooper Union Art School; National Academy
of Design; Art Students League; and with Hawthorne, Savage
and Brackman. Awards: Tiffany Foundation fellowship, 1923;
Allied American Artists, 1928.

STEVENSON, Beulah. Painter. Born: Brooklyn, New York. Studied:
Art Students League with John Sloan and Hans Hofmann.
Awards: Brooklyn Museum; Brooklyn Society of Art; National
Association of Women Artists. Collection: New York Public
Library.

STEVENSON, Edna Bradley. Painter. Born: Hebron, Nebraska in 1887. Studied: Art Institute of Chicago; University of California at Los Angeles; University of Illinois; Julian Academy, Paris; Oklahoma City University; also studied with Emil Bisttram and Snow Froelich. She has exhibited widely throughout the United States.

STEVENSON, Florence Ezzell. Painter. Born: Russellville, Alabama. Studied: Athens College; Tuscaloosa Conservatory of Art and Music; Art Institute of Chicago; Chicago Academy of Fine Arts. Awards: Illinois Society of Fine Arts, 1936; South Side Art Association, 1939; Illinois Federation of Women's Clubs, 1940; National League of American Pen Women, 1945-1957; Cordon Club, 1950; Art Institute of Chicago. Collections: Rosenwald Collection; Hanover College, Indiana; Vanderpoel Collection; Municipal Building, Russellville, Alabama; Morgan Park High School, Chicago; Sutherland School, Gage Park School, Chicago; Midlothian Illinois School.

STEVENSON, Ruth R. Painter. Born: Brooklyn New York in 1897. Studied: Pratt Institute Art School; Art Students League, with John Sloan. Awards: Small Paintings Exhibition, 1928; Pen and Brush Club, 1951, 1954; Salmagundi Club, 1955.

STEWART, Catherine T. Painter. She exhibited her water colors at the Pennsylvania Academy of Fine Arts in 1925.

STEWART, Esther L. Painter. Born: Moorestown, New Jersey in 1895. Studied: Swarthmore College; Philadelphia Museum School of Industrial Art; Pennsylvania Academy of Fine Arts; Corcoran School of Art. Collections:Fairfax County Virginia Court House; Arabian Embassy; Quantico Marine Club.

STEWART, Ethelyn Cosby. Painter. Born: Arlington, New Jersey in 1900. Studied: Cooper Union Art School. Collections:Pennsylvania Academy of Fine Arts; Smithsonian Institute.

STEWART, Grace B. Painter. Born: Atchison, Kansas in 1895. Studied: Art Students League; and with Charles Hawthorne. Awards: Pen and Brush Club; Laconia New Hampshire.

STEWART, Marie H. Painter. Born: Eaton, Ohio in 1887. Studied: Pratt Institute of Art School; John Herron Art Institute; Butler University. Awards: Lincoln tablet designer, 1907; Hoosier Salon, 1942.

STEWART, Marion Louise. Painter. Born: Buffalo, New York. Studied: Radcliffe College; Ecole des Beaux-Arts, Fontainebleau, France; Columbia University; Art Students League. Award: Albright Art Gallery, 1938.

STIMPSON, Helen Townsend. Painter. Born: Brooklyn, New York in 1886. Studied: National Academy of Design; Cooper Union Art School; and with Carlsen and Hawthorne. Awards: Hartford Society of Women Painters, 1940; New Haven Paint and Clay Club, 1941.

STIMSON, Anna K. Sculptor. Born: New York City in 1892. Studied: with Charles Grafly.

STOCKMAN, Helen P. Painter. Born: in 1896. Studied: with Jonas Lie, Luis Mora and Robert Henri.

STODDARD, Alice Kent. Painter, Born: Watertown, Connecticut in 1893. Studied: Pennsylvania Academy of Fine Arts. Collections: Pennsylvania Academy of Fine Arts; Delgado Museum, New Orleans, Louisiana.

STODDARD, Musette Osler. Painter. Born: Carson, Iowa. Studied: Art Students League; also studied with Charles Hawthorne and Ralph Johonnot. Award: Panama-Pacific Exposition, 1915.

STOHR, Julia Collins. Painter. Born: Toledo, Ohio in 1866. Studied: Art Students League with Beckwith, Chase and Alden Weir; also studied with Lathrop in Paris.

STOHR, Julia Collins. Painter. Born: St. Paul, Minnesota in 1896. Exhibited at the 33d Annual Exhibition in New York in 1924.

STOLOFF, Carolyn. Painter. Born: New York City in 1927. Studied: University of Illinois; Columbia University; and studied with Xavier Gonzalez, and Eric Isenburger; also studied abroad.

STOLOFF, Irma. Sculptor. Born: New York City. Studied: Art Students League; and with Alexander Archipenko. Award: National Association of Women Artists, 1943.

STONE, Beatrice. Sculptor. Born: New York City in 1900. Studied: Smith College; and in Paris with Heinz Warneke and Jacques Loutchansky. Awards: Huntington award, 1943; Scarsdale Art Association; Westchester Arts and Crafts Association. Collections: Ethical Culture Society; Hudson Guild; Aluminum Corporation of America.

STONE, Elizabeth. Painter. Born: in 1811 and died in 1872. She was a portrait painter.

STONE, Fern C. Painter. Born: Defiance, Ohio in 1889.
Studied: Defiance College; Van Emburg School of Art,
Plainfield, New Jersey; Fontainebleau School of Fine
Arts, France; and with Carlson and George Elmer Browne.
Award: Pacific Palisades Art Association. Collections:
Bryan Public Library; Defiance High School.

STONE, Iva G. Painter. Born: Cleveland, Ohio in 1917.
Studied: Cleveland School of Art.

STONE, Margaret. Painter. Born: in 1815. An artist and
map maker.

STONE, Maysie. Sculptor. Born: New York City. Studied:
Cornell University; University of Wisconsin; Pennsylvania
Academy of Fine Arts; and with Albert Laessle and Charles
Grafly.

STONE, Ruth. Painter. Born: St. Louis, Missouri in 1914.
Studied: University of Missouri; Art Institute of Chicago;
Kansas City Art Institute; and with Charles Schroeder;
John McCrady and Ross Braught. Awards: Missouri State Fair,
1946, 1948-51; Mississsippi Art Association, 1947, 1948;
Louisiana State Fair, 1955-1957; "Holiday in Dixie"
exhibition, 1955; Regional Art Exhibition, 1955.

STONIER, Lucille Holderness. Painter. Born: Uvalde, Texas
in 1890. Studied: College of the Pacific, Stockton,
California; Chouinard Art Institute; Parsons School of
Design; and with O'Hara, Lester W. Stevens, and S. Peter
Wagner. Awards: Palm Beach Art League, 1938, 1944;
Florida State Federation, 1944; League of American Pen
Women, 1941, 1955; First National Bank Exhibition,
Asheville, 1955. Collections: Norton Gallery, West Palm
Beach, Florida; Veterans Hospital, Oteen, North Carolina.

STORER, Catherine. Painter. A landscapist who exhibited
during the period 1833-1849.

STORM, La Rue. Painter. Born: Pittsburgh, Pennsylvania in
1908. Studied: University of Miami, Coral Gables, Florida;
Art Students League, Woodstock, New York; and in France.
Award: University of Miami, 1955.

STOUT, Ida M. Sculptor. Born: Decatur, Illinois. Studied:
with Albin Polasek. Collections: Mary W. French School,
Decatur, Illinois; Hillyer Gallery, Smith College.

STOWELL, M. Louise. Painter and illustrator. Born:
Rochester, New York. Studied: Art Students League; and with
Arthur W. Dow. Her specialty, water color painting.

STRATTON, Alza. Painter. Born: Lexington, Kentucky in 1911. Studied: University of Kentucky; National Academy of Design; Cincinnati Art Academy with W. E. Hentschel. Awards: Cincinnati Crafters, 1954; Woman's Art Club, 1950. Collections: International Business Machines; Western and Southern Life Insurance Building, Cincinnati, Ohio.

STRAWBRIDGE, Anne W. Painter. Born: Philadelphia, Pennsylvania in 1883. Studied: with W. M. Chase.

STREATFEILD, Josephine. Painter. Born: London, England in 1882. Studied: Slade School, London with Fred Brown. Her specialty portraits, especially pastel portraits of children.

STREAN, Maria J. Painter. Born: Washington, Pennsylvania. Studied: Art Students League with Cox and J. Alden Weir; in Paris with Prinet and Dauchez. Award: Panama-American Exposition, Buffalo, 1901.

STREETER, Julia Allen. Painter. Born: in 1877.

STRINGFIELD, Vivian F. Painter and illustrator. Born: in California. Studied: Pratt Institute; and with Douglas Donaldson and Ralph H. Johonnot. Award: Panama-California Exposition, San Diego, 1915.

STROBEL, Louisa Catherine. Painter. Born: in 1803 and died in 1883. She was a amateur miniature painter.

STROUD, Clara. Painter. Born: New Orleans, Louisiana in 1890. Studied: Pratt Institute Art School; and with Ralph Johonnet, Otto W. Beck, Mary Lantry and Hilton Leech. Awards: American Artists Professional League, 1939, 1952; Montclair Art Museum, 1953; Barmark award, 1954.

STROUD, Ida. Painter and designer. Born: New Orleans, Louisiana in 1869. Studied: Pratt Institute; Art Students League; and with William Chase.

STUART, Jane. Painter. Born: in 1812 and died in 1888. Daughter of Gilbert Stuart, she was a skillful copyist and reproduced many of her fathers paintings.

STUBBS, Mary H. Painter and illustrator. Born: Greenville, Ohio in 1867. Studied: Cincinnati Art Academy; Julien Academy, Paris. Award: Columbian Exposition, Chicago, 1893.

STUCKI, Margaret E. Painter. Born: West New York, New Jersey in 1928. Collections: Hartwick College Art Collection; Evangelical Lutheran Church, Oneonta, New York; Reginald Marsh Collection.

STUEVER, Cecilia M. Painter and etcher. Studied: St. Louis School of Fine Arts; also studied in Paris. Collections: Library of Congress; New York Public Library.

STURGEON, Ruth B. Painter and etcher. Born: Sterling, Kansas in 1883.

STURGES, Lillian B. Painter and illustrator. Born: Wilkes-Barre, Pennsylvania. Studied: with E. F. Savage.

STURGIS, Mabel R. Painter. Born: Boston, Massachusetts in 1865. Studied: Boston Museum of Fine Arts.

STURTEVANT, Edith Louise. Painter. Born: Utica, New York in 1888. Studied: Pennsylvania Academy of Fine Arts; Carnegie Institute; New York University. Awards: Cresson traveling scholarship, Pennsylvania Academy of Fine Arts; fellowship, Pennsylvania Academy of Fine Arts. Collections: Easton Woman's Club; Pennsylvania Academy of Fine Arts.

STURTEVANT, Helena. Painter. Born: Middletown, Rhode Island in 1872. Studied: Boston Museum School with Tarbell; Colarossi Academy in Paris with Blanche and Simon.

STURTEVANT, Louisa Clark. Painter. Born: in 1870. She was also a designer and painter of landscapes.

STUTTMAN, Joy Lane. Painter. Born: Chicago, Illinois in 1929. Studied: University of Chicago; Mills College, Oakland, California; and with Hans Hofmann and Tschacbasov.

SULLIVAN, Frances. Painter. Born: 1861 and died in 1925. She was noted as a portrait painter.

SULLY, Blanche. Painter. Born: in 1814 and died in 1898. She was an amateur painter and sketcher.

SULLY, Ellen Oldmixon. Painter. Corn: in 1816 and died in 1896. She was an amateur artist.

SULLY, Jane Cooper. Painter. Born: in 1807 and died in 1877.

SULLY, Rosalie K. Painter. Born: in 1818 and died in 1847. She was an amateur miniature painter.

SUMMA, Emily B. Painter. Born: In Germany in 1875. Studied: St. Louis School of Fine Arts. Award: St. Louis Artists Guild Exhibition, 1917.

SUMMER, Emily Eugenia. Painter. Born: Newton, Mississippi
in 1923. Studied: Mississippi State College for Women;
Columbia University; and with Edwin Ziegfeld, Hugo Robus
and Dong Kingman. Awards: Mississippi State College for
Women, 1945; Mississippi Art Association.

SUMMY, Anne Tunis. Painter. Born: Baltimore, Maryland in
1918. Awards: National Society of Painters in Casein,
New York. Collections: William Penn Memorial Museum,
Harrisburg; Goethaen Gallery of Art,; Delaware Art League;
Armstrong Cork Company, Lancaster; Bloomsburg College.

SUMMY, Katherine Strong. Painter. Born: Washington, D.C.
in 1888. Studied: George Washington University; Columbia
University; and with Ernest Thurn and Hans Hofman.

SUNDIN, Alelaide. Ceramic Sculptor. Born: Boston,
Massachusetts in 1915. Studied: Massachusetts School of
Art; Massachusetts Institute of Technology; and with Cyrus
Dallin and Raymond Porter. Award: Massachusetts School of
Art, 1936. Collection: portraits in porcelain, Boston,
New York City, Baltimore, Washington, D. C. St. Louis,
Los Angeles, Wilmington and in Sweden.

SUTTON, Harriet M. Painter. Born: in Michigan. Award:
Fiesta Biennial Exhibit, Museum of New Mexico.

SUTTON, Rachel M. Painter. Born: Pittsburgh, Pennsylvania
in 1887. Studied: Carnegie Institute; Chatham College;
Woodstock Summer School of Art; Art Students League.
Awards: Pittsburgh Society of Art, 1932; Garden Club, 1943;
Pittsburgh Water Color Society, 1954. Collection:
Pittsburgh Public Schools.

SUTTON, Ruth Haviland. Painter. Born: Springfield,
Massachusetts in 1898. Studied: Philadelphia Museum School
of Industrial Art; Grand Central Art School; and with Jerry
Farnsworth and Henry B. Snell. Awards: Springfield Art
League, 1926; Association of Junior League of Boston, 1930;
Connecticut Academy of Fine Arts, 1931. Collections:
Aston College, Springfield, Massachusetts; Springfield
Museum of Fine Arts; Library of Congress; Northampton
Massachusetts Public Library; Carnegie Institute; New
Britain Institute, Connecticut; Taylor Gallery, Nantucket;
New York Public Library; Boston Public Library; Museum of
Natural History, Springfield, Massachusetts.

SVET, Miriam. Painter. Born: Newark, New Jersey in 1912.
Studied: Faucett Art School; and with Car Von Schleusing,
Newark; National Academy of Design; Art Students League,
with George Bridgman and Frank V. Dumond. Collections:
Los Angeles City Hall; Brandeis University; Fairleigh
Dickinson College, Teaneck, New Jersey.

SWAIN, Miss C. Crayon portraitist. She was exhibiting her work in the period 1860-65.

SWAIN, Harriet. Painter. A water color portraitist working around 1830.

SWAIN, Jerre. Painter. Born: Yoakum, Texas in 1913. Studied: Mary Hardin-Baylor College, Belton, Texas; University of Colorado; Museum of Fine Arts of Houston; and with Emil Bisttram and Max Beckmann. Collection: St. James Episcopal Church, Houston, Texas.

SWAN, Florence W. Designer. Born: Cambridge, Massachusetts in 1876. Studied: with Amy M. Sacker. Collections: Memorial tablets in Beneficent Congressional Church, Providence; St. James Church, Salem.

SWANTEES, Ethel L. Painter. Born: Madison, Wisconsin in 1896. Studied: Art Students League; and with John Sloan and Harry Wickey.

SWENGEL, Faye. Painter. Born: Johnstown, Pennsylvania in 1904. Studied: Pennsylvania Academy of Fine Arts; Barnes Foundation; and with Daniel Garber, and Arthur B. Carles. Awards: fellowship, Pennsylvania Academy of Fine Arts; Cresson traveling scholarship, Pennsylvania Academy of Fine Arts, 1925; Pennsylvania Academy of Fine Arts, 1937, 1940, 1942, 1946. Collection: Pennsylvania Academy of Fine Arts.

SWENSON, Valerie. Painter. Born: Kansas City, Missouri in 1907. Studied: Kansas City Art Institute; University of Kansas.

SWEZEY, Agnes. Painter. Exhibited at the National Academy of Design in 1925.

SWIFT, Ann Waterman. Painter. A water colorist who worked around 1810.

SWIFT, Florence Alstin. Painter. Born: San Francisco, California in 1890. Studied: Hans Hofmann School of Art. Awards: San Francisco Art Association; San Francisco Society of Women Artists, 1950, 1951; California State Fair. Collections: University of California; Mills College; San Francisco Museum of Art.

SWINDELL, Bertha. Painter. She was exhibiting her miniature paintings at the Pennsylvania Academy of Fine Arts in 1925.

SWINNERTON, Edna Huestis. Painter. Born: Troy, New York
in 1882. Studied: Emma Willard Art School; Cornell
University; Art Students League. She was a miniature painter.
Award: Pennsylvania Society of Miniature Painters, 1951.
Collection: Philadelphia Museum of Art.

SWOPE, Kate F. Painter. Born: Louisville, Kentucky.
Studied: National Academy of Design. Award: Southern Art
League, 1895; Louisville Art League, 1897.

SWOPE, Virginia Vance. Painter. Born: Louisville, Kentucky.
Studied: with Du Mond, Mora, Carlson, Penfield and Bridgman.

SYKES, Annie G. Painter. Born: Brookline, Massachusetts.
Studied: Boston Museum School; Cincinnati Art Academy with
Duveneck.

SYLVESTER, Lucille. Painter. Studied: Art Students League;
Julian Academy, Paris, France. Awards: Knickerbocker Art,
1952; Wolfe Art Club, 1957.

SYMON, Gail. Painter. Born: Boston, Massachussets. Studied:
National Academy of Design; Art Students League; Grand
Central Art School; Otis Art Institute. Award: Silvermine
Guild Art, 1945; New Haven Paint and Clay Club, 1951;
Connecticut Academy of Fine Arts, 1953.

TAAKE, Daisy. Sculptor. Born: St. Louis, Missouri in 1886. Studied: Art Institute of Chicago; St. Louis School of Fine Arts; also studied with Lorado Taft. Award: St. Louis Art League Fountain Competition.

TABARY, Celine Marie. Painter. Born: Vermelles, France in 1908. Studied: in France. Award: United States National Museum, 1951; Washington Society of Art, 1957. Collections: Barnet Aden Gallery; Palais National, Haiti; Phillips Collection, Washington, D.C.

TAGGART, Lucy M. Painter. Born: in Indianapolis, Indiana. Studied: with Forsyth, Chase and Hawthorne; also studied in Europe.

TAHY, Janos (Jean). Painter. Born: in 1865 and died in 1928.

TAIT, Agnes. Painter. Born: New York City in 1897. Studied: National Academy of Design. Collection: New York Public Library; Metropolitan Museum of Art; Library of Congress; Bellevue Hospital, New York; United States Post Office, Laurinsburg, North Carolina.

TAIT, Cornelia Damian. Painter. Collections: Temple University, Philadelphia; The Holy Trinity Room-Orthodox Cathedral, Detroit; St. Mary's Room-Orthodox Church, Cleveland; Christian Endeavor World Headquarters, Columbus.

TALBOT, Cornelia Breckenridge. Painter. Born: Natrona, Pennsylvania in 1888 and died in 1924. Studied: Pennsylvania Academy of Fine Arts.

TALBOT, Grace H. Sculptor. Born: North Billerica, Massachusetts in 1901. Studied: with Harriet W. Frishmuth. Awards: Architectural League, 1922; National Association of Women Artists, 1925.

TALBOT, Sophia D. Painter. Born: Boone County, Iowa in 1888. Studied: Iowa State University; Cumming School of Art. Awards: Wawasee Art Gallery, 1942; Swope Art Gallery 1947, 1948, 1950, 1951, 1953, 1956; National League of American Pen Women, 1950, 1952. Collections: Hawthorne and Lincoln Schools, Mattoon, Illinois; Administration Building and Booth Memorial Library, Eastern Illinois State College; Lowell School, Mattoon, Illinois; Lincoln School, Brookfield, Illinois; National Bank of Matoon.

TALCOTT, Sarah W. Painter. Born: West Hartford, Connecticut in 1852. Studied: with Chase and Cox in New York; and with Bouguereau and Robert-Fleury in Paris.

TALLMAN, M. G. (Mrs.) Painter. Born: Lianidloes, North Wales in 1859. Studied: National Academy of Design; Art Students League; also with F. S. Church, Jane Peterson and Mrs. Coman.

TANBERG, Ella H. Painter. Born: Janesville, Wisconsin. Collection: Janesville Art League.

TANNAHILL, Mary H. Painter. Born: Warrenton, North Carolina. Studied: with Weir, Twachtman, Cox and Mowbray in New York. Award: National Association of Women Painters and Sculptors, 1914.

TANNAHILL, Sallie B. Painter. Born: New York in 1881. Studied: with Arthur W. Dow and V. Preissig.

TARLETON, Mary Livingston. Painter. Born: Stamford, Connecticut. Studied: with Charles W. Hawthorne and Childe Hassam; Art Students League.

TATE, Sally. Painter. Born: Sewickley, Pennsylvania in 1908. Studied: Vesper George School of Art; Parsons School of Design; and with Bernard Keyes, Heinrich Moore and Jose Pillon.

TAYLOR, Anna H. Painter and engraver. Born: in 1879.

TAYLOR, Beatrice M. Painter.

TAYLOR, Bertha F. Painter. Born: New York City in 1883. Studied: Cooper Union Art School; and studied in Paris. Award: Paris Salon, 1937. Collection: Chapel Benmoreel Protestant Church, Norfolk, Virginia.

TAYLOR, Cora Bliss. Painter. Born: Cincinnati, Ohio in 1895. Studied: Art Institute of Chicago; Art Students League; and with Kroll, Hawthorne and Leopold Seyffert. Awards: Art Institute of Chicago, 1925, 1930, Detroit Institute of Art, 1955. Collection: Chicago Public School.

TAYLOR, Eliza Ann. Painter. Shaker artist working in New York around 1845.

TAYLOR, Elizabeth. Painter. Collection: Detroit Institute.

TAYLOR, Emily Drayton. Painter. Born: Philadelphia, Pennsylvania in 1860. Studied: Pennsylvania Academy of Fine Arts; and in Paris with Cecile Ferrere. Awards: gold medal, Earl's Court Exhibition, London, 1900; gold medal, Charleston Exposition, 1902; Panama-Pacific Exposition, San Francisco, 1915; Pennsylvania Academy of Fine Arts. Some of her works are portraits of President and Mrs. William McKinley.

TAYLOR, Grace Martin. Painter. Born: Morgantown, West Virginia. Studied: University of West Virginia; Art Institute of Chicago; Carnegie Institute; Pennsylvania Academy of Fine Arts; Emil Bisttram School of Art; Hans Hofmann School of Fine Arts; Ohio University and with Fritz Pfeiffer, Blance Lazzell and William and Natalie Grauer. Awards: 50 Best Color Prints, 1933; West Virginia Art Association, 1942, 1945, 1947-1949, 1953-1957; Virginia Intermount College, 1948; Tri-State Creative Art Association, 1953-1955; Huntington Gallery, 1955; Hallmark award, 1953.

TAYLOR, Ruth P. Painter. Born: Winsted, Connecticut in 1900. Studied: Pratt Institute Art School; Art Students League; and with Jane Freeman, George Bridgmann and Kimon Nicolaides. Award: Riverside Museum, 1956.

TEAGUE, Marj. Painter. Born: Pittsburgh, Pennsylvania in 1934. Collections: Campus Martius Museum, Marietta, Ohio; Guernsey County Museum, Cambridge, Ohio; Pearl S. Buck Museum, Hillsboro, West Virginia.

TEDFORD, Elsie Mae. Painter. Born: Abington, Massachusetts in 1901. Studied: Art Students League; Tiffany Foundation; and with Hayley Lever. Award: State Rodeo Show, 1955. Collection: International Business Machines.

TEE-VAN, Helen Damrosch. Painter. Born: New York City in 1893. Studied: New York School of Display; and with Jonas Lie and George de Forest Brush. Collections: Berkshire Museum; Bronx Zoo, New York.

TEICHMAN, Sabina. Painter. Born: New York City in 1905. Studied: Columbia University. Award: Westchester Women's Club, 1946. Collections: Carnegie Institute; Brandeis University; Smith Museum of Art; Tel-Aviv Museum, Israel; San Francisco Museum of Art; Whitney Museum of American Art; Butler Institute of American Art; Museum of the University of Puerto Rico; Living Arts Foundation Collection, New York.

TEICHMULLER, M. Painter. Born: La Grange, Texas in 1872. Studied: Sam Houston Normal School; San Antonio Academy of Art. Collections: White House, Washington, D.C.; United States Post Office, Smithville, Texas.

TELLER, Jane. Sculptor. Born: Rochester, New York in 1911. Studied: Skidmore College; Barnard College; and with Aaron Goodelman. Exhibited extensively throughout Pennsylvania.

TELLING, Elisabeth. Painter. Born: Milwaukee, Wisconsin in 1882. Studied: Smith College; and in Munich with Herr Heymann; also studied with Henderson, George Senseney and Hamilton E. Field. Collection: Art Institute of Chicago; Los Angeles Museum of Art.

TENNANT, Allie Victoria. Sculptor. Born: St. Louis, Missouri. Studied: Art Students League; also with George Bridgmann and Edward McCartan. Awards: Dallas Art Association, 1936; Southern States Art League, 1932, 1933, 1936. Collections: State of Texas Building, Dallas; Brookgreen Gardens, South Carolina; Hockaday School, Southwest Medical College, Aquarium, Museum of Fine Arts, and Womans Club, all of Dallas Texas; memorial, Corsicana, Texas; memorial, Bonham, Texas; United States Post Office, Electra, Texas.

TENNEY, Adna. Painter. Born: in 1810 and died in 1900. She was a portrait and miniature painter.

TERPENING, Virginia A. Painter. Born: Lewistown, Missouri in 1917. She has exhibited in 150 groups shows in 20 states; and 4 one-man shows.

TERRY, Clarissa. Painter. An amateur watercolorist working around 1816.

TERRY, Eliphalet. Painter. Born: in 1826 and died in 1896. A painter of landscapes and animals.

TERRY, Marion. Painter. Born: Evansville, Indiana in 1911. Studied: Albright Art School; Buffalo Art Institute; University of Buffalo; Cape School of Art, Provincetown, Massachusetts; University of Florida and with Xavier Gonzalez. Awards: Florida Federation of Art, 1938; Sarasota National Exhibition, 1951; Florida Southern College, 1951; International Exhibition, Havana, Cuba, 1954; Florida State Fair, Tampa, 1956. Collection: New York Hospital Collection; Living War Memorial (476 portraits of every Dade County serviceman who lost his life in World War II).

TEW, Marguerite R. Sculptor. Born: Magdalena, New Mexico in 1886. Studied: Museum School of Independent Artists; Pennsylvania Academy of Fine Arts, with Grafly. Award: Cresson European scholarship, Pennsylvania Academy of Fine Arts, 1913. Collection: Southwest Museum, Los Angeles.

TEWKSBURY, Fanny W. Painter. Born: Boston, Massachusetts. Studied: Massachusetts Institute of Technology; and with Ross Turner in Boston.

THAW, Florence. Painter. Born: in 1864.

THAYER, Emma B. Painter. Born: in 1850 and died in 1924.
Her specialty, flower studies in oil and pastel.

THAYER, Gladys. Painter. Born: Woodstock, Connecticut in
1886. Studied: with her father Abbott H. Thayer.

THAYER, Grace. Painter. Born: in Boston, Massachusetts.
Studied: Boston Museum School; also studied with
Mme. Hortense Richard in Paris.

THAYER, Polly. Painter. Born: Boston, Massachusetts in
1904. Studied: Boston Museum of Fine Arts School; Art
Students League; also with Harry Wickey. Awards:
National Academy of Design, 1929; Boston Tercentenary
Exhibition. Collections: Pennsylvania Academy of Fine
Arts; Boston Museum of Fine Arts; Addison Gallery of
American Art; Springfield Art Museum.

THAYER, Theodora W. Painter. Born: Milton, Massachusetts
in 1868 and died in 1905. Studied: with Joseph De Camp
in Boston. As a miniature painter her portrait of Bliss
Carman is considered outstanding in American miniature
painting achievements.

THECLA, Julia. Painter. Born: Chicago, Illinois. Studied:
Art Institute of Chicago and with Elmer Forsberg. Awards:
Chicago Newspaper Guild; Illinois State Fair; Florida
Southern College; Art Institute of Chicago. Collections:
Art Institute of Chicago; Newark Museum.

THEIS, Gladys H. Sculptor. Born: Bartlesville, Oklahoma
in 1903. Studied: Oklahoma Agricultural and Mechanical
College; Cincinnati Art School; Corcoran School of Art;
and with Miller, Malfrey and Despiau; also in Paris. Awards:
Society of Washington Artists, 1931; National League of
American Pen Women, 1950, 1952; Albuquerque, New Mexico,
1951. Collections: Tulsa High School, Tulsa University,
Boston Avenue Church; Oklahoma Agricalatural and Mechanical
College; University of Mexico; Daufelser School of Music.

THEOBALD, Elizabeth S. Sculptor and painter. Born:
Cleveland, Ohio in 1876. Studied: with Chase, Mora
and Hawthorne.

THOBURN, Jean. Painter. Born: Calcutta, India in 1887.
Studied: Goucher College; Columbia University; New York
School of Fine and Applied Arts; and with Dow, Miller,
Sheets, Kingman and O'Hara. Awards: Association of Artists
of Pittsburgh, 1944; Pittsburgh Water Color Society, 1953.
Collection: One Hundred Friends of Art in Pittsburgh.

THOELE, Lillian. Painter. Born: St. Louis, Missouri in
1894. Studied: Pennsylvania Academy of Fine Arts;
St. Louis School of Fine Arts. Awards: St. Louis
Independent Artists Association; Independent Artists.
Collections: American Youth Foundation Camps at Shelby,
Michigan and New Ossipee, New Hampshire; Gundlack Public
School, St. James Church, German General Orphans Home,
Crippled Children's Home, all of St. Louis, Missouri;
Monsanto Company; Antimite Company and Southwestern
Telephone Company, St. Louis.

THOMAS, Elaine F. Painter. Born: Cleveland, Ohio in
1923. Has exhibited in New York, St. Paul, Atlanta,
Mexico City, Jefferson City, and in Paris, France.

THOMAS, Emma W. Painter. Born: Philadelphia, Pennsylvania.
Studied: Pennsylvania Academy of Fine Arts. Collections:
Pennsylvania Academy of Fine Arts.

THOMAS, Estelle L. Painter. Born: New York City.
Studied: Pittsburgh School of Design for Women; University
of Pittsburgh; Carnegie Institute; Parsons School of
Design; and with Charles Hawthorne and John Sloan.

THOMAS, Marie. Painter. Born: in 1826.

THOMAS, Marjorie. Painter. She exhibited in 1924 at the
Annual Exhibition of Pennsylvania Academy of Fine Arts.

THOMAS, Mary. Painter. Born: Hazelhurst, Georgia in
1905. Studied: Georgia State College for Women; Duke
University; Woman's College, University of North Carolina.
Awards: North Carolina Art Exhibition, 1941, 1942, 1947;
Southern States Art League, 1942, 1946; Association of
Georgia Artists, 1948-1950, 1952. Collections: United
States Department of Purchase for United States Embassies
abroad; University of Georgia; Virginia Museum of Fine
Arts; Atlanta Art Institute; North Carolina Art Society;
Telfair Academy; Gibbes Art Gallery.

THOMAS, Thalia Ann. Painter. Born: Wilkes-Barre,
Pennsylvania in 1935. Has exhibited in the United States
and in Italy.

THOMASITA, Sister Mary. Painter. Born: Milwaukee, Wisconsin
in 1912. Studied: Milwaukee State Teachers College; Art
Institute of Chicago. Award: Wisconsin Painters and
Sculptors, 1950. Collections: Marquette University Memorial
Library; St. Cyprian's Convent, River Grover, Illinois.

THOMPSON, Miss A. C. Painter. As a portrait artist she
exhibited her work around 1835.

THOMPSON, Adele U. Painter. Born: Grosbeck, Texas in
1882. Studied: Art Institute of Chicago; Newcomb College,
Tulane University and with Ellen A. Holmes and Xavier
Gonzalez. Awards: Corpus Christi Art Foundation, 1945,
1946, 1948; Kingsville, Texas Fair, 1947, 1949; Water-
color Exhibition, 1954; Casein Exhibition, 1954.

THOMPSON, Almerin. Painter. Born: in 1819. A portraitist.

THOMPSON, Edith. Painter. Born: Philadelphia, Pennsylvania
in 1874. Studied: with DuMond and Luis Mora. Her specialty,
interiors.

THOMPSON, Georgette R. Painter. Born: New Orleans,
Louisiana in 1905. Studied: Newcomb College, Tulane
University; Chicago Academy of Fine Arts; Art Students
League; and with Will Stevens and Ruth Van Sickle Ford.
Awards: New Orleans Art Association, 1933; Southern States
Art League, 1930. Collection: New Orleans Association of
Commerce.

THOMPSON, Helen L. Painter. Born: Wilkes-Barre,
Pennsylvania in 1889. Studied: Wilkes-Barre Institute;
Vassar College; Corcoran School of Art; Wayman Adams
School of Art; Famous Artists School. Award: Art Week
Alexandria, Virginia, 1944.

THOMPSON, Juliet. Painter. Born: in New York. Studied:
Corcoran Art School. A portrait painter.

THOMPSON, Marietta. Painter. Born: in 1803. A miniaturist.

THOMPSON, Nellie L. Painter and sculptor. Born: Jamaica
Plains, Boston. Studied: South Kensington School with
Alyn Williams; in London with Ball Hughes; Cowles Art School
in Boston with De Camp; and with Henry B. Snell; also with
Sir James Linton. Studied sculpture with Roger Noble
Burnham and Bela Pratt.

THOMPSON, Susie W. Watercolorist. Born: Addison, Maine
in 1892. Collections: Walker Art Museum, Brunswick, Maine;
Library, Northeast Harbour, Maine.

THOREAU, Sophia. Painter. Born: in 1819 and died in
1876. She was an amateur artist.

THORNE, Anna L. Painter. Born: Toledo, Ohio in 1866.
Studied: Art Students League; Art Institute of Chicago;
Chicago Academy of Fine Arts; in Paris with Delacluse; also
studied with Chase and Naum Los. Awards: Toledo Museum of
Art; Scarab Club, Detroit. Collections: Toledo Zoo; Toledo
Public Library.

THORWARD, Clara. Painter. Born: South Bend, Indiana.
Studied: Art Institute of Chicago; Cleveland School of
Art; Art Students League; and with Hans Hofmann and
Henry G. Keller. Awards: Cleveland Museum of Art, 1925,
1926; Art League of Northern Indiana, 1932; National
League of American Pen Women, 1950.

THUM, Patty Prather. Painter. Born: Louisville, Kentucky
in 1853 and died in 1926. Studied: Vassar College with
Henry Van Ingen; Art Students League. Award: Chicago
Exposition, 1893.

THURBER, Caroline. Painter. Born: Oberlin, Ohio.
Studied: in Italy and Germany; in Paris with Jean Paul
Laurens and Benjamin Constant, 1897-1901. Her specialty,
portraiture of children.

THURLOW, Helen. Painter. Born: Lancaster, Pennsylvania.
Award: Cresson traveling scholarship, Pennsylvania Academy
of Fine Arts. Collections: Lancaster Pennsylvania Public
Library; Muhlenberg College, Allentown, Pennsylvania.

THURMOND, Ethel Dora. Painter. Born: Victoria, Texas in
1905. Studied: University of Texas; Sul Ross State Teachers
College, Alpine, Texas; University of Colorado; and with
Xavier Gonzales and Paul Ninas. Collections: High School,
Victoria, Texas; Victoria, Texas College.

THURSTON, Jane. Painter. Born: Ripon, Wisconsin in 1887.
Studied: Art Institute of Chicago; also studied in Europe.
Award: Women Painters of the West, 1922. Collection:
Pasadena Art Institute.

THURWANGER, Veneria. Painter. Born: in 1813. A genre,
religious and portrait painter.

TIEBOUT, Mademoiselle. Painter. A French miniature painter
whose work flourished in New York around 1834.

TIFFANY, Marguerite B. Painter. Born: Syracuse, New York.
Studied: Syracuse University; Columbia University; Parsons
School of Design; also with Emile Walters and William
Zorach. Exhibited very extensively in New Jersey.

TIFFANY, Mary A. Painter. Born: Hartford, Connecticut.
Studied: Connecticut School of Design with Tryon. Paints
in both oil and water colors.

TILDEN, Alice F. Painter. Born: Brookline, Massachussets.
Studied: Boston Museum School; also studied with Chase and
Lucien Simon.

TILLINGHAST, Mary E. Painter. Born: in New York. Studied: with John La Farge in New York; and with Carolus-Duran and Henner in Paris. Designs for stained glass are her specialty.

TILLOU, Elizabeth. Painter. A still-life watercolorist working around 1830.

TILTON, Olive. Painter. Born: Mountain Station, New Jersey in 1886. Studied: in Paris with Collin and Delecluse; and in Munich and London.

TIMBERLAKE, Joyce B. Painter. Born: Roanoke, Virginia in 1940. Awards: Brevard Mall, Florida; Newport News Park, Virginia; Sarah Constant Historical award, Virginia. Collections: Mariners Museum, Virginia; Christopher Newport College, Virginia: John P. Yancey Motor Hotels; Ringling Brothers Museum.

TIMOSHENKO, Marina. Painter. Exhibited her water colors at the Pennsylvania Academy of Fine Arts in 1925.

TISCHLER, Marian C. Painter. Member of the Cincinnati Woman's Art Club.

TITCOMB, Virginia C. Painter. Born: Otterville, Illinois. Also a sculptor in bas-relief. Has exhibited at the National Academy of Design.

TITLOW, Harriet W. Painter. Born: Hampton, Virginia. Studied: with Robert Henri.

TITSWORTH, Julia. Painter. Born: Westfield, Massachusetts in 1878. Studied: Art Institute of Chicago; and in Paris with Collin.

TODD, Frances C. Painter. Born: New York City. Studied: Corcoran School of Art; Breckenridge School of Art with Hugh Breckenridge; Grand Central School of Art.

TOERRING, Helene. Painter. She exhibited her miniature paintings at the Pennsylvania Academy of Fine Arts in 1925.

TOLFORD, Irina Poroshina. Painter. Born: Verni, Russia in 1905. Studied: with McNulty and Corbino. Awards: Rockport Art Association, 1954, 1955. Collections: Ohio Art Institute traveling collection; Women and Children's Hospital, Boston.

TOLLES, Sophie M. Painter. Studied: in Philadelphia in 1864 and with Peter F. Rothermel; also studied in France and Italy. In 1876 and 1878 she was exhibiting her portraits and flower pieces.

TOLMAN, Nelly. Painter. Born: Salisbury, North Carolina.
Studied: Corcoran School of Art; Washington Society of
Miniature Painters, Sculptors and Graphic Artists. Awards:
American Artists Professional League, 1940, 1947;
Washington Society of Miniature Painters, Sculptors and
Graphic Artists, 1946. Collections: National Collection of
Fine Arts, Washington, D. C.; Philadelphia Museum of Art.

TOLMAN, Stacy. Painter. Born: Concord, Massachusetts in
1860. Studied: in Paris with Boulanger, Lefebvre and
Cabanel.

TOMLINSON, Anna C. Painter. She exhibited her water colors
at the Pennsylvania Academy of Fine Arts in 1925.

TOMLINSON, Florence K. Painter. Born: Austin, Illinois.
Studied: Colt School of Art, Madison, Wisconsin; University
of Wisconsin; and with Oscar Hagen, Frederic Taubes.
Awards: Madison Art Guild, 1944-1948; Wisconsin State Fair,
1938, 1942-1944; Madison Wisconsin, 1941, 1942.
Collections: Milwaukee Art Institute; Midland Cooperative,
Minneapolis, Minnesota.

TOMPKINS, Clementina. Painter. Born: Washington, D. C. in
1848 and died in 1931. Studied: in Paris with Bonnat.
She was a portrait and figure-piece painter which work she
exhibited in this country in the period 1876-78.

TOMPKINS, Florence. Painter. Born: Washington, D. C. in
1883. Studied: Corcoran School of Art; also studied with
Buff, and Hansen. Awards: Los Angeles Friday Morning Club,
1941, 1942, 1946, 1947, 1949, 1951, 1952; California Art
Club, 1941; Ebell Club, Los Angeles, 1942-1944, 1951;
Glendale Art Assocation, 1947; Bowers Museum, Santa Ana,
1947; Greek Theatre, Los Angeles, 1948, 1949; Art of the
Southwest, 1952.

TORRENS, Rosalba. Painter. A painter of landscapes she
was working in Charleston, South Carolina around 1808.

TORREY, Mabel L. Sculptor. Born: Sterling Colorado in
1886. Studied: State Teachers College, Greeley, Colorado;
Art Institute of Chicago. Award: Chicago Galleries
Association. Collections: Washington Park, Denver,
Colorado; Omaha Children's Library; Proctor Hospital,
Cincinnati, Ohio; University of Chicago Nursery School;
State Normal College, Greeley, Colorado; University of
Chicago; Decatur, Illinois; Crane School, Cincinnati,Ohio.

TOWLE, Eunice Makepeace. Painter. A portraitist who worked
in the mid 19th century.

TOWNE, Rosalba M. Painter. Born: in 1827. Her specialty is flower paintings.

TOWNSEND, Armine. Painter. Born: Brooklyn, New York in 1898. Studied: Buffalo Art Institute; and with Althea Hill Platt and William B. Rowe. Awards: Greenwich Society of Art, 1948, 1950.

TOWNSEND, Charlotte. Painter. Born: in 1824.

TOWNSEND, Ethel Hore. Painter. Born: Staten Island, New York in 1876. Studied: Metropolitan Museum School of Art; Art Students League, with Henry Snell and Orlando Rouland. She is a miniature painter. Award: New York Watercolor Club.

TOWNSEND, Frances. Painter. Born: in 1863. A painter of landscapes.

TRACY, Lois Bartlett. Painter. Born: Jackson, Michigan. Studied: Michigan State University; Rollins College; Ringling School of Art; and with Lawson, Leech and Hofmann. Awards: Florida Federation of Art, 1933-36; Sarasota Art Association, 1937, 1938; Clearwater Museum of Art, 1946; State of Florida, 1935; World's Fair, New York, 1939; American Association of University Women, 1948; New Hampshire Art Association, 1948; Pen and Brush Club, 1948, 1950; Florida Art Group, 1954; National Association of Women Artists, 1950, 1957; Winston-Salem Gallery, 1958; Norfolk Museum of Art, 1956; Atlanta Museum of Art, 1956; Virginia Intermont Exhibition, 1955, 1956.

TRADER, Effie C. Painter. Born: Xenia, Ohio in 1874. Studied: Cincinnati Art Academy; and in Paris with T. Dube. A miniature painter.

TRAUERMAN, Margy Ann. Painter. Born: Sioux Falls, South Dakota. Studied: Los Angeles City College; State University of Iowa; American Academy of Art, Chicago; Art Students League; and with Jacob Getlar Smith. Awards: Texas Annual, 1951; National Association of Women Artists.

TRAVER, Marion Gray. Painter. Born: Elmhurst, Long Island, New York in 1892. Awards: National Academy of Design, 1931; National Association of Women Artists, 1930, 1934, 1938-1941; Allied Arts of America, 1942; War Workers Jury prize, 1943; Wolfe Art Club, 1926-1928, 1944; Hoffman prize, 1945; Exposition of Women's Art and Industry, 1928.

TRAVIS, Kathryne Hail. Painter. Born: Ozark, Arkansas in
1894. Studied: Galloway College; Art Institute of Chicago;
Cincinnati Academy of Fine Arts; Ohio Mechanics Institute;
Chicago Academy of Fine Arts. Her work is in many private
collections.

TREADWELL, Grace A. Painter. Born: West Chop, Massachusetts
in 1893. Studied: Boston Museum of Fine Arts School; Art
Students League; Grande Chaumiere, Paris. Awards: Pen and
Brush Club; Mississippi Art Association. Collections:
Albright Art Gallery; St. Luke's Church, Smethport,
Pennsylvania; madonna, St. Mark's Church and St. George's
Episcopal Church, New York; Father Flannigan's Boys Town,
Nebraska.

TREADWELL, Helen. Painter. Born: Chihuahua, Mexico in
1902. Studied: Vassar College; Sorbonne, Paris. Award:
Municipal Building, Chile. Collections: Hotel murals,
Hotel New Yorker, New York; Hotel Utah, Salt Lake City;
Hotel Tourraine, Boston; Hotel Southern, Baltimore;
Cipango Club, Dallas; Roslyn County Club, Long Island,
New York; Burlington Railway coach panels; Chase Manhattan
Bank, San Juan, Puerto Rico; Brooklyn Savings and Loan Bank,
Bensonhurst, Long Island; Sun and Surf Club, Atlantic Beach,
Long Island; Guggenheim Dental Clinic for Children, New
York; Okonite Cable Company, Passaic, New Jersey; Standard
Vacuum Oil Company, Harrison, New Jersey.

TREGANZA, Ruth Robinson. Painter. Born: in 1877.

TREIMAN, Joyce Wahl. Painter. Born: Evanston, Illinois in
1922. Studied: Stephens College; State University of Iowa.
Awards: Denver Art Museum, 1948; Illinois State Museum,
1948; Art Institute of Chicago, 1949-1951, 1953; Tupperware
Art Fund Fellowship, 1955-1956; Magnificient Mile Exhibition,
Chicago, 1953; Tiffany Foundation fellowship, 1947-48.
Collections: Art Institute of Chicago; Illinois State Museum;
Denver Art Museum; State University of Iowa.

TRIFON, Harriette. Painter. Born: Philadelphia, Pennsylvania
in 1916. Studied: with Aaron Berkman, Nahum Tschacbasov
and Chaim Gross. Awards: Birmingham Museum of Art, 1954;
Long Island Art, 1953, 1956; Malverne Art, 1954; Nassau Art
League, 1958. Collections: Birmingham Museum of Art;
Staten Island Museum of Arts and Science.

TROEMPER, Olive M. Painter. Born: Mulberry Grove, Illinois.
Collections: Decatur City Collection; Springfield City
Collection; Delray Gulfstream, Incorporated, Florida;
Illinois Bell Telephone Company.

TROTH, Celeste H. Painter. Born: Ambler, Pennsylvania in 1888. Studied: Pennsylvania Academy of Fine Arts; and with C. Ricciardi; and in Rome with Sigda Pozza. Collections: Protestant Episcopal Cathedral, Roxborough, Pennsylvania; Academy of Music, Philadelphia; Woodmere Art Gallery, Chestnut Hill, Pennsylvania.

TROWBRIDGE, Gail. Painter. Born: Marseilles, Illinois in 1900. Studied: Columbia University. Awards: National Association of Women Artists, 1940; Argent Gallery, 1945. Collection: Newark Museum.

TRUAX, Sarah E. Painter. Born: Marble Rock, Iowa. Studied: Art Institute of Chicago; also with Howard Pyle, Alphonse Mucha and Joaquin Sorolla. Awards: Pan-Pacific Exposition, 1915; Los Angeles County Fair, 1928; California State Fair, 1936. Collections: San Diego Fine Arts Society; Women's Club, Lidgerwood, North Dakota; First Unitarian Church, San Diego, California.

TRUE, Virginia. Painter. Award: Denver Art Museum. Collections: University of Colorado; Cornell University.

TRUITT, Una B. Painter. Born: Joaquin, Texas in 1896. Studied: Houston University.

TRUMBULL, Mrs. John (nee Sarah Harvey) Painter. Born: in 1774 and died in 1824. She was an amateur painter of fruit and flowers.

TRUMP, Rachel B. Painter. Born: Canton, Ohio in 1890. Studied: Syracuse University. Awards: Philadelphia Plastic Club, 1938; Woodmere Art Gallery, 1943. Collections: Circuit Court, Richmond, Virginia; Haverford Pennsylvania School; Haverford Friends School; Woman's Medical College, Philadelphia.

TRYON, Mrs. Brown. Painter. A portrait painter who exhibited during the period 1858-59.

TSENG YU-ho, Betty. Painter. Born: Peking, China in 1923. Studied: Fu Jen University, Peking; and in Hawaii. Awards: Rockefeller scholarship, 1953; Watamull Foundation, 1947; Stanford University, 1958. Collections: Honolulu Academy of Art; Art Institute of Chicago; Institute of Oriental Studies, Rome; Catholic Church, Island of Kaui, Hawaii; Cemetery, Manoa, Honolulu; stage design, Juilliard School of Music, New York; St. John's College, Annapolis, Maryland.

TUCKER, Alice. Painter. Watercolorist of flowers who worked around 1807.

TUCKER, Cornelia. Sculptor. She exhibited her work at the Pennsylvania Academy of Fine Arts in 1926.

TUCKER, Mary B. Painter. A water color portraitist working in the mid 19th century.

TUCKERMAN, Lilia. Painter. Born: Minneapolis, Minnesota in 1882. Studied: Corcoran School of Art; and with Charles Woodbury. Collections: St. Paul Church and Trinity Episcopal Church, Santa Barbara, California; Santa Barbara Museum of Natural History.

TUKE, Gladys. Sculptor. Born: Linwood, West Virginia in 1899. Studied: Corcoran School of Art; Pennsylvania Academy of Fine Arts; and with Albert Laessle, Maxwell Miller and Charles Tennant.

TURLE, Sarah A. Painter. A miniaturist who exhibited her work at the Pennsylvania Academy of Fine Arts in 1925.

TURNBULL, Grace Hill. Sculptor. Born: Baltimore, Maryland. Studied: Art Students League; Pennsylvania Academy of Fine Arts; Maryland Institute. Awards: Paris, France, 1914; Huntington prize, 1932, 1944; Baltimore Museum of Art, 1939, 1944, 1945, 1947; National Association of Women Artists, 1946; Metropolitan Museum of Art, 1942: Gimbel award, Philadelphia, 1932; Phi Beta Kappa, Southwestern University, 1956. Collections: Metropolitan Museum of Art; Corcoran Gallery of Art; Baltimore Museum of Art; monument, Eastern High School, Baltimore.

TURNER, Helen M. Painter. Born: Louisville, Kentucky in 1858. Studied: Art Students League with Cox. Awards: New York Women's Art Club, 1912; Association of Women Painters and Sculptors, 1913; National Academy of Design, 1913; Chicago Art Institute, 1913. Collection: Corcoran Gallery, Washington, D.C.

TURNER, Janet E. Painter. Born: Kansas City, Missouri
in 1914. Studied: Stanford University; Kansas City Art
Institute; Claremont College; Columbia University.
Awards: Guggenheim fellowship, 1953; Texas Fine Arts
Association, 1948-1954; Dallas Museum of Fine Arts, 1948,
1948, 1951; Southwest Printmakers Exhibition, 1949-1951;
Wichita Art Association, 1950, 1953; National Association
of Women Artists, 1950-1952; Northwest Printmakers, 1952;
Florida Southern College, 1952; Society of American Graphic
Artists, 1952; Boston Printmakers, 1953; Texas Watercolor
Society, 1953; Springfield Art League, 1955, 1957;
Tupperware fellowship, 1956. Collections: Scripps College;
Texas Fine Arts Association; Smith College; Dallas Museum
of Fine Arts; Witte Memorial Museum; Lyman Allyn Museum;
Princeton Printmakers Club; Library of Congress; Wichita
Art Association; Santa Barbara College; San Francisco
Museum of Art; Seattle Art Museum; New Britain Museum;
Boston Public Library; Yale University; Philadelphia Museum
of Art; Cleveland Museum of Art; Fitchburg Art Center.

TURNER, Janet. Painter. Born: Kansas City, Missouri.
Award: National Academy of Design. Collection: Metropolitan
Museum of Art.

TURNER, Jean. Painter. Born: New York City in 1895.
Studied: Pratt Institute Art School; Cooper Union Art
School; and with Ethel Traphagen.

TURNER, Matilda H. Painter. Born: Jerseyville, Illinois
in 1869. Studied: Marietta Ohio College; Pennsylvania
Academy of Fine Arts; and with William Chase, Cecilia Beaux,
Margaretta Archambault and Sargent Kendall. Award:
Fellowship, Pennsylvania Academy of Fine Arts. Collection:
Philadelphia Museum of Art.

TURNEY, Olive. Painter. Born: in 1847.

TURRI, Ann. Painter. Award: Philadelphia Civic Center.
Collections: Hazleton Art League; Citizens Bank.

TUTHILL, Corinne. Painter. Born: Laurenceburg, Indiana
in 1892. Studied: Columbia University. Award: Carnegie
scholarship, Harvard University, 1942.

TUTTLE, Helen N. Painter. Born: Croton-on-Hudson, New
York in 1906. Studied: Bryn Mawr College; University of
Pennsylvania; and with Thomas Benton, Edward Forbes and
Josef Albers. Has exhibited in Pennsylvania.

TUTTLE, Mary M. Thompson. Painter. Born: Hillsboro,
Highland County, Ohio in 1849. A portrait and landscape
painter. Collection: Cornell University; Billings
Library.

TUTTLE, Mildred J. Painter. Born: Portland, Maine in
1874. Studied: Yale School of Fine Arts; also studied
with Chase. She is also an etcher. Collection: Yale
University.

TWIGG, Miss. Painter. A portraitist working during
1821-1840.

TWITCHELL, Asa Weston. Painter. Born: in 1820 and died
in 1904. She was a portrait painter.

TYLER, Carolyn D. Painter. Born: Chicago, Illinois.
Studied: Art Institute of Chicago with Virginia Reynolds.

TYSON, Mary. Painter. Born: Sewanee, Tennessee in 1909.
Studied: Grand Central School of Art; and with George
Ennis, Howard Hildebrandt and Wayman Adams. Collections:
Nantucket Art Association; Nantucket Foundation.

UHLER, Ruth P. Painter. Born: Pennsylvania. Studied:
Philadelphia School of Design for Women; also studied with
Jean Charlot. Collections: Houston Public Library; Museum
of Fine Arts of Houston.

ULBRICHT, Elsa E. Painter. Born: Milwaukee, Wisconsin in
1885. Studied: Wisconsin School of Art; and with
Frederick F. Fursman, Walter Clute, Alex Mueller and
George Senseney; also Pratt Institute.

ULLMAN, Alice W. Painter and illustrator. Born: Goshen,
Indiana.

ULLRICH, B. Painter. Born: Evanston, Illinois. Studied:
Northwestern University; Art Institute of Chicago;
University of Chicago. Collections: University of Arizona;
Chicago Public Library; Artists Equity Association Midwest
Color Slide Collection.

UNDERWOOD, Elisabeth K. Sculptor. Born: Gerrish Island,
Maine in 1896. Studied: Yale School of Fine Arts.

UNKART, Mrs. E. Painter. As a figure and portrait painter
she was exhibiting her work in 1837.

UNTHANK, Alice G. Painter. Born: Wayne County, Indiana.
Studied: Earlham College; Columbia University; University
of Nebraska; University of Chicago; and in Paris; also
studied with Pedro de Lemos, J. E. Bundy and Martha Walter.
Awards: Arrowhead Exhibition, Duluth, Minnesota, 1928;
American Library Color Slides, 1940. Collections:
Carroll College, Waukesha, Wisconsin; Wisconsin State College.

UNTHANK, Gertrude. Painter. Born: in 1878.

UNWIN, Nora Spicer. Engraver. Born: Surbiton, Surrey,
England in 1907. Studied: Royal College of Art, London;
Kingston School of Art, London. Awards: Boston Society of
Independent Artists, 1952; Society of American Graphic
Artists, 1951; New Hampshire Art Association, 1952; National
Association of Women Artists. Collections: British Museum;
Library of Congress; Boston Public Library; New York Public
Library; Ft. Worth Art Museum; California State Library;
Metropolitan Museum of Art; Fitchburg Art Museum; Lawrence
Museum, Williams College.

UPTON, Florence K. Painter and illustrator. Born: in New
York and died in 1922. Studied: with Kenyon Cox.

USHER, Lella. Sculptor and painter. Born: Onolaska,
La Crosse County, Wisconsin in 1859. Studied: with Saint
Gaudens. Collections: Harvard University; John Hopkins
University; Fogg Art Museum, Cambridge, Massachusetts.

VAIL, Aramenta D. Painter. A miniaturist who was active in 1837-45.

VAILLANT, Madame. Painter. A miniature painter active in New York in 1825.

VALENTIN, Anna. Sculptor. Born: Cincinnati, Ohio. Studied: Cincinnati Art Academy; and with Rodin and Bourdella in Paris.

VALENTINE, Jane H. Painter. Born: Bellefonte, Pennsylvania in 1870. Studied: Pennsylvania Academy of Fine Arts.

VALK, Ella Snowden. Painter. A miniaturist.

VALUE, Miss. Painter. A miniaturist working in 1830-32.

VAN BUREN, Helen. Painter. Studied: San Antonio Art Institute; and studied with Margaret Putnam and Peter Lanyon. Award: Annual Local Artists Exhibition, San Antonio, Texas.

VANCE, Mae H. Painter. Born: in Ohio. Studied: Cleveland School of Art; Corcoran School of Art. Collections: F. D. Roosevelt Collection; White House, Washington, D.C.

VAN CLEVE, Helen. Painter. Born: Milwaukee, Wisconsin in 1891. Studied: University of California; Boston Museum School of Fine Arts; Grande Chaumiere, Paris; also with Bela Pratt, E. Withrow Eliot O'Hara, Rex Brandt, Frederic Taubes and Oscar Van Young. Award: Wisconsin State Fair. Collections: California Playhouse; San Diego Public Library.

VANDERPOEL, Emily N. Painter. Born: New York. Studied: with R. Swain Gifford and William Sartain. Award: Columbian Exposition, Chicago, 1893.

VANDERPOOL, Matilda. Painter. Born: in Holland. Studied: Art Institute of Chicago; also studied with David Ericson.

VAN DER VEER, Mary. Painter. Born: in Amsterdam, New York. Studied: National Academy of Design with Edgar M. Ward and Will H. Low; Philadelphia Art School with Chase; in Paris with Whistler; also studied in Holland. Awards: St. Louis Exposition, 1904; National Academy of Design, 1911.

VANDINE, Elizabeth. Engraver. She with her husband, Henry Vandine of Morris County, Province of New Jersey are allegedly the first counterfeiters on record having counterfeited several bills of the Continental Currency.

VAN DUZEE, Kate Keith. Painter. Born: Dubuque, Iowa
in 1874. Studied: with Arthur Dow, John Johansen and
Charles Woodbury. She specialized in water colors.
Awards: Iowa State Fair, 1917, 1918; St. Paul Institute,
1918; Iowa State Fair, 1919, 1920. Collection: Dubuque
Public Library.

VAN DYKE, Ella. Painter. Born: Schenectady, New York in
1910. Studied: Skidmore College; Columbia University;
Ecole des Beaux-Arts, Fontainebleau, France. Has
exhibited extensively in the United States.

VAN HAITSMA, Eleanor. Painter. Studied: Washington
University; Indiana University Art School. Award:
West Michigan Art Exhibition.

VAN HOESEN, Beth. Printmaker. Born: Boise, Idaho in
1926. Studied: Stanford University; Fontainebleau,
Julian Academy and Grand Chaumiere, Paris; California
School of Fine Arts; San Francisco State College. Awards:
California State Fair, 1951; San Francisco Women Artists,
1956. Collection: Achenbach Foundation for Graphic Art.

VAN HOOK, Nell. Painter. Born: Richmond, Virginia.
Studied: Hamilton College; Art Students League; National
Academy of Design. Awards: East Gloucester Art
Association; Wolfe Art Club; American Artists Professional
League, 1957, gold medal, 1958; Westchester Exhibition,
1957; Atlanta Art Association.

VAN HOUSEN, Beth. Painter.

VAN LAER, Belle. Painter. Born: in Philadelphia in 1862.
Studied: with S. J. Ferris. She was a miniature painter.

VAN LEYDEN, Karin E. Painter. Born: Charlottenburg,
Germany in 1906. Her work is in many museums throughout
Europe, and she has exhibited extensively in the United
States.

VAN LOAN, Dorothy. Painter. Born: Lockport, New York.
Studied: Philadelphia Museum School of Industrial Art;
Philadelphia Sketch Club. She is also a lithographer.
Awards: Cresson traveling scholarship, Pennsylvania
Academy of Fine Arts, 1927-1928; fellowship, Pennsylvania
Academy of Fine Arts, 1944; Philadelphia Printmakers Club,
1944; Philadelphia Sketch Club, 1935; Philadelphia Allied
Artists, 1936. Collections: An American Place, New York;
Philadelphia Museum of Art; American Color Slide Society;
Pennsylvania Academy of Fine Arts.

VAN NESS, Beatrice W. Painter. She exhibited at the
Pennsylvania Academy of Fine Arts in 1924.

VANN, Loli. Painter. Born: Chicago, Illinois in 1913.
Studied: Art Institute of Chicago; and with Sam Ostrowsky.
Awards: Los Angeles Museum of Art, 1944; Chaffey College,
1948; Madonna Festival, Los Angeles, 1953.

VAN NORMAN, Mrs. D. C. Painter. She exhibited her
portrait paintings in 1857-1958.

VAN ROEKENS, Paulette. Painter. Born: Chateau Thierry,
France in 1896. Studied: Pennsylvania Academy of Fine
Arts; Moore Institute; and with Samuel Murray, Henry B.
Snell and Charles Grafly. Awards: Philadelphia Plastic
Club, 1920; Philadelphia Sketch Club, 1923; Pennsylvania
Academy of Fine Arts, 1928; Woodmere Art Gallery, 1946.
Collections: Pennsylvania Academy of Fine Arts;
Pennsylvania State College; Reading Museum of Art;
Woodmere Art Gallery, California; Philadelphia Graphic
Sketch Club.

VAN SCIVER, Pearl A. Painter. Born: Philadelphia,
Pennsylvania. Studied: Moore Institute; Pennsylvania
Academy of Fine Arts; also studied with Seyffert, Violet
Oakley, O'Hara and Snell. Awards: Chestnut Hill,
Pennsylvania; Springside Annual; gold medals, Philadelphia
Plastic Club; Cape May County Court House; Pennsylvania
Academy of Fine Arts. Collections: Allentown Museum;
Rochester Memorial Art Gallery; Ogontz Junior College;
University of Pennsylvania; Woodmere Art Gallery; Cape
May County Court House, New Jersey.

VAN SICKLE, Selah. Painter. Born: in 1812. She was
a portrait and panoramic artist active from 1832-80.

VARIAN, Dorothy. Painter. Born: New York City in 1895.
Studied: Cooper Union Art School; Art Students League;
and in Paris. Award: William Fox Company, New York
Collections: Whitney Museum of American Art; Newark
Museum; Dartmouth College; Fiske University; Ogunquit
Museum of Art.

VERNER, Elizabeth. Etcher. Born: Charleston, South
Carolina in 1883. Studied: Pennsylvania Academy of Fine
Arts; Central School of Art, London, England. Collections:
Metropolitan Museum of Art; Library of Congress; Boston
Museum of Fine Arts; Mt. Vernon Association; Princeton
University; West Point Military Academy; University of South
Carolina; City of Charleston Collection; Honolulu Academy of
Art.

VERSTEEG, Florence. Painter. Born: in 1871.

VETHAKE, Adrina. Painter. Painted landscapes and buildings working with water colors during the period 1795-1801.

VETTER, Cornelia C. Painter and etcher. Born: in Hartford in 1881. Studied: with Robert Henri; and with Andrada in Paris and Spain.

VIBBERTS, Eunice W. Painter. Born: New Albany, Indiana. Studied: Pratt Institute Art School; Art Students League; Beaux-Arts, Fontainebleau, France. Awards: Scarsdale Art Association, 1941, 1943; Greenwich Art Society, 1945, 1946, 1952, 1954; Baekland prize, 1943.

VICTOR, Sophie. Painter. She was exhibiting her work at the Pennsylvania Academy of Fine Arts, in 1924.

VINTON-BROWN, Pamela. Painter. Born: Boston, Massachusetts in 1884. Studied: in Paris with Collin and Courtois; in Baltimore with Edwin Whiteman. Award: Exhibition American Woman's Work, Paris, 1914.

VITACCO, Alice. Painter. Born: Mineola, Long Island, New York in 1909. Studied: New York School of Applied Design for Women; University of Mexico; and with Winold Reiss, Kimon Nicolaides and Lucien Bernhard. Awards: Lexington Gallery, New York, 1939; Wolfe Memorial prize, 1931; DeForest memorial prize, National Association of Women Artists, 1936.

VITOUSEK, Juanita Judy. Painter. Born: Portland, Oregon in 1892. Studied: University of California; and with Millard Sheets. Awards: Honolulu Art Society, 1934; Honolulu Academy of Art, 1937. Collections: Seattle Art Museum; Honolulu Academy of Art.

VIVIAN, Calthea. Painter and etcher. Born: Fayette, Missouri Studied: with Arthur Mathews; also studied in Paris at the Lazar and Colarossi Academies. Collections: Palace of Fine Arts, San Francisco; Arkansas Auditorium Gallery.

VODICKA, Ruth. Sculptor. Born: New York City in 1921. Studied: City College of New York; Sculpture Center with O'Connor Barrett; Art Students League. Awards: National Association of Women Artists, 1954, 1957; National Academy of Design, 1955; Audubon Art, 1957; Silvermine Guild of Art, 1957, 1958.

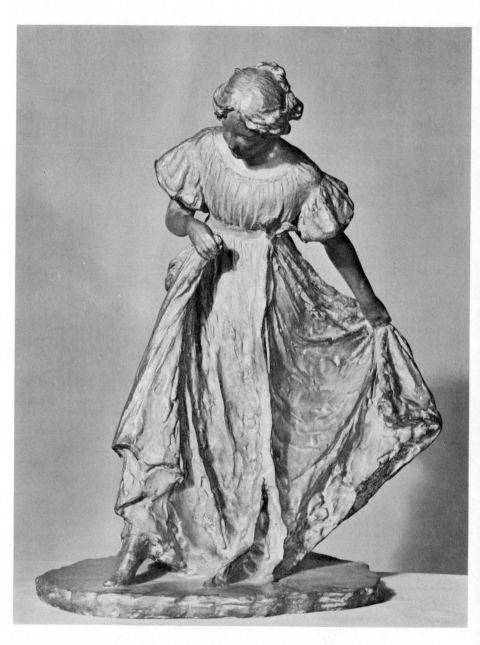

Bessie Potter Vonnoh, GIRL DANCING. Bronze. The Metropolitan Museum of Art (Rogers Fund, 1906).

VOGEL, Valentine. Painter. Born: St. Louis, Missouri in
1906. Studied: Washington University; National Academy
of Design; Grande Chaumiere, Paris; American Academy in
Rome. Awards: St. Louis Art Guild, 1929, 1930; Kansas
City Art Institute, 1930; St. Louis Post-Dispatch, 1931;
St. Louis Little Theatre prize, 1931. Collections:
Crunden Library, Clayton, Missouri; Belvue School,
University City, Missouri; Public Library, Sikstone
Missouri.

VOGNILD, Edna. Painter. Born: Chicago, Illinois. Studied:
Art Institute of Chicago; Colarossi and Delecluse
Academies, Paris; also studied with Hawthorne, Johansen and
Snell.

VOGNILD, Ted. Mrs. Painter. Born: in 1881. Studied:
Art Institute of Chicago; in Paris France; and with Johansen,
Snell and Hawthorne. Award: All-Illinois Society of Fine
Arts, 1937.

VOIGTLANDER, Katherine. Painter. Born: Camden, New Jersey
in 1917. Studied: University of Pennsylvania; Kansas City
Art Institute; Pennsylvania Academy of Fine Arts; University
of Kansas City; also studied with Thomas Benton, George
Harding and Francis Speight. Award: fellowship, Pennsylvania
Academy of Fine Arts; Cresson traveling scholarship,
Pennsylvania Academy of Fine Arts, 1938; Woman Painters,
Wichita, Kansas, 1936; Cumberland Valley Exhibition,
Hagerstown, Maryland, 1944; Pennsylvania Academy of Fine
Arts, 1940.

VON AUW, Emilie. Painter. Born: Flushing, Long Island in
1901. Studied: New York School of Fine and Applied Arts;
Columbia University; University of New Mexico; Grande
Chaumiere, Paris; Ecole des Beaux-Arts, Fontainebleau,
France; Academy of Art, Florence Italy; and in Germany.
Award: New Mexico State Fair.

VON DER LANCKEN, Giulia. Painter. Born: Florence, Italy.
Studied: Royal Academy of Fine Arts, Florence, Italy with
Vivalta, Caloshi, Fattori and Burchi; and in Venice with
Hopkinson Smith. Awards: Diplome of Honor, Academy of
Fine Arts, Florence, Italy; Oklahoma State Art Exhibition;
Tulsa Art Association.

VONNOH, Bessie Potter. Sculptor. Born: St. Louis, Missouri
in 1872. Studied: sculpture at the Art Institute of Chicago
under Lorado Taft. Her specialty is statuettes of women
and children. Awards: Paris Exposition, 1900; gold medal,
St. Louis World's Fair. Collections: Metropolitan Museum of
Art; Capitol, Washington, D.C.

VON PHUL, Anna Maria. Painter. Born: in 1786 and died in 1823. An amateur artist.

VON SCHOLLEY, Ruth. Painter. She exhibited at the Pennsylvania Academy of Fine Arts in 1924.

Von WIEGAND, Charmion. Painter. Born: Chicago, Illinoia in 1899. Studied: Barnard College; Columbia University; New York University. Exhibited extensively in the United States and foreign countries.

VORIS, Millie Roesgen. Painter. Born: Dudley Town, Indiana in 1859. Studied: with Berger, Steele, Cox and Chase. Awards: Chicago World's Fair; Woman's Department Club, 1948; Marshall Field, Chicago; O'Brien Galleries, Chicago; Philadelphia Museum of Art; John Herron Art Institute; Hoosier Salon; Florida Art Club, Miami. Collection: Berlin Art Museum.

VOUTE, Kathleen. Painter. Born: Montclair, New Jersey. Studied: Grand Central School of Art; George Pearse Ennis School of Art. Awards: Montclair Art Museum, 1932; American Artists Professional League, 1931, 1939.

VREELAND, Elizabeth. Painter. Born: in India in 1896. Studied: In New York, Paris, London and Norway.

VYSEKAL, Ella B. Painter. Born: Le Mars, Iowa. Studied: with Macdonald Wright, Harry M. Walcott and Ralph Clarkson. Collection: Portrait of Christian Hoffman, in State Historical Building, Topeka, Kansas.

WACHTEL, Marion K. Painter. Born: Milwaukee, Wisconsin in 1875. Studied: Art Institute of Chicago; also studied with Chase. Collections: California State Building; Friday Morning Club, Los Angeles.

WACKERMAN, Dorothy. Painter. Born: Cleveland, Ohio in 1899. Her specialty, landscapes and mural paintings.

WADE, Caroline D. Painter. Born: in Chicago, Illinois. Studied: Art Institute of Chicago; and with Courtois in Paris.

WADE, Claire E. Painter. Born: Ossining, New York in 1899. Studied: New York University; and with Jerry Farnsworth and Umberto Romano. Awards: Art League of Long Island, 1949; Farnsworth School of Art, Sarasota, Florida.

WADE, Hannah C. Painter. Born: in 1820.

WADE, Jean E. Painter. Born: Bridgeport, Connecticut in 1910. Studied: Yale University. Awards: Bridgeport Art League, 1945, 1955; National League of American Pen Women, 1953-1955; Contemporary Arts and Crafts, 1953; Silvermine Guild of Artist, 1955; Mystic Art Association, 1955; College Art Association of America, 1931.

WADSWORTH, Adelaide E. Painter. Born: In Boston in 1844. Studied: with William M. Hunt, Frank Duveneck, John Twachtman, C. H. Woodbury and Arthur Dow.

WADSWORTH, Frances. Sculptor. Born: Buffalo, New York in 1909. Studied: Albright Art School; and in Italy and France; and with Gutzon Borglum, Charles Tefft, John Effl, Antoinette Hollister. Awards: National League of American Pen Women, 1956, 1958. Collections: sculpture portraits, University of Virginia, Kingswood School, Hartford; American School for the Deaf, West Hartford; garden sculpture Institute of Living, Hartford, Connecticut; St. Catherine's School, Richmond, Virginia; monuments, Thomas Hooker Monument, Hartford; Gallaudet Monument; mural, Institute of Living.

WAESCHE, Metta Henrietta. Painter. Born: in 1806 and died in 1900. She was an amateur artist in crayon and water-colors.

WAGENHALS, Katherine H. Painter. Born: Ebensburg, Pennsylvania in 1883. Studied: Smith College, Art Department; Art Students League; Academie Moderne in Paris. Award: Herron Art Institute, 1916. Collection: Herron Art Institute, Indianapolis, Indiana.

WAGNER, Maria Louisa. Painter. A miniature genre, portrait
and landscape painter active around 1830 until after 1888.

WAGNER, Mary North. Painter, sculptor and illustrator.
Born: Milford, Indiana in 1875. Studied: with John
Vanderpoel, Charles Francis Browne, Mary S. West, Louis
J. Millet, C. J. Mulligan and William M. Chase. Collection:
four drawings for Mrs. Alpha B. Benson's "Second Brownie
Book."

WAITE, Emily Burling. Painter. Born: Worcester,
Massachusetts in 1887. Studied: Worcester Museum of Art
School; Art Students League; Boston Museum of Fine Arts
School; and with Hale, Mora and DuMond. Awards: traveling
scholarship, Boston Museum of Fine Arts School; American
Veteran's Society of Art, 1955; Pan-Pacific Exposition,
1915; League of American Pen Women. Collections: Clark
University, Worcester, Massachusetts; Tufts College,
Medford, Massachusetts; Boston Museum of Fine Arts;
Smithsonian Institute; Metropolitan Museum of Art; Fogg
Museum of Art; Episcopal Theological School, Cambridge,
Massachusetts.

WALCOTT, Anabel H. Painter. Born: Franklin County, Ohio.
Studied: Art Students League; Chase School of Art; also
studied in France and Holland. Award: National Academy of
Design.

WALD, Sylvia. Painter and serigrapher. Born: Philadelphia,
Pennsylvania in 1914. Studied: Moore Institute of Art.
Awards: Museum of Modern Art, 1941; Library of Congress,
1944; National Association of Women Artists, 1949;
Serigraph Gallery, 1948, 1949, 1950; Brooklyn Museum, 1951,
1954. Collections: Howard University; Allen R. Hite
Museum, J. B. Speed Memorial Museum; Ball State Teachers
College; Association of University Women; New York Public
Library; Metropolitan Museum of Art; Princeton University;
University of Nebraska; Munson-Williams-Proctor Institute;
National Gallery, Canada; University of Iowa; United States
State Department; Philadelphia Museum of Art; Museum of
Modern Art; Brooklyn Museum; United States Army; Library
of Congress.

WALDRON, Adelia. Painter. Born: in 1825. She was painter
in oils.

WALDRON, Anne A. Painter. She exhibited her water colors at
the Pennslyvania Academy of Fine Arts in 1925.

WALES, Susan M. L. Painter. Born: Boston, Massachusetts in 1839. Studied: Boston Museum School; Vincente Poveda in Rome; and in Holland with Bloomers. She was known as a landscape artist.

WALKER, Miss A. M. Painter. A marine and landscape painter who worked in 1840-44.

WALKER, Elizabeth L. Painter. A watercolorist working in 1840.

WALKER, Eveline. Painter. Born: in 1827.

WALKER, Frances Antill L. Painter. Born: in 1872 and died in 1916. She was a miniature painter.

WALKER, Nellie V. Sculptor. Born: Red Oak, Iowa in 1874. Studied: Art Institute of Chicago with Lorado Taft. Awards: First Chicago Municipal Art League, 1907; Art Institute of Chicago, 1908; Shaffer prize, Art Institute of Chicago, 1911. Collection: Colorado Springs, Colorado; Art Institute of Chicago; Keokuk, Iowa.

WALKER, Sophia A. Painter, sculptor and etcher. Born: Rockland, Massachusetts in 1855. Studied: in Paris with Lefebvre; and in New York with Mowbray and Chase. Collection: State Normal School, Bridgewater, Massachusetts.

WALKER, Sybil. Painter. Born: New York City in 1882. Collections: Brooklyn Museum; Parrish Museum, Southampton, New York; Tate Gallery, London, England.

WALKINSHAW, Jeanie W. Painter. Born: Baltimore, Maryland. Studied: with Edwin Whiteman, Rene Menard, Lucien Simon in Paris; and Robert Henri in New York. Collections: Temple of Justice, Olympia, Washington; University of Washington, Seattle; Seattle Historical Society; Diocesan House, St. Mark's Cathedral, Seattle; Children's Orthopedic Hospital, Seattle.

WALLACE, Lucy. Painter. Born: Montclair, New Jersey. Studied: New York School of Fine and Applied Arts; Art Students League; and with Miller and Koopman. Award: New Haven Paint and Clay Club, 1923.

WALSH, Elizabeth M. Painter. Born: Lowell, Massachusetts. Studied: Boston Museum of Fine Arts.

WALTER, Martha. Painter. Born: Philadelphia, Pennsylvania.
Studied: Philadelphia Art School; Pennsylvania Academy of
Fine Arts; and with William M. Chase; studied in Paris at
the Julien Academy and the Grande Chaumiere, and in Germany,
Holland, Italy and Spain. Awards: winner of the first
award of the Cresson traveling scholarship in 1908; Mary
Smith prize, 1909. Collections: Toledo Museum, Ohio;
Pennsylvania Academy of Fine Arts.

WALTER, Valerie. Sculptor. Born: Baltimore, Maryland.
Studied: Maryland Institute, and with Ephraim Keyser and
Augustus Lukeman. Award: Corcoran Gallery of Art, 1934.
Collections: Corcoran Gallery of Art; Unitarian Church,
Baltimore; Baltimore Zoo; Aeronautical Ministry, Rome,
Italy.

WALTERS, Doris L. Painter. Born: Sandersville, Georgia
in 1920. Studied: Washington School of Art. Awards:
Melbourne Art Association, 1954, 1955.

WALTERS, Emile. Painter. Born: Winnipeg, Canada in 1893.
Studied: Art Institute of Chicago; Pennsylvania Academy of
Fine Arts; Tiffany Foundation. Awards: Art Institute of
Chicago, 1918, 1919; National Academy of Design, 1923;
Order of the Falcon, King Christian, Denmark, 1939.
Collections: Smithsonian Institute; Philadelphia Art Club;
100 Friends of Art, Pittsburgh, Pennsylvania; Museum of
Fine Arts of Houston; Heckscher Museum of Fine Arts;
Museum of Art, Saskatoon, Canada; Fogg Museum of Art;
Glasgow Scotland Art Gallery; Grainger Museum, Melbourne,
Australia; Museum of Rouen, France; Brooklyn Museum;
Seattle Art Museum; Vanderpoel Collection; Winnipeg
Canada Museum of Fine Arts; Luxembourg Museum, Paris;
Municipal Gallery of Modern Art, Dublin, Ireland; National
Museum, Helsinki, Finland; Museum of Iceland, Reykjavik;
Pomona College., Claremont, California; Palace Legion Honor;
Newark Museum; Los Angeles Museum of Art; Fleming Museum;
Museum of New Mexico, Santa Fe; Springfield Illinois Museum
of Art; Seattle Art Museum; Springville, Utah; United Nations
Collection; Fogg Museum of Art; University Museum, Bangkok,
Thailand.

WALTERS, Emile. Painter. Born: in 1863. A landscapist.

WALTON, Florence L. Painter. Born: East Orange, New Jersey
in 1889. Studied: with George Bellows.

WALTON, Marion. Sculptor. Born: New Rochelle, New York in 1899. Studied: Art Students League; Grande Chaumiere, Paris, with Antoine Bourdelle; Borglum School of Sculpture. Collections: University of Nebraska; World's Fair, New York, 1939.

WALTER, Mildred. Painter. Born: Nebo, Kentucky in 1911. Studied: Art Institute of Chicago; Northwestern University; New York University; and studied with Archipenko, Leger and Moholy-Nagy. Award: Raymond fellowship, Art Institute of Chicago, 1933. Collections: Oak Park Illinois Public School; Chicago Park Board, Administration Building; Cook County Hospital, Chicago; Scott Field, Belleville, Illinois.

WALZER, Marjorie S. Painter. Born: New York City in 1912. Studied: Art Students League with Kuniyoshi and Bouche; Silvermine Guild of Art, with Albert Jacobson, Julius Schmidt.

WANKER, Maude W. Painter. Born: Oswego, Oregon in 1882. Studied: University of Oregon; Art Institute of Chicago; Portland Art Museum School. Awards: American Artists Professional League; Sigma Theta Phi, 1958.

WARD, Elsie. Sculptor. Studied: with Saint Gaudens. Works in Denver, Colorado.

WARD, Irene S. Painter. Born: Oakman, Alabama in 1898. Studied: Mississippi State College. Awards: Virginia Museum of Fine Arts, 1938; Society of Independent Artists, 1943; Montgomery, Alabama, 1938-1946.

WARD, Louisa C. Painter. Born: Harwinton, Connecticut in 1888. Studied: Yale School of Fine Arts. Awards: Los Angeles Library, 1945; Las Artistas Exhibition, Los Angeles 1946, 1948; Los Angeles City Hall, 1953.

WARD, Mary H. Painter. Born: in 1800 and died in 1880. She was a portraitist and coypist.

WARD, Nina B. Painter. Born: Rome, Georgia. Studied: St. Louis School of Fine Arts; New York School of Art; Pennsylvania Academy of Fine Arts. Awards: Cresson European scholarship, Pennsylvania Academy of Fine Arts, 1908 and 1911; Toppan prize, Pennsylvania Academy of Fine Arts, 1912; Mary Smith prize, Pennsylvania Academy of Fine Arts, 1914.

WARD, Winifred. Sculptor. Born: Cleveland, Ohio in 1889. Studied: with Charles Grafly.

WARNER, Lily G. Painter. Born: Hartford, Connecticut. Also an illustrator she painted flower-pieces and illustrated for St. Nicholas Magazine.

WARNER, Mary L. Painter. A member of the Connecticut Academy of Fine Arts.

WARREN, Elizabeth B. Painter. Born: Bridgeport, Connecticut in 1886. Studied: Massachusetts School of Art; Vesper George School of Art; with W. H. Bicknell, Provincetown, Massachusetts; and Charles Simpson, England. Award: Florida Federation of Art.

WARING, Sophia F. Painter. Born: in 1787 and died in 1823. She was an amateur miniature painter.

WARREN, Asa. Painter. A portrait and miniature painter working in 1846-47.

WARREN, Betty. Painter. Studied: National Academy of Design; Cape School of Art, Provincetown, Massachusetts. Award: Albany Institute of History and Art.

WARRICK, Meta Vaux. Sculptor. Born: Philadelphia, Pennsylvania in 1877. Studied: School of Industrial Art; Pennsylvania Academy of Fine Arts; at the Colarossi Academy in Paris; and with Rodin, Collin and Carles. Collection: Cleveland Art Museum.

WARUEN, Miss C. A. Painter. A miniature painter working in 1842.

WARWICK, Ethel H. Painter. Born: New York City. Studied: Moore Institute of Design; Pennsylvania Academy of Fine Arts; also studied with Chase, Breckenridge and Snell. Awards: fellowship, Pennsylvania Academy of Fine Arts; Philadelphia Plastic Club. Collections: Pennsylvania State College.

WASEY, Jane. Sculptor. Born: Chicago, Illinois in 1912. Studied: with Simon Moselsio and John Flanagan in New York; with Paul Landowski in Paris; and with Heinz Warneke in Connecticut. Awards: Lighthouse Exhibition, New York, 1951; National Association of Women Artists; Guild Hall, East Hampton, Long Island, 1949-1956; Architect League, 1955; Parrish Museum, Southampton. Collections: Whitney Museum of American Art; Pennsylvania Academy of Fine Arts; University of Nebraska; University of Arizona; University of Colorado; City Art Museum of St. Louis.

WASHBURN, Jeannette. Painter. Born: Susquehanna,
Pennsylvania in 1905. Studied: Florida State Women's
College; Syracuse University; Art Students League; and
with Kenneth Hayes Miller. Awards: Jacksonville Art
Club, 1951; Jacksonville Art Museum, 1957. Collections:
University of Alaska; Jacksonville Public School No. 11;
Florida State Board of Health.

WASHBURN, Louese B. Painter. Born: Dimock, Pennsylvania
in 1875. Studied: Pratt Institute Art School; Broadmoor
Art Academy; Colorado Springs Fine Arts Center; also
studied with Ross Moffett, and Henry Varnum Poor. Awards:
Tampa, Florida, 1924; Jacksonville Art Club, 1928;
Florida Federation of Art, 1929, 1931, 1933, 1934, 1954;
International Business Machines, 1941. Collections:
St. Luke's Hospital, Jacksonville, Florida; Hope Haven
Hospital for Crippled Children, Florida; Thornwell
Orphanage, Clinton, North Carolina.

WASHBURN, Mary S. Sculptor. Born: Star City, Indiana.
Studied: Art Institute of Chicago and with Carles Mulligan;
also studied with Edwin Sawyer in Paris. Awards: Paris
Allied Artists Association; gold medal, Panama-Pacific
Exposition, San Francisco, 1915. Collections: Milroy Park,
Rensselaer, Indiana; Carnegie Institute, Pittsburgh,
Pennsylvania; Logansport, Indiana.

WASHBURN, May N. Painter. Born: Greenfield, Massachusetts
in 1861. Studied: with D. W. Tryon.

WASHBURN, Mrs. Painter. Daughter of miniature painter
George Munger of New Haven who inherited his skill in
producing delicate miniatures on ivory.

WASHINGTON, Elizabeth F. Painter. Born: Siegfried's
Bridge, Pennsylvania. Studied: Pennsylvania Academy
of Fine Arts; and with Hugh Breckenridge and Fred Wagner.
Awards: Pennsylvania Academy of Fine Arts, 1917.
Collections: Pennsylvania Academy of Fine Arts Collection;
Civic Club, Philadelphia; Pierce Business College.

WATERS, Almira. Painter. A still-life watercolorist
working in 1830.

WATERS, Sadie. Painter. A genre painter who exhibted her
work in 1889 and 1900.

WATKINS, Susan. Painter. Born: in California in 1875.
Studied: Art Students League; and with Collin in Paris.
Awards: Paris Salon, 1889; gold medal, Paris Salon, 1901.

WATROUS, Elizabeth Snowden. Painter. Born: New York in 1858 and died in 1921. Studied: with Henner and Carolus-Duran in Paris.

WATSON, Adele. Painter. Born: in 1873.

WATSON, Amelia Montague. Painter. Born: East Windsor Hill, Connecticut in 1856. She is a painter of New England and Southern scenery working in the mountains and on the seacoast. She made many illustrations in color and has exhibited in Boston and New York.

WATSON, Elizabeth V. Painter. Born: in New Jersey. Studied: with Tarbell and De Camp. Award: Tennessee Centennial Exposition, Nashville, 1897.

WATSON, Eva Auld. Painter. Born: in Texas in 1889. Studied: Pittsburgh School of Design; Pratt Institute, Brooklyn; and with M. O. Leisser. Also a known illustrator. Award: Panama-Pacific Exposition, San Francisco, 1915.

WATSON, Jean. Painter. Born: Philadelphia, Pennsylvania. Studied: Pennsylvania Academy of Fine Arts; and with Earl Horter. Awards: fellowship, Pennsylvania Academy of Fine Arts; Pennsylvania Academy of Fine Arts, 1943, 1951; Pen and Brush Club, 1954; Philadelphia Plastic Club, 1935, 1938; Philadelphia Sketch Club, 1937. Collections: Woodmere Art Gallery, Philadelphia; United States Post Office, Madison, North Carolina; Stoughton, Massachusetts.

WATSON, Jessie N. Painter. Born: in 1870.

WATSON, Minnie. Painter. Studied: with D. W. Tryon in Hartford, Connecticut in 1875 and in New York. Her paintings of still-life subjects are excellent.

WATT, Barbara H. Painter. Born: Wellesley, Massachusetts Studied: with Albert H. Nunsel, V. L. George, De Camp and Connah. Collection: Massachusetts Normal Art School, Boston.

WAUGH, Eliza. Painter. A painter of miniatures who was married to the artist Samuel B. Waugh.

WAUGH, Ida. Painter. Born: in Philadelphia, Pennsylvania and died there in 1919. Studied: Pennsylvania Academy of Fine Arts; and at the Academie Julien and Academie Delecluse in Paris in 1888 and 1891-92. Award: National Academy of Design, 1896. Has exhibited in New York, Chicago and Paris, California and Cincinnati.

WAUGH, Mary E. Painter. A miniaturist working in 1841.

*WAY, Edna. Painter. Born: Manchester, Vermont in 1897.
Studied: Columbia University; and in Paris. Awards:
Stockbridge, Massachusetts, 1934; National Association
of Women Artists, 1936, 1944; Columbus Art League, 1939,
1943, 1946, 1955; Washington Watercolor Club, 1945, 1946;
Ohio Watercolor Club, 1952. Collections: Fleming Museum
of Art, Burlington, Vermont; Addison Gallery of American
Art, Andover, Massachusetts.*

*WAY, Mary. Painter. Painter. A portrait and miniature
painter of New London, Connecticut who did landscapes and
country scenes during the period 1811-19.*

*WAYNE, June C. Graphic Artist. Collections: Achenbach
Foundation for Graphic Arts, San Francisco; Grunwald
Foundation for Graphic Arts, University of California,
Los Angeles; Houghton Library; Los Angeles County Museum;
Museum of Modern Art; Smithsonian Institute.*

*WEBB, Edna Dell. Painter. Born: Cohoes, New York in 1891.
Studied: National Academy of Design; Troy School of Arts
and Crafts.*

*WEBB, Grace. Painter. Born: Vergennes, Vermont in 1888.
Studied: Art Students League; Pratt Institute Art School;
University of Vermont; University of California; Simmons
College; also studied with Miller, Sample, Brandt, Allen
and Carlson. Awards: Vermont Federation of Women's Club,
1954; gold medal, American Artists Professional League,
1958; National League of American Pen Women, 1958.
Collections: Fleming Museum of Art, Burlington, Vermont;
Shelburne Museum of Art.*

*WEBB, Margaret E. Painter and Engraver. Born: Urbana,
Illinois in 1877. Studied: Art Students League; Cooper
Union Art School; also studied with Kenyon Cox, Arthur
Dow, Bridgman, and Twachtman. Awards: American Bookplate
Society, 1924, 1925; Madonna Festival, Los Angeles,
1955. Collections: bookplates, American Antiquarian
Society; Huntington Library; Santa Barbara Natural History
Museum; Wilshire Methodist Church, Los Angeles; Mount
Calvary Monastery, Santa Barbara, California; Liverpool
England Public Library; British Museum, London; Solvang
California Episcopal Church; St. Mary's Church, Santa
Barbara.*

*WEBB, Martha R. Painter. Born: Harlingen, Texas in 1937.
Awards: Tri-State Exhibitions.*

WEBSTER, Bernice M. Painter. Born: Northfield,
Massachusetts in 1895. Studied: Massachusetts School
of Art; Columbia University; and with Snell and Woelfle.
Has exhibited quite extensively in the New England States.

WEBSTER, Mary H. Painter and sculptor. Born: Oberlin,
Ohio in 1881. Studied: Cincinnati Art Academy with
Barnhorn and Nowottny; and with Injalbert, Verlet and
Waldmann in Paris; also studied in Holland with Hitchcock;
in Provincetown with Hawthorne.

WEEDELL, Hazel. Painter and etcher. Born: Tacoma,
Washington in 1892. Studied: with Gustav F. Goetsch,
Robert Koehler and Ernest Batchelder.

WEEKES, Shirley M. Painter. Born: Buffalo, New York.
Awards: Craftsman Press award; Puget Sound Show,
Washington; West Coast Oil Show, Washington. Collection:
Charles and Emma Frye Museum, Washington.

WEEKS, Caroline. Painter. A portrait painter who worked
from 1860 to 1870. Collection: Independence Hall,
Philadelphia.

WEEMS, Katharine L. Sculptor. Born: Boston, Massachusetts
in 1899. Studied: Boston Museum Fine Arts School; also
studied with Charles Grafly, Brenda Putnam and Anna Hyatt
Huntington. Awards: Sesqui-Centennial Exposition,
Philadelphia, 1926; Boston Tercentenary Exhibition, 1930;
Pennsylvania Academy of Fine Arts, 1927; Paris Salon,
1928; National Association of Women Painters and Sculptors,
1928; Grand Central Art Gallery, 1929; National Academy of
Design, 1931, 1932; Architect League, 1942; National
Academy of Women Artists, 1946. Collections: Boston
Museum of Fine Arts; Reading Museum; Pennsylvania Academy
of Fine Arts; Brookgreer Gardens, South Carolina;
Baltimore Museum of Art; Harvard University; fountain,
Boston, Massachusetts; many medals for Merit.

WEESE, Myrtle A. Painter. Born: Roslyn, Washington in
1903. Studied: Los Angeles County Art Institute; and
with George Flower and Ejnar Hansen. Awards: Friday
Morning Club, 1955; Sierra Madre Exhibition.

WEGER, Marie. Painter. Born: Murten, Switzerland in 1882.
Studied: in Munich, Germany with Paul Nauen, Wilhelm von
Dietz. Collection: City Hall, Munich.

WEIDNER, Doris K. Painter. Studied: Barnes Foundation;
Pennsylvania Academy of Fine Arts. Awards: Pennsylvania
Academy of Fine Arts, 1944, 1946; Oklahoma Lithograph
Exhibition, 1941; Pepsi-Cola, 1945. Collections:
Woodmere Art Gallery, Philadelphia; Pennsylvania Academy
of Fine Arts; Library of Congress; Oklahoma Art Center.
She is also a serigrapher and lithographer.

WEILL, Erna. Sculptor. Born: Germany. Studied: Frankfurt,
Germany. Awards: International Exhibition of Women's Art,
1946, 1947. Collections: Tel-Aviv Museum, Israel; Bezalel
Museum, Jerusalem; Hebrew University, Jerusalem; Georgia
State Museum, Athens; Hyde Park Library; Jewish Museum,
New York; Birmingham Museum of Art.

WEINER, Anita K. Painter. Born: Philadelphia, Pennsylvania
in 1935. Award: Philadelphia Civic Center Museum.

WEIR, Irene. Painter. Studied: Yale School of Fine Arts;
Art Students League of New York; Academie, Paris; and
studied with J. H. Twachtman and J. Alden Weir.

WEISS, Dorothea Patterson. Painter. Born: Philadelphia,
Pennsylvania in 1910. Studied: Moore Institute of Art;
Yale School of Fine Arts. Award: El Paso Art Association.
Collections: Museum of New Mexico, Santa Fe; Texas Western
University; Stations of the Cross, Our Lady of the Valley,
Ysleta, Texas; Christo Rey Church, Santa Fe; St. Joseph's
Church, El Paso.

WEISS, Mary L. Painter. She exhibited her work at the
Pennsylvania Academy of Fine Arts in 1924.

WEISSER, Leonie O. Painter. Born: Guadalupe County, Texas
in 1890. Studied: with Minnie Stanford, John E. Jenkins
and R. J. Onderdonk. Awards: Hays County, Texas Fair,
1922-1924; Federation of Women's Club, Lubbock, Texas, 1931.
Collection: Witte Memorial Museum.

WELCH, Mabel R. Painter. Born: New Haven, Connecticut.
Studied: Art Students League; and with Cox and Reid;
studied in Paris with Garrido, Lazar, Scott, Van der Weyden.
Awards: Pan-Pacific Exposition, 1915; Pennsylvania Society
of Miniature Painters, 1920; California Society of Miniature
Painters, 1937; Brooklyn Society of Miniature Painters, 1933;
National Association of Women Artists, 1938; Pennsylvania
Academy of Fine Arts, 1938; American Society of Miniature
Painters, 1935, 1940. Collections: Brooklyn Museum; Corcoran
Gallery of Art; Philadelphia Museum of Art. Her miniature
paintings are beautifully executed.

WELLMAN, Betsy. Painter. An artist who painted watercolor portraits in 1840.

WELLS, Rachel. Sculptor. Her work was mainly small profile bas-reliefs in wax; the portraits were well-modeled and frequently finished in color.

WENDT, Julia B. Sculptor. Born: Apple River, Illinois in 1871. Studied: Art Institute of Chicago in 1887. Assisted Lorado Taft in his studio in 1887-92. Awards: 1st sculpture prize, Chicago, 1898; St. Louis Exposition, 1904; 1st prize for sculpture, Municipal Art League, Chicago, 1905; gold medal, San Diego Exposition, 1915; Mrs. W. P. Harrison prize, Los Angeles, 1918. Collection: Museum of Exposition Park, Los Angeles, California.

WENGER, Dorothy S. Painter. Studied: Pierce Junior College, Woodland Hills, California; Valley Center of Arts, Reseda, California; Honolulu Academy of Arts, Honolulu. Award: Easter Art Festival, Honolulu, Hawaii.

WENIGER, Maria P. Sculptor. Born: Germany in 1880. Studied: in Munich. Some of her outstanding work is miniatures in bronze.

WENTWORTH, Adelaide E. Etcher. Born: Wakefield, New Hampshire. Studied: with Arthur Dow, W. S. Robinson and D. W. Ross.

WENTWORTH, Harriet M. Painter. Born: New Hope, Pennsylvania in 1896. Studied: Pennsylvania Academy of Fine Arts; Grande Chaumiere, Academie Colorossi, Paris; and with Daniel Garber and William Lathrop; also with Archambault, Beaux and Mora. Collections: Smithsonian Institute; Pennsylvania Academy of Fine Arts.

WERBE, Anna Lavick. Painter. Born: Chicago, Illinois. Studied: Art Institute of Chicago. Awards: Michigan State Fair, 1934; Detroit Institute of Art, 1948; Michigan Art, 1952. Collection: Detroit Institute of Art.

WERLEY, Beatrice B. Painter. Born: Pittsburgh, Pennsylvania in 1906. Studied: Cleveland College; Huntington Polytechnic Institute; and studied with Keller, Wilcox and Combs. Award: Cleveland Clinic. Collections: Three animated medical movies for educational purposes; American Medical Exhibits, San Francisco, 1946 and Cleveland, 1946.

WESCHLER, Anita. Sculptor. Born: New York City. Studied: Parsons School of Design; Art Students League with Zorach; Pennsylvania Academy of Fine Arts with Laessle. Awards: Montclair Art Museum; Society of Washington Artists; San Franscisco Museum of Art; Friends of American Art, Grand Rapids, Michigan; fellowship, McDowell Colony; American Federation of Arts traveling exhibition, 1951; National Association of Women Artists, 1952; fellowship, Pennsylvania Academy of Fine Arts, 1957. Collections: Whitney Museum of American Art; Metropolitan Museum of Art; University of Nebraska; Norfolk Museum of Art and Science; Tel-Aviv Museum; United States Post Office, Elkin, North Carolina.

WESCOTT, Sue May. Painter. She exhibited her portrait miniatures in 1922 at the Pennsylvania Academy of Fine Arts.

WESSEL, Bessie Hoover. Painter. Born: Brookville, Indiana in 1889. Studied: Cincinnati Art Academy; and with Frank Duveneck. Awards: Cincinnati Woman's Art Club, 1937, 1939, 1940, 1948, 1950; Hoosier Salon, 1943, 1945, 1947; Collections: Christian College, Columbia, Missouri, National Academy of Design; Anderson House, Washington, D. C. American Legion Auxiliary Headquarters, Indianapolis, Indiana.

WESSELHOEFT, Mary F. Painter and illustrator. Born: in Boston, in 1873. Studied: Boston Art Museum.

WEST, Bernice. Sculptor. Born: New York City in 1906. Studied: with Archipenko, Edmond Amateis, Lu Duble, William Zorach, Winold Reiss. Awards: National Association of Women Artists, 1932; Southern States Art League, 1940; Connecticut Academy of Fine Arts, 1943; Federation of Art, 1955. Collections: monument, Silver Springs, Florida; Mead Botanical Gardens, Winter Park, Florida; Wadsworth Atheneum; Mint Museum of Art; High Point North Carolina Museum; Swarthmore College; mural, Charlotte, North Carolina Little Theatre; Manning House, Dallas.

WEST, Mrs. Thought to be the Mrs. West who painted some excellent portraits about 1820 in Attleboro, Massachusetts.

WEST, Sophie. Painter. Born: in 1825 and died in 1914. She was a landscape painter.

WESTON, Frances M. Painter. She exhibited her water colors at the Pennsylvania Academy of Fine Arts in 1922.

WESTON, Mary. Painter. She worked with miniatures.

WESTON, Mary Pillsbury. Painter. Born: in 1817 and
died in 1894. A portrait and landscape painter.

WETMORE, Mary Minerva. Painter. Born: Canfield, Ohio.
Studied: Cleveland Art School; Art Students League with
Chase and Cox; Julien Academy in Paris with Constant and
Laurens; Colarossi Academy with Courtois and Primet. She
is a portrait painter.

WHALEY, Edna R. Painter. Born: New Orleans, Louisiana
in 1884. Studied: Newcomb School of Art with Woodward.
Has exhibited at Albright Gallery, Buffalo and Academy
of Fine Arts, Hartford, Connecticut.

WHEELER, Cleora. Illustrator. Born: Austin, Minnesota.
Studied: with Julie Gauthier. Award: Minnesota State
Art Society, 1913.

WHEELER, Dora. Painter. Born: Jamaica, Long Island in
1858. Studied: with William M. Chase in New York; and
in Paris with Bourguereau. Although she devoted most of
her time to decorative designing she painted a series of
portraits of English and American Authors.

WHEELER, Helen C. Painter. Born: Newark, New Jersey
in 1877. Studied: with John C. Johansen.

WHEELER, Janet D. Painter. Born: Detroit, Michigan.
Studied: Pennsylvania Academy of Fine Arts; Julien
Academy with Courtois, Paris. Has exhibited in Paris
and at the Pennsylvania Academy of Fine Arts, Philadelphia.

WHEELER, Kathleen. Sculptor. Born: Reading England in
1884. Studied: Slade School, London University, London,
England. Awards: Art Institute of Chicago; Society of
Washington Artists. Collections: Harveys Museum,
St. John's Wood, London; Hackley Art Gallery, Muskegon,
Michigan; Ackermann Gallery, New York; W. Russell Button,
Chicago; Purvell Gallery, Baltimore, Maryland.

WHEELER, Laura B. Painter. Born: Hartford, Connecticut.
Studied: with William Chase and Henry McCarter. She is
also an illustrator and portrait painter.

WHEELER, Zona L. Painter. Born: Linsborg, Kansas in
1913. Studied: Bethany College with Birger Sandzen;
American Academy of Art, Chicago; Wichita Art Association
School. Awards: Prairie Watercolor Club, 1946, 1950;
Naftzger award, 1947; Printing Industry of America; Direct
Mail Advertising. Collections: Wichita Art Association;
Wichita Municipal Museum; Bethany College; Kansas State
College; Women's Federation Clubs of Kansas; Altarpiece,
United States Veterans Hospital, Wichita; mural-decoration,
Hotel Lassen, Wichita.

WHELAN, Blanche. Painter. Born: Los Angeles, California.
Studied: Stanford University; Los Angeles School of Art
and Design; Art Students League. Award: Arizona State
Fair, 1931.

WHETSEL, Gertrude P. Painter. Born: in Kansas in 1886.
Studied: with Clyde Leon Keller. A painter of marine
and landscapes.

WHINSTON, Charlotte. Sculptor. Born: New York City.
Studied: New York School of Fine and Applied Arts;
National Academy of Design; Cooper Union Art School;
Art Students League; and with George Luks, George
Maynard. She is also a painter and graphic artist.
Awards: scholarship, New York School of Fine and Applied
Arts, 1915; Cooper Union Art School, 1921; American
Artists Professional League, 1947; Yonkers Art Association,
1948; New Rochelle Women's Club, 1948, 1951; State Teachers
College, Indiana, Pennsylvania, 1949; Westchester
Federation of Women's Clubs, 1949; City College, New York,
1916; National Academy of Design, 1917; Pen and Brush Club,
1948; Argent Gallery, 1957; Church of the Covenant, 1958;
Seton Hall University, 1958; gold medal, Catholic Art
Society, 1958. Collections: Norfolk Museum of Art; Seton
Hall University; exterior mural, Avenue of the Americas,
New York.

WHITE, Agnes H. Painter. Born: Columbus, Ohio in 1897.
Studied: Columbus Art School; Pennsylvania Academy of Fine
Arts; Ecole des Beaux-Arts, Fontainebleau, France.
Collections: Marietta College; Hobe Sound, Florida;
Airport, Stuart, Florida.

WHITE, Ambrosia Chuse. Painter. Born: Belleville, Illinois
in 1894. Studied: Notre Dame Academy; St. Louis School of
Fine Arts; University of Wisconsin; and with Frederic Taubes.
Exhibited extensively in the midwest.

WHITE, Belle Cady. Painter. Born: Chatham, New York in 1868.
Studied: Pratt Institute; also studied with Snell, Woodbury,
Herbert Adams and Hawthorne.

WHITE, Doris Anne. Painter. Born: Eau Claire, Wisconsin
in 1924. Studied: University Berne, Switzerland; Art
Institute of Chicago. Exhibited in the Wisconsin area.

WHITE, Elizabeth. Etcher. Born: Sumter, South Carolina.
Studied: Columbia University; Pennsylvania Academy of
Fine Arts; and studied with Hutty and Wayman Adams.
Award: Southern States Art League. Collection: Library of
Congress; Carnegie Library, Sumter, South Carolina.

WHITE, Elizabeth A. Painter. She exhibited her miniatures at the Pennsylvania Academy of Fine Arts in 1925.

WHITE, Ethyle H. Painter. Born: San Antonio, Texas in 1904. Studied: San Antonio Art Institute and in Europe; also with Frederick Taubes, Etienne Ret, and Paul Schuman. Has exhibited extensively in Texas.

WHITE, Helene M. Painter. Born: in Philadelphia. Studied: Art Students League; Pennsylvania Academy of Fine Arts; Drexel Institute; also studied in Paris. Award: Mohican Lodge, Red Bank, New Jersey.

WHITE, Mable Dunn. Painter. Born: Charlotte, North Carolina in 1902. Studied: Greenville, South Carolina College for Women. Award: Mint Museum of Art.

WHITE, Margaret W. Painter. Born: Chicago, Illinois in 1893. Studied: with Bridgman.

WHITE, Vera. Painter and lithographer. Born: St. Louis, Missouri. Award: Chester County Art Association. Collection: Temple University; Philadelphia Museum of Art; Pennsylvania Academy of Fine Arts.

WHITEFIELD, Emma M. Painter. Born: Greensboro, North Carolina in 1874. Studied: Art Students League. Collection: State Library, Richmond, Virginia.

WHITEHAM, Edna M. Painter and illustrator. Born: in Nebraska. Studied: Chicago Art Institute.

WHITEHURST, Camelia. Painter. Born: in Maryland. Studied: with William Chase.

WHITESIDE, Henryette S. Painter. Born: Brownsville, Pennsylvania in 1891. Studied: Pennsylvania Academy of Fine Arts; and in Italy with Donati; also studied with Breckenridge, Hawthorne and Thomas Anschutz. Award: National League of American Pen Women. Collections: State House, Dover, Delaware; Wilmington Society of Fine Arts.

WHITIES-SANNER, Glenna. Painter. Born: Kalida, Ohio. Studied: with Leon Pescheret and Mrs. Vance Whities. Collections: Veterans Hospital, Dayton, Ohio; Fort Recovery Ohio Historical Museum.

WHITING, Gertrude. Painter. Born: Milwaukee, Wisconsin in 1898. Studied: Boston Museum of Fine Arts School; Art Students League and with Philip Hale. Award: Allied Artists of America, 1950. Collections: University of Georgia; Princeton University; war memorial, Australia; Marine Biological Laboratory, Woods Hole, Massachusetts; Museum of the City of New York.

WHITLOCK, Mary U. Painter. Born: Great Barrington, Massachusetts. Studied: with Alden Weir. Collection: Museum of Art.

WHITMAN, Sarah. Painter. Born: in Baltimore in 1842 and died in 1904. Studied: with William M. Hunt in Boston; and with Couture in Paris. Collection: Boston Museum of Art.

WHITMAR, Julia. Painter. Born: in 1830.

WHITMER, Helen C. Painter. Born: Darby, Pennsylvania in 1870. Studied: with Breckenridge, Henri and Vonnoh; Also studied at Pennsylvania Academy of Fine Arts; Philadelphia School of Design for Women.

WHITNEY, Anne. Sculptor. Born: in 1821 and died in 1915. Studied: abroad and returned to Boston and began working there in 1873. Collections: Wellesley College; Harvard Law School; Capitol, Washington, D.C.

WHITNEY, Beatrice. Painter. Born: Chelsea, Massachusetts in 1888. Studied: with Tarbell, Benson and Hale. Award: National Academy of Design, 1914.

WHITNEY, Gertrude Vanderbilt. Sculptor. Born: in 1876 and died in 1942.

WHITNEY, Mrs. Harry Payne. Sculptor. Born: New York City. Studied sculpture with Henry Anderson and James E. Fraser in New York; Art Students League; Also studied with Andrew O'Connor in Paris. Collections: Aztec Fountain, Pan-American Building, Washington, D. C.; Titanic Memorial, Washington, D.C.; El Dorado Fountain, San Francisco; panels for Triumphant Arch, New York.

WHITNEY, Helen Reed. Painter. Born: Brookline, Massachusetts in 1878. Studied: Boston School of Drawing and Painting with Hale, Benson and Tarbell.

WHITNEY, Isabel L. Painter and illustrator. Born: Brooklyn, New York. Studied: with Arthur Dow; Howard Pyle; and with Haley-Lever.

WHITNEY, Josepha. Painter. Born: Washington, D.C.
in 1872. Studied: with Messer, Perrie and Cherouzet.

WHITNEY, Margaret Q. Sculptor. Born: Chicago, Illinois
in 1900. Studied: with Charles Grafly.

WHITTEMORE, C. Helen. Painter. Born: in England.
Studied: with William M. Chase.

WHITTEMORE, Frances D. Painter. Born: Decatur, Illinois.
Studied: Art Institute of Chicago; and with Alden Weir
and Kenyon Cox.

WHITTEMORE, Grace Conner. Painter. Born: Columbia County,
Pennsylvania in 1876. Studied: Philadelphia School of
Design for Women; Pennsylvania Academy of Fine Arts; and
with Daingerfield and Snell. Awards: New Jersey State
Federation of Women's Clubs, 1942, 1943; Woman's Club,
Orange, New Jersey.

WIBLE, Mary Grace. Painter. Has exhibited in many
juried shows in Harrisburg, Reading and Allentown,
Pennsylvania.

WICKER, Mary H. Painter. She exhibited in 1926 at the
Annual Exhibition of the Pennsylvania Academy of Fine Arts.

WICKEY, Helen Reed. Painter. She exhibited water colors
at the Pennsylvania Academy of Fine Arts in 1925.

WIECHMANN, Margaret H. Sculptor. Born: New York in 1886.
Studied: Art Student League; National Academy of Design;
and with Phimister Proctor. Her specialty small bronzes
of animals.

WIGAND, A. Albright. Painter. Awards: New York Woman's
Art Club prize, 1908; Shaw memorial prize, National Academy
of Design, 1909; Simpson prize, New York Woman's Art Club,
1909; National Art Club prize, New York Woman's Art Club,
1912.

WIGGINS, Myra Albert. Painter. Born: in 1869. She was
a nature painter.

WILBUR, Dorothy T. Painter. Born: Fincastle, Virginia.
Studied: with Frederick Fursman, Julius Golz and Alice
Schille. Award: Minnesota Society of Art.

WILBY, Margaret C. Painter. Born: Detroit, Michigan in
1890. Studied: Art Institute of Chicago; Art Students
League; Ontario College of Art, Ontario, Canada; and with
Eliot O'Hara.

WILCOCK, Edna M. Painter. Born: Portland, Maine. Studied:
Vassar College; Boston Museum of Fine Arts School; Art
Students League; and with Frank Benson, Edmund Tarbell
and Philip Hale. Collections: Court House, Wilkes-Barre,
Pennsylvania; Bowdoin College, Brunswick, Maine; Court
House, Edmonton, Alberta, Canada.

WILCOX, Ruth. Painter. Born: New York City in 1908.
Studied: Art Students League; New York School of Fine
and Applied Arts; Pennsylvania Academy of Fine Arts;
Julian Academy, Paris. Awards: National Association of
Women Artists, 1932, 1934; National Academy of Design,
1934; Ridgewood New Jersey Art Association, 1935, 1947,
1948; Wichita Art Museum, 1937; Fitzwilliam, New Hampshire,
1938-1941; Montclair Art Museum, 1936, 1939. Collections:
Maugham School, Tenafly, New Jersey; Grammar School,
Leonia, New Jersey; Palisades Interstate Park Commission;
Provident Institution for Savings, Jersey City; Colonial
Life Insurance Company, East Orange, New Jersey;
Knickerbocker Country Club, Tenafly, New Jersey.

WILDE, Ida M. Painter. She exhibited her miniature
paintings at the Pennsylvania Academy of Fine Arts
in 1925.

WILDE, Jenny. Painter. As a native of New Orleans she
was engaged for many years in designing tableaux and
floats for the New Orleans Carnival Organization. Her
work consists of landscape, genre and portrait paintings.
Collection: Louisiana State Museum.

WILDER, Matilda. Painter. Painting watercolors in 1820.

WILES, Gladys. Painter. Born: in New York. Studied:
with Cox and Chase. Awards: National Association of
Women Artists, 1919; medal of French Museum.

WILKEVICH, Eleanor. Painter. Born: New York City in
1910. Studied: Grand Central School of Art; Art Students
League; and with Ennis, Snell and Hibbard. Awards:
San Diego Fine Arts Society, 1943, 1946, 1952; San Diego
County Fair; Carlsbad-Oceanside Guild; Spanish Village
Association. Collections: San Diego Fine Arts Gallery;
Russell Art Museum, Great Falls, Montana; mural, San
Diego County Hospital.

WILLET, Annie Lee. Painter. Born: Bristol, Pennsylvania in 1866. Studied: Pennsylvania Academy of Fine Arts; also studied in France and England. She was a painter of church decorations. Collection: Sanctuary and aisle windows, West Point Military Chapel; Great West Window, Post Graduate College, Princeton; Mather Memorial, Trinity Cathedral, Cleveland; Guthrie Memorial, St. John's Church, Locust Valley, Long Island; St. Paul's Cathedral, Pittsburgh; Harrison Memorial, Calvary Church, Germantown; mural paintings, St. Alvernia's Convent, Pittsburgh; Presbyterian Hospital Chapel, Pittsburgh; Thaw Memorial, Third Presbyterian Church, Pittsburgh; Buchanan Memorial, St. Nathaniel's Church, Philadelphia.

WILLEY, Edith M. Painter and etcher. Born: Seattle, Washington. Studied: with Maring, Ziegler, Camfferman, Edgar Forner, May Marshall and Mark Tobey. Collections: Law Library, State Capitol, Olympia, Washington; John Hay School, King County Court House, First National Bank, Scottish Rite Temple, all in Seattle; Puget Sound Hospital, Bremerton.

WILLIAMS, Abigail O. Painter. Born: in 1823 and died in 1913.

WILLIAMS, Caroline G. Painter. Born: Fulton, New York in 1855. Studied: Cleveland School of Art.

WILLIAMS, Clara E. Painter and illustrator. Award: New York Woman's Art Club, 1912.

WILLIAMS, Esther. Painter. Born: Boston, Massachusetts in 1907. Studied: Boston Museum Fine Arts School; also studied with Philip Hale; and in Paris. Awards: Pennsylvania Academy of Fine Arts, 1935; Worcester Museum of Art, 1935; Art Institute of Chicago, 1938; American Academy of Arts and Letters and National Institute of Arts and Letters grant, 1944; Rockport Art Association, 1955. Collections: Pennsylvania Academy of Fine Arts; Whitney Museum of American Art; Worcester Museum of Art; Bos on Museum of Fine Arts; Metropolitan Museum of Art; Addison Gallery of American Art; New Britain Connecticut Art Museum.

WILLIAMS, Jean T. Painter. Award: State Exhibition of Alabama. Collections: University of Alabama Medical Center.

WILLIAMS, Kate A. Painter. She exhibited her water colors at the Pennsylvania Academy of Fine Arts in 1925.

WILLIAMS, Mary. Painter. A still-life painter who was exhibiting her work during 1811-1814.

WILLIAMS, Mary Elizabeth. Painter. Born: in 1825 and died in 1902.

WILLIAMS, May. Painter. Born: Pittsburgh, Pennsylvania. Studied: Carnegie College of Fine Arts; University of Pittsburgh Fine Arts and Crafts; New York School of Fine and Applied Arts; Ecole des Beaux-Arts, Fontainebleau, France. Collections: Carnegie Institute; Pittsburgh Art Center.

WILLIAMS, Mildred E. Painter and lithographer. Born: Detroit, Michigan in 1892. Studied: Pennsylvania Academy of Fine Arts; Art Students League; also studied with Henri, Locke, Sloan, McCarter and Luks. Awards: Pennsylvania Academy of Fine Arts, 1928; Detroit Institute of Art, 1934, 1939, 1940. Collections: New York Public Library; Pennsylvania Academy of Fine Arts; McGregor Library, Highland Park, Michigan; Detroit Institute of Art; Children's Museum, Detroit.

WILLIAMS, Pauline Bliss. Painter. Born: Springfield, Massachusetts in 1888. Studied: Art Students League; Henri School of Art; and with Frank DuMond, Mora and Bellows. Awards: Springfield, Massachusetts, 1926, 1928; Society for Sanity in Art, Chicago, 1941; Art Institute of Chicago, 1941.

WILLIAMSON, Ada C. Painter. She was exhibiting at the Pennsylvania Academy of Fine Arts in 1924.

WILLIAMSON, Shirley. Painter. Born: in New York. Studied: with Arthur Dow; Art Students League; and in Paris with Constant and Rodin.

WILLOUGHBY, Alice Estelle. Painter. Born: Groton, New York. Studied: Washington Art League; Corcoran Art School.

WILLSON, Martha B. Painter. Born: Providence, Rhode Island in 1885. Studied with Lucia Fairchild Fuller. She specialized in miniatures.

WILLSON, Mary Ann. Painter. A 19th century primitive watercolorist.

WILMETH, Claire P. Painter. Born: Riverton, New Jersey in 1900. Studied: Art Students League with George Bridgman, and Wayman Adams; and studied in France, Italy and South America. Collection: Vanderpoel Collection, Chicago.

WILNER, Marie. Painter. Born: Paris, France in 1910
Studied: Hunter College; Art Students League; New School
for Social Research, New York. Awards: Ross Exhibition,
Newark, New Jersey; Village Art Center; Seton Hall
University; American Artists Professional League.
Collections: Norfolk Museum of Art; New York University;
Lowe Gallery of Art, Coral Gables, Florida; Richmond,
Indiana Art Institute; Evansville Museum of Art; Seton
Hall University and in France.

WILSON, Harriet. Painter. Born: New York City. Awards:
American Watercolor Society; Art Center of the Oranges,
1948-1952, 1954, 1955; Newark Art Club, 1949, 1952;
Allied Arts of America, 1953; New Jersey Watercolor
Society, 1954.

WILSON, Helen L. Sculptor. Born: Chicago, Illinois.
Studied: Wellesley College; and with Bourdella and
Lantchansky in Paris. Awards: National Commission of
Fine Arts, Washington, D. C., 1940; National Association
of Women Artists, 1949, 1957; Architects League, 1952;
Audubon Art, 1957. Collections: United States Post
Office, Lowville, New York.

WILSON, Lucy Adams. Painter. Born: Warren, Ohio in 1855.
Studied: Herron Art Institute, Indianapolis; Art Students
League; and with William Forsyth and T. C. Steele.
Collections: Herron Art Institute; Conservatory of Art
and Music, Miami, Florida.

WILSON, Marjorie. Painter. Born. Ottawa, Ontario,
Canada. Exhibited in Illinois.

WILSON, Mary R. Painter. A still-life watercolorist
working in 1820.

WILSON, Rose Cecil O'Neil. Illustrator. Born: Wilkes-
Barre, Pennsylvania.

WINCHELL, Elizabeth B. Painter. Born: Brooklyn New York
in 1890. Studied: Moore Institute of Design, Philadelphia;
Pennsylvania Academy of Fine Arts; Philadelphia Museum
School of Industrial Art; also studied with Henry Snell
and Samuel Murray. Collections: Moore Institute of Design;
Brunswick Maine Savings Banks; Camden Maine Municipal
collection.

WINGATE, Arline. Sculptor. Born: New York City in 1906. Studied: Smith College; in Europe and with Alexander Archipenko. Awards: National Association of Women Artists, 1945; Amelia Peabody award, 1956; Easthampton Guild Hall, 1958. Collections: National Museum, Stockholm, Sweden; Newark Museum; Ghent Museum, Belgium.

WINKEL, Nina. Sculptor. Born: Borken, Germany in 1905. Studied: in Germany. Awards: National Academy of Design, 1945; Avery award, 1958. Collections: memorial, Seward Park High School, New York; monument, Charlotte, North Carolina.

WINNER, Margaret F. Painter and illustrator. Born: in Philadelphia. Studied: Pennsylvania Academy of Fine Arts; and with Howard Pyle.

WINSLOW, Eleanor. Painter and illustrator. Born: Norwich, Connecticut in 1877. Studied: Art Students League; and in Paris. Award: Third Hallgarten prize, National Academy of Design, 1907.

WINTER, Alice Beach. Painter. Born: Greenridge, Missouri in 1877. Studied: St. Louis School of Fine Arts; Art Students League and with George de Forest Brush and Joseph De Camp. Awards: St. Louis School of Fine Arts; Gloucester Chamber of Commerce, 1954. A painter and illustrator of child life.

WINTER, Ruth. Painter. Born: New York City in 1913. Studied: New York University; Art Students League. Award: National Association of Women Artists, 1957.

WITHERS, Caroline. Painter. A miniature painter working before the Civil War era.

WINTERS, Denny. Painter. Born: Grand Rapids, Michigan in 1909. Studied: Art Institute of Chicago; Chicago Academy of Fine Arts. Awards: Denver Art Museum, 1941; Guggenheim fellowship, 1948; San Francisco Museum of Art, 1941. Collections: Philadelphia Museum of Art; San Francisco Museum of Art.

WINTRINGHAM, Frances M. Painter. Born: Brooklyn, New York in 1884. Studied: with Charles Hawthorne, Robert Henri, George Bellows and Kenneth Hayes Miller.

WIRES, Hazel K. Painter. Born: Oswego, New York in 1903. Studied: Corcoran School of Art.

WIRTH, Anna M. Illustrator. Born: Johnstown, Pennsylvania in 1868. Studied: Pennsylvania Academy of Fine Arts; Philadelphia School of Design for Women. Illustrated "Progressive Pennsylvania," by J. M. Swank.

WISE, Louise W. Painter. She exhibited at the National Academy of Design in 1925.

WISE, Vera. Painter. Born: Iola, Kansas. Studied: Willamette University, Salem, Oregon; Chicago Academy of Fine Arts; Kansas City Art Institute; Awards: Ft. Worth, Texas, 1942; Abilene Museum of Art, 1946, 1950, 1951; Texas Watercolor Society, 1951, 1957; Beaumont Museum, 1954; Chautauqua National, 1958; Texas Fine Arts Association, 1953, 1955. Collections: Idaho State College; Texas Fine Arts Association; South Methodist University.

WHITTERS, Nell. Painter. Born: Grand Rapids, Michigan. Studied: Art Institute of Chicago; Pennsylvania Academy of Fine Arts; Art Students League; Columbia University; also studied with Eliot O'Hara and George Elmer Browne. Awards: Pen and Brush Club; Wolfe Art Club; Art Institute of Chicago; Brooklyn Society of Art.

WOJINSKI, Sister Regina. Painter. Born: Detroit, Michigan in 1910. Awards: Rochester Festival of Religious Arts; San Antonio Artists Exhibition. Collections: St. John Fisher College, Rochester, New York; Siera Heights College, Adrian, Michigan.

WOLCOTT, Katherine. Painter. Born: Chicago, Illinois in 1880. Studied: Art Institute of Chicago. Noted for her miniature paintings.

WOLFE, Ada A. Painter. Born: Oakland, California. Studied: Minneapolis School of Fine Arts; New York School of Art; and with William M. Chase.

WOLFE, Ann. Sculptor. Born: in Poland in 1905. Studied: Hunter College; and in Paris with Despiau. Awards: Society of Washington Artists, 1945; Minnesota State Fair, 1949; Minneapolis Institute of Art, 1951; Minneapolis Woman's Club, 1954. Collections: College of the City of New York; Museum of Art, Jerusalem; Hamline University; Colgate University.

WOLFE, Mildred. Painter. Born: Celina, Ohio in 1912. Studied: Athens College; Alabama State College for Women; Colorado Springs Fine Art Center; Art Institute of Chicago; Art Students League and with Boardman Robinson. Awards: Alabama Art League, 1935, 1940; McDowell Gallery, 1938; Jackson, Mississippi, 1947, 1949, 1950, 1951, 1953, 1955. Collections: Montgomery Museum of Fine Arts; Municipal Art Gallery, Jackson; Mississippi State College; Alabama Polytechnic Institute; Library of Congress; St. Andrew's Episcopal Day School, Jackson, Mississippi; Jacksonian Highway Hotel; Stevens Department Store, Richton, Mississippi.

WOLFE-Parker, Viola. Painter. Born: Minneapolis, Minnesota in 1904. Studied: University of Minnesota; Minneapolis School of Art; also with B.J.O. Nordfeldt, Paul Burlin, and Charles Burchfield. Awards: Minneapolis Institute of Art, 1947, 1949; Minnesota State Fair, 1947, 1949; Woman's Club, 1949. Collections: Minneapolis Woman's Club; Minneapolis Chamber of Commerce; Minnesota Centennial Commission's film "Art in Minnesota," 1958.

WOLFS, Wilma D. Sculptor. Born: Cleveland, Ohio. Studied: Western Reserve University; Cleveland School of Art; University of Minnesota; Radcliffe College; Ecole des Beaux-Arts, Paris; and with Henry Keller and Rolf Stoll. Awards: Museum of Fine Arts, Little Rock, Arkansas, 1939; Arkansas Watercolor Society, 1938; Carnegie Scholarships for study in Paris, France and at New York University, Harvard University and University of Pennsylvania. Collections: University of Arkansas; Hendrix College, Conway, Arkansas; sculpture, Catholic Church, Winter Park, Florida; Research Studio, Maitland, Florida.

WOLTMAN, Nancy C. Painter. Born: East Lynn, Massachusetts in 1913. Studied: Art Students League; Farnsworth School of Art; Amagansett Art School. Awards: Michigan, 1951; National Academy of Women Artists, 1953.

WOOD, Edith L. Painter. Born: Philadelphia, Pennsylvania. Studied: Bryn Mawr College; Pennsylvania Academy of Fine Arts; also studied in England and France. Awards: fellowship, Pennsylvania Academy of Fine Arts; Philadelphia Plastic Club, 1933; Cresson traveling scholarship, Pennsylvania Academy of Fine Arts. Collections: La France Institute, Philadelphia, Pennsylvania; Pennsylvania Academy of Fine Arts; Philadelphia Allied Arts.

WOOD, Ella Miriam. Painter. Born: Birmingham, Alabama in 1888. Studied: Newcomb College, Tulane University; Pennsylvania Academy of Fine Arts; and with Henry McCarter, Charles Hawthorne and Daniel Garber. Award: Newcomb Art School. Collections: mural, altarpieces, St. Augustine Church, New Orleans, Louisiana; Newcomb College, New Orleans; Charity Hospital, New Orleans.

WOOD, Eloise. Etcher. Born: Geneva, New York in 1897. Studied: Albright Art School; Farnsworth School of Art; Art Students League; William Smith College, Geneva, New York; Columbia University. Collections: Metropolitan Museum of Art; altarpieces, St. John's Chapel, Hobart College; windows, Sampson Air Base, New York; 41 Heraldic Shields, Coxe Hall, Hobart College.

WOOD, Mrs. J. G. Painter. Working during the period 1841-42.

WOOD, Jessie Porter. Painter and illustrator. Born: in 1863.

WOOD, Katheryn L. Painter. Born: Kalamazoo, Michigan in 1885. Studied: with Frederick Freer and Lawton Parker. Collection: Continental Memorial Hall, Washington, D.C.

WOOD, Lillian Lee. Painter. Born: Richmond, Virginia in 1906. Studied: Sweet Briar College; Art Students League; and with Kenneth Hayes Miller and Kimon Nicolaides. Award: Virginia Mechanics Institute, 1932. Collection: Richmond Virginia Armory. Specialty, portrait paintings.

WOOD, Memphis Miss. Painter. Born: Dacula, Georgia in 1902. Studied: University of Georgia; University of Florida. Collections: University of Georgia; Murray State Teachers College; Stetson University.

WOOD, Virginia Hargraves. Painter and etcher. Born: St. Louis, Missouri. Studied: with Chase, DuMond and Hawthorne. Also studied abroad. Collection: Mural decorations in Broadway Cafe.

WOODBURY, Marcia O. Painter. Born: in Maine in 1865 and died in 1913. Studied: Woman's Art Club, New York; also studied in Paris with Lassar. Collection: Boston Museum of Fine Arts.

WOODHAM, Jean. Sculptor. Born: Midland City, Alabama in 1925. Studied: Alabama Polytechnic Institute; Sculpture Center, New York; University of Illinois. Awards: National Association of Women Artists, 1956; fellowship, University of Illinois, 1950; New England Annual, 1956-1958; Audubon Art, 1958. Collection: Massillon Museum of Art.

WOODROOFE, Louise M. Painter. Born: Champaign, Illinois. Studied: University of Illinois; Syracuse University; also with Hugh Breckenridge.

WOODRUFF, Corice. Sculptor. Born: Ansonia, Connecticut in 1878. Studied: Art Students League. Her specialty, small sculpture, portrait busts and bas-reliefs.

WOODSON, Marie L. Painter and engraver. Born: in 1875.

WOODWARD, Mabel M. Painter. Born: Providence, Rhode Island in 1877. Studied: with Chase and Cox in New York.

WOOLLEY, Virginia. Painter. Born: Selma, Alabama in 1884. Studied: Art Institute of Chicago; also in Paris. Collection: High Museum of Art, Atlanta.

WOOLRYCH, Bertha H. Painter and illustrator. Born: in Ohio in 1868. Studied: St. Louis School of Fine Arts; also studied in Paris with Morot, Collin and Courtois. Awards: Lewis and Clark Exposition, Portland, 1905; gold and silver medals, St. Louis School of Fine Arts, 1908; St. Louis District General Federation of Women's Clubs.

WORCESTER, Eva. Painter. Born: Erie, Michigan in 1892. Studied: Boston Museum of Fine Arts School; and with Eliot O'Hara, Hobson Pittman and Emile Gruppe. Awards: Grosse Pointe Art, 1955; National League of American Pen Women, 1953. Collections: War Memorial Collection, Detroit; Grosse Pointe Garden Center; National Federation of Women's Clubs, Boston; Lobby, Detroit TV-Radio Station Building.

WRENCH, Mary. Painter. Studied: with Charles Willson Peale. She was working in Philadelphia before the Revolution.

WRIGHT, Alice Morgan. Sculptor. Born: Albany, New York in 1881. Studied: Smith College; St. Agnes School, Albany, New York; Russell Sage College; Art Students League; Academie Colorossi, Ecole Des Beaux-Arts, Paris; and with Hermon MacNeil, Gutzon Borglum and James Earle Fraser. Awards: National Association of Women Artists; National Academy of Design; National Arts Club. Collections: Folger Shakespeare Museum, Washington, D. C. United States National Museum, Washington, D. C.; Newark Museum; Bleecker Hall, Albany, New York; London Museum, Kensington Palace; Bay Ridge High School, Brooklyn, New York; John M. Greene Hall, College Hall and Smith College Library, Northampton, Massachusetts; Brookgreen Gardens, South Carolina.

WRIGHT, Alma B. Painter. Born: Salt Lake City in 1875. Studied: Julien and Colarossi Academies in Paris; and with Bonnat, Laurens and Ecole des Beaux Arts. Awards: State prize, 1904; Utah Art Institute, 1905.

WRIGHT, Bertha S. Painter. Born: Astoria, Long Island, New York. A self-taught artist.

WRIGHT, Catharine M. Painter. Born: Philadelphia, Pennsylvania in 1899. Studied: Moore Institute of Art; and with Henry B. Snell and Leopold Seyffert. Awards: Pennsylvania Academy of Fine Arts; National Academy of Design; Newport Art Association; Germantown Art League; Silvermine Guild of Art, 1955; Allied Arts of America; Springside Pennsylvania School. Collections: Pennsylvania Academy of Fine Arts; Allentown Museum; Moore Institute of Art; New Britain Art Institute; Woodmere Art Gallery; University of Pennsylvania; Pennsylvania State College; Philadelphia Museum of Art; National Academy of Design.

WRIGHT, Elva M. Painter. Born: New Haven, Connecticut. Studied: Columbia University; Art Students League. Awards: New Jersey Art Gallery, Newark, 1938, 1940; Asbury Park Society of Fine Arts, 1939, 1942-1944; American Artists Professional League, 1942, 1950, 1951, 1952, 1953; Deal, New Jersey, 1954, 1955.

WRIGHT, Gladys Y. Painter. Born: Greenville, Texas. Studied: with the McLeod School of Art in Los Angeles.

WRIGHT, Josephine M. Painter. A miniature painter who exhibited her work at the Pennsylvania Academy of Fine Arts in 1925.

WRIGHT, Lavinia S. Painter. Born: in 1805 and died in 1869. She was an amateur artist.

WRIGHT, M. Louise. Painter and illustrator. Born: in Philadelphia, Pennsylvania in 1875. Studied: Pennsylvania Academy of Fine Arts; and in Paris with Whistler and the Julien Academy; and with F. W. Jackson in England.

WRIGHT, Margaret H. Painter. Born: in 1869. She was a watercolorist.

WRIGHT, Patience. Sculptor. Born: Bordertown, New Jersey in 1725 of Quaker parentage and died in 1786. She was well known by her small portraits in wax, chiefly profile bas-reliefs.

WRIGLEY, Viola B. Painter and lithographer. Born: Kendallville, Indiana in 1892. Studied: Oberlin College; University of Kansas; Columbia University; also with Charles Martin.

WUESTE, Louise H. Painter. Born: in 1803 and died in 1875. She was a portrait painter.

WYCKOFF, Isabel D. Painter. She was a flower painter working in 1840.

WYKOFF, Sylvia S. Painter. Born: Pittsburgh, Pennsylvania in 1915. Studied: Syracuse University. Awards: Onondaga Historical Exhibition, 1945; Association of Artists in Syracuse, 1943; National League of American Pen Women, 1948.

WYETH, Henriette. Painter. Born: Wilmington, Delaware in 1907. Studied: Normal Art School, Boston, Massachusetts; Pennsylvania Academy of Fine Arts; also with N. C. Wyeth. Awards: Wilmington Society of Fine Arts; Pennsylvania Academy of Fine Arts, 1935. Collections: Wilmington Society of Fine Arts; Roswell Museum of Art; New Britain Connecticut Museum of Art; Lubbock Museum of Art; Texas Technological College.

WYNNE, Evelyn B. Printmaker. Born: New York City in 1895. Studied: Art Students League; Royal College of Engraving, London, England; University of Michigan; Corcoran Art School; and with Malcolm Osborn, Avard Fairbanks and Eugene Weiss. Award: Corcoran Art School, 1942.

YAFFEE, Edith Widing. Painter. Born: Helsingfors,
Finland in 1895. Studied: Pennsylvania Academy of
Fine Arts; and with Paxton and Hale. Awards: Chaloner
Paris-American prize, 1920; European traveling
scholarship, Pennsylvania Academy of Fine Arts, 1921.

YANDELL, Enid. Sculptor. Born: Louisville, Kentucky in
1870. Studied: with Philip Martiny in New York; and with
MacMonnies and Rodin in Paris. Awards: Chicago Exposition,
1893; Nashville Exposition, 1897; Buffalo Exposition, 1901;
St. Louis Exposition, 1904. Collections: Woman's Building,
Chicago Exposition; Carrie Brown Memorial Fountain,
Providence; Emma Willard Memorial, Albany, New York;
Chancellor Garland, Vanderbilt University, Nashville,
Tennessee; Hogan Fountain, Louisville, Kentucky; Daniel
Boone Monument, Louisville, Kentucky; Thomas Monument,
Nashville, Tennessee; fountain, Mt. Kisco, New York;
fountain, Port Chester, New York.

YATES, Elizabeth M. Painter. Born: Stoke-on-Trent,
Staffordshire, England in 1888. Studied: Pratt
Institute.

YATES, Mrs. Painter. A miniature painter who was exhibiting
her work in 1835.

YATES, Ruth. Sculptor. Born: Greenville, Ohio in 1896.
Studied: Cincinnati Art Academy; Art Students League;
Grand Central Art School; Academie Julian; and with Jose
de Creeft. Awards: National Association of Women Artists,
1939, 1951; Pen and Brush Club, 1945, 1949; Art for
Democratic Living award, 1951. Collections: Norfolk Museum
of Art and Science; Brookgreen Gardens, South Carolina.

YOCHIM, Louise D. Painter. Born: Jitomir, Ukraine in
1909. Studied: Art Institute of Chicago; University of
Chicago. Awards: Chicago Society of Artists, 1953;
American Jewish Art Club, 1947, 1954, 1955, 1958.

YOUNG, Aretta. Painter. Born: in 1864 and died in 1923.

YOUNG, Dorothy O. Sculptor. Born: St. Louis, Missouri
in 1903. Studied: St. Louis School of Fine Arts, Washington
University; Art Students League; and with E. Wuerpel, Leo
Lentelli and George Bridgman. Awards: St. Louis Art Guild,
1925, 1949; Society of Independent Artists, 1937, 1940,
1943, 1944, 1945, 1947-1949; 1950, 1952, 1953, 1955;
Henry Shaw Cactus Society, 1955; St. Louis County Fair,
1947. Collections: Office, St. Louis Council, Boy Scouts
of America; Rockwoods, Missouri Museum; Jackson Park
School, St. Louis.

YOUNG, Eliza M. Painter. Born: Philadelphia, Pennsylvania in 1875. Studied: with Anshutz and Charles Morris Young. Collection: Herron Art Institute, Indianapolis, Indiana.

YOUNG, Eva H. Painter. A miniaturist who exhibited her work at the Pennsylvania Academy of Fine Arts in 1922.

YOUNG, Florence. Painter. Born: Fort Dodge, Iowa in 1872. Studied: Art Institute of Chicago and with John Vanderpoel; Art Students League, with Kenyon Cox, Carol Beckwith, Frank DuMond and William M. Chase. Awards: Los Angeles Museum of Art, 1943; Greek Theatre, 1955; Art of the Southwest, 1951. Collection: Pomona College.

YOUNG, Gladys G. Painter. Exhibited her water colors at the Pennsylvania Academy of Fine Arts in 1925.

YOUNG, Gladys G. Painter. Born: Vevey, Switzerland. Studied: Art Students League; also studied in Paris with Andre L'Hote. Awards: National Association of Women Artists, 1951, 1958.

YOUNG, Mary Eliza. Painter. She was a miniature painter and mother of Frederick J. Waugh the painter.

YOUNG, May Belle. Painter. Born: Charleston, South Carolina in 1891. Studied: Art Students League; National Academy of Design; Pratt Institute Art School; Grand Central School of Art. Collection: Victoria, British Columbia, Public Library.

YOUNG, Miss. Painter. A landscapist who worked in 1856.

YOUNGERMAN, Reyna U. Painter. Born: New Haven, Connecticut in 1902. Studied: Yale School of Fine Arts; Art Students League; and with Wayman Adams, Alexander Brook and Jerry Farnsworth. Awards: fellowship, Tiffany Foundation, 1926-1927; New Haven Paint and Clay Club, 1942; Meriden Society of Art, 1934, 1945, 1946; Miami Art; Blue Dome Fellowship; Pan-American portrait award; American Artists Professional League; Lowe Gallery; Connecticut Academy of Fine Arts; Florida Painters Group; Beaux-Arts. Collections: Tiffany Foundation; Superior Court, New Haven, Connecticut.

YOUNGLOVE, Ruth Ann. Painter. Born: Chicago, Illinois in 1909. Studied: University of California at Los Angeles; and with Orrin White. Awards: Los Angeles County Fair, 1937-1941.

YU, Marlene T. *Painter.* *Born: Taiwan, China.* *Awards:*
Lorillard Wolfe National Exhibition, New York; Great
Kills Exhibition, New York; Altrusa International
Scholarship. *Collections: Taiwan Normal University,*
Taipei, China; University of Colorado, Boulder, Colorado;
Presbyterian Hospital, New York City; Columbia Broad-
casting System, New York City; Chungkuo Insurance Company,
Manila, Philippines.

ZEREGA, Andrea P. Painter. Born: De Zerega, Italy in 1917. Studied: Corcoran School of Art with Richard Lahey, Hobart Nichols, Mathilde Mueden Leisenring; and in Italy with Dr. Gaspare Biggio; Tiffany Foundation. Awards: fellowship, Tiffany Foundation, 1938; Washington Art, 1940; Society of Washington Artists, 1942; Times Herald Exhibition, 1943; Landscape Club, 1945; Baltimore Museum of Art, 1952; Society of Washington Artists, 1945; Landscape Club, 1944, 1946, 1952, 1953; Religious Art Exhibition, Washington, D. C. 1958. Collections: Barnett Aden Gallery; Tiffany Foundation; Butler Institute of American Art; Toledo Museum of Art.

ZEVON, Irene. Painter. Born: New York City in 1918. Studied: Tschacbasov School of Art. Award: National Association of Women Artists, 1957.

ZIEGLER, Laura. Sculptor. Born: Columbus, Ohio. Studied: Columbus Art School; Ohio State University; Cranbrook Academy of Art and in Italy. Awards: Columbus Art League, 1947-1949. Fulbright grant, Rome, Italy, 1950. Collections: Museum of Modern Art; Columbus Gallery of Fine Arts; 18 foot Cross, St. Stephens Episcopal Church, Columbus, Ohio.

ZILVER, Alida. Sculptor. Exhibited at the Annual Exhibition of the Pennsylvania Academy of Fine Arts in 1924.

ZIMMELE, Margaret. Painter, sculptor and illustrator. Born: Pittsburgh, Pennsylvania in 1872. Studied: with Chase, Shirlaw, Whittemore, Lathrop, Carlsen and Hawthorne.

ZIMMERMAN, Elinor C. Painter. Born: St. Louis, Missouri in 1878. Studied: Washington University; Pennsylvania Academy of Fine Arts; also studied with A. M. Archambault, Mabel Welch, Wayman Adams and Gertrude Whiting. Awards: Florida Southern College, 1942. Collection: Philadelphia Museum of Art.

ZINDLER, Mildred. Painter. Born: Brooklyn, New York in 1922. Collection: Architectural relief sculpture for the City of Baltimore.

ZIROLI, Nicola. Painter. Born: Montenero, Italy in
1908. Studied: Art Institute of Chicago. Awards:
Washington Society of Artists, 1934; Art Institute of
Chicago, 1938, 1939, 1948, 1955; Springfield Missouri
Art Museum, 1945, 1946, 1956; Decatur Art Center, 1945,
1946; Ohio University, 1946; Mint Museum of Art, 1946;
Chicago Newspaper Guild, 1946; State Teachers College,
Indiana, Pennsylvania, 1947, 1948; Mississippi Art
Association, 1942; Ohio Valley, 1952, 1954; Magnificient
Mile, Chicago, 1952, 1955; Springfield, Illinois, 1952,
1954; Audubon Art, 1953, 1955, 1956; Butler Art Institute,
1955, 1956; Art Institute of Chicago, 1955; San Francisco
Art Association, 1939; Audubon Art, 1947; National Society
of Painters in Casein, 1947. Collections: Springfield
Museum of Art; International Business Machines;
Vanderpoel Collection; Chicago Public Library; Metropolitan
Museum of Art; Whitney Museum of American Art; University
of Minnesota; University of Nebraska; Washburn University;
Pennsylvania State Teachers College; Illinois State
Teachers College; Ohio University; Mulvane Museum; Butler
Art Institute.

ZORACH, Marguerite T. Painter. Born: Santa Rosa,
California in 1887. Studied: In Paris, France. Awards:
Pan-Pacific Exposition, 1915; Logan medal, Chicago.
Collections: Metropolitan Museum of Art; Whitney Museum
of American Art; Museum of Modern Art; Newark, Museum;
Brooklyn Museum; murals, United States Post Offices at
the following: Peterborugh, New Hampshire; Ripley,
Tennessee; Monticello, Illinois.

SECTION
II

INTRODUCTION

This book was originally conceived as an updated, revised edition of my first book, *WOMEN ARTISTS IN AMERICA, EIGHTEENTH CENTURY TO THE PRESENT*, published in 1973. Two years of continued research found me with a wealth of material on the contemporary woman artist, and this necessitated the compilation of a reference source focusing primarily on those American women who are working now.

This growth in the image of the-woman-as-artist has come about not solely because there are more women who are artists, but also because these women are more in evidence in today's American society. Artificial barriers which once prevented recognition of female artists have been pulled down. Although all the rubble has not necessarily been cleared, what remains can be surmounted by most professional artists.

Through the tireless efforts of organizations such as Women's Interart Center, Inc., Ad Hoc Women Artists, AIA Task Force on Women, Women's International Network, Women's Art Center, in addition to information furnished in publications such as the *FEMINIST ART JOURNAL OF LIBERATION, WOMEN ARTISTS' NEWSLETTER*, and *ART WORKERS NEWS*, women artists are enjoying greater acceptance as contributors to our national aesthetic.

This a recent phenomenon. Historically, though women have been practicing art for centuries, their contributions have, for the most part, been repressed. Kora, the first documented woman artist, was working during the seventh century B.C. in the Greek city of Sicyonia. Today her reputation dwells in the shadows of her male counterparts. Margaretha van Eyck is rarely mentioned relative to the Northern Renaissance masterworks of her brothers, Hubert and Jan. Yet it has been purported that she was an accomplished artist, and in fact worked with her brothers on several paintings.

Through the years, a few things changed for some women. Mary Cassatt, an American, exhibited as an equal with the Impressionists in nineteenth-century France. But it is doubtful that many nineteenth-century women artists were really taken very seriously, due to the conventional belief that to become knowledgeable in the arts was an integral part of a "lady's training." During the first half of this century, women of social-registry and financial means were given modest exhibitions, and received in turn some mention by art critics of the day.

The information presented in this volume was furnished almost exclusively by the artists themselves. It represents a cross section of contemporary women artists working in the United States. My intent was not to assume the role of critic, but simply to list the artists and their achievements as a reference source.

Some two hundred illustrations, submitted by the artists, enable one to perceive individual styles and skills, and to comprehend the varying degrees of aesthetic awareness of contemporary women artists.

Some of the works fall within the "vaginal iconology" category, a term coined by art critic Barbara Rose. This form of expression is an attempt to outrage viewers, play on guilt-feelings, and, at the same time, bring attention to what these artists believe is the plight of women.

On the other hand, the majority of the work illustrated, and so it follows, most of the art produced by women in the United States, is without sex. As art critic Dore Ashton once wrote, " . . . works of art have no gender."

I shall leave it at that.

<div align="right">Jim Collins</div>

Chattanooga, Tennessee
August, 1975

√ THIS SYMBOL BY AN ARTIST'S NAME INDICATES HER WORK IS ILLUSTRATED.

ABBOT, Berencie. Photographer. Born: 1898. Noted for
her portraits. She worked for Man Ray.

ABEND, Arlene. Sculptor. Studied: Cooper Union, New York
City; Syracuse University, New York. Awards: New York
State Fair; Syracuse Ceramic Guild; New York State
Exposition. Exhibitions: Rochester Memorial Museum,
New York; Corning Museum, New York; Associate Artists
Gallery.

ABISH, Cecile. Sculptor. Born: New York City. Studied
Brooklyn College. She has exhibited at The Detroit
Institute of Art, Fairleigh Dickinson University, The
Aldrich Museum of Contemporary Art, and Newark Museum.

ABRAMS, Jane. Painter. Noted for her abstract paintings
in which she uses sexual imagery.

ADAMS, Alice. Sculptor. Noted for her constructions.

ADAMS, Linda. Graphics. Born: Massachusetts in 1948.
Studied: Worcester Art Museum; Boston University School
of Fine Arts. She has exhibited mostly in the Boston
area. Noted for life-size representational nudes of
women.

ADAMS, Pat. Painter. Born: Stockton, California in 1928.
Studied: University of California. Awards: Fulbright to
France, 1956; Yaddo Foundation residency; National Council
for the Arts, 1968. Extensive exhibitions throughout the
United States and Europe. Collections: Whitney Museum of
American Art, New York City; University of Michigan;
University of California at Berkeley; University of North
Carolina at Greensboro.

AIKINS, Louise. Signs her art Weez. Sculptor. Born:
1942. Self-taught as an artist, she has a degree in
psychology. Showing mostly in Massachusetts.

ALDRIDGE, Adele. Painter/graphics. Studied: Silvermine
College of Art; Parsons School of Design; Chicago Art
Institute. Exhibitions: Bodley Gallery, New York City,
1970; Metamorphosis Gallery, Ridgefield, Connecticut,
1971; Three Interpretations of the I Ching, Greenwich
Library, 1972. Currently working on interpreting the
I Ching in 64 separate portfolios of seven prints each.

ALEKNA, Dalia Reklys. Studied: The Art Institute of
Chicago. Exhibitions: Wabash Transit Gallery; Hyde Park
Art Center; Corcoran Gallery of Art, Washington, D.C.;
ARC Gallery, Chicago.

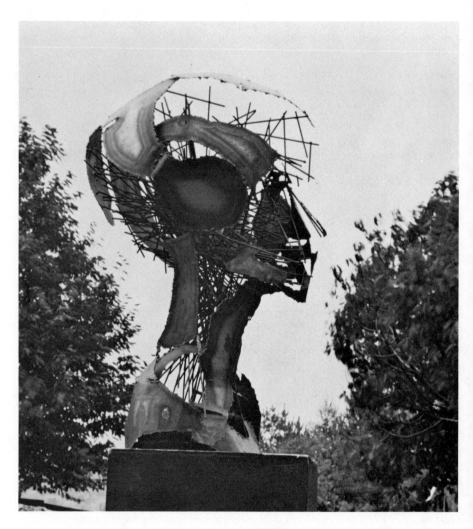

Arlene Abend, FROM WITHIN. Welded steel, 36" high.

Linda Adams, *SELF PORTRAIT*, 1975. Pencil,
24" x 32".

Pat Adams, *GO ROUND*, 1974. Gouache,
22¼" x 17¼". Photo: John A. Ferrari.

Louise Aikins, *NEGATE, CREATE, NEGATE, CREATE.*
Metallized mylar on wood, 54" x 54".

ALLEN, Anne. Painter. Born: Idaho. Noted for her paintings of rodeo and the working aspects of the horse. Began exhibiting her work in 1972.

ALTABE, Joan B. Muralist. Studied: Hunter College; Museum of Modern Art. Collections: Suffolk Museum Contemporary Slide Collection; Archives of American Art, Bureau of Smithsonian Institution; United Nations (Humanitarian Programmes).

✓ ANACREON, Joan. Painter. Studied: Pratt Institute, New York; Rowayton Art Center; The Wooster Community Art Center. Exhibitions: Women in the Arts Show, Community Church Gallery, New York City; The Stamford Museum; Women's Interarts Co-op. Collections: Van Summern & Weigold, New York City; Hamilton Press, Danbury, Connecticut; Connecticut Savings Bank, New Haven, Connecticut.

ANTIN, Eleanor. Noted for her environmental assemblages.

✓ APEL, Barbara. Printmaker. Born: Falls City, Nebraska in 1935. Studied: Kansas City Art Institute, Missouri; University of Illinois, Urbana. Awards: Lincoln College, Illinois, 1966; Springfield Art League Annual, Massachusetts, 1968; Boston Printmakers, 1974. Collections: Worcester Fine Arts Museum; The University of Wisconsin; The University of Illinois.

ARBUS, Diana. Photographer. Born: 1923, died in 1971. Internationally known for her black and white photographs of people and freaks.

ARNOW, Jan. Studied: University of Illinois; Goodman Theatre; The Art Institute of Chicago. Exhibitions: Artists Guild; Barat College; Gallery Shop, Grand Rapids, Michigan; ARC Gallery, Chicago.

✓ ARONSON, Sanda. Sculptor. Born: New York City in 1940. Studied: Oswego State College, New York; New York University. Exhibitions: Women's Interart Center, 1972, 1974, 1975; Women in the Arts, 1975; New York Public Library, Bloomingdale Branch, 1975.

ATTIE, Dottie. Noted for her drawings.

AUBIN, Barbara. Sculptor. Noted for her sculpture using fiber, feathers, beads, and other found objects.

Joan Anacreon, *SNOWY CLIFFS*. Oil on canvas,
50" x 40".

Barbara Apel, CAGED. Etching, 24" x 18"
edition of 15.

Sanda Aronson, MOTHERS-DAUGHTER-MOTHER. Stoneware, 8½" high. Photo: Linda Tarack.

AYLON, Helen. Painter. Noted for her stained color painting.

✓ *AZARA, Nancy. Sculptor/painter. Born: New York City in 1939. Studied: Finch College, New York; Lester Polakov Studio of Stage Design, New York City; The Art Students League, New York City. Exhibitions: Douglass College, Rutgers University, Newark, New Jersey, 1972; Cornell University, 1973; Ocean County College, New Jersey, 1974. She has also done theatrical costume design.*

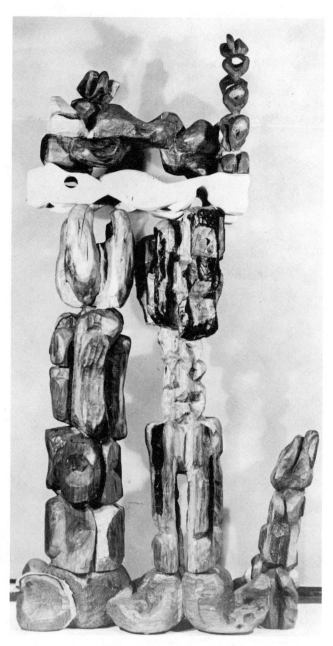

Nancy Azara, *MANY DIFFERENT LEVELS.*
Assembled wood, 84" high.

BACKLUND, Dorothy. Painter. Born: Missouri. Studied: Chicago Institute of Fine Arts; Washington School of Art, Washington, D. C.; Long Beach City College, California. She was a co-founder of the Southwest Traditional Artists Guild.

√ BACON, Reba Broyles. Painter. Born: Greene County, Tennessee. Studied: Tusculum College, Greeneville, Tennessee; George Peabody College for Teachers, Nashville, Tennessee; University of Tennessee at Knoxville. Exhibitions: Cumberland Art Society, Cookeville, Tennessee; Cumberland Mountain Craft Association. She is the founder of the semi-annual Benlee Art Show, Cookeville, Tennessee.

BAKER, Sara Ann Kontoff. Sculptor. Studied: Boston University; Brandeis University; Cambridge Adult Education Center. Exhibitions: Lawrence Academy, Groton, Massachusetts, 1974; Attlesboro Museum, 1974; Center for Advanced Visual Studies, 1975.

BALDWIN, Edith Ella. Portraits and miniatures. Born: Worcester, Massachusetts. Studied: Julian Academy in Paris; Colarossi Studios. Exhibitions: Salon of the Champ de Mars, 1901; Society of American Artists, 1898, Worcester, 1903.

BARBER, Alice. Painter. Born: Illinois. Studied: Indiana University. Exhibitions: University of Texas at Austin; Corcoran Gallery, Washington, D.C.; American Women's Show in Hamburg, Germany. Collections: Museum of Modern Art, New York City; Whitney Museum of American Art, New York City; San Francisco Museum of Art, California.

√ BARD, Joellen. Painter. Born: Brooklyn, New York in 1942. Studied: Pratt Institute; Brooklyn College; Syracuse University. Exhibitions: The Brooklyn Museum, the Little Gallery, 1973; Gallery 91, 1974; Gallery 26, 1975.

BARROW, Annemarie. Painter/graphics. Studied: University of Wisconsin at Milwaukee. Exhibited mostly in Wisconsin.

BARTLETT-LEE, Patricia. Painter. Born: San Diego, California in 1925. Studied with Alfredo de Annunzio. Awards: California All-Invitational Centennial Exhibit, 1968; Artist of the Year, Riverside County, 1969; Nevada Open, Carson City, 1970.

Bob? Brewing Rosen — IMPROVISATION, White

Joellen Bard, VIEWFINDER 3, 1974.
Acrylic, 44" x 44".

√ BARTON, Jean Lutz. Painter. Born: Philadelphia,
Pennsylvania in 1924. Studied: Moore College of Art.
Watercolorist and textile designer. Exhibiting mostly
in New Canaan, Connecticut.

BAT-YOSEF, Myriam. Painter. Noted for her fantasy
abstraction painting in the 1960's.

BAUERMEISTER, Mary. Painter/graphics. She worked in
the 1960's with rock assemblages. Paintings and
drawings had a bubble motif during this period.

√ BAUERNSCHMIDT, Patric. Portrait painter. Studied:
Memphis Art Institute, Tennessee; University of Maryland;
University of Tennessee. Exhibitions: Capital Park,
Washington, D.C.; Takashimaya Salon, Tokyo, Japan;
University of Maryland. Collections: The Kawaiahae
Church; The Straub Clinic; The Hile Lagoon Hotel.

BEAVER, Peggy. Sculptor. Born: Greensboro, North
Carolina in 1931. Studied: University of North Carolina
at Greensboro; University of South Carolina, Columbia,
South Carolina. Awards: South Carolina Craftsmen, 1973;
Bigelow Sanford Award of Merit, Guild of South Carolina
Artists, 1973; Dutch Fork Art Association, 1974.
Collections: Middle Tennessee State University,
Murfreesboro; University of South Carolina; Associated
Distributing Company, Columbia, South Carolina.

BEIGHLEY, Carol. Painter/graphics. Born: White Plains,
New York in 1949. Studied: Lehman College, City Universit
of New York; Hunter College, New York; Columbia University.
Exhibitions: Women's Club Gallery, 1967; Women's Interart
Center, 1975; West Broadway Gallery, New York City, 1975.

BELSLEY, Diane Calder. Painter. Noted for her shaped
canvases of stained fields.

BENGLIS, Linda. Painter. Born: Lake Charles, Louisiana
in 1941. Studied: Newcomb College. Awards: Yale-Norfolk i
1963 and Max Beckman Scholarship, Brooklyn Museum in 1965.
She has exhibited widely throughout the United States.

BENNETT, Juanita. Painter. Born: Missouri. Works in the
style of Robert Wood.

Jean Lutz Barton. Watercolor, 22" x 30".

Patric Bauernschmidt with her work.

√ BENNETT, Philomene. Painter. Born: Lincoln, Nebraska
in 1935. Studied: University of Nebraska. Awards:
Mid-American Exhibition, Nelson Gallery, Kansas City,
Missouri, 1956 and 1962. Collections: Hallmark
Collection, Kansas City; Missouri Historical Society,
Columbia, Missouri; University of Nebraska, Lincoln,
Nebraska.

BENOFF, Miki. Sculptor. Noted for her bronzes using
abstract, organic forms.

√ BENTON, Suzanne. Sculptor. Studied: Queens College,
New York City; Columbia University; Brooklyn College.
Awards: The International Susan B. Anthony Hall of Fame;
Grant from the Connecticut Commission on the Arts.
Narrative Theatre using sculptured metal masks. Sarah &
Hagar, From Genesis, women in patriarchy; Woman of Endor,
The Occult, female power interaction; Lilith, Illuminating
images & realities of archetype.

BEREA, Anna Elaine. Painter. Born: Altoona, Pennsylvania
in 1876 and died at Cruz Bay, St. John, Virgin Islands in
1934. Studied: at the Robert Eugene Swope Studio in Paris
and Dusseldorf, Germany. Mother of T. Benjamin Berea,
author and lecturer on American and British Art.

BERKELEY, Shelia. Sculptor. Born: New York City in 1945.
Studied: Syracuse University, New York; New York University,
New York City. Exhibitions: Hudson River Museum, New York,
1973; Institute of Contemporary Art, Boston, Massachusetts,
1970; Museum of Contemporary Crafts, New York City, 1900.
Commissions and Grants: New York State Council on the Arts,
1969; New York Urban Development Corporation, 1970;
Department of Cultural Affairs, New York City, 1973.

√ BERNSTEIN, Gerda Meyer. Painter. Born: Hagen Germany in
1925. Studied: London, England; Art Institute of Chicago.
Awards: Parke-Bernet Gallery; New Horizon Exhibition, 1975.
Exhibitions: Roosevelt University; Old Orchard Art Festival;
Springfield Museum, 1975; ARC Gallery, Chicago, Illinois.

√ BERRY, Carolyn, used the name, Carolyn Bishop, during the
period 1952-74. Painter. Born: Sweet Springs, Missouri
in 1930. Studied: Christian College for Women, University
of Oklahoma; University of Missouri. Awards: University
of Missouri, 1950; Yakima, Washington, 1974; Monterey
Peninsula Museum of Art, 1974. Collections: Brandeis
University; Marist College; Albrecht Gallery, St. Joseph,
Missouri; Monterey Peninsula Museum of Art.

Philomene Bennett, SPACE SERIES, 1974.
Lacquer on masonite.

Suzanne Benton, THE PERFECT MASK. Steel and copper, 16" high.

Gerda Meyer Bernstein, HOMAGE TO THE QUEEN.
X-ray, montage and drawing.

Carolyn Berry, NEST FIGURE, 1972. Hornet's
nest, resin, papier maché, 16" high.

√ BEZDEK, Joyce. Graphics. Studied: University of Michigan;
The Fine Arts Academy, Munich, Germany; School of the
Museum of Fine Arts, Boston, 1972, 1974; Tufts University,
Bedford, Massachusetts, 1973. Exhibitions: Atlantic Monthly
Gallery, Boston, 1974; Tusculum College, Greeneville,
Tennessee, 1975. She is represented in the collection of
Tufts University.

BIACH, Fulvia Levi. Painter. Using mostly oil medium.

BILLIAN, Cathey. Painter. Born: Chicago, Illinois in 1946.
Studied: University of Arizona; Temple University; The Art
Students League; The Art Institute of Chicago. Exhibitions:
Northern Arizona University, 1969; Larry Aldrich Museum of
Contemporary Art, Ridgefield, Connecticut, 1974; Hudson
River Museum, 1975.

√ BIRGE, Priscilla. Photographic media. Studied: Putney
School, Vermont; Brown University; University of
California, Elisha Benjamin Andrews Scholar, 1955, 1956.
Exhibitions: Lucien Labaudt Gallery, San Francisco, 1965;
Brown University, Providence, Rhode Island, 1975;
Joan Peterson Gallery, Boston, 1975. Collections:
E. B. Crocker Art Gallery, Sacramento, California; Joslyn
Art Museum, Omaha, Nebraska; Pembroke College, Providence,
Rhode Island.

√ BLACK, Lisa. Painter. Born: Lansing, Michigan in 1934.
Studied: University of Paris, Sorbonne; University of
Michigan. Awards: Rowayton Arts Center, 1971; New Rochelle
Art Association, 1971; Springfield Museum National Annual,
Time-Life Building; Smithsonian Magazine.

BLAKE, Caroline. Painter/graphics. Abstract figures and
fantasy imagery in the acrylic medium.

BLONDEAU, Barbara. Photographer.

√ BLUM, June. Painter. Studied: Brooklyn College, New York;
Brooklyn Museum Art School; The New School; Pratt Graphic
Art Center. Exhibitions: Fleisher Memorial Art Gallery,
Philadelphia Museum, 1974; Bronx Museum, "Year of the Woman"
Bronx, New York, 1975; Queens Museum, "Sons and Others,
Women See Men" New York City, 1975. She is represented in
the collection of Brooklyn College.

BOGAT, Regina. Painter. Works with abstract assemblages
on flat surfaces on walls.

Joyce Bezdek, INTERFERENCES. Silkscreen with pastel and pencil, 18" x 24". Edition of 15 with variation.

Priscilla Birge, PIE PIECE, 1974. Photo-
enlargement with acetate overlay.

Lisa Black, *INNER LANDSCAPE SERIES.*
Ink, 30" x 40".

June Blum. Acrylic on canvas, 48" x 50".

√ BOPP, Cheryl. Painter/graphics. Born: Terre Haute, Indiana in 1948. Studied: Indiana State University. Exhibitions: Dulin Print and Drawing Show, Knoxville, Tennessee; Indianapolis 500 Show, Indianapolis, Indiana; Women in Art, West Bend, Wisconsin. She is represented in the collection of Indiana State University, Terre Haute.

BORCHARDT, Marguerite. Painter. Grew up in France, graduating from the Sorbonne. Now lives in New York City. Exhibitions: West Side Savings Bank, New York City: Green Mountain Gallery, New York City; <u>Maison Francaise</u> of New York University, New York City.

√ BOROCHOFF, Ida Sloan. Painter/graphics. Studied: High Museum, Atlanta, Georgia; University of Georgia, Athens; Georgia State University, Atlanta. Awards: Scottdale Enterprises, Inc.; Sandy Springs Junior Women's Club; Atlanta Artists' Club. Exhibitions: Georgia Institute of Technology, 1971; The Lovett School, 1975. Collections: Georgia Institute of Technology; National Academy of Engineering, Washington, D. C.; Veterans Administration Hospital, Atlanta.

BOS, Linsday. Painter. Born: Pittsburgh, Pennsylvania in 1937. Studied: Carnegie-Mellon University; Hoffberger School of Painting; Maryland-Institute College of Art. She has been exhibiting in the United States since 1966.

BOURKE-WHITE, Margaret. Photographer. Noted for her photographs in the 1930's and 1940's of still life, portraits, figures, and landscapes.

BRANT, Sharon. Painter. Noted for her acrylic and resin paintings. In the early 1970's she was doing color-field paintings. Exhibited at O. K. Harris Gallery, New York City.

BRAUNSCHWEIGER, Helen. Painter. Born: Norwich, Connecticut. Studied: Boston University Art School. Awards: Honorary Fellowship, American Artists Professional League and American Institute of Fine Arts. She usually signs her paintings, "Mrs. B".

BRICE, Judy Lerner. Studied: Pratt Institute, Brooklyn, New York; Yale University, New Haven, Connecticut. Exhibitions: Lincoln Center for the Performing Arts, New York City; Yale Fine Arts Museum; ARC Gallery, Chicago.

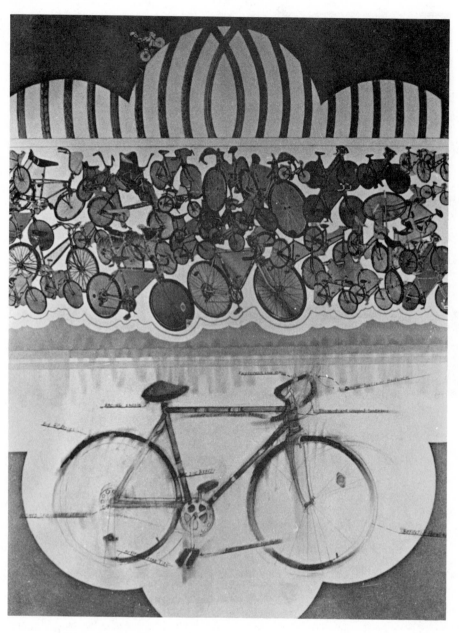

Cheryl Bopp, A LARRY RIVERS BICYCLE, 1975.

Ida Sloan Borochoff, THE CHOIR. Woodcut.

BRIDGES, Fidelia. Painter. Born: Salem, Massachusetts.
Studied: with William Trost Richards in Philadelphia.
Associate of the National Academy of Design, 1878.
Elected a member of the Water-Color Society, 1871.
Exhibited at the Philadelphia Exposition, 1876.

BRODY, Lily. Painter. Born: Budapest, Hungary in 1905.
Studied: with Leopold Herman; Hungarian Art Academy;
Colarossi Academy in Paris. Exhibitions: Museum of
Modern Art, New York City, 1962-64; International Drawing
Exhibition, Rijeka Museum, Yugoslavia, 1970; Whitney
Museum of American Art, 1972; New York Cultural Center,
1973.

BRODY, Sherry. Graphics/sculptor. Noted for her clothing
sewn to canvas. Also for her ink drawings.

BROOKS, Romaine. Painter. She was painting figures and
portraits in the 1920's.

BROWN, Anna P. Painter. Studied art at an early age in
Europe. Later became a fur designer, recently returning
to her painting.

√ BROWN, Anne. Sculptor. Born in 1941. Exhibitions:
Goethe Institute, Boston, 1974; Boston Visual Artists'
Union, 1974; Western Colorado Center for the Arts, Grand
Junction, 1973; Tryingham Galleries, Massachusetts, 1975.

BROWNSCOMBE, Jennie. Studied: National Academy of Design;
The Art Students League, New York City. Noted for her
paintings of genre subjects. Many of her works have been
reproduced in engravings and etchings.

BRUMER, Miriam. Painter. Noted for her organic imagery
in oil and charcoal.

BURKETT, Deena. Painter. Working mainly in a realistic
style using figures as subjects.

√ BURKO, Diane. Painter/graphics. Born: New York City in
1945. Studied: Skidmore College; University of
Pennsylvania. Awarded the Scott Paper Company Award in
"Earth Space Art 73." Exhibitions: William Penn Memorial
Museum, Harrisburg, Pennsylvania, 1971; Philadelphia
Museum of Art-Fleischer Art Memorial, 1972; Bronx Museum
of the Arts, "Year of the Women", 1975.

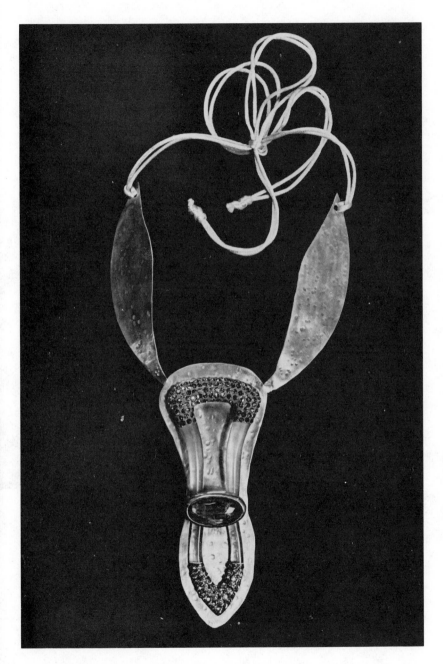

Anne Brown, Hammered brass, glass, 5" x 3".

Diane Burko, HIGHVIEW BASIN, 1973. Oil,
54" x 60". Collection: William Sharp.

√ BURNS, Josephine. Painter. Born: Wales, Great Britain
in 1917. Studied: Cooper Union; The Art Students League,
New York City. Exhibitions: The National Academy of
Design; Audubon Artists; National Arts Club. Collections:
C. W. Post College Museum; Oklahoma Museum; The Lanza
Corporation, New Jersey.

BURROWS, Edith. Photographer. Noted for her work with
landscape and with figures.

Josephine Burns, *GARDEN VIEW*. Oil on canvas, 30" x 24".

CANTERELLA, Virginia. Painter. Doing abstract-expressionist painting during the year 1970's.

CAROOMPAS, Carole. Painter/sculptor. Noted for her wall constructions.

CARR, Emily. Painter. Working in oil between the 1920's and 1950's, she painted landscapes in the Northwest and abstractions.

CARSON, Karen. Sculptor/graphics. Noted for her zippered, canvas sculptures in the early 1970's. Also drawings of plants, horses, and nude women during this period.

√ CASTANIS, Muriel. Sculptor. Born: 1926. Exhibitions: Women Artists at SOHO, New York City; "Feminine Perceptions", Buffalo State University, New York; "Unmanly Art" Suffolk Museum; Portland Museum of Art, Maine. Collections: Andrew Dickson White Museum, New York; Joe and Emily Lowe Museum, Florida.

CELMINS, Vija. Sculptor/graphics. Uses wood and enamel for her sculptures. Her drawings are of the ocean, done in the photo-realist style.

CHAPLINE, Claudia. Sculptor. Noted for her use of fiber in making sculpture.

CHASE-RIBOUD, Barbara. Sculptor. Uses fiber, metal and aluminum for the production of her sculpture.

CHASSY, Laura Sue. Printmaker. Born: Bronx, New York in 1945. Studied: San Diego State College; State University College, New Paltz, New York. Awards: Smithhaven Art Show, Smithtown, New York, 1970; State University College, 1973. She has shown mostly in the Washington, D. C. area.

√ CHENEY, Elenor. Painter. Born: Columbus, Ohio. Studied: Washington University, St. Louis. Awards: Evansville Museum of Art, Indiana; The South Bend Art Association; Art for Religion Exhibit, Indianapolis. Exhibitions: Franklin College of Indiana, 1974; Indiana/Purdue University, Indianapolis, 1974; Marian College, 1975.

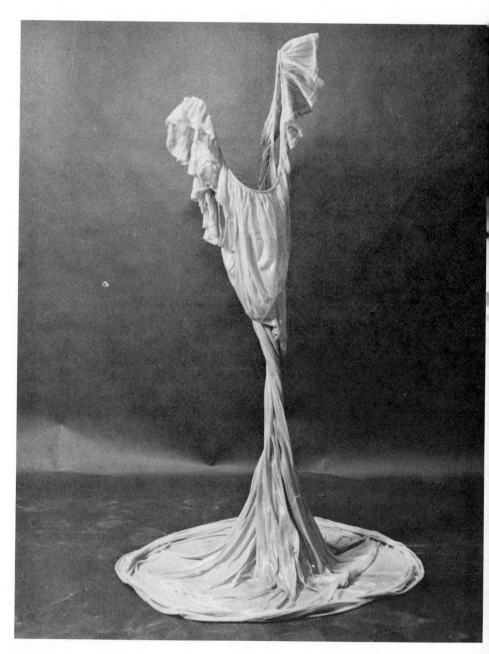

Muriel Castanis, STANDING NIGHTGOWN.
Nightgown and resins, 36" high.

*Elenor Cheney, OPTICAL COEFFICIENT #2.
Acrylic on canvas, 36" x 46".*

√ CHERRY, Lee. Painter. Born: Arlington, Massachusetts. Studied: Massachusetts College of Art, Boston; East Tennessee State University. Awards: Virginia Intermont, 1963; Virginia Fine Arts Festival, Roanoke, 1967; Tennessee Drawing, 1974. Collections: The Security National Bank, Roanoke, Virginia; Tennessee Eastman Company; The American Association of State Colleges and Universities, Washington, D.C.

CHICAGO, Judy. Painter. Born: Chicago, Illinois in 1939. Until 1970 she exhibited under the name of Judy Gerowitz. Studied: UCLA and received her MA in 1964. She is currently involved in the development of teaching methods for the education of young women in the arts. She has been exhibiting since 1966.

√ CHRISTON, Noreen. Jeweler/sculptor. Born: Stamford, Connecticut in 1946. Studied: Monticello College, Godfrey, Illinois; Bridgeport University, Connecticut; Arrowmont School of Crafts, Gatlinburg, Tennessee. Exhibitions: Countryside Briardale Invitation Exhibit, Omaha, 1972; Joslyn Art Museum, Omaha, Nebraska, 1975. Co-founder, Old Market Craftsmen Guild.

CHURCHILL, Diane. Exhibited: Six New Jersey Women Artists, Douglass College Library, New Brunswick, New Jersey, 1975.

CIBULA, Ellen. Painter. Noted for her geometric, color painting. She has exhibited at O. K. Harris Gallery, New York City.

CLARK, Helen. Painter. Born: 1921. Self-taught as an artist. Painting only five years, she is best known for her writing in western magazines: Western Horseman; True West; Frontier Times.

CLARK, LeAnna. Painter. Born: Ulysses, Pennsylvania. Mostly self-taught as an artist; studied with Famous Artists School, Westport, Connecticut. Noted for paintings and drawings of places of worship.

√ CLEARY-BENTLEY, Shirley. Painter. Born: St. Louis, Missouri in 1943. Studied: Washington University, St. Louis; University of San Francisco; Tyler School of Art of Temple University, Philadelphia, Pennsylvania. Awards: St. Louis Artist Guild, 1965, 1966, 1972; Southern Tier Arts and Crafts Show, Corning, New York, 1969; Gravers Society of Washington, D.C. 1974. Collections Drury College, Springfield, Missouri; D.C. Teachers College Washington, D.C.; Great Falls Junior League.

Lee Cherry, ROCK FORMS I, 1973. Watercolor.

Noreen Christon, FLASHBACK. Silver, copper,
bronze and turquoise, 3" x 4".

Shirley Cleary-Bentley, BENCH WARMERS. Oil on
canvas, 47" x 81".

CLEMENT, Ethel. Pastel Artist. Born: San Francisco in 1874. Studied: Cowles Art School, Boston; The Art Students League, New York City. She has received several awards from the California State Fair exhibits.

COHEN, Elaine Lustig. Painter. Noted for her hard-edge color paintings in acrylic.

COLBURN, Carol. Painter. Exhibiting with "The Circle," a group formed in 1971 of five women artists in Phoenix, Arizona.

√ COLE, Frances. Watercolorist. Studied: Antioch College; University of Michigan; University of Dayton. She has exhibited in the Watercolor Society in New York City and throughout the United States.

COLLIER, Bonnie Baldwin. Ceramist. Studied: George Washington University, Washington, D. C.; Radford College, Radford, Virginia. Awards: Alberta College of Art, Banff, Canada, 1973; George Washington University, 1971; Corcoran Concordia, Washington, D.C. 1970.

COLMAN-SMITH, Pamela. Graphics. Noted for her designs for Tarot cards in the early 1900's.

√ CONNOR, Maureen. Sculptor. Studied: Pratt Institute, Brooklyn, New York. Exhibitions: Women's Interart Center, New York City, 1973; Adelphi University, "New Reflections" Staten Island Community College, 1974. Presently Vice-President for Sculpture, Architectural League of New York.

CORITA, Mary. Graphics. Noted for her colorful and whimsical silkscreen posters.

CORWIN, Isabella. Painter. Studied: Cooper Union School of Fine Art. Exhibitions: Marymount College, Tarrytown, New York; Fashion Institute of Technology, New York; "10 Downtown", New York City, 1974.

COSINDAS, Marie. Photographer. Born: 1925. Studied: Boston Museum School. Represented in the collection of Eastman House. Has served as a consultant to Polaroid.

Frances Cole, STORM BREAKS, 12½" x 18".
Collection: Goldmar, Inc.

*Maureen Connor, BREATHING FLOWERS, 1972-73.
Inflatable sculpture, 96" high to 126" high.*

COX, Carol. Painter. Born: South Dakota in 1927. She has exhibited in Montana, Wyoming, Colorado and Arizona. Noted for her paintings of the west.

CUMMENS, Linda. Sculptor/graphics. Studied: Illinois Wesleyan University; Southern Illinois University. Awards: Birmingham, Michigan Art Association, 1963; Royal Oak Art Association, Michigan, 1966; Ball State University, 1975. Collections: Henry Ford Traveling Print Collection; J. L. Hudson Collection, Grosse Point, Michigan; McLean County Bank, Bloomington, Illinois.

CUNEO, Aiko Lanier. Sculptor. Born: 1950. Studied: Pratt Institute, Brooklyn, New York. Currently working in New York City.

CUNNINGHAM, Imogen. Photographer. Born: 1883. Noted for her work with close-ups of plants, portraits, and figures done in the 1920's and 1930's.

DAHL-WOLF, Louise. Photographer. Very active in the 1930's

DAILY, Evelynne Mess. Painter/printmaker. Studied: Herron School of Art of Indiana University; The Bauhaus; Butler University. Exhibitions: Brooklyn Museum; Chicago Art Institute; National Academy of Design. Her work is in the collection of the Library of Congress, Washington, D. C.

DANIELLI, Edie. Sculptor. Born: in 1937. Noted for her environmental set-ups, styrofoam objects, and soft cubes.

√ DANIELSON, Phyllis. Born in 1932. Studied: Ball State University; Michigan State University; Indiana University. Exhibitions: Mint Museum of Art, Charlotte, North Carolina, 1971; Matrix Gallery, Bloomington, Indiana, 1971; South Bend Art Center, Indiana, 1975.

DATER, Judy. Photographer. Born: 1941. Studied: San Francisco State College, California. Noted for her photographs of head studies and group portraits.

√ DAVIDSON, Carol Kreeger. Constructions. Born: Chicago, Illinois in 1932. Studied: Northwestern University; University of Hartford Art School; Rhode Island School of Design. Awards: Connecticut Academy of Fine Arts, 1970, 1971, 1972. New Britain Museum, 1973; Northwestern Community College. She is represented in the collection of The Slater Museum, Norwich, Connecticut.

DEFOE, Jay. Painter. Born: 1929. Studied in California. Noted for her large sculptural paintings in oil.

DE JONG, Jacqueline. Painter. Noted for her grotesque, abstract figure painting.

DELSON, Elizabeth. Painter/printmaker. Studied: Smith College; Hunter College; Pennsylvania Academy of the Fine Arts. Awarded the Audubon Artists Medal of Honor for Graphics. Exhibited in several New York galleries and is in the for-sale collection of Associated American Artists and the Landmarks Collection.

Phyllis Danielson, GOLDEN OPPORTUNITY.

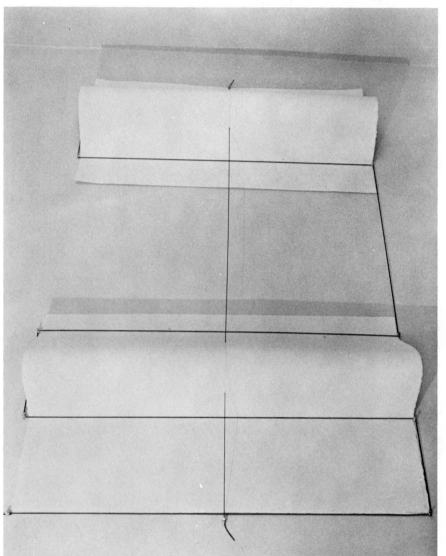

Carol Kreeger Davidson, *THE PERMANENT TIE.*

DEL VALLE, Helen. Painter. Studied: The Art Institute of
Chicago; Philadelphia Academy of Fine Arts. Awards:
Chicago, N.L.A.P.W. 1971, 1973; Municipal Art League of
Chicago, 1973. Exhibitions: Chicago Public Library, 1969;
American Society of Artists, 1973; Balzekas Museum, Chicago,
1973. Past-President of the American Society of Artists.
Her work is included in collections throughout the world.

DE SANDO, Sandra. Sculptor. Born: 1946. Noted for her
mixed-media funky food-sculptures.

DISQUE, Jill. Sculptor. Born: Philadelphia, Pennsylvania.
Studied: Pennsylvania Academy of Fine Arts; University of
Pennsylvania; Parsons School of Design. Exhibitions:
Westchester Community College; Fairfield University;
Bridgeport University. Collections: Housatonic Art Museum;
Westport Public Schools.

DIXON, Martha. Painter. Noted for her singing on the
concert stage before turning to painting. She is active
in the American Institute of Fine Arts.

DODD, Lois. Painter/graphics. Noted for her abstract
works, as well as, her realistic paintings.

DODGE, Marge. Painter. Born: Stoughton, Wisconsin in
1918. Studied: Layton School of Art, Milwaukee, Wisconsin;
Atlanta Art Institute, Georgia; University of Montana,
Missoula. Awards: Savannah Art Exhibition; North Montana
State Fair. Exhibitions: Hockaday Art Center, Kalispell,
Montana; American Artists Professional League, New York City.
Collections: Western Montana Youth Guidance Center, Missoula;
Bozeman High School Art Gallery; DeKalb County Library,
Georgia.

DODSON, Betty. Drawing. Uses pencil for realist, erotic
figure-drawings.

DOLINICH, Christine. Constructions and Drawing. Studied:
Douglass College, Rutgers University; The University of
Oxford. Exhibitions: Rutgers University, 1973; Oxford Art
Centre, 1972; "Found: New Jersey Women Artists, 1973-1974.

Jill Disque, WHITE LIGHT, 96" high.

Marge Dodge, ON THE BEACH. Watercolor,
18" x 24". Photo: Don Dodge.

Christine Dolinich, THE BLOSSOMING OF THE WOULD-BE BLONDE BOMBSHELL AND/OR MY AUTOBIOGRAPHY.

DOLNICK, Beej. Painter. Studied: Stella Elkins Tyler
School of Fine Arts of Temple University; Barnes Foundation.
Exhibitions: Oakland Museum, Oakland, California; Museum
of Modern Art, New York City; Swarthmore College,
Swarthmore, Pennsylvania; plus many exhibitions in the
Northeastern United States.

DONNESON, Seena. Printmaker/sculptor. Born: New York
City. Studied: Pratt Institute; The Art Students League,
New York City. Awards: Edward MacDowell Foundation, 1963-64;
Tamarind Lithography Workshop, 1968; and ten national
competition awards. She has exhibited in twenty-five
museums, galleries, and universities throughout the
United States. Collections: Finch College, New York;
Norfolk Museum, Virginia; Museum of Modern Art, New York;
Los Angeles County Museum of Art, California; plus many
others.

DOWNING, Betty. Painter. Self-taught as an artist.
Exhibitions: Dubois International Show; Wyoming State
Fair. She is noted for paintings of the west.

DREXLER, Rosalyn. Painter. Noted for her figure paintings
and portraits done in the Pop Art style.

DRISCOLL, Ellen. Sculptor. Born: 1954. Studied:
Wesleyan University. Exhibitions: Wesleyan University;
Boston Visual Artists Union Show, 1975. Artists-in-
residence, Pulpit Rock Artists Community, Woodstock,
Connecticut, 1974-75.

DROST, Romola Henson. Pastel Artist. Born: Greenville,
South Carolina. Studied: The University of Tennessee at
Knoxville. Exhibitions: Cumberland Arts Society, Cookeville,
Tennessee; Ben Lee Show, Cookeville, Tennessee; St.
Augustine, Florida.

DUBOIS, Rose Dow. Painter. Studied: Tennessee Tech; George
Peabody College, Nashville, Tennessee. Exhibitions: The
Arts Center, Cookeville, Tennessee; The Cumberland Arts
Society; the Tennessee Art League; La Junta, Colorado.

DUDCHENKO, Nancy. Painter in clay. Born: Philadelphia,
Pennsylvania in 1943. Studied: Kutztown State College,
Pennsylvania. Exhibitions: Baum Art School, Allentown,
Pennsylvania, 1969; Frostburg State College, Maryland,
1972; Trenton State College, New Jersey, 1974. She is
represented in the collection of the John Michael Kohler
Art Center, Sheboygan, Wisconsin.

Beej Dolnick.

Senna Donneson, NOVA. Plastic and steel, 28" high.

Ellen Driscoll, UNTITLED, 1974. Tobacco

Nancy Dudchenko, COILED PLATTER. Salt fired
clay, 28" diameter.

EDELHEIT, Martha. Painter/film-maker. She has been
exhibiting her paintings since 1960 and making films
since 1972.

√ EDELSON, Mary Beth. Mixed Media. Studied: The Art
Institute of Chicago; DePauw University; New York University
Awarded a National Endowment Grant, 1973. Exhibitions:
Indianapolis Museum of Art, formerly John Herron Museum,
1968; Corcoran Gallery of Art, Washington, D. C., 1973;
Ringling Museum of Art, Sarasota, Florida, 1974.
Collections: Corcoran Gallery of Art; Joe Cantor Collection,
Sheldon Swope Gallery.

√ EDWARDS, Beverley. Painter/graphics. Studied: University
of Georgia; Atlanta Art Institute. Exhibitions: Tufts
University, Boston, 1969; Falmouth Artists Guild, Falmouth,
Massachusetts, 1970, 1971; Andover Gallery of Fine Arts,
Andover, Massachusetts, 1975. Collections: First National
Bank of Boston; Keystone Corp.; New England Life Insurance
Company.

EDWARDS, Ellender. Graphic Illustration. Studied: The
Maryland Institute of Art; George Washington University,
Washington, D.C.; The Art Students League of New York.
Awards: Rockville, Maryland N.L.A.P.W.; Shepherd College,
West Virginia; Waterford Foundation, Inc., Virginia.
Exhibitions: University of Arizona; De Young Museum,
California; Montgomery College, Maryland.

√ EGELSON, Polly. Sculptor. Studied: Maryland Institute of
Art; Radcliffe College. Awards: New England Ceramic
League, 1964; Attleboro Art Museum, 1975. Exhibitions:
Highland Gallery, Carmel, California; Copley Society,
1974; Cambridge Art Association, Massachusetts, 1975.

ELKINS, Lee. Painter. Born: Texas. Essentially self-
taught as an artist. Exhibits mostly in the far-western
states. Co-founder of the North Lake Tahoe Art Guild.

ELLER, Evelyn. Noted for Collages. Born: New York City
in 1933. Studied: School for Art Studies, New York City;
The Art Students League, New York City; Academia de Belle
Arte, Rome, Italy. Awarded a Fulbright Fellowship to Rome,
1954-55. Exhibitions: Miami Museum of Modern Art, Florida;
Paul Klapper Library, Queens College, New York; Whitney
Museum of Art, New York City. Collections: Exxon; Anaconda,
Irving Trust Company.

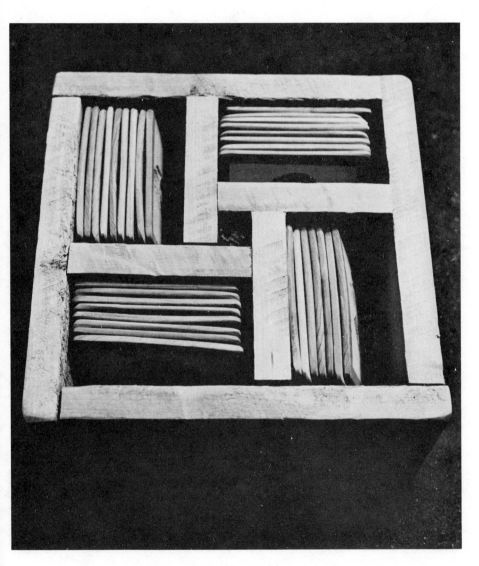

Mary Beth Edelson, SHELLS BOX, 7" high.

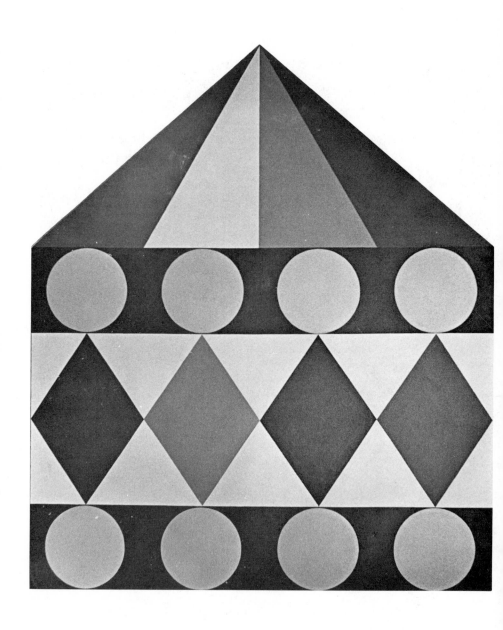

Beverley Edwards, CAROUSEL I, 1973, 72" x 72".

Polly Egelson, THE BUSINESSMEN. Fired clay,
24" high.

√ EMERY, Lin. *Sculptor.* *Studied: Studio of Ossip Zadkine,*
Paris; Sculpture Center, New York City. Awards: First
National Bank of Atlanta, Georgia, 1969; Humanities
Center, University of South Carolina, 1972; South Central
Bell Headquarters, 1972. Collections: New Orleans Civic
Center, Louisiana; Pensacola Art Center, Florida;
Huntington Galleries, Huntington, West Virginia.

√ ENGLE, Barbara. *Painter/graphics. Studied: Honolulu*
Academy of Arts, Honolulu; Chouinard Art Institute,
Los Angeles, California; Otis Art Institute, Los
Angeles. Exhibitions: Pasadena Art Museum, California,
1959; Objects, U.S.A., Touring Show, 1969; Foundry
Gallery, Honolulu, Hawaii, 1975. Collections: Honolulu
Academy of Arts; State Foundation on Culture and Arts,
Hawaii; Department of Education, Hawaii.

√ ENOS, Chris. *Photographer. Born: California in 1944.*
Studied: Foothill College, Los Altos, California; San
Francisco State University; San Francisco Art Institute.
Exhibitions: Photography and Film Center West, Berkeley,
California, 1972; Focus II Gallery, New York, 1974;
Bibliotheque Nationale, Paris, France, 1975. Collections:
San Francisco Museum of Art, California; San Francisco
Art Institute, California; Fogg Museum, Harvard University,
Cambridge, Massachusetts.

√ ENTE, Lily. *Sculptor/painter. Works mostly in black and*
white marble. Exhibitions: Riverside Museum, New York;
Stable Gallery, New York; University of Illinois.
Collections: Phoenix Art Museum; Riverside Museum;
Safad Museum, Israel.

EORCOS, Lucille. *Painter. Noted for her primitive style*
of painting people in environments.

ESTES, Merion. *Studied: University of Colorado. She*
paints with lacquer on vinyl.

Lin Emery, AQUAMOBILE. Bronze, 240" high.
Collection: Fidelity Center, Oklahoma City,
Oklahoma.

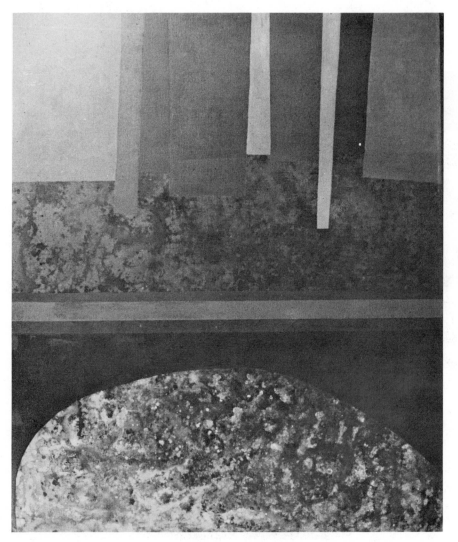

Barbara Engle, MOON SCAPE. Acrylic, 40" x 48".

Chris Enos. Black and white photograph.

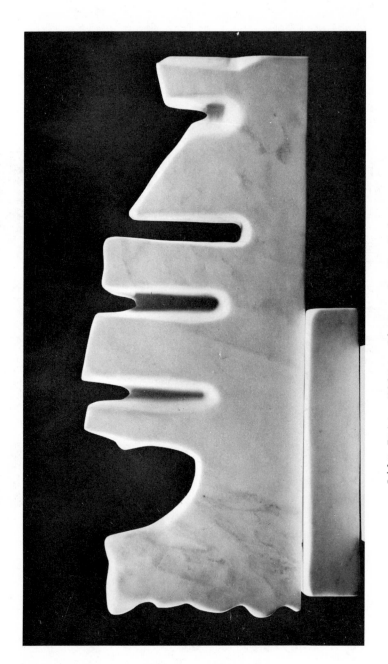

Lily Ente, NOON. Photo: O. E. Nelson.

FAEDMAN, Tanya. *Sculptor/graphics. Works with organic forms in polyurethane foam and pencil.*

FALK, Gathie. *Sculptor. Work in assemblage and ceramics in the 1960's.*

FALKENSTEIN, C. *Sculptor. Worked with copper, iron and found objects to form abstract sculpture in the 1950's.*

FARIAN, Babette S. *Painter. Studied: Parsons School of Fine and Applied Art, New York; Cooper Union School of Art; Modern Museum Art School. Awards: Gotham Painters, Unitarian Church; Martha's Vineyard Fair.*

√ FeBLAND, Harriet. *Painter/constructionist. Born: New York City. Studied: The Art Students League, New York; Pratt Institute; New York University. Exhibitions: Hudson River Museum, Yonkers, New York; Silvermine Guild, New Canaan, Connecticut; Huntington Hartford Museum, New York City. Collections: Cincinnati Art Museum, Ohio; Westchester County Court House, White Plains, New York; Tweed Gallery, University of Minnesota.*

√ FEDERE, Marion. *Collage and Drawing. Studied: Vienna, Austria; Brooklyn Museum; Seide's Workshop; San Miguel De Allende, Instituto, Mexico; Pratt Graphic Center. Exhibitions: Village Art Center; National Academy of Design; Brooklyn Museum; Brandeis University.*

√ FEEZER, Mary Kay. *Painter. Born: Lander, Wyoming. Studied: Academy of St. Mary of the Wasatch, Salt Lake City, Utah; Jackson Hole School of Art; Casper College. Awards: Wind River National Art Show; Wyoming State Fair; Central Wyoming Fair. She is represented in the collection of Fort Casper Museum.*

FENNER, Kathleen Young. *Self-taught as an artist. Exhibitions: Electrum II; MIA Little Festival, 1974; Twin Falls County Annual, Idaho, first award; Boise, Idaho Festival, Juror's Choice award.*

FERAR, Ellen. *Studied: University of Michigan; Wayne State University, Detroit, Michigan. She is associated with the ARC Gallery, Chicago.*

Harriet FeBland, TOTEMS, Acrylic on wood,
57" high to 120" high.

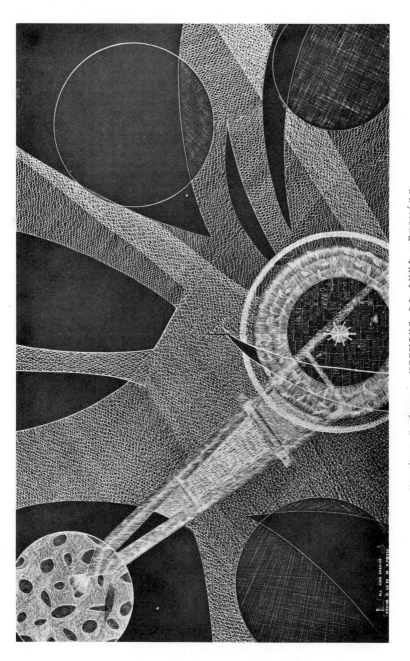

Marion Federe, VIEWING LA LUNA. Drawing, 37" x 25".

Mary K. Feezer, Oil on canvas, 1973.

FERGUSON, Catherine. Sculptor. Born: Sioux City, Iowa
in 1943. Studied: Rosary College, River Forest, Illinois;
Creighton University, Omaha, Nebraska; Arrowmont School
of Crafts, Gatlinburg, Tennessee. She received awards
at the Associated Artists of Omaha Show, 1970, 1973.
Collections: Ahmanson Law Center, Creighton University
Law School, Omaha; Brenton Bank, Des Moines, Iowa.
Co-founder, Old Market Craftsmen Guild.

FERGUSON, Kendra. Graphics. Born: Missoula, Montana
in 1946. Studied: Medill School of Journalism;
Northwestern University, Evanston, Illinois. Exhibitions:
Boston Visual Artists Union Gallery, 1971; Contemporary
Boston Artists, 1974; Parsons Truman Gallery, New York
City, 1975. She is represented in the collection of The
Fogg Art Museum, Cambridge, Massachusetts.

FERRARA, Jackie. Sculptor. Working mainly with fiber in
the early 1970's.

FIELDS, Frederica Hastings. 3-Dimensional Stained Glass.
Born: Philadelphia, Pennsylvania in 1912. Studied:
Wellesley College; The Art Students League, New York;
Awards: Corcoran Gallery of Art, 1955, 1956; Sixth
International Exhibition of Ceramic Arts, 1957.
Collections: Washington Cathedral, Washington, D.C.;
Greenwich Library, Connecticut; Y.M.C.A., Greenwich,
Connecticut.

FISH, Janet. Painter. Born: Boston, Massachusetts in
1938. Studied: Yale School of Architecture; Smith College;
Skowhegan Art School. Awards: Yale Scholarship and
Skowhegan Scholarship. She has exhibited in New York,
Chicago and Hamburg, Germany.

FISKIN, Judy. Photographer. Concerned with abstract
compositions and architecture in her work. Co-director
of Womanspace, Los Angeles, California.

FONSSAGRIVES-PENN, Lisa. Sculptor. Born: Sweden.
Studied: Music and Art History at the Sorbonne, Paris and
The Art Students League in New York.

FRANCES, Hariette. Painter/graphics. Born: San Francisco,
California in 1927. Studied: San Francisco Art Institute;
California School of Fine Art; University of the Pacific.
Awards: James D. Phelan Award, 1965; Marin Society of
Artists, 1973-75; San Francisco Women Artists, 1975.
Collections: Aschenbach Foundation for Graphic Arts at
the California Palace of the Legion of Honor, San Francisco;
Fresno Arts Center.

Catherine Ferguson, POUSEÉ. Soft fabric
sculpture. 42" x 84"

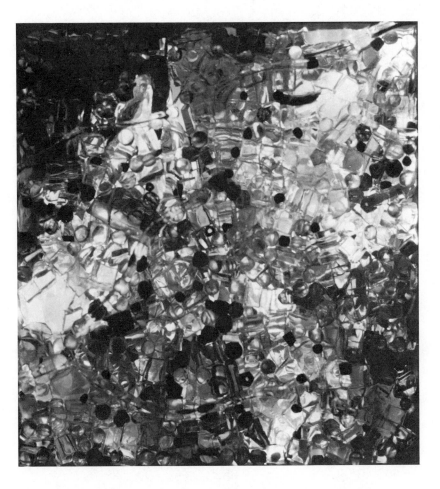

*Fredrica Hastings Fields, EXHIBITION PANEL,
66" x 60". Photo: Kenneth E. Fields.*

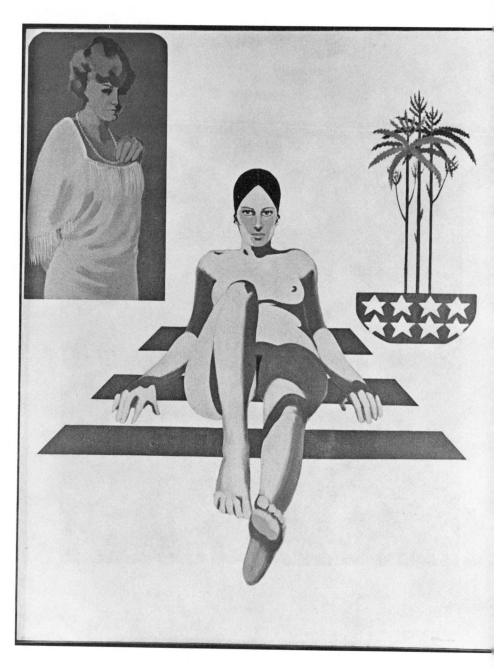

Harriette Frances, OLD GLORY, NEW GLORY.
Acrylic, 50" x 40". Photo: Alissa Crandall.

FREDERICKS, Beverly. Painter. Studied: Colorado Springs with Boardman Robinson. Exhibits mostly in southwestern California.

FREILICHER, Jane. Painter. Worked with oil on canvas doing abstract-expressionistic paintings in the 1950's and 1960's.

FREUND, Sybil Erden. Painter. Born: New York City in 1950. Studied: Academy of Art in San Francisco; San Francisco Art Institute. Exhibitions: San Francisco Art Institute; Museum of Erotic Art; San Francisco Civic Center Art Festival, 1974; The Capricorn Asunder.

FRIED, Sheilah. Sculptor. Studied: University of Toledo; Kent State University; University of Notre Dame. Awards: Kodak International Photographic Competition, 1970; Toledo Area Artists, 1975. Exhibitions: Women 71, University of Illinois, 1971; Fort Wayne Museum of Art, Indiana, 1974; Mansfield Arts Center, Ohio, 1975.

FRIEDLAENDER, Bilgè. Painter. Born: Istanbul, Turkey. Studied: New York University; Academy of Fine Arts, Istanbul; Robert College, Istanbul. Exhibitions: Berkshire Art Museum, Pittsfield, Massachusetts, 1968; Institute of Contemporary Art, Boston, 1973; Betty Parsons Gallery, New York City. Collections: Parasol Press, New York; Smith College Museum, Northampton; Boston Partners.

FRIEDMAN, Sharon. Painter. Studied: Boston University School of Fine Art. Exhibitions: Institute of Contemporary Art, 1972; Sunne Savage Gallery, Boston, Massachusetts, 1974; American Woman Festival, Boston Bicentennial Commission, 1975. Collections: I.B.M.; Boston Redevelopment Authority; Brockton Art Museum.

FUERST, Shirley M. Mixed Media. Born: Brooklyn, New York in 1928. Studied: Hunter College; Brooklyn Museum Art School; Pratt Center for Contemporary Printmaking; Art Students League, New York City. Awards: Village Art Center, 1963; Enjay Art Competition, 1966. National Association of Women Artists, 1970. Exhibitions: "Unmanly Art", Suffolk Museum, 1972; Brooklyn Museum; Riverside Museum. She was a founder member of "Floating Gallery," a women's artist group.

Sybil Erden Freund, THE AWAKENING, 1974.

Sheilah Fried, HEAD OF CHILD (detail). Polyester
fiber and fabric, life size.

Bilgé Friedlaender, BENTHONIC SPACE - THE WALL,
1974. Acrylic and nylon rope with canvas,
80" x 50". Photo: Peter Sramek.

Shirley M. Fuerst, LONG MAY PYTHAGORAS WAVE.
Heat diffusion/mylar, 45" x 63". Photo:
Eric Pollitzer.

FULLER, Elizabeth Helser. Painter. Born: Columbia,
South Carolina. Studied: University of South Carolina;
Greenville Museum School of Art. Exhibited mostly in
the Piedmont area of the United States.

√ FULLER, Mary. Sculptor. Born: Wichita, Kansas in 1922.
Studied: University of California in Berkeley;
California Faience Company of Berkeley. Awarded the
Merit of Honor, San Francisco Arts Festival, 1971.
Exhibitions: Syracuse Museum, New York; San Francisco
Museum of Art; San Francisco Women's Center. Commission:
California Medical Center and the San Francisco General
Hospital. Also noted for her writing of short stories,
novels, and articles on art.

√ FURRER, Marjorie. Painter. Studied: Massachusetts
College of Art, Boston. Awards: Boston Watercolor Society,
1972; Cambridge Art Association, 1972; Sculpin Gallery,
Martha's Vineyard, 1973. Exhibitions: Shore Galleries,
Boston; Salem Public Library, Massachusetts; Museum of
Fine Arts, Boston.

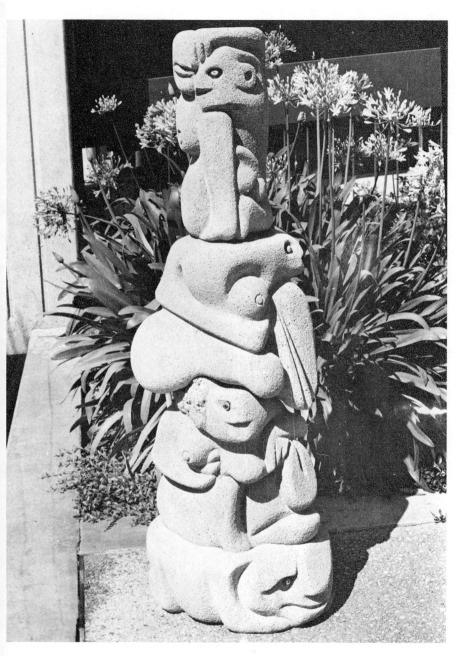

Mary Fuller, BLUE EYED DEVIL TOTEM #2, 1974.
Carved concrete, 60" high.

Marjorie Furrer, ODYSSEY. Acrylic on canvas, 40" x 60".

GAIR, Sondra Battist. Painter. Studied: School of Education, New York University, New York City; University of Texas, Austin, Texas; University of Maryland, College Park, Maryland; The American University, Washington, D. C. Awards: Washington Watercolor Society, 1971-72; Carnegie Institute Exhibit, Pennsylvania, 1962; National Watercolor Society, 1969.

√ GARRETT, Cynthia M. Painter. Born: Boston, Massachusetts in 1938. Studied: Pratt Institute, Brooklyn, New York; Boston University. She has exhibited mostly in the northeastern United States.

√ GAUDIA, Jeanne. Painter. Born: New York City in 1930. Studied: State University College at Fredonia, New York. Awards: Wilcox Mansion Gallery, Buffalo, New York; Albright-Knox Gallery, 1974. Exhibitions: For Arts Sake Gallery, Amherst, New York, 1973; Chautauqua Institution, New York, 1974; Carrol Reece Museum, Johnson City, Tennessee, 1974.

GIBALA, Louise. Painter. Born: Allegheny, Pennsylvania. She is the daughter of Otto E. Hundertmark, granite and marble carver. Studied: National Academy of Fine Arts; The Art Students League, New York City. Awards: Gold Medal, American Artists Professional League; Gold Medal of Honor, Row Ruins Gallery; Gold Trophy, New York City, Cultural Affairs Administration.

√ GILBERT, Sharon. Sculptor. Born: New York City in 1944. Studied: The Cooper Union; The Skowhegan School of Painting and Sculpture; Brooklyn Museum. Exhibitions: Columbia University, New York, 1971; State University of New York at Albany, 1972; Whitney Museum, Art Resources Center, New York, 1974.

√ GILBERTSON, Charlotte. Painter. Born: Boston, Massachusetts. Studied: Boston University; The Art Students League and Pratt Graphics in New York City; Studied with Fernand Léger in Paris. Exhibitions: Galerie Mai, Paris, France, 1949; Bodley Gallery, New York City, 1971 "Along the Yukon"; Iolas Gallery, New York City, 1974.

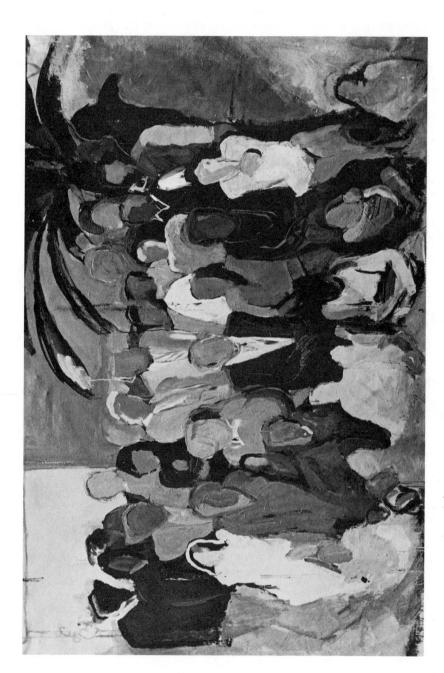

Cynthia M. Garrett, *FAMILY PORTRAIT*, 1975.
Acrylic on canvas, 72" x 108". Photo, Claremont Colleges

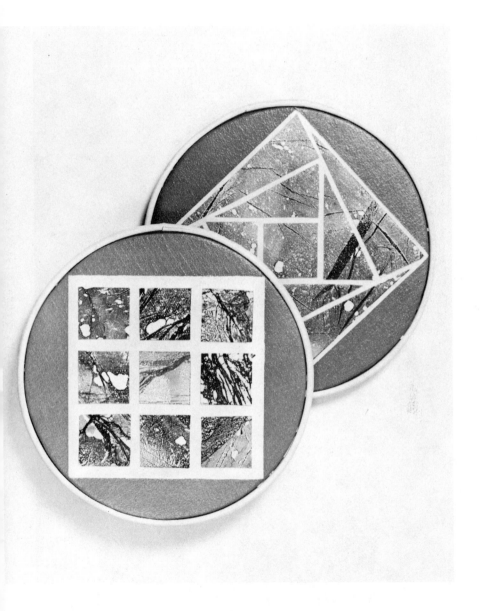

Jeanne Gaudia, Studies for: SIX, SQUARED,
SQUARE, WHIRLED.

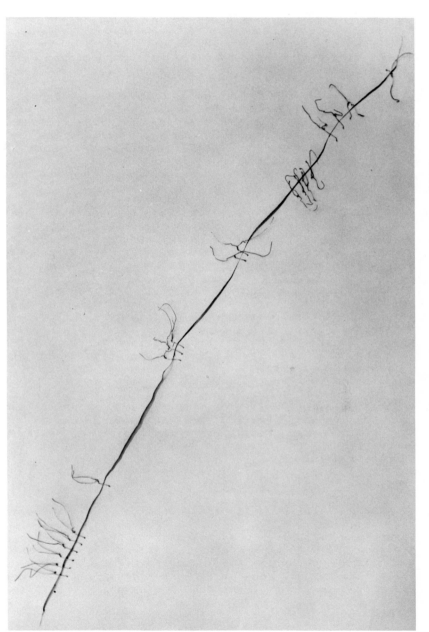

Charlotte Gilbertson, ALONG THE YUKON, 1968.
Tape, wire, and canvas, 22" x 32".

√ GILLIES, Mary Ann. Sculptor. Born: Grand Rapids,
Michigan in 1935. Studied: Michigan State University;
Columbia University; Perugia, Italy. Exhibitions:
Women's Interart Center, New York City; Community Church
Gallery, New York City; Buffalo State University, New York.

√ GINSBERG-PLACE, Ruth. Tapestry. Studied: New School for
Social Research; Syracuse University. Exhibitions:
Southern Illinois University, 1969; The Art Institute of
Chicago, 1970; Albright-Knox Gallery, Buffalo, New York,
1974. Commissions: Temple B'Nai Amoona, St. Louis;
Law Offices of Moldover, Strauss & Hertz, New York City.
Collections: The Art Institute of Chicago; Federal Reserve
Bank of Memphis.

√ GIOELLO, Debbie. Painter. Studied: Fashion Institute of
Technology; Oswego State University; Hebert H. Lehman
College. Awards: Silvermine Guild, Connecticut; New Rochel
Annual; Staten Island Annual. Collections: Hudson River
Museum; Elizabeth Seaton Academy.

GLUECKMAN, Joan. Painting/Tapestry. Studied: Wayne State
University; UCLA; University of Michigan; Detroit Institute
of Arts. Exhibitions: SOHO 20 Gallery, New York City;
Hobart & William Smith Colleges "The Eye of Woman", 1974;
Women's Interart Center's "Erotic Garden," New York City.
Initiated and organized Artists' Cooperative, Feminist
Gallery, SOHO 20, New York City. She also helped
organize and set up the Women's Interart Center.

√ GOODMAN, Marilyn. Graphics. Born: 1947. Studied: Hunter
College, City University of New York; Assumption College,
Worcester, Massachusetts; Boston Architectural Center.
Exhibitions: Mount Wachusett Community College, 1969;
Worcester Polytechnic Institute, 1973; Heaney Gallery at
the Experiment, Holden, Massachusetts, 1971, 1972, 1973,
1974.

√ GOODSPEED, Barbara. Painter/Photographer. Born: Gardener
Massachusetts in 1919. Studied: Stoneleigh College, Rye
Beach, New Hampshire; Clarence White School of Photography,
New York City; Phoenix School of Design, New York City.
Exhibitions: Catherine Lorillard, New York City; Hudson
Valley Art League, New York; Chester Art Guild, Chester,
Vermont. President of the Kent Art Association, 1971-73.

Mary Ann Gillies, J. Welded Metal, 36" x 60"

Ruth Ginsberg-Place, COUPLED FIGURES/SHAPED
TAPESTRY, 90" x 42". Photo: Maida Sperling

Debbie Gioello, THE ESSENCE OF BEING.
Polymer wash, 15" x 9½".

Marilyn Goodman, BOX. Silkscreen.

Barbara Goodspeed.

✓ GORIG, Myra. Sculptor. Born: New York City in 1943. Studied: Fashion Institute of Technology; The Art Students League, New York City; Munich Germany Art University. Exhibitions: Croquis Gallery, New York City; Erotic Art Gallery, New York City. Awarded a prize in the Munich Art Academy Exhibition.

GOTO, Darlene. Graphics. Exhibiting with "The Circle", a group formed in 1971 of five women artists in Phoenix, Arizona.

✓ GRAD, Barbara. Painter/graphics. Born: 1951. Studied: The School of the Art Institute of Chicago. Exhibitions: Allan Frumkin Gallery, Chicago, Illinois, 1973; Suburban Fine Arts Center, Highland Park, Illinois, 1974; Northern Illinois University, DeKalb, Illinois, 1975. She is represented in the collection of The Art Institute of Chicago Museum.

GRADY, Ruby McLain. Painter. Born: southwest Virginia. Studied: Corcoran School of Art, Washington, D.C.; University of Maryland. Awards: Southwest Art Group, 1962-63; Arts Club of Washington; The American Hotel, Washington, D. C. She has exhibited mostly in the Washington, D. C. area.

GRANKE, Thea. Painter. Born: Toronto, Canada. Studied: Society of Arts and Crafts in Detroit, Michigan; University of California. She was Fashion Illustrator for the Detroit News. Exhibited in the Metropolitan Museum of Art and the Goleta Valley Art Association.

GRAVES, Gloria. Painter. Noted for her assemblages in the 1960's.

GRAVES, Nancy. Sculptor/painter. Works with fetish assemblage sculpture using acrylic, fur, feathers, and metal.

✓ GRAY, Mary. Painter/weaver. Born: Delavan, Wisconsin in 1924. Studied: University of Wisconsin in Milwaukee. Exhibitions: Else Forde Gallery, Bismarck, North Dakota; Walker Art Center, Minneapolis, Minnesota; Manisphere, Winnipeg, Canada, Outstanding American Award.

GRAY, Ruth. Painter. Studied: The Art Students League, New York; Brooklyn Museum Art School. Exhibitions: The New School; "Unmanly Art," Brooklyn Museum; Suffolk Museum.

Myra Gorig, CERAMIC SCULPTURE. 22" across.

Barbara Grad, LANDSCAPE IMAGE. Graphite and
paper, 24" x 18"

Mary Gray, SAND BEACH. Weaving with hard
objects, 38" x 50".

√ GREENBERG, Gloria. Painter. Born: 1932. Studied:
Cooper Union Art School, New York City; Yale-Norfolk Art
School; The Brooklyn Museum Art School. Exhibitions:
The Denver Art Museum, 1953; The Joslyn Art Museum,
Omaha, Nebraska, 1953; Columbia University, 1965-66;
55 Mercer, New York City, 1970-74. Collections: Ms. Lucy
R. Lippard and other private collectors.

√ GREENSTEIN, Ilisa. Painter. Born: New York City.
Studied: New York University. Exhibitions: A. M. Sachs
Gallery, New York City, 1964; Suffolk Museum, Stony Brook,
New York, 1972; City University, New York City, 1974.
Collections: New York Cultural Center, New York City;
Stratford College Museum, Stratford, Virginia; Marine
Midland Banks, New York.

GREEVER, Ada M. Painter. Studied: Corcoran School of
Art, Washington, D.C. She paints in Cody,Wyoming and in
Alamos, Sonora, Mexico.

GRIGGS, Brigitia. Sculptor. Born: Bad Wildungen, West
Germany in 1945. Studied: With Max Steiner in West Germany;
University of Alabama in Huntsville, Alabama. Collections:
Many private collections in Japan, Canada, Germany, and
the United States.

GRILO, Sarah. Painter. Worked with abstract paintings in
the 1960's.

GROSS, Amy. Photographer. Working with photo-sensitive
objects.

GROSS, Gussie. Painter. Born: Los Angeles, California.
Studied: Woodward College. Noted for her costume designs.

√ GRYGUTIS, Barbara. Sculptor. Born: 1946. Studied:
University of Arizona, Tucson, Arizona; Travel-study in
Japan. Awards: Tucson Art Center, Arizona, 1968, 1970,
1971, 1975. Exhibitions: University of Arizona Museum of
Art, 1971; Graphic Arts Gallery, Tucson, Arizona, 1972;
Harlan Gallery, Tucson, 1975. Commissions: Union Bank
Branch Office, Tucson; La Placita Shopping Center, Tucson;
Navaho County Governmental Complex, Holbrook, Arizona
(joint project with Charles Hardy).

Gloria Greenberg, SECTION FROM WALL A, 1973.
Acrylic on canvas, 50" x 30". Photo: Christy Park.

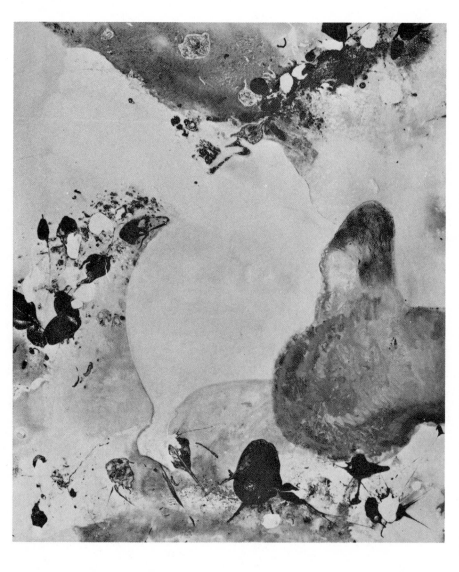

Ilisa Greenstein, ANIMOS, 1973. Acrylic, graphite, charcoal, 60" x 70".
Collection: Shelley and Arnold Gewitz

Barbara Grygutis, WOODBURNING STOVE AND FOOTSTOOL. Stoneware and metal, 36" high.

HACKER, Gertrude "Trudi". Painter. Born: Hanover
Green, Pennsylvania. Studied with Tom Kobata, but is
mostly self-taught as an artist. Paints in the
traditional manner.

HAGBERG, Phillis. Painter. Born: 1942. Painting
nostalgic imagery.

HALL, Susan. Painter. Working mostly with the figure
in environments.

HAMILTON, Marianna. Batik/watercolorist. Born:
Berkeley, California in 1943. Studied: University of
California at Santa Barbara; San Francisco Art Institute;
University of Arizona. Exhibitions: San Francisco
Museum of Art, California, 1965; Phoenix Art Museum,
Arizona, 1967; Monterey Peninsula Museum of.Art,
California, 1973.

HAMMOND, Harmony. Painter. Working with cloth and
acrylic materials to do non-objective, three-dimensional
wall pieces.

HARRIS, Barbara Ann. Stained glass/painter. Studied in
California. Exhibits in the western United States.

√ HASINGER, Dorothy. Painter. Studied: University of
Washington. She has actively exhibited in California
and Hawaii. Very active in the study and teaching of
oriental art.

HATLEN, Hilda. Painter. Born: Somers, Montana in 1908.
Self taught as an artist. Exhibitions: Libby Fine Arts
Group, Montana; Festival of Art, Kalispell, Montana;
Kootenai Gallery, Libby, Montana. She started painting
at age 58.

HAWORTH, Jann. Painter/sculptor. Working with dolls and
assemblage figures. She has exhibited at the Sidney
Janis Gallery, New York City.

HAYASHI, Joy. Sculptor. Working mainly with primary forms.

HEATHERINGTON, Frances. Painter. Born: Riga, Latvia in
1928. Came to the United States in 1939. Studied:
Brooklyn Museum Art School. Exhibitions: Gordon's
Gallery, New York City; Feltrinelli Gallery, Rome, Italy;
Hansen Galleries, New York City.

Dorothy Hasinger. Ink and Chinese watercolor.

HEE, Marjorie Wong. Painter. Born: Honolulu, Hawaii. Studied: University of Hawaii; Honolulu Academy of Arts; Columbia University Teachers College; Art Students League. Awards: Hawaii Easter Art Festival; Hawaii Ten Bamboo Studio; Hawaii Watercolor and Serigraph Society Annual. Collections: Castle Memorial Hospital; The Hawaii State Foundation on Culture and the Arts.

√ HEIMANN, Anne. Drawing. Born: Shanghai, China in 1927. Studied: School of Fine Arts, Syracuse University, New York. Exhibitions: New York University, 1972; The Bronx Museum, New York, 1973; Galerie Borgeson, Sweden, 1974. She was awarded a Creative Artists Public Service Program Fellowship in 1973-74. She is represented in the collection of Albright-Knox Gallery, Buffalo, New York.

√ HEMENWAY, Audrey. Sculptor. Born: New York City in 1930. Studied: Hunter College, M.A., B.F.A.; privately with Willem de Kooning. Awards: National Endowment for the Arts, Short-term Activities Fellowship-Grant, 1973. Exhibitions: Williams College, 1972; SUNY Museum at Albany, 1972; O. K. Harris Gallery, 1970; Katz Gallery, 1970.

√ HENDRIX, Connie Sue. Painter. Studied: Drake University, Des Moines, Iowa. Awards: Tennessee Watercolor Society, 1973; National Bank of Commerce, 1973; Central South Art Exhibition, 1973. Collections: Foothills Art Center, Golden, Colorado; Union Planters National Bank; Commercial and Industrial Bank. President of the Tennessee Watercolor Society, 1975.

HENZE, Claire. Photographer. Born: 1945. Studied: Mills College. Works in black and white photography of people and places.

HERSHMAN, Lynn. Mixed Media. Working with objects dealing with body parts.

HESSE, Eva. Sculptor. Making sculpture and hangings with fiber, plastic, rubber, metal, during the 1960's.

HILTON, Heather. Sculptor. Born: Albany, New York in 1945. Studied: Mary Washington College of the University of Virginia; Virginia Commonwealth University. Awarded the Warner Communications award by the National Sculpture Society, 1974. Exhibitions: The Virginia Museum of Fine Arts, 1969; The Mint Museum of Art, 1972; The High Museum of Art, Atlanta, Georgia, 1972.

Anne Heimann, ALLIGATOR TOPOGRAPHY, 1974.
Ink on paper, 42" x 62".

Connie Hendrix. Watercolor.

HIRSCH, Gilah. Painter. Born: Canada in 1944. Studied: University of California at Los Angeles, California. Realist food as sexual imagery using oil on canvas.

HIRSCH, Moreen. Printmaker. Born: Detroit, Michigan in 1947. Studied: University of Michigan; School of the Museum of Fine Arts, Boston; Nova Scotia College of Art and Design, Halifax. Exhibits in Hawaii.

✓ HITCHCOCK, Livy. Painter. Born: Poncé, Puerto Rico in 1948. Studied: Lasell Junior College, Auburndale, Massachusetts. She has exhibited mostly with the Northern Vermont Artists Association and the Essex Art League.

HOBSON, Diane. Painter. Abstract color painting.

✓ HODES, Suzanne. Painter. Studied: Radcliffe College; Brandeis University; Columbia University. Awards: Kokoschka School, 1959; Brandeis Arts Festival, 1959, 1960; Fulbright Fellowship to Paris, 1963-64; Radcliffe Institute Fellowship, 1970-72. Exhibitions: Weizmann Institute, Israel, 1972; Gund Hall, Harvard Graduate School of Design, 1972. Collections: Fogg Museum, Cambridge, Massachusetts; Rose Art Museum, Waltham, Massachusetts; City of Salzburg, Austria.

✓ HOELTZEL, Susan Sadler. Painter. Studied: University of Alabama, Mobile, Alabama; New York University, New York City. Exhibitions: Carlton Gallery, 1974; Off-Broadway Gallery, 1974; Westchester Art Society, White Plains, New York, 1974. Member of SOHO 20, New York City.

HOFFMAN, Phyliss. Painter. Studied: University of California Berkeley; University College of Arts and Crafts. Awards: Art Fair, Washington, D.C., 1966; Montgomery County Art Association, 1967; National Institute of Health, Bethesda, Maryland, 1973. She exhibits mostly in the Washington, D.C. area.

✓ HOFMANN, Ethel N. Sculptor. Born: New York City in 1915. Studied: Brooklyn College, New York; Cornell University; University of Miami, Florida. Exhibitions: Merritt College, Oakland, California, 1972; California College of Arts and Crafts, 1973; University of California, Extension-San Francisco, 1974.

Livy Hitchcock, MAN. Acrylic.

Suzanne Hodes, AMERICAN RITUAL #1.

Susan Sadler Hoeltzel. Acrylic and pencil on canvas, 45" x 26½".

Ethel N. Hofmann, LOVERS. Soapstone, 20" high.

HOGAN, Irmfriede. Born: Czechoslovakia. Studied: The
Art Institute of Chicago. Exhibitions: The Art Institute
of Chicago; ARC Gallery, Chicago; and in Europe.

HOIE, Helen Hunt. Painter. Born: Leetsdale,
Pennsylvania. Studied: Carnegie Tech. Exhibitions:
Guild Hall Museum, Award, 1970; Long Island Painter's
Show, 1973; Babcock Galleries, New York City, 1974.

HONIG, Ethelyn. Painter/graphics. Studied: Bennington
College; Sarah Lawrence College; Art Students League;
New School for Social Research. Exhibitions:
Contemporaries Gallery, New York City, 1963, 1964;
55 Mercer, New York City, 1974; Heath Gallery, Atlanta,
Georgia, 1975. Collections: Patrick Lannan Foundation;
Museum of Modern Art; Lisson Gallery, London.

HOOD, Dorothy. Born: Bryan, Texas in 1919. She is best
known for her pen and ink drawings.

HOPPER, Pegge. Painter. Born: Oakland, California in
1935. Studied: Art Center School, Los Angeles. She has
had three one-person shows in Honolulu. Noted for her
mural designs for department stores.

HOROWITZ, Brenda. Painter. Born: New York City.
Studied: City College of New York; Cooper Union Art
School; The Hans Hofmann School of Art; City University
of New York. Exhibitions: Croquis Gallery, New York City;
Museum Gallery, 1971; Columbia University Gallery, 1974;
Westbeth Galleries, New York City.

HOROWITZ, Ida. Sculptor. Uses fibers to make sculpture
for walls.

HOTVEDT, Kris. Printmaker. Born: Wautoma, Wisconsin in
1943. Studied: Layton School of Art, Milwaukee, Wisconsin;
San Francisco Art Institute, California; Instituto
Allende, San Miguel de Allende, Gto. Mexico. Pembroke
State University, North Carolina, 1968; Arizona State
University, Tempe, 1973; Oklahoma Art Center, Oklahoma
City, 1974. Collections: Atalya School Art Collection,
Santa Fe, New Mexico; University of Sonora, Hermosillo,
Mexico; Huntington Art Alliance, California.

Helen Hunt Hoie.

Ethelyn Honig, 1970. Duco and pencil on paper.
Collection: Carol Selle.

Pegge Hopper, *CHARCOAL FIGURE STUDY, 1972.*

Brenda Horowitz, *CHARCOAL DRAWING, 1973.*

Kris Hotvedt, *ALONSO ON THE AFTERNOON*, 1974.
Lino cut, 34" x 26".

√ HOWARD, Linda. Sculptor. Born: Evanston, Illinois in 1934. Studied: University of Denver, Denver, Colorado; Hunter College, CUNY, New York City. Awards: Creative Artists Public Service Grant, 1975; North Jersey Cultural Council, 1974; New England Artists, 1970. Exhibitions: Silvermine Guild, Connecticut, 1971; Philadelphia Civic Center Museum, 1974; Sculpture Now Gallery, New York City, 1975.

HYATT, Anna Vaughan. Sculptor. Born: Cambridge, Massachusetts. Studied: Bostock's Animal Arena, Norumbega Park, and at Sportsman's Exhibition. Principal work of the artist is "Boy with Great Dane," done with her sister, Harriet Randolph Hyatt.

HYATT, Harriet Randolph. Painter. Born: Salem, Massachusetts. Studied: Cowles Art School, Boston. Awarded a Silver Medal at the Exposition in Atlanta, Georgia, 1895. Collection of the Bureau of the Society for the Prevention of Cruelty to Animals in New York City.

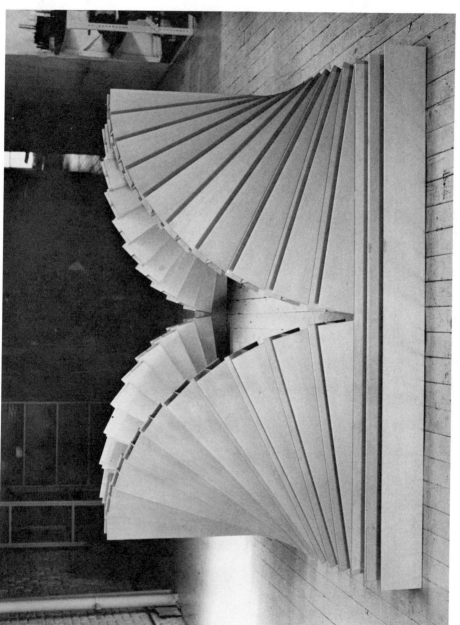

Linda Howard.

IRVINE, Louva Elizabeth. Artist-Film-maker. Studied:
Hans Richter Film Institute, CCNY; School of Visual Arts;
Art Students League. Films: "Sophie Newman, J. Skiles,
NYC"; "Elegy for My Sister"; "Rain". Exhibitions:
Festival of Womens Films, 1972; Second International
Festival of Cinema, Montreal, 1972; Womens Interart
Center, 1973; Whitney Museum, 1972. New Film: "Portrait
of Thomas Messer" (Director of the Guggenheim Museum).

IRVING, Elena. Sculptor. Born: New York City in 1931.
Studied: Fashion Institute of Technology, New York City;
Universidad Iberoamericana, Mexico; The Art Institute,
Milan; Ceramic Sculpture, Queens College, New York City.
Collections: Museum of Modern Art, Mexico City; Trebor
Collection, Oklahoma Art Center, Oklahoma City; Sao
Paulo Contemporary Art Museum, Sao Paulo, Brazil;
Universidad de Navarra, Pamplona, Spain.

ITALIANO, Joan Mylen. Sculptor. Studied: Siena Heights
College, Adrian, Michigan; Barry College, Miami, Florida.
Awards: Toledo Annual, 1950; Palm Beach Art League, 1955,
1956. Collections: The Navy Base Chapel, Key West,
Florida; The Holy Ghost Seminary, Ann Arbor, Michigan;
St. Thomas Aquinas High School, Chicago, Illinois: Mary
Manning Walsh Home, New York City.

ITO, Miyoko. Painter. Born: Berkeley, California in
1918. Studied: University of California; The Art
Institute of Chicago; Smith College. Awards: John Hay
Whitney Fellowship, 1952, and MacDowell Fellowship,
1970, 1971, 1972. She is most active in the Chicago area.

JACKSON, Joan. Painter. Her paintings focused
predominately on flowers, children and quiet subjects
reflect a deep, calm and sincere emotion. She has
been exhibiting in the Dallas, Texas area.

JACKSON, Sandra. Sculptor. Works include boxes using
the assemblage technique.

JACOBS, Hillary. Mixed Media. She works in assemblage
and silkscreen.

JACOBS, Robin. Graphics. Born: 1945. Studied: Harvard
University. Works with embossed intaglio prints in an
abstract style.

√ JACOBSON, Ursula. Painter/sculptor. Born: Milwaukee,
Wisconsin in 1927. Wife of Art Jacobson who is also a
painter. Studied: Milwaukee State Teachers College;
Cleveland School of Art; University of Wisconsin.
Awards: Wisconsin Designer Craftsmen, Milwaukee, 1948;
Weatherspoon Annual, North Carolina, 1967; Phoenix Art
Museum, 1974. Exhibitions: Yares Gallery, Arizona, 1965;
Bolles Gallery, San Francisco, 1966; Four Corners Biennial,
Phoenix Art Museum, 1971-75.

JANTO, Phyllis. Sculptor. Born: Philadelphia,
Pennsylvania in 1932. Studied: Tyler School of Fine Arts;
Moore Institute of Art; Hunter College; Pratt Institute.
Exhibitions: Print Club, 1950; Museum of Contemporary
Crafts, 1962; Hudson Guild Gallery, New York City.

JENKINS, Connie. Painter/graphics. Born: 1945.
Studied: University of Colorado. In the early 1970's
she was working in oil and graphite as a realist.

√ JOHANSON, Patricia. Landscape-sculptor. Born: 1940.
Studied: Bennington College; Hunter College; City College,
School of Architecture. Awards: Guggenheim Fellowship,
1970. Large-Scale Projects: Gardens, House and Garden,
1969. Cyrus Field, 1970-present. Con Edison Indian Point
Visitors Center, 1972; Designs for the new Yale University
Colleges, 1972; Project for Columbus East High School,
Columbus, Indiana, 1973.

JOHNSON, Johnnie. Studied: University of Illinois;
Illinois Institute of Technology. She is represented in
the Smithsonian collection. She is associated with ARC
Gallery, Chicago.

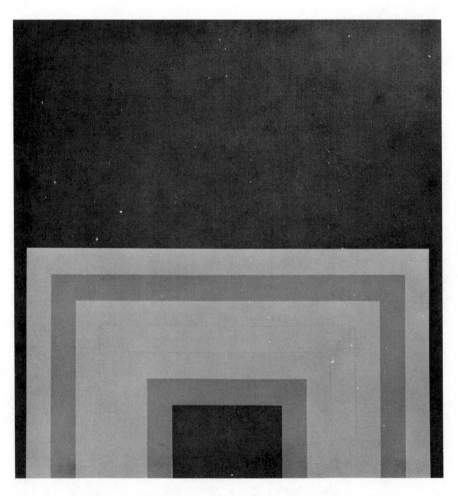

Ursula Jacobson, FLOATING LIFE SERIES #4.
Acrylic.

Patricia Johanson, STEPHEN LONG, 1968. Aerial view,
1600 feet long.

JOHNSTON, Frances. Photographer. Born: in 1864 and died in 1952. Noted for her photographs of groups of people and historical events. She has been called the "American court photographer".

√ JONES, Patty S. Sculptor/weaver. Born: New Orleans, Louisiana in 1949. Studied: Auburn University, Alabama; University of California at Los Angeles. She was Artist-in-Residence in Yuma, 1974-76, National Endowment of the Arts.

Patty S. Jones, BLACK PLASTIC TUBES, 84" x 72".

KAPROW, Alyce. Photographer.

KASEBIER, Gertrude Stanton. Photographer. Born: in 1852.
Died in 1934. Noted for her photographs of figure groups
and portraits using a soft focus.

✓ KASSOY, Hortense. Sculptor. Born: Brooklyn, New York.
Studied: Pratt Institute; Columbia University; University
of Colorado. She was awarded a prize at Painter's Day
at the New York World's Fair. Exhibitions: Toledo
Museum, Ohio, 1947; A.C.A. Gallery, 1954; National Academy
of Design, 1962; Brooklyn Museum, 1974; Lincoln Center,
1975. Vice President of Artists Equity Association of
New York, 1975.

✓ KATZ, Esther. Painter. Studied: Rhode Island School of
Design; Boston Museum School; DeCordova Museum.
Exhibitions: Springfield Museum; Hartford Jewish Center,
1973; Rehovot, Israel, 1969. Her work is represented in
the collection of the Connecticut Savings Bank, New Haven.

KATZEN, Lila. Sculptor. Born: New York City. Studied: The
Art Students League, New York City; Cooper Union, New
York. Awards: Goodyear Fellow, Foxcroft School, Virginia;
Creative Arts, The American Association of University
Women; Corcoran Gallery of Art, Washington, D.C. 1959;
Fellowship, Tiffany Foundation, 1964. Commissions:
Lannan Foundation, Palm Beach, Florida; Architectural
League of New York; Chesapeake & Potomac Telephone
Company, Baltimore, Maryland.

KAUFMAN, Jane. Painter. Noted for her sprayed, acrylic,
color paintings.

KENT, Betty McAlinden. Painter. Born: New Zealand.
Studied: California State College; California State
University. Awards: Orange Art Association, 1972; Women
U.S.A., Laguna Beach Museum of Art, 1973; Hillcrest
Festival of Fine Arts, 1974. She exhibits extensively
on the west coast.

KENT, Caroline. Sculptor. Born: in 1934. She has
worked with assemblage, montage, photo images, and real
objects.

Hortense Kassoy, EVE, 1973. Hardrock maple, 60" high.

Esther Katz, PAINTING COLLAGE, 36" x 48".

KEPNER, Rita. Sculptor. Born: Binghamton, New York in 1944. Studied: Elmira College, New York; Harpur College, State University of New York, Binghamton. Awards: Harpur College, 1966; Waterbury Arts Council Arts Festival, Connecticut, 1967; Study-travel grant to Poland, 1975. Exhibitions: Attica Gallery, Seattle, Washington, 1968; Willoughby Wallace Memorial Gallery, Branford, Connecticut, 1967; Penryn Gallery, Seattle, 1970, 1973.

✓ KIMURA, Sueko M. Painter. Born: Hawaii in 1912. Studied: University of Hawaii; Chouinard Art Institute, Los Angeles, California; Columbia University; Brooklyn Museum Art School. Awards: Artists of Hawaii; Easter Art School; Wichita Art Museum, Kansas. Collections: State Foundation on Culture and the Arts; Contemporary Art Center; Department of Education, Artmobile.

KLAVUN, Betty. Painter. Worked in the 1950's with abstract expressionism. Exhibited with Bertha Schaefer Gallery, New York City.

KLOTZ, Suzanne. Painter/Sculptor. Born: 1944. Studied: Washington University; Kansas City Art Institute; University of Missouri. Awards: Midland Museum of Fine Arts, 1971; Museum of the Southwest, Midland, Texas, 1972; Minnesota Museum of Art, Saint Paul, 1973. Abilene Fine Arts Museum, 1973; Oklahoma Art Center, Oklahoma City, 1974.

KOENIG, Elizabeth. Sculptor. Studied: Wellesley College; Yale University; The Art Students League, New York City; American University, Washington, D.C.; Corcoran School of Art, Washington, D.C. Exhibitions: National Bureau of Standards, 1966; Rockville Civic Center, Municipal Gallery, 1968; Montgomery County Art Association, 1971.

KOPECEK, Vera Wainar. Tapestry. Born: Morenia, Czechoslovakia. Founded her own weaver's workshop in 1910. She has lived and worked in Phoenix, Arizona since 1969. Exhibitions: Arizona State University and throughout the world. Awards: The International Exhibition of Decorative Arts in Paris, 1925; Tucson Craft Exhibition, 1969; Cinco de Mayo, Phoenix, 1971.

KORMAN, Harriet. Painter. Noted for her hard-edge paintings done in the early 1970's.

Sueko M. Kimura, BEFORE THE STORM.

√ KORNBLUTH, Frances. Painter. Studied: Brooklyn College;
Brooklyn Museum Art School; Pratt Institute. Awards:
N.A.W.A. Medal of Honor; New York City Center Gallery;
Connecticut Commission on the Arts Grant, 1975.
Exhibitions: Pennsylvania Academy; National Museum,
Washington, D. C.; Whitehall Galleries, London, England.

KRESSLEY, Margaret Hyatt. Painter. Born: Washington,
D.C. in 1928. Studied: Abbott Art School, Washington,
D.C.; Moore Institute of Art, Philadelphia, Pennsylvania.
Extensive study and travel in Europe. Exhibits at
Gallery 10, Washington, D.C.

√ KRUGER, Louise. Sculptor. Born: Los Angeles, California.
Studied: Scripps College, California. Apprenticed with
Capt. Sundquist, shipbuilder; F. Guastini, Pistoia,Italy;
Chief Opoku Dwumfour, Kumasi, Ghana. Awards: New Talent,
Museum of Modern Art, 1955; National Community Art
Competition, 1973. Exhibitions: Martha Jackson Gallery,
1959; Green Mountain Gallery, New York City, 1973.

√ KUCERA, Kathryn Eleanor. Painter. Born: 1930. Studied:
University of Wisconsin, Madison; School of the Art
Institute of Chicago, Illinois. Exhibitions: Madison Art
Association, Wisconsin, 1951; Wabash Transit Gallery,
Chicago, 1973; Evanston Art Center, Illinois, 1974;
Artemisia Gallery, Chicago, Illinois, 1974.

KUFFLER, Suzanne. Sculptor. Working with language-based
images and assemblage during the early 1970's.

KURT, Kay. Painter. She has worked in a realistic style
doing blow-ups of candies.

√ KURZ, Diana. Painter. Studied: Brandeis University;
Columbia University. Awards: Yaddo Fellowship, 1968-69;
U.S. Government Fulbright Grant in Painting to France,
1965-66. Exhibitions: Green Mountain Gallery, New York
City, 1972-74; Brooklyn College, 1974; University of
Michigan, 1965.

KUSAMA, Yayol. Sculptor. Working with assemblage in the
1960's.

√ KUYKENDALL, Karen. Painter. Born: Denver, Colorado in
1928. Studied: San Jose State, California; University of
Arizona. She has exhibited regularly in the Arizona area
since 1966. Awards: Arizona State Fair Juried Fine Arts
Exhibit, 1974; Arizona's "Most Imaginative" Artist, 1975.

Frances Kornbluth, ROCKS, SEA, AND SKY.
Watercolor 22" x 18". Photo: Brenwassee.

Louise Kruger, *SEATED WOMAN*, 1973.
White Pine, 54" high.

Kathryn Eleanor Kucera, MOUNTED MANUSCRIPT, 1975.
Mixed media, carbon paper, and fabric, 117" x 108".

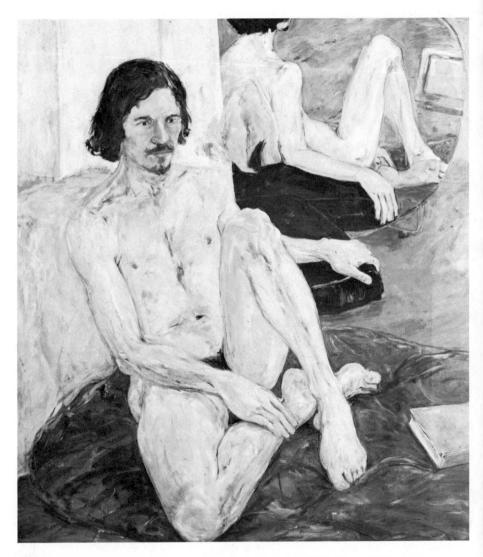

Diana Kurz, S. D. WITH MIRROR, 54" x 60".
Photo: O. E. Nelson.

Karen Kuykendall, *THE JURY*, 1974. *Papier Maché and styrofoam.*

LADUKE, Betty. Painter/graphics. Born: 1933. Noted for her lithography and for her constructions of abstract figures.

✓ LAGUNA, Muriel. Painter. Born: New York City. Studied: New York University; The New School; Brooklyn Museum Art School. Awards: Long Island Festival Competition, 1958; The National Association of Women Artists, 1967; The Grace F. Lee Memorial Prize, 1967. Exhibitions: New York Center Gallery; Chatham College, Pittsburgh, Pennsylvania; The Pennsylvania Academy of Fine Arts Annual, Philadelphia.

LAMB, Rose. Painter. Born: Boston, Massachusetts. Studied: chiefly with William M. Hunt. Awards: Bronze medals in Boston Exhibitions, 1878 and 1879.

LANDWEBER, Ellen. Photographer. Noted for her use of the 3-M color process and black and white photographs of figures and locations.

✓ LANE, Marion. Sculptor. Studied: Brooklyn Museum Art School; The Art Students League, New York City; Pratt Institute. Exhibitions: Brooklyn Museum; Montclair Museum; Edward Williams College, 1971. Awards: Brooklyn Museum, 1958; Montclair Museum, 1960, 1964; Atlantic City Annual, 1963.

LANGE, Dorthea. Born: in 1895 and died in 1965. Most active between the 1930's and 1960's photographing female figures, social situations, and documentaries.

LANNING, Dorothy Rose. Painter. Early training in commercial art. Works mostly by commission. Seascapes and animals portraits her specialty.

LANYON, Ellen. Painter. Born: Chicago, Illinois in 1926. Studied: The Art Institute of Chicago and State University of Iowa. She has exhibited her work extensively in the United States.

✓ LAPLANTE, Louise. Painter. Studied: College of New Rochelle; Art Institute of Boston. She has exhibited mostly with the Northern Vermont Artists Association and in the Essex, Vermont area.

Muriel Laguna, *MIDNIGHT LANDSCAPE*, 50" x 40".

Marion Lane. FREESTANDING PIECE. Aluminum.

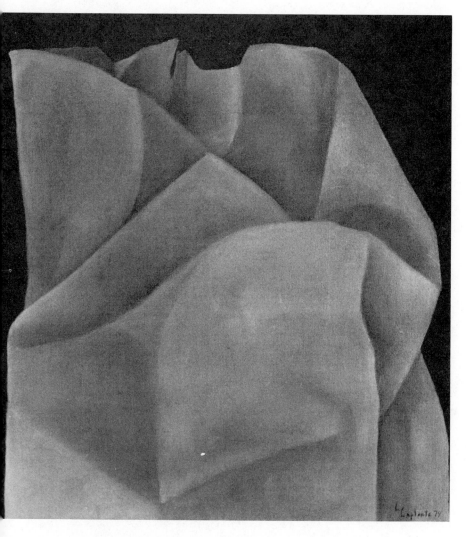

Louise Laplante, *BAG STUDY #3, 1974.*
Oil on canvas, 24" x 26".

√ LARSEN, Dorothy. Painter. Born: Topeka, Kansas. Studied: Drake University, Des Moines, Iowa. Exhibitions: Phoenix Women's Club, Arizona; Glorietta Bay Hotel, Coronado, California; Trailside Gallery, Jackson, Wyoming.

LASNER, Fay. Painter/graphics. Very active in the 1960's and early 1970's working with figurative abstractions.

√ LATOS-VALIER, Paula. Graphics. Born: Philadelphia, Pennsylvania in 1946. Studied: Yale University; University of New Hampshire; Université de Dijon, France; The Ashram, Belmont, Massachusetts. Exhibitions: Boston Visual Artists Union Show, 1971; Boston Center for the Arts, 1974; Attleboro Museum, Massachusetts, 1975. She is noted for her outdoor banners.

LEAF, June. Sculptor. Noted for her sculptural assemblages in the 1960's.

LEBKICHER, Anne Ross. Painter. Born: New York City. Studied: University of Washington; University of Montana; Columbia University. Exhibitions: Palos Verdes Community Arts Association, California, 1950; Los Angeles Regional, 1966; Russell Gallery, Great Falls, Montana, 1973.

√ LEEPER, Doris. Sculptor. Born: Charlotte, North Carolina in 1929. Studied: Duke University, BA in Art History; self-taught as an artist. Collections: National Collection of Fine Arts, Washington, D.C.; 180 Beacon Collection, Boston; Chase Manhattan Bank; Reserve Insurance, Orlando, Florida; Bank of New York; Jacksonville Art Museum, Florida Awarded an individual grant from the National Endowment of the Arts, 1972. She is represented by Bertha Schaefer Gallery, New York City.

√ LEHRER, Robin. Painter. Born: Brooklyn, New York in 1949. Studied: University of North Carolina at Greensboro; Claremont Graduate School, Claremont, California. Exhibitions: "Art is Where You Find It" (Phyllis Stein), Libra Gallery, Claremont, California; Womanspace, Venice Boulevard, Los Angeles, California, 1973; North Carolina Museum of Art, Raleigh, North Carolina, 1973. She sometime assumes the alias Phyllis Stein.

LEONARD, Joanne. Photographer. Working with the female figure during the 1960's.

Dorothy Larsen. Oil on canvas.

Paula Lates-Valier, SOCKEYE ON THE ROAD TRAMPING

Doris Leeper Fiberglass, 120" high. Collection: Reserve Insurance, Orlando, Florida.

Robin Lehrer, PHOTO #1. Detail of a collage from a series of twelve, 50" x 31".

LERMAN, Ora. Painter. Born: Campbellsville, Kentucky
in 1938. Studied: Antioch College; Brooklyn Museum
Art School; Pratt Institute. Awards: Fulbright
Fellowship, Japan, 1963; Outstanding Young Women of
America, 1970, 1972. State University of New York
Research Grant, 1973, 1974. Exhibitions: Prince Street
Gallery; Suffolk Museum; Queens Museum, "Women Artists
See Men", New York.

LERNER, Marilyn. Sculptor. Working in the early 1970's
in wood and rubber making "funky" wall constructions.

LESHER, Marie. Sculptor. Born: Reading, Pennsylvania
in 1919. Studied: The Art Students League, New York
City; Berte Studio in Philadelphia; University of Houston,
Texas. Awards: International Exhibition, Berwick,
Pennsylvania, 1970; Beaumont Art Museum, 1971-73; Del
Mar College, Corpus Christi, Texas, 1972. Collections:
Carver Museum, Tuskegee, Alabama; Art Guild, Shreveport,
Louisiana; Laguna Gloria Art Museum, Austin, Texas.

LEVI, Linda. Sculptor. Born: 1935. Noted for her work
with plastic constructions.

LEVINE, Marion Lerner. Painter. Born: London, England.
Studied: The Art Institute of Chicago. Exhibitions:
First Feminist Art Exhibition, Museum, New York; Prince
Street Gallery, 1970-74; Women Choose Women Exhibition,
New York Cultural Center, 1973.

LEVITT, Helen. Photographer. Noted for her work with
figure groups.

LINDER, Jean. Sculptor. Born: Berkeley, California in
1939. Studied: University of California at Berkeley;
San Francisco Art Institute. Exhibitions: Oakland
Museum, 1962; Richmond Museum, 1963; Whitney Museum
of American Art, 1966, 1970; 55 Mercer, New York City,
1972. Collections: San Francisco Museum, California;
Rose Art Museum of Brandeis University; Trenton State
Museum, New Jersey.

LINDQUIST, Marlene. Painter. Studied: University of
Rochester; Ohio University, Athens; New York University.
She was awarded a prize for painting at the Miami Museum
of Modern Art. Exhibitions: Rockefeller Art Gallery,
State University College, Fredonia, New York; Joe and
Emily Lowe Art Gallery; Design Center, Miami, Florida.

Ora Lerman, MY HEART BELONGS TO DADDY, 1974.
Oil on canvas, 28" x 42".

Marion Lerner Levine, *DEL GAIZO, 1974.*
Oil, 40" x 124".

Jean Linder, MOUND, 1972, 168" across.

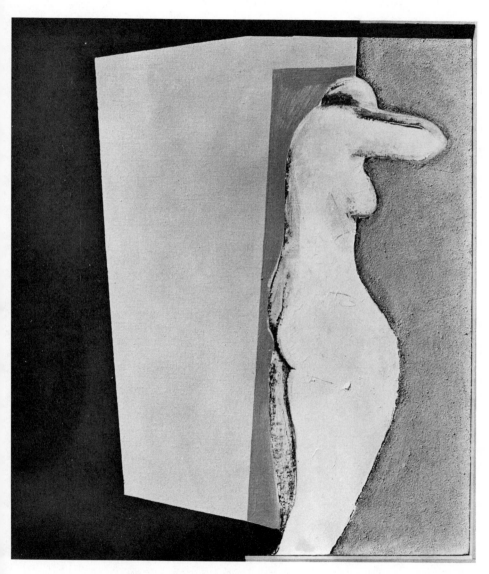

Marlene Lindquist, Mixed media, 36" x 24".

LIPINSKI, Marlene. Painter. Studied: University of Wisconsin at Milwaukee, Wisconsin.

LIPSKY, Pat. Painter. Noted for her painterly, abstract fields of color.

√ *LIVINGSTONE, Biganess. Painter. Born: Cambridge, Massachusetts in 1930. Studied: Massachusetts College of Art; Newton College, Newton, Massachusetts. Awards: Currier Gallery of Art, New Hampshire, 1974; Mural Commission, Cranwell School, Lenox, Massachusetts, 1967. Collections: Harvard University, Cambridge, Massachusetts; Chase Manhattan Bank, New York City; Boston College, Chestnut Hill, Massachusetts.*

LOBSTEIN, Miriam. Graphics. Born: Manhattan, New York in 1926. Studied: Brooklyn College. Exhibitions: Lafayette Art Center, Indiana; Jewish Community of Pacific Palisades; Graphics Workshop, Lafayette, Indiana.

√ *LOCKPEZ, Inverne. Sculptor. Born: Havana, Cuba in 1941. Studied: The National Academy of San Alejandro, Havana; Atelier of Lolo Soldeville, Paris. Living and working in New York City since 1966. Grants: Cintas Foundation, New York, 1970-71; CAPS, New York State Council on the Arts, 1973. Commissions: Latin-American Theatre, New York, 1969; Sculpture, New York City Public Arts Council, McKenna Square, 1972.*

LOTZ, Matilda. Painter. Born: Franklin, Tennessee. This artist is sometimes called "the Rosa Bonheur of America." Noted for her paintings of animals. Studied: San Francisco with Virgil Williams and Van Marcke in Paris. Awarded a Gold Medal at the School of Design in California.

LOWE, Maxine. Exhibitions: Museum of Modern Art, New York; Mbari, Ibaden, Nigeria; Marine Gallery, Lagos, Nigeria. Collections: 777 Building, New York; Nelson Rockefeller; IBM Chicago and International.

√ *LOWELL, Shelley. Painter/sculptor. Born: 1946. Studied: Pratt Institute, Brooklyn, New York. Exhibitions: The Erotic Art Gallery, New York City; International Museum of Erotic Art, San Francisco, California; The Bronx Museum of Art, Bronx, New York, 1975. In the collection of Memorial Sloan-Kettering Cancer Center, New York City.*

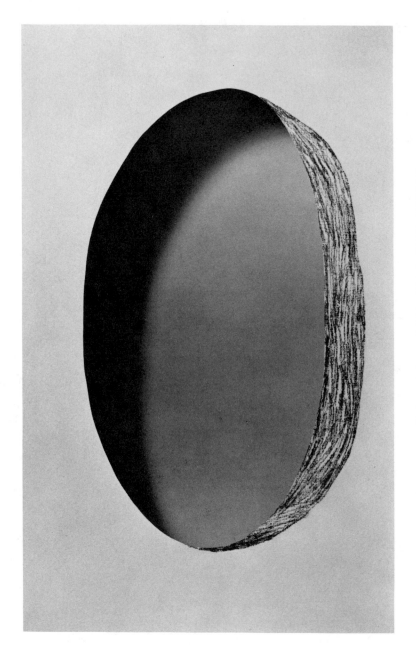

Biganess Livingstone, WIDE HOLE WITH SHADOW.
Acrylic and charcoal on cut canvas, 30" x 48".

Inverna Lockpez, 1972-74. Polyurethane resin

Shelley Lowell, DON'T MAKE ANY NOISE, THE
CAKE WILL FALL, 1973. Acrylic on canvas,
30" x 32".

LUCIER, Mary. Noted for her mixed media environmental sculpture and distance pieces.

LUNDERBERG, Helen. Painter. Working in the 1930's with realistic interiors and self-portraits. Her work in the early 1970's is hard-edged.

√ LUSTIG, Yetta. Painter. Studied: Brooklyn Museum; The Art Students League, New York City; New School for Social Research. Awards: Village Art Center; Bleibtreau Watercolor Prize, Wall Street Art Association; Wall Street Transcript Art Exhibition. She is in the collection of the Colorado Museum. President of Artists League of Brooklyn, Inc.

LUX, Gwen. Sculptor. Noted for her bronze figures.

√ LYNCH, Mary Ann. Photographer. Born: Saratoga Springs, New York in 1944. Studied: Cornell University, Ithaca, New York; University of California, Berkeley. Awards: State Foundation on Culture and the Arts, 1972; City and County of Honolulu, 1972 University of Hawaii, 1974. Exhibitions: The Artist in Hawaii, 1972; Photo 73, Honolulu, 1973; University of Hawaii, 1974.

√ LYNCH, Mary Britten. Painter. Born: Pruden, Kentucky in 1933. Studied: University of Tennessee at Chattanooga. Awards: N.A.W.A. Annual, National Academy Galleries, New York City; Tennessee All-State, Nashville, Tennessee; 4th Annual Print and Drawing Exhibitions, Arkansas Art Center, Little Rock. She has exhibited widely in the Southeastern United States and has been very active in the Tennessee Watercolor Society.

LYONS, Joanne. Photographer. Noted for her work with high-contrast figurative images.

LYTLE, (Mrs. Stuart). Painter. Studied: Radcliffe; Dallas Art Institute; Eagles Nest Art Group; Northern Illinois University, Taft Campus. Exhibitions: National Watercolor Show, Dubuque, Iowa; Greenville Art Association, Greenville, Mississippi; Rockford Art Association, Rockford, Illinois.

Yetta Lustig, *THE BRIDGE*. Oil on canvas, 36" x 50".

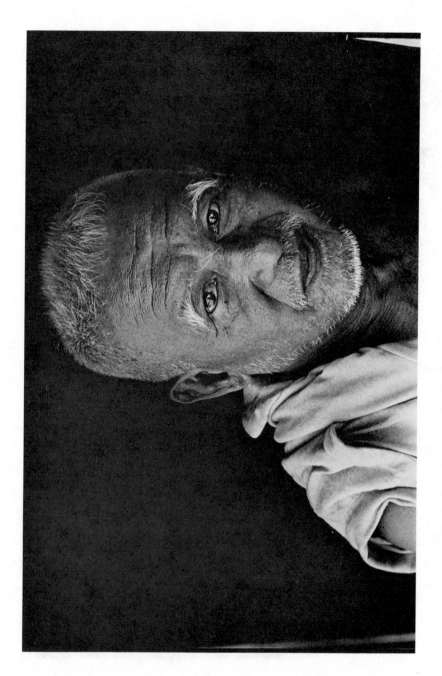

*Mary Ann Lynch, RETIRED PINEAPPLE WORKER, 1975.
Black and white photograph.*

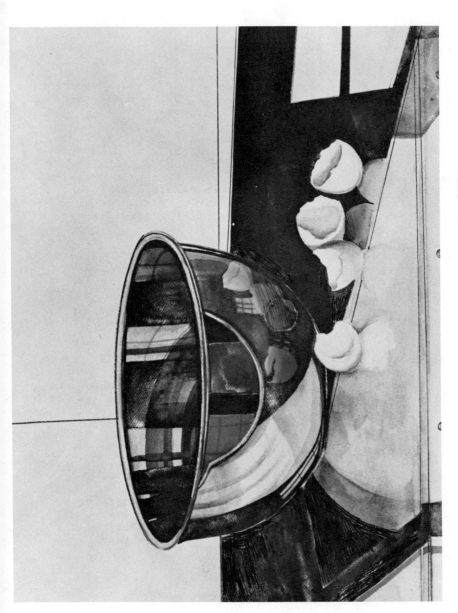

Mary Britten Lynch, CHROME SURFACES, 1974.
Watercolor.

√ MACDONALD, Phyllis. Painter. Born: Chicago, Illinois in
1930. Studied: Ohio Wesleyan University; School of The
Art Institute of Chicago. Exhibitions: Wabash Transit
Gallery, Chicago, 1972; Northeastern Illinois University
Art Center, 1973; "Women in the Arts '74", West Bend,
Wisconsin, 1974; Northern Illinois University, DeKalb,
Illinois, 1975. Noted for her "folded paintings."

MACIVER, Loren. Painter. Most active between 1940's
and 1960's. She was influenced by Klee. Noted for her
paintings of plants, animals, landscape.

MACMONNIES, Mary Fairchild. Painter. Born: New Haven,
Connecticut about 1860. Studied: School of Fine Arts,
St. Louis; Academy Julian, Paris. Awards: Scholarship
in Paris by the St. Louis School of Fine Arts; Medal at
Chicago, 1893; Bronze Medal at the Paris Exposition,
1900; Bronze Medal at Buffalo, 1901; Gold medal at
Dresden, 1902; Julia M. Shaw prize, Society of American
Artists, New York, 1902.

√ MAILMAN, Cynthia. Painter. Studied: Pratt Institute,
Brooklyn, New York; The Art Students League; Brooklyn
Museum Art School. Exhibitions: Sequoia Gallery, Los
Altos, California, 1971; SOHO 20, New York City, 1974;
Queens Museum, Flushing Meadow, New York, 1975. Some of
her work is in the collection of The Prudential Life
Insurance Company.

√ MALIK, Marlene. Sculptor. Born: 1940. Studied: The
Art Institute of Chicago; Roosevelt University, Chicago;
University of Rhode Island. Exhibitions: Deron Gallery,
Chicago, 1960; Helme House Gallery, 1970; URI Group Show,
1973; HERA Women's Cooperative Gallery, Wakefield, Rhode
Island, 1975. She is noted for her "First Memory"
sculptures.

MANGER, Barbara. Sculptor. Used materials of all types
to make floor and wall pieces.

MANKER, Gilberta. Painter. Exhibitions: Ketterer Art
Gallery, Bozeman, Montana; Marion Butler Gallery,
California; The Cody Art League Gallery, Wyoming. She
has illustrated the poetry books of her husband,
Don Manker.

Phyllis MacDonald.

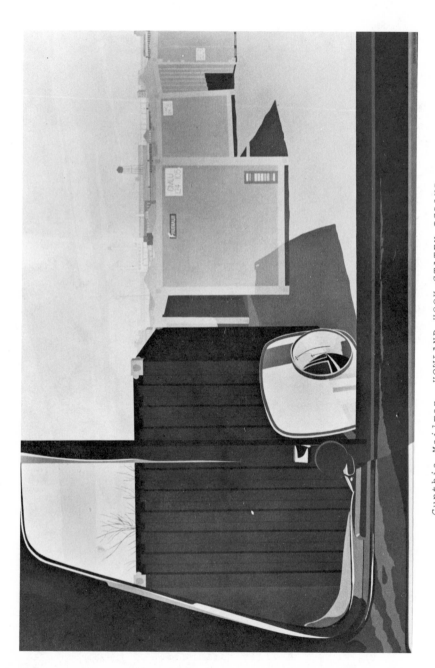

Cynthia Mailman, HOWLAND HOOK-STATEN ISLAND,
174. Acrylic on canvas, 33" x 50".
Photo: Silver Sullivan.

Marlene Malik, Wood, paper and wire, 12" high.

√ MANN, Jean. Sculptor. Exhibitions: Stamford Museum;
Jorgensen Museum at Storrs; Belardo Gallery, New York
City. Awards: New Haven Paintland Clay Club; Village
Art Center, New York City; the John P. Kebabian prize
for sculpture.

MANN, Margery. Sculptor. Noted for her Pop Art food-
sculptures during the 1960's.

MANNING, Diane. Sculptor. Noted for boxes in plastic
and aluminum.

√ MARGARET, Karla. Photographer. Born: San Francisco,
California in 1938. Studied: University of California
at Los Angeles. Exhibitions: San Francisco Art
Festival, 1974; Tides Bookstore, Sausalito, 1974;
Nevada Indian History Week, Ely, Nevada, 1975. Her
book SPACES, poetry and photography, was published
in 1974.

MARGOULIES, Berta. Sculptor. Work mostly in bronze figures.

√ MARK, Marilyn. Painter. Self-taught as a painter.
Awards: International Festival, St. Germain Des Pres,
Paris, France: National League of American Pen Women,
Inc.; Biennial Competition and Exhibit of: Composers,
Authors & Artists of America, Inc.; Washington School
of Arts. Exhibitions: Museum of Modern Art, Paris,
France; The National Museum of Sport; Union Carbide
Corporation.

MARK, Mary Ellen. Photographer.

√ MARK, Phyllis. Sculptor. Born: New York City.
Studied: Ohio State University; with Seymour Lipton.
Exhibitions: Drew University, 1969; Morris Museum,
New Jersey, 1970; The Hudson River Museum, 1971-72.
Collections: Dickerson-White Museum; Cornell University;
The RCA Corporate Collection; Syracuse University.

√ MARSHALL, Nancy. Painter/film-animator. Studied:
Virginia Commonwealth University, Virginia; School of
Visual Arts, New York City; New York Institute of
Photography, New York City. Exhibitions: School of
Visual Arts, New York; St. Mary's College, Maryland;
Palace de Belles Artes, Mexico City, Mexico.

Jean Mann, PORCELAIN SNUFF BOTTLE, 1975.
4½" high. Photo: Gloria Laposka.

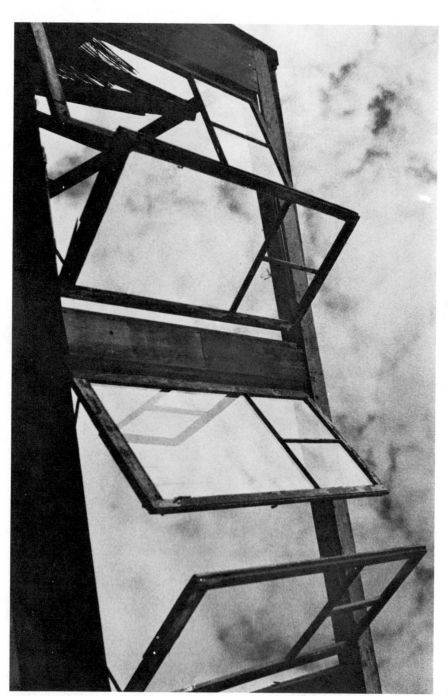

Karla Margaret, COVER PHOTO FOR SPACES, Black...

Marilyn Mark, THE PLAY.

Phyllis Mark.

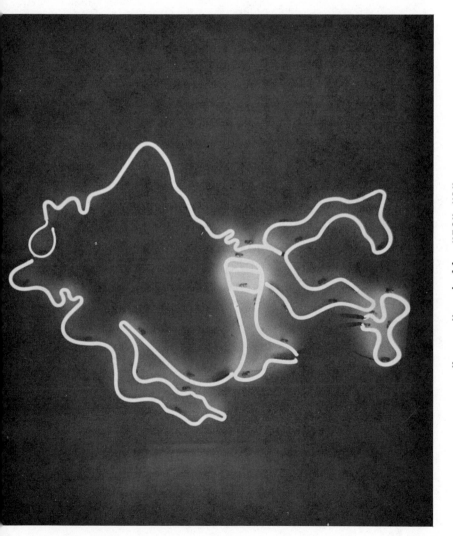

Nancy Marshall, *NEON MAN.*

MARSHBURN, Theresa. Watercolorist. Studied: New York University; Fairleigh Dickinson University, New Jersey; The Art Students League, New York. Awards: Marquette University, Milwaukee, Wisconsin, 1973; Flint Art Museum, Michigan, 1973; Wisconsin Festival of Arts, 1974. Exhibitions: Columbia University, New York, 1966; Artesaneos Festival, Albuquerque, New Mexico, 1973; El Paso Museum of Art, Texas, 1974.

MARTIN, Joyce. Painter. Paints mostly childhood memories of her rural life on the west coast.

MARXER, Donna. Painter. Born: in Florida. Exhibitions: "Works in Progress" and "Games", Women's Interart Center, 1974. She is also a writer in the art field.

√ MATTA, D. Graphics/sculptor. Awards: Chautaqua, New York; Hollywood Circle Exhibitions, Florida. Exhibitions: Hemingway Gallery, New York City; Sheldon Swope Museum, Indiana, 1967; Keuka College, New York. Collections: Bell Telephone Company, Chicago; Edinboro State College, Pennsylvania; Fontbonne College, New Orleans.

√ MEIER, Sigrid. Sculptor/weaver. Born: Switzerland in 1933. Studied: Philadelphia College of Art; Haystack Mountain School, Deer Isle, Maine; Wallingford Community Art Center, Pennsylvania. Awards: Civic Center Museum, Philadelphia, 1970; Philadelphia Guild of Handweavers, 1969, 1970, 1972. She is represented in the collection of The Wilmington Museum of Fine Arts, Wilmington, Delaware.

√ MERWIN, Hester (Mrs. Edward Lindsley Ayers). Painter. She is also known for her drawings. Born: Bloomington, Illinois. Studied: in Italy before attending The Chicago Art Institute; Pasadena Art Institute and with Howard Giles, Andrew Dasburg, and Ward Lockwood. She has shown in leading New York galleries and in more than sixty one-man shows throughout the United States. She has made many drawing safaris in Africa, and has travelled also to Afghanistan, Mexico, South Pacific, and the British West Indies. Her drawings of the last few surviving Island Caribs on the island of Cominica are in the permanent collection of the Smithsonian Institution in Washington, D.C.

Matta D., NEON-PINK LADY.

Sigrid Meier, FEBRUARY 1973, 44" x 40".

Hester Merwin, MAMRA, from the Masai Tribe.
Charcoal.

MEYER, Nan. Painter. Working with watercolor in abstract images.

MEYER, Ursula. Sculptor. Noted for her work in the 1960's which was minimal.

MEYERS, Barbara Cannon. Photographer. Working in the 1960's and early 1970's with heads.

√ MICHOD, Susan Alexander. Painter. Born: 1945. Studied: Smith College, Northampton, Massachusetts; University of Michigan; Pratt Institute, Brooklyn. Awards: Artists Guild of Chicago, 1973; North Shore Art League, Chicago 1971; Illinois State Museum, 1974. Collections: Illinois State Museum; Hastings College, Nebraska.

MIKUS, Eleanor. Painter. Noted for her work in the early 1970's using acrylic in a primitive or child-like style.

MILLER, Jane. Photographer. Working in the 1960's and early 1970's with plants and animals.

√ MILLER, Nancy Tokar. Painter. Born: Detroit, Michigan in 1941. Studied: University of California at Los Angeles; University of Arizona, Tucson. Exhibitions: Council on the Arts and Humanities, Boston, 1967; Arizona State University, Tempe, 1973; Harlan Gallery, Tucson, 1973, 1975.

MILLER, Renee. Painter. Working in the 1960's with abstraction.

√ MILLER, Rose Shechet. Sculptor. Studied: Boston Museum of Fine Arts; Massachusetts College of Art. Awards: Brockton Art Association, 1965; Newport, R. I. Art Association, 1974; National Community Art Program, Washington, D.C., 1974. Exhibitions: Eastern States Exposition, 1964; Boston Visual Artists' Union Gallery, 1975; M.I.T. Faculty Club, 1975.

MIN, Mary Jane. Studied: University of Illinois. Exhibitions: New Horizons; Union League Art Club; Barrington and Highland Park Art Festivals. Associated with the ARC Gallery, Chicago.

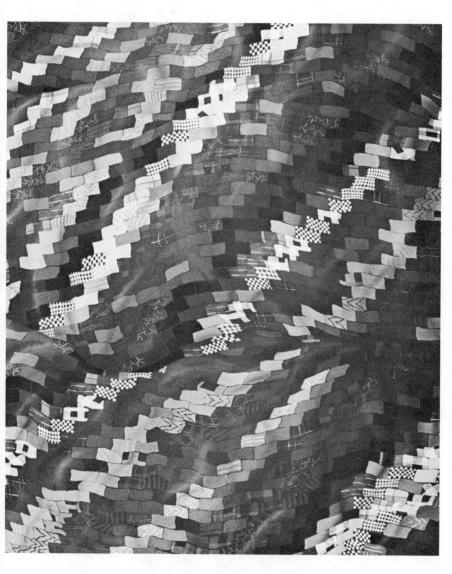

Susan Alexander Michod, STEP-STONE-SPACE, 1975.
Acrylic, 60" x 72". Photo: Carol Turchan.

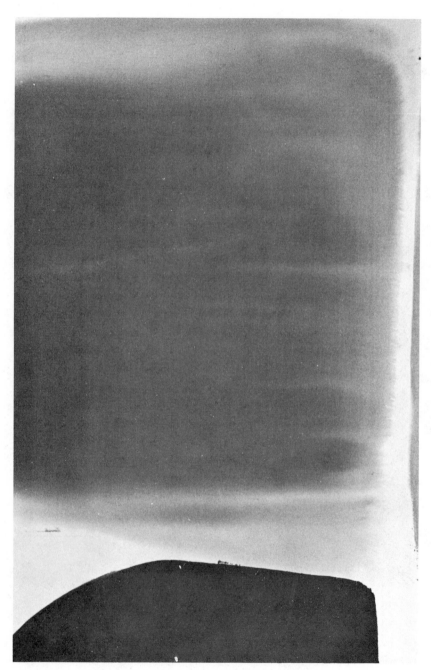

Nancy Tokar Miller, SUNG LANDSCAPE. Acrylic on

Rose S. Miller, ELEMENTS: FIVE. Welded steel, bronze and stained glass.

MINTICH, Mary. Sculptor. Born: Detroit, Michigan.
Studied: Indiana University; University of North
Carolina at Greensboro. Awards: Mint Museum,
Charlotte, North Carolina, 1971; 24th Ceramic National,
1972. Collections: Everson Museum, Syracuse, New York;
Mint Museum of Art, Charlotte, North Carolina; Sea
Islands Development Corp.

MISS, Mary. Sculptor. Noted for her work in the
1960's and early 1970's with wood constructions.

MODEL, Lisette. Photographer. Born: Vienna in 1906.
She was a magazine Photographer in the 1940's and
was on the staff of Harpers, 1947. She is now living
in New York City.

MON, Basha. Exhibited: Six New Jersey Women Artists,
Douglass College Library, New Brunswick, New Jersey,
1975.

√ MOORE, Claire. Printmaker. Studied: Siqueiros Workshop;
The Art Students League, New York City; with Werner Drewes
and Fernand Léger. Exhibitions: Museum of Modern Art;
The Metropolitan Museum of Art; The Green Mountain Gallery,
New York City. Collections: The Newark Public Library,
New Jersey; The University Museum, Minneapolis,
Minnesota. Publishes The Children's Underground Press.
Noted for her experimentation with mimeograph-machine
printing techniques.

MORGAN, Barbara. Photographer. Born: 1900. Noted for
her work with dancers.

MORRIS, Annea. Graphics. Noted for her silkscreens
which are abstract, using the figure as subject.

√ MOSS, Irene. Painter. Born: Eperjes, Czechoslovakia.
Exhibitions: Peter Rose Gallery, New York City; Bacardi
Art Gallery, Miami, Florida, 1974; Suffolk Museum, Long
Island, New York, 1971. Collections: Akron Art Institute,
Akron, Ohio; Norfolk Museum, Norfolk, Virginia; The New
Britain Museum of American Art, New Britain, Connecticut.

√ MYERS, Ruth. Painter. Studied: University of Texas;
University of Oregon, Columbia and Yale. Awards: New
Haven Paint and Clay Club Show, 1973; Mount Carmel Art
Association, 1972. Exhibitions: Chapel Library Center,
New Haven, 1970; Connecticut Mental Health Center,
New Haven, 1972; Silvermine New Member Show, 1974.

Claire Moore. Mimeograph print.

Irene Moss, INTERMOTION, 50" x 50".
Photo: Eric Pollitzer.

Ruth Myers, SILHOUETTE. Acrylic, 58" x 34".

MCMANUS, Mansfield Blanche. Book Illustrator. Born: East Feliciana Parish, Louisiana. Studied: London and Paris. Exhibitions: New Orleans Centennial; The Woman's Department, Chicago, 1903. One of her most important publications is Alice in Wonderland and Through the Looking-Glass, De Luxe edition in color, New York, 1899.

√ *McNEELY, Juanita. Painter. Born: St. Louis, Missouri in 1936. Studied: Washington University, St. Louis; Southern Illinois University, Carbondale; also studied in Mexico. Exhibitions: Prince Street Gallery, New York City; Westbeth Galleries, New York City; Philadelphia Museum of Art. Collections: National Museum of Art, China; Palacio De Las Bella Artes, Mexico; St. Louis Art Museum.*

Juanita McNeely, WOMAN. Oil on canvas,
52" x 72". Photo: eeva – inkerf.

NASH, Mary H. Photographer. Studied: George Washington University. Exhibitions: Art Association of Newport, Rhode Island, 1971; Annapolis Art Festival, Maryland, 1974. She works with a Babette toy camera making black and white photographs.

NESSIM, Barbara. Graphics. Born: New York City in 1939. Studied: Pratt Institute; Pratt Graphic Art Center. Awards: The Society of Illustrators, 1961, 1962; Mead Library of Ideas Award, 1971. Exhibitions: The Rhode Island School of Design, 1966; The Benson Gallery, Bridgehampton, Long Island, 1974. Collections: Westinghouse, Inc.; Shearson, Hamill & Company, Inc.; Moness, Williams, and Sidel, Inc.

NETTLES, Bea. Photographer. Noted for her hand-colored photo-assemblages.

√ NEWHOFF, Natalie E. Stained glass. Born: in Hartford, Connecticut in 1914. Studied: Dayton Art Institute; Antioch College; Chicago Art Institute; School of Design in Chicago with Moholy-Nagy. Exhibitions: MacNider Museum, Mason City, Iowa; Slater Memorial Museum, Norwich, Connecticut; New Britain Museum, Connecticut. She is represented in the collection of the Avon Library, Avon, Connecticut.

√ NEWMAN, Blossom. Sculptor. Studied: Pratt Institute, Brooklyn, New York; University of Hartford Art School, Connecticut; Museum School, Boston, Massachusetts; Karlsruhe, Germany. Awards: Lowell Art, 1967; Sudbury Art, 1965; Exhibitions: Boston Center For Adult Education, 1974; Copley Society, Boston, 1974; Manchester Art Association, Massachusetts, 1974.

√ NEWMAN, Sophie. Mixed Media. Born: Brooklyn, New York. Studied: Kreloff Art School, Brooklyn, New York; Brooklyn Museum Art School. Awards: Plastics Scholarship, Brooklyn Museum Art School, 1972; Pen Women Club at Lever House, 1973; Larry Aldrich Museum, Ridgefield, Connecticut, 1974. She is a founder of the Creative Women's Collective, New York City.

NICHOLSON, Winifred. Painter. Most active in the 1920's and 1930's doing abstract figures in environments.

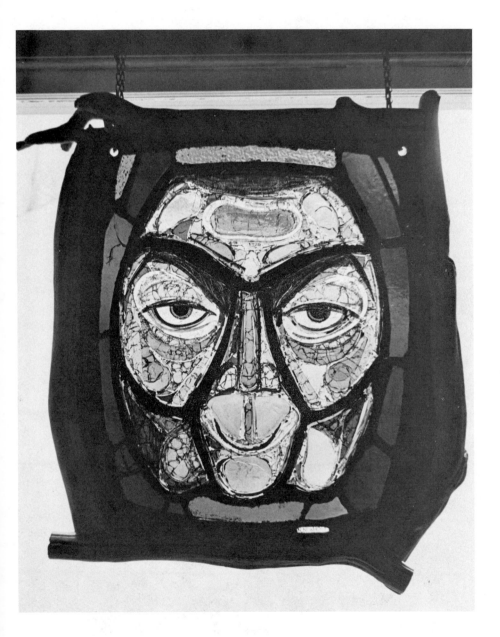

Natalie E. Newhoff, *PORTRAIT*, 1974.
Photo: Cherie Suhie.

Blossom Newman.

Sophie Newman, POLLUTION SERIES. Vacuum formed plastic. Photo: Eric Pollitzer.

NIELSON, Margaret. Drawing. Born: 1948. Noted for her drawings with ink of images in series, interiors, and fantastic images with food in environments.

√ NOECKER, Myra. Painter. Studied: University of Wyoming, Laramie, Wyoming; Casper College, Casper, Wyoming. She has exhibited and won awards in Colorado, Wyoming, and Nebraska.

NOGGLE, Anne. Photographer. Noted for her figures in environments.

√ NORTON, Mary Joyce. Painter. Awards: Phoenix Art Museum, 1966, 1967; Yuma Fine Arts Center, 1967, 1973; Jewish Community Center, Phoenix Arizona, 1966, 1969. Exhibitions: Court Gallery, Scottsdale, Arizona, 1971; Phoenix College Fine Arts Gallery, 1972; Pavilion Gallery, Scottsdale, Arizona, 1975. She is a member of "The Circle".

NORVELL, P. Sculptor. Using glass, mirror, tape, string to form wall pieces.

Myra Noecker, WINTER IN THE BIG HORNS.
Oil on canvas.

Mary Joyce Norton, MOVEMENT VALLEY, 36" x 36".

OBERING, Mary. Painter. Working in the early 1970's
with hard-edge paintings.

ORR, Janice. Sculptor. Born: 1934. Studied: Carleton
College; Northwestern University; University of Wisconsin;
Cranbrook Academy of Art. Awards: Franklin Siden Gallery
Award, Detroit Art Museum; Michigan Biennial of Artists
and Craftsmen; Tidewater Artists Biennial. Collections:
Virginia National Bank, Norfolk, Virginia; University of
South Carolina.

OSTERTAG, Blanche. Decorative artist. Born: St. Louis,
Missouri. Studied: 1892-1896 pupil of Laurens and Raphael
Collin in Paris. Noted for her mural decoration and her
calendars and posters.

PASHIGIAN, Helen. Sculptor. Working in the 1970's using acrylic spheres as form.

PASTOCICH, Wanda. Painter. Noted for her nostalgic landscapes.

√ PAWLIK, S. Alexis. Printmaker. Studied: Montclair State College. She has won several awards for her graphics. Exhibitions: Jersey City State College; Montclair State College; Ocean County College; Jersey City Museum.

PENNER, Kitty. Painter. Studied: Barnard College; City University of New York. Exhibitions: Danbury Public Library, 1972; Zarick Gallery, Farmington, Connecticut; Wilton Gallery, Wilton, Connecticut.

PEPPER, Beverly. Sculptor. Using primary forms and large geometric metal forms for her sculpture in the 1960's and early 1970's.

PEREYRA, Bonnie. Painter. Exhibitions: Southwest Traditional Artists Guild; Inglewood Art League, California; Shows mostly in the Los Angeles area. Noted for her traditional seascapes.

√ PINTO, Marion. Painter. Born: New York City in 1935. Studied: New York University; The Art Students League, New York City. Exhibitions: SOHO Artists Festival Exhibition, 1970; Women's Interart Center, 1973; Queens Museum, New York "Women Artists See Men", 1975.

PORZIO, Lee. Sculptor. Working in Arizona since 1953 with her artist/husband, Allen Ditson. Mostly architectural and commercial commissions. Collections: Valley National Bank, Tempe, Arizona; IMC Magnetics Company, Tempe, Arizona; Phoenix Municipal Building, Phoenix, Arizona.

PRENTISS, Tina. Painter. Studied: Harvard University's Carpenter Center for the Visual Arts; Massachusetts College of Art. Awards: CAA, 1967; SPCA Bronze Medal Boston Tea Party Poster Award, 1973. Exhibitions: Concord Art Association, 1973; Cambridge Art Association, 1973. U. S. Department of Labor, Women's Bureau, Washington, D.C., 1974. She is represented in the collection of Paramount Pictures.

PRESS, Sue. Painter. Working with abstract paintings in the early 1970's.

PRESTON, Dorothy U. Painter. Studied: Smith College; American University, Washington, D.C. Exhibitions: I.F.A., Washington, D.C.; Louisiana State Museum; North Carolina Museum of Art; Winston-Salem Gallery of Fine Arts, North Carolina.

√ PRIEST, T. Painter. Born: Worcester, Massachusetts in 1928. Studied: Worcester Art Museum School; Springfield Art Museum. Exhibitions: Assumption College, Worcester, Massachusetts; DeCordova Museum, Lincoln, Massachusetts; Young American Up-coming Artists, Nashua, New Hampshire. Collections: Aldrich Museum of Contemporary Art, Ridgefield, Connecticut; Honeywell Corporation, Boston, Massachusetts; Bundy Art Center, Waitsfield, Vermont.

PROCTOR, Judith. Sculptor. Studied: University of Alabama in Tuscaloosa and Huntsville. Awards: Birmingham Scrap Metal Sculpture Exhibit, 1964; Scottsboro Art Council, 1973.

PRUITT, Lynn. Sculptor. She is mostly self-taught. Awards: National Institute of Health, Bethesda, Maryland, 1968, 1969, 1970, 1971, 1973. Exhibitions: Montgomery College, Maryland; Prince George's Community College, Maryland; Alexandria City Hall. Collections: Naval Academy, Annapolis, Maryland.

PUTNAM, Sarah Goold. Portrait painter. Born: Boston, Massachusetts. Studied: Boston and New York City with J. B. Johnston, Frank Duveneck, William M. Chase; Munich with Wilhelm Durr. Portraits: Hon. John Lowell, William G. Russell; General Charles G. Loring.

T. Priest, STATIC VARIATIONS: *LOVE*, 1967, Acrylic on canvas

QUINN, Lindon Lou. Painter. Born: Martin, South Dakota
in 1939. Studied: University of Wyoming. She has
exhibited in Utah, Colorado and in Wyoming. A large
part of her childhood was spent on an Ogallala Sioux
reservation and this is a source for her art.

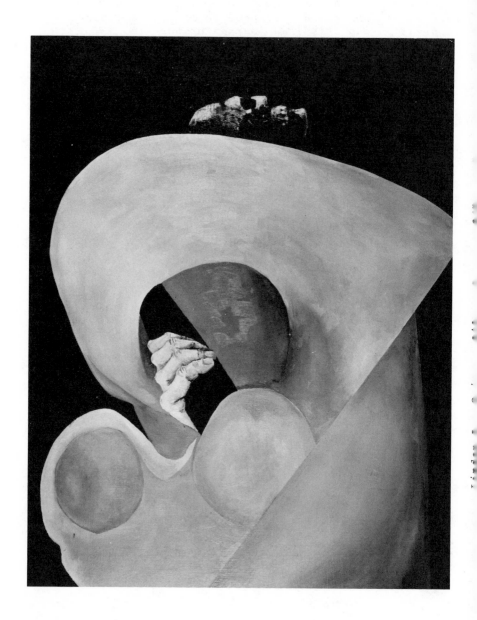

√ RABINOWITZ, Elaine Spatz. Painter. Studied: Tufts University; The Museum School, Boston; Antioch College. Awards: Danforth Fellowship for Women, 1971-73; Strathmore Drawing Award, 1959. Exhibitions: New York University, 1960; Virginia Museum of Fine Arts, 1969; Addison Gallery of American Art, Andover, Massachusetts, 1975.

RABOFF, Fran. Sculptor. Noted for her organic forms made with cast and laminated plastic.

RACITTI, Cherie. Painter. Noted for her resin color paintings.

RAMANAUSKAS, Dalia. Painter. Born: Lithuania in 1936. Working in the 1960's and early 1970's with Pop-Art objects and genre painting.

RANNANJARVI (Mary Jane Patterson). Painter. Studied: The Art Institute of Chicago, Illinois. She has exhibited with the Erie Art Center. Also a poet, she has illustrated a small booklet of poetry.

√ RAPHAEL, Catherine. Silversmith. Born: Pittsburgh, Pennsylvania in 1947. Studied: University of Mexico; Syracuse University. Awards: Bestor Plaza Art Show, Chautauqua, New York, 1969; Syracuse University, 1969, 1970.

√ RAPHAEL, Michi. Sculptor. Studied: Pratt Institute, Brooklyn, New York; New School, New York. Exhibitions: Sunrise Gallery, Charleston, West Virginia; Mainstream 73 and 75, Marietta College, Marietta, Ohio; Union Carbide Galleries, New York City. Collections: Hoffman La Roche Drug Company, Nutley, New Jersey; First National Bank & Trust, Tulsa, Oklahoma; American Steel Products, Syosset, Long Island, New York.

RAYMOND, Lilo. Photographer. Born: Germany in 1922. Working with still-life, people, and situations.

√ REDER, Ronnie. Painted constructions. Born: 1943. Studied: University of Bridgeport; and in Paris. Exhibitions: Warren Benedek Gallery, New York; Gimpel and Weizenhoffer Gallery, New York; Kraushaar Gallery, New York.

Elaine Spatz Rabinowitz. Photo: Greg Heins.

Catherine Raphael, CHALICE. Silver, 8" high.

Michi Raphael, Polished bronze, 36" high.
Photo: Arthur Swoger.

Ronnie Reder, WOOD/MIRROR/CONSTRUCTION, 1974.
Photo: O. E. Nelson.

REICHART, Agnes. Painter. Self-taught as a painter.
Active in the American Institute of Fine Arts and the
Gardena Valley Art Association. Awarded a prize in
the Americana Art Circuit, 1971.

REID, Giorgina. Photographer. Noted for her photographs
of plants and animals.

RICE, Jacquelyn Ione. Sculptor. Born: 1931. Working
in the early 1970's with funky ceramic sculpture.

√ RICHMAN, Vivian. Sculptor. Studied: Columbia University;
The Sculpture Center, New York City; Museum of Fine Arts,
Boston. Awards: Silvermine Guild New England Annual, 1971;
Cambridge Art Association, 1972; Providence Art Association
1972; Newport, Rhode Island, American Annual, 1974.

√ RICKARD, Ruth. Stained Glass. Born: Los Angeles,
California in 1921. Studied: Stanford University;
Saddleback College, California. Exhibitions: Society
of Connecticut Craftsmen, 1971,1972, 1973; Greater
Hartford Civic and Arts Festival, 1972, 1973; Rowayton
Arts Center, 1975.

√ RIVERA, Sophie. Photographer. Studied: Educational
Alliance, New York City; Apeiron Workshops, Inc.,
Millerton, New York; New School for Social Research,
New York City. Exhibitions: Crossroads Gallery, New
York City, 1974; Third Eye Gallery, New York City, 1973;
Women's Interart Center, New York City, 1973, 1974, 1975.
Collections: Apeiron Workshops, Inc.; Women's Interart
Center, New York City.

ROBINSON, Imogene Morrell. Painter. Born: Attlesborough,
Massachusetts. Studied: Dusseldorf with Camphausen; Paris
with Couture. Awards: Medal at the Mechanics' Fair, Boston
Medal at the Centennial Exhibition, Philadelphia, 1876.
Two important works: "The First Battle between the Puritans
and Indians" and "Washington and His Staff Welcoming a
Provision Train."

ROCKBURNE, Dorthea. Sculptor. Cardboard floor and wall
pieces which are based on a set theory.

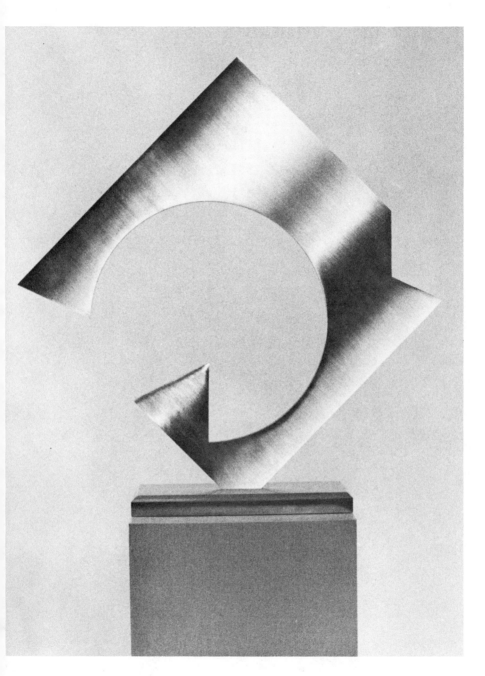

Vivian Richman, EMBLEM ONE. Aluminum, 22" high.

Ruth Rickard, HABITAT FOR CANDLES, 1973.
Stained glass construction.

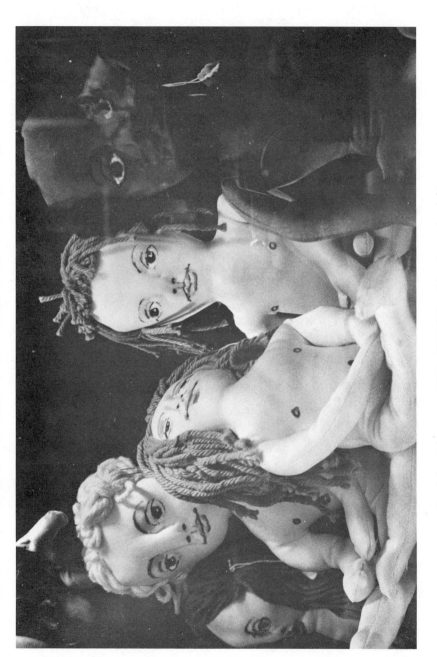

Sophie Rivera, DOLL SERIES, Black and white photograph.

√ RODE, Meredith. Painter/Graphics. Born: Delaware, Ohio
in 1938. Studied: George Washington University; University
of Maryland at College Park. Awards: Lehmann Scholarship
to the Corcoran School of Art, Washington, D.C.; Out-of-Town
Scholarship, The Art Students League, New York City.

ROLYNS, Annette. Painter. Noted for her hard-edge
abstractions.

√ ROSEBERRY, Helen K. Sculptor. Born: 1932. Studied:
East Tennessee State University, Johnson City, Tennessee.
Awards: Sinking Creek Film Celebration, Nashville,
Tennessee, 1973; Tennessee Arts Commission, 1974.
Exhibitions: Beech Galleries, Beech Mountain, North
Carolina, 1972; Milligan College, Milligan, Tennessee,
1973; Tennessee Drawings, 1974.

√ ROSEBROOKS, Ann C. Painter. Born: 1948. Studied: Rhode
Island School of Design, Providence. Awards: Hartford
Civic and Arts Festival, 1973; Virginia Beach Boardwalk
Art Show, 1974; Stamford Museum, Connecticut, 1974.
Exhibitions: Northwestern College, Winsted, Connecticut,
1973; Goethe Institute, Beacon Street, Boston, 1975.

√ ROSEN, Kay. Sculptor. Born: Corpus Christi, Texas in
1943. Studied: Newcomb College, New Orleans; Northwestern
University; The Art Institute of Chicago. Exhibitions:
Del Mar College, Texas; University of Chicago; ARC Gallery,
Chicago, 1975.

ROSENBERG, Civia. Studied: Cooper Union Art School;
Columbia University, New York. She has exhibited at the
Illinois Art Council and with ARC Gallery, Chicago.

√ ROSENBLUM, Regina. Painter. Born: Poland in 1948.
Studied: School of the Art Institute of Chicago;
Northwestern University. Awarded a Ford Foundation
Fellowship in 1970-72. Exhibitions: Lever House, New York
City, 1968; Women Choose Women Show, Wabash Transit Gallery
Chicago, 1973; ARC Gallery, Chicago, 1974.

ROSENSTEIN, Joan. Painter/Sculptor. Studied: The Art
Institute of Chicago; Lake Forest College; Skidmore
College; University of Michigan. Exhibitions: Artists'
Guild of Chicago, 1961; Baltimore Museum of Art, 1971;
Annapolis Art Festival, Maryland, 1974.

Meredith Rode, PROCESSION. Lithograph,
22" x 30", edition of 24.

Helen K. Roseberry, UNTITLED. Bronze, 10½" high.

Ann C. Rosebrooks, *INNER SANCTUM*, 1974
Oil on canvas, 48" x 60".

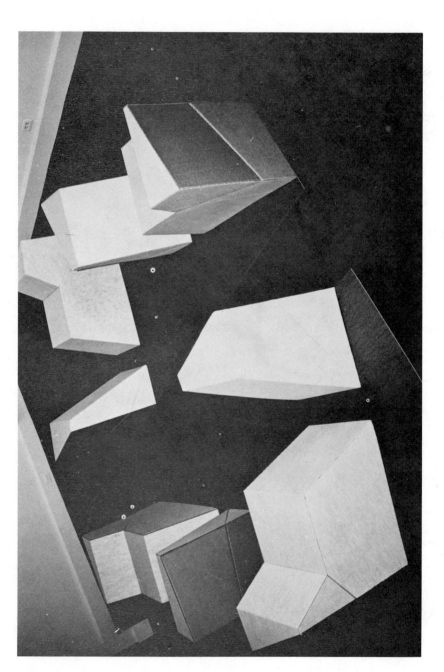

Kay Rosen, Corrugated cardboard, 32" high.

Regina Rosenblum, SPACE STUDY NO IV (with the artist). Oil on shaped canvas, 78" x 62" x 45".

ROSS, Laurel. Born: Youngstown, Ohio in 1947. Studied:
Carnegie-Mellon University; The Art Institute of Chicago.
Exhibitions: University of Illinois, Medical Center;
ARC Gallery, Chicago.

✓ ROSTER, Laila. Painter. Studied: San Mateo College,
California; San Jose State College, California.
Exhibitions: Honolulu Printmakers Annual Exhibition,
1971, 1972, 1973; Easter Art Festival, 1973; Honolulu
Academy of Arts, 1974. She is represented in the
collection of the State Foundation on Culture and the
Arts, Hawaii.

ROY, Mary. Painter. Born: Burlington, Vermont.
Exhibitions: Watercolor USA, Springfield, Missouri;
National Academy of Design, New York City; Audubon
Artists, New York City. Collections: Dulin Gallery
of Art, Knoxville, Tennessee; New Britain Museum of
American Art.

✓ ROZIER, Jane. Painter. Born: Poplarville, Mississippi
in 1946. Studied: George Peabody College, Nashville,
Tennessee. Awards: Tennessee Craft Fair, Nashville,
1973-74; Memphis Academy of Art, Tennessee, 1974;
Metropolitan Center, Nashville, 1975. Collections:
Arrowmont School of Crafts, Gatlinburg, Tennessee;
Tennessee Arts Commission, Nashville; First National
Bank, Tullahoma, Tennessee.

✓ RUBIN, Eleanor. Printmaker. Born: Hollywood,
California in 1940. Studied: Brandeis University,
Waltham, Massachusetts; Harvard University, Cambridge.
Exhibitions: National Graphics Exhibition, South Dakota-
1972; Boston University, 1973; Boston Visual Artists Union
Gallery, 1974. Collections: Photo Graphics Workshop,
New Canaan, Connecticut; California College of Arts and
Crafts, San Francisco.

RUBIN, Sandra. Painter. Noted for her hard-edge paintings.

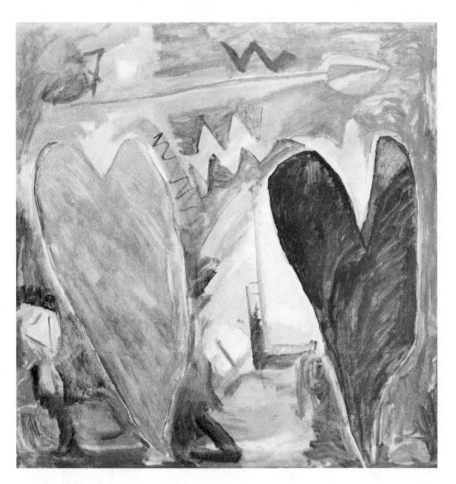

Laila Roster, *LOVE LANDSCAPE*. Acrylic,
42" x 42".

Eleanor Rubin, *SELF PORTRAIT AS A BIRD, 1973.*
Etching, 17" x 11". Photo: Estelle Disch.

√ RUBY, Laura. Sculptor. Awards: Redondo Beach Festival
of the Arts, California, 1973, 1974; La Mirada Fiesta
de Artes, California, 1974. Exhibitions: Art Hawaii II,
1974; Monterey Park Art Association Competition,
California, 1974; University of Hawaii Gallery, 1975.

RUHBERG, Gertrude. Painter. Studied: Hollins College;
University of Minnesota. Exhibitions: Oakland Art
Gallery; The Minneapolis Museum of Fine Art; and
throughout southern California.

RUSSELL, Alicia. Painter. Born: Laurentian Highlands
of Ontario Canada. Studied: Ontario College of Art in
Toronto; El Camino College.

RUSSELL, Dee. Painter. Born: in California. Studied
with Ron Blumberg. An experimentalist.

Laura Ruby, *TRILITHON-STONEHINGE*.

SAAR, Bettye. Painter/sculptor. Studied: University
of California at Los Angeles. Noted for her graphics
and assemblages.

√ SACK, Alice. Painter. Born: San Francisco, California.
Studied: University of Colorado. Exhibitions: National
Arts Club, New York City; The Brick Museum, Kennebunk,
Maine; University of Wyoming, Student Union, 1970, 1972.
She is represented in the collection of North Platte
Valley Museum, Gering, Nebraska.

SAHLSTRAND, Margaret Ahrens. Printmaker. Studied:
Lindenwood College, Missouri; State University of
Iowa. Exhibitions: Japan-Washington Sister State
Exchange Exhibition, 1970; Seattle Center Museum
Gallery, Washington, 1971; Del Mar College, Texas, 1973.

√ SAKAOKA, Yasue. Sculptor. Born: Himeji-City, Japan in
1933 and now a permanent resident of the United States.
Studied: Aoyama Gakuin University, Japan; Reed College;
University of Oregon. Awards: Playground sculpture,
Albany, Oregon; International Alutrusan Award: Fellowship
to Rinehart Institute of Sculpture, Baltimore, Maryland.
Collections: Hollygrove Camp on Lake Gaston, Virginia;
South Hill Park, South Hill, Virginia; Parkside Gardens,
Baltimore, Maryland.

√ SALLICK, Lucy. Painter. Born: Boston. Studied: New
York University; Corcoran School of Art, Washington,
D.C.; The Art Students League, New York. Awards:
Westchester Art Society, 1968, 1969, 1970. Exhibitions:
Peabody Museum of Fine Arts, Nashville, Tennessee; SOHO
20 Gallery, New York City, 1973, 1975; "The Eye of Woman,"
Hobart and William Smith Colleges, Geneva, New York, 1974.

√ SANDMAN, Jo. Painter. Born: Boston, Massachusetts in
1931. Studied: Hans Hofmann School of Fine Arts,
Provincetown, Massachusetts; University of California
at Berkeley; Radcliffe College, Cambridge, Massachusetts.
Exhibitions: DeCordova Museum, Lincoln, Massachusetts,
1952; Nexus Gallery, Boston, 1958, 1961; O. K. Harris Works
of Art, New York City, 1975. Collections: Massachusetts
Institute of Technology, Cambridge; Addison Gallery of
American Art, Andover, Massachusetts; Brockton Art Center,
Lincoln, Massachusetts.

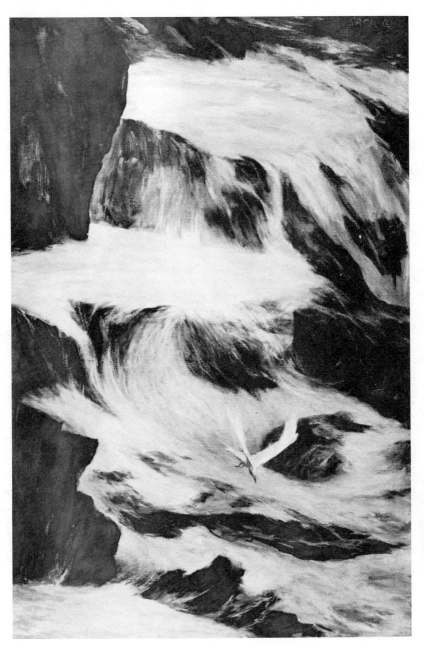

Alice Sack, *RUSHING WATERS*. Oil on canvas,
36" x 24".

Yasue Sakoaka, A STUDY OF A GROUP, 1965.
Limestone, 36" high.

Lucy Sallick, FINISHED WALL HANGING, SKETCH BOOK
AND LEFTOVER YARN, 1974. Oil on canvas, 48" x 50".
Photo: Silver Sullivan.

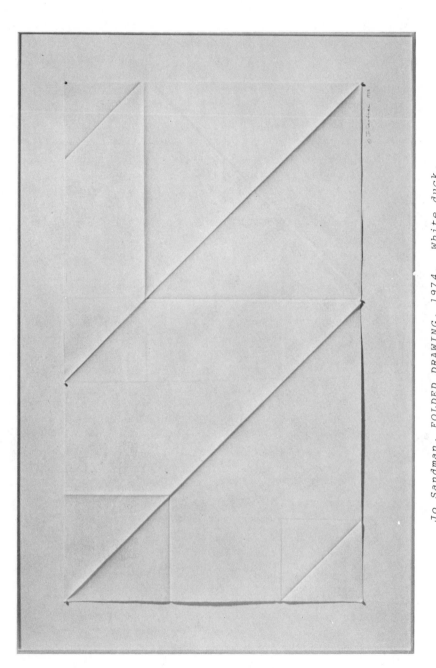

*Jo Sandman, FOLDED DRAWING, 1974. White duck,
25" x 40". Collection: Louis Kane. Photo:
Barney Burstein.*

SANIN, Fanny. Painter. Born: Bogota, Colombia, now living and working in New York City. Studied: University of the Andes, Bogota; University of Illinois, Urbana, Illinois; Chelsea School of Art, London. Awards: I Edinburgh Open 100, Edinburgh, Scotland, 1967; II Coltejer Art Biennale, Medellin, 1970. Exhibitions: Modern Art Gallery, Monterrey, Mexico, 1964; Pan-American Union Gallery, Washington, D. C. 1969; Union Carbide Building, New York City, 1975. Collections: Museum of Modern Art of Bogota, Colombia; Museum of Contemporary Art, Bogota; Museum of Fine Arts of Caracas, Venezuela.

SAPPIN, Gertrude. Painter/graphics. Studied: The Art Students League, New York City; Brooklyn College; Pratt Graphics Center. Exhibitions: Paerdegat Library; Brooklyn College; Yankee Trader Gallery, Beacon, New York. Collections: A. C. Kline & Co.; Brooklyn College; Union Carbide Corp.

SAVITZ, Frieda. Painter. Born: New York City. Studied: New York University; Hans Hofmann School; Cooper Union. Exhibitions: St. Thomas Acquinas College, New York, 1973; Hudson River Museum, New York, 1974; Litchfield Gallery, Connecticut.

SCHABACKER, Betty Barchet. Painter. Born: Baltimore, Maryland in 1925. Studied: Dominican College, California; Connecticut College for Women; University of Rhode Island, Newport. Exhibitions: Erie Art Center, Erie, Pennsylvania, 1966; Chautauqua Art Association Gallery, New York, 1969; California National Watercolor Society Membership Show, 1975. Collections: Western Union, New York; Midland Capital Corporation, New York; McGraw-Edison, Elgin, Illinois.

SCHAPIRO, Miriam. Painter. Born: Toronto, Canada in 1923. Studied: State University of Iowa. Awards: Scholarship, State University of Iowa; Ford Foundation Grant at Tamarind Lithography Workshop, Los Angeles. Represented in the Collection of the Whitney Museum of American Art, New York.

SCHILD, Suzanne Ringer. Painter. Born: Vienna. Awards: Henry Ward Ranger Fund Purchase Award. Exhibitions: First New York City Show in 1968. Collections: National Gallery of Art, Washington, D.C.; Montclair State College.

Fanny Sanin, ACRYLIC #3, 1974, 57" x 53".

Gertrude Sappin, RECOLLECTIONS. Etching.

√ SCHNEIDER, Jane. Sculptor. Studied: Wellesley College;
Columbia University; College of New Rochelle. Awards:
Sekal Lehn Galleries, 1967; Woman's Club of Larchmont,
1967-68; Medal of Honor, National Association of Women
Artists, 1975. Exhibitions: Westchester Art Society,
1970; Silvermine Guild, 1972; Fourteen Sculptors Gallery,
New York City, 1974.

SCHNEIDER, Rosalind. Artist/film-maker. Studied:
Syracuse University School of Fine Arts. The Art Students
League, New York City. Exhibitions: Corcoran Gallery,
Washington, D.C.; Butler Institute of American Art,
Ohio; Brooklyn Museum, New York. Film Festivals:
"Womens' International Film Festival" New York City;
Museum of Modern Art, Paris; Museum of Graz, Austria;
Artists' Space, New York City. Awarded a film retrospective
at the Whitney Museum of American Art, 1973. She is a
founder-member of "Women/Artist/Film-makers" and a charter
member of the "Association of Independent Film-makers".

√ SCHNELL, Shirley Luke. Painter. Born: 1937. Studied:
Minneapolis College of Art and Design; Yale University.
Awards: Undergraduate and graduate scholarships; Union
of Independent Colleges Art Grant, 1969. Exhibitions:
Walker Art Center Biennial; Nelson Gallery-Atkins Museum,
St. Louis, Missouri; Galerie L'Archange, Brussels, Belgium;
Action Art Center.

√ SCHOENWETTER, Frances. Sculptor. Studied: The Art
Institute of Chicago; Illinois Institute of Technology.
Exhibitions: Denver Art Museum, Colorado; Provincetown
Arts Festival, Massachusetts; ARC Gallery, Chicago, Illinois.

SCHONLAU, Ree. Sculptor. Born: Omaha, Nebraska in 1946.
Studied: University of Nebraska at Omaha; Montaval School
of the Arts, San Jose, California. Exhibitions: College
of St. Mary, Omaha, 1971; Columbus Gallery of Fine Arts,
Ohio, 1973; Solstice Marathon Tribute, Joslyn Art Museum,
1975.

√ SCHRATTER, Marlis. Sculptor. Born: Germany, coming to
the United States in 1940. Studied: Baltimore Museum of
Art School; Haystack Mountain School of Crafts in Maine.
Awards: Boston Society of Arts and Crafts; Brockton Art
Association; Cambridge Art Association. Collections:
Everson Museum of Art, Syracuse, New York; Massachusetts
College of Art, Boston, Massachusetts.

Jane Schneider, THE MASK IS THE IDENTITY.
Welded and painted steel, 72" high.

Shirley Luke Schnell, OWENSBY ORCHID, 1974.
Acrylic on canvas, 66" x 66".

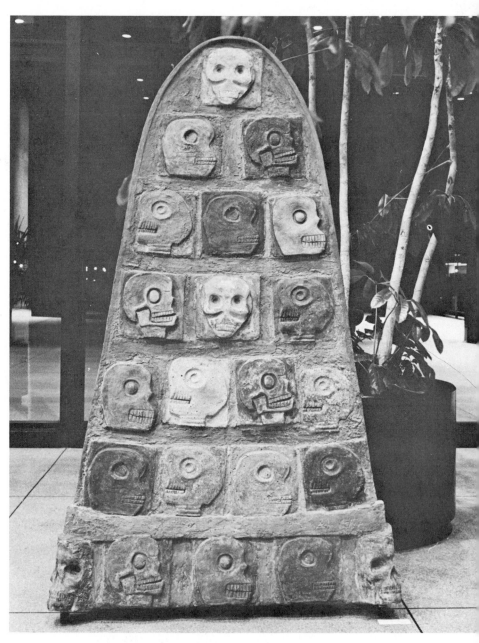

Frances Schoenwetter, SKULLRACK. Polyester resin and cement, 72" high.

Marlis Schratter, SIX SWINGERS. Stoneware and rope.

√ SCULT, Arlene. Graphics/painter. Born: Los Angeles, California. Studied: Briarcliff College, New York; Otis Art Institute and Chouinard Art Institute in Los Angeles, California. Awards: Phoenix Jewish Community Center, 1967, 1968; Tucson Art Center, Arizona, 1969; Regional Art Exhibit, Phoenix, 1968, 1969, 1973. She exhibits with "The Circle," Phoenix, Arizona.

SEABERG, Libby W. Painter. Born: New York City. Studied: Philadelphia College of Art; The Pennsylvania Academy of Fine Arts; The Art Students League of New York; The New School of Social Research; Pratt Graphics Center; Columbia University. Exhibitions: Skylight Gallery, New York City; New York City Community College. She has been librarian of the Whitney Museum of American Art since 1968.

SEAMAN, Bonnie. Sculptor. Born: Bay City, Texas in 1913. Studied: Incarnate Word College, San Antonio, Texas; Museum of Fine Arts School, Houston, Texas; Fourth International Sculpture Casting Conference, University of Kansas. Awards: National Exhibition, Tyler, Texas, 1969; Abilene Museum of Fine Arts, 1971; Jewish Community Center, Houston, Texas, 1972. Included in "20th Century Women in Texas Art," Laguna Gloria Museum, Austin, Texas, 1974.

SEVERSON, Susan. Painter. Born: Brooklyn, New York in 1937. Studied: City College of New York; Brooklyn College. Exhibitions: National Academy of Design; Brooklyn Museum; Far Gallery, New York City.

SHADDLE, Alice. Painter. Born: Illinois. Studied: Shimer College, Oberlin College and The Art Institute of Chicago. Exhibited mostly in the mid-west. Currently working with sculptured environments and boxes.

SHAFFER, Juanita. Painter. Born: Mt. Ayr, Iowa. Studied: Santa Barbara School of Art; with Claude Buck. She is noted for her still-life paintings.

√ SHARP, Anne. Painter/graphics. Born: Red Bank, New Jersey in 1943. Studied: Pratt Institute; Brooklyn College. Exhibitions: The Katonah Gallery, Katonah, New York, 1974; "10 Downtown," New York City; Contemporary Gallery, Dallas, Texas, 1975; Bronx Museum, "The Year of the Woman," 1975.

SHARPLESS, Gretchen. Sculptor. Studied: University of Chicago; Tyler Art School, Temple University; Tulane University. Awards: Louisiana Crafts Council Spring Fiesta Show, 1971; Newcomb Jewelry Show, 1971; Del Mar College, 1973; Amarillo Artist Studio, 1974.

Arlene Scult, *THE OLD MAN AND THE TREE*. Pencil,
42" x 30".

Anne Sharp, MOON-SHOT II. Collage - painting,
30" x 30".

SHATAN, Norma. Painter. Born: New York City in 1932. Studied: Goucher College, Baltimore, Maryland; Columbia Graduate School of Fine Arts and Archaelogy. Exhibitions: Prince Street Gallery, New York City; Image Gallery, Stockbridge, Massachusetts; Art Union, Lenox, Massachusetts.

SHAW, Elsie. Sculptor. Born: Charlotte, North Carolina in 1929. Studied: Salem Academy; Mt. Vernon Junior College; Rollins College. Awards: Mint Museum, Charlotte, North Carolina; Juried Arts National, Tyler, Texas; Salmagundi Club Prize, National Academy of Design. Collections: Mint Museum of Art; Wachovia National Bank, Charlotte; American National Bank, Chattanooga, Tennessee.

SHAW, Joyce. Painter. Working in the 1970's with portable floor paintings and organic forms.

SHECHTER, Laura. Painter. Born: Brooklyn, New York in 1944. Studied: Brooklyn College, cum laude with honors in Art. Exhibitions: Green Mountain Gallery, New York City; Larcada Gallery, New York City; Philadelphia Museum, "In Her Own Image," 1974.

SHECTMAN, Adele. Painter. Born: Cambridge, Massachusetts in 1927. Studied: Vesper George School of Art; Boston University; Boston Museum School. Exhibitions: Childrens' Art Center, Boston, 1967; Psychoanalytic Society and Institute, Boston, 1974; Goethe Institute, 1975. Collections: Leonard Morse Hospital, Natick, Massachusetts; Boston University.

SHERMAN, Z. Charlote. Sculptor/painter. California artist working with abstraction.

SHIEBER, Phyllis Carol. Painter/sculptor. Born: New York City, 1934. Studied: Bard College, Annandale-on-Hudson, New York; State University of New York, New Paltz, New York; Louisiana State University, Baton Rouge, Louisiana. Collections: Louisiana Arts and Science Center, Baton Rouge, Louisiana; Chancellor's Suite, Louisiana State University.

SHIRAS, Myra. Painter. Born: 1936. Studied: California School of Fine Arts, San Francisco; Palos Verdes College, Rolling Hills, California. One-person shows in the Los Angeles area. Collections: Boston Public Library; Downey Museum of Art, California; Pillsbury, Minneapolis, Minnesota. Murals: Brand Art Center, Glendale, California; Palos Verdes Central Library, California; Chapel of Episcopal Seamen's Center, San Pedro, California.

Norma Shatan. Photo: Nathan Rabin.

Elsie Shaw, WOMAN ON A BENCH. Copper and bronze, 8" x 9½".

Laura Shechter, MRS. RUSSO's VASE, 1971.
Oil on masonite, 17" x 14".

Adele Shectman, PANDORA, 1975.

Myrna Shiras, STITCHED PAINTING, 1975.

SIMON, Iris. Mixed Media. Studied: Smith College. Awards:
Elizabeth Morse Genius Foundation Prize, N.A.W.A., 1974;
Bronze Medal, Hofstra University, 1963; Roosevelt Raceway,
1970. Collections: Free Library of Philadelphia;
Tanglewood Preserve; East Meadow Public Library.

SIMON, Jewel W. Painter/sculptor. Born: Houston, Texas
in 1911. Studied: Atlanta University; Atlanta School of
Art; Colorado University. She was the first black to
graduate from the Atlanta School of Art. Awards: Bronze
Woman of the Year in Fine Arts, 1950; Plaque for Distinction,
Atlanta University Alumni Association; John Hope Prize,
1966. Collections: Atlanta University, Georgia; Clark
College; Girls Club of America, Inc.; National Archives Slide
Collection; University of Maryland.

SIMONSON, Beverley Ann. Graphics. Studied: Mayville State
College, North Dakota. She has exhibited mostly in the
midwestern United States.

SIPPRELL, Clara. Photographer. Born: Canada. Worked in
Massachusetts.

SKILES, Jacqueline. Printmaking, sculpture, videotape
Born: St. Louis, Missouri in 1937. Studied: Washington
University, St. Louis; University of Wisconsin, Madison;
New School for Social Research, New York City. Exhibitions:
Vis-a-Vis Gallery, New York City; University of Bridgeport,
Connecticut; Ramapo College of New Jersey; Women's
Interart Center, New York City. Publications: Documentary
History of Women Artists in Revolution;Columbus Started
Something, Posters: Threat to the Peace; For Life on Earth;
Liberation; Rise Up Sisters; Arising. She has been very
active in the women artists movement.

SKOLNIK, Sara. Sculptor. Born: Chicago, Illinois. Studied:
University of Chicago; State University of New York at
Albany; with sculptor Richard Stankiewicz. Awards: Albany
Museum, New York; Schenectady, New York. Exhibitions:
Associated American Artists, 1971; Metropolitan Structures,
"Forty Women," 1974; ARC Gallery, Chicago, 1974.

SKORA, Marie. Printmaker. Born: Arkansas City, Kansas.
Studied: New Mexico Highlands University; Private studio
in Caracas, Venezuela. Exhibitions: Chula Vista,
California, 1954; Center of Fine Arts, Maracaibo,
Venezuela,1964; N.L.A.P.W., Washington, D.C. 1973.
Collections: Smithsonian Institution, Washington, D.C.;
Museum of Fine Arts, Caracas, Venezuela; Rockville Civic
Center Gallery, Maryland.

Jewel W. Simon, THE TUSI PRINCESS. Plaster,
19" high.

Beverley Ann Simonson, MOM AND APPLE PIE. Print.

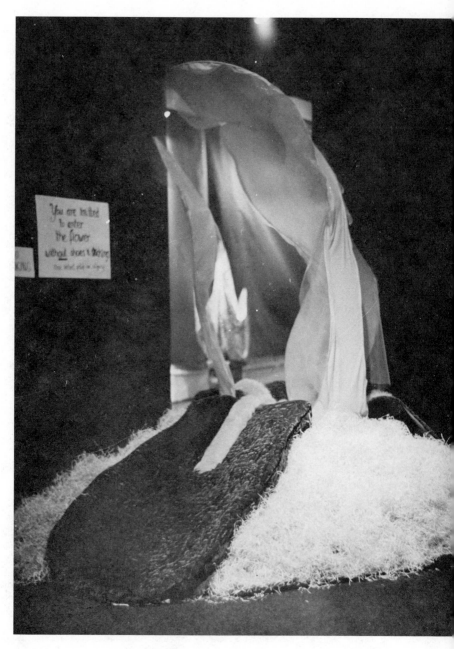

Jacqueline Skiles, O'KEEFFE FLOWER, 1973.

Sara Skolnik, FOR A CITY PARK, MODEL II.
Welded steel, 39" high.

√ SLAVET, Ruth. Sculptor. Studied: Bennington College, Bennington, Vermont; Boston University, School of Fine Arts; Impression Workshop, Boston. Exhibitions: Boston Summerthing Traveling Art Exhibit, Boston, 1968; Brockton Art Center, Brockton, Massachusetts, 1972, 1973; Hayden Gallery, Massachusetts Institute of Technology, 1973.

SLOAN, Eula. Painter. Born: Arkansas in 1899. Mostly self-taught as an artist. She has exhibited mostly in Wyoming.

SLOANE, Patricia Hermine. Painter. Born: 1934. Studied: Hunter College; New York University.

SLOTKIN, Terise. Exhibited: Six New Jersey Women Artists, Douglass College Library, New Brunswick, New Jersey, 1975.

SMITH, Barbara. Sculptor. Studied: Iowa University. Noted for her use of plexiglass and light.

SMITH, Joynnye. Sculptor. Born: 1942. Noted for her ink figures on plexiglass.

√ SMITH, Sharon. Painter/graphic-artist. Studied: California State University at Long Beach, California. Exhibitions: San Luis Obispo County Art Show, 1968; Honolulu Academy of Art, 1974; Hallway Gallery, Bishop Museum, Hawaii, 1975. She is in the collection of the City and County of Honolulu.

SMITH, Shirley. Painter. Working in the 1960's with color-field paintings.

SNYDER-FINK, Joan. Painter. Used acrylic lacquer to do paintings in the abstract-expression style in the 1960's and early 1970's.

√ SOLOMON, Rosalind. Photographer. Born: Highland Park, Illinois in 1930. Studied: Goucher College and with Lisette Model in New York City. Awards: Hunter Museum of Art, 1974; Atlanta Arts Festival, 1974; Arkansas Fine Arts Center, 1971; Exhibitions: Birmingham Museum of Art, Alabama, 1975; Neikrug Galleries, New York City, 1975; Slocumb Gallery, Johnson City, Tennessee, 1975. Her one-person show, Israel:Radishes and Roses, toured the eastern United States. Collections: Museum of Modern Art, New York City; Metropolitan Museum of Art, New York City; Arkansas Fine Arts Center. She is noted for her photographs of Union Depot, Chattanooga, Tennessee and First Monday, Scottsboro, Alabama.

Ruth Slavet, *PORTRAIT OF CATHY II*. Bronze,
life-size.

Sharon Smith, 1975.

Rosalind Solomon, *DOLL HEAD II*. Black and white
photograph. Collection: *Metropolitan Museum of
Art, New York City*.

SPRAGUE, Mary. Sculptor/graphics. Born: 1934. Studied: Stanford University. Noted for her constructions, assemblages, and cloth figures.

√ STANLEY, Idahlia. Painter. Studied: Brandeis University; Harvard University; The Art Students League, New York. Exhibitions: Institute of Contemporary Art, Boston, 1972; Philadelphia Art Alliance, Pennsylvania, 1974; Sketch Club, Philadelphia, 1975.

STECKEL, Anita. Painter. Studied: Cooper Union and with Edwin Dickinson. Exhibitions: Whitney Museum; Aldrich Museum; Portland Museum; Berkeley Museum; Museums in Sweden, China, and Mexico. She was one of the featured artists in Ms. Magazine and New York magazine.

√ STEIN, Carole Clark. Painter. Born: New York City in 1942. Studied: City College of the City University of New York; School of Fine Arts, Boston University; New York Studio School. Awarded a prize for painting, Boston University, 1964. Exhibitions: Douglass College, Rutgers University, 1974; The Aldrich Museum, Ridgefield, Connecticut, 1974; Women's Interart Center, New York City, 1974. Collections: Chase Manhattan Bank; McGraw-Hill, The SONY Corporation.

STEVENS, Edith Barretto. Sculptor. Born: Houston, Virginia in 1878. Studied: The Art Students League, New York City; with Daniel C. French and George Gray Barnard. Principal works: "A Candlestick Representing a Girl Asleep under a Poppy," "Figure of Spring," and "Spirit of Flame."

STEVENS, Kelly. Painter. A noted equine artist. Paints mostly in the traditional portrait manner.

STEVENSON, Margaret Paris. Photographer/Graphics. Born: Roxboro, North Carolina in 1937. Studied: University of North Carolina; American University, Washington, D.C.; Corcoran School of Art, Washington, D.C. Exhibitions: Ikon Gallery, Washington, D.C.; Martin Luther King Memorial Library, Washington, D.C.; Smithsonian Institution, Washington, D.C.

STEWART, Sherry. Sculptor. Noted for her earth and wood environmental-earthworks.

STONE, Sylvia. Sculptor. Uses stainless steel to form abstract and primary forms.

Idahlia Stanley, PRISONERS. Oil on canvas, 22" x 16".

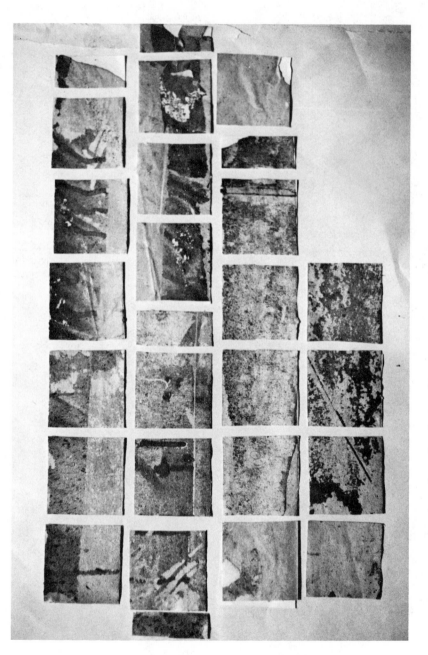

Carole Clark Stein, COLLAGE. Acrylic on tape under plexiglass.

STORER, Maris Longworth. Sculptor and Potter. Born: Cincinnati, Ohio. Studied: Cincinnati Art School, which her father Joseph Longworth endowed. Awarded a Gold Medal at the Paris Exposition, 1900. She was appointed United States Minister to Belgium in 1897, and later Ambassador to Austria. In 1880, after working four years at the Dallas White Ware Pottery, she opened the Rookwood Pottery.

STROMSTEN, Amy. Photographer. Studied: University of Michigan; Cooper Union.

√ STUART, Michelle. Drawing. Born: Los Angeles, California in 1938. Studied: Chouinard Art Institute, Los Angeles, California; Instituto de Bellas Artes, Mexico; New School for Social Research, New York City. Awards: MacDowell Fellowship, 1974; Tamarind Institute Grant, Albuquerque, New Mexico, 1974. Exhibitions: Westchester Art Society, 1971; Windham College, Putney, Vermont, 1973; Museum of Modern Art, New York City, 1974. Collections: International Museum, San Francisco, California; Aldrich Museum, Ridgefield, Connecticut.

√ STUBBS, Lu. Sculptor. Born: New York City in 1925. Studied: Boston Museum of Fine Arts; _Academia di Belle Arti_, Perugia, Italy. Awards: Providence Art Club, 1972; Art Association of Newport, Rhode Island, 1972. Exhibitions: Milton Academy, Milton, Massachusetts, 1968; Thayer Academy, Braintree, Massachusetts, 1972; The American Woman, Jordan Marsh, 1975. Collections: Boston Center for Adult Education; Community Systems by Perini, Boston.

STUMM, Maud. Painter. Born: Cleveland, Ohio. Studied: The Art Students League in Paris with Oliver Merson. Noted mainly for reproductions of her paintings, and her calendars.

SUNDBERG, Wilda Regelman. Painter. Born: Erie, Pennsylvania in 1930. Studied: Albright Art School, University of Buffalo, New York. Awards: Edinboro Summer Gallery, 1969, 1971; Chautauqua National, 1971. Exhibitions: Ashtabula Winter Show, Ohio, 1969; Springfield Missouri Art Museum, 1971, 1972; William Penn Museum, Pennsylvania, 1971. She is represented in the collection of the Erie Public Library.

SWARTZ, Beth Ames. Painter. Exhibiting with "The Circle" a group formed in 1971 of five women artists in Phoenix, Arizona.

Michelle Stuart, No. 6, 1973. Graphite on linen. Photo: Bevan Davies.

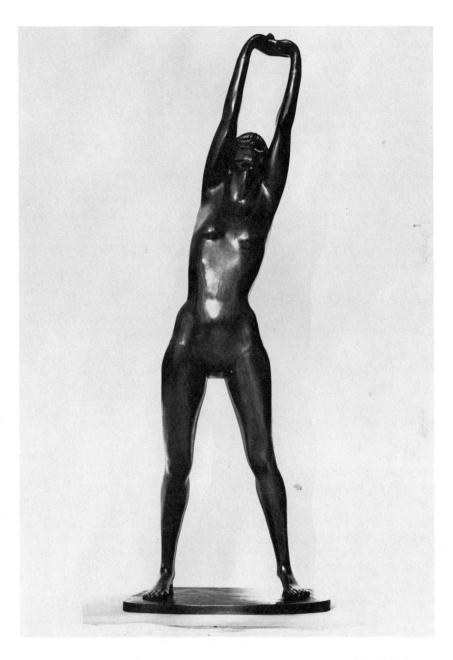

Lu Stubbs, REACHING WOMAN, 1974. Bronze, 84" high.

TACHA, Athena. Sculptor. Born: Larissa, Greece in 1936. Studied: National Academy of Fine Arts, Athens, Greece Oberlin College, Ohio; University of Paris, Sorbonne, France. Awards: Cleveland Museum of Art, 1968, 1971. Exhibitions: Allen Art Museum, Ohio, 1973; Women's Interart Center, New York City, 1973; Dayton Art Institute, Ohio, 1974. She is represented in the Cleveland Museum of Art, Ohio. Also, active in film-making.

√ TAVINS, Paula. Painter. Born: Chicago, Illinois in 1939. Studied: The Art Institute of Chicago; California College of Arts and Crafts. Awarded a fellowship from the New York State Council of the Arts, 1975. Exhibitions: Kent State University, 1972; New York Cultural Center, 1973; 55 Mercer Street, New York City, 1974.

TAWNEY, Leonore. Working in the 1950's and 1960's with silk and wool tapestry.

√ TAYLOR, Ann. Painter. Works mainly with landscapes. Exhibitions: Carl Solway Gallery, Cincinnati, Ohio; The York Gallery, New York City; The Saginaw Museum of Art, Saginaw, Michigan; The Hunter Gallery, Aspen, Colorado.

TECLA. Painter/Sculptor. Studied: National Academy of Design; Cincinnati Art Academy; The Art Students League, New York City. Exhibitions: Brooklyn Museum; Howard University; Butler Institute of American Art; Bates College in Maine.

TERRELL, Sharrel. Painter. Born: California in 1947. Studied: Fullerton College. Exhibitions: Laguna Art Festival, California, 1965; Sunday Art Mart, Honolulu Zoo, 1974, 1975. She is noted for her paintings of wildlife.

THEO. Sculptor. Born: Pennsylvania. She has exhibited in Paris, France and was on the faculty of the Paris American Academy in Paris. She works with the lost wax method of bronze casting.

THOMPSON, Domenicam. Painter/graphics. Born: 1939. Noted for her acrylic and oil paintings of figures.

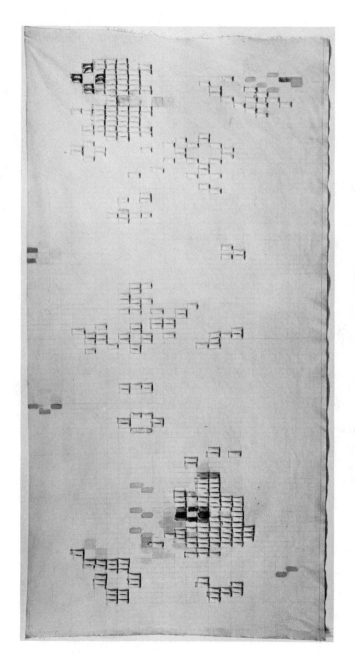

Paula Tavins, EASTER LILY, 1973. Canvas and magna, 114" x 60".

Ann Taylor, UMBER MIST, 1972. Oil on linen, 40" x 40". Photo: Robert E. Mates and Paul Katz.

√ THOMPSON, Judith. Painter. Born: 1940. Studied: Kansas City Art Institute, Missouri; University of Cincinnati & Art Academy, Ohio; Aspen School of Contemporary Art, Colorado. Awards: University of Cincinnati, Graduate Teaching Assistantships; Kansas City Art Institute, Scholarships. Exhibitions: Cincinnati Art Museum; Indiana University, Bloomington, Indiana; College of St. Benedict, Benedicta Arts Center, St. Joseph, Minnesota. She is noted for her lectures on "Women Painters in History."

THRASHER, Joann. Painter. Born: Omaha, Nebraska in 1933. Self-taught as an artist. Mainly a painter of murals, she is represented in the collections of: Campbell County Memorial Hospital, Gillette, Wyoming; Farmers State Bank, Lyman Nebraska; S.S.T. Aviation Museum, Kissimmee, Florida. The mural "Panorama of Flight" for the S.S.T. Museum is 264 x 7 feet, and was painted in four and one-half months by the artist.

TITELMAN, Susan. Sculptor. Working with ceramic and fiberglass.

TORR, Helen. Painter. Born: 1886 and died in 1967. Noted for her abstract landscapes, still-life and nature objects. Influenced by Georgia O'Keefe.

TOTH, Myra. Studied: Mills College, Oakland, California; San Francisco State College. Exhibitions: Crocker Gallery, Sacramento, California; Museum West, San Francisco; De Young Memorial Museum, San Francisco; ARC Gallery, Chicago.

√ TRIEFF, Selina. Painter. Studied: Brooklyn College with Ad Reinhardt and Mark Rothko; Hans Hofmann School in New York City; The Art Students League in New York City. Exhibitions: Several shows in New York City; Stamford Museum, Connecticut; The Wadsworth Atheneum, Connecticut; Provincetown Art Association. She is represented in the collections of Ivan Karp, Norman Mailer, among many other private collections.

TRIGG, Itha Inez. Painter. Studied: California State College. Paints in the traditional manner. Active in the Gardena Valley Art Association.

TRUITT, Ann. Sculptor. Born: 1921. Studied: Bryn Mawr. Working in the 1960's with primary forms in wood and aluminum.

Selina Trieff, SAVAH AND JANE. Oil on canvas, 72" x 72".

√ UDINOTTI, Agnese. Sculptor. Born: Athens, Greece
in 1940. Studied: Arizona State University, Temple,
Arizona. Awards: Phoenix Art Museum, 1964; Jewish
Community Center, Phoenix, 1966-67; Scottsdale Fine
Arts Festival, 1974. Collections: Phoenix Art Museum;
Chicago Medical School; Scottsdale Civic Center.

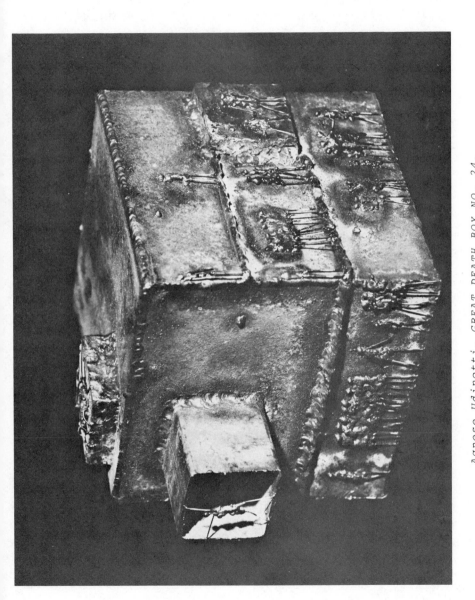

Agnese Udinotti, *GREAT DEATH BOX NO. 24.*
Welded Steel, 78" square.

VALENTI, Nadine. Painter. Born: New York City. Studied:
The Art Students League, New York; Hans Hofmann School.
She was awarded the Boskof Foundation Grant, 1970.
Exhibitions: mostly in New York and Massachusetts.

✓ VAN HARLINGEN, Jean. Sculptor/painter. Born: Dayton,
Ohio in 1947. Studied: Ohio State University; Tyler School
of Art. She has exhibited extensively in Ohio, Pennsylvania
and recently in New York. Noted for her large, vinyl,
inflatable sculpture.

✓ VAN RAAY, Jan. Photographer. Born: Brooklyn, New York in
1942. Studied: School of Art and Design. New York City;
Abracheff School of Art, New York City; New York University,
New York City; New School for Social Research, New York City
Exhibitions: Andre Zarre Gallery, New York City; Archiv
Conz, Asolo, Italy; Documenta 5, Kassel, West Germany;
Festival of Women, University of Toronto, Canada; Finch
College Museum of Art, New York City. Photographs published
The New York Times; The London Times; Newsweek; New York
Magazine; Saturday Review.

VAN VRANKEN, Rose. Sculptor. Born: Passaic, New Jersey
in 1920. Studied: Los Angeles Otis Art Institute,
California; Monona College. Awards: Medal of Honor,
National Association of Women Artists; Los Angeles Museum;
Des Moines Art Center. Collections: Monona Public Library,
Madison, Wisconsin; Smith College, Northampton, Massachusett
Mayland Publishing Company, Madison, Wisconsin.

VARDA, Jean. Painter. Noted for her abstractions and
figure paintings.

VELISSARTOS, Ruth. Photographer. Noted for her special
effects.

VIGNES, Michelle. Photographer. Born: France in 1929.
Her work has been published in several major U.S. news
magazines. She is represented in the collection of the
Oakland Museum.

VODICKA, Ruth Chai. Sculptor. Born: New York City.
Exhibitions: New York Cultural Center, "Women Choose Women,"
Hudson River Museum, 1973; Women's International Arts
Festival, 1974-75. Collections: Norfolk Museum; Montclair
State College; Grayson County Bank, Texas.

VUELKER, Betty. Sculptor. Working in Texas with inflated
vinyl sculpture.

Jean Van Harlingen, Vinyl inflatable sculpture,
132" high.

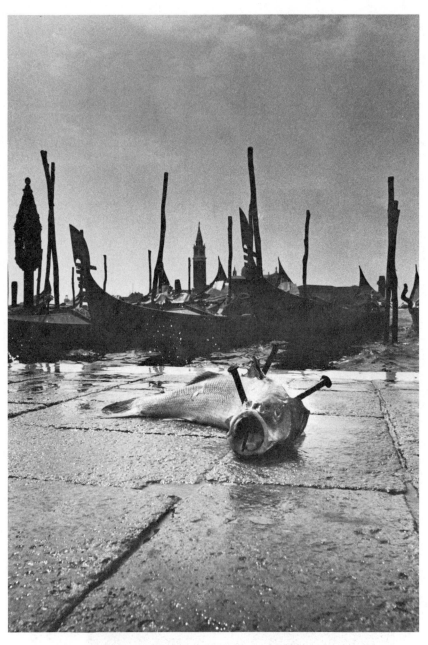

Jan Van Raay, FISH IN VENICE, 1974. Black
and white photograph.

✓ WALINSKA, Anna. Painter. Born: London, England.
Studied: National Academy of Design; The Art Students
League, New York; _Academie André L'hote_, Paris, France.
Awards: National Association of Women Artists, 1957;
Silvermine Guild, 1957; Brooklyn Society, Riverside Museum,
1959. She has been exhibiting since 1936.

WALKINGSTICK, Kay. Exhibited: Six New Jersey Women Artists,
Douglass College Library, New Brunswick, New Jersey, 1975.

✓ WALSH, Alida. Film/sculptural environments. Studied:
The Art Institute of Chicago; Northwestern University;
San Diego State College; Germain School of Photography
and Film-making; New York University. Awards: Ethical
Culture Society, 1967; Vogelstein Foundation in
environmental Sculpture, 1971; CAPS - Creative Artists
Program Service, 1974. Exhibitions: Sculpture in
Cultural Center Exhibit, "Women Choose Women," 1973;
Women's Interart Center, 1973; Women's Film Festival,
New York Cultural Center, 1973; Vienna Museum of Modern
Art, 1974.

✓ WALTER, Beth Cameron. Sculptor. Born: Pittsburgh,
Pennsylvania in 1948. Studied: Carnegie-Mellon University.
Exhibitions: Three Rivers Art Festival, 1969-73;
Associated Artists Show, 1973; Apple Hill Playhouse, 1973.

WARNER, Jeanne. Watercolorist. Born: western New York.
Self-taught artist. Exhibitions: S.A.G.A., Leland House
Hotel, Springville, New York; Allentown Show, Buffalo,
New York; Ogunquit Art Center, Ogunquit, Maine. Owns the
Fair Wind Gallery, Tenants Harbor, Maine.

✓ WATERWORTH, Sherry. Sculptor. Born: Annapolis, Maryland
in 1943. Studied: Towson State College; Ohio University.
Awards: Baltimore Art Festival, 1966; Atlantic City,
New Jersey, 1967; Raleigh Art Museum, 1973; North Carolina
Artist Exhibit, 1974. Exhibitions: Fine Arts Center,
Salem College, Winston-Salem, North Carolina, 1970; Carrol
Reece Museum, Johnson City, Tennessee, 1972; National
Sculpture, 1973. President, Southern Association of
Sculptors, 1974-75.

WEBER, Beverly. Working in California with encaustic
painting.

WEBER-OWENS, Vick. Exhibited Six New Jersey Women Artists,
Douglass College Library, New Brunswick, New Jersey, 1975.

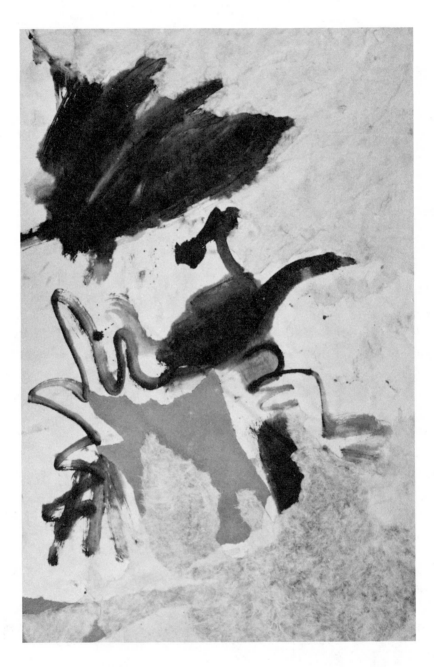

Anna Walinska, THE BIRD, 1961. Paper and oil collage.

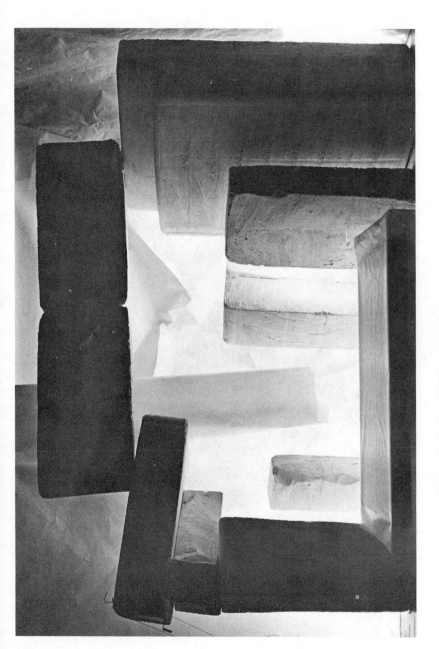

Alida Walsh, 1974. Sculptural environment, 120" high.

Beth Cameron Walter, STUFFED SCULPTURE, 18" high.

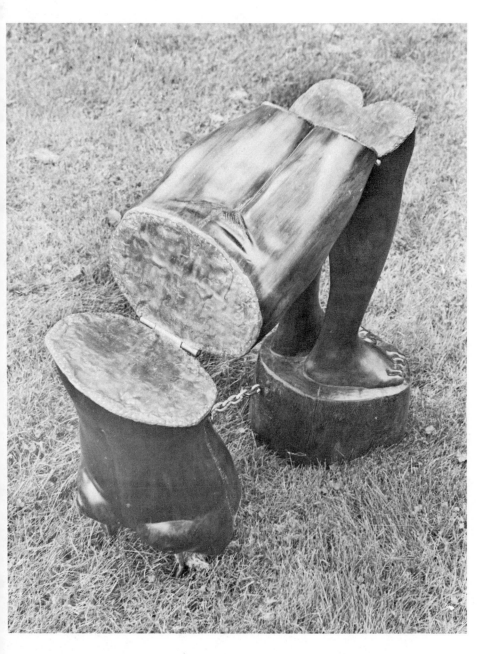

Sherry Waterworth, HINGED WOMAN. Walnut, lead, and hardware, life size.

√ WECHTER, Vivienne Thaul. Painter. Artist in Residence and Chairperson at Fordham University, 1964 to the present. Awards: American Academy of Arts and Letters; Crespi Gallery New York City; Grumbacher prize for Oil Painting, Riverside Museum, New York City. Collections: Corcoran Gallery, Washington, D.C.; Museum of Fine Arts, Houston, Texas; Jewish Museum, New York City; United Nations, New York City. Also, Founder, Trustee, and Chairman of Programming for Bronx Museum of the Arts.

WEHRENBERG, Monika. Born: Berlin, Germany. Studied: North Central College; The Art Institute of Chicago. Associated with the ARC Gallery, Chicago.

√ WEINGARTEN, Hilde. Painter/printmaker. Studied: The Art Students League; Cooper Union School of Art; Pratt Graphics Center. Awards: Painter and Sculptor Society of New Jersey; League of Present Day Artists, National Arts Club, 1974; National Association of Women Artists, 1975. Collections: Brooklyn Museum; Herbert F. Johnson Museum, Cornell Universi Israeli Museum, Jerusalem, Israel.

WEIR, Mina. Painter. Noted landscape artist. Exhibitions: Americana Art Circuit; American Institute of Fine Arts.

WEISBERG, Ruth. Sculptor. Working with bronze, abstract figures.

WENTWORTH, Ola. Painter. Early training was in costume design, later turning to painting of seascapes.

WESTCOAST, Wanda. Sculptor/graphics. Working in California with pencil, plexiglass, and fiberglass. She has shown at The University of Tennessee at Chattanooga.

WILSON, Ann. Painter. Doing abstract landscapes in the 1960's.

WILSON, Jane. Painter. Born: Seymour, Iowa. Studied: University of Iowa. Collections: Museum of Modern Art, New York; Whitney Museum of American Art; Wadsworth Atheneum, Connecticut; Herron Art Museum, Indiana, plus many others in the United States.

Vivienne Thaul Wechter, EQUINOX. Acrylic on Canvas, 68" x 78". Photo: Luigi Pellettieri.

Hilde Weingarten, FACES AND THE CITY. Intaglio,
24" x 16". Collection: New York Public Library.

WILSON, Melva Beatrice. Sculptor. Born: Cincinnati, Ohio in 1875. Studied: Cincinnati Art Museum; Paris, with Rodin. Awarded an Honorable Mention, Paris Salon in 1897. Collections: Corcoran Art Gallery, Washington, D.C.; State of New York; Tiffany & Company, New York City. She was awarded the largest commission given any woman-sculptor for the decoration of the buildings of the St. Louis Exposition.

√ WILLIAMS, Joyce. Painter. Studied: Virginia Intermont College; University of Kentucky; with Edmund J. Fitzgerald. Awards: Texas Fine Arts Association, 1974; Southeatern Art Association, 1973; Bluegrass Annual, 1972.

√ WINDELL, Violet Bruner. Graphics/painter. Born: DePauw, Indiana. Studied: University of Louisville, Kentucky. Noted for her books: The Fairy Bells Tinkle Afar, 1968; Rainbows and Daisies, 1972; A Prospectus, to a Newborn Babe, 1974.

√ WING, Jeanie Prall. Painter. Born: Newark, New Jersey in 1939. Studied: Tyler School of Fine Arts of Temple University, Philadelphia, Pennsylvania; University of Iowa; New York University, New York City. Exhibitions: Avanti Gallery, 1971; Gallery 91, 1972; SOHO Festival, 1975.

WINSOR, Jacqueline. Sculptor working with fiber and hemp.

WOODWARD, Dewing. Painter. Born: Williamsport, Pennsylvania. Studied: Pennsylvania Academy; Paris with Bouguereau, Robert-Fleury, and Jules Lefebvre. Awards: Grand Prize of the Academy Julian in 1894. Exhibitions: Paris Salon, 1893; Venice Exhibition, 1903; Watercolor Club, Baltimore.

√ WRIGHT, Rosemary. Sculptor. Born: Richmond, Indiana in 1939. Studied: Indiana University; Columbia University; New York University. Won an award for sculpture, Baltimore Museum for Fine Art, 1972. Exhibitions: Washington Gallery of Art, Washington, D.C., 1974; Judson Memorial Church, New York City, 1969; 55 Mercer Gallery, New York City, 1972-73. Founder: D.C. Registry of Women Artists.

Violet Bruner Windell. Sketches: former Administration Buildings and the Playhouse, University of Louisville campus.

Jeanie Prall Wing. Oil on canvas, 60" x 48".

Rosemary Wright, GROUND/DONNA, 1973.
Corrugated cardboard, 48" high.

YANKOWITZ, Nina. Painter. Working with gathered cloth, stained paper, and three-dimensional wall pieces. She has exhibited at Kornblee Gallery, New York City.

YOKOI, Rita. Sculptor. Studied: University of California at Berkeley. Noted for her ceramic sculpture and assemblage.

ZARICK, Joye. Painter. Born: Chicago in 1923. Studied:
Maryland Institute; The Art Institute of Chicago.
Exhibitions: University of Connecticut; International
Gallery, New York City; Taft School, Connecticut; Stan
Hope Gallery, Boston.

ZEHR, Connie. Sculptor noted for her environments of
sand, earth, and rope.

ZETLIN, Fay. Painter. Studied: Brown University,
Providence, Rhode Island. Awards: Painting of the Year,
Atlanta Museum; Virginia Museum of Fine Arts, Richmond,
Virginia: Norfolk Museum, Norfolk, Virginia. Exhibitions:
Virginia Museum of Fine Arts, 1960; Rose Fried Gallery,
New York City, 1965; Franz Bader Gallery, Washington, D.C.,
1973; Collections: Houston Museum of Fine Arts, Texas;
Mint Museum, Charlotte, North Carolina; Old Dominion
University, Norfolk, Virginia.

ZIBIT, Melanie. Sculptor. Born: Cambridge, Massachusetts
in 1948. Studied: Mount Holyoke College, South Hadley,
Massachusetts; Pratt Institute, Brooklyn, New York.
Exhibitions: Jags Gallery, Brookline, Massachusetts, 1971;
Vineyard Haven Gallery, Martha's Vineyard, 1971; Rose Art
Museum, Brandeis University, Waltham, Massachusetts.

ZIMMERMAN, Mindy H. Photographer. Studied: Parsons School
of Design, New York City; Washington University, St. Louis.
Awards: Cerf Brothers Tent Company; St. Louis Commerce
Competition; St. Louis Zoo Association; University City
Library.

ZURIK, Jesselyn Bensen. Sculptor. Born: New Orleans,
Louisiana in 1916. Studied: Arts and Crafts School,
New Orleans; Newcomb School of Art, Tulane University,
New Orleans. Awards: Brandeis University Invitational;
Rose Art Museum, Waltham, Massachusetts, 1963; Southern
Association of Sculptors, Arkansas Art Center, 1966;
Picayune Art Festival, Picayune, Mississippi, 1970.
Collections: Mead Packing Company, Atlanta, Georgia;
Haspel Brothers, New York City; Manufacturer's Hanover
Trust, Plaza Towers, New Orleans, Louisiana.

Joye Zarick, *ENDLESS CYCLE OF IDEA AND BEING.*
Oil on canvas, 16" x 36".

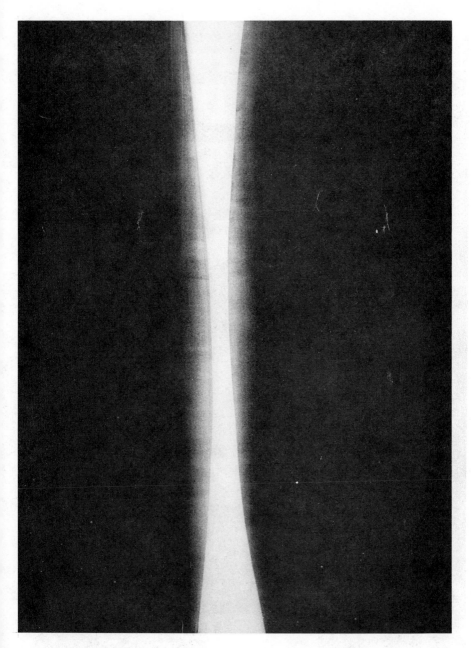

Fay Zetlin, PAINTING, 1974. Acrylic on canvas,
72" x 54".

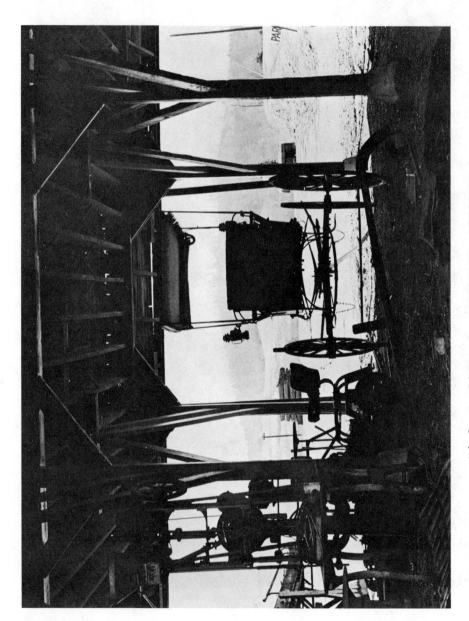

Mindy H. Zimmerman, HERMANN, MISSOURI.
Black and white photograph.

SECTION
III

AALUND, Suzy. Painter, miniaturist. Born: Long Island,
New York. Study: Self-taught. Awards: Second Prize,
Oils, Long Beach Art Association, 1972; First Prize, Oils,
National Miniature Art Show, Miniature Art Society of New
Jersey, 1973. Media: Watercolor, oil, acrylic.

AARON, Evalyn (Wilhelmina). Painter. Born: New York, New
York. Study: Art Students League; private study with
Mario Cooper, Motoi Oi, Professor Kawai and Betty Holiday.
Awards: Sumi-e Society Award, Sumi-e Society of America,
1964 and Cup of Consul General of Japan, 1966; Popular
Award, International Platform Association, 1974. Media:
Watercolor, acrylic.

ADELMAN, Dorothy (Lee) McClintock. Printmaker, painter.
Born: Manhattan, New York. Study: Art Student League,
with Roberto Delamonico and Michael Ponce de Leon; West-
chester Art Workshop, White Plains, New York, with John
Ruddley and Stephen Rogers Peck; Silvermine Guild Artists,
Inc., New Canaan, Connecticut, with Ray Riddaback; Hudson
River Museum, Yonkers, New York, with Harold Wollcott.
Awards: Purchase Award, Westchester Art Workshop, 1969
and Hudson River Museum, 1971; First and Third Award,
Mamaroneck Artist Guild, 1972; First Award, Westchester Art
Society, 1973 and 1975. Media: Intaglio.

ADKISON, Kathleen (Gemberling). Painter. Born: Beatrice,
Nebraska. Study: With Mark Tobey. Awards: Sun Carnival
First Prize, El Paso Museum, 1961; Dr. Fuller Purchase
Award, Northwest Annual, 1961; Prize for Winter Retreat,
Friends of American Art, 1969. Media: Oil.

ADRIAN, Barbara (Mrs. Franklin Tramutola). Painter,
collector. Born: New York, New York, July 25, 1931.
Study: Art Students League, with Reginald Marsh, 1947-
1954; Hunter College, 1951; Columbia University, 1952-
1954. Exhibits: National Academy of Design, New York,
1968; Butler Institute American Art, 1970; Gallery of
Modern Art, New York, 1970; Suffolk Museum, Stony Brook,
New York, 1971; Whitney Museum, 1975. Awards: Benjamin
Altman Prize, National Academy of Design, 1968. Media:
Oil.

AHRENDT, Christine. Painter. Born: Dayton, Ohio. Study: Florida State University; Ohio University; Provincetown Workshop, with Ben Shahn, Will Barnet, Victor Candell and Leo Manso. Exhibits: Columbus Gallery of Fine Arts, Ohio, 1961-1965, 1969 and 1970; Provincetown Art Association Summer Shows, 1962-1972; Pennsylvania Academy of Fine Arts, Philadelphia, 1964; Butler Institute American Art Midyear Show, Youngstown, Ohio, 1965 and 1974; one-man show, East Coast Gallery, Provincetown, 1969. Awards: Huntington Galleries Awards, West Virginia, 1962-1966; MacDowell Colony Fellowship, 1965, 1966 and 1971; S. M. Levy Memorial Award, Columbus Art League, 1969. Media: Acrylic and mixed media.

ALAUPOVIC, Alexandra V. Sculptor, instructor. Born: Slatina, Yugoslavia, December 21, 1921; U.S. citizen. Study: Academy of Visual Arts, University of Zagreb, sculptor and teaching certification, 1948; Academy of Visual Arts, Prague, 1949; University of Illinois, Urbana-Champaign, 1959-1960; University of Oklahoma, M.F.A., 1966. Exhibits: Exposition Association Peintres, Graveurs et Sculpteurs de Croatie, Dubrovnik, Yugoslavia, 1956; 35th Annual Springfield Art Museum, Missouri, 1965; On Music, University of Oklahoma Museum of Art, 1968; Annual Eight State Exhibit of Painting and Sculpture, Oklahoma City, 1971; one-man show, Oklahoma Art Center, 1973. Awards: Jacobson Award, University of Oklahoma, 1964; First Sculpture Award, Philbrook Art Center, Tulsa, 1970. Member: The MacDowell Club Allied Arts; National Society of Literature and Arts. Media: Marble, metals.

ALBRECHT, Mary Dickson. Sculptor, painter. Born: Dothan, Alabama, June 4, 1930. Study: University of Houston; Texas Woman's University, B.S. (sculpture, with honors), 1970. Awards: Juror's choice and circuit merit awards, Texas Fine Arts Association State Citation Show, 1971 and 1972; Purchase award, art acquisition committee, University of Texas, Arlington, 1972. Media: Steel, bronze, metal, plastic.

ALF, Martha Joanne. Painter, writer. Born: Berkeley, California, August 13, 1930. Study: San Diego State University, B.A. (psychology), M.A. (painting), 1963, with Everett Gee Jackson; University of California, Los Angeles, M.F.A. (pictorial arts), 1970, with James Weeks, William Brice and Richard Diebenkorn. Exhibits: Three-person show, Fine Arts Gallery of San Diego, 1971; Invisible/Visible, Long Beach Museum of Art, 1972; 8 x 8 plus 4 x 4, Twelve Regional Artists, Newport Harbor Art Museum, 1975; Whitney Biennial of Contemporary American Art, Whitney Museum of American Art, New York, 1975; Current Concerns, Part II, Los Angeles Institute of Contemporary Art, 1975. Awards: First Prize, Southern California Exposition, Del Mar, 1967; Second Prize Art Guild Exhibition, Fine Arts Gallery San Diego, 1967 and 1970. Media: Oil paint on canvas and pencil on paper.

ALFORD, Gloria K. Sculptor, printmaker. Born: Chicago, Illinois, October 3, 1938. Study: University of California, Berkeley, A.B.; Art Institute of Chicago, Penland School of Crafts, N.C.; Columbia University; Pratt Graphics Center. Exhibits: Environ-Vision, National Competitive Exhibit, Everson Museum, Syracuse and New York Cultural Center, New York, 1972; New Talent Show, Gimpel and Weitzenhoffer, New York, 1973; In Her Own Image, Philadelphia Museum of Art, 1974; 19th Annual Print Exhibit, Brooklyn Museum, 1974; Wisconsin Directions, Milwaukee Art Center, 1975. Awards: Top Honors, University of Wisconsin Art Show, Richland Center, 1972.

ALLEN, Courtney. Illustrator, sculptor. Born: Norfolk, Virginia, January 16, 1896. Study: Corcoran Art School, Washington, D.C., 1915-1916; National Academy Art School, 1920-1921; also with Charles W. Hawthorne, Provincetown, Massachusetts, 1919-1921; and C. W. Bicknell, 1919. Exhibits: Allied Artists of America; Provincetown Art Association; Chrysler Art Museum; Provincetown Historical Museum.

ALLEN, Margaret Prosser. Painter, educator. Born: Vancouver, B.C., January 26, 1913; U.S. citizen. Study: University of Washington, B.A. and M.F.A.; also with Alexander Archipenko and Amadee Ozenfant. Exhibits: Six exhibits, Northwest Annual, 1938-1948; over ten exhibits, Delaware Annual, 1942-1964; Weyhe Gallery, New York, 1947; The Carvings of Sanchi, photography exhibit circulated by Smithsonian Institute, 1968-1972; University of Delaware Faculty Group Show, Delaware Art Museum, 1972; plus regional and group shows, 1965-1975. Awards: Honorable mention, Wilmington Society of Fine Arts, 1947 and First Prize, 1949; Popular Prize (one of five), Northwest Annual, 1948; Grant, University of Delaware, 1968.

ALLMAN, Margo. Sculptor, printmaker. Born: New York,
New York, February 23, 1933. Study: Smith College;
Moore College of Art; University of Pennsylvania;
University of Delaware; with Reginald Marsh and Hans
Hofmann. Exhibits: Philadelphia Artists Who Have
Received Prizes in Recent Years, Philadelphia Museum of
Art, 1962; Philadelphia Women in the Fine Arts, Moore
College of Art, annual, 1962-1968; National Biennial,
National League American Pen Women, Salt Lake City, 1970
and Washington, D.C., 1972; Margo Allman--Sculptor,
Printmaker, Windham College, Putney, Vermont, 1973; 7
Delaware Area Sculptors, University of Delaware, 1975.
Awards: Mildred Boericke Prize, 32nd Annual National
Exhibit of Woodcuts and Wood Engravings, Print Club of
Philadelphia, 1958; Drawing Prize, 51st Annual Show,
Delaware Art Museum, 1965; Best Landscape Painted by
Delaware Artist, Wilmington Trust Bank Prize, Delaware
Art Museum, 1969. Media: Wood and stone; acrylic paint--
woodcuts.

AMES, (Polly) Scribner. Painter, sculptor. Born: Chicago,
Illinois. Study: University of Chicago, Ph.B.; Art
Institute of Chicago; Chicago School of Sculpture, scholar;
also with Jose de Creeft and Hans Hofmann, New York; Hans
Schwegerle, Munich, Germany. Exhibit: One-man shows,
Cultural Center, Netherlands, West Indies, 1947, Galerie
Chardin, Paris, 1949, Cercle Universite, Aix-en-Provence,
1950 and Esher-Surrey Gallery, The Hague, Holland, 1950;
also Closson Gallery, Cincinnati and many others. Awards:
Bronze award for Young Satyr and Friend, Illinois State
Museum, 1962.

AMSTER, Sally. Painter. Born: New York, New York,
January 22, 1938. Study: Cornell University, B.F.A.;
Brooklyn Museum Art School; Columbia University, M.F.A.
Exhibits: Centennial House Gallery, Deer Isle, Maine, 1963,
1964 and 1967; The Landscape, School of Visual Arts, New
York, 1966; Maine Coast Artists, Rockport, 1974; 118
Artists, Landmark Gallery, New York, 1975; Women in the
Arts, New York, 1975; plus seven one-person shows.
Awards: U.S. Representative, First U.S.-U.S.S.R. Student
Exchange, 1958; Cornell University Faculty Medal in Art,
Cornell University, 1959. Media: Oil.

ANDRADE, Edna Wright. Educator, painter. Born: Portsmouth, Virginia, January 25, 1917. Study: Pennsylvania Academy of Fine Arts, 1933-1938; Cresson European traveling scholar, Pennsylvania Academy of Fine Arts, 1936-1937; University of Pennsylvania School of Fine Arts, B.F.A., 1937. Work: Philadelphia Museum of Art; Pennsylvania Academy of Fine Arts, Philadelphia; Yale Art Gallery, New Haven; Albright-Knox Art Gallery, Buffalo; Marian Koogler McNay Art Institute, San Antonio, Texas. Commission: Mosaic mural, Columbia Branch, Free Library of Philadelphia, 1962; marble intarsia mural, Welsh Road Branch, Free Library of Philadelphia, 1967; geometric paintings, Smith Kline & French Company, Philadelphia, 1968; mobile sculpture, Roxborough Branch, Free Library of Philadelphia, 1969; granite paving, Salvation Army Division Headquarters, Philadelphia, 1972. Exhibits: Two-person show, Rutgers University Art Gallery, New Brunswick, 1971; Silkscreen: History of a Medium, Philadelphia Museum of Art, 1972; 18th National Print Exhibit, Brooklyn Museum, 1972; The Invisible Artist, Philadelphia Museum of Art, 1973-1974; Woman's Work, American Art 1974, Philadelphia Civic Center, 1974. Awards: Childe Hassam Member Purchase Awards, American Academy of Arts and Letters, 1967-1968; Mary Smith Prize, Pennsylvania Academy of Fine Arts, 1968. Member: Pennsylvania Academy Fellowship; Print Club (member of the board, 1972); Artists Equity Association; American Color Print Society; College Art Association. Media: Acrylic, silkscreen.

ANGEL, Rifka. Painter. Born: Kalvaria, Russia, September 16, 1899; U.S. citizen. Study: Art Student League, with Boardman Robinson; also with John Sloan, Alfred Maurer and Emil Ganso; Moscow Art Academy. Work: Honolulu Academy of Fine Arts; Chicago Art Institute; Nelson Art Gallery and Mary Atkins Museum of Fine Arts, Kansas City, Missouri; Brandeis University. Exhibits: Chicago Art Institute, 1931, 1933, 1935 and 1939; 16 Cities Exhibit, Museum of Modern Art, New York, 1934; Brooklyn Museum, 1937; one-man show and annual, Honolulu Academy, 1940-1941; one-man shows, Nelson Art Gallery and Mary Atkins Museum of Fine Arts, 1943; plus many other one-man shows in galleries. Awards: For originality in painting, Art Institute of Chicago, 1933; City Museum of St. Louis, 1945; Design for Democratic Living, American Federation of the Arts, 1948. Media: Encaustic.

ARMSTRONG, Jane Botsford. Sculptor. Born: Buffalo, New
York, February 17, 1921. Study: Middlebury College;
Pratt Institute; Art Students League, with Jose De Creeft.
Work: Hayden Gallery, Massachusetts Institute of Technology;
Columbus Gallery of Fine Arts, Ohio; New Britain Museum of
American Art, Connecticut; Worcester Polytechnic Institute,
Massachusetts; Montefiore Hospital, Bronx. Commissions:
Three marble animals, World of Birds, New York Zoological
Society, Bronx, 1972; large white marble free-form,
Research Triangle Institute, Research Triangle Park, North
Carolina, 1974. Exhibits: One-man shows, Frank Rehn Gallery,
New York, 1971, 1973 and 1975, Columbus Museum of Fine Arts,
Ohio, 1972, North Carolina Museum of Art, Raleigh, 1974 and
Columbia Museum of Art, South Carolina, 1975; Critics Choice,
Sculpture Center, New York, 1972. Awards: Gold Medal,
National Arts Club, New York, 1968, 1969 and 1972; Medal of
Honor, Audubon Artists, New York, 1972; Council of American
Artists Society Prize, National Sculpture Society, New York,
1973.

ARNOLD, Florence M. Painter. Born: Prescott, Arizona,
September 16, 1900. Study: Mills College, degree in music;
University of Southern California, B.A.; Claremont Graduate
School. Work: Long Beach Museum of Art; Laguna Art
Association Gallery; Orlando Art Gallery, Encino, California;
California State University, Fullerton; Media Art Gallery,
Santa Ana, California. Exhibits: Gallerias Numero, Florence,
Rome, Milan and Prato Venice, 1963; California Hard-edge
Painting, Newport Beach, 1964; one-man shows, Long Beach
Museum of Art, 1962-1969 and Fresno Art Center, 1969.
Awards: First Prize, Muckenthater Cultural Center, 1967
and 1969; First Prize, Orange County Art Association, 1968;
La Mirada Festival Arts Purchase Award, 1968. Media: Oil
on canvas.

ARONSON, Irene Hilde. Designer, painter. Born: Dresden,
Germany, March 8, 1918; U.S. citizen. Study: Eastbourne
School of Art, England; Slade School of Fine Arts, University
of London; Ruskin School of Drawing, Oxford University;
Columbia University, B.F.A., 1960, M.A., 1962; Art Student
League; Parsons School of Design; also with Professor Schwabe,
Polunin and William S. Hayter. Work: Bibliot National
Print Department, Paris; Victoria & Albert Museum, London;
British Museum Print Department; Museum of Modern Art Print
Department and Metropolitan Museum of Art, New York.
Exhibits: Kunstmuseum, Bern, Switzerland, 1957; Brooklyn
Museum, New York and Boston Museum, Massachusetts, 1958;
International Print Show, Ljubljana, Yugoslavia, 1959; one-
woman show, Museum Arte Moderno, Mexico City, 1959 and
Towner Art Gallery, Eastbourne, England, 1961; National
Association of Women Artists, New York, 1974-1975. Awards:
Gold Medal, Slade School of Fine Arts, 1939; Medal of Honor,
National Association of Women Artists, 1957; plus others.

ASHER, Elise. Painter, sculptor. Born: Chicago, Illinois,
January 15, 1914. Study: Art Institute of Chicago;
Bradford Junior College; Boston College, B.S., summers.
Work: New York University Art Collection; University of
California Art Museum, Berkeley; Rose Art Museum. Brandeis
University; Geigy Chemical Corporation; First National Bank
of Chicago. Commissions: Oil on Plexiglas window,
commission by Dr. John P. Spiegel, Cambridge; cover for
Poetry Northwest, autumn-winter 1964-1965; cover for The
Chelsea, No. 27, 1970; jacket for Stanley Kunitz, The
Testing-Tree (poems), Little, Brown, 1971. Exhibits: One-
man retrospective, Bradford Junior College, 1964; one-man
shows, The Contemporaries, New York, 1966 and Bertha
Schaefer Gallery, New York, 1973; Lettering, traveling show,
Museum of Modern Art, New York, 1967; The Word as Image,
Jewish Museum, New York, 1970; plus many other one-man and
group shows. Media: Multi-layered densities in oil and
enamel.

ASHFORD, Pearl J. Painter, illustrator. Born: Philadelphia,
Pennsylvania. Study: Pratt Institute, New York; Tyler
School of Art, Temple University; also with Morris Blackburn
and Phoebe Shih. Exhibits: 1st New York International Art
Show, New York Coliseum, 1970; Plastic, Women's Art Club,
Philadelphia, 1971; International Art Show, Rotunda Gallery,
London, 1972; 7th and 9th Annual Art Exhibit of the Urban
League Guild, Philadelphia, 1972 and 1974; plus others.
Awards: Second Prize for Geraniums (painting), Willingboro
Art Alliance, 1973. Chinese technique.

ATKINS, Rosalie Marks. Painter. Born: Charleston, West
Virginia, July 21, 1921. Study: Mason School of Music and
Fine Arts, Charleston, West Virginia; Morris Harvey College,
Charleston; workshops with Leo Manso and Victor Candell,
Provincetown, Massachusetts; also with Bud Hopkins, Truro,
Massachusetts. Work: West Virginia Arts and Humanities
Permanent Collection. Exhibits: Allied Artists of West
Virginia Annual Shows, Charleston, 1953-1975; Exhibition
180 and Exhibition 280, Huntington Galleries, 1970 and 1972
Appalachian Corridors, Charleston Art Gallery, 1972;
National League American Pen Women Annual Show, Washington,
D.C., 1972; Provincetown Art Association National Show,
Massachusetts, 1972-1975. Awards: Selected for traveling
show, Art in the Embassies Program, 1970 and National League
American Pen Women, 1972; two Purchase Awards, West
Virginia Arts & Humanities, 1972.

BABER, Alice. Painter. Born: Charleston, Illinois,
August 22, 1928. Study: Indiana University, B.A., graduate
school; also in Fontainebleau, France. Work: Corcoran
Gallery Art, Washington, D.C.; San Francisco Museum of Art,
California; National Collection of Fine Arts, Washington,
D.C.; National Museum of Israel; Peter Stuyvesant (Turmac)
Collection, Holland. Exhibits: Deuxieme Biennial, Paris,
France, 1961; Modern American Painting, U.S. Information
Service, American Embassy, London, England and Edinburgh,
Scotland, 1961-1962; 3rd Kent State University Exhibit, 1968;
Eisenstadt Schloss, Austria, 1969; Trends in 20th Century
Art, University of California, Santa Barbara, 1970. Media:
Oil, watercolor.

BAKER, Grace. Painter. Born: Riverdale, New York. Study:
Finch College, B.A.; and with William Oden-Waller. Work:
American International Underwriters Corp., New York.
Commissions: Portrait, Lawrence J. Troiano, Riverdale, New
York, 1966; still life, Blue Ribbon Restaurant, 1967; Old
Saw Mill, commission by Mr. & Mrs. Henry Fittenrici,
Williamsburg, 1972; Topaz, commission by Holly Patterson,
Williamsburg, 1972; drawing, Chesapeake Pharmaceutical
Association, Virginia, 1973; portrait, commission by Mrs.
James Shuck, Lanexa, Virginia, 1974. Exhibits: Tidewater
Artists Association 21st Biennial, Chrysler Museum, Norfolk,
Virginia, 1971; Special Maritime Exhibits, Newport News,
1971 and 1972; World Health Day 1972, U.N. Postage Stamp
Design Competition, 1971-1972; private exhibit, Bank
Hampton Roads, Virginia, 1972; Peninsula Arts Association
Shows, 1970-1975. Awards: Second Place in Oils, Todd
Center Arts Festival, 1972; Certificate of Excellence in
Oils, Peninsula Arts Association Member Exhibit, 1974;
Certificate of Merit in Graphics and Oil Technique, Inter-
national Biographical Center, Cambridge, England. Media:
Oil.

BANKS, Anne Johnson. Sculptor, printmaker. Born: New
London, Connecticut, August 10, 1924. Study: Wellesley
College, B.A., 1946; Honolulu School of Art, with Wilson
Stamper, 1948-1950; George Washington University, with
Thomas Downing, M.F.A., 1968. Work: Lyman Allyn Museum,
New London; George Washington University. Exhibits:
Virginia Artists 1971, Virginia Museum, Richmond, 1971;
Fairfax County Area Exhibits, 1971-1974; Northern
Virginia Fine Arts Association Area Exhibit, 1972-1974;
one-person show, Alexandria Art League, 1973; plus others.
Awards: Honorable Mention, Fairfax County Area Show, 1971;
Six Merit Awards, Art League, Alexandria, Virginia, 1971-
1974; Merit Award, Northern Virginia Fine Arts Association,
1972. Media: Wood, plastic, silkscreen.

BARTH, Frances. Painter. Born: New York, New York, July 31, 1946. Study: Hunter College, B.F.A. and M.A. Work: Whitney Museum, New York; Herbert F. Johnson Museum, Cornell University; Chase Manhattan Bank Collection, New York. Exhibit: The New Gallery, Cleveland, 1972; Baldessari, Barth, Jackson, Munger, Stephan, Houston Museum of Contemporary Art, 1972; Whitney Biennial Painting, New York, 1972 and 1973; Three New York Artists, Corcoran Gallery of Art, Washington, D.C., 1973; Susan Caldwell Gallery, New York, 1974 and 1975. Awards: Award, Creative Public Service Program, New York State, 1973; Award, National Endowment for the Arts, 1974.

BARTLE, Annette. Painter, illustrator. Born: Warsaw, Poland. Study: Sorbonne, B.A.; Elmira College, B.A.; Art Students League, with Robert Hale, Louis Bouche, R. Johnson, Menkes, Paul Fiene and John Carroll. Work: Lincoln Life Insurance Company Collection, Nebraska; Woodside Savings and Loan Association, New York; C. V. Starr Company; Union Carbide Company. Commissions: Mural, Top of Fair Building, New York World's Fair. Exhibits: U. S. Information Agency, 1963-1965; New York University, 1964; Bass Museum of Art, 1964; American Academy of Arts and Letters, 1964; Philbrook Art Center, 1964 and 1965; plus others. Awards: Scholar, Art Students League; Pan-American Traveling Scholar; Award, East Hampton Guild, New York.

BARTLETT, Jennifer Losch. Painter, writer. Born: Long Beach, California, March 14, 1941. Study: Mills College, B.A., 1963; Yale University, B.F.A., 1964 and M.F.A., 1965, with Jack Tworkov, James Rosenquist, Al Held and Jim Dine. Work: Walker Art Center, Minneapolis; Baxter Labs, Deerfield, Illinois; Goucher College, Baltimore; New York Hospitals. Exhibits: One-woman shows, Reese Palley Gallery, 1972 and Paula Cooper Gallery, 1974 and 1976, New York, Saman Gallery, Genoa, Italy, 1974, Garage, London, 1975 and John Doyle Gallery, Chicago, 1975.

BEARD, Marion L. Patterson. Educator, painter. Born: Vincennes, Indiana. Study: Indiana State University, B.S. (art); Syracuse University, M.F.A. Exhibits: National Association of Women Artists Annual, New York; American Watercolor Society, New York Watercolor Club; Hoosier Art Salon, Indianapolis; National Professional Exhibit Annual, Ogunquit, Maine; one-man show, H. Lieber Art Gallery, Indianapolis. Awards: First Award, Margaret George Bridwell Member Watercolor Award and First Award, William H. Block Company Watercolor Award, Hoosier Art Salon; William E. Tirey Member Watercolor Award, Wabash Valley Artists.

BECKER, Bettie (Bettie Geraldine Wathall). Painter. Born: Peoria, Illinois, September 22, 1918. Study: University of Illinois, B.F.A.; Art Students League, with John Carroll; Art Institute of Chicago, with Lewis Ritman; Institute of Design, Illinois Institute of Technology, with Hans Weber. Work: Witte Memorial Museum, San Antonio, Texas; Union League Club, Chicago, Illinois. Commissions: Mural (with Frank Wiater), Talbot Materials Testing Laboratory, University of Illinois, Urbana, 1940. Exhibits: Drawings U.S.A., St. Paul, Minnesota, 1966-1968; one-woman show, Crossroad's Gallery, Art Institute of Chicago, 1973; Festival de Arte de las dos Banderas, U.S.-Mexico, Douglas, Arizona, 1972; Critic's Choice, Art Institute of Chicago, 1972; Union League Civic and Arts Foundation Exhibits, 1967, 1972 and 1974; plus many others. Awards: Newcomb Prize, University of Illinois College of Fine and Applied Arts, 1940; First Prize for Print, Chicago Society Artists, 1967, 1971 and 1974; H. Barry McCormick Purchase Prize, Union League Club, 1974; plus others. Media: Collage, acrylic.

BECKER, Charlotte (Mrs. Walter Cox). Illustrator, painter. Born: Dresden, Germany; U.S. citizen. Study: Cooper Union; Industrial Arts Night School; Art Students League. Media: Oil. Interest: Painted over a thousand magazine covers, art calendars and art prints, all of children; painting restoration.

BECKER, Natalie Rose. Painter. Born: Philadelphia, Pennsylvania. Study: Fleisher Art Memorial, Philadelphia; Temple University, A.A. (business administration); Pennsylvania Academy of Fine Arts; Art Students League with Robert Phillip and Henry Gasser. Work: Fine Arts Galleries, Carnegie Institute; Bloomfield College. Exhibits: Allied Artists of America, National Academy of Design, New York, 1972, 1973 and 1974 and Audubon Artists of America, 1973 and 1975. Awards: Leon Lehrer Memorial Award Landscape, Allied Artists of America, 1972; Grumbacher Award, National Arts Club, 1975. Media: Oil, watercolor.

BEERMAN, Miriam H. Painter. Born: Providence, Rhode
Island. Study: Rhode Island School of Design, B.F.A.;
Art Students League, with Yasuo Kuniyoshi; New School for
Social Research, with Adja Yunkers; Atelier 17, Paris, with
Stanley Hayter. Work: Whitney Museum of American Art,
New York; Brooklyn Museum; Andrew Dickson White Museum,
Cornell University, Ithaca, New York; New School for Social
Research. Exhibits: The Humanist Tradition in
Contemporary American Painting, New School for Social
Research, 1968; American Drawings of the Sixties, New
School Art Center, 1969; American Academy of Arts and
Letters, New York, 1969; one-woman exhibits, Brooklyn
Museum, 1971-1972 and Graham Gallery, New York, 1972; plus
many others. Awards: Fulbright Grant, 1951-1953; Award,
11th Rhode Island Arts Festival, 1969; Cultural Council
Foundation Grant, Creative Artist's Public Service Program,
1971. Media: Oil.

BEHL, Marjorie. Painter. Born: Pocahontas, Arkansas.
Study: Layton Art Institute, College of William and Mary;
California College of Arts and Crafts; Old Dominion
University; also with George Post and Charles Sibley.
Work: Alfred Khouri Collection, Walter Chrysler Museum,
Norfolk, Virginia; Valentine Museum, Richmond, Virginia;
University of Virginia Permanent Collection, Charlottes-
ville, Virginia; Borden Chemical Company, Smith-Doughlas
Division, Virginia Beach, Virginia; Public School Purchase
Collection, Norfolk, Virginia. Exhibits: One of Three
Rotating Show, Virginia State Museum, Richmond; Society of
Western Artists, M. H. De Young Memorial Museum, San
Francisco, 1964; Tidewater Artists Association Show and
American Drawing Biennial, Norfolk Museum, Virginia, 1964;
one-man show, Norfolk Museum, 1966; State of Florida
Watercolor Show, Sarasota Art Museum, 1972; plus many
others. Awards: First Prize Watercolor, Arkansas State
Watercolor Exhibit, 1957; First Prizes in Watercolor,
Virginia Beach Boardwalk Show, 1957-1968; First Prize for
Watercolor, Tidewater Artists Association Bi-annual, 1965.
Media: Watercolor, oil.

BELL, Coca (Mary Catlett Bell). Painter. Born: Weleetka, Oklahoma, September 26, 1924. Study: University of Oklahoma, B.A. (languages); painting with Milford Zornes, Edith and Richard Goetz and Charles Reid; drawing with Don Coen and Robert Kaupelis. Commissions: Oil painting, Governor's Mansion, Oklahoma City, 1970. Exhibits: 14th Annual Eight State Exhibit, Oklahoma Art Center, 1972; 34th Oklahoma Artists Annual, Philbrook Art Center, Tulsa, 1974; 61st Annual Exhibit, Allied Artists of America, New York, 1974; 150th Annual Exhibit, National Academy of Design, New York, 1975; Watercolor U.S.A., Springfield Art Museum, Missouri, 1975. Awards: Honorable mention, 2nd Annual Oklahoma Art Guild, 1973; Fourth Award, 10th Annual Southwestern Watercolor Society Regional Exhibit, 1973; Second Award for Watercolor 1974, Oklahoma Watercolor Association, 1974. Media: Watercolor, oil.

BELLE, Anna (Anna Belle Birckett). Painter, museum director. Born: Crescent, Oklahoma. Study: Central State University, Edmond, Oklahoma; also with John Pike, Robert E. Wood, Mel Crawford, Merlin Enabnit, John Pellew, Edgar Whitney, Gene Dougheryt, Jack Vallee and many others. Exhibits: Eight Oklahoma Museums Art Annual; Southwestern Watercolor Society, Dallas; one-man shows, Roadrunner Gallery, Raton, New Mexico, 1974, Ponca City, Oklahoma, Owens Gallery and Wilson Gallery, Oklahoma City, 1974 and 1975. Media: Watercolor, oil.

BENDER, Beverly Sterl. Sculptor, designer. Born: Washington, D.C., January 14, 1918. Study: Knox College, B.A.; Art Students League; Sculpture Center, New York; Museum of Natural History, New York. Work: James Ford Bell Museum of Natural History, Minneapolis. Commissions: Memorial, Mrs. Disco, Mystic Seaport, Connecticut, 1969. Exhibits: National Sculpture Society, New York, 1965, 1970 and 1972; National Arts Club, New York, 1969; Smithsonian Institute, Washington, 1970 and 1971; one-man shows, Grist Mill Gallery, Chester, Vermont, 1974 and Southern Vermont Art Center, Manchester, 1975. Awards: First Prize, Beaux Arts, 1964; Gold Medal, Catharine Lorillard Wolfe, 1969; Founders Prize, Pen and Brush Club, 1975. Media: Stone, wood.

BENEDICT, Nan M. Painter, educator. Born: Lynchburg, Virginia, July 27, 1937. Study: Pratt Institute, B.F.A., 1959, M.F.A., 1961. Commissions: Mural, New York City Public Library System, 1969. Exhibits: Pratt Institute Faculty Exhibits, 1961, 1962, 1968 and 1971; Detroit Art Institute, 1963; Brooklyn Museum, 1963 and 1972; Manhattan Center, 1971; one-woman show, Pacem in Terris, New York, 1975.

BENNETT, Harriet. Painter. Born: New York, New York.
Study: Art Students League, with Robert Brackman and Byron
Browne; Brooklyn Museum, with Minna Citron; New School for
Social Research; Pratt Graphic Art Center; Y.W.C.A. Craft
Center. Work: Five paintings, Institute of High Fidelity,
New York; also included in many private collections.
Exhibits: One-man shows, Marino Gallery, New York, 1958.
Condon Riley Gallery, New York, 1959, Cichi Gallery, Rome,
Italy, 1962, Galerie de l'Universite, Paris, France, 1962
and Woodstock Gallery, London, England, 1965. Awards:
Falmouth Artists Guild Award, 1962. Media: Oil.

BERG, Siri. Painter, instructor. Born: Stockholm,
Sweden; U.S. citizen. Study: Institute for Art and
Architecture, University of Brussels; Pratt Graphics Center,
New York. Work: Chase Manhattan Bank, New York; Finch
College Museum, New York; University of Alabama, Birmingham.
Exhibits: Three New Women Painters, East Hampton Gallery,
New York, 1970; one-man show, Phoenix Gallery, New York,
1972 and 1974; Ward-Nasse Gallery, New York, 1974; Year of
the Woman, Bronx Museum of Arts, New York, 1975; Virginia
Museum of Fine Art, Richmond, 1975; plus others.

BERLIN, Beatrice (Beatrice Berlin Sturmer). Printmaker,
painter. Born: Philadelphia, Pennsylvania, May 27, 1922.
Study: Fleisher Art Memorial, Philadelphia; Moore College
of Art; Philadelphia College of Art; printmaking with Sam
Maitin and Victor Lasuchin. Work: Philadelphia Museum of
Art; Brooklyn Museum of Art; Lessing J. Rosenwald,
Jenkintown, Pennsylvania; Grunwald College, University of
California; New York Public Library Print Collection; plus
others. Commissions: Second edition of prints, commission
by Ferdinand Roten, 1970; first edition of print,
Philadelphia Print Club, 1971; first edition of print,
International Graphic Arts Society, 1971; second edition of
prints, Nabis Fine Arts, 1973. Exhibits: National
Academy of Design Annual, New York, 1965 and 1966;
Pennsylvania Academy of Fine Arts Annual (watercolor and
prints), 1965, 1967 and 1969; Library of Congress 21st
National Print Show, 1969; Print Club of Philadelphia Annual
International, 1969, 1973 and 1975; one-woman show,
Philadelphia Print Club, 1970. Awards: First Prize,
Cheltenham Art Center Print Show, 1970; Purchase Prize,
Lebanon Valley College, 1973; Best in Show, Ocean City
Boardwalk, New Jersey, 1973.

BERMAN, Ariane R. Painter, printmaker. Born: Freeport, Danzig, March 27, 1937; U.S. citizen. Study: Hunter College, B.F.A., 1959; Yale University, scholar, 1959-1962 and M.F.A., 1962; American Association of University Women and Fondation Etats-Unis grants, Ecole Beaux Artes, 1962-1963; and with Stanley William Hayter and lithography with Jacques Desjobert. Work: Metropolitan Museum of Art; Philadelphia Museum of Art, Pennsylvania; Philadelphia Art Alliance; U.S. Information Agency via American Color Print Society Exhibit; American Petroleum Institute, Washington, D.C. Commissions: Painting, Seventeen Magazine, 1971; painting, Shipley School, Bryn Mawr, Pennsylvania, 1971; painting, Charles E. Ellis College, Newtown Square, Pennsylvania, 1971; plus others. Exhibits: Several one-man shows, including Fontana Gallery, 1963, 1971 and 1974, Eileen Kuhlik Gallery, New York, 1971 and 1973, Butler Institute of American Art 36th Annual, 1972, Gallery Art Helioart, Rome, 1974; Munson Gallery, Connecticut, 1975; plus many group exhibits. Awards: Painting Prize, Yale University School of Fine Arts, 1962; Gold Medal and Purchase Prize, Philadelphia Art Alliance, 1973; Catherine Lorillard Wolfe Arts Club Gold Medal, 1973; plus others. Media: Acrylic, serigraphs.

BERNAY, Betti. Painter. Born: New York, New York, September 21, 1926. Study: Pratt Institute; National Academy of Design, New York, with Louis Bouche; Art Students League, with Frank Mason; also with Robert Brackman. Work: Circulo Amistad, Cordoba, Spain; Columbus Museum of Arts and Crafts, Georgia; Columbia Museum of Art, South Carolina; Andre Weil Collection, Paris. Commissions: Painting, president of Renault, Madrid, Spain, 1964; painting, Children Have No Barriers, I.O.S. Foundation, Geneva, 1969; paintings, Macaws, Seacost East Building, Miami Beach, Florida, 1969 and mural, Sandy Cove, South Building, 1970. Exhibits: One-man shows, Columbus Museum of Arts and Crafts, 1960, Columbia Museum of Art, 1960, Andre Weil Gallery, 1960 and 1963 and Museum Malaga, Spain, 1965; Salon des Artistes Independants, Grand Palais, Paris, 1963; Salon Populiste, Museum of Modern Art, Paris, 1963; plus many others. Awards: Artistic Merit Medal, City of New York, 1942; Prix de Paris, 1958; Medal of Honor, Museum Bellas Artes, Malaga, 1965. Media: Oil.

BERNSTEIN, Judith. Painter, lecturer. Born: Newark, New
Jersey, October 14, 1942. Study: Pennsylvania State
University, B.S. and M.S.; Yale University School of Art
and Architecture, B.F.A. and M.F.A. Work: International
Museum of Erotic Art, San Francisco. Exhibits: 1st
International Exhibit of Erotic Art, Konsthall, Sweden
and Kunstmuseum, Denmark, 1968; two one-woman shows, A.I.R.
Gallery, New York, 1973; Erotica, Allan Stone Gallery, New
York, 1973; Warren Benedek Gallery, New York, 1973; Five
Americans a Paris, Galerie Gerald Piltzer, Paris, 1975.
Awards: Elizabeth Canfield Hicks Memorial Scholar, Yale
University School of Art and Architecture, 1964-1967;
Individual Artists Fellowship Grant, National Endowment of
the Arts, 1974-1975.

BETTINSON, Brenda. Educator, painter. Born: King's Lynn,
England, August 17, 1929; U.S. citizen. Study: St.
Martins School of Art, London, 1946-1948; Center School
for Arts and Crafts, London, 1948-1950, National Diploma
in Design, 1950; Academy de la Grande Chaumiere, Paris,
1951; Ecole Pratique des Hautes Etudes, Sorbonne, 1951-
1953, Eleve Titulaire, 1952. Commissions: Society for
Renewal of Christian Art, New York; St. Anselm's Abbey,
Washington, D.C.; St. Mary's Benedictine Abbey, Morristown,
New Jersey; Dominican House of Studies, Washington, D.C.;
Our Lady of Grace Monastery, New Guilford, Connecticut.
Exhibits: 4th Biennial Art Exhibit, Detroit, Michigan,
1964; Commission on Worship and Fine Arts, Bridgeport,
Connecticut, 1965; International Exhibit of Religious Art,
National Arts Club, New York, 1966; Cranbrook Academy of
Art, Detroit, 1969; Episcopal Center, Chicago, 1971; plus
numerous one-man shows. Awards: Gold Medal, National Arts
Club, New York, 1966. Media: Oil or acrylic on masonite.

BETZAK, Ida. Painter, restorer. Born: May 18, 1909;
U.S. citizen. Study: New York University; American Art
School. Exhibits: One-woman shows, The Gallery,
Lakewood House, Little Rock, Arkansas, 1968. Lownsbery
Gallery, Roslyn, New York, 1969 and Center Art Gallery,
New York, 1970. Awards: First Prize for painting,
Biennial Composers, Authors and Artists of America, 1967.
Media: Oil.

BEVLIN, Marjorie Elliott. Painter, writer. Born: The Dalles, Oregon, May 9, 1917. Study: University of Colorado, B.F.A.; University of Washington, College of Architecture; New York University, M.S.; also with Jimmy Ernst, 1956. Commissions: Two murals (6 ft. x 24 ft.), Otero Junior College, La Junta, Colorado, 1955. Exhibits: Scottish-American Women's Exhibit, Edinborough Royal Gallery, 1963; National Academy of Design, New York, N.A.W.A. Annual, 1963-1971; British Women's Exhibit, Liverpool, 1964; 8th Annual Prix de Deauville, France, 1972; Prix de Rome, 1972. Awards: Selectionee de Jury, Prix de Deauville, 1972. Media: Mixed watercolor and acrylic, oil.

BIALA, Janice. Painter. Born: Biala, Poland, October 18, 1903; U.S. citizen. Study: National Academy of Art, New York; Art Students League. Work: Whitney Museum, New York; Centre Contemporary Art, Paris, France; Museum Cantonal de Lausanne, Switzerland; Museum National, Oslo, Norway. Exhibit: Bignou Gallery, New York, 1942; Jeanne Bucher Gallery, Paris, 1946; Stable Gallery, New York and Le Point Cardinale, Paris, 1961.

BIANCO, Pamela Ruby. Painter. Born: London, England, December 31, 1906; U.S. citizen. Study: Guggenheim fellowship for creative painting abroad, 1930. Work: Museum of Modern Art and Chase Manhattan Bank, New York; Queens College; New York Public Library; Hirshhorn Museum of Art, Washington, D.C. Exhibits: One-woman exhibits, Leicester Galleries, London, 1919-1920, Anderson Galleries, New York, 1921, Knoedler Galleries, New York, 1924, Graham Gallery, New York, 1969 and Santa Barbara Museum of Art, 1970. Media: Oil.

BISGYER, Barbara G. (Barbara G. Cohn). Sculptor. Born: New York, New York, June 7, 1933. Study: Sarah Lawrence College; Sculptors and Ceramic Workshop, New York; also industrial design with R. R. Kostellow. Work: U.S. Information Agency Permanent Collection, U.S. Embassy; Larry Aldrich Museum of Contemporary Art. Exhibits: Princeton University, 1969; First National City Bank, New York, 1968-1970; Young Sculptors for Channel 13, 1970; Lever House, 1970-1972; Union Carbide, 1971; plus other group and one-man shows. Awards: Medal for Creative Sculpture, 1968 and Today's Art Medal, 1971, Audubon Artists; Merit Award for Outstanding Design and Crafts-manship in Sculpture, Artist Craftsmen New York, 1971. Media: Wax, stone, welded steel.

BITTLEMAN, Dolores Dembus. Weaver, painter. Born: 1931.
Study: Columbia University, B.S. (art), 1952; private
study Anni Albers; workshops in Europe and North Africa,
1961-1962. Work: Museum of Modern Art, New York; Yale
University, New Haven, Connecticut; Columbia University,
New York; Silvermine College of Art, New Canaan, Connecticut.
Exhibits: One-woman shows, Galerie St. Julie-le-Pauvre,
Paris, France, 1954, Barnard College, New York, 1970,
Pennsylvania State University and Webb and Parsons Gallery,
Bedford, New York, 1974; European travel exhibit, U.S.
Information Service, 1954 and 1955; Museum of Modern Art,
New York, 1969; 5th International Biennial de la Tapisserie
Ancienne et Modern, Lausanne, Switzerland, 1971; Skidmore
College, Saratoga, New York, 1971 and 1974; plus many others.
Awards: Columbia University Purchase Prize (oil painting),
General Studies Alumni Association, 1952; C.A.S.T. (computer
weaving project), New York State Arts Council, Syracuse
University, 1974; National Endowment of the Arts Grant,
1975-1976.

BLACK, Mary McCune. Curator, painter. Born: Broadwell,
Ohio, February 14, 1915. Study: Ohio University, B.S.
(education), 1937, M.F.A., 1958; Amagansett School of Art,
Sarasota, Florida; workshop study with Charles Burchfield,
William Thon, Aaron Bohrod, Paul Sample, Elliot O'Hara and
Hilton Leech. Work: F.M.C. Corporation; McJunkin Corpora-
tion; Kanawha County Public Library; Art in Embassies
Program; Lutheran Church, Parkersburg, West Virginia.
Commissions: Three murals for pediatric ward, Charleston
General Hospital Auxiliary, West Virginia, 1953. Exhibits:
Ohio Valley Regional, Ohio University, 1945; Huntington
Galleries Regional, 1954; Intermont College Regional,
Bristol, Virginia, 1957; National League of American Pen
Women, Tulsa, Oklahoma, 1968 and Smithsonian Institute,
Washington, D.C., 1963. Media: Watercolor.

BLACK, Shirley. Painter. Born: New York, New York, June
20, 1921. Study: Art Students League, with E. Yaghijian,
G. Grosz, M. Glasier and Morris Kantor; Phillips Memorial
Gallery, Washington, D.C., 1942; Columbia University
Teachers College, with Arthur Young, 1956-1957; Museum of
Modern Art, with Zoltan Hecht, 1957-1958; National Academy
of Design, with Federico Castellon and Mario Cooper.
Exhibits: Butler Institute of American Art, Youngstown,
Ohio, 1957; The Importance of the Small Painting, Nordness
Gallery, New York, 1960; The Fifth Season, Alonzo Gallery,
New York, 1969; American Watercolor Society, National
Academy School of Fine Arts, New York, 1970-1971; Philbrook
Museum, Tulsa, Oklahoma, 1971.

BLAIR, Helen (Helen Blair Crosbie). Sculptor, illustrator.
Born: Hibbing, Minnesota, December 29, 1910. Study:
Massachusetts School of Art, with Cyrus Dalin; Boston
Museum School; Archipenko School of Art, with Archipenko.
Commissions: Plaques of Dr. Waring, Colorado Medical
School, 1969 and of Dr. Porter, Porter Memorial Hospital,
Denver, 1970. Exhibits: One-man shows, Ardan Studios,
New York, 1934, Portraits, Inc., New York, 1941-1942, Vose
Galleries, Boston, 1944, St. Paul Art Center, Minnesota,
1962 and Martin Gallery, Phoenix, 1973-1974.

BLAIR, Jeanette Anne. Painter. Born: Buffalo, New York,
September 21, 1922. Study: Art Institute of Buffalo.
Work: Butler Institute of American Art, Youngstown, Ohio.
Exhibits: Butler Institute of American Art Annual, 1954,
1956 and 1970; Cooperstown Art Association Annual, New York
1969 and 1970; La Watercolor Society Annual, Baton Rouge,
1970-1972; Arena 75, Binghamton, New York, 1975;
Chautauqua Institute Annual, New York, 1975. Awards:
Purchase Awards for Watercolor, Butler Institute of American
Art, 1954; Buffalo Society Artists Award, Buffalo Savings
Bank, 1968; Arena 75 Purchase Award, Louis N. Picciano &
Sons, Binghamton, 1975.

BLAKESLEE, Sarah (Sarah Blakeslee Speight). Painter.
Born: Evanston, Illinois, January 13, 1912. Study:
Corcoran School of Art; Pennsylvania Academy of Fine Arts;
Cresson European traveling scholars; also with Catherin
Critcher. Commissions: Portraits, East Carolina University,
Greenville and St. Mary's College, Raleigh; portraits, still
life and landscapes in many private collections. Exhibits:
Art Institute of Chicago Annual, 1939 and 1940; Corcoran
Gallery Art Biennial, 1940; Pennsylvania Academy of Fine
Arts Annual, Philadelphia; National Academy of Design Annual;
North Carolina Museum Art Collectors Exhibit, 1968. Awards:
Mary Smith Prize, Pennsylvania Academy of Fine Arts, 1941;
First Prize, Woodmere Art Gallery, Chestnut Hills,
Philadelphia, 1956; First Prize and Gold Medal, Penn-Nat-
Ligonier of Pennsylvania, 1961. Media: Oil.

BLANCHARD, Carol. Painter, graphic artist. Born:
Springfield, Massachusetts, August 29, 1918. Study: Colby
Junior College; Art Students League; Painter's Workshop,
Boston. Work: Pasangrahn, St. Martin, British West Indies;
Bay Roe, Jamaica, British West Indies; San Miguel Allende,
Mexico; also in private collections. Commissions:
Illustrator, Christmas cards, United Nations. Exhibits:
Art Institute, Zanesville, Ohio, 1950; Carnegie Institute,
Pittsburgh, 1951-1959; University of Illinois, 1953;
Walker Art Center, Minneapolis, 1960; Kalamazoo Institute
of Art, Michigan; plus others. Awards: Award, Carnegie
Institute of Art, 1951-1953 and 1959 and Art Directors Club,
1955 and 1956; Benedictine Art Award Creative Arts, 1967
and 1968; plus others.

BLISH, Carolyn Bullis. Painter. Born: Washington, D.C.,
January 14, 1928. Study: Watercolor with Edgar Whitney.
Exhibits: American Watercolor Society, 1965-; Catherine
Lorillard Wolfe Art Club, 1968; Hudson Valley Art Association,
1969; Allied Artists of America, 1969-; one-woman show,
Grand Central Art Galleries, New York, 1970. Awards: Gold
Medal of Honor, Hudson Valley Art Association, 1969;
Washington School of Art Award, American Watercolor Society,
1971 and C.F.S. Award, 1972. Media: Watercolor, oil.

BLOCK, Amanda Roth. Painter, printmaker. Born: Louisville,
Kentucky, February 20, 1912. Study: Smith College;
University of Cincinnati; Art Academy of Cincinnati; Art
Students League; Herron School of Art, Indiana University-
Purdue University, Indianapolis, B.F.A.; and with Garo
Antreasian. Work: J. B. Speed Museum, Louisville,
Kentucky; Cincinnati Art Museum, Ohio; Brooklyn Museum, New
York; New York Public Library; Philadelphia Museum of Art,
Pennsylvania. Exhibits: American Sculpture Show, Chicago
Art Institute, Illinois, 1941; Society of American Graphic
Artists' Show, 1967-; Philadelphia Print Club; Watercolor,
Drawing and Print Biennial, Pennsylvania Academy of Fine
Arts, Philadelphia, 1969; Butler Institute of American Art,
Youngstown, Ohio. Awards: Katherine Mattison Watercolor
Award, Indianapolis Museum of Art, 1963; Watercolor Award,
Indiana Artists Exhibit, Sheldon Swope Art Gallery, 1964;
Ben and Beatrice Goldstein Award, Society of American
Graphic Artists Exhibit, Kennedy Gallery, New York, 1971.
Media: Acrylic, oil; serigraph, lithograph.

BLODGETT, Anne Washington. Painter. Born: New York, New
York, April 17, 1940. Study: Smith College, B.A., 1961;
Boston Museum School of Fine Arts, 1961-1962; Cambridge,
England, School of Fine Arts, 1964; also with George
Demetrios, Boston, 1963. Work: Berkshire Museum, Pittsfield,
Massachusetts; Fitzwilliam College Collection, Cambridge.
Commissions: Large landscape paintings, commissioned by Mr.
and Mrs. George Rowe, New York, 1971, Mr. Charles D. Ravenel,
South Carolina, 1972 and Mr. Lawson Bernstein, New York,
1974. Exhibits: One-woman shows, Berkshire Museum, 1971,
Caravan House Gallery, New York, 1971 and 1974 and Medici
Gallery, London, 1973; New Grafton Gallery, London, 1972;
Pioneer Gallery, Cooperstown, New York, 1974. Media: Oil
and/or collage.

BLOS, May (Elizabeth). Illustrator, painter. Born:
Sebastopol, California, May 1, 1906. Study: University of
California, Berkeley, A.B. (cum laude), 1926; also with
Perham Nahl, Eugen Neuhaus, M. Heymann and Hans Hoffman,
Munich. Commissions: Murals, Tree of Life, 1962,
Echinodermata, 1964, Paleobotany, 1965, Migration of
Molluscs, 1968 and display, Carboniferous, 1971,
Paleontology Department, University of California, Berkeley
(with help of staff). Exhibits: Hunt Botanical Library,
Carnegie Institute of Technology, Pittsburgh, Pennsylvania,
1963; Canessa Gallery, San Francisco, California, 1970;
University of California, Berkeley, 1971; Lawrence Hall
Science, Berkeley, 1975. Media: Tempera, acrylic.

BLUMBERG, Barbara Griffiths. Painter, instructor. Born:
Wheelersburg, Ohio, December 30, 1920. Study: Stratford
College, Danville, Virginia; Marshall University; also
with Fletcher Martin, Elliott O'Hara, Leo Manso and Victor
Caudall. Work: Charleston Art Gallery Permanent Collection,
West Virginia; West Virginia College Graduate Studies;
West Virginia State Capitol Building; F.M.C. Corporation,
New York; Kanawaha County Library, Charleston. Commissions:
Mural, Marshall University, 1957; tapestry, West Virginia
State House, 1970; painting, commission by Gov. Hulette
Smith, 1971; tapestry, T. F. Goldthorpe Collection, Florida,
1973. Exhibits: 280, Huntington, West Virginia, 1954-1974;
International Fabric Exhibit, Asher Gallery, London,
England, 1968; Fabric Structures, one-man national touring
exhibit, 1969; Appalachian Corridors, Fabric Sculpture,
1970; Norfolk Biennial Drawing and Graphics, Virginia, 1970.
Awards: Purchase Award for Dark Quarters, Huntington, West
Virginia, 1970, for Sun Dance, Ala Moana Art Festival,
Honolulu, 1972 and for Hill Patterns, Allied Artists of
West Virginia, 1974-1975. Media: Watercolor, oil, soft
sculpture, fabric.

BOGEN, Beverly. Painter. Born: Jersey City, New Jersey. Study: Syracuse University, B.A.; Art Students League; Pratt Graphic Art Center; and with Victor Perard, Benton Spruance, Harry Sternberg and Leo Manso. Work: Bank of Virginia, Washington, D.C.; also over 500 private collections in U.S. and abroad. Exhibits: Silvermine Guild Artists, Connecticut, 1966; Museum Secondary, Guild Hall, East Hampton, New York, 1969; Allied Artists, National Academy Galleries, New York, 1970; one-man shows, Charles Z. Mann Gallery, Vera Lazuk Gallery, 1971 and Yellow House Gallery, Huntington, New York, 1975. Media: Acrylic.

BOGERT, Grace Warren. Painter. Born: New York, New York. Study: Art Student League, with Charles Chapman, John Costigan and Robert Brackman. Work: Bergen Community Museum, Paramus, New Jersey; Leonia Public Library, New Jersey; High Ridge House, Riverdale, New York. Exhibits: American Artists Professional League, Smithsonian Institute, Washington, D.C., 1963; Exposition International, Monaco and Dieppe, France, 1967-1968; National Arts Club, 1968, Allied Artists of America, National Academy of Design, 1970, New York; Catherine Lorillard Wolfe Art Club, National Academy of Design, 1971. Awards: Catherine Lorillard Wolfe Art Club Award, 1958 and 1972; Annual Waldron Memorial Award, American Artists Professional League, 1963; First Prize (portrait), Bergen County Artists Guild, 1965; plus many others. Media: Oil.

BOHNEN, Blythe. Painter. Born: Evanston, Illinois, July 26, 1940. Study: Smith College, B.A.; Boston University, B.F.A.; Hunter College, M.A. Work: Aldrich Museum of Contemporary Art, Ridgefield, Connecticut; Allen Art Museum, Oberlin College, Ohio; Dallas Museum of Fine Arts, Texas; McCrory Corporation, New York; Whitney Museum of American Art, New York. Exhibits: Penthouse, Museum of Modern Art, New York, 1972; Painting and Sculpture Today, Indianapolis Museum of Art, Indiana, 1972; New American Abstract Painting, Vassar College Museum, 1972; American Women Artists, Kunsthaus, Hamburg, Germany, 1972; Wadsworth Atheneum, Hartford, Connecticut, 1975. Media: Acrylic, graphite.

BOLLEY, Irma S. Painter, designer. Born: Turku, Finland; U.S. citizen. Study: Mass Col Art, dipl; Art Student League; spec study with Jerry Farnsworth, F. D. Greenbowe & Joe Jones. Exhib: 32nd Ann NJ State Exhib, Montclair Mus, 1963; Exhibition of Finnish-American Art, Riverside Mus, New York, 1964; 9th Westfield Art Asn Ann, Union Col, Cranford, NJ, 1970; Crafts for Fun and Function, Union Carbide Corp, New York (courtesy McCalls Needlework & Crafts), 1970; Art from New Jersey, NJ State Mus, Trenton, 1971. Awards: First Prize for oil, Waiting, Finlandia Found, 1963; First Prize for mixed media, Growth, Summit Art Ctr, 1968 & Beneath the Earth, Westfield Art Asn, 1970. Media: Watercolor.

BOLMGREN, Donna Hollen. Educator, painter. Born: Willmar, Minn, May 28, 1935. Study: Univ Minn, B.S. (in art educ), 1957; Univ Pittsburgh, 1958; Carnegie-Mellon Univ, 1959. Work: Pvt collections. Exhib: Assoc Artists of Pittsburgh, Carnegie Mus, 1968-75; Gallery Upstairs, Arts & Crafts Ctr of Pittsburgh, 1970; William Penn Mus, Harrisburg, Pa, 1971-73; Ogleby Mus, Wheeling, W Va, 1972; Butler Mid-Year Nat, 1973. Awards: South Hills Art League Award, 1967-72 & 1974; Pittsburgh Soc of Artists Award, 1968, 1969 & 1971; Harrisburg Arts Festival Award, 1973. Media: Acrylic, mixed media.

BORETZ, Naomi. Painter, educator. Born: New York, N.Y. Study: Art Students League, with Charles Alston; Boston Mus Sch; Rutgers Univ; City Col New York, with Madeleine Gekiere, M.A. (fine arts), 1971. Work: Hudson River Mus, Yonkers; Nicholas Roerich Mus, New York; NY Univ; Fordham Univ at Lincoln Ctr; Norman Bentwich Fund, London. Exhib: One-woman shows, Contemporary Artists, Westminster Arts Coun, London, 1972, Nicholas Roerich Mus, New York, 1975 & Hudson River Mus, 1975; Awards Exhib, Brooklyn Mus Art, 1972; Contemporary Am Watercolorists, Bard Col, 1973; plus many one-woman exhib in US & Eng & many group shows. Awards: Watercolor Award, Brooklyn Mus Art, 1971; Fel, Va Ctr for Creative Arts, 1973 & 1975; Fel, Ossabaw Proj Found, 1975. Media: Acrylic, watercolor.

BORIS, Bessie. Painter. Born: Johnstown, Pa. Study: Art Student League, 1940-42; study with George Grosz and Vaclav Vytlacil. Work: Mills Col, New York; Norfolk Mus Arts & Sci, Va; Univ Mass, Amherst; NY Univ Collection; Chase Manhattan Bank, New York. Exhib: Inst Contemp Art, Boston, 1951; Pa Acad Fine Arts Ann Drawing Show, 1963 & 1969; Am Acad Arts & Lett, Childe Hassam Show, New York, 1970-72. Awards: First Painting Award, Butler Inst Am Art, 1946; First Prize Purchase Award, Mo Valley Artists, Mulvane Mus, 1948; Dana Watercolor Medal, Pa Acad Fine Arts, 1961; plus others. Media: Acrylic, ink, pastel.

BOROS, Billi (Mrs. Philip Bisaccio). Painter, writer. Born: New York, New York. Study: Art Student League, with Edwin Dickinson, Reginald Marsh and Iver Rose; Aviano Academy of Art. Work: Private collections only. Exhibits: Studio 41, the Cortile; National Arts Club, 1965; American Artists Professional League, 1965-1967; National Art League, 1969; Catharine Lorillard Wolfe Art Club, 1966 and 1969; plus others. Awards: Catharine Lorillard Wolfe Art Club Award, 1969.

BORSTEIN, Elena. Painter, lecturer. Born: Hartford, Connecticut, February 5, 1946. Study: Skidmore College, B.S.; University of Pennsylvania, B.F.A. and M.F.A. Work: American Academy of Arts and Letters; University of Idaho Museum. Exhibits: Contemporary Reflections, Aldrich Museum of Art, Ridgefield, Connecticut, 1974; one-woman show, Soho 20 Gallery, New York, 1974-1975; Hassam Purchase Fund Exhibit, American Academy of Arts and Letters, New York, 1975; Year of the Woman, Bronx Museum, 1975; Point of View, Portland Museum of Art, Maine, 1975. Awards: Childe Hassam Purchase Award, American Academy of Arts and Letters, 1975.

BOWEN, Helen Eakins. Painter. Born: Bluefield, West Virginia. Study: University of Alaska; Art Students League; National Academy School of Fine Arts; with Raymond Huit, Paris and Jose de Creeft, Hugh Gumpel, Marshall Glasier and Vincent Malta. Work: Finch College Museum of Art; Chrysler Museum, Norfolk, Virginia; Miami Museum of Modern Art. Exhibits: Catherine Lorillard Wolfe Art Club, New York, 1964; American Artists Professional League, New York, 1967; National Arts Club Gallery, New York, 1968; one-man show, Gibbes Art Gallery, 1969; Allied Artists American National Academy of Design Galleries, New York, 1970. Awards: Mark Trafton Fowler Fellowship, 1963; Louis Jambor Memorial Award, 1964; James A. Suydam Bronze Medal, 1966. Media: Oil, polymer.

BOWERS, Cheryl Olsen. Painter, lecturer. Born: Berkeley, California, September 11, 1938. Study: San Francisco Art Institute, M.F.A. (with honors); University of California, Berkeley with Fred Martin, Bob Hudson, Harold Paris and Peter Plagens. Work: University Museum, University of California, Berkeley; University Museum, Bellingham, Washington; Tamarind Lithographic Institute, Albuquerque. Exhibits: National Drawing Exhibit, Potsdam, New York, 1973; Davidson National Print and Drawing, North Carolina, 1973; Women From Permanent Collection, University Museum, Berkeley, 1973; Biennial, Whitney Museum of American Art, New York, 1975; San Francisco Museum of Art, 1975. Awards: Tamarind Lithographic Institute Fellowship, 1972; S.E.C.A. Award, Society for Creative Arts, San Francisco, 1975.

BOWERS, Lynn Chuck. Painter. Born: Philadelphia, Pennsylvania, December 21, 1932. Study: Art Students League; New School for Social Research. Work: Museum of Modern Art and Chase Manhattan Bank, New York. Exhibits: Martha Jackson Gallery, 1967; Rose Fried Gallery, 1969; Whitney Museum of American Art, 1969-1970; Museum of Fine Art, Boston, 1970; Dorsky Gallery, 1970. Media: Acrylic, watercolor.

BRADLEY, Ida Florence. Painter, instructor. Born: Johnstown, Pennsylvania, October 24, 1908. Study: Puzzletown Art School, with Lee Atkyns; Art League Ligonier Valley, with Lucile Banks and Ralph Reynolds, Indiana. Work: Watercolor, Government Building; painting, Penelec Electric Company; First Methodist Church; painting, Pitt College. Commissions: Three oils, Bethlehem Steel Corporation, Johnstown, 1958. Exhibits: Allied Artists of Johnstown, 1940-; American Artists Professional League, New York, 1972; Johnstown Area Arts Council, 1972; Arts Associates, Johnstown, 1972. Awards: Best of Show, Allied Artists Johnstown, 1953, Best Watercolor Prize, 1959; Best of Show, St. Vincent College, 1971. Media: Watercolor.

BRAMS, Joan. Painter, sculptor. Born: Montreal, Province of Quebec, March 30, 1928; U.S. citizen. Study: Ontario College of Art. Exhibits: Ft. Lauderdale Museum of the Arts, Florida; Columbia Museum of Art, South Carolina; Birmingham Museum of Art, Alabama; John Herron Museum of Art, Indianapolis, Indiana; plus others. Media: Acrylic.

BRANDFIELD, Kitty. Painter. Born: London, England; U.S. citizen. Study: National Academy of Design; Art Students League; also London, Paris and Mexico. Work: Jewish Museum, New York; American Watercolor Society; Parish Museum, Southampton, New York. Commissions: Philbrook Museum, Tulsa, Oklahoma, 1964; Bath and Tennis Club, Westhampton, New York, 1969; Baccarat Glass Exhibit, New York, 1973; Episcopal Church, Southampton, New York, 1975; Hunter College, 1975. Exhibits: American Watercolor Society, 1960, 1962 and 1963; National Academy of Design, 1963; Cord Gallery, Southampton, 1967; Jewish Museum, 1969; Parish Museum, 1974. Awards: First Prizes (oil, watercolor), Fire Island Art Association, 1952-1956; Prize for Drawing, National Academy of Design, 1954; First Prize, Annual Competition, Tulsa, Oklahoma, 1964. Media: Oil, watercolor; clay, wood.

BREIGER, Elaine. Painter, printmaker. Born: Springfield, Massachusetts. Study: Art Student League; Cooper Union, certificate in fine arts; special master printing with Krishna Reddy. Work: Lessing Rosenwald Collection, Jenkintown, Pennsylvania; New York Public Library; State University of New York College at Potsdam; University of Nevada, Reno; New York University. Commissions: Print of etching and acrylic painting for Great Ideas of Western Men series, Container Corporation of America, 1970. Exhibits: Glaser Gallery, La Jolla, California; Contemporary Gallery, Dallas; Leslie Rankow Gallery, New York. Media: Acrylic, oil.

BRENNER, Mabel. Painter. Born: New York, New York, March 27, 1906. Study: With Fred Patrone, Florida; Boston University, with Vincent Ferrini and Sydney Hurwitz; also with Victor Candell, New York and Provincetown. Work: Goddard Memorial Hospital; Chaim Gross Collection; North Easton Savings Bank. Exhibits: One-man shows, Cape Cod Art Association, 1963, Robert Brooks Studio, Hyannis, 1969 and Attleboro Art Museum, Massachusetts, 1966; Attleboro Art Museum, 1975; Avon Library, Massachusetts. Awards: Award, Brockton Art Association, 1960; Award, South Shore Festival, 1970; Award, Lutheran Church Exhibit, 1971. Media: Oil, tempera, acrylic.

BRESCHI, Karen Lee. Sculptor. Born: Oakland, California, October 29, 1941. Study: California College of Arts and Crafts, B.F.A., 1963; Sacramento State University, 1960-1961; San Francisco State University, M.A., 1965. Work: Oakland Museum, California; Crocker Art Gallery, Sacramento; San Francisco Museum of Art. Exhibits: Faculty Show Sculpture, San Francisco Art Institute, 1973, Ceramic Sculpture, 1974; Ceramics Invitational, Hoffman Gallery, School of Arts and Crafts Society of Portland, 1973; Ceramics Show, Philadelphia School of Art, 1974; Ceramics and Glass Shows, Oakland Art Museum, 1974; Clay, Whitney Museum, New York, 1974; plus many others. Awards: First Place for Painted Flower, Oakland Art Museum, 1962; Women's Architecture League Award, Crocker Art Museum, 1963; Award, California State Fair, 1963. Member: West/East Bag. Media: Clay.

BRIGADIER, Anne. Painter, lecturer. Born: New York, New York. Study: Art Student League, with Kimon Nicolaides and Morris Kantor; also with Rudolph Ray; study in France, Italy and Spain. Work: Syracuse University Museum, New York; North Carolina Museum of Art, Raleigh; University of Maryland, Baltimore; Finch College Museum, New York; Newark Museum of Art, New Jersey; plus others. Exhibits: Eastern States Exhibit of Contemporary Painting, Springfield Museum of Fine Arts, Massachusetts, 1960; solo shows, ROKO Gallery, 1961-1966; one-woman show, 30 Collages, 1954-1964, Mansfield State College, Pennsylvania, 1964; Museum of Modern Art Lending Service, Library, New York, 1966-1968; Philadelphia Museum of Art Lending Service, Pennsylvania, 1970-1972; plus others. Awards: Oil Painting Award, November Woods, Cape Cod Art Association, 1957. Media: Oil, acrylic, collage, encaustic.

BRODSKY, Judith Kapstein. Printmaker, painter. Born: Providence, Rhode Island, July 14, 1933. Study: Radcliffe College, B.A. (art history); Tyler School of Art, Temple University, M.F.A. Work: Library of Congress, Washington, D.C.; Fogg Art Museum, Cambridge; New Jersey State Museum, Trenton; First National Bank, Boston; Princeton University, New Jersey. Commissions: The Magic Muse, traveling art environment (with Ilse Johnson, M. K. Johnson and Jane Teller), Association of Arts New Jersey State Museum, 1972; Bicentennial Portfolio, Princeton, New Jersey, 1975. Exhibits: Boston Printmakers, De Cordova Museum, 1971; Society of American Graphic Artists, Kennedy Gallery, New York, 1971; Rose Art Museum, Brandeis University, 1972; one-woman shows, Brown University, Rhode Island, 1973; New Jersey State Museum, Trenton, 1975. Awards: Purchase Prizes, Washington Printmakers, Library of Congress, 1969, New Jersey State Museum, 1970 and 1971 and Boston Printmakers, 1971.

BROOKS, Phyllis Featherstone. Painter. Born: Minneapolis, Minnesota. Study: College of William and Mary; American University, B.A.; self study program in Europe, 1969-1971; also with Robert Gates, Ben Summerford, Helene Hertzbrun, Arthur Smith and Sara Baker. Exhibits: One-woman show, Federal Reserve Board, Washington, D.C., 1964; Landon School, Azalea Festival, Bethesda, Maryland, 1965; Watkins Gallery, Washington, D.C., 1965; 3rd Annual Juried Show, Northern Virginia Fine Arts Association, 1972. Awards: Northern Virginia Fine Arts Association Certificate of Merit, 1972. Media: Oil, mixed media, tempera.

BROTHERTON, Naomi. Painter, instructor. Born: Galveston, Texas. Study: Baylor University, Waco, Texas, B.A. (fine arts); Art Students League; Art Career School, New York; also with Edgar A. Whitney, Milford Zornes, Gerry Pierce, Robert E. Wood, John Pike, Rex Brandt and John C. Pellew. Work: South Arkansas Art Center, Eldorado; Baylor University Permanent Collection; Ft. Worth Public School System; Brownsville Art Association Gallery. Exhibits: American Watercolor Society, New York, 1967; Southwestern Watercolor Society, 1964-1973; Southwestern Watercolor Society Regional Exhibit, 1969; Texas Fine Arts Association Austin, 1973; Watercolor Oklahoma, Oklahoma City, 1975. Awards: Best of Exhibit, Artist and Craftsmen Association, Dallas, 1971; Third Prize, Watercolor Oklahoma, 1975.

BROWN, Gwyneth King (Mrs. Joseph Brown). Painter. Born: Barry, Wales; U.S. citizen. Study: Pennsylvania Academy of Fine Arts, Philadelphia; also with Arthur B. Carles and Dr. R. Tait McKenzie. Work: Library of Congress; Princeton University Graphics Collection; California State Library; Smith College; Free Library of Philadelphia. Exhibits: Art Institute of Chicago, 1958; Carnegie Art Institute, 1950; National Academy of Design, New York, 1951; Newark Museum, New Jersey, 1951; Pennsylvania Academy of Fine Arts, 1964.

BROWN, Judith. Sculptor. Born: New York, New York, December 17, 1932. Study: Sarah Lawrence College, B.A. Work: Memorial Art Gallery, Rochester, New York; Evansville Museum of Art; Riverside Museum, New York; Larry Aldrich Museum; Cathedral Cuernavaca, Mexico; plus others. Commissions: Mural sculpture, Lobby, Radio Station WAVE, Louisville, Kentucky; sculpture, Electra Film Productions, New York; wall sculpture, Youngstown Research Center, Ohio; plus others. Exhibits: Boston Art Festival, 1960 and 1964; Silvermine Guild of Artists, 1963 and 1964; Dallas Museum of Fine Arts, 1964; Riverside Museum, 1964; Hopkins Art Center, Dartmouth College, 1964; plus others. Awards: Frank J. Lewis Award, University of Illinois, 1959; Award, Silvermine Guild Artists, 1964.

BROWN, Marion B. Painter. Born: Brooklyn, New York, October 15, 1913. Study: Pratt Institute, School of Fine and Applied Arts, certificate in teaching; also with Edgar A. Whitney. Work: Dimes Savings Bank of New York, Brooklyn; First National City Bank, Syosset, New York; Long Island Lighting Company. Exhibits: Hudson Valley Art Association, White Plains, New York, 1961-1975; American Watercolor Society, National Academy of Design Galleries, New York, 1962, 1969, 1971-1974; Audubon Artists, National Academy of Design Galleries, 1965 and 1966; American Artists Professional League, New York, 1966-1975, Catharine Lorillard Wolfe Art Club, National Academy of Design Galleries, 1967-1975. Awards: Herb Olsen Award, American Watercolor Society, 1971; Gold Medal, Hudson Valley Art Association, 1971; Gold Medal, Franklin Mint Gallery of American Art, 1973. Media: Watercolor.

BROWN, Peggy Ann. Painter. Born: Ft. Wayne, Indiana, March 15, 1934. Study: Marquette University, B.S. (journalism); Ft. Wayne Art Institute. Work: Indiana University, Bloomington; Indiana University, Ft. Wayne; Emerich Manual High School, Indianapolis; Ernst, Ernst & Ernst, Ft. Wayne; Indiana State Bank, Indianapolis. Exhibits: Allied Artists of America, New York, 1970-1974; Watercolor U.S.A., Springfield, Missouri, 1972-1973 and 1975; National Watercolor Society, Los Angeles, 1972-1974; Ball State University National Drawing and Sculpture, 1973 and 1975; American Watercolor Society, New York, 1974. Awards: Windsor-Newton Award, New Jersey Society Painters and Sculptors, 1973; McCarthey Award Watercolor, Chautauqua National, New York, 1973; Second Award, La National Watercolor Society, 1974. Media: Transparent watercolor, drawings.

BROWNETT, Thelma Denyer. Painter. Born: Jacksonville,
Florida, October 26, 1924. Study: Wesleyan Conservatory,
B.F.A. (magna cum laude), 1946, with Emile Holzhauer;
Columbia University, 1948, with Dr. Edwin Ziegfield;
University of Georgia, M.F.A., 1952, with Lamar Dodd, James
Johnson Sweeny and William Zorack. Work: Georgia Museum
of Art, Athens; Gertrude Herbert Art Museum, Augusta,
Georgia; Atlanta Art Museum, Georgia; Ringling Museum of
Art, Sarasota, Florida; also private collections in the
U.S. and abroad. Commissions: Mural, Puppet Playhouse,
Augusta, Georgia, 1951; hundreds of portraits, 1956-;
Reredos, St. Peter's Church, Jacksonville, Florida, 1958;
Triptych, St. Mark's Episcopal Church, Jacksonville, 1963;
mural, Off Building, San Jose Plaza, Jacksonville, 1965.
Exhibits: American Artists Professional League National
Exhibit, New York, 1952; National Association of Women
Artists, Argent Gallery, New York, 1954; A.C.A. Gallery
National, New York, 1955; Arts Festival Twelve, Regional
International, Jacksonville, 1971; Florida Artist Group
State Exhibit, St. Augustine, Florida, 1972 and 1973.

BROWN GREENE, Lucille. Painter, lecturer. Born: Los
Angeles, California. Study: University of California,
Los Angeles, with Richard Haines, Rice Hebrun and Stanton
MacDonald-Wright. Work: Long Beach Museum of Art,
California; Dixie College, St. George, Utah; Utah State
Agricultural College, Logan; Long Beach State College
Art Department, California. Exhibits: Butler Institute
of American Art; California National Watercolor Society;
Los Angeles County Museum of Art; Pasadena Museum,
California; Museum Belle Arts, Mexico City, Mexico.
Awards: Stairway of the Stars Award, Santa Monica City
and Board of Education, 1968; American Watercolor Society
Award, California National Watercolor Society, 1971; two
Awards, Women Painters of the West, 1971 and 1972.
Media: Acrylic, oil, watercolor.

BRULC, Lillian G. Painter, sculptor. Born: Joliet, Ill.
Study: Art Inst Chicago, George D. Brown Foreign Travel
fel., 1955, with Louis Ritman, Robert Lifvendahl & Egon
Weiner, B.F.A., 1955, M.F.A., 1964; also with Franz Gorse,
N.Y. Work: Major works in permanent architectural
environments, smaller works in private collections.
Comn: Murals & sculpture, Cardinal's Comt for Span
Speaking, Chicago, 1963-64; murals, San Miguelito Center,
Panama, 1965, metal grillwork designs, in process; mural,
Chapel, San Miguelito, Panama, 1966; sculptures (assisted
by Che Torres & Ruben Arboleda), Chapel & Garden, San
Miguelito, 1968-69; murals, Archdiocesan Latin Am Comt,
Chicago, 1971. Exhibits: Prints, Drawings & Watercolors
2nd Biennial by Ill Artists, Art Inst Chicago, 1964; one-
man show, Drawings & Lithographs, Casa de Escultura,
Panama City, 1969; Murals for People (slide of Chicago
works), Mus Contemp Art, Chicago, 1971. Media: Acrylic,
mixed media, clay to cement or plaster; welding.

BRUNER, Lucile Spire. Painter, designer. Born:
Chautauqua Co., Kansas, September 6, 1909. Study: Univ
Okla, Norman, B.F.A.; seminars with Robert Uecher, Robert
Wood & Keith Ward. Work: Oklahoma Hist Soc, Oklahoma
City; Amarillo Pub Libr, Tex; Las Vegas Art Mus, Nev;
Clark Co Pub Libr, Las Vegas. Comn: Mural, WPA, High
School, Muskogee, Oklahoma, 1933; mural, Fathers Waiting
Room, Rose de Lima Hosp, Henderson, Nevada, 1963; murals
for model homes, Sproul Homes; murals, Sun & Sand Motel,
Las Vegas, 1972; murals, Tivoli Motel, Las Vegas, 1975.
Exhibits: One-woman show, Las Vegas Art League, 1955;
Nat League Am Pen Women, Las Vegas, 1957; U.S. Senate,
Howard W. Cannon Bldg, Washington, D.C., 1968; Jayell
Travel Exhib, 1970; All Nev Show & Tour. Awards: Award
of Merit, Am Inst Archit; Jayell Publ Award, Nat Art
Roundup, Las Vegas, 1970; Award for Watercolor, Nat League
Am Pen Women, 1971. Media: Watercolor, oil, acrylic.

BUBA, Joy Flinsch. Sculptor, illustrator. Born: Lloyd's
Neck, N.Y., July 25, 1904. Study: Eberle Studio, New
York; Staedel Kunst Inst, Frankfurt, Ger; Art Acad,
Munich, Ger; also with Theodor Kaerner & Angelo Yank.
Work: David Mannes, Metrop Mus Art, New York; Florence
Sabin, Statuary Hall, Capitol Bldg, Washington, D.C.;
Norman Thomas & Margaret Sanger, Nat Portrait Gallery,
Washington, D.C.; John D. Rockefeller, Jr, Rockefeller
Plaza, New York; Konrad Adenauer, Palais Schaumberg, Bonn,
Ger.

BUBB, Nancy (Jane). Sculptor, curator. Born: Bronx, N.Y.,
January 3, 1945. Study: State Univ NY, Farmingdale;
Greenwich House Pottery, with Bob Stull & Jane Hartsook;
Clay Art Ctr with Jim Howard. Exhibits: Calhoun Col Ann
Craft Expos & Symp, Yale Univ, 1973; Fun & Fantasy, Xerox
Corp Gallery, Rochester, 1973; Folk Roots Contemp Crafts,
Fairtree Gallery, New York, 1975; one-woman show,
Millersville State Col, 1975; two-woman show, Clay & Fiber
Gallery, Taos, New Mexico, 1975. Awards: Court of Honor/
Ithaca, NY State Craftsmen, 1973. Media: Clay, fabric.

BUGBEE, Joan Scott. Sculptor, educator. Born: Oakland,
California, December 17, 1941. Study: Univ Mont; San
Jose State Col, B.A. & M.A.; Art Students League, with
R. B. Hale; Sch of Fine Arts, Nat Acad Design; also with
M. Wildenhain, EvAngelos Frudakis, Joseph Kiselewski,
Granville Carter & Adolph Block. Work: Cordova Pub Libr,
Alaska. Comn: J. Goldsmith Portrait, comn by D.
Goldsmith, New York, 1971; Henrietta Shaw Portrait, comn
by Milton Shaw, New York, 1971; three portraits, comn by
C. Crawford, Forest Hills, N.Y., 1972; Merle K. Smith
Medal, comn by Kenneth Van Brocklin, Cordova, 1972; Bob
Korn Commemorative Plaque, City of Cordova, 1974. Exhib:
One-woman show, Springvale, Maine, 1970; Nat Sculpture
Soc Ann, New York, 1970-73; Allied Artists Am Ann, New
York, 1970-72; Nat Acad Design Ann, New York, 1971 & 1974;
Joan Bugbee, Retrospective, New York, 1972. Awards:
Helen Foster Barnet Prize, Nat Acad Design, 1971; Daniel
Chester French Prize, Nat Sculpture Soc, 1972 & C.
Percival Dietsch Prize, 1973. Media: Fired stoneware
clay, cast bronze.

BUHRMAN, Ruth Ewing. Painter. Born: Easthampton, Mass.,
March 3, 1923. Study: Corcoran Sch Art; Art League
Northern Va, Alexandria, with Joy Luke, James Twitty &
Frank Getlein. Exhibits: Ann Exhibs, Washington Soc
Artists, Smithsonian Mus Nat Hist, Washington, D.C., 1962,
1963 & 1965; Ann Exhibs, Va Mus Fine Arts, Alexandria,
1971 & 1972; Art League Northern Va, 1972. Awards: Blue
Ribbon, 1970 & Cert of Merit, 1972, Va Mus Fine Arts;
Aschille Gorky Award, Waterford Found, 1971. Media:
Acrylic.

BURCH, Claire R. Painter, writer. Born: New York, N.Y.,
February 19, 1925. Study: Wash Sq Col, NY Univ, B.A.,
1947. Work: Butler Inst Am Art, Youngstown, Ohio;
Guild Hall, East Hampton, NY; Birmingham Mus, Ala;
Brooklyn Mus, NY; Beth Israel Hosp, New York. Exhib:
One-man shows, Ruth White Gallery, New York, 1963,
Galerie L'Antipoete, Paris, France, 1963, Southampton Col,
1964-65 & Roko Gallery, 1964; Maniacal Laughter, Westbeth
Gallery, New York, 1971. Awards: First Prize for
Representational Painting, Guild Hall, 1965; First Prize
for Watercolor, North Shore Community Art Ctr, 1965;
Third Prize for Watercolor, Brooklyn Mus, 1965. Media:
Watercolor, collage.

BURNETT, Patricia Hill. Painter, sculptor. Born: Brooklyn,
N.Y. Study: Univ Toledo; Goucher Col; Corcoran Art Sch;
Soc Arts & Crafts; Inst Allende, Mex; Wayne State Univ;
Truro Sch Art; also with John Carroll, Sarkis Sarkisian,
Wallace Bassford, Walter Midener & Seong Moy. Work:
Detroit Inst Arts, Mich; Bloomfield Art Asn, Mich; Wayne
State Univ; Wooster Col; Ford Motor Co Collection, Detroit.
Comn: Oil portrait, Joyce Carol Oates, Windsor, Ont, 1972,
Indira Ghandi, Prime Minister, New Delhi, India, 1973,
Roman Gribbs, Mayor Detroit, 1973, Hiram Walker, Windsor,
1974 & Benson Ford, Ford Motor Co, Detroit, 1975. Exhib:
Michigan Artists Show, Detroit Inst Arts, 1967; Show of
Paintings, Palazzo Pruili Gallery, Venice, Italy, 1971;
Butler Mus Nat Art Show, Cleveland, Ohio, 1972; Int Art
Show, Windsor, Ont, 1973; Ms & Masters, Midland Ctr Arts,
Midland, Mich, 1975. Awards: First Prize Sculpture,
Scarab Club Gold Medal Show, 1966; First Prize Painting,
Figure Painting Show, Boston, 1969; First Prize, Western
Art Show, Albuquerque, New Mexico, 1974. Media: Oil on
canvas; wax for casting in bronze & clay.

BURNSIDE, Katherine Talbott. Painter. Born: Ft. Worth,
Texas. Study: Colorado Springs Fine Art Ctr; Claremont
Col; Ohio Univ; also with Henry Lee McFee, Maurice Sterne,
Josef Albers, Victor Candell & Leo Manso. Work: Arts
& Humanities W. Virginia Collection; IBM Corp Collection;
Charleston Art Gallery, W Va; Huntington Gallery, W Va;
W Va Univ. Exhib: Dayton Art Inst, Ohio, 1962; Nine
Artists of W Va Traveling Show, 1963; Four Arts, Palm
Beach, Florida, 1965; Provincetown Art Asn, Mass, 1973;
W Va Univ Ctr, 1974. Awards: Prize, Cape Cod Art Asn,
1965; Graphics & Drawings Award, Charleston Art Gallery,
1970 Purchase Award, Allied Artists W Va, 1972. Media:
Oil, acrylic.

BURTON, Gloria. Sculptor, painter. Born: New York, N.Y.
Study: Mt. Holyoke Col, Mass; Art Students League; Univ
Calif, Los Angeles. Work: Holyoke Mus Art, Mass. Comn:
Aluminum-bronze sculpture, Stanley Folb Bldg, Hollywood,
1968; bronze, brass & copper sculpture, Empire Savings &
Loan, Santa Ana, Calif, 1969; bronze sculpture, Dillingham
Corp, Los Angeles, 1971; bronze sculpture, Danmour & Assoc
(in mall), Reseda Village Green, Reseda Village, Calif;
2 bronze sculptures, Security Pac Bank, Oxnard, Calif,
1972. Exhib: Sacramento State Fair; San Francisco Mus
Art; two-person shows, Machinations, Mus Sci & Indust, Los
Angeles, 1973 & Chicago, 1975 & Of Art & Medicine, Mus
Sci & Indust, Los Angeles, 1975. Awards: Awards for
People of the City, Southland Ann, Del Mar, Calif, 1969,
Decent, Westwood Art Asn & Revelation, Santa Monica Ann.
Media: Bronze; watercolor.

BUSCH, Julia M. Writer, sculptor. Born: Teaneck, N.J.,
March 27, 1940. Study: Julliard Sch Music; Univ Miami,
with Eugene Massin & Dr. August Freunlich; Columbia Univ,
with Dr. Douglas Frasier, B.A. Comn: Acrylic & light
mural (with Eugene Massin), City Nat Bank of Miami, 1973.
Awards: Scholar, Univ Miami, 1968.

BUSH, Beverly. Painter, sculptor. Born: Kelso, Wash.
Study: Univ Wash, B.A.; Nat Acad Design Sch Fine Arts;
Art Students League. Exhib: Nat Asn Women Artists, 1958;
City Ctr, New York, 1958; Art: USA, 1959; Audubon Artists,
1959; Seattle Art Mus, 1964; plus others. Awards: Youth
Friends Asn Scholar, Nat Acad Design, 1954-55; Joseph
Isador Merit Scholar, 1955-57.

BUSH, Lucile Elizabeth. Painter, educator. Born: Mt.
Sterling, Kentucky, July 26, 1904. Study: Univ Ky, A.B.;
Teachers Col, Columbia Univ, M.A. & Ph.D.; Art Students
League; also with Leger, L'Hote & Marcoussis, Paris. Work:
Skidmore Col, Saratoga Springs, NY. Comn: Portraits,
pvt cols; scenery & costume design, Harwich Jr Theatre,
Mass. Exhib: One-man shows, Saratoga Springs, Schenectady
& Glens Falls, NY. Awards: Carnegie Scholar, 1930;
Elizabeth Avery Colton Fel, Am Asn Univ Women, 1945-46.

BYARD, Carole Marie. Painter, illustrator. Born:
Atlantic City, NJ, July 22, 1941. Study: Fleisher Art
Mem, sculpture with Aurelius Renzetti; New York-Phoenix
Sch Design, painting with Felix & Trini DeCosio, cert.
Comn: Religious mural, House of Light, Ibaden, Nigeria,
1972; panel for Kwanza celebration, Studio Mus, Harlem,
NY, 1973 & 1974; three large outdoor murals, one ceramic,
Archit Asn, NY State & HUD, 1976. Exhib: Kujichagulia,
Studio Mus, Harlem, 1973; Blacks: USA Now, New York Cult
Ctr, 1973; In Her Own Image, Fleisher Art Mem, Philadelphia,
1974; Children of Africa, Am Mus Matural Hist, New York,
1974-75; Sojourn, Carole Byard, Valerie Maynard, Gallery
1199, New York, 1975. Awards: Ford Found Travel Grant,
Inst Int Educ, 1972.

BYRUM, Mary. Painter. Born: Louisville, Ky., September
15, 1932. Study: Art Ctr of Louisville; Univ Louisville;
also portrait painting with John Dempsey & life drawing with
Eugene Leake. Work: Bellarmine Col Gallery, Louisville.
Exhib: Hunter Gallery, Chattanooga, Tenn, 1963;
Evansville Mus, Ind, 1964; one-man shows, Brescia Col,
Owensboro, Ky, 1966, Seaton House Gallery, Jeffersontown,
1968 & Port O'Call Gallery, Louisville, 1970; plus others.
Awards: Best Representational Award, 1962, Second Place,
1964, Ky State Fairs; First in Representational,
Louisville Women's Club, 1966.

CABLE, Maxine Roth. Sculptor. Born: Philadelphia, Pa.
Study: Tyler Sch Fine Art, Temple Univ, A.A.; Corcoran
Sch Art, George Washington Univ, A.B.; Am Univ, with Hans
Hofmann. Work: Allied Chem Corp Gallery, New York; Nat
Acad Sci, Washington, D.C.; George Washington Univ.
Comn: Environ sculpture, Allied Chem Corp, 1969-70;
sculpture, Wolf Trap Farm Performing Arts, Va, 1973.
Exhib: Area Exhibs, Corcoran Gallery Art, 1955-67;
Artists Equity Traveling Exhib, Columbia Mus, SC, 1973-74;
one-woman shows, Adams Morgan Gallery, Washington, D.C.,
1964, Hodson Gallery, Hood Col, Frederick, Md., 1969 &
Gallery Ten, Washington, D.C., 1975. Awards: Sculpture
Award, David Smith, Corcoran Gallery Art, 1955; First
Prize in Painting, Smithsonian Inst, 1967. Media: Mixed
media, natural and man-made.

CAIMITE (Lynne Ruskin). Painter, illustrator. Born: Youngstown, Ohio, January 23, 1922. Study: Syracuse Univ, 1938-40; Cleveland Inst Art, 1940-41; Western Reserve Med Sch, spec study in anat, 1952-53. Work: Butler Inst Am Art, Ohio; Elliott Mus, Fla. Comn: Oil portrait, comn by UN rep from Holland, Van der Heijden, Haiti, 1963; oil landscape, comn by Baroness Von Bronkhurst, San Jaun, PR, 1964. Exhib: One-woman shows, Butler Inst Am Art, Ohio, 1962, La Casa del Arte, PR, 1965 & Elliott Mus, Fla, 1974; Inst Francaise, Haiti, 1963; Ferre Mus, PR, 1964; among other one-woman shows. Media: Oil, watercolor.

CAMPANELLI, Pauline Eble. Painter. Born: New York, NY, January 25, 1943. Study: Ridgewood Sch Art, NJ, grad; Art Students League. Comn: Illus of New York area geol hist, Paterson Mus, NJ, 1969; still life oils, Scafa-Tornabene Art Publ Co, White Plains, NY, 1971. Exhib: One-man shows, Am Art Gallery, Greenwich, Conn, 1967 & Edward Williams Col, 1969; Exhibition of Contemporary American Realism, Hammond Mus, North Salem, NY, 1968; Am Artists Prof League Grand Nat Show at Lever House, New York, 1968 & 1970-72; Hudson Valley Show, White Plains, NY, 1971. Awards: Gold Medal Award for Oils, Catherine Lorillard Wolfe Art Club, 1971; Best in Show Award, Garden State Plaza Art Exhib, 1971 & 1972; Distinguished Serv Award, Am Artists Prof League, 1972. Media: Oil.

CAMPBELL, Dorothy Bostwick. Painter, sculptor. Born: New York, NY, March 26, 1899. Study: Study with Eliot O'Hara, Washington, D.C. & Marilyn Bendell, Cortez, Fla. Work: Cooperstown Art Asn, NY; Mystic Mus, Conn; Pioneer Gallery, Cooperstown. Exhib: Cooperstown Art Asn, var group & one-man shows, 1965; var shows, Sarasota Art Asn, Fla, Pioneer Gallery, Cooperstown & Am Art League, Washington, D.C.; Cortez Art Sch, Fla, 1972. Awards: First Prize for Watercolor, Collectors Corner, Washington, D.C.; Purchase Prize for Watercolor, Cooperstown Art Asn, 1965; Merit Award for Oils, Cortez Sch Art Exhib, 1972.

CAMPBELL, Gretna. Painter, educator. Born: New York, NY, March 23, 1923. Study: Cooper Union; Art Students League, with Morris Kantor. Work: Long View Found. Exhib: Whitney Mus Am Art; Corcoran Gallery Art; Pa Acad Fine Arts: Mus Mod Art. Awards: Pearl Fund Grant, 1947-50; Tiffany Found Grant, 1952-53; Fulbright Fel, 1953-54. Media: Oil.

CAMPBELL, Marjorie Dunn. Painter, educator. Born:
Columbus. Ohio, September 14, 1910. Study: Ohio State
University, B.S. & M.A.; Claremont Col Grad Inst Art;
Teachers Col, Columbia Univ; also with Hans Hofmann,
Emil Bisttram & Millard Sheets.

CANARIS, Patti Ann. Painter. Born: Billings, Mont,
February 27, 1919. Study: Eastern Mont State; Wash State
Univ; Univ Mont, B.F.A. (with honors). Comn: Off ctr
fountain design, Architect Don Miller, Spokane, Wash, 1964;
watercolor, Univ Mont, Missoula, 1971; cover, N Mex
Wildlife Mag, 1972. Exhib: Western Mont Art Potpourri,
Missoula. 1971-74; Southwest Wildflower Contest, Santa
Ana, Calif. 1975; El Prado Galleries. Sedona. Ariz;
Gallery A5. Billings; Dos Pajaros Gallerv. El Pasn, Tex;
plus others. Awards: Montague Commercial Artist of the
Year, 1952; Award, Award Pictures Calif, 1958.

CANFIELD, Jane (White). Sculptor. Born: Syracuse, NY,
April 29, 1897. Study: Art Students League; James Earle
& Laura Gardin Fraser Studio; Borglum Sch; also with A.
Bourdelle, Paris, France. Work: Whitney Mus Am Art;
Cornell Univ Mus Art. Comn: Six animals in lead for gate
posts, comn by Paul Mellon, Upperville, Va, 1940; animals
in lead for gym entrance, Miss Porters Sch, Farmington,
Conn, 1960; St. John Apostle in stone, Church of St. John
of Lattington, Locust Valley, NY, 1963; herons in stone,
Mem Sanctuary, Fishers Island, 1969; Canadian geese in
bronze for pool, Long Lake, Minn, 1971. Exhib: Sculpture
Pavilion, New York World's Fair, 1939; one-man show ,
Brit-Am Art Gallery, New York, 1955 & Far Gallery, New
York, 1961, 1965 & 1974; Country Art Gallery, Locust Valley,
1971. Media: Stone, bronze.

CANRIGHT, Sarah Anne. Painter. Born: Chicago, Ill.,
August 20, 1941. Study: Art Inst Chicago, B.F.A. Work:
Kresge Found, New York; Sam Koffler Found & Ill Bell Tel
Co, Chicago; Gould Corp, Ill. Exhib: Nonplussed Some,
Hyde Park Art Ctr, Chicago, 1968-69; Famous Artists, Mus
Contemp Art, Chicago, 1969; Famous Artists, Another Load.
San Francisco Art Inst, 1970; 73rd Vicinity Show, Art
Inst Chicago & Phyllisteens, Phyllis Kind Gallery, Chicago,
1971. Awards: Armstrong Award, Art Inst Chicago, 1971.
Media: Oil, acrylic.

CARDMAN, Cecilia. Painter. Born: Soveria Mannelli,
Italy; U.S. citizen. Study: Univ Colo, B.F.A.; Inst
Belli Arte, Naples, Italy; with Giuseppe Aprea, Naples;
Nat Acad, New York, with Leon Kroll, Milford Zornes &
E. A. Whitney. Work: Mesa Col, Grand Junction, Colo;
Grand Junction C of C; Cathedral Rectory, Denver, Colo;
Chapel House, Denver Art Mus. Exhib: One-man show,
Naples, Italy & Grist Mill Gallery, Chester Depot, Vt;
Nat Arts Club, Hammond Mus; Gallery North Star, Grafton,
Va; Denver Art Mus; Knickerbocker Artist, Catherine
Lorillard Wolfe Art Club; plus others. Awards: Old Man,
Grand Junction C of C; Shadows & Mexican Doorway,
Jackson Heights Art Club. Media: Watercolor, oil.

CARL, Joan Strauss. Sculptor, graphic artist. Born:
Cleveland, Ohio, March 20, 1926. Study: Cleveland
School Art; Chicago Art Inst; Mills Col; with Dong
Kingman, Bordman Robinson, Carl Morris & Albert Wein;
New Sch Art, with Arnold Mesches & Ted Gilien. Work:
NC Mus Art, Raleigh; Int Cult Ctr for Youth, Jerusalem,
Israel. Comn: Carved walnut pulpit, Methodist Church,
Palm Springs, Calif, 1967; brazed welded steel Menorah,
Eternal Light & Candlesticks, Temple Adat Ariel, Los
Angeles, 1969; bonded bronze relief, Capital Nat Bank,
Cleveland, 1972; poly bronze & welded steel relief, Repub
Savings & Loan, Los Angeles, 1974; mosaic wall, Mt.
Sinai Mem Park, Los Angeles, 1975. Exhib: Am Inst
Architects Design Ctr, Los Angeles, 1968; one-woman show,
Laguna Beach Art Mus, 1969; Fresno Art Mus, 1971;
Muskegon Community Col, 1973; Chai (graphics), Nat & Int
Traveling Show, 1974-75. Awards: Honorable Mention,
Nat Orange Show, San Bernardino, 1958 & Calif State Fair,
Sacramento, 1970 & 1972. Media: Stone, wood.

CARLSON, Cynthia J. Painter, instructor. Born: Chicago,
Ill, April 15, 1942. Study: Chicago Art Inst, B.F.A.;
Pratt Inst, M.F.A. Work: Va Mus Fine Art, Richmond;
Kemper Ins; Atlantic Richfield Co. Exhib: Towards a New
Metaphysics, Allan Frumkin, NY; Paris Biennale for Young
Artists, 1971; one-woman exhibs, Phyllis Kind Gallery,
Chicago, 1973, Hundred Acres, New York, 1975 & Marion
Locks Gallery, Philadelphia, 1975; plus others. Media:
Oil, acrylic.

CARLSON, Jane C. Painter. Born: Boston, Mass., Sept.
1, 1928. Study: Art Students League; Mass Col Art;
study with Charles Kinghan & Robert Davis. Exhib: Hudson
Valley Art Asn, 1969-74; Am Artists Prof League, 1970-75;
Am Watercolor Soc, Nat Acad Design, New York, 1971-75;
Audubon Artists, 1973-74. Awards; James Holton Mem Award,
Audubon Artists, 1973; Robert Simmons Award, Hudson Valley
Art Asn, 1973; Windson & Newton Award, Am Artists Prof
League, 1974.

CARMEL, Hilda Anne. Painter. Born: New York, NY. Study:
Cuty Col New York; NY Univ; Art Students League, with
Reginald Marsh. Work: Jewish Mus, New York; Evansville
Mus Arts & Sci, Ind; Bat Yam Mus & Sholom Ash Mus, Israel;
Long Island Univ Mus, Brooklyn, NY. Exhib: Soc Ecole
Francaise Expos, Paris, 1970; Yonkers Art Asn, Hudson
River Mus, NY, 1971; Painters & Sculptors NJ, Jersey City,
1972; Lehigh Univ, Bethlehem, Pa, 1972; Opening Exhib,
Bronx Mus Art, 1972. Awards: First Prize, Soc Ecole
Francaise Expos, Mus Mod Art, Paris, 1970; Hon Mention,
Bronx Coun on Arts, 1970; Medal of Honor, Cent Studi e
Scambi Int, Italy, 1971.

CARR, Sally Swan. Sculptor. Born: Minong, Wis. Study:
NY Univ; advan sculpture, Phoenix Sch Design; life sketch,
Clay Club; also with John Hovannes, Frederick Allen
Williams & wax tech with Paul Manship; Art Students League.
Work: Am Numismatic Soc, New York; Basketball Hall of
Fame, Springfield, Mass; Cayuga Mus Art & Hist, Auburn,
NY; Florentine Craftsmen, New York. Exhib: Archit League
New York, 1955-71; Catharine Lorillard Wolfe Art Club,
New York, 1960-; Nat Arts Club, New York, 1967-70; Nat
Acad Design, Allied Artists, 1969-70; Acad Artists,
Springfield Mus Art, Mass, 1970. Awards: A. H.
Huntington First Prize Trophy, Catharine Lorillard Wolfe
Art Club, 1970; Founders Prize & Plaque, Pen & Brush Club,
New York, 1970; bronze & silver medals, City of
Kaysersburg, 1970. Media: Stone.

CARREL, Claudia. Painter, sculptor. Born: Paris, France,
Jan. 11, 1921. Study: Boston Mus Fine Arts Sch Fine Arts;
Art Students League; Pratt Graphic Art Ctr; Hans Hofmann
Sch Art. Work: Rose Art Mus, Brandeis Univ; Philip
Johnson Mus, Cornell Univ; Boston Mus Fine Arts; Norfolk
Mus Arts & Sci; Columbia Univ Art Collection; plus others.
Exhib: Am Fedn Arts Traveling Exhib, 1968; Fine Arts Found,
Hartford, Conn; Parrish Art Mus, Southampton, NY; Univ Md
& others; plus many one-man shows, New York. Awards:
Prizes, Nat Acad Design, 1962; Grumbacher Award, Audubon
Artists, 1963. Media: Wood.

CARRINGTON, Joy Harrell. Painter, illuminator. Born: Jacksonville, Tex. Study: Kansas City Art Inst, three years; Am Acad Art, Chicago; Nat Acad Chicago; Chicago Art Inst, with Pougialis; Art Students League, four years; also with Frank Peyraud, Highland Park, Ill & Robert Brackman, Noank, Conn. Work: Long Barrack Mus, Alamo; First Methodist Church, Jacksonville; Alamo Libr; Coppini Acad Fine Arts; San Antonio; State Capitol Bldg, Austin. Exhib: One-man shows, Witte Mem Mus, San Antonio, 1963 & St. Marys Univ, 1964; Ann Western Art Show, Coliseum, San Antonio, 1964-72; Am Artists Prof League Grand Nat Exhib, 1967-72; Meinhard Galleries, Houston, 1967-72. Awards: Coppini Acad Award for Oil Painting, Witte Mus, 1957; Grumbacher Award for Oil Painting, Am Artists Prof League, 1969; Sculpture Award, Kansas City Art Inst. Media: Oil.

CARRON, Maudee Lilyan. Painter, sculptor. Born: Melville, La. Study: Creative Arts Sch, Houston, scholar, with McNeill Davidson; Lamar Univ; & with Dr. James McMurray. Work: Univ Tex Austin. Comn: Poster & stage sets for Glass Menagerie, Who's Afraid of Virginia Woolf? & Macbeth, Univ Tex Austin Drama Dept, 1970 & 1972. Exhib: 16 Southeastern States & Tex Exhib, New Orleans Mus, 1963; Eight State Exhib, Okla Art Ctr, Oklahoma City, 1968; one-man shows, Images, Univ Tex Fine Arts Gallery, 1970, Environment 71, Univ Tex Austin, 1971 & Et Cetera 3, Southwestern Univ, 1972. Awards: Miller Award for Incognito, Beaumont Art Mus, 1968 & two awards for A Dangerous Game in Archaic Form, 1970; Award for A Temple for All Delights, Tex Fine Arts Asn, 1969. Mem: Tex Watercolor Soc; Tex Prof Sculptors Soc; Tex Fine Arts Asn; Beaumont Art Mus; Graphic Soc, Lamar Univ. Media: Metal, acrylic.

CARSTENSON, Cecil C. Sculptor, lecturer. Born: Marquette, Kansas, July 23, 1906. Study: Kansas City Art Inst; Univ Nebr; Art Inst Chicago; also with several sculptors in Italy. Work: Joslyn Mus, Omaha, Nebr; Phoenix Art Mus, Ariz; Univ Mo-Kansas City; Nelson Gallery Art, Kansas City; Jewsih Community Ctr, Kansas City; plus others. Exhib: Mid America, Nelson Gallery Art; Joslyn Art Gallery Show; Mo Pavilion Exhib, New York World's Fair; St. Louis Mus Show; Denver Art Gallery Show. Awards: Hon Mention & Purchase Award, Mid America, Nelson Gallery Art. Media: Wood.

CASE, Elizabeth. Painter, writer. Born: Long Beach, Calif., July 24, 1930. Study: French Inst, New York, 1946, with Mr. Lee; Art Students League, 1948 & 1949, with Vlascov Vytlacil, Robert Hale, Reginald Marsh& Harry Sternberg. Work: U.S.N. Combat Art Collection, Washington, D.C.; Elmira Col Ford Mus, NY. Exhib: One-man shows, Research Libr, Walt Disney Studios, Burbank, Calif, 1956 & 1957, D'Alessio Gallery, 1964 & Gallery 8, Henderson Place, New York, 1969; Am Freedoms Caravan Mural Design Exhib, Nat Arts Club, New York, 1975; Nat Exhib Miniature Paintings, Nutley, NJ, 1975. Awards: Spring Concours Award, Art Students League, 1948; Second Award, Wyn Rogers Gallery, Cliffside Park, NJ, 1964; Honorable Mention, Leonardo da Vinci Art Soc Ann, Bergen Community Mus, NJ, 1971. Media: Egg tempera & oil in mixed technique; elaborate pencil, pen & ink.

CASTORO, Rosemarie. Painter, sculptor. Born: Brooklyn, NY, March 1, 1939. Study: Mus Mod Art, New York, scholar, 1954-55; Pratt Inst, B.F.A. (cum laude), 1956-63. Work: Berkeley Mus, San Francisco; Woodward Found, Washington, D.C. Comn: Procession of Strokes, NY State Coun Arts, 1972. Exhib: Distillation, Tibor de Nagy Art Gallery, New York, 1966 & one-man shows, 1971, 1972, 1973 & 1975; The Drawn Line, 470 Parker St. Gallery, Boston, 1971; Highlights of the 1970-71 Art Season, Aldridge Mus Contemp Art, Conn, 1971; Painting & Sculpture, Storm King Mountain, NY, 1972, 1974 & 1975; one-man show, Syracuse Univ Lubin House Gallery, 1973. Awards: Guggenheim fel, 1971-72; NY State Coun Arts, 1972 & 1974; Nat Endowment Arts, 1975.

CASWELL, Helen Rayburn. Painter, writer. Born: Long Beach, Calif., March 16, 1923. Study: Univ Ore Sch Fine Arts. Comn: Murals, Federated Church, Saratoga, Calif, 1965; Mem Paintings, San Jose Hosp, Calif, 1967 & Emanuel Lutheran Church, Saratoga, 1969. Exhib: De Young Mus Show, Soc Western Artists, 1961; one-man shows, Northwest Mo State Col, 1966 & Rosicrucian Mus, San Jose, 1970; Montalvo Cult Ctr, Saratoga, 1968. Awards: James D. Phelan Award for Narrative Poetry, 1958; San Francisco Browning Soc Award, 1966. Media: Oil.

CATCHI (Catherine O'Childs). Painter, sculptor. Born: Philadelphia, Pa., August 27, 1920. Study: Briarcliff Jr Col, 1937; Commercial Illus Studios, 1938-39; Paul Wood Studio, 1949-55; with Leon Kroll, Harry Sternberg & Hans Hofmann; also with Angelo Savelli, Positano, Italy. Work: Hofstra Univ, Hempstead, NY. Exhib: Rayburn Hall (by Congressional invitation), Washington, D.C., 1968; Alfredo Valente Gallery, New York, 1968; Lever House, New York, four times; Royal Acad Galleries, Edinburgh, Scotland; Royal Birmingham Soc Artists Galleries, Eng. Awards: Grumbacher Award, 1963; Lillian Cotton Mem Award & Medal of Honor, Nat Asn Women Artists, 1966; Irene Sickle Feist Mem Prize, 1971. Media: Oil, watercolor; stone, cast metals.

CATTI (Catherine James). Painter, enamelist. Born: Mount Vernon, NY, October 8, 1940. Study: Boston Univ, B.F.A.; Columbia Univ, M.A. Comn: Acrylic for the Last Jesus (film), Sepia Theater, Toledo, Ohio, 1972; costume design, Harry Belafonte Tour, 1974 & Walter Nicks Dance Theater & Repertory Co, 1974. Exhib: Contemporary Black Artists in America, 1971 & Whitney Ann, Whitney Mus Am Art, 1972; one-woman show, Cinque Gallery, New York, 1971; Projected Art: Artists at Work, & Women in the Arts, Finch Mus, 1971 & 1972. Awards: Creative Artists Coun Grant in Painting, NY State Coun Arts, 1971. Media: Acrylic, plexiglas, enamel, copper.

CAVAT, Irma. Painter, educator. Born: New York, NY. Study: New Sch Social Res; Archipenko Art Sch; Acad Grande Chaumiere, Paris; also with Ozenfant, Paris & Hans Hofmann. Exhib: Recent Drawings, Mus Mod Art, New York, 1950; Ill Nat, Urbana, 1959; Festival of Two Worlds, Spoleto, Italy, 1958-59; Ten Americans, Palazzo Venezia, Rome, 1960; one-man shows, Santa Barbara Mus, Calif & Phoenix Mus, Ariz, 1966-67; one-man shows also in Detroit, Chicago, Los Angeles, New York, Paris, Rome & Trieste. Awards: Yaddo Fel, Trask Found, 1950; Fulbright Fels, 1956-58; Creative Arts Inst Award, Univ Calif, 1970. Media: Acrylic, oil, mixed media.

CECERE, Ada Rasario. Painter. Born: New York, N.Y.
Study: Art Students League; Beaux-Arts Inst New York;
Nat Acad Design. Work: Norfolk Mus Arts & Sci, Va; Ohio
Univ Founder's Collection, Athens; Oklahoma City Mus;
Children's Hosp Founder's Libr, Baltimore; Am Art Arch,
Smithsonian Inst, Washington, D.C. Comn: Sand-carved
mural, U.S. Treas Dept Nat Competition, 1947; Triptych,
altar for Ft. Gordon, U.S.; mural, Hyde Park Restaurant,
New York; mural, Lobby of Hotel Newton, New York. Exhib:
Brooklyn Mus, NY, 1960; Am Watercolor Soc Traveling
Exhibs, 1960 & 1969; Richmond Mus Traveling Exhibs, 1960-
72; Asn Women Artists, U.S., Can, France & Italy, 1972;
Nat Soc Painters in Casein & Acrylics, 1975-76; seven one-
man shows, New York, NY & Pa, 1960-72. Awards: Medal of
Honor for Pastel, Nat Asn Women Artists, 1955; Solo Exhib
Award, Fairleigh Dickinson Univ, 1963; Maria Cantarella
Mem Prize, Allied Artists Am, 1968; plus others. Media:
Oil.

CHANDLER, Elisabeth Gordon. Sculptor. Born: St. Louis,
Mo., June 10, 1913. Study: Pvt study with Edmondo
Quattrocchi; Art Students League, anat. Work: Columbia
Univ Sch Law; Princeton Univ Sch Pub & Int Affairs;
Aircraft Carrier USS Forrestal; Gov. Dummer Acad Libr;
Storm King Art Ctr, Mountainville, NY. Comn: Forrestal
Mem Award Medal, Nat Security Indust Asn, 1954; portrait
bust of James L. Collins, comn by estate for James L.
Collins Parochial Sch, Corsicana, Tex, 1955; Timoshenko
Medal for Applied Mechanics, Am Soc Mech Engrs, 1956;
Benjamin Franklin Medal, New York Univ Hall of Fame, 1962;
bust of Owen R. Cheatham, Founder, Georgia Pac Corp,
Entrance Hall, Portland, Ore, 1970. Exhib: Mattituck
Mus, Waterbury Conn, 1949; Nat Acad Design Ann, New York,
1950-72; Nat Sculpture Soc Ann, 1953-72; Acad Artists,
Springfield, Mass, 1961; Smithsonian Inst, Washington,
D.C., 1963. Awards: First Prize, Brooklyn War Mem
Competition, 1945; Thomas R. Proctor Prize, Nat Acad Design,
1956 & Dessie Greer Prize, 1960. Media: Bronze, marble.

CHASE, Jeanne Norman. Painter. Born: Spokane, Wash.
Study: San Fernando State Col, B.A. (fine arts), 1959.
Work: Bendix Avionics Corp; J. Morris Stone Assocs;
LaGrange Col; over 400 pub & pvt collections throughout US.
Exhib: N Dak Print & Drawing Show, 1973; Soc Four Arts,
Palm Beach, Fla, 1973 & 1974; Joan Miro Int Drawing
Competition, Barcelona, Spain, 1974; 18th Ann El Paso Mus
Painting Exhib, Tex, 1974; 64th Ann Tex Fine Arts Nat
Exhib, Austin, 1975. Awards: First Pl (painting),
Southeast Arts & Crafts Festival, Macon, Ga, 1974; Purchase
Award, LaGrange Col Nat Art Exhib, Ga, 1974; Second Pl
(painting), Coconut Grove Art Festival, Fla, 1975.

CHAUDHURI, Patricia M. Sculptor, painter. Born: New
York, NY, July 6, 1926. Study: Simmons Col, B.S.; Boston
Mus Fine Arts, five yr cert, painting with Karl Zerbe &
David Aronson; Skowhegan Sch Painting & Sculpture, summer
scholar, 1951; Yale Summer Art Sch, scholar, 1952; also
sculpture with George Demetios. Exhib: Painting, Boston
Arts Festival, 1955 & Sculpture, 1963; Sculpture, Nat Acad
Design Am Ann Exhib, 1961 & 1963; New Eng Sculpture Asn,
1969-71. Awards: Louis T. Comfort Tiffany Award for
Sculpture, 1961.

CHERNOW, Ann. Painter, instructor. Born: New York, NY,
February 1, 1936. Study: Syracuse Univ, 1953-55; NY
Univ, B.S., 1957, M.A., 1969; with Irving Sandler, Jules
Olitski, Hale Woodruff & Robert Kaupelis. Work: Butler
Inst Am Art, Youngstown, Ohio; Lyman Allyn Mus, New London,
Conn; Housatonic Mus Art, Bridgeport, Conn; Mus de L'Art/
Contemporain, Skopje, Yugoslavia; Roberson Arts & Sci Ctr,
Binghamton, NY. Exhib: One-woman shows, Greenwich Art
Soc, Conn & Silvermine Guild Art, New Canaan, Conn, 1969,
Bel Gallery, 1973 & Westport Mus Art, Sci & Indust,
Bridgeport, Conn; New Eng Ann, Silvermine Guild Art, 1969
& 1974; 13 Women Artists, Westport Weston Arts Coun, 1971.
Awards: First Prize (painting), Bridgeport Mus, 1967;
Edwards Watercolor Award, New Eng Ann, 1973; Conn Comn
Arts Grant for pub art proj, 1974. Media: Acrylic, oil,
silkscreen.

CHUBB, Frances Fullerton. Painter, educator. Born:
Saint Maries, Idaho, October 6, 1913. Study: Univ
Puget Sound, B.F.A.; Univ Wash, M.F.A.; also with George
Z. Heuston. Exhib: Seattle & Tacoma Galleries, Wash,
1939-. Awards: Prizes, Tacoma Art Asn, 1940 & Olympia
Ann, 1953 & 1957. Media: Oil, watercolor.

CLARK, Nancy Kissel. Sculptor. Born: Joplin, Mo.,
January 27, 1919. Study: Mo Southern Col; Del Art Mus,
with Henry Mitchell; Fliecher Art Mem, Philadelphia, with
Aurelius Renzette. Work: Woodmere Art Gallery; Univ
Del, Newark; Pa Mil Col, Chester; Provident Nat Bank
Gallery, Philadelphia; Spiva Art Gallery Mo Southern Col,
Joplin. Comn: Bald Eagle (steel sculpture), Joplin
Munic Bldg, Mo, 1963; Crucifix (metal sculpture), Oblates
of St. Francis, Camp Brisson, Childs, Md, 1964; steel
sculpture, Walter Piel Mem, Corkran Gallery, Rehoboth,
Del, 1965; metal sculpture, Wood-Haven Kruse Sch,
Wilmington, 1966; Christ (3'), Notre Dame Brothers, St.
Edmon's Acad Chapel, Wilmington, 1974. Exhib: Galeria
Munic, Guadalajara, Mex, 1966; Allied Artists Am Ann, Nat
Acad Design, New York, 1966; Catharine Lorillard Wolfe
Art Club Ann, Nat Arts Club, NY, 1967; June Week, US Naval
Acad Mus, Annapolis, 1969; Nat Sculpture Soc Ann, Lever
House, New York, 1971-73. Awards: First Binswanger Award,
Philadelphia Mus at Civic Ctr, 1966; First Award, Nat
League Am Pen Women Biennial, Tulsa, Okla, 1966; Artist
of the Year Award for Christ in Christmas, Wilmington
Coun Churches, 1969.

CLARKE, Ruth Abbott. Painter. Born: Greensboro, NC,
December 10, 1909. Study: Univ NC, A.B., 1931, M.F.A.,
1955; Hans Hofmann Sch Art, 1955; Art Students League,
1956; Teachers Col, Columbia Univ, 1962. Work: Univ NC,
Greensboro; Wake Forest Col; Elliott Hall Collection;
Wachovia Bank Collection. Exhib: Winston-Salem Gallery
Contemp Art, 1964; Mint Mus Art,Charlotte, NC, 1965;
Wilmington Col, NC, 1967; Asheville Mus Art, NC, 1967;
Greensboro Col, 1967; plus others. Awards: Prizes, Assoc
Artists NC, 1961; Winston-Salem Gallery Fine Arts, 1961,
1963 & 1964; Greensboro Art League, 1964; plus others.

CLINEDINST, Katherine Parsons. Painter, lecturer. Born:
Stamford, Conn, July 13, 1903. Study: Pratt Inst, with
Jessie Leigh; China Inst, with Prof Wang. Exhib:
Smithsonian Inst, Washington, D.C.; Springfield Mus,
Mass; Asbury Park Mus, NJ; Hammond Mus, South Salem, NY.
Pos: Asst mgr, Boston Soc Arts & Crafts, New York, 1923-24.
Awards: Hudson Valley Art Asn Award for Dr. Woodrow,
White Plains, NY, 1963; Meridan Art Asn Award, Conn, 1967;
Mt. Vernon Art Asn Award, NY, 1967. Media: Watercolor,
oil.

CLOAR, Carroll. Painter. Born: Earle, Ark., January 18, 1918. Study: Southwestern at Memphis, B.A.; Memphis Acad Arts; Art Students League, MacDowell fel, 1940. Work: Metrop Mus Art, Mus Mod Art & Whitney Mus Am Art, New York; Brooks Mem Art Gallery, Memphis; Joseph H. Hirshhorn Mus, Washington, D.C. Exhib: Retrospective, NY Univ, Albany; Pittsburgh Int; Whitney Ann, New York; Pa Acad Fine Arts Ann, Philadelphia; Brooks Mem Art Gallery, Memphis. Pos: Bd trustees, Brooks Mem Art Gallery, 1969-71. Awards: Guggenheim Fel, 1946; Am Acad Arts & Lett Prize, 1967.

CLOSE, Marjorie (Perry). Painter, lecturer. Born: Chloride, Ariz., November 11, 1899. Study: Calif Sch Fine Arts, four yr scholar Univ Calif, 1918-20; Art Inst Chicago, 1920-22; Wana Derge Studio, Berkeley, Calif; San Francisco Art Inst; with George Post, 1936; San Francisco City Col, 1951-57; Rudolf Schaeffer Sch, 1965; also with Matteo Sandona, 1952-56 & Thomas Leighton, 1956-68. Comn: Portraits, Marjorie Markel & Molly Parker, 1953 & Admiral John Redman, 1954, San Francisco; Cinerarias (still life) Col. & Mrs. R. F. Elliott, Arlington, Va, 1960; Elizabeth Stoddard Huntington, Southern Pac RR Co, San Francisco, 1969. Exhib: Four shows, Nat Asn Women Artists, Nat Acad Design, New York, 1961-72; one-artist shows, Rosicrucian Mus, San Jose, Calif, 1967-73, Univ Club San Francisco, 1970 & Charles & Emma Frye Mus, Seattle, 1973; six shows, Calif State Fair, Sacramento, 1967-74; Soc Western Artists, Charles & Emma Frye Mus, 1971; 23rd Acad Art Asn Ann, Springfield, Mass, 1972; plus many others. Awards: Trompe l'Oeil Still Life Award, Dan Le Gear Mem Award, San Francisco, 1966, 1967 & 1971; Pres Award & Best Still Life Award, Am Artists Prof League, New York, 1969-71; Premier Grand Prix Award (still-life painting), 23rd Int Grand Prix, Deauville, France, 1972; plus many others. Media: Oil. Publ: Co-auth, Color, Form & Composition, 1966.

COBB, Ruth. Painter. Born: Boston, Mass., February 20, 1914. Study: Mass Col Art, cert. Work: Boston Mus Fine Arts; Va Mus Fine Arts, Richmond; Butler Inst Am Art, Youngstown, Ohio; Munson-Williams-Proctor Inst, Utica, NY; Brandeis Univ, Waltham, Mass. Exhib: Am Watercolor Exhib, Metrop Mus Art, New York, 1952; 22nd Biennial Int Watercolor Exhib, Brooklyn Mus, NY, 1963; Am Watercolor Soc Ann, 1968-72; Watercolor U.S.A., Springfield Art Mus, Miss, 1969; 35 Years in Retrospect, Butler Inst Am Art, 1971. Awards: Purchase Award, Nat Acad Design, 1968; Lena Newscastle Mem Award, Am Watercolor Soc, 1970 & Emily Lowe Award, 1974.

COBB, Virginia Horton. Painter, lecturer. Born:
Oklahoma City, Okla, November 23, 1933. Study:
Community Col of Denver; Colo Univ; also with Edgar
Whitney, Chen Chi & Edward Betts. Work: Foothills Art
Ctr, Golden, Colo. Exhib: Am Watercolor Soc, Nat Acad
Galleries, New York, 1973-75; Nat Watercolor Soc Travel
Exhib, 1974; Midwest Biennial, Joslyn Art Mus, Omaha,
1974; Butler Inst Am Art, Midyear Show, 1975; Mainstreams
'75, Marietta Col Int Competitive Exhib. Teaching:
Instr watermedia painting, Foothills Art Ctr, Golden,
1972-74; instr watercolor seminar, Arts Coun, Oklahoma
City, 1973. Awards: Elmer Fox Purchase Award, Watercolor
U.S.A., Springfield Art Mus, 1973; Century Award of Merit,
Rocky Mountain Nat Watermedia Exhib, 1974; Paul B. Remmey
Mem Award, Am Watercolor Soc, 1974. Media: Watermedia,
graphic.

COBURN, Bette Lee Dobry. Painter. Born: Chicago, Ill.
Study: Grinnell Col, Iowa; Art Inst Chicago; Univ NC;
Art Students League; watercolor with Eliot O'Hara. Work:
U.S. Army Air Corps, Washington, D.C.; SC State Art Comn
Collection, Columbia; Greenville Co Mus Art, SC; Univ NC,
Greensboro; Univ Ga, Athens; plus many others. Comn:
Mural, Evanston Art Ctr, Ill, 1954; First Fed Bank,
Henderson, NC, 1965; mural, Ivey's Pres Off, Greenville,
1969; space murals, Astro Theatre I, 1970 & Astro Theatre
II, 1971, Greenville. Exhib: Hunter Art Ann, Chattanooga,
Tenn, 1968; 23rd Southeastern Ann, High Mus Art, Atlanta,
1969; 6th Piedmont Ann, Mint Mus, Charlotte, NC; Nat
Asn Women Artists Nat Traveling Exhib, US, 1970-75; Della
Citte Etterno, Pallazzio delle Exposizioni, Rome, 1973;
plus many others. Awards: First Pl Grand Prix de
Abstract, 23rd Int de Peinture, Deauville, France, 1972;
M. Grumbacher Award, Nat Acad Art, Nat Asn Women Artists,
New York, 1973; First Place Oils, Greenville Artists
Guild, Greenville Co Mus Art, 1975; plus many others.
Media: Oil, acrylic.

COCKER, Barbara J. Painter, designer. Born: Uxbridge, Mass, October 16, 1923. Study: Becker Jr Col, A.A.; Mt. St. Mary Col; New York Sch Interior Design; also pvt study with artist mother. Work: Riverview Hosp, Red Bank, NJ; Monmouth Med Ctr, Long Branch, NJ; Cent Jersey Bank & Trust Co, Freehold & Rumson, NJ; also in many pvt collections. Comn: Two seascapes, Judge William Kirkpatrick, Rumson, 1965 & 1972; two seascapes, Mr. & Mrs. John Holton, Rumson, 1966 & 1970; seascape, Dr. J. Putnam Brodsky, Rumson, 1968; seascape, Vpres Jack A. Baird, Bell Tel Labs, Holmdel, NJ, 70; sailboat scene, Virgin Islands, Mr. & Mrs. William Crawford, Washington, D.C., 1972. Exhib: Catharine Lorillard Wolfe Exhib, Nat Acad Design, New York, 1970; Burr Artists Ann, Lever House & Burr Artists Show Salmagundi Club, New York, 1970; one-man shows, Little Gallery at the Barbizon, New York, 1971, The Old Mill Asn, NJ, 1971, Pacem in Terris Gallery, New York, 1972 & Cent Jersey Bank & Trust Co, 1971 & 1972. Awards: First Prize, Oceanport Hist Soc Art Show, 1966 & Monmouth Med Ctr Art Show, 1969; highest award, Art for Arthritis Benefit, 1972. Media: Acrylic.

COCKRILL, Sherna. Painter, instructor. Born: Chicago, Ill. Study: Univ Ark, B.A. & M.A.; Malden Bridge Sch Art, 1967 & 1968; also study with R. Y. Goetz, 1965-69. Work: Smithsonian Inst Archives Am Art, Washington, DC; Ozark Art Ctr, Springdale; First Nat Bank, Little Rock. Comn: Many portrait comn. Exhib: Okla Eight State Exhib, Oklahoma City, 1968; Philbrook Mus Ann Exhib, Tulsa, 1968 & 1969; Greater New Orleans Nat Exhib, 1973; Tex Fine Arts Asn Ann, Austin, 1973. Awards: First Prize, Okla Mus Art Ann, 1970; First Prize in Art, Little Rock Ten State Arts Fair, State of Ark, 1973; Top Award Ark Festival Art, 1973 & 1974 & Top Award Ark Festival & Art Invitational, 1975. Media: Oil, acrylic.

COHEN, Adele. Sculptor, painter. Born: Buffalo, NY. Study: Art Inst Buffalo; Albright Sch Buffalo; Parsons Sch Art, New York. Work: Albright-Knox Art Gallery, Member's Gallery, Buffalo, NY: Mus Arts & Sci, Evansville, Ind; Univ Mass, Amherst; Towson Col, Baltimore, Md. Comn: Stage sets sculpted of polyester resins & fibres for the play, Fando, Buffalo Fine Arts Acad & Workshop Repertory Theater, NY State Theater, 1967. Exhib: Art Across Am, Inst Contemp Art, Boston, 1965; Western NY Exhib, Buffalo Fine Arts Acad, 1957-71; Patteran Artists, NY State travel tour, 1975-77; Unordinary Realities, Xerox Corp, Rochester, NY, 1975; Michael C. Rockefeller Arts Ctr Gallery, State Univ Col Fredonia, NY, 1975. Awards: Best of Show, Western NY Exhib, 1964; Painting Award, Ann New England Exhib, Silvermine Guild Artists, 1965 & 1966; Paul Lindsay Sample Mem Award, Chautauqua Exhib Am Art, 1967.

COLE, Joyce. Painter. Born: New York, NY, September 3, 1939. Study: Syracuse Univ; NY Univ; Finch Col, B.A. (hist art); Art Students League; Will Barnett, Jacob Lawrence & Ben Cunningham; Sch Visual Arts. Work: Aldrich Mus Contemp Art, Ridgefield, Conn. Exhib: Andre Emmerich Gallery, NY, 1972; Whitney Mus Am Art Biennial, New York, 1973; Contemporary Reflections, Aldrich Mus Contemp Art, 1973; Galerie Denise Rene, New York, 1973; Soho Ctr Visual Arts, Aldrich Mus, New York, 1974.

COLORADO, Charlotte. Painter. Born: Denver, Colorado, January 18, 1920. Study: Colo Woman's Col; Otis Art Inst; Jepson Art Inst; Chouinard Art Inst. Comn: Auth & dir, three theatre pieces (with Alex Haye's Los Angeles Summer Theatre Piece Lab), 1967; spec proj, Covina Parks & Rec, 1971-72. Exhib: Pa Acad Fine Arts; Fine Arts Gallery San Diego; Long Beach Art Mus; Jewish Community Ctr; Signs of Neon Traveling Exhib, Mod Art Gallery, Washington, DC, 1969-71; plus others. Awards: Prizes, Los Angeles Mus Art, 1960, Westside Jewish Community Ctr, Los Angeles, 1963 & First Methodist Church, Santa Monica, 1963.

CONNAWAY, Ina Lee Wallace. Painter, sculptor. Born: Cleburn, Texas, December 27, 1929. Study: Baylor Univ; also with Rhinhold Ewald, Hanau, Ger & Junicero Sekino, Alaska; Famous Artist Course, Univ Alaska; Corcoran Sch Art; George Washington Univ, B.A. Work: Alaskan State Mus, Juneau; John F. Kennedy Elem Sch, Ft. Richardson, Alaska; P. E. Wallace Jr High Sch, Mt. Pleasant, Tex; Cora Kelly Elem Sch, Alexandria, Va; Kate Duncan Smith DAR Sch, Ala. Exhib: Lasting Americana, a Series on the United States, Ft. Richardson, Juneau & Anchorage, Alaska, 1962-65; Am Artists Prof League Grand Nat, 1966; Sovereign Exhibs Ltd, Va, NC & SC, 1970-71; U.S. Mil Acad Libr Exhib, 1970; DAR Army & Navy Chap Exhib, 1971. Awards: Prizes, Beaux Arts Ball, Artist of the Month & Am Art Wk, Anchorage, 1963; Alaska State Fair, Palmer, 1964. Media: Oil, stone, wood, bronze.

CONNERY, Ruth M. Painter. Born: New York, NY. Study: Mills Col, A.A.; Art Students League, with William von Schlegell & Hans Hofmann. Work: First Nat Bank, Rye, NY; Henry Bruckner Jr High Sch, Bronx, NY. Comn: Portraits, comn by Mr. & Mrs. Peter Sulon, Rye, Mrs. & Mrs. Victor Wook, New York, Mr. & Mrs. Anthony Rizzo, Jupiter Island, Fla & Mr. & Mrs. H. Canale, Larchmont, NY. Exhib: Nat Asn Women Artists, New York, 1949-69; Jersey City Mus, 1955; Mus of Southern France, 1967; Leger Bldg, Park Ave, New York, 1967-68; Norton Gallery, West Palm Beach, Fla, 1970-71. Awards: Pres Prize, New Rochelle Art Asn, 1965; Group Show Award, Westchester Arts Workshop, 1967; One-man Show Award, Contemporaries, Inc, New York. Media: Oil, acrylic.

CONRAD, Nancy R. Painter. Born: Houston, Texas, January 29, 1940. Study: Houston Mus Fine Arts; Randolph Macon Woman's Col, B.A.; study with Henry Gadbois, Robert Fuller, Elliot Twery & Herb Mears. Work: Randolph Macon Collection Am Women Painters, Lynchburg, Va; El Paso Mus Fine Arts, Tex; Continental Oil Co Collection & Dresser Indust Collection, Houston; Aviation Am Bldg, Love Field, Dallas. Exhib: Pacific Artists Show, Tacoma Mus Fine Arts, Wash, 1965; Delta Five State Exhib, Ark Art Ctr, 1972; Sun Carnival Exhib, El Paso Mus Fine Arts, 1973-75; Tex Painting & Sculpture, Dallas Mus Fine Arts; 52nd Ann Nat Exhib, Shreveport, La, 1974. Awards: Foley Award, Foley's of Houston, 1970; First Place Jurors Choice, Assistance League of Houston, 1973; Purchase Award, El Paso Mus Art, 1973. Media: Airbrush watercolor; oil or acrylic on canvas.

COOKE, Kathleen McKeith. Painter, sculptor. Born: Belfast, Ireland, September 30, 1908; U.S. citizen. Study: With Arthur Schweider, Samuel Adler, Madeleine Gekiere, Collette Roberts & Theodoros Stamos. Work: Univ Utah, Cornell Univ, Arts Coun Northern Ireland, Bank Ireland & Univ Notre Dame; plus others. Exhib: One-man shows, Betty Parsons Gallery, 1970 & 1975, David Hendriks Gallery, Dublin, Ireland, 1971 & 1973; Kunstmuseum, Odense, Denmark, 1973, Carstens Gallery, Copenhagen, 1973, Compass Gallery, Glasgow, 1973, Galerie Rivolta, Lausanne, 1973 & Arts Coun Gallery, Belfast, 1973; Philadelphia Mus Art, 1971; Hillsborough Art Ctr, Northern Ireland, 1971; Drawings by Living Americans, Nat Endowment Humanities Traveling Exhib, 1972; Gordon Lambert Collection, Munic Gallery Mod Art, Dublin, 1972; plus others. Media: Oil, dry point; clay, stone.

COOLEY, Adelaide Nation. Painter, ceramist. Born: Idaho Falls, Idaho, April 18, 1914. Study: Stephens Col for Women, Columbia, Mo, AA; Univ Wis-Madison, B.S.; Bradley Univ, Peoria, Ill. Work: Peoria Art Guild Collection, St. Paul's Episcopal Cathedral Collection, Carson Pirie Scott & Co, Peoria, Ill. Comn: Altar paraments, Univ United Methodist Church, Peoria, Ill, 1967. Exhib: Quatre Femmes, Sears Vincent Price Gallery, Chicago, 1967; 20th N Miss Valley Exhib, Ill State Mus, Springfield, 1967; 10th Ann Rochester Religious Art Festival, NY, 1968; Collectors Finds, Davenport Munic Art Mus, Iowa, 1968; 24th Ann Invitational, Ill State Mus, 1971. Pos: Ed, Peoria Art Ctr News, 1962-65; chmn, Pub Art Comt, Peoria, Ill, 1975-. Awards: First Prize for Painting, Ill Art League, 1965, Second Prize for Painting, 1966; First Prize for Ceramic Constructions, Pekin Art Asn, Ill, 1972. Media: Oil, watercolor; earthenware, porcelain.

COOPER, Joanne Beckman. Painter. Born: Columbus, Ohio, April 14, 1930. Study: Art Students League, with Edwin Dickinson & Harry Sternberg; Carnegie Hall & Mus Mod At, with Zoltan Hecht; Northwestern Univ, three yrs; Ohio State Univ. Work: Iona Inst Arts, Iona Col, New Rochelle, NY. Exhib: Nat Acad Design, New York, 1966; Max 24-66, Purdue Univ, Ind, 1966; Benedictine Art Awards, 1971; Nat Soc Painters in Casein & Acrylic, 1971 & 1972. Awards: First Prize, Riverdale Art Show, 1968; First Prize, Haddonfield Arts & Crafts League, 1969; Hon Mention, Benedictine Art Awards, 1971. Media: Polymer.

COOPER, Lucille B. Painter, sculptor. Born: Shanghai, China, November 5, 1924; US citizen. Study: Univ Calif, Los Angeles; Univ Hawaii; Honolulu Acad Art. Work: Painting, Hawaii Loa Col. Comn: 48 collages, Polynesian Hotel, Honolulu, Hawaii, 1960; oil painting, Fiji Hotel, 1971. Exhib: 3 Plus 1 Show, Ala Moana, Honolulu; Honolulu Acad Art Ann; Easter Art Festival; Hawaii Painters & Sculptors League Ann; Honorary Retrospective, Hawaii Loa Col, 1970. Awards: Best in Show for Watercolor, Watercolor & Serigraph Soc; Hon Mention for Watercolor. Mem: Hawaii Painters & Sculptors League (secy); Hawaii Potters Guild; Hawaii Craftsmen (vpres); hon mem Windward Art Guild (pres). Media: Oil, watercolor; clay, acrylic.

CORDINGLEY, Mary Bowles. Painter. Born: Des Moines, Iowa, January 1, 1918. Study: Minneapolis Sch Art & Design; Minneapolis Art Inst; Univ Minn; Colorado Springs Fine Arts Ctr; also with Steve Rettegi, New York, Hilton Leech, Fla & Paul Olsen, Minneapolis. Work: In over 190 pvt collections. Comn: Numerous portraits. Exhib: Traveling Exhibs, 1966 & 1967 & Print Show, 1970. Mont Inst Arts; Nat League Am Pen Women Nat Biennial, Washington, D.C., 1967 & 1970; Jr League Print Show, Great Falls, Mont, 1971; plus seven one-man shows incl C. M. Russell Mus, Great Falls, 1967 & 1971. Univ Mont, 1970 & Univ Minn. Media: Oil, pencil.

CORREA, Flora Horst. Painter. Born: Seattle, Wash, February 16, 1908. Study: Univ Wash, B.A. (art); also with Kenneth Callahan, Sergei Bongart, Richard Yip & Raymond Brose. Work: Erb Mem Mus, Univ Ore; Seattle First Nat Bank Collection; Craftsman Press, Seattle; Pac First Fed Savings & Loan Asn, Seattle; Rainier Bank, Seattle. Exhib: Puget Sound Area Exhib, Frye Art Mus, 1964-65, 1967-68 & 1975; Univ Ore Invitationals, 1967 & 1971-72; Northwest Watercolor Ann, Seattle, 1964-67 & 1972-75; Watercolor Exhib, Seattle Pac Col, 1975; Grand Galleria Exhib, 1975. Awards: Henry Rachen, Frye Art Mus, 1968; First in Oils, Penwomen's Wash State Biennial, 1970 & 1972; First Award, Women Painters of Wash Ann, 1974. Media: Acrylic, collage.

CORSE, Mary Ann. Painter, sculptor. Born: Berkeley, Calif., December 5, 1945. Study: Univ Calif, 1963; Calif Inst Arts, Chouinard scholar & B.F.A., 1968. Work: Los Angeles Co Mus Art; Solomon R. Guggenheim Mus, New York; Robert Mitchner Collection, Univ Tex. Exhib: Whitney Sculpture Ann, Whitney Mus Am Art, New York, 1970; Permutations, Light & Color, Mus Contemp Art, Chicago, 1970; 24 Young Artists, Los Angeles Co Mus, 1971; Theodoron Awards, Solomon R. Guggenheim Mus, 1971; 15 Los Angeles Artists, Pasadena Art Mus, 1972. Awards: New Talent Award, Los Angeles Co Mus, 1968; Theodoron Award, Solomon R. Guggenheim Mus, 1970.

COX, Marion Averal. Painter, instructor. Born: Washingtonville, Ohio. Study: With H. Gauguin, W. Goodrich, H. Radio, B. I. Payne, C. Wallace, J. M. Jehu, N. Bel Geddes, Max Reinhardt (Ger.), and many others. Exhib: Sixty Text Books, Am Inst Graphic Arts, Grand Cent Palace, 1944 & 1954; 13th Ann Ohio Artists & Craftsmen, Massillon Mus, 1948; 14th New Years Show, Butler Art Inst, 1949; American Painting Today, Metrop Mus Art. Media: Pen, ink; watercolor, oil.

CRANE, Marie. Painter. U.S. citizen. Study: Art
Students League; also with Feodor Zakharov & Wayman Adams.
Work: Oceanographic Inst, Woods Hole, Mass. Exhib: Nat
Arts Club Ann & open exhib annually; Am Artists Prof
League Exhib, Hanover Mfr Bank & Grand Nat Exhibit, Lever
House. Awards: Hon Mention, Nat Arts Club, 1969.
Media: Oil, watercolor, pencil.

CRIQUETTE (Ruth Dubarry Montague). Painter, writer.
Born: Paris, France; U.S. citizen. Study: Ecole Beaux
Arts, Paris; Univ Nev, M.F.A.; seminars at Metrop Mus
Art; Lumis Art Acad; also with Roland Pierson Prickett.
Work: Many in pvt collections. Exhib: Da Vinci Exhib
Artes, Rome, Italy, 1969; Repertorium Artis Exhib, Monaco,
1970; Int Exhib Artes, Rome, 1971; 14th & 15th Int Exhib,
Gallerie Int, New York, 1972; Int Inst Arts & Lett
Perpetual Exhib, Switz. Media: Oil.

CULBERTSON, Janet Lynn (Mrs. Douglas Kaften). Painter,
instructor. Born: Greensburg, Pa, March 15, 1932.
Study: Carnegie Inst Technol, B.F.A., 1953; Art Students
League, 1954; graphics, Atelier 17, New York, 1955; NY
Univ, M.A., 1963; Pratt Graphic Arts Inst, 1964-65. Work:
Univ Mass, Amherst Mus Collection AT&T, Chicago; Delta
Corp, NY. Exhib: One-woman shows, Molly Barnes Gallery,
Los Angeles, 1970, Midtown Gallery, Atlanta, Ga, 1971 &
Lerner-Heller Gallery, New York, 1971, 1973 & 1975;
Philadelphia Mus Art, 1974; Heckscher Mus, New York, 1975;
Brooklyn Mus, 1975; Am Acad Arts & Lett, 1975; plus
others. Awards: Award, Palos Verdes Mus Ann, 1970;
Award, Cape Coral 9th Ann, Fla, 1975. Media: Acrylic,
silver point.

CUNNINGHAM, Francis. Painter. Born: New York, NY,
January 18, 1931. Study: Art Students League, with Edwin
Dickinson & Robert Beverly Hale. Work: Berkshire Mus,
Pittsfield, Mass. Exhib: One-man shows, Hirschl & Adler
Galleries, New York, 1967, 1970 & 1975; Butler Inst Am
Art, Youngstown, Ohio, 1967, 1972 & 1974; Nat Acad Design,
New York, 1967, 1969 & 1971-73; one-man show, Welles
Gallery, Lenox Libr, Mass, 1971; Contemporary Figure,
Suffolk Mus, Stony Brook, NY, 1971. Media: Oil.

CUSICK, Nancy Taylor. Painter. Born: Washington, D.C.
Study: Am Univ, B.A., 1959, M.A., 1961, Elizabeth Van
Swinderin scholar & with Gates, Calfee, D-Arista &
Summerford; Corcoran Art Sch, 1968; Univ Calif, 1971,
with Lindgren. Exhib: Washington Watercolor Soc Nat
Exhib, Smithsonian Inst, Washington, D.C., 1963; three-
man show, Art Asn Newport, RI, 1965; Corcoran Gallery Art
Area Exhib, Washington, 1967; area show, Washington Co
Mus, Hagerstown, Md, 1967; Washington Artists Today,
Massillon Mus, Ohio, 1969; plus one other. Awards: First
Prize for Painting, Blue Boots, Soc Washington Artists,
1966; Best in Show, Hagerstown Mus, Pangborn Corp, 1967.
Media: Constructions, mixed media, acrylic.

CUTLER, Ethel Rose. Painter, designer. Born: New York,
NY, March 13, 1915. Study: Hunter Col, with Joseph
Cummings Chase, B.A.; Columbia Univ, M.A.; Sch Prof Arts,
cert advert & interior design; N.Y. Univ; ceramics &
sculpture with Michael Lekakis & Rudolph Staffel; Univ
Mo; Inst Design, Ill Inst Technol; Am Artist Sch, grant
& with Nahum Tschachbasov; New Sch Social Res, with
Yasua Kunyioshi & Alexei Brodovitch. Exhib: New York
City Ctr Gallery; Design Derby, Hialeah, Fla; Young
American Artist Group, New York; Lynn Kottler Galleries,
New York; Sch Home Econ, Univ Mo-Columbia; plus others.
Awards: Award for Boats, New York City Ctr Gallery, 1959;
Award for Brothers, Macy's Gallery; Grant, Metrop Mus
Art, New York, 1968. Media: Watercolor, oil.

CUTLER, Grayce E. Painter, writer. Born: Salt Lake City, Utah. Study: Univ Utah; Art Students League, with Kuniyoshi & Morris Kantor; New York Sch Design, cert; Hans Hofmann Sch Art, Provincetown, Mass; also with Eliot O'Hara. Work: Granite Schs Admin Art Collection, Salt Lake City; Pollard Collection, Greater Victoria Art Gallery, B.C.; Alice Merrill Horne Collection, Utah; also Royal Family of Saudi Arabia & numerous other pvt collections. Exhib: Springville Art Mus Ann Exhib, 1964-; Burr Artists, New York World's Fair, 1965; Soc Western Artists Ann, De Young Mus, San Francisco, 1966, 1968 & 1969; San Francisco Women Artists Exhib, Kaiser Ctr, Oakland, 1968; one-woman show, Rosicrucian Egyptian Mus & Gallery, San Jose, 1968 & 1971; plus others. Awards: First Prize for watercolor, Utah State Fair, 1969; Watercolor Award of Honor, Intermountain States Traveling Exhib, Utah Inst Fine Arts, 1970; Watercolor First Award, Nat League Am Pen Women Biennial, Washington, D.C., 1972; plus one other. Media: Watercolor, acrylic, oil.

DAPHNE, Annette. Painter. Born: Paris, France. Study: Acad Grande Chaumiere, Paris; Art & Publicite Paris; Acad Art Bezalel, Jerusalem, with Ardon; Acad Art Avni, Tel Aviv with Marcel Janco; Art Students League. Work: Acad Art Bezalel, Jerusalem. Exhib: Israel Painters, Tel, Aviv, 1956-58; one-man shows, Theodor Herzl Gallery, New York, 1961, Rose Sheskin Gallery, 1965, Panoras Gallery, 1973 & Avanti Gallery, New York, 1975; plus many others. Awards: First Prize Israel Govt, 1956. Mem: Artists Equity Asn New York; Nat Soc Lit & Arts. Media: Oil.

DAPHNIS-AVLON, Helen. Painter, sculptor. Born: Manhattan, NY, June 18, 1932. Study: Brooklyn Mus, 1950-53; Colorado Springs Fine Arts Mus, 1953; Hunter Col, B.F.A., 1953 & M.A., 1957. Work: Chrysler Mus; Sonnabend Art Collection, NY. Comn: Painting, 1959. Exhib: Bertha Schaeffer Gallery, New York, 1959-62; Provincetown Art Asn, Mass, 1960-72; Wadell Gallery, New York, 1969; Peace Exhib, Mus Mod Art, New York, 1970; Westbeth Gallery, New York, 1970; plus others. Awards: Ten year outstanding achievement award, Hunter Col, 1963. Media: Acrylic, ceramics, metal, graphics, photo-silk screen.

DAWSON, Eve. Painter. Born: Somersetshire, Eng; U.S. citizen. Study: Art Students League. Work: In pvt collections in U.S., Eng, Malta & Australia. Exhib: 32 one-man shows in New York & Vt; Nat Acad Design; Nat Arts Club; plus two- and three-man shows. Awards: First Award, Nat Pen Women Am; two First Awards, Pen & Brush Club; two Hon Mentions, Nat Arts Club.

DECAPRIO, Alice. Painter, instructor. Born: Marshall, Michigan, February 10, 1919. Study: Mich State Univ, A.B.; Northwestern Univ, M.A.; Sloan Sch, with Michael Lenson & John Grabach; also watercolor with Ray G. Ellis & Nicholas Reale; Hilton Leech Sch, Sarasota, Fla, with Valfred Thelin. Work: Ocean Co Col, NJ; Chatham Hist Soc, NJ. Comn: Four hist paintings, Chatham Fish & Game Club, NJ, 1970; three collages relating to textile & sewing, Mary Ann Silks & Woolens, Evanston, Ill, 1971; eight drawings of hist bldgs, Chatham Twp Bicentennial Comt, 1975. Exhib: Open Show, NJ Watercolor Soc, 1966, 1969 & 1973; Watercolor Shows, Nat Arts Club, New York, 1970-75; Ann Traveling Exhib, Nat Soc Painters in Casein & Acrylic, 1970-; Audubon Artists, 1974 & Nat Soc Painters in Casein & Acrylic, 1974, Nat Acad Gallery. Awards: Winsor-Newton Award, Nat Show, NJ Painters & Sculptors Soc, 1971; First Award Watercolor, Winner's Show, Venice Area Art League, Fla, 1975; First Prize Graphics, Somerset Art Ctr, NJ, 1974. Media: Watercolor, ink.

DE CHAMPLAIN, Vera Chopak. Painter. Born: Germany; U.S. citizen. Study: Art Students League; spec studies with Edwin Dickinson. Work: Permanent Collection of Fusco Galleries, New York & in Collections abroad. Exhib: Interlaken, Switz, 1966; Rudolph Gallery, Woodstock, NY, 1967; Seamen's Bank for Savings, New York, 1969; Artists Equity Gallery, New York, 1970 & 1972; Fontainebleau Gallery, New York, 1972 & 1974. Awards: Award, Twilight & Onteora Club, Haines Falls, NY, 1965. Media: Oil, watercolor.

DELUIGI, Janice Cecilia. Sculptor, painter. Born: Indianapolis, Ind., November 27, 1915; Italian & Am citizen. Work: Ill Bell Tel Co, Chicago; Art Inst Chicago; Civic Mus Revltella, Trieste, Italy. Comn: Sculpture in memory of John F. Kennedy & Robert F. Kennedy, Community of Milano, Italy, 1969; stained glass windows, San Giorgio Maggiore, Benedictine Monastery, 1973 & Cini Found & Benedictine M. Nuovalese, 1973; artistic glass sculpture of Murano for the best film presented at the VII Festival Int Film of Sch & Fiction, Trieste, 1969. Exhib: Gallery Art, Muova Spazio, Tolgaria, Italy, 1975; Gallery Art, San Marco, Venice, 1975; La Cappella, Art Ctr, Trieste, 1975; The Women of Today, Italian Inst Cult, Vienna, 1975; Engravings, Int Ctr Grafics, Venice, 1975. Awards: First Prize Int Painting & Sculpture, Fruili-Venezia Guilia, 1971; Silver Medal for Painting, Pope Paul VI, 1973. Media: Glass; oil, watercolor.

DE NAGY, Eva. Painter. Born: Hungary. Study: Acad
Royal Beaux-Arts, Brussels, Belg. Work: Color slides,
Guild Libr, Church Archit Guild Am, Washington, D.C.
Exhib: Provincetown Art Asn, 1960 & 1961; Ecclesiastical
Crafts Exhib, Pittsburgh, 1961 & 1962; Painters &
Sculptors Soc NJ, 1961 & 1962; Am-Hungarian Art Asn, New
York, 1962 & 1963; Catharine Lorillard Wolfe Art Club,
1962 & 1964; plus many others. Awards: Prizes, NJ
State Fedn Women's Club, 1954 & 1959; Bronze Medal,
Seton Hall Univ, 1956; Prize, NJ State Med Asn Convention
Art Exhib, 1958 & 1960; plus others.

DE NORONHA, Maria M. (Mrs. David Gallman). Painter,
lecturer. Born: Cascais, Portugal; U.S. citizen.
Study: Jr Col Sagrado Coracao, Port; Hunter Col, B.A.;
Montclair Col; Art Students League; Am Ctr Students &
Artists, Paris, France; also with Doug Kingman, New York
& Roger Barr, Paris. Work: Grumbacher Co, New York;
Oglethorpe Univ, Atlanta, Ga; George Washington Carver
Mus; Col Charleston; Am Ctr Students & Artists, Paris.
Exhib: U.S. Embassy, Saigon, Vietnam, 1970; Nat Acad
Design, New York, 1971; State Dept, Washington, DC, 1971;
Washington Mus, Md, 1971; Southeastern Art Exhib, 1972;
plus others. Awards: M. Grumbacher Award as Painter of
the Year, 1962; Southeastern Art Exhib Award for Seas,
1965; Oglethorpe Univ Res Grant, 1966; Lauro Accademico,
Paris, 1974.

DENTON, Pat. Painter, instructor. Born: Scottsbluff,
Nebraska, July 20, 1943. Study: Art Student Tour,
Europe, 1960; Univ Kans, 1961; Univ Denver, cert painting,
1962; also with Virginia Cobb, John Pellew, Charles Reid,
Lee Weiss & Asterio. Work: Greeley Nat Bank, Colo;
Lunnon Haus, Golden, Colo; Mux Tex Tech Univ; Lutheran
Med Clin, Wheatridge, Colo; United Banks Colo, Denver.
Exhib: Miniature Painters, Sculptors & Gravers Soc,
Washington, DC, 1972 & 1974; Nat Small Paintings Exhib,
N Mex Art League, Albuquerque, 1972-75; Catherine Lorillard
Wolfe Art Club, Inc, New York, 1974; W Tex Watercolor Asn
Exhib, Mus Tex Tech Univ, 1974; Cody Country Western Nat,
1975. Awards: First Prize in Graphics, N Mex Art
League, 1972; First Prize in Watercolor, Nat Fete,
Scottsbluff, 1973; Ida Becker Mem Award, Catharine
Lorillard Wolfe Club, 1974. Media: Graphics, watercolor
& acrylic.

DICKERSON, Betty. Painter, lecturer. Born: Nashville, Kansas, February 11, 1908. Study: Univ Kans, A.B.; Wichita Art Asn; and with Albert Bloch, Karl Mattern, B.J.O. Nordfeldt & William Dickerson. Work: Wichita Art Mus; Wichita Art Asn; Kans State Univ; also pvt collections. Exhib: Kans State Univ; Kans Watercolor Soc, 1970-73; Kans State Fedn Art, 1974; Sandzen Mem Gallery, 1974. Media: Oil, watercolor.

DICKINSON, Eleanor Creekmore. Painter, draftsman. Born: Knoxville, Tenn., February 7, 1931. Study: Univ Tenn, with C. Kermit Ewing, B.A., 1952; San Francisco Art Inst, with James Weeks, 1961-63. Work: Corcoran Gallery Art, Washington, D.C.; San Francisco Mus Art; Butler Inst Am Art, Youngstown, Ohio; Libr Cong Collection, Washington, D.C.; Nat Collection Fine Arts, Washington, D.C.; plus others. Exhib: One-artist shows, San Francisco Mus Art, 1965, Santa Barbara Mus Art, Calif, 1966, Corcoran Gallery Art, 1970 & 1974, Poindexter Gallery, New York, 1972 & Fine Arts Mus San Francisco, 1975; plus others. Awards: San Francisco Women Artists Pres Prize, San Francisco Mus, 1959; Purchase Award, Butler Inst Am Art, 1960; Graphics Prize, City of San Francisco, 1974; plus others. Media: Mixed media, graphics.

DORST, Claire V. Painter, educator. Born: Plymouth, Wisconsin, June 4, 1922. Study: Beloit Col, B.A., 1949; Univ Iowa, M.A., 1953; Univ Wis-Madison, United Lutheran Church Am scholar, 1962-63, M.F.A., 1963. Work: Univ Iowa Collection; Univ Wis Collection; also in pvt collections. Exhib: Wisconsin at Work, Mem Mus, Milwaukee, 1950 & Wisconsin Painters & Sculptors Ann, 1964; Fla State Fair Show, Tampa, 1965; Nat Exhib Contemp Painting, Soc Four Arts, Palm Beach, Fla, 1966 & 1970; Hortt Mem Exhib, Mus Arts, Ft. Lauderdale, Fla, 1968 & 1970. Awards: Tellus Madden Award, Wis Spring Show, 1963; First Prize in Painting, Winter Park Art Fair, 1965; Atwater Kent Award, Soc Four Arts Nat Exhib, 1966.

DOWDEN, Anne Ophelia Todd. Painter, illustrator. Born:
Denver, Colo, September 17, 1907. Study: Univ Colo;
Carnegie Inst Technol; Art Students League. Work: Hunt
Bot Libr, Pittsburgh, Pa. Comn: Paintings for
reproduction as facsimile prints, Frame House Gallery,
Louisville, Ky, 1969-72; painting of three azaleas.
Callaway Gardens, Pine Mountain, Ga, 1971; painting of
tulip tree flowers, New York Bot Garden, 1972; painting
of rhododendron, Holden Arboretum, Cleveland. Exhib:
American Textiles, Metrop Mus Art, New York, 1948;
Decorative Arts Today, Newark Mus, 1948; Int Group Shows,
Hunt Bot Libr, 1964, 1968 & 1972, one-man show, 1965.
Awards: Tiffany Found Fel, 1929-31. Media: Watercolor.

DRAGUL, Sandra Kaplan. Painter, printmaker. Born:
Cincinnati, Ohio, May 23, 1943. Study: Art Acad
Cincinnati with Julian Stanczak, 1960-61; Pratt Inst,
Deans Scholar, 1962-65, B.F.A. (with hons), 1965; City
Univ New York, with Richard Linduer, Stephen Greene,
Jacob Landau, 1968-70. Work: PTI Restaurant, Houston,
Tex; John Mansville Corp, Chicago; Midland Fed Savings
Bank, Denver, Colo; Ideal Basic Industries Denver; US
Plywood Corp, New York; plus numerous pvt collections.
Exhib: First Colo Biennial, Denver Art Mus, 1971 &
Denver Metrop, 1972 & 1974; one-woman shows, William
Kastan Gallery, Denver, 1974, Pavilion Gallery, Scotsdale,
Ariz, 1974 & 1975 & Attitudes Gallery, 1975; Rocky
Mountain Nat Watermedia Exhib, Golden, Colo, 1974.
Awards: Deans Medal in Graphic Arts, Pratt Inst, 1975;
Best of Show, Jefferson Unitarian Church, Golden, Colo,
1975. Media: Acrylic, watercolor, plaster relief, silk
screen.

DRESKIN, Jeanet Elizabeth. Painter, printmaker. Born:
Greenville, S.C., June 8, 1952. Study: Smith Col, B.A.;
Univ Mich. Work: S.C. State Art Collection, Columbia;
Chrysler Mus Art,Norfolk; Nat Parks Collection,
Gatlinburg, Tenn; Greenville Co Mus Art; S.C. Nat Bank.
Comn: Ed of 60 lithographs, First Piedmont Mortgage Co,
S.C., 1974. Exhib: Appalachian Corridors, Charleston,
1972 & 1975; Dixie Ann, Montgomery Mus Art, Ala, 1973;
Mt. Holyoke Nat Print & Drawing Exhib, 1974; Southeastern
Graphics, Piedmont Graphics, 1965; Tidewater Regional,
Norfolk, 1975. Awards: Purchase Award, S.C. State
Invitational, Clemson, 1974; Mich Artists Print
Competition Award, 1974; Purchase Award, Appalachian
Corridor Exhib, 1975.

DRESKIN, Jeanet Steckler. Painter, instructor. Born:
New Orleans, La., September 29, 1921. Study: Newcomb
Col, Tulane Univ, with Xanvier Gonzales, B.F.A., 1942;
Johns Hopkins Univ, med art cert, 1943; John McCrady Sch,
New Orleans; Clemson Univ, M.F.A. 1973. Work: SC State
Art Collection, Columbia Mus Art; Ga Mus Art, Athens;
Greenville Co Mus Art, SC; Guild Hall Mus, East Hampton,
NY; Nat Parks Collection, Great Smoky Mountains, Tenn.
Comn: Seals, painting & plaque, SC State Bd Health,
Columbia, 1957 & SC Heart Asn, Greenville, 1958; painting,
Fiber Industs, Imp Chem, Dorchester, Eng, 1966; mixed
media mural, Piedmont Industs, New York, 1967; wood block
print, SC Tricentennial Comn, Greenville, 1970. Exhib:
Hunter Ann, George Thomas Hunter Gallery Art, Chattanooga,
Tenn, 1967 & 1974; Piedmont Ann, Mint Mus Art, Charlotte,
NC, 1969-72; U.S.A. Charlotte, NC, 1969-72; Nat Asn
Women Artists, Nat Acad, New York, 1970-74, U.S.A.
Traveling Exhib, 1970-77; Int Grand Prix, Deauville,
France, 1973; 38th Ann Mid-Year Show, Butler Inst Am Art,
Youngstown, Ohio, 1974; plus many others. Awards: Owen
H. Kenan Mem Award of Merit, Am Contemp Exhib, Soc Four
Arts, Fla, 1968; Merit Award, Int Grand Prix, Cannes,
France, 1973; Tex Fine Arts Asn Purchase Award, 63rd Nat
Exhib, Austin, 1974; plus others. Media: Polymers.

DREW, Joan. Printmaker, sculptor. Born: Indianapolis,
Ind., December 21, 1916. Study: Mass Col Art; Art
Students League; graphics with Sternberg. Work:
Rochester Mem Art Gallery: Philadelphia Mus Art; Lyman
Allyn Mus Art; New York Pub Libr; Princeton Univ; plus
others. Exhib: Mus Mod Art, 1957, 1958 & 1960; Boston
Printmakers, Boston Mus Fine Arts, 1957-68; one-man shows.
Lyman-Allyn Mus, 1959; Albright-Knox Art Gallery, 1964;
Art in Embassies, 1964-65; plus many others. Media:
Graphic.

DREXLER, Lynne. Painter. Born: Newport News, Va.
Study: Richmond Prof Inst, B.F.A.; Hunter Col; Col William
& Mary; Hans Hoffman Sch Fine Arts, scholar. Work:
Prentice Hall Collection, Englewood Cliffs, NJ; Ciba-
Geigy Collection, Hudson River Mus; Tamarind Print Collection,
Mus Mod Art, New York; Univ Mass, Amherst. Exhib: One-
man show, Tanager Gallery, 1959; Norfolk Mus Regional Show,
1960; Galleria, San Miguel de Allende, Mex, 1962; Tetra-
Centennial, Va Mus Fine Arts, Richmond, 1966; Traveling
Show, mus in West & South, 1966; plus others.

DRIGGS, Elsie. Painter. Born: Hartford, Conn., August
5, 1898. Study: Art Students League; also with Maurice
Sterne, Rome. Work: Whitney Mus Am Art; Baltimore Mus
Art; Yale Univ Mus; Phillips Gallery, Washington, D.C.;
Sheldon Mem Gallery, Lincoln, Nebr. Comn: Animal
cartoons & W African gold weights, Works Prog Admin,
Harlem House, New York, 1934; La Salle, Post Off,
Huntsville, La, 1935; Indian Village, pvt comn, New York,
1938. Exhib: 35 Under 35, Mus Mod Art Opening Show,
1930; A Mile of Art, Munic Art Exhib RCA Bldg, 1934;
Edward J. Gallagher, III Collection, Baltimore Mus Art,
1953; Root Collection, Metrop Mus Art, 1954; The
Precisionists, Whitney Mus Am Art, 1963. Media: Oil.

DROWER, Sara Ruth. Painter, illustrator. Born: Chicago,
Ill., October 15, 1938. Study: Roosevelt Univ, B.S., 1959;
Univ Ill, Chicago, M.S., 1961; Art Inst Chicago. Work:
Ill State Mus, Springfield; Minn Mus Art, Minneapolis;
Borg-Warner Corp, DePaul Univ & Standard Oil, Chicago.
Exhib: One-person exhib, Ill Art Coun, Chicago, 1973;
Ill State Mus, Springfield, 1971-73; Nat Print & Drawing
Exhib, Western Ill Univ, Macomb, 1972-74; Drawings U.S.A.
'73, Minneapolis, 1973; Mid-Western Graphics, Tulsa, Okla.,
1975. Awards: First Prize Watercolors, Union League
Club, Chicago, 1972; Purchase Award Drawing, Field
Enterprises, Chicago, 1972; Best of Show, Fine Art Exhib,
Artists Guild Chicago, 1974. Media: Drawing & watercolor.

DRUMMOND, Sally Hazelet. Painter. Born: Evanston, Ill.,
June 4, 1924. Study: Rollins Col, 1942-44; Columbia
Univ, B.S., 1948; Inst Design, Chicago, 1949-50; Univ
Louisville, M.A., 1952. Work: Mus Mod Art, New York;
Whitney Mus Am Art; Speed Mus Art, Louisville; Univ Iowa
Mus, Iowa City; Joseph Hirshhorn Collection, Greenwich,
Conn. Exhib: Am Artists Ann, Whitney Mus Am Art, New
York, 1960; Lyric Abstraction in America, Am Fedn Arts
Traveling Exhib, 1962-63; Americans 63, Mus Mod Art, New
York, 1963; Focus on Light, NJ State Mus, Trenton, 1967;
21st New Eng Painting & Sculpture Ann, Silvermine, Conn,
1970. Awards: Fulbright Grant, Venice, 1952; Guggenheim
Grant, France, 1967. Media: Oil.

DUANE, Tanya. Painter. Born: New York, New York. Study: Washington Sq Col, B.A. & M.A. Exhib: One-woman shows, Ahda Artzt Gallery, 1962 & 1963, Contemp Art Gallery, 1965 & Caravan House, 1974, New York; Arts in the Embassies Prog, Nairobi, Kenya & Kuala Lampur, Malaysia, 1967-69; Brooklyn Mus, 1975; plus many others.

DUIS, Rita (Rita Duis Astley-Bell). Painter. Born: New York, NY. Study: Nat Acad Design; Art Students League; Banff Sch Fine Arts, Univ Alta; China Inst; also with Rex Brandt, Edgar Whitney, George Post, Robert Wood, Mario Cooper, Carl Molno, Louis Bouche & Edwin Dickenson. Exhib: American Art Week, Nat Collection Fine Arts, Smithsonian Inst, Washington, D.C., 1963; Am Watercolor Soc, Nat Acad Design, New York, 1970, 1971 & 1973; Painters & Sculptors Soc NJ, Jersey City Mus, 1971; Watercolor USA Nat Ann, Springfield Art Mus, Mo, 1972; Women in Art, 18th Century to Present, Hammond Mus, North Salem, NY, 1974. Awards: Gold Medal of Honor for Watercolor, Open Nat Ann, Catharine Lorillard Wolfe Art Club, 1969; Medal of Honor for Watercolor, Open Nat Ann, Knickerbocker Artists, 1970; Bronze Medal of Honor for Watercolor, Nat Arts Club Ann, NY, 1971. Media: Watercolor, oil.

DUNCAN, (Eleanore) Klari. Painter, instructor. Born: Hungary; U.S. citizen. Study: Pratt Graphic Ctr; Acad Grande Chaumiere, Paris, France, 5 yrs with Prof. Jean Aujame; New York Phoenix Sch Design, NY State scholar. Work: Ulmann Collection, Paris; Ecole de France, Paris; Cornell Club, New York. Comn: Pen & ink drawings of Paris, Pariscope, Supreme Hq Allied Powers, Europe, 1963-65; Gen. Eisenhower (oil portrait), comn by Jean de Pescay, Pershing Hall, Paris, 1964; USS Sarsfield (oil painting), comn by officers & men of ship, 1965; Hon. & Mrs. Robert F. Wagner (oil portraits), comn by Barbara Wagner, 1967, 1968 & 1975; Juanita Lake, Kirkland, Wash (oil painting), comn by Mr. E. Smalley, Roseburg, Ore, 1972. Exhib: Galerie Andre Weil, Paris, 1964; Mus Art Mod, Paris, 1964-65; Expos Intercontinentale de Monaco, 1968; Maitland Art Ctr, Fla, 1972-73; one-woman show, Cornell Club, New York, 1975. Awards: Cert of Appreciation of Recognition of Outstanding Serv to U.S. Navy Recruiting Serv, New York Recruiting Serv, 1966; Hon Mention, Paris Acad. Mem: Nat Arts Club; Burr Artists, New York.

DUNCAN, Ruth. Painter. Born: Greeley, Colo, February 19, 1908. Study: Stephens Col, A.A.; Univ Okla, B.F.A.; and with Harold A. Roney, Simon G. Michael & Warren Hunter. Work: Stephens Col, Columbia, Mo; San Antonio Jr Col Libr, Tex; Royal Bldg, Dallas; Bexar Co Court House & Bexar Co Nat Bank, San Antonio. Comn: Many. Exhib: 36 one-man shows; Exposition Intercontinentale, Congres des Palais, Monaco; Stephens Col, 1968; Witte Mem Mus, San Antonio; Univ Tex, Austin; San Antonio Main Libr, 1968 & 1975; among others. Awards: Wonderland Gallery Award, 1971 & Coppini Acad Fine Arts Award for Best Conserv Painting, 1972, River Art Group; Order of the Rose Award for Achievement & Success in Chosen Field with nat & int acclaim, Delta Gamma Sorority, 1973. Media: Oil, watercolor.

DUNKELMAN, Loretta. Painter. Born: Paterson, NJ, June 29, 1937. Study: Douglass Col, B.A., 1958; Accad delle Belle Arti, Florence, Italy, 1960-61; Hunter Col, with Tony Smith & Ralph Humphrey, M.A., 1966. Work: City Univ Grad Ctr, New York; Univ Cincinnati; Univ Kans Art Mus. Exhib: Whitney Biennial Contemp Art, 1973 & Am Drawings 1963-73, Whitney Mus Am Art, New York; Of Paper, Newark Mus, NJ, 1973; Women Choose Women, New York Cult Ctr, 1973; one-artist shows, AIR Gallery, NY, 1973 & 1974 & Univ RI, 1975; plus many others. Awards: Nat Endowment for the Arts Fel-Grant, 1975. Media: Oil & Wax Chalks on Paper; Fresco Painting.

DU PRE, Grace Annette. Painter. Born: Spartanburg, SC. Study: Converse Col; Grand Cent Sch Art, with Greacen, Wolfe, Karl Anderson, Hildebrandt, Wayman Adams & Frank V. Dumond. Work: Charleston City Hall Collection of Portraits, SC; U.S. Supreme Court, Washington, D.C.; New York Main Post Off Collection; State House, Columbia, SC; Church of the Ascension Collection of Rectors' Portraits, New York. Comn: 14 paintings of judges from life, U.S. Court Appeals, 7th Circuit, Chicago, 1954-61; double portrait of Pres Truman & his mother, now in Truman Collection; Dr. Hu Shih (portrait from life), Columbia Univ Low Libr; plus many others, including four portraits of James F. Byrnes, now in pub collections. Exhib: Allied Artists Am Ann, New York, NY, 1942-63; Nat Arts Club Ann, 1942-63; Am Artists Prof League Ann, 1943-62; Nat Exhib Am Paintings, Ogunquit, Maine, 1951 & 1958; one-man show, Wofford Col, 1975; plus others. Awards: Second Prize for Portrait, Mint Mus Regional Exhib, 1943; Award, 31st Nat Exhib Am Painting, 1951; Prize for Portrait, Catharine Lorillard Wolfe Art Club Ann, 1955. Media: Oil.

ECKE, Betty Tseng Yu-Ho. Painter, art historian. Born:
Peking, China, November 29, 1923; U.S. citizen. Study:
Fu-jen Univ, Peking, B.A., 1942; Univ Hawaii, M.A., 1966;
Inst Fine Arts, NY Univ, Ph.D., 1972. Work: Honolulu
Acad Arts, Hawaii; Walker Art Ctr, Minneapolis; Nat Mus
Mod Art, Stockholm, Sweden; Mus Cernuschi, Paris, France;
Stanford Art Gallery, Calif. Comn: Mural, St. Katherine's
Church, Kaui, Hawaii, 1957; mural, Manoa Chinese Pavilion,
Honolulu, 1968; mural, Golden West Savings & Loan, San
Francisco, Calif, 1964; wall painting, Castle & Cooke Co,
Ltd, Honolulu, 1968; wall painting, Honolulu Int Airport,
1972. Exhib: Contemporary American Painting & Sculpture,
Univ Ill, Urbana, 1958, 1961 & 1965; Carnegie Inst Painting
& Sculpture Int, Pittsburgh, Pa, 1961 & 1965; Kunstverein,
Munich & Frankfurt, Ger; Walker Art Ctr; San Francisco Mus
Art, Calif; plus others. Awards: Am Artists of the
Western States Award, Stanford Art Gallery; NY Univ
Founders Day Award for Outstanding Scholarship, 1972.
Media: Watercolor, collage, plexiglas.

EDWARDS, Ethel (Mrs. Xavier Gonzalez). Painter. Born:
New Orleans, La. Study: Newcomb Col Art Sch; also with
Xavier Gonzalez. Work: IBM Collection; Chase Manhattan
Bank, NY; Commerce Trust Bank, Kansas City, Mo; Boston Mus
Fine Arts; Springfield Mus Fine Art; plus others. Exhib:
Butler Inst Am Art, Youngstown, Ohio, 1964-69; Whitney
Mus Am Art, 1964 & 1965; Hartford Atheneum, 1967 & 1968;
Watercolor: USA, Springfield, Ill, 1967-69; Cape Cod Art
Asn, 1969. Awards: Larry Aldrich Prize, Silvermine
Guild Artists; Prizes, Watercolor: USA, Springfield,
Ill, 1967 & Ball State Univ, Muncie, Ind, 1967.

ELDREDGE, Mary Agnes. Sculptor. Born: Hartford, Conn.,
January 21, 1942. Study: Vassar Col, with Concetta
Scaravaglione & Juan Nickford, B.A.; Pius XII Inst,
Florence, Italy, with Josef Gudics, M.F.A. Work:
Dartmouth Col Collection. Comn: Cemetery monument, Mt.
Calvary Children's Plot, Portland, Ore, 1971; exterior
copper relief, Our Lady of Mt. Carmel Church, Staten
Island, 1972; Sts. Mary & John, St. Paul Church, Nassau,
Bahamas, 1973-74; four copper sculptures, St. Joseph
Church, Roseburg, Ore, 1974; St. Therese, St. Vincent
Ferrer Church, New York, 1975; plus others. Exhib: Mostra
dell' Arte Religiosa per Pasqua, Florence, 1965; Nat Arts
Club Religious Art Exhib, New York, 1966; Acad Artists
Asn Nat Exhib, Springfield, Mass, 1967; Modern Art and the
Religious Experience, Fifth Ave Presby Church, New York,
1968; 6th Biennial Nat Religious Art Exhib, Cranbrook
Acad Art, 1969. Awards: Therese Richard Mem Prize, Nat
Arts Club, 1966; Acad Artists Asn Award, 1967. Mem:
Southern Vt Artists, Inc. Media: Copper, stone.

EMERSON, Edith. Painter, curator. Born: Oxford, Ohio.
Study: Art Inst Chicago; travel in Japan & Mex; Pa
Acad Fine Arts; two Cresson scholarships to Europe; travel
to Europe & India. Work: Plays & Players Theatre,
Philadelphia, Pa; Philadelphia Mus Art; Woodmere Art
Gallery, Philadelphia; Bryn Mawr Col; Haverford Col; plus
others. Comn: Stained glass window in memory of Theodore
Roosevelt, Temple Keneseth Israel, 1919; two panels, The
Sacred Heart & St. Joseph with the Christ Child, Lower
Church of the Nativity of the Blessed Virgin Mary; five
triptych altarpieces for Army & Navy, 1942-43; four
panels, The Life of St. Joseph & chancel decorations,
Nativity Convent, Sisters of St. Joseph, 1946; plus
others. Exhib: Nat Acad Design, New York; Archit League,
New York; Pa Acad Fine Arts, Philadelphia; Corcoran
Gallery Art, Washington, D.C.; Woodmere Art Gallery,
Philadelphia; plus many others. Awards: Granger Prizes,
Pa Acad Fine Arts; Medal of Honor, Philadelphia Watercolor
Club, 1969; Medal Community Service, Chestnut Hill College,
1974. Media: Oil, watercolor.

ENGELSON, Carol. Painter. Born: Seymour, Ind., April 19,
1944. Study: Carnegie-Mellon Univ, B.F.A. Work: Aldrich
Mus Contemp Art, Ridgefield, Conn; Chase Manhattan Bank,
New York. Exhib: Women Choose Women, New York Cult Ctr,
1973; Recent Paintings by Carol Engelson, Pace Univ, 1973;
3rd Ann Contemp Reflections, 1973-74, Aldrich Mus Contemp
Art, 1974; Soho Ctr Visual Artists, 1974; Contemp
Reflections 1971-74, Selections from Aldrich us, Am Fedn
Arts Nat Touring Exhib, 1975-77. Awards: MacDowell Colony
Residence Fel, 1967, 1971, 1972, 1974 & 1975; Comt Visual
Arts Grant, 1974; Change, Inc Grant, 1974. Media: Acrylic
& oil on canvas, pastel.

ERBE, Joan (Mrs. Joan Erbe Udel). Painter. Born:
Baltimore, Md., November 1, 1926. Work: Munic Court,
Washington, D.C.; Peale Mus, Baltimore; Baltimore Mus Art;
Morgan Col. Exhib: Peale Mus, 1951-61; seven shows,
Baltimore Mus Art, 1954-65; Smithsonian Inst, 1956;
Corcoran Gallery Art, 1957-60; Butler Inst Am Art, 1960 &
1961; plus others. Awards: Prizes, Artists Equity Asn,
1960 & 1961; Prizes, Corcoran Gallery Art, 1960 & 1962;
Prizes, Baltimore Mus Art, 1963, 1964 & 1966; plus others.

ESSERMAN, Ruth. Painter. Born: Chicago, Ill., May 21, 1927. Study: Univ Ill, B.A. & M.A.; Univ Mex; Art Inst Chicago. Exhib: Roosevelt Univ-Pan-Am Exhib, 1957; New Horizons, 1958; Denver Art Mus, 1959 & 1960; Chicago Sun-Times Competition, 1960-62; Minneapolis Inst Art, 1964; plus others. Awards: Recipient of numerous prizes and awards.

ETTINGER, Susi Steinitz. Painter, lecturer. Born: Berlin, Ger, July 29, 1922; U.S. citizen. Study: Univ Louisville, B.F.A. (cum laude in art hist), 1943; with Dr. Justus Bier. Work: Springfield Art Mus, Mo; State Hist Soc Mo, Columbia; Sch of the Ozarks, Point Lookout, Mo; Greenwood Lab Sch, Springfield. Exhib: Ann Ten State Regional Competition, Springfield Art Mus, 1961-72 & 1974 & Watercolor USA, 1966-67; Ann Delta Art Exhib, Little Rock, Ark, 1968 & 1970; Mid-West Bi-Ann, Joslyn Art Ctr, Omaha, Nebr, 1970; 7 Missouri Painters, Mo State Coun of Arts Touring Show, 1973-74. Awards: Regional Ten State Competition Purchase Award, Springfield Art Mus, 1969; First Prize Painting, Mo Col Fac Show, 1970; Juror's Selection & Purchase Award, Sch of the Ozarks Ann Regional, 1974. Media: Acrylic, charcoal.

EVANS, Minnie. Painter. Born: Long Creek, NC, December 12, 1892. Work: Newark Mus, NJ; Ill Bell Tel, Chicago; L'Institut de L'Art Brut, Paris; Nat Collection Fine Arts; Whitney Mus Am Art. Exhib: One-man shows, Davison Art Ctr, Wesleyan Univ, 1969 & 1970, Portal Gallery, London, Eng, 1970, St. John's Art Gallery, Wilmington, 1970; Deson Zaks Gallery, Chicago, 1975; Whitney Mus Am Art, 1975. Media: Crayon, oil.

EVANS, Nancy. Painter. Born: New York, NY. Study: Cult Ctr, Naha, Okinawa, with Prof. Yasutaro Kinjo, cert, 1964; Ikebana, cert, 1964; Ikenobo Art Ctr, New York, cert (floral art), 1970. Exhib: Two-man exhib paintings, Naha, Okinawa, 1964; paintings, Enid Pub Libr, Enid Artist League, 1965; paintings, Mat Gallery, New York, 1969; paintings & floral art, Japan House Gallery, 1970; paintings & floral art, Bd Trade, New York, 1970. Awards: Hon Mention, Bryant Park Flower Show, New York, 1969; Hon Mention, Sumie Soc Am, Inc, 1971-72; Second Prize, Horticultural Soc NY, 1973.

FAILING, Frances Elizabeth. Painter. Born: Canisteo,
NY. Study: Pratt Inst, dipl; Western Reserve Univ, B.S.;
Columbia Univ, M.A. Work: Phoenix Pub Libr Gallery
Awards Collection, Ariz; John Herron Art Inst, Indianapolis;
Plymouth Art Club Collection, City Mus, Eng; Washington
High Sch Libr, Indianapolis. Exhib: Indiana Artists,
John Herron Art Mus, Indianapolis, 1933-51; Hoosier Salon,
Chicago & Indianapolis, 1934-47; Le Salon-148 Expos Beaux
Arts, Grand Palais, Paris, 1935; Int Watercolor Exhib, Art
Inst Chicago, 1937; 9th Biennial Int Exhib Watercolors,
Brooklyn Mus, 1937; plus many one-man shows in mus,
galleries & univs. Awards: Leidy Prize, Nat Asn Women
Artists, 1937; Purchase Prize, Ariz State Fair, O'Brien
Gallery Art, Scottsdale, Ariz, 1956; First Premium for
watercolor, Maricopa Fair, Ariz, 1958. Media: Watercolor,
oil.

FALCONIERI, Virginia. Painter, instructor. Born:
Paterson, NJ, March 18, 1943. Study: Entwistle Sch Art,
Ridgewood, NJ, one year; Ridgewood Art Sch, three years.
Work: Solar Syst, Bergen Community Mus, 1976. Comn:
Mural of the universe, Paterson Mus, 1964. Exhib:
Catharine Lorillard Wolfe Art Club, 1975; Salmagundi
Club, 1975; Am Artist Prof League, 1975; Composers,
Authors & Artists Am, New York Chap, 1975; Nat Arts Club
Washington DC, 1975. Awards: Am Artist Prof League
Award, 1973; Catharine Lorillard Wolfe Art Club Merit,
1973; Burr Artist of New York Award, 1974. Media: Oil.

FARBER, Maya M. Painter. Born: Timisoara, Rumania,
January 24, 1936; U.S. citizen. Study: Pratt Inst,
with Edwin Oppler; Hunter Col; Hans Hoffman Sch; Art
Students League, with Reginald Marsh. Work: Butler
Inst Am Art, Youngstown, Ohio; Int Tel & Tel, New York;
Columbia Mus Art, SC; Ga Mus Art, Athens; Jacksonville
Art Museum, Fla. Exhib: One-man shows, Chase Gallery,
1968 & 1974, Telfair Acad Art, Savannah, Ga, 1969 &
Sheldon Swope Art Gallery, Terre Haute, Ind, 1970; NY
State Fair, 1970; Rochester Festival Relig Art, 1972.
Awards: Second Prize, Jamaica Festival Art, 1967.
Media: Oil, acrylic, collage.

FARNHAM, Emily. Painter, writer. Born: Kent, Ohio, May 27, 1912. Study: Kent State Univ, B.S.C. (educ); Art Students League; Cleveland Sch Art; Hans Hofmann Sch Fine Arts; Ohio State Univ, M.A. & Ph.D. Comn: Murals, Cine Sonora, Hermosillo, Sonora, Mex, 1947. Exhib: Works in Competition for World's Fair, Rocky Mountain Region, Denver Art Mus, 1939; one-man shows, Art Ctr, Salt Lake City, 1940 & Univ Va, Charlottesville, 1958; 6th Nat Exhib, Okla Printmakers Soc, Oklahoma City, 1964; Traveling Show, Assoc Artists NC, 1968. Awards: Biography, Charles Demuth: Behind a Laughing Mask, nominated for Nat Bk Award, 1972.

FAULCONER, Mary (Fullerton). Painter, designer. Born: Pittsburgh, Pa. Study: Pa Mus Sch Art; also with Alexey Brodovitch. Work: Mr. & Mrs. Paul Mellon; Mrs. Gilbert Miller; Mr. & Mrs. Richard Rheem; Mr. & Mrs. John Hay Whitney; Dutchess of Windsor; plus many others. Comn: Designed stamp, US Postal Serv, Philatelic Affairs Div, Washington, DC, 1972; two paintings for UNICEF, 1972; paintings for Steubin Glass; designed six stamps, U.S. Postal Serv, 1974. Exhib: Alex Iolas Gallery, New York, 1955, 1958 & 1961; Philadelphia Art Alliance, 1962; Bodley Gallery, New York, 1964, 1966, 1969 & 1972; Tenn Fine Arts Ctr, Nashville, 1967; De Mers Gallery, Hilton Head, SC, 1971-72. Awards: Distinctive Merit Award, 1954, 1957 & 1961, Silver Medal, 1958 & 1959, Art Dir Club. Media: Gouache.

FEDELLE, Estelle. Painter, lecturer. Born: Chicago, Ill. Study: Art Inst Chicago; Northwestern Univ; Inst Design; Am Acad Fine Arts; Colo State Christian Col, hon Ph.D., 1973. Exhib: Am Artists Prof League; Grand Cent Galleries, New York; Barron Galleries, Chicago & Las Vegas; Kenosha Pub Mus, Wis; Chicago Pub Libr.

FEIGENBAUM, Harriet (Mrs. Neil Chamberlain). Sculptor. Born: New York, NY, May 25, 1939. Study: Art Students League; Nat Acad Sch Fine Arts; Columbia Univ. Work: Andrew Dickson White Mus, Cornell Univ; Colgate Univ Mus. Exhib: Hundred Acres First Sculpture Ann, New York, 1971; one-person show, Warren Benedek Gallery, 1972 & 1974; New York Artists on Tour-3, Sculpture, 1973, Dept Cult Affairs; New York Today--Works on Paper, Univ Mo, St. Louis, 1973; Cinquantenaire De La Parution Du Manifeste Surrealiste, Services Culturels Francais, New York, 1973. Awards: Hallgarten Traveling Fel, 1961.

FEIGIN, Marsha. Printmaker, painter. Born: New York,
NY, June 17, 1946. Study: Univ Hawaii, M.F.A.; City Col
New York, B.A.; Cooper Union; Syracuse Univ. Work: Minn
Mus Art; Indianapolis Mus Art; State Found Cult & Arts,
Hawaii; Charles Rand Penney Found, New York; Minneapolis
Inst Arts. Comn: Etching, Creative Artists Pub Serv Prog,
New York, 1975. Exhib: 22nd Nat Exhib Prints, Libr of
Cong, 1971; Graphikbiennale, Vienna, Austria, 1972 & 1975;
18th Nat Exhib Prints, Brooklyn Mus, 1972; 10th & 11th
Biennial Graphic Art, Ljubljana, Yugoslavia, 1973 & 1975;
5th Int Biennial Graphic Art, Crakow, Poland, 1974.
Awards: NY State Coun Arts CAPS Prog Grant Printmaking,
1973 & 1975; Nat Endowment Arts Grant Printmaking &
Drawing, 1975. Media: Intaglio; watercolor, acrylic.

FEIGL, Doris Louise. Painter. Born: Bayonne, NJ,
August 19, 1916. Study: Portrait study with Emily
Nichols Hatch, 1935-37; Grant Cent Sch Art, 1938-40, with
Edmund Graecon & Jerry Farnsworth; Art Students League,
5 yrs, with Joseph Hirsch, Bruce Dorfman & Sidney
Dickenson. Exhib: Bergen Mall Ann, Paramus, NJ, 1965-
72; Bergen Co Artist Guild Ann, Paramus, 1966-72;
Catharine Lorillard Wolfe Club Ann, Nat Arts Club, New
York, 1966-72; Allied Artists Show, Nat Acad Design, New
York, 1967; An Artists Prof League Grand Nat, Lever House,
New York, 1968-71; plus others. Awards: Best in Show,
Bergen Co Artists Guild, 1966, First Prize for Oil, 1969;
Award for Oil, Catharine Lorillard Wolfe Art Club, 1970.
Media: Oil.

FELD, Augusta. Painter, printmaker. Born: Philadelphia,
Pa, April 18, 1919. Study: Fleisher Art Mem & Music
Settlement Sch, Philadelphia; Philadelphia Col Art, B.A.;
Tyler Sch Fine Arts, Temple Univ; Pa Acad Fine Arts, M.A.
Work: Woodmere Art Gallery, Philadelphia; Marple-New Town
Libr, Broomall, Pa; Acad Fine Arts, Philadelphia; permanent
collection of Philadelphia Sch Dist; Hahnemann Hosp,
Philadelphia. Comn: Tree of Life (mural of wood inlays,
gold paint and vinyl, with Joseph Brahim), Del Co
Community Ctr, Springfield, Pa, 1964; dance mural (oil
painting), Melita Dance Studio, Philadelphia, 1968.
Exhib: Woodmere Art Gallery, 1961-; Wilmington Soc Fine
Arts, Del, 1971; Earth Show, Philadelphia Civic Ctr, 1974;
Artist Equity Asn, Philadelphia, 1974; Philadelphia Art
Alliance, 1974-75. Awards: Van Sciver Award, Woodmere
Art Gallery, 1962; First Prize for oils, Atlantic City C
of C, 1968; First Prize, print exhib, Cheltenham Art Ctr,
1971.

FELDMAN, Bella Tabak. Sculptor. Born: New York, NY.
Study: Queens Col, City Univ New York, B.A.; Calif Col
Arts & Crafts; Calif State Univ, San Jose, M.A. Work:
Oakland Mus, Calif; Berkeley Art Mus, Univ Calif. Comn:
Sculptures, Marshal Tulin, Hydronautics Inc, Silver Spring,
Md, 1964, Sasaki-Walker Landscape Architects, Newport
Shopping Ctr, Newport Beach, Calif, 1965 & Royston
Hanamoto Landscape Architects, Potrero Park, Richmond,
Calif, 1966. Exhib: Palace of the Legion of Honor, San
Francisco, 1961; Summer Series, San Francisco Mus, 1964;
Berkeley Art Ctr, 1974; San Francisco Art Inst, 1975; Univ
Calif, Santa Barbara, 1975. Awards: Calif Mus Trustees
Award, 1967; First Prize, San Francisco Women Artists,
1967. Media: Metal, paper, resin.

FELDMAN, Hilda (Mrs. Neville S. Dickinson). Painter,
educator. Born: Newark, NJ, November 22, 1899. Study:
Newark Sch Fine & Indust Art, grad; Pratt Inst, alumni
class, 5 yrs. Work: Reading Mus & Art Gallery; Marine
Hist Asn, Mystic Seaport, Conn; Ford Motor Co, Detroit;
Seton HallUniv, South Orange, NJ; many in pvt collections.
Exhib: Am Watercolor Soc & Nat Asn Women Artists, New
York; Audubon Soc, New York & NJ Galleries; plus traveling
shows in Can, Holland, Belg, Japan & Switz. Awards:
Winsor Newton Prize, 1955 & B. W. Hamm Prize, 1968; Nat
Asn Women Artists; plus others from several NJ exhibs.
Media: Watercolor.

FERRITER, Clare. Painter, collage artist. Born:
Dickinson, N Dak, June 18, 1913. Study: Mass Col Art,
Boston; Yale Univ, B.F.A.; Stanford Univ, M.A. Work:
Butler Inst Am Art, Youngstown, Ohio; Univ Del, Newark;
George Washington Univ; Massillon Mus, Ohio; Addison
Gallery Am Art, Andover, Mass. Comn: Portrait of Miss
H. D. Lamont, comn by Class of 1909 for Westover Sch,
Middlebury, Conn, 1959. Exhib: One-man shows, Univ PR
Mus, 1962 & Corcoran Gallery Art, Washington, D.C., 1963;
regional exhibs, Del Art Ctr, Wilmington, 1966, Baltimore
Mus, 1968 & Univ Del, 1971. Awards: Nat Asn Women
Artists, 1963 & 1966; Baltimore Mus, 1966; Soc Washington
Artists, 1964, 1966 & 1972. Media: Oil, acrylic, metallic.

FFRENCH (Phyllis Marjorie Linnell-Ffrench). Painter.
Born: Melbourne, Australia, June 16, 1921; U.S. citizen.
Study: With Caroline Weir, Melbourne; Melbourne Nat
Gallery; with Sir John Langstaff, Melbourne; with Dr.
George Wang Wu, Shanghai, China; with Max Meldrum,
Melbourne; Corcoran Gallery Art, Washington, D.C. Work:
Yellow Roses (painting), Hornsby Col, NSW, Australia;
Easter Lily (painting), Rosenberg Found & Mus Philadelphia.
Comn: Mrs. Helen Caskin (portrait in oils), Philadelphia,
1947; Col George Donnelly (portrait in oils), New York,
1948; two portraits in oil of Dr. Mary Roos Podea &
Charles Roos, Jr., New York, 1949; Prince Siradje Ali ed
Din (portrait in oils), Algiers, Algeria, 1953; Kenneth
Huebner (portrait in oils), New York, 1964. Exhib: One-
man shows, Proud's, Sydney, Australia, 1944, McClees,
Philadelphia, 1945, Galerie de Bennecaze, Algiers, 1953,
Grife Y Escoda, Barcelona, Spain, 1954; one-man retro-
spective, Church of St. Vincent Ferrer, New York, 1969.
Awards: First Prize for Fuschia (pastels), Canterbury
Hort Soc, 1929; First Prize for Gladioli (watercolor),
Caroline Weir, 1932. Media: Oil, watercolor, pencils.

FISK, Evi Ester. Painter. Born: Helsinki, Finland, U.S.
citizen. Study: Art Students League; Mus Mod Art; also
with Theodoros Stamos, Byron Brown, Steven Green & Julian
Levi. Work: Riverside Mus, New York; Norfolk Mus Art &
Sci, Va; Fleisher Art Mem, Philadelphia; plus pvt
collections. Exhib: American Women Artists, Nat Acad
Gallery, New York, 1973; Award Winner Show, Eastside
Gallery, 1968; Festival d'art deaville, Trouville, France,
1969; Riverside Mus, 1970; one-man show, Jersey City Art
Mus, NJ, 1973. Awards: Award Winner Selection Show,
Allied Arts Guild, 1963; Samuel Fleisher Art Mem Prize,
1969; Purchase Prize, Norfolk Mus, 1972. Media: Oil,
watercolor.

FLACK, Audrey L. Painter, instructor. Born: New York,
NY, May 30, 1931. Study: Cooper Union, grad, 1951;
Cranbrook Acad Art; Yale Univ, scholar & study with Josef
Albers. Work: Whitney Mus Am Art, New York; Rose Art
Mus, Brandeis Univ; NY Univ Art Collection; Riverside Mus
& Mus Mod Art, New York. Comn: Family portrait comn by
Oriole Farb, Dir, Riverside Mus & Stuart M. Speiser
Collection. Exhib: 22 Realists, Whitney Mus Am Art,
1970; Painter & the Photograph, Riverside Mus, 1970;
Whitney Mus Am Art Ann, 1972; Tokyo Metrop Art Mus, 1974;
Tokyo Mus Art, 1975. Awards: Albert Dorne Prof, Univ
Bridgeport, 1975; Nat Exhib Paintings Second Prize, Butler
Inst Am Art, 1974. Media: Oil.

FOHR, Jenny. Sculptor, instructor. Born: New York, NY.
Study: Hunter Col, B.A.; Alfred Univ; Univ Colo, M.A.;
City Col. Work: Norfolk Mus, Va; Long Beach Island Found
Arts & Sci, NJ; Dr. Wardell Pomeroy, New York; Oakland
Mus, Calif; Charles Suter, Ciba-Geigy, New York. Exhib:
One-man show, Chautauqua Art Asn Galleries, NY, 1960 &
Brooklyn Mus, 1961; Nat Asn Women Artists, Chauteau de la
Napoule, France, 1965; Nat Asn Women Artists Traveling
Show, India, 1966; NJ State Mus, Trenton, 1968; Am Color
Print Soc Traveling Show, 1972. Awards: Medal of Honor,
Painters & Sculptors Soc, NJ, 1963; Samuel Mann Award,
Am Soc Contemp Artists, 1971; May Granick Award, Nat Asn
Women Artists, 1975.

FONER, Liza. Painter. Born: New York, NY, July 13, 1912.
Study: Painting with Jack Levine, Robert Gwathmey &
Joseph Solman as well as in museums in U.S. & Europe.
Work: Chrysler Mus, Norfolk, Va; Colby Col Mus, Waterville,
Maine. Exhib: Catharine Lorillard Wolfe 64th Ann, Nat
Arts Club, Grammercy Park, NY, 1961; 82nd Ann, Nat Asn
Women Artists, New York, 1971 & 86th Ann, 1975; 149th Ann,
Nat Acad Design, New York, 1974 & 150th Ann, 1975.
Awards: Medals of Honor, Catharine Lorillard Wolfe Ann,
1961 & Nat Asn Women Artists, 1971; Zuita & Joseph James
Alston Found Prize, Nat Asn Women Artists, 1975. Media:
Oil, graphic.

FOOSANER, Judith Ann. Painter. Born: Sacramento, Calif,
August 10, 1940. Study: Univ Calif, Berkeley, B.A.
(Eng.), 1964, dean's award, 1961, univ grant & M.A. (art),
1968. Exhib: San Diego Fine Arts Gallery, Calif, 1970;
one-woman show, Wenger Gallery, 1971. Media: Acrylic, oil.

FORMAN, Alice. Painter, designer. Born: New York, NY,
June 1, 1931. Study: Cornell Univ, with Kenneth Evett &
Norman Daly, B.A.; Art Students League, with Morris Kantor.
Exhib: Whitney Mus Am Art, 1960; White Mus Art, Cornell
Univ, 1961; Phoenix Gallery, NY, 1966, 1968, 1971 & 1974;
Marist Col, 1968 & 1971; Butler Inst Exhib, 1972; plus
others. Awards: Nat Student Asn Regional Awards; Daniel
Schnackenberg Merit Scholar, Art Students League. Media:
Oil.

FOULKES, Llyn. Painter. Born: Yakima, Wash, November 17, 1934. Study: Cent Wash Col Educ; Univ Wash; Chouinard Art Inst. Work: Whitney Mus Am Art, New York; Art Inst Chicago; Los Angeles Co Mus Art; Mus Mod Art, New York; Mus des 20 Jahrhunderts, Vienna, Austria. Exhib: 7th & 9th Sao Paulo Biennial, Mus Mod Art, Sao Paulo, 1963 & 1967; New York World's Fair, 1965; 5th Paris Biennial, Mus Mod Art, Paris, 1967; Whitney Ann Am Painting, 1967 & 1969 & American Art of Our Century, 1971, Whitney Mus Am Art, New York; one-man shows, Pasadena Art Mus, Calif, 1962, Oakland Mus Art, Calif, 1964 & Galerie Darthea Speyer, Paris, 1970. Awards: First Award for Painting, San Francisco 82nd Ann, San Francisco Mus Art, 1963; New Talent Purchase Grant, Los Angeles Co Mus Art, 1964; Medal of France (first award for painting), 5th Paris Bienniale, Mus Mod Art, Paris, 1967. Media: Oil, acrylic.

FRANK, Mary. Sculptor. Born: London, Eng, February 4, 1933. Study: With Max Beckmann, 1950 & Hans Hofmann, 1951. Work: Art Inst Chicago; Kalamazoo Inst Art; Mus Mod Art; Southern Ill Univ; Worcester Mus Art, Mass; plus others. Exhib: Yale Univ; Brandeis Univ; Mus Mod Art; Hans Hofmann & His Students Traveling Exhib, 1963-64; Whitney Mus Am Art Biennial, New York, 1973; plus others. Awards: Ingram Merril Found Grant, 1961; Longview Found Grant, 1962-64; Nat Coun Arts Award, 1968.

FRASER, Bertha (Riese). Designer, painter. Born: Duvall, Wash. Study: Univ Wash; with Eliot O'Hara; Edison Tech Sch, with Fay Chong; Traphagen Sch Fashion, with Chrisee Condaras; Art Students League, with Agnes Hart; Sch Visual Arts, with Tom Gill & Nils Boedecker. Exhib: Changing Scene in Washington, Seattle, 1965; Sumi-e Exhib, Sumi-e Soc Am, 1966 & 1970-72. Media: Watercolor, Sumi-e.

FREILICH, Ann. Painter. Born: Czestochowa, Poland: U.S. citizen. Study: Educ Alliance Art Sch. Work: Brooklyn Mus, New York; Peabody Mus, Nashville, Tenn; Art Lending Collections, Philadelphia Mus Art & Mus Mod Art; Syracuse Univ. Exhib: Six one-man shows, Roko Gallery, 1965-73; Riverside Mus, 1964; Bucknell Univ Drawing Exhib, 1965; Gallery Mod Art, Huntington Hartford Mus, 1967; Am Acad Arts & Lett, 1970-72. Media: Oil, watercolor.

FRERICHS, Ruth Colcord. Painter. Born: White Plains, NY. Study: Conn Col, B.A. (fine arts); Art Students League, lithography with Armin Landeck; watercolor with William B. Schimmel & F. Douglas Greenbowe. Work: Thunderbird Bank, Phoenix, Ariz; Valley Nat Bank, Ariz; First Nat Bank of Ariz; Empire Machinery Co, Mesa, Ariz. Exhib: Southwest Watercolor Soc Regional Exhib, Dallas, Tex, 1969; Wichita Nat Centennial Watercolor Exhib, Kans, 1970; Am Watercolor Soc Ann, New York, 1970; Watercolor U.S.A., Springfield, Mo, 1972; Watercolor West, Nat Exhib, Riverside, Calif, 1972. Awards: Gold Medal, Low Ruins Nat Exhib, Tubac, 1965; Award, Southwest Watercolor Soc Regional, 1969; Ariz Dimensions '73 Exhib Spec Award.

FREY, Viola. Sculptor, painter. Born: Lodi, Calif, August 15, 1937. Study: Delta Col, Stockton, Calif, A.A.; Calif Col Arts & Crafts, B.F.A.; Tulane Univ, M.F.A. Work: Leslie Ceramic Collection, Berkeley, Calif; Oakland Mus, Calif. Exhib: One-man shows, Art Inst Chicago, 1960's & Haggin Mus, Stockton, 1971; Oakland Myths, Wenger Gallery, 1973 & Seat of Civilization, 1974; Sculpture Exhib, Hank Baum Gallery, San Francisco, 1975.

FRUHAUF, Aline. Painter, printmaker. Born: New York, NY, January 31, 1907. Study: Parsons; Art Students League; and with Boardman Robinson, Kenneth Hayes Miller & Charles Locke. Work: Phillips Gallery, Libr Cong, Nat Collection Fine Arts & Smithsonian Inst, Washington, D.C.; Baltimore Mus Fine Art, Md. Exhib: Corcoran Gallery, Washington, DC; one-woman shows, Univ Nebr, 1941, Caricatures of American Artists, 1944, Caricatures of Washington Artists, 1950 & Face of Music in Washington, Baltimore Mus & Making Faces, Smithsonian Inst, 1965-66. Media: Oil, watercolor, lithography, woodcut.

FUHRMAN, Esther. Sculptor. Born: Pittsburgh, Pa., February 25, 1939. Study: Pa State Univ, 1956-57; Frick Dept Fine Arts, Univ Pittsburgh, B.A., 1960; also with Sabastiano Mineo & Hana Geber, New York. Work: Port of New York Authority; Deere & Co, Moline, Ill. Comn: Marble lobby piece, Int Educ & Training, Inc., NY, 1970; bronze & acrylic wall sculptures, comn by Hon. & Mrs. I. D. Davidson, New York, 1971 & 1972 & Mr. & Mrs. G. Strichman, 1974. Exhib: Nat Asn Women Artists, Nat Acad Art, New York; Six Contemp Artists, Montclair Mus Art NJ; Sculptors League, Columbia Univ Club, New York; Citicorps, New York, ann; Three Contemp Sculptors, Queens Coun Arts, Queens Co Supreme Ct Bldg; Am Soc Contemp Arts, Lever House, New York. Awards: Ann Exhib Award, Nat Asn Women Artists, 1972 & 1974. Media: Bronze with acrylics and gemstone materials.

FURMAN, Gloria Violet. Painter, art dealer. Born: New
York, NY, March 21, 1927. Study: Hunter Col, B.A.; Art
Students League; Brooklyn Mus Sch, with Reuben Tam.
Exhib: Provincetown Artists Asn; Art Students League,
Woodstock, NY; Brooklyn Mus Summer Show; Christ Church
Ann, Cobble Hill, NY; one-man show, Gallery 91, 1972.
Pos: Dir & organizer, Gallery 91, Brooklyn, NY, 1971.
Media: Collage, oil, acrylic.

GABLIK, Suzi. Writer, painter. Born: New York, NY,
September 26, 1934. Study: Black Mountain Col, NC,
summer 51; Hunter Col, B.A., 1955, with Robert Motherwell.
Work: Hirshhorn Collection; Sarah Robbie Found. Exhib:
Terry Dintenfass, Inc, New York, 1972.

GALEN, Elaine. Painter, sculptor. Born: New York, NY,
July 12, 1928. Study: Philadelphia Mus Sch Art, dipl,
1950; Univ Pa, B.A., 1951; Art Students League, 1955-59;
NY Univ, M.A., 1963; major study with Morris Kantor.
Work: Philadelphia Mus Art; Mus Rigaud, France; Rey
Collection, Perpignan, France; Atelier 45. Comn: Images
from the Wind (portfolio, also co-auth), NY, 1962 & Mythic
Encounters (litho suite), Chicago, 1974, Ed Du Grenier.
Exhib: Whitney Mus Am Art Ann, New York, 1961; Brooklyn
Mus Int, 1963; NJ State Arts Coun, 1970; one-man show, Pa
Acad Fine Arts, Peale House, 1972; State Mus Ill, 1974;
numerous one-man shows and others. Awards: Chautauqua
Inst First Prize for Painting, 1963; Nat Print Award,
Hunterdon Ctr, NJ, 1970; Am Iron & Steel Inst Award for
Design Excellence, 1972; plus others. Media: Oil, pencil-
ink; stainless steel.

GANTHIERS, Louise Marie. Painter. Born: New York, NY,
October 16, 1907. Study: Art Students League, with
Vaclav Vytlacil, 1939-40; Am Artists Studio, New York,
with Moses Soyer, 1941; Brooklyn Mus, with Rufino Tamayo,
fall 1944. Work: Mus N Mex, Santa Fe; Roswell Mus, N Mex;
Helene Worlitzer Found, Taos, N Mex; Univ Calif Los Alamos
Labs, N Mex; Aspen Inst, Colo. Exhib: Southwest American
Art, Okla Art Ctr, Oklahoma City, 1959; 7th Int Exhib
Women Artists, Mus Mod Art, Paris, 1962; one-man shows,
Mus N Mex, 1963, Roswell Mus, 1963 & Palace of Legion of
Honor, San Francisco, 1966. Awards: Nonobjective Group
Third Prize, N Mex State Fair, 1953; Purchase Award, Mus
N Mex, 1956; Purchase Award, Dr. William Oakes, Los Alamos,
1958. Media: Oil, watercolor.

GARDNER, Joan A. Painter, film maker. Born: Joliet, Ill.,
May 3, 1933. Study: Univ Ill, Kate Neal Kinley Mem fel,
1955, B.F.A. & M.F.A.; Norfolk Summer Art Sch, Yale Univ,
fel, 1956, with Rico Lebrun & Gabor Peterdi. Work: Univ
Ill; Am Fedn Art; Art Inst Chicago. Exhib: Conn Acad
Fine Arts, 1969; John Slade Elyhouse, New Haven, Conn, 1970;
Conn Arts Festival, Hartford, 1971; New Britain Mus Art,
Conn, 1971; 55 Mercer Gallery, 1973-75, traveling show,
1974-75. Awards: Conn Acad Fine Arts Award, New Britain
Mus, 1969; Fulbright-Hays Award, 1974.

GARDNER, Susan Ross. Painter, printmaker. Born: New
York, NY, October 25, 1941. Study: Brooklyn Mus, 1959;
Antioch Col, B.A., 1963; Ohio State Univ, M.A., 1966. Work:
Metrop Mus Art, New York; Southern Ill Univ; Northern Ill
Univ; Atlantic Richfield Corp. Exhib: Boston Printmakers
21st, 22nd & 23rd Ann, 1969-71; 100 Acres, Soho 20, New
York, 1971 & 1972; Allan Frumkin Gallery, Chicago, 1972;
18th Nat Print Exhib, Brooklyn Mus, 1972; one-woman show,
Terrain Graphics, Soho, 1974. Awards: Purchase Award,
Northern Ill Univ, 1971. Media: Silkscreen, acrylic.

GARY, Jan (Mrs. William D. Gorman). Painter, printmaker.
Born: Ft. Worth, Tex, February 13, 1925. Study: Art
Ctr Sch, Los Angeles; San Antonio Art Inst, Tex; Art
Students League. Work: Butler Inst Am Art, Youngstown,
Ohio; Pensacola Art Ctr, Fla; Wis State Univ, Eau Claire;
Brandeis Univ, Waltham, Mass; Rosenberg Libr, Galveston,
Tex. Exhib: One-man shows, Centenary Col Women,
Hackettstown, NJ, 1967 & Ringwood Manor State Mus, NJ,
1968; Am Acad Arts & Lett, 1967-68; Four NJ Artists,
Canton Art Inst, Ohio, 1971; Cent Wyo Mus Art, Casper,
1975. Awards: M. Grumbacher Purchase Award, Audubon
Artists Ann, 1966; Childe Hassam Fund Purchase Award, Am
Acad Arts & Lett, 1968; Dorothy F. Seligson Mem Prize,
Nat Asn Women Artists Ann, 1975. Media: Acrylic, casein,
woodcut.

GASTON, Marianne Brody. Painter, illustrator. Born: New
York, NY. Study: Washington Irving Art Sch; Metrop Mus
Art & Mus Natural Hist, scholar, 1934-36; Parsons Inst
for Fashion Illus, scholar, 1936; Art Students League,
with Brackman, Vytlacil & R. Soyer; Parsons Sch Design;
Great Neck Art Asn, with M. Soyer & Irving Maranz; pvt
study with Jack Levine. Work: New York Pub Libr; Art
Dirs Club New York. Comn: Cover article & color ads,
Vogue, Harpers Bazaar, Cue, Glamour & others. Exhib: Nat
Asn Women Artists, 1950-60; Best & Co, New York, 1958;
Gilgolde Gallery, Great Neck, NY, 1959 & 1960; The Art
Gallery, Dallas, Tex, 1961; Hotel Fontainebleau, Miami
Beach, Fla, 1961; plus others. Awards: Alexander Medal,
Sch Art League, 1934; Art Dirs Club Award for Fashion
Illus, 1941; Atkins Award, Nat Asn Women Artists, 1955.

GATRELL, Marion Thompson. Educator, painter. Born:
Columbus, Ohio, November 13, 1909. Study: Ohio State
Univ, B.S.Ed., 1931, M.A., 1932. Work: Butler Inst Am
Art, Youngstown, Ohio; Columbus Gallery Fine Arts;
Massillon Mus Art, Ohio; Otterbein Col, Westerville,
Ohio; Schumacher Gallery, Capital Univ Colo. Exhib:
Audubon Artists Nat, 1945; Butler Art Inst Regional Ann,
1950 & 1957; Nat Asn Women Artists, Scotland, Eng &
India, 1964-65; Int Womens Competition, Cannes, France,
1969; Florence & Naples, Italy, 1972; plus traveling shows
in U.S. Awards: Purchase Award, Butler Art Inst, 1957;
Baldwin Purchase Award, Massillon Mus, 1964; Pace Gallery
Award, Schumacher Gallery, Capitol Univ, 1968 & 1974.
Media: Graphics, watercolor.

GAY, Zhenya. Painter, designer. Born: Norwood, Mass.
Study: Columbia Univ, 1919-22; also with Solon Borglum,
New York, Winold Reiss, Gaston Dorfinant. Comn: Costume
designer, Brooks Theatrical Costumes. Exhib: Montross
Gallery, New York, 1930; Dutton's Gallery, New York, 1931;
H. H. De Young Mus, San Francisco, 1931; Am Mus Natural
Hist, New York, 1935; Rains Galleries, New York, 1939.
Awards: Cert, NY State Asn Supvn & Curric Develop, 1961.

GEBER, Hana. Sculptor, instructor. Born: Praha, Czech.,
February 14, 1910; U.S. citizen. Study: Teachers Col,
Prague; Art Students League; Sculpture Ctr, New York.
Work: Yeshiva Univ Mus; Jewish Mus, New York; Rose Art
Mus, Brandeis Univ; Mus Ethnography & Folklore, Ramat-Aviv,
Israel; Lowe Art Mus, Univ Miami. Comn: Wedding altar,
Temple Emanuel, Yonkers, NY; memorial, Verona High Sch,
NJ; statue, Riverdale Temple, Bronx; statue, Temple Sinai
of Long Island, NY; silver wallpiece, Free Westchester
Synagogue; plus others. Exhib: One-man shows, Montclair
Art Mus, Union Am Hebrew Congregations, New York, Sculpture
Ctr, New York, Am Jewish Hist Soc, Waltham & Boston, Mass
& Pa Acad Fine Arts, Philadelphia; plus others. Awards:
Mem Found Jewish Cult Fel, 1969; Gold Medal, Nat Asn Women
Artists; First Prize, Am Soc Contemp Artists; plus others.
Media: Silver, bronze.

GECHTOFF, Sonia. Painter, educator. Born: Philadelphia, Pa, September 25, 1926. Study: Philadelphia Mus Col Art, B.F.A., 1950. Work: San Francisco Mus Art; Woodward Found for U.S. Embassies, Washington, D.C.; Univ Mass, Amherst; Oakland Art Mus, Calif; Am Tel & Telegraph Co, New York; plus others. Exhib: American Painters, U.S. Pavilion, Brussels Fair, Belg, 1958; Carnegie Inst, Pittsburgh, 1958; First Paris Bienale, France, 1959; Sao Paulo Bienale, Brazil, 1961; Women Choose Women, New York Cult Ctr, 1973; plus others. Awards: Purchase Award, San Francisco Mus Art, 1957; Ford Found Fel, Tamarind Lithography Workshop, 1963; Drawing Prize, Four Corners States Bienale, Phoenix Art Mus, 1975; plus others.

GECSE, Helene. Painter, etcher. Born: Astoria, NY. Study: Glendale Col, Calif, with Jean Abel; Otis Art Inst, Los Angeles, with Joseph Mugnaini, Shiro Ikegawa & Guy Maccoy. Work: Brand Libr Art Ctr, Glendale. Exhib: One-man show, Huntington Galleries, W Va, 1965; 11th Ann Drawing & Sculpture Show, Ball State Univ, Muncie, Ind, 1965; 6th Nat Prints & Drawings, Ultimate Concerns, Ohio Univ, 1965; 32nd Nat Graphics Arts Exhib, Wichita Art Asn, Kans, 1965; Arts Southern Calif, Long Beach Mus, 1966-67. Media: Graphic.

GEHNER, Marjorie Nielsen. Painter. Born: Florence, Wis., May 26, 1909. Study: Ripon Col, 1926-28; Univ Wis-Milwaukee, with Gustav Miller, B.E., 1931; New Sch Social Res, with Emilio Egas, 1935-36; Columbia Univ, with Arthur Young, M.F.A., 1959, prof dipl, 1961. Work: Ripon Col, Wis; Leonia Pub Libr, NJ; Leonia Pub Sch, NJ. Exhib: Am Watercolor Soc Traveling Exhib, 1968 & 1974; Nat Asn Women Artists Traveling Exhibs, France, 1969 & U.S., 1972 & 1974. Awards: Goldie Paley Award, Nat Asn Am Women, 1961; Ann Show Award, Am Asn Univ Women, 1970; Antoinette Graves Goetz Award, Am Watercolor Soc, 1974.

GEHR, Mary (Mary Ray). Printmaker, painter. Born: Chicago, Ill. Study: Smith Col; Art Inst Chicago, with Paul Wieghardt; Inst Design of Ill Inst Technol, with Misch Kohn. Work: Art Inst Chicago; Philadelphia Mus; Libr Cong, Washington, D.C.; Nelson Rockefeller Collection; Free Libr, Philadelphia. Comn: Golden Santorini (intaglio-edition of 210 etchings printed by Leterio Calapai), Int Graphic Arts Soc, 1967. Exhib: Chicago & Vicinity Exhibs & Soc Contemp Am Art, Art Inst Chicago; Brooklyn Mus Nat Print Exhib; Boston Printmakers, Mass; Print Club, Philadelphia. Awards: Print Fair Award, Philadelphia; First Purchase Award, Artist Guild Chicago; Award for Graphics, Old Orchard Festival, Chicago. Media: Intaglio, batik.

GEIGER, Edith Rogers. Painter. Born: New Haven, Conn., July 13, 1912. Study: Smith Col, B.A., 1934; Art Students League, 1934-35; Yale Univ, with Joseph Albers. Work: Wadsworth Atheneum, Hartford; Tryon Art Mus, Smith Col; Springfield Art Mus, Mass; Art Mus, Ann Arbor, Mich; Bridgeport Univ Art Collection. Exhib: Brooklyn Mus 21st Int Watercolor Biennial; Detroit Nat Watercolor Exhib; Boston Art Festival; Providence Festival, RI; solo exhibs, Bodley Gallery, New York, 1956, Ruth White Gallery, New York, 1959 & 1962, Naples Art Gallery, Fla, 1969 & 1970. Awards: Best in Show Awards, New Haven Festival Arts, 1957 & 1962; Woman's Award, Am Watercolor Soc, 1962; Nat Asn Women Artists Award, 1963. Media: Mixed media.

GEKIERE, Madeleine. Painter, film maker. Born: Zurich, Switzerland, May 15, 1919; U.S. citizen. Study: Art Students League, with Kantor; Brooklyn Mus Art Sch, with Tamayo; NY Univ, with Sam Adler. Work: Worcester Art Mus, Mass; Fogg Mus Art, Cambridge, Mass; NY Univ Collection; Brooklyn Mus, NY; Currier Gallery of Art, Manchester, NH; plus others. Exhib: Univ Ga, 1967; Western Carolina Univ, 1972; Audubon Artists, New York; NY Univ Loeb Ctr; also many one-man shows; film showings, Millenium & Artists Space, NY. Awards: Best Illustrated Book of Year, New York Times, 1957, 1959 & 1963; Audubon Medal of Honor, 1969; Childe Hassam Purchase Prize, Soc Art & Lett, 1973. Media: Ink, oil.

GELLER, Esther (Esther Geller Shapero). Painter, printmaker. Born: Boston, Mass., October 26, 1921. Study: Mus Fine Arts Sch, Boston, dipl; also with Karl Zerbe. Work: Mus Fine Arts, Boston; Addison Gallery Am Art, Andover, Mass; Brandeis Univ; Walters Gallery, Regis Col; St. Mark's Sch Gallery, Southboro, Mass. Exhib: Art Inst Chicago Ann; Univ Ill Ann, Urbana; Boston Art Festivals; U.S. Info Serv Circulating Exhibs in the U.S. & Far East; one-man show, Am Acad Art Gallery, Rome, 1971. Awards: Pepsi-Cola Prize; Cabot Fel, 1949; Fels, MacDowell Colony, Yaddo & Am Acad, 1950-71. Media: Encaustic, watercolors.

GENTILE, Gloria Irene. Designer, sculptor. Born: New
York, NY. Study: Cooper Union, New York, 1947-50; Yale
Univ, 1951-54, B.F.A. & M.F.A.; study with Josef Albers,
Will Barnet, Abraham Rattner, Marscicano, Stuart Davis,
Buckminster Fuller, Philip Johnson, Frederick Kiesler,
Louis Kahn, Frank Lloyd Wright & Alvin Lustig. Exhib:
One-person shows, Harbrace Gallery, 1967, Aleksandra
Kierekieska Gallery, 1968, Art Dir Club Gallery, 1968,
Young & Rubican Gallery, New York, 1968 & Ogilvy & Mather
Inc Gallery, 1968. Media: Bronze with ball joints.

GETZ, Dorothy. Sculptor. Born: Grand Junction, Iowa,
September 7, 1901. Study: Ohio State Univ, B.A., 1923,
M.A., 1932; Acad Belle Arti, Perugia, Italy, summers 1962,
1963 & 1965. Work: Columbus Gallery Fine Arts, Ohio;
Akron Inst Am Art, Ohio; Sassaferato, Italy. Exhib:
Ceramic Nat, Syracuse, NY, 1952 & 1954; Five Ohio Ceramic
& Sculpture Shows, Akron, 1955-64; Drawing & Small
Sculpture Ann, Ball State Univ Art Gallery, 1956, 1958 &
1959. Awards: Salvi Prize, 4th Piccolo Europa,
Sassaferato, Italy, 1963; Purchase Prize, Ohio Ceramic &
Sculpture Show, Akron Inst Am Art, 1964; Purchase Prize,
Columbus Gallery Fine Arts, 1966.

GILLESPIE, Dorothy Merle. Painter, art administrator.
Born: Roanoke, Va., June 29, 1920. Study: Md Inst Col
Art, Baltimore; Art Students League; Clay Club, New York;
Atelier 17, New York, with Stanley William Hayter. Work:
State Collection, Kessel Mus, Ger; Helena Rubenstein
Pavilion, Tel Aviv Mus, Israel; San Marcos Univ, Lima,
Peru; Univ Miami, Fla; Fordham Univ, New York. Exhib:
Va Mus Fine Arts, Richmond; Norton Gallery, Palm Beach,
Fla; New York Cult Ctr; San Francisco Mus; NY Univ.

GLADSTONE, Evelyn Anderson. Painter. Born: Clarkton,
NC. Study: Flora MacDonald Col, 1926-28; Univ NC, 1928-
30. Work: Represented in numerous pvt collections.
Comn: State Seal of North Carolina, comn by Sen. John
J. Burney, 1968, Home & Camp Site, 1970; posters, Nat
Presby Church, Washington, D.C., 1974; Seascape, Seapth
Condominium, 1975. Exhib: Arts Club Washington, D.C.,
1965; Corcoran Art Gallery, Washington, D.C., 1967;
Austrian Embassy, Washington, D.C., 1967; Rehoboth Art
League, Del, 1967; Nat League Am Pen Women, 1972-74.
Awards: Miniature Painters, Sculptors & Engravers Soc
Hon Mention, 1967; First Award for Oils, St. Luke's
Methodist Church, 1968; Second Award for Oils, Nat League
Am Pen Women, 1975. Media: Oil.

GODDARD, Vivian. Painter. Born: San Francisco, Calif.
Study: Calif Sch Fine Art; Art Students League; Stanford
Univ, with Ed Farmer & Dan Mendelowitz; Art League San
Francisco; Robert Brackman Summer Sch, Noank & Madison,
Conn; Otis Art Sch, Los Angeles; Acad Grande Chaumiere,
Paris; Simi Studio, Florence, Italy. Work: Pioneer Mus
& Hagan Gallery, Stockton, Calif; Hall Justice, San
Francisco; City Sacramento, Calif; Stanislaus State Col.
Comn: Portraits, Richard Cragin, Alexander Capurso, Otto
Kruger, Mrs. Bernard McFadyen, Hubert Latimer, plus many
others. Exhib: One-man shows, Windblad Gallery, San
Francisco, 1968, Pioneer Mus & Hagan Gallery, 1969,
Stanislaus State Col, 1969 & Rosecrucian Mus, San Jose,
Calif, 1969 & 1972; Soc Western Artists, De Young Mus,
1968-70; plus others. Awards: First Award for Graphics
& Award for Oil Portrait, Soc Western Artists, 1967; Award
for Portrait, Mother Lode Nat, 1970; plus others. Media:
Oil.

GOEDIKE, Shirl. Painter. Born: Los Angeles, Calif, 1923.
Study: Univ Calif, Los Angeles; Art Ctr Sch, Los Angeles.
Work: Los Angeles Co Mus Art; Pasadena Mus Art; Palm
Springs Mus; Home Savings & Loan, Los Angeles; Hirshhorn
Mus, Washington, D.C.; plus others. Exhib: Los Angeles
Co Mus, 1955-56; Stanford Univ, 1956; one-man show, Palace
Legion of Honor, San Francisco, Calif, 1959; Santa Barbara
Biennial, Santa Barbara Mus & Nat Tour, 1959; 26th
Biennial, Corcoran Gallery Art, Washington, D.C. Awards:
Los Angeles Co Art Mus Purchase Prize, 1955; All-City Art
Festival Honorable Mention, Home Savings & Loan Los
Angeles, 1956 & 1957; First Honorable Mention, James D.
Phelan Award, 1957. Media: Oil.

GOELL, Abby Jane. Painter, printmaker. Born: New York,
NY. Study: Art Students League, with Harry Sternberg &
Charles Alston; Syracuse Univ, B.A.; NY Sch Interior
Design, cert; Columbia Univ, with Robert Motherwell,
Stephen Greene & John Heliker, M.F.A. (painting). Work:
Mus Mod Art, New York; Yale Univ Art Gallery; Chase
Manhattan Bank Collection, New York; Kresge Art Ctr, Mich;
Atlantic Richfield Oil Co, Calif; plus others. Comn:
Original print, Pratt Graphics Ctr, 1975. Exhib: South
London Art Gallery, 1967; Westchester Art Ann, 1967;
Brooklyn Mus Print Biennial, 1970; Hudson River Mus,
Yonkers, NY, 1971; one-man show, Automation House, New
York, 1973; plus others. Media: Oil, acrylic; serigraph,
lithograph, collage.

GOLD, Leah. Painter, printmaker. Born: New York, NY.
Study: With Ruth Reeves & Hans Hofmann. Work: Birmingham
Mus Art, Ala; Slater Mem Mus, Norwich, Conn. Exhib: Int
Watercolor Exhib, Brooklyn Mus, NY, 1952, Nat Print Exhib,
1956; Int Airpost Exhib, Nat Philatelic Mus, 1954; Am
Jewish Tercentenary Exhib, Riverside Mus, Corcoran Gallery
Art, Albright-Knox Art Gallery, Cleveland Mus Art & Dallas
Mus Fine Arts, 1954-55; 2nd Biennial Exhib, Birmingham Mus
Art, 1956. Awards: Mrs. John T. Pratt Prize for Woodcut,
Nat Asn Women Artists, 1957; Prize for Casein Painting,
Painters & Sculptors Soc NJ 18th Ann, 1959; Award for
Stained Glass Sculpture, Brooklyn Soc Artists, 1959.
Media: Casein, graphics, stained glass.

GOLDBERG, Virginia Eagan. Painter, illustrator. Born:
Lebanon, Pa., February 27, 1914. Study: Univ Buffalo;
also with Florence Hauer, Lebanon, Raymond R. Goldberg,
George Tschamber & John Pike. Work: Many pvt collections.
Comn: Portraits, comn by H. W. Arnold, Wheaton, Md, 1968;
watercolor still life, comn by Dr. George Jaspin, Manhasset,
NY, 1969; watercolor landscape, comn by E. F. Nasierowski,
Lynbrook, NY, 1970; flowers in oil, comn by Mrs. N.
Koopman, Cornwall, Pa, 1971; oil seascape, David Hadar,
Rockport, 1975. Exhib: Am Artists Prof League Grand Nat,
1972-75; Knickerbocker Artists, 1973; Hudson Valley Art
Asn, 1974-75; Catherine Lorillard Wolfe Art Club, 1975;
Pen & Brush, 1975. Awards: Oil Award for Sunday, Malverne
Artists Long Island, 1972; Oil Award for Day of Rest,
Knickerbocker Artists, 1973; Acrylic Award for Fog Burning
Off, Nat Art League, 1974; plus others. Media: Oil,
watercolor.

GOLDEN, Libby. Printmaker, painter. Born: New York, NY,
November 18, 1913. Study: Cooper Union Art Sch, dipl,
1934; Hunter Col, NY Univ & Art Students League, 1934-42;
Pratt Graphic Arts Inst, 1958-60. Work: Philadelphia
Mus Art, Pa; Detroit Inst Arts, Mich; Grand Rapids Mus Art,
Mich; Colby Col Mus Art, Mass; U.S. State Dept. Exhib:
Silvermine Guild, Conn, 1966-68; Boston Printmakers,
Boston Mus Fine Arts, Mass, 1966-69; Northwest Printmakers,
Seattle Mus Art & Portland Mus Art, 1968 & 1969; Audubon
Artists, New York, 1970 & 1971; Colorprint, U.S.A.,
Lubbock, Tex, 1971; plus five one-man shows. Awards:
Print Prizes, Mich State Fair, 1965-69 & Nat Acad Design,
New York, 1969; Purchase Prize, Mich Painters & Printmakers.

GOLDSMITH, Elsa M. Painter. Born: New York, NY, January 26, 1920. Study: Parsons Sch Fine & Appl Art, scholar award, prof cert; NY Univ; Pratt Inst (lithography); etching with Ruth Leaf; painting with Betty Holiday. Exhib: One-man show, Art Image Gallery, New York, 1969; Salon Int de la Femme, Cannes, France, 1969; Am Drawing Biennial, Norfolk Mus, Va, 1971; Palazzo Vechio, Florence, Italy, 1972; Brooklyn Mus, NY, 1975. Awards: Int Gold Medal of Honor, City of Cannes, France, 1969; First Prize-Award Exhib, Guild Hall Mus, East Hampton, NY, 1969; Susan Kahn Award, Nat Asn Women Artists, New York, 1974. Media: Painting, etching.

GOODACRE, Glenna. Painter, sculptor. Born: Lubbock, Tex, August 28, 1939. Study: Colo Col, B.A.; Art Students League. Work: Tex Tech Mus, Lubbock; Presby Hosp, Denver, Colo; Diamond M. Found Mus, Snyder, Tex. Comn: Bronze bust of Dr. W. C. Holden, Tex Tech Univ, 1972; bronze of Dan Blocker, City Ctr, Odonnell, Tex, 1973; bronze of J. Evetts Haley, Haley Libr, Midland, Tex, 1973; bronze of C. T. McLaughlin, Diamond M. Found, 1973; bronze relief of Dr. Kenneth Allen, Presby Hosp, Denver, Colo, 1975. Exhib: Catharine Lorillard Wolfe Art Club, New York, 1972; Tex Fine Arts Nat Show, Austin, 1973; West Tex Nat Watercolor Show, Mus Tex Tech Univ, 1973; Allied Artists Am, New York, 1974; Nat Acad Design, New York, 1975. Awards: Catharine Lorillard Wolfe Art Club Cash Award for Oil Portrait, New York, 1972; Allied Artists of Am Award for Sculpture, New York, 1974. Media: Oil, pastel, watercolor, bronze.

GOODMAN, Brenda Joyce. Painter, instructor. Born: Detroit, Mich., July 21, 1943. Study: Ctr for Creative Studies, B.F.A. Work: Detroit Inst Arts, Mich. Exhib: One-woman shows, Willis Gallery, 1973 & Gertrude Kasle Gallery, 1974, Detroit; Michigan Focus, Detroit Inst Arts, 1974-75; 4th Mich Biennial, Kresge Art Ctr Gallery, Mich State Univ, 1975; Mich Surv Exhib, Cranbrook Acad Art & Mus & San Diego Mus Art, 1975-76. Awards: Drawing Prize, 15th Ann Mid-Mich Exhib, 1974; First Prize, Founders Soc, Detroit Inst Arts, 1974-75. Media: Oil, mixed media.

GOODMAN, Estelle. Sculptor. Born: New York, NY. Study: Barnard Col, B.A. Work: Norfolk Mus Art, Va; also pvt collections in U.S. & Eng. Exhib: Allied Artists; Audubon Artists; Fordham Univ; Union Col; Pace Col; plus others. Awards: Prizes, Painters & Sculptors of NJ, 1963 & 1967; Yonkers Art Asn; Vt Art Ctr; plus others.

GORDLEY, Marilyn F. M. Painter, educator. Born: St. Louis, Mo., August 4, 1929. Study: Washington Univ, B.F.A.; Univ Okla, M.F.A.; Ohio State Univ, doctoral study. Work: Greenville Art Ctr, NC: Spring Mills, Lancaster, SC; Univ Okla; NC Nat Bank, Greenville. Comn: Portraits of Gov. Kerr Scott, Arthur Tyler, Henry Belk, Elmer Browning & Weldell Smiley, E Carolina Univ, 1964-74. Exhib: Nat Acad Design, New York, 1964 & 1968; 18th Irene Leache Mem Exhib, Norfolk, Va, 1966; XXII Am Drawing Biennial, Norfolk (Smithsonian traveling exhib), 1967; Cent South Exhib, Nashville, Tenn, 1969; Nat Drawing Exhib, Southern Ill Univ, Carbondale, 1975. Awards: 18th Irene Leache Award, Norfolk Mus, 1966; Spring Mills First Prize, 1967; Cent South Exhib Award, 1969. Media: Oil.

GORDON, Josephine. Painter. Born: Walla-Walla, Wash. Study: Univ Guadalajara, with Maria Medina; Ariz State Univ, with Dr. Harry Wood; Sedona Art Ctr, Ariz, with Nassan Abiskhairoun; also with A. E. Park, William Kimura & Wassily Sommer, Anchorage, Alaska; and with Perry Acher, Seattle, Wash. Work: Bank of North Anchorage; Art Timm, CPA, Anchorage; Miller Construction Co, Anchorage; Walter Camp, LaCross, Wash; Alaska Seafood Corp, Homer. Exhib: All Alaska Exhib, 1970 & 1971; Artists of Alaska Traveling Show, 1973-75; one-woman show, Artique, Ltd, 1973-75. Media: Acrylic, watercolor.

GORELICK, Shirley. Painter, printmaker. Born: Brooklyn, NY, January 24, 1924. Study: Brooklyn Col, B.A.; Teachers Col, Columbia Univ, M.A. Work: Norfolk Mus, Va; Phoenix Mus, Ariz; Post Col; Nassau Community Col, NY; Aldrich Mus, Ridgefield, Conn. Exhib: 2nd Int Young Artists Pan Pac Exhib, Japan, 1962; Women Choose Women, New York Cult Ctr, 1973; 3rd Ann Contemporary Reflections, Aldrich Mus, 1974; one-man show, Soho 20 Gallery, New York, 1975; Sons & Others, Queens Mus, New York, 1975. Awards: RI Arts Festival Award, 1964; Long Island Painters Exhib Award, 1965; Purchase Award, Nassau Community Col, 1972. Media: Acrylic.

GOUREVITCH, Jacqueline. Painter. Born: Paris, France, October 28, 1933; U.S. citizen. Study: Black Mountain Col, NC, 1950; Art Students League, 1952; Univ Chicago, B.A., 1954; Art Inst Chicago, 1954-55. Work: Chase Manhattan Bank, Amstar Corp & Skidmore, Owings & Merrill, New York; Ball State Univ Mus, Muncie, Ind; Univ Art Mus, Berkeley, Calif. Exhib: One-woman shows, Tibor de Nagy Gallery, New York, 1971, 1972 & 1973 & Wadsworth Atheneum Mus, Hartford, Conn, 1975; Painting & Sculpture Today, Indianapolis Mus Art, 1972; Whitney Mus Am Art Ann, 1973; MacNay Art Inst, San Antonio, Tex, 1974; plus others. Awards: Artist in Residence, Tamarind Inst, Albuquerque, N Mex, 1973; Purchase Award, Am Acad Arts & Lett, New York, 1973. Media: Oil, drawing.

GOVAN, Francis Hawks. Educator, painter. Born: Marianna, Ark., December 19, 1916. Study: Hendrix Col, B.A.; Art Inst South, Memphis; Univ Wis; Layton Sch Art; Columbia Univ, M.A.; San Miguel, Mex. Exhib: Am Watercolor Exhib, France, 1953-55; one-man shows, Feigl Gallery, New York, 1954, 1955 & 1965; retrospective, Brooks Mem Art Gallery, Memphis, 1957 & 1966; Kunst Am, 1957-58; Art in the Embassies & Smithsonian Inst, 1967-68. Awards: First Prize in Watercolor, Memphis Biennial, 1946; Carnegie Found Grants Res Ark Pottery Clays, 1949 & Mus Fine Art, 1950. Media: Oil, watercolor.

GRAMBERG, Liliana. Painter, printmaker. Born: Treviso, Italy, U.S. citizen. Study: Univ Rome, with Laurea; Escuela Nac Bellas Artes, Madrid; Ecole Nat Super Beaux Arts, Paris, Atelier Gravure, with Bersier; Atelier 17, Paris, with Hayter; Calif Col Arts & Crafts, M.F.A. Work: Mus Art Mod Ville Paris; Brit Mus London; Nat Collection Fine Arts, Washington, D.C.; Albertina Graphische Sammlung, Vienna; Rosenwald Collection, Jenkintown, Pa; plus others. Exhib: Northwestern Printmakers; Silvermine Guild; Pa Acad Fine Arts; Alvarez Penteado Found, Sao Paulo, Brazil; many one-man shows, Smithsonian Inst, Univ Chile, Kunstnerforbundet, Oslo & other insts.

GRASS, Patty Patterson. Painter, craftsman. Born:
Oklahoma City, Okla., January 16, 1909. Study: Univ
Okla, B.F.A.; Ecole Beaux-Arts, Fontainebleau, France;
Taos Sch Art; Art Students League; Okla State Univ;
Univ Okla; also with Emil Bistram, Robert E. Woods,
Milford Zarnes, George Post, Edgar Whitney & Millard
Sheets. Exhib: One-woman show, YWCA, Oklahoma City;
Mass Inst Technol; Oklahoma City Art Ctr, 1962-64; Art
Students League; Okla Mus Art. Awards: Okla Art League
Prize, 1942; First Prize, Watercolor Okla, 1975; Spec
Award, Okla Art Guild, 1975.

GRAUPE-PILLARD, Grace. Painter. Born: New York, NY,
September 28, 1941. Study: City Univ New York, B.A.,
1963; Art Students League, George Bridgman scholar, with
Morris Kantor, Joseph Hirsch, Marshal Glasier & Julien
Levi, 1964-68. Work: Roland Gibson Found, Potsdam, NY.
Comn: Family portrait (8 x 6 ft), comn by Dennis & Sue
Spokany, Washington, DC, 1975. Exhib: N Mex Fine Arts
Biennial, 1973; Roswell Mus, N Mex, 1973; one-woman
shows, Razor Gallery, New York, 1974 & 1975 & Douglass
Col, 1974. Awards: N Mex Biennial Juror's Award, 1973;
Women in the Arts Honorarium, Rutgers Univ, 1974. Media:
Acrylic, pastel.

GRAY, Gladys. Painter, muralist. Born: Truckee,
Calif. Study: Fresno State Univ, Calif, A.B.; Univ
Calif, Berkeley, grad study; Claremont Col, Calif; study
with Eliot O'Hara, Phil Paradise, Rex Brandt, Jean Ames
& others. Work: Long Beach Mus Art, Calif; Laguna
Beach Mus Art, Calif; Utah State Univ; Calif State
Polytech Univ; Art Ctr, San Luis Obispo, Calif. Comn:
Murals depicting history of the area, comn by Morgan
Flagg, Convalescent Hosp, Hacienda, San Luis Obispo,
1963, Hacienda, Livermore, Calif, 1966, Hacienda,
Petaluma, Calif, 1969, Hacienda, Roseville, Calif, 1969,
Hacienda, Porterville, Calif, 1969 & Hacienda, Woodland,
Calif, 1969. Exhib: Three Women Painters, Crocker Art
Gallery, Sacramento, Calif, 1959; one-woman show, Laguna
Beach Mus Art, 1961 & 1971; 21 Paint in Polymer, M.
Grumbacher Co Exhib, Grand Cent, NY, 1965; Grand Prix
de Peinture de la Cote d'Azur, 1971; Watercolor West,
Utah State Univ Gallery, 1972. Awards: Purchase Award
for Triptych, Los Angeles Madonna Festival, 1961; Spec
Mention for Top Till, Grand Prix Int, Rome, Italy, 1972;
Award for Cycle Shapes, Grand Prix Int de Peinture de
Deauville, 1972. Media: Transparent watercolor, acrylic.

GREENBERG, Shirlee Bernice. Painter. Born: Brooklyn, NY, April 5, 1925. Study: Pratt Inst, cert in illus; Brooklyn Mus, with Isaac Soyer; Art Students League, with Sidney Dickenson; also with Alexander Dobkin & Paul Margin. Work: Reflections No 11, Mont State Univ, Bozeman; Univ Mass, Amherst. Exhib: North Shore Community Ann, 1967; Berkshire Art Asn Fall Show, Mass, 1968; 19th Ann New Eng Exhib, Conn, 1968; 2nd Ann NY Exhib Painters & Sculptors, 1969; Am Acad Arts & Lett Ann, New York, 1969. Awards: Eloise Egan Mem Award, Silvermine Guild Artists, 1968; Charles Pincu Mem Award, Berkshire Art Mus, 1968; Childe Hassam Purchase Award, Am Acad Arts & Lett, 1969. Media: Acrylic.

GREENE, Ethel Maud. Painter. Born: Malden, Mass., November 11, 1912. Study: Boston Univ Sch Art; Sch Boston Mus; Mass Sch Art. Work: Calif Western Univ, Fine Arts Gallery & Fine Arts Collectors, Inc, San Diego; Southwestern Col, Chula Vista, Calif; La Salle Col, Philadelphia. Exhib: Artists of Los Angeles & Vicinity, Los Angeles Co Mus, 1950, 1952 & 1955; one-man shows, La Jolla Mus, Calif, 1956, Feingarten Gallery, Los Angeles, 1970 & Ariz State Univ, Tempe, Ariz, 1972; two-man show, Fine Arts Gallery, San Diego, 1961. Awards: San Diego Co Expos Awards, 1948, 1954, 1963 & 1972; La Jolla Mus Ann Award, 1958; Two Californias Award, Calif Western Univ, 1963. Media: Acrylic.

GREY, Estelle (Estelle Ashby). Painter, sculptor. Born: Scranton, Pa., December 8, 1917. Study: Traphagan Sch Fashion; Art Students League. Work: Randolph Macon Woman's Col; Butler Inst Am Art. Exhib: Fish Univ; Riverside Mus, 1960; Kaymar Gallery, 1968-72; Tirca Karlis Gallery, 1970-74. Media: Oil; terra cotta; metal.

GRIGOR, Margaret Christian. Sculptor. Born: Forres, Scotland, March 2, 1912; U.S. citizen. Study: Mt. Holyoke Col, B.A.; Pa Acad Fine Arts. Work: Mt. Holyoke Col, South Hadley, Mass; Smithsonian Inst, Washington, DC; Medallic Art Co, Danbury, Conn. Comn: Am Med Asn Medal, 1948; Alaska-Hawaii Medal, Soc Medalists, 1965; Alexander Hamilton Medal, Hall of Fame Great Am, NY Univ, 1971; designed Am Revolution Bicentennial Medal for 1975, 1974. Exhib: Nat Sculpture Soc Ann, 1969, 1972 & 1974 & Nat Acad Design, New York, 1973. Awards: Lindsay Morris Mem Prize, Nat Sculpture Soc, 1969; Semi-finalist, Bicentennial Coin Competition, 1974. Media: Plasteline, plaster.

GRIPPE, Florence (Berg). Painter, potter. Born: New
York, NY, January 6, 1912. Study: Educ Alliance, 1932-34;
Works Proj Admin Art Courses, 1934-38; pottery with
William Soini, 1939-41. Comn: Portraits comn by Doris
Brewer Cohen, Lexington, Mass, 1969, Signora Attilio
Roveda, Locarno, Switz, 1970, Dr. Luis Martinez & Julio
Farinos Castillo, Valencia, Spain, 1970 & Jose Marina
Galvao Telles, Lisbon, Portugal, 1971. Exhib: Avant
Garde Artists Ninth St Exhib, 1951, Brooklyn Mus Art Sch,
1951 & Contemporary American Art, New Sch Social Res, New
York, 1957; Lower East Side Independent Artists 3rd Ann
Exhib, 1958; Guild Hall, Southampton, Long Island, 1975.

GRISSOM, Freda. Painter, silversmith. Born: Groom, Tex.
Study: W Tex State Univ, Canyon, B.S.; Univ Tex, Austin;
also watercolor workshop with Millard Sheets. Work:
Montgomery Mus Fine Arts, Ala. Exhib: Ann Dixie Exhib,
Montgomery Mus Fine Arts, 1968; Nat Arts Roundup, Las
Vegas, Nev, 1968; Greater New Orleans Nat, 1971; 9th Grand
Prix Int, Cannes, France, 1973; Galerie Rene Borel,
Deauville, France, 1973. Pos: Co-chmn, Nat Sun Carnival
Art Exhib, El Paso, Tex, 1965-71. Awards: Purchase
Award, Montgomery Mus Fine Arts, 1968; Second Prize,
Greater New Orleans Nat Exhib, 1971; Medaille de la Ville
de Cannes, First Prize, Watercolor, 9th Grand Prix Int,
Cote D'Azur, 1973. Media: Transparent watercolor,
acrylic, oil; gold, silver.

GROFF, June. Designer, painter. Born: North Lawrence,
Ohio, June 26, 1903. Study: Pa Acad Fine Arts, traveling
scholar, 1935; Barnes Found; also with Henry McCarter.
Work: Pa Acad Fine Arts, Philadelphia; Mus Mod Art, New
York; Friends Central Col, Philadelphia; Pa State Univ;
Philadelphia Mus Art; also in pvt collections & others.
Comn: Fabric design, Harper's Bazaar, Hattie Carnegie,
Clare Potter & others; design & execution of hanging
stained glass cross for St. Barnabas Episcopal Church,
Marshalltown, Del, 1962; stained glass windows & bars for
three Philadelphia restaurants & lounges. Exhib: One-
man shows, Little Gallery, Philadelphia, 1961 & D'Ascenzo
Studios, Philadelphia, 1969; Moore Col Art, 1962-64;
Drawing Soc New York Traveling Show, 1965-66; Am Fedn
Arts Traveling Exhib, 1965-66. Pos: Fabric designer,
Jack L. Larsen Inc, New York, 1955-; designer contemporary
stained glass, D'Ascenzo Studios, currently. Awards:
Textile Exhib, Mus Mod Art, New York, 1947; Prizes, Int
Textile Exhib, Women's Col, Greensboro, 1947, 1953, 1954
& 1956.

GROSCH, Laura. Painter, printmaker. Born: Worcester,
Mass., April 1, 1945. Study: Wellesley Col, Mass, B.A.
(art hist), 1963-67; Univ Pa, Philadelphia, B.F.A.
(painting), 1968; study with Gertrude Whiting, James
Rayen, Neil Welliver & Piero Dorazio. Work: Libr Cong &
Smithsonian Inst, Washington, D.C.; Mint Mus Art, Charlotte,
NC; Brit Mus, London; Hunt Inst Botanical Documentation,
Carnegie-Mellon Univ, Pittsburgh. Comn: Mural, Litchfield
Plantation, Pawley's Island, SC, 1969. Exhib: Color Print
USA, Tex Tech Univ, Lubbock, 1973-74; 36th Ann NC Artists
Exhib, NC Mus Art, Raleigh, 1973; Rose Mus, Glenbow-
Alberta Gallery, Calgary, Alta, 1974; 27th Ann Exhib
Boston Printmakers, Boston Mus Fine Arts, 1975; 11th Int
Exhib Graphic Art, Mod Galer'ja, Ljubljana, Yugoslavia,
1975. Awards: Purchase Award, 11th Ann Piedmont Graphics
Exhib, Greenville Co Mus Art, Greenville, SC, 1974; First
Nat Bank of Boston Purchase Award, Boston Printmakers,
1975; Purchase Award, Western Ill Univ Ann, Macomb, 1975.
Media: Acrylic; litho pencil.

GROSS, Sandra Lerner. Painter, lecturer. Born: New
York, NY. Study: Brooklyn Col; Pratt Graphic Inst;
Artists in Am Art Sch; also with Harry Sternberg & Leo
Manso; C. W. Post col, with Jerry Okimoto. Work: Twp of
Wantagh, NY. Exhib: Nat Acad Design, New York, 1966 &
1973; Audubon Artists, Nat Acad Galleries, 1965, 1968,
1974 & 1975; Silvermine Guild of Artists, New Canaan,
Conn, 1970; Nat Asn Women Artists, Nat Acad Galleries,
1973-75; Works on Paper, Women in Arts, Brooklyn Mus, 1975.
Awards: Purchase Prize, Nassau Community Col, 1970 &
1974; Benjamin Altman Landscape Prize, Nat Acad Design,
1973; Anne Eisner Award, Nat Asn Women Artists, 1973.
Media: Oil, acrylic, mixed media.

GROSSMAN, Nancy. Sculptor, painter. Born: New York, NY,
April 28, 1940. Study: Pratt Inst. Work: Whitney Mus
Am Art, New York; Princeton Univ Art Mus; Univ Mus,
Berkeley, Calif; Dallas Mus Fine Arts; Israel Mus,
Jerusalem. Exhib: Corcoran Gallery Art Biennial Exhib,
Washington, DC, 1963; Whitney Mus Am Art Sculpture Ann,
1968 & Whitney Biennial, 1973; Stadtische Kunsthalle
Recklinghausen, Ruhrfestspiele, 1970; Recent Figure
Sculpture, Fogg Art Mus, Harvard Univ, 1972. Awards:
Ida C. Haskell Found Scholar for Foreign Travel, 1962;
Guggenheim Mem Found Fel, 1965; Am Acad Arts & Lett/Nat
Inst Arts & Lett Award, 1974.

GROTZ, Dorothy Rogers. Painter. Born: Philadelphia,
Pa. Study: Univ Berlin, 1929; Columbia Univ, M.S.,
1945; Art Students League, 1947. Work: Rochester Univ
Mus Art; Santa Barbara Mus Fine Arts; Norfolk Mus Arts
& Sci; Evansville Mus Arts & Sci. Exhib: Avery Libr,
Columbia Univ, 1950, Van Diemen Lilienfeld Gallery, 1962-
1967 & Bodley Gallery, New York, 1972; Univ Wis, 1967;
Columbus Gallery Fine Arts, Ohio, 1972. Media: Oil.

GRUBB, Pat Pincombe. Painter, writer. Born: Cleveland,
Ohio, November 29, 1922. Study: Flora Stone Mather Col,
Case Western Reserve Univ; Cleveland Inst Art; also with
Carl Gaertner. Work: US Dept Interior, South Wellfleet,
Mass; Massillon Mus, Ohio; Maple Heights Regional Libr &
Akron Med Ctr, Ohio. Exhib: Cleveland Artists &
Craftsmen Show, Massillon Mus, 1966 & Fine Arts Regional
Exhib, 1967; Nat League Am Penwomen Nat Biennial,
Washington, D.C., 1968 & Salt Lake City, Utah, 1970;
Butler Inst Am Art Mid-Year Nat, Youngstown, Ohio, 1970;
Boston Mills Invitational, Peninsula, Ohio, 1974 & 1975.
Awards: Baldwin Purchase Award Drawing, Massillon Mus,
1963; Best in Show Award, Southgate Ann, Maple Heights
Women's Civic League, 1965; First Award in Oils, Boston
Mills Invitational, 1974. Media: Acrylic polymer,
gouache.

GUNNING, Eleonore Victoria. Painter. Born: El Reno,
Oklahoma, May 3, 1916. Study: Univ Okla, B.F.A.; also
study with Milford Zornes, Mario Cooper, Millard Sheets &
Robert E. Wood. Work: Hacienda El Cobano, Colima, Mex.
Exhib: Southwestern Watercolor Soc, Dallas, Tex, 1972 &
Oklahoma City, 1973; Expos Colectiva de Pinturas, Govt
Palace, Colima, Mex, 1973; Okla Art Guild, Oklahoma City,
1974; 14th Ann Artists Salon, Okla Mus Art, Oklahoma City,
1975. Awards: 4th Prize & Award of Merit, Okla Chap,
Southwestern Watercolor Soc, 1973; First Prize in
Watercolor, Norman Art League, 1974; Honorable Mention,
14th Ann Artists Salon, 1975.

HALL, Doris. Designer, painter. Born: Cleveland, Ohio,
February 5, 1907. Study: Cleveland Inst Art, portraiture;
Hawthorne Sch, Provincetown, Mass, portraiture. Work:
Cleveland Mus Art; Syracuse Mus, N.Y.; Cranbrook Mus,
Bloomfield Hills, Mich; Cooper Union, New York;
Philadelphia Art Alliance, Pa. Comn: Formed enamel
mural, Whiting Lane Sch, West Hartford, Conn, 1952; 4
enamel altar panels, Greendale Lutheran Church, 1954; 7
six-ft. enamel candlesticks & 4 eight-ft. enamel candle-
sticks, Immanuel Lutheran Church, Chicago, 1955; 3 vitreous
formed enamels, comn by Ralph Calder, Architect, Mich
State Univ, 1956; ceiling mural, Sidney Hill Country Club
Chestnut Hill, Mass, 1956. Exhib: Cleveland Mus Art,
1941-58; Archit League New York, 1953-54; State Dept
Traveling Show, Europe, 1956; Smithsonian Traveling Show,
1960; one-man show, Berkshire Mus, Pittsfield, Mass, 1963.
Awards: 1st Prize, Syracuse Nat, 1949; Silver Medal,
Archit League, 1953; Horace Potter Silver Medal. Media:
Oil, watercolor, etching, enamels.

HALVORSEN, Ruth Elise. Painter, writer. Born: Camas,
Washington. Study: Portland Art Mus Sch, Ore; Pratt
Inst, Brooklyn; Columbia Univ; and with Walter Beck,
Charles Martin & Albert Heckman. Work: Reed Col,
Portland; Georgia-Pacific, Portland; Univ Ore, Eugene;
Ft. Sumner Marine Hosp, N Mex; Portland Art Mus. Exhib:
San Francisco World's Fair, 1939; Henry Gallery, Univ
Wash, 1943; Rockefeller Ctr, New York, 1948; Fifth Army
Midwestern Travel Show, 1955; Portland Art Mus Show, 1971.
Awards: Pratt Inst Alumni Award for Distinguished Serv
in Art Educ, 1972; Distinguished Serv Award, Nat Art
Educ Asn, 1974. Media: Watercolor, oil.

HAMPTON, Lucille Charlotte. Painter, sculptor. Born:
Brooklyn, N.Y., July 22, 1922. Study: Columbia Bible
Col, S.C.; Brooklyn Col, N.Y.; NY Univ. Comn: The
American Breed, 1971, comn by Dr. Alton Ochsner, New
Orleans & The Bronc-5 Minutes to Midnight, 1974; The
Sidewinder, 1971, comn by Donald C. Cook, New York &
Adam & Eve, 1972-73; Bicentennial Special (4 animals),
comn by Robert Lewis White, Winston-Salem, N.C., 1975.
Exhib: Hudson Valley Art Asn, Westchester, N.Y., 1971;
Catharine Lorillard Wolfe Art Club, New York, 1972; Am
Artists Prof League, Lever House, New York, 1973 & 1974;
Pen Women of Am, New York, 1975. Awards: John Newington
Award, Hudson Valley Art Asn, 1971; Anna Hyatt Huntington
Award, Am Artists Prof League, 1973; Coun of Am Artist
Socs Award, 1974.

HARDAWAY, Pearl (Pearl Hardaway Reese). Painter.
Born: Brooklyn, NY, April 11, 1917. Study: Brooklyn
Col, B.A. (fine arts); Art Students League, with Vaclav
Vytlacil, Will Barnet; Acad Bildenden Kunst, Munich, Ger.
Work: Queens Col Art Collection, Flushing, NY; Queens
Col Print Collection; First Methodist Church of Jamaica,
NY. Exhib: Am Exhib, Haus der Kunst, Munich, 1954;
one-woman show, Queens Col, City Univ New York, 1955;
Butler Inst Am Art, Youngstown, Ohio; Audubon Artists
Ann, Acad Fine Arts, New York; New York Artists, Brooklyn
Mus, NY. Awards: Emily Lowe Award, Ward Eggleston,
New York. Media: Oil, watercolor.

HARMAN, Maryann Whittemove. Painter. Born: Roanoke,
Va., September 13, 1935. Study: Univ Va, Mary Washington
Col, B.A.; Va Polytech Inst & State Univ, M.A. Work:
Minn Mining & Mfg Corp, Minneapolis; Philip Morris Corp,
Richmond, Va; Hunter Mus, Chattanooga, Tenn; Gen Elec
Corp, Salem, Va; Roanoke Fine Arts Ctr. Exhib: Hunter
mus Art Ann, 1964 & 1969-74; Va Mus Fine Arts Biennial,
1965 & 1973; Irene Leach Mem Exhib, Chrysler Mus, Norfolk,
1967-72; Butler Inst Art Nat Show, Youngstown, Ohio, 1969
& 1972; Galery Ariadne Group Show, New York, 1974; plus
others. Awards: Purchase Award, Roanoke Fine Arts, 1973;
Purchase Awards, Hunter Mus, 1974; Cert of Distinction,
Va Mus Fine Arts, 1974. Media: Acrylic, oil.

HARMON, Eloise (Norstad). Sculptor. Born: St. Paul,
Minn., August 28, 1923. Study: Hunter Col; Art Students
League; Alfred Univ; also with Maija Grotell, Albert
Jacobson & Norman La Liberte. Comn: Mural, Inn at the
Landing, Kansas City, 1968; mural, New York Apt, 1970;
murals, Park Sheraton Hotel, New York, 1970; Fountain,
El Conquistador Hotel, PR, 1970; altar cross, Our Redeemer
Lutheran Church, New York, 1972. Exhib: Commission On,
Worship & Fine Arts Show, Bridgeport, 1969; Cranbrook Art
Show, Detroit, 1969; Int Exhib, Am Inst Decorators, 1970;
Relig Art Show, Episcopal Church Ctr, Chicago, 1971; New
Eng Exhib, New Canaan, Conn, 1972. Awards: Int Award,
Am Inst Decorators, 1970. Media: Clay.

HARMS, Elizabeth. Painter. Born: Milwaukee, Wisconsin,
May 26, 1924. Study: Art Inst Chicago, B.F.A. & M.F.A.
Work: Newark Mus, N.J. Exhib: One-man shows, Traverse
Festival Gallery, Edinburgh, Scotland, 1965, Hewlett
Gallery, Carnegie-Mellon Univ, 1967, Mus Art, Carnegie
Inst, 1969 & Fischbach Gallery, New York, 1975; 7th
Triennial, Newark Mus, NJ, 1971. Awards: Third Prize
Nat Watercolor exhib, Smithsonian Inst, 1963; Armstrong
Prize, Art Inst Chicago, 1963; Hon Mention, Pratt
Graphic Ctr, New York, 1974. Media: Oil, watercolor.

HARPER, Eleanor O'Neil. Painter. Born: Newburyport,
Mass., December 23, 1919. Study: Radcliffe Col, A.B.
(fine arts); Sch Practical Art, Boston; also with Donald
Stoltenberg, Betty Lou Schlemm & Arthur Pope. Exhib:
Jordan Marsh Ann Exhibs, Boston, 1969-73; Copley Soc,
Boston, 1969-75; Catharine Lorillard Wolfe Art Club Exhib,
Nat Arts Club, New York, 1972-73; Rockport Art Asn,
Mass, 1974-75; Nat Exhib, Mus Fine Arts, Springfield,
Mass, 1975. Awards: Best of Show, Newburyport Art Asn,
1974; Maurice E. Goldberg Mem Award, Rockport Art Asn,
1975. Media: Oil.

HARRIS, Margo Liebes. Sculptor. Study: Art Students
League; also in Italy. Work: Portland Mus, Maine; Roseman
Collection; Lehman Collection; Zorach Collection; Frank
Alt-Schul Collection; plus others. Comn: Sheraton
Southland Hotel, Dallas; Show Mart, Dallas; portraits,
Prince Aziz Elganian, Teheran; fountains, N. P. Hildum
Interiors; Sheraton Hotel, Chicago; plus others. Exhib:
Whitney Mus Am Art; Portland Mus Fine Arts; Detroit Art
Inst; Sculpture Ctr, New York; Boston Arts Festival; plus
others. Awards: Nat Acad Design First Prize, Nat Asn
Women Artists; Sculpture Medal of Honor Prize, 1971; Mr.
& Mrs. Charles Murphy Prize, 1972; plus others.

HARRIS, Marian D. Painter. Born: Philadelphia, Pa.,
April 22, 1904. Study: Pa Acad Fine Arts, 1922-26,
Cresson traveling scholar, 1925, Acad Summer Sch, Chester
Springs, Pa, 1921-24 & 1932; Hugh Breckenridge Summer
Sch Art, East Gloucester, Mass, 1926; with Wayman Adams,
Elizabethtown, NY, 1933, 1935 & 1938. Work: Albright-
Knox Art Gallery, Buffalo, NY; Fellowship Pa Acad Fine
Arts; Philadelphia Art Alliance; Gov. Bacon Hosp, Del;
YWCA, Wilmington, Del; among others. Exhib: Pa Acad
Fine Arts Ann, 1932; Nat Acad Design Ann, New York, 1932;
Art Inst Chicago Int Watercolor Exhib, 1935; Am Watercolor
Soc Ann, New York, 1952; Newark Mus Triennial, NJ, 1964;
plus many others. Awards: George A. Rhodes Prize,
Wilmington Soc Fine Arts, 1930; Public Choise, Triennial,
South Jersey, 1964; Second Prize, Heritage Show,
Smithville, 1973; and others. Media: Oil, watercolor.

HARRISON, Helen Mayer. Conceptual artist, photographer.
Born: New York, N.Y. Study: Queens Col, B.A.; Cornell
Univ; NY Univ, M.A. Work: Powers Inst, Univ Sydney,
Australia. Comn: Lagoon (with Newton Harrison), Hartley,
Los Angeles, 1973-74. Exhib: Vesuvio (with Newton
Harrison), Gallerie II Centro, Naples, Italy, 1973; In
a Bottle, art gallery, Calif State Univ, Fullerton, 1973;
one-man show, Grandview Gallery, Los Angeles, 1974; A
Response to the Environment (with Newton Harrison),
Rutgers Univ Art Gallery, 1975. Media: Photography,
collage, drawing, writing.

HARWOOD, June Beatrice. Painter, instructor. Born:
Middletown, NY, June 16, 1933. Study: Syracuse Univ,
B.F.A.; Univ Calif, Los Angeles, Art Ctr Sch; Calif State
Univ, Los Angeles, M.A. Work: Calif State Univ, Los
Angeles; Home Savings & Loan, Los Angeles; Time Mirror,
Los Angeles; Univ Calif, Santa Barbara; Western States
Producing Co, San Antonio. Exhib: One-man shows,
Hollis Galleries, San Francisco, 1966, Santa Barbara Mus
Art, 1967, Molly Barnes Gallery, Los Angeles, 1968, Rex
Evans Gallery, Los Angeles, 1970-71 & David Stuart
Galleries, Los Angeles, 1975. Media: Acrylic.

HAUT, Claire (Joan). Designer, painter. U.S. citizen.
Study: Augustana Col; Am Acad Art, Chicago; Sch Design,
Chicago, Lazlo Moholy-Nagy scholarship; Inst Design;
also with Hin Bredendieck, John Kearney & Gyorgy Kepes.
Work: Libr Cong, Washington, D.C. Comn: Screen,
woven and printed drapes, rug and upholstery, Teachers
Rm & Home Econ Rm, Saarinens Crow Island Sch, Winnetka,
Ill, 1940; libr traveling display throughout S & Cent Am,
Am Libr Asn, 1940; plus pvt comn. Exhib: State Dept
sponsored traveling exhib of Works Progress Admin crafts
to eight European countries; Traveling Exhib Works
Progress Admin Crafts, Chicago Art Inst, Mus Mod Art,
New York, Corcoran Mus, Carnegie Inst, San Francisco Mus,
Mus St. Louis & Toledo Mus; Southwest Biennial & Traveling
Show, Mus N Mex, Santa Fe, 1968-69; All American, The
Gallery, Barnegat Light, NJ, 1973; 1st Body Ornament
Show, Southwest Crafts Ctr Gallery, San Antonio, Tex &
BAU Hous Gallery, Houston, 1973-74.

HAY, Dorothy B. Painter, etcher. Born: Red Oak, Iowa,
November 22, 1901. Study: Stanford Univ, B.A.; Calif
Sch Fine Arts; Art Students League; Acad Andre L'Hote;
also sculpture with Bourdelle, Paris & painting with
Eliot O'Hara, Jon Corbino & F. Taubes. Work: Mus N Mex,
Santa Fe; Mus Art, El Paso, Tex. Comn: Decorative
murals, Santa Fe RR, Southwest, 1940-53; children's murals,
Bishops' Lodge, Santa Fe, 1946-55; children's murals
(with Dr. B. Massey), Children's Wing Thomason Gen Hosp,
El Paso, 1960. Exhib: Assoc Am Artists, New York, 1937
& Philadelphia Print Club, 1939; Mus N Mex Traveling
Shows, 1947 & 1952; Acad Artists Asn, Springfield, Mass,
1957 & 1959; Albany Ann Print Show, NY, 1967 & 1968;
Southwestern Art Festival, Tucson, Ariz, 1969. Pos:
Co-founder, Nat Sun Carnival Exhib, El Paso, 1958-59;
judge, Nat Art Exhib, Tubac, Ariz, 1965. Awards: Tex
Fine Arts Purchase Prize, 1960; Sweepstakes Prize, El
Paso Mus Art Regional, 1961; Woman Artist of Yr, Ariz
Daily Star, 1964. Media: Oil, watercolor.

HEISKELL, Diana. Painter, designer. Born: Paris, France;
U.S. citizen. Work: Santa Barbara Mus Art, Calif;
Slater Mus, Norwich, Conn. Exhib: Whitney Mus Am Art
Ann, 2 yrs; Chicago Art Inst; Boston Arts Festival; De
Cordova & Dana Mus, Lincoln, Mass; Southern Vt Art Ctr,
Manchester; plus others. Awards: Hon Mention, Berkshire
Art Asn; Grumbacher Prize, Southern Vt Art Ctr.

HELIOFF, Anne Graile (Mrs. Benjamin Hirschberg). Born:
Liverpool, Eng.; U.S. Citizen. Study: Art Students
League, with Nicolaides, Homer Boss & Kuniyoshi; also pvt
summer classes; Hans Hofmann Sch. Exhib: Paintings of
the Year, all maj mus of the U.S.; Pa Acad Fine Arts,
Philadelphia; Dedication Exhibition, Nat Gallery Art,
Washington, D.C.; Art USA, New York & all maj cities of
the U.S.; American Exhibition, Palazzo Uecchio, Florence,
Italy & Mus Naples, Italy, 1972; plus four solo shows in
New York galleries. Pos: Mem bd control, Art Students
League; mem, US Deleg to 5th Cong, Int Asn Artists, Tokyo,
1966; exec bd, Phoenix Gallery, New York, 1970-72. Awards:
Silver Medal & Hon Mention for oil and watercolor, Albany
Mus Hist & Art, 1960; Oil Award, Am Soc Contemp Artists,
Riverside Mus, 1962; Three Cert of Merit, Am Soc Contemp
Artists, 1970. Media: Oil, acrylic.

HELLER, Dorothy. Painter. Born: New York, NY. Study:
With Hans Hofmann. Work: Univ Calif Art Mus, Berkeley;
Allen Mem Art Mus, Oberlin, Ohio; Mus Mod Art, Haifa,
Israel; Greenville Co Mus Art, SC. Exhib: One-man shows,
Tibor de Nagy Gallery, New York, 1953, Galerie Faccetti,
Paris, France, 1955, Poindexter Gallery, New York, 1956-
57, Betty Parsons Gallery, New York, 1972 & Fairlawn Libr,
NJ, 1975; Whitney Mus Am Art, New York, 1956; Carnegie
Int, Pittsburgh, Pa, 1959; Mus Mod Art, New York, 1963;
Wadsworth Atheneum, Conn, 1964. Media: Acrylic.

HELMAN, Phoebe. Sculptor. Born: New York, NY, October
29, 1929. Study: Wash Univ, with Paul Burlin, B.F.A.;
Art Students League; also with Raphael Soyer. Work:
Hampton Inst Mus, Va; Ciba-Geigy, Ardsley, NY; Fox,
Flynn & Melamed, New York; Friedlich, Fearon & Strohmeier,
New York. Comn: Steel wall piece, comn by Milan Stoeger,
New York, 1973; steel wall piece, comn by Muriel Mannings,
New York, 1973. Exhib: Two-woman show, Emily Lowe
Gallery, Nofstra Col, 1969; one-woman show, Max Hutchinson
Gallery, 1974; Sculpture Now, Inc, Gallery 1, 1974;
plastics, State Univ NY Potsdam, 1975. Media: Laminite
& wood; steel.

HEMENWAY, Nancy (Mrs. Robert D. Barton). Painter, designer. Born: Boothbay Harbor, Maine, June 19, 1920. Study: Wheaton Col, 1937-41; with Matheu, Europe, 1954-56; Univ Madrid, 1956; Art Students League, 1957-61; Columbia Univ, M.A., 1966. Work: Net (Bayetage), Woodmere Art Gallery, Germantown, Pa; Sea Edge, Chase Manhattan Bank, New York; plus many works in pvt collections in Europe, Latin Am & USA. Comn: Monkeys, Crab & Mask (Bayetages), Mrs. Walter Ford, Detroit, Mich, 1972; Tidal (two part screen in silk and velvet), Mr. & Mrs. Arthur Schultz, Chicago, Ill, 1972; Amulet, Hon. & Mrs. Hugh Scott, 1973; Milkweed, Hon. & Mrs. Dewey Bartlett, 1974; Serpent, Masque with Jaguars, William Clements, Jr., 1975. Exhib: Woodmere Gallery Art, Germantown, 1971; Copley Soc Boston, Mass, 1972; McNay Art Inst, San Antonio, Tex, 1973; Mus N Mex, Santa Fe, 1974; Mus Fine Arts, Montgomery, Ala, 1975.

HERTZBERG, Rose. Painter, printmaker. Born: Passaic, NJ, December 17, 1912. Study: With Ben Benn; Hans Hofmann Art Sch; Art Students League, with Vaclav Vytlacil & Will Barnet; New York Graphics Workshop; Rockland Community Col; Fairleigh Dickinson Univ Art Seminars. Work: Edward Williams Col, Hackensack, NJ; Rockland Community Col, Suffern, NY; Bloomfield Col; Broadway Bank & Trust Co, Paterson, NJ; Hackensack Pub Libr & Ramsey Pub Libr, NJ. Comn: Many pvt commissions. Exhib: Am Watercolor Soc, New York, 1967, 1969 & 1971; Trenton State Mus, NJ, 1969-71; Painters & Sculptors Soc NJ, Jersey City, 1969-; NJ Watercolor Soc, Morristown, 1971; Nat Asn Women Artists, 1971-; plus many one-woman shows. Awards: Mary S. Litt Award, Am Watercolor Soc, 1967; Freyling-huysen Award, NJ Watercolor Soc, 1970; Putnam Mem Award, Nat Asn Women Artists, 1971. Media: Oil, watercolor.

HIGHBERG, Stephanie Wenner. Instructor, painter. Born: Kalamazoo, Mich., December 29, 1941. Study: Univ Mich Col Archit & Design, B.S. (drawing & design); and with Guy Palazzola, Milton Cohen & Mildred Fairchild; Columbia Univ Teachers Col, M.A. (fine arts & fine arts educ). Exhib: Mystic Art Mus Regional Show, Conn, 1968; Slater Mus, Norwich, Conn, 1969; Gilman Gallery, Chicago, 1972; Lord & Taylor Gallery, New York, 1972; Flora & Fauna of Madeira, Funchal, Madeira, Portugal, 1973. Awards: Am Cancer Soc Art Awards, 1967 & 1968; Lyme Art Asn Second Prize for Painting, 1968. Media: Impasto, oil wash.

HILL, Joan (Chea-Se-Quah). Painter, illustrator. Born: Muskogee, Oklahoma. Study: Northeastern State Col, B.A. Educ., 1952; Famous Artists Course, 1953-; spec study Indian art, with Dick West, 1958-63; pvt study with int artists, 1958-72; extensive air-travel-study on T. H. Hewitt Painting Workshops, 1965-1975, with Dong Kingman, Millard Sheets, Rex Brandt & George Post. Work: Heard Mus, Phoenix; Dept Interior, Arts & Crafts Bd, Washington, D.C.; Mus of the Am Indian, Heye Found, New York; Fine Arts Mus N Mex, Santa Fe; Philbrook Art Ctr Mus, Tulsa, Okla. Comn: Portraits (pastel), Hardin Nelson Co, Muskogee, 1959; mural-type oil paintings of Cherokee Nation through Dept Interior, Tahlequah, Okla, 1967; portrait (gouache) for book, Sam Houston with the Cherokees, comn by Rennard Strickland & Jack Gregory Collection, Tulsa, 1967; portrait & illus for book poetry, Five Civilized Tribes Mus, Muskogee, 1968; oil painting, USA Ctr Mil Hist for Bicentennial Collection, Washington, D.C., 1975. Exhib: Five Ann Center Arts Indian America, Dept Interior, 1964, 1967-70; American Embassies Overseas, Dept Interior Traveling Exhib, 1965-66; America Discovers Indian Art, Smithsonian Inst, Washington, D.C., 1967; Outstanding Indian Painters & Sculptors Hon Exhib, Princeton Univ, 1970; Am for Indian Opportunity Hon Exhib, Washington Gallery of Art, 1971; plus others. Awards: First Award, Philbrook Art Ctr Mus, 1966, 1968, 1971 & 1975; Walter Bimson Grand Award, Scottsdale Nat Indian Arts Exhib Ariz, 1968; Grand Spec Award, All Am Indian Art Exhib, Sheridan, Wyo, 1971; plus many others. Media: Oil, gouache; collage, acrylic.

HODGKINS, Rosalind Selma. Painter. Born: Farmington, Maine, May 25, 1942. Study: Univ S Fla; Pratt Inst, B.F.A.; Art Students League. Work: Southern Ill Univ, Carbondale; Bronx Mus Fine Arts, NY; Hewitt Sch, New York. Exhib: One-woman shows, Warren Benedek Gallery, New York 1972 & 1973; Univ Mo-St. Louis, 1973; State Univ NY Col Potsdam, 1974; Kensington Arts Asn, Toronto, Ont, 1975. Media: Acrylic polymer emulsion; oil.

HOFER, Ingrid (Ingeborg). Painter, instructor. Born: New York, NY. Study: Meisterschule Fuer Mode, Hamburg, Ger, B.A., 1948; Univ Hamburg; Traphagen Sch Design, New York, 1951; with A. Odefey, Goettingen, Ger, Albert Bross, Jr, Pauline Lorentz, John R. Grabach, Adolf Konrad & Nicholas Reale. Work: Fairleigh Dickinson Univ. Comn: Many pvt coms in Ger, Switz & US, 1956-71. Exhib: Painters & Sculptors Soc NJ, Jersey City Mus, 1970-72; Hudson Valley Art Asn, White Plains, NY, 1970 & 1971; Catharine Lorillard Wolfe Art Club, Nat Acad Design, New York, 1970 & 1971; Am Artist Prof League Grand Nat, Lever House, New York, 1970-72; Am Watercolor Soc, 1973. Media: Watercolor, graphics.

HOFFMAN, Andrea. Sculptor. Born: Los Angeles, Calif.,
January 3, 1946. Study: Univ Calif, Riverside, A.B.,
1967; San Diego State Univ., M.A., 1974; Univ Southern
Calif, PhD cand, 1975; Tomassis Bronze Foundry, Italy;
study with Robert Maclean, Benedict Cippolini & Jacques
Lipchitz. Work: Chiostro di S. Lazzaro, Camaiore,
Italy. Comn: Two Brothers (bronze), Dante Tedeschi,
Carrara, Italy, 1973; marble cardinal, Hoover High Sch,
San Diego, 1974; Banjo Player (bronze), James Howard,
San Diego, 1975. Exhib: Int Sculpture Sect, Nat Marble
Show, Carrara, Italy, 1972; Ai Frati, 5th Ann Int Exhib,
Camaiore, Italy, 1972. Awards: Ann Gift Purchase Prize,
Artists Equity Asn, San Diego, 1975. Media: Marble,
bronze.

HOFFMAN, Elaine Janet. Painter. Born: Oak Park, Ill.
Study: Averett Col; Portland Art Mus; Northwest Watercolor
Sch, with Irving Shapiro; also with Charles Mulvey, Perry
Acker, George Hamilton & Phil Austin. Exhib: Watercolor
Soc Ore Traveling Tours, 1968-75; Artists of Oregon,
Portland Art Mus, 1970; Am Artists Prof League, New York,
1971; George Fox Col Invitational, Newberg, Ore, 1972-74;
Prof Ore Artists Invitational Exhib, Coos Bay Mus, Ore,
1972-74. Awards: Grand Award, Soc Wash Artists, 1968;
Spec Merit Award, Watercolor Soc Ore, 1969 & 1970; Purchase
Award, Coos Bay Mus, 1973; plus others. Media: Watercolor.

HOFFMAN, Helen Bacon. Painter. Born: San Antonio, Tex,
July 14, 1930. Study: Ogontz Col, Philadelphia; Parsons
Sch Design. Work: N Am-Mex Inst Cult Relations, Mexico
City, Mex; Wichita Art Asn, Kans. Exhib: One-man shows,
North Starr Gallery San Antonio, Tex, 1966-75, Grand
Cent Art Galleries, New York, 1969-74 & Veerhoff Galleries,
Washington, D.C., 1964 & 1974; plus others. Awards:
Philadelphia Award, Pa Acad Fine Arts, 1969; First Pla
Award, Catherine Lorillard Wolfe Art Club Show, 1973;
First Place Painting, Salmagundi Club, 1974; plus others.
Media: Oil.

HOLCOMBE, Blanche Keaton. Painter, educator. Born:
Anderson, SC, July 19, 1912. Study: Anderson Col, A.A.,
1934; Furman Univ, B.A., 1958; Univ SC, Charleston;
Clemson Univ Sch Archit, 1963. Work: Mayor's Off,
Anderson City Hall; SC Employment Off, Anderson;
Anderson Savings & Loan Co; Town House, Anderson. Exhib:
Florence Art Gallery, SC, 1953; Columbia Mus Art, SC,
1953 & 1968; Gibbes Art Gallery, Charleston, SC, 1954;
Winston-Salem Art Gallery, NC, 1959; Int Platform Exhib,
Washington, D.C., 1967. Awards: First Prize, Watson
Village Art Show, Watson Village Merchants Asn, 1964 &
1965; First Prize in Prof Div, Christian Art Festival,
Baptist Church, Seneca, SC, 1965. Media: Oil.

HOLGATE, Jeanne. Painter, illustrator. Born: London,
Eng., March 11, 1920. Study: Self-taught. Work: Queen
Elizabeth, the Queen Mother, Brit Mus & Royal Horticultural
Soc, London; Hunt Inst for Botanical Documentation,
Pittsburgh; Franklin Mint, Pa. Exhib: One-man shows,
Tryon Gallery, London, Los Angeles Co Mus, 1966, Incurable
Collector, New York, 1970, Hunt Inst for Botanical
Documentation, 1973 & Gertrude Posel Gallery, 1973.
Teaching: Instr flower illus, Longwood Gardens, Kennett
Square, Pa, 1967-70. Awards: Royal Horticultural Soc
Gold Medals, London, 1963 & 1964; Silver Trophy for Best
Educ Exhib, 5th World Orchid Conf, Long Beach, Calif, 1966;
Silver Trophy, Del Orchid Soc, 1969. Media: Watercolor,
oil.

HOLLIDAY, Betty. Painter, photographer. Born: New York,
N.Y. Study: Barnard Col, with Julius Held, B.A.; Fogg
Mus, Harvard Univ, with Jacob Rosenberg, M.A.; Art Students
League, with Vaclav Vytlacil. Work: Art Students League;
Nat Asn Mus Publ. Exhib: Recent Drawings: USA, Mus Mod
Art, New York, 1956; Drawings: The Currier Gallery,
Manchester, NH, 1969-72; Photographs & Photo-Sculptures,
Post Col, 1969; Unmanly Art, Suffolk Mus, Stonybrook, NY,
1972; Traveling Exhib Drawings & Photographs, New Eng
Cult Ctr, Durham, NH; Dartmouth Col, and others. Awards:
Currier Award, Currier Gallery, Manchester, NH, 1969.
Media: All drawing media; acrylic on canvas; black &
white composite photographs on sculptural supports.

HOLLINGER, (Helen Wetherbee). Painter, lecturer. Born:
Indianapolis, Ind. Study: Herron Sch Art, dipl fine
arts; also with Donald Mattison, Henrik Mayer & Emile
Gruppe. Work: First Fed Savings & Loan Asn, Miami, Fla;
Herron Sch Art; Hialeah, Miami Springs Realty Bd. Exhib:
One-man exhib, Bacardi Gallery, Miami, 1968 & Gables Art
Gallery, Coral Gables, 1970; Grand Nat Exhib, Am Artists
Prof League, New York, 1969-72; Am Artists Prof League,
New York, 1969-75; Nat Biennial Art Exhib, Nat League Am
Pen Women, Salt Lake City, Utah, 1970; Miami Shores
Community Ctr, 1973 & 1975. Awards: Nat League Am Pen
Women First Prize for Portraiture, Fla State Art Exhib,
1969; First Place Art Achievement Award, Wometco Enter-
prises, Miami, 1971; Poinciana Art Exhib Best in Show,
Burdine's, Miami, 1972. Media: Oil, pastel, acrylic.

HOLLISTER, Valerie (Dutton). Painter. Born: Oakland, Calif., December 29, 1939. Study: Stanford Univ, A.B., 1961 & M.A., 1965; San Francisco Art Inst; Col Art Study Abroad, Paris. Exhib: Corcoran Biennial Contemp Am Painting & Corcoran Gallery Area Show, Washington, D.C., 1967; Whitney Mus Ann Contemp Am Painting, 1967-68; plus other one-woman & group shows. Media: Acrylic.

HOLMES, Ruth Atkinson. Painter, sculptor. Born: Hazlehurst, Miss. Study: Miss State Col Women; Tulane Univ; Mis Col & Southwest Jr Col. Work: Univ La, Alexandria & Baton Rouge; Miss State Col Women, Columbus; Miss State Univ, Starkville. Comn: Mural (with Bess Dawson), Church of God, McComb, Miss; mural (with Bess Dawson & Halcyone Barnes), Progressive Bank, Summit, Miss; mural (with Bess Dawson & Halcyone Barnes), First Nat Bank, McComb; 14 Stations of the Cross, Church of Mediator, McComb, 1972. Exhib: One-man shows, Ahda Artzt, New York, 1964, Mary Chilton Gallery, Memphis, Tenn, 1966, Brooks Mem Gallery & Mus, Memphis, 1969, Univ La, Alexandria, 1969 & Bryant Gallery, Jackson, Miss, 1971. Awards: First Prize Pastel, Chautauqua Art Asn, NY, 1962; First Prize, Miss Art Asn Nat Oil Show, Jackson, 1966; First Prize, La Fona Workshop, S Cent Bell Tel Co, Pascagoula, Miss, 1968.

HOLT, Nancy Louise. Sculptor, film maker. Born: Worcester, Mass, April 5, 1938. Study: Jackson Col; Tufts Univ, B.S. Comn: Landscape sculptures, Univ Mont, 1972, Univ RI, 1972 & Artpark, Lewiston, NY, 1974. Exhib: Interventions in the Landscapes, Mass Inst Technol, 1974; Painting & Sculpture Today, Indianapolis Mus, 1974; Collectors Video, Los Angeles Co Mus, 1974; Response to the Environment, Rutgers Univ, 1975; Video '75, Corcoran Mus, Washington, DC. Awards: Nat Endowment Arts Grant, 1975; CAPS Grant, 1975.

HOPPER, Marianne Seward. Painter, art dealer. Born: Rochester, NY, June 10, 1904. Study: Cleveland Sch Art; RI Sch Design; Montclair Art Mus, with Michael Lenson, also portraits with Douglas Prizer, acrylics with Tom Vincent, watercolors with Avery Johnson & sculpture with Ulric Ellerhausen. Work: Pvt collections in NJ, N Mex, Calif, Fla, Ohio & Ill. Comn: Paintings for private individuals and businesses, 1964-75. Exhib: Nat Miniature Art Exhib, Nutley, NJ, 1972-75; NJ State Show, Ocean Co Col, Toms River, NJ, 1973; Bergen Community Mus, State Show, Paramus, NJ, 1974; Nat Miniature Art Show, Bellair, Fla, 1975; Nat Am Artists Prof League Lever House Show, New York, 1975. Awards: Best in Show, Garden State Plaza, Paramus, NJ, 1964; Purchase Awards, McBride Agency, Franklin Lakes, NJ, 1971 & 1972; ITT Space Award, Int Tel & Tel Defense Space Group, Nutley, NJ, 1973. Media: Acrylic, oil.

HORTER, Elizabeth Lentz. Painter. Born: Philadelphia, Pa., January 4, 1900. Study: Westchester State Teachers Col; Temple Univ, B.S.Ed.; Tyler Sch Fine Arts, Temple Univ, M.F.A.; Cornell Univ; Univ Pa; Moore Inst Art; Philadelphia Mus Sch Art, with Earle Horter. Work: Woodmere Art Gallery. Exhib: Libr of Cong, Washington, DC; Pa Acad Fine Arts, Philadelphia; Carnegie Inst, Pittsburgh; Brooklyn Mus, NY; Print Club Philadelphia; plus others.

HOUSKEEPER, Barbara. Sculptor, painter. Born: Ft. Wayne, Ind., August 25, 1922. Study: Knox Col, Ill; RI Sch Design; Art Inst Chicago. Work: Ill Bell & Tel, Chicago; Gould Found, Rolling Meadows, Ill; Kemper Ins Co, Long Grove; Mercury Rec, Chicago. Comn: Large sculptures, Exec Off Condecor Mfg, Mundelein, Ill, 1972, Mr. & Mrs. William Goldstandt Collection, Glencoe, Ill, 1972, Mr. & Mrs. Leonard Sax Collection, Northfield, Ill, 1972 & Reception Hall, Kemper Ins Co Home Off, Long Grove, Ill, 1974; Mem Sculpture, Am Bar Asn, Chicago, 1975. Exhib: New Horizons in Art (wide regional ann), since 1966; Theme Ecology Invitational, Univ Wis Gallery, Madison, 1970; Springfield State Mus All Summer Show, 1973; one-person show, Michael Wyman Gallery, Chicago, 1973 & 1976; 1st Chicago Sculpture Invitational, Fed Bldg, Chicago, 1974. Awards: First Prize-Painting, New Horizons in Art Ann, 1969 & First Prize-Painting, 1970; Second Prize-Sculpture, Old Orchard Festival Ann, 1973. Media: Acrylic sheet, stainless steel.

HOWELL, Elizabeth Ann (Mitch). Painter, illustrator.
Born: Hartselle, Ala., February 27, 1932. Study:
Birmingham Southern Col, B.A.; Famous Artists Sch;
watercolor & advan tech with John G. Kramer. Work:
Birmingham Mus Art, Ala; Montclaire Gallery, Birmingham.
Comn: Illus & cover for bk of sermons, Rev. Ralph K.
Bates, United Methodist Church, Hartselle, 1967; portrait
class mem, Morgan Co High Sch, Hartselle, 1969; children's
portraits, Mr. & Mrs. Thomas Caddell, Decatur, Ala, 1970;
children's portraits, Dr. & Mrs. William Sims, Decatur,
1971; illus & cover for cook bk, Decatur Jr Serv League,
Inc, 1972. Exhib: Southeastern Art Exhib, Panama City,
Fla, 1968; Birmingham Art Asn Jury Show, 1969; Williams-
burg Art Exhib, Va, 1970; Charleston Art Exhib, SC, 1970;
Int Platform Asn Art Exhib, Washington, DC, 1971. Awards:
Hannah Elliott Award, Lovemans of Birmingham, 1969; Second
Pl Award, Decatur Art Guild Jury Show, Decatur Art Guild,
1969; Second Pl Award, Richwood Park, Richter Bros,
Cullman, Ala, 1970. Media: Watercolor, acrylic.

HUDSON, Winnifred. Painter. Born: Sunderland, England,
May 21, 1905; U.S. citizen. Study: Honolulu Acad Arts;
Univ Hawaii; with Joseph Feher, Wilson Y. Stamper, John
Hultberg & Norman Ives; also with James Pinto, Mex.
Work: Honolulu Acad Arts; State Found Cult & Arts;
Contemp Arts Ctr; Castle & Cooke Ltd. Exhib: One-man
shows, Recent Paintings, 1967 & Winnifred Hudson Paintings,
1972, Contemp Arts Ctr; Three Plus One, Ala Moana Art Ctr,
1969; Honolulu Acad Arts Ann; Honolulu Printmakers Ann.
Awards: Purchase Award for Print, Watumull Found, 1967;
First Prize for Painting, Ala Moana Festival. Media:
Oil, acrylic, collage.

HUI, Helene. Painter, film maker. Born: New York, NY,
June 24, 1935. Study: Brooklyn Mus Art Sch, 1957-60.
Work: Hampton Col Mus, W Va. Exhib: 13 Women Artists,
New York, 1972; NY Women Artists, State Univ NY Albany,
1972; Bard Col, Annandale on Hudson, NY, 1973; 3rd Ann
Contemp Reflections 1973-74, Aldrich Mus Contemp Art,
Ridgefield, Conn, 1974. Media: Painting; film.

HUNTINGTON, Daphne. Painter, muralist. Born: Ketchikan, Alaska. Study: Ecole du Louvre, Paris; London Sch Arts & Crafts; Slades, London. Comn: Wave Poetry (seascape), Mary Pickford Collection, Pickfair, Beverly Hills, 1964; Christ of World Peace, with Sister Venetia Epler, St. Francis Chapel, Episcopal Church, Glendale, 1971; 11 stained glass windows, Church of Relig Sci, Beverly Hills, 1974; Life of Christ Mural, with Sister Venetia Epler, Forest Lawn Mausoleum, Covina, 1975. Exhib: Calif State Fair, Sacramento, 1959; Am Inst Fine Arts Competition, Los Angeles, 1969; Grand Nat Competition, Am Artists Prof League, 1971; Invitational Show, Los Angeles Co Mus, 1972. Awards: Best of Show, Calif State Fair, Sacramento, 1959; Fels, Am Inst Fine Arts, 1965 & Am Artists Prof League, 1971. Media: Oil, watercolor.

HURT, Susanne M. Painter. Born: New York, NY. Study: Duke Univ; Art Students League, with Frank V. Dumond & Kenneth Hayes Miller; Corcoran Sch Art; also with Wayman Adams & A Ginsburg. Work: In pvt collections. Exhib: One-man show, Cayuga Mus Hist & Art, Auburn, NY, 1971; Catharine Lorillard Wolfe Art Club, Nat Acad Design, New York, 1971; Hudson Valley Art Asn, Westchester Co Ctr, White Plains, NY, 1972; Am Artists Prof League, Lever House, New York, 1972-75; Nat Art League, Long Island, NY, 1972. Awards: Spec Award for Oil, Art League Long Island, 1968; Anna Hyatt Huntington First Prize for Painting, Catharine Lorillard Wolfe Art Club, 1970; First Prize for Oil, Composers, Authors & Artists Am, 1972. Media: Oil.

HUTCHISON, Elizabeth S. Painter. Study: Otis Art Inst; and with Joseph Mugnaini & Aimee Bourdieu. Work: Rice Univ Permanent Collection; Utah State Univ Permanent Collection; Chaffey Col Permanent Collection, Alta Loma, Calif; Am Fedn Social Settlements Permanent Collection, New York; plus many others in pvt collections. Exhib: Nat Watercolor Soc Ann, 1966-74; Watercolor USA, Spring- field, Mo, 1969, 1970 & 1972-73; Southern Calif Expo, Del Mar, 1969-75; Old Bergen Art Guild, 1970-75; Nat Acad Design, New York, 1970-72; plus many other group & one-man shows. Awards: Purchase Award, Watercolor USA, 1969; First Prize in Acrylic, Southern Calif Art for 1975, Del Mar; Purchase Prize, Fifth Ann St Raymond's Art Show, Thousand Oaks, Calif, 1971; plus many others. Media: Oil, watercolor.

INGRAHAM, Esther Price. Painter. Born: Needham, Mass. Study: Mt. Holyoke Col, B.A.; Cleveland Sch Art; Montana State Univ; Famous Artists Sch, Westport, Conn, cert; also with Taubes, Earl Cordrey, John Pike, Jade Fon & Tadeshi Sato. Exhib: Maui Art Shows, Hawaii, 1964-68; Easter Art Festival, Honolulu & Windward Artists Shows, Hawaii, 1968-74. Awards: Watercolor Prize, Maui Art Soc, 1966. Mem: Windward Artists Guild (bd Dirs, 1968-73); Artists of Hawaii.

INGRAM, Judith. Printmaker, painter. Born: Philadelphia, Pa., October 12, 1926. Study: Philadelphia Col Art; printmaking with Carol Summers. Work: Del Mus Art, Wilmington; Free Libr Philadelphia, Pa; Univ Pa Law Sch, Philadelphia; Philadelphia Mus Art; RCA Corp, Eastern US & PR. Exhib: Philadelphia Print Club Exhib; Boston Printmakers Ann, 1970; Hooks-Epstein Gallery, Houston, Tex; Philadelphia Art Alliance; NJ State Mus, Trenton; solo exhibs, Gallery 252, Philadelphia, 1967, 1969 & 1971.

INSLEE, Marguerite T. Painter, collector. Born: Grand Rapids, Mich., June 17, 1891. Study: Univ Mich Exten, Grand Rapids Art Mus; Colorado Springs Fine Arts Ctr, with Emerson Woelfer; Inst Allende, San Miguel de Allende, Mex, Western Mich Show grant, 1959; Escuela Bellas Artes, Taxco, Mex; Int Summer Acad Fine Arts, Salzburg, Austria, with Oscar Kokashka. Exhib: Grand Rapids Art Mus, 1959; Sch Fine Arts, Taxco, Mex; one-woman shows, Steel Case, Inc, Women's Club & Fountain Street Church, Grand Rapids. Awards: Prize for Oil, Grand Rapids Art Mus, 1959. Media: Oil.

ISHAM, Sheila Eaton. Painter. Born: New York, NY, December 19, 1927. Study: Bryn Mawr Col, B.A. (cum laude), 1950; Hochschule Fiu Bildende Kunste, Berlin, Ger, 1950-54. Work: Mus Mod Art, New York; Nat Collection Fine Arts, Washington, DC; Philadelphia Mus Art, Pa; Corcoran Gallery Art, Washington, DC; San Francisco Mus Art. Exhib: One-man shows, Jefferson Place Gallery, 1968-70, French & Co Gallery, New York, 1970 & Brockton Art Ctr, Mass, 1972; Am Cult Ctr, Paris, 1973; Corcoran Gallery, Washington, DC, 1974; Albright-Knox Gallery, NY, 1974. Awards: Print Award, Corcoran Gallery Art, 1958; Print Award, Libr Cong, Pennell Comt, Wash Soc Printmakers, 1960 & 1961.

IVES, Elaine Caroline. Painter. Born: New York, NY, October 20, 1922. Study: Jacksonville Art Sch, with Paul Toleffson & William Pachner; Inst de Allende, with Jim Pinto. Exhib: Soc Four Arts, Palm Beach, 1966-68; Sarasota Art Asn, 1967-71; Butler Inst Am Art, Youngstown, Ohio, 1969; Fla Artist Group, 1972-74; Loch Haven Art Ctr, Orlando, 1974. Awards: Best in Show for Causway Gale, Fla Fedn Art, 1964; Second Prize for Wipe Out, Sarasota Art Asn, 1970; Best in Show for Transition, Latin Quarter Gallery, 1974. Media: Oil, acrylic, ink.

JACKSON, Sarah. Sculptor, graphic artist. Born: Detroit, Mich., November 13, 1924. Study: Wayne State Univ, B.A., 1946, M.A., 1948. Work: Joseph H. Hirshhorn Collection, Washington, DC; Nat Gallery Can, Ottawa; Montreal Mus Fine Arts; Montreal Mus Contemp Arts; Art Gallery Ontario, Toronto. Comn: Dancer (bronze), Cloverdale Shopping Ctr, Toronto, 1966; Metamorphosis (bronzes) & Mindscape (bronze hanging), Student Union Bldg, Dalhousie Univ; plastic & bronze sculpture, Mt. Sinai Hosp, Toronto. Exhib: Montreal Mus Fine Arts; Ontario Graphic Artists; Gadatsy Gallery Toronto; Mt. St. Vincent Univ; one-man show, St. Mary's Univ; plus many others. Awards: Sculpture Award, Winnipeg Art Gallery; Ontario Arts Coun Grant, 1974. Media: Bronze, plastic; drawings.

JACKSON, Suzanne Fitzallen. Painter, writer. Born: St. Louis, Mo., January 30, 1944. Study: San Francisco State Col, B.A.; Otis Art Inst, Los Angeles, with Charles White. Work: Joseph Hirshhorn Mus Mod Art, Smithsonian Inst, Washington, DC; Palm Springs Desert Mus, Calif; Mafundi Inst, Watts, Calif; Daniel, Mann, Johnson & Mendenhall, Co, Los Angeles. Comn: Peace Bird, Secy State Edmund G. Brown, Jr., Sacramento, 1972; Stephen Chase, Arthur Elrod & Assoc, Palm Springs, 1974; Sonny Bono, Bel Air, 1975; Artful Living, William Chidester Co, Pac Design Ctr, Los Angeles, 1975. Exhib: Joseph Hirshhorn Collection, Palm Springs Desert Mus, 1970; Black Untitled II/Dimensions of the Figure, Oakland Mus, 1971; Blacks: USA: Now, New York Cult Ctr, 1973; Directions in Afro-American Art, Herbert F. Johnson Mus Art, Cornell Univ, 1974; Pioneer Mus, Haggin Art Galleries, Stockton, Calif, 1975; plus others. Collections Arranged: Coordr art exhibs & ed catalog for San Francisco Bay Area Black Expo, 1972. Awards: Int Latham Found Humane Kindness & World Peace Scholar, 1961; Univ of the Pac & Pioneer Mus Artists Merit Award, 1975. Media: Acrylic wash.

JACOBS, Helen Nichols. Painter. Born: Kent, Conn., February 16, 1924. Study: With Spencer B. Nichols & Arthur Maynard. Exhib: Catharine Lorillard Wolfe Arts Club, Nat Arts Club, 1974-75; Am Artists Prof League, New York & NJ, 1975; Ridgewood Art Asn, NJ, 1975; Kent Art Asn, Conn, 1975. Awards: Tercentenary Award, Closter, NJ, 1970; First Prize in Oils, NJ Am Artists Prof League, 1973 & Kent Art Asn, Conn, 1975. Media: Oil.

JACOBSON, Yolande (Mrs. J. Craig Sheppard). Sculptor. Born: Norman, Okla, May 28, 1921. Study: Univ Okla, B.F.A.; also study in Norway, France & Mex. Work: Gilcrease Mus Art, Tulsa, Okla; Jacobsen Mus Art, Norman; State Hist Soc, Reno, Nev; Hist Mus, Carson City, Nev. Comn: Sen Patrick McCarran (bronze statue), Statuary Hall, Washington, DC, 1961; president's portrait bust, Univ Nev, Reno, 1962; bronze sculpture, Gov Mansion, Carson City, 1965. Exhib: Denver Mus Art, 1941; Okla Ann, Tulsa, 1942-45; Mid-West Ann, Kansas City, 1951; Oakland Mus Art, 1956; Silver Centennial, Virginia City, Nev, 1961. Awards: Mid-West Ann, Kansas City, 1941; Denver Mus Art, 1941; Silver Centennial, Virginia City, 1961. Media: Bronze, wood.

JACQUETTE, Yvonne Helene (Yvonne Helen Burckhardt). Painter, educator. Born: Pittsburgh, Pa., December 15, 1934. Study: RI Sch Design, 1952-56, with John Frazier & Robert Hamilton; also with Herman Cherry & Robert Roche. Work: Weatherspoon Gallery, NC; Whitney Mus Am Art, New York; RI Sch Design Mus, Providence; Colby Col Mus, Waterville, Maine. Comn: Five panel painting in oil, N Cent Bronx Hosp, NY, 1973; five color lithograph, Horace Mann Sch, Riverdale, NY, 1974. Exhib: Skying, Rutgers Univ Art Gallery, 1972; Whitney Painting Ann, Whitney Mus Am Art, 1972; Women Choose Women, New York Cult Ctr & US Traveling Show, 1972-73; New Image in Painting, Int Biennial, Tokyo, Japan, 1974; Small Scale in Contemporary Art, Art Inst Chicago, 1975. Media: Oil, watercolor.

JAGOW, Ellen T. Painter. Born: Wisconsin Rapids, Wis., September 21, 1920. Study: Concordia Teachers Col, B.S.; Art Inst Chicago. Work: Butler Inst Am Art, Youngstown, Ohio; Riverview Sch, Milwaukee, Wis; Fox-Richmond Gallery, Keuka Park, NY; Lincoln Col, Ill; Galesburg Civic Art Ctr, Ill. Exhib: Cent Ill Exhib, Peoria, 1965; Miss Valley Artists, Ill State Mus, Springfield, 1966; Butler Inst Am Art, Youngstown, 1969; Massillon Mus Show, Ohio, 1969; Allied Artists Am, 1974. Awards: Purchase Award, Midyear Show, Butler Inst Am Art, 1969. Media: Acrylic.

JAIDINGER, Judith C. (Judith Clarann Szesko). Printmaker, painter. Born: Chicago, Ill., April 10, 1941. Study: Art Inst Chicago, B.F.A.. Work: Minot State Col, N Dak; Washington & Jefferson Col, Washington, Pa; N Mex Art League, Albuquerque; Jayell Publ Co, Miami, Fla. Exhib: Nat Acad Design Ann, New York, 1967, 1968, 1970, 1973-75; 39th Int, Northwest Printmakers, Seattle, 1968; 51st Print Exhib, Soc Am Graphic Artists, New York, 1971; Graphics '71, Western N Mex Univ, Silver City, 1971; 12th Midwest Biennial Exhib, Joslyn Art Mus, Omaha, 1972. Awards: Graphics Award, Mercyhurst Col, Erie, Pa, 1970; Smithsonian Traveling Exhib Award, Contemp Am Drawings V, Norfolk Mus Arts & Sci, 1971-74; Graphics Award, Okla Mus Art, 1975. Media: Wood engraving; opaque watercolor, mixed media.

JANELSINS, Veronica. Illustrator, painter. Born: Riga, Latvia, May 20, 1910; U.S. citizen. Study: State Acad Fine Arts, Riga, grad, 1940. Work: State Hist Mus Riga; State Art Mus Riga; Baumgarten-Schuler Collection, Stuttgart, W Ger; Vitols Collection, Venezuela, Caracas. Exhib: Latvian State Art Mus, 1940; Expos des Artistes en Exile, Paris, 1949; Madonna Festival, Los Angeles, Calif, 1955; Los Angeles Co Mus, 1956; one-man show, Stockholm, 1970; plus many others. Awards: Madonna Festival Awards, 1953 & 1955.

JANICKI, Hazel (Mrs. William Schock). Painter, instructor. Born: London, Eng., February 9, 1918; U.S. citizen. Study: Cleveland Inst Art, dipl. Work: Cleveland Mus Art, Ohio; Chicago Art Inst, Ill; Univ Ill, Champaign; Detroit Inst Fine Arts, Mich; Melbourne Art Inst, Australia. Comn: Painted & sculptured door for children's story rm, Akron Pub Libr, Ohio, 1969. Exhib: Five one-man shows, Durlacher Bros Gallery, New York, 1952-67; two-man show, Fairweather Hardin Gallery, Chicago, 1970; Am Painting & Sculpture 1948-1969, Univ Ill, Champaign, 1971; one-man show, Distinguished Alumni Series, Cleveland Inst Art, 1972; 36th Midyear Show, Butler Inst Am Art, Youngstown, Ohio, 1972. Awards: Louis Comfort Tiffany Found Award, 1949; Nat Inst Arts & Lett grant, 1955; Third Medal, 36th Midyear Show, Butler Inst Am Art, 1972. Media: Egg tempera.

JARAMILLO, Virginia. Painter. Born: El Paso, Texas, March 21, 1939. Study: Otis Art Inst, 1958-61. Work: Long Beach Mus Art, Calif; Pasadena Art Mus, Calif; Aldrich Mus Contemp Art, Ridgefield. Comn: Schenectady Mus, NY. Exhib: Whitney Mus Am Art Ann, New York, 1972; Contemporary Reflections 1971-72, Aldrich Mus Contemp Art, Ridgefield, 1972; group exhib, Douglas Drake Gallery, Kansas City, Kans, 1975 & one-man show, 1976; traveling exhib contemp art throughout Eastern Europe, 1976; plus others. Awards: Ford Found Grant, 1962; Nat Endowment Arts, 1972-73; Creative Artists Pub Serv Prog Grant, 1975. Media: Acrylic, oil.

JENCKS, Penelope. Instructor, sculptor. Born: Baltimore, Md. Study: With Hans Hoffman; Skowhegan Sch Painting & Sculpture; Boston Univ, B.F.A. Work: MacDowell Colony Collection. Exhib: Nat Inst Arts & Lett, New York, 1966; Young Talent, Mass Coun Arts & Humanities, Boston, 1968; 21 Alumni, Boston Univ, 1969; 14 Aspects of Realism, Boston Visual Artist Union, 1974; Living Am Artists & the Figure, Mus Art, Pa State Univ, 1974. Awards: Colonist, MacDowell Colony, 1975. Media: Terra-cotta.

JENKINS, Mary Anne K. (Mary Anne K. Jenkins Proctor). Painter, instructor. Born: Pitt Co, NC, November 20, 1929. Study: Ferree Sch Art, Raleigh, dipl fine arts; NC State Univ Sch Design, with Joseph H. Cox; San Carlos Art Sch, Mexico City. Work: NC Mus Art, Raliegh; Minn Mus Art, St. Paul; NC A&T State Univ; NC State Fair Collection, Raleigh; WITN TV Collection of Eastern NC Artists; plus others. Comn: Interior mural, Radio Station WPTF, Raleigh, 1971. Exhib: Exhib Contemp Art, Soc Four Arts, Palm Beach, 1969; 5th Dulin Nat Print & Drawing, Dulin Gallery Art, Knoxville, Tenn, 1969; Frontal Images 70 & Traveling Show, 60th Nat Competitive Exhib Am Art, Jackson, Miss, 1970; 7th Ann Small Sculpture & Drawing Show, Western Wash State Col, 1970; 9th Ann Drawing & Small Sculpture Show, Delmar Col, 1975; plus others. Awards: Paul Lindsay Sample Memorial Award, Chautauqua Exhib Am Art, NY, 1969; 3rd James River Art Exhib First Patron Award, Mariners Mus, Newport News, Va, 1969; Drawings USA Purchase Award, Minn Mus Art, St. Paul, 1971. Media: Oil, watercolor, acrylic.

JENRETTE, Pamela Anne. Painter. Born: Ft. Bragg, NC, August 24, 1947. Study: Univ Tex, B.F.A., 1969. Exhib: Whitney Biennial, New York, 1975; Cologne Art Festival, Ger, 1975. Awards: Competition Award, Conde Nast, 1969. Media: Acrylic, watercolor.

JOHNSON, Katherine King. Art administrator, painter. Born: Lincoln, Nebr. Study: Univ Nebr Col Fine Arts, with Dwight Kirsh, Francis Colburn, Darwin Dunkin & Marshel Merritt. Work: Lyndon B. Johnson Mem Libr, Austin, Tex; Bennington Mus Art & Hist, Vt; Fleming Mus, Burlington, Vt; Southern Vt Art Ctr, Manchester; Rutland Hosp Mem Collection, Vt. Exhib: Southern Vt Artists Nat Traveling Show, 1956; Nat League Am Pen Women Regional, 1965-71; Indio Date Festival, Calif, 1968; Hale Galleries Exhib, Palm Springs, Calif, 1970; Stratton Art Festival, Vt, 1970. Collections Arranged: Loan exhibition of Currier & Ives Prints; traveling exhibit of prints & drawings by Kay Cassill, 1970; Humor in Art, commemorating 75th year of the comicstrip & Honduras Art Loan Exhibit, 1971; Gottlob Briem Memorial Exhibit, 1972. Media: Oil.

JOHNSON, Patricia Paul. Painter. Born: Camden, Ark., July 24, 1946. Study: La Tech Univ, B.F.A.; Skowhegan Sch Painting & Drawing, with James McGarrell, Phillip Pearlstein & Jacob Lawrence; Univ Ariz, M.F.A. Work: La Tech Univ, Ruston; Tucson Art Ctr, Ariz. Exhib: Monroe Ann, Masur Mus, Monroe, La, 1969; one-man show, El Dorado Art Ctr, Ark, 1969; Painting & Sculpture Biennial, Phoenix Art Mus, Ariz, 1971; Tucson Festival Exhib, Tucson Art Ctr, Ariz, 1972; Fraser-Gifford Gallery, Tucson, 1972. Awards: Award, 1971 & Purchase Award, 1972, Tucson Art Ctr; George Bright Mem Award, Phoenix Art Mus, 1971. Media: Oil.

JONES, Barbara Nester. Painter. Born: Oklahoma City, Okla., February 14, 1923. Study: Phillips Univ, B.F.A.; Univ Calif, Fullerton, M.A.; Okla Univ, postgrad; also with Ken Tyler, Gemini GEL, Los Angeles. Work: Laguna Beach Mus Art, Calif; Riverside Art Ctr & Mus, Calif. Comn: Mural, Community Bank of Enid, Okla, 1966. Exhib: 26th Ann Exhib, Philbrook Art Ctr, Tulsa, Okla, 1966; Art in Politics, Lytton Ctr of Visual Arts, Los Angeles, 1968; 11th Art Unlimited, Downey Mus Art, Calif, 1968; 13th Ann Purchase Prize Competition, Riverside Art Ctr & Mus, 1974; 21st All Calif Show, Laguna Beach, 1975. Awards: Painting Award, Downey Art Mus, 1968; Painting Award, Laguna Beach Mus Art, 1973; Painting Award, Harry Hopkins, San Francisco Mus Art, 1975. Media: Acrylic on canvas.

JONES, Claire (Deann Burtchaell). Painter, instructor.
Born: Oakland, Calif. Study: Stanford Univ, A.B.;
Otis Art Inst; Univ Calif, Irvine; Laguna Beach Sch Art;
also with Dong Kingman, Mario Cooper, Rex Brandt.
Work: Hunt Wesson, Fullerton, Calif; HEAR Found,
Pasadena, Calif. Comn: Many pvt comns. Exhib: Southern
Calif Expos, Del Mar, 1969-72; Death Valley Invitational,
Furnace Creek, Calif, 1971-75; Watercolor West, Riverside,
Calif, 1972-75; Cedar City Invitational, Utah, 1974;
West Coast Americana Realists, Fullerton. Awards: First
Award Watercolor, Southern Calif Expos, 1969; Hon Mention,
Watercolor West, 1972 & 1975; Best of Show, Hillcrest
Invitational, 1974.

JONES, Elizabeth. Sculptor, medalist. Born: Montclair,
NJ, May 31, 1935. Study: Vassar Col, B.A., 1957; Art
Students League, 1958-60; Scuola Arte Medaglia, The Mint,
Rome, Italy, 1962-64; Acad Brasileira Belas Artes, Rio de
Janeiro, hon dipl, 1967. Work: Creighton Univ. Comn:
Portrait of Albert Schweitzer, Franklin Mint, Pa, 1966;
gold sculptures with precious stone, Govt Italy, 1968;
portrait of Picasso, comn by Stefano Johnson, Milan,
Italy, 1972; Gold Medal Award for Archeol, Univ Mus, Univ
Pa, 1972; Holy Year Jubilaeum; plus many others. Exhib:
Tiffany & Co, New York, Houston, Los Angeles, Chicago &
San Francisco, 1966-68; Montclair Art Mus, NJ, 1967; many
int medallic art shows, Rome, Madrid, Paris, Athens,
Prague & Cologne; Smithsonian Inst & Nat Sculpture Soc,
New York, 1972; USIS Consulate, Rome, Italy, 1973.
Awards: Outstanding Sculptor of the Year, Am Numismatic
Asn, Colorado Springs, Colo, 1972. Media: Wax, plaster;
silver, gold.

JONES, Ruthe Blalock. Painter. Born: Claremore, Okla.,
June 8, 1939. Study: Bacone Col, with Dick West, A.A.;
Univ Tulsa, with Carl Coker, B.F.A., grad study. Work:
Mus Am Indian, Heye Found, New York; Indian Arts & Crafts
Bd, US Dept Interior, Washington, DC; Heard Mus, Phoenix;
Philbrook Art Ctr, Tulsa; Five Civilized Tribes Mus,
Muskogee, Okla. Exhib: US Dept Interior Invitational
Indian Exhib, Washington, DC, 1965; Indian Ann, Philbrook
Mus, Tulsa, 1968 & 1972, Okla Ann, 1972; Indian Ann, Five
Civilized Tribes Mus, Muskogee, 1969 & 1970; Scottsdale
Indian Nat Art Exhib, Ariz, 1972. Awards: First for
Traditional Indian Painting, Philbrook Mus, 1968; Spec
Award, US Dept Interior, Okla State Soc; Second for
Watercolor Painting, Scottsdale Nat Indian Art Exhib, 1972.
Media: Watercolor, acrylic, oil.

JORDAN, Barbara Schwinn. Painter, illustrator. Born:
Glen Ridge, NJ, October 20, 1907. Study: Parsons Sch
Design; Grand Cent Art Sch; Art Students League, with
Frank DuMond, Luigi Lucioni & others; Grande Chaumiere &
Acad Julian, Paris, France. Exhib: One-man exhibs,
Soc Illustrators & Barry Stephens Gallery; Nat Acad
Design, 1955; Royal Acad, London, Eng, 1956; Guild Hall,
1969. Awards: Prizes, Guild Hall & Art Dirs Club.
Mem: Soc Illustrators.

JORDAN, Christine. Painter. Born: Washington, DC,
December 10, 1940. Study: Art Students League, with Will
Barnet & Peter Golfinopoulos. Exhib: Contemporary
Reflections, Aldrich Mus, Ridgefield, Conn, 1974; New
Talent Festival, Gimpel & Weitzenhoffer Gallery, New York,
1974; 19 Creative Women, Portland Mus, Maine, 1974; group
show, 1974 & one-woman show, 1975, Aames Gallery, New
York. Media: Acrylic & pastel on canvas.

JORGENSEN, Sandra. Painter, educator. Born: Evanston,
Ill., April 21, 1934. Study: Lake Forest Col, with
Franz Schulze, B.A., 1957; Akademie der Bildenden Kunste,
Vienna; Art Inst Chicago, with Paul Wiegardt & Whitney
Halstead, M.F.A., 1964. Exhib: Chicago Print Show,
Allan Frumkin Gallery, Chicago, 1969; Black & White Show,
Kovler Gallery, Chicago, 1969; New Talent '74, Richard
Gray Gallery Chicago, 1974; Contemp Still Life,
Renaissance Soc, Univ Chicago, 1974. Media: Oils on
canvas.

JUDKINS, Sylvia. Painter. Born: New York, NY. Study:
Pratt Inst; Sch Visual Arts, New York; China Inst, New
York; also painting tours with Edgar Whitney & Barse
Miller; Nat Acad Fine Arts, scholar, 1968-70. Exhib:
Am Artists Prof League Grand Nat Exhib, Lever House, New
York, 1967 & 1970; Parrish Mus Ann Exhib, Southampton,
NY, 1970; Nat Art League Spring Exhib, Adelphi Univ, 1971;
Am Watercolor Soc Ann, Nat Acad Design, New York, 1973-75;
Painters & Sculptors Soc NJ, Nat Arts Club, 1975; plus
others. Awards: Award, Am Artists Prof League Grand Nat
Exhib, 1970; High Winds Medal, Am Watercolor Soc, 1975;
Medal of Honor, Painters & Sculptors Soc NJ, 1975; plus
others. Media: Watercolor, acrylic.

JUDSON, Jeannette Alexander. Painter. Born: New York, NY, February 23, 1912. Study: Nat Acad Design, with Robert Phillip & Leon Kroll; Art Students League, with Vaclav Vytlacil, Charles Alston, Carl Holty & Sidney Gross. Work: Joseph H. Hirshhorn Collection; NY Univ Collection; Brandeis Univ; Brooklyn Mus, Fordham Univ; plus many other pub & pvt collections. Exhib: One-man shows, Bodley Gallery, New York, 1967-73, Laura Musser Mus Art, Muscatine, Iowa, 1969, Pa State Univ, 1969, NY Univ, 1969 & Syracuse Univ House, New York, 1975. Awards: Grumbacher Award, Nat Asn Women Artists, 1967. Media: Oil, acrylic.

JUNKIN, Marion Montague. Painter, educator. Born: Chunju, Korea, August 23, 1905; US citizen. Study: Washington & Lee Univ, A.B., 1927, hon D.A., 1949; Art Students League, 1927-30; also with Luks, Locke & McCartan, 1930-32. Work: Va Mus Fine Arts; IBM Corp Collection. Comn: Murals, Hq Va State Police Dept, Richmond, McCormick Libr, Lexington, Stonewall Jackson Hosp, Lexington & Fed Savings & Loan Asn, Memphis; frescoes, Memphis, Tenn, Richmond & Roanoke, Va. Exhib: Art Inst Chicago; Pa Acad Fine Arts, Philadelphia; Corcoran Art Gallery, Washington, DC; Carnegie Inst, Pittsburgh; Whitney Mus Am Art, New York, NY; plus others.

KAHN, Susan B. Painter. Born: New York, NY, August 26, 1924. Study: Parsons Sch Design; also with Moses Soyer. Work: New York Cult Ctr; Montclair Mus, NJ; Butler Inst Am Art, Youngstown, Ohio; Reading Mus, Pa; Joslyn Art Mus, Omaha. Exhib: Audubon Artists, New York, 1969; Nat Acad Design, 1970; Butler Inst Am Art, 1973; Albrecht Gallery Mus, St. Joseph Mo, 1974; New York Cult Ctr, 1974; plus others. Awards: Knickerbocker Artists Medal of Honor, 1964; Nat Arts Club Award, 1967; Famous Artists Sch Award, Nat Asn Women Artists, 1967. Media: Oil.

KAN, Diana. Painter, lecturer. Born: Hong Kong, March 3, 1926; US citizen. Study: With Chang Dai Chien, China, 1946; Art Students League, 1949-51, with Robert Johnson & Robert B. Hale; Ecole Beaux Arts, Paris, 1952-54, with Paul Lavelle. Work: Metrop Mus Art, New York; Philadelphia Mus Art; Nelson Gallery, Atkins Mus, Kansas City, Mo; Nat Hist Mus, Taiwan; Elliott Mus, Stuart, Fla. Comn: Lotus painting, Nat Hist Mus, Taiwan, 1971. Exhib: Royal Acad Arts, London, Eng, 1964; Royal Soc Painters, London, 1964; one-man shows, Elliott Mus, 1967 & 1974, Nat Hist Mus, Taiwan, 1971 & New York Cult Ctr, 1972; plus others. Awards: Am Watercolor Soc Traveling Award, 1968, 1973 & 1975; Barbara Vassillieff Mem Award, Allied Artists Am, 1969; Anna Hyatt Huntington Bronze Medal, Catharine Lorillard Wolfe Art Club, 1970 & 1974. Media: Watercolor.

KAPLAN, Marilyn. Painter. Born: Brooklyn, NY. Study: Syracuse Univ, B.F.A.; Columbia Univ Teachers Col, M.A. (art educ); Art Students League, with Harry Sternberg. Work: New York Port Authority; Publ Clearing House, Port Washington, NY; Squibb Collection, New York; Lanvin-Charles of the Ritz Collection, New York; United Mutual Savings Bank, Great Neck. Comn: Poster, No More War by Personality Posters, New York for Nat Peace Movement, 1969. Exhib: Audubon Artists, New York, 1966, 1970 & 1971; Allied Artists of Am, New York, 1969; Hecksher Mus Ann Competition, Huntington, 1969-72 & 1975; Nat Acad Design, New York, 1970, 1972 & 1975; New Eng Ann Exhib, Silvermine, Conn, 1972-73. Awards: Second Prize Oils, Hecksher Mus, 1972; Gran Prix for Painting in Oper Democracy Ann, Prudential Savings Bank, 1973; Benjamin Altman Landscape Prize for Painting, Nat Acad Design, 1975. Media: Oil & acrylic on canvas.

KAPLAN, Rhoda B. Painter, instructor. Born: Newark, NJ, June 23, 1916. Study: Newark Sch Fine & Indust Arts; Hull Art Sch, Union, NJ; also pvt study with John R. Grabach. Exhib: Exposition Inter-Continentale, Monaco, Deuville & others; Am Artists Prof League Grand Nat, New York; Catharine Lorillard Wolfe Art Club, Nat Arts Club & Nat Acad Design, New York; Montclair Mus; Hudson Valley Art Asn, NY; plus others. Media: Oil, charcoal, pastel.

KARAWINA, Erica (Mrs. Sidney C. Hsiao). Painter, stained glass artist. Born: Germany; U.S. citizen. Study: Study in Europe; also with Frederick W. Allen & Charles J. Connick, Boston. Work: Metrop Mus Art, New York; Mus Mod Art, New York; Boston Mus Fine Arts; Libr Cong, Washington, DC; Honolulu Acad Arts. Comn: 20 lancets of faceted glass in concrete, Robert Shipman Thurston, Jr Mem Chapel, Punahou Sch, Honolulu, 1967; Crux Gemmata (glass in concrete), Manoa Valley Church, Honolulu, 1967; six windows of sculptured glass, St. Anthony's Church, Kailua, Oahu, Hawaii, 1968; This Earth is Ours (sculptured glass), News Bldg Foyer, Honolulu Advertiser, 1972; translucent glass mosaic murals, Hawaii State Off Bldg, Honolulu, 1975; plus others. Exhib: Dance Int, Rockefeller Ctr, New York, 1937; Competition of State of Mass, New York's Fair, 1939; Protestant Orthodox Ctr, New York World's Fair, 1939; Protestant Orthodox Ctr, New York World's Fair, 1964; one-man show, China Inst Int, Taipei, Taiwan, 1956; plus others. Awards: John Poole Mem Prize, Honolulu Acad Arts, 1952; James C. Castle Award, Narcissus Art Festival, Honolulu, 1961. Media: Stained glass.

KARESH, Ann Bamberger. Painter, sculptor. Born:
Bamberg, Germany; U.S. citizen. Study: Willesden Tech
Col, London, Eng; Hornsey Col Art, London. Work:
Gibbes Art Gallery, Charleston, SC; Home Fed Savings &
Loan Asn Collection, SC; Jewish Community Ctr Collection,
Charleston; Columbia Mus Art, SC. Exhib: Watercolor
USA, Nat Watercolor Exhib, 1962; 23rd Ann Contemp Am
Painting, Palm Beach, Fla, 1962; Directors Choice, 10
SC Artists Traveling Exhib, 1965; Contemp Artists, SC
Invitational, 1970-71; one-man show, Columbia Mus Art,
1972 & B'nai B'rith Mus, Washington, DC, 1975; plus
others. Awards: First Prize in Painting, SC Artists
Ann, 1963; Best in Enamel, SC Craftsmen, 1968, Best in
Metal, 1970. Media: Acrylic; metal, wood.

KARN, Gloria Stoll. Painter, instructor. Born: New
York, NY, November 13, 1923. Study: Art Students League;
also with Eliot O'Hara & Samuel Rosenberg. Work: Yale
Univ; Carnegie Inst Mus, Pittsburgh; Brooklyn Mus;
Pittsburgh Pub Schs. Exhib: Assoc Artists Pittsburgh
Ann, 1949-; Butler Inst Am Art Ann, 1961; one-man shows,
Pittsburgh Plan for Art, 1965 & Carnegie Inst Mus, 1966;
Sacred Arts Show, St. Stephens, Pittsburgh, 1966. Awards:
Purchase Prize, Brooklyn Mus Nat Print Ann, 1949;
Carnegie Inst Purchase Prize, 1960; Westinghouse Purchase
Prize, 1966. Media: Oil.

KARNIOL, Hilda. Painter, instructor. Born: Vienna,
Austria, April 28, 1910; U.S. citizen. Study: With
Olga Konetzny-Maly & A. F. Seligman, Vienna, 1925-28;
Acad for Women, 1926-30. Work: St. Vincent Abbey,
Latrobe, Pa; Del Art Ctr, Wilmington; Lycoming Col;
Lincoln Sch, Honesdale, Pa; US Dept Health, Educ &
Welfare. Comn: Portrait of Dr. Gustave Weber, Pres of
Susquehanna Univ, 1968; plus many other pvt portraits.
Exhib: Pa State Mus, Harrisburg, 1954; Adha Artzt
Gallery, New York, 1960; Drexel Inst Technol, 1960; La
Salle Col, 1964; La State Univ, New Orleans, 1971; plus
many others. Awards: First Prize in Portraiture,
Berwick Art Ctr, Pa, 1965; First Merit & Purchase Prize,
Lewisburg Art Asn, 1975. Media: Oil.

KASHDIN, Gladys S. Painter, educator. Born: Pittsburgh, Pa., December 15, 1921. Study: Art Students League, with Stefan Hirsch; Univ Miami, B.A. (magna cum laude), 1960; Fla State Univ, with Karl Zerbe, M.A., 1962, Ph.D. (humanities), 1965. Work: Otterbein Col, Ohio; Hillsborough Aviation Authority, Tampa, Fla; Columbus Mus Arts & Crafts, Ga; Pensacola Art Ctr, Fla; Futan Univ, Shanghai, China. Comn: Silkscreen eds, LeMoyne Art Found, Tallahassee, Fla, 1970, 1971 & 1973. Exhib: 28th Ann Brooklyn Mus, 1944; 2nd & 3rd Southeastern Ann, High Mus, Atlanta, 1947, one-woman show, 1948; Palm Beach Art League, Norton Gallery, West Palm Beach, 1948-63, one-woman show, 1962; LeMoyne Art Found, Tallahassee, 1966-74, one-woman shows, 1969 & 1974; one-woman show, Columbus Mus Arts & Crafts, Ga, 1973. Awards: Awards of Merit, Palm Beach Art League, 1958, 1960 & 1963; Gold Medals, Univ Miami, 1960; One-Person Exhib, Bank of Clearwater, Fla, 1966. Media: Ink, acrylic.

KATZ, Eunice. Painter, sculptor. Born: Denver, Colo., January 29, 1914. Study: Art Student League, with Harry Sternberg, Sculpture Ctr, with Dorothea Denslow; also with Angelo di Benedetto, Frederick Taubes, Donald Pierce & Edgar Britton. Work: US State Dept Art for Embassies Prog, Washington, DC; Temple Emanuel Collection, Denver, Colo; Denver US Nat Bank; Hillel House, Boulder; Children's Hosp, Pittsburgh, Pa. Comn: Stained glass window, BMH Congregation, Denver, 1967 & 13' walnut & bronze tablet, 1975; stained glass window, East Denver Orthodox Congregation, 1968; four figure sculpture (bronze), Beth Israel Hosp, 1970; two stained glass windows, Hebrew Congregation, Wichita, Kans, 1972. Exhib: Allied Artists Am, Nat Acad, 1949-66; Nat Soc Painters & Sculptors, NJ, 1964; one-man shows, Pietrantonio Gallery, New York, 1965 & Lafayette Univ, 1965; Int Soc Designers & Craftsmen, El Paso, Tex, 1972. Awards: Award of Merit, Rocky Mountain Liturgical Arts, 1958; Patron's Award, Art Mus N Mex Biennial, 1966; First Place Award, Am Asn Univ Women, 1966. Media: Oil, bronze.

KEANE, Lucina Mabel. Painter, printmaker. Born: Gros, Nebraska, 1904. Study: Ashland Col; Ohio State Univ, B.S. (educ); Teachers Col, Columbia Univ, M.A.; Pa State Univ; Temple Univ; NY Univ. Exhib: Allied Artists W Va; Clarksburg Art Ctr, W Va; Centennial Exhib, Huntington Art Gallery, W Va. Awards: Five Prizes, Allied Artists W Va, 1936-59.

KEENA, Janet Laybourn. Painter. Born: St. Joseph, Mo.,
September 11, 1928. Study: William Woods Col; Univ Kans;
Univ Calif, Los Angeles; also with Sergei Bongart &
Kathleen Spagnola. Work: Albrecht Mus, St. Joseph, Mo;
Park Col, Parkville, Mo; Dart Drug Hq, Los Angeles;
Regional Comnr, Govt Serv Admin, Washington, DC. Comn:
Painting, comn by Exhcange Bank Bd Dirs, Richmond, Mo,
1971; painting, Weight Watchers Hq, Kansas City Mo, 1974;
Designs for Miniature Gallery, Hallmark Cards, Kansas
City, 1974. Exhib: 13th Ann Delta Art Exhib, Little
Rock, Ark, 1970; Nelson Art Gallery, Kansas City, 1970;
Albrecht Art Mus, 1972; Ft. Smith Art Ctr, Ark, 1972;
Int Traveling Show Americana, Am Art by Mid-West Artists,
1972. Awards: First Prize & Best in Show, Parkville
Festival of Arts, 1970; First Publ Award, Fine Arts
Discovery Mag, 1970; First Prize, Mo State Fair, 1971 &
1972. Media: Oil.

KEENE, Maxine M. Sculptor, educator. Born: Cleveland,
Ohio, April 7, 1939. Study: Kent State Univ, B.F.A.,
grad study; Cranbrook Acad Art, Bloomfield Hills, Mich,
M.F.A. Work: Ball State Univ Gallery Art, Muncie, Ind.
Comn: Bronze bas reliefs, Am United Life, Muncie, 1970
& Doctors Accounting Serv Co, Indianapolis, Ind, 1971.
Exhib: Mid States Art Exhib, Evansville Mus Art, Ind,
1969; 150 Yrs Ind Art Invitational, Anderson Fine Arts
Ctr, 1969; Presenting Seven Sculptors, Sculptors Gallery,
Washington, DC, 1970; 23rd Ann Ceramic & Sculpture Show,
Butler Inst Am Art, Youngstown, Ohio, 1970; 53rd Ann May
Show, Cleveland Mus Art, 1972. Awards: Contemp Art Soc
Award & Morris-Goodman Talbot Gallery Award, Herron Mus
Art. Mem: Col Art Asn Am; Muncie Art Asn. Media:
Bronze.

KEMPTON, Greta. Painter. Born: Vienna, Austria, March
22, 1903. Study: Nat Acad Design; Art Students League.
Work: The White House, The Pentagon, US Treas Dept,
US Supreme Court, Nat Portrait Gallery, Apostolic
Delegation & Georgetown Univ, Washington, DC; plus many
other mus & pvt collections in US & ebroad. Exhib: One-
woman shows, Corcoran Gallery Art, Washington, DC, Canton
Art Inst, Ohio, Col Wooster, Ohio, Art Asn Harrisburg,
Pa, Akron Art League, Ohio & Circle Gallery, Cleveland,
Ohio; plus many others.

KENDA, Juanita Echeverria. Painter, writer. Born: Tarentum, Pa., November 12, 1923. Study: Stephens Col; Art Students League; Temple Univ, B.F.A.; Univ Hawaii; also with Jon Corbino, Sam Hershey, Boris Blai, Raphael Sabatini, Jean Charlot, George Bridgman & others. Comn: Murals, Straub Clinic & Children's Hosp, Honolulu. Exhib: The Gallery, Honolulu, 1960; Honolulu Painters & Sculptors, 1960 & 1961; Moorestown Friends Sch, 1961; Univ Hawaii, 1965; Galeria Santiago, San Juan, PR, 1967; plus many others.

KENNY, Bettie Ilene Cruts (BIK). Painter, writer. Born: Longmont, Colo, June 5, 1931. Study: Pac Lutheran Univ, with George Roskos; design with James Marta; Univ Wash, B.A. (Eng, with hons); with Norman Lundin, Everett Du Pen, Edward L. Praczukowski & George Tsutakawa; also with Florence Gould, Jack Cady & E. H. Smith. Work: Commemorative portrait of President J. F. Kennedy on glass, Smithsonian Inst; pictures & slides of diamond-point work, Corning Mus Glass, NY; Henry Art Gallery Arch of Artists, Seattle, Wash; Smiling Abraham Lincoln (portrait), Corning Mus Glass; Gov Evans (portrait), Gov Mansion, Olympia. Comn: Joan French (oil portrait), Gilbert & Sullivan Operetta Co, Seattle, 1958; Anniversary Commemorative (drawing in diamond-point), Church of God, 1971; diamond-point drawing (32 percent glass lead), Baptist Church, Seattle, 1972; Ski Scene (drawing in diamond-point), State of Wash to be presented at Heavenly Valley Ski Races, 1972. Exhib: 10th Ann Puget Sound Area Exhib, Charles & Emma Frye Art Mus, Seattle, 1968; Lambda Rho Art for Collectors' Sale, 1971 & Women in Art, 1972, Henry Art Gallery, Seattle; Mus Hist & Indust, Seattle; State Capitol Mus, Olympia, Wash, 1973 & 1974. Awards: Creative thinking merit awards, Boeing Co, Seattle, 1958-59; letter of commendation from Gov. Daniel J. Evans, State of Wash, 1972; commendation for portrait on glass, Lawrence Welk, 1972. Media: Oil on linen canvas, lead glass.

KENNY, Lisa A. Painter, sculptor. Born: Mineola, NY. Study: Studied with Thomas Henry Kenny. Work: Mus Mod Art, Miami, Fla; Madison Art Ctr, Wis; Print Collection, Philadelphia Pub Libr; Wooster Col Mus Art, Ohio; Nassau Community Col Firehouse Gallery, Garden City, NY. Exhib: Graphics 1971, Miami Mus Mod Art. Media: Lithography, sculpturing.

KEPALAS (Elena Kepalaite). Sculptor, painter. Born: Vilnius, Lithuania; U.S. citizen. Study Ont Col Art, Toronto; Brooklyn Mus Sch Art. Work: Pa Acad Fine Arts, Philadelphia; Univ Mass Art Gallery, Amherst; Libr & Mus of Performing Arts, Lincoln Ctr, NY; Lithuanian Mus, Adelaide, Australia; Mus Mod Art Lending Serv, New York. Comn: Bronze bust, Mr. Louis Horst, New York, 1962; bronze bust, Mrs. Gunilla Kessler, New York, 1971. Exhib: Pa Acad Fine Arts, Philadelphia, 1968; Silvermine Guild Artists Ann, New Canaan, Conn, 1969; Jersey City Mus, NJ, 1969-71; Phoenix Gallery, New York, 1970, 1972 & 1974; one-man show, Brooklyn Mus, NY, 1964. Awards: 1970 Sculpture House Award, Jersey City Mus, 1970; Am Soc Contemp Artists First Prize Award, Union Carbide, New York, 1974.

KERFOOT, Margaret (Mrs. M. W. Jennison). Painter. Born: Winona, Minn., July 4, 1901. Study: Hamline Univ, B.A., 1923; Art Inst Chicago, 1925; Paris Atelier of Parsons Sch Art, 1929; Univ Iowa, with Grant Wood, M.A., 1937; Harvard Univ, Carnegie grant, 1940; Univ Ore, Carnegie grant, 1941. Work: Denver Pub Schs, Colo; St. Lawrence Univ, Canton, NY. Exhib: Chicago Artists, Art Inst Chicago, 1934; Midwestern Artists, Kansas City Art Inst, 1942; Everson Mus Art Regional, Syracuse, 1955-73; Artists of Central New York, Munson-Williams-Proctor Mus, Utica, 1958-71; Finger Lakes Exhib, Rochester Mem Art Gallery 1960-63. Awards: Purchase Prize for Red Landscape, First Trust Bank, Syracuse, 1972; Purchase Prize, Merchants Bank, Syracuse, 1973.

KERKOVIUS, Ruth. Painter. Born: Berlin, Germany, June 9, 1921; U.S. citizen. Study: Munich, Germany, 1946-49; New Sch Social Res; Art Students League; Pratt Graphic Art Ctr, scholar; Sch Visual Arts. Work: New York Pub Libr; Mus Fine Arts, Boston; Mus Western Art, Ft. Worth, Tex; White House; Ford Found; plus others. Exhib: Print Club, Philadelphia, 1967; Asheville Art Mus, NC, 1968; Assoc Am Artists, New York, 1969; Tenn Fine Arts Ctr, Nashville, 1968; C Troup Gallery, Dallas, 1970; plus others. Awards: Second Prize for intaglios, Jersey City Mus, 1962 & Wesleyan Univ, 1967; Soc Am Graphic Artists Prizes, 1963, 1967 & 1973.

KERSTETTER, Barbara Ann. Painter, instructor. Born:
Kokomo, Ind, March 20, 1928. Study: Art Inst Pittsburgh;
Univ Hawaii; Univ Pittsburgh, B.A. (cum laude); Seton
Hill Col, with Frank Webb. Work: Air Force Mus Art
Collection, Dayton, Ohio. Exhib: Three Rivers Art
Festival, 1972 & 1975; Hoosier Salon Indianapolis, 1972;
Am Artists Prof League Exhib, New York, 1974 & 1975;
Washington & Jefferson Nat Painting Exhib, Washington, Pa,
1975; one-man show, Clarion State Col, Pa, 1975. Awards:
Gold Medallion Award, Twin Towers Art Exhib, Ingomar, Pa,
1972; Best of Show Award, Indiana Co Fair Art Exhib, Pa,
1973; Mus Award, Greensburg Art Asn, Pa, 1973. Media:
Oil, watercolor.

KESSLER, Edna Leventhal. Painter, instructor. Born:
Kingston, NY. Study: Parsons Sch Design, teaching cert;
NY Univ; Columbia Univ; Queens Col; Inst San Miguel, Mex;
also with Joseph Margulies, Paul Puzinas, Edgar A.
Whitney, Charles Kinghan, Dong Kingman & Victor D'Amico.
Exhib: Hudson Valley Art Asn, White Plains, NY, 1964-69;
Travel Show, USA, Am Watercolor Soc-Nat Acad Design, New
York, 1965; Am Artists Prof League Grand Nat, New York
& Dallas, 1962-69; Fine Arts Festival, Parrish Mus,
Southampton, NY, 1965-69; La Biennale Int, Vichy &
Clermont-Ferrand, France, 1966-68. Awards: Gold Medal,
Nat Art League, 1961; Arbogast Mem Award, Fine Arts
Festival, Parrish Mus, 1965; Grand Prix d'Aquerelle, La
Biennale Int, 1966. Media: Oil, watercolor, graphic.

KESSLER, Shirley. Painter, instructor. Born: New York,
NY. Study: Art Students League. Work: Iowa State Mus,
Iowa City; Nashville Mus Art, Tenn; Asheville Mus Art,
NC; Norfolk Mus Art, Va. Exhib: Museo Nacional Bellas
Artes, Buenos Aires, 1963; Am Watercolor Soc Ann, 1964
& Audubon Artists, 1965, Nat Acad Design, New York; 1st
Int Exhib Women Painters, Cult Ctr, Cannes, France, 1966;
Int Peinture de Saint Germaine-des-Pres, Paris, 1970.
Awards: Art Laureate, Dipl & Rosette, Medal of Honor,
Soc D'Encouragement au Progress, Paris, 1970; Palmes d'Or
Promotion Queen Fabiola, Belg, 1975; Grand Prix Humanitaire
de France & Medaille d'Argent with Laureate Dipl, Int
Arts Festival, De Saint Germain-des-Pres, France, 1975.
Media: Oil, watercolor, acrylic polymer.

KIAH, Virginia Jackson. Painter, museum director. Born: East St. Louis, Ill., June 3, 1911. Study: Philadelphia Mus & Sch Art, 1927-31, dipl; Art Students League, 1929-32, study with Louis Bouche, Robert Brackman & Vincent Damonde; Columbia Univ, A.B., 1949 & M.A., 1950. Comn: Portrait of Congressman Adam Powell, Community Ctr, Abbysinia Baptist Church, New York, 1937; portrait of Finley Wilson, Elks, Washington, D.C., 1940; portrait of JudgeThomas L. Griffith, comn by self, Los Angeles, Calif, 1941; two portraits of Mrs. Thomas Dyett, comn by Thomas Dyett, New York, 1952; portrait of Rev. Harry Hoosier, Washington Delaware Conf, Methodist Church, Gulfside, Miss, 1954. Exhib: Philadelphia Mus & Sch Art Ann Exhib, 1930; Baltimore Mus Art Ann Md Artists Show, 1935; Nat Columbia Motion Pictures Portrait Painting Contest Prizewinners Exhib, Eggleston Galleries, New York, 1937; Art Students League Ann Show, 1937; Southern Regional Art Show, Williamsburg, Va, 1969. Awards: First Prize Life Drawing, 1930 & Second Prize, 1931, Philadelphia Mus & Sch Art; Honorable Mention Anna Lucasta Portrait Painting, Columbia Motion Pictures, 1937; Nat Conf of Artists Distinctive Merit, 1960-62, 1968 & 1970-72. Media: Oil.

KIMBROUGH, (Sara) Dodge. Painter. Born: New York, NY. Study: Cooper Union; Grand Cent Art Sch, scholar; also with William DeLeftwich Dodge, Henry Lee McFee, Jerry Farnsworth & Frederick MacMonnies. Work: Phoenix Pub Libr, Ariz; Leflore Co Courthouse, Greenwood, Miss; US Sen Pat Harrison Libr, Univ Miss; Mem Rm, Davison Speech Sch, Atlanta, Ga; Beauvoir, Jefferson Davis Shrine, Biloxi, Miss. Comn: Many portrait commissions of prominent persons, 1930-72. Exhib: Mellon Gallery, Washington, DC; Ariz State Fair, Phoenix, 1951-57; Nat Asn Women Painters & Sculptors; Am Artists Prof League; one-man shows, Phoenix Art Ctr & Meridian Mus Art, Miss; plus many others. Awards: League Am Pen Women, 1936; Grand Nat Finalist, Am Artists Prof League, 1953; Award, Ill Valley Art Exhib, 1960. Mem: Miss Art Asn; Gulf Coast Art Asn; regional mem Portraits, Inc; Nat Soc Lit & Arts.

KIRKWOOD, Mary Burnette. Painter. Born: Hillsboro, Oregon, December 21, 1904. Study: Univ Mont, B.A.; Univ Ore, M.F.A.; Harvard Univ Sch Fine Arts, art hist with Prof. Paul J. Sachs; Royal Art Sch, Stockholm, Sweden, with Prof. Otte Skold; Art Students League, with Reginald Marsh; also with Joseph Stefanelli & Robert Goldwater, Paris. Work: Cheney Cowles Mus, Spokane, Wash; Boise Art Gallery, Idaho; IBM Corp; Bank of Idaho; Boise Cascade Corp. Comn: Murals for agr sci bldg, 1948 & libr, 1952, Univ Idaho. Exhib: West Coast Juried, Seattle Art Mus, 1962; West of the Mississippi Exhib, Colorado Springs, 1963; Intermountain Exhib, Salt Lake City Art Ctr, 1963 & 1965; Fifty States Exhib, Burpee Art Mus, Rockford, Ill, 1966; Western States Exhib, Denver Art Mus, 1971; plus others. Awards: Third Prize for Miercoles Santo, Pac Coast Ann, Wenatchee, Wash, 1963; Best of Show for El Cristo de la Columna, 1963 & Second Prize for Trampoline, 1966, Cheney Cowles Mus, Spokane, Wash. Media: Oil.

KISCH, Gloria. Sculptor. Born: New York, NY, November 14, 1941. Study: Sarah Lawrence Col, B.A., 1963; Boston Mus Sch, 1964-65; Otis Art Inst, Los Angeles, B.F.A. & M.F.A., 1969. Work: Palm Springs Desert Mus, Calif; Downey Mus Art, Calif; Otis Art Inst, Los Angeles. Comn: Female/Male (free standing sculpture), Jack & Lyn Meyers, Beverly Hills, Calif. Exhib: One-woman shows, Suzanne Saxe Gallery, San Francisco, 1973, Newport Harbor Art Mus, Newport Beach, Calif, 1974; Cirrus Gallery, Los Angeles, 1974 & 1975 & Wade Stevenson Gallery, Paris, 1975.

KLARIN, Winifred Erlick. Painter. Born: Portland, Maine, December 8, 1912. Study: Portland Mus Fine Art, Hayloft scholar, 1930; Vesper George Sch Art, grad, 1933; Soc Arts & Crafts, Detroit, 1958-60; Wayne State Univ, 1958-62; Cranbrook Grad Sch Art, 1963. Work: US Libr, State Dept, Washington, DC; Owens-Corning Fiberglass Corp, Toledo, Ohio; Steel Case Corp, Grand Rapids, Mich; First Fed Savings & Loan, Detroit; Masco Corp, Ypsilanti, Mich. Exhib: One-woman shows, Pace Gallery, 1966, J. B. Speed Art Mus, Louisville, Ky, 1969, Forsythe Gallery, Ann Arbor, Mich, 1967, 1969 & 1971 & Clossons Gallery, Concinnati, Ohio, 1969-71; Henry Ford Col, 1966; Rackham Gallery & Univ Mich, Ann Arbor, 1966-67; plus others. Awards: Outstanding Mich Artist, Nat Bank Detroit, 1965; two Top Awards--Best in Show, Scarab Club & Palette & Brush, 1967. Media: Acrylic.

KLAVANS, Minnie. Painter, sculptor. Born: Garrett Park, Md., May 10, 1915. Study: Wilson Teachers Col, B.S.Ed., 1935; pvt instr in silversmithing, 1951-55; painting with Laura Douglas, 1958-60; Am Univ, 1960-64; with Luciano Penay, 1965-70; Corcoran Gallery Art, plastics with Ed McGowin, 1970-71. Work: Nat Collection Fine Arts, Smithsonian Inst, White House, Corcoran Gallery Art & Nat Endowment Arts, Washington, DC; Mus Contemp Art, Madrid, Spain; Baltimore Mus Art, Md. Exhib: Corcoran Gallery Art, 1965 & 1967; Baltimore Mus Art, Md, 1967 & 1972; Cisneros Gallery, New York, 1967; Mus Mod Art, Bilbao, Spain, 1969; Chrysler Mus Art, Norfolk, Va, 1972. Awards: First Prize for silversmithing, Smithsonian Inst, 1953 & 1955; Spec Award, Baltimore Mus Art, 1967.

KLEIN, Beatrice T. Painter, printmaker. Born: Lynchburg, Va., February 7, 1920. Study: Md Inst Art, cert fine arts; Art Students League, with Yasuo Kuniyoshi, Va Commonwealth Univ; also with Hans Hofmann, Provincetown Work: Va Mus Fine Arts; Rocky Mount Art Ctr, NC; Philip Morris Co; First & Merchants Nat Bank, Richmond. Comn: Portrait of prof med, Med Col Va, 1970; portrait of pres of Va Commonwealth Univ, 1975. Exhib: One-man show, Va Mus, 1957, Va Printmakers, 1975; Anderson Gallery, Va Commonwealth Univ, 1973; one-man show of prints, Fells Point Gallery, Baltimore, 1975; Va Artist Biennials. Awards: Cert of Distinction, Va Mus Fine Arts, 1955 & 1957; Third Prize, Anderson Gallery, Va Commonwealth Univ, 1973. Media: Oil, watercolor; silk screen.

KLEIN, Doris. Painter. Born: New York, NY, November 10, 1918. Study: Art Students League, with Sidney Gross; Works Progress Admin Sch, with James Leschay & Anton Refregier; also sculpture with Maurice Glickman. Work: Univ Maine Permanent Collection. Exhib: Mus Belles Artes, Arg, 1963; Alley Gallery, Houston, Tex, 1966; Maxwell Gallery, San Francisco, 1967; Audubon Artists, 1968; Roko Gallery, New York, 1968-72. Awards: Best of Show, Jersey City Mus, 1963-66; Marion K. Haldenstein Mem Prize, Nat Asn Women Artists, 1968; Grumbacher Award, Mamaroneck Artists Guild, 1969.

KLEINMAN, Sue. Painter. Born: New York, NY. Study: Pratt Inst, Brooklyn, B.F.A; Caton-Rose Inst Fine Arts; New Sch Social Res, New York; Mus Mod Art, New York, with Zoltan Hecht & Donald Stacey; also with Raphael Soyer & Anthony Toney. Work: Brown Univ, RI; Fairleigh Dickinson Univ, Rutherford, NJ; Maimonides Hosp, Brooklyn. Comn: Privately comn portraits only. Exhib: Knicker-bocker Art, 1959 & Audubon Art, Weiner Gallery, 1960, New York; one-man shows, Crown Gallery, 1962, Ctr Gallery, 1965 & 1969 & Int Hotel, 1967, New York. Pos: Chmn mem comt, 1954-58 & treas, 1958-60, Kew Forest Art Asn; lectr, Ft. Lauderdale Mus Art. Awards: Bronze Medal, Village Art Ctr, 1958; hon mention, Rockport Art Asn, 1960; Silver Medal, Trade Bank New York.

KLEMENT, Vera. Painter, educator. Born: Danzig, Poland, December 14, 1929; U.S. citizen. Study: Cooper Union Sch Art & Archit, grad, 1950. Work: Mus Mod Art, New York; Philadelphia Mus Art; Ill State Mus, Springfield; Univ Tex. Comn: Ed of etchings, NY Hilton/Rockefeller Ctr, 1961; 27 & 1/2 ft painting, Kemper Ins Co, Long Grove, Ill, 1975. Exhib: Modern Art in US, Mus Mod Art Traveling Exhib, New York, 1956; NC Mus Art, Raleigh, 1960; Print Club, Philadelphia, 1962; Art Inst Chicago, 1967; Ill State Mus, 1974. Awards: Emily Lowe Award, NY, 1950; Louis Comfort Tiffany Found Award, 1954; Longview Found Purchase Award, 1961. Media: Oil on canvas.

KLINE, Alma. Sculptor. Born: Nyack, NY. Study: Radcliffe Col, A.B.; also sculpture with Jose De Creeft. Work: Cronkhite Grad Ctr, Cambridge, Mass; Norfolk Mus Arts & Sci, Va; St. Lawrence Univ, NY. Exhib: Women's Int Art Club, London, 1955; Nat Asn Women Artists, Mus Bellas Artes, Buenos Aires, 1963; ten one-man shows, Travel Art Guild, 1964; one-man show, Thomson Gallery, New York, 1969; Soc Animal Artists, Natural Hist Mus, Smithsonian Inst, 1971. Awards: Grumbacher Purchase Award, Audubon Artists, 1960; Medal of Honor, Knickerbocker Artists, 1964; Patrons of Art Award, Painters & Sculptors Soc NJ, 1969.

KLINE, Harriet. Painter, printmaker. Born: New York, NY, September 25, 1916. Study: Hunter Col, B.A.; also with Isaac Soyer, 1945-59; Art Students League, with Robert Philipp & Morris Kantor; China Inst, NY, with Prof. Y. C. Wang. Work: Art Collection, NY Univ; State Univ NY Col Oswego; Western New Eng Col. Exhib: Art USA, 1958; Silvermine Nat Exhib, Silvermine Guild, New Canaan, Conn, 1959; Nat Asn Women Artists, Nat Acad, New York, 1959-; 38th Ann, Butler Inst Am Art, 1974; var one-man shows, 1960-. Awards: Alice Standish Buell Prize Graphics, Ann Nat Asn Women Artists, 1972 & Aileen O. Webb Prize Watercolor, 1975; Laura M. Gross Prize Watercolor, 24th Ann Silvermine Exhib, New Eng, 1973. Media: Oil, watercolor, etching.

KLOSS, Gene (Alice Geneva Glasier). Etcher, painter. Born: Oakland, Calif, July 27, 1903. Study: Univ Calif, Berkeley, A.B. (hon in art), 1924; Calif Sch Fine Arts, 1924-25; Calif Sch Arts & Crafts. Work: Libr of Cong, Washington, DC; Metrop Mus Art, New York; Carnegie Inst, Pittsburgh; Pa Acad Fine Arts, Philadelphia; Mus Tokyo, Japan. Comn: Prints, Soc Print Connoisseurs, New York, 1949; prints, Print Club Albany, NY, 1952; prints, Soc Am Graphic Artists, New York, 1953; prints, Print Makers Calif, Los Angeles, 1956. Exhib: Three Centuries of Art in United States (in collab with Mus Mod Art, New York), Paris, 1938; Nat Acad Design Ann, New York, 1950-; Embassy Bldg., New Delhi, India, 1961; Soc Am Graphic Artists, yearly; The West by Members of the National Academy of Design, Phoenix Art Mus, Ariz, 1972; plus one-man shows. Awards: Eyre Gold Medal, Pa Acad Fine Arts, 1936; Purchase Award, Libr of Cong, 1953; anonymous prize, Nat Acad Design, 1961. Media: Oil, watercolor, etchings.

KNAPP, Sadie Magnet. Painter, sculptor. Born: New York, NY, July 18, 1909. Study: NY Training Sch Teachers, lic; City Col New York; Brooklyn Mus Art Sch; Atelier 17; Sculpture Ctr. Work: Ga Mus Art, Athens; Norfolk Mus Art, Va; Riverside Mus, New York. Exhib: Corcoran Gallery Art, Washington, DC; Baltimore Mus; Pa Acad Fine Arts, Philadelphia; Butler Inst Art, Youngstown, Ohio; plus others in Can, Eng, France, Switz, Arg, Mex, Japan, India, Scotland & Italy. Awards: Awards for Paintings, Baltimore Mus, 1956, 1958 & 1961; Award for Painting, Silvermine Guild Artists, 1965; Grumbacher Award for Painting, Nat Acad Design, 1968.

KNERR, Sallie Frost. Painter, printmaker. Born: Plattsburg, Mo., April 7, 1914. Study: Univ Mo; Cincinnati Acad Com Art; Corcoran Sch Art; Canal Zone Jr Col; Nat Acad Design; Am Univ; George Washington Univ, B.A., 1964; Univ Ga, scholarship for travel-study in Mex. & Guatamala, 1967, M.F.A., 1968. Work: Biblioteca Nac, Panama; Greenville News Piedmont, SC. Exhib: Contemporary Artists of South Carolina, Greenville Co Mus Art & Gibbes Gallery Art, Charleston, SC, 1970; La Watercolor Soc 3rd Int Show, 1971; 13th Dixie Ann Montgomery Mus Fine Arts, Ala, 1972. Awards: First in watercolor, Marshall Award Show, Art League Northern Va, 1962; hon mention for woodcut, SC Guild Artists Show, Greenville, 1965; Award of Merit, Coastal Carolina Fair, 1970.

KNIEF, Janet (Helen Jeanette). Painter. Born: Brooklyn, NY, July 16, 1909. Study: Art Students League, with Bridgeman, l'Olinsky & S. Dickinson; Brooklyn Mus Art Sch, with Victor Candell, David Stone Martin; Nat Acad Sch, with Robert Phillip; Phoenix Sch Design; Pratt Inst. Work: Work in over 200 private collections. Comn: Portraits, pres of Flushing Savings Bank, NY, 1954, police comnr, Nassau Co Police Dept, 1955, seven grand- children, comn by Mrs. John Ryan, Baldwin, NY, 1964-74; Phillip Chasin, shown in his honor at Waldorf Astoria Dinner, 1974 & Mr. B. C. Cobb, comn by Mrs. Carl Miller, New York, 1974. Exhib: Brooklyn Mus, NY, 1957; Long Beach Arts Asn, NY, 1969-70; Nat Acad Gallery, New York, 1970-71; Lever House, Union Carbide, NY, 1971-72; Garden City Galleries, Kans, 1975; plus several one-man shows. Awards: First Prize, Kathy, Malverne Artists Long Island, 1968; First Prize, Walled Garden & Second Prize, The Garden, Long Beach Art Asn, 1970. Media: Oil, pastel.

KNOWLTON, Grace Farrar. Sculptor. Born: Buffalo, NY, March 15, 1932. Study: Smith Col, B.A.; Corcoran Sch Art; Am Univ; painting with Kenneth Noland & Vatclav Vitlacil; drawing & sculpture with Lothar Brabanski, welding steel with Martin Chirino. Work: J. Patrick Lannan Mus, Palm Beach, Fla; Lloyds of London, Washington, DC; Newark Mus, NJ; Storm King Art Ctr, NY. Comn: Pottery prototypes for Appalachian Workshops, Am Fedn Arts, New York, 1971. Exhib: One-man shows, Hinckley & Brohel Gallery, Washington, DC, 1969, Spectrum Gallery, New York, 1971, Henri Gallery, Washington, DC, 1973, Razor Gallery, New York, 1974.

KNOX, Elizabeth Ann. Painter. Born: Miami, Fla., June 13, 1944. Study: Parsons Sch Design, cert (honors); New Sch Social Res; Art Students League, with Robert Beverly Hale. Comn: Symposium Erotic Art, Univ Notre Dame, 1969; Whitney Biennial, Whitney Mus, 1975. Media: Oil, conte lead on paper.

KOBLICK, Freda. Sculptor. Born: San Francisco, Calif. Study: San Francisco City Col; San Francisco State Col; Plastic Indust Tech Inst, plastic engr, 1943. Comn: Cast acrylic doors, Sheraton Dallas Hotel, Tex, 1961; prismatic construct of acrylic, comn by Anshen & Allen, Int Bldg, San Francisco, 1963; cast acrylic relief, Rohm & Haas Co, Independence Hall, Philadelphia, 1964; cast acrylic fountain, comn by Robert Royston, City of Vallejo, Calif, 1966. Exhib: One-woman shows, Mus Contemp Crafts, New York, 1968, Ariz State Univ, Tempe, 1970 & Fountain Art Gallery, Portland, 1971; Pierres de Fantasie, Oakland Mus, Calif, 1970 & Object USA Int Tour. Awards: Louis Comfort Tiffany Found Grant in Aid, 1969; Guggenheim Found Fel, 1970-71. Media: Plastic.

KOCH, Virginia Greenleaf. Painter. Born: Chicago, Ill. Study: Yale Univ Sch Fine Arts; Am Univ; also with Ivan Olinsky, Robert Brackman & Gene Davis. Exhib: Mariners Mus, Newport News, Va, 1970 & 1971; Phillips Collection, Washington, DC, 1971; one-man shows, Studio Gallery, Washington, DC, 1971 & Main St. Gallery, Nantucket. Media: Acrylic.

KOCHTA, Ruth (Martha). Painter. Born: Ridgewood, NY. Study: Art Students League, with Rudolf Baranik & Julian Levi; also with E. B. Whitaker & Leo Manso. Work: Philathea Col Mus, Ont; First & Merchants Bank, Richmond, Va; Nat Bank N Am, New York. Exhib: Nat Acad Design Ann, New York, 1968; Heckscher Mus, Huntington, NY, 1969 & 1971; Wadsworth Atheneum, Hartford, Conn, 1971; Elizabeth Ney Mus, Austin, Tex, 1971; New Brit Mus, Conn, 1972. Awards: Best in Show, Manhasset Art Festival, 1970; First in oils, Bedford Art Show, 1971; First in oils, Gracie Sq Art Show, 1974. Media: Oil.

KOPLIN, Norma-Jean. Painter. Born: Chicago, Ill. Study: RI Sch Design; Yale Univ, with Joseph Albers, B.F.A.; Fontainebleau Ecole Beaux Arts. Work: Finch Col Mus. Exhib: One-man shows, David Herbert, 1962, Graham Gallery, 1968 & Benson Gallery, 1972; Mus Mod Art Penthouse, 1962-69; Philadelphia Mus Art, 1967. Media: Pencil.

KOPPELMAN, Dorothy. Painter, gallery director. Born: New York, NY, June 13, 1920. Study: Brooklyn Col; Am Artists Sch; Art Students League; also with Eli Siegel. Work: Yale Univ, New Haven, Conn; Hampton Inst, Va. Exhib: Mus Mod Art, New York, 1962; San Francisco Mus Art, Calif; Pratt Graphics Traveling Exhib, 1962-63; two-man show, Terrain Gallery, 1969 & three-man exhib, The Kindest Art, 1970; plus many others. Awards: First Prize for Painting, City Ctr Gallery, 1957; Prize for Painting, Brooklyn Soc Artists, 1960; Tiffany Found Grant, 1965-66. Media: Oil.

KORJUS, Veronica Maria Elisabeth. Painter, lecturer. Born: Tallinn, Estonia; U.S. citizen. Study: Prof Women's Col, Higher State Acad Art, Estonia, dipl, 1942; Univ Stockholm, 1943-45; Columbia Univ, M.A., 1952; Phoenix Sch Art, 1953-56; Nat Acad Design, New York, 1960-61; La Grande Chaumiere, Paris, 1961 & 1969-70; also pvt studies in Mus Louvre, Mus Jeu Paume & others. Work: Yasuda Art Collection. Comn: Portraits, UN Ambassador Dr. Jan Papanek, Scarsdale, NY, 1963; Dr. Richard Fafara, 1969, Susan Bell, 1970, Countess Maria Therese Perez de Cavanillas, 1970 & Ingrid Bergman, 1972; three comn portraits, World Coun Churches. Exhib: Ctr Art Gallery, New York, 1964; Int Art Gallery, Toronto, 1964-66; one-man shows, IBM Country Club, Poughkeepsie, NY, 1964 & 1969 & Las Mimosas, Tangier, Morocco, 1966; Barnard Col Art Asn, New York, 1969. Media: Oil, pastel.

KORMAN, Barbara. Sculptor, instructor. Born: New York, NY, April 8, 1938. Study: Art Students League; NY State Col Ceramics, Alfred Univ, B.F.A., cum laude, 1959, grad fel, 1959-60, M.F.A. Work: In many pvt collections throughout the world. Exhib: Rochester Mem Art Gallery, NY, 1959; Albright-Knox Art Gallery, Buffalo, NY, 1960; Hartford Mus Gallery Shop, Conn, 1961; Hudson River Mus, Yonkers, NY, 1973-74; Nat Acad Design, New York, 1973-75. Awards: House of Heydenryk Prize for Sculpture, 1974.

KOROW, Elinore Maria. Painter. Born: Akron, Ohio, July
31, 1934. Study: Cleveland Inst Art, with Rolf Stoll,
Paul Riba & John Teyral. Work: Portrait of Richard
Oberlin, Dir, Play House Gallery Collection, Cleveland.
Comn: Portraits of Louis Triscaro, Pres of Teamsters
Local 436 & George Hilden, Pres of Osco Drugs, Chicago.
Exhib: Butler Inst Am Art, Youngstown, Ohio, 1968-70;
Canton Art Inst All Ohio Show, 1971; Virginia Beach Nat
Art Show, Va, 1973; Am Watercolor Soc, New York, 1973;
Rocky Mountain Nat Watermedia Exhib, Golden, Colo, 1974.
Awards: Best in Oils, Cleveland Press Club, 1966; Award
of Excellence, Jewish Community Ctr, 1972.

KOSCIELNY, Margaret. Sculptor. Born: Tallahassee, Fla,
August 13, 1940. Study: Tex Woman's Univ, with Toni
Lasalle; Univ Ga, B.A.(art hist) & M.F.A., with Irving
Marantz & Charles Morgan. Comn: Plexiglas sculpture,
John Portman, Atlanta, Ga, 1969 & 1970; Plexiglas sculpture,
Maurice D. Alpert, Int City Corp, Atlanta, 1972 & 1975;
Omni, Norfolk, Va, 1975. Exhib: Fla State Fair, Tampa,
1965; American Drawing 1968, Philadelphia, 1968; Drawing
USA, St. Paul, Minn, 1969; Cummer Gallery, Jacksonville,
1972; Art Celebration, Jacksonville, 1973 & 1974. Media:
Plexiglas.

KOZLOFF, Joyce. Painter. Born: Somerville, NJ, December
14, 1942. Study: Carnegie Inst Technol, B.F.A., 1964;
Columbia Univ, M.F.A., 1967. Exhib: One-woman exhibs,
Tibor de Nagy Gallery, New York, 1970-74, Douglass Col
Libr, 1973, Univ RI, Kingston, 1974, Kingpitcher Gallery,
Pittsburgh, 1975, Queens Col Libr, 1976 & Palomar Col,
San Marcos, Calif, 1976; Women Choose Women, New York Cult
Ctr, 1973; New Acquisitions, Mus Mod Art, 1973; Woman's
Work: American Art 1974, Mus of Philadelphia Civic Ctr;
Collector's Choice, St. Antonio Mus, 1974; plus other
group & one-man shows. Awards: Grant, Tamarind
Lithography Inst, Albuquerque, N Mex, 1972; CAPS Grant,
NY State Coun Arts, 1973; Am Asn Univ Women Grant, 1975.
Media: Acrylic.

KRAMER, Marjorie Anne. Painter. Born: Engelwood, NJ,
April 21, 1943. Study: Cooper Union, B.F.A., 1966; New
York Studio Sch, with M. Matter & C. Cajori. Exhib:
Green Mountain Gallery, New York, 1969-76; New Eng
Landscapes, Fleming Mus, Burlington, Vt, 1971; New
Images in American Figurative Painting, Queens Mus, NY,
1974-75; Portraits 1970-75, Frumkin Gallery, 1975; Ten
Realists, Hera Women's Gallery, RI, 1975; plus others.
Media: Oil, watercolor.

KRASHES, Barbara. Painter, instructor. Born: New York, NY. Study: Art Students League, with Reginald Marsh, Julian Levi & Vaclav Vytlacil; NY Univ, B.S.; Hunter Col, NY; Educ Alliance, with Chaim Gross; New Sch Social Res, New York. Work: McKnight Art Mus, Wichita State Univ, Kans; St. Lawrence Univ Mus, Canton, NY; Am Can Co, New York; Kidde Constructors, Inc, New York; Valley Bank, Springfield, Mass. Exhib: Work by New Jersey Artists 1958, Newark Mus; Art: 1965, Am Express Pavilion, New York World's Fair; Future Greats, Westchester Art Soc, White Plains, NY, 1965; Art Today 1967, NY State Fair, Syracuse; Am Abstract Artists 32nd Anniversary Exhib, Riverside Mus, NY, 1968. Awards: George B. Bridgman Mem Scholar, Art Students League. Media: Acrylic polymer emulsion.

KRUGER, Barbara. Painter. Born: Newark, NJ, January 26, 1945. Study: Syracuse Univ; Parsons Sch Design; Sch Visual Arts. Exhib: New York Avant Garde-28 Painters, Montreal, Can, 1973; Whitney Biennial of Contemporary American Art, 1973; Basel Art Fair, Switz, 1974; one-woman shows, Artists Space, 1974 & Fischbach Gallery, 1975.

KRUSKAMP, Janet. Painter. Born: Grants Pass, Oregon, December 10, 1934. Study: Chouinard Art Inst, Los Angeles, scholars; also with Viona Ann Kendall, North Hollywood. Work: Rosicrucian Egyptian Mus, San Jose & Triton Mus Art, Santa Clara, Calif. Exhib: Soc Western Artists Ann, M. H. De Young Mus, San Francisco, 1971; Artistes USA, Salon Prix Paris, 1971; Frye Mus Art, Seattle, 1971; Am Artists Prof League Grand Nat, 1972; Soc Western Artists, Rosicrucian Egyptian Mus, 1972; many solo shows nationally. Teaching: Pvt art classes, 1966-. Awards: Best of Show, Santa Clara Co Hist Landmarks Exhib, 1969; Soc Western Artists Ann First Place Oils, 1970; Trustees' Award & Andy Trophy, Grand Galleria Art Competition, Seattle, 1972 & First Grand Prize, 1973; plus others. Media: Oil, egg tempera.

KUCHAR, Kathleen Ann. Painter, instructor. Born: Meadow Grove, Nebraska, February 4, 1942. Study: Kearney State Col, B.A. (educ), 1963; Ft. Hays Kans State Col, M.S., 1966; Brooklyn Mus Art Sch, Max Beckmann Mem scholar, 1966-67, with Reuben Tam, 1967; Wichita State Univ, M.F.A., 1974. Work: Wichita State Univ Art Gallery; Ft. Hays Kans State Col Art Gallery. Exhib: 9th Midwest Biennial, Joslyn Art Mus, Omaha, Nebr, 1966; Watercolor USA, Springfield Art Mus, Mo, 1968; one-person show, Nat Design Ctr, New York, 1968; 3rd Nat Polymer Exhib, Eastern Mich Univ, 1969; Drawing & Small Sculpture Exhib, Ball State Univ, 1972. Awards: Purchase Award, Kans Bank, 1974. Media: Acrylic; felt markers.

KUCZUN, Ann-Marie. Painter. Born: Springfield, Mass.
Study: Bay Path Jr Col, A.S.; also with William Urton.
Exhib: Boulder Artist Asn, Colo, 1968, 1969 & 1973;
Okla Art Ctr, 1972; Boulder Fine Arts Ctr, 1972; Tex Del
Mar Col, 1973; 2nd Nat Sci Art Show, Colo, 1975. Pos:
Rep, Community Gallery Coun, 1971-72; bd dirs, publicity
chmn & exhib chmn, Boulder Fine Arts Ctr, 1972-73.
Media: Acrylic on canvas; drawing collage on paper.

KUEHN, Frances. Painter. Born: New York, NY, February
16, 1943. Study: Douglass Col, Rutgers Univ, B.A.,
Rutgers Univ, New Brunswick, M.F.A. Work: J. B. Speed
Art Mus, Louisville, Ky; Weatherspoon Art Gallery, Univ
NC; Power Inst, Univ Sydney, Australia; Allen Mem Art
Mus, Oberlin, Ohio. Comn: Portrait for private collection,
1972. Exhib: Whitney Mus Ann, 1972 & Biennial, 1973;
one-woman shows, Douglass Col Libr, 1973 & Max Hutchinson
Gallery, 1973 & 1974; Contemporary Portraits by Well-
Known American Artists, Lowe Art Mus, Coral Gables, Fla,
1974; Selections in Contemporary Realism, Akron Art Inst,
Ohio, 1974. Media: Acrylic.

KULLER, Hyacinthe. Painter, art dealer. Born: New York,
NY, May 12, 1936. Study: Art Students League, with
Ethel Katz, 1947-48 & Frank Mason, 1973; New Sch, with
Chaim Gross, 1961. Comn: Boys Town of Italy Journal,
Starlight Ball, Mrs. Julia Skouras, New York, 1964;
portrait of Martha Raye, comn by Lee Guber, Westbury
Music Fair, NY, 1968; portrait of Ellen Feld, Waif/ISS,
New York, 1974; portrait of Mrs. Saloman, Nat Tay Sachs
Orgn, New York, 1974; portrait of Claire Chambers, comn
by Robert Chambers, Bloomfield Hills, Mich, 1975.
Exhib: N Shore Ann Arts Festival, Long Island, NY, 1968;
Child Study Art Benefit, New York, 1969 & 1973; Allied
Artists Am, Nat Acad Galleries, New York, 1973; Mother
& Child, Performing Arts Found of Long Island, 1975;
plus many other one-man shows across the country.
Awards: First Prize for Portrait, 10th Ann Westchester
Art Exhib, 1969; First Prize for Litho, Washington Square
Art Show, 1970; Hon Mention, Allied Artists, Nat Acad
Galleries, 1973. Media: Oil; stone lithography.
Specialty: Portraiture, hand painted fabrics, lithographs,
paintings.

KURZ, Diana. Painter, lecturer. Born: Vienna, Austria;
U.S. citizen. Study: Brandeis Univ, B.A. (fine arts
cum laude); Columbia Univ, M.F.A. (painting). Exhib:
100 Contemporary American Drawings, Univ Mich, Ann Arbor,
1965; one-artist show, Green Mountain Gallery, New York,
1972 & 1974; Rose Art Mus, Brandeis Univ, 1974; Sons &
Others-Women Artists See Men, Queens Mus, NY, 1975.
Awards: Brevoort-Elckemeyer Fel, Columbia Univ, 1969;
Fulbright Grant in Painting, 1965-66; Yaddo Fel, 1968 &
1969. Media: Oil, watercolor.

KUSHNER-WEINER, Anita May. Painter. Born: Philadelphia,
Pa, November 30, 1935. Study: Univ Pa, B.A.; Temple
Univ, M.A.; New Sch Social Res, with Egas & Poussette
d'Arte; Pa Acad Fine Arts. Work: Mus Mod Art, Haifa,
Israel; B'nai B'rith Mus, Washington, DC; Univ Amsterdam,
Holland; Picadilly Galleries, London, Eng; Grabar
Galleries, Philadelphia. Exhib: Pa Acad Fine Arts
Biannual Drawing & Watercolor, 1967; New Talents, Whitney
Mus Am Art, New York, 1968; Okla Mus Traveling Art Show,
1968; one-man show, B'nai B'rith Int Mus, 1971; two-man
show, Philadelphia Art Alliance, 1971. Awards: First
Prize Graphics, Philadelphia Civic Mus, 1968, First
Print Painting, 1969; Critics Choice List, New York
Times, 1967. Media: Watercolor.

KUSSOY, Bernice (Helen). Sculptor. Born: Brooklyn, NY,
1934. Study: Art Students League; Cooper Union; Western
Reserve Univ, B.S.; Cleveland Inst Art, M.F.A. Work:
Butler Inst Am Art, Youngstown, Ohio; Kalamazoo Art Inst,
Mich; Univ Calif, Santa Barbara; Mex-Am Inst Cult Rels,
Mexico City; Bundy Art Gallery Waitsfield, Vt; plus
other pub & pvt collections. Comn: Brancusi Marble Co,
Los Angeles, United Res Serv, Burlingame & Temple Beth
Israel, Pomona, Calif. Exhib: Laguna Beach Art Asn,
1964; Otis Art Inst, Los Angeles, 1964; Pioneer Mus &
Haggin Galleries, Stockton, Calif., 1964; Mexico City,
1965; Judah L. Magnes Jewish Mus of the West, Berkeley,
Calif, 1968; plus others. Awards: Butler Inst Am Art,
1958 & Cincinnati Mus Asn Prizes, 1958.

KUVSHINOFF, Bertha Horne. Painter. Born: Washington.
Work: Seattle Art Mus, Wash; Phoenix Art Mus, Ariz;
Evansville Art Mus, Ind; Eureka Col Mus, Ill; Miami Art
Mus, Fla. Exhib: Inaugural Art Exhib, Washington State
Capitol Mus, Olympia, 1965; Seattle Russian Ctr, 1966;
Cath Ctr Gallery, Baltimore, Md, 1967; Edmonds Art Gallery,
Wash, 1970; Eureka Col Gallery, Ill, 1971. Awards:
Silver Medal, 1970 & Gold Medal, 1971, Acad Int Tommasso
Companelia, Rome, Italy. Media: Oils on canvas.

LAFON, Dee J. Painter, sculptor. Born: Ogden, Utah,
April 23, 1929. Study: Weber State Col; Univ Utah,
B.F.A., 1960, M.F.A., 1962; also with Francis de Erdley,
Phil Paradise & Marquerite Wildenhain. Work: Utah State
Fine Art Collection, Salt Lake City; Okla Art Ctr,
Oklahoma City; Philbrook Art Mus, Tulsa, Okla; Univ Okla,
Norman; Dillard Collection, Univ NC, Greensboro. Comn:
Wood sculpture, Univ Okla, 1972; copper fountain, E Cent
State Col, 1972. Exhib: Watercolor USA, Springfield,
Mo, 1968; Nat Oil Painting Exhib, Jackson, Miss, 1968; Am
Drawing Bienniale, Norfolk, Va, 1969; Int Miniature
Prints Show, Pratt Graphic Ctr, New York, 1970; Midwest
Bienniale, Omaha, Nebr, 1972. Awards: Eight State Exhib
Purchase Award, 1970; Hon Mention, Midwest Bienniale, 1972;
Tulsa Regional Painting & Drawing Award, 1972. Media:
Paintings usually in oil; sculpture in multi-media.

LA FON, Julia Anna. Painter, craftsman. Born: New Salem,
Pa, November 24, 1919. Study: George Washington Univ;
Univ N Mex. Work: Jonson Gallery, Univ N Mex; Mus
Albuquerque, N Mex. Exhib: Nat Sun Carnival, Mus El
Paso, Tex, 1970-72; one-man shows, Jonson Gallery, Univ
N Mex, 1971, 1973 & 1975; Southwest Fine Arts Biennial,
Mus N Mex, 1972; Regional Amarillo Art Competition,
Amarillo Art Ctr, 1975; Colorado Springs Fine Art Ctr,
1975. Awards: Best of Show & Purchase Award, N Mex Jr
Col, Hobbs, 1969; First & Second Prizes, Contemp Crafts
Exhib, Albuquerque, 1971; First Prize, Carlsbad Regional
Art Exhib, N Mex, 1973.

LAFRENIERE, Isabel Marcotte. Painter. Born: Providence, RI. Study: RI Sch Design, grad; RI Univ; pvt study in Paris. Exhib: Paris, New York, Boston, Hartford, Conn, Washington, DC, Ogunquit, Maine & others. Teaching: Pvt art classes; lectr hist of art; art demonstr. Awards: Figure Award, Rockport Art Asn, Mass, 1970; Grumbacher Award, Nat Art League, 1970; Best in Show, Medford, Mass, 1970.

LAM, Jeannett (Brinsmade). Painter, educator. Born: Ansonia, Conn, May 2, 1911. Study: Yale Univ, B.F.A. & M.F.A., with Josef Albers. Work: Mus Mod Art & Whitney Mus Am Art, New York; Brooklyn Mus, NY; Philadelphia Mus Fine Arts, Pa; Yale Art Gallery. Exhib: Carnegie Inst Int, 1964; Painting Ann, 1965 & Women in Permanent Collection, 1971, Whitney Mus Am Art; USA Group 67, US Embassy, Paris & Mus France, 1967; Selections from Chase Manhattan Collection, Finch Col Mus, 1971. Awards: MacDowell Colony Fel, 1960 & 1961. Media: Oil.

LANYON, Ellen. Painter, printmaker. Born: Chicago, Ill, December 21, 1926. Study: Art Inst Chicago, B.F.A., 1948, with Joseph Hirsch; State Univ Iowa, M.F.A., 1950, with M. Lasansky; Courtauld Inst, Univ London, with Helmut Reuhman. Work: Art Inst Chicago; Denver Art Mus, Colo; Libr of Cong, Washington, DC; Krannert Art Mus, Univ Ill, Champaign; Nat Collection Fine Arts, Boston Pub Libr. Comm: Lithograph, Ravinnia Asn, 1968; painting, Florists' Tel Delivery Asn Traveling Exhib, 1970; paintings, Ill Bell for Directory Cover, 1971; Container Corp Am; Great Ideas, US Dept Interior Bicentennial Exhib. Exhib: Art Inst Chicago Am Biennials, 1946-61 & Vicinity Ann, 1946-71; Young Printmakers, Metrop Mus Art, 1953; Recent Painting USA: The Figure, Mus Mod Art, New York, 1962; The Painter & The Photograph, Am Fedn Arts Traveling Exhib, 1965-66; The Chicago School, Imagist Art, Mus Contemp Art, Chicago & NY Cult Ctr, 1972; 26 one-woman shows. Awards: Cassandra Found Award, 1971; Nat Endowment Arts Award, 1974; Yaddo Fel, 1974-75. Media: Acrylic, lithography.

LAUB-NOVAK, Karen. Painter, printmaker. Born:
Minneapolis, Minn., August 25, 1937. Study: Carleton
Col, Northfield, Minn, B.A.; State Univ Iowa, with
Mauricio Lasansky, M.F.A.; Sch Vision, Salzburg, Austria,
with Oskar Kokoschka. Work: Carleton Col; Yale Univ;
St. Vincent's Archabbey; Union Theol Sem, New York;
Pac Sch Relig. Comn: 12-ft bronze tribute to Norman
Borlaug, 1971 Nobel Peace Prize Winner, Cresco, Iowa.
Exhib: One-woman shows, Des Moines Art Mus, 1966; Union
Court Gallery, San Francisco, 1966-68, Los Robles Gallery,
1968, Rochester Art Ctr, Minn, 1970, Rockefeller Found,
1974, Univ Tenn, 1974, Pac Sch Relig, 1974 & Yale Univ,
1975; plus others.

LAUFFER, Alice A. Painter, printmaker. Born: Mokena,
Ill., October 25, 1919. Study: Chicago Acad Fine Art,
cert; Art Inst Chicago; also with Paul Weighardt. Work:
Art Inst Chicago; Minn Mus Art, St. Paul. Exhib:
Drawings USA, Minn Art Mus, St. Paul, 1968, Traveling
Exhib, 1973-75; Nat Print & Drawing Competition, Dulin
Gallery, Knoxville, 1970 & 1973; Contemporary American
Drawings V, Smithsonian Traveling Exhib, 1972-74; Nat
Collection Fine Arts, Washington, DC & Smithsonian
Traveling Exhib, 1973-75; Nat Print & Drawing Show,
Second St Gallery, Va, 1975; among others. Awards:
James Broadus Clarke Award, Art Inst Chicago, 1969;
Drawings USA Purchase Award, Minn Mus Art, 1973. Mem:
Arts Club Chicago. Media: Acrylic, watercolor.

LAURINE (Virginia Laurine Grover). Painter. Born:
Durham, Maine, September 15, 1920. Study: Famous
Artists Sch, dipl fine arts; also with Alicia
Stonebreaker & Lillian Hale. Work: St. Joseph's Col;
RCA Distributors, Portland, Maine; Jean O. Mamin, Paris.
Comn: Oil painting, Dr. & Mrs. Donald Cowing, Dresden,
Maine, 1971; oil painting, Judge Charles J. Luke, II,
Daytona Beach, Fla, 1972. Exhib: Harlow Gallery,
Hallowell, Maine, 1967-70; Ogunquit Gallery, Maine,
1969-71; Berkshire Mus, Pittsfield, Mass, 1971;
Decatur Art Guild Nat Show, Ala, 1972; Benedictine Art
Awards, New York, 1972. Awards: Best in Show, Decatur
Art Guild, 1971; Benedictine Award of Merit, 1972;
Purchase Prize Award, RCA Distributors. Media: Oil.

LAVATELLI, Carla. Sculptor, weaver. Born: Rome, Italy, August 21, 1929; US citizen. Study: Nat Gallery, Rome, Italy; Phillips Collection, Washington, DC; Stanford Univ New Law Bldg; H. E. Leone, Pres Repub Italy; Freidburgh Univ, Ger. Comn: Lobby Spingold Theater, Brandeis Univ, 1969; New Bldg Upjohn Pharmaceuticals, Kalamazoo, Mich, 1970; portrait group of S.A.S. Ranier, III Prince of Monaco & his family, 1971; Imperial Majesties Shah & Shahbanou Iran, 1974; Kasser Found, NJ, comn by Mr. & Mrs. A. Kasser & Mr. & Mrs. S. Mouchary, 1974-75. Exhib: Spoleto, Palazzo Collicola, Italy, 1966; Palazzo della Quadriennale, 1967; one-man shows, Hakone Mus, Japan, 1972-73 & Philips Collection, Washington, DC, 1974; San Francisco Mus Art, 1975-76. Media: Stone, bronze, stainless steel, white & black yarns.

LAY, Patricia Anne. Sculptor. Born: New Haven, Conn., August 14, 1941. Study: Rochester Inst Technol, M.F.A.; Pratt Inst, B.S. Work: NJ State Mus, Trenton. Exhib: 25th Ceramic Nat, Everson Mus Art, Syracuse, NY, 1968-69; Warren Benedek Gallery, New York, 1973; one-person show, NJ State Mus, 1974; Contemporary Reflections, Aldrich Mus, Ridgefield, Conn, 1975; Whitney Mus Am Art Biennial, 1975. Media: Fired clay, metal, wood.

LECKY, Susan. Painter. Born: Los Angeles, Calif., July 19, 1940. Study: Univ Southern Calif, B.F.A.; also European travel. Work: Los Angeles Co`Mus. Exhib: Los Angeles Vicinity, 1961 & 1962; Midwest Ann, Decatur, Ill., 1968 & 1969; Univ Southern Calif, 1970; Joslyn Mus, Omaha, 1972; one-man show, Urbana, Ill., 1966. Media: Acrylic, watercolor.

LEE, Eleanor Gay. Painter. Born: Atlanta, Ga. Study: Nat Acad Design Sch Fine Art. Work: Mus City of New York; Mus Fine Art, Hickory, NC; Mus Fine Art, Greenville, SC; River Edge Mus, Can; Tamassee Daughters Am Revolution, SC. Exhib: Parrish Mus, Southampton, NY, 1960; Guild Hall, East Hampton, NY, 1963; Burr Galleries, New York, 1971; Nat Biennial Composers, Authors & Artists Am, 1971; Catharine Lorillard Wolfe Art Club Open, 1971. Awards: First Prize for oils, NY Co Fair, 1955 & Composers, Authors & Artists, 1971. Media: Oil, pastel.

LEE, Margaret F. Painter. Born: South St. Paul, Minn.,
May 19, 1922. Study: Rochester Art Ctr, with Adolph
Dehn, Arnold Blanch & Robert Birmelin, 1960-74; John
Pike Watercolor Sch, Woodstock, NY, 1972; watercolor
with Zoltan Szabo, 1974; Japanese woodblock with Toshi
Yoshida, 1974; Univ Minn, B.A. (art), 1975. Work:
YMCA-YWCA Permanent Collection, Rochester, Minn. Exhib:
Minn State Fair Exhibs, St. Paul, 1971-73; one-man show,
Augsburg Col, Minneapolis, 1973; 17th & 18th Int, Galerie
Int, New York, 1973-74; Mainstreams USA, Marietta Col,
Ohio, 1974; American Painters in Paris, French Ministry
& Paris City Coun, 1975. Awards: Best of Show, Red Wing
Art Asn, Minn, 1968; Merit Award in Drawing, Minn State
Fair Exhib, 1970; First Place, Minnesota '75.

LEEBER, Sharon Corgan. Sculptor. Born: St. Johns, Mich.,
October 1, 1940. Study: Univ Wyo; Trinity Univ. Work:
Shreveport Mus, La; Del Mar Col; Las Cumbres, Acapulco,
Mex; 2001 Club, Dallas, Tex. Comn: Six welded steel
pieces, Stemmons Inn, Dallas, Tex, 1972; large welded
male, John Higenbothim, III Collection, Dallas, 1972;
four welded figures, Fryburger Collection, San Antonio,
1975. Exhib: Tex Fine Arts Nat, Austin, 1969; one-man
retrospective show, Elizabet Ney Mus, Austin, 1971; Tex
Sculpture & Painting, Dallas, 1971; Okla Painting &
Sculpture, Oklahoma City, 1971; Tex Ann Erotic Show, San
Antonio, 1971 & 1972. Awards: Purchase Award, Shreveport
Mus, 1969; Purchase Award, Del Mar Col. Media: Steel,
aluminum, marble.

LEEDS, Annette. Painter. Born: Boston, Mass., May 2,
1920. Study: Mass Col Art, grad; Art Students League;
Brooklyn Mus, with Moses Soyer; also with Paul Puzinas
& Howard Boesendahl. Exhib: Catharine Lorillard Wolfe,
Nat Acad Design-Nat Arts Club, 1973-74; Burr Artists,
Lever House, 1973; Caravan House Gallery, 1974; Garden
City Gallery, 1975; plus others. Awards: First Prize
& Gold Medal, Art League Long Island, 1963, Spec Award,
1964; Third Prize, Art League Nassau Co, 1965.

LEFF, Rita. Printmaker, painter. Born: New York, NY.
Study: Art Students League; Brooklyn Mus; Parsons Sch
Design; also with Abraham Rattner, Louis Shanker, Adja
Yunkers, Worden Day & Louis Calapai. Work: Metrop Mus
Art, New York; Libr Cong, Washington, DC; Brooklyn Mus;
Pa Acad, Philadelphia; Dallas Mus. Exhib: Libr Cong
Print Ann; Pa Acad Design Print & Watercolor Ann; one-
man shows, Esterhazy Gallery, Palm Beach, 1971,
Gallery Cassell, Palm Beach, 1973 & Lighthouse Gallery,
Tequesta, Fla, 1975; plus others. Awards: Medals of
Honor, Nat Asn Women Artists, 1964, 1966, 1968 & 1969;
Grand Prix, Salon Int De Femme, Cannes, France, 1969;
First Prize Norton Gallery, Palm Beach, 1971 & 1972.
Media: Oil, collage, watercolor.

LEIFERMAN, Silvia W. Painter, sculptor. Born: Chicago,
Ill. Study: Univ Chicago, 1960-61; extensive study
Chicago, Ill, Provincetown, Mass, Mex, Rome, Italy &
Madrid, Spain. Work: Miami Mus Mod Art, Fla; Lowe Art
Mus, Univ Miami; Roosevelt Univ, Chicago; in collections
of Jack Benny & Gov. Haydon Burns; also in pvt collections
throughout the world. Exhib: Int Platform Asn, 1967;
Artists Equity Show, Crystal House, Miami Beach, 1968;
Lowe Art Mus; Beau Art Gallery, Univ Miami; one-man shows,
Hollywood Mus Art, Fla, 1968 & Miami Mus Mod Art, 1972;
plus others. Pos: Co-founder & vpres, Silvia & Irwin
Leiferman Found; founder, Mt. Sinai Hosp Greater Miami &
Greater technion Inst Technol Israel; pres, Active
Accessories by Silvia, Chicago, 1964-. Media: Oil,
acrylics, hot wax.

LERNER LEVINE, Marion. Painter. Born: London, Eng.,
October 31, 1931; US citizen. Study: Univ Chicago,
1946-49; Art Inst Chicago, Raymond Scholar, 1951-54, with
Paul Wieghardt, Vera Berdick, Max Kahn, B.F.A., 1954;
Chicago Graphic Workshop, 1954-55. Exhib: Max 24-64,
Purdue Univ, Ind, 1964; Long Beach Mus Ann, 1965; one-
woman shows, Prince Street Gallery, New York, 1971, 1973
& 1975; Women Choose Women, New York Cult Ctr, 1973;
Report from Soho, Grey Gallery, NY Univ, 1975; plus
others. Awards: Hon Mention, Newport Harbor All-Calif
Exhib, 1965 & Downey Mus Art, Calif, 1965. Media: Oil,
watercolor.

LEVENTHAL, Ruth Lee. Painter, sculptor. Born: New York, NY, October 5, 1923. Study: Art Students League; Nat Acad Design; also with John Terken, Robert Tompkins, Maxim Bugaster & Frank Eliscu. Work: Fedn Jewish Philanthropies, New York; YMHA & YWHA, Brooklyn; Riverside Mem Chapel, New York. Comn: Three paintings, New York World's Fair, 1964-65; sculpture, Riverside Mem Chapel, 1970, six sculptures, 1972; portrait of Golda Meir, pvt comn, 1972. Exhib: Six shows, Nat Acad Design, New York; New York World;s Fair, 1964-65; five shows, Nat Arts Club, New York; one-man shows, Kottler Galleries, New York, 1970 & Temple Sinai, Roslyn, Long Island, 1971; Sculptured Gold Jewelry, Bergdorf-Goodman, New York, 1972. Awards: Catharine Lorillard Wolfe Art Club Gold Medal, Nat Acad Design, 1970; Gold Medal, Nat Arts Club, 1973; Salmagundi Award, 1975; plus others. Media: Wax, clay.

LEVIN, Jeanne. Painter, collector. Born: Cleveland, Ohio, December 13, 1901. Study: Cleveland Sch Art; Wells Col, B.A.; Cranbrook Acad Art; Soc Arts & Crafts, Detroit; Norton Gallery & Sch Art; pvt study with Gerald Brockhurst, Ernest Fiene, Bruce Mitchell & Zubel Katchadoorian. Exhib: One-man shows, Contemp Gallery, Palm Beach, Fla, 1963, 1965 & 1968 & Norton Gallery, 1967; Benson Gallery, Bridgehampton, NY, 1967; Compass Gallery, Nantucket, Mass, 1967; Am Contemp Exhib, Soc Four Arts, Palm Beach. Pos: Assoc trustee, Friends of Modern Art, 1958-63, chmn, 1958-63; chmn, Futurists Exhib, Detroit Inst Arts, chmn, Acquisition Comt Mod Art; founding mem, Gallery Contemp Art, Palm Beach; trustee, New York Studio Sch, 1965-. Awards: Hon Mention, Mich Artists Exhib, Detroit Inst Arts, 1946; Paley Award, Norton Gallery, 1962 & 1966; Four Arts Soc, Palm Beach, 1968.

LEVIN, Kim (Kim Pateman). Painter, art critic. US citizen. Study: Vassar Col, A.B.; Yale-Norfolk Summer Sch Art; Columbia Univ, M.A. Exhib: One-man shows, Suffolk Mus, Stony Brook, Long Island, 1963, Poindexter Gallery, NY, 1964 & 1967 & Vassar Col Art Gallery, 1965. Teaching: Lectr drawing, Philadelphia Col Art, 1967-70; lectr drawing & painting, Parsons Sch Design, New York, 1969-72.

LEVINE, Marilyn Anne. Sculptor, educator. Born: Medicine Hat, Alta, December 22, 1935. Study: Univ Calif, Berkeley, M.A., 1970, M.F.A., 1971. Work: Montreal Mus Fine Arts; Nat Mus Mod Art, Kyoto & Tokyo; Utah Mus Fine Arts, Salt Lake City; William Rockhill Nelson Gallery Art, Kansas City; Univ Art Mus, Berkeley. Exhib: One-man shows, Hansen-Fuller Gallery, San Francisco, 1971 & 1975 & O. K. Harris Gallery, New York, 1974; Sharp Focus Realism, Sidney Janis Gallery, New York, 1972; Canada Trajectories, Mos Art Mod, Paris, 1973; Retrospective, Norman McKenzie Art Gallery, Regina, 1974. Teaching: Asst prof sculpture & ceramics, Univ Utah, 1973-. Awards: Gold Medal, XXVII Concorso Int della Ceramica Arte, 1969; Can Coun Arts Grant, 1969 & 1973; Ceramics Int Medal, 1973. Media: Clay.

LEVINE, Reeva (Anna) Miller. Painter, instructor. Born: Los Angeles, Calif., November 23, 1912. Study: With Emil Bistrom & Alexander Rosenfeld. Work: Temple Israel, Long Beach; E. Madison YMCA, Seattle; Mt. Zion Baptist Church, Seattle; Temple De Hirsch Sinai, Seattle; Beth Sholom Temple, Richland, Wash, 1974. Comn: Stained glass windows, Temple Beth Sholom, Santa Monica, 1944; stained glass windows, Temple Sinai Wedding Chapel, Oakland, 1948; ceiling of dome, Al Jolson Mem, Los Angeles, 1951; mosaic, Temple Beth Sholom, Anchorage, 1966; relig arks, Temple Beth Israel, Aberdeen, Wash, 1966; plus numerous portraits. Exhib: One-man shows, Santa Monica Art Asn, 1948, Olympia Art League, 1970 & Unity Church Tacoma, 1975; Seattle World's Fair Liturgical Conf, 1962; Seattle Art Mus, 1967. Pos: Art dir, Camp Ben Swig, Saratoga, Calif, 1952-58. Awards: First in Drawing, Santa Monica Art Asn, 1945, Second in Watercolor, 1948; Artist of Year, Music & Art Found, Seattle, 1970. Media: Oil, acrylic, watercolor.

LEWIS, Golda. Painter, sculptor. Born: New York, NY. Study: With Vaclav Vytacil, Hans Hofmann & Jack Tworkov; woodblock with Seong Moy, Papermaking with Douglass Howell & sculpture with Robert Laurent. Work: Ciba-Geigy Chem Co, Ardsley, NY; Madden Corp, New York; Hercules Powder Co, Wilmington, Del; Foundations of Paper Hist, Haarlem, Holland; Cheney Pulp & Paper Co, Franklin, Ohio; plus other pub & pvt collections. Exhib: Landmark Gallery, New York, 1973; Women Choose Women, New York Cult Ctr Mus, 1973; Weatherspoon Art Gallery, Univ NC, Greensboro, 1974; Kresge Art Ctr Gallery, Mich State Univ, 1974; one-woman shows, Alonzo Gallery, New York, 1974, Peter M. David Gallery, Minneapolis, 1974 & Benedicta Arts Ctr Gallery, Col St. Benedict (Minn), 1974; plus many others. Awards: NY State Coun Arts Grant, 1971. Media: Assemblages/time.

LEWIS, Mary. Sculptor, illustrator. Born: Portland,
Oregon, June 18, 1926. Study: Univ Ore, 1945-50, B.S.
(sculpture), 1949; Ore Div Am Asn Univ Women Mabel
Merwin fel, 1950, Syracuse Univ, with Ivan Mestrovic,
tech asst to Mestrovic, 1951, M.F.A., 1952. Work: In
pvt collections. Comn: Five-ft mahogany & hammered
copper bird & three-ft Carrara marble skunk cabbage,
comn by Joseph Stein & Waterbury Club, Conn, 1964;
small stone carving, Prouty Garden, Children's Hosp Med
Ctr, Boston, 1965; Madonna and Child (walnut relief from
half round log 20 by 30 inches), St. Louis de Montfort
Sem Chapel, Litchfield, Conn, 1966. Exhib: Artists of
Ore, Portland Mus Art, 1951 & 1969; 12th & 14th Ann New
Eng Exhibs, Silvermine Guild Artists, New Canaan, Conn,
1961 & 1963; 62nd & 63rd Ann Exhib, New Haven Paint &
Clay Club, John Slade Ely Ctr, New Haven, 1963 & 1964;
Plaza Seven 3rd Ann Arts Festival Regional Exhib,
Hartford Nat Bank & Trust Towers, 1967. Awards:
Tiffany Traveling Scholar, 1953; Fulbright Lectr, 1958-
59; Assoc, Nat Col Arts, Pakistan, 1959. Media: Most
sculptural media; ink, watercolor.

LIEBER, France. Printmaker, painter. Born: Newark,
NJ. Study: Art Students League; Pratt Graphic Ctr, New
York; Kean Col, NJ. Exhib: 16th Nat Print Exhib,
Montclair Art Mus, Bergen Mus & Hunterdon Art Ctr, 1972;
Airlift 549, Women's Interart Ctr, NY, 1973; Women
Printmakers, Philadelphia Focuses on Women in the Visual
Arts, Del Art Mus, Wilmington & Print Club, Philadelphia,
1974; Nat Asn Women Artists 86th Ann Exhib-Int Women's
Year, Nat Acad Design, 1975; Nat Asn Women Artists
Traveling Graphic Exhib, USA, 1975-76; among others.
Awards: First Prize (oils & graphics), Cranford Art Asn,
1965, 1970 & 1973; First Prize (graphics), Somerville
Art Asn, 1973; Nat Asn Women Artists Medal of Honor for
Graphics, Nat Acad Gallery, NY, 1975; plus many others.
Media: Silkscreen, intaglio; oils, pen & ink.

LIS, Janet Chapman. Painter. Born: Cleveland, Ohio,
January 9, 1943. Study: Cleveland Inst Art, scholar,
1957-61; Ohio Univ Sch Fine Arts, B.F.A., 1961-65;
Western Reserve Univ, 1966; also with David Driesbach,
Gary Pettigrew & Dave Hostetler. Work: Hollywood Mus
Art, Fla; Int Inst Human Rights, Strasbourg, France;
Nat Red Cross, Cleveland; Ft. Lauderdale Symphony Orch,
Fla; Holy Cross Hosp, Ft. Lauderdale. Comn: Poster,
Cleveland Inst Art, 1961; card design, Timco Rubber
Prod, Cleveland, 1965; painting of New River Hist Soc
Ft. Lauderdale, 1974; portrait of Charles Bachman,
Football Hall of Fame, comn by Charles Bachman, Jr,
Pompano Beach, Fla, 1974; Hist Silver Thatch Bldg
(charcoal drawing), Gen Builders Corp, Pompano Beach,
1975. Exhib: 51st Ann Nat Art Exhib, Springville Mus
Art, Utah, 1975; 55th Ann Nat Exhib Paintings, Ogunquit
Art Center, Maine, 1975; N Mex Int Art Show, Univ N Mex,
Portales, 1975; Women Artists, Metrop Mus Dade Co,
Miami, 1975; 5th New Orleans Art Exhib, 1975. Awards:
Wind River Valley Art Asn Award, 1974; El Centro, Calif
Women's Club Award, 2nd Ann Nat Fall Festival Art, 1974;
C. Duaine Dillin Award, 11th Ann Southeastern Art Exhib,
1975. Media: Acrylic on canvas, charcoal.

LIVINGSTON, Charlotte (Mrs. Francis Vendeveer Kughler).
Painter, art administrator. Born: New York, NY.
Study: Nat Acad Design; Art Students League; Columbia
Univ; Realgymnasium, Kassel, Ger. Work: Ford Mus,
Dearborn, Mich; Jumel Mansion, New York; Tamassee DAR
Schs, SC; Hickory Mus Art, NC; Greenville Mus, NC.
Exhib: Hotel Monmouth, Spring Lake, NJ, 1972, 1973 &
1974; Nat Arts Club, 1972; Authors, Artists & Writers,
Pacem in Terris, 1972; Grand Cent Art Gallery, New York;
Hudson River Mus, Ridgewood, NJ. Awards: Mary Yates
Medal, 1970; Eva Rappleye Medal, 1971; Anna Morse Medal,
1972; plus other hon mentions.

LIVINGSTON, Virginia (Mrs. Hudson Warren Budd). Painter,
illustrator. Born: Baltimore, Md. Study: Md Inst
Art; Cooper Union Art Sch; Art Students League; Nat
Acad Design; Beaux Art Am, Fontainbleau, France; with
Fernand Leger, Paris Acad, France; also with Brackman,
Ryerson, Kroll, O'Hara & Phillip, New York. Work:
Draped Figure, Home Fed Bank Bldg, Charleston, SC.
Exhib: Salon de L'Arte Libre, Paris, 1951; Miniature
Painters, Sculptors & Gravers Soc, Smithsonian Inst,
Washington, DC, 1952; Am Watercolor Soc Ann & Allied
Artists Am Ann, Nat Acad Art, New York, 1954-60;
Corcoran Gallery Art, Washington, DC, 1955; one-man
show, Mus City New York, 1960; plus many others. Awards:
First Prize, Ann Studio Club, YWCA, New York, 1952; Hon
Mention, Smithsonian Inst, 1952; Medal of Honor, Ann
Artists Prof League, New York, 1956; plus others. Media:
Watercolor.

LOGEMANN, Jane Marie. Painter. Born: Milwaukee, Wis.,
November 12, 1942. Study: Layton Sch Art, Milwaukee,
summers; Aspen Sch Contemp Art, Colo, summers; Univ Wis-
Milwaukee, B.A. Work: James Michener Collection, Univ
Tex, Austin. Exhib: LoGiudice Gallery, New York, 1971;
Multiples, New York, 1973; Video, Everson Mus, Syracuse,
NY, 1974; Margo Leavin Gallery, Los Angeles, 1975;
Video, Long Beach Mus, Calif, 1975; plus others.

LOMAHAFTEWA, Linda (Linda Joyce Slock). Painter, educator.
Born: Phoenix, Arizona, July 3, 1947. Study: Inst Am
Indian Arts, Santa Fe, N Mex; San Francisco Art Inst,
B.F.A. & M.F.A. Work: Ctr Arts Indian Am, Washington,
DC. Exhib: Riverside Mus, New York, 1965; Mus N Mex,
Santa Fe, 1965-66; Ctr Arts Indian Am, 1967-68; San
Francisco Art Inst Spring Show, 1970-71; Scottsdale Nat
Indian Art Exhib, Ariz, 1970-71. Awards: Hon Mention for
Oil Painting, Mus N Mex, 1965; First Place in Graphic Arts
Purchase Award, Ctr Arts Indian Am, 1967; Third Place
in Drawing, Scottsdale Nat Indian Art Exhib, 1970.

LOPEZ, Rhoda Le Blanc. Sculptor, educator. Born:
Detroit, Michigan, March 16, 1912. Study: Detroit Art
Acad, Wayne State Univ; Cranbrook Acad Art, with Maija
Crotell. Work: Detroit Inst Arts; Univ Wis-Madison;
Scripps Col, Claremont, Calif. Comn: Figure of Christ
(incised in concrete), Claremont Lutheran Church, 1967;
two sculpted brick fireplaces, 1969 & one high relief
fireplace, 1970, Sim Bruce Richards; baptismal fountain,
University City Lutheran Church, 1970; wall fountain,
Med Ctr, Dr. Larry Fine, 1971. Exhib: Syracuse Nat,
1949-55; Mich Craftsmen Ann, 1949-58; five shows, Scripps
Invitational, 1953-66; Allied Craftsmen Ann, San Diego,
1960-72; Design 8-11, Pasadena, 1965, 1968 & 1971.
Media: Clay.

LORENTZ, Pauline. Painter, instructor. Born: Newark, NJ. Study: Newark Sch Fine & Indust Arts, NJ, grad; Art Students League; also with John R. Grabach. Exhib: Am Artists Prof League Grand Nat, New York, 1965, 1967-69; Expos Intercontinentale, Monaco & Dieppe, France, 1967-68; 24th Am Drawing Biennial, Norfolk Mus Arts & Sci, Va, 1971; 22nd Ann Nat Exhib, Mus Fine Arts, Springfield, Mass, 1971; Smithsonian Traveling Exhib, US, 1971-73. Awards: Gold Medals for Drawing, Catharine Lorillard Wolfe Art Club, 1967 & 1969, Am Artists Prof League, 1967 & 1970 & Arts Atlantic, Gloucester, Mass, 1972; plus many others. Media: Oil, charcoal.

LOVE, Rosalie Bowen. Painter, instructor. Born: Jamestown, NY. Study: Jepson Art Sch; also with Karl Seethaler, Hayward Veal, Will Foster, J. Thompson Pritchard, Bennett Bradbury & Paul Puzinas. Work: De Grimm Gallery, Detroit; Chautauqua Art Inst, NY; Fri Morning Club, Severance Salon, Los Angeles. Comn: Christ Mural, Come unto Me, Christ Church, Unity, Los Angeles, 1972. Exhib: Nat Orange Show, San Bernardino, Calif, 1967; Frye Mus, Seattle, 1968, Chautauqua, NY, 1968; Tucson, Ariz, 1969; Wilshire Ebell, Los Angeles, 1972. Awards: Popular Award, Nat Orange Show, 1967; First Award, City Hall Gallery, Los Angeles, 1968; First Award, Wilshire Fed Gallery, Beverly Hills, 1969. Media: Oil.

LUDWIG, Eva. Sculptor. Born: Berlin, Germany, May 25, 1923; US citizen. Study: Greenwich House Pottery, 1958-62, with Lu Duble; Sculptor's Workshop, 1964, with Harold Castor; Craft Students League, 1968, wood sculpture with Domenico Facci. Exhib: Contemp Liturgical Art, Philadelphia, 1963; Own Your Own, Denver Art Mus, 1968; Rochester Festival Religious Art, NY, 1971; Cooperstown Art Asn Ann, NY, 1971, 1973 & 1974; Nonmem Exhib, Nat Sculpture Soc, New York, 1972. Awards: Best in Wood, Woodstock Guild Craftsmen, 1969, Bert Wangler Mem Award, 1972; First Prize in Sculpture, Cooperstown Art Asn, 1971. Media: Wood, clay.

LUITJENS, Helen Anita. Instructor, painter. Born:
Bakersfield, Calif. Study: Univ Redlands, B.A.; Univ
Southern Calif, M.A.; Univ Hawaii, scholar, 1963; Univ
Calif, Los Angeles; Inst Art San Miguel de Allenda.
Work: Munic Art Dept, Los Angeles; Inst Mex Norte-
americano de Relaciones Cult, Mexico City; Anderson
Konstmuseum, Helsinki, Finland; Konst Salongen Kavaletten,
Uppsala, Sweden; Union Bank, Los Angeles. Exhib: Inst
Mexicano Norteamericano de Relaciones Cult, 1969; Konst
Salongen Kavaletten, 1973; Nat Watercolor Soc, Laguna
Beach, Calif, 1974; Pac Cult Mus Pasadena, 1974; Palos
Verdes Art Mus, 1975. Awards: 30 awards in art shows
in Southern California, 1965-75. Media: Watercolor.

LUND, Jane. Painter, ceramist. Study: Pratt Inst,
1956. Work: Nelson Gallery Found, Kansas City, Mo;
De Cordova Mus, Lincoln, Mass. Exhib: 21st Exhib New
Eng & NY State Artists, Berkshire Mus, 1972; New Talent
New England, 1973 & New England Women 1975, De Cordova
Mus, Mass; 55th Nat Exhib Springfield Art League, Mass,
1974; Exhib of Paintings Eligible for Childe Hassam Fund
Purchase, Am Acad Arts & Lett, New York, 1974. Awards:
Cini Found Summer Scholar, Venice, Italy, 1966. Media:
Highly Finished Pastels & Lithographs.

LYNCH, Jo (Marilyn Blanche). Painter, instructor.
Born: Chicago, Ill., August 20, 1928. Study: Iowa
State Col; Art Inst Chicago; Burnley Commercial Art Sch,
cert. Work: Nat Bank Com, Seattle; Assoc Grocers,
Seattle; also in collections of Daniel Evans, Robert
Hallowell & Mullavey, Hageman & Prout, Attorneys.
Exhib: Northwest Watercolor Exhib, Seattle Art Mus,
1971 & Cascade Gallery Seattle, 1975; Soc Western
Artists Exhib, Pioneer Mus, Stockton, Calif, 1973;
Puget Sound Area Exhib, Frye Art Mus, 1974; one-man
show, Cherry & Terry, 1974. Media: Black & colored inks,
acrylic.

MABRY, Jane. Painter, art dealer. Study: Univ N Mex,
B.F.A.; Art Students League; Corcoran Sch Art; also with
Jerry Farnsworth; Grand Cent Sch Art; Critcher Sch Art,
with Catherine Critcher. Exhib: N Mex State Fair, 1940-
73; Smithsonian Inst, Washington, DC, 1945; Mus N Mex
Biennial, 1964; All Am Indian Exhibition, Indianapolis,
Ind, 1974. Pos: Former staff artist, Nat Park Serv;
charter mem, N Mex Arts Comn, 1966-74, chmn, 2 yrs; co-
owner, Galeria del Sol. Awards: Numerous first place
ribbons for pastels and oils. Media: Oil and pastels
over acrylic.

MACLEAN-SMITH, Elizabeth. Sculptor, lecturer. Born: Springfield, Mass., February 18, 1916. Study: Wellesley Col, A.B.; Belgian-Am Educ Found traveling fel, Belg, 1937; Boston Mus Sch, with Frederick Warren Allen & Sturdivant traveling fel, Mex, 1941. Work: Mus Fine Arts, Boston; Mus Fine Arts, Springfield, Mass; Williams Col, Williamstown, Mass. Comn: Polyester murals, Dini's Sea Grill, Boston, 1962-70; fountain & garden sculptures & portraits in pvt collections. Exhib: New Eng Sculptor's Asn Exhibs at most New Eng mus, 1948-72; seven Boston Arts Festivals, 1955-65; New Eng Sculptor's Asn, Prudential Ctr, Boston, 1968 & 1970; one-man shows, G. W. V. Smith Mus, Springfield, 1950, Tufts Col, Medford, Mass, 1952, Crane Mus, Pittsfield, Mass, 1956 & McIver-Ready Gallery, Boston, 1968. Media: Wood, stone, clay.

MAINARDI, Patricia M. Painter, writer. Born: Paterson, NJ, November 10, 1942. Study: Vassar Col, A.B., 1959-63; Columbia Univ, 1963-65; New York Studio Sch, with Mercedes Matter & Charles Cajori, 1965-66. Exhib: The Representational Spirit, State Univ NY Albany Gallery, 1970; Drawing Each Other, Brooklyn Mus, NY, 1971; New Images: Figuration in American Painting, Queens Mus, 1974; one-artist show, Green Mountain Gallery, New York, 1971 & 1974 & Ingber Gallery, 1975. Teaching: Vis lectr, Moore Col, 1969, NY Univ, 1969, Pratt Inst, 1971, Univ RI, 1971, State Univ NY Buffalo, 1972, State Univ NY Old Westbury, 1973 & Mass Col Art, 1973 & 1974.

MALLINSON, Constance (Constance Mallinson Alter). Painter. Born: Washington, DC; May 10, 1948. Study: Univ Ga, B.F.A. Exhib: Atlanta 1st Nat, Ga, 1971; Piedmont Art Exhib, Atlanta, 1971; Illien Gallery, Atlanta, 1971; Northern Va Fine Arts Exhib, Alexandria, 1972; one-woman show, Atheneum, Alexandria, Va, 1972. Awards: Best in Show, Northern Va Fine Arts Asn, 1972.

MALSCH, Ellen L. Painter, instructor. Born: Copenhagen, Denmark; US citizen. Study: Art Inst Chicago. Work: Univ Wis-Madison; Luther Col, Decorah, Iowa; Univ Wis-La Crosse; Waukesha Co Tech Inst, Pewaukee, Wis; Univ Wis, Rockcount Campus, Janesville. Exhib: Wis Painters & Sculptors Show, Milwaukee Art Ctr, 1962; three-man show, Wright Art Ctr, Beloit Col, Wis, 1964; Drawings USA, Nat Biennial Show, St. Paul, Minn, 1966; Ill State Fair Prof Show, Springfield, Ill, 1969; Watercolor USA, Springfield, Mo, 1971; plus others. Awards: Purchase Prize, Beloit Col Vicinity Show, 1965; Purchase Prize, Univ Wis-La Cross, 1969; Best of Show Award, Wis Festival of Arts, 1975. Media: Watercolor.

MANGIONE, Patricia Anthony. Painter. Born: Seattle, Wash. Study: Fleisher Art Mem, Philadelphia; Barnes Found, Merion, Pa. Work: Inst Contemp Art, Dallas; Fleisher Art Mem; Fidelity Bank, Philadelphia; Westchester State Mus, Pa; Rochester Mem Art Gallery, NY. Comn: Acrylic on wood mural, Continental Bank & Trust Co, Philadelphia, 1969. Exhib: Five one-man shows, Frank Rehn Gallery, 1960-74; one-man shows, Univ Pa, 1964 & US Govt Gallery, Palermo, Italy, 1965; Rosemont Col, Pa, 1967 & 1974; Philadelphia Art Alliance, 1975. Awards: Philadelphia Art Teachers Asn First Prize, 1957 & 1964; five Yaddo Resident Fels, 1962-72; Saratoga Springs Oil Prize, 1966. Media: Oil, acrylic.

MANGOLD, Sylvia Plimack. Painter. Born: New York, NY, September 18, 1938. Study: Cooper Union, cert, 1959; Yale Univ Art Sch, B.F.A., 1961. Exhib: Selections in Contemporary Realism, Akron Art Inst, Ohio, 1974; New Images in American Painting, Queens Mus, New York, 1974; The Herbert & Dorothy Vogel Collection, Inst Art & Urban Resources, New York, 1975; 20th Century Drawings, Hawthorne Gallery, Skidmore Col, 1975; 16 Realists, Fischbach Gallery, New York, 1975. Media: Acrylic.

MANILLA, Tess (Tess Manilla Weiner). Painter. Born: Poland; US citizen. Study: Educ Alliance, New York, with Abbo Ostrowsky; Brooklyn Mus Art Sch, with Reuben Tam, Victor Candell, Manfred Schwartz & Louis Finkelstein; Art Students League, with Morris Kantor, Sidney Gross & Morris Davidson; Pratt Graphics Ctr, with Walter Ragolsky; Provincetown Workshop, with Leo Manzo. Work: Long Island Univ. Exhib: Union Carbide Gallery, 1973, Lever House, 1974 & Aames Gallery, 1975, Metrop Painters & Sculptors; one yr traveling watercolor show, Nat Asn Women Artists, Va Mus & State of Va; Nat Acad NY, 1975. Awards: Helen Hurzberger Scholar, Art Students League, 1961; Nat Asn Women Artists Award, 1972; Medal of Merit, League of Present Day Artists, 1974. Media: Oil, collages.

MANN, Katinka. Painter, printmaker. Born: New York, NY, June 29, 1925. Study: Univ Hartford Art Sch; Pratt Graphic Arts, New York. Work: Nassau Community Col, Garden City, NY. Exhib: Soc Am Graphic Artists-Assoc Am Artists 50th Ann, 1969; Light Happening, Suffolk Mus, Stony Brook, NY, 1970; US Info Agency, Washington, DC, 1971-73; Nat Asn Women's Artists Ital Exhib, Florence, Naples & Milan, 1972; Int Miniature Print Exhib, Assoc Am Artists Gallery, New York, 1972-73. Awards: Judith Leiber Co Purchase Award, Soc Am Graphic Artists, 1969; Purchase Award, Nassau Community Col, 1971. Media: Polymers.

MARAIS (Mary Rachel Brown). Painter. Born: New York, NY. Work: J. Aberbach Collection, Long Island, NY; Theodora Settele Collection, New York. Exhib: Galerie St Placide, Paris, 1961; Panoras Gallery, New York, 1971; Community Temple Gallery, Long Island, 1972; Galerie Chantepierre, Aubonne, Switz, 1972; Galerie Internationale, New York, 1975.

MARGULES, Gabriele Ella. Illustrator, painter. Born: Tachau, Czech., May 30, 1927; US citizen. Study: Cambridge Sch Art, Eng, nat dipl fine arts; Royal Acad Schs, London; New York, studies with Hans Hofmann, Camilo Egas & Norman Carton. Work: Kerlan Collection, Univ Minn Res Ctr for Children's Books, Minneapolis. Exhib: 100 Best Children's Books, Am Inst Graphic Arts, 1968 & 1970; Sumi-e Soc New York, 1970-73; New York Ctr; Sale Collection, Jr Coun, Mus Mod Art. Awards: Two-Year Grad Scholar, Cambridge Co Coun, Eng, 1948; Silver Medal-First Prize for Life Drawing, Royal Acad, London, 1949; Myers Art Scholar, New Sch Social Res, 1961. Media: Sumi-e ink, watercolor, pastel.

MARIANO, Anne. Painter. Born: Rochester, NY, October 16, 1934. Work: Brown Univ, Providence, RI; Nat Bank Geneva, NY. Exhib: Chatauqua Nat, NY, 1963 & 1964; Rochester Festival Religious Arts Nat, 1963-65 & 1970-72; Western NY Nat, Albright-Knox Art Gallery, 1964; NY State Exhib, 1967; Provincetown Art Asn, 1967 & 1968. Awards: Schuler-Pierce Design Award, 1968; Award, Rochester Relig Arts Comt, 1968; McAlpine Relig Art Award, 1969. Media: Acrylic.

MARIANO, Kristine. Painter. Born: Rochester, NY, January 16, 1939. Study: Sch Fine Arts, Rochester Inst Technol, B.F.A.; also at MemArt Gallery, Univ Rochester. Work: Univ Mem Art Gallery, Univ Rochester, NY; St. John Fisher Col, Rochester; Am Embassy Art Collection; Eastman Kodak Co; Xerox Corp. Exhib: Everson Mus Art, Syracuse, NY, 1963; Provincetown Art Asn, Mass, 1966-70; Chautauqua Nat Exhib Am Art, NY, 1963 & 1967; Albright-Knox Gallery, Buffalo, NY, 1967; one-man shows, Kendall Art Gallery, Wellfleet, Mass, 1967, 1968, 1971 & 1973-75. Awards: Painting Awards, Rochester Relig Arts Festival, 1965-67; Painting Award, Am Asn Univ Women, Brockport Ann Regional, 1967.

MARIN, Kathryn Garrison. Painter, printmaker. Born: Birmingham, Ala., July 14, 1936. Study: Hollins Col, B.A., 1958; Univ Iowa, M.F.A., 1964. Work: Ga Comn Arts, Atlanta; Ga State Univ; Mint Mus Art, Charlotte, NC; Columbia Mus Art, SC; Dreher High Sch, Columbia; Waccamaw Arts & Crafts Guild, Myrtle Beach, SC. Comn: Illustrations, This Issue Mag, Atlanta, 1970-71. Exhib: 4th Dulin Nat Print & Drawing Competition, Knoxville, Tenn, 1968; 23rd Am Drawing Biennial, Norfolk, Va, 1969; 10th Hunter Gallery Ann, Chatanooga, Tenn, 1969; 10th Ann Piedmont Painting & Small Sculpture Exhib, Charlotte, NC, 1970; 3rd Nat Print Exhib, Atlanta, 1972. Awards: Alice Collins Dunham Prize, 58th Conn Acad Fine Arts Exhib, 1968; Three-Man Show Award, Columbia Artist Guild, 1969; Purchase Award, Ga Comn Arts, 1972. Media: Oil, pencil.

MARK, Enid (Epstein). Printmaker, painter. Born: New York, NY, 1932. Study: Art Students League; Smith Col, B.A.; Westchester State Col, with Victor Lasuchin (lithography); Cheltenham Art Ctr, with Limont & Bergenfeld (printmaking). Work: Del Art Mus, Wilmington; Civic Ctr Mus, Philadelphia; Univ Del; Free Libr Philadelphia; First Pa Bank. Exhib: 4th Int Miniature Print Exhib, Pratt Graphics, Ctr, New York, 1971; one-woman show, The Print Club, Philadelphia, 1972; Philadelphia Art Alliance, 1973; Nat Print Show, Soc Am Graphic Artists, 1973; The Philadelphia Scene, Pa State Univ, 1974; plus others. Awards: Copeland Purchase Prize, Del Art Mus, 1972; Earth Art Show Print Purchase Prize for Phoenix House, Jr League Philadelphia, 1973; Wayne Art Ctr First Prize for Printmaking, 1973. Media: Acrylic, hard-edge; silkscreen; lithography.

MARLIN, Hilda Van Stockum. Painter. Born: Rotterdam, Holland, February 9, 1908; US citizen. Study: Dublin Sch Art; Amsterdam Acad Art, cert; Corcoran Sch Art; also with Andre L'Hote, Paris. Exhib: Corcoran Biennial, Washington, DC, 1937; one-man show in Dublin, 1954, Holland, 1964, Geneva, 1964 & Washington, DC, 1966, 1969 & 1972; Montreal Acad, Can, 1958; Royal Acad, London, 1959; New York, 1972. Media: Oil.

MARSHALL, Mara. Painter. Born: Nice, France, July 21, 1926; US citizen. Study: With Rosamond Gaydash, Washington, DC. Exhib: 25th Biennial Art Exhib, Nat League Am Pen Women, Salt Lake City, 1970; one-man shows, First Fed Gallery, Chicago, 1971 & Nat League Am Pen Women, Washington, DC, 1972; 41st Ann Exhib, Miniature Painters, Sculptors & Gravers Soc, Washington, DC, 1974; Am Art League Exhib, Rehoboth Art League Galleries, Del, 1975. Awards: State Art Exhib First Prize, Nat League Am Pen Women, 1971, President's Citation, 1974, DC Br Annual Award First Prize, 1975. Media: Oil, acrylic.

MARTIN, Loretta Marsh. Painter, cartoonist. Born: Plymouth, Ind., January 22, 1933. Study: Art Inst Chicago, B.A.E., 1955; Univ Notre Dame, M.A., 1968; also with Jozef Wrobel & Ed Basker. Work: Many pvt collections in US & other countries. Exhib: One-woman show, First Unitarian Church, South Bend, Ind., 1962; Northern Ind Artists; La Porte,Ind., Fine Arts Asn; Alumni Asn Art Inst Chicago; Hernando Co Fair, Fla; Artists 1970 & 1971, Citrus Co, Fla; El Paso Centennial Mus Arts & Crafts Show, 1972.

MARTIN, Lucille Calar (Mrs. Hampton Martin). Painter. Born: Carlsbad, N Mex, June 7, 1918. Study: With La Vora Norman; Frederic Taubes Workshops, Cloudcroft & Ruidoso; Merlin Enabnit Art Sch, Chicago, dipl. Work: Carlsbad Libr & Mus, N Mex; Houston Med Ctr, Tex. Comn: Jordan River (mural), Hillcrest Baptist Church, Carlsbad, 1962; Sacred River (mural), First Baptist Church, McCrory, Ark, 1963; El Capitan (mural), Security Savings & Loan, Carlsbad, 1964; N Mex State Bird-Roadrunner, Young Democrats for Gov Off, State Capitol, Santa Fe, 1964; roadrunner painting, comn by Gov. Campbell for aircraft carrier Constellation, 1964. Exhib: Fla Int Art Exhib, Lakeland, 1952; Nat Palo Duro Art Show, W Tex State Univ, Canyon, 1964; Nat Sun Carnival Art Exhib, El Paso Mus Art, 1964; Boulder City Art Festival, Nev, 1970; one-man show, N Mex State Univ, Las Cruces, 1965. Awards: Grand Sweepstakes, Tri-State Art Exhib, El Paso, 1957; First Place, Carlsbad Area Art Asn Exhibs, 1964, 1965 & 1966; First Place, Nat Parks Show, 1973 & 1975.

MARTIN, Margaret M. Painter, designer. Born: Buffalo,
NY, August 15, 1940. Study: Boston Univ, B.F.A.;
watercolor workshops with John Pike, Robert E. Wood,
John Pellew, Rex Brandt & Milford Zornes. Exhib: Am
Watercolor Soc, 1973 & Catharine Lorillard Wolfe Art,
1974, Nat Acad Design Galleries, New York; one-woman
show, Pen & Brush Gallery, New York, 1975; Rocky Mountain
Nat Watermedia, Foothills Art Ctr, Golden, Colo, 1975;
Far Away Places, Old Bergen Art Guild Travel Tour, 1975-
76. Awards: Travel Award, Am Watercolor Soc, 1970;
First Prize for Watercolor, The Pen & Brush, New York,
1974; Addy Award, Am Advert Fedn, 1974. Media:
Watercolor, ink.

MARTINEZ-MARESMA, Sara (Sara Sofia Martinez). Painter.
Born: Havana, Cuba; US citizen. Study: San Alejandro
Art Sch, Havana, with Leopoldo Romanach & Armando Menocal,
prof drawing & painting (summa cum laude). Work:
Cardinal's Arteaga (portrait), Cardinal's Palace, Havana;
St. Jose Pignatelli (painting), Church Sagrado Corazon,
Havana; Holy Family (painting), Noviciado de St.
Stanislao's Col, Havana; John F. Kennedy (portrait),
White House, Washington, DC; Stephen P. Clark (portrait),
City Hall, Miami. Exhib: Havana Univ Gallery, 1948;
Cuban Mus, Daytona Beach, Fla, 1963; Am Artists Prof
League, New York, 1971 & 1972; one-woman shows, Bacardi
Gallery, 1970 & Big Five Club, Miami, 1974. Awards:
First Prize, Am Cancer Soc, 1967; hon mention, Jordan
Marsh, 1969; Prestige Award, Am Artists Prof League, 1969.
Media: Oil.

MARTINO, Eva E. Painter, sculptor. Born: Philadelphia,
Pa. Study: Gwynedd Mercy Col; Montgomery Co Community
Col; also with Giovanni Martino. Exhib: Reading Mus, Pa,
1962; Nat Acad Design, New York, 1965; Pa Acad Fine Arts,
Philadelphia, 1966; Edinboro Teacher's Col, Pa, 1967;
Butler Inst Am Art, Youngstown, Ohio, 1970. Awards:
Bronze Medal, Da Vinci Alliance, 1953; First Prize,
Plymouth Meeting Hall, 1967; Third Prize, Philadelphia
Sketch Club, 1972. Media: Oil, wood.

MASON, Bette. Painter. Born: Texas. Study: Trinity
Univ; Syracuse Univ; Art Students League; Mus Mgt Sem,
Mus Mod Art, New York. Exhib: Westchester Art Soc
Juried Exhib Painting & Sculpture, Tarrytown, NY, 1970-
72; one-man shows, Christopher Gallery, New York, 1971
& Scarsdale Gallery Contemp Art, NY, 1972; Union
Carbide Co Invited Artists Exhib, New York, 1972;
Galerie Int Group Exhib, New York, 1972. Teaching: Dir
art dept, Westchester Learning Ctr, Fleetwood, NY, 1971-
72. Awards: First Award, Scarsdale Art Soc, 1970;
Beaux-Arts Award, Federated Woman's Clubs, New York, 1971;
Merit Award, Westchester Art Soc, 1972. Media: Acrylic,
oil.

MATSON, Greta (Greta Matson Khouri). Painter. Born:
Claremont, Va. Study: Grand Central School Art, New
York; also with Jerry Farnsworth, Cape Cod. Work: New
Britain Mus Am Art, Conn; Va Mus Fine Arts, Richmond;
Little Rock Mus, Ark; Tex Technol Col, Lubbock; Longwood
Col, Farmville, Va. Comn: Portraits, Dean Grace
Landrum, William & Mary Col, Williamsburg, Va, 1946 &
Mary Calcott, Calcott Sch, Norfolk, Va, 1953. Exhib:
Nat Drawing Ann, Albany Inst Hist & Art, NY, 1940 &
1945; Oil Nat, Carnegie Inst, Pittsburgh, 1941, 1944 &
1945; Oil & Watercolor Nat, Art Inst Chicago, 1942,
1943 & 1946; Oil Nat, Butler Art Inst, Youngstown, Ohio,
1943, 1945, 1957 & 1959; Oil Nat, Va Mus Fine Arts,
Richmond, 1953 & 1957. Awards: Altman Figure Prize,
Nat Acad Design, 1945; Am Artist Mag Medal, Am Watercolor
Soc, 1955; Allied Artists Am Gold Medal, 1962. Media:
Oil, watercolor.

MATTHEWS, Harriett. Sculptor. Born: Kansas City, Mo.,
June 21, 1940. Study: Sullins Jr Col, Briston, Va,
A.F.A.; Univ Ga, B.F.A. & M.F.A.; with Leonard DeLonga.
Work: Univ Ga Art Mus; Colby Col Art Mus. Comn:
Designed awards for the Maine Arts & Humanities Comn,
1969. Exhib: Twoan shows, Univ Okla Art Mus, 1965 &
Colby Col Art Mus, 1975; one-man show, Vanderbilt Univ
Mus, 1974 & Col Atlantic, 1975; New England Women,
DeCordova Mus, Lincoln, Mass, 1975. Media: Welded
steel.

MAUGHELLI, Mary L. Painter, lithographer. Born: Glen Lyon, Pa., November 20, 1935. Study: Univ Calif, Berkeley, B.A. & M.A.; Pratt Graphic Ctr. Exhib: Galleria Re Magi, Milan, Italy, 1960; 14th & 15th Ann Nat Exhib Prints & Drawings, Okla Art Ctr, 1972 & 1973; Fresno Artists Leland House, Taipei, Taiwan, 1973; one-woman show, Grandview One Gallery, Los Angeles, 1974; Calif Soc Printmakers Traveling Exhib, 1975-76. Awards: Ann Bremer Prize in Art, Univ Calif, Berkeley, 1958-59; Fulbright Painting Fel, Italy, 1959-61. Media: Acrylic; lithography.

MAYNARD, Valerie. Sculptor, lecturer. Born: New York, NY, August 22, 1937. Study: Goddard Col. Work: Johnson Publ, Chicago; Riksutstallningar, Stockholm, Sweden; Arnot Mus, Elmira, NY; Nat Lawyers Guild, New York; IBM Corp, White Plains, NY. Comn: Ceramic mural (with Bennington Potters, Vt & Archit Renewal Comt Harlem, Inc, New York), comn by J. P. Resnick & Son, 1975; monument for Harlem Park Plaza, A. Phillip Randolph Park, New York, 1975. Exhib: Millenium, Philadelphia Mus Art, 1973; Herbert F. Johnson Mus, Cornell Univ, 1974; Riksutstallningar, Stockholm, 1975; Sojourn Gallery 1199, New York, 1975; Arnot Mus, 1975. Awards: CAPS Grants, NY Coun Arts, 1972 & 1974. Media: Sculpture, graphics.

MCCARTY, Lorraine Chambers. Painter, instructor. Born: Detroit, Mich., August 17, 1920. Study: Detroit Art Acad, Wayne State Univ, with G. Alden Smith; Meinzinger Art Acad; Stephens Col, with Albert Christ-Janer, also with Glen Michaels, Emil Weddidge, Clifford B. West. Work: Butler Mus Am Art, Youngstown, Ohio; Northern Ill Univ De Kalb; Beech Aircraft Air Mus, Wichita, Kans; Northwood Inst, Midland, Mich; plus others. Comn: Painting, Bohn Copper & Brass, Detroit; painting, R. L. Polk Co Int Hq, Detroit, 1973; painting, Truss Wall Int Hq, Troy, Mich, 1974; mural, Jud Pilots, New York, 1975; mural, Int Women's Air & Space Mus, Dayton, Ohio, 1977. Exhib: Butler Mus Am Art Ann, 1967 & 1970-74; Detroit Inst Art Ann, 1969; Women 71, De Kalb; Flint Inst Arts Ann, Mich, 1974; Womanart, Saginaw Mus Arts, Mich, 1974. Awards: Purchase Prize, Butler Mus, 1967; Best Painting by a Woman, Detroit Inst Arts, 1970; 16th Ann Midland Mich Grand Jury Award & Purchase Prize, Northwood Inst, 1975. Media: Acrylic, oil.

MCCOY, Ann. Painter, draftsman. Born: Boulder, Colo,
July 8, 1946. Study: Univ Colo, B.F.A., 1969; Univ
Calif, Los Angeles, M.A., 1972. Work: Whitney Mus Am
Art, New York; Nat Gallery Australia; Dudley Peter Allen
Mem Art Mus, Oberlin, Ohio; Los Angeles Co Art Mus.
Comn: Mural in pencil, Harris Bank. Exhib: Choice
Dealers-Dealers' Choice, New York Cult Ctr, 1974; Woman's
Work-American Art, Mus Philadelphia Civic Ctr, 1974;
Painting & Sculpture Today, Indianapolis Mus Art &
Contemp Art Ctr, Cincinnati, 1974; 71st Am Exhib, Art
Inst Chicago, 1974; Both Kinds: Contemporary Art from
Los Angeles, Univ Calif Art Mus, Berkeley, 1975; plus
many others. Media: Pencil.

MCELROY, Nancy Lynn. Sculptor, designer. Born: New
London, Conn., July 23, 1951. Study: Calif State Univ,
San Diego; Univ Calif, Davis; with Roy DeForest. Work:
Archiv Sohm, Markgroningen, Ger; Vancouver Art Gallery,
BC. Comn: Soft zipper sculpture, comn by Terry Arnold,
San Diego, 1974; woven textile designs, Sammlung Maurer,
Fluxus Arch, Budapest, Hungary, 1975. Exhib: Vancouver
Art Gallery, BC, 1972; Oakland Mus, Calif, 1972; Henry
Art Gallery, Univ Wash, Seattle, 1972; Joslyn Art Mus,
Omaha, Nebr, 1973.

MCFARREN, Grace. Painter. Study: Sch Design for
Women; Graphic Sketch Club; Pierce Jr Col, Philadelphia;
Cleveland Inst Art, study with Clayton Bachtel, Peter
Dubaniewicz & Joseph McCullough; Del Art Ctr, Wilmington,
with Robert McKinney, 1960; study with Edgar Whitney,
New York, 1969; also study with Marion Bryson & Doris
Peters. Work: Univ Del; Hagley Mus; DuPont de Nemours
& Co; Hotel DuPont; three Wilmington Banks. Exhib:
Ann May Show, Cleveland Art Mus; Dayton Art Mus Lending
Libr of Paintings; Smithsonian Inst, Washington, DC;
Philadelphia Mus Art; Del Mus Art. Awards: Three
Purchase Prizes, Univ Del Ann Regional Shows, First,
Second & Hon Mention, Chester Co Art Asn; Best in Show,
Nat League Am Pen Women Nat Show & Rehoboth Art League.
Media: Watercolor, acrylic, oil.

MCGAHEE, Dorothy (Dorothy McGahee Braudy). Painter,
educator. Born: Los Angeles, Calif. Study: Univ Ky,
B.A.; NY Univ, M.A. (art educ); pvt study with Richard
Pousette-Dart; Art Students League, with Stamos, Kantor
& Glasier; Columbia Univ Teachers Col. Comn: Portrait,
comn by David Brooks Family, London, 1974; portrait,
comn by Richard Poirier, New York, 1975; portrait comn
by David Latt Family, Providence, 1975. Exhib: Three
Figurative Artists, Off-Broadway Gallery, 1973; Works
on Paper, Pratt-Phoenix Gallery, 1974; Recent Works,
Second Story Spring St. Gallery, 1975. Media: Painting,
etching, printmaking.

MCGINNIS, Christine. Painter. Born: Philadelphia, Pa.
Study: Pa Acad Fine Arts. Work: Mus Nat Sci,
Philadelphia; Civic Ctr Mus, Philadelphia; Free Libr
Philadelphia; Am Embassy, Dublin, Ireland; Pa Acad Fine
Arts. Exhib: Pa Acad Fine Art Nat Ann, 1959; Philadelphia
Art Mus Regional Exhib, 1964; Brooklyn Art Mus 14th Nat
Exhib, New York, 1965; Am Express Pavilion, New York
World's Fair, 1966; Libr Cong 20th Nat, Washington, DC,
1967. Awards: Thomas Eakins Prize, Pa Acad Fine Arts,
1958, H. S. Morris Mem Drawing Prize, 1961; Cresson
Traveling Scholar, 1960. Media: Acrylic, graphics.

MCILROY, Carol Jean. Painter, art dealer. Born:
Sandpoint, Idaho, February 21, 1924. Study: Univ
Colo, with John Pellew; Univ N Mex, with Joe Morello,
Arthur Sussman & Sam Smith. Work: Am Bank Com,
Albuquerque N Mex; N Mex Jr Col. Exhib: Mainstreams,
1969; Regional Art Exhib, Phoenix, 1971; McAddo II
Gallery, Prescott, Ariz, 1973; Lubbock Tex Art Exhib,
1974. Awards: Grand Prize & Best of Show, Sky Country,
Montrose Art Festival, Colo, 1970; First Prize, R.F.D.,
N Mex State Fair, 1971; First Prize Landscape, 4th
Regional Art Exhib, Phoenix, 1971. Media: Oil.

MCKENNIS, Gail. Printmaker, painter. Born: Wilmington, NC, May 12, 1939. Study: Richmond Prof Inst, Va Commonwealth Univ, B.F.A. & M.F.A.; Royal Col Art; Visual Studies Workshop. Work: Victoria & Albert Mus, London; Southern Regional Arts Asn, Eng; NC Mus Art; Mint Mus Art, Charlotte, NC; Dillard Collection, Univ NC, Greensboro. Exhib: 3rd & 4th Brit Int Print Biennales, Bradford, Eng, 1972 & 1974; 4th Int Print Biennale, Cracow, Poland, 1972; Mod Prints, Bethnal Green Mus, London; Paperworks, Washington Gallery Art, 1974; one-person show, Va Mus Fine Arts, 1968. Teaching: Instr painting, printmaking & drawing, Va Commonwealth Univ, 1965-69; instr printmaking & drawing, Univ NC, Wilmington, 1969-71; instr silkscreen, Univ Reading, Eng, 1972-73; asst prof art, Roberts Wesleyan Col, Rochester, NY, 1974-75. Awards: Va Mus Fine Arts Biennial Exhib Awards, 1967 & 1969; Purchase Award, 3rd Brit Int Print Biennale, 1972; Purchase Award, Gallery Contemp Art, Winston-Salem, 1973. Media: Print.

MCLEAN, Doris Porter. Painter. Born: Norfolk, Va. Study: With Hans Hofmann, Capri, Italy, 1928; Pa Acad Fine Arts, 1933; Wayne State Univ, B.A. & M.A. (art educ), 1937; Univ Mich, M.F.A., 1942; also with Zoltan & Vaclav Vytlacil. Work: Pa Acad Fine Arts, Philadelphia; Cranbrook Mus, Bloomfield Hills, Mich; Univ Mich. Comn: Mural, St. Mary's Hall, Burlington, NJ, 1933; mural, Ford Sch, Highland Park, Mich, 1935; Sweitzer (bust), Sweitzer Sch, Wayne, Mich, 1965. Exhib: Pa Acad Fine Arts, 1933; Nat Acad Design, 1933; Corcoran Gallery Art, 1940; Michigan Artists, Toledo, 1949 & Detroit Mus, 1950; plus one other. Pos: Consult art, Wayne Pub Schs, 1950-1956; owner & dir, Olde Towne Gallery, Portsmouth, Va, 1970; former head, Frederick Col, Dartsmouth, Va; free lance artist. Awards: Lambert Award, Pa Acad Fine Arts, 1933; Grosse Pointe Artists Award, 1934 & 1950; Women Painter's Award, Detroit Soc Women Painters & Sculptors, 1949. Media: Oil, watercolor.

MCMILLAN, Constance. Painter. Born: Millinocket, Maine, March 10, 1924. Study: Bennington Col, painting with Karl Knaths & sculpture with Simon Moselsio, B.A., 1946; Colorado Springs Fine Arts Ctr, with Boardman Robinson, 1946; Mills Col, fel, 1953-55, art hist with Alfred Neumeyer & ceramic sculpture with Antonio Prieto, M.A., 1955. Exhib: One-man shows, Morris Gallery, New York, 1956 & Panoras Gallery, New York, every two yrs, 1959-; Artists Market Gallery, Detroit, 1972; Guthrie Frankenberg Gallery, 1974 & 1975; The Gallery, West Cornwall, Conn, 1975; plus others. Awards: First Prize, Morris Gallery, 1956; First & Hon Mention Awards, Mich Watercolor Soc Ann, 1967 & 1968.

MCQUILLAN, Frances C. Painter, instructor. Born:
Chicago, Ill., December 1, 1910. Study: New York Sch
Fine & Appl Art, grad; Art Students League; Fairleigh
Dickinson Univ; Montclair Art Mus Adult Sch; Caldwell
Col, B.F.A. Exhib: Conn Acad Fine Arts, 1959 & 1972;
Allied Artists Am, 1967; Expos Intercontinental Exhib,
Dieppe, France, 1967 & Monaco, 1968; Am Artists Prof
League, 1966-69 & 1972; Montclair Art Mus Exhib, 1968.
Teaching: Instr drawing, watercolors, oils & acrylics,
Montclair Art Mus, NJ, 1950-; instr drawing, Montclair
Adult Sch, 1967-70; instr oil painting, Yard Sch Art,
Montclair, 1967-70. Awards: Silver Medal for oil
painting, Knickerbocker Artists, 1953; First Prize in
watercolors, Am Artists Prof League, 1970; First Prize
in oils, Art Ctr Oranges, 1972. Media: Watercolor,
oil, acrylic.

MCWHORTER, Elsie Jean. Painter, sculptor. Born: Laurel,
Miss., April 5, 1932. Study: Univ Ga, B.F.A., 1954 &
M.F.A., 1956, with Lamar Dodd, Howard Thomas, Abbott
Patterson, Joseph Di Martini, Ulfert Wilkie & Dan Lutz;
Brooklyn Mus Art Sch, Max Beckmann scholar, 1956-57,
with Reuben Tam & Yonia Fain. Work: Gibbes Art Gallery,
Charleston, SC; Brooks Art Gallery, Memphis, Tenn;
Greenville Co Mus Art, SC; Arts Comn SC, Columbia; Miss
Art Asn, State Coliseum, Jackson; plus others. Comn:
Seal for Sumter Co, SC, 1965; welded bronze fountain,
Tom Jenkins Realty Co, Columbia, 1966; mural, US Post
Off, Camden, SC, 1967; mural, Baker Bldg, Southern Bell
Tel Co, Columbia, 1968; plus others. Exhib: US Info
Agency Show-Europe & Near East, 1956-57; Mid-South Exhib,
Memphis, Tenn, 1962; Butler Inst Am Art Ann, Youngstown,
Ohio, 1963; Drawing USA, St. Paul 2nd Biennial Competition,
St. Paul Art Ctr, Minn, 1963; 23rd Ann Nat Watercolor
Exhib, Miss Art Asn, 1964; plus others. Awards: First
Prize, 5th Ann All-State Show, Knoxville, Tenn, 1955;
First Prize, 24th Nat Watercolor Show, State Coliseum,
Jackson, Miss, 1965; First Prize, Flower Festival,
Greenwood, SC, 1971; plus others.

MEDOFF, Eve. Painter, printmaker. Born: Philadelphia,
Pa. Study: Pa Acad Fine Arts, merit scholar; Tyler
Sch Art; Pratt Graphics Ctr. Work: Hudson River Mus,
Yonkers, NY; Wagner Col for Women, Staten Island, NY;
Holmes Pub Sch, Mt. Vernon, NY; Gestetner Corp, Yonkers;
Fellowship of Reconciliation, Nyack, NY. Exhib: ACA
Gallery, New York, 1962; Riverside Mus, New York, 1965;
Albany Inst Art & Hist, 1966; Westchester Printmakers,
Fordham Univ, 1967; one-man show, Katonah Gallery, NY,
1972. Pos: Ed arts page, Yonkers Rec, 1966-70; ed
artslett & interarts, Coun for Arts in Westchester, 1968-
1969; exhib juror, Westchester & Conn, 1961-71. Awards:
Hudson River Mus Purchase Awards, 1957 & 1970; Hon Title,
Mus Assoc in Art Res, Hudson River Mus, 1964; Gestetner
Corp Print Competition Award, 1971.

MEIXNER, Mary Louise. Painter, educator. Born:
Milwaukee, Wis., December 7, 1916. Study: Milwaukee-
Downer Col, B.A.; State Univ Iowa, M.A.; Art Students
League, with Hale; Univ Minn & Bowling Green Univ, with
Max Weber; Mills Col, with Yasuo Kuniyoshi; Am Sch,
Fontainebleau, France; Carpenter Ctr Visual Arts, Harvard
Univ. Work: Nat Am Home Econ Asn, Washington, DC; Des
Moines Art Ctr, Iowa; Denison Arts Asn Gallery, Iowa.
Exhib: Des Moines Art Ctr Ann, 1954, 1955 & 1962; Mid
Am Ann, Kansas City, Mo, 1955; solo show, Nat Design Ctr,
New York, 1969; MacNider Mus Ann, Mason City, Iowa, 1970-
75; Red River Ann, Moorhead, N Dak, 1971. Awards:
Regional exhib awards. Mem: Col Art Asn Am; Intersoc
Color Coun; Mid Am Art Asn; Delta Phi Delta; Milwaukee
Art Ctr. Media: Oil, acrylic.

MELIKIAN, Mary. Painter. Born: Worcester, Mass.
Study: RI Sch Design, Providence, B.F.A., 1955; Columbia
Univ Teachers Col. Work: Worcester Mus Art, Mass; Mint
Mus, Charlotte, NC; Yerevan Mus, Armenia; Vassar Col Art
Mus; Art for US Embassies, State Dept. Exhib: One-man
shows, Nat Arts Club, New York, 1969 & 1970; retrospective,
Centenary Col, Hackettstown, NJ, 1975. Awards: First
Prize, Kit Kat Club, 1961, Armenian Student Asn, 1961 &
1962 & Women's Nat Repub Club, 1970, 1972, 1973 & 1975.
Media: Watercolor, oil.

MENG, Wendy. Painter. Born: Fla, February 15, 1944. Study: Seishen Daibako, Tokyo, 1961-62; Kansas City Art Inst, B.F.A., 1967; Md Inst Col Art, M.F.A.(with honors), 1969. Work: Chase Manhattan Bank, New York. Comn: Painting, comn by Richard S. Kramisen, New York, 1975; School of Fish (lithograph), Spec Proj Group for Bicentennial, Chicago, 1975. Exhib: New Editions 1974-75, New York Cult Ctr, 1975; 1975 Potsdam Drawing Exhib, State Univ NY Col Potsdam, 1975; New Talent, Alpha Gallery, Boston, 1975; Invitational Exhib, 1975 & one-woman show, 1976, James Yu Gallery. Awards: Print Honorarium, Spec Proj Group, 1975. Media: Oil on canvas.

MERCHANT, Pat (Jean). Instructor, painter. Born: Oklahoma City, Okla, October 8, 1928. Study: Sch Fine Art, Univ Okla, Norman, B.F.A. & M.A.Ed. Work: Okla Art Ctr, State Fair Park, Oklahoma City; State of Okla Art Collection, Okla Art Ctr. Exhib: 31st Okla Ann Exhib, Philbrook Mus Art, Tulsa, 1960, 1961 & 1971; Ann Eight-State Exhib Painting & Sculpture, Okla Art Ctr, 1960, 1967 & 1968; Southwest Fine Arts Biennial, Mus N Mex, Santa Fe, 1970; 13th & 14th Ann Delta Exhib, Ark Art Ctr, Little Rock, 1970 & 1971. Awards: Purchase Award, Ann Eight-State Exhib, Okla Art Ctr, 1968; Painting Award, 31st Okla Ann Exhib, Philbrook Mus, 1971; Purchase Selection, State of Okla Art Collection, Okla State Arts & Humanities, 1972. Media: Acrylic; fiber.

MERRITT, Francis Sumner. Painter, designer. Born: Danvers, Mass., April 8, 1913. Study: Vesper George Sch Art; San Diego Acad Fine Art; Mass Sch Art; Boston Mus Sch; Yale Univ Sch Fine Arts; Colby Col, Hon D.F.A., 1971. Comn: Murals, Bd Educ, New London High Sch, NH, 1943 & Knox Co Med Ctr, Rockland, Maine, 1952. Exhib: Directions in American Art, Am Fedn Arts Traveling Unit, Carnegie Inst, 1942; Int Watercolor Show, Art Inst Chicago, 1942-43; Artists for Victory, Metrop Mus Art, 1942; Butler Art Inst Ann, Youngstown, Ohio, 1947; Greetings Exhib, Mus Mod Art, New York, 1947; plus others. Awards: First Award Painting, Flint Inst Art Ann, 1947.

MESEROLE, Vera Stromsted. Painter, art administrator.
Born: New York, NY, August 10, 1927. Study: Wellesley
Col, Mass, B.A. (hist art, painting), with A. Abbot,
B. Swann & E. Frisch & archit with J. MacAndrew. Exhib:
Northern New Eng Artists, Univ Vt, Burlington, 1954; New
Eng Artists, New York World's Fair, 1964; Nat League Am
Pen Women, Tulsa, Okla, 1966 & Salt Lake City, Utah,
1970; Vt Pavilion, Expo, Montreal, 1970. Awards: First
Prize, Champlain Valley Expos, 1960; First Prize Portraits,
Nat League Am Pen Women, Vt, 1966 & 1970. Mem: Northern
Vt Artist Asn (vpres, 1965-67, pres, 1967-74); Med Ctr
Hosp Vt Art Comt (chmn, 1960-70); Southern Vt Art Asn;
Nat League Am Pen Women, Vt (pres north br, 1974-75).

METZGER, Evelyn Borchard. Painter, sculptor. Born: New
York, NY, June 8, 1911. Study: Vassar Col, A.B., 1932,
with C. K. Chatterton; Art Students League, with George
Bridgman & Rafael Soyer; also George Grosz, sculpture
with Sally Farnham, Guzman de Rojas in Bolivia &
Demetrio Urruchua in Arg. Work: Fine Arts Gallery of
San Diego, Balboa Park, Calif; Ariz State Mus, Tucson;
Lyman Allyn Mus, New London, Conn; Univ Mo-Columbia;
Butler Inst Am Art, Youngstown, Ohio; also in over 40
mus including Art in the Embassies Prog. Exhib: One-
man shows, Galeria Muller, Buenos Aires, 1950, Gallerie
Bellechasse, Paris, 1963; Norfolk Mus Art, Va, 1965;
Mex-Am Cult Inst, Mexico City, 1967; Van Diemen-
Lilienfeld Gallery, New York, 1966. Media: Oil,
enamel, acrylics & mixed media.

MEYER, Felicia. Painter. Born: New York, NY, May 15,
1912. Study: Art Students League, with Kenneth Hayes
Miller & Rimon Nicolaires. Work: Whitney Mus; Addison
Gallery; New Britain Mus; Mus City New York.

MICHELSON-BAGLEY, Henrietta. Sculptor, painter. Born:
Kansas City, Mo. Study: Long Beach Jr Col, Calif;
Univ Mex, Mexico City; Univ Mo, B.A.; Univ Caracas,
Venezuela; also with Andre L'Hote, Paris & Edwiggi
Poggi, Florence; Art Students League, with Morris Kantor,
George Grosz & V. Vytlicil. Comn: Set for play,
Thomas Andros, Circle Repertory Theatre Co, New York,
1973 & set for E. E. Cummings Play, Him, Circle
Repertory Theatre Co, 1974. Exhib: Sao Paulo Bienial,
Brazil, 1963; New Eng Ann, Silvermine Guild, New Canaan,
Conn, 1966 & 1968; Drawings, Paintings & Theater Images,
Artists Space, New York, 1975. Media: Wood, acrylic;
pastel & crayon.

MILLER, Mariann (Mariann Helm). Painter. Born: Ancon, CZ, March 19, 1932. Study: Ohio State Univ, B.F.A., 1959; Cornell Univ, M.F.A., 1962. Work: Robertson Mem Ctr, Binghamton, NY; Sneed Mus Art, Louisville, Ky; Ponce Mus, PR. Exhib: One-woman show, Stefanotty Gallery, New York, 1974; Directors Choice Exhib, New York Cult Ctr, 1974; Women Artists, Philadelphia Mus, 1974; Imagist Realist, Art Mus, Palm Beach, Fla, 1974; Painting & Sculpture Today, Contemp Art Soc, Indianapolis Mus Art, 1974. Media: Oil.

MILLS, Agnes. Sculptor, printmaker. Born: New York, NY. Study: Cooper Union Art Sch, grad; Pratt Inst, B.F.A.; NY Univ Sch Archit; Art Students League; Design Lab; Am Artists Sch; and with Raphael Soyer, Yasua Kunyoshi & Ruth Leaf. Work: Hunterdon Co Mus, Clinton, NJ; Univ Maine, Amhurst; Washington Soc Painters, Sculptors & Printmakers; Calif Sch Arts & Crafts, Oakland; C. W. Post Col. Exhib: Audubon Ann, Nat Acad Design, 1970 & 1971; Butler Inst Am Art Ann, 1971-72; Pa Acad Art Ann, 1973; Okla Art Mus Ann Printmaking Exhib, 1973 & 1974; Seattle Art Mus Ann, 1974. Awards: First Prize in Printmaking, Washington Miniature Prints & Sculpture, 1970; Purchase Prize, Hunterdon Co Art Mus, 1972; Purchase Award, Nassau Community Col, 1974. Media: Etching in color, colograph; acrylics, welded steel.

MINA-MORA, Dorise Olson. Painter. Born: New York, NY, June 8, 1932. Study: Art Students League, with Hale & Louis Bosa; Salmagundi Club scholar & study with Daniel Greene. Work: Southampton High Sch; William Cook Shipping Co & R. Chapdelaine & Co, New York. Exhib: Brooklyn Mus Community Galleries, 1968-71; Nat Arts Club Watercolor Ann; Catharine Lorillard Wolfe Art Club Exhib & Allied Artists Am, Nat Acad Design; Parrish Art Mus Spring Watercolor Show, 1972; Winners Circle, Brooklyn Mus, 1975; plus others. Awards: Gold Medal of Honor, Knickerbocker Artists, 1968 & Nat Art League, 1970; Grumbacher Award for Watercolor, Nat Arts Club, 1970; Windsor & Newton Watercolor Award, Catharine Lorillard Wolfe Art Club, 1972. Media: Watercolor, acrylic.

MINNICK, Esther Tress. Painter. Born: Chicago, Ill.
Study: Art Students League; also with Edgar Whitney,
Wong Suiling & Barbara Vassilioff. Work: Va State Col;
Mem Hosp, New York; also in many pvt collections. Exhib:
Nat Women's Republican Club, New York, 1967; Nat Soc
Painters Casein & Travel Exhib, New York, 1968; Garden
State Watercolor Soc, Princeton, NJ, 1970; Princeton Art
Asn, 1971; two one-man exhibs, 1974; plus others.
Awards: First Award, Larchmont, 1960; First & Third
Prizes, Nat Women's Republican Club, 1967; Princeton
Bank Award, 1970. Media: Watercolor.

MIOTKE, Anne E. Painter, instructor. Born: Milwaukee,
Wis., August 31, 1943. Study: Mount Mary Col,
Milwaukee, with S. Remy Revor, B.A., 1965; Univ Wis-
Milwaukee, with Laurence Rathsack, M.S., 1970 & M.F.A.,
1973. Work: Univ Wis-Madison & Milwaukee; Wehr Corp &
Joseph P. Jansen Co, Milwaukee; Liberty Nat Bank,
Louisville, Ky; plus others. Exhib: Wisconsin Painters
& Sculptors Exhib, Milwaukee Art Ctr, 1972-74; Of/On
Paper, John Michael Kohler Arts Ctr, Sheboygan, Wis,
1973; 10th Union League Art Biennial, Chicago, 1974; 8-
State Ann: Painting, J. B. Speed Art Mus, Louisville,
1974; 31st Ann Wabash Valley Exhib, Swope Art Gallery,
Terre Haute, Ind, 1975; plus others. Awards: Summer Fel,
Grad Sch, Univ Wis-Milwaukee, 1972; Nat Endowment Arts
Vis Specialist Grant to Milwaukee Art Ctr, 1975.

MITCHAM, Georgia Whitman. Sculptor. Born: Providence,
RI, July 4, 1910. Study: Slade Sch Art, Univ London;
with Naum M. Los, New York. Work: Am Mus Natural Hist,
New York; Smithsonian Inst, Washington, DC; Bennington
Mus, Vt; Norwich Univ, Northfield, Vt; Harvard Univ,
Cambridge, Mass. Comn: Two champion Angus bulls, comn
by Gifford Cochrane, North Salem, NY; bas-relief of
dinosaur, Am Mus Natural Hist; plus others. Exhib: One-
man shows, Studio Guild, New York, 1938, Southern Vt
Art Ctr, Manchester, 1969 & Bennington Mus, 1972 & 1973;
Audubon Artists, New York, 1964; Child's Gallery, Boston,
1964. Awards: First for Sculpture, Northern Vt Artists,
1963, Saratoga Art Festival, NY, 1964 & Norwich Show,
Northfield, Vt, 1975. Media: Aluminum, lead, iron.

MITCHELL, Joan. Painter. Born: Chicago, Ill., 1926.
Study: Smith Col, 1942-44; Columbia Univ; Art Inst
Chicago, B.F.A., 1947; NY Univ, M.F.A., 1950. Work:
Basel Mus, Switz; Albright-Knox Art Gallery, Buffalo;
Art Inst Chicago; Mus Mod Art, New York; Phillips
Collection, Washington, DC; plus others. Exhib: Pa
Acad Fine Arts, Philadelphia, 1966; Two Decades of
American Painting, Mus Mod Art, circulated in Japan,
India & Australia, 1967; Univ Ill, 1967; Jewish Mus,
1967; one-man show, Galerie Fournier, Paris, 1967; plus
many others.

MOMENT, Joan. Painter, educator. Born: Sellersville,
Pa., August 22, 1938. Study: Univ Conn, B.S., 1960;
Univ Colo, with William Wiley, M.F.A., 1970. Work: NY
State Develop Corp, New York. Exhib: Calif Artists
Drawing Show (traveling), San Francisco Art Inst, 1970,
Sacramento Valley, 1972; Sacramento Sampler I (traveling),
E. B. Crocker Art Gallery, Sacramento & Oakland Mus,
1972; Contemp Am Art Biennial, Whitney Mus Am Art, New
York, 1973, one-woman show, 1974. Media: Acrylic on
watercolor board and on rubberized canvas.

MONTLACK, Edith. Painter. Born: New York, NY. Study:
Metrop Mus Art Sch, scholar, with Michael Jacobs; Nat
Acad Design, with Louis Bouche; Art Students League.
Exhib: Parrish Mus; Riverside Mus, Hall of Art,
Knickerbocker Artists & Nat Arts Club Gallery, New
York; plus many others. Awards: Emil Kohn Medal; St.
Gaudens Medal; First Prize for Watercolors, Nat Asn
Women Art. Media: Oil.

MOORE, Ina May. Instructor, painter. Born: Hayden,
Ariz., February 20, 1920. Study: Univ Ariz, B.A.
(educ, art & music); Ariz State Univ, M.A. (art educ).
Work: Phoenix Col, Ariz; Valley Nat Bank, Ariz; Ariz
Bank, Phoenix; Western Savings & Loan Asn, Yuma, Ariz;
First Fed Savings & Loan Asn, Yuma. Exhib: Phoenix
Art Mus; Ariz Watercolor Asn Traveling Exhib Ann; Nat
Art Exhib, Tubac, Ariz; Invitational Exhib, Univ S Dak,
1968; Nat League Am Pen Women, Salt Lake City, Utah,
1971. Awards: Purchase Prizes, Valley Nat Bank, 1966,
Ariz Bank, 1968 & Phoenix Col, 1969. Media: Watercolor.

MOREZ, Mary. Painter, illustrator. Born: Tuba City, Ariz. Study: Univ Ariz, Rockefeller Found scholar; Ray-Vogue Schs Com Art, Chicago; Maricopa Tech Col, Phoenix, Ariz. Exhib: 5 exhibs, Scottsdale Nat Indian Art Show, Ariz, 1967-72; Nat Indian Art Shows, Sheridan, Wyo, 1968-70; Heard Mus Ann Indian Arts & Crafts, 1969-71; Red Cloud Indian Art Shows, Pine Ridge, S Dak, 1969-71; Trail of Tears, Cherokee Nat Hist Soc, 1972. Awards: Best of Show for Navajo Creation, Red Cloud Indian Art Show, 1969; Award for Changing Woman & Her Weaving Loom, Nat Indian Art Show, Sheridan, 1969; Award for Father Sky & Mother Earth, Heard Mus Ann Indian Arts & Crafts, 1972.

MORGAN, Darlene. Painter. Born: Salt Lake City, Utah, February 1, 1943. Study: With Merle Olson. Work: Pac Northwest Indian Ctr. Exhib: Flathead Int Art Festival & Show, 1971; Pac Northwest Indian Ctr Art Auction Ann, 1971-; Charles Russell Exhib & Auction Ann, 1972-74; Nat Parks Centennial Exhib, Glacier Park, Mont, 1972. Awards: Best in Show, Pac Northwest Indian Art Auction, 1972. Media: Ink, oil.

MORGAN, Frances Mallory. Sculptor. Born: Memphis, Tenn. Study: Art Students League; Nat Acad Design; Pa Acad Fine Arts; also with John Hovannes & Alexander Archipenko. Work: Brooks Mem Art Gallery, Memphis; IBM Corp. Comn: Neely Grant (bronze), Mrs. Neely Grant, Memphis, 1934; Sen. Gilbert Hitchcock, 1945 & bronze fountain, 1949, Mrs. Gilbert Hitchcock, Washington, DC; bronze fountain, Vance Norfleet, Memphis, 1952; many portraits of children. Exhib: World's Fair, New York, 1939-40; Whitney Mus Am Art, New York, 1940; Artists for Victory, Metrop Mus, New York, 1942; Philadelphia Art Alliance, 1946; Pa Acad Fine Arts, 1947. Awards: Anna Hyatt Huntington Award for Olympia, 1941 & Prize for Peace Again, 1944, Nat Asn Women Artists; Award for Fish, Audubon Artists, 1961. Media: Clay, stone, wood.

MORGAN, Norma Gloria. Painter, engraver. Born: New Haven, Conn. Study: Art Students League, with Julian Levi; Hans Hofmann Sch Fine Art, New York; Atelier 17, New York, with Stanley W. Hayter. Work: Nat Gallery Art & Pennell Collection, Libr of Cong, Washington, DC; Mus Mod Art, New York; Victoria & Albert Mus, London; Philadelphia Mus Art. Comn: Granite Tor (engraving on copper), Int Graphic Arts Soc, New York, 1955; Moorland Sanctuary (oil mural), Old White Lion Inn, Haworth, Eng, 1963; Carolina Paraquets (engraving on copper), 1969 & Labrador Duck (engraving on copper), 1975, Wildlife Int, Cincinnati; Moorland Sanctuary (engraving on copper), Assoc Am Artists, 1972. Exhib: New York World's Fair, 1965; Soc Am Graphic Artists, 1967; Assoc Am Artists; one-man traveling show, Bergen Art Guild, Bayonne, NJ, 1975-76. Awards: Gold Medal for Graphics, Am Artists Prof League, Smithsonian Inst, 1963; Gold Medal for Graphics, Painters & Sculptors Soc NJ 26th Ann, 1967; Blue Ribbon-First Prize for Graphics, Composers, Authors & Artists Conv, 1969. Media: Acrylic, watercolor; engraving on copper.

MOSES, Betty (Betty Moses McCart). Painter. Born: Eagle Bridge, NY, February 2, 1917. Study: With Grandma Moses. Exhib: Lord & Taylor Gallery, Atlanta, Ga, 1971 & 1974-75; Lighthouse Gallery, Tequesta-Jupiter, Fla, 1972; Art Wagon Galleries, Scottsdale, Ariz, 1972 & Elaine Horwitch Gallery, 1973-74. Media: Oil.

MOY, May (Wong). Painter, lecturer. Born: New York, NY, December 2, 1913. Study: Parsons Sch Fine & Appl Arts, NY; Montclair Teacher's Col; Oriental Artists Sch. Exhib: Sumi-e Soc Am, 1963, 1964, 1969, 1970 & 1975. Awards: Zen, Sumi-e Soc Am, 1963, Bamboo, 1969 & Heart of Winter, 1975.

MUCCIOLI, Anna Maria. Painter, sculptor. Born: Detroit, Mich., April 23, 1922. Study: Soc Art & Crafts; with Sarkis Sarkisian, Charles Culver & Hay Holland. Exhib: Butler Inst, Youngstown, Ohio, 1969; Birmingham Mus, Ala, 1970; Nat Acad Galleries, New York, 1971; Carrol Reece Mus, Tenn, 1974; one-man show, Liggett Sch, 1974. Awards: Detroit Windor Int Second Place Award, 1969; Hon Mention, Mich Watercolor Soc, 1970; Third Place, Scarab Club, 1971.

MULCAHY, Freda. Painter, art administrator. Born:
Staten Island, NY. Study: Am Art Sch; Nat Acad Design;
New Sch Social Res; also with Jack Tworkov. Work:
Staten Island Mus. Exhib: City Ctr Gallery, New York,
1955; Art USA, 1958; Corcoran Gallery, Washington, DC,
1960; Washington & Regional Artists Show, Smithsonian
Inst, 1960. Awards: Hon Mention, ACA Gallery Int Show,
1955; Staten Island Mus Awards, 1955-57; Hon Mention,
City Ctr Gallery, 1958 & 1959. Media: Acrylic, pastels.

NALDER, Nan. Painter, designer. Born: Spokane, Wash.,
December 9, 1938. Study: Wash State Univ, B.F.A. (Hons).
Work: Haseltine Collection of Northwestern Art; Univ
Ore Mus Art, Eugene; Crocker Collection, Sacramento, Calif;
US Bank Collection, Portland, Ore; Bank of Calif,
Sacramento. Comn: Two large paintings, US Nat Bank,
Medford, Ore, 1968; painting, City Hall, Medford, 1970.
Exhib: Northwest Ann, 1967; Portland Art Mus Ann, 1967-
71 & 1973; Frye Mus Ann, 1969; Tacoma Art Mus, 1970;
Portland Art Mus, 1972. Awards: First Place, Edmonds
Art Festival, Community of Edmonds, Wash, 1963; First
Place, Ore Competition of Painting, Rogue Valley Art Asn,
1965; Frye Mus Award, Henry Rashin, 1969. Media:
Acrylic, mixed media.

NATHANS, Rhoda R. Photographer. Born: Detroit, Mich.,
May 29, 1940. Study: Wayne State Univ, B.S.; NY Univ
Sch Continuing Educ, photog under Dr. Roman Vishniac.
Exhib: One-woman exhib, in collab with Save the Children
Fedn, Community Church Gallery, New York, 1969; group
show, Neidrug Gallery, New York UN Woman's Year, 1974;
one-woman exhib, Avanti Gallery, New York, 1974; group
exhib, Mus of City of New York, 1974.

NATHUKA, Kurumi. Painter. Born: Tokyo, Japan, 1940.
Study: Tokyo Art Univ; Univ Del; Vassar Col. Exhib:
Silvermine Art Guild; New England Exhib; Westchester
Art Assoc; Boston Philharmonic Hall; Vassar Col Art Gal,
Poughkeepsie, NY; Cary Arboretum, Millbrook, NY. Work:
Tokyo Art Univ; many private collections. Media: Oil,
acrylic, screen printing.

NAZARENKO, Bonnie Coe. Painter. Born: San Jose, Calif.,
October 26, 1933. Study: San Jose State Col; Carmel
Art Inst, under John Cunningham. Work: Mint Mus,
Charlotte, NC. Exhib: Gallery Contemp Art, Winston-
Salem, NC, 1970; Am Artists Prof League, New York, 1972;
Soc Animal Artists, Grand Cent Art Gallery, New York,
1972, 1974 & 1975. Awards: Beaufort Art Festival Award,
SC, 1966; Mint Mus Purchase Award, 1968. Media: Oil.

NECHIS, Barbara (Friedman). Painter. Born: Mt. Vernon, NY. Study: Univ Rochester, B.A., 1958; Alfred Univ, M.S., 1959; Manhattanville Col, 1968. Work: CBS Records, Milford, Conn; Banco de Crefisul, Sao Paulo, Brazil; IBM Collection, Armonk, NY. Exhib: Ann Watercolor Exhib, Nat Arts Club, New York, 1970-73, Knickerbocker Artists Exhib, 1970-73; Am Watercolor Soc Exhib, Nat Acad Design, New York, 1970, 1973 & 1975, Audubon Artists Exhib, 1975; Hudson River Mus. 1972. Media: Watercolor.

NEEL, Alice. Painter. Born: Merion Square, Pa., January 28, 1900. Study: Philadelphia Sch Design for Women, 1921-25; Moore Col Art, hon Dr, 1971. Work: Mus Mod Art & Whitney Mus Am Art, New York; Robert Mayer Collection, Winetka; Dillard Inst, New Orleans, La; Graham Gallery, New York. Exhib: Retrospectives, Moore Col Art, 1971 & Whitney Mus Art, 1974. Awards: Longview Found Award, 1962; Am Acad Arts & Lett Award, 1969; Benjamin Altman Figure Prize, Nat Acad Design, 1971. Media: Oil.

NELSON, Lucretia. Painter, educator. Born: Nashua, NH, February 19, 1912. Study: Univ Calif, A.B. & M.A.; Calif Inst Technol. Exhib: Pa Acad Fine Arts, 1938; one-man show, Seattle Art Mus, 1947; De Young Mem Mus; San Francisco Art Asn. Awards: Taliesin Fel, 1934-35; Europ Scholar; Univ Calif, 1936-37; San Francisco Soc Women Artists Prize, 1944.

NEWMAN, Libby. Painter, printmaker. Born: Rockland, Del. Study: Tyler Sch Fine Arts, Philadelphia, 1954; Philadelphia Col Art, 1962; also with Julius Block, Sam Feinstein & Victor Lauschin. Work: Nat Mus Belgrade, Yugoslavia; Philadelphia Mus Art; Mus Philadelphia Civic Ctr; Mus Mod Art, Buenos Aires, Argentina; Glassboro State Col. Comn: Woodcut print ed 50, Univ Pa Law Sch, 1970; woodcut print ed 100, Circle Gallery, New York, Chicago & Calif, 1973, woodcut print ed 50, 1973 & 1974. Exhib: Nat Watercolor & Drawing Exhib, Pa Acad Fine Arts, 1964; Del Regional Watercolor Exhib, Del Art Mus, 1964; Eastern Cent Drawing Exhib, Philadelphia Mus Art, 1965; Benjamin Mangel Gallery, Bala Cynwyd, Pa, 1970-75; Pa State Mus, Harrisburg, 1971. Awards: Gold Medal Award, Da Vinci Art Alliance, Philadelphia, 1964; Best Picture of Year Award, Philadelphia Art Alliance, 1965; National Print Award, Cheltenham Art Ctr, Pa, 1970. Media: Acrylic; woodcut.

NEWMARK, Marilyn (Marilyn Newmark Meiselman). Sculptor.
Born: New York, NY, July 20, 1928. Study: Adelphi
Col; Alfred Univ; also with Paul Brown, Garden City,
NY. Comn: Hacking Home Trophy, Prof. Horseman's Asn,
1971; Hobson Perpetual Trophy, Liberty Bell Race Track,
Pa, 1972; American Gold Cup Medallion Award, 1972;
Appaloosa Horse Club Medallion Award, 1974; Triple Crown,
comn by Sam Lehrman, 1975; plus others. Exhib: Allied
Artists Am, New York, 1970-74; Nat Sculpture Soc, New
York, 1970-73 & 1975; Nat Art Mus Sport, New York, 1971;
James Ford Bell Mus Natural Hist, Minneapolis, Minn,
1971; Nat Acad Design, New York, 1971, 1972, 1974 &
1975. Awards: Anna Hyatt Huntington Gold Medal Award,
Catharine Lorillard Wolfe Art Club, 1973; Am Artists
Prof League Gold Medal Award, 1974; Ellen P. Speyer Award,
Nat Acad Design, 1974; plus others. Media: Bronze.

NEWPORT, Esther. Painter. Born: Clinton, Ind., May
17, 1901. Study: Art Inst Chicago, B.A.; St. Mary of
the Woods Col, A.B.; Syracuse Univ, M.F.A.; St. Mary's
Col (Ind), L.L.D., 1956. Exhib: Five shows, Hoosier
Salon, 1933-42; John Herron Art Inst, 1938; Metrop Mus
Art, 1944; Contemp Relig Art, Tulsa, Okla, 1949; Int Expos
Sacred Art, Rome, Italy, 1950. Collections Arranged:
US Sect,Int Expos Sacred Art, Rome, 1950. Awards:
Prizes, Hoosier Salon, 1937, 1939 & 1942; First Place,
Am & Int Needlepoint Exhib, Chicago, 1974.

NICHOLS, Alice W. Painter, educator. Born: St. Joseph,
Mo., June 15, 1906. Study: Tex Woman's Univ; Pratt
Inst; Univ Tex, Austin, B.A. & M.A.; Teachers Col,
Columbia Univ, Ed.D. Work: Ball State Univ Art Gallery;
Anderson Fine Arts Found, Ind. Collections Arranged:
18 Ann Drawing & Small Sculpture Shows, 1955-; Crafts
1967, Ball State Univ Art Gallery, 1967, Collages by
American Artists, 1971. Awards: Gibson Award Out-
standing Contribution to Indiana Architecture, Ind Soc
Architects, 1972; Ind Arts Comn Award Outstanding Arts
Leadership, 1973. Media: Collage.

NORDSTRAND, Nathalie Johnson. Painter. Born: Woburn, Mass. Study: Bradford Jr Col; Barnard Col; Columbia Univ; also with Jay Connaway, Roger Curtis, Paul Strisik & Don Stone. Work: First Nat Bank Boston; Am Mutual Ins Co, Wakefield, Mass; Am Tel & Tel Co, New York; Goodrich Tire Co, Mich; Pilot Life Ins Co, NC. Exhib: Acad Artists Am, 1967-75; Am Watercolor Soc Ann, 1969-74; Allied Artists Am, 1969-75; Mainstreams 71, Ohio, 1971; New England Art in Hong Kong, Am Chamber Com, 1974. Awards: Bronze Medal, Catharine Lorillard Wolfe Art Club, 1970; Gold Medal, Am Artists Prof League, 1971 & 1975; 102nd Ann Watercolor & Sculpture Exhib Louis E. Seley Prize, Salmagundi Club, New York, 1974. Media: Watercolor, oil.

NOSSAL, Audrey Jean. Painter, writer. Born: London, Eng., March 12, 1929. Study: With Tsai Pei Chiu, Siu Lap Sing & Tang Hung. Exhib: City Hall, Hong Kong, 1970; YWCA, Hong Kong, 1971; Sumie Soc, New York, 1972; Abbott Gallery, Washington, 1974 & 1975. Media: Monochrome.

O'CONNELL, Ann Brown. Painter, collector. Born: Worcester, Mass., June 3, 1931. Study: Bradford Col, A.A.; Boston Univ Exten; Sumi-e with Evalyn Aaron, Port Washington, NY; Chinese brush painting with Audrey Nossal, Potomac, Med. Exhib: Sumi-e Soc Am Inc Ann Exhibs; 6th Ann Exhib, Bank of Tokyo Trust Co, New York, 1969; 7th Ann Exhib, Nippon Club, New York, 1970. Awards: President's Prize, Sumi-e Soc Am, Inc, 1969.

O'DELL, Erin (Anne). Painter, designer. Born: Phoenix, Ariz., December 7, 1938. Study: Moore Col Art, B.F.A. (textile design); Ariz State Univ; also with John Pike in Mexico, Jamaica, Ireland, Italy & Guatemala. Work: Ariz Bank, Phoenix; Colo Nat Bank, Colorado Springs; First Nat Bank, Mesa, Ariz; Valley Nat Bank, Scottsdale & Mesa, Ariz. Exhib: Ann Artists Salon, Oklahoma City, Okla, 1973 & 1974; Two Flags Festival Arts, Douglas, Ariz, 1973-75; Nat Garden Valley Show, Colorado Springs, 1974; Dagres Gallery Watercolor Show, Phoenix, 1975; Phippen-O'Brien Gallery Watercolor Show, Scottsdale, 1975. Awards: Mesa Artist of the Year, Mesa Art League, 1973; Watercolor Award, Douglas Art Asn, 1973; Most Talented Artist, Ariz Saguaro Artists League, 1975. Media: Watercolor; tempera, gouache.

OLINSKY, Tosca (Mrs. Charles F. Barteau). Painter.
Born: Florence, Italy. Study: Nat Acad Design; Art
Students League. Exhib: One-man show, Lyman Allyn
Mus, New London, Conn, 1958; Nat Acad Design; Allied
Artists Am; Audubon Artists; Am Watercolor Soc; plus
others. Awards: Jane Peterson Prize, 1957 & Lamont
Prize, 1959, Audubon Artist Ann; Gloria Layton Prize,
Allied Artists Am, 1960; plus others.

ORDER, Trudy. Painter. Born: Munich, Germany, November
22, 1944; U.S. citizen. Study: Akad Mallkunst, Munich;
Scoula di Pictura, Ancona, Italy; Nat Acad Design, New
York, with Maxwell Starr & Umberto Romano. Work:
Columbia Mus Art, SC; Mt St Vincent Col; Ft Tyron Jewish
Ctr, New York; Holy Rood Episcopal Church, New York.
Comn: The Gift (oil), comn by Mme Trau, Antwerp, Belg,
1970; Bar Mitzwa (oil), comn by Signora Cagli, Ancona,
1972; Bar Mitzwa (graphic), comn by Mme Tilli le Brewster,
Paris, 1973; In the Park (oil), comn by Ernest Raaschou,
St Thomas, VI, 1973. Exhib: Audubon Artists, New York,
1961; Allied Artists, New York, 1962; Knickerbocker
Artists, New York, 1964; one-man shows, Mt St Vincent
Col, 1966-74 & Pietrantonio Gallery, New York, 1968.
Awards: First Prize for Oil, Twilight Park Artists, 1963,
Second Prize for Pastel, 1963 & First Prize for Watercolor,
1963. Media: Oil, watercolor.

OSBY, Larissa Geiss. Painter. Born: Artemowsk, Russia,
June 7, 1928; US citizen. Study: Lyceum & Univ
Goettingen, Ger; Univ Munich; Acad Fine Arts, Munich,
Ger. Work: Carnegie Inst, Pittsburgh; Alcoa Collection;
US Steel Collection; Westinghouse Elec Co Collection;
plus others. Comn: Koppers Co & First Fed Savings &
Loan Asn, Pittsburgh, 1972. Exhib: One-man shows,
Pittsburgh Plan for Art Gallery, 1963, 1968 & 1971; Walker
Art Ctr Biennial, Minneapolis, 1966; Pennsylvania 1971,
William Penn Mem Mus, Harrisburg, 1971; one-man show,
Carnegie Inst Mus Art, Pittsburgh, 1972; plus others.
Awards: Jury Award of Distinction, Mainstreams Int,
1968; First Prize, Pittsburgh Watercolor Soc, 1968; Jury
Award of Distinction, Assoc Artists Pittsburgh Ann, 1969.

OZONOFF, Ida. Painter. Born: La Crosse, Wisconsin,
July 27, 1904. Study: State Teachers Col, Milwaukee,
grad, 1924; Milwaukee Downer Col, 1958 & 1959; Univ Wis-
Milwaukee, 1960-64 & 1969-70. Work: Print Div,
Smithsonian Inst, Washington, DC; Milwaukee Pub Schs;
Univ Wis, Fond du Lac Campus; Abilene Fine Arts Mus, Tex;
Carleton Col, Northfield, Minn. Exhib: Walker Art Ctr
Exhib, Minn, 1964; Butler Inst Am Art, Ohio, 1965, 1967 &
1968; Audubon Artists Exhib, New York, 1966, 1968 & 1969;
Nat Acad Design Exhib, New York, 1968 & 1969; Allied
Artists An Exhib, New York, 1970. Awards: Purchase
Award, Western Publ, 1966; Benjamin Altman First Prize,
Nat Acad Design, 1968; Carleton Col Purchase Award,
Charles E. Merrill Trust Fund, 1975.

PACHECO, Maria Luisa. Painter. Born: La Paz, Bolivia,
October 22, 1919; US citizen. Study: Acad de Bellas
Artes, La Paz; Real Acad San Fernando, Madrid, Spain;
also with Daniel Vazquez, Diaz, Madrid. Work:
Guggenheim Mus, New York; Mass Inst Technol; Pan-Am
Union, Washington, DC; Mus Mod Art, Sao Paulo & Rio de
Janeiro, Brazil; Mus Art, Dallas. Comn: Triptych,
Mobil Oil Labs, Princeton, NJ, 1971. Exhib: 2nd, 3rd &
5th Biennial, Mus Mod Art, Sao Paulo, 1951, 1953 & 1957;
Contemporary Painting & Sculpture, Urbana, Ill, 1963;
Tredicesimo Premio Lissone, Italy, 1963; Magnet: New
York, 1965; Emergent Decade, Guggenheim Mus, New York,
1966. Awards: Guggenheim Fel Award, 1958 & 1960; Award
for Painting, Biennial Sao Paulo, 1959; Acquisition
Prize, Pan-Am Union, 1959. Media: Wood & sand, acrylic
& oil on canvas.

PACKER, Clair Lange. Painter, writer. Born: Geuda
Springs, Kans., August 27, 1901. Study: Univ N Mex,
Taos, with Millard Sheets & Barse Miller; also with
Harry Anthony De Young, San Antonio, Tex & Paul Barr,
Grand Forks, N Dak. Work: Gilcrease Mus, Tulsa. Exhib:
Philbrook Mus, Tulsa; Houston Mus; Gilcrease Mus, Tulsa;
Elizabet Ney Mus, Austin; Dallas Mus. Awards:
Honorable Mention for Watercolor, Houston Mus; Gilcrease
Mus Purchase Prize for Watercolor, Fourth Nat Bank, Tulsa.
Media: Watercolor, oil, crayon.

PALMER, Mabel (Evelyn). Painter. Born: Denver, Colo., October 19, 1903. Study: With Richard Yip, Warren Brandon, Vernon Nye & Michael Green. Work: Revue Studios Hollywood; City Santa Rosa; Bank Am Regional Off, Santa Rosa; Security Bank Antioch, Calif; Napa Co Fair Bd, Calistoga, Calif. Comn: First Telegraph Line, Union Pac Gold Spike Centennial, Calif & Nev, 1969. Exhib: M. H. De Young Mem Mus, San Francisco, 1965-66, 1968-69 & 1971; Watercolor USA, Springfield, Mo, 1969; 141st Ann Exhib, Nat Acad Design, New York, 1966; Charles & Emma Frye Mus, 1971; 105th Ann, Am Watercolor Soc, New York, 1972; plus many others. Awards: Villa Palette Award, De Young Mus, 1966; First Award, Mother Lode Nat Art Show, 1967 & 1970; Best of Show & First Award, All Western Art Show, Ellensburg, Wash, 1972; plus many others. Media: Acrylic, transparent watercolor.

PARIS, Lucille M. (Lucille M. Bichler). Painter. Born: Cleveland, Ohio, April 8, 1928. Study: Univ Calif, Berkeley, B.A., Taussig traveling fel, 1950-51, McEnerney grad fel, 1952 & M.A.; Atelier 17, Paris. Work: Butterfield Collection; Newark Mus Collection of Contemp Art. Exhib: Artist-Bay Area Graphics, 1964; Monmouth Col, 1964, 1965, 1968 & 1972; Univ Minn Art Gallery, 1965; one-man show, Aegis Gallery, New York, 1965; NJ State Mus, Trenton, 1968 & 1972; plus others. Awards: Purchase Award, Ball State Univ, 1956; Bainbridge Award, Argus Gallery, NJ, 1963; Monmouth Col Award, 1965.

PARISH, Jean E. Painter, educator. Born: Oneonta, NY. Study: Ohio State Univ, B.S.; Parsons Sch Design; Art Students League, with Kunyioshi, Zorach & Sidney Gross; Drake Univ, M.F.A.; Arrowmont Sch Crafts, Univ Tenn; Mass Inst Technol, summer scholar & cert. Work: Munson-Williams-Proctor Inst, Utica; Fox Hosp, Oneonta. Comn: Paramonts & Cloths, United Methodist Church, Oneonta, 1971; murals, Goldman Theater, Philadelphia & Ritz Carleton, Montreal. Exhib: Art Today, NY State Fair, 1967, Graphics Nat, 1969; 19th Ann New Eng Exhib, Silvermine Guild Artists, 1968; Nat Exhib Contemp Am Painting, Soc Four Arts, Palm Beach, 1969; Miss Nat Ann Art Asn, Jackson, 1970. Awards: Purchase Award, Munson-Williams-Proctor Inst, 1967, 1973 & 1974; Juror's Choice Award, 33rd Regional Artists Upper Hudson, 1968; First Prize Drawing, Roberson Ctr Ann, 1971.

PARSONS, Betty Bierne. Painter, art dealer. Born: New York, NY. Study: Study with Bourdelle, Paris; sculpture with Archipenko & Zadkine; summers in Brittany studying watercolor with Arthur Lindsey. Work: Montclair Art Mus, NJ; Nat Collection Fine Arts, Washington, DC; Whitney Mus Am Art, New York; plus many pvt collections. Exhib: Pa Acad Fine Arts Jury Meeting, 1957; Nat Coun Women of the US, 1959; Am Abstract Artists, 1962; Soc Four Arts, 1964; Artists of Suffolk County, Part II: Abstract Tradition, Heckscher Mus, 1970; plus many other group & one-woman exhibs.

PARSONS, Kitty (Kitty Parsons Recchia). Painter, writer. Born: Stratford, Conn. Study: With Richard Recchia; also life classes, Rockport Art Asn. Work: Syracuse Univ. Exhib: One-woman shows, Doll & Richards Gallery, Boston, Walker Art Mus & Bowdoin Col; Corcoran Gallery; Mint Mus. Awards: Hon mention, Ogunquit Art Ctr, 1935 & Nat Art Exhib, 1945; Prize, Nat League Am Pen Women, 1955 & 1956. Media: Watercolor.

PEARLMAN, Etta S. Painter. Born: New York, NY, March 30, 1939. Study: Brooklyn Col, B.A., 1960; Brooklyn Mus Art Sch. Work: Power Gallery Contemp Art, Univ Sydney, Australia; Brooklyn Mus. Exhib: One-woman shows, Brooklyn Mus Little Gallery Series, painting, 1973 & collages, 1974 & Pleiades Gallery, 1975; Gallery 91, Brooklyn, 1975; Brooklyn Mus Art Sales & Rental Gallery, 1975.

PEDERSON, Molly Fay. Painter, sculptor. Born: Waco, Texas, April 26, 1941. Study: Pvt study with Carl Cogar, Las Cruces, N Mex, James Woodruff, Houston, Mary Berry, McKinney, Tex, Ramon Froman, Dallas, Tex, Ken Gore, Mass, Stewart Matthews, Arnold Vail & H. E. Fain, Dallas. Exhib: Richardson Civic Arts Soc Ann, Tex, 1968-70; Artists Market, Dallas, 1968-72; Bond's Alley Art & Craft Show, Hillsboro, Tex, 1969-70; Tex Fine Arts Asn Exhib, Dallas, 1970; Temple Emanu-El Ann Brotherhood Art Festival, Dallas, 1970-72. Awards: Award for Manarola, Texans Asn Art Show, 1968; Richardson Community Fair Award, 1969; Award for Black & White Abstract, Bond's Alley Arts & Crafts Show, 1970. Media: Oil, acrylic; brass, copper.

PERRET, Nell Foster. Painter. Born: Brooklyn, NY.
Study: Pratt Inst; Art Students League; Design Lab.
Work: Southampton Col, Long Island Univ; East Hampton
Guild Hall; St Mary's Univ; Wichita State Univ. Exhib:
Audubon Artists, Nat Acad Design Gallery, 1971-74;
Westbeth Graphics Workshop, Palacio Bellas Artes, Mex,
1971-72; East Hampton Guild Hall Ann; Chung Hsing
Galleries, Taiwan, 1973; Assoc Am Artists, 1974.
Awards: Two awards, East Hampton Guild Hall, 1961 &
1962; three awards for graphics, Parrish Art Mus, 1963,
1964 & 1967.

PERRY, Kathryn Powers. Painter, illustrator. Born:
Chico, Calif, March 13, 1948. Study: Concordia Col,
seminar in Italy with Barbara Glasrud, 1969, with Cy
Running, B.A. (art, Eng), 1970; Stanford Univ, 1968; Art
Students League, with Will Barnet, Earl Mayan, Knox
Martin & Gregory d'Alessio, 1971-74, Emily Ferrier-Spear
scholarship, 1973-74. Comn: Stage design for var
festivals, Concordia Col, 1968-69, posters & bk covers,
1969-70. Exhib: Tri-College Traveling Exhib,
Concordia Col, 1969; Orpheus Gallery, New York, 1974;
Women's Mus Group Show, New York, 1975; Berkshire Art
Asn 21st Spring Exhib, Berkshire Mus, Pittsfield, Mass,
1975; Aames Gallery, New York, 1976. Media: Acrylic,
oil; pen & ink, charcoal & pencil.

PETERSON, Audrey Mount. Painter, sculptor. Born:
Salt Lake City, Utah, May 11, 1914. Study: Univ Utah;
Univ Chicago; Art Inst Chicago; also with Edward A. F.
Everett, Millard Sheets, Donald Yacoe, Richards Reuben,
Eijnar Hansen & Leonard Edmondson. Work: Art League
Gallery, Great Falls, Mont. Exhib: Denver Art Mus
Biennial, Colo, 1958; Laguna Beach Art Asn, Calif, 1959;
Chaffey Community Art Asn, Calif, 1962; Watercolor USA,
Springfield Art Mus, Mo, 1964 & 1971; Gallery Rene Borel,
Deauville, France, 1971. Awards: Hon Mention, Nat
Watercolor Soc, Los Angeles, 1958; First Prize, Nat
Orange Show, San Bernardino, 1959; Purchase Prize, Art
League, Great Falls, 1969. Media: Watercolor, oil,
acrylic, casein.

PETHEO, Bela Francis. Painter, educator. Born: Budapest, Hungary, May 14, 1934; US citizen. Study: Univ Budapest, M.A., 1956; Acad Fine Arts, Vienna, 1957-59, with A. P. Guetersloh; Univ Vienna, 1958-69; Univ Chicago, M.F.A., 1963. Work: Hungarian State Mus Fine Arts, Budapest; Kunstmus, Bern, Switz; Univ Minn Permanent Collection, Minneapolis; Carleton Col Permanent Collection, Northfield, Minn; plus others. Comn: Kindliche Untugenden (mural), Asn Austrian Boyscouts, Vienna, 1958; The History of Handwriting (exhib panel), Noble & Noble Publ for Hall of Educ, New York World's Fair, 1964; plus others. Exhib: Hamline Univ, 1966; Coffman Gallery, Univ Minn, 1968; Moorhead State Col, 1969; Biennale Wis Printmakers, 1971; Duluth: A Painterly Essay, Tweed Mus Art, Minn, 1975; plus others. Awards: Belobende Anerkennung, Acad Fine Arts, Vienna, 1958; graphic prize, Univ Chicago, 1962. Media: Lithography.

PETRIE, Sylvia Spencer. Printmaker, painter. Born: Wooster, Ohio, June 15, 1931. Study: Col Wooster, B.A.; State Univ Iowa, with Mauricio Lasansky & Eugene Ludens; Univ RI. Work: Graphics Soc, Hollis, NH; Art Ctr Mus, Wooster Col; Gilbert Stuart Birthplace, Saundertown, RI; Fantle's, Sioux Falls, S Dak; Wayne Gallery, Providence, RI. Exhib: 4th Midwest Biennial, Joslyn Art Mus, Omaha, Nebr, 1956; Mo Valley Exhib Oil Painting, Mulvane Art Mus, Topeka, Kans, 1956; 9th Nat Print Exhib, Silvermine Guild, New Canaan, Conn, 1972; Images on Paper, Springfield Art Asn, Ill, 1973; 64th Am Ann, Art Asn Newport, RI, 1975; plus others. Awards: Netta Strain Scott Prize Art, Wooster Col, 1953; First Prize & Purchase Award, Fantle's, 1956; First Prize Graphics, Westerly Art Festival, 1975; plus many others. Media: Intaglio, collagraph; oil, pastel.

PHILLIPS, Marjorie. Museum director, painter. Born: Bourbon, Ind., October 25, 1894. Study: Art Students League; also with Kenneth Hayes Miller & Boardman Robinson. Work: Whitney Mus Am Art, New York; Corcoran Gallery Art, Washington, DC; Yale Univ Art Gallery; Phillips Collection, Washington, DC; Mus Fine Arts, Boston. Exhib: Exhibition of American Painting, Tate Gallery, London, 1946; Carnegie Inst Int, Pittsburgh, several yrs; one-woman shows, Calif Palace of Legion of Honor, San Francisco, 1959, Edward Root Art Ctr, Munson-Williams-Proctor Inst, Utica, NY, 1965 & retrospective, Marlborough Galleries, London, 1973. Awards: Award of Merit, Pa Mus Sch Art, 1959; D.F.A. (hon), Smith Col, 1972. Media: Oil.

PICARD, Lil. Painter, sculptor. Born: Landau, Ger;
US citizen. Study: Col Strassbourg, Alsace-Loraine;
study in Vienna, Austria & Berlin, Ger; Art Students
League, with Jevza Modell. Work: Schniewind Collection,
Nevege, Ger; Hahn Collection, Cologne, Ger. Exhib:
Parnass Gallery, Wuppethal, Ger, 1962; Insel Gallery,
Hamburg, Ger, 1963; Smolin Gallery, New York, 1965;
Kunsthalle, Baden-Baden, Ger; Stedelijk Mus, Holland;
plus others.

PIERCE, Delilah W. Painter, educator. Born: Washington,
DC, March 3, 1904. Study: DC Teachers Col, dipl;
Howard Univ, B.S.; Columbia Univ, M.A.; also with Lois
Jones, Celine Tabary, Ralnh Pearson, James Lesene Wells
& Jack Perlmutter. Work: Howard Univ Gallery Art &
DC Teachers Col, Washington, DC; Anacostia Mus,
Smithsonian Affil. Comn: Portrait of Dr. Eugene A.
Clark, comn by family for Eugene A. Clarke Pub Sch,
Washington, DC, 1969. Exhib: Atlanta Univ Art Show,
1952 & 1953; Area Show, 1957-59 & Travel Exhib, 1960-61,
Corcoran Gallery Art; Baltimore Gallery Art Area Show,
1959; Smith-Mason Gallery Nat Exhib, 1971; Trenton Mus,
1972. Awards: Agnes Meyer Summer Fel, 1962; award for
achievement in field of art & art educ, Phi Delta Kappa,
1963; mus donor prog purchase award, Am Fedn Art, 1964;
Smith-Mason Achievement & Serv Award. Media: Oil,
acrylic.

PIERCE, Elizabeth R. Painter. Born: Brooklyn, NY.
Study: Art Students League, with John Groth, John
Stewart Curry & Anne Goldthwaite; Art League Long Island,
NY, with Edgar A. Whitney; Columbia Univ Exten. Work:
Children's room, Jamaica Pub Libr, NY. Exhib: Nat Asn
Women Artists Ann, Nat Acad Design Galleries; Nova Scotia
Soc Artists, Halifax; Nat Mus, Washington, DC; Yarmouth
Art Soc, NS. Media: Oil.

PINKOWSKI, Emily Joan. Painter. Born: Chicago, Ill.
Study: Mundelein Col, scholar; Univ Chicago, Ph.B.; Am
Acad Art, com art cert. Exhib: Butler Inst Am Art,
Youngstown, Ohio, 1969-72; New Horizons in Art, Ill
Competition, Chicago, 1970-75; Women '71, Northern Ill
Univ, DeKalb, 1971; Chicago & Vicinity Show, Art Inst
Chicago, 1973; 27th Ill Exhib, Ill State Mus, Springfield,
1974. Awards: Second Prize, New Horizons in Art, Ill
Competition, North Shore Art League, 1971; Second Prize,
Styka Show, Am Coun Polish Cult Clubs, 1971; Borg-
Warner Purchase Award, 1972.

POLAN, Nancy Moore. Painter. Born: Newark, Ohio.
Study: Marshall Univ, A.B.; Huntington Galleries;
Fletcher Martin, Hilton Leech, Paul Puzinas & Robert
Friemark; Al Schmidt, Fla. Work: Huntington Galleries;
Admiral House, Naval Observ, Washington, DC; OVAR Mus,
Portugal. Exhib: Am Watercolor Soc, 1961, 1966, 1972
& 1974 & Framed Travel Exhib, 1972-73; Nat Arts Club, New
York, 1962-73; Joan Miro Graphics, Barcelona, 1970 &
Travel Exhib, 1970-71; 21st Contemp Art, La Scala,
Florence, Italy, 1971; one-woman show, New York World's
Fair, 1965; plus many other group & one-woman shows.
Awards: Ralph & Elizabeth C. Norton Mem Award, 3rd Nat
Jury Show Am Art, Chautauqua, NY, 1960; Nat Arts Club
Watercolor Award, Ann Artist Mem Exhib, 1969; Bronze
Medal, 1971 & Acad Laurel Medal & Dipl, 1974, Centro
Studi e Scambi Internazionali, Rome, Italy. Media:
Watercolor, acrylic.

POLITINSKY, F. Augusta (Flora). Painter, sculptor. Born:
Paterson, NJ. Study: Am Art Sch, New York; Nat Acad
Design; Newark Mus; Art Students League. Work: Many pvt
collections. Exhib: Nat Acad Sch, Gotham Painters, New
York, 1960; Paterson Mus, 1963; Ahda Artzt Gallery, New
York, 1967-69; Burr Artists, Jersey City Mus, 1969;
Empire Savings, Hannover Trust, New York, 1971. Awards:
Best in Show, Gotham Painters, 1965; Hon Mention,
Composers, Auth, Artists Am, 1972. Media: Watercolor,
casein, oil; papier mache, copper, aluminum wire.

POLLAK, Theresa. Painter, educator. Born: Richmond,
Va., August 13, 1899. Study: Richmond Art Club;
Westhampton Col, Univ Richmond, B.S.; Art Students League;
Fogg Mus, Harvard Univ, Carnegie fel; Steiger Paint
Group, Edgartown, Mass; with Hans Hofmann, Provincetown,
Mass; Univ Richmond, hon D.F.A., 1973. Work: Va
Commonwealth Univ, Richmond; Va Mus Fine Arts, Richmond,
Chrysler Mus Norfolk, Va; Univ Va, Charlottesville;
Washington & Lee Univ, Lexington, Va. Exhib: 12th
Biennial Exhib Contemp Am Painting, Corcoran Gallery Art,
Washington, DC, 1930; 1st Biennial Contemp Am Painting,
Whitney Mus Am Art, New York, 1932; New Eng Soc Contemp
Art, Boston Mus Fine Arts, 1933; 19th Irene Leache Mem
Regional Painting Exhib, Chrysler Mus Norfolk, 1968;
Virginia Artists 1971, Va Mus Fine Arts, Richmond.
Awards: Distinguished Alumna Award, Westhampton Col,
1964; Cert Distinction, Va Mus Fine Arts, 1971; Theresa
Pollak Bldg of Fine Arts, Va Commonwealth Univ, 1971.
Media: Oil.

POLSKY, Cynthia. Painter. Born: New York, NY,
February 16, 1939. Study: Art Students League, with
Will Barnet; New Sch Social Res, with Julian Levy;
Columbia Univ. Work: Corcoran Gallery Am Art, Washington,
DC; Israel Mus, Jerusalem; Fogg Art Mus, Cambridge, Mass;
Guild Hall, East Hampton, NY; American Embassy, London,
Eng. Comn: Wooden painted murals, Manhattanville Col
Music Festival, 1966; rec jacket, UNICEF, 1966. Exhib:
One-man shows, Benson Gallery, Bridgehampton, Long
Island, NY, 1968, Comara Gallery, Los Angeles, 1969,
Artisan Gallery, Houston, Tex, 1970 & Palm Springs
Desert Mus, 1972-73; Laguna Beach Art Asn Exhib 10, 1971;
Watercolor Exhib, Comara Gallery, 1972; one-woman shows,
Andrew Crispo Gallery, New York, 1973 & 1974. Media:
Acrylic, watercolor.

POOR, Anne. Painter. Born: New York, NY, January 2,
1918. Study: Bennington Col; Art Students League, with
Alexander Brook, William Zorach & Yasuo Kuniyoshi; Acad
Julian, Paris, painting with Jean Lurcat & Abraham
Rattner; also asst for in fresco to Henry Varnum Poor.
Work: Whitney Mus Am Art; Brooklyn Mus; Art Inst
Chicago; Wichita Mus; Des Moines Art Ctr. Comn: Murals,
Pub Works Admin, 1937; murals in true fresco, comn by
Nathaniel Saltonstall, Wellfleet, Mass, 1951-52, Skowhegan
Sch Painting & Sculpture, 1954, South Solon Free Meeting
House, Maine, 1957 & Mr. & Mrs. Robert Graham, Stamford,
Conn, 1958. Exhib: Artists for Victory, Metrop Mus
Art, 1942; Am Brit Art Ctr, New York, 1944, 1945 & 1948;
Maynard Walker Gallery, New York, 1950; five shows, Graham
Gallery, New York, 1957-71; plus others. Awards: Edwin
Austin Abbey Mem Fel for Mural Painting, 1948 & First
Prize for Landscape Painting, 1970, Nat Acad Design; Nat
Inst Arts & Lett Grant in Art, 1957. Media: Oil,
watercolor.

PORTMANN, Frieda Bertha Anne. Painter, sculptor. Born: Tacoma, Wash. Study: With Fernand Leger, Glenn Lukens, Clifford Still, Norman Lewis Rice, Peter Camfferman, Edward Du Penn, Julius Heller, Hayter, Lasansky & H. Matsumoto. Work: Univ Southern Calif, Los Angeles; Art Inst Chicago; Calif Col Fine Arts, Oakland; plus many in pvt collections. Comn: Sacajawea (wooden garden sculpture), Seattle; Beer & Skittles (mural), pvt home, Seattle; Pioneer Teacher (oil), Pioneer Asn, Seattle; Lily Madonna (ceramics), Garden, Cath Sch, Seattle; numerous portraits in oil. Exhib: Prints, Boston Mus Arts; Paintings, Prints, Sculpture & Crafts, Seattle Art Mus; Sculpture, Denver Mus Art; Painting & Print, Oakland Mus Art; Paintings, Argent Gallery, New York. Media: Leather, weaving, ceramics.

POST, Anne B. Sculptor, graphic artist. Born: St. Louis, Mo. Study: Bennington Col, B.A. (fine arts); study with Simon Moselsio, Stephen Hirsch & Edwin Park; study in Europe. Work: Israel Mus, Jerusalem; Norfolk Mus, Va; Art Dept Mus, Wellesley Col; Dept Fine Arts Mus, Univ Chicago; Dept Visual Art Mus, Bennington Col. Exhib: Toledo Mus Art; St Louis Mus Art; Contemp Art Exhib, New York World's Fair; NY Univ; J. B. Neumann Gallery, New York. Media: Wood, stone.

POTTER, Joan Terese. Painter. Born: Cambridge, Mass. Study: Mass Sch Art, B.F.A.; also with David Leffel, 1970-72. Exhib: Allied Artists Am, 1972-74; Catharine Lorillard Wolfe Art Club, 1972-74; West Side Outdoor Art Exhib, 1972-75; Hudson Valley Art Asn, 1973-74; Am Artists Prof League, 1975. Awards: First in Still Life Prize, Hudson Valley Art Asn, 1974; Second Prize in Oils, NY-Conn Chap, A Artists Prof League, 1974; West Side Outdoor Art Exhib Grand Prize, 1975; plus others. Media: Oil.

PRIMERANO, Joan Walton. Painter. Born: Buffalo, NY, October 9, 1926. Study: Albright Art Sch, Buffalo; Art Inst Buffalo. Exhib: Benedictine Art Awards, New York, 1970; Audubon Artists Exhib, New York, 1971 & 1972. Mainstreams '72, Marietta Col, Ohio, 1972; Allied Artists Exhib, New York, 1972. Awards: Harold J. Cleveland Mem Award, 14th Nat Juried Show, Chautauqua, NY, 1971. Media: Oil.

PUNIA, Constance Edith. Painter. Born: Brooklyn, NY.
Study: Brooklyn Mus Art Sch; oil with Edwin Dickinson
& Yonia Fain; oil and sumi-e with Murray Hantman. Exhib:
Fine Arts Festival, Parrish Art Mus, Southampton, NY,
1967 & 1968; Asn Belgo-Hispanique Int Festival Art,
Chartier Mus, Brussels, Belg, 1973 & Paris, France, 1974
& 1975; Les Surindependants, Paris, 1975; Grand Prix
Humanitaire de France, Paris, 1975. Awards: Palmes
d'Or Medal, Asn Belgo-Hispanique, 1973 & 1974; Silver
Medal & Laureate of Honor, Grand Prix Humanitaire de
France, 1975; Bronze Medal, Akad Raymond Duncan, 1975.
Media: Oil, sumi-e.

PUSEY, Mavis. Painter, printmaker. Born: Jamaica, WI.
Study: Art Students League with Will Barnet, Harry
Sternberg; New Sch Social Res; Printmaking Workshop with
Robert Blackburn. Work: Mus Mod Art; Chemical Bank,
NY; First Nat Bank Chicago; New York Pub Libr; Cleveland
State Univ. Exhib: Galerie Louis Soulange, Paris, 1967;
Curwen Gallery London, 1968; Whitney Mus Art, 1971;
Marist Col, 1975; Stony Brook Union Gallery, State Univ
NY Stony Brook, 1975. Awards: Louis Comfort Tiffany
Found Grant, 1974 & Purchase Award, 1974; Award, Staten
Island Mus, 1975. Media: Oil.

PUTTERMAN, Florence Grace. Painter. Born: Brooklyn,
NY, April 14, 1927. Study: NY Univ, B.S.; Bucknell
Univ; Pa State Univ. Work: Bucknell Univ, Lewisburg,
Pa; Lycoming Col, Williamsport, Pa. Exhib: Ga State
Print Ann, Atlanta, 1972 & 1973; Mainstreams 74,
Marietta Col, Ohio; Potsdam Print Ann, NY, 1974;
Philadelphia Print Club, 1974; Ball State Drawing Ann,
Muncie, Ind, 1975. Awards: Best in Show Award,
Everhart Mus, Scranton, Pa, 1968; Purchase Awards,
Appalachian Corridors, Charleston, W Va, 1975 & Arena
1975, Binghamton, NY.

QUAT, Helen S. Printmaker, painter. Born: Brooklyn, NY,
October 2, 1918. Study: Skidmore Col; Columbia Univ;
Art Students League; also with Raphael Soyer, Joseph
Solman, Leo Manso, Ruth Leaf & Krishna Reddy. Work:
Univ Mass, Amherst; NJ State Mus, Trenton; Nassau
Community Col. Exhib: Pratt Graphics Ctr 3rd Int
Miniature Print Exhib, 1968; 164th Ann, Pa Acad Fine Arts,
1969; Int Exhib Women Artists, Ont & France, 1969; State
Univ NY Potsdam 10th Print Ann, 1969-70; Nat Exhib
Prints & Drawings, Okla Art Ctr, 1969-72. Awards:
Vadley Art Co Award for Graphics, Catharine Lorillard
Wolfe Art Club, 1967; Purchase Prize, Hunterdon Art Ctr,
NJ, 1970; Mr. & Mrs. Benjamin Ganeles Prize, Nat Asn
Women Artists, 1971.

CUISGARD, Liz Whitney. Painter, sculptor. Born:
Philadelphia, Pa., October 23, 1929. Study: Md Inst
Col Art, dipl, 1949, B.F.A. (summa cum laude), 1966;
also with Morris Louis, 1957-60; Rinehart Sch Sculpture,
M.F.A., 1966. Work: Univ Ariz Ghallager Mem Collection,
Tucson; Lever House, New York; Univ Baltimore, Md.;
Johns Hopkins Univ; Hampton Sch, Towson, Md. Exhib:
Corcoran Biennial Am Painting, Corcoran Gallery Art,
Washington, DC, 1963; Univ Colo Show, 1963; Am Painting
& Sculpture Ann, Pa Acad Fine Arts, Philadelphia, 1964;
Art Inst Chicago Ann, 1965; one-man shows, Jefferson
Place Gallery, Washington, DC, 1961, Emmerich Gallery,
New York, 1962, Univ Md, 1969, Gallery 707, Los Angeles,
1974, South Houston Gallery, New York, 1974 & Arts &
Sci Ctr, Nashua, NH, 1975. Awards: Artists Prize,
Baltimore Mus Regional Exhib, 1958; Rinehart Fel, Md
Inst, 1964-66; Best in Show, Loyola Col, 1966.

RAHJA, Virginia Helga. Painter, art administrator.
Born: Aurora, Minn., April 21, 1921. Study: Hamline
Univ., B.A., 1944; Sch Assoc Arts, D.F.A., 1966. Exhib:
Many exhibs & ann, Walker Art Ctr, Minn Art Inst, St.
Paul Gallery Minn State Fair & Hamline Galleries.
Media: Oil.

RAMBERG, Christina (Christina Ramberg Hanson). Painter.
Born: Camp Campbell, Ky., August 21, 1946. Study: Art
Inst Chicago, B.F.A., 1968. Exhib: Famous Artists, 1969
& Chicago Imagist Art, 1972, Mus Contemp Art, Chicago;
Spirit of the Comic in the 50's & 60's, Univ Pa,
Philadelphia, 1969; False Image II, Hyde Park Art Ctr,
Chicago, 1969; Whitney Ann, Whitney Mus Am Art, New
York, 1972 & 1973. Media: Acrylic.

RANDALL, (Lillian) Paula. Sculptor, designer. Born:
Plato, Minn., December 21, 1895. Study: Minneapolis
Inst Arts; Univ Southern Calif; Otis Art Inst, Los
Angeles. Work: Western Div, Nat Audubon Soc,
Sacramento, Calif; Off Tournament Roses, Pasadena,
Calif. Exhib: All Calif Exhib, Laguna Beach Art Mus,
Calif, 1964; Univ Taiwan, Formosa, 1964; Brandeis Univ
Exhib, Granada Hills, Calif, 1967; Form & the Inner Eye
Tactile Show, Calif State Univ, Los Angeles & Pierce
Col, San Fernando, Calif, 1972; one-person show,
Galerie Vallombreuse, Biarritz, France, 1975. Awards:
Laguna Beach Art Mus Award, All Calif Show, 1964; Spec
Achievement Award, All Calif Exhib, Indio, 1966;
Pasadena Soc Artists Spec Award, 1971. Media: Wood,
stone, plastics, welded metals.

RANDEL, Lucille Marie-Berthe. Painter. Born: Cohoes, NY, July 4, 1908. Study: McGill Univ, 1926-28; also with Al Bross, Jr, Michael Lenson, Nicholas Reale & John Grabach. Work: Bell Tel Lab, Murray Hill & Wayne, NJ; Allied Chem Corp, Morristown, NJ; Union-Camp Paper Co, Wayne; Summit & Elizabeth Trust Co, NJ. Exhib: NJ Watercolor Soc, 1967-; Allied Artists, Nat Acad, New York, 1972 & 1973, Audubon Artists, 1974; Hudson Valley Artists, White Plains, NY, 1972-74; Nat Soc Painters Casein & Acrylic, Nat Arts Club, New York, 1975. Awards: Bronze Medal & Winsor Newton Award, Audubon Artists, 1974; President's Award, Nat Asn Painters in Casein, 1975; First Hon Mention, Am Artists Prof League, 1975. Media: Casein, watercolor.

RAPP, Lois. Painter. Study: Philadelphia Col Art, dipl teacher's training & cert illus, 1925-29; also with Earl Horter. Work: Woodmere Art Gallery, Philadelphia; Valley Forge Mem Chapel, Pa; Gwynedd-Mercy Col, Gwynedd Valley, Pa; Norristown Pub Libr, Pa; Montgomery Hosp, Norristown. Exhib: Am Drawing Ann XV, Norfolk, Va, 1957; Am Watercolor Soc 91st Ann, New York, 1958; Regional Exhib, Philadelphia Mus Art, 1959; Philadelphia Watercolor Club, 1971; Woodmere Art Gallery, 1972. Awards: Gold Medal for Along the Schuylkill River, Lansdale Art League, 1952; Awards for Meeting House Interior, 1960 & Falls of the Potomac, 1963, Woodmere Art Gallery. Media: Watercolor, oil, pastel.

RAVE, Georgia. Painter, educator. Born: Mt. Vernon, NY, June 3, 1936. Study: Hunter Col, B.F.A., 1957 & M.A., 1966. Awards: City Univ Fac Res Grant, City Univ New York, 1968; Shuster Grant, Hunter Col, 1969. Media: Acrylic, ink.

REGAT, Mary E. Sculptor, muralist. Born: Duluth, Minn., November 12, 1943. Study: Univ Alaska. Work: Anchorage Fine Arts Mus, Alaska; Pfeils Prof Travel Agency, Anchorage; Post Oak Towers Bldg, Alaska Interstate Corp., Houston, Tex; Anchorage Natural Gas. Exhib: All Alaska Juried Art Show, Anchorage; one-woman shows, Color Ctr Gallery, 1970 & 1971 & Artique Gallery, 1972-75; Alaska State Mus, Juneau, 1973; plus others. Awards: Sculpture Award, Design I, 1971; Purchase Award, Anchorage Fine Arts Mus, 1971. Media: Stone, wood; oil.

REININGHAUS, Ruth (Ruth Reininghaus Smith). Painter,
instructor. Born: New York, NY. Study: Hunter Col,
1944-46 & 1950-52; Nat Acad Design, Nell Boardman scholar,
with Morton Roberts, 1962; Frank Reilly Sch, Robert
Lehman scholar, with Frank Reilly, 1963; Art Students
League, with Robert Philipp, Robert Beverly Hale, Roberto
Maione & Rudolph Colao, 1966; NY Univ, scholar, 1968.
Exhib: Hudson Valley Art Asn Ann, Westchester Community
Ctr, NY, 1969-72; Am Artists Prof League Ann, Lever
House, NY, 1969-72; Allied Artists Am Ann, Nat Acad
Design, NY, 1971; Berkshire Art Asn, Pittsfield Mus,
Mass, 1972. Awards: Nell Boardman Award, Nat Acad
Design, 1962; Robert Lehman Award, Frank Reilly Sch,
1963. Media: Oil.

REMINGTON, Deborah Williams. Painter. Born: Haddonfield,
NJ, June 25, 1935. Study: San Francisco Art Inst,
B.F.A., 1957; studies in Asia, 1957-59. Work: Whitney
Mus Am Art, New York; Mus Boymans von Beuningen,
Rotterdam, Holland; Centre Nat Art Contemp, Paris;
San Francisco Mus Art; Toledo Mus Art. Exhib: L'Art
Vivant Americain, Fondation Maeght, St. Paul de Venice,
France, 1970; Whitney Mus Ann Exhib, 1972; 71st Am Exhib,
Art Inst Chicago, 1974; Image, Color, and Form, Toledo
Mus Art, 1975; Painting Endures, Inst Contemp Art, Boston,
1975. Awards: Fel, Tamarind Inst, Albuquerque, 1973.
Media: Oil on canvas.

RHOADS, Eugenia Eckford. Painter. Born: Dyesburg,
Tenn., January 9, 1901. Study: Miss Univ Women, A.B.,
1923, Columbia Univ, M.A., 1924; Am Beaux Art Sch,
Fontainbleau, summer 32; also with Robert Brackman,
Francis Speight, Walter Stuemig, Helen Sawyer & Henry
Pitz. Work: Del Art Mus, Wilmington; Miss Univ Women
Art Collection; Univ Del Art Collection; Du Pont Co
Collection, Wilmington & Atlanta; Wilmington Trust Co.
Exhib: Brooks Mem Art Gallery, Memphis, Tenn, 1955;
Nat Collection, Smithsonian Inst, Washington, DC, 1956-
58; Birmingham Art Mus, Ala, 1962; Allied Art, Nat Acad,
1966; Am Watercolor Soc, 1967. Awards: Trio Award,
Birmingham Mus Art, 1962; Breath of Spring Award, Nat
League Am Pen Women, 1963; Best in Show Founders Award
for Reflections, Rehoboth Art League, 1973; plus others.
Media: Watercolor, oil.

RIGG, Margaret Ruth. Painter, calligrapher. Born: Pittsburgh, Pa., December 14, 1929. Study: Carnegie-Mellon Univ, 1945-49; Fla State Univ, B.A., 1951; Scarrett Col; Presby Sch, M.A., 1955; George Peabody Col; Chicago Art Inst, 1965; painting with Edmund Lewandowski & Florence Kawa; design & theory with Mathias Goeritz. Work: Tenn Collection, Smithsonian Inst; Emille Mus, Seoul, Korea; Turku Univ Mus, Finland; NH Mus, Manchester; Korea Fulbright House, Seoul. Comn: Stained glass windows, Mexico City Nat Cathedral, 1961; stained glass window, communion table, lecturn & celtic cross, Univ NC, Chapel Hill, 1961; calligraphy mural, Experiment House, Vere, Jamaica. Exhib: Man's Disorder, God's Design, Univ Ill, 1952 & Krannert Art Mus, Univ Nebr-Lincoln, 1961; Am Artists, Am Cult Ctr, Seoul, 1973; Bicentennial Art, Mus Fine Arts. St. Petersburg, Fla, 1975-76; Ringling Mus Art Arch, Sarasota. Fla. Awards: Fulbright-Hays Sr Res Grant in Chinese Calligraphy, Korea. 1972. Media: Quill & ink, brush & Chinese ink.

RINGGOLD, Faith. Painter, sculptor. Born: New York, NY, October 8, 1934. Study: City Col New York, B.S., 1955, M.A., 1959; also with Robert Gwathney. Work: Chase Manhattan Bank, New York. Comn: For the Womens House (mural), Women House Detention, Rikers Island, NY, 1971. Exhib: Memorial for MLK, Mus Mod Art, New York, 1968; American Women Artists, Kunsthaus, Hamburg, Ger, 1972; Women Choose Women, New York Cult Ctr, 1973; Faith Ringgold, Retrospect, Univ Art Gallery, Rutgers Univ, 1973; Jubilee, Boston Mus, 1975. Awards: Creative Arts Pub Serv Prog, Grant, 1971. Media: Mixed.

ROBB, Peggy Hight. Painter. Born: Gallup, N Mex, September 14, 1924. Study: Univ N Mex, B.F.A. & M.A., with Raymond Jonson & Kenneth Adams; Art Students League. Work: Univ N Mex, Albuquerque. Comn: Stained glass window, Christian Ctr, Albuquerque, 1975. Exhib: N Mex Biennial, Santa Fe, 1958-63; N Mex State Fair, Albuquerque, 1959 & 1963; Southwestern Fiesta, Santa Fe, 1966; Sun Carnival Art Exhib, El Paso, Tex, 1971. Awards: First Prize, N Mex State Fair, 1959 & 1963; Hon Mention, N Mex Biennial, Santa Fe, 1961. Media: Oil, acrylic.

ROBERTS, Lucille D. (Malkia). Painter, educator. Born: Washington, DC. Study: Howard Univ; Univ Mich, AM; NY Univ; Acad Grande Chaumiere, Paris; Univ Ghana; also with Jose Gutierriez, Maxico City, Mex. Work: Atlanta Univ Collection; W Va State Col Collection; Jefferson Community Col, Water Town, NY. Exhib: Nat Exhib Black Artists, Smith-Mason Gallery, Washington, DC, 1971; Black Artists Exhib, Afro-Am Cult Ctr, Cleveland State Univ, 1972; one-man shows, Porter Gallery, Howard Univ, 1971 & Col Mus, Hampton Inst, 1972. Awards: First Prize, Mem Show, 1965 & Evening Star Award, 1966, Soc Washington Artists; James A. Porter Award, Cleveland State Univ, 1972. Media: Oil, acrylic.

ROBINSON, Sally W. Painter, printmaker. Born: Detroit, Mich., November 2, 1924. Study: Bennington Col, B.A.; Wayne State Univ, M.A. & M.F.A.; Cranbrook Acad Art; also with Hans Hofmann, Karl Knaths & Leon Kroll. Work: Prints and art work in pvt collections. Exhib: Two-man show, Univ Mich, 1973; one-man show, Klein Vogel Gallery, Royal Oak, Mich, 1974; Asset Gallery, London, Eng, 1975; Toledo Mus, Winston Traveling Show; Zella 9 Gallery, London, Eng. Awards: Second Prize, Bloomfield Art Asn, 1972; Second Prize, Soc Women Painters, 1974 & First Prize, 1975.

RODA (Rhoda Lillian Sablow). Designer, painter. Born: Port Chester, NY, November 26, 1926. Study: Univ Wis; Rochester Inst Technol; Art Students League; also with Frank Vincent DuMont & Frank Reilly. Work: Needle Arts Gallery, Birmingham, Mich. Comn: Cranbrook 50th Anniversary (needlepoint rug), Cranbrook Acad, Bloomfield Hills, Mich, 1973. Exhib: Allied Artists Am, Nat Acad, New York, 1969; Ahda Artzt Gallery, New York, 1970; Needle Arts Gallery, Birmingham, Mich, 1971 & 1974.

ROLAND, Lorinda. Instructor, sculptor. Born: New York, NY, April 21, 1938. Study: Art Students League, 1957-58; Skowhegan Sch Painting & Sculpture, 1959; Cranbrook Acad Art, B.F.A., 1960. Work: Pvt collections only. Exhib: Sculpture Los Angeles 1965, Munic Art Gallery. Awards: Tiffany Award, 1961-62; Guggenheim Fel, 1963-64. Media: Raised copper, polyester resin, wood, bone.

ROLLER, Marion Bender. Sculptor, painter. Born:
Boston, Mass. Study: Vesper George Sch Art, dipl; Art
Students League, with John Hovannes; Greenwich House,
with Lu Duble; Queens Col, B.A.; also watercolors with
Edgar Whitney. Comn: Head of child, Nassau Ctr
Emotionally Disturbed Children, Woodbury, NY, 1968.
Exhib: Allied Artists Am, 1959-74; Nat Acad Design, New
York, 1962-69; Am Artists Prof League, 1965, 1966 &
1968; Nat Sculpture Soc, New York, 1969-; Audubon
Artists, 1973. Awards: Mrs. John Newington Award, Am
Artists Prof League, 1965, Archer Milton Huntington
Award, 1968; Knickerbocker Artists Prize for Sculpture,
1966; Gold Medal, Pen & Brush, 1971, Honorable Mention
for Sculpture & Watercolor, 1975, Brush Award for Etching,
1975.

ROMOSER, Ruth Amelia. Painter, sculptor. Born: Baltimore,
Md., April 26, 1916. Study: Baltimore Art Inst, grad;
sculpture with Xavier Corbera, Barcelona, Spain; Robert
Motherwell Workshop; graphics with Joseph Ruffo. Work:
Miami Mus Mod Art, Fla; Lowe Mus, Univ Miami; Miami
Herald; Nat Cardiac Hosp, Miami; Int Gallery, Baltimore,
Md. Comn: Two paintings for 12 productions, Actors
Studio M, Coral Gables, Fla, 1963-64. Exhib: Ringling
Southeast Nat Art Show, Sarasota, Fla, 1961-63; Nat
Drawing Exhib, Cheltenham, Pa, 1964; Four Arts Plaza Nat,
Palm Beach, 1966; Hortt Mem Regional, Ft. Lauderdale Mus
Arts, 1966; one-man show, Nat Design Ctr, New York, 1967.
Awards: Eighth Ann Hortt Mem Award, Fort Lauderdale Mus
Arts, 1967; Design Derby Award, Designers-Decorators
Guild, 1969; Artspo 70, Coral Gables, 1970. Media: Oil,
acrylic.

ROSEN, Beverly Doris. Painter, educator. Born: Boston,
Mass. Study: Simmons Col, B.S.; Univ Colo; Univ Denver,
M.A. Work: Knight Pub Sch, Denver; Gallery Fine Arts
Ctr, Canon City, Colo; Univ Denver. Comn: Painting,
New Eng Life, Salt Lake City, 1970; two outside murals,
Colo Agency, State Mutual Am, Denver, 1973, two inside
paintings, 1973. Exhib: 73rd Western Ann, Denver Art
Mus, 1971; 12th Midwest Biennial Exhib, Joslyn Art Mus,
Omaha, Nebr, 1971; 50th Ann Nat Exhib, Springville Mus
Art, Utah, 1974; 6th Biennial Exhib, Salt Lake Art Ctr,
1974; Southwest Biennial, Mus Fine Arts, Santa Fe, N Mex,
1974. Awards: Purchase Prize, Gallery Fine Arts Ctr,
1970; Monied Prize, Gilpin Co Art Asn, Central City, Colo,
1970; Nat Educ Asn Grant & Colo Coun Grant for Gallery
Exhib, Univ Denver Gallery, 1975. Media: Acrylic on
canvas.

ROSENBLATT, Suzanne Maris. Painter, draftsman. Born:
Hackensack, NJ, July 2, 1937. Study: Oberlin Col,
Ohio, B.A., 1959; Cent Sch Arts & Crafts, London, 1957-
58; Cooper Union, 1960; Art Students League, 1961-63.
Work: Libr Performing Arts, Dance Film Col, Lincoln
Center, NY. Comn: Courtroom Drawings, WISN-TV, Milwaukee,
1973-75 & Milwaukee's Pub TV, 1974. Exhib: One-woman
shows, Bradley Gallery, Milwaukee, 1971, Wustum Mus,
Racine, 1972, Oshkosh Pub Mus, Wis, 1972 & New York
Center Gallery, 1976; Roko Gallery, New York, 1972;
Tenn Fine Arts Ctr, Nashville, 1974. Awards: Hon
Mention, Media Am, Seattle, Wash, 1975. Media: Acrylic
on wood & paper; ink & brush on paper.

ROSENBLUM, Sadie Skoletsky. Painter, sculptor. Born:
Odessa, Russia, February 12, 1899; US citizen. Study:
Art Students League; New Sch Social Res; also with
Raphael Soyer, Kunioshr, Ben-Zion & Samuel Adler. Work:
Philadelphia Mus Art; Ohio Univ; El Paso Mus Art;
Brandeis Univ Mus; Lowe Art Mus, Univ Miami. Exhib:
Mus Mod Art, New York; Corcoran Gallery Art, Washington,
DC; one-man shows, Mus Arts, Ft Lauderdale, Fla, 1962 &
1965, Lowe Art Mus, Univ Miami, 1964 & Columbia Mus,
SC, 1972. Media: Oil.

ROSENTHAL, Gloria M. Painter. Born: Brooklyn, NY,
May 24, 1928. Study: Com Art Training, Archit Design,
Univ Cincinnati; Post Col; Artist in Am Sch; Queen's Col;
Provincetown Workshop; Nassau Community Col; Pratt
Graphic Ctr; pvt & independent study. Work: Bankers
Trust, New York; Sperry Gyroscope, Lake Success, NY;
Weaver Schs, Milwaukee, Wis; Lutz Jr Mus, Manchester,
Conn; Col Town, Inc, New York. Exhib: Audubon Artists;
Nat Asn Women Artists; Nat Acad Design, 1970-75;
Silvermine Regional, Silvermine, Conn, 1972; one-man
show, Saratoga Performing Art Ctr, NY, 1972; Palazzo
Vecchio, Florence, Italy, 1972; Winners of the Past Ten
Years, Brooklyn Mus, 1975. Awards: Grumbacher Award,
Audubon Artists, Nat Acad Design, 1970; Charles H.
Woodbury Award, Nat Asn Women Artists, 1972 & Medal of
Honor, 1975. Media: Oil, collage.

ROSENTHAL, Rachel. Sculptor. Born: Paris, France, November 9, 1926; US citizen. Study: New Sch Social Res, New York; Sorbonne, Paris; also with Hans Hofmann, Karl Knaths, William S. Hayter & John Mason. Exhib: Rental Gallery, Los Angeles Co Mus, 1972; Ceramic Int, Calgary, Can, 1973; Ceramic Conjunction, Glendale, Calif, 1973 & 1975; one-woman show, Woman's Bldg Los Angeles, Grandview Gallery, 1974; 1st Ann Calif Sculpture Exhib, Calif State Univ, Northridge, 1974. Awards: Gold Medal Art, High Sch Mus & Art, New York, 1945. Media: Stoneware, raku.

ROSS, Beatrice Brook. Painter. Born: New York, NY. Study: Brooklyn Mus Art Sch, with Ruben Tam; Sch Chinese Brushwork, scholar, study with Wang Chi Yuan; also with Leo Manso. Work: Ford Productions, Toronto, Can; Textured Prod, New York; pvt collection of D. H. Northington, New York, W. Thornton, New York, Laura Ford, Ontario, Can, Hideo Hikawa, Tokyo, Japan. Comn: Two paintings, Muller, Jordan & Herricks Advert Agency, New York, 1971. Exhib: Silvermine Guild Artists, New Canaan, Conn, 1968 & 1970; Audubon Artists, New York, 1968 & 1970; Guild Hall Mus, Easthampton, NY, 1969-72; Nat Arts Club, New York, 1970; Four Contemp Artists, Suffolk Mus, Stony Brook, NY, 1971. Awards: Benjamin Altman Landscape Prize, Nat Acad Design, 1968; Second Prize Oil, Heckscher Mus, 1970; McDowell Colony Fel, 1975. Media: Oil, collage.

ROSS, Janice Koenig. Painter. Born: Harrisburg, Pa. Study: Pa State Univ, B.A.; Univ Ill, M.F.A. Exhib: Dixie Ann, Montgomery Mus Fine Arts, Ala, 1971 & 1972; Hunter Gallery Ann, Chattanooga, 1972; Chattahoochie Valley Ann Nat Painting & Sculpture Exhib, La Grange, Ga, 1972 & 1973; Piedmont Ann Crafts Exhib, Mint Mus, Charlotte, NC, 1973; Ann Exhib, Springfield Art Mus, Mo, 1974. Media: Oil, graphic media.

ROSSMAN, Ruth Scharff. Painter, art administrator. Born: Brooklyn, NY. Study: Cleveland Inst Art; Case-Western Reserve Univ, B.S.; Kahn Inst Art; Univ Calif, Los Angeles; also with Sueo Serisawa & Rico Lebrun. Work: Pa Acad Fine Arts; Univ Redlands; Nat Watercolor Soc; Brandeis Inst; Ahmanson Collection, Calif. Exhib: Denver Mus Art Ann, 1958, 1959 & 1962; Recent Paintings USA: Figure, Mus Mod Art, New York, 1961; one-woman shows, Heritage Gallery, Los Angeles, 1963 & 1966 & Canton Community Ctr, Ohio, 1967; Marymount Col. Media: Acrylic, oil.

ROTHSCHILD, Judith. Painter. Born: New York, NY.
Study: Fieldston Sch, with Victor D'Amico & Alex Brook;
Art Students League, with Reginald Marsh; Cranbrook
Acad Art; Wellesley Col, B.A. (art hist); study with Hans
Hoffmann; Atelier 17, with Hayter. Work: Guggenheim
Mus, New York; Fogg Art Mus, Harvard Univ, Cambridge, Mass;
City Art Gallery, Auckland, New Zealand First Nat Bank
Chicago, Chicago & New York; Roy R. Neuberger Collection,
New York. Exhib: One-man shows, Rose Fried Gallery, 1958,
La Boetie Gallery, 1968 & Lee Ault Gallery, 1975, New York
& Annely Juda Gallery, London, Eng, 1975-76; The Non-
Objective World, Annely Juda Gallery, London, Galleria
Milan, Milan & Liatowich Gallery, Basle, 1973-74. Media:
Oil, collage; silk screen.

RUNNING DEER, Mary (Mary Lee Townsend). Painter, sculptor.
Born: Ethel, Okla., January 18, 1931. Study: Art Instr
Inc, 1941-43, with Rockwell, Jon Witecomb, Howe, also
with Hutton Webster. Comn: Three oil portraits, Levey's
Dept Store, 1970. Exhib: Wildlife Show, Gallery Am
West, Scottsdale, Ariz, 1971; one-woman show, Mankato
State Col, Minn, 1971; Kermezaar, El Paso Art Mus, 1971-
73; Art Shows, 1972-74 & Sculpture 2, 1974, Heard Mus,
Phoenix, Ariz. Awards: Second Prize Sculpture, 2nd Pima
Co Fair, 1971; First Prize Sculpture, 1973 & First Prize
Oil Painting, 1972 & 1973, White Mountains Fine Arts;
People's Choice Ribbon Sculpture, Pima Co Fair, 1975.
Media: Oil, clay.

RUTHERFORD, Erica. Painter. Born: Edinburgh, Scotland,
February 1, 1923. Study: Royal Acad Dramatic Art;
Slade Sch Fine Art, theatre design with I. V. Pulunin;
Academia, Florence, theatre design with Vangetti. Work:
Corcoran Gallery, Washington, DC; Indianapolis Mus; Mus
Contemp Art, Madrid, Spain; Arts Coun Gt Brit;
Confederation Art Ctr Mus, PEI. Comn: Puppets,
Telegoons, BBC Film Ser; theatre designs, Eng. Exhib:
Leicester Galleries, London, Eng., 1959-64; one-man
shows, Indianapolis Mus, 1969 & Pollock Gallery, Toronto,
Ont., 1975; Landscape Abbreviations, Victoria Art Gallery,
1974; Through the Looking Glass, Ont Gallery Art, 1975.
Awards: Best of Show Award, J. B. Speed Mus Regional
Biannual, 1969; Hon Mention, Brooks Mem Gallery, Memphis,
Tenn, 1972; Colorprint USA Purchase Award, Tex Tech
Univ, 1974. Media: Acrylic, screenprint.

RYERSON, Margery Austen. Painter, etcher. Born: Morristown, NJ. Study: Vassar Col., A.B.; Art Students League, with Robert Henri; also with Charles Hawthorne, Provincetown, Mass. Work: Oil portrait, Vassar Col Gallery, Poughkeepsie; Fr Mus, Seattle, Wash; etchings, Metrop Mus Art, New York; oil portrait, Philbrook Art Ctr, Tulsa, Okla; etching, Bibliot Nat, Paris. Exhib: Allied Artists Am, New York, 1971; NJ Watercolor Soc, Morristown, 1971; Am Watercolor Soc, 1972; Nat Acad Design & Audubon Artists, 1972, New York. Awards: Maynard Prize, Nat Acad Design, 1959; Hook Prize, Am Watercolor Soc, 1962; Silver Medal, Nat Arts Club, 1971. Media: Watercolor, oil.

SABO, Betty Jean. Painter, art dealer. Born: Kansas City, Mo., September 15, 1928. Study: Univ N Mex; also with Randall Davey, Carl von Hassler, Charles Reynolds & Al Merrill. Comn: Baldequino (mural), designed wrought iron & line etchings on windows, St. Bernadettes Cath Church, Albuquerque, 1961; painted windows, Ascension Church, Pojoaque, N Mex, 1963; 15 paintings for children murals, pediatrics ward, St. Joseph's Hosp, 1966. Exhib: N Mex State Mus Bicentennial, Santa Fe, 1968; Albuquerque I, Albuquerque Mus, 1968; Ariz-N Mex Regional Exhib, Phoenix, Ariz, 1970-71; Catharine Lorillard Wolfe Exhib, Nat Acad, NY, 1971 & Nat Arts Club, NY, 1972-73. Awards: Grand Award, N Mex State Fair Prof, 1968 & First Prize Oils, 1970; Purchase Award, Regional Art Exhib, Phoenix, 1970. Media: Oil.

SACHSE, Janice R. Painter, printmaker. Born: New Orleans, La., May 6, 1908. Study: La State Univ, with Albrizio; Newcomb Col, Tulane Univ, with William Woodward. Work: New Orleans Mus Art; Anglo Am Mus of La State Univ; Alexandria Libr Collection, La State Univ. Awards: First Prize, La State Art Comn, 1954; First Bd Dirs Prize, Beaumont Art Mus, 1965; Purchase Prize, La State Bicentennial Art Co, 1974. Media: Oil, watercolor.

SALAMONE, Gladys L. Painter. Born: New York, NY. Work: US Army War Col, Carlisle, Pa; Lobo Arts Theater, Albuquerque; Kirtland AFB Officers Club, N Mex; Albuquerque Nat Bank; Bank of N Mex. Exhib: Ouray Co Art Asn, Colo, 1968-74; Denver Art Mus, 1969; Lawton, Okla Art Coun Int Art Show, 1970-73; Nat Art Show, Pikes Peak Art Asn Colo, 1970-74; Okla Mus Art, 1975. Awards: Best of Show, N Mex Art League, 1970; First Prize in watercolor, Montrose Art League, 1972; First Prize in graphics, N Mex Art League, 1974.

SALEMME, Lucia (Autorino). Painter, writer. Born: New York, NY, September 23, 1919. Study: Nat Acad Design, 1936; Art Students League, 1938. Work: Whitney Mus Am Art; Nat Gallery Art, Washington, DC; Ital Embassy; New York Pub Libr Print Collection. Comn: Mosaic mural, Mayer & Whittlesey, New York, 1958; many portraits, 1959-72; art restoration, Art Students League Painting Collection, New York, 1972. Exhib: One-woman exhibs, Duveen-Graham Gallery, 1956, Loeb Student Ctr, NY Univ, 1962, Grand Cent Mod Gallery, 1964, Dorsky Gallery, 1965 & Fair Lawn Pub Libr, NJ, 1976. Awards: Solomon R. Guggenheim Found Scholar, 1942; MacDowell Colony Fel, 1962. Media: Watercolor, ink.

SAMBURG, Grace (Blanche). Painter, lithographer. Born: New York, NY. Study: Art Students League, painting with Morris Kantor & Raphael Soyer; New Sch for Social Res, stage design & lighting; Contemp Art Gallery Graphic Workshop, with Michael Ponce de Leon; also with Philip Guston. Work: Slide Collection, Mus Fine Arts, Boston. Exhib: One-woman shows, Womens Interart Ctr & Green Mountain Gallery, New York, 1973; Silvermine Guild of Artists Ann, New Canaan, Conn, 1959; ACA Gallery, New York, 1961-63; Works on Paper, Brooklyn Mus, New York, 1975. Media: Oil on canvas.

SANCHEZ, Carol Lee. Painter. Born: Albuquerque, N Mex, January 13, 1934. Study: Radford Sch, El Paso, with Carillo P. Gonzales; Univ N Mex, with Wez Haas, Walter Kuhlman & Kenneth Adams, 1960-63. Comn: Portrait (charcoal), comn by Maurice Bonney, Albuquerque, 1961; portrait (charcoal & conte), comn by N. D. Patterson, S. Africa, 1964; landscape (oil), comn by Hon. E. Lee Francis, Cubero, N Mex, 1966; portrait (conte), comn by Philip Rose, Vt, 1968; landscape with Am Indian symbols (oil), Native Am Studies, San Francisco State Univ, 1976. Exhib: San Francisco Art Festival, 1967 & 1972 & one-man shows, 1973-75. Media: Conte, charcoal, oil.

SANDLER, Barbara. Painter. Born: New York, NY, September 14, 1943. Study: Art Students League, George Bridgeman scholar, 1963, also with Edwin Dickenson & Robert Beverly Hale. Work: Joseph Hirshhorn Mus, Washington, DC; Chase Manhattan Bank; Bicentennial Comt, Smithsonian Inst. Comn: Poster & lithograph for Bicentennial, Spec Proj Group, Chicago, 1975. Exhib: Aspects of Realism, Bernard Danenberg Gallery, New York, 1972 & one-woman show, Re Releases, 1973; Gimpel Weitzenhoffer Gallery, New York, 1974 & one-woman show, 1975; Contemporary American Painting, Lehigh Univ, 1975. Awards: Elizabeth T. Greenshields Mem Found Grant, 1974. Media: Oil on canvas; graphite on paper.

SANDOR, Josephine Beardsley. Sculptor. Born: New York, NY. Study: Grand Cent Sch Art; Columbia Univ Sch Painting & Sculpture, with Oronzio Maldarelli, 5 yrs; Art Students League, with William Zorach & John Hovannes, 3 yrs & Robert Beverly Hale. Exhib: Nat Sculpture Soc, New York, 1961; Audubon Artists, New York, 1962 & 1963; Nat Acad Design, New York, 1963-72; Allied Artists, New York, 1969 & 1974; one-man show, Pen & Brush, 1971. Awards: Sydney Taylor Mem Award for Sculpture, Knickerbocker Artists, 1964, Award of Merit Medal for Sculpture, Knickerbocker Artists, 1964, Award of Merit Medal for Sculpture, 1973; Pen & Brush Solo Award, 1970. Media: Stone, terra cotta.

SCHAFFER, Rose. Painter, lecturer. Born: Newark, NJ. Study: Art Students League, 1935-40, with George Bridgeman & Ivan Oninsky; also with Bernard Karfiol, Sol Wilson, Seong Moy & Antonio Frasconi. Work: Smithsonian Inst, Washington, DC; Norfolk Mus Arts & Sci, Va; Springfield Mus Art, Mass; State NJ Cult Ctr; J. F. Kennedy Libr. Exhib: Nat Acad Design, New York; Boston Mus Art, Mass; Delgado Mus, New Orleans; Brooklyn Mus, NY; Philadelphia Print Club, Pa. Awards: Terry Nat Award, Miami Beach, Fla, 1955; Seton Hall Univ Award, 1956; Two Purchase Prizes, Art for Overlook, 1955-60. Media: Acrylic, oil.

SCHEHTER, Laura Judith. Painter. Born: Brooklyn, NY, August 26, 1944. Study: Brooklyn Col, B.A. (art, cum laude), 1965. Exhib: One-man shows, Green Mountain Gallery, New York, 1971 & Suffolk Co Mus, Stony Brook, 1971; Selections in Contemporary Realism, Akron Art Inst, Ohio, 1974; Davidson Nat Print & Drawing Competition, Davidson Col, 1975; Works on Paper, Brooklyn Mus Print Gallery, 1975; plus others. Awards: Graphics Award, Brooklyn Col, 1965. Media: Oil on masonite; hard pencil or silver point on paper.

SCHILLER, Beatrice. Painter, graphic artist. Born: Chicago, Ill. Study: Inst Design; Ill Inst Technol; Art Inst Chicago; also with Richard Florsheim, Jack Kearney, Herbert Davidson; Kwak Wai Lau & Stanley Mitruk. Work: Standard Oil Bldg, Chicago; Excel Packing Co, Wichita, Kans. Exhib: Nat Exhib Small Paintings, Purdue Univ, West Lafayette, 1964; 17th Ann Nat Exhib Realistic Art, Mus Fine Arts, Springfield, Mass, 1966; Art Inst Chicago Art Rental & Sales Gallery, 1966-; Butler Inst Am Art, Youngstown, Ohio, 1967; New Horizons in Sculpture & Painting, Chicago, 1970. Awards: Honorable Mention, Munic Art League Chicago, 1971; Honorable Mention, Chicago Soc Artists, 1974; Honorable Mention, Munic Art League, 1974; plus others. Media: Watercolor, graphic, acrylic.

SCHLEMM, Betty Lou. Painter. Born: Jersey City, NJ, January 13, 1934. Study: Phoenix Sch Design, New York, scholar; Nat Acad Design, New York, scholar. Work: USN; also in many pvt collections. Exhib: Am Watercolor Soc; Butler Inst Am Art; Nat Acad Design; Allied Artists Am; Audubon Artists. Awards: Silver Medal, Am Watercolor Soc, 1964; Gold Medal, Hudson Valley Art Asn, 1965; Robert Lehman Travel Grant, Washington Sq Outdoor Art Exhib, 1967. Media: Transparent watercolor.

SCHLOSS, Edith. Painter, art critic. US citizen. Study: Art Students League. Exhib: Assemblage, Mus Mod Art, New York, 1961; Women in Art, Stamford Mus, Conn, 1972; one-woman shows, Il Segno, Rome, 1968 & 1975, Green Mountain Gallery, 1970, 1972 & 1974, Am Acad Rome, 1971 & Ingber Gallery, 1974 & 1975. Media: Watercolor, oil.

SCHNEIDER, Jo Anne. Painter. Born: Lima, Ohio, December 4, 1919. Study: Sch Fine Arts, Syracuse Univ. Work: Butler Inst Am Art, Youngstown Ohio; Syracuse Univ; Allentown Mus, Pa; St. Lawrence Univ; Neuberger Mus, Purchase, NY. Exhib: Corcoran Gallery Art; Whitney Mus Am Art Ann; 50 Years of American Art, Am Fedn Art, 1964; Childe Hassam Fund Exhib, Am Acad Arts & Lett, 1971; plus one-man exhibs, 1954-. Awards: First Prize, Guild Hall, 1967; Marion K. Haldenstein Mem Prize, Nat Asn Women Artists, 1970; Stanley Grumbacher Mem Award, Audubon Artists, 1972. Media: Oil.

SCHREIBER, Eileen Sher. Painter, lecturer. Born: Denver, Colo. Study: Univ Utah, 1942-45; NY Univ Exten, 1966-68; Montclair State Col, 1975. Work: Morris Mus Arts & Sci, Morristown, NJ; Seton Hall Univ; Bloomfield Col; Morris Co State Col; Hunterdon Art Ctr, Clinton, NJ; also in collection of Sen. Harrison Williams, NJ. Comn: Painting on NJ beach area, Broad Nat Bank, Newark, 1970; Wolfgang Rapp Architects, Elkins Park, Pa, 1972; Lanza Indust, 1974. Exhib: NJ Mus in Trenton, 1969 & 1973; Am Watercolor Soc Nat, Nat Acad Galleries, New York; Audubon Artists, New York; Pallazzo Vecchio, Florence, Italy; Va State Mus, 1975; plus others. Media: Collage, acrylic, watercolor.

SCHREYER, Greta L. Painter, lecturer. Born: Vienna,
Austria, July 28, 1923; US citizen. Study: Acad Arts,
Vienna; Columbia Univ, with Seong Moy; Art Students
League; Pratt Inst; also with Moses Soyer & Fred Taubes.
Work: Mus Ha'aretz, Tel Aviv, Israel; Jersey City State
Col; New Sch Social Res, New York; Pasadena Mus, Calif;
Mus Art & Sci, Norfolk, Va. Exhib: Four shows, New
Sch Art Ctr, New York, 1960-68; Knickerbocker Artists,
New York; one-man shows, St. Olaf Col, 1966 & Panama
Art Asn, Fla, 1967; Roko Gallery, New York, 1972.
Awards: Grumbacher Awards, 1956 & 1969. Media: Oil,
watercolor, lithography.

SCHULLER, Grete. Sculptor. Born: Vienna, Austria; US
citizen. Study: Vienna Lyzeum; Vienna Kunstakademie;
Art Students League, sculpture with W. Zorach; Sculpture
Ctr, New York. Work: Norfolk Mus Arts & Sci, Va; Mus
Natural Hist, New York; Mus Sci, Boston. Exhib: Acad
Arts & Lett, 1955; Univ Notre Dame, 1959; Detroit Inst
Arts, 1959-60; Pa Acad Fine Arts, Philadelphia, 1959-60;
150 Years American Art, New Westbury Garden, NY, 1960;
plus many others. Awards: Pauline Law Prize, Allied
Artists Am, 1972; Roman Bronze Foundry Prize, Nat
Sculpture Soc, Lever House, 1973, Bronze Medal, 1975;
Goldie Paley Prize, Nat Asn Women Artists, 1975; plus
others. Media: Stone.

SCHULTZ, Caroline Reel. Painter, lecturer. Born:
Evansville, Ind., July 5, 1936. Study: Art Ctr Col
Design, Los Angeles, 1958; Univ Ill-Urbana, 1960-62;
Wellfleet Sch, with W. Kennedy, 1960; Art Mart Sch,
Martha's Vineyard; European Sch, Mallorca, Spain, 1961;
also with Nichola Ziroli & Billy M. Jackson. Work: Mt.
Kenya Safari Club, E Africa; Pavillon, Scottsdale, Ariz;
New Masters, Carmel, Calif; Bruners Fine Art, Santa
Rosa, Calif. Comn: Wildlife (screen), comn by John
Batten, III, Twin Disc Corp, Racine, Wis, 1975. Exhib:
One-woman shows, San Diego Art Inst, Balboa Park, Calif,
E African Wild Life Asn Gallery, Nairobi, Kenya, La
Jolla Art Asst, Calif; Game Coin, San Antonio, 1975;
Shikar Safari Club 1975, San Diego Zoo, 1975; Safari Int,
Las Vegas, 1976; Abercrombie & Fitch, San Francisco,
1976. Awards: Purchase Award, Comedians Classic, 1972;
three Awards, Palm Springs Festival Arts & Music, 1971
& 1972; Lenten Art Festival, San Diego, 1972. Mem:
San Diego Art Inst; La Jolla Art Asn; Desert Art Ctr,
Palm Springs, Calif.

SCHULZ, Cornelia. Painter. Born: Pasadena, Calif., October 21, 1936. Study: Los Angeles Co Art Inst, 1956-58; San Francisco Art Inst, B.F.A., 1960, M.F.A., 1962. Exhib: Contemp Calif Sculpture, Oakland Art Mus, Kaiser Ctr, 1963; Univ Art Mus, Univ Calif, Berkeley, 1972; Mills Col Art Gallery, Oakland, Calif, 1974; Hansen-Fuller Gallery, San Francisco, 1975; North, East, West, South & Middle, Contemp Am Drawings, Moore Col Art, Philadelphia, 1975. Awards: Soc Encouragement of Contemp Art Grant, 1975. Media: Enamel paint on canvas.

SCHWALBACH, Mary Jo. Painter, sculptor. Born: Milwaukee, Wis., July 8, 1939. Study: Pine Manor Jr Col, A.A.; Univ Wis, B.S.; NY Univ Inst Fine Arts; Sch Visual Arts; also in Paris & Rome. Work: Univ Calif Mus, Berkeley; Jazz Mus, New York; Kellogg State Bank, Green Bay, Wis; Am City Bank, Menomonee Falls, Wis; Kimberly State Bank, Wis. Comn: Sculpture, 1st Fed Savings & Loan, Menomonee Falls, 1969; three hockey sculptures, Philadelphia Flyers, The Spectrum, Philadelphia, 1970; sculpture of Mario Andretti, Clipper Mag, New York, 1972. Exhib: One-man shows, Rhoda Sande Gallery, New York, 1969, West Bend Mus Fine Arts, Wis, 1969 & Dannenberg, New York, 1972; retrospective, Bergstrom Mus, Neenah, Wis, 1970; Beyond Realism, Upstairs Gallery, East Hampton, NY, 1972. Media: Mixed media.

SCHWARTZ, Barbara Ann. Painter, writer. Born: Philadelphia, Pa., August 23, 1948. Study: Carnegie-Mellon Univ, B.F.A. Exhib: Marion Locks Gallery, Philadelphia, 1972; Brooklyn Mus, NY, 1974; Whitney Biennial Exhib Contemp Am Art, 1975; Artists Space, New York, 1975; John Doyle Gallery, Chicago, 1975.

SCHWARTZ, Therese. Painter, writer. Born: New York, NY. Study: Corcoran Sch Art, Washington, DC; Am Univ; Brooklyn Mus Art Sch. Work: Corcoran Gallery Art; Howard Univ; Fred C. Olsen Found; Ciba-Geigy Corp; Barnet Aden Collection. Comn: Traveling Watercolor Show, Howard Univ under Cong grant, Southern univs & mus, 1953-54. Exhib: Phillips Mem Gallery, 1954; Mus Art Mod, Paris, 1956; Univ NC, 1969; Stanford Mus, Conn, 1972; Suffolk Co Mus, 1972. Awards: Second Prize for Oils, Corcoran Gallery Art Regional Show, 1952; New Talent USA Award, Art Am, 1962, Women Artists Year Three, Mabel Smith Douglass Libr, Rutgers Univ, 1973.

SCHWARTZ, Gladys. Painter. Born: New York, NY. Study:
Art Students League, with George Grosz; Pratt Graphic
Workshop; Blackburn Graphic Workshop. Work: Collectors
Am Art; plus several pvt collections. Comn: Series of
rehearsal drawings for Broadway plays comn by producers,
Raisin in the Sun, 1958-59 & The Sign in Sidney Brusteins
Window, 1964. Exhib: Butler Inst Am Art, Youngstown,
Ohio, 1969; one-woman shows, Ella Lerner Gallery, New
York, 1970, Damon Runyon-Winchell Gallery, New York, 1975
& Heritage Gallery, Los Angeles; 13th Ann Nat Print &
Drawing Exhib, Okla Art Inst, 1971; Graphic Nat Print &
Drawing Exhib, West N Mex, 1971. Awards: Hon Mention,
5th Ann Nat Print Exhib, Springfield, Mass, 1972.

SCHWEISS, Ruth Keller. Sculptor, designer. US citizen.
Study: Wash Univ, St. Louis, fine arts cert; Cranbrook
Art Acad, Bloomfield Hills, Mich, three yr int fel,
sculpture with Carl Milles. Work: Cranbrook Art Mus;
plus many pvt collections. Comn: Life size garden
sculpture, comn by Lawrence Roos, St. Louis, 1965; bear
for pool garden, comn by J. A. Baer, II, St. Louis, 1970;
Blachette (six ft. bronze), Founder Monument, St. Charles,
Mo, 1972; Children in the Rain, Ger Coun, Hamm, Ger,
1973; Sons of Founders (bronze reliefs), Stix, Baer &
Fuller, St. Louis, 1975. Exhib: Nat Acad Design, New
York, 1943; Detroit Art Mus Regional Show, Mich, 1943;
Pacific Show, Hawaiian Art Mus, Honolulu, 1944; Int Art
Show, Rotunda Gallery, London, 1973; Ars Longa Gallery,
Houston, 1974. Awards: Mus Purchase Prize, Cranbrook
Art Mus, 1942; Ruth Renfrow Sculpture Prize, St. Louis
Art Mus, 1945; Thalinger Sculpture Prize, St. Louis
Artists Guild, 1950. Media: Bronze castings of limited
editions from any carved or modeled medium.

SCOTT, Martha (Fitts). Printmaker, sculptor. Born:
Washington, DC, November 11, 1916. Work: Jewish
Community Ctr, Cleveland, Ohio; Cooperstown Art Asn, NY.
Exhib: Artists of the Western Reserve Traveling Exhib,
Cleveland Mus Art, 1965; one-woman exhib, Baltimore Mus
Art, 1969; Nat Exhib Prints & Drawings, Okla Art Ctr,
1969-74; Nat Print Exhib, Hunterdon Art Ctr, Clinton,
NJ, 1971, 1973 & 1975; 2nd Miami Graphics Biennial, Int
Print Exhib, Fla, 1975. Awards: First Prize Award,
Md Inst Art, 1936; Purchase Prize & Awards, Jewish
Community Ctr, Cleveland, 1962, 1963, 1964; Purchase
Prize, Cooperstown Art Asn, 1967. Media: Etching,
aquatint, intaglio.

SCURIS, Stephanie. Sculptor, educator. Born:
Lacedaemonos, Greece, January 20, 1931. Study: Sch Art
& Archit, Yale Univ, B.F.A. & M.F.A., with Josef Albers.
Work: Jewish Community Ctr, Baltimore, West View Ctr,
Baltimore. Comn: Sculpture, Bankers Trust Co, New York;
lobby sculpture, Cinema I & II, New York. Exhib: New
Haven Art Festival, 1958-59; Art: USA Traveling Exhib,
1958 & 1960; Mus Mod Art, New York, 1962; Whitney Mus Am
Art, New York, 1964; plus others. Awards: Winterwitz
Award, Prize for Outstanding Work & Alumni Award, Yale
Univ; Peabody Award, 1961-62; Rinehart Fel, 1961-64.

SELONKE, Irene A. Painter. Born: Chicago, Ill,
September 4, 1910. Study: Art Inst Chicago; Kansas City
Art Inst; also with Joseph Fleck, Taos, N Mex & Olga
Dormandi, Paris, France. Work: Ralph Foster Mus, Point
Lookout, Mo; Gill Studios, Olatha, Kans; Johnson Co Nat
Bank, Prairie Village, Kans; Golden Ox, Washington, DC;
Mo State Hist Soc. Comn: Tron furs, Sylvan Tron,
Kansas City, 1960; hist mural, comn by Mr. & Mrs. Dave
Lorenz, Platt Woods, Mo, 1966. Exhib: Coun Am Artists,
Lever House, New York, 1964; Nat League Am Pen Women
Biennial State Show, St. Louis, Mo, 1965; Nat League Am
Pen Women Nat Exhib, Salt Palace, Salt Lake City, 1969;
All Western Art Exhib, Ellensberg, Wash, 1973; W Tex
Watercolor Exhib, Lubbock, 1975. Awards: Nat League Am
Pen Women, 1962-69; Greater Kansas City Art Asn, 1962-68;
Pikes Peak Nat Award, 1972. Media: Watercolor, oil.

SELTZER, Phyllis. Printmaker, painter. Born: Detroit,
Mich., May 17, 1928. Study: Univ Iowa, B.F.A. & M.F.A.;
Lasansky's Workshop, sr study hist of technol, with M.
Kranzberg. Work: Brooklyn Art Mus; Cleveland Mus Art;
Minn Mus Art, Minneapolis; Nat Gallery Art, Ottawa, Ont;
Butler Mus, Youngstown, Ohio. Comn: Bicentennial print,
Cleveland Area Arts Coun, 1975; ed of 25, Exodus print,
Cleveland Health Dept. Exhib: Davidson Nat Print &
Drawing 1973; Cleveland Mus Art May Show, 1973 & 1974;
19th Nat Print Exhib, Brooklyn Mus, 1974; Focus, Mich
Artists, Detroit Art Inst, 1974; A.A.A., New Talent in
Printmaking, New York, 1975. Awards: Tiffany Fel, 1952;
Painting Award, Walker Mus, 1961; Purchase Award,
Brooklyn Mus 19th Nat, 1975. Media: Ozalid, silkscreen;
acrylic on canvas.

SEMMEL, Joan. Painter. Born: New York, NY, October 19, 1932. Study: Cooper Union, dipl, 1952; Art Students League, with Morris Kantor, 1958-59; Pratt Inst, B.F.A., 1963, M.F.A., 1972. Work: Mus Mod Art, Seccion Contemporaneo, Barcelona, Spain; Mus Plastic Arts, Montevideo, Uruguay; Mus Contemp Art, Ibiza, Spain, Pratt Inst & Alan Stone Collection, New York. Exhib: Salon de Mayo, Barcelona, Spain, 1965; Concurso Nac, Madrid, 1967-69; Contemporary Reflections, Larry Aldrich Mus, Ridgefield, Conn, 1974; Sons & Others, Queens Mus, New York, 1975; two-person show, Soho Visual Arts Ctr (Larry Aldrich Mus), 1975. Awards: Off Educ EPDA Fel, 1970-72; Creative Artists Pub Serv Prog Award, NY State Coun on Arts, 1975-76. Media: Oil.

SENSEMANN, Susan. Painter, educator. Born: Glencove, NY, October 6, 1949. Study: Syracuse Univ, NY, B.F.A. (printmaking, magna cum laude), 1971; Tyler Sch Art, Rome, Italy, spring 70 & Tyler Sch Art, Temple Univ, M.F.A. (painting), 1973. Work: Southern Ill Univ, Carbondale; Univ Del, Newark; Univ Rochester, NY; Quincy Art Ctr, Ill; Guild Creative Art, Shrewsbury, NJ. Exhib: Ball State Small Sculpture & Drawing Exhib, Muncie, Ind, 1973-74; US Info Serv Gallery, Ankara, Turkey, 1974; Mid States Exhib, Evansville Mus Arts & Sci, 1974; 28th Ann, Ill State Mus, Springfield, 1975; Works on Paper, Waterloo Munic Gallery, Iowa, 1975. Awards: Purchase Award, Univ Del, 1973; Purchase Award, Quincy Art Ctr, 1974; Purchase Award, Southern Ill Univ, 1975. Media: Oil, egg tempera.

SHECTER, Pearl S. Painter. Born: New York, NY, December 17, 1910. Study: Hunter Col, B.F.A.; Columbia Univ, M.F.A.; Hans Hofmann Sch Painting; Archipenko Sch Art, New York; New Bauhaus Sch Design, with Moholy-Nagy; Acad Grande Chaumiere, Paris. Work: NY Univ; John F. Kennedy Libr; Miami Univ, Ohio; Int Rels Found, New York; also in many pvt collections. Exhib: Walker Art Ctr, Minn, 1963; Carnegie Endowment Ctr, New York, 1963; Lehigh Univ, Allentown, Pa, 1967; Mfs Hanover Trust Bank, 1970 & 1971; Union Carbide Gallery, New York, 1972 & 1975. Awards: Carnegie Found Grant, 1950; Gold Medal, Patronato Scholastico Arti, Italy, 1963. Media: Acrylic, gold leaf, collage.

SHEEHAN, Evelyn. Painter. Born: Hymera, Ind., December 27, 1919. Study: Scripps Col, with Jean Ames; also study with Phil Dike & Rex Brandt. Work: Lytton Collection, Los Angeles; Calif Bank, San Francisco; Mus Art, Univ Ore, Eugene; Tacoma Bank, Wash; Automatic Sales Co, Portland, Ore. Exhib: 144th Ann Exhib, Nat Acad Design, New York, 1969; Spokane Ann Art Exhib, Cheney-Cowles Mus Art, Wash, 1969; Watercolor USA, Springfield Art Mus, Mo, 1970; 32nd Ann Northwest Exhib, Seattle Art Mus, Wash, 1971; one-man show, Mus Art, Univ Ore, Eugene, 1971. Awards: Top Cash Award, Nat Soc Painters in Casein, 1967; Lytton Purchase Award, Watercolor USA, 1967; Mo Award, 32nd Ann Nat Watercolor Soc, 1971. Media: Water-based media for painting; collage.

SHEEHE, Lillian Carolyn. Painter. Born: Conemaugh, Pa., October 16, 1915. Study: Indiana Univ Pa, B.S. (art); ceramics & sculpture with Sheldone Grumbling, majolica with Hugh Geise & painting & sculpture with George Ream. Work: Court of Gabrielle (serigraph), David Glosser Libr; Trees at Christmastime in California (serigraph), Flood Mus; 130 glass-fired paintings & sagged bottle collection, C of C, Johnstown, Pa. Comn: Golf mural, J. Cover, Johnstown, Pa, 1944; designed & printed Christmas cards, Pa Rehab Ctr & Bur Voc Rehab, 1959-71; emblem design, Lee Hosp Rehab Med Dept, 1966; landscape mosaic, Mrs. Lyn Hoffman, 1970; art calendar, Allied Artists Am, 1971. Exhib: All Allied Artists Shows, 1936-; Pittsylvania Ceramic Guild All-Pa Competition, 1964-71; Three Rivers Arts Festival, 1965 & 1966; Allied Artists Graphic Arts Show, 1970; Sheraton '75. Awards: Purchase Award, 1961 & Allied Artists Best of Show, 1970, US Bank Show; Phoebe Jerema Award, Pittsylvania Ceramic Guild, 1971; David Glosser Libr Craft Award, 1973. Media: Fired glass, oil, copper enameling.

SHEETS, Nan Jane. Painter. Born: Albany, Ill. Study: Valparaiso Univ; Univ Utah; Broadmoor Art Acad; also with John F. Carlson, Robert Reid, Everett L. Warner, Birger Sandzen & Hugh H. Breckenridge. Work: Springfield Art Asn, Mo; Okla Art Ctr, Oklahoma City; Univ Okla Art Mus, Norman; Philbrook Art Ctr & Mus, Tulsa, Okla; Cowboy Hall of Fame & Western Heritage Ctr, Oklahoma City. Exhib: Midwestern Artists Traveling Show, Am Fedn Arts, 1923; Artists US, Brooklyn Mus, 1928; Woman's Int Exhib, Detroit, 1929; Off Exhib, New York World's Fair, 1939 & 1940; Coronado Cuarto Centennial Expos, Albuquerque, N Mex, 1940. Awards: Birger Sandzen Prize for Best Landscape, Broadmoor Art Acad, 1923; Purchase Prize, Midwestern Art Exhib, 1924; Mrs. Adolph Wagner Prize, Witte Mem Mus, 1929. Media: Oil.

SHERBELL, Rhoda. Sculptor, collector. Born: Brooklyn, NY. Study: Art Students League, with William Zorach; Brooklyn Mus Art Sch, with Hugo Robies; study in Italy & France. Work: The Dancers, Okla Mus Art, Oklahoma City; The Flying Acrobats, Colby Col Art Mus, Waterville, Maine; Sculpture Garden, Stony Brook Mus, NY. Comn: Marguerite & William Zorach Bronze, Nat Arts Collection, Smithsonian Inst, Washington, DC, 1964; Casey Stengel, Country Art Gallery Long Island, Baseball Hall of Fame, Cooperstown, NY; Yogi Berra, comn by Percy Uris. Exhib: Pa Acad Fine Arts & Detroit Inst Art, 1960; Am Acad Arts & Lett, 1960; Brooklyn Mus Art Award Winners, 1965; Nat Acad Design & Heckscher Mus Show, 1967; Retrospective Sculpture & Drawing Show, Huntington Hartford Gallery, New York, 1970. Awards: Am Acad Arts & Lett & Nat Inst Arts & Lett Grant, 1960; Ford Found Purchase Award, 1965; Louis Comfort Tiffany Found Grant, 1966. Media: Bronze.

SHERMAN, Lenore (Walton). Painter, lecturer. Born: New York, NY, May 11, 1920. Study: With Leon Franks, Hayward Veal, Orrin A. White & Sergei Bongart, watercolor with James Couper Wright & portrait with Eignar Hansen. Work: San Diego Law Libr; Chateaubriand Restaurant, San Diego; var banks. Exhib: San Diego Art Inst 18th Ann, 1971; Mission Valley Expos Art, Calif, 1967; Rancho Calif, 1970-71; Southern Calif Expos, Del Mar, Calif, 1970-72; Calif Fed Women's Club Fine Arts Festival, 1971. Awards: First Award for Oils, San Diego Landmarks Theme, Southern Calif Expos, 1970; First Award for California Landmarks & Second Award for Still Life, Calif Fedn Clubs Fine Arts Festival, 1971; Purchase Award, San Diego Art Inst 18th Ann, 1971.

SHERWOOD, A. (Frances Ann Crane). Sculptor, printmaker. Born: Birmingham, Ala., September 12, 1932. Study: Univ Fla; Hampton Inst; Wesley Col; Del State Col; Univ Philippines; Okaloosa Walton Col, Niceville, Fla; Univ W Fla, Pensacola. Work: Lilliputian Found, Washington, DC; Acad Art, Easton, Md; USN; USAF; Mobile Art Gallery, Ala. Comn: Oil paintings, Phillips Sch, Hampton, Va, 1966, Col. & Mrs. W. O. Brimberry, 1967 & Mrs. Lenora Whitmire Blackburn, 1974-75. Exhib: Norfolk Mus, Va, 1966 & 1967; Va Mus Fine Arts, Richmond, 1967; Audubon Soc, Washington, DC, 1969; Royal Art Gallery, Manila, Philippines, 1972; Meat Packers Gallery, Pensacola, 1974. Awards: Atlantic City Nat Art Show, NJ, 1968 & 1969; Mobile Art Fair, Ala, 1973 & 1974; Billy Bowlegs Art Festival, Ft. Walton Beach, Fla, 1973, 1974 & 1975.

SHORE, Mary. Painter. Born: Philadelphia, Pa., March 19, 1912. Study: Cooper Union Art Sch, scholar; Art Inst Chicago. Work: Addison Gallery Am Art, Andover, Mass; Fitchburg Art Mus, Mass; Baltimore Art Mus. Exhib: One-man shows, Norlyst Gallery, New York, 1949, Lyceum, Havana, Cuba, 1950, De Cordova Mus, Lincoln, Mass, 1956 & 1957, Boris Mirski Gallery, Boston, 1964; Philadelphia Art Alliance, 1965, Fitchburg Art Mus, 1965, Hilliard Gallery, Martha's Vineyard, Mass, 1971, Pingree Sch Gallery, Hamilton, Mass, 1972, Stockbridge Sch Gallery, 1972 & Horizon Gallery, 1975; Traveling Assemblage Exhib, Mus Mod Art, US & Can, 1963. Awards: Blanche E. Colman Art Found Award, 1966.

SIEGEL, Irene. Painter. Born: Chicago, Ill. Study: Northwestern Univ, B.S.; Univ Chicago; Ill Inst Technol Inst Design, Moholy-Nagy scholar, 1954, MS. Work: Art Inst Chicago; Mus Mod Art, New York; Los Angeles Co Mus; World Bank, Washington, DC; Pasadena Mus, Calif. Exhib: Drawing Soc Show, Mus Fine Arts, Houston, Tex, 1965; Form & Fantasy, Am Fedn Art, 1969; Tamarind Prints, Mus Mod Art, 1969; Soc Contemp Art, Art Inst Chicago, 1971; Relativerend Realisme, Van Abbemuseum, Eindhoven, Holland, 1972. Awards: Mr. & Mrs. Frank Logan Prize, 1966; Tamarind Fel, Ford Found, 1967.

SILBERSTEIN, Muriel Rosoff. Instructor, painter. Born: Brooklyn, NY. Study: Carnegie Inst Technol, B.F.A.; Philadelphia Mus Art, with Hobson Pitman; Inst Mod Art, with Victor D'Amico, Donald Stacy & Jane Bland. Comn: Prog drawings, Philadelphia Symphony Orch Children's Concerts, 1949; murals & other projs, Mt. Sinai Hosp & Philadelphia Psychiat Hosp. Exhib: Jewish Community Ctr Group Show, 1971-72; one-woman show, Panoras Gallery, New York, 1972; Pacem in Terris Gallery, NY, 1975. Awards: Woman of Achievement, Staten Island Advan, 1967; Achievement Award, Lambda Kappa Mu Sorority. Media: Assemblage, collage.

SILINS, Janis. Painter. Born: Riga, Latvia, June 1, 1896; US citizen. Study: Univ Moscow; Riga Univ, M.A. & Ph.D.; Univ Stockholm; Univ Marburg; Art Sch Ilya Mashkov, Moscow; Art Sch Kazan. Work: Univ Art Collection, Riga; Art Mus Jelgava, Latvia. Exhib: One-man shows, Wurzburg, Ger, 1946 & Yonkers, NY, 1968 & 1969; Exhib Artists in Exile, Stuttgart, Ger, 1948; Ringling Mus Art, Sarasota, 1963; Latvian Exhib Arts & Crafts, Boston, 1964; Latvian Artist Group New York, 1967. Awards: Order of Three Stars, Govt Latvia, 1936; Kriskian Baron Award, Riga Univ, 1937. Media: Oil, watercolor.

SIMMONS, Cleda Marie. Painter. Born: Douglas, Wyo., June 24, 1927. Study: Univ N Mex, Albuquerque, with Ralph Douglas & Raymond Jonson; studied seven yrs in Madrid, Spain. Work: Ateneo de Belles Artes, Madrid; Pan Am Gallery, San Antonio, Tex. Exhib: USIS Traveling Show, Mus Mod Art, Paris & Madrid, 1953; one-woman shows, Ateneo de Belles Artes, 1954 & Roswell Art Mus, N Mex, 1961; two-woman show, Jonson Gallery, Univ N Mex, 1956; Detroit Art Inst, 1964. Media: Acrylic, ink.

SIMON, Helene. Sculptor. Born: Bagdad, Iraq; US citizen. Study: Bedford Col, London; Am Univ, Beirut, Lebanon; Islamic Art with Mary Devonshire, Cairo, Egypt; painting with Anthony Toney & Jacob Lawrence; New Sch, sculpture with Lorrie Goulet. Work: Phoenix Art Mus, Ariz; Jewish Mus, New York; Hirshhorn Mus, Washington, DC; NY Univ Art Collection, New York; Fordham Univ Art Collection, Bronx; also in pvt collections, Paris, London, Teheran, Iran & Milan, Italy. Exhib: One-man shows, Bodley Gallery, New York, 1971 & 1973, Fordham Univ, 1975; Sculptors 9, Caravan House, New York, 1971; Stable Gallery, Scottsdale, Ariz, 1973. Media: Marble, bronze.

SINAIKO, Suzanne Fischer. Illustrator, painter. Born: Brussels, Belg., March 23, 1918; US citizen. Study: Social serv schs, Brussels; Columbia Univ; art schs, New York; with Hans Hofmann; Turtle Bay Sch Music, New York, art ther. Work: Soldiers Home, Jerusalem. Exhib: Provincetown Art Asn; one-man show, Galery L'Angle Aigu, Brussels; Artists Equity Gallery; Acad Europ des Arts, Namur, Belg; Riverdale Temple, NY. Media: Oil, watercolor.

SINGER, Esther Forman. Painter, art critic. Born: New York, NY. Study: Art Students League, 1940-41; Temple Univ, 1941-44; NY Univ, 1947-49; New Sch Social Res, 1968-70. Work: NJ State Mus, Trenton; Finch Mus Contemp Art, New York; Hudson River Mus, Yonkers, NY; Seton Hall Univ Collection, South Orange, NJ; Bloomfield Col Mus Collection. Exhib: Kenosha Pub Mus, Wis, 1970; Brandeis Univ, 1973; Ft. Hood Spec Serv, 1974; Women Artists, Newark Pub Libr, 1975; J. F. K. Mem Libr, Piscataway, NJ, 1975; plus many other group & one-man shows. Awards: Nat Design Ctr Award for Contemp Art, 1966; First Prize for Oils, Roseland Festival Art, 1966, 1967 & 1968 & Summit Art Ctr-Collage, 1968. Media: Oil, acrylic, mixed media.

SINNARD, Elaine (Janice). Painter, sculptor. Born: Ft.
Collins, Colo, February 14, 1926. Study: Art Students
League, 1948-49, with Reginald Marsh; NY Univ, 1951,
with Samuel Adler; also with Robert D. Kaufmann, 1951;
Sculpture Ctr, 1955, with Dorothea Denslow; Acad Grande
Chaumiere, Paris, 1956; also with Betty Dodson, 1960.
Comn: Five wall hangings (with Mrs. Cris Darlington,
Marlin Studios), Scandinavian Airline, New York, 1961;
three oil paintings, Basker Bldg Corp 5660, Miami Beach,
Fla., 1970. Exhib: City Ctr Gallery, New York, 1954;
Riverside Mus 8th Ann, New York, 1955; 1st Ann Metrop Young
Artists, Nat Arts Club, New York, 1958; one-woman shows,
Ward Eggleston Galleries, New York, 1959 & Fairleigh
Dickinson Univ, NJ, 1960. Media: Oil.

SKINNER, Clara (Clara Skinner Guy). Painter, printmaker.
US citizen. Study: Univ Southern Calif; Art Students
League; also with Hans Hofmann. Work: Metrop Mus Art
Print Collection, New York; San Francisco Mus Art;
Cleveland Mus Art; Olson Found Collection; Walter
Chrysler Found Collection. Exhib: 50 Best American
Prints Traveling Exhib, Am Fedn Arts, 1935; Mod Mus
Moscow, Russia, 1940; Responsive Eye, Mus Mod Art, New
York, 1965; one-man show, Castallone Gallery, 1968.

SKLAR-WEINSTEIN, Arlene (Joyce). Painter, printmaker.
Born: Detroit, Mich., October 25, 1931. Study: Parsons
Sch Design; Mus Mod Art, New York scholar & with
Bernard Pfreim; Albright Art Sch; NY Univ, with Hale
Woodruff, B.A., 1952, M.S. (art educ), 1955; Pratt
Graphics Ctr, with Andrew Stasik; Ctr for Understanding
Media, film making, 1974. Work: Mus Mod Art, New York;
New York Pub Libr Permanent Print Collection; Grace
Gallery, New York City Community Col, Brooklyn; Hudson
River Mus Permanent Collection, Yonkers, NY; Mfrs
Hanover Trust Co, Mount Vernon, NY. Exhib: Regional
graphics, Albright-Knox Gallery, Buffalo, NY, 1952; The
Visionaires, East Hampton Galleries, New York, 1968;
Yonkers Art Asn Regional, Hudson River Mus, 1970 & 1971;
Nat Asn Women Artists Nat, Lever House, New York, 1972;
one-man shows, Evolutions, Hudson River Mus, 1971 &
West Broadway Gallery, 1972, 1973 & 1975. Awards:
Geigy Award for Painting, Ciba-Geigy Corp, 1969; First
Prize, Hudson River Mus Regional, Yonkers Art Asn, 1971;
Print Competition Award, Gestetner Corp, 1971. Media:
Acrylic.

SLAVIN, Arlene. Painter. Born: New York, NY, October 26, 1942. Study: Cooper Union, B.F.A.; Pratt Inst, M.F.A. Exhib: Whitney Biennial Contemp Art, 1973; Am Drawings 1967-1973, Whitney Mus; Women Choose Women, New York Cult Ctr, 1973; one-woman shows, Janie C. Lee Gallery, Tex, 1973 & Fischbach Gallery, 1973 & 1974; Painting & Sculpture Today, Cincinnati Contemp Art Ctr, 1974. Media: Acrylic on canvas, hand-colored prints.

SLEIGH, Sylvia. Painter, instructor. Born: Llandudno, Wales. Study: Brighton Sch Art, Eng. Exhib: One-artist shows, Bennington Col, Vt, 1963, Soho 20 Gallery, 1973, Fine Arts Ctr, Univ RI, Kingston, 1974 & AIR Gallery, 1974; Tokyo Int Biennial: New Images in Painting, 1974. Media: Oil on canvas.

SLIDER, Dorla Dean. Painter. Born: Tampa, Fla., September 9, 1929. Study: Study with Walter Emerson Baum, 1940-48. Work: Hartford Ins Group, Conn; Marietta Col, Ohio; Plymouth Meeting Mall Asn, Pa; Philco Corp, Pa. Exhib: Am Watercolor Soc, Nat Acad Design, New York, 1967-75; Allied Artists of Am, Nat Acad Design, 1967-74; Pa Acad Fine Arts, Philadelphia, 1969; Audubon Artists, Nat Acad Design, 1972-74; William Penn Mus, Harrisburg, Pa, 1975. Awards: Gold Medal, Catharine Lorillard Wolfe Art Club, Nat Acad Design, New York, 1970; Award of Excellence, Mainstreams Int, Ohio, 1971; Herb Olsen Award, Am Watercolor Soc, New York, 1972.

SMITH, Thelma Degoede. Painter, teacher. Born: Los Angeles, Calif., May 5, 1915. Study: Calif State Univ, Los Angeles, B.A. (with hons); Calif State Univ, Fullerton, M.A. Work: Long Beach Mus Art, Calif; Downey Mus Art, Calif; Ill State Univ; Nat Orange Show Hq, San Bernardino, Calif; Hunt Foods Inc Collection, Fullerton. Exhib: All Calif Purchase Prize Exhib, Laguna Beach Mus Art, 1969-71; Calif Hawaii Regional, San Diego Mus Art Fine Arts Gallery, 1971, 1972 & 1974; one-woman show, Loma Linda Univ, 1971 & Palos Verdes Mus Art, 1974; All Calif Exhib, Palos Verdes Mus Art, 1973-74; American Painters in Paris, New Conv Ctr, 1976. Awards: Best of Show, First Award & Purchase Prize, 13th Ann Art Unlimited, Downey Mus Art, 1970; Purchase Award, 16th All Calif Competition, Laguna Beach Mus Art, 1970; First Purchase Prize, Nat Orange Show, San Bernardino, 1971 & 1974. Media: Acrylic.

SONNENBERG, Frances. Sculptor, instructor. Born:
Brooklyn, NY, September 17, 1931. Study: With Prof
Alfred Van Loen. Comn: Five ft carved acrylic sculpture,
Aquarius, Fla, 1975. Exhib: Audubon Artists, Nat Acad
Gallery, New York, 1973 & 1974; Nat Sculpture Soc, Lever
House, New York, 1974; Nat Asn Women Artists, Nat Acad
Gallery, 1975; one-woman shows, Stephan Gallery, New York,
Buyways Gallery, Fla, & Shelter Rock Gallery, NY.

SOREFF, Helen. Painter. Born: New York, NY. Study:
Atlanta Art Inst, B.F.A.; Art Students League; NY Univ,
C. W. Post Col, Long Island Univ. Comn: Painting, Big
Thing Show, Seattle Wash Art Comt, 1969; painting, Inter-
Disciplinary Jour, Queens Col, NY, 1972. Exhib:
Corcoran Mus Lending Libr, Washington, DC, 1964-66;
Albright-Knox Mus, Buffalo, NY, 1965-66; Seattle Art Mus,
1969; Women Choose Women, New York Cult Ctr, 1972; one-
woman show, Lamagna Gallery, New York, 4-5/75. Awards:
High Mus of Art Scholar, Atlanta, 1950; Beaux Arts
Scholar, Atlanta Art Inst, 1952; Grand Concours, Art
Students League, 1953. Media: Acrylic.

SOROKA, Margery. Painter. Born: New York, NY, May 30,
1920. Study: Hunter Col; Art Students League; with
Edgar A. Whitney & Rex Brandt. Work: Va State Col;
Northland State Jr Col, Thief River Falls, Minn; E. R.
Squibb Sci Info Libr, New Brunswick, NJ; Forbes, Inc,
New York; Old Queens Gallery, Highland Park, NJ. Exhib:
Am Watercolor Soc, var times, 1964-75; Watercolor USA,
1968; Audubon Artists, 1968-69. Awards: Lena Newcastle
Award, Am Watercolor Soc, 1968; Winsor Newton Award, Nat
Arts Club, 1968; Salmagundi Art Club Award, 1974.
Media: Watercolors.

SOVARY, Lilly. Painter, designer. Born: Sovar, Hungary;
US citizen. Study: Calif State Univ, San Francisco, with
Alexander Nepote; Calif State Univ, San Jose, with Dr.
Tansey; Univ Idaho, with John Davis & Ray Obermyer.
Work: Collections of own paintings, sculptured driftwoods
and collages being held in its entirety for presentation
at some future date. Exhib: San Francisco Univ Art
Dept Exhib, 1953-54, Univ Idaho Archit & Art Dept, 1956-
59 & 81st Ann Painting Exhib, San Francisco Mus Art, 1962.
Media: Watercolor, casein, oil, crayon & driftwood.

SPANDORF, Lily Gabriella. Painter. Study: Acad Arts, Vienna, grad. Work: Smithsonian Inst & Libr Cong, Washington, DC; Washington Co Mus Fine Arts, Hagerstown, Md; Munic Mus, Rome, Italy; White House, Washington, DC. Comn: Paintings, presented as gifts of State to Princess Margaret, Pres of Korea, Chung Hoo Park & former pres of Iceland, Asgeir Asgeirsson by President Lyndon B. Johnson; designed US postage stamp for Christmas, 1963, Post Off Dept. Exhib: Washington Watercolor Asn Nat, 1961-67; Am Drawing Ann & Smithsonian Travel Exhib, Norfolk Mus, Va, 1963; Metrop Art Exhib, Smithsonian Inst, 1963-66; one-man shows, Agra Gallery & Bodley Gallery, New York. Awards: Numerous awards, Italy, Eng & US. Media: Gouache, watercolor, mixed media.

SPELMAN, Jill Sullivan. Painter. Born: Chicago, Ill., February 17, 1937. Study: Hilton Leech Art Sch, Sarasota, Fla, 1955-57; and with Paul Ninas, New Orleans, 1956-58. Work: Univ Mass, Amherst. Exhib: Three-man shows, Sarasota Art Asn, Fla, 1958 & Landscape of the Mine, Phoenix Gallery, New York, 1971; Watercolor USA, Springfield Art Mus, Mo, 1967; Mainstreams '70, Marietta Col, Ohio, 1970; Salon 72, Ward Nasse Gallery, New York, 1972; one-man shows, Phoenix Gallery, New York, 1973 & 1975. Awards: Sarasota Art Asn First Prize, Art Student Exhib, 1957; Hamel Prize, Sarasota Art Asn Ann, 1958; Grumbacher Oil Prize, Knickerbocker Artists Ann, 1970. Media: Acrylic.

SPENCER, Lorene. Sculptor, ceramist. Born: Wallace, Idaho, March 26, 1923. Study: Univ Ore; also with Kenneth Callabon & Hamada. Work: Folk Gallery, Japan; Homoda Folk Collection. Comn: Pottery accessories, State Libr, Olympia, Wash; ceramic letters for bldg identification, Grade & High Schs, Seattle; tile screen for Seattle bus firm; plus many pvt comns. Exhib: Craftsmen Exhib, Syracuse Mus; Northwest Artists Ann & Women of Wash, Seattle Art Mus; Craftsmen of Ore, Idaho & Mont, Spokane; Bellevue Fair. Awards: Award in Archit & Painting & Pottery Grant, Bellevue Fair.

SPERO, Nancy. Painter. Born: Cleveland, Ohio,
August 24, 1926. Study: Art Inst Chicago, B.F.A.,
1949; Atelier Andre L'Hote; Ecole des Beaux Arts, 1949-
50. Work: Mass Inst Technol; Judson Mem Church, New
York; First Nat Bank, Chicago. Exhib: Huit Americains
de Paris, Am Cult Ctr, Paris, 1964; Collage of Indignation
II, New York Cult Ctr, 1971 & Women Choose Women, 1973;
American Women Artist Show, Gedok, Kunsthaus & Hamburg,
1972; In Her Own Image, Philadelphia Mus Art, 1974; one-
woman shows, Galerie Breteau, Paris, 1962, 1965 & 1968,
Univ Calif, San Diego, 1971, Woman's Ctr, Williams Col,
1974, Douglass Col Libr, Rutgers Univ, 1974 & AIR
Gallery, New York, 1973, 1974 & 1976. Media: Collage on
paper.

SPEYER, Nora. Painter. Born: Pittsburgh, Pa. Study:
Tyler Sch Fine Art, Philadelphia. Work: Union Carbide;
Ciba-Geigy Corp; Univ Ill Mus; First Nat Bank, Chicago;
also pvt collection of David Rockefeller. Exhib: One-
woman shows, Darthea Speyer Gallery, Stable Gallery,
Poindexter Gallery, Landmaak Gallery; Pittsburgh Int.
Media: Oil.

SPRAGUE, Nancy Kunzman. Sculptor. Born: New York, NY,
September 27, 1940. Study: RI Sch Design; Univ Pa,
B.F.A.; Tyler Sch Art, Temple Univ; Univ Kans; Univ Iowa,
M.A. & M.F.A. Work: Tenn Sculpture '71, Tenn Arts
Comn, Fairleigh Dickinson Univ. Comn: Bronze sculpture,
Friends of Elvis Presley, 1971. Exhib: 16th Ann
Drawing & Small Sculpture, Ball State Univ, 1970; Mid S
Art Exhib, Brooks Mem Art Gallery, Memphis, 1971; 24th
Ann Iowa Artists Exhib, Des Moines Art Ctr, 1972;
Goldsmith Civic Ctr Sculpture Show, Memphis, Tenn, 1973;
Mainstreams 74, Marietta Col, Ohio. Media: Cast bronze,
welded steel.

SPROUL, Ann Stephenson. Painter. Born: DeWitt, Mo., August 9, 1907. Study: Cent Mo State Univ; also with William B. Schimmel, Ariz, John Pike & Edgar Whitney, New York & John Pellew, Conn. Work: Pvt galleries in Chile, Switzerland, Czechoslovakia, England & Canada. Comn: Mural of Frontier Town, Silver Spur Salon & Restaurant, Cave Creek; Christmas card designs, comn by Mr. & Mrs. Dow Patterson, Phoenix, 1973-74 & Cave Creek Community Schs, 1974; illus Christmas letter, comn by Armstrong Congoleum, Cecil Armstrong, Carefree, Ariz, 1974. Exhib: Plaza Art Fair, Kansas City, Mo, 1963-69; Gtr Kansas City Art Asn, Kansas City Mus, 1964; Ararat Temple Beaux Arts, Ararat Temple Auditorium, Kansas City, 1964; one-man show, Am Asn Univ Women, Sophian Plaza, Kansas City, 1965; Discovery of Art Mag Exhib, Kansas City, 1968. Awards: First in Watercolor, Gtr Kansas City Art Asn, 1964 & Mo Div, Nat League Am Pen Women, 1965; Publisher's Award, Discovery of Arts Mag, 1968. Media: Watercolor, pencil.

SPURGEON, Sarah (Edna M.). Painter, educator. Born: Harlan, Iowa, October 30, 1903. Study: Univ Iowa, B.A. & M.A.; Harvard Univ; Grand Cent Sch Art; also with Grant Wood, Paul Sachs & others. Work: Iowa Mem Union, Iowa City; Seattle Art Mus, Wash; Ginkgo Mus, Vantage, Wash; Henry Gallery, Univ Wash, Seattle. Comn: Mural, Univ Experimental Sch, Iowa City. Exhib: Kansas City Art Inst; Joslyn Mus; Des Moines Art Salon; Seattle Art Mus; Gumps, San Francisco; plus others. Awards: Carnegie Fel, 1929-30; Prizes, Iowa Art Salon, 1930 & 1931; Prizes, Univ Iowa, 1931.

SQUIRES, Norma-Jean. Sculptor, painter. Born: Toronto, Ontario; US citizen. Study: Art Students League; Cooper Univ, cert, 1961; also spec studies with James Rosati, sculptor. Work: Sterling Forest Gardens, Long Island, NY; Galeria Vandres, Madrid, Spain. Exhib: One-woman shows, Hudson River Mus, Yonkers, NY, 1966, East Hampton Gallery, New York, 1969 & Kieran Gallery, Riverside, Calif, 1974; Affect-Effect, La Jolla Mus Art, Calif, 1969; Recent Trends in American Art, Westmoreland Co Mus Art, Greensburg, Pa, 1969; 4x4 plus 4x8, Newport Harbor Mus, 1975; plus others. Awards: Sarah Cooper Hewitt Award for the Advan of Sci & Art, Cooper Union, 1961. Media: Wood, aluminum, mirrors, motors.

STALLWITZ, Carolyn. Painter, photographer. Born: Abilene, Texas, April 27, 1936. Study: W Tex State Univ, with Clarence Kincaid, Jr, B.S. (art); also with Emilio Caballero, Stefan Kramer & Lee Simpson. Work: Pioneer Natural Gas Co, Amarillo, Tex; Ark Art Ctr Gallery, Little Rock; Amarillo Art Ctr Shop. Exhib: Southwestern Watercolor Soc Exhib, 1969; Tex Watercolor Soc, 1970; Wichita Centennial Nat Art Exhib, 1970; Best of Southwest, 1971; Amarillo Fine Art Asn Citation Show, 1973. Media: Watercolor, pencil.

STEINBERG, Isador N. Painter, designer. Born: Odessa, Russia, June 14, 1900. Study: Sch Design & Lib Arts, scholar; Art Students League; NY Univ; Grand Chaumiere, Paris, France; and with John Sloan & Max Weber. Comn: USA courses in Botany, Surveying, Lettering, Mechanical Drawing & others. Exhib: Newark Art Club; Am Inst Graphic Arts Fifth Books of the Year & Textbook Exhib; plus others. Awards: Fifty Bks of the Yr Award, 1939.

STEINMETZ, Grace Ernst Titus. Painter, lecturer. Born: Lancaster, Pa. Study: Pa Acad Fine Arts; Barnes Found; Millersville State Col, B.S.; Univ Pa, M.S. Work: Univ Southern Fla, Lakeland; Franklin & Marshall Col; Elizabethtown Col, Pa; Millersville State Col, Pa; Lancaster Co Art Asn, Pa. Exhib: Am Watercolor Soc, 1968; Painters & Sculptors Soc NJ, 1969; Knickerbocker Soc, 1970; Moore Col Art, 1970; Nat Soc Painters Casein & Acrylic, 1972. Awards: Best of Show, Lancaster Co Art Asn, 1967 & 1975; Award for Nontraditional Watercolor, Painters & Sculptors Soc NJ, 1968; Grumbacher First Prize, Nat Soc Painters Casein & Acrylic, 1969. Media: Oil, casein, acrylic.

STEPHENS, Nancy Anne. Sculptor, film maker. Born: Santa Barbara, Calif, November 18, 1939. Study: Univ Kans, 1957 & 1959-62; Northwestern Univ, 1958-59; Kansas City Art Inst, 1963. Work: Art Res Ctr, Kansas City, Mo; Galeria Grada Zagreba, Zagreb, Yugoslavia. Comn: Tapestry, Kansas City Parks & Recreation Dept, 1969; graphics, Harrison St Rev & Westport Trucker, 1971-72. Exhib: New Ctr US Art Series, 1963-64; Art Res Ctr Series, 1966-72; Sir George Williams Univ, Montreal, PQ, 1967; Anonima Studio, New York, 1968; Novo Tendencija 4, Zagreb, Yugoslavia, 1969.

STERN, Irene Monat. Painter. Born: November 20, 1932;
US citizen. Study: New Sch Social Res; classes at Mus
Mod Art & Whitney Mus; mainly self-taught. Work: Nat
Collection of Fine Arts, Smithsonian, Gen Elec World Hq,
Joseph H. Hirshhorn Mus, First Nat City Bank, Int Off.
Comn: Am Broadcasting Co Western Hq; Atlantic Richfield
Collection; Pac Mutual Life Ins Co Exec Hq; Dr. Wallace
Baer, Rand Corp; Welton Becket, architect. Exhib:
Esther Robles Gallery, Los Angeles, 1973; Color-73,
Brand Mus & Libr; Am Acad Arts & Lett, 1974; Downtown
Gallery, Honolulu, 1974; Source Gallery, San Francisco,
1975. Media: Acrylics on canvas.

STERNE, Hedda. Painter. Born: Bucharest, Romania,
August 4, 1916; US citizen. Study: Pvt study in Paris,
Bucharest & Vienna. Work: Univ Ill; Metrop Mus Art;
Mus Mod Art; Univ Nebr; Art Inst Chicago. Exhib:
Painting & Sculpture Today, Art Asn Indianapolis, 1965-
66; Flint Inst Invitational, 1966-67; The Visual Assault,
Univ Ga, 1967-68 & Barnard Col, 1968; Phillips Collection,
Westmoreland Mus, 1969; Lee Ault & Co, New York, 1975.
Awards: Fulbright Fel to Venice, 1963; First Prize, Art
Inst Newport Ann, 1967; Tamarind Fel, 1967.

STEVENS, Marjorie. Painter. Born: Terre Haute, Ind.,
March 8, 1902. Study: Largely self-taught; instr from
George Post & Dong Kingman; Univ Calif Exten; Acad
Advert Arts. Exhib: Calif State Fair, every year since
1952; one-woman shows, De Young Mem Mus, San Francisco,
1955 & Emma Frye Mus, Seattle, 1960; Am Watercolor Soc,
1963, 1965, 1966, 1969, 1974 & 1975; West Coast Watercolor
Soc, all shows since 1963. Awards: Irma Rittigstein
Mem, Soc Western Artists, 1966 & Klumpkey Mem, 1968;
Larry Quackenbush Mem, Am Watercolor Soc, 1970. Media:
Watercolor, transparent and opaque; collage.

STEWART, Dorothy S. Painter. Born: Brooklyn, NY.
Study: Art Students League; Nat Acad Sch Fine Art, New
York; NY Univ; and with Edgar Whitney, Paul Puzinas &
Anthony Toney. Work: Gregory Mus, Hicksville, NY; Mercy
Hosp, Rockville Centre, NY. Exhib: Allied Artists Am
56-61st Ann, 1969-74; Catharine Lorillard Wolfe Art Club
68-78th Ann, 1965-74 & Am Watercolor Soc 105th Ann, 1972,
all at Nat Acad Galleries; Am Artists Prof League Grand
Nat, Lever House, New York, 1973; Women in Art, Hammond
Mus, 1974. Awards: First Prize Oil Painting, Gregory
Mus, 1972; Ivy Larric Kevlin Prize, Kent Art Asn, 1974;
Washington Sq Outdoor Art Exhib Scholar, 1974.

STONEBARGER, Virginia. Painter, instructor. Born: Ann
Arbor, Mich., March 9, 1926. Study: Antioch Col, B.A.,
1950; Colorado Springs Fine Arts Ctr, 1950-51; Art
Students League, 1951-52; Hans Hofmann Sch, 1954; NY Univ,
1954 & 1956; Univ Wis-Milwaukee, M.S., 1972. Exhib: Univ
Minn, 1954; Art: USA, 1958; Univ Wis, 1959; Milwaukee Art
Ctr, 1959-61; one-woman shows, Lakeland Col, 1969 & Univ
Wis, 1971. Awards: Prize, Watertown, Wis, 1958; Prize,
Milwaukee Art Ctr, 1960; Danforth Found Fel, 1969; plus
others.

STRATTON, Dorothy (Mrs. William A. King). Painter,
printmaker. Born: Worcester, Mass. Study: Pratt Inst,
cert, 1942; Brooklyn Mus Sch, 1942-43; Univ Calif, with
Rico Lebrun, 1956-57; Univ Calif, Los Angeles, 1961; Univ
Calif, San Diego, 1966-67. Work: Long Beach Mus Art;
Tunisian Ministry Cult Affairs, Tunis; Los Angeles Munic
Art Collection, City Hall; Art in Embassies, Dept of State,
Washington, DC; Southwestern Col (Calif). Exhib: One-
woman shows, Pasadena Art Mus, 1959, La Jolla Mus Art,
1962 & Tunisian Comt Cult Coop US Info Serv, Tunis, 1965;
Art in Embassies Prog, 10 countries, 1965-72; Calif Soc
Printmakers Nat, Richmond Art Ctr, 1972; Univ San Diego,
1973. Awards: First Prize West Competition, Motorola,
Inc, 1962; First Purchase Prizes, Regional Exhib,
Southwestern Col, 1963; Kogo Time-Life Award & First
Purchase Prizes, Art Guild Exhib, Fine Arts Gallery San
Diego, 1963.

STRIDER, Marjorie Virginia. Sculptor. Born: Guthrie,
Okla. Study: Kansas City Art Inst, Mo; Okla Univ, B.F.A.
Work: Albright Knox Mus, Buffalo; Larry Aldrich Mus, NY;
NY Univ; Des Moines Art Ctr; Hirschhorn Mus, Washington,
DC. Exhib: Am Fedn Art Traveling New York Show, 1966;
one-woman show, Park Col, 1968 & Hoffman Gallery, New
York, 1973 & 1974; Whitney Sculpture Ann, Whitney Mus Am
Art, New York, 1970; Collage of Indignation II, New York
Cult Ctr, 1971. Awards: McDowell Colony Fel, 1973;
Longview Found Grant, 1973; Nat Endowment Arts Grant,
1974. Media: Plastic, bronze.

STROTHER, Virginia Vaughn. Painter. Born: Ft. Worth, Texas, July 19, 1920. Study: Tex Christian Univ, B.F.A. (with hons) & Spec Div Courses printmaking; watercolor with Barse Miller. Work: Tex Fine Arts Asn Permanent Collection, Austin; Univ Tex, Arlington; Sci Dept, Tex Christian Univ; Woman's Club Ft Worth Permanent Collection; plus many others. Exhib: Nat Invitational Art Exhib, Cedar City, Utah, 1972-74; Tex Fine Arts Asn Nat Ann, Laguna Gloria Mus, Austin, 1972 & 1975; Delta Seven State Exhib, Ark Art Ctr, Little Rock, 1972; Eight State Exhib Painting & Sculpture, Okla Art Ctr, Oklahoma City, 1974; Monroe Nat Ann, Masur Mus Art, La, 1973. Awards: Citations & Travel Awards, Tex Fine Arts Asn, 1969, 1970 & 1972; Award of Merit, N Mex Art League, Albuquerque, 1971; Award, Ft Worth Art Mus, 1973.

STURTEVANT, Harriet H. Painter, designer. Born: Manchester, NH, May 2, 1906. Study: Albright Art Sch; Parsons Sch Design, New York & Paris, 1928-30. Exhib: Nat Arts Club, 1954-64; Catharine Lorillard Wolfe Art Club, 1954-65 & 1967; Knickerbocker Artists, 1958-64; Watercolor: USA, 1962 & 1963; one-man show, Pen & Brush Club, 1969. Awards: Prizes, Long Island Art League, 1953 & 1964; Prizes, Catharine Lorillard Wolfe Art Club, 1956, 1960 & 1963, Gold Medal, 1967; Prizes, Knickerbocker Artists, 1962 & 1964; plus others.

STUSSY, Maxine Kim. Sculptor. Born: Los Angeles, Calif, November 11, 1923. Study: Univ Southern Calif, art scholar, 1943; Univ Calif, Los Angeles, A.B., 1947; also res & pvt study in Rome (Brunifoundry), France, Eng, Ger, 1959 & 1963. Comn: Bob Hope Award Trophy, Bob Hope Athletic Award Comn, 1960; Bob Hope New Talent Award, Universal Studios, 1961; Wall Sculptures in Wood, Neuropsychiatric Hosp Lobby, Univ Calif, Los Angeles, 1968; Wood Sculpture, St Martin of Tours Church, Brentwood, 1972. Exhib: Los Angeles Co Mus, Los Angeles, 1954, 1958, 1959, 1961; Art USA, Madison Sq Garden, New York, 1958; Galleria Schneider, Rome, Italy, 1959; Denver Art Mus, 1960; 25 Calif Women of Art, Lytton Ctr of Visual Arts, Los Angeles, 1968. Awards: First Prize, Sculpture, Bronze, Los Angeles Co Art Mus, 1961. Media: Laminated or carved wood, metal; bronze, concrete.

SUAREZ, Magdalena Frimkess. Painter, sculptor. Born: Venezuela, July 22, 1929. Study: Escuela de Artes Plasticas, Caracas, 1943-45; Cath Univ Chile, with Sewell Sillman, 1958-61; also with Norman Calberg & Paul Harris. Exhib: Venezuela Ann Salon, 1944; Chilean Ann Salon, 1953; one-man show, Brazilian Inst Cult, Chile, 1961; Fridmen Galerie, Encino, Calif, 1973; Fred Mayer Collection Ceramics, Claremont, Calif, 1974.

SUBA, Susanne. Painter, illustrator. Born: Budapest, Hungary. Study: Pratt Inst, grad. Work: Metrop Mus Art, New York; Brooklyn Mus, NY; Art Inst Chicago; Mus City of New York; Kalamazoo Inst Art, Mich. Exhib: Ansdell Gallery, London, Eng; Hammer Gallery, New York; Kalamazoo Inst Art; Art Inst Chicago; Mus Mod Art, New York. Awards: Awards, Am Inst Graphic Art, Art Dirs Club New York & Art Dirs Club Chicago.

SUNDERLAND, Nita Kathleen. Educator, sculptor. Born: Olney, Ill., November 9, 1927. Study: Duke Univ; Bradley Univ, B.F.A. & M.A. Comn: Archit sculpture, Bradley Univ Bookstore, 1964, monumental sculpture, Williams Hall Mall, 1967; archit sculpture, St John's Cath Church, Woodhull, Ill, 1969; monument bronze sculpture, City Beautiful Comt, City Peoria, Fulton Street Mall, 1975. Exhib: Eastern Mich Univ Sculpture Exhib, 1964; one-man show, Lakeview Ctr Arts & Sci, 1965; one-man show, Gilman Galleries, 1965 & group exhib, Art for Archit, 1968; Ill State Mus Exhib, Ill Artists, 1966. Media: Stone, wood; bronze, aluminum.

SWAN, Barbara. Painter. Born: Newton, Mass., June 23, 1922. Study: Wellesley Col, B.A.; Boston Mus Sch. Work: Philadelphia Mus Art; Boston Mus Art; Worcester Mus; Fogg Art Mus; Boston Pub Libr. Exhib: Carnegie Ann, 1949; Contemporary American Painting, Univ Ill, 1950; View 1960, Inst Contemp Arts, Boston, 1960; Brooklyn Mus Biennial Print Exhib, 1965; New Eng Women, De Cordova Mus, 1975. Awards: Albert Whitin Traveling Fel, Boston Mus Art, 1948; Assoc Scholar, Inst Independent Study, Radcliffe Col, 1961-63; George Roth Prize, Philadelphia Print Club, 1965. Media: Oil.

SWENSEN, Mary Jeanette Hamilton (Jean). Painter, printmaker. Born: Laurens, S.C., June 25, 1910. Study: Columbia Univ, with Hans Mueller, B.S., 1956, with Arthur Young, M.A. (graphic arts), 1960; Fine Arts Sch for Am, Fountainbleau, France, with Lucien Fontanerosa; Ariz State Univ, with Arthur Hahn, 5 summers. Work: Metrop Mus Art, New York; Nat Graphic Arts Collection, Smithsonian Inst, Washington, DC; Graphic Arts Collection, New York Pub Libr; Laurens Pub Libr, SC. Exhib: Soc Western Artists, M. H. de Young Mus, San Francisco, 1964; Nat Art Roundup, Las Vegas, Nevada, 1965; Fine Arts Bldg, Colo State Fair, Pueblo, 1965; Duncan Gallery, Paris, 1974. Awards: Honorable Mention for Drawing, Soc Western Artists, 1964; Duncan Gallery Prix de Paris, 1974.

SWENSON, Anne. Painter, lecturer. Born: Stafford Springs, Conn. Study: Art Students League; also with William Fisher, Vincent Drennan, Paul Giambertone & Tetsuya Kochi. Work: St Peter's Rectory, Staten Island, NY. Exhib: Staten Island Mus, 1955-61; Nat Arts Club, New York, 1969; Washington Mus Fine Arts, Hagerstown, Md, 1971; Metrop Mus Art, 1975; Avery Fisher Hall, Cork Gallery, 1975. Awards: Anna B. Morse Gold Medal, Gotham Painters, 1966; New York City Chap Second Place Award for Watercolor, Composers, Auth & Artists Am, 1969, Nat Exhib Honorable Mention for Oil, 1971. Media: Oil, watercolor.

SWIRNOFF, Lois (Lois Swirnoff Charney). Painter, lecturer. Born: Brooklyn, NY, May 9, 1931. Study: Cooper Union, cert of grad, 1951; Yale Univ, with Josef Albers, B.F.A., 1953, M.F.A., 1956. Work: Addison Gallery Am Art, Andover; Radcliffe Inst, Harvard Univ; Jewett Art Ctr, Wellesley Col. Exhib: Americans in Italy, Munson-Williams-Proctor Inst, Utica, NY; American Fulbright Painters, Duveen-Graham Gallery, New York, 1957; Boston Arts Festivals, 1963-64; Affect/Effect, La Jolla Mus, Calif, 1968. Awards: Fulbright Fel to Italy, 1951-52; Radcliffe Inst Independent Study Fel, 1961-63; Univ Calif Fel for Jr Fac, 1967. Media: Acrylic, gouache, oil.

SZESKO, Lenore Rundle. Painter, printmaker. Born: Galesburg, Ill, March 13, 1933. Study: Art Inst Chicago, B.F.A. (drawing, painting, illus), 1961, M.F.A. (painting), 1966; wood engraving with Adrian Troy. Work: Standard Oil Co, Chicago; NJ State Mus; Jayell Publ House, Miami, Fla; Springfield Col; Kemper Ins Co Collection, Long Grove, Ill. Exhib: Conn Acad Fine Arts 62nd Ann, Wadsworth Atheneum, Hartford, Conn, 1972; Cedar City Ann Fine Art Exhib, Utah, 1972-75; Contemp Am Graphics, Old Bergen Art Guild, Bayonne, NJ (traveling exhib), 1972-76; Soc Am Graphic Artists 52nd Nat Print Exhib, New York & Chicago, 1973; NH Print Club 1st & 2nd Int, Nashua, 1973-74. Awards: Anonymous Prize Graphics, Nat Acad Design, New York, 1970; James R. Marsh Mem Purchase Prize, Hunterdon Art Ctr 16th Print, Clinton, NJ, 1972; Muth Award, Miniature Painters, Sculptors & Gravers Soc of Washington, DC, 1973. Media: Wood engraving ink drawing; watercolor.

TABACHNIK, Anne. Educator, painter. Born: Derby, Conn.,
July 28, 1933. Study: Hans Hofmann Sch, 3 yrs scholar;
Hunter Col, B.A. (anthrop); Univ Calif, Berkeley & NY
Univ, grad study in art. Work: Hyde Collection, Glens
Falls, NY; Mus of Univ Calif, Berkeley; Mus Of Univ Mass,
Amherst; Radcliffe Col; Dayton Art Inst, Ohio. Exhib:
Many one-woman shows in New York & other cities, 1951-75;
Mus Mod Art Traveling Show-Hofmann & His Students, 1962;
one-woman shows, Dayton Art Inst, 1965, La State Univ
Gallery, 1975 & Hyde Collection, 1976. Awards: Longview
Found Award, 1960; Radcliffe Inst Fels, Harvard Univ,
1967-69; Creative Artists Pub Serv Fel, NY State Coun on
Arts, 1974. Media: Acrylic on canvas & paper.

TAIT, Katharine Lamb. Painter, designer. Born: Alpine,
NJ, June 3, 1895. Study: Friends Sem, NY; Nat Acad
Design; Art Students League; Cooper Union Art Sch. Comn:
All nave & rose windows, Protestant & Roman Cath Chapels,
US Marine Corps, Camp Lejeune, NC; all windows, Old
Mariners Church, Detroit, Mich & Calvary Methodist Church,
Dumont, NJ. Exhib: Guild Relig Archit, Detroit; Nat Arts
Club, New York; Tenafly Pub Libr, NJ; Stained Glass Asn
Am.

TALABA, L. (Linda Talaba Cummens). Sculptor, printmaker.
Born: Detroit, Mich., July 15, 1943. Study: Detroit
Inst Technol, with Maxwell Wright; pvt instr with Lois
Pety; Ill Wesleyan Univ, with Fred Brian, B.F.A.;
Southern Ill Univ, with David Folkman, master printmaker
from Tamarind, Tom Walsh, sculptor & Lewis Brent Kington,
Metalsmith, M.F.A. Work: Henry Ford Found Print
Collection, Detroit; J. B. Speed Mus Traveling Print
Collection, Tenn; Albion Univ Print Collection; Leopold
Schepp Found Collection, New York; Detroit Art Inst
Rental Gallery & Collection. Comn: Painting, Waterford
Twp Bd Educ, 1961; painting, Isaac E. Crary, Jr High Sch,
1963; painting, Burton Title & Abstract Co, Detroit, 1967;
bronze door ornaments, Little Grassy Mus, Southern Ill
Univ, 1970. Awards: Nat Scholarships Inc, Grant in
Metals, New York, 1972; Ill State Mus Craftsmans Award,
1975; Ball State Univ Nat Award for Sculpture, 1975.
Media: Bronze, plexiglas; graphics, intaglio & serigraph.

TALVACCHIO, Helen Steiner. Painter. Born: Akron, Ohio,
May 5, 1921. Study: Cleveland Inst Art, cert; Univ
Akron. Exhib: Butler Nat, Youngstown, Ohio, 1963; Am
Vet Show, New York, 1966; Cooperstown Art Asn, NY, 1966
& 1968; Catharine Lorillard Wolfe Art Club, New York,
1968; Knickerbocker Artists, Nat Arts Club, New York, 1971.
Awards: First in Prints, Cleveland Mus May Show, 1949;
Second in Oils, Nat League Am Pen Women, Washington, 1968
& Salt Lake City, 1970. Media: Oil, watercolor.

TANKSLEY, Ann. Painter. Born: Pittsburgh, Pa., January 25, 1934. Study: Carnegie Inst Technol, with Samuel Rosenberg & Balcomb Green, B.F.A.; Art Students League, with Norman Lewis. Work: Johnson Publ Co, Chicago. Exhib: Freedomways Exhib, Hudson River Mus, Yonkers, NY, 1971; USA 1971, Carnegie Inst, Pittsburgh, 1971; Rebuttal to Whitney Mus Exhib, Acts of Art Gallery, New York, 1971; Black Women Artists, Mt Holyoke Col, 1972; Hon. & Mrs. Bruce Wright Collection Exhib, Fordham Univ, 1974. Media: Oil.

TANNER, Joan Elizabeth. Painter. Born: Indianapolis, Ind., November 25, 1935. Study: Univ Wis, B.A., 1957, teachers cert, 1958. Work: Santa Barbara Mus Art. Exhib: 25 Calif Women of Art, Lytton Art Ctr, Los Angeles, 1968; Wellinton-Ivest Collection, Inst Contemp Art, Boston, 1968; 9 West, San Diego Mus Art, 1969; Surrealism if Alive & Well in the West, Calif Inst Technol, 1972; Abstraction: Alive-Well, State Univ NY Col Potsdam, 1975.

TATERKA, Helene. Painter, sculptor. Born: Breslau, Ger., December 2, 1901. Study: Munic Art & Craft Sch, Breslau, Ger, 3 yrs; Acad Fine Art, Breslau, Ger, 1 yr; also sculpture with Harold Castor & painting with Revington Arthur, US. Work: Alfred Khouri Mem Collection, Norfolk Mus Arts & Sci, Va; Smithsonian Inst. Exhib: Audubon Artists Ann, New York; Nat League Am Pen Women Biennial, Smithsonian Inst; Painters & Sculptors of NJ Ann; Silvermine Guild Artists Ann; Sculptors League Ann, New York. Awards: Julia Ford Pew Award for Sculpture, Nat Asn Women Artists, 1964; Bronze Medal for Creative Sculpture, Audubon Artists, 1965; Mary & Gustave Kellner Award for Sculpture, Am Soc Contemp Artists, 1970. Media: Polymer, watercolor; bronze, lost wax.

TAUCH, Waldine Amanda. Sculptor, collector. Born: Schulenburg, Tex. Study: With Pompeo Coppini. Work: Witte Mem Mus, San Antonio, Tex; Pan Handle Plains Hist Mus, Campos, Tex; Wesleyan Mus, Ga. Comn: Heroic monument to Bedford, Ind, State Ind, 1922; The Doughboy Statue, Am Legion, Austin, Tex, 1931; Moses Austin Monument, State Tex, 1941; Higher Education, comn by Mr. & Mrs. Andrew Casoles for Trinity Univ (Tex), 1968; Gen. Douglas MacArthur, Howard Payne Col, Brownwood, Tex, 1969. Exhib: Nat Sculpture Soc Traveling Show, 1931; Women Painters & Sculptors, New York, 1932; Coppini Acad Fine Arts, 1954-; Witte Mem Mus; Nat Acad Design, New York.

TAYLOR, Fran (Frances Jane). Art administrator, painter.
Born: Philadelphia, Pa., March 2, 1925. Study: Four
yrs pvt study with Emilie DeS Atlee. Exhib: ADVAC
Traveling Exhib for Award Winners, William Penn Mus,
Harrisburg, Pa, 1966; Philadelphia Art Festival, 1967;
Artist Equity Triennial Exhib, Philadelphia, 1974; Am
Artist Grand Nat Art Exhib, New York, 1975; Nat Miniature
Art Exhib, Nutley, NJ, 1975. Awards: Newtown Square
Silver Medal, Women's Club Newton Square, Pa, 1964 & 1966;
Tavistock Gold Medal Best in Show, Perkiomen Valley Art
League, Schwenksville, Pa, 1966. Media: Oil.

TAYLOR, Marie. Sculptor. Born: St. Louis, Mo., February
22, 1904. Study: Art Students League; Wash Univ Sch Art,
1923-24. Work: St. Louis Art Mus; also in many pvt
collections. Comn: Main altar, St. Paul's Church, Peoria,
Ill, 1960; Jefferson Mem Nat Expansion, St Louis Riverfront,
for Mansion House, St Louis, 1967. Exhib: Joslyn Mus
Art; Kansas City Art Inst; Southern Ill Univ, Carbondale,
1952; Brooks Mem Art Gallery, Memphis, Tenn, 1955;
Sculpture 1969, Span Int Pavillion, 1969. Awards: Prizes,
Cleveland Art Mus, St Louis Art Guild & Nat Asn Women
Artists.

TAYLOR, Sandra Ortiz. Painter, printmaker. Born: Los
Angeles, Calif, April 27, 1936. Study: Univ Calif, with
William Brice & Sam Amato, B.A.; Iowa State Univ, with
Byron Burford, M.A. Work: Univ Iowa; Macy's Corp, New
York; Univ Calif Res Libr, Los Angeles; Oakland Mus.
Exhib: 3rd Ann Bay Area Regional Print Exhib, De Anza
Col, 1974; Palo Alto Print Invitational, Palo Alto Cult
Ctr, 1974; Photomorphosis, Berkeley Art Co-op, 1975;
Prints California, Oakland Mus & Contemp Graphics Ctr,
Santa Barbara Mus, 1975; 15th Nat Print Show, Bradley
Univ, 1975. Media: Acrylic, oil; graphic.

TEN EYCK, Catryna (Catryna Ten Eyck Seymour). Painter.
Born: New York, NY, June 30, 1931. Study: Smith Col;
Art Students League. Work: Nat Collection Fine Arts,
Smithsonian Inst, Washington, DC; Calif Palace Legion
Hon, San Francisco; Denver Art Mus; Honolulu Acad Arts;
Munson-Williams-Proctor Inst, Utica, NY. Exhib: 60th
Am Ann Exhib, Art Asn Newport, RI, 1971; one-man show,
New Sch Social Res, New York, 1973; Ann Juried Exhib,
Sahron Creative Arts Found, Conn, 1974. Awards: First
Prize for Graphics, Springfield Art League, 1971; First
Prize, Tanglewood Poster Design Competition, Berkshire
Art Asn, 1975. Media: Graphic, acrylic.

TEWI, Thea. Sculptor. US citizen. Study: Art Students
League; Greenwich House, with Lou Duble; Clay Club, with
D. Denslow; New Sch Social Res, with Seymour Lipton.
Work: Nat Collection Fine Arts, Smithsonian Inst,
Washington, DC; Cincinnati Art Mus; Norfolk Mus Arts &
Scis, Va; Univ Notre Dame; Am Ins Co Corp Collection,
Galveston, Tex. Exhib: 18th-20th Ann New Eng Exhib,
Silvermine Guild Artists, 1965 & 1967-69; Nat Arts Club
Exhib Relig Art, 1966; Erie Summer Festival Arts, Pa State
Univ, 1968; 6th Biennial of Sculpture, Carrara, Italy,
1969. Awards: Medal of Honor & First Prize for Sculpture,
Nat Asn Women Artists, 1969, Sculpture Prize, 1975; First
Prize for Sculpture, Am Soc Contemp Artists, 1971, Contemp
Art Award, 1975; Nat Arts Club Medal of Merit, League
President Day Artists, 1974. Media: Stone.

TEXDON, Jasmine. Painter, instructor. Born: New York,
NY, September 19, 1924. Study: Nat Acad Design, with
Gilford Beal, H. Hildebrandt & Charles Hinton, 4 yrs with
honors; Brooklyn Mus Art Sch, with Bocour; Art Students
League, with Byron Browne. Work: Christ the King (mural),
Marian Col Art Gallery Permanent Collection, Fond du Lac,
Wis; relig mural, Monastery St Lazarro Mus, Venice, Italy;
painting, Col Armeno Permanent Collection, Venice; relig
paintings, St Mary's Convent, Yonkers & Church Holy
Cross Sch, New York. Exhib: Raymond Duncan Gallery,
Paris, France, 1962, 1965, 1968 & 1969; Lynn Kotler
Gallery, New York, 1963; Int Exhib Drawings, Florence,
Italy, 1971; one-man shows, Manhattan Col, New York, 1955
& Burr Gallery, New York, 1959. Awards: Honor for Art
Work, Nat Acad Design Sch, 1947; Prix de Paris, Ligoa
Duncan Gallery, 1962, 1965, 1968 & 1969. Media: Oil.

THOMAS, Alma Woodsey. Painter. Born: Columbus, Ga.,
September 22, 1891. Study: Howard Univ, B.S., 1924;
Columbia Univ, M.F.A., 1934; Am Univ, 1950-60; also in
Europe, 1958, under auspices Temple Univ. Work: Corcoran
Gallery Art & Smithsonian Inst Collection Fine Arts,
Washington, DC; Fisk Univ Gallery Art, Nashville, Tenn;
Whitney Mus Am Art, New York. Exhib: Howard Univ Gallery
Art, 1966 & 1975; Franz Bader Gallery, Washington, DC,
1968 & 1970-74; Whitney Mus Am Art, 1972; retrospective,
Corcoran Gallery Art, 1972; Martha Jackson Gallery, New
York, 1973. Awards: Purchase Prize, Howard Univ, 1963;
Soc Washington Artists, 1963, 1968 & 1971. Media: Oil,
acrylic.

THOMPSON, Joanne. Painter, sculptor. Born: Chicago,
Ill. Study: Univ Colo. Work: Americana Galleries,
Northfield, Ill. Exhib: Nat Arts Club Gallery, New
York, 1965-69; Mus Fine Arts, Springfield, Mass, 1965-
70; Am Artists Prof League Grand Nat, New York, 1966-70;
Hammond Mus, Westchester, NY, 1968; one-man shows,
Americana Galleries, 1968 & 1970. Awards: Best of
Show/Jury's Choice, Orange Co Fair, Calif, 1964; hon
mention for still life, Acad Artists, 1967; First Prize
for sculpture, Mt Prospect, Ill, 1968. Media: Oil,
bronze.

THOMPSON, Tamara (Tamara Thompson Bryant). Painter,
instructor. Born: Anderson, Ind., April 8, 1935.
Study: Univ Ky, B.A. (with hon in art); Ind Univ,
M.F.A.; and with Leon Golub, Creighton Gilbert & Rudy
Pozzatti. Work: Ind Univ, Bloomington; Colgate Univ;
Univ Ky; Headley Mus, Lexington, Ky. Exhib: One-man
shows, Ind Univ, Bloomington, 1959 & NY Univ, Heights
Campus, 1964; 17 Connecticut Artists, Wadsworth Atheneum,
Hartford, 1960; Colgate Univ, 1973; Arts of Cent New
York 36th Ann, Munson-Williams-Proctor Inst, Utica, 1973.
Awards: First Prize, Hartford Soc Women Painters, 1960
& 1961. Media: Oil, acrylic, fabric.

THORNHILL, Anna. Sculptor, painter. Born: Berlin, Ger.,
August 2, 1940; British citizen. Study: St Martins
Sch Art, London, dipl design; Royal Col Art, London,
ARCA. Work: World Bank, Washington, DC; Hong Kong Mus
Art; Hofstra Univ. Comn: Mosaic mural, P&O Shipping
Lines, Ocean Terminal, Hong Kong, 1966; two murals,
August Films, Hq, New York, 1969; mural, Johnson, Stokes
& Master, Hong Kong, 1969; painted sculpture, Wells TV,
Hq, New York, 1972; wall mural, Larry Spegel Productions,
Tarzana, Calif, 1973. Exhib: Royal Acad Art, London,
1962-64; County Hall, London, 1963; Young Contemporaries,
London; Brighton Mus Art, Eng, 1964; one-woman show,
Meisel Gallery, New York, 1973. Media: Wood; plastic.

TIETZ, Evelyne. Painter. Born: Grants, N Mex. Study: Finch Col, with Leon Kroll & Louise Stinnet; Univ Ariz, B.F.A. (art educ); Cappello Sch Art, Florence, Italy, with Gastone Canessa; also with Ramon Froman & Nathan Robinson. Work: El Paso Mus Art; Oshkosh Mus, Wis. Comn: Oil painting, El Paso Symphony Debutante Ball, 1975. Exhib: El Paso Art Asn, 1969; El Paso Mus Art, 1960-73; Benedictine Brandy Co Exhib, New York, 1970-74; Midwest Biennial, Omaha, 1973. Awards: Best in Oil, El Paso Art Asn, 1969; Sun Carnival Show Purchase Prize, El Paso Mus Art, 1969; Benedictine Brandy Co Art Awards, 1970, 1973 & 1974. Media: Oil.

TIRANA, Rosamond (Mrs. Edward Corbett). Painter. Born: New York, NY, January 29, 1910. Study: Swarthmore Col., B.A., 1931; London Sch Econ, 1931-32; Univ Geneva, 1931 & 1932; painting with Bernice Cross, E. R. Rankine & Hans Hofmann. Exhib: Corcoran Gallery Art, Washington, DC, 1956-59 & 1966; Provincetown Art Asn, Mass, 1957-65; Art for Embassies, Nat Collection Fine Arts, 1968, US Embassy, Turkey, 1969; Franz Bader Gallery, Washington, DC, 1969. Awards: Prizes, Lycee Mooiere, Paris, 1924; Va Regional Exhib, 1959; Washington Post Area Competition, 1959.

TRIPLETT, Margaret L. Painter. Born: Vermillion, S Dak, December 30, 1905. Study: Univ Iowa, B.A.; Boston Mus Fine Arts Sch; Yale Univ, M.A.; also with Grant Wood. Work: Munson-Williams-Proctor Inst, Utica, NY; Slater Mem Mus, Norwich, Conn. Exhib: Am Watercolor Soc; Conn Watercolor Soc; De Cordova & Dana Mus; Slater Mus Art; Lyman Allyn Mus. Awards: Jesse Smith Noyes Found Grant, 1969.

TRIVIGNO, Pat. Painter, educator. Born: New York, NY, March 13, 1922. Study: Tyler Sch Art; NY Univ; Columbia Univ, B.A. & M.A. Work: Solomon R. Guggenheim Mus, New York; Brooklyn Mus, NY; Everson Mus, Syracuse, NY; New York Times; Gen Elec Corp. Comn: Murals, Lykes Steamship Lines & Cook Conv Ctr, Memphis. Exhib: Whitney Mus Am Art Ann; Art Inst Chicago; Pa Acad Fine Arts; Am Acad Arts & Lett; Univ Ill Biennial, plus 12 one-man shows. Media: Acrylic, oil.

TRUBY, Betsy Kirby. Painter, Illustrator. Born: Winchester, Va., November 8, 1926. Study: Hiram Col; Cleveland Sch Art; N Mex Inst Mining & Technol; Univ N Mex; also with David Moneypenny, Oden Hillenkramer & Joe Morello. Work: Int Moral Re-Armament Ctr, Mackinaw Island, Mich; Cancer Res & Treatment Ctr, Albuquerque; Gallery Southwestern Art, Old Town, Albuquerque; La Quinta Mus, Albuquerque. Exhib: Fine Arts Gallery, Carnegie Inst, Pittsburgh, 1946; N Mex Fiesta Biennial, State Mus, Santa Fe, 1964 & 1968; Nat Alpine Holiday Exhib, Ouray, Colo, 1968; Nat Art Show, Lawton, Okla, 1974; Nat League Am Pen Women Mid-Ad Cong, Phoenix, Ariz, 1975. Awards: Second Prize Oil Portrait, Southern Regional, Nat League Am Pen Women, Boulder, Colo, 1965 & First Premium Pastel Portrait, Nat Mid-Ad, Salt Lake City, 1973; Second Premium Pastel Portrait, N Mex, State Fair, 1973. Media: Oil, pastel.

TRUITT, Anne (Dean). Sculptor. Born: Baltimore, Md., March 16, 1921. Study: Bryn Mawr Col, B.A., 1943; Inst Contemp Art, Washington, DC, 1948-49; Dallas Mus Fine Arts, 1950. Work: Univ Ariz Mus Art, Tucson; Nat Collection Fine Arts, Washington, DC; Mus Mod Art; Whitney Mus Am Art; Walker Art Ctr. Exhib: One-woman shows, Andre Emmerich Gallery, 1963, 1965, 1969 & 1975, Baltimore Mus Art, 1969 & 1974, Pyramid Gallery, 1971, 1973 & 1975, Whitney Mus Am Art, 1974 & Corcoran Gallery Art, 1974. Awards: Guggenheim Fel, 1971; Nat Endowment Arts, 1972. Media: Wood, acrylic.

TUROFF, Muriel Pargh. Sculptor, painter. Born: Odessa, Russia, March 1, 1904; US citizen. Study: Art Students League; Pratt Inst; Univ Colo. Work; Smithsonian Inst Portrait Gallery, Washington, DC; Jewish Mus, New York. Comn: Enamel on copper artifacts, comn by St. James Lutheran Church, Coral Gables, Fla, 1974. Exhib: Syracuse Mus Art, NY, 1945; Mus Natural Hist, New York, 1958; Cooper Union Mus, New York, 1960; Lowe Mus Beaux Arts, Miami, Fla, 1968; YM-YWHA, Miami, Fla, 1971. Awards: Blue Ribbon for best in show, Blue Dome Art Fel, 1966 & 1973; Second Prize, YM-YWHA, 1971. Media: Metal, enamel.

UHL, Emmy. Sculptor. Born: Bremen, Germany, May 10, 1919; US citizen. Work: Hudson River Mus, Yonkers, NY. Exhib: Yonkers Art Asn Ann, NY, 1967-70; Westchester Art Soc Ann, NY, 1969-71; N Shore Community Arts Ctr, NY, 1970; Knickerbocker Artists Ann, New York, 1970-72; Audubon Artists, New York, 1971. Awards: Armbruster Award, Yonkers Art Asn, 1967; Knickerbocker Artists Award Merit, 1972.

UHRMAN, Celia. Painter. Born: New London, Conn., May 14, 1927. Study: Brooklyn Col, B.A. & M.A., 1953; Brooklyn Mus Art Sch, 1956-57; Teachers Col, Columbia Univ, 1961; City Univ New York, 1966. Work: Brooklyn Col; Ovar Mus; govt bldgs in Spain & Portugal. Exhib: 2nd All New England Drawing, Lyman Allyn Mus, New London, Conn, 1960; 26th Ann Contemp Am Paintings, Soc Four Arts, Palm Beach, Fla, 1964; Premi Int Dibeaux, Joan Miro, Barcelona, Spain, 1970; 26th Expos Int d'Art Contemporain, Luxembourg, 1974; Des Beaux-Arts Exhib, Monaco, Monte-Carlo, 1969, 1970 & 1972. Awards: George Washington Medal of Honor, USA, Freedoms Found, Valley Forge, Pa, 1964; Silver Medal, Centro Studi E Scambi, 1969 & Gold Medal, 1972; Academic Laurel, 27th Int Exhib Contemp Art, Moka Club, Paris, 1974 & others. Media: Oil, watercolor.

UNDERWOOD, Evelyn Notman. Painter. Born: St. Catharines, Ontario; US citizen. Study: Pratt Inst, grad; Berkshire Summer Sch Art, grad; State Univ NY Buffalo; Millard Fillmore Col; also with Charles Burchfield, Millard Sheets, Ernest Watson & Rex Brandt. Work: Roswell Park Inst, Buffalo, NY; Vet Hosp, Buffalo. Exhib: Butler Inst Am Art 19th Ann, Youngstown, Ohio, 1954; Indust Niagara Art Exhib, 1965; Int Platform Asn Art Shows, Sheraton Hotel, Washington, DC, 1970 & 1971; Burchfield Ctr, State Univ NY Col Buffalo, 1970 & 1972; Nat League Am Pen Women Regionals, New York; plus others. Awards: First Prize, Nat League Am Pen Women; Paul Lindsay Sample Mem Award, Chautauqua Nat Art Show, 1973; Outstanding Merit Award, 1st Ann Erie Co Art Festival, 1974.

URBAN, Reva. Painter, sculptor. Born: Brooklyn, NY, October 15, 1925. Study: Art Students League, Carnegie scholar, 1943-45. Work: Mus Mod Art, New York; Art Inst Chicago; Univ Mus, Berkeley; Finch Col Mus, New York; Averthorp Gallery, Jenkintown, Pa. Exhib: Pittsburgh Int, 1958-; 1st Biennale Chrislicher Kunst der Gegenwart, Salzburg, Austria, 1958; Continuity & Change, Wadsworth Atheneum, Hartford, Conn, 1962; Documenta III, Kassel, Ger, 1964; Seven Decades-Crosscurrents in Modern Art 1895-1965, exhib at ten New York galleries, 1965. Awards: Tamarind Fel. Media: Oil, aluminum.

VACCARO, Luella Grace. Ceramist, painter. Born: Miles City, Montana, June 2, 1934. Study: Univ Wash, Seattle; Univ Calif, Berkeley; workshops with Peter Voulkas. Work: Antonio Prieto Collection, Mills Col, Oakland, Calif; Ceramics Monthly Collection, Columbus, Ohio. Exhib: Ceramic & Sculpture Ann, Butler Inst Am Art, Youngstown, Ohio, 1958 & 1966; Nat Print Exhib, Honolulu Acad Art, Hawaii, 1959; 32nd & 33rd Int Print Exhib, Seattle Art Mus, Wash, 1961-62; 13th Southwest Print Exhib, Dallas Mus Fine Arts, 1963; Kans Artist-Craftsman, Mulvane Art Ctr, Topeka, Kans, 1971-73. Awards: Laguna Gloria Award, Tex Fine Arts Asn, Austin, 1961; Kans Designer Craftsman Award, Kans Univ Art Mus, Lawrence, 1968; Ceramic Monthly Award, Ceramics Monthly, Columbus, Ohio, 1971. Media: Oil paint; stoneware clay.

VALENSTEIN, Alice. Painter, collector. Born: New York, NY, February 12, 1904. Study: Teachers Col, Columbia Univ, study with Winold Reiss, Morris Davidson, Victor Candell & Leo Manso. Work: Staten Island Mus, NY; Emily Lowe Mus, Coral Gables, Fla; Hofstra Univ, NY; Miami Mus Mod Art, Fla; Mills Col, Oakland, Calif. Exhib: One-woman shows, Krasner Gallery, NY, Carus Gallery, NY, Katonah Gallery, NY, Miami Mus Mod Art & Alonzo Gallery, NY. Awards: Scarsdale Art Asn; Westchester Arts; Brandeis Univ.

VAN DER POEL, Priscilla Paine. Educator, painter. Born: Brooklyn, NY, April 9, 1907. Study: Smith Col, A.B. & A.M.; Art Students League; Brit Acad in Rome; also with Frank DuMond, George Bridgman, Sherrill Whiton & others. Exhib: Studio Club, Tryon Mus, Northampton, Mass, 1936-45.

VAN DER VOORT, Amanda Venelia. Painter. Born: Alliance, Ohio. Study: Pratt Inst, grad; Grant Cent Sch Art; Metrop Sch Art; Nat Acad Sch Fine Arts, Columbia Univ; NY Univ; also with Helen Lorenz, Ogden Pleisner, Romanovsky, Robert Philipp, Dong Klingman & Howard Hildebrandt. Exhib: Allied Artists Am, New York, 1956-57; Am Artists Prof League, New York, 1956-72; Nat Acad Design, New York, 1957; Hudson Valley Art Asn, White Plains, NY, 1959-72; Acad Artists Asn, Springfield, Mass, 1965-71. Awards: For Figure Painting, Catharine Lorillard Wolfe Art Club, 1970 & Art Soc Old Greenwich, 1971; Best in Show for Oil Portrait, Conn State Fedn Women's Clubs, 1972. Media: Oil, watercolor, graphics.

VAN METER, Mary. Painter, educator. Born: Knox Co., Ind, February 5, 1919. Study: Vincennes Univ Jr Col, A.A., 1940; Ind State Univ, B.S., 1950; Ind Univ, M.A., 1956; also with Alma Eikerman, Alton Pickens & Jack Tworkov. Work: Vincennes Univ Art Dept Gallery, Inc. Exhib: Art for Religion, Lutheran Church, Indianapolis, 1961; one-man show, Old Bank Gallery, 1967; Northwest Territory Art Guild Exhib, Swope Art Gallery, Terre Haute, Ind, 1967, Wabash Valley Exhib, 1968. Awards: Ind Univ Cert Scholastic Achievement, 1956; First Prize for Oil Painting, Little Gallery, Bloomfield, Ind, 1960; First Hon Mention for Print, Art for Relig, 1961. Media: Acrylic.

VAN ROIJEN, Hildegarde Graham. Painter, sculptor. Born: Washington, DC, November 1, 1915. Study: Rollins Col; Am Univ; Corcoran Gallery Sch Art, Washington, DC. Work: Drawings of Egypt, Brooklyn Mus, NY. Comn: Watercolor, Jr League Hq, Washington, DC. Exhib: Am House, Vienna, Austria; Va Mus, Richmond; Corcoran Gallery Art, Washington, DC; Galerie im Ram Hof, Frankfurt, Ger, 1974; Kunstler Haus-Galerie, Vienna, Austria, 1974. Awards: First for Pride's Sin, Univ Va, Charlottesville, 1971. Media: Metal, graphics.

VAN WYK, Helen. Painter, lecturer. Born: Fair Lawn, NJ. Study: Art Students League; New Sch Social Res; also with Maximilian Aureal Rasko. Work: Norfolk Mus Arts & Sci, Va; Bergen Co Mus, NJ; St Vincent's Col, Latrobe, Pa; Minneapolis Club; Livonia Sch Syst, Mich. Exhib: Acad Artists, Springfield, Mass, 1953 & 1957; Audubon Artists, New York, 1954, 1955 & 1963; Nat Acad Design, New York, 1954, 1955 & 1964; Silvermine Guild Artists, Conn, 1959. Pos: Ed, Palette Talk, Grumbacher, Inc, 1967-. Awards: John C. Pierson Prize, Ogunquit Art Ctr, Maine, 1949; First Prize for Still Life, Catharine Lorillard Wolfe Art Club, 1955; Curtis Mem Award, Rockport Art Asn, 1972 & 1973. Media: Oil, acrylic.

VARGA, Margit. Painter, writer. Born: New York, NY,
May 5, 1908. Study: Art Students League, with
Boardman Robinson & Robert Laurent. Work: Metrop Mus
Art; Springfield Mus Fine Arts, Mass; Univ Ariz, Tucson;
IBM Collection; Pa Acad Fine Arts. Comn: Mural for
lobby, Kidder, Meade & Co, Paramus, NJ. Exhib: Whitney
Mus Am Art, 1951; Univ Ill, 1951; Art Inst Chicago;
Carnegie Inst; Corcoran Gallery Art. Media: Oil.

VIRET, Margaret Mary (Mrs. Frank Ivo). Painter, instructor.
Born: New York, NY, April 18, 1913. Study: Terry Art
Sch; Miami Art Sch; Miami Art Ctr, Univ Miami; also with
Dong Kingman, Eliot O'Hara, Xavier Gonzalez, Eugene
Massin, Georges Sellier & Jack Amoroso; plus many other
prominent instrs. Work: Norton Gallery; Lowe Art
Gallery. Exhib: Tampa Art Mus, 1955; Fla Fedn Art, 1955-
56; Bass Art Mus, Miami Beach, 1955-57, 1962 & 1963; Lowe
Art Gallery, 1960, 1962 & 1970; American Contemporary,
Four Arts Soc, 1965; plus others. Awards: Best Watercolor
for Flowers, Fla Fedn Women's Clubs, 1961; Best Watercolor
for Marine, Bass Art Mus, 1962; Best Watercolor for
Flowers, Burdines Coral Gables Art Club, 1963. Media:
Watercolor, oil, acrylic.

VISSER'T HOOFT, Martha. Painter. Born: Buffalo, NY,
May 25, 1906. Study: Acad Julien, Paris, 1922. Work:
Albright-Knox Art Gallery, Buffalo; Whitney Mus Am Art,
New York; Columbia Mus Art, SC; Rollins Col Mus Art;
Munson-Williams-Proctor Inst, Utica, NY. Exhib:
American Painting Today, Metrop Mus Art, New York, 1950;
Carnegie Inst Int, Pittsburgh, 1952; Art Inst Chicago,
1956; Artistas Brasileros Americanos, Mus Mod Art, Sao
Paulo, Brazil; one-man show, Charles Burchfield Ctr,
State Univ NY Col Buffalo, 1973. Awards: Purchase
Award, Columbia Mus Art, 1959; Second Prize in Oil,
Chautauqua Inst Art, 1964; NY State Univ Buffalo Community
Coun Award, 1975; plus others.

VIVENZA, Francesca. Painter. Born: Rome, Italy, May 4,
1941. Study: High Sch Fine Art, Milan, Italy; Acad
Belle Arti Brera, Milan; frescos with Gianfilippo Usellini.
Comn: Geology & Metamorphosis of Sci (drawings), Univ
Toronto Mining Bldg, 1974. Exhib: One-man shows, Albert
White Gallery, Toronto, 1972 & 1974 & Galleria Clovasso,
Milan, 1975; graphics with open studio, Pollock Gallery,
Toronto, 1975 & Glenbow-Alta Inst, Calgary, 1975; Scan,
Vancouver Art Gallery, 1974; plus others. Awards: Munic
Alessandria Award, Italy, 1965; Award for Flowers, Genova,
Italy, 1971; Contemp Ital Art Award, Vienna, Austria, 1973;
plus others. Media: Pen & ink, oil.

VOLKIN, Hilda Appel. Printmaker, painter. Born: Boston, Mass., September 24, 1933. Study: Mass Col Art, B.S., 1954; Radcliffe Col, M.A., 1956. Work: Cleveland Mus Art, Ohio; Massillon Mus, Ohio; Beth-Israel, West Temple, Cleveland. Exhib: Massillon Mus Ann, 1964 & 1973; Cleveland Mus Art Travel Exhib, 1971 & May Shows, 1973 & 1974; SPAR Nat Art, Shreveport, La, 1973; Canton Art Inst Ann, All Ohio Show, 1973 & 1974. Awards: Purchase Award for Watercolor, Massillon Mus, 1966; Third Prize for Serigraphs, Canton Art Inst, Ohio, 1968; Graphics Award, Cleveland Mus Art, 1974.

VOLLMER, Ruth. Sculptor. Born: Munich, Ger; US citizen. Work: Nat Collection Fine Arts, Smithsonian Inst, Washington, DC; Mus Mod Art Whitney Mus Am Art, New York; NY Univ Art Collection; Rose Art Mus, Brandeis Univ. Exhib: Mus Mod Art Lending Serv, New York, 1963-; For Eyes & Ears, Cordier Ekstrom Gallery, New York, 1964; Whitney Mus Am Art Ann, 1964-70; 2nd Salon Int Galeries Pilotes, Lausanne, Switz, 1966; one-person show, Everson Mus Art, Syracuse, NY, 1974. Media: Plastic.

WAITZKIN, Stella. Sculptor, painter. Born: New York, NY. Study: Alfred Univ; NY Univ; Columbia Univ; also with Meyer Shapiro & Hans Hofmann. Work: Richmond Mus Fine Arts, Va; Newark Mus, NJ; Butler Mus Am Art, Ohio; Calhoun Col, Yale Univ; Wis Univ Ctr for 20th Century Studies. Exhib: Destruction Show, Finch Col Mus, 1968 & Recent Acquisitions, 1974; one-woman show, Serious Literature, Calhoun Col, Yale Univ, 1974; Potsdam Plastics, NY Univ, 1975; Contemp Am Sculpture, Va Mus Downtown Gallery, 1975; James Yu Exhib, 1975; plus others. Awards: Yaddo Found Fels, 1973 & 1974; MacDowell Found Fels, 1974 & 1975. Media: Sandstone, polyester resin.

WALSH, Patricia Ruth. Painter. Born: Cleveland, Ohio. Study: Col Mt St Joseph, Cincinnati, B.A.; Art Students League; Syracuse Univ, NY, M.F.A. Exhib: Northwest Printmakers Int, Seattle Art Mus, 1965; Paintings, Calif Col Arts & Crafts Gallery, Oakland, 1969; Pollution Show, Oakland Mus, 1970; Three Watercolorists, San Jose Civic Art Ctr, 1973; Spaces & Places, Palo Alto Cult Ctr, 1975. Media: Oil, watercolor.

WALTNER, Beverly Ruland. Painter. Born: Kansas City,
Mo. Study: Yale Univ, with Joseph Albers; Univ Miami,
B.A.; Northern Ill Univ, M.F.A.; Kent State Univ,
Blossom-Kent Art Prog, with Richard Anuszkiewicz.
Work: Northern Ill Univ, De Kalb. Exhib: 10th Midwest
Biennial, Joslyn Art Mus, Omaha, Nebr, 1968; Mid-Am I,
NelsonGallery Art, Kansas City & City Art Mus, St Louis,
Mo, 1968; 35th Ann Midyear Show, Butler Inst Am Art,
Youngstown, Ohio, 1970; 33rd Ann Exhib Contemp Am
Painting, Soc Four Arts, Palm Beach, Fla, 1971; Ann
Exhib Nat Soc Painters in Casein, Inc., Nat Arts Club,
New York, 1972. Awards: New Horizons in Painting Top
Award, N Shore Art League, Chicago, 1966; Chautauque
Exhib Am Art First Place, Chautauque Art Asn, 1968,
Louis E. Seiden Mem Award, 1970. Media: Acrylic.

WARRINER, Laura B. Painter. Born: Tulsa, Okla.,
January 18, 1943. Study: Okla Baptist Univ; Oklahoma
City Univ. Exhib: Nat Watercolor Soc 54th Ann, Laguna
Beach Mus, Calif, 1974; Watercolor USA, Springfield Art
Ctr, Mo, 1974; Nat Acad Design, 149th Ann Exhib, 107th
Ann Exhib Am Watercolor Soc & Allied Artists Am 60th Ann
Exhib, Nat Acad Design Galleries, New York 1974 & 1975.
Awards: Award for Watercolor, Allied Artists Am 60th
Ann Exhib, 1974; Barbara Vassilieff Award for Flowers-
Still Life, Allied Artists Am 61st Ann Exhib, 1975;
Century Award of Merit, Rocky Mountain Nat Watermedia
Exhib, 1975. Media: Watercolor, drawing.

WASILE, Elyse. Painter, designer. Born: New York, NY,
May 27, 1920. Study: Univ Calif, Los Angeles. Work:
Nassau Art Gallery, Bahamas; Commonwealth of Bahamas
Post Off, Nassau. Comn: Murals, Widner Estate, Palm
Beach, Fla, 1951, Palm Beach Int Airport, 1960 & Nassau
Beach Hotel, 1961; definitive stamp issue (15), Post Off
Dept, Bahamas, 1971. Exhib: S Fla Fair & Expos, 1960;
Bahamas Art Soc, Nassau, 1967; Nassau Art Gallery Ann.
Awards: Blue Ribbon, S Fla Fair & Expos, 1960. Media:
Acrylic, gouache, oil.

WASSER, Paula Kloster. Educator, painter. Born: Hatton, N Dak. Study: Univ Minn; Minneapolis Sch Art; Univ N Dak, B.S., 1926; Stanford Univ, M.A., 1931, grad study, 1948; Univ Mex, grad study, 1933; Univ Southern Calif, 1939; also study var art schs. Exhib: Phoenix Fine Arts Asn; Tucson Fine Arts Festival; Ariz Art Guild; Ariz State Fair; Univ Nev, Reno; one-man shows, Phoenix, Ariz; plus others. Media: Oil, acrylic, watercolor.

WATFORD, Frances Mizelle. Painter, gallery director. Born: Thomasville, Ga., September 6, 1915. Study: Hilton Leech Art Sch, summers 1952-59; Sarasota Sch Art, Portas Studio & Ringling Sch Art, Fla, summers 1959-64; spec workshop with Dong Kingman, Columbia, Ga, 1966; Famous Artists Sch, grad, 1969. Work: Montgomery Mus Fine Arts, Ala; Birmingham Mus Art, Ala; Houston Mem Libr, Dothan, Ala; Dothan High Sch Gallery; Ala Arts & Humanities Coun, Montgomery. Comn: Portraits for pvt collections, Dothan, 1958 & 1962, Elba, Ala, 1960 & 1964 & Graceville, Fla, 1960; murals for pvt collections, Dothan, 1964-66. Exhib: Dothan-Wiregrass Art League, 1961-75; Bienniale Int Vichy, France, 1964; Honored Exhibitor, Birmingham, Ala, 1966; Arts & Crafts Festival Dothan, 1971-75; one-man shows, Montgomery Mus Fine Arts, 1961, Dothan, 1961, 1964 & 1970 & Columbus Mus Arts & Crafts, Ga, 1966. Awards: Purchase Awards, 1958-61 & 1959 & Cline Award, 1966, Ala Art League; Dipl d'Honneur, Bienniale Vichy, 1964; Best of Show Purchase Award, Houston Arts & Crafts Festival, Dothan, Ala, 1973 & 1975. Media: Watercolor, acrylic, oil.

WATSON, Darliene Keeney. Painter. Born: Amarillo, Texas, March 16, 1929. Study: Univ Colo, B.F.A.; Art Inst Chicago; Malden Bridge Sch Art, NY; also with Dick Goetz, Oklahoma City & New York; Lui-Sang Wong, San Francisco & Ho Nien Au, Taiwan. Exhib: 10th, 11th & 12th Exhibs, Sumie Soc Am, 1973-75; Art Barn, Artists Equity & Nat Parks, 1974; Art League Northern Va; Fairfax County Coun Arts; var local & regional shows in East & Southwest US. Awards: First Prize Cup of the Consul Gen Japan, Sumie Soc Am, 1973 & 1975; Third Prize, St Peter's 5th Ann Exhib, 1975. Media: Watercolor, acrylic.

WEBB, Constance Olleen. Painter. Born: Camphill, Ala.,
June 10, 1923. Study: George Washington Univ; Inst
Allende, San Miguel de Allende, Mex; also with Richard
Goetz, Oklahoma City. Comn: 20 Indian Portraits, A. C.
Leftwich, Duncan, Okla, 1972. Exhib: Int Art Show,
Lawton, Okla, 1971; Nat MIniature Art Show, Garden State
Plaza, Paramus, NJ, 1972; 1st Ann Western Art Roundup-
Women Artists Am West, Riverside, Calif, 1973; 39th &
41st Ann Miniature Painters, Sculptors & Gravers Soc of
Washington, DC, Art Club of Washington, 1972 & 1974.
Awards: First Place for Portrait, Madill Art Festival,
Okla, 1969; Award of Merit, Lawton-Ft Sill Art Coun, 1970;
First Place for Pastel, Chickasha Art Guild, Okla, 1973.

WEBB, Virginia Louise. Painter. Born: Brooklyn, NY,
June 2, 1920. Study: Art Students League; Julian Acad,
Paris, France; landscape painting with Jay Connaway,
Pawlet, Vt; portrait painting with Wallace Bassford, North
Truro, Mass. Work: Berkshire Mus, Pittsfield, Mass; Mus
Fine Arts, Springfield, Mass; Benedictine Abbey Collection,
Fecamp, France; Laurance Rockefeller's Woodstock Inn
Collection; Southern Vt Art Ctr. Exhib: Berkshire Art
Asn, Pittsfield, Mass, 1956, 1962, 1963 & 1974;
Benedictine Art Award Show, New York, 1969; Southern Vt
Art Ctr, Manchester, Vt, 1970; Acad Artists Asn,
Springfield, Mass, 1972-74; Allied Artists Am, New York,
1974. Awards: Berkshire Art Asn Award for Summer Still
Life, 1962; Purchase Award for Abandoned, Mus Fine Arts,
1971; Muriel Alvord Mem Award for Apples & Pears, 1972.
Media: Oil painting; pentel drawing.

WEBER, Idelle. Painter. Born: Chicago, Ill. Study:
Scripps Col; Univ Calif, Los Angeles, B.A. & M.A. Work:
Albright-Knox Art Gallery Buffalo, NY; Yale Univ Art
Gallery New Haven, Conn. Exhib: Mus Mod Art, 1956;
Bertha Schaefer Gallery, New York, 1962-64; Guggenheim
Mus, 1964; Hundred Acres Gallery, 1973 & 1975; Realismus
und Realitat, Darmstadt, W Ger. Awards: Nat Scholastic
Art Awards, Scripps Col, 1950. Media: Oil, watercolor.

WEEBER, Gretchen. Painter. Born: Albany, NY. Study: Albany Inst Hist & Art; Inst Allende, San Miguel Allende, Mex; also with Betty Warren. Work: Rensselaer Co Hist Soc, Troy, NY; Home Savings Bank, Albany; NY State Conf Mayors, Albany; First Lutheran Church, Albany; Robert Appleton Collection, Albany. Exhib: NY State Expos, Syracuse, 1964; Eastern States Expos, Springfield, Mass, 1965; Berkshire Ann, Pittsfield, Mass, 1968; Artists Asn Nantucket, Kenneth Taylor Galleries, Mass., 1969-; Artists of the Upper Hudson, Albany Inst Hist & Art, 1970. Awards: Raymond Scofield Prize for Best Watercolor, Albany Artists Group, 1964; First Prize, Rennselaer Co Hist Soc, 1968; First Prize for Nantucket Subjects, Artists Asn Nantucket, 1969.

WEST, Amy M. Painter. Born: New York, NY, May 31, 1936. Study: Fr Inst Art, 1946; with Michael Lensen, Nutley, NJ, 1952; Cornell Univ, A.B., 1957; Art Students League, with Rudolph Baranik. Work: Cornell Univ Student Collection. Exhib: Painters & Sculptors Soc NJ Exhib, Jersey City Mus, 1974 & Nat Arts Club, New York, 1974; Art Ctr of Oranges Nat Exhib, East Orange, NJ, 1974 & 1975; Springville Mus Art 51st Nat Exhib, Utah, 1975; Soc Painters in Casein & Acrylic, Nat Acad Arts, New York, 1975. Awards: DeWitt Savings & Loan Award for Oil, Painters & Sculptors Soc, 1974, Robert Simmons Award, 1975; Directors Award, Art Ctr Oranges, 1974. Media: Oil, acrylic.

WEST, Clara Faye. Painter, conservator. Born: Coffeeville, Miss., May 8, 1923. Study: Corcoran Sch Art, Washington, DC, with Eugen Weisz, Nicolai Cikovsky & Heinz Warneke; also with Jaska Shaffran. Work: Mitchell Mem Libr, Miss State Univ; Res & Develop Ctr, Jackson State Univ; Hist Mus, Columbus, Miss. Exhib: Mary Buie Mus, Oxford, Miss, 1949; Mid-South Exhib, Brooks Mem Gallery, Memphis, 1959; one-man shows, West Memphis Libr, Ark, 1959; Miss State Univ, 1965, 1967 & 1972 & Hogarth Student Ctr, Miss Univ Women, 1970. Awards: First Prize for Seeds for Britain (poster), Brit War Relief Soc, 1943. Mem: Am Inst Conservators Hist & Artistic Works; Art Asn Columbus (pres, 1972-73); Miss Art Asn; Birmingham Art Asn. Media: Oil, acrylic, egg tempera.

WETHINGTON, Wilma Zella. Painter. Born: Clinton, Iowa, April 15, 1918. Study: Clinton High Sch; Marshall Univ, Huntington, W Va; Wichita State Univ; also with Mario Cooper, John Pike, Charles R. Kinghan, Tom Hill, Clayton Henri Staples, Robert Wood & others. Work: Univ Wyo, Laramie; Wichita State Univ, Kans; Episcopal Diocese Kans, Topeka; Briarcroft Savings & Loan Asn, Lubbock, Tex; Parsons Art Mus, Kans. Exhib: Am Watercolor Soc, New York, 1972; Hudson Valley Art Asn, New York, 1972-74; Southwestern Watercolor Soc, Dallas, Tex, 1973, 1974; New Orleans Int Art Mart, 1974; Nat Soc Painters in Casein & Acrylic, New York, 1975. Awards: First Prize, 8th West Biennial, Grand Junction Art Mus, Colo, 1970; Best of Show, North Platte Artists Guild, Nebr, 1973; First Award in Watercolor, Okla Mus Art, 1975. Media: Oil, pastel.

WHIDDEN, Constance. Painter, instructor. Born: Cambridge, Mass. Study: Boston Mus Sch Fine Arts, 1932-38, Sturdivant traveling fel Europe, 1938-39; also with Hans Hofmann & Ferdinand Leger. Work: US Embassy, Brussels; St George's Gallery, London; Boston Mus Fine Arts; Smithsonian Inst; Honolulu Acad Art. Exhib: New Selection of Works by Contemporary Artists, St. George's Gallery, London, 1946; Salon de Mai, Paris, 1950; NJ State Mus Ann, 1967-68; one-woman show, Reflections of Hawaii, Honolulu Acad Art Mus, 1970; Contemporary American Drawings, Cranbrook Acad Art Mus Flint Inst Art, 1975. Awards: Nat Scholar Art Educ, Harvard Univ, 1939; Purchase Award, Anglo-French Ctr, London, 1947.

WHITMORE, Lenore K. Painter. Born: Lemont, Pa., August 9, 1920. Study: Pa State Univ, B.S.; Herron Sch Art; Provincetown Workshop; and with Garo Antresian, Will Barnet, Edward Manetta, Victor Candell & Leo Manso. Work: John Calvert Collection; G. D. Sickert Collection; Indianapolis Found; DePauw Univ, Jerone Picker Collection. Exhib: Eastern Mich Nat Polymer Exhib, 1968; Audubon Artists Exhibs; Int de Femme, 1969; Painters & Sculpturs Soc NJ; traveling exhib, US, 1975. Awards: Motorola Nat Art Exhib Awards, 1961 & 1962; Mark A. Brown Award in Composition, Hoosier Salon, 1963; Permanent Pigments Award, Painters & Sculptors Soc NJ, 1968. Media: Mixed media.

WIENER, Phyllis Ames. Painter. Born: Iowa City, Iowa, September 17, 1921. Study: Univ Iowa, 1940-41; Univ Mo, 1943-44; Univ Minn, 1952, 1954 & 1956, with Cameron Booth; Inst Allende, San Miguel, Mex, with Pinto, 1961. Work: Minneapolis Art Inst; Walker Art Ctr, Minneapolis; Patrick Lannon Collection, Chicago; Am Asn Univ Women; Grand Rapids Art Mus. Exhib: Walker Biennial, 1952-64; US State Dept Traveling Show, 1962; Pa Acad Fine Arts, Philadelphia, 1964; Butler Inst Art, Youngstown, Ohio, 1965; one-man show, Minneapolis Art Inst, 1967; plus others. Awards: Walker Art Ctr Biennial Awards, 1954, 1958 & 1962; Minneapolis Inst Art Awards, 1955, 1958 & 1962. Media: Oil, acrylic.

WIEST, Kay Van Elmendorf. Painter, photographer. Born: Little Rock, Ark., May 24, 1915. Study: Art Inst Chicago, with Louis Rittman; Am Acad Art, Chicago, with St. John; London City & Guilds Sch, Eng, with Middleton Todd; L'Ecole des Beaux Artes, Paris, with Msgr Souverbie; Univ N Mex, Albuquerque, with Raymon Johnson. Work: Univ N Mex Sch Jour, Albuquerque; Nat Hq Pen Women, Washington, DC; N Mex Fine Arts Mus, Santa Fe. Exhib: Int Exhib, Stevens Hotel, Chicago, 1942; Newton Art Gallery, New York, 1946; Univ N Mex, Albuquerque, 1950; Univ Ind, Indianapolis, 1958; N Mex Fine Arts Mus, Santa Fe, 1967. Awards: First Prize Portraiture, Int Art Show, Chicago, 1942; Portraiture, La Gallerie de Boetie, Paris, 1945; First Prize Portraiture, Botts Gallery, Albuquerque, N Mex, 1953.

WILKE, Hannah. Sculptor, instructor. Born: New York, NY, March 7, 1940. Study: Temple Univ, B.F.A., 1961, B.S., 1962. Work: Albright-Knox Art Mus, Buffalo, NY; Allen Art Mus, Oberlin, Ohio; Brooklyn Mus, NY; Power Inst, Sydney, Australia; Metro-Media, Channel 5, New York. Exhib: One-woman shows, Sculpture & Drawing, Ronald Feldman Fine Arts, NY, 1972, 1974 & 1975, Drawing Show, Margo Leavin Gallery, Los Angeles, 1974; Whitney Mus Biennial, New York, 1973; Woman Choose Woman & Soft Sculpture, NY Cult Ctr, 1973; 5 Americans in Paris, Galerie Gerald Piltzer, France, 1975. Awards: Sculpture Award, Creative Arts Prog Serv, NY State Coun Arts, 1974. Media: Latex rubber, terra-cotta; video.

WILLIAMS, Shirley C. Sculptor. Born: Hackensack, NJ, August 22, 1930. Study: Art Students League, with Sidney Dickenson, Gene Scarpantoni & William Dobbin; Frank Reilly Sch Art, New York, with Jack Faragasso. Work: Northeastern Loggers Exhib Hall, Old Forge, NY. Exhib: Catharine Lorillard Wolfe Art Club 70th Ann, Gramercy Park, New York, 1967; Vermont Lumberjack Roundup, State of Vt, Lake Dunmore-Killington, 1968-71; Int Wood Collectors Exhib, US Nat Arboretum, Washington, DC, 1971; Am Artists Prof League Grand Nat, New York, 1972; Northeastern Loggers Exhib Hall, 1972. Awards: Hon Mention, Am Artists Prof League, 1972. Media: Wood.

WILLIAMSON, Clara McDonald. Painter. Born: Iredell, Texas. Work: Dallas Mus Fine Arts, Inc, Amon Carter Mus, Ft. Worth, Tex; Valley House Gallery, Dallas; Mus Mod Art, New York; Wichita Art Mus, Kans. Exhib: One-man show, Dallas Mus Fine Arts, 1948; American Painting of Today, 1950, Metrop Mus, New York, 1950; Am Contemp Natural Painters, 1953-54 & Am Primitive Painting Exhib, 1958 & 1959, Smithsonian Inst, Washington, DC; Int Exhib Primitive Art, Bratislava, Czech, 1966. Awards: Raiberto Comini Purchase Award, 1945 & 1947; Dealey Purchase Award, 1946 & Summerfield G. Roberts Award, 1954, Dallas Mus Fine Arts.

WILSON, May. Sculptor. Born: Baltimore, Md., September 28, 1905. Work: Whitney Mus Am Art, New York; Baltimore Mus; Goucher Col, Baltimore; Corcoran Gallery Art, Washington, DC; Dela Banque de Pariset, Brussels, Belg. Exhib: New Idea, New Media Show, Martha Jackson Gallery, New York, 1960; Mus Mod Art Traveling Assemblage, New York, 1962; Am Fedn Arts Patriotic Traveling Show, New York, 1968; Human Concern Show, 1969 & Whitney Sculpture Ann, 1970, Whitney Mus Am Art. Awards: Baltimore Mus Art Show Awards, 1952 & 1959.

WILSON, Sybil. Painter, designer. Born: Tulsa, Okla., March 20, 1923. Study: Art Students League, with Ernest Fiene; Yale Univ Sch Art & Archit, with Josef Albers, B.F.A. & M.F.A.; also with Anni Albers. Work: NY Univ Collection; Univ Ky Collection; Univ Mass Collection; Univ Bridgeport Collection; Chase Manhattan Bank Collection. Exhib: One-man shows, Grand Cent Mod Gallery, New York, 1962 & 1965, East Hampton Gallery, New York, 1970 & Woods, Gerry Gallery, RI Sch Design, 1972; Retinal Art in US Traveling Exhib, 1966. Awards: Am Inst Graphic Arts 50 Best Bks Award, 1960. Media: Acrylic.

WINDROW, Patricia (Patricia Windrow Klein). Painter,
illustrator. Born: London, Eng., September 12, 1923;
US citizen. Work: Parrish Mus, Southampton, NY.
Exhib: Allied Artists Am, New York, 1969 & 1973. Awards:
First Prize in Oils for the Kite, Guild Hall Ann Mem
Exhib, Easthampton, 1957; First Prize for Shrouded
Muchacha, Catharine Lorillard Wolfe Club, New York, 1968;
First Prize for Still Life, Miniature Art Soc New York
Ann, 1970. Media: Oil.

WOLLE, Muriel Sibell. Painter, writer. Born: Brooklyn,
NY, April 3, 1898. Study: NY Sch Fine & Appl Art, two
diplomas; NY Univ, B.S., 1928; Univ Colo, M.A., 1930.
Work: Springfield Mus, Mo; Univ Colo Mem Ctr, Boulder;
Mont State Mus, Helena. Exhib: Denver Art Mus Ann
Show, 1928-47; Nat Asn Women Artists, 1930-48; Artists
West of the Mississippi, 1939; one-man shows, Denver Art
Mus, 1956 & Iowa State Univ Gallery, Mem Union, 1967.
Awards: Norlin Medal, 1957 & Stearns Award, 1966, Univ
Colo; Laureate Key, Delta Phi Delta, 1958. Media:
Lithographic crayon, watercolor.

WOLPERT, Elizabeth Davis. Painter, instructor. Born:
Ft. Washington, Pa., September 12, 1915. Study: Moore
Col Art, B.F.A.; Pa State Univ, M.A.Ed; and with Hobson
Pittman. Work: Woodmere Art Gallery, Philadelphia, Pa;
Pa State Univ, University Park; Temple Univ, Philadelphia;
Bob Jones Univ, Greenville, SC; Univ Miami, Coral Gables.
Exhib: Pa Acad Fine Arts, Philadelphia, 1948; Phila-
delphia Mus Art, 1962; Butler Inst Art, Youngstown, Ohio,
1965. Awards: Charles K. Smith First Prize & First
Mem Prize, Woodmere Art Gallery, 1953; First Purchase
Prizes, Junto, Philadelphia, 1958-59. Media: Oil.

WOODSON, Doris. Educator, painter. Born: Richmond, Va.,
January 13, 1929. Study: Xavier Univ, New Orleans, B.A.;
Commonwealth Univ, Richmond, Va, M.F.A. Work: Bank of
Va, Richmond; Univ Pa. Exhib: 11th Ann Piedmont
Painting Show, Mint Mus, Charlotte, NC, 1971; Mainstreams
71, Int Painting, Marietta, Ohio, 1971; Virginia Artists,
Va Mus, Richmond, 1971 & 1975; Artists Showcase Gallery,
Virginia Beach, Va, 1973. Awards: Petersburg Art
Festival, Petersburg Area Art Leagues, 1968-74; Norfolk
Art Festival, Tidewater Artists Asn, 1973; Lynchburg Art
Festival, Lynchburg Art Asn, 1974. Media: Acrylic,
plexiglas.

WOODSON, Shirley Ann. Painter, educator. Born: Pulaski, Tenn., March 3, 1936. Study: Wayne State Univ, B.F.A., M.A.; Art Inst Chicago. Work: Dulin Gallery Art, Knoxville, Tenn; Detroit Pub Schs, Mich. Exhib: Childe Hassam Found Purchase Exhib, Acad Arts & Lett, New York, 1968; Mich Artists Exhib, Detroit Inst Arts, 1960. Awards: Purchase Prize, Print & Drawing Exhib, Dulin Gallery Art, Knoxville, Tenn, 1965; Fel, MacDowell Colony, 1966-67.

WORTH, Karen. Sculptor. Born: Philadelphia, Pa., March 9, 1924. Study: Tyler Art Sch, Temple Univ; Pa Acad Fine Arts, Acad Grande Chaumiere, Paris. Work: Smithsonian Inst; West Point Acad, NY; Am Jewish Hist Asn, Boston; Jewish Mus, New York; Israel Govt Coins & Medals Div, Jerusalem. Exhib: Nat Acad, New York, 1965; Lever House, New York, 1966-; Ceramic Sculpture of Western Hemisphere. Awards: Second Place for Sculpture, Ceramic Sculpture Western Hemisphere, 1941; Pa Acad Fine Arts Award for Sculpture, 1942; Allied Artists Am Award for Sculpture, 1965. Media: Clay, bronze.

WYBRANTS-LYNCH, Sharon. Painter, instructor. Born: Miami Beach, Fla., September 29, 1943. Study: Art Students League, 1953-54 & 1968; with Antiono Gattorno, 1958-60; Sullins Col, A.A., 1961-63; RI Sch Design, 1963; Ohio Wesleyan Univ, B.F.A., 1965; Ind Univ, grad work, 1966-68; Hunter Col, M.A. (painting), 1973. Work: Ohio Wesleyan Univ; Western Ill Univ. Exhib: One-person show, Soho 20 Gallery, New York, 1973 & 1974; Eye of Woman, Hobart & William Smith Cols, 1974; Am Acad Arts & Lett, 1974; Year of the Woman, Bronx Mus Arts, NY, 1975. Awards: Childe Hassam Fund Purchase Award, Am Acad Arts & Lett, 1974. Media: Acrylic, pastel.

YANISH, Elizabeth. Sculptor, lecturer. Born: St. Louis, Mo. Study: Wash Univ; Denver Univ; also with Frank Varra, Wilbur Verhelst, Edgar Brittor, Marian Buchan & Angelo DiBenedetto. Work: Tyler Mus, Tex; Colo State Bank, Denver, Martin-Marietta Co, Denver; Colo Womens Col; Ball State Col. Exhib: Denver Art Mus Exhib, 1961-75 & Western Ann, 1965; Midwest Biennial, Joslyn Mus, Omaha, Nebr, 1968; Int Exhib, Lucca, Italy, 1971; one-man show, Woodstock Gallery, London, Eng, 1973; Artrain, Mich Fine Arts Coun, 1974. Awards: Purchase Award Golden Web, Colo Women's Col, 1963; McCormich Award, Ball State Univ, 1964; Purchase Award, Tyler Mus, Tex, 1965. Media: Welded steel, bronze, copper.

YANOW, Rhoda Mae. Painter, illustrator. Born: Newark,
NJ. Study: Newark Arts Club; Parsons Sch Design;
Newark Sch Fine & Indust Arts; Heritage Art Sch; Nat
Acad Design, with Henry Gasser, Daniel Greene, Harvey
Dinnerstein & John Grabach. Work: West Orange Home
for Senior Citizens, NJ; Newark Pub Libr. Exhib: 78th
Ann Open Exhib, Catharine Lorillard Wolfe Art Club, Inc.,
1974; Nat Arts Club Pastel Show, 1974; Muhlenberg Col
Festival of Arts, 1975; Am Artists Prof League Grand Nat
Exhib, 1975; Salmagundi Club Watercolor Show, 1975.
Awards: Andrews/Nelson/Whitehead Award, Nat Arts Club,
1974; Coun Am Artist Socs Award, Am Artists Prof League
Grand Nat, 1975; Louis La Beaum Mem Award, Nat Acad
Design, 1975. Media: Pastels, pen & ink, oil.

YARBROUGH, Leila Kepert. Printmaker, painter. Born:
Katoomba, NSW, Australia, March 23, 1932; US citizen.
Study: Univ Fla; Atlanta Col Art, Ga. Work:
Chrysler Mus, Norfolk, Va; Augusta Mus Art, Ga; Piedmont
Col, Demorest, Ga; Loch Haven Art Ctr, Orlando, Fla;
Great Smoky Mts Nat Park Art Collection, Gatlinburg,
Tenn. Exhib: Drawing Soc Nat Travel Exhib, Am Fedn
Arts, 1965-66; Contemporary American Drawing V: Norfolk,
Smithsonian Inst Travel Exhib, 1971-73; 34th Ann Contemp
Am Painting, Soc of Four Arts, Palm Beach, Fla, 1972; 1st
Nat Monoprint/Monotype, Oglethorpe Univ, Atlanta, Ga,
1973; 64th Ann, Conn Acad Fine Arts, Hartford, 1974.
Awards: Am Drawing Purchase Award, Norfolk Mus, 1971;
First Prize, The Single Impression, Oglethorpe Univ,
Atlanta, 1973; Great Smoky Mts Nat Park Purchase Award,
US Govt Art Purchase Prog, 1974. Media: Intaglio,
monoprints; casein; mixed.

YATES, Sharon Deborah. Painter. Born: Rochester, NY,
April 3, 1942. Study: Syracuse Univ, scholar to
Florence, Italy, 1963, B.F.A., 1964; Tulane Univ, La,
M.F.A., 1966. Work: Okla Art Ctr, Oklahoma City.
Exhib: Am Fedn Arts Traveling Exhib, New York, 1967-;
Okla Art Ctr 10th Ann, 1968; Mainstreams '70, Marietta
Col Fine Arts Ctr, Ohio, 1970; Exhib Contemp Realists,
Cleveland Inst, 1972; one-man show, Univ Louisville, Ky,
1967; plus many others. Awards: Grand Prize,
Mainstreams, 1970; Prix de Rome, 1972. Media: Oil.

YOUNG, Marjorie Ward. Painter. Born: Chicago, Ill.,
June 25, 1910. Study: With Florence Reed, Chicago,
1924; Art Inst Chicago Sat Sch, 1925-27, Day Sch, 1928-32;
with William B. Schimmel, 1955-56, Jossey Bilan, 1958-62,
Edgar A. Whitney, 1969 & 1971, Richmond Yip, 1970 & J.
Douglas Greenbowe & Milford Zornes, 1972. Work: Ariz
Bank, Phoenix; First Nat Bank Ariz, Phoenix; Walter Bimson
Collection, Phoenix; Phoenix Country Club; Western Serum
Co, Tempe, Ariz. Exhib: 16th Ann Tucson Festival Art,
Ariz, 1966; Fine Arts Festival S Dak State Univ, 1969;
2nd Ariz Watercolor Biennial, Phoenix Art Mus, 1970; Nat
Diamond Biennial, Nat League Am Pen Women, Washington, DC,
1972; Ariz Watercolor Asn Show in Taiwan, 1974. Awards:
Second in Watercolor for Filibusters, Low Ruins Spring Nat,
Tubac, Ariz, 1965; Hon Mention for A Study in Brief, Nat
Diamond Biennial, 1972 & First in Watercolor & Best of
Show for Pencil Sketch, League Show, 1975, Nat League
Am Pen Women.

YUDIN, Carol. Printmaker, painter. Born: Brooklyn, NY.
Study: Pratt Graphic Ctr, with Sid Hammer, Michael Ponce
de Leon, Roberto di Lamonica, Andrew Stasik & painting
with Michael Lenson. Work: NJ State Mus, Trenton;
Jersey City Mus, NJ; St Peter's Col, Jersey City;
Miniature Art Soc NJ, Paramus; Belleville Pub Libr, NJ.
Comn: Tree of Life, Congregation Ahavath Achim,
Belleville, 1965. Exhib: Art from NJ, NJ State Mus,
1969; 4th Int Miniature Print Exhib, 1971; 7th Triennial
NJ Artists, Newark Mus, NJ, 1971; 31st Ann Painters &
Sculptors Soc NJ, 1971; Nat Asn Women Artists, Jersey City
& New York, 1971. Awards: Purchase Awards, NJ State
Mus, 1969, Painters & Sculptors Soc NJ, 1969 & Nat
Miniature Art Soc Exhib, 1970.

ZIEGLER, Jacqueline. Sculptor, educator. Born: Mt.
Vernon, NY, February 23, 1930. Study: With Frederick
V. Guinzburg, 1943, Ruth Nickerson, 1944, Columbia
Univ, sculpture with Oronzio Maldarelli & casting with
Ettore Salvatore, 1947; Art Students League, life
drawing with Klonis, 1948; Univ Chicago, A.B., 1948;
Fashion Inst Technol, 1948-50; Royal Acad Fine Arts,
Copenhagen, Denmark, 1960-62. Work: Many Hands (3-ton
wood carving), Govt of Nigeria, Enugu, Nigeria; Judge
Charles Fahy (bronze portrait), Georgetown Law Libr,
Washington, DC; Portrait Plaques, Onondaga Community Col,
Syracuse, NY; Bushwoman of the Kalahari, Smithsonian
Inst, Washington, DC; Ecce Homo, Jesuit Curia, Rome.
Exhib: Charlottenborg, Copenhagen, Denmark, 1962; Nat
Collection of Fine Arts, Washington, DC, 1963; Washington
Gallery Art, 1966; Everson Mus, Syracuse, NY, 1972; one-
man show, St. Peter's Gallery, Soc Art, Relig & Cult,
New York, 1975. Media: Clay, wood & stone; acrylic,
painting.

ZIMMERMAN, Kathleen Marie. Painter, collage artist.
Born: Floral Park, NY. Study: Art Students League;
Nat Acad Sch Fine Arts. Work: Butler Inst Am Art,
Youngstown, Ohio; Sheldon Swope Art Gallery, Terre Haute,
Ind; Univ Wyo Art Mus, Laramie; Lowe Art Mus, Univ
Miami, Coral Gables, Fla; NC Mus Art, Raleigh; and
others. Exhib: Art USA, 1958; Silvermine Guild, Conn,
1962; Nat Acad Design, 1969 & 1975; one-man show,
Westbeth Gallery, 1973 & 1974 & Am Watercolor Soc, 1975,
New York. Awards: Scholar, John F. & Anna Lee Stacey
Found, 1954; five Prizes, Nat Asn Women Artists, 1957-
72. Media: Oil, acrylic.

ZUCKER, Barbara Marion. Sculptor, instructor. Born:
Philadelphia, Pa., August 2, 1940. Study: Univ Mich,
B.S. (design), 1962, sculpture with Joe Goto & Paul
Suttman; Cranbrook Acad Art, Bloomfield Hills, Mich;
Kokoschka Sch Vision, Salzburg, Austria, 1961. Work:
Whitney Mus Am Art; pvt collections of Lowell Nesbit,
Claes Oldenburg & Kermit Bloomgarten. Exhib: 26
Contemporary Women Artists, Aldrich Mus Art, Ridgefield,
Conn, 1971; one-woman show, Douglass Col, Rutgers Univ,
New Brunswick, NJ, 1973, Focus, Philadelphia Civic Ctr
Mus, 1974 & 112 Greene St Gallery, 1976; Seven Sculptors,
Inst Contemp Art, Boston, 1974. Awards: Hon Soc, Univ
Mich, 1952; Col Art Asn Am, M.F.A., 1975; Nat Endowment
Arts Fel Grant, 1975. Media: Sculpture; organic
abstraction.

ZWICK, Rosemary G. Sculptor, printmaker. Born:
Chicago, Ill., July 13, 1925. Study: Univ Iowa, with
Phillip Guston & Abrizio, B.F.A., 1945; Art Inst
Chicago, with Max Kahn, 1945-47; De Paul Univ, 1946.
Work: Oak Park Libr Collection, Ill; Albion Col Print
Collection, Mich; Rearis Sch Collection, Chicago;
Phoenix Pub Schs Collection, Ariz; Crow Island Sch,
Winnetka, Ill; plus others. Exhib: Art Inst Chicago,
1954-75; Ceramic Nat, Everson Mus Art, Syracuse, NY, 1960,
1962 & 1964; Soc Washington Printmakers, Nat Mus,
Washington, DC, 1964; Mundelein Col, Chicago, 1964-71;
Indianapolis Mus Art, 1970-75. Media: Ceramics.